St. James Guide to

HISPANIC ARTISTS

St. James Guide to

HISPANIC ARTISTS

Profiles of Latino and Latin American Artists

With a Preface by
Fatima Bercht
Chief Curator of El Museo del Barrio

Editor
Thomas Riggs

Published in Conjunction with the Association of
Hispanic Arts and the Association for Latin American Art

ST. JAMES PRESS

GALE GROUP

THOMSON LEARNING

Detroit • New York • San Diego • San Francisco
Boston • New Haven, Conn. • Waterville, Maine
London • Munich

Thomas Riggs, *Editor*

Mariko Fujinaka, Kay Grissom-Kiely, *Associate Editors*
Janice Jorgensen, Stephen Meyer, Sara Olenick, *Contributing Editors*
Robert Rauch, *Senior Line Editor*
Tony Craine, Laura Gabler, Joan Hibler, Amy Tao, Amy Tikkanen, *Line Editors*
Madeline Nager, Tara Spies, Rebecca Stanfel, *Researchers*
Miles Waggener, *Translator*

Margaret Mazurkiewicz, *Project Coordinator*
Erin Bealmear, Joann Cerrito, Jim Craddock, Stephen Cusack, Miranda H. Ferrara, Kristin Hart, Melissa
Hill, Carol A. Schwartz, Christine Tomassini, Michael J. Tyrkus, *St. James Press Staff*

Peter M. Gareffa, *Managing Editor, St. James Press*

Mary Beth Trimper, *Manager, Composition and Electronic Prepress*
Evi Seoud, *Assistant Manager, Composition Purchasing and Electronic Prepress*
Dorothy Maki, *Manufacturing Manager*
Rhonda Williams, *Buyer*

Pamela A. E. Galbreath, *Senior Art Director*

Barbara J. Yarrow, *Manager, Imaging and Multimedia Content*
Dean Dauphinais, *Senior Editor, Imaging and Multimedia Content*
Leitha Etheridge-Sims, Mary K. Grimes, David G. Oblender, *Image Catalogers*
Lezlie Light, *Imaging Coordinator*
Randy Bassett, *Imaging Supervisor*
Robert Duncan, *Senior Imaging Specialist*

Maria L. Franklin, *Manager, Rights & Permissions*
Shalice Shah-Caldwell, *Permissions Associate*

Cover photo: *Tepepul the Fortune Teller,* 1972, by Carlos Mérida. © Christie's Images/Corbis © Estate of Carlos Mérida/Licensed by
VAGA, New York, NY.

Library of Congress Catalog Cataloging-in-Publication Data
St. James guide to Hispanic artists : profiles of Latino and Latin American artists / editor,
Thomas Riggs.
 p. cm.
 "Published in association with the Association of Hispanic Arts and the Association for Latin
American Art."
 Includes bibliographical references and indexes.
 ISBN 1-55862-470-8 (alk. paper)
 1. Hispanic American art-20th century. 2. Hispanic American artists-Biography. I. Title: St. James
guide to Hispanic artists. II. Riggs, Thomas, 1963- III. Association of Hispanic Arts (New York,
N.Y.) IV. Association for Latin American Art.
N6538.H58 S7 2002
704'.0368'00904-dc21
[B] 2001041935

Printed in the United States of America

St. James Press is an imprint of Gale Group
Gale Group and Design is a trademark used herein under license
10 9 8 7 6 5 4 3 2 1

CONTENTS

PREFACE

The *St. James Guide to Hispanic Artists* is being published at a time of unprecedented recognition, in the United States and elsewhere, of the work of Latino and Latin American artists. As this growing and diverse group of artists has attracted more attention, the need for a comprehensive guide has become evident. The guide is not, however, simply an academic exercise. It is an effort to capture the richness and complexity of a remarkable group of artists whose backgrounds are vastly diverse but who share many essential cultural, linguistic, and historical touchstones in the production of their work.

Virtually all of the artists discussed in this guide were born or have worked in Latin America—that is, Mexico, Central America, South America, and the Spanish-speaking islands of the Caribbean—or in the United States. Of the American artists, many were born in Puerto Rico, in the former Spanish colonial territories that now make up the Southwestern states and California, or in Florida or the major urban centers of the East and Midwest, especially New York City and Chicago.

These artists have gained prominence through exhibitions in nonprofit and educational institutions as well as in commercial venues. Their works have been discussed in a broad range of publications, which has helped to make their presence felt in the art world. In the case of contemporary artists, they are increasingly participating in academic life as students and teachers, and they are being commissioned for public works and being sought out by private and institutional collectors. This guide aims to do justice to their wide range of activities and contributions by profiling some of the most prominent Hispanic artists of the past century.

It may be useful to inquire what is meant by the terms Hispanic, Latino, and Latin American, which are used in the title and subtitle of this book. These overlapping, but not equivalent, terms denoting cultural identity are inadequate to capture the diversity of the artists included here, though most of these artists would identify with them to some degree. By the term Hispanic this guide refers to artists whose background and cultural heritage are connected to Latin America—an area linguistically and culturally rooted in the Spanish and, to a much lesser extent, the Portuguese colonial legacy. The term originally derived from the Latin word *Hispania,* the Roman name for the Iberian Peninsula of Spain and Portugal.

For a variety of reasons, including the connection of "Hispanic" to just one part of the cultural background of Latin America, some people prefer the term Latino (which also refers to those of Latin American descent). Some of the artists discussed here identify with their Amerindian heritage—with indigenous cultures whose roots can be traced to 11,000 B.C.E. in North America and to at least 7,000 B.C.E. in parts of South America. Others identify closely with West African cultures, for they are descended from people brought to the New World as slaves. Many Hispanics describe themselves as having multiethnic backgrounds, which provides yet another layer to their complex multicultural indentity.

The Hispanic identity shared by these artists cannot be detached from the particular colonial aspects of their heritage. The Spanish conquest of much of North, Central, and South America and of the Caribbean beginning in 1492 left an imprint on the cultures of these areas. Later, in the nineteenth century, the former Spanish territories of Texas, New Mexico, Arizona, California, and Puerto Rico became part of the United States as a result of military action or acquisition and were subsequently integrated into the broader U.S. culture. Thus, the formation of Hispanic identify has been an ongoing process resulting from immigration and migration, a process that has, with each successive generation, continuously modified the Spanish legacy with complex overlays of European, Indian, African, and homegrown American culture.

It is also important to note that geographical factors have been agents of influence. The terms Hispanic and Latino cast a net over people in countries that stretch from the United States, in the north, to Argentina, at the tip of South America. The vastly different physical geography encompassing these two continents has served to shape culture in dramatic ways. In such disparate physical environments—the plains of Uruguay, the lush tropical islands of the Caribbean, or the high ranges of the Andes—artists have responded by creating different aesthetics. One can see this, for example, in the paintings by Joaquín Torres-Garcia of Montevideo, done in a limited, muted palette, in the Afro-Cuban spirituality of Wifredo Lam, and in the abstract images of Fernando de Szyszlo inspired by the Inca culture of the Andes.

While it is difficult to be all-encompassing, this guide strives to illuminate the achievements of those who have shaped the development of Latino and Latin American art in the twentieth century and who will likely continue to exert great influence. In the Hispanic community, at least through the 1950s, young people with an artistic gift, if it was recognized and approved by his or her family, could pursue and refine their talent through an apprenticeship in the studio of an established artist. Artists such as the Afro-Cuban Agustín Cárdenas were able to study at fine arts academies under the supervision of a local master or painter. The Argentine artist Antonio Berni, on the other hand, was raised in a small town without such schools and was first trained in the craft of making stained glass before getting the opportunity to study painting. Young Latinos living in the United States found their way to workshops or to schools of art affiliated with museums, as was the case with Lorenzo Homar and José Morales.

Although there remain alternative types of apprenticeship in the art world, universities since the 1960s have also become legitimate venues for the training of artists. Masters of fine arts programs have opened the way for many artists to have viable careers. Hispanic youth, however, have continued to face the limited educational opportunities afforded to what is a largely underprivileged community. For most contemporary Latino artists the road to realizing their talents continues to be a solitary path, intersected by exchanges with other artists, friends, teachers, art professionals such as critics, and, as noted above, institutional arts programs. Some in the United States have taken a less isolated route, aligning themselves with collectives of like-minded artists. This is the case with collectives such as the Puerto Rican Taller Boricua in New York City, established in 1970, and with those associated with the Chicano movement—the Royal Chicano Air Force in Sacramento (1968), ASCO in Los Angeles (1971), and Los Four in Los Angeles (1973). These collectives were catalyzed by the U.S. civil rights movements of the 1960s and were inspired by the Mexican muralist movement and the Taller de Gráfica Popular of the postrevolutionary 1930s.

The politics of the artists represented in this guide, especially those working in the United States, encompass a broad range of concerns and passions. Nationalism, ethnicity, gender, and history have all been themes these artists have explored as they look for opportunities to make their work known and to have their voices acknowledged. Among their many contributions have been the establishment of vibrant cultural centers in such cities as San Francisco, Los Angeles, New York, Chicago, and San Antonio during the 1960s and 1970s. These centers, which have continued to flourish, perform the vital function of promoting involvement in and access to the visual and performing arts for communities that are poorly served by mainstream institutions.

Just as it is tempting to use the all-encompassing net of Latino and Latin American artists, so one might presume the existence of an all-encompassing aesthetic. But it is an overstatement to speak of a Latino and Latin American aesthetic. It is more accurate to characterize the immense body of work created by Hispanic artists as a multiplicity of visual syntaxes that have developed in tandem with each artist's aspirations and within the social, cultural, political, and historical contexts in which these artists have worked. One revealing way to demonstrate this diversity is to point out the broad range of themes that are addressed in the works of Latino and Latin American artists: the human figure; the social scene; history; the physical landscape in its various natural, agrarian, urban, and industrial settings; the realms of spirituality, religiosity, and fantasy; and the absence of references to the figurative world, as in the case of abstraction.

The diversity of Hispanic art can also be grasped by considering the many means and techniques deployed, with painting, drawing, printmaking, sculpture, assemblage, photography, video, and spatiotemporal installations being among the most important. The entries in this guide indicate that, even within the career of a single artist, the idiosyncratic path he or she follows over time may develop in distinctly different ways, as, for example, with the Nicaraguan painter Armando Morales, whose lyrical abstractions of the 1960s later gave way to images celebrating the human figure. Another example is Antonio Martorell, a Puerto Rican artist whose visual talents were once conveyed almost exclusively through printmaking but who has since explored another dimension of his aesthetics through the creation of large multimedia installations.

The accomplishments of the 375 artists profiled in the following pages suggest the vitality and complexity of evolving notions of Hispanic identity. The cultural matrix of the Hispanic communities throughout the Americas continues to influence a new generation of artists and to inspire their work in myriad ways. It is hoped that these profiles will help a broader audience to appreciate the dynamics of this exchange and the richness of the creative process in the context of an ever-changing world.

—Fatima Bercht
Chief curator, El Museo del Barrio

EDITOR'S NOTE

The *St. James Guide to Hispanic Artists* contains biographical and career information, as well as brief critical essays, on 375 prominent Latino and Latin American artists of the past century. About two-thirds were alive at the time of publication. Illustrating the book are 256 photographs of entrants and their works.

All the entrants in the book are visual artists. Many are painters and sculptors, but printmaking, photography, video, assemblage, installation, and other media are also represented. Of the entrants, 41 are Caribbean, 29 Central American, 57 Mexican, 131 South American, and 117 American (including those from Puerto Rico). These entrants were selected with the help of our distinguished advisory board. We could not include all the artists recommended to us, but we hope to add more to future editions of the guide.

Of the many challenges in putting together this book, two deserve to be mentioned here. First, as a general term for people of Latin American descent, both Hispanic and Latino are in common use, but only one could be included in our title. Some people object to Hispanic—among other reasons, because it is seen as emphasizing just one aspect, the Spanish colonial legacy, of Latin America. Others prefer the term, finding it more inclusive than Latino. Wishing to offend no one, St. James Press has chosen Hispanic for the title and Latino for the subtitle.

Second, determining the nationality of some entrants, especially those who were born in one country but moved to another, was difficult. We contacted the living entrants, consulted with our advisers and contributors, and did research. We apologize in advance for any error in assigning a nationality to an entrant.

I would like to thank the various people involved in the project, including the 9 advisers and 64 contributors, many of whom spent a great amount of time researching artists for the book. Because of the primary research done for the entries, the *St. James Guide to Hispanic Artists* contains information not available in any other source. I would like to express our gratitude to the artists and galleries that kindly responded to our requests for biographical and career information.

The book's staff deserves recognition for its hard work and commitment: Kay Grissom-Kiely, who, in addition to many other responsibilities, commissioned writers and corresponded with them; Mariko Fujinaka, who oversaw the compilation of the biographical and career sections, reviewed text for errors, and headed many day-to-day organizational tasks; Sara Olenick, who helped compile the biographical and career sections; Janice Jorgensen, who reviewed text for errors; Robert Rauch, who, in addition to editing many of the essays, helped plan and oversee the editing of the text; Tony Craine, Laura Gabler, Joan Hibler, Amy Tao, and Amy Tikkanen, who edited essays; Tara Spies, Madeline Nager, and Rebecca Stanfel, whose research for the book proved essential; Stephen Meyer, who conducted research, edited text, and, with the suggestions of the advisers, compiled the bibliography; Miles Waggener, who translated essays submitted in Spanish; and Margaret Mazurkiewicz, who, as the project coordinator, handled the many in-house responsibilities, including the acquisition of photographs and the proofreading. I appreciate the support and patience of Margaret and others at St. James Press.

Finally, I would like to thank the Association of Hispanic Arts, which was involved with the book from the beginning and helped organize the advisory board; and the Association for Latin American Art, which helped identify appropriate writers for the essays. This guide is being published in association with these organizations, and it is hoped that the affiliation with them expresses our commitment to the field of Hispanic, or Latino and Latin American, art.

—Thomas Riggs
Editor

ADVISERS

Jacqueline Barnitz
Professor of Latin American Art History
University of Texas at Austin

Roberto Bedoya
Executive Director
National Association of Artists' Organizations
Washington, D.C.

Fatima Bercht
Chief Curator
El Museo del Barrio
New York, New York

Pablo Martínez
Artistic Director
Guadalupe Cultural Arts Center
San Antonio, Texas

Gerardo Mosquera
Adjunct Curator
New Museum of Contemporary Art
New York, New York

Marysol Nieves
Senior Curator
Bronx Museum of the Arts
Bronx, New York

Virginia Pérez-Ratton
Director Founder
TEOR/éTica
San José, Costa Rica

Carolina Ponce de León
Executive Director
Galería de la Raza
San Francisco, California

Edward J. Sullivan
Chairman of Department of Fine Arts
New York University

CONTRIBUTORS

Susan Aberth
Erin Aldana
Eliud Alvarado Rodríguez
Alejandro Anreus
Rocío Aranda-Alvarado
Carrie Barker
Konstantin Bazarov
Jane Bell
Marimar Benítez
Francine Birbragher
Anne Byrd
Deborah Caplow
Mario A. Caro
Rosina Cazali
H. Rafael Chácon
Sally Cobau
Laura J. Crary
David Craven
Carol Damian
Gerard Dapena
Elizabeth Ferrer
Miki Garcia
Nora Garcia
Jorge Glusberg
Jennifer Gonzalez
Julieta González
Michele Greet
Kay Grissom-Kiely
Salvador Güereña
Martha Gutiérrez-Steinkamp
Alicia Haber
James G. Harper
Mary Hebert
Amy Heibel
Pablo Helguera
Gabriela Hernández-Lepe
Marianne Hogue

Judith Huacuja-Pearson
Luiza Interlenghi
Hitomi Iwasaki
Kaytie Johnson
Andrea Kalis
Graciela Kartofel
Monica E. Kupfer
Daniel Lahoda
Glenda Leon
Marcelo Guimarães Lima
Dominique Liquois
Adrian Locke
Vivianne Loría
Andree Maréchal-Workman
Susan N. Masuoka
David Maulen
Lola McDowell
Christine Miner Minderovic
Linda A. Moore
Tariana Navas-Nieves
Elena Pellegrini
Virginia Pérez-Ratton
William H. Robinson
José Roca
Susan Merrill Rosoff
Horacio Safons
Adrienne Samos
Jerry A. Schefcik
John F. Scott
Rebecca Stanfel
Martha Sutro
Sean M. Ulmer
Haydee Venegas
G. S. Whittet
Stacie G. Widdifield
Raúl Zamudio

St. James Guide to

HISPANIC ARTISTS

LIST OF ENTRANTS

Eduardo Abela
Rodolfo Abularach
Laura Aguilar
Regina Aguilar
Olga Albizu
Brooke Alfaro
Juana Alicia
Carlos D. Almaráz
Julio Alpuy
Lola Álvarez Bravo
Manuel Álvarez Bravo
Celia Alvarez Muñoz
Francis Alÿs
Jesse Amado
Francisco Amighetti
Raúl Anguiano
Nemesio Antúñez
Débora Arango
Felipe B. Archuleta
Carmelo Arden Quin
Santiago Armada
Dr. Atl
David Avalos
Margarita Azurdia

Judith F. Baca
Myrna Báez
José Balmes
Patrociño Barela
Rafael Barradas
Luis Barragán
Santa Barraza
Moisés Barrios
Jacques Bedel
José Bedia
Patricia Belli
Luis F. Bénedit
Cundo Bermúdez
Antonio Berni
Adolfo Best Maugard
Juan Manuel Blanes
Olga Blinder
Marcelo Bonevardi
Arturo Borda
Jacobo Borges
Norah Borges
Angel Botello
Fernando Botero
Claudio Bravo
Rolando Briseño
Francisco Brugnoli
Tania Bruguera

Waltércio Caldas
Miguel Calderón
Sérgio de Camargo
Enrique Camino Brent
Luis Camnitzer
María Magdalena Campos-Pons
Benjamín Cañas
Noé Canjura
Carlos Capelán
Tony Capellán
Agustín Cárdenas
Santiago Cárdenas
María Fernanda Cardoso
Antonio Caro
Barbara Carrasco
Mario Carreño
Charlie Carrillo
Lilia Carrillo
Leonora Carrington
Josely Carvalho
Mel Casas
Rolando Castellòn
Amílcar de Castro
Enrique Castro-Cid
Emiliano di Cavalcanti
Enrique Chagoya
Jean Charlot
José Chávez Morado
Wilfredo Chiesa
Lygia Clark
Elena Climent
Carlos Collazo
Guillermo Collazo
Rafael Colón Morales
Jaime Colson
Eduardo Costa
Miguel Covarrubias
Mário Cravo Neto
Luis Cruz Azaceta
Carlos Cruz-Diez
Germán Cueto
José Luis Cuevas
José Cúneo

Jaime Davidovich
Juan Dávila
Olga de Amaral
Ernesto Deira
Irene Delano
Jack Delano
Jorge Luis de la Vega
Isabel De Obaldía
Fernando de Szyszlo

Marius de Zayas
Antonio Dias
Cícero Dias
Gonzalo Díaz
Eugenio Dittborn
Tarsila do Amaral
Juan Downey
Arturo Duclós

Camilo Egas
Antonia Eiriz
Sandra Eleta
Juan Francisco Elso
Carlos Enríquez

Fernando Fáder
Manuel Felguérez
Agustín Fernández
Arístides Fernández
Lola Fernández
Teresita Fernández
Gabriel Fernández Ledesma
Rafael Ferrer
Pedro Figari
Ever Fonseca
Gonzalo Fonseca
Lucio Fontana
Ramón Frade
Antonio Frasconi
Ismael Frigerio

Julio Galán
Daniel Galvez
Diane Gamboa
Harry Gamboa, Jr.
Carlos Garaicoa
Rupert García
Arturo García Bustos
Gego
Gunther Gerzso
Mathias Goeritz
Francisco Goitía
Guillermo Gómez-Peña
Juan Gómez Quiróz
Beatríz González
Juan Francisco González
María Elena González
Jorge González Camarena
Luis González Palma
Felix Gonzalez-Torres
Robert Graham
Enrique Grau
Victor Grippo
Gronk
Sylvia Gruner
Oswaldo Guayasamín
Jesús Guerrero Galván
Cecilio Guzmán de Rojas

Ester Hernández

Luis Hernández Cruz
José Antonio Hernández-Diez
Saturnino Herrán
Willie Herrón III
Lorenzo Homar
Salomón Huerta

Carlos Irizarry
Graciela Iturbide
María Izquierdo

Alfredo Jaar
Luis Jiménez
Marisel Jiménez
Max Jiménez
Roberto Juárez

Frida Kahlo
Leandro Katz
Kcho
Eduardo Kingman
Gyula Kosice
Guillermo Kuitca

Wifredo Lam
Julio Larraz
Agustín Lazo
Ricardo Legorreta
Jac Leirner
Leonilson
Julio Le Parc
Pedro Linares
Benjamin Lira
Guido Llinás
Carmen Lomas Garza
Alma López
Cándido López
Yolanda M. Lopez
Marcos Lora Read
Los Carpinteros
Richard A. Lou
Gilbert ''Magu'' Luján
Pedro Lujan
James Luna

Rómulo Macció
Eduardo MacEntyre
Estuardo Maldonado
Tomás Maldonado
Anita Malfatti
Iñigo Manglano-Ovalle
Víctor Manuel
Ralph Maradiaga
Marisol
César Martínez
Daniel J. Martinez
Raúl Martínez
María Martínez-Cañas
Maria Martins
Antonio Martorell

Roberto Matta
Alejandro Mazón
Cildo Meireles
Xenia Mejía
Leopoldo Méndez
Ana Mendieta
Manuel Mendive
Carlos Mérida
Amalia Mesa-Bains
Pedro Meyer
Marta Minujín
Tina Modotti
Pablo Monasterio
Priscilla Monge
Roberto Montenegro
José Montoya
Malaquías Montoya
Armando Morales
José Morales
Vik Muniz
Óscar Muñoz

Edgar Negret
Manuel Neri
Ernesto Neto
Luis Noé
Marina Núñez

Alejandro Obregón
Juan O'Gorman
Pablo O'Higgins
Hélio Oiticica
Francisco Oller
María de Mater O'Neill
Gabriel Orozco
José Clemente Orozco
Mario Orozco Rivera
Rafael Ortiz
Pepón Osorio
Nadín Ospina
Alfonso Ossorio
Alejandro Otero

María Luisa Pacheco
Lygia Pape
Diógenes Paredes
Luis Paredes
Catalina Parra
César Paternosto
Amelia Peláez
Amado M. Peña, Jr.
Umberto Peña
Alicia Peñalba
Marta María Pérez Bravo
Emilio Pettoruti
Jorge Pineda
Marcelo Pogolotti
Fidelio Ponce
Ricardo Porro
Liliana Porter

Cándido Portinari
René Portocarrero
José Guadalupe Posada
Miguel Pou
Ernesto Pujol

Nick Quijano
Alfred J. Quiróz

Raquel Rabinovich
Belkis Ramírez
Mel Ramos
Nelsón Ramos
Armando Rascón
Rosângela Rennó
José Resende
Armando Reverón
Fermín Revueltas
Adolfo Riestra
Miguel Angel Rios
Carlos Raquel Rivera
Dhara Rivera
Diego Rivera
Arnaldo Roche
Francisco Rodón
Juan Luis Rodríguez
Mariano Rodríguez
Patricia Rodríguez
Angel Rodríguez-Díaz
Carlos Rojas
Miguel Rojas
Leopoldo Romañach
Frank Romero
José Rosa
Julio Rosado del Valle
Melquíades Rosario
Lotty Rosenfeld
Alfredo Rostgaard
Julio Ruelas
Antonio "El Corcito" Ruíz
Isabel Ruíz
Noemí Ruiz

José Sabogal
Soledad Salamé
Bernardo Salcedo
Doris Salcedo
Osvaldo Salerno
Emilio Sánchez
Juan Sánchez
Juan Manuel Sánchez
Robert Sanchez
Fanny Sanín
Mira Schendel
Lasar Segall
Antonio Seguí
Daniel Senise
Andrés Serrano
Regina Silveira
David Alfaro Siqueiros

Ray Smith
Orlando Sobalvarro
Jesús Rafael Soto
Bibiana Suárez
Pablo Suárez
Darío Suro

Enrique Tábara
Jorge Tacla
Rufino Tamayo
Luis Eligio Tapia
Clorindo Testa
Francisco Toledo
Tonel
Mario Toral
Rigoberto Torres
Salvador Roberto Torres
Joaquín Torres-García
Rúben Torres Llorca
Guillermo Trujillo
Tilsa Tsuchiya
Nitza Tufiño
Rafael Tufiño
Tunga

Gastón Ugalde

Meyer Vaisman
John Valadez
Roberto Valcárcel
Patssi Valdez
Leonel Vanegas
Adriana Varejão
Kathy Vargas
Remedios Varo
Regina Vater
José María Velasco
Humberto Vélez
Germán Venegas
Cecilia Vicuña
Jorge Vinatea Reinoso
Oswaldo Viteri
Alfredo Volpi

Liliana Wilson-Grez

Alejandro Xul Solar

Julio Zachrisson
David Zamora Casas
Nahum B. Zenil
Carlos Zerpa
Francisco Zúñiga

ABELA, Eduardo

Cuban painter

Born: San Antonio de los Baños, 1889. **Education:** Academia de San Alejandro, 1912; Académie de la Grande Chaumière, Paris, 1927–29. **Career:** Lived in Spain, 1921–24; visited Paris, 1927. Director, Free Studio of Painting and Sculpture, Havana, 1937; Cuban cultural attache, to Mexico, 1942–46, to Guatemala, 1947–52. Created the cartoon character *El Bobo,* which appeared in *El Diario de la Marina,* Havana, 1930–34. Member, *Grupo Minorista,* Havana, *ca.* 1924. **Awards:** Prizes, National Salons, 1938, 1956. **Died:** 1965.

Individual Exhibitions:

1924	Galería de Arte, Madrid
1929	Galerie Zak, Paris
1955	*14 oleos de Eduardo Abela en su primer aniversario,* Galería Cubana, Havana
1964	Galería de la Habana, Havana (retrospective)

Abela humorando, Galería UPEC, Cuba; *Dos propuestas para ti,* Galería La Rama Dorada, Panama; *Tres generaciones Eduardo Abela,* Domingo Padrón Art Gallery, Coral Gables, Florida; *Triple A,* Galería La Acacia, Cuba; *Feria internacional de arte contemporáneo,* Arte + Sur, Granada.

Selected Group Exhibitions:

Tesis, Galería Francisco Javier Báez, Cuba; Galería Guerrero, Bienal de la Habana; *Jóvenes del Taller Experimental de Gráfica mutua ilicitana,* Elche, Spain; *IV gran subasta de excelencias,* Fundación San Felipe, Panama; Feria de Arte Moderno, Mexico; *Exposición colectiva de grabado,* Galería Concha Ferrán, Cuba; *Cien años de pintura cubana,* UNESCO, Centro Universitario Mediterráneo, France; *Cuban Masters & Young Artists Living in Cuba Today,* Delray Beach, Florida.

Publications:

On ABELA: Books—*El Bobo: Ensayo sobre el humorismo de Abela* by Enrique Gay-Calbó, Havana, Ucar García, 1949; *Abela . . . ,* Havana, Instituto Nacional de Cultura, 1956, and *14 oleos de Eduardo Abela en su primer aniversario,* exhibition catalog, Havana, Galería Cubana, 1955, both by Loló de la Torriente; *Abela: Exposición retrospectiva,* exhibition catalog, by Alejo Carpentier, Havana, Galería de la Habana, 1964; *Hacerse el Bobo de Abela* by Adelaida de Juan, Havana, Editorial de Ciencias Sociales, 1978; *Eduardo Abela, cerca del cerco* by José Seoane Gallo, Havana, Editorial Letras Cubanas,

1986; *Abela: Dibujos de Eduardo Abela,* with text by Pedro de Oraá, Havana, Unión de Escritories y Artistas de Cuba, 1987; *Hijos de su tiempo: Once pintores mayores de Cuba* by Juan Sánchez, Havana, Publicigraf, 1994.

* * *

Eduardo Abela was a major figure in the first generation of Cuban modernists of the twentieth century. A painter, political activist, diplomat, and teacher, he played a principal role in transforming the visual arts of the island nation. His work was responsive to major trends in modernism, including surrealism and social realism, but, like Carlos Enríquez, Víctor Manuel, Fidelio Ponce de León, Amelia Peláez, and others of his generation, he was also preoccupied with forging a union between modernist aesthetics and the Cuban cultural ethos.

Born in San Antonio de los Baños, Abela spent his early years as a worker in a tobacco plant. In 1912 he entered the Academy of San Alejandro in Havana and also began working as an illustrator for newspapers. In 1921 he traveled to Spain and three years later had his first solo exhibition at the Galería de Arte in Madrid.

Upon returning to Cuba in 1924, Abela became active in Grupo Minorista, Havana's avant-garde, a movement that rejected academic realism and the elite system of patronage that had operated in the country since independence at the turn of the century. He also continued his activities as a political cartoonist and in the next decade actively criticized the dictatorship of Pres. Gerardo Machado (1924–33). Like the nineteenth-century cartoonists Honoré Daumier and José Guadalupe Posada, Abela created a character, El Bobo (The Idiot), to satirize the corruption of the regime. In the mid-1920s he was also active in the modernist publication *Revista de Avance* and exhibited in the *Exposición de Arte Nuevo,* the great exhibition of modern art held in Havana in 1927. He traveled to Paris in that year and continued to draw and paint throughout the late 1920s and early 1930s. In 1928 he completed an early masterpiece, *El triunfo de la tumba* (''The Triumph of Rumba''), a painting of a woman dancing. Its swirling composition and vibrant colors evoke the percussive rhythms of Afro-Cuban dance and music. The work signaled an acknowledgment of the contribution of African slaves and their descendants to Cuban culture.

After the toppling of Machado in 1933, Abela took a post as the Cuban consul in Milan. He took advantage of his position to study Italian art of the early Renaissance as well as the modern movements of cubism, surrealism, and futurism. His position came to an end when he returned to Cuba to assume the directorship of the Estudio Libre de Pintura y Escultura in 1937. This experimental school, modeled after a Mexican institution, accepted students free of charge, did not discriminate in terms of sex, race, or class, and was guided by principles of artistic freedom and exploration.

Abela admired both the aesthetics and the politics of the Mexican muralist movement, particularly the work of Diego Rivera, whom

he had befriended. Abela's paintings from his ''classical,'' or ''creole,'' period are reminiscent of Rivera's style and subjects. His well-known *Guajiros* of 1938 depicts an intimate group of Cuban campesinos (peasants), dressed for a party and gathered around their fighting cocks in a rural setting. The concentration on folk characters, rendered in geometric simplicity, can be read as either a step back to earlier themes in Cuban art or as an integration of more social realist aesthetics into his work.

Abela resumed his diplomatic career in 1942, taking posts in Mexico and Guatemala. Although he did not produce much art during World War II and the years immediately after, in 1950 he launched yet another successful phase of his career, one that lasted until his death in 1965. He began a series of small semiabstract paintings featuring images of children and of birds and other animals in fantastic settings. The delicate figures, inhabiting surrealist spaces, are rendered in an almost iconic fashion, like those of prehistoric paintings, and seem to allude to a private mythology or to the realm of childhood dreams and innocence. Abela continued to travel to Europe in the 1950s, and he received numerous national and international awards for his painting. A major retrospective of his work was held in Havana in 1964, the year before his death.

—H. Rafael Chácon

ABULARACH, Rodolfo
Guatemalan painter, sculptor, and graphic artist

Born: Marco Antonio Rodolfo Abularach, Guatemala City, 7 January 1933. **Education:** San Carlos University, Guatemala City, 1950, 1954; Pasadena City College, California, 1953; National School of Fine Arts, Guatemala City, 1954; Art Student's League, New York, 1958; Pratt Graphic Art Center, New York, 1962–64; Tamarind Lithograph Workshop, Los Angeles, 1966. **Career:** Drawing and painting instructor, National Art School, Guatemala City, 1956–57; graphics instructor, University Rodrigo Facio, San Jose, Costa Rica, 1976; graphics professor, Taller Novo Arte, Bogota, 1982, 1983; member of the intervention, 1998–99, director, 2000–01, National Art School, Guatemala City. **Awards:** Second prize in painting, 1956, first prize in painting, 1957, first honorable mention, 1959, *Certámen centroaméricano,* Guatemala City; Simon Guggenheim Foundation grant, 1959, 1960; prize in drawing, *V Biennial,* São Paulo, 1959; first prize in painting, *Certámen nacional de cultura,* El Salvador, 1959; prize in drawing, New York University, 1961; honorable mention, Central American Art Exhibition, Guatemala City, 1962; first prize in drawing, *Arte actual de américa y españa,* Madrid, 1963; first prize in painting, *Salón esso de jóvenes artistas,* El Salvador, 1965; first prize in drawing, Central University, Caracas, 1967; prize in graphics, Postdam College, New York, 1969; prize in graphics, Zegri Gallery, New York, 1969; first prize in drawing, *IX Art Festival,* Cali, Colombia, 1969; prize in graphics, Dulin Gallery, Knoxville, Tennessee, 1969, 1970; prize in graphics, Silvermine Guild of Artists, Connecticut, 1970; ''Relaciones Exteriores'' prize, *Biennial of American Graphics,* Santiago, 1970; first prize in drawing, *National Drawing Exhibition,* San Francisco Museum of Art, 1970; first prize in drawing, *Panamerican Exhibition of Graphic Arts,* Cali, Colombia, 1970; prize in graphics, University of Atlanta, 1971; prize in graphics, *IV International Exhibition of Miniature Graphics,* New York, 1971; prize in graphics, *II Biennial of Latinoamerican Graphics,* San Juan,

Puerto Rico, 1974; prize in graphics, *Ibizagrafic,* Museum of Contemporary Art, Ibiza, Spain; prize in graphics, Siskiyous College, California, 1975; prize in graphics, *I Biennial of American Graphics,* Venezuela, 1977; special edition prize and award of merit, *III International Biennial,* World Print Council, San Francisco, 1980; silver medal, *Latin American Biennial,* Buenos Aires, 1987; first prize in graphics, *55th International Miniature Art Exhibition,* Miniature Society of Washington, D.C., 1988, 1989; third prize in painting, *16th International Miniature Art Exhibition,* Miniature Society of Florida, 1990; best of show, *Miniature National Exhibition,* Laramie Art Guild, Wyoming, 1991. **Agent:** Clara Diament Sujo, C.D.S. Gallery, 76 East 79th Street, New York, New York 10021, U.S.A. **Address:** 14 West 17th Street, Apartment 4S, New York, New York 10011, U.S.A., or 18 Av. A, 0–63, VH2, Zona 15, Guatemala City, Guatemala.

Individual Exhibitions:

1947	Sala Nacional de Turismo, Guatemala City
1954	Arcada Gallery, Guatemala City
1957	Escuela Nacional de Artes Plásticas, Guatemala City
1959	Pan American Union, Washington, D.C.
1961	David Herbert Gallery, New York
1966	Sala Luis Angel Arango, Bank of the Republic, Bogota
1967	Schaefer-Díaz Gallery, Guatemala City
1969	Bucholz Gallery, Munich
1970	Colibri Gallery, San Juan, Puerto Rico
	Vertebra Gallery, Guatemala City
	Graham Gallery, New York
	San Carlos University of Guatemala, Guatemala City
	Pyramid Gallery, Washington, D.C.
1971	San Diego Gallery, Bogota
1972	Westbeth Gallery, New York
1973	Museum of the University of Puerto Rico
	Sala Estudio Actual, Caracas
	Mendoza Foundation Gallery, Caracas
1974	Museum of Modern Art, Bogota
	La Tertulia Museum of Modern Art, Cali, Colombia
	Macondo Gallery, Guatemala City
	National School of Plastic Arts, Cultural Center, Guatemala City
	Pecanis Gallery, Mexico City
	Forma Gallery, San Salvador
1975	Twentieth Century Gallery, Quito, Ecuador
	Briseno Gallery, Lima
	Center of Current Art, Pereira, Colombia
1976	Echandi Gallery, Ministry of Culture, San Jose, Costa Rica
	Forma Gallery, San Salvador
	Tague Galle, Managua, Nicaragua
	Quintero Gallery, Baranquilla, Colombia
	Estructura Gallery, Panama City
	Alternative Center for the Arts, New York
1977	Current Art of Iberoamerica, Madrid
	Artes Gallery, Quito, Ecuador
1978	San Diego Gallery, Bogota
	El Túnel Gallery, Guatemala City
	University of Medellin

Rodolfo Abularach: *Aparición.* **Photo courtesy of the artist.**

Quintero Gallery, Barranquilla, Colombia
1979 La Galería, Quito, Ecuador
El Túnel Gallery, Guatemala City
1980 Partes Gallery, Medellin
1981 Rayo Museum, Roldanillo, Colombia
Moss Gallery, San Francisco
EMUSA Gallery, La Paz, Bolivia
Arte 80 Gallery, Panama City
1982 Center of Current Art, Pereira, Colombia
Borjeson Gallery, Malmo, Sweden
Worshop Gallery, La Tertulia Museum of Modern Art,
 Cali, Colombia
Atenea Gallery, Barranquilla, Colombia
Siete, Siete Gallery, Caracas
1983 Diner Gallery, Bogota
Etcetera Gallery, Panama City
1984 El Túnel Gallery, Guatemala City
1985 1–2–3 Gallery, San Salvador
Ixchel Museum, Guatemala City
1986 House of Culture Gallery, Santa Cruz, Bolivia

National Museum of Art, La Paz, Bolivia
Portales Cultural Center, Cochabamba, Bolivia
Epoca Gallery, Santiago
1988 Patronato de Bellas Artes Gallery and El Túnel Gallery,
 Guatemala City
1989 Patronato de Bellas Artes Gallery and El Túnel Gallery,
 Guatemala City
1991 El Túnel Gallery and Plástica Contemporánea Gallery,
 Guatemala City
Art Miami 91, Miami
1992 Rayo Museum, Roldanillo, Colombia
Brattlebord Museum, Art Center, Vermont
1994 Museum of Contemporary Art, Panama City
1996 *Sculptures of Rodolfo Abularach,* El Attico Gallery,
 Guatemala City
1997 Galería Valanti, San Jose, Costa Rica
Museo Paiz de Arte Contemporáneo, Guatemala City
1998 Aldo Castillo Gallery, Chicago
1999 C.D.S. Gallery, New York
2000 Ixchel Museum, Guatemala City

Rodolfo Abularach: *Volcan Herido.* Photo courtesy of the artist.

Selected Group Exhibitions:

1958	*Pan American Exhibition,* Milwaukee Art Center
1959	*The United States Collects Latin American Art,* Art Institute of Chicago
1960	Museum of Modern Art, New York
1966	*Art of Latin America since Independence,* Yale University, New Haven, Connecticut, and University of Texas, Austin
1970	*The Inflated Image,* Museum of Modern Art, New York
1974	*Latinamerican Graphics,* Museum of Modern Art, Center for Interamerican Relations, New York
1988	*Latin American Biennial of Graphics,* Museum of Contemporary Hispanic Art, New York
1989	*The Latin American Spirit: Art & Artists in the United States, 1920–1970,* Bronx Museum, New York
1990	*Masters of Guatemalan Painting,* El Túnel Gallery, Guatemala City
1997	*Guatemalan Art,* Organization of American States, Washington, D.C.

Collections:

Museum of Modern Art, New York; Metropolitan Museum of Art, New York; Brooklyn Museum of Art, Brooklyn, New York; Los Angeles County Museum of Art; Museum of the Americas, Washington, D.C.; Museum of Graphic Art, Cairo; Museum Cuevas, Mexico City; Dirección General de Bellas Artes, Guatemala City; Philadelphia Museum of Art; Museum of the University of Puerto Rico, San Juan; Museum Rayo Roldanillo, Colombia; Museo de Arte Moderno, Medellin; Sala Luis Angel Arango, Bogota; High Museum of Art, Atlanta; Museo de Arte Moderno, Bogota; Museo de Bellas Artes, Caracas; San Francisco Museum of Art; Museo de Arte Moderno, Guatemala City; Milwaukee Art Center; El Museo del Barrio, New York; Museo de Arte Contemporáneo, Panama; University of Texas, Austin.

Publications:

On ABULARACH: Books—*Rodolfo Abularach,* exhibition catalog, text by Paula Dunaway Schwartz, New York, David Herbert Gallery, 1961; *Rodolfo Abularach, artista testimonial* by Roberto Cabrera, Guatemala, Ministerio de Educación, 1974; *Rodolfo Abularach,* exhibition catalog, Cali, Colombia, Museo de Arte Moderno, 1974; *Rodolfo Abularach,* exhibition catalog, text by Bélgica Rodríguez, n.p., Taller de Ediciones Don Quijote,1993; *Rodolfo Abularach oleos,* exhibition catalog, text by Pedro Luis Prados, Panama, Museo de Arte Contemporáneo de Panama, 1994; *Homage Exhibition to Rodolfo Abularach,* exhibition catalog, text by Roberto Cabrera Padilla, Guatemala City, Museo Paiz de Arte Contemporáneo, 1997; *Guatemala: Arte contemporáneo* by Luz Méndez de la Vega, Roberto Cabrera, and Thelma Castillo Jurado, Guatemala City, Fundación G&T, 1997.

* * *

Rodolfo Abularach was born in Guatemala City in 1933. His first exhibition took place at the Sala Nacional de Turismo de Guatemala in 1947, when he presented a series of paintings that were the result of two years of work on bullfighting themes. In 1953 he moved to Mexico. Once back in Guatemala, he was introduced to the formal experimentation of modern art. His early works closely followed the formulas of Guatemalan artists such as Carlos Mérida, Arturo Martínez, and Roberto Ossaye, and he adopted ideas that were stimulating the creation of American art. He divided his time as a teacher of drawing and painting between the Escuela Nacional de Artes Plásticas and the Instituto Guatemalteco Americano. In 1958 he received a scholarship to study engraving at the Art Students League in New York City. As he settled in New York, the Museum of Modern Art acquired one of his works for its collection.

A year later José Gómez Sicre, the director of the Pan-American Union, invited Abularach to show his work at the organization's headquarters in Washington, D.C. In addition, Abularach represented Guatemala in the Bienal de São Paulo, receiving an award in the category of drawing. Shortly afterward he received a grant from the Guggenheim Foundation, as well as from the Organization of American States, which allowed him to continue his studies in engraving at the Pratt Graphic Art Center in New York from 1962 to 1964.

The year 1966 became one of the most important in the artist's career. At a time when Latin American engraving was beginning to enjoy popularity, the Tamarind Lithograph Workshop of Los Angeles invited Abularach to study there. This professional experience allowed him to discover the potential of the eye as an image, especially its symbolic possibilities. By 1968 the numerous works featuring

Abularach's images of eyes began to receive international recognition. For an extended period the artist obsessively insisted on exploring this theme, and the eyes of Abularach became a kind of personal trademark. He began to think of them as objects of focus and as a container for all possible meanings. Rendered with extreme care and detail in oil and especially in metal engravings, the eyes began to become independent of the body, transformed into cyclops characters with lives of their own.

During the 1980s Abularach began to expand his repertoire and to work on a new series entitled *Paisajes oníricos,* which culminated in the exhibition *Infernos y Erupciones,* a series of oil paintings of volcanic eruptions. He also has experimented with sculpture by engraving directly on hard surfaces.

—Rosina Cazali

AGUILAR, Laura
American photographer

Born: San Gabriel, California, 1959. **Education:** East Los Angeles Community College; Friends of Photography Workshop; Santa Fe Photographic Workshop, New Mexico. **Career:** Curator, Los Angeles. Artist-in-residence, Light Works, Syracuse, New York, 1993, California Arts Council, 1991, 1993, and ArtPace, San Antonio, Texas, 1999. **Awards:** Brody Arts fellowship, 1992, and J. Paul Getty grant, 1998, California Community Foundation, Los Angeles, 1992; Artist's Project grant, LACE, Los Angeles, 1991; fellowship, California Arts Council, Los Angeles, 1994; James D. Phelan Art award, San Francisco Foundation, 1995; artist grant, Los Angeles Cultural Affairs Department, 2000; Anonymous Was a Woman award, New York, 2000.

Individual Exhibitions:

1986	*The Black & White of It All: Portraits by Laura Aguilar,* Los Angeles Photography Center
1989	*The Photography of Laura Aguilar,* LACE, Los Angeles
	The World around Me—Black & White Photography of Laura Aguilar, Los Angeles City Hall Bridge Gallery
1990	Highways Performance Space Gallery, Los Angeles (with Joe Smoke)
1996	*Tangible Realities,* Women's Center Gallery, University of California, Santa Barbara (with Esther Hernandez)
1997	*Shifting Terrains: Laura Aguilar and Maxine Waters,* Zone Gallery, Newcastle, England
1998	*El jo divers,* Fundacio la Caixa, Barcelona, Spain
1999	ArtPace, San Antonio, Texas
2000	*Stillness & Motion,* Susanne Vielmetter Los Angeles Projects
	Galerie Kaempf, Zurich, Switzerland

Selected Group Exhibitions:

1986	*Seven Latin Photographers,* Self Help Graphics, Los Angeles
	Women Photographers in America 1987, Los Angeles Municipal Art Gallery
1988	*Contemporary Latin Photography,* Los Angeles Photography Center
1992	*Breaking Barriers: Revisualizing the Urban Landscape,* Santa Monica Museum of Art, California
1994	*Bad Girls,* New Museum of Contemporary Art, New York
1995	*Temporarily Possessed: The Semi-Permanent Collection,* New Museum of Contemporary Art, New York
	P.L.A.N.—Photography Los Angeles Now, Los Angeles Museum of Art
1997	*Sunshine & Noir—Art in L.A. 1960–1997,* Louisiana Museum of Modern Art, Humlebaek, Denmark (traveled to University of California, Los Angeles)
	American Voices: Latin Photographers in the United States, Smithsonian Institution, Washington, D.C.
2000	*Made in California,* Los Angeles County Museum of Art

Publications:

By AGUILAR: Books—*LACPS and LAPC Present the Visual Statement: Contemporary Photography Lecture Series,* with Jorge Daniel Veneciano, Los Angeles, LACPS, LAPC, 1991; *Portraiture: Front, Back & In-Between,* exhibition catalog, Pasadena, California, Armory Center for the Arts, 1999.

On AGUILAR: Books—*L.A. Iluminado: Eight Los Angeles Photographers,* exhibition catalog, text by Glenna Avila, Los Angeles, Otis/Parsons Gallery, 1991; *Chicano and Latino Artists of Los Angeles* by Alejandro Rosas, Glendale, California, CP Graphics, 1993; *Pervert: Laura Aguilar,* exhibition catalog, text by Catherine Lord, Irvine, California, University of California, Irvine, 1995; *Lesbian Art in America: A Contemporary History* by Harmony Hammond, New York, Rizzoli, 2000. **Articles**—''Profile: Laura Aguilar'' by Diana Emery Hulick, in *Latin American Art,* 5(3), 1993, pp. 52–54; ''Other Bodies'' by Claudine Isé, in *Artweek,* 26, July 1995, p. 17; ''Laura Aguilar and Maxine Walker'' by Mark Little, in *Creative Camera* (United Kingdom), 345, April/May 1997, p. 44; ''Black and White in Technicolour'' by Franco Fanelli, in *Art Newspaper,* 9(81), May 1998, p. 16; ''Bodies and Subjects in the Technologized Self-Portrait: The Work of Laura Aguilar'' by Amelia Jones, in *Aztlan* (Los Angeles), 23(2), fall 1998, p. 203; ''Laura Aguilar at Susanne Vielmetter Los Angeles Projects'' by Victoria Martin, in *Artweek,* 31(5), May 2000, p. 24.

* * *

Laura Aguilar is a photographer who invents possibilities for portraiture. She composes her images, as do conventional portraitists, in order to document the lives of her sitters. But unlike traditional portraits, her images do not attempt to summarize a subject's history. Her pictures, instead, emphasize a state of being captured at the moment in which her subject poses for the camera, the moment in which an identity is being performed for the camera. It is this emphasis on the momentary pose that makes her representations not merely records of personal histories, but declarations of identity.

Aguilar has been exhibiting work since the mid-1980s. From the start her photographs have been concerned with addressing issues of

race, gender, and sexuality. These are aspects of identity that are mediated by dominant notions of what is considered normal. They are also parts of one's identity that are often negotiated within the visible realm. Through her photographic work, Aguilar makes visible identities otherwise relegated to invisibility.

An important aspect of Aguilar's work is her depiction of relationships. Her images capture the kind of intimacy that is seen between friends, couples, or family members. In her series *Clothed/ Unclothed* (1990) these bonds are expressed through body language. The subjects are shown in two states, dressed and undressed, but these different moments are stabilized through their gestures of love. Aguilar's photographs can also convey the connection between her subjects and their community. Her *Plush Pony* series of 1992, for example, represents women who frequented the Plush Pony, a Latina lesbian bar in Los Angeles. In these images not only the poses but also the fact that they were produced as a series help communicate a sense of a community in which coherence is based on shared gender, sexual, and ethnic identities.

One reason for Aguilar's success in portraying the relationships of her sitters is that she shares many of their frustrations with how identities are normalized. She addresses these frustrations through her production of self-portraits. Aguilar identifies as Chicana, which according to normative notions of race places her, as a light-skinned Mexican-American, somewhere between the whiteness imagined for Euro-Americans and the brownness that Latin Americans are expected to have. *Three Eagles Flying* (1990) is an image in which she represents herself as being located literally between Mexico and the United States, national identities she constantly traverses. The triptych consists of two panels with the flags from each nation flanking an image of her nude body, her lower half wrapped in the U.S. flag and her head shrouded in the flag of Mexico. In terms of gender she questions the visual practices that promote certain ideals, such as thinness, for female bodies. *In Sandy's Room* (1991) displays Aguilar comfortably sitting nude in a lounge chair. She sits with her eyes closed, a drink in her hand, and a fan at her feet. The image brazenly presents the viewer with a large, content, and confident body.

Aguilar's work also produces an eroticism that is based on the relationship between the image and the viewer. While normative sexuality is often depicted through signs that relegate masculinity to men and femininity to women, Aguilar's work disrupts this simple correlation by complicating how sexualities are visually configured. Although her subjects often occupy complex identities, the viewer is not given a voyeuristic view into their lives but is instead invited into an intimate space that straddles the public and private, subject and object, insider and outsider. There are technical aspects to her work that contribute to creating this sense of intimacy. In her black-and-white photographs, Aguilar often places the subject against a dark background, which lessens the perceived distance between subject and viewer. Some of her work also features text, often in the form of narrative writing, which literally gives a voice to her sitter. She also produces works in series, giving the viewer access to a coherent grouping.

Although there are always risks involved in presenting images that announce an identity, in Aguilar's photographs any discomfort that is felt lies solely with the viewer. This is part of what makes her work so effective. The subjects, as Aguilar notes, "are people who are comfortable with who they are."

—Mario A. Caro

Regina Aguilar. Photo courtesy of the artist.

AGUILAR, Regina
Honduran sculptor

Born: Tegucigalpa, Honduras, 27 February 1954. **Education:** Massachusetts College of Art, Boston, art degree 1985; studied in Berlin, Belgium, Brazil, and France. **Career:** Lived abroad for twenty years before returning to Honduras in 1991. Founder, 1991, and since 1991 director, Fundación San Juancito, San Juancito School/Workshop and Magic School for Children, Honduras. **Awards:** Prize for excellence, Sociedad Cultural Hondureño, New York, 1987; Beca Otorgada por la Fundación Isla Negra, New York, 1988; Golden Prize, Kukukcan for Sculptors, 2000. **Address:** Aveniuda Republica de Panama 2139, Tegucigalpa, Honduras. **Online Address:** aguilaregina@yahoo.com.

Individual Exhibitions:

1989 Galerie Gotlschaik-Betz, Frankfurt, Germany
1991 The Glass Gallery, Washington, D.C.
1998 *Al final,* Sala Mujeres del Arte Contemporáneo MUA, Banco Central de Honduras, Tegucigalpa (traveling)
1999 Banco Central de Honduras, Tegucigalpa

Selected Group Exhibitions:

1996 *Mesótica II: Centroamérica: Re-generación,* Museo de Arte y Diseño Contemporáneo, San Jose, Costa Rica (traveling)
1997 *Extravíos,* Galería Nacional de Arte, Tegucigalpa
 El arte un espacio de pertenencia, Mujeres en las Artes, Sala Mujeres del Arte Contemporáneo, Tegucigalpa
1998 *XXIV bienal internacional de São Paulo,* Brazil
1999 Museo de Arte Contemporáneo Panamá
 Fine Arts Museum, Taipei

Regina Aguilar: *Voyages,* **1985. Photo courtesy of the artist.**

XIV Annual Glass Arts Society Conference, Tampa,
 Florida
II iberoamerican biennale, Lima, Peru
2000 *VII Biannual of Havanna,* Centro de Arte
 Contemporaneo Wilfredo Lam, Havanna
2001 *49th Venice Biennale,* Venice, Italy

Collections:

Galería Nacional de Arte de Tegucigalpa; Capitolio del Estado de la
Florida, Tallahassee; Musée des Arts Décoratifs, Laussane, Suiza.

Publications:

On AGUILAR: Articles–"Women of Power," *Metamorphosis in
Glass* (Boston), October 1987; Beeldhouwkunst in Honduras," in
HIVOS (Amsterdam), 3(2), 1997; "Regina Aguilar–Museo de Arte y
Diseñp Contemporáneo" by Luis Fernando Quirós, in *Fanal* (San
Jose, Costa Rica), 15, 1997; "Mesótica II: Regeneración necesaria"
by Dermis Pérez Léon, in *Art Nexus* (Colombia), 24, April/June 1997.

* * *

Regina Aguilar is an activist artist. Trained in sculpture and
having specialized in glass casting, she has gained recognition not
only as one of the most internationally active visual artists, but also as
a powerful agent of change in her community. She has spent most of
her time in San Juancito, a small mining town a few hours from

Tegucigalpa that was abandoned many years ago by an extracting
company. There she created a foundation and restored buildings to
open a large multidisciplinary workshop—which includes a foundry,
ceramic kilns, and glass casting and pouring—for plaster work, iron
work, and other crafts. Aguilar has trained the young people of the
town in these disciplines, which not only has helped her in the
production of her own artwork, but also has allowed the youngsters to
have a survival option of their own.

Aguilar's early work deals mainly with her own personal experi-
ence as a woman struggling for her own space. She was forced to
leave Honduras for many years, and during this time she finished her
training in the United States and participated successfully in many
exhibitions, mostly displaying works done in glass. She finally
returned to Honduras in 1991 and completely changed her orienta-
tion. After doing several public commissions, one of which was
destroyed at night by paid vandals, Aguilar used her training in glass
casting and mixed these technical skills with the rudiments of
everyday stone cutting used locally to make corn-grinding stones.
These have retained the ancestral shapes and are still used by both the
indigenous populations and the mestizos. In later work she appropri-
ated other pre-Hispanic stone forms to re-create them, provoking an
ambiguous feeling on the part of the viewer. The material, from the
original quarries that are still used by the indigenous populations, and
the forms, that closely recall the pre-Columbian metates and architec-
tural structures, trouble the viewer by the inclusion of useless ele-
ments to apparently ancient utilitarian objects or by a modification of
the object that renders it absurd, a tragic metaphor of a social "sans
issue" situation. These former works are pure in shape and perfectly

Regina Aguilar: *Antichrist*, 1989. Photo courtesy of the artist.

finished. The strong formal commitment, however, does not over-shadow the historical implications of both material and form, but rather reinforces her conceptual basis. On some occasions she presented these objects in conjunction with glass prisms into which she inscribed signs found in the Copán ruins. These pieces are a symbolic reference to the composition of regional culture: the constant confrontation between the ancestral and the contemporary, the elementary production techniques still practiced in many fields, and the customs, fabrication processes, and composite cultures created by the intrusion of modernity in daily life. Aguilar also introduced into these metate pieces a very subtle reference to the subordination of women to the tough and eternally cyclic daily tasks that sustain the social tissue but are based on unequal responsibilities.

For the Sao Paulo Biennale of 1998, Aguilar departed from the more intimate small-scale sculptures and created a large installation piece constructed of a cast acrylic irregular cylinder with a stone interior, a larger and more elaborated version of the stone and glass pieces of the 1980s. In this piece the two worlds are no longer only juxtaposed but initiate a process of familiarization, symbolized by the high-tech acrylic casting that wraps the over-dimensioned grinding stone, two worlds so distant and yet coexisting.

By also referring to one material imposed on the other and the gestation process implicated in this piece, Aguilar related for the first time to issues of cloning and genetic manipulation, to which she has subsequently referred and has developed in various ways. At the II Iberoamerican Biennale of Lima in 1999, she presented a piece dealing with such concerns, this time using cast glass eggs laid in a multitude of barbed-wire nests distributed around the room and completed with a theatrical backdrop of red cloth. Her later pieces have excluded elements produced by her own workshop to include photographs and found objects of mass-produced consumer items and have continued a reflection on the implications of cloning and on the masculine authority and power in Latin America.

—Virginia Pérez-Ratton

ALBIZU, Olga
American painter

Born: Ponce, Puerto Rico, 1924; moved to the United States, 1956. **Education:** Universidad de Puerto Rico, B.A. 1948; Art Students League, New York (Universidad de Puerto Rico scholarship), 1948–51; Grand Chaumiére, Paris, and Academia de Belli Arti, Florence, *ca.* 1951. **Career:** Painted covers for record albums, RCA Records and others, late 1950s. **Awards:** New York City scholarship, 1948; second prize, Salón Esso de Artistas Jóvenes, San Juan, Puerto Rico, 1964; second prize, Ateneo Puertorriqueño, 1967.

Individual Exhibitions:

1956	Panoras Gallery, New York
1957	Ateneo Puertorriqueño, San Juan, Puerto Rico
1958	Ateneo Puertorriqueño, San Juan, Puerto Rico
1959	Roland de Aenlle Gallery, New York
1960	Roland de Aenlle Gallery, New York
	Pan American Union, Washington, D.C.

1961 Ateneo Puertorriqueño, San Juan, Puerto Rico
1969 Galería Santiago, San Juan, Puerto Rico

Selected Group Exhibitions:

1956 New York City Center
1957 Riverside Museum, New York
 Instituto de Cultura Puertorriqueña, San Juan, Puerto
 Rico
 Stable Gallery, New York
1960 *Thirty Latin American Artists,* Riverside Museum, New
 York
1962 Instituto de Cultura Puertorriqueña, San Juan, Puerto
 Rico
1963 Casa de Arte, San Juan, Puerto Rico
1964 RCA Pavilion, World's Fair, Queens, New York
1966 Pan American Union, Washington, D.C.
1989 *The Latin American Spirit: Art & Artists in the U.S.,*
 Bronx Museum, New York

Collections:

Museo de Arte Contemporáneo de Puerto Rico; Ateneo Puertorriqueño,
San Juan, Puerto Rico; Instituto de Cultura Puertorriqueña, San Juan,
Puerto Rico; Museo de Arte de Ponce, Puerto Rico; Museum of
Modern Art of Latin America, Washington, D.C.; Universidad de
Puerto Rico, San Juan..

Publications:

On ALBIZU: Book—*The Latin American Spirit: Art & Artists in the
U.S.,* exhibition catalog, text by Luis R. Cancel and others, New York,
Bronx Museum, 1989. **Article—**''Mujeres que aman y otras alegorías''
by Jorge Rodríguez, in *El Vocero,* 10 February 2000, pp. E12-E13
(illustrated). **Film—***9 Artists of Puerto Rico* by Jose Gomez-Sicre,
Washington, D.C., Art Museum of the Americas, 1970.

 * * *

Olga Albizu was born in Ponce, Puerto Rico, in 1924, during a
period of desperate poverty. Twenty-four years later she arrived in
New York on a postgraduate fellowship from the University of
California. For decades the Puerto Rican government had been
offering a generous fellowship program to encourage students to
study abroad, and Albizu joined a growing community of Puerto
Rican artists in New York. A surge of Puerto Rican nationalism and
solidarity led to the establishment of various exhibition spaces and
sponsorship programs devoted to the cultivation of Puerto Rican
culture. During this period Albizu joined the Art Students League,
which had a long-established reputation as a center of avant-garde
innovation and instruction. She studied with the painter Hans Hofmann
before departing for Europe, where she continued her studies in Paris
and Florence. In 1956 Albizu settled permanently in New York.

Albizu's abstract compositions, with their arrangement of geo-
metric shapes against a bright background and their dynamic juxtapo-
sition of colors and forms, are reminiscent of Hofmann's work. Her
vivid palette and vigorous gestures as well as the density of her
canvases reflect Hofmann's influence and that of the abstract expres-
sionist movement that dominated the New York art world at the time

of Albizu's arrival. Albizu is perhaps best known for the album covers
she designed for RCA in the 1950s, primarily for jazz artist Stan Getz.
At the time Getz was known for his cool jazz sound, which was
characterized by careful control and subtle variations. In the early
1960s he helped popularize bossa nova, a mixture of jazz and samba.
Albizu's bold, spontaneous brushstrokes communicate an energy and
rhythm that make them an appropriate counterpart to Getz's
musical innovations.

Albizu is unusual both as a female abstract expressionist who
gained recognition in the 1950s and '60s and as a Latin American
artist who chose abstraction over more narrative subject matter. She
received a warm critical reception in Puerto Rico, but her work
diverges from the dominant styles among Puerto Rican artists of her
generation. It can be tempting to locate a specifically Puerto Rican
character in her bright color palette—bold forms set against a brilliant
blue background that is like the sea—or her exuberant brushwork.
Anglo audiences in particular tend to interpret work by Latin Ameri-
can artists in light of their social and political context, but artists such
as Albizu are also part of the vital art-historical movements of their
time, and her work is inseparable from the context of American
abstract expressionism. Her career inspired a younger generation of
Puerto Rican artists, especially those living in New York, who could
look to her success as evidence of expanding opportunities for Puerto
Rican artists in the galleries, museums, and commercial outlets of
U.S. culture.

 —Amy Heibel

ALFARO, Brooke
Panamanian painter, sculptor, and video artist

Born: Panama City, 5 September 1949. **Education:** University of
Panama, degree in architecture 1976; Art Students League, New
York, 1980–83. **Award:** Honorable mention, *II Biennial for Interna-
tional Painting,* Cuenca, Ecuador.

Individual Exhibitions:

1979 Instituto Panameño de Arte, Panama City
1981 Galería Arte 80, Panama City
1982 Galería Arteconsult, Panama City
1985 Galería Arteconsult, Panama City
1986 Museum of Contemporary Latin American Art, Wash-
 ington, D.C.
 Copley Society of Boston
1990 Galería del Instituto Nacional de Arte y Cultura,
 Panama City
 Centro de Bellas Artes, Maracaibo, Venezuela
1991 Galería Arte Hoy, Caracas, Venezuela
1992 Elite Fine Art, Miami
1993 Galería Mvsevm, Panama City
 Elite Fine Art, Miami
 Miami Dade Community College
1995 Arts and Culture Center, Hollywood, Florida
1997 *Cuando nuestros mundos se cruzan,* Galería Ramis
 Barquet, Monterrey, Mexico

1999 Elite Fine Art, Miami

Selected Group Exhibitions:

1985 *13 manifestaciones artísticas,* Galería Arteconsult, Pan-
 ama City
1992 Galería Anonimous, Panama City
1993 *Magia y realismo en el arte centroamericano
 contemporáneo,* Galería Plástica Contemporánea,
 Guatemala
1995 *II bienal del barro,* Maracaibo, Venezuela
1996 *Tres lustros de arte en Latinoamérica,* Galería
 Arteconsult, Panama
1998 *Crosscurrents: Contemporary Paintings from Panama,
 1968–1998,* Americas Society Art Galley, New York,
 and Bass Museum, Miami Beach
 I bienal centroamericana, Guatemala
1999 *II bienal latinoamericano,* Lima, Peru
2000 *Colectiva del simposio temas centrales,* Galería
 Nacional, San José, Costa Rica
 Panameños en la bienal de Lima, Museo de Arte
 Contemporáneo, Panama

Publications:

On ALFARO: Books—*Magia y realismo: Arte contemporáneo de
Centroamerérica,* exhibition catalog, Tegucigalpa, Galería Tríos,
1992; *Cuando nuestros mundos se cruzan,* exhibition catalog, text by
Ricardo Pau-Llosa, Garza García, México, Galeria Ramis Barquet,
1997; *Políticas de la diferencia* by Kevin Power and others, Valencia,
Spain, Ed. Generalitat de Valencia, 2001. **Articles**—''Elite Fine Art,
Coral Gables, Fla; exhibit'' by Carol Damian, in *Latin American Art,*
5(3), 1993, p. 64; ''Empecemos a pensar en Comanche III,'' in
Talingo (Panama), 385, 8 October 2000, and ''La década clave,'' in
Artefacto (Managua, Nicaragua), 20, November 2001, both by
Adrienne Samos.

 * * *

 The main source of Brooke Alfaro's work is found in the
marginal people of Panama, especially those from the neighborhood
of San Felipe, where he lived and painted for 12 years and where he
still goes almost daily to interact and work. Alfaro tries to expose the
vital core of this popular urban sector in all its pathos, beauty, and
repulsion, packed with countless ambiguities and contradictions. He
employs a biting and deceitful sense of humor that destabilizes any
possible interpretation of his paintings and, beginning in the late
1990s, of his sculptures and video installations.
 Each one of the characters Alfaro paints is without equal, given
its distinctive expression and the irregular configuration of face and
body that he achieves by overlaying strokes of colors. They all,
however, share expressive ambiguity, scars, or disfigurements as well
as a wistful lethargy that communicates both decrepitude and sensual-
ity. These characters seem to ''move'' at a peculiar rhythm character-
istic of those who have acquired a cyclical concept of time, since
every day embodies a renewed struggle for survival.
 In the early 1990s Alfaro's painting–always distinguished by the
''double character of the sublime and the ridiculous,'' to quote

Arnold Hauser–evolved from a technique appropriated from masters
such as Rembrandt, Hals, Velázquez, Bosch, and Brueghel to the
radical transformation of form. Alfaro broke away from the naturalis-
tic mold in order to set free, and at the same time manipulate, the
figures and space itself but also to project certain emotional and
psychological states. Spatial unity was dissolved, and proportion was
managed on varying scales. This extreme ''dimensional incongruity''
responded to a formal search that became progressively more dis-
tanced from the traditional canon. His Madonnas, Virgins, mestizo
saints, and numerous other components of the Roman Catholic
iconography, which originated with Alfaro's strong interest in the
colonial baroque (specifically that of the prolific Cuzco school of the
seventeenth and eighteenth centuries), gradually started disappearing
from his work.
 Another obsession, however, began to take their place: the
pulsating and ominous waters and jungles of the tropics. The critic
Ricardo Pau-Llosa has suggested that ''the density of the figures runs
parallel to that of nature. But–by force of gesture and personality,
ritual and pose–those figures reflect an individual mixture of human
passions and frailties which divides them from the expansive flesh,
diversified but uniform, of nature.'' Alfaro's canvases with crammed
boats, full of people in promiscuous closeness that navigate tumultu-
ous waters, evoke the crowded tenement housing as well as the
perilous life of the poor. Since then he has simplified his composi-
tions, excluding all fantasy and focusing on giving full intensity of
expression to a person or a natural element–a tree, a cloud, a wave.
 Alfaro has also created sculptures, mainly in clay and wood.
Anyone (1997), for example, is a tall man made of mud and hay, his
head buried under his arms while he leans on a wall, clawing it.
Comanche (1999–2000), a huge installation conceived along with the
photographer Sandra Eleta, incorporates video, sound, photography,
text, sculpture, and architecture. Centered on a destitute man, on the
eccentric underworld he inhabits, and on Panama's arbitrary political
history, it also explores two projections of the human psyche: the
labyrinth and the public plaza.
 For his videos Alfaro records scenes from the life of people with
whom he has previously established a close relationship. He then
recomposes the footage–including the audio, a key element–in order
to establish unexpected symmetries and contrasts. He often directs
these people as characters enacting absurd, inexplicable situations.

 —Adrienne Samos

ALICIA, Juana
American muralist, illustrator, printmaker, and painter

Born: 1953. **Family:** Married Emmanuel C. Montoya; one daughter.
Career: Instructor, World College West, Petaluma, California, New
College, San Francisco, Stanford University, California, Skyline
College, San Bruno, California, San Francisco Art Institute, and
California College of Arts and Crafts, San Francisco Bay. Cofounder,
East Bay Center for Urban Arts. **Award:** Sisters of Fire award,
Women of Color Resource Center, Berkeley, California, 1999.

Individual Exhibitions:

1989 *Pinturaltura,* Galería de la Raza, San Francisco (with
 Barbara Carrasco)

1990 *Mission Street Manifesto*, mural, Student Union Build-
 ing, San Francisco State University
2000 *Santuario*, mural, Gateroom 97, Terminal G, San
 Francisco Airport (with Emmanuel C. Montoya)

Selected Group Exhibitons:

1995 *Si Se Puede*, mural, Cesar Chavez Elementary School,
 San Francisco
1999 *10 x 10: Ten Women, Ten Prints*, Palmer Museum of
 Art, Pennsylvania State University, University Park
2000 *Maestrapeace*, mural, San Francisco Women's Building,
 California

Collection:

Galería de la Raza, San Francisco.

Publications:

By ALICIA: Book—*Chicana Critical Issues*, with others, Berkeley,
California, Third Woman Press, 1993. **Books, Illustrated**—*Esta
Puente, Mi Espalda* by Cherrie Moraga, with others, Ism Press, Inc.,
1988; *10 X 10*, by Robbin Henderson, with others, California,
Berkeley Art Center, 1995.

On ALICIA: Books—*Artistas Chicanas: A Symposium*, Santa Bar-
bara, University of California Women's Center, 1991; *Latin Ameri-
can Women Artists of the United States* by Robert Henkes, Jefferson,
North Carolina, McFarland, 1999. **Articles**—''Collection,'' in *Here-
sies*, 7(3), 1993, p. 52; ''Veterans of Bay Area Art,'' in *Artweek*,
30(12), December 1999, p. 17–18. **Video**—*Lorna Dee Cervantes and
Juana Alicia,* Rohnert Park, California, Sonoma State University and
World College West, 1988.

 * * *

The San Francisco artist Juana Alicia creates bright, elaborate
murals with provocative messages. Her murals include a surrealistic
portrait of an Hispanic boy walking toward or away from danger (it
can be interpreted either way), an abstract, movement-filled piece
depicting life in the city, and a controversial collage about women and
AIDS. The murals are intricately designed constructions that place
people among natural elements—mountains, stars, animals, plants,
trees, shrubs, and gnarled trees. The natural elements create a sense of
harmony, even in the most chaotic city scenes. In a brochure about her
work, Alicia once stated, ''I want my work to contribute to the
transformation of a violent world into a humane one, reflecting love,
mutual respect, and awe at the beauty of nature.''

Although Alicia wants to convey a message, her work can also
be mysterious and opaque. The meaning of the symbols in her work is
not always clear. For example, in her piece *Auto Vision* (1990) two
female hands stretch up to the sky. The hands are not gently reaching,
but rather there is strain and pressure in the movement. Around one
wrist there is a bracelet, with a large eye peering from the center. This
is a symbol, but a symbol of what? The hands reach toward heaven,
but there is nothing heavenly or otherworldly about the piece. Rather,

there is a heaviness, emphasized by the thick rings, the traceable veins
in the hands, and the earthy quality of the hands themselves. In *Alto al
fuego/Cease Fire* (1988) the message behind the painting is also
obscure. A Hispanic boy walks out of the mountains toward a new
life, but what life is he walking into? Missiles line the foreground of
the painting. Is the boy walking toward war? At the same time the
missiles are shielded by two outstretched hands, similar to the hands
in *Auto Vision*. Is the boy free or is he walking into a trap?

The beauty of the vibrant mural *Mission Street Manifesto* lies in
the contrasting images that are blended together in a depiction of city
life. In the center of the piece is an attractive Hispanic woman. Behind
her she holds a ball, which seems to be spinning out of her hands. A
runner comes toward the ball. He is an impressive Olympian, a long-
distance runner drawn to look like a champion. Above his head is a
deer that also seems to rush forward. From the background cars and
buses rush forward toward the two figures. The images are blurred
and alive. When looking at the piece, one can almost hear the honking
of horns and the swish of traffic.

In the 1990s Alicia created a mural on Haight Street in San
Francisco. The work, a 15-by-45-foot mural about women with
AIDS, proved to be highly controversial, especially by those who felt
that it was antimale, and it was eventually vandalized. In the mural
Alicia strove to depict a cross section of women with AIDS, including
homeless women, prostitutes, women in prison, lesbians, and female
activists. Most prominent are three HIV-negative women, including
Alicia, who convey hope and reassurance. Surrounding the women
are skeletons, empty pill bottles with dollar signs on them, and
corporate leaders with pig noses. When the mural was vandalized, the
faces of the women and children were painted over, creating specula-
tion that the cause of the vandalism was the mural's perceived
antimale tone. After the vandalism Alicia reconstructed the piece,
altering the design to include a prominent male figure kneeling below
photographs of people who had died from complications of AIDS.
Undaunted by the vandalism to the piece, Alicia has remained
committed to the mural as a place to create political awareness. She
has said, ''Murals are places to address social concerns . . . murals are
a place to dream in public.''

 —Sally Cobau

ALMARÁZ, Carlos D.
American painter and muralist

Born: Mexico City, Mexico, 5 October 1941; moved to the United
States, 1942. **Education:** Loyola University, Los Angeles, *ca.* 1960;
Los Angeles Community College, *ca.* 1960; California State Univer-
sity, Los Angeles, early 1960s; Otis/Parsons Art Institute, Los Ange-
les (on scholarship), early 1960s, 1972–74, M.F.A. 1974; University
of California, Los Angeles, early 1960s. **Family:** Married Elsa Flores
ca. 1980; one daughter. **Career:** Moved to Los Angeles, *ca.* 1950; to
New York, 1967–70; returned to Los Angeles, 1971. Commercial
artist, New York, 1967–70; artist and muralist for Cesar Chavez and
the United Farmworkers Union, early 1970s. Cofounder and member,
Chicano art collective *Los Four,* Los Angeles, 1973–83. **Died:** 1989.

Individual Exhibitions:

1986 Jan Turner Gallery, Los Angeles

1989 Art Institute of Southern California, Laguna Beach (with
 Elsa Flores)
1990 Jan Turner Gallery, Los Angeles
1997 *The Life and Work of Carlos Almaráz, 1941–1989,*
 Mexican Museum, San Francisco

Selected Group Exhibitions:

1973 *Los Four,* University of California, Irvine
1974 Los Angeles County Museum of Art (with *Los Four*)
1984 Fisher Gallery, University of Southern California, Los
 Angeles
 Los Angeles Municipal Art Gallery
1991 Wight Art Gallery, University of California, Los
 Angeles
2001 *Arte Latino: Treasures from the Smithsonian Museum of
 American Art,* Terra Museum of American Art,
 Chicago (traveling)
 Sentimientos, Lisa Coscino Gallery, Pacific Grove,
 California

Collection:

Corcoran Gallery of Art, Washington, D.C.

Publications:

By ALMARÁZ: Book—*Los Angeles Latino Artists,* exhibition
catalog, Los Angeles, Pico House, 1989.

On ALMARÁZ: Books—*Los Four,* exhibition catalog, Irvine, Uni-
versity of California, 1973; *Carlos Almaráz: Selected Works,
1970–1984,* exhibition catalog, Los Angeles, Los Angeles Municipal
Art Gallery, 1984; *Carlos Almaráz: A Survey of Works on Paper,*
exhibition catalog, Los Angeles, Jan Turner Gallery, 1990; *Moonlight
Theater: Prints and Related Works,* exhibition catalog, text by Efram
Wolff, Cynthia Burlingham, and Patrick H. Ela, Los Angeles, Grunwald
Center for the Graphic Arts, University of California, 1991. **Articles**—
"Latin Americans Aqui/Here" by Shifra M. Goldman, review of an
exhibition at the University of Southern California, in *Artweek,* 15, 1
December 1984, pp. 3–4; "Scratching the Surface" by Lawrence
Gipe, review of an exhibition at Jan Turner Gallery, Los Angeles, in
Artweek, 17, 23 August 1986, p. 5; "L.A. Chicano Art" by Kristina
van Kirk, in *Flash Art* (Italy), 141, summer 1988, pp. 116–117;
"Carlos Almaráz/Elsa Florez. Art Institute of Southern California,
Laguna Beach" by Betty Ann Brown, in *Artweek,* 20, 28 October
1989, p. 13; review of an exhibition at Jan Turner Gallery, Los
Angeles, by Peter Clothier, in *Art News,* 89, November 1990, p. 178;
"An Artist's Path" by Casey Fitzsimons, in *Artweek,* 24, 8 April 1993.

* * *

Recognized as one of the most influential modern Chicano
artists, Carlos D. Almaráz played a significant role in making a place
for a distinct Chicano voice in the upper echelons of the art world.
Almaráz's paintings and prints are as eclectic and varied as was his
life, although the bulk of his better-known works portrayed the reality

of life–especially Hispanic life–in Los Angeles. He recorded scenes
of urban life, ranging from violent car crashes to meditative views of
Los Angeles's Echo Park, in a number of different artistic styles.
Underpinning all of Almaráz's work was his unique sensibility, a
combination of his connection to Chicano culture, his formal art
training, and his political beliefs.

After graduating from the Otis Art Institute, Almaráz left his
childhood home in East Los Angeles for New York City. He spent the
early 1960s working as a graphic arts designer and painter. Although
his canvases from the period are quite unlike his mature work,
elements of his later style are recognizable in the hard-edged lines of
these juvenile efforts. Most of his first paintings are abstract and
minimalist, reflecting the style popular in New York at the time.

Almaráz's life and art changed dramatically in the mid-1960s
when he returned to Los Angeles and became involved in the Chicano
identity movement. Galvanized by the death of a younger brother as a
result of a drug overdose, Almaráz became a barrio social worker.
While he did not abandon art altogether, he dedicated himself largely
to political movements, including Cesar Chavez's fight for the rights
of Mexican farm workers. Almaráz eventually wearied of such street-
level activism, however, and began concentrating on creating art that
reflected his political and social beliefs. These painting were large,
raw, and angry and were done in a cartoonlike style. In one 1974 piece
portraying the standoff between farm workers and union members the
figures are composed of the dark, nervous lines that would become
Almaráz's trademark. This painting was included in a seminal exhibi-
tion at the Los Angeles County Museum of Art in 1974. The exhibit,
the first significant show of Chicano art ever held, featured works of
Almaráz as well as of Frank Romero, Beto de la Rocha, and Gilbert
Lujan. This quartet of young artists, known as Los Four, strove to
make room in the mainstream for art that conveyed a barrio sensibility.

Almaráz's style underwent another major shift in the early
1980s. He turned away from overt political messages and adopted the
neoexpressionist style that was prevalent during that period. These
paintings used electric colors and an energetic realism to bring the
urban landscape of Los Angeles to life. Often violent, Almaráz's
work limned the disjunction between an ideal world and the brutality
of everyday life. He received particular acclaim for his so-called car
crash paintings, such as the 1984 *Crash in Pthalo Green,* which
vividly captured the feeling of colliding metal. Other works from this
period also evoke the barrio reality of destroyed hope. In *Burning
Dreams* (1984) a family of three watches their house burn. Although
the subject is painful, the painting is exuberant. The blazing building
shoots orange flames into the night sky, tinting it red and mauve.

As the 1980s progressed, Almaráz began to portray another side
of East Los Angeles. He started his *Echo Park* series, a collection of
pastels and oils that are considered to be among his best work. Rather
than employ the jarring lines of the car crash pieces, Almaráz used an
impressionistic style to capture the character of this urban park near
his home. The *Echo Park* pieces reflect the intense beauty and
mystery of this haven for the Chicano community. Figures appear to
dance or float on the dark background of the canvases.

By the late 1980s Almaráz's work had shed almost all of its
political connotations. Rather than paint the specific reality of Chi-
cano politics and culture, he created works that expressed mythic
themes in a colorful surrealism. Nevertheless, his paintings still
reflected his Chicano heritage. *Early Hawaiians,* for example, an
undated painting from this period, is a mural-sized work that portrays
an idealized primitive past. Red and golden figures inhabit a lush

paradise of blue and green. The nude figures combine features and body types of Hispanic, Greek, oriental, and Indian ideals. Yellow squiggles energize the canvas. Other paintings from the period feature jungle scenes, pre-Columbian monuments, spotted horses, and mystical beings such as jaguar men. Still others, such as *Portrait of the Artist as Monet* (1986), claim European subjects for their own. Almaráz's last works were his darkest. He turned from mythic themes to moody portraits of interiors, with dark figures looming in the backgrounds of fanciful scenes.

—Rebecca Stanfel

ALPUY, Julio
Uruguayan painter and sculptor

Born: Tacuarembó, 1919. **Education:** Taller Torres-García, Montevideo, 1935–50. **Career:** Teacher, Taller Torres-García, Montevideo, *ca.*1943–57. Painted murals in Montevideo, 1949–57. Traveled to Peru, 1945, to Europe and the Middle East, 1951–53, and to Chile, 1957. Moved to Bogotá, *ca.* 1957, then to Caracas, 1959, and to New York, 1961. **Awards:** New School for Social Research fellowship, 1963, 1965; National Endowment for the Arts grant, 1983; New York Council for the Arts grant, 1986; Gottlieb Foundation grant, 1990.

Individual Exhibitions:

1958	*112 exposición del Taller Torres-García,* Biblioteca Luis Angel Arango, Bogotá
1959	Fundación Mendoza, Caracas
	Universidad de Carabobo, Ateneo de Valencia, Venezuela
1960	Biblioteca Luis Angel Arango, Bogotá
1964	Centro de Artes y Letras El País, Montevideo
	University of Massachusetts, Amherst
	J. Walter Thompson Company, New York
1969	Zegry Gallery, New York
1972	Center for Inter-American Relations, New York
	Galeria do Diario de Noticias, Lisbon
1976	Galería Losada, Montevideo
1977	La Galerie, Bogotá
1978	Galería La Trinchera, Caracas
1979	Alianza Cultural Uruguay-Estados Unidos, Montevideo
1980	Galería Sarmiento, Buenos Aires
1982	Galería Vermeer, Buenos Aires
1983	Museo Rayo, Roldanillo-Valle, Colombia
1985	Museum of Contemporary Hispanic Art, New York
1988	Galería Dialogo, Brussels
	Walter F. Maibaum Fine Arts, New York
1989	Galería Palatina, Buenos Aires
1994	*Works: 1953–1993,* Cecilia de Torres, Ltd., New York
1997	*Journeys of Julio Alpuy,* Sidney Miskin Gallery, Baruch College, New York
	Journeys on Paper, Cecilia de Torres, Ltd., New York
1999	Centro Cultural Recoleta, Buenos Aires (retrospective)
	Municipalidad de Montevideo (retrospective)
	Julio Alpuy, 80th Birthday Show—Recent Paintings, Cecilia de Torres, Ltd., New York

Selected Group Exhibitions:

1953	*II Biennial,* Museo de Arte Moderno de São Paulo
1964	*Magnet: New York,* Bonino Gallery, New York
1967	*Five Latin American Artists Working in New York,* Center for Inter-American Relations, New York
1970	Museo Nacional de Bellas Artes, Buenos Aires
1978	*Arte iberoamericano,* Museo de Bellas Artes, Caracas
1989	*The Latin American Spirit: Art & Artists in the U.S.,* Bronx Museum, New York
1991	*The School of the South, El Taller Torres-García and Its Legacy,* Centro de Arte Reina Sofía, Madrid (traveling)
1995	*65 Years of Constructivist Wood,* Cecilia de Torres, Ltd., New York
1996	*Constructive Universalism,* Art Museum of the Americas, Washington, D.C.
1997	*T-G y 10 artistas del taller,* Galería Ruth Benzacar, Buenos Aires

Collections:

Museo Nacional de Artes Visuales, Montevideo; Banco de la República y Biblioteca Angel Arango, Bogotá; University of Texas, Austin; Bronx Museum of the Arts, New York; Museum of Tel Aviv, Israel; Museum of Trenton, New Jersey.

Publications:

On ALPUY: Books—*In the World and Workshop of Alpuy,* exhibition catalog, New York, Center for Inter-American Relations, 1972, and *Julio Alpuy,* exhibition catalog, New York, Museum of Contemporary Hispanic Art, 1985, both by Ronald Christ; *Torres-García and His Legacy,* exhibition catalog, text by Cecilia Buzio, New York, Camillos Kouros Gallery, 1986; *Julio Alpuy,* exhibition catalog, Buenos Aires, Galería Palatina, 1989; *Torres-Garcia y 10 artistas del taller,* exhibition catalog, Buenos Aires, Ruth Benzacar Galería de Arte, 1997; *Retrospectiva,* exhibition catalog, Montevideo, Galería Cecilia de Torres, 1999. **Article—**''Julio Alpuy'' by John Angeline, in *Art Nexus* (Colombia), 27, January/March 1998, p. 135.

* * *

When the 21-year-old Uruguayan Julio Alpuy entered Taller Torres-García, it meant not only learning techniques but above all understanding the thoughts of the master, Joaquin Torres-García, who elaborated the most important theories on modern art in Latin America. A complex primitivity; local, urban, and geographic subjects, such as Montevideo's harbor; circle and square forms; and a grid to simplify and intensify the importance of each painted element were some of the entangled art components in those conceptualizations that Torres-García developed and demonstrated in oral and written forms. It was not an academic teaching but order, concentration, information, and conversations. Alpuy recalled what Torres-García used to tell them: ''You are lucky not having an academic instruction, it takes a long time to get over it and to be able to be creative.'' Being creative and constructivist were basic topics.

Alpuy's intuitiveness, and the devoted comprehensiveness of Torres-García's concepts, marked the origin of Alpuy as a professional artist. In the 1950s Alpuy traveled to Bogotá, where he stayed

for three and a half years, before moving to New York City in 1961. In 1963 the characteristic grid element he had acquired at El Taller began to become diluted. Alpuy's compositions are eloquently structured by forms such as circles, labyrinths, elliptical forms, and serpentine shapes. Squares and right angles take a subdued place in his paintings. There are visions of enclosed lakes, clouds, islands, Möbius strips, and the rings of tree trunks, all of which are both literal and symbolic in his work. Either connected or isolated, each of these meaningful forms was also related to his admiration for Paul Cézanne. Single human figures as well as groups inhabit his paintings.

Feelings have been important for Alpuy as well, and the peaceful, ideal situations in which he has depicted trees, horses, birds, waterfalls, and the like all belong to his much-admired nature. Alpuy has played proportions and sizes, revealing ingenuity in a dreamer's spirit. He has told no stories, although there seem to be many hidden in the center, in the islands, in the corners, and in the meanderings of each painting. Voluminous package forms float in the composition as animaloide-like clouds. As Alpuy was born in the countryside, he directly related to natural colors and materials. In terms of color, earthen tones shared an ample palette, which also included intense colors as the years began to pass. Blue, white, brown, and gray reign.

Alpuy has considered himself a painter and a sculptor. As a painter, he has worked with oil on canvas and wood, he has drawn extensively, and occasionally he has turned to watercolor and tempera. His sculptures are mainly in oak or pine; he preferred the softer woods so that he could finish and sand them deeply. He has never split his time between painting and sculpture; he has devoted long periods to one or the other. During one stretch he went 13 years doing only sculpture. Alpuy returned to painting because his students did not grasp some of the concepts he was teaching them; therefore, he decided to paint with them. Inside and outside the nucleus of his works there was activity and reference to ''human and animal behaviour as a model.'' The ''islands'' look interchangeable, but the delicate equilibrium they withstand should never be altered. In Alpuy's style, birds fly and people kiss in a constant birth.

—Graciela Kartofel

ÁLVAREZ BRAVO, Lola
Mexican photographer

Born: Delores Martinez de Anda, Lagos de Moreno, 3 April 1907. **Education:** Colegio del Sagrado Corazón. **Family:** Married Manuel Álvarez Bravo, *q.v.,* in 1924 (separated *ca.* 1935, divorced 1949); one son. **Career:** Assistant to Manuel Álvarez Bravo, *ca.* 1925–35; photographer, Secretaría de Educación Pública, beginning in the late 1930s; director, department of photography, Instituto de Bellas Artes, 1930s-1960s; photography teacher, Escuela de Pintura y Escultura de la Esmeralda, 1940s and 1950s. Member, Liga de Escritores y Artistas Revolucionarios, 1934–37. Director, Galería de Arte Contemporáneo, Mexico City, *ca.* 1953. Contributor, *Mexican Folkways* magazine. **Died:** 1993.

Individual Exhibitions:

1944 *Exposición de fotografías de Lola Álvarez Bravo,* Palacio de Bellas Artes, Mexico
1953 *Salón de la Plástica Mexicana,* Mexico City

1965 *100 fotos de Lola Álvarez Bravo,* Instituto Nacional de Bellas Artes, Museo del Artes Plásticas, Mexico City
1979 *Fotografías de Lola Álvarez Bravo,* Galería de la Alianza Francesa de Polanco, Mexico (retrospective)
1982 Galería Osuna, Washington, D.C.
1984 Centro Cultural el Nigromante, Mexico
 De las humildes cosas, Museo de la Alhóndiga de Granaditas, Guanajuato, Mexico
1985 *Lola Álvarez Bravo, elogio de la fotografía,* Centro Cultural Tijuana (traveling)
1986 Instituto Francés de América Latina, Mexico
1989 Anahuac Museum, Mexico City
 Reencuentros, Museo Estudio Diego Rivera, Mexico
1991 *Lola Álvarez Bravo, Photographs,* Carla Stellweg Gallery, New York
 Lola Álvarez Bravo, Barry Whistler Gallery, Dallas (traveling)
 Frida y su mundo: Fotografías de Lola Álvarez Bravo, Galería Juan Martín, Mexico City
1992 *Lola Álvarez Bravo: Fotografías selectas 1934–1985,* Centro Cultural Arte Contemporáneo, Mexico City
 Frida-Lola, Galería Quetzalli, Oaxaca, Mexico
1994 *Lola Álvarez Bravo: Fotografías,* Culiacán, Museo de Arte de Sinaloa
 Galería Arvil, Mexico City
1996 *Lola Álvarez Bravo: In Her Own Light,* Americas Society Art Gallery, New York (traveling)
 Lola Álvarez Bravo, Throckmorton Fine Art, New York
1997 *Manuel Álvarez Bravo & Lola Álvarez Bravo: Mexican Photography,* Throckmorton Fine Art, New York
2001 *Lola Álvarez Bravo & Her Friend, Frida Kahlo,* POSCO Art Museum, Daechi- dong, Seoul

Selected Exhibitions:

1951 *Arte y telas,* Galería de Arte Mexicano, Mexico
1955 *The Family of Man,* Museum of Modern Art, New York (traveling)
1977 *Exposición nacional de homenaje a Frida Kahlo,* Sala Nacional del Palacio Nacional de Bellas Artes, Mexico City
1981 *La creación femenina,* Kunstlerhaus Bethanien, Berlin (traveling)
1982 *5 fotógrafas de México,* Casa de Fotografía del Consejo Mexicano de Fotografía, Mexico
1989 *Memoria del tiempo: 1847–1959,* Museo de Arte Moderno, Mexico City (traveling)
 Mujer por mujer, Museo de San Carlos, Mexico (traveling)
1990 *Compañeras de Mexico: Women Photograph Women,* University of California, Riverside (traveling)
 Photography Works: 3 Generations of Mexican Women, Carla Stellweg Gallery, New York
2000 *El ojo fino/The Exquisite Eye,* Garduño, Reyes de Cana

Publications:

By ÁLVAREZ BRAVO: Books—*Galería de mexicanos: 100 fotos de Lola Álvarez Bravo,* exhibition catalog, Mexico, Instituto Nacional de Bellas Artes, 1965; *Lola Álvarez Bravo: Recuento fotográfico,* text

by Luis Cardoza y Aragón, Mexico, Editorial Penelope, 1982; *Escritores y artistas de México: Fotografías de Lola Álvarez Bravo,* Mexico City, Fondo de Cultura Económica, 1982; *Lola Álvarez Bravo, reencuentros,* exhibition catalog, Mexico City, Instituto Nacional de Bellas Artes, Museo Estudio Diego Rivera, 1989; *The Frida Kahlo Photographs,* introduction by Salomon Grimberg, Dallas, Society of Friends of the Mexican Culture, 1991. **Book, photographed—** *Acapulco en el sueño* by Francisco Tario, Mexico City, Centro Cultural Arte Contemporáneo, 1951.

On ÁLVAREZ BRAVO: Books—*Compañeras de Mexico: Women Photograph Women,* exhibition catalog, essays by Amy Conger and Elena Poniatowska, Riverside, California, University of California, 1990; *Lola Álvarez Bravo: Fotografias selectas 1934–1985,* exhibition catalog, Mexico City, Fundacion Cultural Televisa, 1992; *Lola Álvarez Bravo: In Her Own Light,* exhibition catalog, with text by Oliver Debroise, Tucson, Arizona, Center for Creative Photography, University of Arizona, 1994; *Lola Álvarez Bravo: Fotografias,* exhibition catalog, Culiacán, Museo de Arte de Sinaloa, 1994. **Articles—**''From the Fringes–Compañeras de Mexico: Women Photograph Women'' by Josef Woodard, in *Artweek,* 22, 23 May 1991, pp. 9–10; ''Lola Álvarez Bravo: A Modernist in Mexican Photography'' by Elizabeth Ferrer, in *History of Photography,* 18, autumn 1994, pp. 211–218.

* * *

One of the most respected photographers of the generation of Tina Modotti and Manuel Álvarez Bravo, Lola Álvarez Bravo was born in Lagos de Moreno, Jalisco, although her family moved to Mexico City when she was a young child. In 1924, at the age of 18, she married photographer Manuel Álvarez Bravo, a family friend. In 1925 they lived for a year in Oaxaca, where she gained a great appreciation for the indigenous art and culture of the region. While she was married she assisted her husband in taking photographs and in darkroom work. After separating from her husband around 1935, Lola Álvarez Bravo shared an apartment with painter María Izquierdo in Mexico City and worked as a photographer for the Secretaría de Educación Pública (SEP; Ministry of Education). She took photographs for *El Maestro Rural,* an SEP periodical distributed to rural schoolteachers throughout Mexico. From the 1930s to the '60s she was also the director of photography at the Instituto de Bellas Artes (Institute of Fine Arts) in Mexico City. She was in charge of exhibitions and photographic documentation of cultural events, including theater and dance performances and archaeological excavations. During the 1940s and '50s she was the only woman photojournalist in Mexico, taking photographs for the journals *Voz* and *Vea* as well as for the Instituto de Bellas Artes. Her photographic work enabled her to travel throughout Mexico. In the 1950s and '60s Álvarez Bravo taught photography courses at the Escuela de Pintura y Escultura de la Esmeralda. Among her students was the photographer Mariana Yampolsky.

During the 1920s Manuel and Lola Álvarez Bravo had a close friendship with Tina Modotti. Like her husband, Lola Álvarez Bravo was strongly influenced by the photographic styles of Modotti and Modotti's companion and mentor, Edward Weston. When she left Mexico in 1930 Modotti sold Manuel and Lola Álvarez Bravo her camera equipment. In fact, one of the first pieces of equipment Álvarez Bravo used for her own work was an eight-by-ten camera that had belonged first to Weston and then to Modotti. Throughout her life

Álvarez Bravo was associated with most of the major artistic and literary figures of Mexico City, including Diego Rivera, Frida Kahlo, and David Alfaro Siquieros. She also maintained strong ties with the Contemporános, a group of writers and artists whose work emphasized modernist aesthetics. She was a member of the Liga de Escritores y Artistas Revolucionarios (LEAR; League of Revolutionary Writers and Artists) from 1934 to 1937. She created photomontages for *Frente a frente,* LEAR's journal, including *El Sueño de los pobres II* [''Dream of the Poor''] in which a small, ragged child lies asleep under a looming pile of coins and wheels. This work was also shown in a special exhibition of posters by LEAR women artists organized by María Izquierdo in 1935. In LEAR Álvarez Bravo started the first film club in Mexico, showing avant-garde films like *Le Chien Andalou* by Luis Buñuel and Salvador Dalí as well as films by Max Linder and Charlie Chaplin, among others. She made a film about Rivera's Chapingo murals sometime in the 1940s or '50s. Her friendship with Kahlo was especially close; her photographs of Kahlo are among the most dramatic and personal of the many images made of the painter. In the 1950s Álvarez Bravo ran the Galería de Arte Contemporáneo in Mexico City, where she exhibited Kahlo's work in 1953. This was the only solo exhibition Kahlo had in Mexico until after her death.

In her photographic work Álvarez Bravo explored a wide range of subject matter, including photographs of urban and rural environments: city dwellers; indigenous people; historical, vernacular, and modern buildings; and archaeological monuments and landscapes. Her style is characterized by unusual conjunctions of form and meaning, sometimes bordering on the surreal. She made a large number of photographs of well-known cultural figures. Her portraits are notable for their intimate, insightful portrayals of the sitters' personalities. Her portrait of Rivera with his eyes downcast shows the muralist in a pensive moment, while her portrayal of María Izquierdo, her imposing head surrounded by vegetation, gives the impression of the painter's strength and determination. Her photographs of elements of vernacular architecture focus on the abstract, textural patterns of details, such as the adobe shelves and woven roof of *Cocina* (''Kitchen''). *Entierro en Yalalag* (''Burial in Yalalag'') demonstrates the sensitivity of her compositions. The white highlights on the flowing garments of women in a funeral procession establish a rhythmic, lyrical pattern, creating an otherworldly effect. *Unos suben y otros bajan* (''Some Go Up and Others Go Down'') is a poetic study of the angles of light and shadows with people in an urban environment. *Ciego* (''Blind''), her photograph of a blind child, bears a resemblance to Paul Strand's photograph of a blind woman, but Álvarez Bravo, through strong contrasts of light and shadow and her close-up view, invests her image with great poignancy. Because of her emphasis on unusual conjunctions of visual form and cultural meaning, Álvarez Bravo's photographic work has served as a model for later Mexican photography.

—Deborah Caplow

ÁLVAREZ BRAVO, Manuel
Mexican photographer

Born: Mexico City, ca. 1902. **Education:** Academia Nacional de Bellas Artes, 1918. **Family:** Married Lola Álvarez Bravo, *q.v.,* in

1925 (separated 1935); one son. **Career:** Worked for the Mexican Department of Treasury, 1920s-31; instructor of photography, Escuela Central de Artes Plásticas, 1929–30; freelance photographer, *Mexican Folkways* magazine, ca. 1930; cinematographer for the film *Que Viva Mexico*, 1930–31; instructor, Hull House, Chicago, 1936, and Sindicato de Trabaladores de la Producción Cinematografica de Mexico, 1940s and 1950s. Founding member, El Fondo Editorial de la Plástica Mexicana, 1959. **Award:** First prize, Regional Exhibition of Oaxaca, Mexico, 1926.

Individual Exhibitions:

1932 Galeria Posada, Mexico City
1968 *Manuel Álvarez Bravo: Fotografías de 1928–1968,* Palacio de Bellas Artes, Mexico City
1971 Pasadena Art Museum, California (traveling)
1972 *Manuel Álvarez Bravo: 400 fotografías,* Palacio de Bellas Artes, Mexico City (traveling)
1978 *Retrospectiva de la obra de Manuel Álvarez Bravo,* Museo de Arte Moderno, Mexico City
 Corcoran Gallery of Art, Washington, D.C. (traveling)
1980 *Manuel Álvarez Bravo: El gran teatro del mundo,* Museo de San Carlos, Mexico City
1982 *Manuel Álvarez Bravo: Exposición homenaje,* Museo de Arte Moderno, Mexico City
1983 *Manuel Álvarez Bravo,* Photo Gallery International, Tokyo
 Dreams-Visions-Metaphors: The Photographs of Manuel Álvarez Bravo, Israel Museum (traveling)
1984 *The Photographs of Manuel Álvarez Bravo,* Photographer's Gallery, London
 Maestros de la fotografía: Manuel Álvarez Bravo, Museo Nacional de Bellas Artes, Havana
1985 Salas Pablo Ruiz Picasso, Madrid
1986 *Manuel Álvarez Bravo: 303 photographies 1920–1986,* Musée d'Art Moderne de la Ville de Paris
 Manuel Álvarez Bravo: A Retrospective, International Center of Photography, New York
 Encontros: Manuel Álvarez Bravo, Palacio de Cidadela, Cascais, Portugal (traveling)
1989 *Manuel Álvarez Bravo: Retrospective Exhibition,* Witkin Gallery, New York (traveling)
 Mucho sol: Manuel Álvarez Bravo, Museo del Palacio de Bellas Artes, Mexico City (traveling)
 ¡Bravo Maestro!, Museo de Arte Moderno, Buenos Aires
1990 *Revelaciones: The Art of Manuel Álvarez Bravo,* Museum of Photographic Arts, San Diego, California (traveling)
 Manuel Álvarez Bravo: Los años decisivos, 1925–1945, Museo de Arte Moderno, Mexico City
1995 *Manuel Álvarez Bravo: Nudes 1930s-1990s,* Witkin Gallery, New York
1996 *Caja de visiones: Fotografías de Manuel Álvarez Bravo,* Museo Nacional Centro Reino Sofía, Madrid
 Álvarez Bravo, Centro Fotográfico Álvarez Bravo, Oaxaca, Mexico
1997 Museum of Modern Art, New York (retrospective)
 Manuel Álvarez Bravo & Lola Álvarez Bravo, Throckmorton Fine Art, New York

Manuel Álvarez Bravo Vintage Photographs, Robert Miller Gallery, New York
Manuel Álvarez Bravo at Ninety-Five, Gallery of Contemporary Photography, Santa Monica, California
Variaciones, 1995–1997, Centro de la Imagen, Mexico City
2001 J. Paul Getty Museum, Los Angeles

Selected Group Exhibitions:

1935 Julien Levy Gallery, New York (with Henri Cartier-Bresson and Walker Evans)
1995 *Caja de visiones: Fotografías,* Museo Nacional Centro de Arte Reina Sofia, Madrid
1996 *Photography in Latin America: A Spiritual Journey,* Brooklyn Museum of Art, New York
1997 *The Sex Show: Sex & Eroticism in 20th Century Photography,* Yancey Richardson Gallery, New York
1998 Museo de Arte Contemporáneo de Caracas Sofía Imber, Caracas
2000 *Reflections: Photos of Water,* Sag Harbor Picture Gallery, New York

Collection:

J. Paul Getty Museum, Los Angeles; Museum of Modern Art, New York; Museum of Photographic Arts, San Diego, California; National Museum of Photography, Mexico.

Publications:

By ÁLVAREZ BRAVO: Books—*Photographs,* Geneva, Switzerland, Acorn Editions, 1977; *Manuel Álvarez Bravo: Un estilo, una estela,* Madrid, PhotoVision, 1982; *Variaciones, 1995–1997,* exhibition catalog, Mexico City, Centro de la Imagen, 1997. **Book, photographed**—*Los lienzos de Tuxpan* by José Luis Melgarejo Vivanco, Mexico, Editorial la Estampa Mexicana, 1970.

On ÁLVAREZ BRAVO: Books—*Manuel Álvarez Bravo, 400 fotografías,* exhibition catalog, Mexico City, Instituto Nacional de Bellas Artes, 1973; *Dreams, Visions, Metaphors: The Photographs of Manuel Álvarez Bravo,* Jerusalem, Israel Museum, 1983; *Manuel Álvarez Bravo,* Milan, Gruppo Editoriale Fabbri, 1983; *Mucho sol: 150 años de la fotografía Mexico,* exhibition catalog, text by Teresa del Conde, Mexico City, Museo del Palacio de Bellas Artes, 1989; *Revelaciones: The Art of Manuel Álvarez Bravo,* exhibition catalog, Albuquerque, University of New Mexico Press, 1990; *Manuel Álvarez Bravo: El artista, su obra, sus tiempos* by Elena Poniatowska, Mexico City, Banco Nacional de Mexico, 1991; *Manuel Álvarez Bravo: Photographs and Memories* by Frederick Kaufman, New York, Aperture, 1997; *Manuel Álvarez Bravo,* exhibition catalog, text by Susan Kismaric, New York, Museum of Modern Art, 1997; *Manuel Álvarez Bravo at Ninety-Five,* exhibition catalog, text by Roberto Tejada, Santa Monica, California, Gallery of Contemporary Photography, 1997; *Manuel Álvarez Bravo,* exhibition catalog, Caracas, Museo de Arte Contemporáneo de Caracas Sofía Imber, 1998;

Manuel Álvarez Bravo by Brigitte Ollier, Paris, Hazan, 1999; *Manuel Álvarez Bravo: Photographs from the J. Paul Getty Museum,* exhibition catalog, Los Angeles, J. Paul Getty Museum, 2001. **Articles—** "Manuel Álvarez Bravo: Mexico's Poet of the Commonplace" by David Roberts, in *Architectural Digest,* 44, May 1987; "On His Own in Mexico, A Quiet Ovation for a Quiet Visionary" by Kathryn E. Livingston, in *American Photographer,* 19, August 1987; interview with Manuel Álvarez Bravo by Liba Taylor, in *British Journal of Photography,* 137, 11 January 1990, pp. 27–31; "Manuel Álvarez Bravo," in *Southwest Art,* 20, November 1990; "Luz y tiempo: Colección de Manuel Álvarez Bravo" by Eduardo Vázquez Martín, in *Artes de Mexico,* 32, 1996, pp. 90–93; Manuel Álvarez Bravo issue of *Aperture,* 147, spring 1997; "Manuel Álvarez Bravo" by Barry Schwabsky, in *Artforum International,* 35, May 1997, p. 105; "Manuel Álvarez Bravo's Exemplary Minor Art" by Ben Lifson, in *On Paper,* 1, May/June 1997, pp. 17–19; "Manuel Álvarez Bravo: The Impossibility of the Archive" by Mónica Amor, in *Art Nexus* (Colombia), 25, July/September 1997, pp. 80–83.

<p style="text-align:center">* * *</p>

Perhaps Latin America's best-known twentieth-century photographer, Manuel Álvarez Bravo has pioneered an influential approach to photographic practice, witnessed in compositions richly layered with meaning and infused with a sense of lyric poetry. Various commentators have remarked upon the presence of "magic realism," or "the marvelous," in his oeuvre, a reflection of Álvarez Bravo's predilection for evoking the myriad cultural realities that have informed Mexican life. In his long career he has pursued an impressive range of subject matter, including portraits, nudes, landscape, moody studies of anonymous individuals framed by architecture or in their familiar settings, and abstract compositions based on common objects or elements of nature.

Álvarez Bravo's early exposure to photography was to pictorialism, the dominant turn-of-the-century style characterized by soft focus and romanticized depictions of people and places. Yet when he decided to pursue photography professionally in the mid-1920s, he demonstrated a sophisticated knowledge of modernist currents in the United States and Europe. Such early works as the two abstract compositions *Paper Games* (both 1926–27) and the elegant study of contrasting forms *Squash and Snail* (1928) evince the important formative influence of Edward Weston, the American photographer who had spent time in Mexico in the 1920s. This period was also the heyday of Mexican muralism, a movement of painters whose often monumentally scaled, public artworks promoted postrevolutionary values and indigenous Mexican cultures. Álvarez Bravo shared an affinity with sensibilities associated with these artists, and in the 1930s he increasingly directed his photography toward an exploration of *lo mexicano*–that which is distinctly Mexican, whether it be spiritual values, traditions, or cultural concepts. For example, *The Daughter of the Dancers* (1933) shows the back of a graceful, traditionally dressed young woman who peers into the portal of a weathered colonial facade, a symbolic evocation of the layers of time and history that permeate much of everyday life in Mexico.

Later in the decade, in 1939, Álvarez Bravo created one of the photographs for which he is best known, *Good Reputation Sleeping.* Produced at the behest of André Breton, who spent time in Mexico to organize the *International Surrealist Exhibition,* the composition depicts a young woman whose otherwise nude body is bandaged around her ankles and hips. With eyes shut, she reclines on a blanket and is surrounded by spiny star cacti. Suffused with mystery, the composition provokes questions about the improbable juxtaposition of elements and invites a Freudian reality based on the girl's sexually charged appearance and the physically threatening objects surrounding her.

Throughout his long career Álvarez Bravo has demonstrated a preoccupation for exploring the human form, whether in such symbolically charged images as *The Daughter of the Dancers* and *Good Reputation Sleeping* or in numerous female nudes, a theme to which he has been especially devoted in his late career from the 1980s onward. He has also enjoyed evoking the human form by creating visual puns of inanimate objects. In *Fallen Sheet* of the 1940s a casually arranged sheet on a tile floor appears as nothing less than the drape of a corpse. Álvarez Bravo has also created incisive portraits, including those of Mexican artists and traveling luminaries in Mexico–Frida Kahlo, Diego Rivera, Sergey Eisenstein, and Leon Trotsky, among others.

In the mid-1940s Álvarez Bravo shifted his creative efforts to film, but even while working as a cinematographer, he never abandoned his work with still photography. His film work remains little known or studied, but his love of the medium has had a lasting impact on his photography. In photographs like *Bicycles on Sunday* (1966) he shows a small, common moment wrought large and evokes a sense of narrative clearly linked to filmic modes.

In some of his best-known photographs Álvarez Bravo has explored traditional Mexican culture's preoccupation with death. *Striking Worker Assassinated* (1934) is a startlingly violent scene of a young, fallen man whose body is heavily stained with blood. Although he is inert and clearly dead, his eye is slightly open and catches a glint of light. Through the image violence is eerily calmed, but it also curiously beckons through the hand of the victim, which projects outward as if beckoning the viewer. A contrasting perspective to the theme is offered in *Ladder of Ladders,* a 1931 photograph of a coffin maker's shop in Mexico City made poignant by the inclusion of a child's small coffin perched on a shelf at the shop's entrance.

The majority of Álvarez Bravo's photographs have depicted everyday people and common things. At times he has exalted the commonplace as he imbues prosaic activities with a poetic resonance. In other instances he has demonstrated his mastery of mediating the moment by constructing the image, which he memorializes with the camera. Regardless of the mode in which he has worked, his greatest subject has been human life captured with wit, eloquence, and grace.

<p style="text-align:right">—Elizabeth Ferrer</p>

ALVAREZ MUÑOZ, Celia

American painter, photographer, printmaker, and installation artist

Born: El Paso, Texas, 1937. **Education:** Texas Western College (now University of Texas, El Paso), B.A. in commercial art and printmaking1964; North Texas State University, Denton, 1979–82,

M.F.A. 1982. **Family:** Married in 1968. **Career:** Art teacher, ca. late 1960s.

Individual Exhibitions:

1983 *Bookworks: Celia Muñoz,* University of Texas, El Paso
1988 *Vista Series,* San Angelo Museum of Art, Texas
 Polstales y sin remedio: A Series of Paintings and Installation by Celia Alvarez Muñoz, Tyler Museum of Art, Texas
1989 *Rompiendo la liga,* New Langton Arts, San Francisco, and Center for Research for Contemporary Arts, University of Texas, Arlington
 Postales, Bridge Center for Contemporary Arts, El Paso
 30th Annual Invitational, Longview Museum and Arts Center, Texas
 Lana suve, lana baja, Lannan Museum, Lake Worth, Florida
1990 University of Texas, El Paso
 Paper Dolls and Patron Saints, Adair Margo Gallery, El Paso
 Modern Dallas Art, Dallas
1991 *Abriendo Tierra, Breaking Ground,* Dallas Museum of Art
 Smithsonian Institution, Washington, D.C.
1993 Ronald Feldman Gallery, New York
 David Winton Bell Gallery, Brown University, Providence, Rhode Island
1996 *Fibra y furia: Exploitation Is in Vogue,* Center for the Arts, San Francisco (traveling)
2000 *Celia Alvarez-Munoz: A Retrospective,* Blue Star Art Space, San Antonio, Texas

San Diego Museum of Contemporary Art, California; Dallas Museum of Art; San Antonio Museum of Art, Texas.

Selected Group Exhibitions:

1983 *Chicana Voices and Visions: National Exhibit of Women Artists,* Social and Public Arts Resource Center, Venice, California
1987 *Third Coast Review: A Look at Art in Texas,* Aspen Museum of Art, Colorado (traveling)
1988 *The First Texas Triennial,* Contemporary Art Museum, Houston (traveling)
1989 *Sin Fronteras: Crossing Borders,* Gallery of Contemporary Arts, University of Colorado, Colorado Springs (traveling)
1990 *Personal Odysseys: The Photography of Celia Alvarez Muñoz, Clarissa T. Sligh, and Maria Martinez-Cañas,* Intar Latin American Gallery, New York (traveling)
 Chicano Art: Resistance and Affirmation, Wight Art Gallery, University of California, Los Angeles (traveling)
1991 *Whitney Museum Biennial,* Whitney Museum of Contemporary Art, New York
1993 *Revelaciones/Revelations: Hispanic Art of Evanescence,* Herbert F. Johnson Museum of Art, Cornell University, Ithaca, New York

1995 *New Orleans Triennial,* New Orleans Museum of Art
2001 *Mysterious Openings,* Lazo & Bustos Gallery, Dallas

Collection:

New Mexico State University Art Gallery, Las Cruces.

Publications:

By ALVAREZ MUÑOZ: Book—*Enlightenment #1,* Arlington, Texas, Enlightenment Press, 1982.

On ALVAREZ MUÑOZ: Books—*Personal Odysseys: The Photography of Celia Alvarez Muñoz, Clarissa T. Sligh, and Maria Martinez-Cañas,* exhibition catalog, text by Moira Roth and Inverna Lockpez, New York, Intar Gallery, 1990; *Revelaciones=Revelations: Hispanic Art of Evanescence,* exhibition catalog, Ithaca, New York, Cornell University, 1993; *Celia Alvarez Muñoz: Medium and Message,* exhibition catalog, text by Bonnie Clearwater, Providence, Rhode Island, Brown University, 1994; *1995 New Orleans Triennial,* exhibition catalog, text by Dan Cameron, New Orleans, New Orleans Museum of Art, 1995; *Latin American Women Artists of the United States: The Works of 33 Twentieth-Century Women* by Robert Henkes, Jefferson, North Carolina, McFarland, 1999. **Article**—Exhibition review, in *Art New England,* 15, June/July 1994, pp. 70–71.

* * *

The artist Celia Alvarez Muñoz was born in 1937 in El Paso, Texas, on the border of the United States and Mexico. Because she was raised in this environment, her works retain a distinctly bilingual and bicultural style that is derived from the diverse issues surrounding the Southwest border region. As a Mexican-American woman coming of age during the 1960s and 1970s, Alvarez Muñoz created work that carries with it an exploration of the meanings of community, memory, and identity.

Alvarez Muñoz graduated from Texas Western College (now the University of Texas at El Paso) in 1964 with a B.A. in commercial art and printmaking. Educated in the academic traditions of art history up to the postwar period of abstract expressionism, she was also influenced by the Chicano and other civil rights movements of the era. Upon graduating from college, she worked as an art teacher and in 1968 married, and she then traveled throughout the country for several years before embarking on a professional art career.

In the 1970s Alvarez Muñoz began constructing handmade art books dealing with themes of identity, loss of innocence, and self-discovery that were loosely based on her own childhood experiences. Her work is deeply rooted in the rich storytelling traditions passed down by Mexican-American families for generations. In the artist's case it was her grandmother who provided her with an oral history of her family and culture. The power of language and the juxtapositioning of text and image inspired Alvarez Muñoz. In her initial years as an artist she cultivated a visual style that endeavored to represent complex notions of contradiction, assimilation, and hybridity. These themes affected a majority of second- and third-generation Mexican-Americans, who struggled to retain their cultural values while simultaneously trying to find a place for themselves in the context of American culture.

In 1979 Alvarez Muñoz entered graduate school at North Texas State University in Denton to pursue an M.F.A. degree. While in

graduate school, she became interested in the Mexican printmaker José Guadalupe Posada. In his often witty and satirical caricatures Posada represented the social and political events of his day in the form of inexpensive mass-produced leaflets that were directed at a largely illiterate population. Posada's influence on Alvarez Muñoz would be far-reaching, and for the next several years she worked primarily with lithographs and other printmaking processes.

Alvarez Muñoz eventually moved into the field of photography and began to incorporate conceptual strategies into her work. She became well known for moving beyond the political and didactic frameworks of previous Chicano art stylistics into a broader and multifaceted vocabulary that expressed both personal and collective themes. She continued, however, to adhere to the notion of narrative structures and text in her work. From this point on she began to move away from two-dimensional formats and to experiment with large-scale installations and mixed-media works. Enriched by her academic experiences and the vigorous cultural and political atmosphere of the late 1960s and early 1970s, Alvarez Muñoz created an artistic style that communicated her life experiences in the same vein as storytelling and that could be passed on to future generations.

—Miki Garcia

ALŸS, Francis
Mexican painter, sculptor, and photographer

Born: Antwerp, Belgium, 1959; moved to Mexico, 1987. **Education:** Institut d'Architecture de Tournai, Belgium, 1978–83; Instituto Universitario di Architettura di Venizia, Venice, 1983–86.

Individual Exhibitions:

1994 *Francis Alÿs–Raymond Pettibon,* Expo-Arte,
 Guadalajara, Mexico
1995 Opus Operandi, Ghent, Belgium
1996 ACME, Santa Monica, California
 Museo de Arte Contemporáneo de Oaxaca, Mexico
1997 Museo de Arte Moderno, Mexico City
 Jack Tilton Gallery, New York
1998 Contemporary Art Gallery, Vancouver, Canada (traveled
 to Portland Institute for Contemporary Art, Oregon)
 Dia Center for the Arts, New York
1999 Lisson Gallery, London
 Kilchmann Galerie, Zurich
2000 Galerie d'Art de l'Université du Québec, Montreal
 Centro de Arte Reina Sofia, Madrid
2001 Witte de With, Rotterdam

Selected Group Exhibitions:

1995 *Longing and Belonging,* Site Santa Fe, New Mexico
1996 *NowHere,* Louisiana Museum, Copenhagen
1997 *In Site 97,* Tijuana, Mexico/San Diego, California
 Antechamber, Whitechapel Art Gallery, London
1998 *Rotieros. Rotieros. Rotieros. Rotieros.
 Rotieros. Rotieros.,* São Paulo Bienal

Insertions, Arkipelag, Stockholm

Publications:

On ALŸS: Books—*Francis Alÿs: The Liar: The Copy of the Liar,* exhibition catalog, Guadalajara, Mexico, Arena, 1991; *Fantasies of Fate: The New Latin American Magic Realism,* exhibition catalog, text by Claudia Leaño and Adam Sheffer, New York, Galeria Ramis Barquet, 1996; *Francis Alÿs,* exhibition catalog, n.p., Galeria Camargo Vilaça, 1995; *Francis Alÿs: Walks/Paseos,* exhibition catalog, Mexico City, Museo de Arte Moderno, 1997; *Walks=Paseos,* exhibition catalog, Guadalajara, Mexico, Museo de Arte Moderna, 1997; *Le Temps du sommeil,* exhibition catalog, text by Kitty Scott, Vancouver, British Columbia, Contemporary Art Gallery, and Portland, Oregon, Portland Institute for Contemporary Art, 1998; *Francis Alÿs: The Last Clown,* exhibition catalog, text by Michele Theriault, Montreal, Galerie de l'UQAM, 2000. **Articles**—"Francis Alÿs, Galería Ramis Barquet" by Yishai Jusidman, in *ArtForum,* January 1995; "Francis Alÿs at Jack Tilton" by Raphael Rubinstein, in *Art in America,* November 1995; "Francis Alÿs" by Bruce Ferguson, in *Flash Art,* May-June 1996; "Francis Alÿs and the Return to Normality" by Michael Darling, in *Frieze,* March-April 1997; "Francis Alÿs: The Liar and the Copy of the Liar" by MagalXi Arriola, in *Art Nexus* (Colombia), 28, May/July 1998, pp. 112–113; "Head to Toes: Francis Alÿs's Paths of Resistance" by Carlos Basualdo, in *Artforum International,* 37(8), April 1999, pp. 104–107; "Francis Alÿs: Hypotheses for a Walk" by Issa Maria Benitez Dueñas, in *Art Nexus* (Colombia), 35, February/April 2000, pp. 48–53; "Francis Alÿs: Streets and Gallery Walls" by Gianni Romano, in *Flash Art* (Italy), 23(211), March/April 2000, pp. 70–73; "Francis Alÿs, Just Walking the Dog" by David Torres and others, in *Art Press* (France), 263, December 2000, pp. 18–23.

* * *

Francis Alÿs's diverse body of work to date can be formally characterized as conceptual in nature, deploying strategies of poststudio practice. Poststudio practice is a broad rubric that is anchored in the site specificity of the 1960s and '70s conceptual and environmental art. The reconfiguration of this paradigm by Alÿs is evinced in his on-site art projects that are of an ephemeral nature, as well as in his idiosyncratic technique of recruiting nonartists for the completion of his works. There is always a collaborative dimension to Alÿs's art. This can be discerned in his involvement with commercial sign painters, as was the case with his early forays into conceptual painting, or with collaborations that entailed the wider public in general, exemplified in his art projects executed in the day-to-day world.

In one of his early pieces, for example, Alÿs pushed a block of ice through the sidewalks of Mexico City. This project was as much about a performative impulse that intervened into daily life as it was about an aesthetic of process. These notions of process and interaction are formal and conceptual linchpins that navigate Alÿs's work in myriad directions. In another site-specific work, titled *Narcoturismo* (1996), Alÿs walked through Amsterdam for a week under the influence of a different drug each day. Site specificity in this case had less to do with Alÿs's absorption of the work into the physical constitution of the city than it had to do with Amsterdam's notoriously

lax drug laws that engendered a response toward deregulation articulated in the nature of the project as a social and not physical site-specific work. This is just one narrative strand of many, and *Narcoturismo* is testament to how Alÿs can address complex political, cultural, and social issues with the simplest of means. What sets the performative dimension of Alÿs's work apart from that of others who work in the public sphere is that he incorporates elements that might be seen as supplementary or auxiliary to the performance; *Narcoturismo* was documented via "photographs, notes, or any other media that became relevant."

Alÿs's early work in general is an exploration of the urban landscape and its social affectation on the anonymous individual. This emphasis has its roots in early modernism, as cited in the work of Charles Baudelaire and his idea of the flaneur, and in 1960s situationism, specifically in its concepts of the *dérive* (drift) and psychogeography. In researching cities around the world, Alÿs seems to concomitantly play different roles that hint at his poststudio practice. Urban geography, sociology, and ethnography are some of the disciplinary endeavors that converge in his work.

As a Belgian living in Mexico City who has spent a lot of time abroad, Alÿs has been privy to urban machinations, both conscious and unconscious, that compel urbanites to act in particular ways. Alÿs has said this about his art: "I spend a lot of time walking around the city . . . the initial concept for a project often emerges during a walk. As an artist, my position is akin to that of a passer-by constantly trying to situate myself in a moving environment." Recently Alÿs has worked in other media such as video and the Internet, but his continued investigations of cosmopolitanism and urbanity seem to be one of his recurrent themes, however they are configured. His Internet project titled *The Thief* (2000), for the Dia Foundation in New York City, critically merged Renaissance theories of vision and painting with Western twentieth-century modernist concepts of visuality, aesthetics, and urbanism.

Before arriving in Mexico City, Alÿs studied architecture and engineering in Belgium and Italy. After moving to Mexico City and living there for some 15 years, he began artistically to explore urbanity but through the lenses of his previous academic practices. Alÿs's aesthetic strategies at this time were less informed by historical and contemporary international artistic trends than they were about addressing the cosmopolitan center in the way an architect or urban planner might approach it. In other words, Alÿs perceived the city as a dynamic entity in flux, a constellation of social members in perpetual process of negotiation with each other and their environment. It is in this notion of dynamism that Alÿs's work can be understood and that helps to illuminate the complexity of his artistic practice and importance in the international contemporary art arena.

—Raúl Zamudio

AMADO, Jesse
American painter and sculptor

Born: San Antonio, Texas, 1951. **Education:** University of Texas, Austin, B.A. in English 1977; University of Texas, San Antonio, B.F.A. 1987, M.F.A. 1990. **Career:** Artist-in-residence, Fabric Workshop, Philadelphia, 1990, Bemis Center for Contemporary Arts,

Omaha, Nebraska, 1994, ArtPace Foundation for Contemporary Art, San Antonio, Texas, 1995, and City Gallery of Kwangju, South Korea, 1997. Worked as a firefighter. **Military service:** U.S. Navy. **Awards:** Jurors award, *Tenth Annual Texas College Art Show,* Mountain View College, Dallas, 1983; Creative Excellence award-graduate category, University of Texas, San Antonio, 1989; grants, National Endowment for the Arts, 1990, 1991; grant, Art Matters, Inc., New York, 1992. **Agent:** Barbara Davis Gallery, 2627 Colquitt, Houston, Texas 77098, U.S.A.

Individual Exhibitions:

1989 *Pursuit of Transient Aims,* Koehler Cultural Art Center, San Antonio, Texas
1991 Philadelphia Fabric Workshop
1992 Jansen-Perez Gallery, San Antonio, Texas
 Galveston Arts Center, Texas
1993 David/McClain Gallery, Houston, Texas
1994 Bemis Center for Contemporary Art, Omaha, Nebraska
 Milagros Contemporary Art Gallery, San Antonio, Texas
1995 David/McClain Gallery, Houston
 Jesse Amado: A Flirtation with Fire, Carla Stellweg Gallery, New York
1996 Milagros Gallery, San Antonio, Texas
 Jesse Amado: Renascence, Contemporary Arts Museum, Houston
1997 Wolfson Gallery, Miami
 Jesse Amado: Con carino, Line Gallery, Kwangju, South Korea
 Sala Diaz, San Antonio, Texas
 Jesse Amado: Common Task, Barbara Davis Gallery, Houston
1998 Blue Star Art Space, San Antonio, Texas
1999 *Disenchantment,* Rose Amarillo, San Antonio, Texas
2000 Finesilver, San Antonio, Texas (with Donald Moffet)

Selected Group Exhibitions:

1990 *Three Sculptors–Three Coasts,* Blue Star Art Space, San Antonio, Texas
1991 *Tejanos–Artistas Mexicanos–Norteamericanos,* Museo de Arte Alvar y Carmen de Carrillo Gil, Mexico City
 The Perfect World, San Antonio Museum of Art, Texas
1993 *TEXAS Between Two Worlds,* Contemporary Arts Museum, Houston (traveled to Modern Museum of Fort Worth, Texas, and Museum of South Texas, Corpus Christi)
1995 *New Works for a New Space,* Pace Roberts Foundation for Contemporary Art, San Antonio, Texas
1996 *Tres proyectos latinos,* Austin Museum of Art, Texas
 Synthesis & Subversion, University of Texas, San Antonio
1998 *Collective Visions,* San Antonio Museum of Art, Texas
 Art on Paper: Thirty Third Annual Exhibition, Weatherspoon Art Gallery, University of North Carolina, Greensboro
1999 *Material, Process, Memory,* Jones Center for Contemporary Art, Austin, Texas

Collections:

Museum of Fine Arts, Houston; San Antonio Museum of Art, Texas.

Publications:

On AMADO: Books—*Taking Liberties,* exhibition catalog, Houston, DiverseWorks Artspace, 1993; *ArtPace: New Works for a New Space,* exhibition catalog, San Antonio, Texas, Pace Roberts Foundation for Contemporary Art, 1993; *Jesse Amado: Renascence,* exhibition catalog, text by Dana Friis-Hansen, Houston, Contemporary Arts Museum, 1996. **Articles**—"In Context: The Work of Jesse Amado and Alejandro Diaz" by Joe Daun, in *Voices of Art,* October 1994; "While Floating: Jesse Amado at ArtPace" by Meredith Jack, in *Voices of Art,* March/April 1995; "Ten Minutes with Jesse Amado" by Peter Doroshenko, in *CIRCA,* fall 1995; "Studio View: San Antonio, Texas: Jesse Amado" by Roger Welch, in *New Art Examiner,* 26(5), Feburary 1999, p. 45; "Jesse Amado, Zen-Texan," in *New Art Examiner,* March 1999; "San Antonio: Jesse Amado and Donald Moffet at Finesilver" by Frances Colpitt, in *Art in America,* 88(3), March 2000, p. 137.

* * *

Jesse Amado's drawings, sculptures, installations, and performance art pieces are known for their minimalist elegance and their intelligence. He is recognized as one of the most important contemporary artists to emerge from Texas, although his work is often difficult for a casual viewer to grasp. His hallmark has been to pair materials and meanings in his work to create installations that make profound statements about universal themes as well as personal events. His work draws from two powerful sources. On the one hand, he has followed in the footsteps of Joseph Beuys, Jannis Kounellis, and other European artists of the *arte povera* movement. On the other hand, his work is informed by his Latino heritage and the specific connotations this cultural background holds for him.

Amado's path to the visual arts was a circuitous one. His interest in modern art blossomed during a stint in the navy. When his tour of duty was finished, he moved to New York City, intending to become a writer. He eventually returned to his home in San Antonio to be near his parents, and he became a firefighter to help support them. It was not until the 1980s that he began to express himself through the visual arts. He returned to school, having long since received a degree in English, and earned a M.F.A, degree in 1990 from the University of Texas at San Antonio.

Amado's artistic direction was shaped by his tenure as an artist-in-residence at the Fabric Workshop in Philadelphia in 1991. There he became acquainted with the work of Beuys and experimented with the use of materials such as felt in sculptural objects. He ultimately produced a piece that used felt and zippers as a visual metaphor for the body and layers of consciousness. Returning to San Antonio, he created tables and wall reliefs that paired antithetical elements–hardware and soft substances, opaque sheets and veils, industrial materials and natural elements. In 1995 he was selected as one of the first resident artists at ArtPace Foundation for Contemporary Art in San Antonio. At the end of his residency he held an exhibition that introduced his cutting-edge style to a broader audience. His exhibit incorporated hundreds of bars of soap from a local botanica with mirrors and glass to convey a theme of purity and cleansing.

In 1996 Amado had a solo exhibition at the Contemporary Arts Museum in Houston. The installation, called *Renascence,* was a critical success. The pieces, both individually and collectively, limned the theme of rebirth. Throughout the exhibit there were images of fragility, death, and renewal. Once again, Amado's genius lay in his melding of materials and meanings. *Lily Pond,* for instance, featured a bouquet of calla lilies that had been beheaded by a steel office paper cutter. A felt blanket, stained with the water that had kept the flowers alive, cushioned the decapitated stems. Like much of Amado's work, *Lily Pond* suggested multiple meanings. The lily, traditionally a symbol of Christian purity, had been ravaged by the industrial equipment. At the same time calla lilies are prevalent in Mexican funerals. There were also psychosexual elements in the work. The beauty of the flower had been wantonly destroyed; it had literally been deflowered by efficiency. But the water connoted life, virginity, and vitality.

In 1997 Amado was selected to represent San Antonio in the Kwangju Biennial in South Korea, where he focused on using only found objects to create his installation. In fact, he took no tools or materials with him. In a 2000 exhibition held at Finesilver Gallery in New York City, Amado again evoked the themes of life and death in his unique minimalist style. *Me, We* consisted of a pair of industrial-sized pallets, one of dark granite, the other of white marble, placed on the floor of the gallery. They were made of tombstone material and bound to the floor, and the shapes were funereal.

Amado's work shifted radically in 2000 and 2001 when he began to incorporate elements of performance art into his pieces. *Disenchantment,* for example, was a multimedia study of the dichotomy between love and desire. It combined moving images, individual pieces, and performance art. The work included video clips of buzzing wasps and of a man undressing, as well as a series of graphite rubbings. It also involved a woman with a gun prowling the audience and "shooting" men with stickers. The show finished with Amado climbing atop a steel cage and singing the Beatles' *Love Me Do.* Another multimedia performance piece of 2000, *Moving Images,* dealt more directly than any of his previous works with his experiences as a Latino. The piece was centered around two subtitled movies–Luis Buñuel's *The Exterminating Angel* and Stanley Kubrick's *Spartacus*–and examined the issue of translation.

—Rebecca Stanfel

AMIGHETTI, Francisco
Costa Rican painter, engraver, and muralist

Born: San José, 1 June 1907. **Education:** Escuela Nacional de Bellas Artes, 1931; University of New Mexico, late 1930s; studied in Argentina, mid-1940s, on scholarship. **Family:** Married 1) Emilia Prieto in 1929 (divorced), two children; 2) Flora Luján *ca.* 1936 (divorced), two daughters; 3) Isabel Vargas Facio *ca.* 1980. **Career:** Met sculptors Juan Manuel Sánchez, *q.v.,* and Francisco Zúñiga, *q.v.,* 1929; became interested in wood engraving and first published his wood engravings in *Repertorio americano,* 1929; contributed wood engravings to various periodicals and books. Instructor of drawing and wood engraving, Escuela Normal, Heredia, 1931; also taught at Liceo de Costa Rica and Facultad de Bellas Artes de la Universidad de

Costa Rica, *ca.* 1936. Traveled to Argentina, Bolivia, and Peru, 1932; to New York, late 1930s and early 1940s; to Mexico, mid-1940s. Member, artist group *Círculo de Amigos del Arte.* **Awards:** First prize, *IX exposición centroamericana de artes plásticas,* Costa Rica, 1937; primer premio en grabado, Juegos Florales Abelardo Bonilla, Costa Rica, 1969; académico de número, Academia Nacional de Bellas Artes de Argentina, 1969; premio magón, Costa Rica, 1970; primer premio de grabado, *Segundo salón anual de artes plásticas,* Costa Rica, 1973. Commandateur de l'ordre des arts et des lettres, gobierno de Francia, 1974; honorary doctorate, Universidad de Costa Rica, 1993. **Died:** 1998.

Selected Exhibitions:

1931	*Salones anuales de artes plásticas,* San José
1932	*Salones anuales de artes plásticas,* San José
1933	*Salones anuales de artes plásticas,* San José
1934	*Salones anuales de artes plásticas,* San José
1935	*Salones anuales de artes plásticas,* San José
1936	*Salones anuales de artes plásticas,* San José
ca. 1967	Dirección de Artes y Letras de Costa Rica (retrospective)
1976	Facultad de Bellas Artes de Costa Rica (retrospective)
1979	Costa Rican Museum of Art (retrospective)
1985	*Francisco Amighetti Holzchnitie,* Bonn, Germany
1987	Museo de Arte Costarricense, San José (traveling retrospective)
1989	Taiwan Museum of Art

Museo del Grabado, Argentina; Museo de Grabado Latinoamericano de Puerto Rico; El Palacio de Bellas Artes de México; Ibero Club, Bonn, Germany; Galería Paula Moderson Becker Haus, Bremen, Germany; Casa Andrés Bello, Caracas; Galer a Track, Caracas; UNESCO, Paris; National Theatre of Romania; Galerídel Teatro, Israel.

Collections:

Museum of Modern Art, New York; Museo de Grabado, Buenos Aires; Museo del Grabado Latinoamericano, San Juan, Puerto Rico; Ibero Club, Bonn, Germany; Museo de Arte Latinoamericano, Havana; Museo de Arte Costarricense, San José; Museo de Arte Moderno, Rio de Janeiro; Museo de Arte Moderno, Osaka, Japan.

Publications:

By AMIGHETTI: Books—*Album de grabados,* with others, Costa Rica, 1934; *Francisco en Harlem,* Mexico, Ediciones Galería de Arte Centroamericano, 1947; *Francisco y los caminos,* San José, Editorial Costa Rica, 1963; *Francisco en Costa Rica,* San José, Editorial Costa Rica, 1966; *Poesías,* San José, Editorial Costa Rica, 1974; *Poesia gráfica,* exhibition catalog, San José, Museo de Arte Costarricense, 1984. **Books, illustrated**—*El tunco* by Arturo Mejía Nieto, Buenos Aires, Editoria Tor, 1932; *Cuentos de maravilla* by Evangelina Gamboa, San José, Librería Atenea, 1954.

On AMIGHETTI: Books—*Amighetti: Grabador—engraver—Holzschneider,* exhibition catalog, text by Luis Ferrero, San José, Don Quijote, 1967; *Amighetti,* exhibition catalog, San José, Museo de

Arte de Costarricense, 1979; *Francisco Amighetti* by Stefan Baciu, Heredia, Costa Rica, Editorial de la Universidad Nacional, 1985; *El desorden del espíritu: Conversaciones con Amighetti* by Rafael Angel Herra, San José, Editorial de la Universidad de Costa Rica, 1987; *Amighetti: 60 años de labor artistica,* exhibition catalog, text by Carlos Guillermo Montero, San José, Museo de Arte Costarricense, 1987; *Francisco Amighetti* by Sonia Calvo, San José, Editorial de la Universidad de Costa Rica, 1989; *A-mi-kai-t'i pan hua yao ch'ing chan,* exhibition catalog, text by T'ai-wan sheng li mei shu kuan, Taiwan, Taiwan Museum of Art, 1989; *Costa Rica: Poesía escogida,* second edition, by Roberto Brenes Mesén and Carlos Francisco Monge, San José, EDUCA, 1998.

* * *

Francisco Amighetti was one of the foremost artists of the local Costa Rican avant-garde movement. From his beginnings in the world of art in the 1920s, Amighetti sought inspiration from a wide range of sources that were spurring the European and Latin American avant-garde movements, to which he gained access through publications brought to him from Europe by Max Jiménez as well as through the journeys he made in Argentina, Mexico, and the United States. The avant-garde internationalism of the Argentine magazine *Martín Fierro* as well as the interest of the Mexican mural movement in native Indian aesthetics showed themselves to be essential influences for Amighetti and for the artists of the Costa Rican avant-garde as a whole.

Although he had a brief fascination with cubism, Amighetti's first works were seen to be clearly marked by a Japanizing taste for postimpressionist reminiscences. These were linear drawings in which the subtle play of the lines and the equilibrium of the spaces were framed in a sense of synthesis that was later to impregnate several of his color xylographs. The drawings, as can be seen in the *Album of Drawings* of 1926, reveal Amighetti's interest in the traced line, which came to be fully developed in his xylographic work. He began with wood carving, denoting an increasing affinity with expressionism, which initially adhered to the Costa Rican avant-garde's growing interest in the postulates of the popularization of art that spurred Mexican muralism. Because xylography enabled a work to be reproduced in multiple form through several editions, the movement saw in the technique a clear realization of the desire to communicate and of the exercise of social criticism.

The expressionist current, which also came to influence the work of Costa Rican avant-garde artists such as Juan Manuel Sánchez and Max Jiménez, led Amighetti to develop a style in line with his growing critical view of daily life in Costa Rica. In the important *Album of Drawings* of 1934, a major proportion of the artists involved in local avant-garde movements, including Francisco Zúñiga, took part. In his xylographs, which were often expressionist and which referred to social questions, Amighetti still showed a clear inclination toward the chinoiserie that inspired his drawings. The construction of areas of expressive color in his later polychromatic wood engravings reveal these first trials to be centered around the relationship between the spaces that arose from the early Japanese influence.

Amighetti's intense pictorial production, which included several mural projects, occurred mainly in the period from the 1930s to the 1960s and denotes a concentration on the construction of grounds, discarding the volumetric effect and achieving a generally ingenuous air in which the figures seem to be flat. His trips to New York City,

Central America, Mexico, and Argentina served to develop his sense of cultural contrasts and led him to incorporate stylistic and iconographic elements from diverse sources, especially Mexican muralism and Central American popular culture. In this way he came to incorporate motifs such as the skull and crossbones and religious processions and to deal with the subject of the life of Saint Francis of Assisi.

After periods devoted to easel painting and murals, at the age of 60 Amighetti embarked upon color xylography, a technique that was to bring him back to his original interest in Japanese art. His most important production is his xylographic work of the 1960s and 1970s, years in which he produced brilliant works such as *Conflicto entre niño y gato* (1969; ''Fight between a Child and a Cat'') and *La niña y el viento* (1969; ''The Little Girl and the Wind''). Motivated by the images of ukiyo-e, especially those of Hiroshige and Hokusai, Amighetti applied subtly Japanizing features to his strong lines and to his use of the expressiveness of the wood grain even within the areas of color. One can see in Amighetti's color xylographs, which are essentially expressionist, the richness of the color, the sense of equilibrium between grounds, and the appreciation of the empty spaces as expressive areas that reveal the inspiration in the ''world of floating shadows'' of Japanese color xylography. Constant features in the work of Amighetti are the opposition of good and evil, life and death, and the sensuality of youth and impotence of old age.

—Vivianne Loría

ANGUIANO (VALADEZ), Raúl
Mexican painter

Born: Jalisco, 1915. **Education:** Escuela Libre de Pintura, Guadalajara, 1930; studied mural technique in Mexico City, 1930s; Art Students League, New York, 1940–41. **Career:** Instructor, La Esmeralda, and administrator of artistic studies, Instituto Nacional de Bellas Artes, Mexico City, 1934. Joined League of Revolutionary Writers and Artists and Taller de Gráfica Popular, 1937. Traveled to Cuba and the United States, 1940–41. Guest professor, Trinity University, San Antonio, Texas, 1966. Founding member and vice president, Asociación Mexicana de Artes Plásticas, 1968. **Awards:** Prize, *Salón de Invierno,* Instituto Nacional de Bellas Artes de Mexico, 1953, 1954; José Clemente Orozco medal, Jalisco, 1956; first prize and gold medal, *Salón panamericano de arte,* Brazil, 1958; Premio Jalisco, 1988; Premio Ocho Columnas de Oro, governor of the state of Jalisco, 1989. Honorary degree, University of California, Los Angeles, 1983.

Individual Exhibitions:

1935	Palacio de Bellas Artes, Mexico City
1953	San Francisco Museum of Art
1966	Gallery of the Mexican Consul General, Washington, D.C.
1980	Centre Culturel du Mexique, Paris
1982	Museo del Palacio de Bellas Artes, Mexico City (retrospective)
1985	Instituto Cultural Cabañas, Guadalajara
1990	Pinacoteca del Estado de Tlaxcala, Mexico (traveling)
1992	Museo Nacional de la Estampa, Mexico City
1995	*Raul Anguiano: Obra gráfica,* Museo Nacional de la Estampa, Mexico City
1999	*Anguiano por Anguiano,* Galería Dr. J. Pilar Licona Olvera, Universidad Autónoma de Hidalgo

Selected Group Exhibitions:

1940	*Twenty Centuries of Mexican Art,* Museum of Modern Art, New York
	Art Institute of Chicago
	Institute of Modern Art, Boston
1943	Museum of Modern Art, New York
1958	Cincinnati Art Museum
1966	*Contemporary Mexican Artists,* Simon Patrich Galleries, Los Angeles
1989	*The Latin American Spirit: Art & Artists in the U.S.,* Bronx Museum, New York

Collections:

Colorado Springs Fine Arts Center, Colorado; Museum of Fine Arts, Boston; Museum of Modern Art, New York; Ministry of Public Education, Mexico City; Vatican Museum, Rome; Royal Museum of Art and History, Brussels, Belgium; Peking National Museum, China.

Publications:

By ANGUIANO: Books—*Por qué es tan cara la vida?,* Mexico City, Taller de Gráfica Popular, 1942; *Anguiano por Anguiano,* exhibition catalog, Hidalgo, Mexico, Universidad Autónoma del Estado de Hidalgo, 1997; *Journal of an Expedition to the Lacandon Jungle, 1949,* Mexico, Quálitas Compañia de Seguros, 1999. **Books, illustrated—***Rural Mexico* by Nathan L. Whetten, n.p., 1953; *On the Watch* by Adolfo López Mateos, n.p., 1970.

On ANGUIANO: Books—*Raúl Anguiano* by Justino Fernández, Mexico, Ediciones de Arte, 1948; *5 Interpreters of Mexico City: Diego Rivera, Feliciano Peña, Gustavo Montoya, Amador Lugo and Raul Anguiano,* Mexico, n.p., 1949, and *R. Anguiano,* Mexico City, EDAMEX, 1983, both by Jorge J. Crespo de la Serna; *Raúl Anguiano* by Margarita Nelken, Mexico, Editorial Estaciones, 1958; *7 pintores: Carlos Orozco Romero, Jorge González Camarena, Raúl Anguiano, Fernando Castro Pacheco, Luis Nishizawa, José Reyes Meza, Trinidad Osorio,* Mexico, Plástica de México, 1968; *Raúl Anguiano* by Carmen Barreda, Saltillo, Mexico, Centro de Artes Visuales e Investigaciones Estéticas, 1981; *R. Anguiano: Exposición retrospectiva, 1930–1982,* exhibition catalog, Mexico City, Instituto Nacional de Bellas Artes, 1982; *Raúl Anguiano: Una vida entregada a la plástica y catálogo de la exposición de pinturas, dibujos, estampas, tapices, esculturas y cerámicas,* exhibition catalog, text by Emmanuel Palacios and Xavier Moyssén Echeverría, Guadalajara, Instituto Cultural Cabañas, 1985; *En la pintura de Raul Anguiano* by José Pascual Buxó, Mexico City, Ediciones de Comunicacíon, 1986; *Raúl Anguiano* by Antonio Luna Arroyo, Mexico City, Grupo Arte Contemporáneo, 1990; *Raúl Anguiano,* exhibition catalog, Mexico City, Museo Nacional de la Estampa, 1992; *Raúl Anguiano: Uno de los cuatro ases del muralismo mexicano* by María de los Angeles Cajigas, Mexico City, EDAMEX, 1995; *Raul Anguiano: Obra gráfica,* exhibition catalog,

Instituto Mexico City, Nacional de Bellas Artes, 1995; *Raúl Anguiano, remembranzas* by Jorge Tiribio, Toluca, Universidad Autónoma del Estado de México, 1995; *Raúl Anguiano,* Mexico City, Miguel Angel Porrúa, 1997; *Raúl Anguiano* by Bertha Taracena, Mexico, Departamento del Distrito Federal, 1997; *Trazos de vida* by Luz García Martínez, Mexico, Fundación Ingeniero Alejo Peralta y Díaz Ceballos, 1999.

* * *

The long and productive career of Raúl Anguiano Valadez, who was born in 1915, spanned the important political and cultural apexes of twentieth-century Mexico. He was developing as a young artist, studying in his natal home of Guadalajara, as the country saw the Porfirio Díaz dictatorship end with the victories of the Mexican Revolution of 1910–20. He studied painting under José Vizcarra, and in 1934, at age 19, he moved to the capital of Mexico City, where he saw the blossoming of the works created by muralists like Diego Rivera through the leadership of José Vasconcelos, the education secretary of the new government. These extraordinary projects were to be found throughout the capital in public buildings such as the National Palace and the Ministry of Education as well as in the provinces.

Thus, it was during this historic era that the young Anguiano went to the capital to teach painting and drawing at La Esmeralda School. It was in the same year that he painted his first large mural, entitled *La educación socialista.* At the age of 20 he painted five murals at the Instituto Politécnico Nacional and numerous other murals in the provinces of Michoacán and Puebla. Anguiano became part of the second and third generations of Mexican muralists, which included Jesús Guerrero Galván, Roberto Reyes Pérez, Juan Manuel Anaya, and Máximo Pacheco. Along with many other artists of the era, they formed part of the Escuela Mexicana de Pintura, which was born in the cultural regeneration under Vasconcelos. Anguiano's works of the period represent a Mexican vision that gives dignity to humble Mexican peasants and their struggles.

To be an artist during the 1930s in Mexico was to be fully immersed in an intellectual movement of which Anguiano was both a participant and a leader. He was a member of the League of Revolutionary Writers and Artists, which he joined in 1937. That same year a group, including Anguiano, broke away to found the Taller de Gráfica Popular, which led to the dissolution of the league. The workshop made an important contribution in popularizing the Mexican Revolution through prints, primarily linocuts, woodcuts, and lithographs. Anguiano had made prints, such as his first lithograph, entitled *El Zapata,* as early as 1930, and he has continued to make them throughout his career, carrying on the tradition of José Guadalupe Posada. Many muralists turned into printmakers in order to continue to communicate the messages of the revolution and to support Lázaro Cárdenas, president from 1934 to 1940, in his effort to institutionalize and cement the goals of the revolution. Easier to manage and with a wider distribution possible, posters, cards, and broadsheets were produced with images as powerful as those on the murals and with messages about current issues such as the expropriation of foreign-owned oil resources. The Taller de Gráfica Popular continued its work and had a significant influence on the style of communicating social and political messages in a number of other countries.

Easel painting, including portrait painting, occupied Anguiano along with his use of other media. His work was shown in 1940 and 1943 at the Museum of Modern Art in New York City, and he had exhibitions in a number of New York galleries. In 1940–41 he traveled to Cuba and then to the United States, where he studied and worked, continuing to use the themes of Mexican life. Throughout the second half of the twentieth century he continued to be included in numerous foreign exhibitions in Chile, Russia, Italy, and France and in many major cities in the United States.

In 1964 Anguiano completed a significant commission for the new Museum of Anthropology in Mexico City. The mural, which shows the creation of Mayan man and numerous rituals and religious customs of the Mesoamerican world, contains detailed drawings of gods that include Quetzalcoatl, Tlaloc, and Tepeyolotli, all figures taken from codices and other archaeological finds. Environmental themes and other contemporary issues have also appeared in his work over the past few decades. Mural commissions have continued to come to Anguiano, who painted a large mural about mestizos in 1992 at the age of 77.

Throughout his extensive career Anguiano has rendered powerful figures that have served to enlighten the public about the history and struggles of the Mexican people and to inspire another generation of Mexican artists about their cultural heritage. His dignified, unassuming figures, painted with a forceful expressiveness, have their roots deep in the tradition of the great Mexican muralists. During nearly a century of artistic production, Anguiano has evolved and changed with the social and cultural issues of his country and the times.

—Linda A. Moore

ANTÚÑEZ, Nemesio
Chilean painter

Born: Santiago, 1918. **Education:** Studied architecture at Universidad Católica de Santiago, 1937–43; Columbia University, New York (Fulbright fellow), M.S. in architecture 1945; studied printmaking at Stanley William Hayter's Graphic Workshop, New York, 1948–49, and Paris, 1950–53. **Career:** Director, Museo de Arte Contemporáneo, Universidad de Chile, Santiago, 1961–64; cultural attaché, Chilean embassy, New York, 1964–69; director, National Museum of Fine Arts, Santiago, 1969–73; director, Museo Nacional de Bellas Artes, 1991–92. Lived in Paris, 1950–53, Barcelona, 1973, London, 1978–82. Founder, Taller 99 printmaking workshop, Santiago, 1953. **Died:** May 1993.

Individual Exhibitions:

1945	Norlyst Gallery, New York
1950	Bodley Gallery, New York
1966	Bodley Gallery, New York

Selected Group Exhibitions:

1965	Galerie Couturier, Stamford, Connecticut
1966	*Art of Latin America since Independence,* Yale University, New Haven, Connecticut, and University of Texas, Austin
	Bodley Gallery, New York

Collections:

Cincinnati Art Museum; Library of Congress, Washington, D.C.; Metropolitan Museum of Art, New York; Museum of Modern Art, New York; New York Public Library, New York; Rhode Island School of Design, Providence.

Publications:

By ANTÚÑEZ: Books—*Aullido,* with Allen Ginsberg, Fernando Alegría, and others, Santiago, La Editorial del Pacifico, 1957; *Carta aérea,* with Hernán Garfias, Santiago, Editorial Los Andes, 1988; *El amor de Chile,* with Raúl Zurita, Hernán Garfias, and others, Santiago, Editorial Los Andes, 1989.

On ANTÚÑEZ: Books—*Conversaciones con Nemesio Antúñez* by Patricia Verdugo, Santiago, Ediciones Chile América, 1995; *N. Antúñez* by Montserrat Palmer Trías, Santiago, Ediciones ARQ, 1997; *Nemesio Antúñez: Exposición retrospectiva,* exhibition catalog, Santiago, Museo Nacional de Bellas Artes, 1997.

* * *

Nemesio Antúñez is without a doubt the most significant modern Chilean painter after Roberto Matta. Born in Santiago, Antúñez received his undergraduate degree in architecture (like Roberto Matta) from the Universidad Católica in Santiago. In the early 1940s he attended Columbia University in New York City, graduating in 1945 with an M.S. degree in architecture. While in New York, Antúñez took up painting and became familiar with the work of American abstractionists as well as the French surrealists, then living in exile in the city. After two years of travel abroad, he returned to New York in 1948 and studied printmaking at Stanley William Hayter's Graphic Workshop. In 1950 Antúñez followed Hayter to Paris to continue his printmaking studies. He returned to Santiago in 1953 and founded Taller 99, a printmaking workshop that, although modeled after Hayter's Atelier 17, focused on the boundaries between traditional printmaking and photomechanical reproductions. Taller 99 had a major influence on the generation of Chilean graphic artists who were trained in the 1950s.

Antúñez's earliest work consisted of softly colored, almost tonal landscapes of Chile. This was followed by a colorful neorealist depiction of the urban landscape of New York. A committed democratic leftist, Antúñez served as director of the Museo de Arte Contemporáneo in Santiago during the government of Eduardo Frei, and during the Salvador Allende government he was director of the Museo Nacional de Bellas Artes, also in Santiago. After the military coup of September 11, 1973, Antúñez went into exile. His work from the mid-1970s until his death was undoubtedly his best. These paintings, drawings, and prints reflected the political oppression and unrest of his native Chile during the Augusto Pinochet dictatorship. He achieved this first through a series of dark paintings of stadiums, where violence seems to be perpetrated upon the spectators by the players, and later in a group of black paintings depicting rectangular boxes containing distorted fragments of human figures. Antúñez's artistic achievement lay in his synthesis of both surrealistic and geometric elements into a deliberate political imagery that is never propagandistic.

—Alejandro Anreus

ARANGO (PÉREZ), Débora
Colombian painter

Born: Medellín, 11 November 1907. **Education:** Instituto Bellas Artes, Medellín, 1935; Escuela Nacional de Bellas Artes, Mexico City, 1946; Technical College of Reading, London, 1960; studied under Eladio Vélez. **Career:** Professor, Instituto Bellas Artes, Medellín, 1933–35. Traveled to Europe, 1954. **Awards:** Premio a las Letras y las Artes, Secretariat of Education and Culture of Antioquia, 1984; Order of Boyacá, 1994; medalla Alcaldía de Medellín, 1995; medal of distinction, Ministerio de Educación Nacional, Bogota, 1995; premio a la Antioqueña de oro, government of Antioquia, 2001. Honorary doctorate, University of Antioquia, Medellín, 1995.

Individual Exhibitions:

1939 Union Club, Medellín
1975 Biblioteca Pública Piloto, Medellín
1993 *Homenaje a la obra de Débora Arango,* Universidad de Antioquia, Medellín
1994 *Cuatro temas en la obra de Débora Arango,* Museo de Arte Moderno de Medellín (traveling)
1996 Banco de República, Biblioteca Luis Angel Arango, Bogota (retrospective)

Selected Group Exhibitions:

1948 Museo de Zea, Medellín
1979 *Historia de la acuarela en Antioquia,* Turantioquia, Medellín
1980 Museo de Arte Moderno de Medellín
1981 *Diez maestros Antioqueños,* Museo de Arte de Medellín
1993 *300 años del retrato en Antioquia,* Museo de Antioquia, Medellín
1995 *La virtud del valor,* Sala de Arte Suramericana de Seguros, Medellín
2001 Museum of Contemporary Art Sofía Imber, Caracas

Collection:

Museum of Modern Art of Medellín.

Publications:

On ARANGO: Books—*Débora Arango,* exhibition catalog, by Darío Ruiz Gómez, Bogota, Museo de Arte Moderno de Medellin, Villegas Editores, 1986; *Débora Arango: Exposición retrospectiva,* exhibition catalog, Bogota, Banco de República, Biblioteca Luis Angel Arango, 1996; *Débora Arango: Vida de pintora* by Santiago Londoño Vélez, Bogota, Ministerio de Cultura, República de Colombia, 1997. **Article**—''Débora Arango'' by Natalia Gutierrez, in *Art Nexus* (Colombia), 22, October/December 1996, pp. 136–138.

* * *

Débora Arango Pérez belonged to Colombia's nationalist generation, a group of artists also known as the Bachue Group, who

firmly broke with academism and expressed varied interests in local realities. Her early work was severely criticized for its crude depictions of female nudes, drunken women, and realistic births. Ostracized by the traditional Roman Catholic society in which she was raised, she confined herself to her home and continued to depict the violent, the grotesque, the sordid, and the contradictory of her social environment. Her solitary journey to self-recognition through her pictorial work was unknown to the public until a major retrospective was organized in Medellin in 1984. She was 74 years old.

During her first years as a student of the Instituto de Bellas Artes, Arango learned portrait technique with Eladio Vélez. She liked working in a figurative style, but she felt constrained by the rigidity of classicism. Being a temperamental and sensitive young woman, she craved to represent reality in a more dynamic way. She turned to Pedro Nel Gómez, one of the first artists from Antioquia to depict social themes, with whom she learned watercolor technique. As a member of the Pedro Nel Gómez school, Arango adopted a more modern and revolutionary approach, and her style evolved into a new type of figurative painting. Her watercolors dating from 1939 to 1944 clearly transgressed the norm of regional academism. She abandoned the typical colorful landscape to depict the local environment in a crude and expressionistic manner. She was particularly fond of the nude and used it as a powerful tool to depict social issues such as prostitution and poverty in works like *Trata de blancas* (1940) and *El patrimonio* (1944). Her works were highly criticized and in many cases were banned for being immoral. Her response was that, for her, art was independent of morality.

In 1946 Arango traveled to Mexico to learn from the muralists. She was particularly fond of José Clemente Orozco, an artist who had a definitive influence on her painting of social themes. During her stay in Mexico she learned from Orozco the power of narration, the handling of space, the extra scale, the treatment of faces, the use of simplification, the caricaturized vision of politics and the government and, therefore, zoomorphism. Her capacity for metamorphosis inspired some of her best pictures from the 1950s, including the controversial *La salida de Laureano,* depicting Pres. Laureano Gómez as a frog being carried on a stretcher; *La masacre del 9 de abril,* a personal rendition of the assassination of the popular caudillo Jorge Eliécer Gaitán; *Huelga de estudiantes,* dominated by the crucifixion of a military figure on the poles of banners carried by angry demonstrators; and *La república,* a powerful interpretation of Colombia's political reality represented by a demonlike figure carrying a human-headed dove, two rows of men raising their left or right hands (possibly symbolizing the two major political parties), a group of wild beasts wrapped in the Colombian flag, and a naked woman being bitten by two buzzards.

Arango's violent and crude themes were in tune with her expressionistic style. The use of sordid colors and undefined lines emphasized the strong contrasts she powerfully pursued. She managed to produce works that opposed the norm at all levels. Hers was an individual quest for freedom, a rejection of tradition, deeply rooted in Colombian art and society. Her work was not only the testimony of a difficult social and political reality but also a personal interpretation of her tormented world. Arango was a true modernist. Among Latin American artists she was probably one of the few who truly adopted Diego Rivera's definition of art. Her legacy is certainly antidecorative, antiaesthetic, anti-intellectual, brutal, human, eloquent, real, universal, and truly overloaded with social responsibility.

—Francine Birbragher

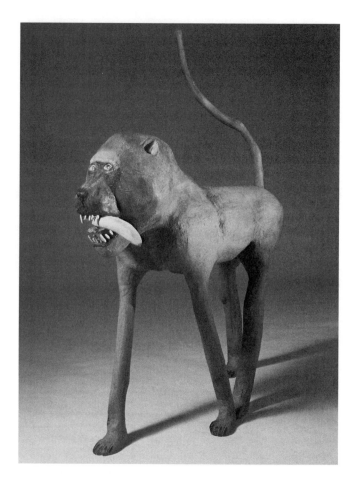

Felipe B. Archuleta: *Baboon,* 1978. © Smithsonian American Art Museum, Washington, D.C./Art Resource, NY.

ARCHULETA, Felipe B(enito)
American sculptor

Born: Santa Cruz, New Mexico, 1910. **Career:** Worked for the Civilian Conservation Corps and the Works Progress Administration; carpenter, 1943-c. 1973. Also worked as a manual laborer. Began woodcarving after retirement. **Award:** New Mexico Governor's Award for Excellence and Achievement in the Arts, 1979. **Died:** 1991.

Individual Exhibition:

1984 *Felipe Archuleta: Modern Folk Master,* Contemporary Arts Museum, Houston

Selected Group Exhibitions:

1970 *Four Southwestern Folk Artists,* New Mexico State University, Las Cruces
1976 *Folk Sculpture USA,* Brooklyn and Los Angeles County Museums
1977 *Hispanic Crafts of the Southwest,* Taylor Museum of the Colorado Springs Fine Arts Center
1978 *American Folk Art: From the Traditional to the Naive,* Cleveland Museum, Ohio

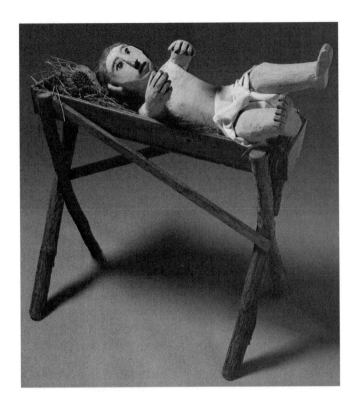

Felipe B. Archuleta: *Christ Child in Manager,* **1978–79. © Smithsonian American Art Museum, Washington, D.C./Art Resource, NY.**

1979 *One Space/Three Visions,* Albuquerque Museum
1981 *American Folk Art: The Herbert Waide Hemphill Jr. Collection,* Milwaukee, Wisconsin

Publications:

On ARCHULETA: Books—*Four Southwestern Folk Artists,* exhibition catalog, text by Richard Wickstrom, Las Cruces, New Mexico, New Mexico State University, 1970; *Folk Sculpture USA,* exhibition catalog, edited by Herbert W. Hemphill, Jr., New York, Brooklyn Museum, 1976; *American Folk Art: From the Traditional to the Naive,* exhibition catalog, Cleveland, Ohio, Cleveland Museum of Art, 1979; *American Folk Art: The Herbert Waide Hemphill Jr. Collection,* exhibition catalog, Milwaukee, Milwaukee Art Museum, 1981; *Felipe Archuleta: Modern Folk Master,* exhibition catalog, Houston, Contemporary Arts Museum, 1984; *Animal Carvers of New Mexico* by Elizabeth Wecter, Museum of American Folk Art, New York, 1986. **Articles—**"Felipe Archuleta, Folk Artist" by Davis Mather, in *Clarion,* 1, summer 1977, pp. 18–20; "A Big . . . Story" by Jim Sagel, in *Journal North* (Santa Fe, New Mexico), 15 May 1982, p. E4; "The End of the Trail" by Mark Stevens, in *Newsweek,* 1 September 1985, pp. 76–77.

* * *

Felipe B. Archuleta spent most of his life in Tesuque, New Mexico. There he was exposed to a long-standing Mexican-American tradition of religious wood carving. These wooden *santos,* or *bultos,* were produced in workshops where master carvers passed on their skills and techniques to a new generation of apprentices. Their carvings decorated churches and home shrines and were a highly visible part of daily life.

Archuleta shared very much in the culture that produced the *santos,* but until late middle age he worked primarily as a carpenter and manual laborer. In the mid-1960s, when he was 57 years old, work grew scarce. As he later explained to his dealer, Davis Mather, he asked God for guidance. "You have to do something. So one time I was bringing in my grocery and I ask God for some kind of a miracle . . . to give me something to make my life with So I started carvings after that."

Archuleta's carvings share the iconic intensity of the *santos* tradition, but his subject is secular. He began making small sculptures of animals native to New Mexico. Later, he moved to more exotic wildlife and—encouraged by dealers and collectors—larger carvings made from multiple pieces of wood. He carved *Gorilla* (1976) after studying pictures of silverback mountain gorillas in *National Geographic.* He found models for other carvings in children's books. The result is often both parodic and evocative. In *Baboon* (1978) Archuleta emphasized the animal's cocky and aggressive behavior, creating an amusing but sympathetic depiction.

One source of the humor in Archuleta's work is his imaginative use of organic and everyday materials. In *Lion* (1977) the lion's straw mane and the nails sticking out of his paws to represent claws present a cartoon version of the animal's real features—just similar enough to keep the representation from becoming cute or toylike, but dissimilar enough to give the work a comic edge.

These qualities made Archuleta's work very popular among folk-art collectors, and by the 1970s demand for his work increased sufficiently for him to begin working according to the master-apprentice model that had historically dominated the production of *santos* in New Mexico. He began producing copies of earlier carvings, both on commission and in anticipation of the market that existed for them. These reproductions are generally felt to lack the detailed craftsmanship of earlier, one-of-a-kind pieces and to lack their integration of idea and material. Archuleta himself had mixed feelings about the responsibilities of success: "Too many people come out and want this and that . . . I can't satisfy the whole world, amigo. I'm not a machine gun, I'm . . . not god."

Archuleta has been described as a folk artist. He was self-taught, and it is not unusual for a folk artist to describe his or her inspiration as primarily divine rather than artistic. But because his carvings were more or less mass produced towards the end of his life, some writers have questioned whether or not "folk art" is the best descriptor of his work.

—Anne Byrd

ARDEN QUIN, Carmelo
Uruguayan painter

Born: Carmelo Herberto Alves, Riviera, 16 May 1913. **Education:** Studied art history with Emilio Sans, 1925; Colegio de los Hermanos Maristas, Santa Ana, Brazil, 1929; Universidad de Buenos Aires, 1938. **Family:** Married Marcelle Saint-Omer in 1956 (died 1966). **Career:** Cofounder and member, abstract art group *Arturo,* Buenos

Aires, 1943; member, *Grupo Madí,* 1946; reorganized *Grupo Madí,* 1950s. Editor and contributor, *Arturo* magazine, ca. 1945, and *Arte Madí* magazine, 1947–59. Traveled to Paris, 1948; returned to Buenos Aires, 1955; moved to Paris, 1956. Cofounder, abstract art group *Asociación Arte Nuevo,* Buenos Aires, 1955; founder, Centre de Recherches et d'Etudes Madistes. **Award:** First prize, *I bienal de la Habana,* 1986.

Individual Exhibitions:

1977 Galería Quincampoix, Paris (retrospective)
1978 Galerie de la Salle, Saint Paul de Vence, France
1979 Galerie Trente, Paris
1981 Galerie de la Salle, Saint Paul de Vence, France
1985 Galerie Alexandre de la Salle, Saint Paul de Vence, France
 Espace Latino-Americain, Rome (retrospective)
 Museo de Arte Contemporáneo, São Paulo, Brazil
1986 Galería Nizzi, Brescia, Italy
1987 Galerie de la Salle, Saint Paul de Vence, France
 Retrospective 1943–1956, Galerie Downtown, Paris
1988 Galería El Patio, Bremen, Germany
 Galería Franka Berndt, Paris (retrospective)
1989 Galerie Krief, Paris
1990 Galerie Metaphore, Paris
 Galerie de la Salle, Saint Paul de Vence, France
 Galerie Franka Berndt, Paris
1996 Ibercaja, Zaragoza, Spain
1997 Telefónica Museum, Madrid (retrospective)
1998 Galerie Krief, Paris

Selected Group Exhibitions:

1936 Casa de España, Montevideo, Uruguay
1939 Sala de Exposiciones de Montevideo, Uruguay
1945 Galería Conte de Ignacio Pirovano, Buenos Aires (with *Arturo*)
1946 *II exposición de Arte Madí,* Escuela Libre de Artes Plásticas, Buenos Aires
1946 Instituto Francés de Estudios Superiores (with *Grupo Madí*)
1952 *Primera exposición internacional de arte,* Galería Cuatro Muros, Caracas, Venezuela
1963 *Del arte concreto a la nueva tendencia,* Museo de Arte Moderno de Buenos Aires
1984 Maison de l'Amérique Latine, Paris
1996 *50 años después,* Museo Reina Sofía, Madrid (traveling)
1998 *Orígenes,* Museo Extremeño e Iberoamericano de Arte Contemporáneo, Badajoz, Spain
2001 *Outside the Box: Eleven Artists of MADI International,* Polk Museum of Art, Lakeland, Florida (traveled to Gulf Coast Museum of Art, Largo, Florida)

Publications:

On ARDEN QUIN: Books—*Face a la machine,* exhibition catalog, Paris, La Maison de l'Amérique Latine, 1984; *Carmelo Arden Quin* by Agnes de Maistre, Nice, France, Demaistre, 1996; *Arden Quin,*

exhibition catalog, Madrid, Telefónica Museum, 1997. **Article—** "Cholet. Musée d'Art et d'Histoire" by Bernard Fauchille, in *La Revue du Louvre et des Musées de France,* December 1996, p. 118.

* * *

Carmelo Arden Quin has been an innovative abstract-concrete artist considered a pioneer in both Montevideo and Buenos Aires, who gave a big experimental push to the River Plate region in the 1940s and then continued his career in Europe. Everything began in Buenos Aires in the late 1930s and developed through the mid-1940s when a group of daring Uruguayan and Argentine artists, joined by foreigners residing in the Argentine capital, shook the art scene with innovative proposals in abstract art. The Uruguayan artists played a preponderant role, first through the projection of Joaquín Torres García's work and then with key involvements in the development of the constructivist movements, including the work of Arden Quin and Roth Rothfuss. Those experiments were a happy melding of European inheritances from abstract languages created by Vasily Kandinsky, Piet Mondrian, Kasimir Malevitch, Laszlo Moholy Nagy, Theo Van Doesburg, the Stijl group, the Bauhaus, and Russian constructivism, along with Torres García's constructive universalism.

In the summer of 1944 the magazine *Arturo* was published in Buenos Aires as the voice for those concerns involving abstract-concrete art. From the theoretical standpoint the most significant contribution at that time was made by Arden Quin, general coordinator of *Arturo.* Arden Quin preached in *Arturo* in the conclusive style of the avant-gardes of the time. He advocated inventiveness over automatism, proclaiming the need for pure, playful, inventive creation without falling into primitivism, realism, or decadence and rejecting expression, representation, symbolism, and surrealism. Arden Quin sought a new art for a new era.

Arden Quin and the others involved in that concrete experimentation received the contribution of the creativity of Rothfuss, who played an essential role as defender of the cutoff and irregular frame (later called the shaped canvas). According to his posture the frame should be structured according to the composition of the painting, and the border of the canvas should play an active role in visual creation.

The results of these ideas were soon to be seen in the Madí pieces done between 1944 and 1945. The Argentine Gyula Kosice created his famous wooden piece *Röyi* working with manipulable elements stuck to one another, and from there began a whole unique line of expression in which he fused dynamism with linear and curvilinear elements. Arden Quin, in turn, in *Coplanal,* became involved in the creation of relief with mobile elements in wood to transform the traditional pictorial support, creating geometric structures united by an articulated structure.

By 1945 the group had formed under the leadership of Arden Quin and Kosice and was organizing exhibitions and performances at the home of Dr. Enrique Pichon Riviere and the home of the photographer Grete Stern. In August 1946 the famous Grupo Madí was created to bring those artists together at the show held at Instituto Francés de Estudios Superiores, with the presence of Arden Quin, Kosice, Rothfuss, Diyi Laañ, and Martín Blaszko.

Later the artists separated into different groups. Arden Quin went to Paris in 1948 and settled there permanently in 1956. He reorganized Grupo Madí and created the Centre de Recherches et d'Etudes Madistes with Latin American and French artists and also was involved in poetry and in the French avant-garde magazine *Ailleurs.* The Madí movement is still alive and has more than 60

members in Europe and the United States. They consider themselves to be the heirs and continuers of Torres García.

Arden Quin's creation is distinguished by the irregular frame, articulated paintings, sculpture with articulated movement, rectangular forms, cut off and punctured planes, valorization of empty space, use of primary colors, and chromatic richness in the composition of planes. He expressed himself through the rupture with the orthogonal frame, surmounting of planismo, and use of articulated planes of color. Arden Quin demonstrated his way of working relief in proposals of rotating movement. Constant variations and permutations are part of his work. Breaks, curved lines, dents, protruding surfaces, and reliefs characterize his pieces. Circles, conical forms, interplays of planes and the irregular frame, and hollows transform his works into object paintings distinguished by their multiple chromatism. Examples of his work include *Cosmópolis V* (enamel on cardboard, 1946), *Círculo azul* (oil on cardboard, 1947), *Cira forma H* (oil on wood, 1953), *Domaine* (acrylic and plastic), and *Professionally Altered* (mixed technique, 1994).

—Alicia Haber

ARMADA, Santiago (Chago)
Cuban painter and illustrator

Pseudonym: Chago. **Born:** Santiago Rafael Armada Suárez, Palma Soriano, Santiago, 20 June 1937. **Education:** Studied accounting, Santiago. **Military Service:** Fought with the rebel army, Cuba. **Career:** Worked for various periodicals, including *Revolution,* 1959–65, *El Cubano Libre, El Pitirre, Palante,* and *Bohemia;* art editor and designer, newspaper *Granma,* 1967–95. Created the comic strip *Julito 26,* 1958, and the cartoon character ''Salomón,'' 1961. Founder, guerilla newspaper *El Cubano Libre, ca.* 1958, and humor magazine *El Pitirre,* 1960. **Award:** Medal for National Culture, Cuban Ministry of Culture. **Member:** Union of Journalists of Cuba; Union of Writers and Artists of Cuba; International Organization of Journalists. **Died:** Havana, May 1995.

Individual Exhibitions:

1975	*Humor gnosis, ninguno, otro,* Granma, Havana
1978	*Diseño de prisa,* Galería L, Havana
	Sierra y llano, humorismo, Galería Carlos Manuel Céspedes, Havana
1982	*Humor: Chago y Tonel,* Galería del Cerro, Havana (with Tonel)
1986	*Ráfagas de garabato en pequeño formato o de los anhelos y esperanzas sin piedad,* Galería Juan David, Havana
	Risa de los enigmas para desreir humores, Galería Servando Moreno, Havana
1995	*Nace el topo,* Espacio Aglutinador, Havana
	Eyaculaciones con antecedentes penales, Espacio Aglutinador, Havana
1996	*Levántate Chago, no jodas Lázaro,* Espacio Aglutinador, Havana (with Lázaro Saavedra)
1998	*El inquitante umbral de lo simbólico,* Galería Habana, Havana
2000	*Salomón,* Centro de Desarrollo de las Artes Visuales, Havana
2001	*From Sierra Maestra to La Habana: The Drawings of Chago,* The Drawing Center, New York

Selected Group Exhibition:

1999	*II salón de artes cubano,* Palacio de Convenciones, Havana

Collections:

Museo de Bellas Artes, Havana; Museo del Humor, San Antonio de los Baños, Havana.

Publications:

By ARMADA: Book—*El humor otro,* Cuba, 1963.

On ARMADA: Books—*Chago: Nace el topo,* exhibition catalog, Havana, Espacio Aglutinador, 1995; *From Sierra Maestra to La Habana: The Drawings of Chago,* exhibition catalog, text by Luis Camnitzer and Sandra Ceballos, New York, The Drawing Center, 2001. **Article—**''Santiago Armada: Centro de Desaroollo de las Artes Visuales'' by Elena Hernandez, in *Art Nexus* (Colombia), 39, February/April 2001, pp. 131–133.

* * *

Santiago Rafael Armada Suárez, known as Chago, was born on 20 June 1937 in Palma Soriano, Santiago de Cuba. He made his first drawings while studying to become an accountant, before he joined the rebel army in the Sierra Maestra. As part of the guerilla newspaper he had created called *El Cubano Libre,* in May 1958 he conceived *Julito 26,* a comic strip. In 1960 he started the humor magazine *El Pitirre,* and a year later he created Salomón, a character he continued to develop for many years. In 1963 he published his first book, *El humor otro* (''The Other Humor''), which contributed to his evolving approach; two years later he was calling it ''humor gnosis.'' He was the art editor and designer of the newspaper *Granma* from 1967 to 1995. During his lifetime he had only seven one-person shows, but over the years he received many honors and awards, among them the Medal for National Culture from the Cuban Ministry of Culture. His work was shown in a posthumous exhibit at the Drawing Center in New York City in 2001. It is part of the permanent collections of the Museo de Bellas Artes of Cuba and of the Museo del Humor in San Antonio de los Baños, Havana.

Chago became famous for being the cartoonist of the revolutionary troops while they were operating in the Sierra Maestra. Having created art and fought next to Che Guevara and Fidel Castro, he imbued the art trade with as much revolutionary energy as was conceivably possible. His humor, which addressed issues of philosophy, eroticism, and eschatology, did not produce drawings that were suitable for spaces like formal art galleries, but it helped engender a hybrid medium that merged elements of cartoon and drawing. For younger Cubans, Chago became a symbol of what was essential in the revolution. Once the revolution settled into power, Chago became an outspoken critic of Cuban social mores and continued to address existential issues that conventional political discourse ignored.

In 1961 Chago created the personage Salomón, through whom he explored what can be called his "mind-travels." Skeptical and subjective, Salomón asked questions that were unpopular with the new government. The strip complained about life's conundrums; at noontime in Cuba, for example, shadows hid under people. Throughout his work Chago addressed dialogue and communication–as well as their opposites, monologue and the failure to communicate–in what he viewed as a darkened world. In his art interlocutors cannibalize one another, a disembodied hand metamorphoses into a resentful dog, a solitary man crawls from a pile of dirt, having taken on some of its formal properties, and socialism runs the risk of becoming mere fashion or a subject for idle gossip. His philosophical sophistication was born of a complex intertwining of his personal inquiries and of their parallels in the struggle of a revolutionary nation to find an authentic voice separate from the canonical mores.

—Martha Sutro

ATL, Dr.
Mexican painter

Pseudonym for Gerardo Murillo Cornado. **Born:** Guadalajara, 3 October 1875. **Education:** Studied painting under Felipe Castro, 1890; Escuela Nacional de Bellas Artes, Mexico City, 1896; studied philosophy and law, University of Rome, ca. 1897. **Career:** Organizer of an art exhibit, *Savia Moderna* magazine, Mexico, 1910; director, Escuela Nacional de Bellas Artes, ca. 1914. Founder, *Vanguardia* newspaper, Orizaba, and *Acción Mundial,* Mexico City, ca. 1915. Lived in the United States, 1916–20. President, League of American Writers, 1925. Established Nacional de las Artes Populares committee, 1929. Member, El Colegio Nacional, 1950–51. **Awards:** Silver medal, *Salon de Paris,* 1890; National Arts award, *Primera bienal interamericana de pintura y grabado,*1958. Decoration "José Clemente Orozco," government of Jalisco, 1954. **Died:** Mexico City, 15 August 1964.

Selected Exhibitions:

1913	Salon d'Automne, Paris
	Salon des Indépendents, Paris
1925	Palacio de Minería, Mexico
1933	Convento de la Merced
1937	*Paisajes del Dr. Atl,* Galería de Arte Mexicano, Mexico
1939	Club de Leones, Mexico City
1944	*El valle de México. Pinturas y dibujos del Dr. Atl,* Palacio de Bellas Artes Mexico City
1947	*45 autorretratos de pintores mexicanos,* Palacio de Bellas Artes, Mexico City
1948	*Valles y montañas de México,* Museo Nacional de Artes Plásticas, Mexico City
1950	Palacio de Bellas Artes, Mexico City
1951	*Paisajistas mexicanos antiguos y modernos,* Museo Michoacano de Morelia, Guadalajara
1956	Galería Proteo, Mexico
1958	Salón de la Plástica Mexicana, Mexico City
1959	Salón de la Plástica Mexicana, Mexico City
	Mexican Art Gallery, San Antonio, Texas

1962	*Cuarenta dibujos del Dr. Atl,* Galería de Antonio Souza, Mexico City
	Pintura mexicana del siglo XX, Puebla, Mexico

Collection:

Instituto Nacional de Bellas Artes, Mexico City.

Publications:

By ATL: Books—*Catalogo de las pinturas y dibujos de la Colección Pani,* exhibition catalog, text by Atl, Mexico, Universidad Nacional, 1921; *Las sinfonias del Popocatepetl,* Mexico, Ediciones Mexico Moderno, 1921; *Las artes populares en México,* two volumes, Mexico City, Editorial Cultura, 1922; *!Oro! Más oro,* Mexico City, Ediciones Botas, 1936; *Ante la carroña de Ginebra,* Mexico City, Editorial Polis, 1938; *El padre eterno, satanás y Juanito García* (novel), Mexico, Editorial Botas, 1938; *Petróleo en el valle de Méjico,* Mexico City, Editorial Polis, 1938; *Como nace y crece un volcán, el Parícutin,* Mexico City, Editorial Stylo, 1950; *Gentes profanas en el convento,* Mexico, Editorial Botas, 1950.

On ATL: Books—*Dr. Atl: El valle de Méjico,* exhibition catalog, Mexico City, Palacio de Bellas Artes, 1944; *Una moneda de oro y otros cuentos mexicanos modernos* by Ruth Stanton Lamb and Louise Lodge, New York, Harper, 1946; *Dr. Atl, pintor de México* by Salvador Echavarría, Guadalajara, Mexico, Xallixtlico, 1951; *Dr. Atl: Pinturas y dibujos,* prologue by Carlos Pellicer, Fondo Mexico City, Editorial de las Plástica Mexicana, 1974; *Dr. Atl: Inventor de paisaje,* Mexico, Fomento Cultural Banamex, 1978; *Gerardo Murillo, el Dr. Atl* by Arturo Casado Navarro, Mexico City, Universidad Nacional Autónoma de México, 1984; *Dr. Atl, 1875–1964: Conciencia y paisaje* by Jorge Hernández Campos, Monterrey, Mexico, Seguros Monterrey, 1986; *Dr. Atl* by Antonio Luna Arroyo, Mexico City, Salvat, 1992; *Dr. Atl: El paisaje como pasión* by Beatriz Espejo, Mexico City, Fondo Editorial de la Plástica Mexicana, 1994; *Fuentes para el estudio de Gerardo Murillo, Dr. Atl* by Sergio Sánchez Hernández, Mexico, Universidad Nacional Autónoma de México, 1994; *Arte y recreación: Grandes maestros mexicanos,* Mexico City, Centro Cultural/Arte Contemporáneo, 1998; *Dr. Atl: Paisaje de hielo y fuego* by Alma Lilia Roura, Mexico City, Círculo de Arte, 1999. **Article**—"The Stridentists" by Serge Fauchereau, in *Artforum International,* 24, February 1986, pp. 84–89.

* * *

Gerardo Murillo Cornado, better known as Dr. Atl—a Náhuatl name he chose to create a distance between himself and the seventeenth-century Spanish painter Bartolomé Murillo—led many of the most important cultural movements in Mexico in the first decades of the twentieth century. Known chiefly as a painter of volcanoes using his own medium dubbed "Atlcolor," Atl initiated much of the resistance to the European dominance of Mexican culture in the years leading up to the Mexican Revolution. In 1910 he organized an exhibit of indigenous Mexican art to compete with an exhibition of Spanish art organized by the Mexican government ironically to celebrate the centennial of independence from Spain. Along with the photographer Guillermo Kahlo, father of the painter Frida Kahlo, Atl wrote a multiple-volume work, *Las iglesias de Mexico* ("Mexican Churches"), in 1916. His notable contributions to Mexican art

include the organization of a series of exhibitions of Mexican popular arts and writing a two-volume illustrated catalogue, *Las artes populares en Mexico* (''Mexican Popular Arts''), in 1922.

Atl ensured his place in Mexican art history by conceiving the muralist program that was to invigorate the country's culture in the years after the revolution. He had traveled widely throughout Europe in the 1890s and early 1900s, returning to Mexico with a grand vision for the spiritual force of art. He formed the Centro Artistico in 1910 with the purpose of finding walls in public buildings upon which to paint murals. Atl became director of the Academy of San Carlos during the revolution and proceeded to convince several students, including José Clemente Orozco and David Alfaro Siqueiros, to join him in supporting the constitutionalist army of Venustiano Carranza. Though Atl did not distinguish himself as a painter of murals, his influence on younger painters helped to spur the revolutionary character of the mural movement and served as its initial inspiration.

Atl's own painting did not convey his political radicalism in the way that his early activities and writings did. Instead, he focused on depictions of the Mexican landscape as a way of conveying the spiritual grandeur of the nation as embodied in nature. His interest centered on volcanoes, and again he published a book, *Volcanes de Mexico* (''Volcanoes of Mexico''), in 1939. Most of his paintings up until 1941 are panoramic views of the valley of Mexico with the pair of volcanoes Popocatépetl and Iztaccíhuatl. In 1942 he turned his attention to the newly formed volcano Parícutin. Atl's landscapes display brilliant colors, a feature of his Atlcolor technique. The technique uses resin, wax, and melted pigments formed into sticks like oil pastels, applied to a highly textured surface. The resulting images convey the drama of the Mexican landscape suffused with the artist's peculiar fervor regarding the volcanoes. Even his portraits use the vibrant tones to make the Mexican landscape in the background equal or greater in importance to the sitter. By the late 1940s, in such works as *Dawn on the Mountain* (1949) and *Iztaccíhuatl* (1950), the color and landscape combine in nearly abstract compositions. Atl's landscapes appear to owe as much to the highly emotional renderings of Vincent Van Gogh as to the nineteenth-century Mexican painter José María Velasco.

—Laura J. Crary

AVALOS, David

American muralist, sculptor, installation artist, and performance artist

Born: San Diego, California, 1947. **Education:** San Diego State University, 1972–75; University of California, San Diego, 1975–77, B.A. in communications 1978, M.F.A. in visual arts 1993. **Career:** Since 1991 professor, California State University, San Marcos. Artist-in-residence and program coordinator, Centro Cultural de la Raza, San Diego, 1978–88; coordinator, Border Art Workshop/Taller de Arte Fronterizo, San Diego, 1984–87; guest artist, California State University Arts Faculty Institute, Kirkwood, California, 1988; artist-in-residence, California Institute of the Arts, Valencia, 1989; visiting artist, Department of Fine Arts, University of Colorado, Boulder, 1990; commissioned artist, Pace Roberts Foundation for Contemporary Art, San Antonio, Texas, 1995; visiting artist, Institute for Visual and Public Art, California State University, Monterey Bay, 1997;

commissioned artist, in SITE97, San Diego, 1997. **Awards:** Artist-in-residence grants, California Arts Council, 1984, 1985, and 1986; individual visual artist fellowship, National Endowment for the Arts, 1986; project grant (collaboration), Art Matters, Inc., 1987; multicultural entry grant (collaboration), California Arts Council, 1987; interdisciplinary artist grant (collaboration), LACE, 1988; individual visual artist fellowship, National Endowment for the Arts, 1988; inter-arts new forms grant (collaboration), National Endowment for the Arts, 1989; visual arts artists fellowship, California Arts Council, 1998.

Individual Exhibitions:

1985	*David Avalos*, Galeria Posada, Sacramento, California
1989	*Cafe Mestizo*, INTAR Gallery, New York
1990	*Intifada: Birth of a Nation*, Spectacolor Lightboard, Times Square, New York
1994	*Y-QUE, Selected Works and Collaborations, 1972–1993*, Boehm Gallery, Palomar Community College, San Marcos, California
2000	*Chicano Curios*, Porter Troupe Gallery, San Diego

Selected Group Exhibitions:

1985	*Border Realities*, Galeria de la Raza, San Francisco, organized by Border Art Workshop/Taller de Arte Fronterizo, San Diego
1986	*End of the Line*, USA/Mexico Border at the Pacific Ocean, organized by Border Art Workshop/Taller de Arte Fronterizo, San Diego
1987	*911—A House Gone Wrong*, La Jolla Museum of Contemporary Art, San Diego
	California Mission Daze, Installation Gallery, San Diego
1988	*Welcome to America's Finest Tourist Plantation*, posters on 100 San Diego Metropolitan Transit System buses
1990	*CARA, Chicano Art: Resistance and Affirmation*, Wight Art Gallery, University of California, Los Angeles
1991	*mis-ce-ge-NATION*, University of Colorado, Boulder
1993	*La Frontera/The Border*, Centro Cultural de la Raza and La Jolla Museum of Contemporary Art, San Diego
2000	*Hecho en Califas*, Plaza de la Raza, Los Angeles
	Made in California, Los Angeles County Museum of Art

Collections:

California Chicano Mural Archive; Social and Public Art Resource Center, Venice, California; Smithsonian Institution's Archives of American Art, Southern California Branch; Chicano Studies Library, Stanford University, Palo Alto, California; Coleccion Tloque Nahuaque and California Ethnic and Multicultural Archives, University of California, Santa Barbara; Califas Archival Collection, University of California, Santa Cruz.

Publications:

By AVALOS: Books—*David Avalos in Three Catalogues*, with others, three exhibitions and M.F.A. thesis, San Diego, University of California, 1993; *Art Out There: Toward a Publicly Engaged Art Practice*, with others, edited by Jean Fulton, Chicago, School of the Art Institute of Chicago, 1996.

On AVALOS: Books—*David Avalos at Galeria Posada*, exhibition catalog, Sacramento, California State University, 1986; *David Avalos: Café mestizo*, exhibition catalog, New York, INTAR Gallery, 1989; *American Visions/Visiones de las Américas: Artistic and Cultural Identity in the Western Hemisphere*, edited by Noreen Tomassi, Mary Jane Jacob, and Ivo Mesquita, New York, ACA Books in association with Arts International: Allworth Press, 1991; *La reconquista: A Post-Columbian New World: 3rd International Istanbul Bienali*, exhibition catalog, San Diego, California, Centro Cultural de la Raza, 1992; *New works 95.3: Antony Gormley, David Avalos, David Zamora Casas*, exhibition catalog, San Antonio, Texas, ArtPace, 1996; *The Ethnic Eye: Latino Media Arts*, edited by Chon A. Noriega and Ana M. López, Minneapolis, University of Minnesota Press, 1996. **Articles**—"The Artist As Citizen" by Emily Hicks, in *High Performance*, 9(3), 1986, pp. 32–38; "David Avalos, Louis Hock, and Elizabeth Sisco: San Diego Transit Corporation Buses; Installation" by Susan Freudenheim, in *Artforum International*, 26, April 1988, p. 155; "Bait or Tackle? An Assisted Commentary on Art Rebate/Arte reembolso" by John C. Welchman, in *Art and Text* (Australia), 48, May 1994, p. 31; "Public Audit: An Interview with Elizabeth Sisco, Louis Hock, and David Avalos" by Cylena Simonds, in *Afterimage*, 22, summer 1994, pp. 8–11; "Art and Economics at the Border: Arts Rebate/Arte reembolso" by Rachel Weiss, in *Art Nexus* (Colombia), 14, October/December 1994, pp. 62–65; "Conflict over 'Border': Whose Subject, Whose Border, Whose Show?" by Jo-Anne Berelowitz, in *Third Text* (United Kingdom), 40, autumn 1997, pp. 69–83.

* * *

Since the mid-1970s David Avalos has worked as both a visual artist and social activist. Avalos first became involved with art using posters, leaflets, and other forms of mass-produced graphic art. A native of National City, California, the artist sought to express his concerns about the state of the Chicano community in southern California, with specific regard to those in the San Diego area. Since then his work has taken on many forms, including mural painting, sculpture, and installation art. Yet he has consistently integrated social dimensions into visual art practices. In 1984 Avalos became one of the founding members of the Taller de Arte Fronterizo/Border Arts Workshop along with Victor Ochoa, Michael Schnoo, Guillermo Gomez Peña, Sara Jo Berman, Jude Eberhard, and Isaac Artestein. This grassroots artistic community has addressed the sociopolitical environment of the U.S./Mexico border region.

Avalos's *Hubcap Milagro* (1999), which employs found objects to create a postmodern *retablo*, or altar, embodies the artist's stylistic concerns. Borrowing from folk and craft art as well as urban iconography, the artist sought to depict the hybrid identity of Mexican-American people. The work engages paradoxical notions such as high versus low art, religious versus secular, or public versus private, which are at the heart of Avalos's oeuvre.

Avalos often worked collaboratively with other artists and writers to form a shared base that could reach a broader public audience. Together with Louis Hock and Elizabeth Sisco, Avalos worked on several rousing projects that employed themes such as immigrant and migrant labor, illegal border crossing, and social and economic disparities between U.S. and Mexican residents. Among this group's works was the 1993 performance *Art Rebate,* which consisted of the distribution of $4,500 in 10 dollar bills to undocumented workers. The work was meant to raise issues regarding the

nature of the U.S. economy and its relation or dependence on illegal immigration and documentation. Since one-third of the funds used were part of a grant from the National Endowment for the Arts, however, the performance received national attention with both criticism and praise. Throughout his career Avalos has maintained a willingness to confront the ever present issues regarding the border area and to champion the rights of the dispossessed.

—Miki Garcia

AZURDIA, Margarita
Guatemalan painter and sculptor

Also known as Margot Fanjul. **Born:** Antigua, 1931. **Family:** Divorced. **Career:** Professor of architecture, Guatemala, beginning in 1967. Lived in France and wrote poetry and studied dance, 1974–82. Founder, artist group *Laboratorio de Creatividad,* Guatemala, 1982. **Awards:** Second prize, *XIII certamen de cultura de El Salvador;* second prize, *Primer certamen independiente DS,* 1968. **Died:** 1998.

Selected Exhibitions:

1964	Escuela Nacional de Artes Plásticas, Cruz Azul, Mexico
1967	Galería DS, Guatemala
	XIII certamen de cultura de El Salvador, San Salvador
1968	Cisneros Gallery, New York
	Feria Hemisférica, Houston
	Galería Vittorio, Guatemala (retrospective)
	Primer certamen independiente DS, Guatemala
	Exposición cultural olimpiades de México
1969	*II bienal de São Paulo,* Brazil
1994	*Indagaciones,* Sol del Río, Guatemala City

X bienal de São Paulo, Brazil; *Second Bienal de Arte Coltejer*, Medellín, Colombia.

Collection: Museo Margarita Azurdia, Guatemala City

Publications:

On FANJUL: Books—*Serie "Asta 104" de Margot Fanjul* by Edith Recourat, Guatemala, Departamento de Artes Plásticas de la Dirección General de Cultura y Bellas Artes de Guatemala, 1969; *Guatemala: Arte contemporáneo* by Luz Méndez de la Vega, Roberto Cabrera, and Thelma Castillo Jurado, Guatemala, Fundación G&T, 1997. **Articles**—"Exhibition at Cisneros Gallery," in *Arts Magazine,* 42, February 1968, p. 58; "Margot Fanjul, la escultura es poesía," in *El Tiempo* (Bogota), November 1972.

* * *

In Guatemalan history Margarita Azurdia is associated with the principle proponents of the avant-garde of the 1960s and '70s. She was born in La Antigua, Guatemala, in 1931. As she began her artistic career, she was known as Margot Fanjul. After her divorce and a long creative process of self-affirmation, the artist adopted the name Margarita Azurdia. She made her first personal exhibition in 1964 in the Escuela Nacional de Artes Plásticas as well as in the Cruz Azul

building in Guatemala City, where she presented a series of canvases featuring abstract expressionism. In the following years she produced a series of paintings demonstrating her permanent formal unconformity and her insistence on exploring the experimental. In the manner of Frank Stella, with flat colors and geometric and linear figures, Azurdia achieved various results by synthesizing designs from textiles indigenous to Guatemala. These pieces explored the variety of vibrant colors combined with the shrill quality of her work. At the same time, psychologists sent her books to try to convince her that she was demented.

After these paintings the artist created *Asta 104,* the series that began her exploration into larger sizes and her profound incorporation of theories from philosophers such as Teilhard de Chardin. This consisted of a series of elliptical forms associated with mandalas, a constant in the artist's work thereafter. These mandalas translated into reflections on a human being embroiled in an existential crisis in which nature and science reveal both duality and unity. The pieces in *Asta 104* were created in acrylic on canvas stretched on wooden frames fashioned in an elliptical shape. In 1969 the artist participated in the second Biannual de São Paulo, where she presented pieces from the series and received an honorable mention.

In the early 1970s Azurdia participated in the second Bienal de Arte Coltejer in Medellín, Colombia. There she exhibited a series of marble sculptures constructed with pieces of geometric lines heavily polished and joined together with mechanisms that permitted them to turn and assume different shapes. In these same years, however, she made a radical shift in her series of sculptures entitled *Homenaje a Guatemala.* This consisted of sixty wood carvings created with the assistance of artisans specializing in traditional religious wood figures. The artist created sketches that represented anthropomorphic and zoomorphic shapes. Then she decorated them with the features and skins of exotic animals and painted them with crude colors, making them resemble popular religious imagery and masks used in traditional dances on the Guatemalan altiplano. The collection was exhibited in an open field. In 1974 Azurdia moved to Paris, leaving behind all of her sculpture and large paintings.

As a result of a significant change of space—sharing twenty-seven square meters with two other persons—the artist learned how to draw and began writing poetry. Some of her poems were included in the *Anthology of Central American Women,* edited by Zeo Anglesey for Granite Press of New York. At the age of forty-two she began her foray into contemporary dance under the direction of Nora Parissy and Tanaka Min in the experimental center of La Forgue. In 1982 she returned to Guatemala and formed a group of artists in different disciplines known as the *Laboratorio de Creatividad.* Under her direction the group presented a series of performances that incorporated corporal experimentation in plazas, art galleries, and theaters. In the ensuing years she continued her explorations in movement and creativity through workshops that she convoked and directed. In 1986 the art journal *The Massachusetts Review* dedicated a special issue to her work in wood sculpture, which she later showed to the public for the first time in 1993. But this did not divert her interest in movement. In 1994 she was invited to participate in a collective exhibition that featured artistic experiments with nontraditional mediums. During the exhibition, entitled *Indagaciones* and held at the gallery Sol del Río, Azurdia performed one of her final sacred dance projects, which brought together many of her ideas about life and art. It consisted of a ceremony dedicated to the goddess Gaia and involved eleven women of different ages. A ceremony followed at the archeological site of Kaminal Juyú located in Guatemala City.

In the final years of her life Azurdia dedicated herself to drawings, poetry, and the publication of her book *Illuminaciones,* which brought together those facets of her artistic life in a series of images depicting her reflections on life and her practice of spiritual healing. She died in 1998. A collection of her work and personal objects is on display in the Museo Margarita Azurdia in Guatemala City.

—Rosina Cazali

BACA, Judith F(rancisca)
American painter, sculptor, and muralist

Also known as Judy Baca. **Born:** Los Angeles, 20 September 1946. **Education:** California State University, Northridge, B.A. in art 1969, M.A. in art education 1979; studied mural techniques at Taller Siquieros, Cuernavaca, Mexico, 1977. **Career:** Mural program director, City of Los Angeles Department of Recreation and Parks, 1974–78; assistant professor, 1981–89, associate professor, 1990–91, and full professor, 1992–95, Studio Arts Department, University of California, Irvine; full professor, California State University, Monterey Bay, 1995–98. Founder and executive director, 1976–79, and since 1981 artistic director, Social and Public Art Resource Center (SPARC), Venice, California; since 1996 full professor, University of California, Los Angeles. **Awards:** Hispanic Recognition award in visual arts, Los Angeles Recognition Committee, 1983; Arts Award Hispanic Women, City of San Francisco, 1986; Outstanding Latina Visual Artist, Commission Feminil de Los Angeles, 1987; Rockefeller fellowship award, UCLA Chicano Studies Research Center, 1991; Hispanic Excellence award, Northern Trust Bank, 1993; Artist of the Year award, Bilingual Foundation for the Arts, 1997; Cultural Fluency award, Mount St. Mary's College, 1998; Influential Woman Artist award, Women Caucus for the Arts, 1998; Creative Vision award, Liberty Hill Foundation, 2001; Master Muralist award, Precita Eyes Muralists Association, 2001. **Address:** SPARC, 685 Venice Boulevard, Venice, California 90291. **Online Address:** sparc@sparcmurals.org. **Website:** http://www.sparcmurals.org.

Individual Exhibitions:

1980	Matrix Gallery, Wadsworth Atheneum Museum, Hartford, Connecticut
1984	Social and Public Art Resource Center, Venice, California
1985	University Art Gallery, University of California, Riverside
1989	*World Wall: A Vision of the Future without Fear,* Social and Public Art Resource Center, Venice, California (traveling)
1992	*Judith F. Baca: Sites and Insights, 1974–1992,* Nelson Fine Arts Center, Tempe, Arizona (traveling retrospective)
1994	*A World without Borders: The Work of Judith F. Baca,* Galeria de la Raza, San Francisco (retrospective)
1995	Trinity University, San Antonio, Texas
	Hilltop Gallery, Nogales, Arizona
1996	University of California, Los Angeles

2000	*Arte Intimo: Paintings and Drawings by Judy Baca,* Social and Public Art Resource Center, Venice, California
	Highways Gallery 2, Santa Monica, California

Selected Group Exhibitions:

1984	*Social Works,* Los Angeles Institute of Contemporary Art
	On the Wall: A 10 Year Celebration of Los Angeles Murals Program, Los Angeles Bridge Gallery
1986	*Chicano Expressions,* Inter Hispanic American Arts Center, New York
1990	*Chicano Art: Resistance and Affirmation,* Wight Art Gallery, University of California, Los Angeles
1991	*Las Adelitas,* Mexican Museum, San Francisco
1993	*Latinas: Power and Strength,* Galeria Otra Vez, Los Angeles
	Art of the Other Mexico: Sources and Meaning, Mexican Fine Arts Center Museum, Chicago (traveling)
1994	*Urban Revisions: Current Projects for the Public Realm,* Museum of Contemporary Art, Los Angeles
1997	*Borders, Barriers, and Beaners: Attacking the Myths,* Social and Public Art Resource Center, Venice, California
2000	*Arte Latino: Treasures from the Smithsonian American Art Museum,* Smithsonian National Museum of American Art, Washington, D.C. (traveling)
	Pictorial Currents in Contemporary Southern California Art, Frye Art Museum, Seattle

Publications:

By BACA: Books—*Dialectics of Isolation: An Exhibition of Third World Women Artists of the United States,* exhibition catalog, New York, A.I.R. Gallery, 1980; *Cultures in Contention,* Seattle, Real Comet Press, 1985; exhibition catalog, Santa Fe, Museum of Fine Arts, Museum of New Mexico, 1992; *Sabres es Poder/Interventions,* exhibition catalog, Los Angeles, Museum of Contemporary Art, 1994; *Notes from the Other Side,* n.p., exhibition catalog, 1994. **Article**—''World Wall: A Vision of the Future without Fear,'' in *Frontiers,* XIV(2), 1994, pp. 81–85.

On BACA: Books—*Signs from the Heart: California Chicano Murals* by Eva Sperling Cockcroft and Holly Barnet-Sánchez, Venice, California, Social and Public Art Resource Center, 1990; *Judy Baca, artista* by Mayra Fernández, Cleveland, Modern Curriculum Press, 1994; *State of the Arts: California Artists Talk about Their Work* by Barbara Isenberg, New York, Morrow, 2000; *Voices: Luis*

Judith F. Baca and youth assistants, *Great Wall of Los Angeles,* **1976. Photo courtesy of the artist and Social and Public Art Resource Center.**

Valdez, Judith Francisca Baca, Carlos J. Finlay by Alma Flor Ada, Isabel F. Campoy, and others, Miami, Alfaguara/Santillana, 2000. **Articles—**''The Artist As Citizen'' by Emily Hicks, in *High Performance,* 9(3), 1986, pp. 32–38; ''Towards a World in Balance'' by Moira Roth, in *Artweek,* 22, 14 November 1991, pp. 10–11; ''Step One: Put Money Where Mouth Is'' by David Sterling, in *Communication Arts Magazine,* 42(3), July 2000, pp. 200–206. **Film—***Judith F. Baca* by Marlo Bendau, South Burlington, Vermont, Annenberg/CPB Collection, 1997.

* * *

Judith F. Baca is a Los Angeles-based mural painter. Like many Los Angeles murals, hers have largely Chicano themes; women's issues also feature prominently in her work.

Baca described her early work as a search for ''the perfect Chicano,'' an ideal beauty that she found absent in the media, which largely disregarded Latino experience. Her efforts led her to Mexico, where she studied in the Taller Siquieros in Cuernavaca—learning to make murals in the tradition of David Alfaro Siquieros that would give public expression to her pride in Chicano history and community.

Baca's work is more overtly feminist than most of the murals in that tradition. In 1979 she painted *Uprising of the Mujeres,* a vibrantly colored and intricately detailed but boldly graphic call for women—and Chicana women in particular—to reevaluate their roles in society. The central figure wears a harsh expression and with one hand points rather accusingly at something out of view. This figure is related to La Malinche, an Aztec woman who legendarily helped Hernán Cortés defeat her people—her presence in the mural is meant to suggest the need for women to shake off the injustices and perceptions of the past.

Baca founded the Social and Public Art Resource Center (SPARC) in Venice, California, in 1976. SPARC has continued to coordinate public arts projects meant to improve lower-income communities aesthetically and involve teenagers from the community in their production. Perhaps the most notable of these projects is the *Great Wall of Los Angeles* (1976–83), a half-mile-long mural that is said to be the longest in the world. Located in the San Fernando Valley Tujunga Wash, it took over five summers for more than 400 teenagers under Baca's supervision to complete. The mural is a history of the people of California—one that focuses on the groups and peoples who had been left out of the history books. The mural is organized into multiple episodes, including *The Division of the Barrios and the*

Judith F. Baca: Detail of *Triumph of the Heart* from the ''World Wall,'' 1991. Photo courtesy of the artist and Social and Public Art Resource Center.

Chavez Ravine (completed in 1981) and *Olympic Champions, 1948–1964, Breaking Barriers* (1983). The latter depicts a female runner carrying the Olympic torch, the smoke from which swirls into scenes of athletes who had overcome discrimination or other adversities to win Olympic events. These and other murals, such as *Pickers* (1990), demonstrate Baca's ambition to be a history painter for the Chicano community.

In the late 1990s Baca has brought digital imaging techniques to the production of murals. Digital imaging allows her to work on aluminum, which has a longer life span than the average wall, and to adapt the design more easily to the site. It also makes it possible to take advantage of temporary sites without destroying the mural. One such mural is *La memoria de nuestra tierra* ("The Memory of Our Land," 2000) in the Denver, Colorado, airport. It depicts Baca's family history and creates a mythology of the land from which she came, mixing elements of landscape and portraiture. She hand painted the landscape and scanned it at a high resolution, finally printing it onto a 10-foot-long piece of aluminum.

—Anne Byrd

BÁEZ, Myrna
American painter and graphic artist

Born: Santurce, Puerto Rico, 18 August 1931. **Education:** Universidad de Puerto Rico, B.S. in natural sciences 1951; Academia de San Fernando, Madrid, 1951–57, M.A. in art 1957; Taller de Lorenzo Homar, Instituto de Cultura Puertorriqueña, San Juan, 1958–61; Pratt Institute, New York, 1965, 1969–70, 1981; Taller de Dimitri Papagiorgiu, Spain, 1978–79. **Career:** Instructor, Escuela Intermedia de Artes Plásticas Luchetti, San Juan, Puerto Rico, 1962–63, Universidad del Sagrado Corazón, Santurce, Puerto Rico, 1963–85, Escuela de Artes Plásticas del Instituto de Cultura Puertorriqueña, San Juan, 1981, and Liga de Estudiantes de Artes, San Juan, Puerto Rico, 1981–87. Since 1974 visiting summer professor, Universidad Interamericana de Puerto Rico, San Germán. Vice president of arts section, Ateneo Puertorriqueño; founding member, First Federal Savings Bank's Galería de Arte Contemporáneo and Hermandad de Artistas Gráficos de Puerto Rico; resident artist, Universidad del Sagrado Corazón. **Awards:** First prize in painting, Festival de Navidad, Ateneo Puertorriqueño, San Juan, 1963, 1967; prize, *Pratt Graphics Center Exhibition*, 1970, 1977; second prize in painting, *Segundo salón de pintura del United Federal Savings Bank*, San Juan, Puerto Rico, 1974; prize in painting, *Certamen revista sin nombre*, Instituto de Cultura Puertorriqueño, San Juan, 1975; third prize, *Primera bienal del grabado de America*, Maracaibo, Venezuela, 1977; fellowship, National Endowment for the Arts, 1980; third prize in painting, *1era bienal internacional de pintura*, Museo de Arte Moderno, Cuenca, Ecuador, 1987; Premio Nacional a la Pintura, Instituto de Cultura Puertorriqueño, San Juan, 1996; Visual Arts fellowship, Institute of Puerto Rican Culture, 1997; Medal of Culture, Institute of Puerto Rican Culture; medal, First Painting Biennial of Cuenca, Ecuador. Honorary doctorate, Universidad de Sagrado Corazón, Santurce, Puerto Rico, 2001. **Agent:** Galería Botello, #1 Jamaica, Floral Park, Hato Rey, Puerto Rico 00917-3430. **Online Address:** botello@botello.com.

Individual Exhibitions:

1962	Instituto de Cultura Puertorriqueña, San Juan
1964	Museo de Arte de Ponce, Puerto Rico
1966	Galería Colibrí, San Juan, Puerto Rico
	Instituto Panameño de Arte, Panama
1968	Colegio Universitario del Sagrado Corazón, San Juan, Puerto Rico
	Universidad Interamericana, San Germán, Puerto Rico
1972	Colegio de Ingenieros, Arquitectos y Agrimensores, Hato Rey, Puerto Rico
1974	Galería Santiago, San Juan, Puerto Rico
1975	Universidad de Puerto Rico, San Juan
1976	Museo de la Universidad de Puerto Rico, San Juan, and Galería G, Caracas
1981	Galería Botello, Plaza las Américas, San Juan, Puerto Rico
	Galería Calibán, San Juan, Puerto Rico
1982	*Myrna Báez: Diez años de gráfica y pintura, 1971–1981*, El Museo del Barrio, New York (traveling)
1985	Museo de Bellas Artes del Instituto de Cultura Puertorriqueña, San Juan
1987	Galería Francisco Oller-José Campeche, Philadelphia
1988	*Tres décadas gráficas de Myrna Báez, 1958–1988*, Museo de Arte de Puerto Rico, San Juan
	Gráficas de Myrna Báez, Museo de Arte y Casa de Estudio Alfredo Rámirez de Arellano y Rosell, San Germán, Puerto Rico
1989	Hostos Art Gallery, Hostos Community College, New York
	Hospital San Pablo, Bayamón, Puerto Rico (retrospective)
1990	Universidad del Sagrado Corazón, San Juan, Puerto Rico
1992	Galería Botello, San Juan, Puerto Rico
1994	Galería Botello, San Juan, Puerto Rico
1996	Galería Botello, San Juan, Puerto Rico
1998	Galería Botello, San Juan, Puerto Rico

Selected Group Exhibitions:

1959	*Graphics from Puerto Rico*, Riverside Museum, New York
1962	Universidad de Puerto Rico, San Juan
1973	*The Art Heritage of Puerto Rico*, Metropolitan Museum, New York and El Museo del Barrio, New York
1986	*The Latin American Graphic Arts Biennal*, Museum of Contemporary Hispanic Art, New York
	25 años de pintura puertorriqueña, Museo de Arte de Ponce, Puerto Rico
1987	*Exposición anual de la asociación de mujeres artistas de Puerto Rico*, Plaza Las Américas, San Juan, Puerto Rico
	XIX bienal de São Paulo
1989	*The Latin American Spirit: Art & Artists in the U.S.*, Bronx Museum, New York
1992	*Muestra de pintura y escultura latinoamericana*, Galería Espacio, San Salvador

Myrna Báez: *Juego de cartas (Card Game)*, **1971. Photo by John Betancourt; courtesy of the artist.**

Myrna Báez: *Desnudo frente al espejo (Nude at the Mirror),* **1980. Photo by John Betancourt; courtesy of the artist.**

1995 *Caribbean Visions: Contemporary Paintings and Sculptures,* Center of Fine Arts, Miami (traveling)

Collections:

Fort Lauderdale Museum, Florida; Instituto de Cultura Puertorriqueña, San Juan; Metropolitan Museum of Art, New York; El Museo del Barrio, New York; Museo de Arte de Ponce, Puerto Rico; Museum of Modern Art, New York; Universidad de Puerto Rico, San Juan.

Publications:

On BÁEZ: Books—*Myrna Báez: Diez años de gráfica y pintura, 1971–1981,* exhibition catalog, New York, El Museo del Barrio, 1982; *Pintura y gráfica de Myrna Báez,* exhibition catalog, San Juan, Museo de Bellas Artes del Instituto de Cultura Puertorriqueña, 1985; *Tres décadas gráficas de Myrna Báez, 1958–1988,* exhibition catalog, San Juan, Cooperativa de Seguros Múltiples de Puerto Rico, 1988; *Conversando con nuestros artistas* by Eneid Routté Gómez, San Juan, Museo de Arte Contemporáneo de Puerto Rico, 1999. **Article**—''Myrna Bàez'' by Jose Antonio Perez Ruiz, in *Art Nexus* (Colombia), 23, January/March 1997, pp. 135–136. **Film**—*Myrna Baez los espejos del silencio* (documentary) by Sonia Fritz, San Juan, Maga Films, 1989.

* * *

The importance of Myrna Báez to plastic arts in Puerto Rico must be measured not only by her creative phase but also by her untiring artistic promotion efforts. For this woman of sturdy character and great verticality, there has been no injustice nor any insult to culture that she has not confronted, her presence felt as the victims' defender. She has expressed herself directly and without hesitation; there was neither ambiguity nor evasion in her approach. She has been an active defender of independence for Puerto Rico and a loyal friend.

Báez received an impeccable education. Like many children, she dreamed of a career in the health field, and with her characteristic determination she prepared to become a doctor. After receiving a bachelor's degree in sciences from the University of Puerto Rico, she left for Spain in 1951 in order to study medicine. It was there that she discovered the possibility of becoming an artist. She took the entrance examination for the Academia San Fernando in Madrid, and on her second attempt she became one of the few candidates to be accepted. Thus her life took a new course. During the five years she studied art in Madrid, she attended concerts and exhibitions, traveled to Europe's principal museums, and widened her general knowledge.

When she arrived back in Puerto Rico in 1957, she found a country that had suffered formidable changes, political as well as artistic. Artists who had returned to their country after World War II had already established themselves, and there was a notable effervescence in the arts. The Institute of Puerto Rican Culture had been created (1955), and the graphics workshop under the master Lorenzo Homar counseled young artists in search of direction. Báez quickly became an apprentice in Homar's print workshop, where she stayed from 1958 to 1961. In addition to perfecting techniques for silk screen and engraving in relief, she delved into Puerto Rican history and culture in greater depth and reaffirmed her identity. It was also there that she met fellow artists Antonio Torres Martinó and Antonio Martorell. With them, she began her pilgrimage through Puerto Rican arts and culture.

In graphics as well as in her painting there existed two seemingly contradictory constants: drama and poetry. As a plastic artist Báez was a poet of complicated and conflictive metaphors, with a deceptive appearance that hid a country's drama in a constant dilemma. This has been her immutable path.

Báez has been an artist who plays and complicates, who merges, confuses, and embroils the images, colors, spaces, the real, and primarily the beáutiful: interiors that are exteriors, landscapes that are inserted within themselves, creating two planes in one; red cows and plantains; rosy plants and yellow landscapes; mirrors in which one can see others giving back images transmuted or denuded. These are a few of the tricks Báez presented to allow her audiences to arrive at their own conclusions, letting them reflect and speculate.

Báez feared nothing, neither solitude—*En el bar* (''In the Bar,'' 1967)—nor working with the multiple and complicated levels of prejudice, complexity, and falseness in Puerto Rican society—*Lámpara Tiffany* (''Tiffany Lamp,'' 1975)—nor of undressing before her audience, showing them works such as *Self-Portrait* (1986) and *Retrato de un sueño* (''Portrait of a Dream,'' 1988–90)—not to mention Puerto Rico's colonial reality, while she showed its dangers— *Las vacas rojas* (''The Red Cows,'' 1991). In the 1990s her works were intimate, and between 1992 and 1994 she primarily displayed the interiors of her home and urban landscapes. Since 1994 she has done innumerable portraits of her friends. She also has continued appropriating famous works of art, something she began early in her career and which has been a constant, primarily in her graphic work.

Year after year Báez collected information from her surroundings, and although she insisted that the objects were ''only a motif for painting,'' she presented them in an open and intriguing way that

could be deciphered in multiple interpretations. All were charged with an intense personal and political relationship, but at the same time they belonged to everyone.

Báez has participated in numerous local and international exhibitions. She was included in the exposition *Figuración y Fabulación: 75 años de pintura en Latinoamérica* ("Imagination and Fantasy: 75 Years of Painting in Latin America") at the Caracas Fine Arts Museum. Among the positions she obtained were that of vice president of the arts section of the Ateneo Puertorriqueño, founding member of First Federal Savings Bank's Galería de Arte Contemporáneo, founding member of the Hermandad de Artistas Gráficos de Puerto Rico, and resident artist at the Universidad del Sagrado Corazón. The Institute of Puerto Rican Culture awarded her the prestigious Medal of Culture, and the Universidad del Sagrado Corazón granted her a doctorate. She became a promoter of various publications and videos, particularly the video and book *Puerto Rico arte e identidad* ("Puerto Rico Art and Identity"). She has won innumerable international prizes, such as a medal in the First Painting Biennial of Cuenca, Ecuador.

—Haydee Venegas

BALMES, José
Chilean painter

Born: Montesquieu, Spain, 1927; exiled to Chile, 1939. **Education:** Escuela de Bellas Artes, Universidad de Chile, Santiago, 1943–49; studied in France and Italy. **Career:** Professor of painting, 1950–73, director, 1966–72, and dean, 1970–73, Escuela de Bellas Artes, Universidad de Chile, Santiago; professor of painting, L'Universite de París, 1974; professor of painting, Universidad Católica de Chile, ca. 1986. **Awards:** First prize in painting, *Salón oficial,* 1954; painting prize, *Bienal de Paris,* 1961; first prize, *Bienal americana de arte,* Cali, Colombia, 1971; first prize, Exposición Internacional "Intergraphic," Berlin, Germany, 1977; first prize, *Bienal iberoamericana,* Buenos Aires, 1986; Premio Nacional de Artes Plásticas de Chile, 1999.

Individual Exhibitions:

1952	Museo de Arte Contemporaneo de la Universidad de Chile
1968	Galería Ibero Club, Bonn, Germany
1974	Palais des Congrés, Paris
1976	Galerie de l'Art et la Paix, Paris
1981	Musée des Beaux-Arts André Malraux, Le Havre, France (with Gracia Barrios)
1983	Galerie Pierre Lescot, Paris
1984	*Balmes, 1962–1984: Mirada pública: Pinturas, dibujos,* Galería Plástica 3, Santiago
1989	*En Tierra: A 50 años del Winnipeg,* Galeria Plastica Nueva, Santiago
1995	*José Balmes: Pinturas-dibujos-gráfica, 1944–1994,* Galería Tomás Andreu, Santiago
	Museo de Bellas Artes, Santiago (retrospective)
1996	Conarte, Buenos Aires
1998	Museo José Luis Cuevas, Mexico

Selected Group Exhibitions:

1994	*Ocho pintores chilenos,* Museo de Arte Moderno, Mexico City
1995	*Burchard, Balmes, Barrios: Exposición de gabinete,* Museo Nacional de Bellas Artes, Santiago

Collections:

Museo de Bellas Artes, Santiago; Museum of Contemporary Art, Paris; Museo de Arte Contemporaneo, Madrid; Museum of Contemporary Art of Berlin, Germany.

Publications:

On BALMES: Books—*Balmes, 1962–1984: Mirada pública: Pinturas, dibujos,* exhibition catalog, text by Alberto Pérez and others, Santiago, Instituto Chileno Francés de Cultura, 1984; *En tierra: A 50 años del Winnipeg,* exhibition catalog, Santiago, Galeria Plastica Nueva, 1989; *Ocho pintores chilenos,* exhibition catalog, text by Gabriel Barros, Mexico City, Museo de Arte Moderno, 1994; *José Balmes: Pinturas-dibujos-gráfica, 1944–1994,* exhibition catalog, Santiago, Galería Tomás Andreu, 1995; *Burchard, Balmes, Barrios: Exposición de gabinete,* exhibition catalog, with text by Francisco González Vera, Santiago, Museo Nacional de Bellas Artes, 1995; *Balmes, viaje a la pintura,* exhibition catalog, text by Gonzalo Badal, Santiago, Ocho Libros Editores, 1995; *Balmes, tiempo presente, 1996,* exhibition catalog, Buenos Aires, Conarte, 1996; *Balmes,* exhibition catalog, Mexico, Museo José Luis Cuevas, 1998.

* * *

Much of Chilean art is marked by a tradition of staunch resistance to illustrative objectivism. This resistance has at times been extreme, often paradoxical; the same artists who have demanded more open forms of expression have been the most bitter opponents of illustrative painting, to the point of attempting to deflate the market value of such works by somehow subverting their production. Since a real art market has never existed in terms of an honest estimation of the true value of the work—as a transference of variable value—efforts to control the buying and selling of art have inevitably been frustrated by intense competition among the artists themselves. Many prominent Chilean artists of the mid-1990s, like those of the early 1980s, had retained—despite occasional flirtations with modernism—this attitude of resistance, barely concealing their disregard for trends in the international art market. On one hand, one must understand this phenomenon in the context of the political unrest of the time, particularly at the close of the 1980s, when the military supervised all cultural institutions. To locate the core of this resistance, however, one must go back to the 1970s, when José Balmes was working toward an art that transcended historical class divisions. This movement toward a classless art was characterized by a renewed fascination with traditional painting formats, the materiality of which was regarded as a means of delivering a more direct, and therefore more truthful, artistic testimony.

As early as 1952 Balmes was exhibiting work in the Museo de Arte Contemporaneo de la Universidad de Chile that demonstrated a range of avant-garde influences, predominantly that of concrete art. Concrete art had been thriving in Argentina, Brazil, and Uruguay

since the 1940s, peaking with the formation of MADI in Argentina in 1946 and of the *ruptura* movement in Brazil in 1952, which anticipated the minimalism and conceptual art that dominated the New York art scene in the mid-1960s. By 1955 the *rectángulo* movement was formed in Santiago de Chile with the aim of devising a means of analyzing art through a synthesis of its many languages—in effect, to locate new forms of representation within the broader scope of art history. At the same time, it sought to develop a theory of representation based on the equation of time and space; in fact, the movement would later come to be called form and space.

It was in reaction to this trend toward conceptualism that painters like Balmes eventually turned toward the distinctly physical, untheoretical character of more traditional forms. Unlike artists of the early 1980s, whose return to painting was essentially mandated by the repressive actions of the dictatorships, Balmes and his contemporaries were reacting positively to the innovations of movements like Spanish informalism, which wielded a powerful influence on Chilean art after a breakthrough exhibition in Santiago in the early 1960s. These artists included various members of the *rectángulo* movement. This situation forms a compelling contrast to the rise of hard-edge abstraction and cool painting in the United States, where certain artists had begun to regard abstract expressionism as a mere cultural tool calculated to stall the emergence of an analytic-synthetic European aesthetic, with its radicalization of visual language through the masking of surfaces with serialized colors, and so on.

Balmes thrived in the 1960s, playing a fundamental role in university politics and in the continuation of romantic machismo. His commitment to university reform led to his appointment as dean of the Fine Arts College and of the Unidad Popular program from 1970 to 1973. The same period saw the emergence of Ramón Vergara-Grez, mentor of Signo y Forma y Espacio, whose famous *Geometria Andina* makes a number of illustrative references to Picasso, and of the minimalist Carlos Ortuzar, who created his best work between 1968 and 1973. The overthrow of the Unidad program eventually forced Balmes into exile, and he lived in Paris until 1985, when he once again took up permanent residence in Chile.

The para-institutional and critical scene that developed in Chile in the late 1970s was ultimately undermined by the art of the 1980s, which rejected psychoanalysis, poststructuralism, semiology, and other ideals of the previous generation. In this new atmosphere the dominant art criticism became irrevocably intertwined with politics. In spite of this trend artists like Francisco Brugnoli (who had been both a student and an assistant of Balmes) worked to revive the analytic climate of the early 1960s, both as a reaction to the political tyranny of the dictatorships and the artistic tyranny of its cultural agenda. Even in exile José Balmes remained an active participant in the debate over these ideas.

—David Maulen

BARELA, Patrociño

American sculptor and woodcarver

Born: Bisbee, Arizona, 1908. **Family:** Married a widow; four step-children and three children. **Career:** Worked as a ranch hand, migrant laborer in Colorado and Wyoming, sheepherder, and coal miner, 1920s. Moved to Canon, New Mexico, 1930. Began carving, 1931. Worked for the Works Progress Administration's Federal Art Project, 1936–39; worked for the Project Administration's Art Project, 1940–43. **Died:** 24 October 1964.

Individual Exhibitions:

1965	Museum of International Folk Art, Santa Fe, New Mexico
1972	University of Albuquerque, New Mexico
1974	Museum of Albuquerque, New Mexico
1980	Sanctuario de Guadalupe, Santa Fe, New Mexico
1982	Harwood Foundation Museum, Taos, New Mexico
1990	Albuquerque Museum, New Mexico
1992	Rod Goebel Gallery, Taos, New Mexico
1996–98	*Spirit Ascendant: The Art and Life of Patrociño Barela,* Harwood Museum, University of New Mexico, Taos (traveled to Roswell Museum and Art Center, Roswell, New Mexico; Snite Museum, University of Notre Dame, Indiana; Albuquerque Museum)
1998	*The Life and Art of Patrociño Barela,* Albuquerque Museum, New Mexico

Selected Group Exhibitions:

1936	*New Horizons in American Art,* Museum of Modern Art, New York
	National Museum, Washington, D.C.
1940	*Coronado Cuarto Centennial, 1540–1940,* University of New Mexico, Albuquerque
1955	*Craftsmen of New Mexico,* Museum of International Folk Art, Santa Fe, New Mexico
1969	*3 Cultures–3 Dimensions,* Museum of Fine Arts, Santa Fe, New Mexico
1988	*Santos, Statues, and Sculpture: Contemporary Wood-carving from New Mexico,* Craft and Folk Art Museum, Los Angeles (traveled to Mexican Museum, San Francisco)
1994	*Hispano Woodcarving in the Southwest,* National Museum of American Art, Washington, D.C.
	Crafting Devotion: Tradition in Contemporary New Mexico Santos, Gene Autry Western Heritage Museum, Los Angeles
1995	*The Human Figure in American Sculpture,* Los Angeles County Museum of Art (traveled to Montgomery Museum of Art, Alabama; Wichita Art Museum, Kansas; and National Academy of Design, New York)

Collections:

Harwood Foundation Museum, University of New Mexico, Taos; National Museum of American Art, Smithsonian Institution, Washington, D.C.; Albuquerque Museum, New Mexico; Kit Carson Historic Museums, Taos, New Mexico; Museum of Fine Arts, Santa Fe, New Mexico; Museum of International Folk Art, Santa Fe, New Mexico; Museum of Modern Art, New York; Museum of Modern Art, San Francisco; Roswell Museum and Art Center, New Mexico;

Patrociño Barela: *Activity.* © Smithsonian American Art Museum, Washington, D.C./Art Resource, NY.

Taylor Museum, Colorado Springs, Colorado; University of Arizona Art Museum, Tucson.

Publications:

On BARELA: Books—*Patrocinio Barela: Taos Wood Carver* by Mildred Crews, Wendell Anderson, and Judson Crews, Taos, New Mexico, Taos Recordings and Publications, 1962; *Spirit Ascendant: The Art and Life of Patrocino Barela,* exhibition catalog, by Edward Gonzales and David L. Witt, Santa Fe, Red Crane Books, 1996. **Articles**—''Expressionist Carver'' by Carmella M. Padilla, in *El Palacio,* 101(3), winter 1996, p. 38; ''Espíritu ascendente: El arte y la vida de Patrociño Barela'' by David L. Witt and Edward Gonzalez, in *Artes de Mexico* (Mexico), 39, 1997.

* * *

In 1936 *Time* magazine proclaimed American-born sculptor Patrociño Barela the ''discovery of the year.'' The *New York Times* and *Washington Post* also singled out Barela for praise. Barela had reached the pinnacle of his artistic career when eight of his carvings were featured in an exhibition of Federal Art Project artists entitled *New Horizons in American Art.* The show at the Museum of Modern Art in New York City displayed more of Barela's work than that of any of the other 171 artists represented. He was recognized for his innovative style and artistic genius. Just five years earlier this artist from Taos, New Mexico, had begun carving at the age of 31. According to Barela, he was inspired one night when a priest showed him an old figure of a broken saint and asked him to fix it. When he saw the santo, he noticed that it was made in jointed pieces. He recalled, ''I get it in my head if you make it solid, no joints, it will be better . . . I can't sleep all night. I make a little Santa Rita with one pocketknife and one single chisel. And that's the way I started.'' At the time Barela was unable to earn his living as an artist, so he continued to work as a laborer by day and carved at night. He used cedar boles and branches, occasionally pine. His carvings, varying in size from a few inches to a few feet, feature religious and secular themes exploring many aspects of human relationships. Barela often

said that the subject of a work was determined by the piece of wood itself and that the story was already there—his job was to carve away the cover from it. This ''life'' of the piece, or energy within the piece of wood, was evident in all his works.

Through the undulations of his twisted forms and the simplicity of their abstract expressions, Barela touched on deep and complex emotions. The inability of critics and art historians to categorize Barela's work has led to his carvings being compared to eleventh-century Romanesque, Byzantine, German expressionist, Meso-American, and even South Pacific works. Perhaps the similarities to the Romanesque, Byzantine, and German expressionist artworks are found in the great stylization and expressionistic distortions of the natural forms. And the simplicity of design of Meso-American and South Pacific works is perhaps what modern critics see in Barela's creations. Mainly, however, he has been described as having developed out of the nineteenth-century New Mexican *santero* (makers of saints' images) tradition. But while his beginnings might have been connected to this 300-year-old artistic legacy, his religious figures, if compared with the traditional santos, are very different from the classical representation of realistic figures that inspired him. First, he carved in cedar rather than pine and made the pieces from one piece rather than in sections. Second and more importantly, Barela took a modernist approach in depicting religious imagery. His innovative interpretation of the subject matter was reflected in the overall simplicity and semiabstract forms of the sculptures. He was also closely aligned with modernism because of his successful treatment of three-dimensional space. He was always able to achieve a harmonious balance, even in his most complex creations.

In many of his works Barela utilized Christian iconography to depict autobiographical events and relationships. The subjects of mother and child as well as family, for example, were especially important for him. His own longing for the mother he lost at a young age has been represented in depictions of the Madonna and Child. And carvings of the Holy Family make references to familial love and the complex dynamics resulting from the overwhelming responsibilities of his own family, which included four children of the widowed woman he married and three children from their union. These family dynamics were revealed in powerful carvings of scenes showing

families rejoicing and others depicting turbulent domestic times. Other themes that the artist explored were his profound sentiment of loss and rejection rooted in his youth (he left his father at a young age and grew up on his own) and heightened by his turbulent marriage and alcohol addiction. Barela understood these personal and spiritual struggles as part of one's life journey, a journey that can be any man's experience.

Although he created numerous carvings of biblical scenes and figures, most of his pieces are nonreligious in nature. He even created some erotic works. But whether religious or secular, all his sculptures seem to emerge from the depth of the cedar wood into fluid, organic shapes and sensuous forms that have deeply expressive qualities and are introspective in nature. His creations, even when they depict a domestic scene, show the artist's humorous side, or explore aspects of his battle with alcohol abuse, always have a spiritual content. Of a piece entitled *O Save Me from My Sins,* for example, the artists said, "But Christ say / you don't go to church to find Him / you find Him anywhere / And this old man / is crying out all alone / to be saved." In other words a man in need can find hope and salvation no matter where he is. This reflects Barela's deep spirituality, even though he believed you did not need to go to church in order to find God. His work touches on the universal aspects of faith, spirituality, and the human condition while exploring profound emotions such as love, pain, anger, and hope. His work fits in the context of the modernist conceptions of being able to manipulate the three-dimensional aspects of the wood to create complex expressionistic scenes in an abstract manner. This great achievement of integrating abstraction with emotion is exemplified in how Barela seemed to consciously carve the imagery in a way that the life of the living tree was still preserved in the undulating forms and in the intense emotions of the subjects rendered.

—Tariana Navas-Nieves

BARRADAS, Rafael (Pérez)
Uruguayan painter and illustrator

Born: Montevideo, 7 January 1890. **Education:** Studied under Vicente Casanova y Ramos. **Career:** Illustrator for newspapers and magazines, including *La Semana, Bohemia, El Tiempo, La Razón,* and *Tableros.* Artistic director, *Alfar* magazine, ca. 1920. Traveled to Spain, Italy, and France, 1913; lived in Spain, 1914–28. Founder, *El Monigote,* 1913. Also worked as a stage designer. **Award:** Grand prize, *Exposición internacional de artes decorativas e industriales de Paris,* 1925. **Died:** 12 February 1929.

Individual Exhibitions:

1911	Casa Moretti, Montevideo
1912	Salón Maveroff, Montevideo
	Casa Moretti, Montevideo
1913	Casa de Música ODEON, Milan
1915	Galería de Revista "Paraninfo," Zaragoza, Spain
	Lawn Tennis, Zaragoza, Spain

1918	Galerías Layetanas, Barcelona, Spain
1919	Librería Mateu, Madrid
1920	Teatro Eslava, Madrid
	Ateneo, Madrid
	Teatro Goya, Barcelona, Spain
	Galería Dalmau, Barcelona, Spain
1921	Ateneo, Madrid
1922	Ateneo, Madrid
1926	Galería Dalmau, Barcelona, Spain
1927	Galería Dalmau, Barcelona, Spain
1928	Galería Dalmau, Barcelona, Spain
1929	Galería Dalmau, Barcelona, Spain
1930	Asociación Wagneriana, Buenos Aires
	Ateneo de Montevideo
1931	Biblioteca "Artigas," Colón, Uruguay
	Amigos del Arte, Montevideo
1934	Asociación de Intelectuales, Artistas Plásticos y Escritores, Montevideo
	Amigos del Arte, Montevideo
1943	Club Católico, Montevideo
1945	Biblioteca Popular de Colón, Uruguay
1947	Museo Municipal de Arte de San José, Uruguay
1960	Museo Nacional de Bellas Artes, Buenos Aires
1972	Museo Nacional de Bellas Artes, Buenos Aires

Selected Group Exhibitions:

1910	Salón Moretti, Montevideo
1918	Layetanas Galleries, Barcelona, Spain
1920	*VI salón de humoristas,* Madrid
1923	Salon de Primavera, Círculo de Bellas Artes, Montevideo
1925	*Exposición internacional de artes decorativas e industriales de Paris*
1926	*Modernismo pictórico catalán confrontado con selección de obras de artistas extranjeros,* Galería Dalmau, Barcelona, Spain
1927	*1 er. salón de primavera,* Comisión Nacional de Bellas Artes, Montevideo
1955	*Bienal hispanoamericana de arte,* Barcelona, Spain
1966	*Art of Latin America Since Independence,* Yale University, New Haven, Connecticut, and University of Texas, Austin
1987	*Seis maestros de la pintura uruguaya,* Museo Nacional de Bellas Artes, Buenos Aires

Publications:

On BARRADAS: Books—*Rafael Barradas* by Julio J. Casal, Buenos Aires, Editorial Losada, 1949; *Rafael Barradas,* exhibition catalog, by Raquel Pereda, Punta del Esta, Uruguay, Galería Sur, 1990; *Barradas: Exposición antologica, 1890–1929,* exhibition catalog, Comunidad de Madrid, ca. 1992; *Rafael Barradas a Catalunya i altres artistes que passaren la mar* by Enric Jardí, Barcelona, Generalitat de Catalunya, 1992; *Barradas/Torres-García: Agosto-setiembre-1995,* exhibition catalog, Museo Nacional de Bellas Artes

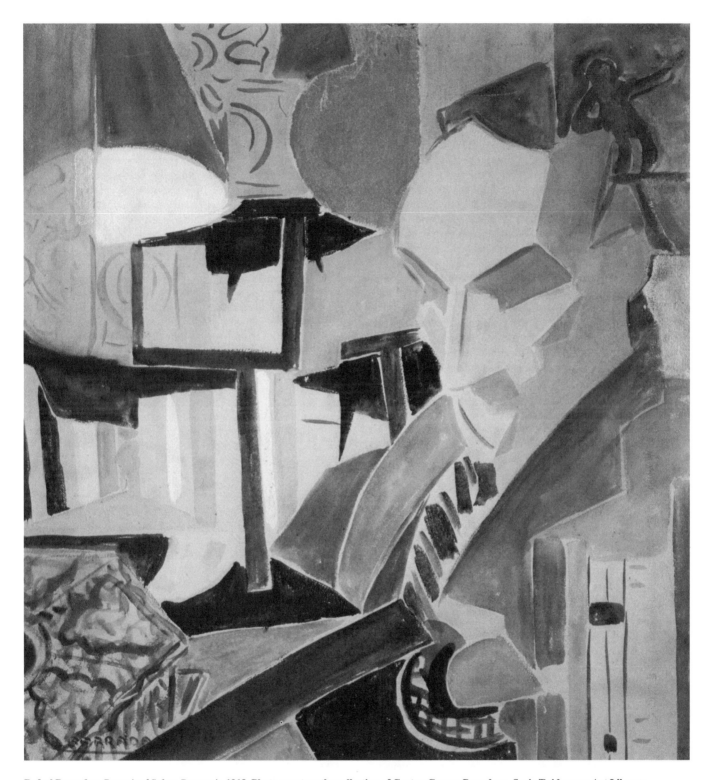

Rafael Barradas: *Portrait of Salvat-Papasseit,* 1918. Photo courtesy the collection of Gustau Camps, Barcelona, Spain/Bridgeman Art Library

de Buenos Aires, 1995; *Rafael Barradas y Juan Gutiérrez Gili, 1916–1929,* exhibition catalog, Madrid, Residencia de Estudiantes, 1996; *Rafael Barradas* by Raquel Pereda and Juan Manuel Bonet, Buenos Aires, Palatina, 1997.

* * *

One of the artists who helped to modernize Uruguay was the draftsman, caricaturist, scenographer, illustrator, poster artist, and painter Rafael Barradas. Barradas is a key figure in the history of Uruguayan art and is considered among the country's most important masters. He was very much linked to the European scene. His career unfolded primarily in Spain, where he was closely involved in

different avant-garde trends, and he returned to Uruguay to leave his transcendental legacy, evidenced in his diverse series of works.

In his youth he was linked to the Montevideo bohemian context and was a habitué of the early twentieth-century cafés, where between 1910 and 1913 he did drawings, caricatures, and humoristic notes and illustrated the newspaper *El Monigote,* in addition to working as a draftsman for *La Semana* and *El Tiempo.* At the same time he had begun painting, in an outline-type style, free of all stiffness, but his work was not well received, and some conservative sectors attacked his loose, synthetic and easy way of approaching the portrait. His deviation from academic codes was already evident.

Barradas moved to Europe in 1913, and he stayed primarily in Barcelona as of 1914, spending some time also in Zaragoza and Madrid. In Barcelona the environment was ripe for developing a more avant-garde language, especially in Catalonia, where numerous exhibitions of cutting-edge European creators were being held. Barradas came into contact with the Uruguayan master Joaquín Torres García and with the front-runners in literature and criticism.

In Barcelona between 1916 and 1918 Barradas conceived a style called vibracionismo (''vibrationism''), one of his most important contributions. It is an aesthetic of the discontinuous and of the counterpoint that focuses on modern urban life, idiosyncratically melding simultaneist and cubist trends with Italian futurism, while at the same time having a relationship with the spirit of peninsular ultraismo, including its lyricism, a sense of humor, the capacity for innovation, and certain ludic elements. Barradas wanted to do painting that captured the instant.

Using dynamic drawing, interpenetrated planes, complex visual games, syncopated rhythms, the poetics of the discontinuous, and the display of color, Barradas constructed works in this aesthetic that revealed the bustle of the city. This same aesthetic is apparent in a particularly successful series of collages. The intensity of the color is striking and transforms the works into powerful magnets. Reds, yellows, blues, and greens are multiplied in diverse planes, creating active, powerful dialogues having a peculiar vitality. He made reference to modern urban life through letters, signs, posters, and faces in a café. An example is his work *Todo al 65* (oil on canvas, 1919).

In 1920 he set up in Madrid. There he came into contact with ultraista writers and met Federcio García Lorca, Luis Buñuel, Rafael Alberti, and Salvador Dalí. He did costume design, scenography, graphic illustration, posters, comic books, and illustrations of some of the most innovative publications, including the magazine *Alfar,* which was directed by the Uruguayan Julio J. Casal. Barradas thus became involved in the most stimulating literary, journalistic, and theatrical scenes. He expressed the world that surrounded him in the vibracionista style, and to that he added a variant he called ''clownista,'' in which he expressed humor and a playful spirit. Examples are *Hombre en el café* (collage, 1925) and *Collage vibracionista* (mixed technique).

In *Los Magníficos* (1923–25), another culminating moment in his aesthetics, Barradas focused on the figure, taken as a unitary element, solid and solemn, in which he sought essences, archetypes. He calmed his palette and left aside the ruptures of forms and syncopated rhythms, as seen in works such as *Hombre en la taberna* (1922), *Hombre en el café* (oil on canvas, 1923), and *Molinero de Aragón.* He seemed to clearly feel the influence of his experiences in Luco de Jiloca (Teruel) in 1924 when he was in direct contact with Spanish rural reality, but at the same time there was a personal search for the more perennial, a flight from the ephemeral and transitory reflected in his frontal figures, in the flat painting, in the absolute

stillness, in the monumentality, stacticness, and planarism, and in the search for the archetypical and the essential. It was a more severe painting that paid homage to everyday human types.

In 1925 he settled in Hospitalet, where the most noteworthy among the Spanish and Catalan intellectuals would meet at his home. He did religious paintings in a low palette and began the series *Estampones,* featuring Montevideo life. In *Estampones nativos* he rendered characteristic scenes of Montevideo, charged with nostalgia for a city that he would come to enjoy for a mere four months before dying from consumption. It is the city of his youth, of his bohemian years at the beginning of the century, the socio-urban framework for his everyday adventures. It is an evocation full of humor and irony. He captured the conversation of a pair of young lovers under the watchful eye of a chaperone, the formal sitting room visit, bourgeois décor, the stiffness of an officious doctor, and moments of diversion in cafés, brothels, and the port, where he rendered prostitutes and everyday characters. In these water-colored drawings the planes intercross, creating powerful visual games and simultaneously representing in a single scene various instances of action. The colors are tenuous and reflect a certain melancholy. Examples include *Negro con mandolina* (pencil and watercolor on paper), *Señorita sentada al piano* (pencil and watercolor), *Marineros y negras* (oil on canvas), and *Negra y marineros* (pencil and watercolor on paper).

—Alicia Haber

BARRAGÁN, Luis
Mexican architect

Born: Guadalajara, Jalisco, 1902. **Education:** Engineering diploma, Guadalajara, 1925; self-taught architect. **Career:** Architect, Guadalajara, 1927–36; real estate developer, Mexico City, 1936–40; involved with real estate and planning studies, 1940–45; cofounder and director, Jardines del Pedregal de San Angel, Mexico City, 1945–52; partner, Luis Barrágan y Raul Ferrera Arquitectos, 1976–88. Traveled in Spain and France, 1924–26; attended lectures of Le Corbusier in Paris, 1931–32. Member, Mexican Academy of Architects; fellow, American Institute of Architects. **Awards:** Pritzker Architectural prize, 1980; Jalisco Architecture award, State of Jalisco Coll. Architects, 1985; Jalisco Prize for Plastic Arts, 1985. Honorary doctorate, Autonomous University, Guadalajara, 1984. **Died:** 22 November 1988.

Works:

1928	Enrique Aguilar House, Guadalajara
	E. Gonzalez Luna House, Guadalajara
1929	Children's Playground, Parque de la Revolucion, Guadalajara
1936–40	Apartment building, Plaza Melchor Ocampo, Mexico City
1940	Painters' studios, Plaza Melchor Ocampo, Mexico City
1945	Three private gardens, Avenida San Jeronimo, San Angel, Mexico City
1947	Barrágan House, Tacubaya, Mexico City
1950	Eduardo Prieto Lopez House, El Pedregal, Mexico City
1955	Hotel Pierre Marquez gardens, Acapulco

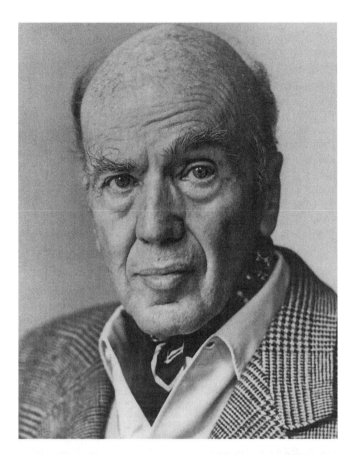

Luis Barragán, 1980. AP/Wide World Photos, Inc. Reproduced by permission.

	Chapel of the Sacramentarian Capuchins, Mexico City
	Gálvez House, Mexico City
1957	Satellite City Towers (with Mathias Goeritz), Queretaro Highway, Mexico City
1959	Las Arboledas, El Pedregal, Mexico City
1964	Los Clubes master plan, public landscaping, and building code, Mexico City
1967–68	Egerstrom House and other buildings, Mexico City
	Cuadra de San Cristóbal, Mexico City
1976	Gilardi House (with Raul Ferrera and Alberto Chauvet), Tacubaya, Mexico City

Individual Exhibitions:

| 1976 | Museum of Modern Art, New York |
| 1985 | Museo Rufino Tamayo, Mexico |

Publications:

By BARRAGÁN: Articles—"Gardens for Environment–Jardines del Pedregal," in *Journal of the American Institute of Architects,* April 1952; "The Construction and Enjoyment of a Garden Accustoms People to Beauty, to Its Instinctive Use, Even to Its Accomplishment," in *Via 1: Ecology in Design* (Philadelphia), 1968.

On BARRAGÁN: Books—*The New Architecture in Mexico* by Esther Born, New York, 1937; *Mexico's Modern Architecture* by I. E.

Myers, New York, 1952; *Latin American Architecture since 1945* by Henry-Russell Hitchcock, New York, 1955; *Builders in the Sun: Five Mexican Architects* by Clive Bamford Smith, New York, 1967; *Mexican Landscape Architecture–From the Street and from Within* by Rosina Greene Kirby, Tucson, Arizona, 1972; *The Architecture of Luis Barragán,* exhibition catalog, by Emilio Ambasz, New York, 1976; *GA 48: House and Atelier for Luis Barragán,* edited by Yukio Futagawa, Tokyo, 1979; *Luis Barragán, Clásico del silencio,* edited by Enrique de Anda, Colombia, 1989; *Luis Barragán* by Wiel Arets and Wim van den Bergh, Rotterdam, 1990; *The Life and Works of Luis Barragan* by Jose Maria Buendia Julbez and others, New York, Rizzoli, 1997; *Luis Barragan: 1902–1988* by Antonio Riggen Martinez, Milan, Electa, 1997; *Luis Barragan* by Rene Burri, Harrisburg, Pennsylvania, Phaidon Press, 2000. **Articles—**"Mexican Villas: Luis Barragán, Architect," in *Architectural Record,* September 1931; "Recent Work of a Mexican Architect–Luis Barragán," in *Architectural Record,* January 1935; "The Gardens of Pedregal" by Mary Saint Albans, in *Modern Mexico,* April 1946; "Jardines del Pedregal, Mexico City," and "House by Luis Barragán, Architect," in *Arts and Architecture,* August 1951; "Arbeiten von Luis Barragán, Mexico" by Horst Dohnert, in *Baukunst und Werkform* (Darmstadt, West Germany), November 1954; "I muri di Luis Barragán," in *Domus,* November 1968; "Designing for a Dry Climate," in *Progressive Architecture,* 52, August 1971; "Luis Barragán," in *Arquitectura Mexico,* January/February 1977; "Luis Barragán and His Works" by M. Schjetan Garduno, in *Arquitectura Mexico,* September/October 1978; "The Haunting Art of Luis Barragán," in *Progressive Architecture,* June 1980; "Luis Barragán–Alchemist of Architecture," in *Arkkitehti,* 4, 1980; "The Works and Background of Luis Barragán," in *Architecture and Urbanism,* August 1980; "Imponderable Substance: Luis Barragán's Casa Gilardi in Mexico" by Emilio Ambasz, in *Progressive Architecture,* September 1980; interview with Barragán by Jorge Salvat, in *Archetype,* Autumn 1980; "The Influential Lyricist of Mexican Culture" by Mario Schjetnan G., in *Landscape Architecture,* January 1982; "Modern Mexican Architecture," in *Process: Architecture,* July 1983.

* * *

Luis Barragán, Mexican architect, urban designer, and developer, was born in Guadalajara, in Jalisco state, in 1902. He studied engineering and architecture in Guadalajara and graduated in 1925. After a two-year trip to Europe, where he visited the Alhambra and the Generalife in Granada, he developed an interest in the relationship between landscape and architecture. He then returned to Guadalajara and did his first building projects and landscape designs. In 1936 he moved to Mexico City, already having had some of his works shown in American architecture magazines. After 1940 Barragán engaged in real estate development, purchasing lots on which he would later build residences. He set out to develop an area near Mexico City covered with lava rock, a material he ingeniously utilized to design gardens. Along with associate José Alberto Bustamante, he purchased an extension of Pedregal San Angel and developed it into an important residential area in the south of Mexico City. Barragán's intention was to create a harmonious neighborhood in relation to the existing landscape. During the 1950s Barragán worked on large developments in Guadalajara as well as on private residences and on the renovation of the Capilla para las Capuchinas convent in Tlalpan, which is considered one of his most important works.

In 1959 Barragán was invited to develop an urban landmark for Ciudad Satélite, the newly constructed suburb of Mexico City. In collaboration with Matias Goeritz, he designed a group of vertical towers known as the Torres de Satélite. Throughout the 1960s and 1970s Barragán created additional residential developments, including Lomas Verdes, a development for 100,000 people. He collaborated with the Mexican architect Ricardo Legorreta on various projects. Among Barragán's most important works were his home studio (1947), Casa Gálvez (1955–56), Cuadra de San Cristóbal and Casa Egerstrom (1967–68), and Casa Gilardi (1976). Barragán was awarded the 1980 Pritzker Architecture Prize in recognition of the contributions he had made throughout his career. He died in Mexico City in 1988.

Barragán's influence in architecture went far beyond that of any other Mexican architect or designer of the twentieth century. He began working in the 1930s during the height of the Mexican muralist movement, at a time when architecture in Mexico was driven by international trends such as art deco and functionalism. From its very beginning Barragán's work was characterized by a counterpoint between organic landscape and modernist architecture. By creating juxtapositions of such elements, Barragán's work balanced a restrained minimalist approach with the expressiveness and spirituality of color and textural surfaces. His architectural language was inspired by aspects of international modernist tendencies and utilized the language of geometry and color. Barragán further adapted these elements in a highly individual way, however, through his close understanding of the nature of the light and the land of Mexico, his sense of urban living, and his use of materials such as stucco and volcanic rock. Barragán's architecture became so pervasive that toward the last quarter of the twentieth century his name became synonymous with modern architecture in Mexico.

Toward the beginning of the twentieth century Mexican architecture had carried the heavy historical weight of the aesthetic of excess. In contrast, Barragán's oeuvre was exemplary of a language that, while remaining true to its localism, was handled with an elegant simplicity and purity of design. Even since his death Mexican architecture has continued to show the influence of Barragán's legacy.

—Pablo Helguera

BARRAZA, Santa (Contreras)
American painter and muralist

Born: Kingsville, Texas, 1951. **Education:** University of Texas, Austin, B.F.A. and M.F.A. in painting and drawing. **Career:** Cofounder, Mujeres Artistas del Suroeste, Austin; owner, Diseño Studios, Austin. Professor, La Roche College, Pittsburgh, Pennsylvania, Pennsylvania State University, University Park, and Art Institute of Chicago. Chair, art department, Texas A & M University, Kingsville. Member, artist group *Con Safo*, 1960s.

Individual Exhibitions:

1999–00 Museum of Texas Tech University, Lubbock
2000 *Touring Exhibit of Art by Santa Barraza,* Community Art Center, Victoria, Texas

Santa Barraza: A Mexic Tejana Artist from Nepantla, Ben Bailey Art Gallery, Texas A & M University, Kingsville

Selected Group Exhibitions:

1989 *Raza Si!,* La Peña, Austin
1993–94 Mexican Museum, San Francisco (traveling)
1994 *Something in Common,* Artemisia Gallery, Chicago
1995 *Ain't I a Woman?,* Artspace at ECA Yale, New Haven, Connecticut
1996 *Mujeres de pelo en pecho,* Western Illinois University, Chicago
1999 Museum of Texas Tech University, Lubbock
2000 *Images and Histories: Chicana Altar-Inspired Art,* de Saisset Museum, Santa Clara University, California

Collection:

Metropolitan Museum of Art, New York.

Publications:

By BARRAZA: Book—*Santa Barraza, Artist of the Borderlands,* with María Herrera-Sobek, Shifra M. Goldman, Tomás Ybarra-Frausto, and Dori Grace Udeagbor Lemeh, College Station, Texas A & M University Press, 2001.

On BARRAZA: Books—*Ceremony of Spirit,* exhibition catalog, text by Amalia Mesa-Bains, San Francisco, Mexican Museum, 1993; *Something in Common,* exhibition catalog, Chicago, School of the Art Institute of Chicago, 1994; *Mujeres de pelo en pecho,* exhibition catalog, Chicago, 22nd Annual Conference, National Association for Chicana and Chicano Studies and Western Illinois University, 1996; *Latin American Women Artists of the United States* by Robert Henkes, Jefferson, North Carolina, McFarland, 1999; *Santa Barraza,* biofile, Denton, Texas Woman's University Library, 1999. **Article**—''Collection'' in *Heresies,* 7(3), 1993, p. 52.

* * *

The source of Santa Barraza's painting is a mixture of her family history, mythology, and the landscape of her childhood. Growing up in southern Texas, Barraza was influenced by life in a border town. *Nepantla* is a Nahuatl word meaning an ''in-between state.'' This feeling of *nepantla,* of existing between two worlds—whether it be the unconscious and conscious world or the Anglo and Mexican world—is an integral part of Barraza's work. Although Barraza moved east for teaching jobs after college, her work includes motifs from the barren Texas landscape, including the maguey plant, which became a sort of icon for her. Maguey plants appear everywhere in Barraza's work: they surround the Virgin Mary, and their leaves protect and nourish the women in her paintings. In her autobiography Barraza writes of the Texas landscape: ''My artistic vision comes from this timeless land. It comes from looking at the South Texas horizon line and observing the land melting into the sky—the two merging together in infinity.''

The range of scope and dimension in Barraza's painting is vast. She has created murals for the sides of buildings and book-sized

paintings, which imitate the form of *retablos* and *codices*, small oil paintings on tin or iron used for devotional purposes. Traditionally *retablos* depict a saint or holy figure; the Virgin Mary is an especially popular choice. Having studied the *retablo* aesthetic on a grant to Mexico, Barraza used the form to create personal *retablos*, combining traditional elements with autobiography. For example, in one *retablo* Barraza honors the Virgin Mary for protecting her sister during heart surgery.

Autobiography mixed with mythology is a large part of Barraza's work. Not only does she draw from her familial ties but also she connects these women to mythic representations of women, as in her painting *La mano poderosa de Coyolxauhqui*, which features the moon goddess, and another painting that depicts La Llorona, the weeping woman. Early in her career Barraza worked exclusively in black and white, creating portraits of her family and herself. In one early work Barraza depicts herself as a "shattered woman." In this self-portrait she shows her brain slipping out of her head. This painting symbolically describes the difficulties Barraza faced early in her education and career being a woman and being Chicana (she was unhappy with an art department she found Eurocentric at the University of Texas). In another early work she shows her aunt with her husband; early in their courtship the couple seem to be floating away. In one of her first exhibited works—a large black-and-white drawing—Barraza uses the Depression-era photographs of Russell Lee as a starting point for her painting *Los migrantes*. In the painting a migrant worker sleeps with his daughter.

After her early work in black and white, Barraza began exploring a palette of bright Southwestern colors. Barraza's style, which has been called both surreal and primitive, is influenced by folk art as well as Catholic imagery. The women in her paintings are clearly set apart from their background. There is a certain control in her work, a certain geometry, which is not surprising given that she worked for several years as a graphic designer. Women are the focus. Although the women in her culture were traditionally supposed to be docile, passive, and subordinate to men, Barraza's paintings show the strength of her ancestors. By delving into family history, Barraza attempts to connect with the past, to honor the sacred. In a painting called *Homage to My Mother, Frances,* Barraza's mother is placed in the center of a protective maguey plant (Barraza's mother always told her daughter to plant a maguey in the front yard for good luck). Surrounding her are her relatives, as well as the Virgen con Corazon. The painting is a tribute to a mother's love and sacrifice and a link between past and future generations of women, a bridge between two worlds.

—Sally Cobau

BARRIOS, Moisés

Guatemalan painter, photographer, engraver, and collage artist

Born: San Pedro Sacatepéquez, San Marcos, 1946. **Education:** Escuela Nacional de Artes Plásticas, Guatemala; Facultad de Bellas Artes de Costa Rica; studied engraving at Academia de San Fernando, Madrid. **Career:** Has worked as a graphic designer and artist. Cofounder, Imaginaria Gallery, Guatemala City, 1986, and member, artist collective *Imaginaria*.

Individual Exhibitions:

1988 Galería Laberinto, San Salvador, El Salvador
1992 *Sublimis Deus,* Galería Laberinto, San Salvador, El Salvador
 De amor también se muere, Galería Sol del Río, Guatemala City
1993 *Eterna memoria,* Engramme, Quebec
1994 *Bésame mucho,* Galería Laberinto, San Salvador, El Salvador
1995 *Pacífico Guatemalteco,* Galería Sol del Río, Guatemala City
1996 *Resurección,* Galería Sol del Río, Guatemala City
1997 *Tabula rasa,* Galería Sol del Río, Guatemala City
1999 *Arcadia,* Galería Belia de Vico, Guatemala City
 Café Malinowsky (photo-installation), Casa de América, Madrid

Selected Group Exhibitions:

1988 Museo de Arte Moderno, Chapultepec Park, Mexico City (with *Imaginaria*)
1989 Museum of Contemporary Hispanic Art, New York (with *Imaginaria*)
1994–95 *Tierra de tempestades,* The Harris Museum and Art Gallery, Preston, Lancashire, England (traveling)
1996 *Mesótica II: Centroamérica re-generación,* Museo de Arte y Diseño Contemporáneo, San José, Costa Rica
 Biennial of Central America and the Caribbean, Santo Domingo, Dominican Republic
1997 ARCO, Madrid
1998 *1265 km. arte de Guatemala en Cuba,* Centro Wifredo Lam, Havana
 24a Bienal de São Paulo, Brazil
2001 *Contemporary Art in Guatemala,* Municipal Room of Exhibitions, Valladolid, Spain

Publications:

On BARRIOS: Books—*Presencia imaginaria,* exhibition catalog, text by Francisco Morales Santos, Mexico City, Museo de Arte Moderno, 1988; *Pacífico guatemalteco,* exhibition catalog, text by Ana María Rodas, Guatemala City, 1994; *Tierra de tempestades,* exhibition catalog, text by Joanne Bernstein, Preston, Lancashire, England, Harris Museum and Art Gallery, 1994; *Mesótica II: Centroamérica re-generación,* exhibition catalog, text by Rossina Cazali, San José, Costa Rica, 1996. **Article**—"Imaginaria: Amidst Sausages and Hams" by Rossina Cazali, in *Art Nexus* (Colombia), 27, January/March 1998, pp. 60–63.

* * *

Moisés Barrios was born in San Pedro Sacatepéquez, San Marcos, Guatemala, in 1946. He began his education at the Escuela Nacional de Artes Plásticas de Guatemala and at the Facultad de Bellas Artes de Costa Rica. He went on to specialize in engraving at the Academia de San Fernando de Madrid.

For 25 years Barrios divided his time between working in graphic design and pursuing his profound interest in art, upon which he left a profound mark as an innovative projector of images. The

motifs most important to his work include the blending of the rural and the urban with graphic elements. Nevertheless, the chaotic and violent situation of the Guatemalan civil war, which lasted more than three decades, resulted in a body of work that can be interpreted as a document examining distinct moments of this period in so far that it motivates reflection and the interpretation of the conflict's repercussion upon the Guatemalan psyche.

In 1986, with Luis González Palma, Barrios opened the Imaginaria Gallery in Antigua Guatemala, which served as a headquarters for the Grupo Imaginaria. This artist collective, of which Barrios and González Palma belonged, motivated Barrios to appreciate and develop contemporary languages in his own work and to establish an open perspective that assimilated Western culture. The reworking and incorporation of contemporary Western elements in his work indicate that he had begun to eliminate any prejudice and stereotypes that conservative ideologies had unleashed from the left and the right upon local artistic production. Along with the *imaginarios* the artist exhibited his work in the Museo de Arte Moderno of Mexico City in 1988 and in the Museum of Contemporary Hispanic Art of New York in 1989.

In 1996 Barrios entered an artistic phase that would change his personal and creative sensibilities. He produced a series of realist paintings that abandoned themes directly associated with Guatemalan society. This period involved techniques used by painters of popular labels as well as methods of visual communication in advertising. Likewise it demonstrated the artist's fascination for advertisements printed in American magazines in the 1950s that were circulating the country. In his exhibition *Mesótica II: Centroamérica re-generación,* carried out in the Museo de Arte y Diseño Contemporáneo de San José, Costa Rica, he presented the first of his banana tree series in the form of magazine covers, accompanied by well-known logos like that of *Life* magazine. This period involved a valuable discovery of the banana fruit as a symbol, which he began to study obsessively. The banana icon allowed him to develop a complex discourse combining his interest in history, science, and both Western and Latin American literature. Likewise it suggests further thought on postmodern debates concerning otherness, as well as an extensive self-criticism on the characteristics that make up citizens of these named banana republics.

A product of this period was the *Café Malinowski* series, presented in 1998 in 24a [sic] Bienal de Sao Paulo. *Café Malinowski* is a collection of photographs where different icons from the history of universal art acknowledge each other. Barrios links these with the third-world icon of the banana to create a dialogue with otherness. The title *Café Malinowski* refers to Café Voltaire, a hideout for the dadaists in Zurich at the turn of the century. The artist plays with the figure of the famous anthropologist and creates a fictitious situation where Malinowski's search for an idealized and exotic paradise results in a luck of contradictions with the original story.

Right from the beginning of the banana series, Barrios created a central metaphor that articulates the totality of his project and that leans toward his conceptual values as an artist. The artist explores the contamination of paradise, both his own and others, the local and external, through the use of the banana as a classic, yellow ocher and black blotches, a varnish that he adds over different surfaces and objects. In 2001 he began a new series, entitled *Flora Lunar/Musa Ornamental,* which confronts the viewer with a snare of stereotypes. He used one of the extensions of the banana plant, the flower, a little known and recently incorporated decorative possibility. Although this became a new leitmotiv, it was stripped of any aesthetic suggestion. The flower, named musa ornamental, acted as a preamble to a paradise painted in white and black, a decolonization of color.

With more than 30 years of work, Barrios is one of the most solid Guatemalan artists. His work articulates itself through an understanding of his obsession for ancient and contemporary history, for the value of the images, and for wordplay in the titles he gives his work. For these titles his knowledge of philosophers such as Ludwig Wittgenstein as well as his interest in other artists such as Ian Hamilton Finlay have been important. Equally influential has been the German Gerhard Richter in his use of photography as an original and translatable reference to painting.

—Rosina Cazali

BEDEL, Jacques
Argentine sculptor

Born: Buenos Aires, 1947. **Education:** Studied architecture, School of Architecture and Urbanization, University of Buenos Aires. **Career:** Member, artist group *Grupo Cayc,* Buenos Aires. **Awards:** Scholarship, French government, 1968; prize, British Council, London, 1974; gold medal, Exposición de las Naciones Unidas, 1975; grand prize, *XVI bienal de São Paulo,* 1977; Fulbright grant for research at National Astronomy and Ionosphere Center, Cornell University and NASA, Washington, D.C., 1980; grand prize of honor, *I bienal internacional de Montevideo,* 1980; first prize, Concurso Internacional por el Instituto Latinoamericano para la Integración y Desarrollo, 1985; gold medal, *II bienal internacional de arquitectura,* 1987; diploma of merit, Konex Foundation, 1992.

Selected Group Exhibitions:

1981	Musée Cantonal del Beuax Arts, Lausanne, Switzerland (with *Grupo Cayc*)
1986	Ruth Benzacar Galería de Arte, Buenos Aires
1990	*Grupo Cayc, El Dorado,* Ruth Benzacar Galería de Arte, Buenos Aires
1992	John Good Gallery, New York
1993	*CAYC Group,* Striped House Museum of Art, Tokyo
1999	*XLVIII biennale di Venezia,* Venice

Publications:

On BEDEL: Books—*Jacques Bedel, esculturas, Americo Castilla, pinturas e instalaciones, Humberto Rivas, fotografias,* exhibition catalog, Buenos Aires, Ruth Benzacar Galería de Arte, 1986; *Grupo Cayc, El Dorado,* exhibition catalog, text by Jorge Glusberg, Buenos Aires, Ruth Benzacar Galería de Arte, 1990; *Art of the Americas, the Argentine Project,* exhibition catalog, text by Joseph Azar, Hudson, New York, Baker & Co., 1992; *CAYC Group,* exhibition catalog, Buenos Aires, Centro de Arte y Comunicación, 1993; *Bedel, Benedit, Bony y Bruzzone en la XLVIII bienal internacional de Venecia,* exhibition catalog, Buenos Aires, Dirección General de Asuntos Culturales del Ministerio de Relaciones Exteriores, 1999. **Articles—** ''Art of the Americas, the Argentine Project'' by Ken Johnson, review of an exhibit at John Good Gallery, New York, in *Art in America,* 80, April 1992, pp. 164–165; ''Argentinien'' by Michael

Hübl, in *Kunstforum International* (Germany), 147, September/November 1999, pp. 128–129.

* * *

Throughout his career the Argentine conceptual artist Jacques Bedel has worked to create acute allegories on destiny, life, and death. His art reflects his fascination with an architectonic approach to the structures and spaces that people imagine, create, and inhabit. His form is the sculptural book, giant, seemingly ancient tomes that stand three feet tall or higher. Made of lightweight resin, they are coated to look like rusted steel, which enhances their sense of mass, gravity, and permanence. The books are hinged, and they open to reveal sculptural reliefs representing cubist abstractions, geological topographies, archaeological ruins, and human discoveries. In Bedel's conformation the book represents the permanence of the idea and symbolizes culture, marking discovery and knowledge at any moment in history. Legends, astronomy, and mathematical and scientific principles become anecdotal abstractions of human intention. Addressing these topics through visual metaphors, Bedel builds mental labyrinths, providing many paths toward intellectual revelation; mythical abstractions and limited information are obstacles that redirect the viewer through another passage. As a result of this labyrinthine journey, sculpture, which is placed within the book's form, comes to assume a poetic vocabulary of concepts. The physical act of opening the book and thereby searching and discovering establishes the original dialectic in Bedel's work, positioning the uniform exterior against the labyrinthine interior and concealment against revelation. As a symbol of intellectual consciousness and intellectual encounter, the book then becomes its own source of inspiration.

In his series *Las ciudades de plata* (1977–79; "The Silver Cities") Bedel constructed imagined ruins of the mythical silver cities. Often cited as the paradigmatic example of the European encounter with Latin America, the legendary cities came to represent the temptation of riches that led, in the case of the late sixteenth-century conquistadors, to untimely and dramatic deaths. Bedel sculpted the topographies of the cities, including general architectural remains and passageways as imagined from an aerial view. As one opens a book, the city unfolds. Where a structure stands on one "page," there is a necessary void on the opposite page, which allows the book to open and close. For each presence there is an absence. By constructing a city in ruins, Bedel inquires into the possible evolution of an elusive, unknown space.

In *La memoria de la humanidad–la luna de la tierra* (1979; "Mankind's Memory–The Earth's Moon"), Bedel investigates human intellect, not by examining a humanly constructed object, but by revealing that our capacity to explore places extends beyond Earth. A massive tome made of almost indestructible stainless steel, the work requires a physical interaction that surpasses the standard rituals of reading. The book opens to reveal precise etchings of the Moon's face on one page and of its dark side on the other. Instead of writing an accompanying text, which future interpretations would render subjective, he includes mathematical equations, postulating that math will endure beyond language. The book is a study of the permanence of idea, symbol, and sphere.

Bedel's investigations into the subjects of time, erosion, and infinity are sharpened in his 1984 work *El libro de arena*. In this book, which must lie flat with its spine on the ground, loose sand falls differently each time it is opened. The content overrides the form, since anybody can affect the form by manipulating the sand within its

covers. The piece recognizes that literature is a human pursuit and that every reader interprets the same text in a different way in accordance with individual predispositions. Bedel has produced his *Scrolls* series, begun in 1992, in individual chapters. In them he devotes himself to the exploration of the remote and constant dialogue between man and the absolute. In these works there is no mysticism or theological end; rather, the focus is on the endless search by human beings to know themselves and their destiny. For Bedel man is the spirit of man in all times and places, and the notion of apocalypse is directed at the spirit of man. In his scroll that delves into the Apocalypse of John, Bedel chooses four quotes that are linked to the hope of redemption and not to the disasters described, and these selected quotes are visible only in the light that, according to the Creation myth, originated with Yahweh on the first day.

Bedel, a graduate of the School of Architecture and Urbanization at the University of Buenos Aires, was invited in 1969 to take part in the 10th International Architects Congress as a delegate for the Association Internationale des Arts Plastiques, under the jurisdiction of UNESCO. For most of his career Bedel has been a member of CAYC (Center for Art and Communication). Under the CAYC rubric he won the grand prize at the XVI Biennial of São Paulo and has participated in several international exhibitions.

—Martha Sutro

BEDIA (VALDÉS), José
Cuban painter and installation artist

Born: Havana, Cuba, 1959. **Education:** Escuela de Artes Plásticas San Alejandro, Havana, graduated 1976; Instituto Superior de Arte, Havana, graduated 1981. **Career:** Artist-in-residence, State University of New York, College at Old Westbury, 1985. Lived in Mexico, 1991. Since 1993 has lived and worked in Miami. **Awards:** Grand prize, Salon del Paisaje, Havana, 1982; prize, *II Havana Biennial,* 1986; fellowship, Guggenheim Foundation, 1994; fellowship, Oscar B. Cintas Foundation, 1997.

Individual Exhibitions:

1978 Moncada, Havana
1984 *Persistencia del uso,* Museo Nacional de Bellas Artes, Havana
1986 Galeria del Centro Wifredo Lam, Havana
1989 Centre George Pompidou, Paris
1990 *Recent Works,* Forest City Gallery, London, Ontario, Canada
1991 *Drawings,* Frumkin/Adams Gallery, New York
 Sueño circular, Ninart, Centro de Cultura, Mexico City and Galería Ramis Barquet, Garza García, Mexico
 Los presagios, IV Havana Biennial
1992 *Brevísima relación de la destrucción de las Indias,* Mueso de Arte Contemporáneo Carrillo Gil, Mexico City
 El hombre de hierro, Galería Curare, Mexico City
 Frumkin/Adams Gallery, New York
 Galería Ramis Barquet, Garza García, Mexico and Ninart Centro de Cultura, Mexico City
1993 *Fábula,* Galería Fernando Quintana, Bogotá

José Bedia: *Sombra Incontrolable,* **1999. Photo courtesy of Galeria Ramis Barquet, New York.**

Kulturhuset, Stockholm, Sweden (with Carlos Capelán)
La isla en peso, Galería Nina Menocal, Mexico City
Museum Ludwig, Cologne, Germany
1994 *De dónde vengo,* Institute of Contemporary Art, Philadelphia (traveled to Center for the Fine Arts, Miami and Museum of Contemporary Art, San Diego)
Casi todo lo que es mio, Fredric Snitzer Gallery, Coral Gables, Florida

Frumkin/Adams Gallery, New York
1995 *Mundele quiere saber,* Fredric Snitzer Gallery, Coral Gables, Florida
Round Things, Museum of Art, Fort Lauderdale, Florida
1996 *Mi esencialismo,* Hyde Gallery, Trinity College, Dublin, Ireland (traveled to George Adams Gallery, New York and Tademuseo, Pori, Finland)
New Drawings, Fredric Snitzer Gallery, Coral Gables, Florida

José Bedia: *Equilibrio entre 3 casas no es facil,* **2000. Photo courtesy of Galeria Ramis Barquet, New York.**

Drawings by Jose Bedia, Porter Troupe Gallery, San Diego

Expoarte, Guadalajara, Mexico

La isla, el cazador, y la presa, Galería Der Brücke, Buenos Aires

1997 George Adams Gallery, New York

Historia de animales, Fredric Snitzer Gallery, Miami

Crónicas Americanas, Museo de Arte Contemporáneo de Monterrey, Mexico

Obra reciente, Galería OMR, Mexico City

The Island, the Hunter, and the Prey, SITE, Santa Fe, New Mexico

Der Brücke Arte International, Buenos Aires, Argentina

1998 *Objetos de trueque,* Fredic Snitzer Gallery, Miami

Crónicas americanas, Museo Rufino Tamayo, Mexico City

The Island, the Hunter, and the Prey, Edwin Ulrich Museum, Wichita, Kansas

I Lima Biennial, Peru

1998–99 *20/21: Jose Bedia,* Joslyn Art Museum, Omaha, Nebraska

1999 Ramis Barquet Gallery, New York

Annina Nosei Gallery, New York

Art Museum, Florida International University, Miami

2000 George Adams Gallery, New York

Selected Group Exhibitions:

1981 *First Look: 10 Young Artists from Today's Cuba,* WestBeth Gallery, New York

1989 *Trajectoire cubaine,* Centre d'Art Contemporain de Corbeil-Essonnes, France and Museo Civico di Gibellina, Italy

1989–90 *Contemporary Art from Havana,* Riverside Studios, London and Museo de Arte Contemporaneo de Sevilla, Spain

1992 *Latin American Artists of the Twentieth Century,* Museum of Modern Art, New York (traveling)

1993 *Cartographies,* Winnipeg Art Gallery, Manitoba

1996 *Going Places,* George Adams Gallery, New York

Nuevo arte de Cuba y México, David Floria Gallery, Woody Creek, Colorado and Galería Nina Menocal, Mexico

1997 *New Editions,* Joan Prats Gallery, New York

Artistes Latino-Américains, Galerie Daniel Templon, Paris

1998 *Twenty Years Anniversary Exhibition,* Fredric Snitzer Gallery, Miami

Collections:

Arkansas Art Center, Little Rock; Centro Cultural Arte Contemporáneo, Mexico City; Ludwing Forum für Internationale Kunst, Aachen, Germany; Museo de Arte Contemporáneo de Monterrey, Mexico; Museo de Bellas Artes, Caracas, Venezuela; Museo Nacional de Bellas Artes, Havana; Museum of Art, Rhode Island School of Design, Providence; Norton Gallery, West Palm Beach, Florida; Perseus Collection, Honolulu, Hawaii; Philadelphia Museum of Art, Pennsylvania; Phoenix Art Museum, Arizona; Porin Taidemuseum, Finland; San Diego Museum of Art, California; Whitney Museum of American Art, New York; Hirshhorn Museum and Sculpture Garden, Smithsonian Institution, Washington, D.C.

Publications:

By BEDIA: Book—*Rúben Torres Llorca,* essay in exhibition catalog, Monterrey, Mexico, Galería Ramis Barquet, 1996.

On BEDIA: Books—*Trece artistas jóvenes* by Gerardo Mosquera, Havana, Departamento de Cultura, Universidad de la Habana, 1981; *New Art from Cuba,* exhibition catalog, Old Westbury, Long Island, New York, State University of New York, 1985; *Trajectoire cubaine,* exhibition catalog, text by Pierre Gaudibert, Corbeil-Essonnes, France, Centre d'Art Contemporain, 1989; *Contemporary Art from Havana,* exhibition catalog, London, Riverside Studios, 1989; *José Bedia: Sueño circular,* exhibition catalog, Mexico City, Ninart, Centro de Cultura, 1991; *José Bedia,* catalog, Garza García, Mexico, Galería Ramis Barquet, 1992; *José Bedia,* exhibition catalog, text by Edward J. Sullivan, Garza García, Mexico, Galería Ramis Barquet, 1992; *Cartographies,* exhibition catalog, text by Alison Gillmor, Manitoba, Winnipeg Art Gallery, 1993; *José Bedia: Fábula,* exhibition catalog, Bogotá, Galería Fernando Quintana, 1993; *José Bedia: La isla en peso,* exhibition catalog, text by Giulio Blanc, Mexico City, Galería Nina Menocal, 1993; *José Bedia: De donde vengo,* exhibition catalog, text by Melissa E. Feldman and Gustavo Pérez Firmat, Philadelphia, Institute of Contemporary Art, University of Pennsylvania, 1994; *José Bedia: La isla, el cazador, y la presa,* exhibition catalog, Buenos Aires, Brücke Ediciones, 1996; *Nuevo arte de Cuba y México,* exhibition catalog, Woody Creek, Colorado, David Floria Gallery, 1996; *José Bedia: Mi esencialismo,* exhibition catalog, Dublin, Ireland, Douglas Hyde Gallery, 1996; *José Bedia: La isla, el cazador, y la presa,* exhibition catalog, Santa Fe, New Mexico, SITE, 1997; *Crónicas americanas,* exhibition catalog, Monterrey, Mexico,

Museo de Arte Contemporáneo, 1997; *José Bedia,* exhibition catalog, Omaha, Nebraska, Joslyn Art Museum, 1998; *José Bedia,* exhibition catalog, text by Roni Feinstein, Miami, Art Museum at Florida International University, 1999. **Articles—**"Art: Diego Rivera, José Bedia, and Frida Kahlo Tango through the Museum of Modern Art" by Kay Larson, in *New York,* 26(25), 21 June 1993, p. 66; "José Bedia: Galería Fernando Quintana" by Carlos Jiménez, review of exhibition, in *Art Nexus* (Colombia), 12, April/June 1994, pp. 180–181; "José Bedia: Institute of Contemporary Art, Philadelphia" by Monica Amor, review of exhibition, in *Art Nexus* (Colombia), 13, July/September 1994, pp. 161–162; "Fredric Snitzer Gallery, Coral Gables" by Elisa Turner, review of exhibition, in *Art News,* 93, October 1994, pp. 196–197; "Miami: José Bedia" by David M. Rohn, in *Art Papers,* 18(6), November 1994, p. 39; "José Bedia: Center for the Fine Arts, Miami" by Francine Birbragher, review of exhibition, in *Art Nexus* (Colombia), 14, October/December 1994, pp. 107–108; "José Bedia: Where I'm Coming from, Center for Fine Arts, Miami" by David M. Rohn, review of exhibition, in *Art Papers,* 18, November/December 1994, p. 39; "José Bedia: Casi todo lo que es mio" by Carol Damian, review of exhibition, in *Latin American Art,* 5(4), 1994, p. 68; "The Strangers at Hand" by Ricardo Pau-Llosa, in *Drawing,* 16, January/February 1995, pp. 102–105; "José Bedia: Museum of Art, Fort Lauderdale" by Francine Birbragher, review of exhibition, in *Art Nexus* (Colombia), 18, October/December 1995, pp. 123–124; "José Bedia: Fredric Snitzer Gallery" by John Sevigny, review of exhibition, in *Art Papers,* 20, September/October 1996, p. 46; "José Bedia: Cave Paintings and Comic Books" by Elisa Turner, in *Art News,* 95, October 1996; pp. 93–94; "José Bedia: George Adams Gallery" by Victor Zamudio Taylor, in *Art Nexus* (Colombia), 22, October/December 1996; pp. 150–152; "José Bedia: Cuban Painter" by Judith Bettelheim and Melissa E. Feldman, review of exhibition, in *Bulletin* (Oberlin, Ohio), 50(1), 1997, pp. 6–7; "Au sud de l'Amérique: Sus à l'exotisme" by Cyril Jarton, review of exhibition, in *Beaux Arts Magazine* (France), 154, March 1997, p. 28; "Artistes Latino-Américains" by Michel Nuridsany, review of exhibit, in *Art Press* (France), 224, May 1997, pp. 78–79; "SITE Santa Fe" by David Clemmer, review of exhibition, in *Flash Art* (Italy), 195, summer 1997, p. 98; "Sacred Silhouettes" by Robert Farris Thompson, in *Art in America,* 85, July 1997, pp. 64–71; "José Bedia: New Mexico Museum" by Stuart Ashman, review of exhibition, in *Art Nexus* (Colombia), 25, July/September 1997, pp. 141–142; "José Bedia: American Chronicles" by Cecilia Fajardo, review of exhibition, in *Art Nexus* (Colombia), 26, October/December 1997, pp. 104–106; "Three Transitional Artists" by Judith Bettelheim, in *International Review of African American Art,* 15(3), 1998, pp. 42–48; "José Bedia" by Mary Schneider Enriquez, review of exhibition, in *Art News,* 97(4), April 1998, p. 176; "Individuality and Tradition" by Lowery Stokes Sims, in *African Arts,* 32(1), spring 1999, pp. 36–39; "José Bedia: Only the Most Valuable Things" by Sherry Gaché, interview, in *Sculpture,* 18(5), June 1999, pp. 42–49; "José Bedia: Florida International University Art Museum" by Francine Birbragher, in *Art Nexus* (Colombia), 33, August/October 1999, pp. 148–149; "Behind the Masks" by Elisa Turner, in *ARTnews,* 99(7), 2000, pp. 178–183; "José Bedia," in *Art and Antiques,* 23(2), February 2000, p. 63; "Gauguin on Tahiti" by Stefano Casciani, in *Abitare* (Italy), 395, May 2000, pp. 171–182; "José Bedia: George Adams Gallery" by Mary Schneider Enriquez, review of exhibition, in *Art Nexus* (Colombia), 38, November/January 2000–01, p[. 149–150.

* * *

The work of the Cuban-born painter and installation artist José Bedia Valdés has embraced aspects of Amerindian and Afro-American culture from North and South America in a manner that deliberately transcends geographical boundaries and seeks to unite the Americas as a whole. Driven by his criticism of the colonial experience of the Americas, Bedia uses an artistic language that emerges from his own religious belief and that connects the present to the past. The result is a deliberate continuum strongly suggesting that, in many ways, the colonial legacy is still present across the region. Indeed, Bedia embraces the experience of diverse marginalized social groups in order to reinforce this message.

Bedia, who was born in 1959, began producing art in 1976, the year he graduated from the Escuela de Artes Plásticas San Alejandro in Havana. He continued his art studies at the Instituto Superior de Arte in Havana, from which he graduated in 1981. His first body of work, *American Chronicles* (1978–83), consists of photocopies of images of North American and Amazonian Indians glued onto paper and reworked using text and drawings such as Yanomani body painting. In 1981 Bedia participated in the seminal exhibition *Volumen I* in Havana, which heralded an emerging group of young Cuban artists eager to promote an expressive art free from state control.

In 1983, following a long interest in the Afro-Cuban religions of Santeria, which originated in Nigeria, and Palo de Monte, also known as Regla de Monte or Mayombe, from the Congo, Bedia was initiated into the latter. These religions were brought to the Caribbean through the colonial slave trade and are still widely practiced across Cuba despite being censored during the Spanish colonial period and by the revolutionary regime, although such repression has been relaxed since the 1980s. They provide Bedia with the perfect language to tackle issues of colonial repression and identity. As a practitioner of Palo de Monte, he has developed a visual language that uses ritual objects in combination with drawing, and he often works directly on gallery walls in the process of creating an artwork. For example, *The Beat of Time* (1986) consciously uses imagery drawn from Palo de Monte in such a way as to reaffirm the differences between the artist, and the people he represents through his art, and the viewer. This reaffirmation of the divide between the initiated and the uninitiated underscores Bedia's sense of continuity between the oppressed sectors of colonial society, the indigenous and African populations, and modern, Western-looking America. Bedia reveals that these oppressed groups do not speak the same language as the dominant sectors of society. Between 1984 and 1994 he made a number of installations mixing ritual objects with painting, including *Second Encounter* (1992) and *Kakuisa the Songe, Iron Flight* (1994).

In 1985 Bedia traveled to the United States, where he was artist-in-residence at the State University of New York College at Old Westbury. While in the United States he traveled with the Native American artist Jimmie Durham to a reservation of the Dakota Sioux. It was there Bedia adopted their characteristic style of line drawing. The experience demonstrates the way in which he unites disparate minority groups through their means of representation. In 1991, for instance, Bedia resided in Mexico, where he began to draw on *amate* (native bark) paper. Works such as *Polyptych of Ogun* (1992) combine *amate* paper, used by pre-Columbian Mexican cultures for recording written histories, genealogies, and almanacs, with images of Afro-Cuban religion. Thus, two distinct forms of expression come together to create a new visual form born out of the American experience.

In effect, this is the energy underlying Bedia's work. His interest in anthropology, which has led to extensive travel around the world

and to periods of residence in the United States and Mexico, combines with his active participation in Palo de Monte to create a rich visual language. His language contains knowledge and understanding that emphasize the differences between regions and peoples but that, paradoxically, also serve to unite them. In many ways Bedia presents art as an inclusive, as opposed to an exclusive, means of communication. Imbued with religious ritual and overt references to the indigenous and African populations of the Americas, his work points to those cultures that are often overlooked in the appraisal of Latin America yet have contributed to make it unique. Bedia deliberately sets out to create a work that reveals the religious and spiritual heart of Cuba and Latin America, where art is an integral aspect of identity, and that challenges the viewer to find out more about the work in order to understand it.

—Adrian Locke

BELLI, Patricia
Nicaraguan painter and installation artist

Born: Managua, 8 November 1964. **Education:** Loyola University, New Orleans, 1982–86, B.A. in visual arts 1986; Universidad Centroamericana, Managua, 1992–97, B.A. in art and literature 1997; San Francisco Art Institute, 1999–2001, M.F.A. candidate. **Family:** One son. **Career:** Traveled to Europe, 1992. Member and participant on editorial board of magazine, group *Artefactoria,* Managua. Artist-in-residence, Alcaldía de Delft, Netherlands, 1991, and Delfina Studios Trust, London, 1991–92. **Awards:** Premio Nacional de Dibujo, *VIII certámen nacional de artes plásticas,* Managua, 1988; Premio Nacional de Instalaciones and Gran Premio Rodrigo Peñalba, *IX certámen nacional de artes plásticas,* Managua, 1989; Fulbright scholarship, 1999; first prize, *II biennial,* Managua, 1999; Delta Kappa Gamma World fellowship, 1999.

Individual Exhibitions:

1986	*Maps,* Loyola University, New Orleans
1987	Alianza Francesa, Managua
1988	*Trabajos recientes,* Galería Fernando Gordillo, Managua
1992	*Carencias,* Bolívar Hall, London
1995	*Locura,* Artefactoría, Managua
1996	*Velos y cicatrices,* Epikentro Gallery, Managua
1997	*Punciones,* Palacio de la Cultura, Managua
1998	Centro de Mujeres en las Artes, Tegucigalpa, Honduras
	Intimidades, Literatur Werkstatt, Berlin
1999	*Obras,* Museo Nacional, Managua (retrospective)
	Domestica/La casa, Museo de la República Antigua Casa Presidencial, Tegucigalpa, Honduras
2000	*Rag Dolls,* Diego Rivera Gallery, San Francisco Art Institute

Selected Group Exhibitions:

1989	*III bienal de la Habana,* Havana
1990	*X certámen nacional de artes plásticas,* Managua
1991	*Tres mujeres,* Galería Praxis, Managua
1992	*500 años de resistencia cultural,* Museo Julio Cortázar, Managua
1993	*Latin American Art Show,* Bolivar Hall, London
1994	*II bienal centroamericana y del caribe,* Dominican Republic
	XIII certámen nacional de artes plásticas, Managua
1996	*Mesótica II,* Museo de Arte y Diseño Contemporáneo de Costa Rica, San Jose (traveling)
1997	*I bienal de arte iberoamericano,* Lima
1998	*Pintura nicaragüense contemporánea,* Centre Cultural la Beneficencia, Valencia, Spain

Publications:

On BELLI: Book—*Mujeres,* exhibition catalog, with text by Julio Valle-Castillo, Alejandro Aróstegui, and Juanita Bermúdez, Managua, CODICE Galeria de Arte Contemporáneo, 1993.

* * *

Patricia Belli emerged in the second half of the 1990s as one of Nicaragua's strongest artists but also as someone whose legitimacy created strong controversy. In a context in which painting has been the most privileged medium, understood specifically and only as pigment on canvas and accepted within the aesthetics linked to former masters, Belli has resorted to the use of the humblest materials associated with feminine crafts and occupations. In some of her initial ''paintings'' she applied stitched pieces of colored rags to the canvas or mounted secondhand clothing in awkward positions on stretchers, often adding sewn twigs and thorny branches that pierced the garments. In 1999 she presented a major installation piece at MUA Instala in Tegucigalpa, Honduras, composed of similar works but also including objects from daily life such as a table set with ragged cutlery, bundles of clothing in a bannerlike composition, elegant evening shoes with an insole of pins, and impossible-to-use furniture.

Belli's work seems at first glance to register within a very intimate discourse. In fact, the artist has projected her personal emotional experiences toward a kind of reconciliation of political and poetical issues. Her metaphorical language, in trying to name the unmentionable, refers to the impotence and alienation of a system that not only burdens human beings but also stands little chance of change. The perspective of the artist is marked by her own personal experience as the other, from his terrain, not from an imagined external space. Her otherness has been evident to her since she was very young, driving her to a conflictive relation with her own body and a precocious consciousness of gender issues.

From early works like *Velos y cicatrices* (''Veils and Scars,'' 1995–96) up to later assemblages and installations of rag dolls, in which can be detected a strong influence of Louise Bourgeois, Belli's work wanders among desolation and destruction, among pain and healing, among hope and despair, and exorcizes her childhood experiences. Her deep perception of a body she did not completely know how to deal with drove her to the reading of philosophy, particularly phenomenology texts regarding concepts of an awareness of the visible world. As the artist's herself has put it, her work starts from darkness, the darkness that is repressed in society and finds its way out through pornography, spectacles, and rituals. She is obsessed by the limits between good and evil, between pain and pleasure, between fiction and reality.

The work of Belli is characterized formally by the practice of reconstruction and recycling. The production of pieces from rags, cloth remnants, or cut, reconstituted, and resewn secondhand garments works like a metaphor of local economies and systems. In a way Central America lives in secondhand, precut garments, functions in handed-down structures that become in their local derivations sociopolitical freaks.

Belli is also an important figure in local artistic activism. She was one of the founders of the group Artefactoria, which functions as an alternative project, an option for contemporary artistic expression, and which emerged as a result of the dismantling of the cultural infrastructure in the early 1990s. The project came as a continuation of the work done in previous years by the artists' booklike journal *ARTE Facto.*

—Virginia Pérez-Ratton

BÉNEDIT, Luis F(ernando)
Argentine painter and architect

Born: Buenos Aires, Argentina, 12 July 1937. **Education:** Facultad de Arquitectura, Universidad de Buenos Aires, 1956–63, Diploma Arquitecto 1963; studied popular architecture, Instituto de Cultura Hispanica, Madrid, 1964–65; studied drawing and landscape, Facoltà d'Architecttura, Rome, 1967–68. **Military Service:** Argentine Air Force, Buenos Aires, 1958. **Family:** Married Monica Prebisch in 1963; two daughters and two sons. **Career:** Architect, Estudio Prebisch, Buenos Aires, 1969–71. **Awards:** Premio Ver y Estimar, Buenos Aires, 1962; Premio Rosa Galisteo, *Salón de Santa Fe,* Argentina, 1962; Premio en el Arte, San Isidro, Argentina, 1968; Premio de la Critica, *Salon nacional,* Buenos Aires, 1968. **Agents:** Galeria Bonino, Marcelo T. de Alvear 636, Buenos Aires, Argentina; Spectrum Gallery, Leopoldstraat 10, 2000 Antwerp, Belgium; Galerie Buchholz, Maximilianstrasse 29, Munich 22, West Germany. **Address:** Ingeniero Huergo 1191, Buenos Aires, Argentina.

Individual Exhibitions:

1961 Galeria Lirolay, Buenos Aires
1962 Galeria Lirolay, Buenos Aires
1963 Galeria Rubbers, Buenos Aires
1964 Galeria Lirolay, Buenos Aires
1965 Galerie Europe, Paris
1966 Galerie La Balance, Brussels
1967 Galeria Rubbers, Buenos Aires
1968 Galeria Rubbers, Buenos Aires
1969 Pan American Union, Washington, D.C.
1972 *3-Labyrinthe von Luis F. Benediti ein Versuc uber der Displazierung,* Galerie Buchholz, Munich
1973 C.A.Y.C., Buenos Aires
1975 Spectrum Gallery, Antwerp
 Luis Fernando Benedit: Projects and Labyrinths, Experimental Gallery, London
 Galerie Bonino, Buenos Aires

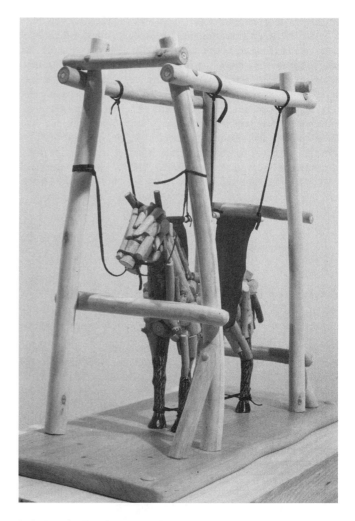

Luis F. Bénedit: *El Primer Caballo (The First Horse),* **1991. Photo courtesy of George Adams Gallery, New York; from the collection of Alice and Arthur Kramer.**

 Projects and Labyrinths, Whitechapel Gallery, London
 Galerie Buchholz, Munich
 Galerie Estudio Actual, Caracas
1976 *Luis F. Benedit: Tentoonstellingen,* Internationaal Cultureel Centrum, Antwerp
 Gabinete del Grabado, Buenos Aires
1977 Galerie Anne van Horenbeeck, Brussels
 Center for Art and Communication, Buenos Aires
1978 Galerie Mathias Fels, Paris
1981 Institute of Contemporary Art, Los Angeles
 Center for Interamerican Relations, New York
 Phyllis Kind Gallery, New York
1982 Striped House Museum, Tokyo
1984 *Pinturas y objectos,* Ruth Benzacar Galería de Arte, Buenos Aires
 Galerie Camino Brent, Lima
1986 Galerie Jaime Conci, Cordoba
1991 John Good Gallery, New York
1992 *Obras 1989–1992,* Ruth Benzacar Galería de Arte, Buenos Aires
1993 Palacio San Miguel, Buenos Aires

1994 Rachel Adler Gallery, New York
1996 Museo Nacional de Bellas Artes, Buenos Aires
1997 "Luis F. Benedit: Work from 1960–1996," National
 Museum of Fine Arts, Buenos Aires

Selected Group Exhibitions:

1963 *Painting of Argentina,* Santiago, Chile
1966 *Salón des jeunes,* Musée d'Art Moderne, Paris
1968 *Materiales, nuevas, técnicas, nuevas expresiónes,* Museo
 de Bellas Artes, Buenos Aires
1972 *Toys by Artists,* Musée des Arts Décoratifs, Paris
 (traveling)
1974 *13 New Artists,* Lobby Gallery, Chicago
1977 *18 Latin American Artists,* Gallery Art Core, Koyto
1979 *Argentine Contemporary Art,* Tokyo Metropolitan Art
 Museum, Japan
1981 *Recent Art of Latin America and Japan,* National
 Museum of Art, Osaka
1983 *Group of 13,* Center of Culture, Buenos Aires
1985 *Buenos Aires through Writers and Architects,* U.I.A. XV
 Congress, Cairo
1987 *Ideas and Images from Argentina,* Museo Alvar Aalto,
 Finland
1988 *Grupo CAYC,* Ruth Benzacar Galería de Arte, Buenos
 Aires
1989 *Painting Degree Zero,* Terne Gallery, New York
1990 *Art for Artists,* Museo de Arte Moderno de Buenos
 Aires
1992 *Art of the Americas,* John Good Gallery, New York
1993 *Latin American Artists of the Twentieth Century,*
 Museum of Modern Art, New York (traveling)
 Art from Latin America, Museum of Contemporary Art,
 Sydney
1994 *Dibujos de Arquitectos,* Museo Nacional de Bellas
 Artes, Buenos Aires
 Galerie Palatina, Buenos Aires
1995 *Fuera del Centro,* Museo de Bellas Artes, Caracas
1996 *Container '96, Art Across Oceans,* Copenhagen
 The Limits of the Photograph, Museo Nacional de
 Bellas Artes, Buenos Aires
 Arte BA, Galerie Ruth Benzacar, Buenos Aires
1997 *Caballos: Political Animals, Azaceta, Bedia, Benedit,
 Elso, Roche,* George Adams Gallery, New York
1998 *Annual Collector's Show,* Arkansas Arts Center, Little
 Rock
1999 *Cantos paralelos,* Jack S. Blanton Museum of Art,
 University of Texas, Austin (traveling)

Collections:

Museo de Arte Moderno, Buenos Aires; Museo de Bellas Artes,
Buenos Aires; Museo de Bellas Artes, La Plata, Argentina; Museo
Rosa Galisteo de Rodrizuez, Santa Fé, Argentina; Museo de Bellas
Artes, Tandil, Argentina; Museum of Modern Art, New York; Museum
of Rhode Island, Providence; Museum of the Organization of Ameri-
can States, Washington, D.C.; Braniff Collection, University of
Texas at Austin.

Publications:

By BÉNEDIT: Book—Prologue in *Bienal de Arte Coltejer,* exhibi-
tion catalog, Medellin, Colombia, 1970. **Film, edited**—*4,000 abejas
en Venezia* by Pedro Roth, Venice, Italy 1970.

On BÉNEDIT: Books—*3-Labyrinthe von Luis F. Bénedit: Ein
Versuch über die Kunst der Displazierung,* exhibition catalog, Munich,
A. M. Battro, 1972; *Luis Fernando Bénedit: Projects and Labyrinths,*
exhibition catalog, London, Whitechapel Art Gallery, 1975; *Luis F.
Bénedit: Tentoonstellingen,* exhibition catalog, Antwerp, Internationaal
Cultureel Centrum, 1976; *Luis Bénedit,* exhibition catalog, edited by
Bridget Johnson, Los Angeles, Los Angeles Institute of Contempo-
rary Art, 1980; *Hacia una crítica de la arquitectura: Con dibujos
originales de los arquitectos Luis Bénedit y Clorindo Testa* by Jorge
Glusberg, Buenos Aires, Espacio Editora, 1980; *Pinturas y objetos,*
exhibition catalog, Buenos Aires, Ruth Bezacar Galería de Arte,
1984; *Luis Fernando Bénedit: Memorias australes desde el Rio de la
Plata hasta el Canal del Beagle,* text by Enrique Molina and Jorge
Glusberg, Milan, New York, and Buenos Aires, Ediciones Philippe
Daverio, 1990; *Luis F. Bénedit,* exhibition catalog, Buenos Aires,
Ruth Benzacar Galería de Arte, 1992; *Art of the Americas, the
Argentine Project* by Jacques Bedel, Sally Baker, and Joseph Azar,
Hudson, New York, Baker & Co., 1992; *Momentos de Bénedit,*
exhibition catalog, Buenos Aires, Américana de Publicaciones, 1993;
Art from Latin America=La cita transcultural, exhibition catalog, by
Nelly Richard, Bernice Murphy, and Néstor García Canclini, Sydney,
Museum of Contemporary Art, 1993; *Luis F. Bénedit en el Museo
Nacional de Bellas Artes: Obras 1960–1996,* exhibition catalog, text
by Jorge Glusberg, Buenos Aires, Museo Nacional de Bellas Artes,
1996; *Cantos paralelos: La parodia plástica en el arte argentino
contemporáneo,* exhibition catalog, by Mari Carmen Ramírez, Marcelo
Eduardo Pacheco, and Andrea Giunta, Austin, Jack S. Blanton
Museum of Art, University of Texas, 1999. **Articles**—"Intra-Func-
tional Modules" by Jorge Glusberg in *Art and Artists* (London), July
1970; "Art of the Americas, the Argentine Project" by Ken Johnson,
in *Art in America,* 80, April 1992, pp. 164–165; "Critics' Choice," in
Art News, 92, summer 1993, pp. 138–147; "Latin Soliloquies" by
Edward Leffingwell, in *Art in America,* 81, December 1993, pp.
72–83; "Recollecting the Essence of Identity: Argentine Artist Luis
Fernando Bénedit Reconstitutes the Past, While Seeking to Define
Himself" by Caleb Bach, in *Americas,* 47(5), 1995; "Homes of
porteños architects," in *Abitare* (Italy), July/August 1995, pp. 178–197;
"Luis F. Bénedit" by Alberto Collazo, in *Art Nexus* (Colombia), 23,
January/March 1997, p. 120.

*

Luis F. Bénedit comments:

I am interested in designing physical spaces that can be inhab-
ited, explored, or observed and where the major evidence is a certain
sort of behavior, individual or collective. I use persons, animals, or
physical phenomena simply as protagonists. My aim is to force
culturally the aesthetic participant of my works. I consider my work
justified if I am able to provoke just one reflection out of the daily
routine about his inner self.

These works are experiences in the field of art, but if their mechanism is operated by a scientist, they can be transformed into real experiments with consequences in the field of aesthetics.

* * *

Luis F. Bénedit shows how every plant constitutes by itself a laboratory. By means of a process of osmosis, their roots obtain the possibility of elaborating the food substances that could be either in the earth or in the inert substances in which they arrive, a nutritive solution. Furthermore, the roots separate out the acids that help out in the dissolution of the minerals existent in the earth or in the plastic material. The roots also serve as deposits of the assimilated products. The stem and the branches act as a system to transport the liquids, and the fibrovasculars work like small channels. It is not until the food substances that have been absorbed by the roots and converted into sap (solutions that circulate inside the plants) get into the leaves that they can be utilized by means of a process called chlorophyllous synthesis, in which by utilizing solar light the plant obtains the energy it needs for its subsistence and reproduction.

In the works of Bénedit the plants find the same environmental conditions that nature offers them, and the artificial nutritive solution is the basis of his experiment. With this system the artist models along with the scientist the conditions the earth offers to vegetables. The botanical experiments of Bénedit, an architect and painter who studied the drawing of landscapes with the Italian master Francesco Fariello, are surely a result of the lessons he was allowed to enjoy from European gardens. The elements of landscape painting are precisely the plants, the birds, water, and the sun, all of which are elements Bénedit utilizes in his investigations: the presentation of natural facts, their representation, the relation between the works of art and animals, their functions, without a scientific explanation but simply showing what is observable.

From *Biotron,* his most important work with animals (an experiment with 4,000 bees), Bénedit went on to present the behavior of plants, varying the parameters and conditioning them in accordance with scientific experiments such as hydroponics. In *Phitotron,* Bénedit put the spectator in front of a natural system of live organisms that developed and modified, allowing in addition a direct observation of the growth and change during a determined length of time.

The proposal is not a direct scientific observation of the phenomenon but rather the development that could grow out of his proposal. Adhering to and developing the ideas of Marcel Duchamp, Bénedit thinks that the observation of these natural phenomena, in terms of the different context in which he proposes them, produces a different effect in the spectator. Every science not only uses models of other sciences but also uses them on distinct levels of abstraction in order to anticipate kinds of happenings or realities. The models serve as objects of representation, as constructions that reproduce phenomena in such a way as to make them more accessible or easier to investigate.

In the case of Bénedit's botanical experiments, the marks of reference elected are the investigations by means of vegetable models, a kind of scientific laboratory where collective behavior in a vegetable community is studied. Bénedit operates as a social anthropologist, and he has elaborated a series of interesting models that, although exhibited as artistic facts, go beyond the purely descriptive or documental study. In August 1968, in the Museum of Fine Arts in Buenos Aires, Bénedit made his first *Animal Habitat,* and in December of that year, in the Rubbers Gallery, he worked painstakingly with cats, lizards, fish, turtles, birds, a hive of bees in full activity, and botanical experiments in fecundation and germination.

The objects of Bénedit's studies are not industrial or folkloric structures, as are the objects of Duchamp. Rather, they are located at a level in which the object nearly tends to disappear due to its being used, something like an object that carries its presence to the limit of perception. He does not establish a cultural dialogue with the spectator but rather liberates activity and existence in the animal and vegetable world in a process in which every possible intellectual intervention is reduced. He puts in the forefront the elements of reality and makes them react among themselves in order to investigate their own expressive charges.

—Jorge Glusberg

BERMÚDEZ, Cundo
Cuban painter and printmaker

Born: Havana, 1914. **Education:** Academy of San Alejandro, Havana; University of Havana, *ca.* 1934–37, Ph.D. in political science and economics 1941; Academia de San Carlos, Mexico, *ca.* 1938; National University, Mexico. **Career:** Organizer, open-air art exhibition, Havana, 1937; worked as a color separator for a magazine. Returned to Cuba, *ca.* 1955; exiled from Cuba, 1960; moved to Puerto Rico; moved to Florida, 1990s. **Awards:** Award, *Gulf Caribbean Art Exhibition,* Houston, 1958; honorable mention, *UNESCO Graphics Biennial,* San Juan, Puerto Rico, 1972; fellowship, Cintas Foundation, 1973; prize ''Homage to Picasso,'' Organization of American States, Washington, D.C., 1973; Excellence award, Facts about Cuban Exiles (FACE), 1996.

Individual Exhibitions:

1975	Metropolitan Museum and Art Center, Coral Gables, Florida
1978	Lowe Art Museum, University of Miami
	Forma Gallery, Coral Gables, Florida
1979	Museum of Modern Art of Latin America, Washington, D.C.
	De Armos Gallery, Miami
	Forma Gallery, Coral Gables, Florida
1980	Forma Gallery, Coral Gables, Florida
1987	*Cundo Bermúdez: Un homenaje,* Cuban Museum of Art and Culture, Miami
1999	*Cuba Nostalgia,* AXA Art Gallery, Miami

Selected Group Exhibitions:

1941	Capitolia Nacional, Havana
1944	Museum of Modern Art, New York
1958	*Gulf Caribbean Art Exhibition,* Houston
1972	*Pintura cubana,* Miami Art Center
1976	Cuban Museum of Art and Culture, Miami
1980	John and Mable Ringling Museum of Art, Sarasota, Florida
1987	*Latin American Drawing,* Art Institute of Chicago
1992	*Lam and His Contemporaries: 1938–1952,* Studio Museum, New York

2000 *La palma espinada,* Instituto Cultural Cubano-
 Americano, Cuba
2001 *Latin Flavors,* Tobey C. Moss Gallery, Los Angeles

Collections:

National Museum of Cuba, Havana; Museum of Modern Art, Miami; Museum of Modern Art of Latin America, Washington, D.C.; Museum of Modern Art, New York.

Publications:

On BERMÚDEZ: Book—*Cundo Bermúdez: Un homenaje,* exhibition catalog, Miami, Cuban Museum of Arts and Culture, 1987.

* * *

Cundo Bermúdez was a major figure in the second generation of Cuban modernists of the early twentieth century, and he has become one of the better known Cuban artists living in exile. A follower of the Grupo Minorista, the first Cuban modernist movement, as well as of the European painters Cezanne, Fernand Léger, Matisse, and Picasso, among others, Bermúdez developed a loosely constructed painterly style suffused with intense color and light. He also adhered to the popular folk themes and nationalistic subjects that characterized the Cuban avant-garde of the early twentieth century.

Bermúdez was born in Havana in 1914 and studied at the University of Havana in the 1930s, graduating in 1941 with degrees in political science and economics. His focus shifted to the visual arts, however, and he briefly attended art classes at the Academy of San Alejandro in Havana. In 1938 he traveled to Mexico City and enrolled at the Academy of San Carlos. There he was drawn to the work of the Mexican muralists, who in the previous decade had developed a public art in which they tried to balance modernist values with popular and revolutionary subjects. Upon his return to Cuba, Bermúdez worked doing color separations for a magazine in Havana.

Following in the steps of the first generation of Cuban modernists, particularly Eduardo Abela, Víctor Manuel, and Amelia Peláez, Bermúdez painted scenes of peasants in lush tropical settings or city dwellers in neocolonial interiors. His paintings are notable for their geometric abstraction as well as their romantic and often humorous content, and their anecdotal charm appealed greatly to the new Cuban middle class. As with the Mexican muralists, Bermúdez's focus in the 1940s and 1950s was on the common man. His work, like that of Abela and Manuel, focused on the lives of Cubans, primarily of poor Spanish and creole descent, who had found a modicum of prosperity in urban life and who yet retained their rural customs and lore. It is said that Bermúdez drew the inspiration for his compositions of voluptuous naked lovers from the sentimental imagery on the labels of cigar boxes. It is more likely that his monumental figural style developed from his observations of Picasso's neoclassical period as well as from the work of the Mexican muralists and the earlier generation of Cuban modernists.

In the 1950s Bermúdez turned away from his earlier narrative subjects and began exploring fantastic and surrealist environments with cryptic images of clocks, musical instruments, and staircases. He also developed mysterious figures of tall women without mouths and with long noses, dark skin, and four-fingered hands and wearing tall Africanized headdresses. The figures are often depicted playing musical instruments or engaged in enigmatic conversations. Bermúdez initially supported the Cuban revolution of 1958, but he became increasingly marginalized in the 1960s. He went into exile in Puerto Rico in 1967, but continued to exhibit internationally.

—H. Rafael Chácon

BERNI, Antonio
Argentine painter

Born: Rosario, 14 May 1905. **Education:** Roldan, Santa Fe Province, 1915, 1917–20; apprenticed in a stained-glass workshop and studied drawing, Catala Centre, Rosario, 1916; studied in Madrid, 1925, and under André Lhote and Orthon Friesz, Grand Chaumiére, Paris (on Santa Fe government scholarship), 1925–30. **Family:** Married 1) Paule Cazenave in 1930 (divorced), one daughter; 2) Nelida Gerino in 1950, one son. **Career:** Painter, Pampas, 1921–24; municipal employee, Rosario, 1931; cofounder, *New Realism* movement in Argentina, 1932–40; worked with David Alfaro Siqueiros, *q.v.,* Buenos Aires, 1934; instructor, Escuela Nacional de Bellas Artes, Buenos Aires, 1935–46; muralist, with Eneas Spillimbergo, Argentine Pavilion, World's Fair, New York, 1939; lived with cotton harvesters and woodcutters and painted popular subjects, Santiago del Estero, 1947–56. **Awards:** Prix, 1925, Premier Prix, 1940, and Grand Prix, 1943, *Salon nacional,* Buenos Aires; Prix d'Honneur, *Salon internacional,* Buenos Aires, 1960; Grand Prix International de la Gravure, *Biennale,* Venice, 1962; Prix de la Commission Culturelle, *Biennale prix intergrafik,* Berlin, 1967. **Died:** 13 October 1981.

Individual Exhibitions:

1921 Witcomb Gallery, Buenos Aires
1922 Witcomb Gallery, Buenos Aires
1923 Witcomb Gallery, Buenos Aires
1928 Salon Nancy, Madrid
1932 Galeria Amigos del Arte, Buenos Aires
1938 Galeria Amigos del Arte, Montevideo
1952 Galeria Viau, Buenos Aires
1954 Teatro del Pueblo, Buenos Aires
1955 Galeria Creuze, Paris
1957 Galeria Witcomb, Buenos Aires
1958 Galeria Serra, Buenos Aires
1961 Galeria Peuser, Buenos Aires
 Galeria Witcomb, Buenos Aires
1963 Galeria du Passeur, Paris
 Museo de Arte Moderno, Buenos Aires
 Miami Museum of Modern Art
1964 Museo de Arte Moderno, Santiago de Chile
 (retrospective)
 Galeria Rubbers, Buenos Aires
1965 Instituto di Tella, Buenos Aires (retrospective; traveled
 to Cordoba and Santa Fe)
1966 Galleria due Mondi, Rome
 New Jersey State Museum, Trenton
1967 Galeria Rubbers, Buenos Aires
1968 Galeria Rubbers, Buenos Aires
1969 Galeria El Taller, Buenos Aires

1970 Galiera Exposhow, Buenos Aires
1971 ARC/Musée d'Art Moderne de la Ville, Paris
 Galeria Rubbers, Buenos Aires
1973 Atelier Jacob, Paris
 Galeria Rubbers, Buenos Aires
1974 Wells Gallery, Ottawa
 Galeria del Mar, Buenos Aires
 Galeria Imagen, Buenos Aires
 Galeria Rubbers, Buenos Aires
1975 Galleria Zunini, Rome
 Galeria Rubbers, Buenos Aires
1976 Galeria Carmen Waugh, Buenos Aires
 Galeria Imagen, Buenos Aires
1977 Museo de Bellas Artes, Caracas, Venezuela
 (retrospective)
 Bonino Gallery, New York
1978 Galeria Bonino, Buenos Aires
 Galeria Imagen, Buenos Aires
1980 Galeria Arte Nuevo, Buenos Aires
 Fundacion San Telmo, Buenos Aires
 Museo de Arte Contemporaneo, Mar del Plata, Argen-
 tina (retrospective)

Selected Group Exhibitions:

1940 *Latin American Exhibition of Fine Arts,* Riverside
 Museum, New York
1942 San Francisco Museum of Art
1955 *Hommage a machado,* Maison de la Pensée, Paris
1962 *Art latino-américain,* Centre Georges Pompidou, Paris
1965 *New Art of Argentina,* Walker Art Center, Minneapolis
 Art latino-américain, Centre Georges Pompidou, Paris
1966 *Art of Latin America since Independence,* Yale Univer-
 sity, New Haven, Connecticut, and University of
 Texas, Austin
1967 *La Nature moderne,* Palais de Glace, Paris
1969 *Art et cybernétique,* Galeria Bonino, Buenos Aires
 (traveled to Caracas, Venezuela)
1972 *Encuentro de artistas plasticas del cono sur,* Santiago
 de Chile

Collections:

Museo Nacional de Bellas Artes, Buenos Aires; Museo de Arte
Moderno, Buenos Aires; Museum of Modern Art, New York; Musée
Municipal, Saint-Denis, France; Museum of Modern Art of Latin
America, Washington, D.C.; University of Texas, Austin.

Publications:

By BERNI: Articles—''Siqueiros et l'art des masses,'' in *Nueva
Revista* (Buenos Aires), 1935; ''Le peintre colonial melchor Perez de
Holquin,'' in *Prensa* (Buenos Aires), 15 February 1942; ''Goribar,
peintre de quito,'' in *Prensa* (Buenos Aires), 31 May 1942; ''La
culture de quito a l'epoque coloniale,'' in *Prensa* (Buenos Aires), 25
April 1943; ''El arte como experiencia,'' in *Continente* (Buenos
Aires), 16 April 1952; ''Persecucion a la inteligencia,'' in *Propositos*
(Buenos Aires), 18 December 1957; ''El arte, su desarrollo, promocion y
mercado,'' in *La Opinion* (Buenos Aires), 9 June 1972.

On BERNI: Books—*Antonio Berni* by Geo-Dorival, Buenos Aires,
1944; *Antonio Berni* by Roger Pla, Buenos Aires, 1945; *Biennale di
Venezia,* exhibition catalog, text by Jorge Romero Brest, Venice,
1962; *Naissance d'un art nouveau* by Michael Ragon, Paris, 1963;
Antonio Berni, exhibition catalog, text by Gérald Gassiot-Talabot,
Buenos Aires, 1965; *Ramona Montiel* by E. Sabato and E. Schoo,
Buenos Aires, 1966; *Panorama de la pintura argentina contemporanea*
by Aldo Pellegrini, Buenos Aires, 1967; *Berni* by Rafael Squirru,
Montevideo, 1968; *Vingt-cinq ans d'art vivant* by Michel Ragon,
1969; *A History of Latin American Art and Architecture* by Leopoldo
Castedo, London, 1969; *Antonio Berni* by Jorge Glusberg, Buenos
Aires, Museo Nacional de Bellas Artes, 1997; *Antonio Berní* by
Fermín Fevre, Buenos Aires, Banco de Inversión y Comercio Exte-
rior, 1999; *Berni: Escritos y papeles privados* by Marcelo Eduardo
Pacheco, Buenos Aires, Temas Grupo Editorial, 1999; *Murales de
Antonio Berní en el cine general San Martín de Avellaneda* by Isaura
Molina, Elisa Radavanovic, and others, Buenos Aires, Academía
Nacional de Bellas Artes, 2000. Articles—''Antonio Berni'' by
Rafael Squirru, in *Journal of Inter-American Studies* (Washington,
D.C.), July 1965; ''Antonio Berni'' by Gérald Gassiot-Talabot, in
Depuis (Brussels), 45(2), 1970; ''Antonio Berni'' by Michel Troche,
in *Opus International* (Paris), May 1971; ''Bernie's Objects from the
1960s'' by Nelly Perazzo, in *Art Nexus* (Colombia), 25, July/Septem-
ber 1997, pp. 60–64.

* * *

Considering that he exhibited his work when he was 14 years old
at the Salón Mary & Cía in his hometown of Rosario, it is not
surprising that the Argentine painter Antonio Berni was regarded as a
prodigy. Three one-man shows followed between 1921 and 1924 in
the Witcomb Gallery. He went to Paris on a scholarship in 1925 and
after a brief cubist period (*Naturaleza muerta con guitarra*) discov-
ered surrealism and the Italian metaphysical movement. He then
began a pictorial period connected to surrealism, which made him the
first Argentine artist to be related to the movement. In Madrid in 1928
he attended a conference given by the writer Filippo Tommaso
Marinetti, who made a significant impression on him. Berni re-
marked, ''What Marinetti said upset me, I did not really understand it,
but it shook me up as if it were an earthquake.''

Berni's work during the period from 1928 to 1932 consisted of a
series of paintings (among them *Napoleón III, El botón amarillo u
objetos n° 1, La uerta abierta,* and *Landrú en el hotel*) and collages
and photo montages (*Susana y el viejo*) in which the associations
between the objects and characters were of a strange nature (*La
muerte en cada esquina*), a typical French surreal and Italian meta-
physical trait. With the 1930 military coup d'état in Argentina, Berni
ended his surrealist period and began working in a style called critical
realism. The political situation led to the creation of Plásticos de
Vanguardia (Avant-Garde Artists), a group from Rosario; the forma-
tion of a society called the Mutualidad Popular de Estudiantes y
Artistas Plásticos (Students and Artists' Popular Mutual Society); a
visit from David Alfaro Siqueiros; and the beginning of a group mural
experience at Natalio Botana's home in Don Torcuato. Even though
Berni did not believe the idea to be viable in Argentina, he agreed that
social art could be manifested in monumental pictorial compositions
on canvas.

It was from this point of view that Berni produced paintings with
political and social contents, large canvases from which the charac-
ters emerged with a clear reference to photographic registers

(*Manifestación; Desocupados o desocupación*, rejected by the jury of the 1935 National Salon; *Chacareros*). Many were taken from journalistic publications of the same period. This kind of production was a realism that seemed to seek the mural's large scale, with the characters' space and the perspective conceived in an opera-like sense of drama. Tension and credibility provided the canvases with an unusual expressive force. This type of painting, with the exception of *Medianoche en el mundo* (1936–37), which was created to support the Spanish Republican cause, came to an end when Berni decided in 1936 to reside permanently in Buenos Aires. During this period Berni also produced work that the critic Jorge López Anaya called melancholy's iconographic representation, in which he applied a more metaphysical sense of realism (*La muchacha del libro, Primeros pasos, Composición,* and *Retrato de mujer de los guantes*).

After Berni's journey across Latin America in 1941–42, his work was inspired by various American cultures in less formal and more spontaneous works (*Domingo en la chacra o el almuerzo, La marcha de los cosecheros, Los algodoneros*). He also painted a series of landscapes that reflected poor districts and suburbs and began using paint more abundantly and in a more textured way, as in *La carnicería o la carne* (1958) and in the series of paintings representing kitchen appliances he exhibited at the H Gallery in 1960 (*La olla azul, La olla y el mortero*).

In 1958 Berni's collages and assemblages with cast-off materials introduced his characters Juanito Laguna and Ramona Montiel. These works were constructed with a variety of materials found in shantytowns, including rusted metal, tin, cardboard, cloth, broken parts of machinery, nails, and shoes. Poverty oozes out in all its drama in the story of the *pibe,* or ''kid'' (Juanito Laguna), and of the humble woman surrendered to prostitution (Ramona Montiel). These are works in which the reality of the materials used fit with the iconography of brutal social exclusion and the painter's exultant poetry. The characters' sagas were created by Berni in a series that journeyed throughout the international art world and were broadened by means of new experiences, new outlooks, and constant language renewal. He exhibited for the last time in April 1981, with *Cristo en el departamento,* among the works shown, a summary of the author's inspiration and excellence.

—Horacio Safons

BEST MAUGARD, Adolfo
Mexican painter

Born: Mexico City, 11 June 1891. **Career:** Lived in Europe, 1900–13; returned to Mexico, 1913; sent by Mexican government to France to copy Mexican artifacts, 1915–19; returned to Mexico, 1921; secretary to the minister of the National Preparatory Schools, 1921–27; participated in the Mexican mural movement, 1920s; experimental filmmaker, ca. 1930s, producing *La mancha de sangre.* Created scenography for ballets, 1918. Promoted a new theory of art education. Participated with *Escuelas al Aire Libre*. **Died:** Athens, 25 August 1964.

Selected Exhibition:

1986 Universidad Nacional Autónoma de Mexico, Mexico City

Publications:

By BEST MAUGARD: Books—*Album de colecciones arqueológicas,* with Franz Boas and Manuel Gamio, Mexico, Imprenta del Museo Nacional de Arqueología, Historia y Etnografía, 1921; *Método de dibujo. Tradición, resurgimiento y evolución del arte mexicano,* Mexico, 1923, as *A Method for Creative Design,* New York and London, Knopf, 1926; *Le corps humain, en schémas simplifiés, para la methode Best-Maugard,* Paris, Hachette, 1930; *Draw Animals!* New York, Knopf, 1931; *The Simplified Human Figure,* New York, Knopf, 1936; *The New Knowledge of the Three Principles of Nature,* Mexico, Instituto de Investigaciones Cientificas de la Exegesis de la Existencia, 1949. **Book, illustrated**—*To and Again* by Walter Rollin Brooks, New York and London, Knopf, 1927.

On BEST MAUGARD: Book—*Una época, dos visiones: Adolfo Best Mougard* (sic), exhibition catalog, text by Rosa María Sánchez Lara, Mexico City, Universidad Nacional Autónoma de Mexico, 1986.

* * *

During the period of the formation of Mexican independence, art learning and teaching was complex. It was especially articulated after the end of the revolution (1920), as it began to create its own artistic, educational, and national programs, with an emphasis on the political elements of the time. The open-air schools and the free workshops for artistic expression were an essential part of the educational program. Art has always been present in Mexico's impressive and varied cultures, but the approach to modernism together with the interest to reinvigorate national art were taking place during Adolfo Best Maugard's younger years. This period was as significant in the social and political arena as it was in the artistic one. Pre-Columbian art, popular culture, and modernism were the focus of the newly generated artistic and educational patterns.

Best Maugard made three important contributions to the Latin American art scene. The first was his research and creation of the book *Método de dibujo. Tradición, resurgimiento y evolución del arte mexicano* (''A Method for Drawing: Tradition, Resurgence, and Evolution of Mexican Art''), published in Mexico in 1923. The second was that he simplified and offered a drawing method that was quickly incorporated into the curricula for primary schools. In 1924 and 1925 this method was modified by the artist Manuel Rodríguez Lozano but was soon thereafter withdrawn from schools and had no further official public use. The third topic—still not valued enough—was the thorough study and interpretation of the ancient designs and the relation that they have with modern art and Mexican popular culture.

Best Maugard's theories were based on the following analysis: pre-Columbian forms can be understood through seven primary uses of a line, which are spiral, circle, half circle, two half circles, wave, zigzag, and straight. In his texts he also compared them with forms found in nature that carry these designs, adding two basic rules for the use of the seven prototypes. ''Never cross lines, or allow one line to interfere with another, but let every line go on its way without touching the others. When using one or more lines, as in border arrangements, they should be drawn in parallel and at equal distance.'' In 1926 Alfred A. Knopf published the English version of Best Maugard's book, *A Method for Creative Design.* It is an accessible reading to all ages—that was how Best Maugard intended it to be. The cover provides valuable information about the origins of

Best Maugard's research, as it notes, "About fifteen years ago the author of this book was engaged by Prof. Franz Boaz to make drawings of archeological discoveries in Mexico." And the following quote from the preface of that same book tells about the intention of the author: "Individual creation should give us a relief from the routine of everyday work, and in this method we will try to make our designs merely for our own amusement. Art is to be considered as a plaything, a refreshing pursuit by which we may find an outlet for our emotions through our own creations."

Best Maugard also embarked on other arenas, as he produced the film *La mancha de sangre* ("The Blood Stain"), created the scenography for two of Ana Pawlowa's ballets in 1918, did oil paintings and drawings, and published some of his other text and research, including "The Simplified Human Figure." As Best Maugard was looking for the essential elements to build up a method to teach and learn the arts of drawing, he simplified the topic with quality and wisdom. At that time he was about the only one convinced that folk and popular Mexican art deserved deep respect; he also was open-minded enough to accept that, because of commercial exchanges, conquest, and the like, elements of other cultures could occasionally appear in local production. Despite the fact that Best Maugard's contributions are no longer a formal component of educational programs, individual artists from different generations are still going back to his theories.

—Graciela Kartofel

BLANES, Juan Manuel
Uruguayan painter

Born: Montevideo, 8 June 1830. **Education:** Studied under painter Antonio Ciseri, Florence, Italy (on Uruguayan government grant), 1861–64. **Family:** Married María Linari de Copello in 1860 (relationship began as an affair in 1854); two sons. **Career:** Typographer for newspapers *El Defensor de la Independencia Americana,* 1945–51, and *La Constitución,* Montevideo, 1851–53; opened an art studio where he specialized in portraits, Montevideo, 1854; instructor, College of the Humanities, Salto, Uruguay, c. 1855. Traveled to Buenos Aires, 1957–59, 1864, 1870; to Chile, 1873; to Italy, 1879, 1890. **Awards:** Second place medal, *Exposición internacional de bellas artes,* Santiago, Chile, 1875; gold medal, *Exposición continental de Buenos Aires,* 1882. **Died:** Pisa, Italy, 15 April 1901.

Individual Exhibitions:

1856 Palacio de San José, Argentina
1941 Teatro Solis, Montevideo
 Museo Nacional de Bellas Artes, Buenos Aires
 (retrospective)

Selected Group Exhibitions:

1875 *Exposición internacional de bellas artes,* Santiago, Chile
1882 *Exposición continental de Buenos Aires*
1900 *Paris Exposition*

Juan Manuel Blanes: *Parana Landscape,* c. 1875. © Christie's Images/Corbis.

1987 *Seis maestros de la pintura uruguaya,* Museo Nacional
 de Bellas Artes, Buenos Aires

Publications:

By MANUEL BLANES: Book—*Memoria sobre el cuadro de los treinta y tres,* n.p., 1878.

On MANUEL BLANES: Books—*Juan Manuel Blanes, su vida y sus cuadros* by José M. Fernández Saldaña, Montevideo, Impresora Uruguaya, 1931; *Exposición de las obras de Juan Manuel Blanes,* exhibition catalog, Montevideo, Impresora Uruguaya, 1941; *La obra pictórica de Juan Manuel Blanes* by Agustín N. Benzano, Montevideo, Impresora Uruguaya, 1942; *Blanes, el hombre, su obra y la época* by Eduardo de Salterain y Herrera, Montevideo, Impresora Uruguaya, 1950; *Proceso de las artes plásticas en el Uruguay* by José P. Argul, Montevideo, Ministerio de Educación y Cultura, 1975; *Blanes en el Palacio San José,* Entre Ríos, Uruguay, Ed. Offset Yusty, 1980, and *Blanes y Urquiza,* Montevideo, Intendencia Municipal de Montevideo, 1980, both by Manuel E. Macchi; *Seis maestros de la pintura uruguaya,* exhibition catalog, Buenos Aires, Museo Nacional de Bellas Artes, 1987; *Historia de la pintura uruguaya de Blanes a Figari,* Montevideo, Ediciones de Banda Oriental, 1993, *El paisaje a través del arte en Uruguay,* Montevideo, Ed. Galería Latina, 1994, and *Blanes, dibujos y bocetos,* Montevideo, Intendencia Municipal de Montevideo, 1995, all by Gabriel Peluffo; *The Art of Juan Manuel Blanes* by Alicia Haber and others, Buenos Aires, Fundación Bunge y Born, 1994; *Las vanguardias artísticas del siglo XX* by Mario de Micheli, Madrid, Alianza Editorial, 1995.

* * *

Juan Manuel Blanes, commonly regarded as Uruguay's first professional painter, is credited with providing an iconography that contributed to his country's nation building. His historical canvases, portraits of Montevideo's bourgeoisie, and poetic images of gauchos chronicle life in the Río de Plata area (spanning what is today

Juan Manuel Blanes: *Twilight.* **Photo courtesy of Museo Municipal, Montevideo, Spain/Index/The Bridgeman Art Library.**

Uruguay and Argentina) following its independence from Spain. Through these works Uruguayans gained a sense of national pride and the symbols of a collective identity.

Blanes seems to have begun painting in the 1850s without much of an artistic education. In 1854 he opened a studio and two years later received his first important commission, a series of eight large-scale oil paintings commemorating Gen. Justo José de Urquiza, a hero of the wars of independence. Historical themes, often battle scenes, became a specialty of Blanes. Unlike most contemporary European history painters, he did not turn to ancient Rome or the Middle Ages for subject matter. Nor did he re-create episodes from his native land's pre-Columbian period, as Mexican painters were doing at the time. Instead, Blanes sought inspiration in Uruguay's immediate past, generating a body of work that resonated with the urgent concerns of the present. *The Oath of the Thirty-three Orientales* (1877), arguably his finest historical painting, celebrates a pivotal event in Uruguay's struggle for independence. Another important canvas, *The Death of General Venancio Flores* (1868), alludes to the political strife that later plunged the Río de Plata region into a prolonged civil war.

Like many Latin American artists eager to perfect their craft, Blanes spent several years in Europe. However, rather than traveling to Paris, home to the most adventurous art making of the time, Blanes settled in Italy, studying under the academic painter Antonio Ciseri in 1861. His choice of destination and teacher indicates a conservative artistic sensibility. Indeed, throughout his career Blanes shunned innovation and experimentation. Although he visited Italy on two later occasions (1879 and 1890), his work evinces a complete

indifference to the formal languages being developed in Europe at the end of the nineteenth century.

Combining a naturalist aesthetic and a somewhat fastidious attention to detail with a moralizing message, Blanes's work is characteristic of the school of academic painting that derived from Jean-Auguste-Dominique Ingres. Blanes tended to draw from real-life models and later resorted to photography as a basis for documentation and as an aesthetic model. A commitment to realism informs even his most allegorical images, although he did not depict overt violence or disagreeable content. His portraits in particular display meticulous draftsmanship, sculptural plasticity, and smooth brushwork executed in a uniform style. In keeping with his academic training, Blanes favored centralized, symmetrical compositions, endowing his sitters with dignified features and a classical sense of repose. With its concentrated stillness, crisp contours, even lighting, harmonious color palette, and intense psychological insight, Blanes's portrait of Carlota Ferreira de Regunaga (1883) best exemplifies his mature style.

Blanes is also widely admired for his idyllic paintings of gauchos, the fiercely independent cowboys that became archetypes of Latin American masculinity and icons of Argentinean and Uruguayan identities. His gauchos are idealized, divested of the wanton behavior of their real-life models and of the poverty and lawlessness that marked their everyday existence. They are imbued instead with a dignity and poise that implicitly posits them as emblems of a nascent nationhood. There is also a nostalgic quality that betrays the fact that, as these paintings were being made, gauchos were quickly vanishing under the dual onslaught of urbanization and industrialization.

While Blanes's images of gauchos—solitary figures depicted against the awe-inspiring vastness of nature—recall the romantic tradition of landscape painting, they also manifest an attraction to colorful detail and picturesque settings characteristic of *costumbrismo* (genre painting). Their execution is looser and more spontaneous than Blanes's customary linear, plastic style, a change that has been attributed to the influence of the Macchiaioli, a nineteenth-century Italian school of painters who espoused a free, vibrant application of paint and a pursuit of atmospheric effects. Although many of these works are not dated, Blanes is believed to have painted a number of them while living in Italy. Their moody, evocative lighting and serenity conveys the timelessness of a classical pastoral.

—Gerard Dapena

BLINDER, Olga
Paraguayan painter

Born: Asunción, 30 December 1921. **Education:** Facultad de Ingeniería, Asunción, 1939–43; Facultad de Filosofía, Asunción, 1962–65, license 1965. **Family:** Married Isaac Schvartzman, one son and one daughter. **Career:** Director, Escolinha de Arte, Asunción, 1959–76, Taller de Expresión Infantil, Asunción, 1976–98, and Instituto de Arte, Asunción, 1992–98. Since 1996 director, Instituto Superior de Arte, Asunción. **Awards:** Gold medal, *II bienal de Córdoba,* Argentina, 1964; premio ''Derechos Humanos,'' concurso de Afiches, Asunción, 1992. **Address:** Mary Lions 222 esq. Rio de Janeiro, Edificio Rio de Janeiro, 2° piso, Dpto. 202, P.O. Box 1402, Paraguay. **E-mail Address:** blinder@quanta.com.py.

Olga Blinder: *Conjunto de detalles de obras.* **Photo courtesy of the artist.**

Individual Exhibitions:

1969	Sala de Santa Catalina del Ateneo, Madrid
	Instituto Catalán de Cultura Hispánica, Barcelona
1990	Casa de Cultura Ecuatoriana Benjamín Carrión, Quito, Ecuador
1992	*Los tiempos en la obra de Olga Blinder,* Centro Cultural de la Ciudad
1998	*Pequeñas pinturas/objeto,* Galería Fábrica, Asunción
1999	*Lo mismo, pero diferente,* Casa Castelví-Manzana de la Rivera, Asunción

Selected Group Exhibitions:

1992	*Voces de ultramar,* Centro Atlántico de Arte Moderno, Cabildo de Gran Canaria (traveling)
	Trienal internacional de grabado, Fredrikstad, Norway
1993	*Presencia del Paraguay,* Galería Latinoamericana, Casa de las Américas, Havana
	The First International Print Bienial, Maastricht, Holland
	Muestra de arte latinoamericano, Visual Arts Center, Hong Kong
1994	*IX bienal iberoamericana de arte,* Palacio de Bellas Artes, Mexico City
	Asunción en Lisboa, Lisbon
1995	*Estampa,* Salón Internacional del Grabado Contemporáneo, Madrid
1996	*X bienal iberoamericana de arte,* Mexico City
	Gravados & gravuras—96, Casa de la Cultura Latinoamericana, Brasilia

Publications:

By BLINDER: Books—*Dibujos Ache-Guajaki,* with José Antonio Gómez-Perasso, Asunción, Centro Paraguayo de Estudios Sociológicos, 1979; *Dibujos Ava-Kwe-Chiripá,* with José Antonio Gómez-Perasso, Asunción, Centro Paraguayo de Estudios Sociológicos, 1980; *Arte actual en el Paraguay, 1900–1980,* with Josefina Plá and Ticio Escobar, Asunción, Ediciones IDAP, 1983; *1956–1985 comentarios: Pintura-dibujo-fotografía-grabado,* Asunción, Ediciones IDAP, 1985.

On BLINDER: Book—*Olga Blinder,* exhibition catalog, text by Josefina Plá, Madrid, Publicaciones Españolas, 1969.

* * *

Painter and printmaker Olga Blinder is considered to be among the first modern artists in Paraguay. She is generally associated with the Paraguayan art movement known as *neofiguración* (''neofiguration''), which was established in the late 1960s. Before that time most of the country's artists had been trained in Europe and were influenced by traditional European art. Neofiguration was started in Asunción, Paraguay, by a group of artists who intended to develop a characteristic style that was separate from the distinctive European figurative style. Blinder, along with other artists including Carlos Columbino, William Riquelme, and Ricardo Migliorisi, has been credited with the establishment of neofiguration.

During the mid-twentieth century many Latin American countries were preoccupied with developing a distinct national style. It is important to note that by mid-century European culture had merged, to a considerable degree, with indigenous traditions. Many of the new Latin American art movements were concerned with including an awareness of historical events that were not traditionally part of the artist's worldview. In other words, Latino artists were introducing a temporal dimension into a traditionally timeless conception of art. The neofiguration movement, which coincided with the development of abstract expressionism in the United States, is a form of expressionist painting that incorporates the human figure to express existential, social, and historical concerns.

Blinder's print *Useless Wait,* for example, refers to the political dictatorship in Paraguay. The print depicts an old woman, hunched over with her hands held in a begging gesture. This print is an example of the way in which Blinder has attempted to express the misery caused by the repressive political regime in her country.

—Christine Miner Minderovic

BONEVARDI, Marcelo
Argentine painter and sculptor

Born: Buenos Aires, 13 May 1929. **Education:** Studied architecture at Universidad Nacional de Córdoba, Argentina. **Family:** Married Elena Merida (died 1976); one daughter and one son. **Career:** Instructor, school of architecture, Universidad Nacional de Córdoba, 1956–58. Traveled to Italy, 1950; lived in the United States, beginning in 1958. **Awards:** Fellowship, John Simon Guggenheim Memorial Foundation, 1959; fellowships, New School for Social Research, 1963–65; Premio de Adquisición, *Certamen 10 artistas argentinos en las Naciones Unidas;* Premio Internacional, *X Bienal de São Paulo,* Brazil. **Died:** 1994.

Individual Exhibitions:

1956	Galería O, Rosario, Argentina
	Museo Dr. Genaro Pérez, Córdoba, Argentina
1957	Galería Antígona, Buenos Aires
1959	Radio Nacional de Córdoba, Argentina
	Amigos del Arte, Rosario, Argentina
	Gallery 4, Detroit
1960	Roland de Aenlle Gallery, New York
	Pan American Union, Washington, D.C.
1961	Latow Gallery, New York
1965	Bonino Gallery, New York
1966	J.L. Gallery, Detroit
1967	Bonino Gallery, New York
1968	Arts Club of Chicago
1969	Bonino Gallery, New York
	Museo Emilio A. Caraffa, Córdoba, Argentina
	Bonino Gallery, Buenos Aires
1970	Bonino Gallery, Buenos Aires
1973	Bonino Gallery, New York
1974	Galería Pecanins, Mexico City
	Musée du Quebec, Canada
1976	Bonino Gallery, Buenos Aires
1977	Galería Imagen, Buenos Aires

1978	Bonino Gallery, New York
	Galería Ponce, Mexico City
1979	Galerie Joillet, Quebec
	Galería del Retiro, Buenos Aires
	Art Contact Gallery, Miami
	Galería San Diego, Bogota
1980	Center for Inter-American Relations, New York
	Galería Ponce, Mexico City
1981	Galería Jaime Conci, Córdoba, Argentina
	Museo de Arte Moderno de Buenos Aires
	Museo de Arte Moderno, Mexico City
1982	Galería del Retiro, Buenos Aires
1983	Arco 83, Madrid
1988	Museo Emilio A. Caraffa, Córdoba, Argentina
	Museo Juan B. Castagnino, Rosario, Argentina
	Centro de Arte Contemporaneo, Córdoba, Argentina
1989	Mary-Anne Martin/Fine Art, New York
1990	Galería Jaime Conci, Harrods, Buenos Aires
	Museo de Bellas Artes, Caracas, Venezuela
1991	Galería Zurbarán, Buenos Aires
	Museo Dr. Genaro Pérez, Córdoba, Argentina
1997	Colección Alvear de Zurbarán, Buenos Aires

Selected Group Exhibitions:

1960	*Thirty Latin American Artists,* Riverside Museum, New York
1964	*Magnet: New York,* Bonino Gallery, New York
1965	*Selections from the Nancy Sayles Day Collection,* Museum of Art, Rhode Island School of Design, Providence
	Museum of Modern Art, New York
1975	*Arte argentino contemporáneo,* Museo de Arte Moderno, Mexico City
1976	*Creadores latinoamericanos contemporáneos: 1950–1976,* Museo de Arte Moderno, Mexico City
1979	*Modern Latin American Paintings,* Center for Inter-American Relations, New York
1987	*Latin American Artists in New York Since 1970,* Archer M. Huntington Art Gallery, University of Texas, Austin
1988	*Latin American Spirit,* Bronx Museum of the Arts, New York
1991	*Arte Buenos Aires '91,* Centro Cultural Recoleta, Buenos Aires

Collections:

Albright-Knox Art Gallery, Buffalo, New York; Brooklyn Museum, New York; Solomon R. Guggenheim Museum, New York; Museum of Modern Art, New York; Philadelphia Museum of Art; Rhode Island School of Design, Providence; University of Southern Illinois, Carbondale; University of Texas, Austin.

Publications:

On BONEVARDI: Books—*Marcelo Bonevardi: Dibujos,* exhibition catalog, by Damián Bayón, Mexico, Galeria Ponce, 1978;

Bonevardi: Exhibition Tour, 1980–1981, exhibition catalog, essay by Dore Ashton, New York, Center for Inter-American Relations, ca. 1980; *Marcelo Bonevardi: Ultimas obras,* Córdoba, Argentina, Subsecretaría de Cultura de la Provincia de Córdoba, 1997.

* * *

Marcelo Bonevardi grew up in Argentina's second most important educational and industrial city, as his family moved to Córdoba when he was six years old. His mother, who had studied in Perugia's Academy of Fine Arts, initiated him in painting, but from that point on he was self-taught in that field. In 1948 he began his architecture studies, and in 1950 he traveled to Italy for a year. In Córdoba he was one of the few nonfigurative painters, using geometry as a means of developing a new aesthetic approach. Toward the 1960s, Buenos Aires was active in the visual arts scene: it was full of international activity, it was home to different styles, Jorge Romero Brest was the leading avant-garde critic, the Instituto di Tella was founded, and the Ver y Estimar association and publications were created. His architectural studies and his trip to Italy provided him with the necessary elements to better understand the universalismo constructivo (''constructive universalism''), the theory created by Joaquín Torres García. Bonevardi did not follow that path directly, but he did not ignore it either. In 1958 he received a Simon Guggenheim grant. That was the beginning of his lifelong relationship with New York, where he lived permanently until the mid-1980s, when he started to return to Córdoba every year for a few months.

Already in New York in the early 1960s, the artist was working on what became his distinctive style: paintings-constructions. They were more than just reliefs: they acknowledged the shaped canvas and the hard edge movement, since there was a personal combination of materials, techniques, and a desire to approach the unknown, not only physical areas but also spiritual dilemmas (which later on incorporated the tragic spell of political torture). He was working thick wooden blocks, carving their corners, and creating uneven surfaces in which he also dug some holes. A sector of each block was then covered with flaglike heavy canvas, which he had previously sewn and then painted. In some instances he would also carve small objects to put into the holes. The shapes would be rectangular (vertical) or square. Parallel to this paintings-constructions, he did drawings and a few print-based pieces. For him drawing was the method through which to express fear as well as denounce torture instruments that had been set up by Argentine and other Latin American military regimes. From pencil to paper he created real and stylized symbols of terror, anonymous portraits of aggression. The drawings predominantly consist of undetermined spaces or cubic architectural forms accompanied by figurative elements—engineering parts and/or tool-like hooks. He was an abstract artist, but he would combine figurative elements when needed. During an unusual and brief period of time in the early 1980s, Bonevardi also painted flowers instead of the iron tool kind of subjects. He would deal with every technical aspect of his work but rarely discussed it. Color had a definitive presence, earthen-acid tones of red, yellow, and blue, but white and black would interest him too. Textural encounters of sanded wood and pigmented sackcloth, articulated shapes of the big blocks with their small unevenness and secret holes, plus stitches and occasional brush strokes were the visual elements that configured Bonevardi's legacy.

Being brought up in a country with a big Catholic influence, the little objects he carved were both religious and ritual elements.

Inextricable mysteries were hidden in the small holes, occasionally looking as altars, empty or with an object, which would have visual and symbolic meanings. Although Buenos Aires and Córdoba were definitely religious cities, references to the sacred were less frequently made there than throughout the rest of the Latin American region. Bonevardi explored the allowed and the forbidden, the opened and the hidden. He was interested in the formal experiments as much as he was concerned with arcane mysteries. The origins and consequences of those situations were always embedded on Bonevardi's work. He was a solitary artist. He passed away without the wide scope of institutional recognition that his artwork deserved.

—Graciela Kartofel

BORDA, Arturo
Bolivian painter

Born: La Paz, 14 October 1883. **Education:** Self-taught artist. **Career:** Civil servant and union organizer. Began by painting portraits of family members, 1899–1920. Painted native Bolivians and local landscapes, then experimented with color abstraction, early 1950s. Cofounder, first workers' federation in Bolivia. **Died:** La Paz, 1953.

Selected Exhibitions:

1996 *Between the Past and the Present: Nationalist Tendencies in Bolivian Art 1925–1950,* Inter-American Development Bank, Washington, D.C.

Exhibited in La Paz fourteen times; in Buenos Aires, 1920 and 1950.

Collection:

Museo Nacional de Arte, La Paz.

Publications:

By BORDA: Book—*El loco,* La Paz, Municipalidad de La Paz, 1966.

On BORDA: Books—*El ateneo de los muertos* by Porfirio Díaz Machicao, La Paz, Buri-Ball, 1956; *El anarquismo de Arturo Borda* by Guillermo Lora, La Paz, Ediciones "Muela del Diablo," 1994; *Between the Past and the Present: Nationalist Tendencies in Bolivian Art 1925–1950,* exhibition catalog, Washington, D.C., Inter-American Development Bank, 1996.

* * *

Arturo Borda was a pioneering Bolivian painter and writer. Self-taught, he began painting in 1899. Much of his life he worked as a civil servant in various departments of the government. He also worked as a union organizer with his brother Hector. Together they founded the first workers' federation in Bolivia.

Borda began by doing eclectic, detailed portraits of family members. He developed his painting style for nearly 20 years as he painted such portraits, including *Hector* (1915), *My Two Sisters* (1918), and *Yatiri* (1918). *Yatiri,* one of the first Bolivian paintings in which an indigenous person appears as the main subject, was integral in the general acceptance of indigenism in Bolivia. These paintings achieved great notoriety and exemplify Borda's technical ability and stylistic versatility. While his portraits of family members show affinities with hyperrealism and surrealism, and while he also depicted native social themes, another of his great interests was the Bolivian landscape and its population.

A growing sense of social commitment led Borda to work within indigenism and portray native Bolivians, often within powerful local landscapes. He was particularly noted for painting Mount Illimani, near La Paz, five times. He exhibited his work in La Paz on 14 occasions and twice in Buenos Aires in 1920 and again in 1950. He spent the years between 1920 and 1940 mostly working as a public servant and an active union member, and for that reason he completed few paintings during this period.

As a relatively educated Bolivian, he demonstrates in his paintings a substantial modern and classical literary element, as seen in his *Critique of "isms"* and the *Triumph of Classical Art* (both 1948). In these works Borda uses specific figures that reject approved artistic ideals. A laughing mother earth rejects indigenism, while the Bolivian Mount Illimani, the Parthenon, the Venus de Milo, Homer, and Pericles reign. This is significant as many other Bolivian artists, like Cecilio Guzmán de Rojas and Avelino Nogales, introduced landscape painting to the Bolivian people and romanticized the life in the Quechua and Aymara villages of Bolivia, which Borda then rejected through his work, preferring a more classical artistic history as opposed to an indigenous version. Borda's work at this time is a critique of other artists' approaches of sympathizing with the indigenous people. Other works convey an emerging critique of society, such as in the 1918 *Filicidio.* Many of the artist's illustrations from this period appear in his autobiography, *El loco* ("The Madman"), which was published posthumously in 1966.

From 1940 he began an intensive new period of painting, focusing more on allegorical scenes with a stronger sense of social criticism, as in *Portrait of My Parents* (1943), which also has surrealistic elements. In 1950–53 Borda experimented with color abstraction, furthering his modern vision for art in Bolivia. His death in 1953 coincided with great change in Bolivia. His death happened on the heels of a national revolution, and much of the art created was as large murals and often continued on Borda's theme of social and political criticism.

—Daniel Lahoda

BORGES, Jacobo
Venezuelan painter

Born: Catia, 1931. **Education:** Escuela de Artes Plásticas y Aplicadas Cristóbal Rojas, Caracas, 1949–51; Salon des Jeunes Artistes of Musée de l'Art Moderne de la Ville de Paris, Paris (on scholarship), 1952–56; Taller Libre de Arte, Caracas, 1957. **Career:** Worked in advertising and as a cartoonist, c. 1950; set and costume designer, *The*

Inkwell, 1965; worked on audiovisual production, *Imagen de Caracas,* 1966–68. Instructor, Salzburg Summer Academy, 1995, 1996, 1998, 1999, and 2000. Cofounder, artist group *Techo de la Ballena,* c. 1960. **Awards:** Honorable mention, *Fourth São Paulo Biennale,* 1957; national prize for painting, Official Salon, Caracas, 1963; Armando Reverón Biennial award for painting, 1965; fellowship, John S. Guggenheim Foundation, New York, 1987.

Individual Exhibitions:

1951 Taller Libre de Arte, Caracas
1952 Museo de Arte Moderno, Paris
1956 Lauro Gallery and Museum of Fine Art, Caracas
1976 *Magic of Realistic Critic,* Museum of Modern Art,
 Mexico City, and Museum of Fine Art, Caracas
 (retrospective)
1978 Galería de Arte Nacional, Caracas
1981 *La comunión: Jacobo Borges,* Galeria de Arte Nacional,
 Caracas
1983 CDS Gallery, New York
1984 *1st Wifredo Lam Biennale,* Havana
1985 CDS Gallery, New York
1987 Staatliche Kunsthalle, Berlin (retrospective)
 60 obras de Jacobo Borges, Museo de Monterrey,
 Mexico (traveling)
 Indianapolis Museum of Art
1988 Museo de Arte Contemporáneo, Caracas (retrospective)
 Galería Arvil, Mexico City
 CDS Gallery, New York
1989 Galería Eva Poll, Berlin
 Art Museum, Florida International University, Miami
1990 Galería der Bruecke, Buenos Aires
1991 Centro Cultural Consolidado, Caracas
1992 Galería Eva Poll, Berlin
 Fondation Vasarely, Aix-en-Provence, France
1993 Museum of Modern Art, New York
 Instituto de América de Santa Fe, Granada
1995 *IX feria internacional del libro de Guadalajara,* Museo
 de las Artes, Universidad de Guadalajara, Mexico
 Galerie im Traklhaus, Salzburg
1996 *Borges and the Communion of Instinct and Spirit,*
 Museo del Oeste Jacobo Borges, Caracas
1999 *Approximations of Paradise Lost,* Galería Freites,
 Caracas

Selected Group Exhibitions:

1958 *XXIX bienal de Venicia,* Venice
 Bienal de São Paulo, Brazil
1964 Solomon R. Guggenheim Museum, New York
 Museo de Arte Moderno, Bogota, Colombia
1965 American Federation of the Arts, Washington, D.C.
 Pan American Union, Washington, D.C.
 The Emergent Decade, Solomon R. Guggenheim
 Museum, New York, and Cornell University, Ithaca,
 New York
1966 *Art of Latin America since Independence,* Yale University, New Haven, Connecticut, and University of
 Texas, Austin

1987 *Art of the Fantastic: Latin America, 1920–1987,*
 Indianapolis Museum of Art (traveling)
1992 Museum of Modern Art, New York

Collections:

CDS Gallery, New York; Solomon R. Guggenheim Museum, New York.

Publications:

By BORGES: Books—*La montaña y su tiempo,* Caracas, Petróleos de Venezuela, 1979; *Two Cities,* Caracas, Museo Jacobo Borges, 1998; *El río,* Caracas, Museo Jacobo Borges, 1998.

On BORGES: Books—*Jacobo,* exhibition catalog, text by Inocente Palacios, Estudio Actual, Caracas, 1972; *Jacobo Borges,* exhibition catalog, text by Juan Calzadilla, Marta Traba, and others, Galeria de Arte Nacional, Caracas, 1976; *Jacobo Borges,* exhibition catalog, text by Roberto Guevara, Museo de Arte Moderno, Mexico City, 1976; *Arte actual de iberoamerica: Jacobo Borges,* exhibition catalog, Instituto de Cultura Hispanica en el Centro Cultural de la Villa de Madrid, Madrid, 1977; *La comunión: Jacobo Borges,* exhibition catalog, text by Maria Elena Ramos, Lucila Anzola Guerra, and Manuel Hernández Serrano, Galeria de Arte Nacional, Caracas, 1981; *Jacobo Borges* by Dore Ashton, Armitano Press, Caracas, 1985; *60 obras de Jacobo Borges,* exhibition catalog, text by Carter Ratcliff, Monterrey, Mexico, Museo de Monterrey, 1988; *Jacobo Borges,* exhibition catalog, Buenos Aires, Der Brücke Ediciones, 1990; *Jacobo Borges: Itinerario de viaje 1987–1990,* exhibition catalog, Caracas, Centro Cultural Consolidado, 1991; *Lo humano en Jacobo Borges,* exhibition catalog, text by Wieland Schmied, Caracas, Consejo Nacional de la Cultura, 1995. **Articles**—''Lectura a la inversa'' by Berta Taracena, in *Hispano,* 16 August 1976, p. 60; ''Borges: Bajo los focos'' by Marta Traba, in *Rev. Nacional de Cultura,* 226, August-September 1976, pp. 129–144; ''Borges the Communicator'' by Roberto Guevara, in *Venezuela Now,* 11(1), 30 December 1976; ''Jacobo Borges'' by Donald Kuspit, in *Artforum* (New York), April 1987; ''Borges and the Communion of Instinct and the Spirit'' by Victor Guédez, in *Art Nexus* (Colombia), 19, January/March 1996, pp. 126–127; ''Venezuela: Jacobo Borges: Without Frontiers,'' in *Art News,* 95, June 1996, pp. 140–141, and ''Jacobo Borges: Freites,'' in *Art News,* 98(9), October 1999, p. 203; both by Russell John Maddicks.

* * *

Jacobo Borges was born and grew up in Catia, a working-class community near Caracas. His working-class roots and the left-wing politics derived from this would be a consistent source of his art between the years 1962 and 1965. Borges studied at the Escuela de Artes Plásticas in Caracas (1949–51), earned his living in advertising, and also drew a comic strip. While an art student, he visited the hermitlike Venezuelan painter Armando Reverón in Macuto. He also met the exiled Cuban novelist Alejo Carpentier and was influenced to a degree by the writer's theory regarding magic realism. In 1951 Borges was expelled from the Escuela de Artes Plásticas after leading a student strike; he then briefly attended the Taller Libre de Arte. Borges lived in Paris from 1952 to 1956 and during this time painted

in a brightly colored, cubist-derived style. Back in Caracas he became associated with two left-wing literary groups: Tabla Redonda and El Techo de la Ballena.

In 1962 Borges was already working in his first mature pictorial style, which consisted of grotesque figures placed in fragmented compositions filled with movement. His application of paint during this period was thick and impastoed, his drawing agitated, and his palette filled with both bright and acidic colors. Among his most significant works at this time are the series *Personajes de la coronación* (1963, loosely based on David's *Coronation of Napoleon Bonaparte*), *Humilde ciudadano* (1964), *Ha comenzado el espectáculo* (1964), and *Altas finanzas* (1965). These highly expressionistic canvases possess grim and even violent overtones. Ultimately, they are fierce critiques of the political situation in Venezuela in the early 1960s. The visual sources for Borges's very personal expressionism can be found in Goya's ''black paintings,'' the drawings of Daumier, the allegories of James Ensor, and the grotesqueries of de Kooning's series *Women*.

In 1965 Borges ceased to paint, and from 1966 to 1968 he collaborated with filmmakers on the audiovisual production *Imagen de Caracas*. In 1971 he returned to painting and drawing and produced four series of graphic work: *Los novios, Los traidores, La farsa*, and *El Che*. Although these works continue to be critical of authority and the status quo of Venezuelan society, formally they are less expressionistic and subtler. Throughout the 1970s Borges's paintings become more dreamlike: landscapes penetrate interior spaces; figures from old, faded photographs appear and disappear within the compositions; and his sense of color becomes more mysterious and monochromatic. The vitriol of the early 1960s gave way to a kind of melancholic, meditative quality, as evident in *Con mi madre niña* (1977), a self-portrait of the middle-aged artist as he encounters his mother as a child.

Throughout the 1980s Borges produced drawings in pastel, many of which are self-portraits. Unlike the self-portraits of his Mexican contemporary José Luis Cuevas, however, Borges avoided narcissism in favor of the comical and the tender, while paying homage to the self-portraits of Rembrandt. During the late 1980s and early 1990s, Borges became occupied with both swimmers and chamber music as the subjects of his art – both were an excuse for hermetic, densely painted compositions that at times evoke Carpentier's notions of magic realism.

Borges's achievement lies in his creation of a politically critical expressionism that was very much a part of the neo-figuration of the early 1960s. His later, more poetic and personal work is indicative of the disillusion of the left-wing politics of the 1960s.

—Alejandro Anreus

BORGES, Norah

Argentine painter

Born: Buenos Aires, 4 March 1901. **Education:** Ecole de Beaux Artes, Geneva, 1915; Academia San Fernando, Madrid, 1920. **Family:** Married Guillermo de Torre in 1928; two sons. **Career:** Moved to Europe, 1914; returned to Buenos Aires, 1921. Illustrator, *French Manometre,* 1923, *Martín Iron,* 1924, and *Prow* magazine. Moved to Spain, 1932–35; lived in Madrid, 1958. Instructor, Biblioteca Nacional,

Buenos Aires, 1959. Traveled to Spain, 1968. Frequently collaborated with her brother, the writer Jorge Luis Borges. **Died:** 20 July 1998.

Individual Exhibitions:

1926	Asociación Amigos del Arte, Buenos Aires
1930	Asociación Wagneriana, Buenos Aires
1934	Museo de Arte Moderno, Madrid
1940	Amigos del Arte, Buenos Aires
1943	Galería Greco, Buenos Aires
1957	Galería Rubbers, Buenos Aires
1958	Galería Bonino, Buenos Aires
1967	Galería Van Riel, Buenos Aires
1972	Galería Rubbers, Buenos Aires
1975	*Pueblos de España,* Librería Española, Instituto de Cultura Hispánica, Buenos Aires
1990	Galería Art House, Buenos Aires
1996	*Norah Borges, casi un siglo de pintura,* Centro Cultural Borges, Buenos Aires

Selected Group Exhibitions:

1925	*Exposición de artistas ibéricos,* Madrid
1927	*Primera exposición permanente de arte argentino,* Salón Florida, Buenos Aires
1929	*Nuevo salón,* Amigos del Arte, Buenos Aires
	Galerie Hodebert, Paris
1930	*Salón de pintores y escultores modernos,* Amigos del Arte, Buenos Aires
1931	*Primer grupo argentino de pintores modernos,* Salón Centenario, Montevideo, Uruguay
1936	*Exposición nacional de bellas artes,* Madrid
	L'Art espagnol contemporain, Jeu de Paume, Paris
1946	*Arte moderno,* Museum of Modern Art, Paris
1995	Galeria Saudan, Buenos Aires

Collection:

Museum of Modern Art, New York.

Publications:

By BORGES: Books, illustrated—*El pez y la manzana* by Ricardo E. Molinari, Buenos Aires, Proa, 1929; *Platero y yo* by Juan Ramón Jiménez, fourth edition, Buenos Aires, Editorial Losada, 1942; *Antología para niños y adolescentes* by Juan Ramón Jiménez, Buenos Aires, Editorial Losada, 1950; *Estrellitas: Poesías para los más pequeños* by Renata Donghi Halperin, Buenos Aires, NEAR, 1956; *Cinco poemas* by Silvina Ocampo, Buenos Aires, Colombo, 1973; *Quintín o memorias de un gorrión* by Manuela Mur, second edition, Buenos Aires, Francisco A. Colombo, 1974; *Autobiografía de Irene* by Silvina Ocampo, Buenos Aires, Ediciones de Arte Gaglianone, 1982; *Breve santoral* by Silvina Ocampo, Buenos Aires, Ediciones de Arte Gaglianone, 1985.

On BORGES: Books—*Norah Borges* by Ramón Gómez de la Serna, Buenos Aires, Editorial Losada, 1945; *Norah* by Jorge Luis Borges,

Milan, Il polifilo, 1977; *Norah Borges: Obra gráfica, 1920–1930* by Patricia Artundo, Buenos Aires, Fondo Nacional de las Artes, 1994; *Norah Borges, casi un siglo de pintura,* exhibition catalog, Buenos Aires, El Centro Cultural Borges, 1996.

* * *

Born in Buenos Aires in 1901, Nora Borges was the vivacious sister of the writer Jorge Luis Borges. The two would work together closely throughout their careers, sharing ideas and influencing each other. Jorge Borges said of his sister, ''In all our games I was the straggler, the timid one. She raised the roof, climbed to trees and hills.'' Borges had a European education after her father moved the family to Geneva for health reasons. She stayed in Europe until both she and her brother returned to Buenos Aires in 1921.

Believing that painting had been ''invented to give joy to the painter and the spectator,'' Borges also produced artwork that reflected her involvement with surrealism. She illustrated magazines, including *Prow* and *Martín Iron,* with engravings. She designed the cover for the first edition of *Fervor of Buenos Aires* (1923). She married literary critic Guillermo de Torre in 1928 and with him was part of the literary circle in Buenos Aires. She was also heavily involved with the ultraísta movement, opening up her home for meetings and social gatherings.

—Sally Cobau

BOTELLO (BARROS), Angel
American painter and sculptor

Born: Villa de Gangas de Morrazo, Galicia, Spain, 20 June 1913. **Education:** Ecole des Beaux Arts, France, 1930–34; Academia de Bellas Artes, San Fernando, Spain, 1935–36. **Family:** Married Christiane. **Career:** Exiled from Spain after the Civil War, 1936. Traveled to Haiti, Puerto Rico, and the Dominican Republic, late 1930s and 1940s. Settled in Puerto Rico, 1953. Founder, Galeria Botello, San Juan, Puerto Rico. **Died:** Puerto Rico, 1986.

Selected Exhibitions:

1972	*Exxon Exhibition,* Pratt Institute, New York
1977	Museo de Ponce, Puerto Rico
1980	Galeria Botello, San Juan, Puerto Rico
	Nahan Galleries Art Expo, Washington, D.C. and New York
1987	La Galerie des Serbes Cannes, France
	Sotheby's, New York
	Latin Art Exposition, Riverside Museum

Collections:

Museo de Arte de Puerto Rico, San Juan; Galeria Botello, Hato Rey, Puerto Rico; Hakone Art Museum, Japan; Kennedy Center, Washington, D.C.; Fresno Art Institute, California; Dayton Art Institute, Ohio; George Washington University, Washington, D.C.; Hispanic Museum, New York.

Publications:

On BOTELLO: Books—*Botello: Paintings and Sculptures,* exhibition catalog, San Juan, Puerto Rico, Galeria Botello, 1980; *Botello,* exhibition catalog, by José del Castillo, San Juan, Puerto Rico, Galeria Botello, 1988; *Angel Botello en la historia del exilio gallego* by Matilde Albert Robatto, La Coruña, Ediciós do Castro, 1995.

* * *

Although Angel Botello was born in Spain and lived and was educated in France, his best-known works reflect the influence of living in the Caribbean for many years. Botello's work is largely figurative, and female figures are prominent in his art. His paintings and color lithographs, if one were to compare his style to a major twentieth-century influence, resemble those from Pablo Picasso's cubist period; however, Botello's style is unique, and comparisons between Botello and any other artist merely reveal similar influences. For example, Picasso's primitive faces are reminiscent of African art, while Botello's evoke the African heritage of Haiti. Comparing the human faces in Botello's *Girl with a Dream* and *Nino con Caballo* (both 1981) with one of his works created 20 years earlier, *Woman with Flowers* (1960), the viewer can appreciate the stylistic changes, but the form is essentially the same—flat and masklike. His lithograph *Nino Peinandose* (1981) is clearly cubist in form. In his figurative sculptures, such as *Caballos* and *Mujer Pensanda,* one can detect the elongated sticklike quality of Alberto Giacometti's figures mixed with the sleekness of a Constantin Brancusi figure. Other figures clearly show the influence of Henry Moore.

Critics have described Botello's early works as academic, most likely because Botello studied art at L'Ecole des Beaux Arts in Paris, where he graduated with honors. While Botello came from a small town in northwestern Spain and studied academic art in Paris, he cannot have remained unaffected by the cultural and artistic effervescence in the French capital in the 1930s. Paris was the artistic capital of the world, and Botello absorbed a variety of avant-garde styles, particularly cubism. In 1935 Botello returned to Spain and studied at the Academia de Bellas Artes de San Fernando in Madrid. His training in Madrid in 1936 was interrupted by the Spanish Civil War, and Botello, along with his family, moved back to France and lived in a refugee camp.

Shortly thereafter, Botello left Europe and traveled to the Caribbean, where he spent the rest of his life, and created his best-known work. After arriving in the Caribbean, Botello and his family settled in the Dominican Republic, where he was warmly received by the artistic community. Many of his paintings that were created at that time were part of the Latin Art Exposition at the Riverside Museum in 1940. In 1943 the Botello family spent almost a year in Cuba and then returned to Santo Domingo. In Santo Domingo a foreign government official took notice of Botello's work and convinced him to show his art in Haiti. It should be noted that by the early 1940s Haiti had developed a large and strong artistic community. Botello met his wife, Christiane, in Haiti and lived there for about 10 years. In the early 1950s they moved to Puerto Rico, where the first Galleria Botello opened in 1953. Botello lived in Puerto Rico until his death in 1986.

Botello's work has often been compared to Paul Gaugin's because both artists' work underwent a profound transformation after they moved to a tropical region. Botello, who regarded the Caribbean as his spiritual home, explained once that the light and brilliant colors of the surroundings opened a whole new artistic and intellectual world

for him; not only does his choice of color and form reflect pre-Columbian traditions but his subjects, themes, and symbolism are steeped in African-Caribbean folklore and history.

—Christine Miner Minderovic

BOTERO, Fernando
Colombian painter and sculptor

Born: Fernando Botero Angulo, Medellin, Antioquia, 19 April 1932. **Education:** Liceo de la Universidad de Antioquia, Medellin, 1950, B.A.; Real Academia de Bellas Artes de San Fernando and Museo del Prado, Madrid, Spain, 1952–53; Accademia San Marco and Università degli Studi, Florence, Italy, 1953–54. **Family:** Married 1) Gloria Zea in 1955 (divorced 1960), two sons and one daughter; 2) Cecilia Zambrano in 1964 (divorced 1975), one son (deceased). **Career:** Illustrator, Sunday Literary Supplement, *El Colombiano*, Medellin, 1948–51; set designer, Compania Lope de Vega touring Spanish theatre group, 1950; professor of painting, Escuela de Bellas Artes, Universidad Nacional, Bogotá, 1958–60. Since 1951 independent artist. Lived in Madrid, 1952–53; traveled in Paris during summers, 1953–54; lived and painted in Florence, 1953–54; returned to Bogotá, 1955; lived in Mexico City, 1956–57; visited New York and Washington, D.C., 1957, 1958; lived in Bogotá, 1957–60; fresco painter, Banco Central Hipotecario, Medellin, 1960; lived in New York, 1961–73; established a studio in Bogotá, 1971; established a studio in Paris, 1972; moved to Paris, 1973; focused almost entirely on sculpture, 1976–77; established Sala Pedro Botero at Museo de Zea, Medellin, 1977. **Awards:** Second prize, *IX salon anual de artistas colombianos*, Biblioteca Nacional, Bogotá, 1952; second prize, *X salon anual de artistas colombianos*, Museo Nacional, Bogotá, 1957; first prize, *XI salon anual de artistas colombianos*, Museo Nacional, Bogotá, 1958; Colombian Section award, *Guggenheim International Award Exhibition*, New York, 1960; first prize in painting, *Primer salon intercolombianos artistas jovenes*, Museo de arte Moderne, Bogotá, 1964. Andrés Bello award, President of Venezuela, 1976; Cruz de Boyacá, Government of Antioquia, for service to Colombia, 1977. **Addresses:** 900 Park Avenue, #22A, New York, New York 10021–0231, U.S.A.; c/o Nohra Haime Gallery, 41 East 57th Street, Floor 6, New York, New York 10022–1908, U.S.A.

Individual Exhibitions:

1951	Galerias de Arte Foto-Estudio Leo Matiz, Bogotá
1952	Galerias de Arte Foto-Estudio Leo Matiz, Bogotá
1955	Biblioteca Nacional, Bogotá (traveled to Club de Professionales, Medellin)
1957	*Fernando Botero of Colombia,* Pan American Union, Washington, D.C.
	Galeria Antonio Souza, Mexico City
	Gres Gallery, Washington, D.C.
1958	*Oleos,* Galeria Antonio Souza, Mexico City
	Recent Oils, Watercolors, Drawings, Gres Gallery, Washington, D.C.
1959	*Obras recientes,* Biblioteca Nacional, Bogotá
1960	Gres Gallery, Washington, D.C.
1961	Galeria de Arte El Callejón, Bogotá

1962	Gres Gallery, Chicago
	The Contemporaries, New York
1964	*Obras recientes,* Museo de Arte Moderno, Bogotá
	Bosquejos realidades, Galeria Arte Moderno, Bogotá
1965	*Recent Works,* Zora Gallery, Los Angeles
1966	Staatliche Kunsthalle, Baden-Baden, West Germany (traveled to Galerie Buchholz, Munich)
	Ölbilder and Zeichnungen, Galerie Brusberg, Hannover, Germany
	Recent Works, Milwaukee Art Center, Wisconsin
1968	Galeria Juana Mordó, Madrid
	Paintings by Fernando Botero and Leopold Richter, Walter Engel Gallery, Toronto
	Galerie Buchholz, Munich
1969	*Peintures, Pastels, Fusains,* Galerie Claude Bernard, Paris
	Center for Inter-American Relations, New York
1970	*Boreo/Cuevas: Paintings, Drawings,* Walter Engel Gallery, Toronto
	Hanover Gallery, London
	Staatliche Kunsthalle, Baden-Baden, West Germany
1971	*Botero/Lindner/Wesselmann: Ausgewähte Bilder, Zeichnungern und Grafik,* Galerie Brusberg, Hannover, Germany
1972	*Bleisftzeichnungen, Sepiazeichnungen, Aquarelle,* Galerie Buchholz, Munich
	Marlborough Gallery, New York
	Pastels, Fusains, Sanguines, Galerie Claude Bernard, Paris
1973	Marlborough Galleria d'Arte, Rome
	Retrospectiva 1948–1972, Colegio San Carlos, Bogotá
	Botero/Akawie, Pyramid Galleries, Washington, D.C.
1974	*Aquarelle und Zeichnungen,* Galerie Brusberg, Hannover, Germany
	Sala de Arte, Biblioteca Publica Piloto, Medellin
	Marlborough Galerie, Zurich
1975	Museum Boymans-van Beuningen, Rotterdam
	Galeria Adlec Castillo, Caracas
	Marlborough Gallery, New York (traveled to Marlborough Godard, Toronto, and Marlborough Godard, Montreal, 1976)
1976	*Aquarelles et Dessins,* Galerie Claude Bernard, Paris
	Museo de Arte Contemporaneo, Caracas
	Pyramid Galleries, Washington, D.C.
	Arte Independencia, La Galeria de Colombia, Bogotá
1977	*Las sala Pedro, Botero,* Museo de Arte de Medellin (permanent installation)
	Sculptures, FIAC, Grand Palais, Paris
1978	*Das Plastische Werk,* Galerie Brusberg, Hannover (traveled to Skulpturenmuseum der Stadt Marl, West Germany)
1979	Galerie Calud Bernard, Paris
	Marlborough Gallery, New York
	Galerie Isy Brachot, Knokke, Belgium
	Musée d'Ixelles, Brussels (traveled to Konsthall, Lund, Sweden, and Sonja Henie-Neils Onstad Foundations, Oslo)
	Hirshhorn Museum and Sculpture Garden, Smithsonian Institution, Washington, D.C. (retrospective; traveled to Art Museum of South Texas, Corpus Christi, 1980)

Fernando Botero: *Theatre Characters,* 1977. Photo courtesy of Private Collection/James Goodman Gallery, New York, USA/Bridgeman Art Library. © Fernando Botero, courtesy, Marlborough Gallery, New York.

1980	*Aquarelles, Dessins, Sculptures,* Galerie Beyeler, Basle		Benjamin Mangel Gallery, Philadelphia
1981	Marlborough Gallery, New York		Galeria Quintana, Bogotá
	Betsy Rosenfield Gallery, Chicago	1983	Galerie Beyeler, Basle
1982	*Sculpture and Drawings,* Hokin Gallery, Chicago		Thomas Segal Gallery, Boston
	Hooks-Epstein Gallery, Houston		Palazzo Grassi, Venice

Fernando Botero: *Still Life with Fruit Juice,* 1983. Photo courtesy of Private Collection/James Goodman Gallery, New York, USA/Bridgeman Art Library. © Fernando Botero, courtesy, Marlborough Gallery, New York.

Marlborough Gallery, London
Fondation Veranneman, Kruishoutem, Belgium
1984 Sala de Escultura Fernando Botero (permanent installation), 1984
Proctor Institute, Utica, New York
Adler Gallery, Los Angeles
Everhart Museum, Scranton, Pennsylvania
Cornell University, Ithaca, New York
Purdue University, Lafayette, Indiana
Botero, International Art Expo, Chicago
1985 Marlborough Gallery, New York
National Museum, Bogotá
Museo de Ponce, Puerto Rico
1986 Tokyo Art Gallery, Shibuya, Japan
Museum of Contemporary Art, Caracas
Kunsthalle der Hypo-Kulturstiftung, Munich
Kunsthalle, Bremen, West Germany
Hokkaido Museum of Modern Art, Japan
Daimaru Museum, Osaka
City Art Museum, Niigata, Japan
1990 Foundation Pierre Gianadda, Martigny, Switzerland (retrospective)
1991 Marlborough Fine Art, Tokyo
Forte di Belvedere, Florence
1992 Botero aux Champs-Elysees, Paris
Pallazo delle Fesposizioni, Rome

Kunst Haus Wien, Vienna
Galeries Nationales du Grand Palais, Paris
1992–93 Palais des Papes, Avignon
Pushkin Museum, Moscow
Hermitage Museum, St. Petersburg
1993 Botero on Park Avenue, New York
1994 Grant Park, Chicago
Museo Nacional de Bellas Artes, Buenos Aires
Paseo de Recoletos, Madrid

Selected Group Exhibitions:

1948 *Exposición de pintores antioqueos,* Instituto de Bellas Artes, Medellin
1959 *Botero/Grau/Obregón/Ramirez/Villegas/Wiedemann,* Galeria de Arte Callejón, Bogotá
Arte de Colombia, Galleria Nazionale d'Arte Moderna, Rome (traveled to Liljevalchs Konsthall, Stockholm; Rautenstrauch-Joest-Museum, Cologne; Staatliche Kunsthalle, Baden-Baden, West Germany; Sociedad Espaola de Amigos del Arte, Madrid)
1965 *The Emergent Decade: Latin American Painting,* Solomon R. Guggenheim Museum, New York (traveling)
Contemporary Art of Latin America, Institute of Contemporary Arts, Washington, D.C.

73

1966 *Art of Latin America since Independence,* Yale University, New Haven, Connecticut, and University of Texas, Austin

1967 *Latin American Art: 1931–1966,* Museum of Modern Art, New York

1970 *Latin American Paintings and Drawings from the Collection of John and Barbara Duncan,* Center for Inter-American Relations, New York (traveling)

1971 *12 Artists from Latin America,* Ringling Museum of Art, Sarasota, Florida

1977 *Recent Latin American Drawings 1969–1976: Lines of Vision,* Center for Inter-American Relations, New York (traveling)

Collections:

Museo de Zea, Medellin; Museo de Arte Moderno, Bogotá; Museo de Bellas Artes, Santiago; Museum of Modern Art, New York; Solomon R. Guggenheim Museum, New York; New York University; Baltimore Museum of Art, Maryland; Neue Pinakothek, Munich; Museo d'Arte Moderno del Vaticano, Rome; Museo de Arte Contemporaneo, Madrid; Walrat-Richarts Museum, Cologne; Hirshhorn Museum and Sculpture Garden, Washington, D.C.; National Museum, Tokyo; Milwaukee Art Center, Wisconsin; Museo de Arte de Ponce, Puerto Rico; Pennsylvania State University, State College; Rhode Island School of Design, Providence; University of Texas, Austin.

Publications:

By BOTERO: Books—*Botero,* portfolio of 20 black-and-white reproductions, with an introduction by Walter Engel, Bogotá, 1952; *Fernando Botero: Paintings and Drawings,* edited by Werner Spies, Munich, Prestel, 1993; *Fernando Botero,* Barcelona, Polígrafa, 1996; *Botero: New Works on Canvas,* with Ana Maria Escallon, translated by Asa Zatz, New York, Rizzoli, 1997; *Botero: Drawings,* with Benjamín Villegas Jiménez and Marc Fumaroli, Bogotá, Villegas Editores, 1999; *Botero Sculptures,* with A. Lambert, Jean Clarence Lambert, and Jimene Villegas, Bogotá, Villegas Editores, 1999. **Articles—**''Picasso y la inconformidad en el arte,'' in *El Colombiano* (Medellin), 17 July 1949; ''Anatomia de una locura,'' in *El Colombiano* (Medellin), 7 August 1949.

On BOTERO: Books—*Fernando Botero,* exhibition catalog, Bogotá, 1951; *Botero,* exhibition catalog, Bogotá, 1952; *Botero* by Walter Engel, Bogotá, 1952; *Gulf-Caribbean Art Exhibition,* exhibition catalog, with foreword by Lee Malone and an introduction by José Gómez-Sicre, Houston, 1956; *Fernando Botero of Colombia,* exhibition catalog, Washington, D.C., 1957; *Fernando Botero; Recent Oils, Watercolors, Drawings,* exhibition catalog, Washington, D.C., 1958; *Botero: Obras recientes,* exhibition catalog, Bogotá, 1959; *Botero,* exhibition catalog, Chicago, 1962; *Botero; Recent Works,* exhibition catalog, Los Angeles, 1965; *Fernando Botero,* exhibition catalog, with text by Daniel Robbins, Baden-Baden, West Germany, 1966; *Fernando Botero: Recent Works,* exhibition catalog, with a foreword by Tracy Atkinson, Milwaukee, 1966; *The Emergent Decade: Latin American Painters and Painting in the 1960's,* Ithaca, New York, 1966; *Paintings by Fernando Botero and Leopold Richter,* exhibition catalog, Toronto, 1968; *Fernando Botero,* exhibition catalog, with foreword by Stanton Catlin, and essay by Klaus Gallwitz, New York,

1969; *Botero: Peintures, Pastels, Fusains,* exhibition catalog, with text by Fernando Arrabal, Paris, 1969; *Botero* by Klaus Gallwitz, Munich, 1970; *Fernando Botero,* exhibition catalog, by Wibke von Bonin, New York, 1972; *Fernando Botero,* exhibition catalog, by Titia Berlage, Rotterdam, 1975; *Botero 1980,* exhibition catalog, introduction by Carter Radcliff, New York, Marlborough Gallery, 1980; *Botero: Philosophy of the Creative Act* by Marcel Paquet, London, Cromwell, 1992; *Fernando Botero: Monograph & Catalogue Raisonne Paintings 1975–1990* by Edward J. Sullivan and Jean-Marie Tasset, Lausanne, Acatos, 2000; *Botero,* exhibition catalog, by Paola Gribaudo, Milan, Electra, 2000; *Fernando Botero,* Parkstone Press, 2001. **Articles—**''An Interview with Fernando Botero'' by Ingrid Sischy, in *Artforum International,* 23, May 1985, pp. 72–74; ''A Gift for Being Different'' by Margaret Moorman, in *Art News,* 85, February 1986, pp. 71–79; ''Boteros Kolumbien'' by Erwin Leiser, in *Du* (Switzerland), 7, 1986, pp. 14–49; ''Botero's Tucurinca: The Artist's House in the Colombian Countryside'' by Michael Peppiatt, in *Architectural Digest,* 45, January 1988, pp. 134–139; ''Sculpture News: Autumn and Botero in New York'' by Susan Hirsch, in *Sculpture Review,* 42(3), 1993, p. 32; ''Botero's Corpulent Creations on a Global Roll'' by Jason Edward Kaufman, in *Art Newspaper,* 5, May 1994, p. 10; ''Fernando Botero'' by Annalisa Bellerio, in *FMR,* 99, August/September 1999, p. 11; ''Botero Donates His Collection to Colombia'' by Celia Sredni de Birbragher, in *Art Nexus,* 34, November 1999/January 2000, pp. 64–67; ''Botero's Peace Offering'' by Cathleen Farrell, in *Art News,* 99(3), March 2000, p. 74.

* * *

Fernando Botero emerged as a painter in the 1950s, an era when a younger generation of artists in many parts of Latin America–among them, José Luis Cuevas and Alberto Gironella in Mexico, Jacobo Borges in Venezuela, and members of the Otra Figuración group in Argentina–were pursuing new, expressionistic forms of figurative painting meant to reflect the postwar, urban condition in their developing societies. In Colombia, Botero, along with his compatriot Enrique Grau, was a leader in this move toward figuration. Since that time Botero has become internationally known for his highly distinctive figurative style of painting–sensually rotund subjects that belie the artist's inventive reworkings of art historical themes and his ability at astute social commentary.

Botero has been a serious student of the history of Western art, and throughout his career he has creatively mined subject matter and artistic styles drawn from various periods. Within his native Colombia he has been inspired by colonial religious painting and sculpture as well as by popular art forms. A period of study and travel in Europe in the 1950s provided him with firsthand experience of the art of the Italian Renaissance, and he was especially attracted to the volumetric representations of horses and people by Paolo Uccello; he also admired paintings by Piero della Francesca, Andrea Mantegna, Diego Velázquez, and Peter Paul Rubens. In addition, he lived in New York City in the 1960s, where he met such painters as Willem de Kooning, Mark Rothko, and Red Grooms. By this time he had already begun the strategy of appropriating from art history, an approach that he shared with American and European pop artists of the period. As early as 1959, Botero had created his own interpretation of the Mona Lisa, *Mona Lisa at Age Twelve* (in the Museum of Modern Art, New York); since that time he has also produced works in homage to Mantegna, Jan van Eyck, Cézanne, and other European masters.

La familia presidencial (1967), an oil on canvas in New York's Museum of Modern Art, characteristically demonstrates Botero's use of art history. Modeled after Goya's painting *Charles IV and His Family,* it shows an extended family comprised of the president, his spouse, his mother, a child, a military official, and a cleric, pompously posing as for an official portrait. As in Goya's composition, Botero includes a self-portrait in the background, at work on a large canvas. All of the figures seem to be equally vapid in character, and the work richly satirizes Latin American officialdom at midcentury, with bloated figures representing excess wealth, power, and self-importance.

Guerra (1973), an oil on canvas in a private collection, is emblematic of Botero's interest in using his pictorial language to comment upon Latin American social realities. A heaving mass of bloodied, mostly nude corpses forms a large semicircle that fills most of the canvas. Here, in a biting commentary on the corruption and violence common in Latin America in the 1970s, generals, prostitutes, businessmen, priests, and children have all met the same ignominious fate. *Guerra* as well as paintings of subsequent decades focusing on military subjects and political themes also evoke the artist's own experience of growing up in Colombia during the 1940s, a decade now known in that country as *la violencia* because of the civil unrest and police brutality that defined those years.

Early in Botero's career, his painting was more expressionistic, and brush strokes were visible upon the canvas. By the 1960s brushwork and textural variations had become essentially invisible, while smooth forms and distorted proportions were emphasized. Commenting upon his peculiar mode of interpreting people and things, Botero once stated, ''When I inflate things I enter a subconscious world rich in folk images. For me, rotundity in art is linked to pleasure. Basically, it's a matter of rationalizing natural impulses.'' Indeed, whether portraying sumptuous nudes or still lifes bursting with plump forms, Botero is frank in his intimations of sensual enjoyments in his oeuvre.

Botero's subjects have included personages ranging from prostitutes to bourgeois couples, animals, and the bullfight. The artist, who studied bullfighting as an adolescent, has remained an ardent follower of the spectacle. During the mid- and late 1980s he focused on this theme in paintings and works on paper, producing scenes of bullrings, bullfighters, and rituals associated with the bullfighting tradition. In *Matador* (1985), an oil on canvas, Botero shows a young, masculine bullfighter ready to meet the bull. Near his head hovers a miniature skeleton brandishing a sword–an angel of death–suggesting the fate soon to befall this tragic character.

In 1992 Botero produced a series of enormous bronze sculptures depicting human and animal forms. They were placed on display along the Champs-Élysées in Paris; subsequent showings were held in New York, Chicago, and Buenos Aires. These playful but impressively monumental works demonstrate Botero's capacity to deploy his signature style to new ends.

—Elizabeth Ferrer

BRAVO, Claudio

Chilean painter

Born: Valparaíso, 8 November 1936. **Education:** Colegio San Ignacio, Santiago, 1945; studied with Miguel Venegas, 1948–49. **Career:** Professional ballet dancer, Santiago, *ca.* 1954. Lived in Spain, 1961–72. Since 1972 has lived in Tangier, Morocco. **Award:** Gold medal of honor, Casita Maria Settlement House, New York, 1996. **Agents:** Galeria Vandres, Don Ramon de la Cruz 26, Madrid 1, Spain; Marlborough Fine Art, 40 West 57th Street, New York, New York 10019, U.S.A. **Address:** 49 rue du Village, Marshan, Tangier, Morocco.

Individual Exhibitions:

1954	Salón Trece, Santiago
1970	Gallery Staempfli, New York
1971	Galeria Egam, Madrid
1972	Gallery Staempfli, New York
	Galeria Vandres, Madrid
1974	Galería Vandrés, Madrid
	Staempfli Gallery, New York
1976	Galerie Claude Bernard, Paris
1980	F.I.A.C. Paris
1981	Marlborough Gallery, New York
1982	*Claudio Bravo: Pinturas y dibujos,* Museo de Monterrey, Mexico
	Marlborough Gallery, New York
1983	*Claudio Bravo: Recent Paintings and Drawings,* Marlborough Fine Art, London
1984	Marlborough Gallery, New York
	Galeria Quintana, Bogota, Colombia
1985	*Claudio Bravo: Pastels 1985, Still Lifes,* Marlborough-Gerson Gallery, New York
1987	*Claudio Bravo, Painter and Draftsman,* Elvehjem Museum of Art, University of Wisconsin, Madison (retrospective; traveled to Meadows Museum, Southern Methodist University and Duke University Museum of Art, Duke University)
1989	*Claudio Bravo: Recent Paintings and Pastels,* Marlborough Gallery, New York
1991	*Claudio Bravo: Works on Paper,* Marlborough Gallery, New York
1992	Marlborough Gallery, New York
1994	Museo Nacional de Bellas Artes, Santiago (retrospective)
1998	Marlborough Gallery, New York
	Wrapped Packages, Bass Museum, Miami Beach
1999	Marlborough Gallery, New York
2000	Marlborough Gallery, New York

Selected Group Exhibitions:

1972	*Documenta 5,* Kassel, West Germany
	Relativerend realisme, Stedelijk Van Abbemuseum, Eindhoven, Netherlands
1973	*Artistes hyper-realistes,* Galerie des Quatre Mouvements, Paris
1974	*Ars 74: Alternatives of Realism,* Fine Arts Academy of Finland, Helsinki
1976	*Modern Portraits: The Self and Others,* Wildenstein Galleries, New York
1981	*International Contemporary Art,* Museo Rufino Tamayo, Mexico City
1983	*48th Carnegie International,* Carnegie Institute, Pittsburgh

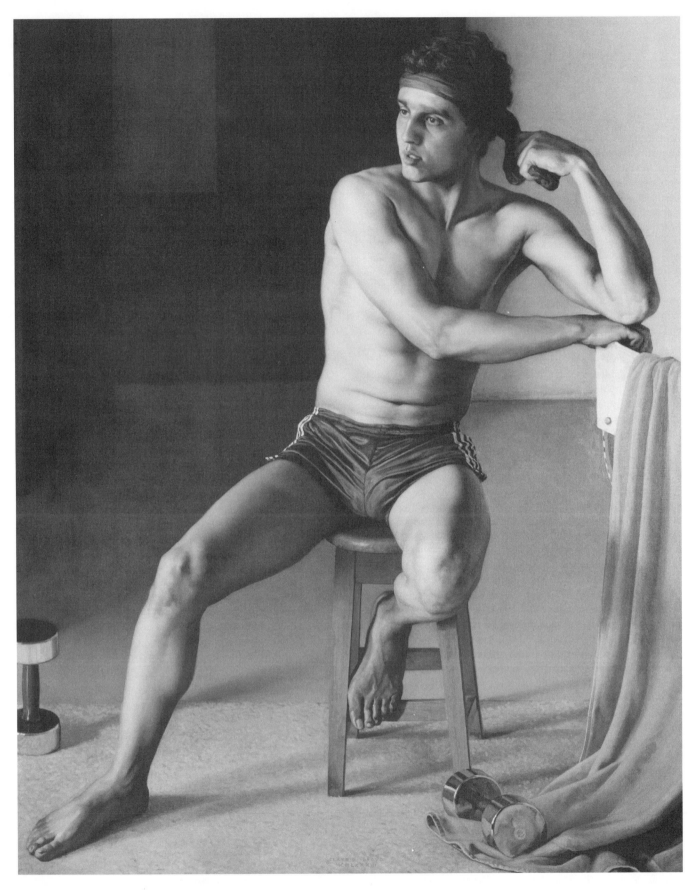

Claudio Bravo: *Noureddine,* **c. 1970s. © Christie's Images/Corbis.**

Claudio Bravo: *Sahara Landscape,* 1982. © Christie's Images/Corbis.

1984 *The Classic Tradition in Painting and Sculpture,*
 Aldrich Museum of Contemporary Art, Ridgefield,
 Connecticut
1985 *Contemporary Narrative Figure Painting,* Moravian
 College, Bethlehem, Pennsylvania

Collections:

Baltimore Museum of Art, Maryland; Metropolitan Museum of Art, New York; Museo Nacional de Bellas Arte, Santiago; Museum Boymans-van Beunigen, Rotterdam; Museum of Modern Art, New York; Peter Ludwig Museum, Cologne, Germany; Philadelphia Museum of Art; Rufino Tamayo Museum of International Contemporary Art, Mexico.

Publications:

On BRAVO: Books—*Claudio Bravo,* exhibition catalog, Madrid, Cedesa, 1974; *Claudio Bravo: Pinturas y dibujos,* exhibition catalog, Monterrey, Mexico, New York, Museo de Monterrey, 1982; *Claudio*

Bravo: Pastels 1985, Still Lifes, exhibition catalog, New York, Marlborough-Gerson Gallery, 1985; *Claudio Bravo, Painter and Draftsman,* exhibition catalog, with text by Edward J. Sullivan, Madison, Wisconsin, Elvehjem Museum of Art, 1987; *Claudio Bravo: Recent Paintings and Pastels,* exhibition catalog, New York, Marlborough Gallery, 1989; *Claudio Bravo: Works on Paper,* exhibition catalog, New York, Marlborough Gallery, 1991; *Claudio Bravo,* exhibition catalog, New York, Marlborough Gallery, 1992; *Important Paintings and Drawings by Claudio Bravo from the Forbes Magazine Collection,* New York, Christie's, 1993; *Latin American Artists in Their Studios* by Marie-Pierre Colle, New York, Vendome Press, 1994; *Claudio Bravo: Visionario de la realidad,* exhibition catalog, with text by Edward J Sullivan, Santiago, El Museo, 1994; *Claudio Bravo: Wrapped Packages,* exhibition catalog, with text by Diane W. Camber, Dr. Melvin Blake, and Edward J. Sullivan, Miami Beach, Florida, Bass Museum of Art, 1997; *Claudio Bravo: Paintings and Drawings* by Paul Bowles, Mario Vargas Llosa, and Hugo Valcarce, Madrid, Lerner & Lerner, 1996, and New York, Abbeville Press, 1997; *Claudio Bravo: Recent Works,* exhibition catalog, New York, Marlborough Gallery, 1998; *Claudio Bravo: New Works=Obras*

recientes, exhibition catalog, New York, Marlborough Gallery, 1999.
Articles—''Lettre de New York: Claudio Bravo, Staempfli Gallery''
by J. P. Marandel in *Art International* (Lugano, Switzerland), January
1971; ''Flashback su Kassel'' in *Flash Art* (Milan), September/
October 1972; ''The New Spanish Realists'' by W. Dyckes in *Art
International* (Lugano, Switzerland), September 1973; ''Claudio
Bravo in Tangier: Moroccan Tranquillity Inspires the South Ameri-
can Artist,'' in *Architectural Digest,* 47, March 1990, pp. 234–238,
and ''Art: Latin American Still Lifes, an Exuberant Heritage of
Imagery and Symbolism,'' in *Architectural Digest,* 51, September
1994, both by Edward J. Sullivan; ''Claudio Bravo: Marlborough
Gallery'' by Christian Viveros-Fauné, in *Art Nexus* (Colombia), 30,
November 1998/January 1999, p. 147.

<p style="text-align:center">*</p>

Claudio Bravo comments:

At present nothing interests me except the resurrection. I don't
want movements or fashions. Art is something so subtle that these
things do not last. They are poor flowers that test the brightness and
quickly fade.

One has to be forgotten, and work as an honest laborer, perhaps
for some years, not to be mistaken as the follower of a trend. Neither
Leonardo nor Vermeer knew anything about tendencies; they did
what they had to do and what they believed in—alone, very alone and
quietly. One has to be forgotten, like the dead—to disappear.

I live beside a Moroccan cemetery that I see every morning when
I open my window to let the sun into my place on the bed. My
experiences each day are so long and serene that I don't have even a
moment to think of the neurotic involvements of other artists in big
cities. I am apart from time in my beautiful Arabian palace, quiet and
white like a dove sitting next to a rose.

Hyperealism, realism, superrealism and other isms will pass;
they fly far above my studio and only come to visit. I am shut in,
painting, and don't open my windows to them; like Abel with the
Angel I will fight to be alone.

One day will come the resurrection.

<p style="text-align:center">* * *</p>

Born in Valparaíso, Chile, in 1936, Claudio Bravo first came to
international attention as a highly sought-after society portrait painter
in Spain. Although immensely popular in this genre and much in
demand, Bravo abruptly switched to painting wrapped packages, the
contents of which were unknown to the viewer. These works were
approached in much the same way as Bravo approached his portraits.
Sometimes intimate, other times grand, they display an extreme
attention to the subtle details of surface texture and the caressing light
that falls across those textures. The paintings also reveal Bravo's
adeptness at creating a three-dimensional image on a two-dimen-
sional surface. They are, to all intents and purposes, ''portraits'' of
wrapped packages and thus can be seen as an outgrowth of his society
portraits. Additionally, as with portraits, these wrapped packages
immediately engage the viewer in the assemblage of surface details
while at the same time creating intrigue with what may lie underneath.
For example, in *White Package* (1972; in the Fundacíon America
Collection), which Bravo completed just before moving to Tangier,
Morocco, the viewer is witness to his technical virtuosity in realizing,
on a large scale, an immense, loosely wrapped package tied with
twine, also highly rendered.

Throughout his career Bravo has investigated a number of
themes. While in Madrid he frequently visited the Prado Museum,
where he was exposed to many of the great Spanish masters, includ-
ing Diego Velázquez and Francisco de Zurbarán. It is thus not
surprising that Bravo painted a series of still lifes, given the centuries-
old Spanish still-life tradition, as well as a number of works based on
mythological and religious themes. Examples of the latter include
Minerva and Ariadne (1981) and a *sacra conversazione* of the
Madonna and Child in the company of saints (1979–80). All these
subjects received the same attention that Bravo lavished on his sitters
and wrapped packages.

Just as intriguing are Bravo's series of canvases, dating from the
late 1990s, that depict various hung fabrics. Sometimes simply hung,
other times tied in loose knots, the fabrics communicate their lush
textures and striking colors with the same virtuosity found in all his
works. They appear often in overlapping layers and conceal what is
underneath. An added dimension is the works' titles. In one series
Bravo gave each canvas the name of a Christian apostle. Similarly,
canvases depicting hanging fabrics exist with the titles *Annunciation,*
Sanctum, and *Pontifici.* While realistic depictions of drapery and
fabrics had been part of religious paintings for centuries, they had
never before been the entire subject. Bravo also produced a series of
paintings of cloth—red, yellow, and blue—entitled Bacchus, Apollo,
and Zeus, three mythological gods. Such titles encouraged the viewer
to think differently about what was being represented and added a
new layer to Bravo's work.

<p style="text-align:right">—Sean M. Ulmer</p>

BRISEÑO, Rolando
American sculptor

Born: San Antonio, Texas, 1952. **Education:** National Autonomous
University, Mexico City; Cooper Union, New York; University of
Texas, Austin, B.F.A. in art history 1973, B.A. in art 1975; Columbia
University, New York, M.F.A. 1979. **Career:** Artist-in-residence,
Bellagio Study Center, Rockefeller Foundation, Lago de Como, Italy,
1990. **Awards:** Public Service fellowship, New York State Creative
Artists, c. 1983; fellowship, National Endowment for the Arts, 1985;
fellowship, Pollack-Krasner Foundation, 1987–88, 1993; grant, New
York State Council on the Arts, 1994; grant, Joan Mitchel Founda-
tion, 1995. **Address:** 1241 W. French Place, #2, San Antonio,
Texas 78201, U.S.A. **E-mail Address:** rolandoBriseño@yahoo.com.
Website: http://www.rolandoBriseño.com.

Individual Exhibitions:

1981	Cayman Gallery, New York
1982	Bronx Museum of the Arts, New York
1984	P.S. 1, Special Projects Room, Long Island, New York
1986	Idra Duarte, Naples, Italy
1987	V.S.V., Turin, Italy
1989	Blue Star Art Space, San Antonio, Texas
	Maloney Butler Gallery, Santa Monica, California
	Arte Moderno, San Antonio, Texas
1990	Milagros Contemporary Art, San Antonio, Texas
1991	Rempire Gallery, New York
	Milagros Contemporary Art, San Antonio, Texas

Macy's Windows, Herald Square, New York
1992 Universidad Nacional Autonoma de Mexico at San
 Antonio, Texas
 Governor's Gallery, World Trade Center, New York
1993 *The Table: A Survey,* Whitehall Gallery, New York
1996 ArtPace, San Antonio, Texas
1997 *Rolando Briseño: A Survey,* Mexic-Arte, Austin, Texas
 Back to the Table, Center for Art and Spirituality,
 University of the Incarnate Word, San Antonio, Texas
1998 *Moctezuma's Table,* Instituto Cultural Mexicano, San
 Antonio, Texas
2000 *New Giclée Print Series,* Guadalupe Cultural Arts
 Center, San Antonio, Texas
2001 *Tablescapes,* Galeria Inframundo, New York

Selected Group Exhibitions:

1982 *Untitled, Without Theme,* Alternative Museum, New
 York
1987–89 *Contemporary Hispanic Art in the U.S.,* Houston
 Museum of Fine Art
1991 *Tejanos,* Museo Carillo Gil, Mexico City
1992 *Latin American Artists from New York in Miami,* Javier
 Lumbreras Fine Art, Coral Gables, Florida
1993 *Ima Ritma,* Cast Iron Gallery, New York
1995 *Ponder These Things,* New York State Museum,
 Albany, New York
1996 *Feast for the Eyes,* Laguna Gloria Art Museum, Austin,
 Texas
1997 *Tres proyectos latinos,* Laguna Gloria Art Museum,
 Austin, Texas
1998 *Close to the Border,* University of New Mexico, Las
 Cruces
2001 *Figurative Works on Paper,* Blue Star Contemporary
 Art Space, San Antonio, Texas

Collections:

Brooklyn Museum, New York; Bronx Museum of the Arts, New
York; El Museo del Barrio, New York; Corcoran Gallery of Art,
Washington, D.C.; Houstatonic Museum, Bridgeport, Connecticut;
University of Texas, Austin; University of Arizona, Tempe; MexicArte
Museum, Austin, Texas; Texas A&M University; University of Rio
Piedras, San Juan, Puerto Rico; Contemporary Art Museum, San
Juan, Puerto Rico.

Publications:

On BRISEÑO: Books—*5+5: Artists Introduce Artists,* exhibition
catalog, New York, City Gallery, 1981; *Rolando Briseño,* exhibition
catalog, text by Giovanni Carandente, New York, Wessel O'Connor,
1987; *Rolando Briseño,* exhibition catalog, text by Dan R. Goddard,
San Antonio, Texas, Milagros Gallery, 1990; *Rolando Briseño,*
exhibition catalog, text by Coco Fusco, New York, Rempire Fine Art
and Gallery, 1992. **Articles**—''Hispanic Artist and Other Slurs'' by
Coco Fusco, in *Village Voice,* 9 September 1988; ''Plastica hispana
en norteamerica formas plasticas'' by Enrique Praders, in *Revista de
Arte* (Madrid), spring, 1989; interview, in *Rakan* (Tokyo), 1989; ''El
chicanismo vivo de Roland Briseño'' by John Santos, in *Mas,*

September 1991; ''A Cultural Diamond in the Rough'' by Hector
Tobar, in *Los Angeles Times,* 2 August 1999; ''South Texas Works
Look to Define Ethnicity'' by Dan R. Goddard, in *San Antonio
Express-News,* 30 March 2000. **Films**—*Hispanic Art in the U.S.,*
produced by De Colores, Houston, Texas Connection, 1987; *Heritage, Segment Profile,* produced by Joseph Tovares, San Antonio,
Texas, KLRN, 1989; *Rolando Briseño,* produced by Sylvia Orozco,
Austin, Texas, Mexic-Arte, 1997.

* * *

Rolando Briseño's work has straddled his Latino heritage,
European art, and popular culture. By uniting the symbols of these
three distinct worlds in individual paintings, he has forged a new,
contemporary narrative in his art. He is best known for his works that
depict tables and food, particularly Mexican food. In collages, painted
cutouts, paintings, and cast-metal reliefs, Briseño has shown the table
as a symbol of communication and coming together that is threatened
by modern technology.

Briseño was raised in a Mexican community in San Antonio,
Texas. He spent some time at the National Autonomous University of
Mexico in Mexico City before attending Cooper Union in New York
City. He left Cooper Union without a degree and completed his
undergraduate studies at the University of Texas, but he returned to
New York for graduate school. Although he considered himself to be
a ''universal artist,'' one can see in his movements between the New
York art world and the Latino communities of Texas the negotiation
between these worlds that later characterized his work.

Briseño began depicting the table in his work while living in
New York during the 1980s. The topic became his signature subject,
as he continued to mine this theme for new meanings. In these works
the table, and the food placed upon it, are typically Mexican. Briseño
frequently depicted the food and table in motion, as in the expressionistic *Mayan Table,* in which the whirling plates represent the hectic
pace of contemporary life and the rush of time.

While in New York Briseño was often pigeonholed as a Latino
artist. Being pegged as such made him interested in the possibility of
incorporating various elements of his Mexican-American heritage
more fully into his work. To be closer to his cultural roots, he returned
in 1994 to San Antonio, where his exploration of cultural traditions in
relation to a broader popular and artistic legacy intensified.

Briseño has created his most vital work through the negotiation
of different cultural symbols. In *Mexico,* for instance, he brought
together three distinct wellsprings of inspiration—his Latino background, European artistic tradition, and popular culture. In this work
he depicted a table set for tea with white and blue Talavera pottery
from Mexico. The pottery, which is arranged in a cruciform pattern,
partially obscures Mayan imagery on the tablecloth beneath it. Three
of the four plates bear an orange, the fourth, a handgun. Off to one side
of the painting is a remote control. Briseño's other works lay claim to
his Mexican roots more directly. In his 2000 show, *Montezuma's
Table,* for example, he portrayed the food of pre-conquest Mexico.
The dishes presented were drawn from a collection of centuries-old
recipes Briseño had come across while vacationing in Mexico.

Another defining characteristic of Briseño's work has been his
willingness to use materials that shed new light on his subject. Some
of the works in *Montezuma's Table* were painted with chili powder
and mole paste in addition to traditional art supplies. For Briseño,
these unique ingredients not only added a rich hue to the paintings but
also illuminated his subject, as form became content. In the late 1990s

he began experimenting with digital imagery. He produced a series of giclee prints, which resemble a cross between photography and lithography. Briseño explained that he ventured into this new area because he was anxious to work in a more contemporary medium.

—Rebecca Stanfel

BRUGNOLI, Francisco
Chilean mixed-media, conceptual, and installation artist

Born: Santiago, 10 October 1935. **Education:** Universidad de Chile, Santiago, 1959–64, degree in art; International University of Art, Florence, 1980; University of Maryland. **Career:** Professor, Faculty of Arts and Faculty of Architecture, Universidad de Chile, Santiago. Since 1998 director, Museo de Arte Contemporáneo de la Universidad de Chile, Santiago. Founder, Escuela de Arte de la Universidad Arcis. Visiting professor, A.K.I. Amsterdam, 1977, Universidad de San Juan, Argentina, 1997–98, and Universidad Nacional de Cuyo, Argentina, 1998. **Award:** Premio del Jurado, *Concurso internacional print biennial,* 1980.

Selected Exhibitions:

1963	*LXXIV salón oficial de Santiago*
1979	*Trienal de grabado latinoamericano,* Buenos Aires
1983	*Chile vive,* Madrid
	Paisajes, Galería Sur, Montevideo, Uruguay
1984	*Cirugía plástica 3,* Santiago
1989	*Cirugía plástica,* Kunsthalle, Berlin
1991	*IV bienal de la Habana,* Havana
2000	Museo Arte Contemporáneo, São Paulo, Brazil

Museo de Arte Contemporáneo, Santiago; Museo Nacional de Bellas Artes, Santiago; Galería Gabriela Mistral, Santiago.

Publications:

By BRUGNOLI: Books—*Cantico del hermano sol,* Santiago, Taller Artes Visuales, 1976; "La escritura crítica y su efecto," in *Arte en Chile desde 1973: Escena de avanzada y sociedad,* edited by Nelly Richard, Santiago, FLASCO, 1987; *Visualidad y neguentrópia: Un enfoque al equilibrio visual,* with Sofía Letelier, Santiago, Universidad de Chile, 1992; *El ojo móvil: Matilde Pérez,* exhibition catalog, with Magdalena Eichholz and Leonor Castañeda, Santiago, Museo Nacional de Bellas Artes, 1999; *Alejandra Ruddoff: Arte en Chile,* Santiago, Ezio Mosciatti Olivieri, 2000.

* * *

Francisco Brugnoli's position as a member of the avant-garde in Chile was cemented during the mid-1960s when he hosted a studio for young artists working in an experimental vein. During that time he began to exhibit his nontraditional work influenced by popular culture in Chile and, in a more general way, by pop art from the United States. Working closely with this group of emerging artists, Brugnoli helped to usher in some of the most cutting-edge work in the history of Chilean art.

The artist's earliest work provoked strong public reaction. Inheriting his critical approach from the legacy of Marcel Duchamp, Brugnoli began incorporating a variety of found objects into his work to raise questions about the meanings of these objects once they were placed outside their expected context. Coveralls, printed texts, photographs of poor children, pieces of newsprint, and other objects were included in his installations, which began to grow to fill entire gallery spaces, creating a kind of "environment of the marginalized." Incorporated as cultural detritus, these objects raised a significant conversation between the spectator and the object in order to explore the shifting of the object's meaning in the altered context of a work of art. By incorporating an ordinary object into the work, Brugnoli felt that he was creating a more direct connection to the spectator than he could have through a more traditional expressive mode, such as painting. He has stated, "It is easier to communicate through the everyday object that one introduces onto the canvas than through the brushstroke."

These installation works gradually took on a more refined and excessive expression. Looking carefully at materials for their aesthetic as well as their connotative value, Brugnoli created large-scale installations that mixed a variety of ordinary household objects with collaged imagery taken from the world of advertising and art history. Other works paired clothing with painted egg cartons or simply treated the garments as material to be used in the creation of a sculpture of accumulation. The artist dubbed these works los pegoteados ("the stuck-togethers") because he used glue to stiffen the fabric elements, which he then adhered to the surface of painted egg cartons or to one another. Highly present in the artist's work from this period was the strong influence of popular art, which in the Chilean context included colonial imagery and allegorical elements borrowed from the Renaissance works of the Spanish painter Pedro Berruguete (ca 1450–1503). Public reception of these works was again critical; however, the artist believed this to be significant, noting that at least some dialogue between the artist and the public was being established.

As the Chilean political situation began to deteriorate, Brugnoli's works also began to reference contemporary social problems, particularly poverty and unemployment. With these installations Brugnoli began to move outside the gallery or to move objects from the outdoor environment into the gallery. The artist built a small shack similar to the homes of the impoverished in Chile as well as a replica of the tiny structure that houses the head of a construction crew on a developing site. Over the door of this shed Brugnoli placed a sign reading "no vacancies," alluding to rampant unemployment in Chile. Other related works from this period included a sheet of black plastic installed over a window, blocking out all conceivable light and alluding to the political climate in Chile under the dictatorship of General Augusto Pinochet (1974–90).

Brugnoli's work throughout subsequent decades has continued to reference the obsession with the acquisition of material goods in contemporary (and increasingly Americanized) Chilean culture. By focusing specifically on the debris of everyday life, Brugnoli stoically refused to allow his work to become slick, beautiful, or commercial. In a 1983 review of his exhibition, Chilean cultural critic Nelly Richard stated that the exhibition had a historical air, a kind of militantly 1960s critical expression. This criticism was frequently invoked against the artist during the 1980s. Later critics have acknowledged, however, that a visual comparison of Brugnoli's work of the 1960s to the '80s reveals a clear move toward a rethinking of the objects included in the work. Underlining the inherent contradictions and antagonistic oppositions of everyday life under a dictatorial

regime, Brugnoli incorporated conceptual reflections on light as a metaphor for truth and enlightenment, both of which were compromised under the military. In reworking such elements Brugnoli again interfered with the meaning and function of the various objects, conferring upon them a new significance in the context of his work of art.

—Rocío Aranda-Alvarado

BRUGUERA, Tania
Cuban painter and performance artist

Born: Havana, 1968. **Education:** Escuela Elemental de Artes Plásticas, Havana, 1980–83; Academia de Artes Plásticas San Alejandro, Havana, 1983–87; Instituto Superior de Arte, Havana, 1987–92. **Career:** Professor of painting, Instituto Superior de Arte, Havana, 1992–96; coordinating director, Tomas Sanchez Foundation, 1992–93. Teacher, Comunidad Las Terrazas, Pinar del Río, Cuba, 1994, and *Juego de imagenes, XVII Festival of New Latin American Film,* Instituto de Arte e Industria Cinematográfica, Havana, 1995; curator, *Una brecha entre el cielo y la tierra,* Centro de Artes Plásticas y Diseño, Havana, 1994. Artist-in-residence, Xamaca Workshop, Crystal Spring, Jamaica, 1995, ART/OMI International Workshop, Hudson, New York, 1995, Slade College of Art, London, 1995, Gasworks Studios, London, 1995, Ephemeral Sculpture International Workshop, *VI Havana biennial,* Pinar del Rio, Cuba, 1997, Western Front, Vancouver, British Columbia, 1997, School of the Art Institute of Chicago, 1997, Art in General, Bronx Council for the Arts, 1997, Fundación Museo de Arte Contemporáneo de Maracay Mario Abreu, Maracay, Venezuela, 1998, and Headlands Center for the Arts, Sausalito, California, 1998. **Award:** John S. Guggenheim Memorial Foundation fellowship, New York, 1998. **Address:** 1354 W. Carmen, Chicago, Illinois 60640, U.S.A.

Individual Exhibitions:

1986 *Marilyn Is Alive,* Galería Leopoldo Romañach, Academia de Artes Plásticas San Alejandro, Havana
1992 *Ana Mendieta,* Sala Polivalente, Centro de Desarrollo de las Artes Visuales, Havana
1993 *Memoria de la postguerra,* Galería Plaza Vieja, Fondo Cubano de Bienes Culturales, Havana
1995 *Lo que me corresponde,* artist's home, Havana
 Soñando, Gasworks Studios Gallery, London (with Fernando Rodriguez)
1996 *Cabeza abajo,* Espacio Aglutinador, Havana
 Lágrimas de tránsito, Centro de Arte Contemporáneo Wifredo Lam, Havana
1997 *El peso de la culpa,* Tejadillo 214, Havana
 Anima, Base Space, School of the Art Institute of Chicago
1999 Museo X-Teresa, Mexico City
 Lo que me corresponde, Iturralde Gallery, Los Angeles (traveling)

Selected Group Exhibitions:

1988 *El ISA en casa,* Casa de las Américas, Havana

1989 *II festival de la creación y la investigación,* Instituto Superior de Arte, Havana
1992 *Second International Poster Biennial,* Museo José Luis Cuevas, Mexico City
1995 *New Art from Cuba,* Whitechapel Art Gallery, London Museo Nacional de Bellas Artes, Havana
1996 *23rd Biennial de São Paulo*
1997 *Las mieles del silencio,* Galería Latinoamericana, Casa de las Amerias, Havana
1998 *Obsesiones,* Centro de Arte Contemporáneo Wifredo Lam, Havana
 Art in Freedom, Boijmans van Beuningen Museum, Rotterdam, Netherlands
1999 *Cuba–Maps of Desire,* Kunsthalle, Vienna

Collections:

Museo Nacional de Bellas Artes, Havana; Centro de Arte Contemporáneo Wifredo Lam, Havana; New Museum for Latin American Art, Essex, England; Colección Barro de América, Maracaibo, Venezuela.

Publications:

On BRUGUERA: Books—*New Art of Cuba* by Luis Camnitzer, Austin, University of Texas Press, 1994; *New Art from Cuba,* exhibition catalog, text by Antonio Eligio Fernandez, London, Whitechapel Art Gallery, 1995; *Islas,* exhibition catalog, Las Palmas de Gran Canaria, Spain, Ed. Centro Atlántico de Arte Moderno, 1997; *1990s Art from Cuba: A National Residency and Exhibiton Program,* exhibition catalog, text by Betty Sue Hertz and Valerie Cassell, n.p., 1997; *Performance Live Art since 1960* by Roselee Goldberg, New York, Abrams, 1998. **Articles**—"Tania Bruguera + Sandra Ceballos" by Lazara Castellaños, in *Lo que venga* (Havana), 2(1), 1995, pp. 20–21; "Reanimating Ana Mendieta" by Gerardo Mosquera, in *Poliester* (Mexico City), 4(11), winter 1995, pp. 52–55 (illustrated); "Tania Bruguera: El enigma de lo enigmático" by Luis Fernando Quiros, in *Fanal* (San Jose, Costa Rica), 2(13), March-April 1996, pp. 19–23 (illustrated); "Bruguera, Tania: Performance Artist" by Euridice Arratia, in *Flash Art* (Italy), 32(204), January/February 1999, p. 48.

* * *

If I didn't think that the water which encircles me a cancer I would be able to sleep like a log.

—Virgilio Piñera

Inheriting the ritualism and the silence of Ana Mendieta, Tania Bruguera occupies a significant place in the contemporary performance art scene. Nonetheless, when her works break away from concrete experiences in the social and political context, there is in them a human essence, a universal message that speaks of power and oppression. For example, in *El Peso de la Culpa* ("The Burden of Guilt"), *El Cuerpo del Silencio* ("The Body of Silence"), or *Estudio de Taller* ("Studio Study"), performances that employ metaphors of submission and obedience, she uses the presence of a living lamb, a sacrificial animal that can intercede with its flesh, its heart, and its skeleton.

In some performances it is the artist herself who symbolizes power. In *Cabeza Abajo,* for instance, Bruguera walks on top of a group of people piled up on the floor, their hands tied with strips of red cloth, which also covers their mouths and eyes. At the same time, embedded among them is a flag that matches the red strips. After repeating the movement, she makes her way to the audience and repeats the process before drawing back again. In other performances, as in *El Cuerpo del Silencio,* Bruguera assumes the role of the oppressed. In a small cubicle whose inner walls are "lined" with lamb's meat, she finds herself correcting a history book she later finds fault with. She tries to make the book disappear by tearing out the pages and shoving them into her mouth, which no longer emits words but merely erases.

The ambience of Bruguera's installation pieces have powerful emotional effects on those who participate in them. It is for their emotional power that Bruguera utilizes not only her own gestures but also the objects she puts before her or the effects she incorporates as part of the scene. These include the use of light to obscure passageways and of sound, such as the baying of lambs in her video installation *La Isla en Peso,* techniques that provoke feelings of helplessness, a lack of control, and certainly fear. Integrated into this nearly always tragic and agonizing state, the audience at times resembles a flock or herd.

Likewise, in her use of repetition Bruguera creates a mechanism that is indispensable for the communication of these states. As a ritual, her actions extend in time, creating her own time. To reiterate the same action or to prolong it, as in slow motion, re-creates one of the principal characteristics of torture. It seems as if the torture were memory itself, to repeat and not to forget.

Bruguera has reproduced her own torture and with it her resistance to torture. Thus, she reacts to extreme situations, which, like primitive rituals, are allegories for actual situations. Her reaction is self-oppressive, above all, utopian, for it is never possible to eliminate actual pain. We can feel the presence of guilt, of the state it carries, and a crushing power. There is tragedy, there is tension, and there is history in every move and in every performance.

—Glenda Leon

C

Waltércio Caldas: *All of a sudden . . .* , 1998. Photo courtesy of the artist and Galerie Lelong, New York.

CALDAS, Waltércio

Brazilian sculptor

Born: Rio de Janeiro, 6 November 1946. **Education:** Studied painting with Ivan Serpa, 1965. **Career:** Lives and works in Rio de Janeiro. **Awards:** Premio Anual de Viagem, *Melhor exposição,* Associação Brazileira de Críticos de Arte, 1973; Premio Basília, Museu de Arte de Brasília, 1990; Premio Mário Pedrosa, *Exposição do ano,* Associação Brazileira de Críticos de Arte, 1993. **Agent:** Galerie Lelong, 20 West 57th Street, New York, New York 10019, U.S.A. **E-mail Address:** art@galerielelong.com. **Website:** http://www. artnet.com/lelong.html.

Individual Exhibitions:

1973 Museu de Arte Moderna do Rio de Janeiro

1974	Galeria Luiz Buarque e Paulo Bittencourt, Rio de Janeiro
1975	*A natureza dos jogos,* Museu de Arte de São Paulo
	Galeria Luisa Strina, São Paulo
1976	Museu de Arte Moderna do Rio de Janeiro
1979	*Aparelhos,* Galeria Luisa Strina, São Paulo
1980	*Ping-ping,* Galeria Saramenha, Rio de Janeiro
	O é um, Projeto ABC/Funarte, Rio de Janeiro
1982	Gabinete de Arte Raquel Arnaud Babenco, São Paulo
1983	Gabinete de Arte Raquel Arnaud Babenco, São Paulo
1984	Galeria GB Arte, Rio de Janeiro
1986	Galeria Paulo Klabin, Rio de Janeiro
	Gabinete de Arte Raquel Arnaud, São Paulo
1988	Galeria Sergio Milliet/Funarte, Rio de Janeiro
	Galeria Paulo Klabin, Rio de Janeiro
1989	Gabinete de Arte Raquel Arnaud, São Paulo

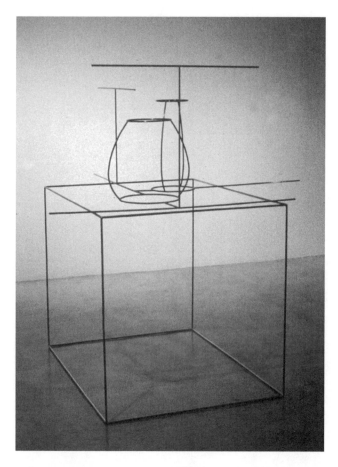

Waltércio Caldas: *The Yellow,* **1998. Photo courtesy of the artist and Galerie Lelong, New York.**

1990	Galeria 110 Arte Contemporánea, Rio de Janeiro
	Tekeningen, Pulitzer Art Gallery, Amsterdam
1991	Gabinete de Arte Raquel Arnaud, São Paulo
	Kanaal Art Foundation, Kortrijk, Belgium
1992	Stedelijk Museum Schiedam, Holland
1993	*O ar mais próximo,* Museu Nacional de Belas Artes, Rio de Janeiro
1994	Gabinete de Arte Raquel Arnaud, São Paulo
1995	Joel Edelstein Arte Contemporánea, Rio de Janeiro
	Centre d'Art Contemporain, Geneva
1996	*Anotações 1969–1996,* Paço Imperial, Rio de Janeiro
	A história da pedra, Museu Chácara do Céu, Rio de Janeiro
1997	*New Sculptures,* Quintana Gallery, Miami
	Galeria Javier Lopes, Madrid
1998	*Mar nunca nome,* Centro Cultural Light, Rio de Janeiro
	Galeria Paulo Fernandes, Rio de Janeiro
	Galerie Lelong, New York
1999	Christopher Grimes Gallery, Santa Monica, California
	Museu de Arte moderna do Rio de Janeiro
2000	Celma Albuquerque Galeria de Arte, Belo Horizonte
	Museu de Arte da Pampulha, Belo Horizonte
	Uma sala para Velázquez, Museu Nacional de Belas Artes, Rio de Janeiro
	Galeria Laura Marsiaj Arte Contemporánea, Rio de Janeiro

Selected Group Exhibitions:

1984	*I bienal de Havana*
	Abstracts attitudes, Center for Inter-American Relations, New York
1993	*Latin American Artists of the Twentieth Century,* Museum of Modern Art, New York (traveling)
	Brasil 100 años de arte moderna, Museu Nacional de Belas Artes, Rio de Janeiro
1994	*Mapping,* Museum of Modern Art, New York
1995	*Drawing on Chance,* Museum of Modern Art, New York
1996	*XXIII bienal internacional de São Paulo*
1997	*Re-aligning Vision,* El Museo del Barrio, New York
1999	*Global Conceptualism: Points of Origin 1950s-1980s,* Queens Museum of Art, New York, and Walker Art Center, Minneapolis
2000	*Entre a arte e o design,* Museu de Arte Moderna de São Paulo

Publications:

By CALDAS: Books—*Manual a ciencia popular,* text by Paulo Venancio Filho, Rio de Janeiro, Funarte, 1982; *Velasquez,* São Paulo, Editora Anonima, 1996; *Disenhos,* Rio de Janeiro, Reila Gracie Editora, 1997. **Film—***Um Rio,* 1996.

On CALDAS: Books—*Waltercio Caldas: Aparelhos* by Ronaldo Brito, Rio de Janeiro, GBM Editora, 1979; *Waltercio Caldas,* exhibition catalog, text by Ilse Kuijken, Paulo Venancio Filho, and Sonia Salzstein, Brazil, Armazens Gerais Columbia, 1992; *Precisão: Amilcar de Castro, Eduardo Sued, Waltercio Caldas,* exhibition catalog, text by Irma Arestizábal and Piedade Epstein Grinberg, Rio de Janeiro, Centro Cultural Banco do Brasil, 1994; *Por que Duchamp?: Leituras duchampianas por artístas e críticos brasileiros* by Vitória Daniela Bousso, São Paulo, Paço das Artes, 1999. **Articles—**"The Mental Carpenter of Rio" by Geri Smith, in *Art News,* 90, October 1991, pp. 98–99; "Out of Place" by Robin Laurence, in *Canadian Art,* 11, spring 1994, p. 74; "Waltercio Caldas" by Lisette Lagnado, in *Art Nexus* (Colombia), 22, October/December 1996, pp. 60–63; "Waltercio Caldas" by Adriano Pedrosa, in *Artforum International,* 35, November 1996, p. 105. **Films—***Apaga-te sesamo, Objects and Sculptures* by Miguel Rio Branco, 1986; *Software, uma escultura* by Ronald Tapajos, 1989.

* * *

Waltércio Caldas's artistic practice can be broadly characterized as sculpture, though by nature his work seeks to unravel historical, academic categories and conventions. For Caldas himself alluded to his work as consisting of "sculpturic instances." This term refers to the way Caldas's sculptures create situations that articulate ideas rather than privileging the art object as an end in itself. Paradoxically Caldas's sculptures are also astutely formally executed and highly aesthetic, and coupled as they are with rigorous concept, they serve to destabilize the viewer's perceptual relationship to the experience of a

work of art. This destabilization is also meant to subvert the artistic experience from becoming solely an aesthetic one to one that redirects the viewer back into the social world that he or she is a part. In operating between these two poles of affirming the aesthetic while concomitantly negating it through complex conceptual content, Caldas reveals his artistic intelligence. Yet his work innately aspires to something more than art—it does not simply call attention to the context in which that art is made and situated. It is both and neither of these concerns. And it is here where Caldas's art enigmatically resides: in the interstices of being and nothingness, in the convergence of an idea and its materialization, and between the object and its relationship to the space that encompasses it. In other words, Caldas's work is a Cartesian conundrum where the artwork becomes the point of departure in engendering philosophical dialogue. This modus operandi is evident in one of his early memorable works, titled *Perception Conductors* (1969).

Perception Conductors consists of two glass rods that lie in a velvet box. Though they evoke some sort of pseudoscientific gadgetry, they bring to attention the positivist impulse of Western rational epistemology that seeks to know the world empirically through technology alone. The formal and conceptual power of *Perception Conductors* is exemplary of Caldas's art: the ostensible seamless merger of form and idea and of content and aesthetics. Like Caldas's work in general, *Perception Conductors* is pregnant with a myriad themes that it poetically yet critically addresses. The work questions the historical relationship of the viewer's complacency to art, brings philosophical attention to the uncertainty principle about knowing the world, and specifically targets the ontology of the art object that was crucial to international artistic discourse of the 1960s.

After finishing his studies with Ivan Serpa in 1965, Caldas entered the arena of international art in the 1960s when North American critics were pronouncing "the dematerialization of the art object." Inheriting a rich artistic legacy from Hélio Oiticica and Lygia Clark, Caldas and Cildo Meireles were the most visible Brazilian artists. Meireles was a contemporary of Caldas and was reconfiguring the ready-made on his own terms. Like Meireles, Caldas was advancing the formal investigations initiated by Oiticica and Clark in equally different directions. While Oiticica reworked the monochrome into a phenomenological model and Clark explored the performative through the modality of psychotherapy, Caldas focused on formal issues and their relationship to perception. Caldas's formal investigations concern themselves with the viewer's sensory perceptions, though not as gestalt as was the case with Clark but instead as a form of self-questioning that engages social reality and fosters an intellectual praxis of critical awareness. This type of commitment to an artistic practice is what marks Caldas's oeuvre to date and how it sustained itself through the cataclysmic years during the reign of Brazil's military dictatorship in the 1960s and after.

Caldas's work after the 1960s became increasingly conceptual and incorporated ready-made elements that continued his idiosyncratic formal investigations. Works such as *Matisse with Talc* (1973), which consists of an open book that displays a Matisse painting lightly covered in talcum powder, became both sculpture as well as drawing, simultaneously two- and three-dimensional. Since the work seemed to be extremely fragile, the photograph of *Matisse with Talc* exceedingly came to be construed as the work itself. The either-or philosophical dichotomy of whether the photograph was the work or

the work was that which was photographed became an apt analogy to Caldas's diluting or tainting of modernism's emphasis on purity of media. Caldas operates in registers of what can be outwardly interpreted as formalism, yet this is only the entry point into an artistic strategy that seeks to interrogate modernity itself. As an artist whose visual poetics focus on complex philosophical issues through what sometimes seems to be the simplest of means, Caldas sums up his project as a reconfiguration of the Cartesian mind-body problem to one of matter and energy: "I would like to produce an object with the maximum presence and the maximum absence."

—Raúl Zamudio

CALDERÓN, Miguel
Mexican photographer, painter, sculptor, and video artist

Born: Mexico City, 1971. **Education:** Cambridge School of Weston; Maryland Institute of Art; Temple University, Rome; La Sapienza, University of Rome; San Francisco Art Institute, B.F.A. in experimental film and video 1994. **Career:** Since 1994 cofounder and coordinator, alternative art space *La Panaderia,* Mexico City. Lead singer, Intestino Grueso.

Individual Exhibitions:

1995		Andrea Rosen Gallery, New York (with Iñigo Manglano-Ovalle)
		National Museum of Natural History, Mexico City
1996		Andrea Rosen Gallery, New York
1998		*Aggressively Mediocre/Mentally Challenged/Fantasy Island,* Andrea Rosen Gallery, New York
1999		Rufino Tamayo Museum, Mexico City
		Andrea Rosen Gallery, New York

Selected Group Exhibitions:

1996		*Pushing Image Paradigms,* PICA, Portland, Oregon
1998		*Ridiculum Vitae,* La Panadería, Mexico City
2000		*People,* Andrea Rosen Gallery, New York

Publications:

On CALDERÓN: Articles—"Miguel Calderon e Iñigo Manglano" by Victor Zamudio Taylor, in *Art Nexus* (Colombia), 22, October/December 1996, pp. 152–154; "'Ridiculum Vitae': La Panadería, Mexico City" by Keith Miller, in *Art/Text* (Australia), 62, August/October 1998, p. 92; "Mexican Photography: From Chiapas to Fifth Avenue" by Rubén Gallo, in *Flash Art* (Italy), 32(206), May/June 1999, pp. 78–80; "Miguel Calderon: Rufino Tamayo Museum" by Victor Zamudio Taylor, in *Art Nexus* (Colombia), 34, November 1999/January 2000, pp. 129–130; "High Noon in Desire Country: The Lingering Presence of Extended Adolescence in Contemporary

Art'' by Gean Moreno, in *Art Papers,* 24(3), May/June 2000, pp. 30–35; ''Letter from the Louvre'' by Giovanni Intra, in *Art/Text* (Australia), 72, February/April 2001, pp. 41–43.

* * *

Working in such media as photography, video, film, installation, and performance, the Mexico City native Miguel Calderón decodes the sociocultural dissonance that results from the rapid globalization of his nation's capital. The lead singer for the neopunk band Intestino Grueso (Large Intestine) and cofounder of the artists' cooperative La Panaderia, an active forum of local and international art established in 1994, Calderón belongs to the first generation of Mexicans with broad exposure to cultures other than their own. With a keen awareness of the postcolonial perspectives that cross between Mexico and the United States, the artist strategically appropriates styles of mass media such as the *telenovela* (soap opera), tabloid imagery, music videos, Mexican punk cartoons, and diverse cinematic genres.

Intellectually subversive, Calderón explores the aesthetics of globalized adolescent culture, examining how it operates within a Mexican context. In *Evolución del hombre* (1995; ''Evolution of Man''), a set of six C-prints, the artist photographed himself in a series of poses, beginning nude and squatting (*Homo erectus*) and ending standing erect, fully dressed in sagging pants and equipped with machine guns (*Homo sapiens*). While his wild Afro hairstyle and goatee remain the same in each photo, Calderón signaled the evolution by swapping the weapons he carried, from knife to automatic firearms. Echoing a form of ethnographic and scientific documentation, he performs the process of sociocultural contamination that is accelerated, exaggerated, and stylized by mass media.

Informed by his study of experimental film at the San Francisco Art Institute, Calderón uses *tableaux vivants* to examine the mechanisms of theatricality and visual display. In *Serie historia artificial* (1995; ''Artificial History Series''), a group of large-scale photographs, the artist inserted himself within dioramas at Mexico City's National Museum of Natural History. The work was exhibited next to the dioramas for one night. Reminiscent of stills from low-budget action movies, the photos show Calderón as an urban savage, a Latino homeboy complete with Afro wig, sunglasses, and weapons, terrorizing the stuffed wild animals in the diorama. The series satirically calls into question the museum's systems of display, which categorize, interpret, and impose authority on the ''other.''

Calderón's interest in challenging such systems of display and the social apparatus of institutions manifests itself as a postmodern critique of museums. His *Employee of the Month Series* (1998), another *tableau vivant,* laid bare the elitist, authoritative construct of museums. He engaged guards and maintenance workers at the National Museum of Art in Mexico City to re-enact the museum's late eighteenth- and nineteenth-century academic paintings. The staff posed for the photographs using the tools of their daily duties—mops, brooms, trash cans—as props and mimicked the composition of each painting. Seemingly irrelevant and absurd, the series pointed out the invincibility of the prevailing popular culture as well as the greater issues of class and politics that pervade Mexico.

Calderón's compulsive use of humor, defiant conceptual approach, and posturing as a rebellious adolescent suggest a political incorrectness throughout his oeuvre. Like Paul McCarthy and Mike

Kelley, Calderón mines the myths of adolescence, using them to underscore the sense of alienation and disaffection, the resistance to the adult world of compromise and inertia. Calderón's adaptation of mass media not only affirms its epidemic power and ability to invade every corner of our lives but also reveals its infrastructure as one that co-opts and homogenizes art and society alike.

—Hitomi Iwasaki

CAMARGO, Sérgio de

Brazilian sculptor

Born: Rio de Janeiro, 1930. **Education:** Altamira Academy, Buenos Aires, 1946; studied philosophy, Sorbonne, Paris, *ca.* 1948. **Career:** Lived in Paris, 1961–72; traveled annually to Italy to work in his atelier, 1964–90. **Awards:** Jury prize, Salão Nacional de Arte Moderna, Rio de Janeiro, 1954; acquisition prize, *Salão Paulista de arte moderna,* São Paulo, 1954; international sculpture prize, *III biennial of Paris,* 1954; gold medal, best national sculptor, *VIII bienal de São Paulo,* 1965; Stern Critic prize, Resumo JB, 1966; best exhibition of sculpture prize, 1977, and best retrospective of the year prize, 1980, both Associação Paulista de Críticos de Arte, São Paulo. **Died:** 1990.

Individual Exhibitions:

1958	Galeria GEA, Rio de Janeiro
	Galeria de Arte das Folhas, São Paulo
1964	Signals Gallery, London
1965	Museu de Arte Moderno do Rio de Janeiro
	Galeria São Luiz, São Paulo
1967	Galleria del Naviglio, Milan
	Galeria L'Obelisco, Rome
	Galleria la Polena, Genova, Italy
1968	Gimpel et Hanover Galerie, Zurich
	Gimpel Fils Gallery, London
	Galleria Notizie, Turin, Italy
	Galeria Buchholz, Munich
1969	Gimepl e Weitzenhoffer, New York
1970	Gimpel Fils Gallery, London
	Galeria Gromholt, Oslo
1971	Galeria M. Bochum, Germany
1972	Estúdio Actual, Caracas
	Galeria Collectio, São Paulo
	Petite Galerie, Rio de Janeiro
1974	Gimpel Fils Gallery, London
	Galeria Gromholt, Oslo
	Museo de Arte Moderno, Mexico City
1975	Museu de Arte Moderna do Rio de Janeiro
	Galeria de Arte Global, São Paulo
1977	Gabinete de Artes Gráficas, São Paulo
1980	*Espaço arte brasileira contemporânea,* FUNARTE, Rio de Janeiro
	Galeria Paulo Klabin, Rio de Janeiro
	Museu de Arte de São Paulo

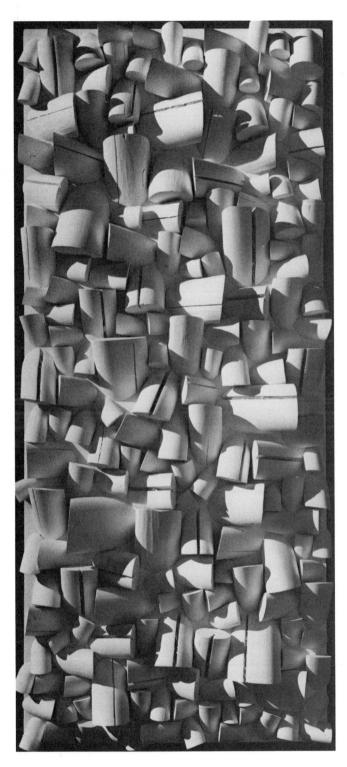

Sérgio de Camargo: *Large Split White Relief No. 34/74,* **1964–65.** ©Tate Gallery, London/Art Resource, NY.

	CAYC, Buenos Aires
1981	Galeria Sagittaria, Pordenone, Italy
	Museu de Arte Moderna do Rio de Janeiro
1982	Galeria Belleschasse, Paris
	Gimpel Fils Gallery, London
1983	Gabinete de Arte Raquel Arnaud, São Paulo

1985	Gabinete de Arte Raquel Arnaud, São Paulo
1987	Gabinete de Arte Raquel Arnaud, São Paulo
	Paço Imperial, Rio de Janeiro
1988	Galeria 111, Lisbon
1990	Gabinete de Arte Raquel Arnaud, São Paulo
1994	Fundação Calouste Gulbenkian, Lisbon
	Museu de Arte Moderna do Rio de Janeiro
	Galeria Paulo Fernandes, Rio de Janeiro
	Henie-Onstad Kunstsenter, Oslo
	Charlotteenborg Museum, Copenhagen
	Stedelijk Museum, Schiedam, Netherlands
1996	Museum of Modern Art, Oxford, England
	Galerie Denise René, Paris
	Maison de líAmérique Latine, Paris
1997	Gabinete de Arte Raquel Arnaud, São Paulo
1999	Palácio do Itamaraty, Brasília

Selected Group Exhibitions:

1951	Salão Nacional de Arte Moderna, Rio de Janeiro
1957	*Arte moderno brasileño,* Museum of Modern Art, Buenos Aires (traveling)
1966	*Artistas brasileños contemporaneos,* Museums of Modern Art of Montevideo, Uruguay, and Buenos Aires
1967	*Lumière et mouvement,* Musée d'Art Moderne, Paris
1968	*Latin American Artists,* Delaware Art Center, Wilmington
1969	*Art Experimental,* Musée d'Art et d'Industrie, Saint Etienne, France
1975	*X salão de arte contemporânea de campinas,* São Paulo
1978	*Panorama de arte atual brasileira,* Museu de Arte Moderna de São Paulo
1985	*Geometric Abstraction in Latin American Art,* CDS Gallery, New York
1987	*Modernidade: Arte brasileira do século XX,* Musée d'Arte Moderne de la Ville de Paris and Museu de Arte Moderna de São Paulo

Collections:

Albright Knox Art Gallery, Buffalo, New York; Casa de las Americas, Havana; Centre National d'Art Contemporain, Paris; Contemporary Art Society, London; Dallas Museum of Fine Arts; Fundação Gunnar Didrichsen Gruno, Finland; Fundación Jesus Soto, Ciudad Bolivar, Venezuela; Galleria Nazionale d'Arte Moderna, Rome; Hirshhorn Museum and Sculptural Garden, Washington, D.C.; Musée d'Art Moderne de la Ville de Paris; Museo de Arte Moderno, Mexico City; Museo de Bellas Artes, Caracas; Museo Tamayo, Mexico City; Museu de Arte Brasileira da Fundação Alvares Penteado, São Paulo; Museu de Arte Moderna do Rio de Janeiro; Museu de Arte Moderna do Estado de São Paulo; Museu Nacional de Belas Artes, Rio de Janeiro; Nasjonalgalleriet, Oslo; University of Texas, Austin.

Publications:

On CAMARGO: Books—*Camargo* by Guy Brett, London, Signals London, 1966; *Sérgio Camargo: Relevos e esculturas,* exhibition catalog, Rio de Janeiro, MAM, 1975; *Sérgio de Camargo,* exhibition

catalog, São Paulo, Museu de Arte Moderna do Rio de Janeiro, 1981; *Camargo* by Ronaldo Brito, São Paulo, Edições Akagaway, *ca.* 1990. **Article—**"Sérgio Camargo: Sculptures" by M. Ellenberger, in *Cimaise* (France), 43, July/August 1996, p. 75.

* * *

During the 1940s Brazil was invaded by abstractionism, with informal and geometric abstract movements consolidating their position in the following decade. Geometrical abstraction had a special development and a great projection and influence in Brazil, particularly at the end of the 1950s, the greatest expressions of which were the concrete and neoconcrete movements. Within the latter came the production of key Brazilian artists such as Hélio Oiticica and Lygia Clark. The work of artists whose aesthetic affiliation had its roots in constructivism, as is the case of Sérgio Camargo, was also of great relevance, however.

From his training in the 1940s Camargo maintained a close relationship with constructivism. Nevertheless, in a first phase he worked with figuration, abandoning it toward the mid-1950s to research abstract forms. After a short period devoted to casting in bronze, he began to use painted wood. His work began to be characterized by the construction of geometric reliefs in which the edges and curves transmitted a rhythm and vibration that were visibly potentiated by the effects of light and shadow. During the 1970s and 1980s Camargo moved from working with wood to using Carrara marble and a black fossil stone. In this period he created volumes that gave major protagonism to protuberances and total self-referentiality.

From the 1950s Camargo was influenced by European artists. Especially relevant was the influence of Constantin Brancusi. In *Homage to Brancusi* (1968), which Camargo created for the Bordeaux Faculty of Medicine, there is a reference to the *Endless Column* of this Romanian artist. *Homage to Brancusi* consists of cylindrical segments joined by irregular connections to form angles that break the ascending line of the column. In Camargo's works the modular construction of the volumes seeks to approach the question of tensions between masses. Nevertheless, these tensions are resolved within a general, austere aspect that is very much controlled, which reveals the strict organization of the geometric patterns in order to achieve specific effects of apparent chaos. In his wood reliefs of the 1960s the crucial role of the geometric elements–especially the cube and cylinder–can already be seen as repetitive patterns juxtaposed or interconnected that serve to construct vibrant surfaces on which there is no axis. This disperse, eccentric character is manifested in his marble sculptures as a principle of instability.

Camargo's preference for carving marble distinguished him from the artists of neoconcretism who recurred to industrial materials. But Camargo's marbles were carved industrially. In fact, the choice of Carrara marble was partly because of its ideal adaptation to machine cutting. The involvement of the machine indicates Camargo's entry into contemporary thought on what defines the authorship of a work of art, no longer determined by the artist's own involvement in terms of actually crafting the work.

Camargo's sculptures denote appreciation of pure form, with some references to the visual effects proper to optic art. In these works the modular and disperse nature and the economy of resources are crucial, something also cultivated by minimalism. There is as well a certain desire for sensory experimentation, which relates them to neoconcretism. Nevertheless, the use of marble indicates a certain modern classicism that once again refers to the avant-garde movements at the commencement of the twentieth century.

—Vivianne Loría

CAMINO BRENT, (Gustavo) Enrique
Peruvian painter

Born: Lima, 22 July 1909. **Education:** Colegio "San Agustín," Lima; Colegio Nacional "Nuestra Señora de Guadalupe," Lima, 1923–26; Escuela Nacional de Bellas Artes, Lima, graduated 1932; studied architecture, Escuela Nacional de Ingenieros, 1930–32. **Family:** Married María Rosa Macedo Cánepa in 1938; one son. **Career:** Teacher, Escuela Nacional de Bellas Artes, 1937–43; director, Escuela de Bellas Artes y Artesanía, Universidad de Huamanga, Ayacucho, Peru, 1959–60. Founder, Galería de Lima, 1941; founding member, Instituto de Arte Peruano, 1945. Traveled to the United States, Mexico, and Guatemala, 1946; visited Europe, 1956. **Awards:** Gold medal, Escuela Nacional de Bellas Artes, 1932; Premio de Honor Abraham Rodríguez, Salón de Pintura Viña del Mar, Chile, 1940; Premio "Motivos sobre Talara," Lima, 1941; posthumous gold medal, City of Lima, 1961. **Died:** Lima, 15 July 1960.

Individual Exhibitions:

1936	Sociedad Filarmónica, Lima
1938	Sala de la Academina Nacional de Música Alceda, Lima
1939	Galería Witcomb, Buenos Aires
	La Prensa, La Plata, Argentina
1949	Galería Witcomb, Buenos Aires
	Insula, Miraflores, Peru
1955	Pan American Union Gallery, Washington, D.C.
	Salón de la Alianza Francesa, Santo Domingo, Dominican Republic
1960	Sala de Exposiciones del Teatro Principal Manuel A. Segura, Lima
1961	Instituto Cultural Peruano Norteamericano, Lima
1963	Instituto de Arte Contemporáneo, Lima
1967	Art Center, Miraflores, Peru
1968	Galería Carlos Rodríguez, Miraflores, Peru
1974	Galería Municipal "Pnacho Fierro," Lima
1975	Galería de Arte Enrique Camino Brent, San Isidro, Peru

First exhibited in 1930 in Lima.

Selected Group Exhibitions:

1940	Salên de Pintura, Viña del Mar, Chile
1946	Teatro Municipal el Ballet Estampas Peruanas, Peru
1952	*Seis pintores peruanos,* Instituto Cultural Peruano Norteamericano, Lima
1970	*Cinco maestros del tema peruano,* La Galería Carlos Rodríguez, Miraflores, Peru
1979	Galería de Arte Moll, Miraflores, Peru

Collection:

Galeria de Arte Moll, Lima.

Publications:

On CAMINO BRENT: Book—*Enrique Camino Brent, 1909–1960* by Eduardo Moll, Peru, Editorial Navarrete, 1988. **Article**–''Notes on Contemporary Artists,'' in *Quarterly Bulletin of the San Francisco Museum of Art,* 2(2/4), 1942, p. 37.

* * *

Peruvian painter Enrique Camino Brent played an important role in the development of his nation's postcolonial art. A member of the first generation of artists associated with the Escuela Nacional de Bellas Artes (ENBA), Camino Brent was a pioneer of the indigenist style, an artistic nationalism that took Peruvian figures, buildings, and landscapes as its subject.

ENBA was founded in 1919 to formalize the artistic developments that were taking place in postcolonial Peru. The school exerted a profound influence on the development of Camino Brent's artistic career. He began attending the school when he was only 12 or 13 years old. While at ENBA Camino Brent studied under the Peruvian painter José Sabogal, as well as with Daniel Hernández and Manuel Piqueras Cotoli. He held his first exhibition in Lima in 1930, two years before he eventually finished his studies at ENBA.

This Lima exhibition featured paintings in the indigenist style to which he would cleave throughout his life. The paintings incorporated movement and bold contrast and were informed by images that he had seen during his travels to Cuzco, Puno, and Ayacucho, in rural Peru. Together with Sabogal and others Camino Brent produced a strain of art that was of a piece with the nationalistic government of Peruvian President Augusto B. Leguía y Salcedo.

After graduating from ENBA Camino Brent joined the school's faculty. He began exhibiting his work outside Peru in the early 1930s but also remained focused closer to home, establishing Galería de Lima in 1941. Camino Brent traveled widely during the 1940s and '50s, making frequent visits to the United States, Europe, and North Africa. Throughout this period his work retained his unique indigenist cast. In such paintings as *Herod's Balcony* and *Church of St. Sebastián at Huancavelica* (both 1937), he depicted distorted figures and architecture harking back to Peru's precolonial history. Camino Brent also frequently painted the run-down buildings of rural villages.

—Rebecca Stanfel

CAMNITZER, Luis

Uruguayan painter, printmaker, installation artist, and sculptor

Born: Lübeck, German, 6 November 1937; immigrated to Uruguay, 1939, moved to the United States, 1964. **Education:** Escuela Nacional de Bellas Artes, Universidad de la Republica, Montevideo, Uruguay, 1953–59, degree in sculpture 1959; Facultad de Arquitectura, Universidad de la Republica, Montevideo, Uruguay, 1957–62; Akademie der Bildende Künste, Munich, Germany, 1957–58. **Family:** Married 1) Liliana Porter, *q.v.,* in 1965 (divorced 1978); 2) Selby

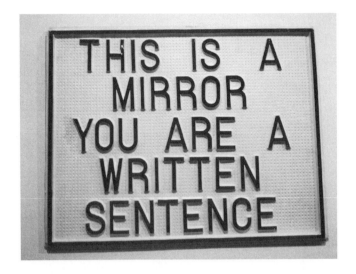

Luis Camnitzer: *This Is a Mirror. You Are a Written Sentence,* 1966–68. Photo courtesy of the artist.

Hicken in 1979, two sons. **Career:** Instructor, Escuela Nacional de Bellas Artes, Montevideo, Uruguay, 1960–64, and Fairleigh Dickinson University, Madison, New Jersey, 1968–69. Professor, 1969–2000, and since 2000 professor emeritus, State University of New York, Old Westbury; since 1999 curator, viewing program, The Drawing Center, New York. Guest instructor, Pratt Graphic Arts Center, New York, 1966, 1983–86; artist-in-residence, University of Pennsylvania, 1968. **Awards:** Annual printmaking prize, Academy of Munich, 1958; Arcobaleno Printmaking prize, Uruguay, 1961; John Simon Guggenheim memorial fellowship for creative printmaking, 1961, for visual art, 1982; Pratt Graphic Arts Center grant, 1962; second prize, Xylon, International Woodcutters Exhibition, Switzerland, 1965; Purchase prize, Museum of Trenton, New Jersey, 1968; prize, Biennial of Puerto Rico, 1970; prize, British International Print Biennial, Bradford, 1974; Art Matters grant, 1991; first prize ES96, Tijuana, Mexico, 1996; Latin American Art Critic of the Year award, Argentine Association of Art Critics, 1998. **Address:** 124 Susquehanna Avenue, Great Neck, New York 11021, U.S.A. **E-mail Address:** camnitzer1@aol.com.

Individual Exhibitions:

1960	Centro de Artes y Letras, Montevideo, Uruguay
1962	Galería Galatea, Buenos Aires
1963	Galería Sudamericana, New York
	Semanario Marcha, Montevideo, Uruguay
1964	Van Bovenkamp Gallery, New York
1966	Galería Lirolay, Buenos Aires
	Amigos del Arte, Montevideo, Uruguay
1967	*Mail Exhibition,* New York Graphic Workshop (traveling)
1969	Museo de Bellas Artes, Caracas
	Associated American Artists, New York
	Museo de Bellas Artes, Santiago de Chile
1970	Bienville Gallery, New Orleans
	Paula Cooper Gallery, New York
1971	*C.L.I.P. Documents,* Paula Cooper Gallery, New York
1972	Galleria Diagramma, Milan

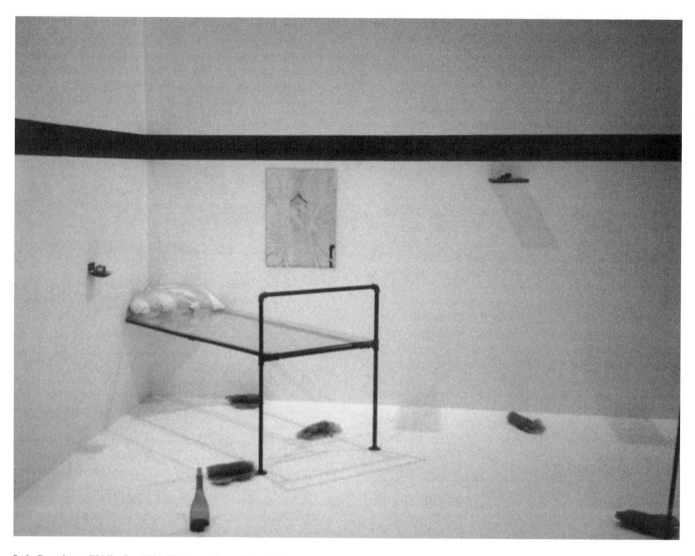

Luis Camnitzer: *El Mirador,* 1996. Photo courtesy of the artist.

	Libreria Einaudi, Milan
	Printshop, Amsterdam
1973	Galería Colibrí, San Juan, Puerto Rico
	Galleria Conz, Venice
	Galleria Banco, Brescia, Italy
1974	Galerie Stampa, Basel, Switzerland
1975	Stadt Bibliothek, Mainz, Germany
1976	Galerie Stampa, Basel, Switzerland
	Billa Schifanoia, Florence, Italy
	Galerie Space, Wiesbaden, Germany
	Galleria Ariete Grafica, Milan
1977	Museo de Arte Moderno, Bogota
	Museo de Arte Moderno, Cartagena, Colombia
	Commune di Adro, Brescia, Italy
	Gallery for New Concepts, University of Iowa, Iowa City
1978	Museo La Tertulia, Cali, Colombia
	C-Space Gallery, New York
	Marian Goodman Gallery, New York
1979	Galería San Diego, Bogota
	Cámara de Comercio, Medellin, Colombia

	Galería La Oficina, Medellin, Colombia
1980	Museum Wiesbaden, Germany
	Galerie Stampa, Basel, Switzerland
	Galerie 31, Strasbourg, France
	Cinemateca, Montevideo, Uruguay
1981	Cinemateca, Montevideo, Uruguay
1982	Galería San Diego, Bogota
	Galería Partes, Medellin, Colombia
1983	Museo de Gráfica y Dibujo Latinoamericano, Roldanillo, Colombia
	Casa de las Américas, Havana
1984	Alternative Museum, New York
	Galerie Stampa, Basel, Switzerland
	Isis Gallery, Notre Dame University, South Bend, Indiana
1986	Graphic Eye Gallery, Port Washington, New York
	Artworks, Berlin, Maryland
	Museo de Artes Plásticas, Montevideo, Uruguay (retrospective)
	Massachusetts College of Art, Boston
1987	Galerie Stampa, Basel, Switzerland

	Artworks, Berlin, Maryland
	Fundación San Telmo, Buenos Aires
	Fototeca, Havana
1988	Museo Histórico, Santa Clara, Cuba
	Centro Municipal Miraflores, Lima
1989	Museo Universidad Nacional, Bogota
1990	Carla Stellweg Gallery, New York (with David Lamelas)
1991	Parque Lussich, Punta del Este, Uruguay (with Mario Sagradini)
	Lehman College Art Gallery, Bronx, New York (retrospective)
	Nexus Contemporary Art Center, Atlanta (retrospective)
	Museo Blanes, Montevideo, Uruguay
	Galleria II Bisonte, Florence, Italy
	M.I.T. List Visual Arts Center, Cambridge, Massachusetts (retrospective)
1992	Cleveland State University Art Gallery (retrospective)
	I.C.I., Buenos Aires
1993	Museo Carrillo Gil, Mexico City
	Subterraneo Municipal, Montevideo, Uruguay
1994	Galería Tovar y Tovar, Bogota
	Museo La Tertulia, Cali, Colombia
1995	Galerie Basta, Hamburg, Germany
	El Museo del Barrio, New York
	Carla Stellweg Gallery, Nwe York
	City Gallery of Contemporary Art, Raleigh, North Carolina
1996	Museo Blanes, Montevideo, Uruguay
1997	Galerie Basta, Hamburg, Germany
2000	Casa de América, Madrid
	Blue Star Gallery, San Antonio, Texas
	The Tire Shop, Raleigh, North Carolina
2001	Anthony Giordano Gallery, Islip Museum at Dowling College, Oakdale, New York
	The Kitchen, New York

Selected Group Exhibitions:

1968	Smithsonian Institute, Washington, D.C.
1970	*Information,* Museum of Modern Art, New York
1984	*The Verbally Charged Image,* Queens Museum, New York
1987	*Latin American Artists in New York Since 1970,* University of Texas, Austin
1988	*Committed to Print,* Museum of Modern Art, New York
	The Latin American Spirit, Bronx Museum, New York
1991	*El paisaje en el arte uruguayo,* Museo de Bellas Artes, Santiago, and Museo de Artes Plásticas, Montevideo, Uruguay
1992	*Latin American Artists of the Twentieth Century,* Estación Plaza de Armas, Seville, Spain (traveling)
	Ante América, Biblioteca Luis Angel Arango, Bogota (traveling)
2000	*Versions del sur: 5 propuestas en torno al arte en Latinoamérica,* Museo Nacional Centro de Arte Reina Sofía, Madrid

Collections:

Museum of Modern Art, New York; Metropolitan Museum of Art, New York; Whitney Museum, New York; Fairleigh Dickinson University, New Jersey; Museo de Arte Moderno, Buenos Aires; Museo del Grabado, Buenos aires; Museo de Bellas Artes, Santiago; Museo Universitario, Mexico; Museo de Bellas Artes, Caracas; Museu de Arte Contemporaneo, São Paulo, Brazil; Museum of Malmo, Sweden; Museum of Trenton, New Jersey; Yeshiva University, New York; Bibliotheque Nationale, Paris; Biblioteca Communale, Milan; Library of Jerusalem; Museo de Arte Moderno, Bogota; Museo de Arte Moderno, Caragena, Colombia; Museo La Tertulia, Cali, Colombia; Museum Wiesbaden, Germany; National Museum of Modern Art, Baghdad; Museo de Gráfica y Dibujo Latinoamericano, Roldanillo, Colombia; College at Old Westbury, New York; Casa de las Américas, Havana; Museum Skopje, Yugoslavia; Centro Wifredo Lam, Havana; Museo Nacional de Bellas Artes, Havana; Jewish Museum, New York; Museum Lodz, Poland; Notre Dame University, South Bend, Indiana; Museo de Artes Plásticas, Montevideo, Uruguay; Museum of Contemporary Graphic Art, Fredrikstad, Norway; El Museo del Barrio, New York; Queens Museum, New York; University of Texas, Austin; Museum of Fine Arts, Houston.

Publications:

By CAMNITZER: Books—*Art in Editions: New Approaches*, exhibition catalog, New York, Pratt Graphics Center, New York University, 1968; ''Texto,'' exhibition catalog essay, New York, New York Graphic Workshop, 1969; exhibition catalog, San Juan, Puerto Rico, Galería Colibrí, 1973; exhibition catalog, Bogota, Museo de Arte Moderno, 1977; exhibition catalog, Medellin, Colombia, Chamber of Commerce Galería La Oficina, 1979; exhibition catalog, Germany, Museum Wiesbaden, 1980; exhibition catalog, Havana, Casa de las Américas, 1983; exhibition catalog, with Madeleine Burnside and Robert Browning, New York, Alternative Museum, 1984; exhibition catalog, Montevideo, Uruguay, Museo de Artes Plásticas, 1986; *Latin American Biennial of Prints,* exhibition catalog, New York, Museum of Contemporary Hispanic Art, 1986; *Signs of Transition: 80s Art from Cuba,* exhibition catalog, New York, Museum of Contemporary Hispanic Art, 1988; *Jimmie Durham: Dancing Serious Dances,* exhibition catalog, New York, Exit Art, 1989; *Young Cuban Art,* exhibition catalog, with others, Pori, Finland, Pori Museum of Fine Arts, 1990; exhibition catalog for Elso Padilla, Mexico City, Museo Carrillo Gil, 1990; *Luis Camnitzer: Retrospective Exhibition 1966–1990,* exhibition catalog, New York, Lehman College Art Gallery, 1991; *New Art of Cuba,* Austin, University of Texas Press, 1994; revised edition, 2002; *Global Conceptualism: Points of Origin,* exhibition catalog, with Jane Farver and Rachel Weiss, New York, Queens Museum of Art, 1999; ''Colonial Contemporary Art,'' in *Conceptual Art: A Critical Anthology,* edited by Alexander Alberro and Blake Stimson, Cambridge, Massachusetts, MIT Press, 1999; *Arte y Enseñanza: La ética del poder,* Madrid, Casa de América, 2000. **Articles**—''El hombre de la manzana y los otros,'' in *Marcha* (Montevideo, Uruguay), 28 August 1964; ''Interview con Salvador Dalí,'' in *Marcha* (Montevideo, Uruguay), 8 June 1964; ''Mas Pop: Entre el tedio y la nada,'' in *Marcha* (Montevideo, Uruguay), 23 April 1965; ''A Redefinition of the Print,'' in *Artist's Proff* (New York), VI (9–10), 1966, pp. 103–105; ''Tres Argentinos en Nueva York,'' in *Marcha* (Montevideo, Uruguay), 25 March 1966; ''Teatro social hippy,'' in *Marcha* (Montevideo, Uruguay), 19 January 1968; ''Museos,

calles y banquetes,'' in *Marcha* (Montevideo, Uruguay), 9 January 1970; ''Arte negro en Nueva York,'' in *Marcha* (Montevideo, Uruguay), 4 June 1971; ''Conceptuales vs. hiperrealistas,'' in *Arte en Colombia* (Bogota), 8, July 1978, pp. 63–66; ''Answers to Five Questions,'' in *Journal,* Los Angeles Institute of Contemporary Art, 25, November/December 1979, pp. 43–47; ''Exhibiciones recientes: Algunas consideraciones,'' in *Arte en Colombia* (Bogota), 9, April 1979, pp. 30–33; ''Selected Work,'' in *Gnome Baker Magazine* (New York), VI, spring 1980, pp. 20–35; ''La bienal de Venecia de 1980,'' in *Arte en Colombia* (Bogota), 19, October 1981, pp. 44–47; ''Ideologia y estética: Arte naz de los años treinta,'' in *Arte en Colombia* (Bogota), 21, May 1983, pp. 40–53; ''Visiones del norte,'' in *Arte en Colombia* (Bogota), 20, February 1983, pp. 54–56; ''Report from Havana, the First Biennial of Latin American Art,'' in *Art in America* (New York), December 1984, pp. 41–49; ''Es posible la enseñanza del arte?'' in *Arte en Colombia* (Bogota), 25, May 1984, pp. 58–68; ''Schwitters, personal, independiente, casi perfecto,'' in *Brecha* (Montevideo, Uruguay), 14 February 1986; ''Art Education in Latin America,'' in *New Art Examiner* (Chicago), 14(1), September 1986, pp. 30–33; ''Proyecciones de la enseñanza de arte,'' in *Plástica* (San Juan, Puerto Rico), 14, March 1986, pp. 29–30; ''La segunda bienal de la Habana,'' in *Arte en Colombia* (Bogota), 33, May 1987, pp. 79–85; ''Access to the Mainstream,'' in *New Art Examiner* (Chicago), July 1987, pp. 20–23; ''Arte inmaculado?'' in *Revista de Casa de las Américas* (Havana), 168, 1988, pp. 20–27; ''La computadora y el arte,'' in *Brecha* (Montevideo, Uruguay), 11 November 1988; ''An Art of Secular Mysticism: The Legacy of Juan Francisco Elso Padilla,'' in *New Art Examiner* (Chicago), November 1990, pp. 28–30; ''Spanglish Art,'' in *Third Text* (London), 13, winter 1990/ 1991, pp. 43–47; ''The Idea of the Moral Imperative in Contemporary Art,'' in *Art Criticism* (New York), 7(1), 1991, pp. 17–22; ''Art, Politics, and the Evil Eye,'' in *Third Text* (London), 20, 1992, pp. 69–75; Latin American art issue of *Art Journal* (New York), 51(4), 1992; ''Art and Politics: The Aesthetics of Resistance,'' in *NACLA* (New York), 2, 1994, pp. 38–43; ''Venice Biennial,'' in *Art Nexus* (Bogota), 34, 1999, pp. 56–61; ''Liliana Porter: The Poetry of Communication,'' in *Art Nexus* (Bogota), 35, 2000, pp. 68–71.

On CAMNITZER: Books—*Encounters/Displacements,* exhibition catalog, by Beverly Adams, Jacqueline Barnitz, and others, Austin, University of Texas, 1992; *The Subject of Torture: The Art of Camnitzer, Nuñez, Parra and Romero* (thesis) by Beverly Adams, Austin, University of Texas, 1992; *Ante América,* exhibition catalog, with text by Gabriel Peluffo, Bogota, Biblioteca Luis Angel Arango, 1992; *Camnitzer, Zanoobia,* exhibition catalog, text by Wolfgang Becker, Hamburg, Germany, Galerie Basta, 1995; *Luis Camnitzer: Critical Reality* (thesis) by Heather Van Horn, Albuquerque, University of New Mexico, 1999. **Articles—**''Benjamin, Camnitzer y nosotros: Sombras breves'' by Oscar Brando, in *Brecha* (Montevideo, Uruguay), 16 July 1993, p. 21; ''Luis Camnitzer: Pionero del arte conceptual en América Latina'' by Miguel González, in *El Pueblo* (Cali), 28 August 1983, pp. 8–10; ''El conceptualismo de Luis Camnitzer'' by Gerardo Mosquera, in *Casa de las Américas* (Havana), 139, July-August 1983, pp. 148–152; ''Luis Camnitzer: Análisis, lirismo, compromiso'' by Alicia Haber, in *Plástica* (San Juan, Puerto Rico), September 1988, pp. 34–40; ''Luis Camnitzer'' by Ana Tiscornia, in *Art Nexus* (Bogota), January 1996, pp. 88–89.

*

Luis Camnitzer comments:

I believe that art realizes itself in the viewer, not in the object. The object is a corridor that determines itineraries and flows between artist and recipient. The fact that historically the object has become a commercial fetish works as an obstacle to communication since the artist becomes a manufacturer of commodities instead of a cultural worker. Immersion in the work somewhat distracts from that obstacle by favoring experience over appearance. As a consequence I have given primacy to the installation mode for over three decades. Although with installations one runs the danger of the spectacle (another form of commodity), this seems a more manageable factor.

Once the immersion of the viewer is achieved, the artist may transmit data and stimuli. The viewer registers data as information. Data remains alien and doesn't affect the viewer until it becomes stimuli. I thus prefer to provide stimuli directly (when I use data I don't use it as information but as stimuli) trying to evoke things instead of narrate or explain them. It is in the process of evocation that the viewer is forced to organize him/herself, to make sense of the work, to complete it. It is in the determination of the parameters of evocation that the artist defines his or her mission.

The function of the parameters of evocation is twofold: one is to peek at my own conclusions within a thematic interesting to me; the other is to enable viewers in the search of their own conclusions. In that sense my own conclusions are incidental, autobiographic and anecdotal. They are, of course, a part of an ideology, but on an epidermic level. The enablement of the viewer, hi/her passage from consumer to agent, is part of a deeper ideology that brings to the fore my need to create freedom-generating catalysts. These are things unrelated to the issues of beauty. They are things that only have to do with what can be rescued from the space that was stolen from us.

* * *

Although he was born in Germany (a German Jew) and later migrated to the United States, Luis Camnitzer considers himself Uruguayan and holds a Uruguayan passport. He has defined himself as a ''citizen of memory,'' and his work is related to Uruguay and to his life there, based on the ties that attracted him to that country. An anti-mainstream attitude defines his work.

Camnitzer has been a leading conceptual and political artist in Uruguay as well as a conspicuous figure in those areas. He has fought against commodification of art and has sought to demystify of the role of the artist in capitalist society. Questioning traditional artistic practice, he has favored the ethical dimension of art that can resist repression and concentrates on political matters, particularly those related to Latin America. His work reveals interests in cultural identity, resistance and memory, the suffering caused by exile and political persecution, and critiquing of power.

At the same time his conceptual work deals with tautological and open meanings, metaphoric statements, and the evocative power of the image and the objects in relation to language. In his work after 1969 he explores the relationship between image and text and later between image, text, and objects. It establishes conflictive, unpredictable, disconcerting, and evocative moments creating contradictions, paradoxes, oxymoron, ambiguities, and open meanings. He works with the idea of the arbitrariness of meaning and lets the viewer interpret the work as he or she wishes. His objects are related to

aesthetics of poverty, and he has used pieces of shattered materials to show the fragmentation and complexity of reality, the lack of a united and coherent reality, and the difficulties involved in interpreting the world.

Camnitzer is an important figure in the field of art theory and thinking in Latin America. In his writings he deals with the freedom and repression, the ethics debate, language, identity, violence, and the discourse of art.

He started his career as a printer making etchings. He valued the social aspects of prints and knew that they could reach a great number of people. His intention was to democratize art. An expressionist style was present in those prints. In 1965 he started to make enormous woodcuts to emphasize the risk factor in creating them; his intention was to apprehend the unpredictable—to convey meanings and realities not evident or previously perceived. In 1965 he, Liliana Porter, and José Guillermo Castillo established the New York Graphic Workshop, putting a strong emphasis on art made for a mass audience.

But disappointment and a feeling of frustration caused by not achieving his goals led him to decide to work on an intellectual level—to use ideas to fight against the possession of an object. From then on he considered himself a cultural worker. He began to work with texts without images, then he used texts and images, and he worked with tautology as he did in *This is a Mirror You are a Written Sentence"* (1966), *Adhesive Labels* (1966), *Envelope* (1967), *Fragment of a Cloud* (1967), and *Self Portrait* (1969). In 1968 he created an environment of words, re-creating a living and dining room, and a year later it was exhibited in the Museum of Fine Arts of Caracas. One of his conceptual works was the selling of his signature per centimeter in 1971, in which irony was very much present.

He opened up to other facets that were not referential, and he became unsatisfied with tautology. In 1967 and 1968 he worked with dictionary pages; any image could accept all the meanings attributed by himself or the viewer. He started to produce random combinations of objects and titles written in advance; images, objects, and text are related in a peculiar way following a line explored by René Magritte. The pieces are open to various connotations and meanings. The relationships between text, objects, and images is complex and arbitrary, and the viewer is invited to participate in free association, although there are some meanings that are inaccessible. Some examples are *Arbitrary Objects and Their Titles* (1979), *In the Archeology of a Spell* (1979), *Fragments of a Novel* (1980), and *Treaty of Landscape* (1996).

Politics has been one of his major subject matters, particularly in relation to Latin America and repression there. *Massacre of Puerto Mont* (1969) was his first work in that area, which he has continued to explore, although later it became central in his productions, including *Common Grave* (1970), *From the Uruguayan Torture Series* (1982), *The Agent Orange Series* (1985), the Venice Biennale Installation (Uruguayan Pavillion, 1988), *Los San Patricios* (1991), and *The Books of the Walls* (1993).

He rejects oversimplified political art, the rhetoric of political demagogy, and any attempt to attribute specific meanings to his works; he prefers ambiguity and invites the viewer to awaken to perceptual, political issues and moral imperatives. Sometimes he acts as a historian and conducts thorough research, as he did for *Los San Patricios*.

—Alicia Haber

CAMPOS-PONS, María Magdalena
American photographer and mixed-media artist

Born: La Vega, Matanzas, Cuba, 1959; emigrated to the United States, 1990. **Education:** National School of Art, Havana; Superior Institute of Art; Massachusetts College of Art. **Family:** Married; one son. **Career:** Involved with the Cuban Artistic Renaissance and artist group *Bolume Uno,* Cuba, 1980s. Artist-in-residence, Bunting Institute, Radcliffe College at Harvard University, Cambridge, Massachusetts, *ca.* 1994. Based in Boston.

Selected Exhibitions:

1992	Contemporary Arts Museum, Houston
1994	*Rejoining the Spiritual: The Land in Contemporary Latin American Art,* Maryland Institute, College of Art, Baltimore
	Transcending the Borders of Memory, Norton Gallery of Art, West Palm Beach, Florida
	Intar Gallery, New York
1997	Schneider Gallery, Chicago
	Mario Diacono Gallery, Boston
	Johannesburg Biennale
1998	Museum of Modern Art, New York
	Lehman College Art Gallery, New York
	Crossings, National Gallery of Canada, Ottawa
1999	*Meanwhile, the Girls Were Playing,* Massachusetts Institute of Technology, List Visual Arts Center, Cambridge
2000	Howard Yezerski Gallery, Boston
	When I Am Not Here, Estoy Alla, Paul Creative Arts Center, University of New Hampshire Art Gallery
	William Benton Museum of Art, University of Connecticut, Storrs
2001	*Body/Culture/Spirit: Photographs by María Magdalena Campos-Pons,* Cleveland Museum of Art, Ohio
	Nesting, Howard Yezerski Gallery, Boston

Publications:

By CAMPOS-PONS: Article, photographed—"Santeria: An Alternative Pulse" by Elizabeth Hanly, with Tania Jovanovic, Luis Medina, and Bastienne Schmidt, in *Aperture* (San Francisco), 141, 1995, p. 30.

On CAMPOS-PONS: Books—*Rejoining the Spiritual: The Land in Contemporary Latin American Art,* exhibition catalog, text by Suzanne Garriques, Inverna Lockpez, and Barbara Price, Baltimore, Maryland, Maryland Institute, College of Art, 1994; *María Magdalena Campos-Pons: Meanwhile, the Girls Were Playing,* exhibition catalog, Cambridge, Massachusetts, MIT List Visual Arts Center, 1999; *Afro-Cuba, 'Woman,' and History in the Works of Ana Mendieta, María Magdalena Campos-Pons, and Marta María Pérez Bravo,* exhibition catalog, text by Robin Greeley, Storrs, Connecticut, University of Connecticut, 2000. **Articles**–"Portfolio" by Inverna Lockpez, in *Heresies,* 7(3), 1993, p. 84; "Transcending the Borders of Memory" by Randy Miller, exhibition review, in *Art Papers,* 19, May/June 1995, p. 43; "María Magadalena Campos-Pons" by Lois Tarlow, interview, in *Art New England,* 18, April/May 1997, p. 23;

María Magdalena Campos-Pons: *Replenishing,* **2000. Photo courtesy of Schneider Gallery.**

"History of People Who Were Not Heroes: A Conversation with María Magdalena Campos-Pons" by Lynne Bell, in *Third Text,* 43, summer 1998, pp. 33–42; "María Magdalena Campos-Pons: Museum of Modern Art, New York" by Olga Valle Tetkowski, in *Glass* (New York), 72, fall 1998, pp. 62–63; "New York: María Magdalena Campos-Pons at MOMA and Lehman College" by Eduardo Costa, in *Art in America,* 87(4), April 1999, p. 149; "Turning Points" by Lois Tarlow, in *Art New England,* 21(1), December 1999/January 2000, pp. 24–26; "María Magdalena Campos-Pons: MIT List Visual Arts Center" by Graciela Kartofel, in *Art Nexus* (Colombia), 36, May/July 2000, pp. 148–149; "Howard Yezerski Gallery/Boston: Nesting" by Shawn Hill, in *Art New England,* 22(2), February/March 2001, p. 49.

* * *

Born in the small town of La Vega in Matanzas, Cuba, María Magdalena Campos Pons immigrated to the United States in 1990. This move marked a significant shift in her work. The artist herself has noted that upon arriving in the United States, she became increasingly concerned with issues of race and gender and became more attuned to the meaning of being Cuban outside her home country. Fabrics, such as white cotton, and unexpected media, such as glass, found their way into Campos Pons's works as she began to reflect on the role of women and women's labor in society. Rather than overt references to such issues, however, the artist has preferred to make use of subtle symbolic elements and the role of memory in creating her imagery.

Using multimedia installation as her primary vehicle, Campos Pons has explored history and its relation to contemporary society through the experiences and lives of her Afro-Cuban ancestors. Taking the mundane and invisible as her starting point, the artist rendered domestic activity as a kind of ritualistic performance that she infused with aesthetic value. Interested in unofficial versions of history, Campos Pons called forth alternative narratives to reconstruct lost or forgotten stories through their protagonists.

In 1993 the artist began to work on a large three-part series titled *History of People Who Were Not Heroes: Growing Up in a Slave Barrack,* which she conceived of as both a personal narrative and "a monument to the history of every single black family in Cuba." The second part of this series, a video installation titled *Spoken Softly with Mama* (1998), was exhibited at the Museum of Modern Art in New York City. This work presented portraits of the artist's aunt and grandmother juxtaposed with images of the artist herself performing mundane domestic chores, all projected onto upright ironing boards. Neatly stacked linens were included and embroidered with the words *para su . . .* ("for her . . ."), a phrase that might be completed with words such as *marido, papá, hijo,* or *hermano* ("husband," "father," "son," or "brother"), alluding to the traditional roles occupied by women in society. Irons cast in glass are used to underscore this point. Fascinated by Marcel Duchamp's *Large Glass* (1915–23), Campos Pons took up glass as a way of divulging realities through transparency. In constructing her installations Campos Pons carefully considered which materials she would use—choosing clay, for example, to reference bricks and mortar—as she considered these kinds of materials to symbolize authenticity.

Other important installations and photographic series make reference to the significant role that African heritage has played in Cuban culture. The importance of this physical presence was reemphasized through the artist's use of her own body in her works. Often painted with symbolic images or colors, the body acts as further

evidence of the African tradition and its expression in both daily life and ritual. In the diptych *When I Am Not Here, Estoy Alla* (1996) the artist used her body as the canvas upon which to inscribe a narrative about being a part of two different places, two homelands, two nations, two realities. In the series *Identity* (1996) six images of the artist's face serve to evoke invisibility as the progressive "lightening" of the figure causes her face to fade into the background. In both these series the concept of a photograph as a highly reproducible object was undermined in Campos Pons's work. Taking large-scale Polaroid photographs, Campos Pons underscored the uniqueness of each of her images by creating large, single-edition, color-rich prints.

In her work *The Seven Powers Come by the Sea* (1993) Campos Pons juxtaposed seven large-scale panels, representing the seven *orishas,* or deities, of the Santeria pantheon. A mix of African and Catholic religions, Santeria is a belief system that fuses Yoruba deities with Catholic saints. Rites and rituals that take elements from both religions are also prevalent in Santeria. In this work the artist used miniature black-and-white photographs of individuals as surrogate *offrendas,* or offerings, to the deities. The portraits document a verifiable, physical history of the African presence in the Caribbean that the artist has attempted to regain through her work.

—Rocío Aranda-Alvarado

CAÑAS, Benjamín
Salvadoran painter, sculptor, and architect

Born: José Benjamín Cañas Herrera, Tegucigalpa, Honduras, 4 June 1933. **Education:** Studied architecture, 1952–57, graduated 1957, and painting, 1958–60, Universidad Nacional de El Salvador, San Salvador; studied sculpture under Enrique Salaverria and ceramics under Cesar Sermeno, 1960–62; studied drawing under Benjamin Saul, 1965–69. **Family:** Married Dora de Leon Vieytez in 1954; three children. **Career:** Worked in the Ministry of Public Works, San Salvador, 1952; worked in the architectural firm Noltenius & Choussy, San Salvador, 1954, and in the firm of José María Duran, San Salvador, 1955; director, Department of Plastic Arts, Universidad Nacional de El Salvador, San Salvador, 1969; architect, Watergate Improvement and Associates Inc., Washington, D.C., 1969. Moved to Washington, D.C., 1970; traveled to Paris, 1972, to Europe, 1973, to Germany, 1987. **Awards:** Honorable mention, *Biennial of São Paulo,* Brazil, 1987. **Died:** 8 December 1987.

Individual Exhibitions:

1964	Intercontinental Hotel, San Salvador
1969	Galeria Dideco, San Salvador
1970	Organization of American States, Washington, D.C.
	IBD, Washington, D.C.
1971	Janus Gallery, Greensboro, North Carolina
1972	*Neo-Humanism,* Watergate Gallery, Washington, D.C.
1973	La Maison de l'Amerique Latin, Paris
	Jean Camion Gallery, Paris
	Latin American Institute, Rome
1974	Brickell Gallery, Miami
1976	Galeria Alexis, San Salvador
1977	*XVI Biennial of São Paulo,* Brazil (retrospective)
1978	Janus Gallery, Washington, D.C.

1979 Washington World Gallery, Washington, D.C.
1980 Galeria Arte 80, Panama City
1988 Museo Forma, El Salvador
1989 Museum of Contemporary Art of Latin America,
 Washington, D.C.

Selected Exhibitions:

1965 Instituto National de Turismo, San Salvador
1967 Museo de Arte Moderno, Mexico City
1969 *São Paulo Biennial,* Brazil
1975 Museo Ponce de Leon, San Juan, Puerto Rico
1976 Modern Art Museum of Latin America, Washington,
 D.C.
1978 Museo de Bellas Artes, Caracas, Venezuela
1985 *Contemporary Latin American Masters,* CDS Gallery,
 New York
1986 Museo Nacional de Bellas Artes, Buenos Aires
1989 Art Museum of the Americas, Washington, D.C.
 (retrospective)
1999 Organization of American States Art Museum, Wash-
 ington, D.C.

Collections:

Art Museum of the Americas, Washington, D.C.; Museo Ponce de Leon, San Juan, Puerto Rico; Museo de Bellas Artes, Caracas, Venezuela; Miami Art Center; Museum of Contemporary Latin American Art, Washington, D.C.; Museo Forma, San Salvador.

Publications:

On CAÑAS: Book—*Tribute to Benjamín Cañas of El Salvador,* exhibition catalog, Washington, D.C., Museum of Modern Art of Latin America, 1989.

* * *

Benjamín Cañas's primary achievement was his formulation of a unique style of art that drew equally from his Central American roots and the European surrealist movement. He incorporated abstractionism and references to the Mayan culture of his native El Salvador to create neofigurative works, which he referred to as neohumanistic. His work was at once cosmopolitan and distinctly Central American.

Cañas's first interest was not art but architecture, which he studied at the National University in San Salvador. Upon graduation he found work with the firm of José María Duran, where he met and collaborated with José Napoleón Duarte, the future president of El Salvador. The fine-lined draftsmanship that characterized Cañas's later work had its roots in his training and work as an architect.

In 1958, after a stint in Mexico designing hospital buildings, Cañas enrolled in the School of Fine Arts in San Salvador. He studied painting from 1958 to 1960 and then shifted his focus to sculpture, under the direction of Enrique Salaverria, and ceramics, under Cesar Sermeno. At the same time that he immersed himself in art training, he continued to design buildings, including the Salvadoran Club (1958) and the National Expiratory Center of the Sacred Heart of R.R.P.P. Salecians in Guatemala (1964).

Cañas studied drawing under Benjamin Saul from 1965 to 1969. Saul, a Spanish artist who had mastered traditional European drawing techniques, exerted a profound influence on Cañas's artistic career. From Saul, Cañas learned surrealism and abstractionism, which would inform the first phase of his career. Cañas's early works, from about 1964 to 1968, belong to what has been classified as his "abstract period." Most notable among these works is *The Vase of History,* an abstract work painted in oil over etched plywood that Cañas exhibited at the Salvadoran Exposition at the São Paulo Biennial.

In the second phase of his career–the so-called Mayan period–Cañas turned to his country's Mayan background and mythology for his colors and themes. These works, which were completed from 1969 to 1972, followed in the Mayan tradition of employing a vocabulary of human forms to convey an abstract message. During this period Cañas garnered international recognition for his work. In 1970 he held an exhibit at the Visual Arts Unit of the Organization of American States in Washington, D.C. The 12 drawings and 8 oils, including the masterful *La creación del tiempo* (1969; "The Creation of Time") and *Angeles Mayas* (1970; "Mayan Angels"), sold on opening night.

In 1973 Cañas's style shifted again. He set aside the Mayan world as his sole source of inspiration and began to meld the principles of abstract and figurative painting. The result was both a new surrealism and a new figurative style. Cañas called the works neohumanistic. In these pieces he created a world reminiscent of Franz Kafka's novels, realistic, yet dreamlike. In *The Doll's Party* (1975), for instance, his subjects are isolated within cubist spheres. Their bodies are distorted, and miniature animals and people occupy the abstract spaces with them. Other works, such as *El crítico y el escultor* (1978; "The Critic and the Sculptor") and *Eros* (1977), are redolent with sexual themes.

In this neohumanistic period Cañas forged a paradigm of new figurative expression in Latin American art. He also demonstrated that Latin American artists could appropriate the themes and styles of European art and put a unique Latin American stamp on them. In *Icarus,* for instance, Cañas reworked both the myth of Icarus and European surrealism in a style that was entirely his own. Unfortunately, Cañas's career was cut short by his untimely death in 1987.

—Rebecca Stanfel

CANJURA, Noé
Salvadoran painter

Born: Apopa, 1922. **Education:** Academia de Valero Lecha, El Salvador (scholarship); studied on Salvadoran government grant in Mexico and Paris, 1949-late 1950s. **Career:** Involved with artist group *Group of Young Salvadoran Painters,* El Salvador, ca. 1945. Moved to Paris. **Died:** Paris, 1970.

Selected Exhibition:

2000 *Two Visions of El Salvador: Modern Art and Folk Art,*
 Inter-American Development Bank, Washington, D.C.

Publications:

On CANJURA: Books—*Canjura: Ou l'amerique, perdue et reconquise* by George Waldemar, Paris, Avant le Repas du Soir,

1961; *Two Visions of El Salvador: Modern Art and Folk Art,* exhibition catalog, Washington, D.C., Inter-American Development Bank, 2000.

* * *

The Salvadoran painter Noé Canjura began his studies on a scholarship at the painting academy of the Spanish-born Valero Lecha in San Salvador. Canjura, who later received a government grant to study outside El Salvador, belonged to a group of artists who came to be known as the ''academics,'' partly because of the influence of Lecha. For them art was a discipline, not an area for innovation. The paintings done by Canjura in the 1940s were almost identical in the way they were created and in their adherence to a regional realism that emphasized the ability to paint well according to traditional studio training. The academics solidified their identity partly as a result of the formation of another group of painters, the ''independents,'' who considered themselves vaguely proletarian and who were more politically active. In 1949 Canjura, with the most notable of the other academics and a few of the independents, left El Salvador to study in Mexico and then in Paris. At the end of the 1950s practically all of them, including Canjura, returned home and, together, established contemporary Salvadoran painting.

Canjura, although trained in the academic tradition, was in fact a proletariat. He sometimes had to walk 10 miles between Apopa, his native village, and San Salvador in order to attend painting classes. His later work, however, shows his sophisticated sensibility and a total divorce from the Salvadoran context, which he abandoned when he lived in France. Mauricio Aguilar and Benjamín Cañas were two other Salvadorans who followed his path and ultimately, unlike Canjura, made their lives in Europe. According to some critics, the central issue in defining contemporary Salvadoran art is the question of social purpose. The desire has been to revitalize painting by injecting it with social purpose through the use of imagined figurations. What has been sharpened is the idea of producing art with a social function and of directing it at an intellectually progressive society instead of at the peasants.

Color and the effects of light on form–as was understood by the postimpressionists–were Canjura's point of departure throughout his collection of pictorial works. In his 1969 piece *La multitud* (''The Crowd'') a suggestion of modern anonymity is enhanced by a fragmenting, flattening, and boxing of the faceless individual forms so that their parts–torso, forearm, striped pant legs–appear almost as pieces of a collage instead of paintings of pieces of a whole. Canjura was one of the driving forces behind the establishment of Salvadoran painting, which has become the primary medium for Salvadoran visual expression.

—Martha Sutro

CAPELÁN, Carlos
Uruguayan painter

Born: Montevideo, 1948. **Education:** Art Forum, Malmö, Sweden, 1978–81. **Career:** Lived in Lund, Sweden, 1974–96; moved to Costa Rica, 1996. Taught at Vestland's Art Academy, Bergen, Norway.

Individual Exhibitions:

1978	Galleriet (Anders Tornberg), Lund, Sweden
1979	Galerie Leger, Malmö, Sweden
	Universidad Central, Caracas
1982	Centre Chaillot-Galliera, Paris
1983	Galerie Leger, Malmö, Sweden
1985	*Ansikte,* Fotogalleri Ariman, Lund, Sweden
1986	*Ritual-Ytor-Bilder,* Galleri Mors Massa, Gothemburg, Sweden
	Skånska Konstmuseum, Lund, Sweden
	Galería Alternativa, Mexico City
1987	*superficies RITUAL imágenes,* Galerie El Patio, Bremen, Germany
	Rituals and Surfaces, Massachusetts School of Art, Boston
1988	Krognohuset, Lund, Sweden
	L'Espace Latinoaméricain, Paris
	Massachusetts School of Art, Boston
1989	Ronneby Art Center, Sweden
	Galerie El Patio, Bremen, Germany
	III Havana biennial
1990	*Pilgrims and Relics,* One Twentieth Gallery, New York
1991	*Karte-Landschaft-Raummalerei,* Gallerie Basta, Hamburg, Germany
	Galleri Mors Massa, Gothemburg, Sweden
1992	*Kartor och landsckap,* Lunds Konsthall, Lund, Sweden
	Mapas y paisajes, Subte Municipal, Montevideo
	Gallery Hertz, Bremen, Germany
1993	*Bedia och Capelán,* Kulturhuset, Stockholm
	Thanatocenosis, Jacob Karpio Gallery, San Jose, Costa Rica
	De Andra, Malmö Festivalen, Sweden
1994	Galería Fernando Quintana, Bogota
	Galería Angel Romero, Madrid
	Neuf, Maison de l'Amerique Latine, Paris
	Song to Myself, V Havana biennial
1995	*Faade,* Museum of Contemporary Art, Chicago
	XI mostra america, Museu de Gravura, Curitiba, Brazil
	La Zitelle, Venice
	Galerie Leger, Malmö, Sweden
1996	Lund's Cathedral, Lund, Sweden
1997	Miami Art Museum of Dade County, Miami
	Die Welt als Vorstellung, Galerie Monique Knowlton, New York (traveling)
	Galeria Caracol, Zaragoza, Spain
	La casa de la memoria, Museo Extremeño e Iberoamericano de Arte Contemporáneo, Badajoz, Spain
	Galerie Le Monde de l'Art, Paris
1998	Galería David Pérez-MacCollum, Guayaquil, Ecuador
1999	*Homage to the Native Nations of Germany,* WeltSichten, IFA Galerie, Berlin
	400 metros al norte del quiosco del Morazán, Fundación Teorética, San Jose, Costa Rica
2000	Galerie Leger, Malmö, Sweden
	Jet Lag Mambo, Henie Onstad Kunstsenter, Oslo, Norway
2001	*Post-Colonial Liberation Army,* Galería Angel Romero, Madrid

Selected Group Exhibitions:

1984 *Havana Biennale*
1989 *Latinoamérica despierta—Latin America Awakened,*
 Massachusetts School of Art, Boston
 Latinamerican Art Today, Art Center of Ronneby,
 Sweden
1992 *Ante América,* Banco de la República, Biblioteca Luis
 Angel Arango, Bogota (traveling)
1995 *Viajeros del sur,* Museo Carrillo Gil, Mexico
1996 *On Time,* Museum of Modern Art, Stockholm
1997 *I bienal Mercosur,* Museu de Arte de Porto Alegre,
 Brazil
1998 *Mesótica III: Instalomesótica,* Museo de Arte y Diseño
 Contemporáneo, San Jose, Costa Rica
 XXIV São Paulo Biennale
 Bienal del barro, Museo de Arte Contemporáneo Sofia
 Imbert, Caracas

Collections:

Art Museum of Gothemburg, Sweden; Art Museum of Sdertlje,
Sweden; Casa de las Américas, Havana; Centro Wifredo Lam,
Havana; Art School of Havana; Museo Extremeño e Iberoamericano
de Arte Contemporáneo, Badajoz, Spain.

Publications:

On CAPELÁN: Books—*In Fusion: New European Art,* exhibition
catalog, text by Gavin Jantjes, London, Ikon Gallery, 1993; *Carlos
Capelán: Obra reciente,* exhibition catalog, Bogota, Galería Fernando
Quintana, 1994; *Interzones: A Work in Progress,* exhibition catalog,
text by Octavio Zaya and Anders Michelsen, Copenhagen, Tabapress,
1996. **Articles—**''Carlos Capelán: Texts and Spirits'' by Gerardo
Mosquera, in *Third Text* (United Kingdom), 26, spring 1994, pp.
43–47; ''The Past As Subjective Experience'' by Ivonne Pini, in *Art
Nexus* (Colombia), 23, January/March 1997, pp. 52–56; ''Carlos
Capelán'' by Carol Damian, in *Art Nexus* (Colombia), 27, January/
March 1998, pp. 131–132; ''Crossings'' by Ruth Kerkham, in *Para-
chute* (Canada), 95, July/September 1999, pp. 44–45.

* * *

Diaspora permeated the work and life of Carlos Capelán. For
more than 20 years, since 1974, he resided in Lund, Sweden, where
he chose to live and work a hemisphere's distance from his na-
tive Montevideo. Observing one's homeland from a distance, in
Capelán's case, produced an interesting visual dialogue that reinter-
preted his memories of his Uruguayan roots and attempted to define
his displacement.

The themes of broken memories and displacement permeate
Capelán's multimedia works, where books, jails, cages, loose pages,
bottles, drawings, and photographs all form part of the visual display.
At times those dreamlike realities took the shape of paintings, and at
times they filled a room with conceptual installations. Capelán's
artistic and geographic wanderings, taking him to reside in Costa
Rica, have resulted in a rich tapestry asking questions about rootedness,
the powerful versus the powerless, and the hegemony of Western
culture over non-Western civilizations.

Anthropological sources influence Capelán's figures, which
appear almost always as two-dimensional line drawings with a power
that communicates with basic human instincts. Maps are referential
compass points for pieces like those shown in the *Ante America*
exhibition of 1992, but the maps traverse psychological and spiritual
spaces. The sacred and the ritual penetrate these maps and landscapes,
mixing the familiar with the dreamlike. The *Ante America* show,
organized by highly respected curators such as Cuban Gerado
Mosquera, was said to be important because it was one of the few
exhibitions organized from Latin America that traveled to the United
States. Capelán's presence in the show demonstrated the notion that
art and artists were globalized and did not need to remain physically in
a place to be able to identify with the place. Thus, the titles of
Maps and *Landscapes* assigned to the works he exhibited take on
additional meaning.

Capelán studied art formally at the Art Forum in Malmö,
Sweden, but clearly his education derived from internal conversations
about the meaning of his existence as a Latin American in self-
imposed exile. He has exhibited frequently in Europe, presenting his
mixed-media pieces in numerous photographic exhibitions, including
in Cologne and Hamburg, Germany. He has had numerous presenta-
tions in Malmö, Göteborg, and Lund. He was invited to exhibit at the
Havana Biennale in 1984, 1986, and 1989, and he represented
Uruguay in the São Paulo Biennale of 1998.

At the first Mercosur Biennale in 1997 in Pôrto Alegre, Brazil,
curators chose to organize around Latin American aspects of politics,
history, ecology, and culture (unlike traditional biennials with exhib-
its organized around participating countries). Capelán, working in
exile for so many years, found himself in the cartographic and
ecological sections. In his installation, a mural of powerful, primitive
figures dominates the space where wooden pillars seem to incarcerate
or contain them. The paradoxes presented by Capelán in his works
leave the viewer at times struggling to untangle the complexities of
books, piled high and forced shut with heavy stones, pages every-
where, and bottles filled with the ashes of charred texts. Capelán,
along with contemporary Latin American artists such as Uruguayan
Rimer Cardillo, struggled to interpret his own map filled with cultural
and emotional as well as geographic displacement. Capelán's intense
works raised questions about these themes in a way that boldly
confronted and intimately confided at the same time.

—Linda A. Moore

CAPELLÁN, Tony
Dominican painter, printmaker, and mixed-media artist

Born: Tamboril, 1955. **Education:** Universidad Autónoma de Santo
Domingo, Dominican Republic; Art Students League, New York.
Awards: Honorable mention, Concurso Carteles, Fundación Héroes
Constanza, Maimón y Estero Hondo, 1979; second prize, Carteles
Alfabetización, Secretaría de Estado de Educación, 1982; first prize,
Cartel Mujer Trabajadora, 1984; second prize in drawing, Día Mundial
de la Alimentación, 1986; first prize, Día Internacional de la Mujer,
1986; second prize, *XII bienal de artes E. León Jimenes,* Santiago,
1988; second prize, Concurso de Carteles CODIA, 1988; Premio
Unico de Dibujo, *Primer salón nacional de dibujo,* Museo de Arte
Moderno, Santo Domingo, 1989; first prize in sculpture, *XIII concurso*

bienal de arte E. León Jimenes, 1990; first national prize in engraving, *XVII bienal nacional de artes visuales,* 1990; first prize, *Bienal de San Juan del grabado latinoamericano,* Puerto Rico, 1991; gold medal, *Ier bienal de pintural del Caribe y Centroamérica,* Museo de Arte Moderno, Santo Domingo, 1992; second prize in drawing, *XVI concurso de arte E. León Jimenes,* 1992; second prize in drawing and honorable mention in painting, *Concurso duarte visual,* 1992; special prize in drawing, Banco Central, *XVIII bienal nacional de artes visuales,* 1992; Mid America Alliance/United States Information Agency International Fellowship and Residency Program, 1993–94; UNESCO-Aschberg grant, 1994; UNESCO Promoción de las Artes, 1995.

Individual Exhibitions:

1979 *Figuras del tiempo,* Círculo de Coleccionistas, Santo
 Domingo
1987 *Xilografías,* Biblioteca Nacional, Santo Domingo
 Grabados, Casa de Bastidas, Santo Domingo, and
 Ruinas del Gran Hotel, Managua, Nicaragua
1988 *Obsesiones cotidianas,* Museo de las Casas Reales,
 Santo Domingo
1990 *Trazos ceremoniales,* Plaza de la Cultura, Santiago,
 Chile
 Mitología y ritos, Galería de Arte Moderno, Santo
 Domingo
1991 *Trucámelos,* Galería Raíces, San Juan, Puerto Rico
 Zona mágica, Casa de Bastidas, Santo Domingo
1992 *Mitos del Caribe,* Museo de Arte e Historia de San
 Juan, Galería Raíces, Puerto Rico
 Amuletos, Casa de Francia, Santo Domingo
1993 *Kábalas,* Galería de Arte Nader, Santo Domingo
 Galería Nacional de Arte Contemporáneo, San José,
 Costa Rica
 Utopías, Casa de Bastidas, Santo Domingo
 Bastones de mando, Museo Universitario, Universidad
 Nacional Autónoma de Mexico
1994 *Exportadores de almas,* Museo de Arte Moderno, Santo
 Domingo
 Signos del Caribe, Galería Vértice, Guadalajara, Mexico
 Composite Caribe, Gary Nader Fine Art, Coral Gables,
 Florida
1995 *Marcha forzada,* Casa de Bastidas, Santo Domingo
 Preguntas sin repuesta, European Ceramics Center,
 Holland
 Exportadores de almas, Museo de Arte Moderno, Santo
 Domingo
1996 *Campo Minado,* Casa de Francia, Santo Domingo

Selected Group Exhibitions:

1983 *VI bienal de San Juan del grabado latinoamericano,*
 Puerto Rico
1987 *Arte domincano actual,* Museo de Arte e Historia de
 San Juan, Puerto Rico
1988 *Concurso carteles, IX festival nuevo cine
 latinoamericano,* Havana
1990 *Sculpture of the Americas into the Nineties,* Museum of
 Modern Latin American Art, Washington, D.C.

1993 *Festival internacional de fotografías: Fin de milenio,*
 Museo de Arte Moderno, Santo Domingo
1995 *Reaffirming the Spiritual,* El Museo del Barrio, New
 York
 Africus, I International Art Biennal, Johannesburg
1996 *XXIII bienal internacional de arte de São Paulo,* Brazil
 *Modern and Contemporary Art of the Dominican
 Republic,* Americas Society Art Gallery, New York,
 and Spanish American Institute, New York
1997 *Latin American Artists,* East Tennessee State University
 (traveling)

Publications:

On CAPELLÁN: Books—*Tony Capellán: Instalaciones,* exhibition catalog, Santo Domingo, Secretaria de Estado de Educación, Bellas Artes y Cultos, 1996; *Modern and Contemporary Art of the Dominican Republic,* exhibition catalog, New York, Americas Society Art Gallery and Spanish American Institute, 1996. **Articles**—"Tony Capellan" by Marianne de Tolentino, in *Art Nexus* (Colombia), October/December 1995, pp. 115–116; "Tony Capellán: El ritual de la contemporaneidad" by José Manuel Noceda, in *Atlantica,* 16, 1997, pp. 137–141.

* * *

Tony Capellán is a leading member of a generation of artists in the Dominican Republic whose work of the 1980s and '90s represented a departure from the generally conservative tendencies that had long characterized the visual arts in that nation. During this period of new economic prosperity and relatively greater political openness, younger artists were able to travel more and had greater exposure to international trends in the art world. A major influence for these artists was the Bienal de la Habana; many Dominican artists began to travel to and exhibit work in this international gathering of artists from First World and Third World nations. These developments encouraged Dominican artists to experiment with new artistic formats—especially the language of installation—and to direct their work toward examining the contemporary social and political realities of their region. It was in this environment that Capellán emerged as an influential voice for his artistic generation.

Early in his career Capellán painted small square canvases, each inhabited by such symbolic forms as silhouettes of the human body and pictograms that evoked his country's indigenous Arawak culture. He arranged the individual squares to create larger, richly symbolic works. In the early 1990s Capellán turned to installation to create pointed commentaries about Dominican and, more broadly, Caribbean life. These installations often involve the repetitive display of common, even cast-off, objects, as in *Pequeña esperanza* (1996; "Small Hope, Variable Dimensions"), in which clotheslines hold row upon row of schoolboys' uniform shirts. Each pocket poignantly holds a piece of bread and a pencil. With this work Capellán expresses the most common needs and hopes in a nation long gripped by poverty and illiteracy. Another installation of the same year, *La bandera de los ahogadas* ("The Flag of the Drowned"), expresses a stark social reality: the loss of Dominicans, as well as other would-be exiles from such nearby countries as Haiti and Cuba, who flee the island on flimsy boats or rafts only to drown at sea. The work is made up of a plethora

of well-worn sandals and shoes surrounding a cross-shaped container filled with water. With works like these Capellán has devised an aesthetic borne of poverty that relies on humble, relic-like forms to proffer meaning. Repetition becomes a device to underscore his message, as if each shirt or pair of shoes embodied an urgent but voiceless plea.

In his oeuvre Capellán has also explored a range of social issues, including the exportation of women from the Third World for prostitution and environmental problems in the Caribbean.

—Elizabeth Ferrer

CÁRDENAS, Agustín

Cuban sculptor

Born: Matanzas, 1927. **Education:** Escuela Nacional de Bellas Artes ''San Alejandro,'' Havana, 1943–49. **Career:** Cofounder and member, artist group *Los Once,* 1953–55. Moved to the United States, 1953, to Paris, 1955; returned to Cuba, 1994. **Awards:** National prize for sculpture, 1954; prize in sculpture, *Biennale de Paris,* 1961; **Died:** 2001.

Individual Exhibitions:

1955	Palacio de Bellas Artes, Havana
1961	Galerie du Dragon, Paris, and Galerie R. Feigen, Chicago
1962	Galleria Schwarz, Milan
1971	Galleria Lorenzelli, Bergamo, Italy
1973	*Cárdenas, sculptures récentes, 1972–1973,* Le Point Cardinal, Paris
1975	Centre d'Animation Culturelle, Montbéliard, France
	Cárdenas, sculptures récentes, 1973–1975, Le Point Cardinal, Paris
1979	*Cárdenas, marbres et bronzes, 1975–1979,* Le Point Cardinal, Paris
1980	FIAC, Paris
1981	*Cárdenas, marbres et bronzes, 1980–1981,* Le Point Cardinal, Paris
1982	Museo de Bellas Artes, Caracas, Venezuela
1984	FIAC, Paris
1990	*Agustin Cárdenas: Marbles, Woods, Bronzes,* Galeria Durban, Caracas, Venezuela
	JGM Galerie, Paris
	International Gallery, Chicago
1992	Galerie de l'Echaudé, Paris
1997	Galleria del Credito Valtellinese, Refettorio delle Stelline, Milan, and Couvent des Cordeliers, Paris (retrospective)

Selected Group Exhibitions:

1953	*Eleven Painters and Sculptors,* La Rampa, Havana
1956	L'Etoile Scellée Gallery, Paris
1996	*VIII International Biennial of Sculpture,* Carrara, Italy

Collections:

Museo de Arte Contemporáneo, Caracas, Venezuela; Musée d'Ixelles, Brussels, Belgium; Musee d'Art et d'Industrie, St. Etienne, France; George-Pompidou Center, Paris; Museo Nacional, Havana.

Publications:

On CÁRDENAS: Books—*Cárdenas,* exhibition catalog, by Edouard Glissant, Paris, Galerie du Dragon, and Chicago, Galerie R. Feigen, 1961; *Cárdenas: Mostra personale,* exhibition catalog, by José Pierre, Milan, Galleria Schwarz, 1962; *Agustin Cárdenas,* exhibition catalog, Bergamo, Italy, Galleria Lorenzelli, 1971; *La sculpture de Cárdenas* by José Pierre and Martine Franck, Bruxelles, La Connaissance, 1971; *Cárdenas, sculptures récentes, 1972–1973,* exhibition catalog, Paris, Le Point Cardinal, 1973; *Cárdenas: Sculptures,* exhibition catalog, Montbéliard, France, Centre d'Animation Culturelle, Maison des Arts et Loisirs Montbéliard, 1975; *Cárdenas, sculptures récentes, 1973–1975,* exhibition catalog, preface by André Pieyre de Mandiargues, Paris, Le Point Cardinal, 1975; *Cárdenas, marbres et bronzes, 1975–1979,* exhibition catalog, text by Edouard Glissant, Paris, Le Point Cardinal, 1979; *Cárdenas, marbres et bronzes, 1980–1981,* exhibition catalog, Paris, Le Point Cardinal, 1981; *Cárdenas: Bois,* exhibition catalog, Paris, JMG Galerie, 1990; *Agustin Cárdenas: Marbles, Woods, Bronzes,* exhibition catalog, Caracas, Galeria Durban, 1990; *Cárdenas: Sculture: 1947–1997,* exhibition catalog, text by Anna Ziliotto, Milan, Skira, 1997. **Article**—''Agustin Cárdenas'' by Christine Frérot, in *Art Nexus* (Colombia), 26, October/December 1997, pp. 142–144.

* * *

Agustín Cárdenas was one of the most significant Cuban artists of his time, receiving the national prize for sculpture in 1954. After graduating from the Academia de Bellas Artes of Havana, he worked with the sculptor Juan José Sicre from 1943 to 1949. In 1953 he became a founding member of the highly influential group Los Once (The Eleven), who called for a departure in style from Cuban art produced by the previous generations of artists. Although antecedents can be found in exhibitions in 1952, the formal launching of the group occurred on 18 April 1953, with the exhibition *Eleven Painters and Sculptors* at La Rampa, a commercial center in Havana. The exhibition was organized by painter Guido Llinás and sculptor Tomás Oliva and included painters René Avila, José I. Burmudez, Hugo Consuegra, Viredo Espinosa, Fayad Jamís, and Antonio Vidal and sculptors Francisco Antigua, Agustín Cárdenas, and José A. Diaz Peláez. The exhibition was well received in the press and led to six more group shows in the next two years. Later in 1953 Bermudez left to live in the United States; Rául Martínez replaced him and became one of the group's most outspoken leaders.

The Los Once group was much more than a band of artists emulating a New York style. Not only were they responsible for introducing abstract art into Cuba but they were also social and political activists. In protesting Fulgencio Battista's regime, Los Once artists refused to show in any official exhibitions and often created their own ''counter-exhibitions.'' It was Cárdenas's acceptance of a scholarship to study in Paris that precipitated the dissolution of the group, whose official disbanding was published in a note to a

newspaper on 6 June 1955. Although Los Once was short-lived, its influence cannot be underestimated. In addition to breaking with older generations of artists' depictions of the noble peasant and an investigation of what was "Cuban" in Cuban art, Los Once members introduced an entirely new vocabulary of visual ideas that were to be felt for many years.

Cárdenas contributed to Los Once and Cuban art in general by introducing an African-inspired aesthetic into nonfigurative Western sculpture. He first began this style of work in the early 1950s; he developed it further after establishing himself in Paris, where he had gone on a state-sponsored scholarship. In Paris Cárdenas settled in Montparnasse and met André Breton, who in 1956 invited him to participate in a surrealist group show at L'Etoile Scellée Gallery. Breton was a strong proponent of young Latin American artists, having supported and written on the work of Wifredo Lam, Roberto Matta, and Rufino Tamayo. Like Lam, Cárdenas reduced his African sources into a formal vocabulary without making any direct connection or reference to a specific African theme. Cárdenas's *Untitled,* a wood sculpture in the collection of Anita and Jay Hyman, dates from the 1950s and is a good example of this borrowing and reinterpretation of African sources and motifs. Like much of his work, this piece has been so abstracted by Cárdenas that its figures have become simple, rounded, softened forms. Its biomorphic shapes and undulations are as much about the artistic principles of line, shape, and balance as they might be about any particular (or general) figuration.

Cárdenas successfully translated this vocabulary into wood, marble, and bronze sculpture, as well as into fully realized drawings and gouaches, choosing scale and media appropriate to each piece. A fine example of his work in bronze is *Narcissus* from 1989. Although much later than his *Untitled,* this work, constructed of reduced geometric elements, nonetheless retains simplified, elegant forms. The figure's gaze downward, that expressive moment of the mythological story, is manifested by a solid, slender mass of bronze, making the gaze seen by the viewer. In some ways Cárdenas's figures not only remind the viewer of African forms and symbols but also, to a certain extent, the elegant figures found in art of the ancient Cycladic islands in the Aegean.

—Sean M. Ulmer

CÁRDENAS (ARROYO), Santiago
Colombian painter

Born: Bogotá, 1937. **Education:** Cummington Art School, Massachusetts, summer 1959; Rhode Island School of Design, Providence, B.F.A. in painting 1960; Yale University, New Haven, Connecticut, M.F.A. in painting 1964. **Career:** Professor, University of the Andes and National University, Bogotá. **Awards:** First prize in painting, 1960, and first prize in drawing, 1965, Providence Art Club, Rhode Island; first prize in painting, New Haven Arts Festival, Connecticut, 1964; first prize in painting, *III salón croydon,* Región de Bogotá, 1966; honorable mention in drawing, *I salón austral y colombiano de dibujo,* Museo de Arte Moderno La Tertulia, Cali, Colombia, 1968; Best Colombian Artist, *II bienal de Medellín,* Colombia, 1970; first prize in painting, *III bienal de Medellín,* Colombia, 1972; first prize in painting, *Salón nacional regional de tunja,* Colombia, 1976; first prize in painting, *XXVIII salón nacional de artistas colombianos,*

Bogotá, 1976; honorable mention, *LIV bienal de São Paulo,* Brazil, 1977; first prize in painting, *XXVI salón nacional de artes visuales.*

Individual Exhibitions:

1963	Asociación de Arquitectos Javerianos, Bogotá
1966	Museo de Arte, Universidad Nacional, Bogotá
1967	Galería Belarca, Bogotá
1970	Biblioteca Luis Angel Arango, Bogotá (with Carlos Rojas)
	Galería Belarca, Bogotá
1971	Museo de Antioquia, Medellín, Colombia
1972	Galería Belarca, Bogotá
1973	Center for Inter-American Relations, New York (with Carlos Rojas)
	Galería Conckright, Caracas, Venezuela
1974	Galerie 22, Paris
1975	Galería Aele, Madrid, Spain
1976	Galería Adler/Castillo, Caracas, Venezuela
	Museo de Arte Moderno, Bogotá
1978	Galería Cambio, Madrid, Spain
	Sala del Banco de la República, Popayán, Colombia (with Juan Cárdenas)
1980	FIAC, Grand Palais, Paris
	Centro de Arte Actual, Pereira, Colombia
	Museo de Arte, Universidad Nacional, Bogotá
	Galería Garcés Velásquez, Bogotá
1982	*Santiago Cárdenas: 1956–1982,* Museo de Arte Moderno La Tertulia, Cali, Colombia
	Museo de Arte Moderno, Medellín, Colombia
	Galería Garcés Velásquez, Bogotá
	FIAC, Grand Palais, París
1983	Frances Wolfson Art Gallery, Miami Dade Community College
	Rachel Adler Gallery, New York
1985	Galería Garcés Velásquez, Bogotá
1986	*Homenaje a Popayán, 450 años,* Centro Colombo Americano, Bogotá (with Edgar Negret and Juan Cárdenas)
	Museo Rayo, Roldanillo, Colombia
1987	Galería Garcés Velásquez, Bogotá
	Fundación Da Vinci, Manizales, Colombia
1988	Galería Cooperarte, Bogotá
	Galería Freites, Caracas, Venezuela
	FIAC, Grand Palais, París
1990	Galerie Ruta Correa, Freiburg, Germany
1991	*Santiago Cárdenas: Obra gráfica,* Banco de la República, Bogotá
	B. P. Galerie, Brussels, Belguim
1995–96	*Pintar la pintura,* Fundación Museo de Arte Contemporáneo Sofía Imber, Caracas, Venezuela, Museo Rufino Tamayo, Mexico City, and Biblioteca Luis Angel Arango, Bogotá (retrospective)
1997	James Goodman Gallery, New York

Selected Group Exhibitions:

| 1970 | *II bienal de Medellín,* Colombia |

1976 *XXVIII salón nacional de artistas colombianos,* Bogotá
 *Recent Acquisitions of Contemporary Painting and
 Sculpture,* Museum of Modern Art, New York
1977 *LIV bienal de São Paulo,* Brazil
1980 *Realism and Latin American Painting, the 70s,* Center
 for Inter-American Relations, New York and Museo
 de Monterrey, Mexico
1982 Inter-American Art Gallery, New York
1988 *Latin American Presence in the United States,* Bronx
 Museum of Art, New York
1994 *Cinco maestros colombianos,* Sala de Arte SIDOR,
 Guayana, Venezuela
1997–98 *Latin American Modern Works,* Rachel Adler Fine Art,
 New York
2000 *Una mirada al dibujo,* Museo de Arte, Universidad
 Nacional, Bogotá

Collections:

Museum of Art, Rhode Island School of Design, Providence; Chase
Manhattan Bank Collection, New York; Museum of Art, University
of Texas, Austin; Window South, Glendale, California; Museo de
Bellas Artes, Caracas, Venezuela; Casa de las Américas, Havana,
Cuba; Museum of Modern Art, New York; Museo de Zea, Medellín,
Colombia; Patronato Colombiano de Artes y Ciencias, Bogotá;
Instituto Colombiano de Cultura, Bogotá; Banco del Comercio,
Bogotá; Biblioteca Luis-Angel Arango, Bogotá; Museo de Arte
Contemporáneo, Minuto de Dios, Bogotá; Museo de Arte Moderno,
La Tertulia, Cali, Colombia; Centro de Arte Actual, Pereira, Colom-
bia; Museo de Arte Moderno, Río de Janeiro; Museo de Arte,
Universidad Nacional, Bogotá.

Publications:

On CÁRDENAS: Books—*Santiago Cárdenas and Carlos Rojas:
Obras recientes,* exhibition catalog, text by Galaor Carbonell, Bogotá,
Biblioteca Luis Angel Arango, 1970; *Santiago Cárdenas and Carlos
Rojas,* exhibition catalog, text by Bernice Rose, New York, Center for
Inter-American Relations, 1973; *Diez artistas y un museo* by Germán
Rubiano Caballero, Cartagena, Colombia, Museo de Arte Moderno,
1979; *Realism and Latin American painting, the 70s,* exhibition
catalog, text by Lawrence Alloway, New York, Center for Inter-
American Relations, 1980; *Santiago Cárdenas: 1956–1982,* exhibi-
tion catalog, Cali, Colombia, Museo de Arte Moderno La Tertulia,
1982; *Drawing,* exhibition catalog, New York, Inter-American Art
Gallery, 1982; *Santiago Cárdenas: Pinturas y dibujos* by Antonio
Caballero, Maria Mercedes Carranza, and Maria Elvira Samper,
Bogotá, Seguros Bolivar, 1989; *Santiago Cárdenas: Obra gráfica,*
exhibition catalog, text by Raúl Cristancho, Bogotá, Banco de la
República, 1991; *Santiago Cárdenas: Exposición retrospectiva,* ex-
hibition catalog, Bogotá, Banco de la República, 1995. **Articles**—
''Latin American Art: Surviving Distortion'' by Ricardo Pau-Llosa,
in *Drawing,* 14, November/December 1992, pp. 77–80; ''Santiago
Cárdenas: Luis Angel Arango Library, Bogotá'' by Germán Rubiano
Caballero, review of exhibition, in *Art Nexus* (Colombia), 20, April/
June 1996, p. 88–89; ''Santiago Cárdenas: James Goodman Gallery,
New York'' by K. K. Kozik, review of exhibition, in *Art Nexus*
(Colombia), 26, October/December 1997, p. 155–156.

* * *

After graduating from the Rhode Island School of Design and
earning a master's degree at Yale University, Santiago Cárdenas
Arroyo returned in 1966 to his native Colombia, where he established
his artistic practice. He is part of the generation of artists whose work
has reinvigorated a very conservative art scene in Colombia, a
generation that includes Bernardo Salcedo, Beatríz González (Aranda),
and Feliza Burzstyn, among others. In his early work it is possi-
ble to discern the influence of Allen Jones, Alex Katz, and Tom
Wesselman, but Cárdenas soon shifted to depicting everyday objects
like mirrors, coat hangers, and electrical cords in stark settings in
which the presence of architectural details acquired great importance.
These early canvases became literally tridimensional, with pictorial
planes that were detached from the main image and entered the
exhibition space.

One main characteristic of these works is that–not unlike
minimalist practices in the United States at the same time–they shifted
the viewer's emphasis from the work of art as such to its relation to the
architectural environment in which it was shown. These shaped
paintings, which sometimes covered part of a wall or floor in order to
extend the illusion of depth, gave way to a more pictorial illusion:
large canvases depicting empty interior spaces, with an occasional
isolated element such as a chair, an umbrella, or an electrical cord
plugged into a wall. These everyday objects were precisely executed,
with attention given to the play of light on the surfaces and the
shadows they projected on the spaces in which they were set.

Despite his mastering of the technique of painting, in particular
his command of visual illusion, Cárdenas is above all an analytical
artist whose visual research is centered on the perception of reality
and the limits of the medium, on work that blurs the frontiers between
reality and illusion. For example, paintings that depicted a mirror
leaning against a wall, a venetian blind, an empty frame, or a flattened
cardboard box seemed so real that viewers had doubts about the actual
nature of what was before them, and thus the experience of seeing was
replaced with one of doubt and awe. Faced with such a visual illusion,
people often tried to touch the pictures in order to regain command of
the situation.

But where Cárdenas's work is at its most radical is in his series
Pizarras. (He represented Colombia in the São Paulo Biennial of
1977 with this work.) The works consist of large painted surfaces that
resemble blackboards, with erasures and sometimes loosely drawn
figures on them. The paintings were executed with such mastery that
the viewer's attention is immediately drawn to the barely visible
markings on the blackboard, only to realize that even the thin wooden
frame that seems to surround the black surface is also painted. Subject
matter and its representation become one.

In the early 1980s Cárdenas shifted to an investigation of early
modernist imagery, with Matisse-like figures loosely drawn on the
''blackboards,'' whose neutral surfaces eventually became highly
colored and textured. The sensual chaos of the background in these
works contrasted with the pictorial precision of the object in the
foreground. Thus, after confounding the subject and its representa-
tion, Cárdenas became more interested in stressing the pictorial
nature of painting by exacerbating the contrast between the figure and
its background.

In 1995 the Luis Ángel Arango Library in Bogotá organized a
large retrospective of Cárdenas's work. The exhibition was also
shown at the Museo de Arte Contemporáneo de Caracas Sofia Imber
in Caracas and at the Museo Tamayo in Mexico City.

—José Roca

CARDOSO, María Fernanda

Colombian sculptor and installation artist

Born: Bogotá, 1963. **Education:** Studied in Colombia and the United States. **Career:** Has lived and worked in Sydney and San Francisco.

Individual Exhibitions:

1993	*The Frog Game,* Nohra Haime Gallery, New York
1994	MIT List Visual Arts Center, Cambridge, Massachusetts
1996	*The Cardoso Flea Circus,* Contemporary Arts Museum, Houston (traveling)
1997	*Flea Circus,* New Museum of Contemporary Art, New York
1998	New Museum, New York
1999	*ModernStarts: People, Places, Things,* Museum of Modern Art, New York

Selected Group Exhibitions:

1996	Ifa-Galerie Stuttgart, Germany (traveled to Ifa-Galerie Bonn, Germany)
1997	Monique Knowlton Gallery, New York

Collections:

Haines Gallery, San Francisco; New Museum of Contemporary Art, New York.

Publications:

On CARDOSO: Books—*María Fernanda Cardoso,* exhibition catalog, text by Ron Platt, Cambridge, Massachusetts, MIT List Visual Arts Center, 1994; *Cultura vita natura mors: Maria Fernanda Cardoso, Juan Fernando Herrán, José Alejandro Restrepo, Victor Robledo, Carlos Uribe,* exhibition catalog, by Iris Lenz, Stuttgart, Ifa, 1996; *Fuera de límite: Liliana González, María Fernanda Cardoso, Juan Fernando Herrán, Miguel Huertas,* exhibition catalog, Santafé de Bogotá, Colombia, Banco de la República, Biblioteca Luis Angel Arango, 1996. **Articles**—"Little Big Top" by Marilyn Berlin Snell, in *Utne Reader,* 75, 1 May 1996, p. 66; "María Fernanda Cardoso: In Search of Nature," in *Art Nexus* (Colombia), 20, April/June 1996, pp. 68–71; by Cathy Byrd, in *Art Papers,* 22, January/February 1998, p. 45; *María Fernanda Cardoso* by Nicolas Guagnini, in *Art Nexus* (Colombia), 29, August/October 1998, pp. 135–136; *Natural Selections* by David Weintraub, in *Art News,* 99(5), May 2000, p. 176; "Over a Fleapit, the Littlest Big Top Ever" by Peter Gotting, in *Sydney Morning Herald,* 26 July 2001.

* * *

María Fernanda Cardoso's work is based on the relationship between art and life. Through her sculptures and installations she promotes awareness of ecological destruction and questions the survival of the individual in the postindustrial era. Based on her observation of nature, her art refers in many cases to the scientific classification of objects. She chooses elements that, although they may be present in everyday life, few people take the time to understand or experience directly because of the denaturalized state of contemporary life.

Cardoso's pieces include natural elements such as dissected flies, lizards, toads, and sea horses. By placing them in a specific context or arranging them carefully in geometrical shapes, she gives them new conceptual meanings. Her work shares compositional characteristics with minimalism and *arte povera.* She experiments with the organic nature of objects to create compositions through the multiplication of natural forms. In *Untitled* (1990) frogs, lizards, crickets, and other dissected animals are assembled in geometrical patterns inspired by pre-Columbian abstract designs. In addition to the presentation of the objects as such, Cardoso's interventions often emphasize their natural balance and equilibrium.

The reference to pre-Columbian cultures can also be seen in Cardoso's installations. In *The Frog Game,* presented at the Nohra Haime Gallery in New York City in 1993, the artist displayed frogs, calabashes covered with gold leaf, a ball made of two human skulls, and gold droplets. The frog game is a popular pastime played in Colombia since pre-Columbian times. It consists of throwing rings at an open-mouthed frog placed in a box. The person scores if the ring enters the animal's mouth. Drinking while playing is customary, and *chicha* or *aguardiente,* local drinks, are usually served in calabashes. Cardozo uses objects loaded with spiritual and utilitarian meanings and rearranges them on the floor, creating her own version of the game. The golden element, also a clear reference to pre-Columbian objects, and the ball made of skulls, representing death and violence, add a new meaning. As with most of her works, Cardoso succeeds in creating a new order, merging aesthetics and symbolism.

In the work entitled *The Cardoso Flea Circus* (1996) the artist engages in an ongoing process of direct experimentation. After carefully researching earlier flea circuses, she re-creates her own version of this unusual spectacle. In her circus live fleas are observed, trained, and manipulated. The process, documented in video, is based on her interpretation of the relationship between art and life as expressed through the work with the fleas. Her intention is comprehensive, making her work a metaphor for the relationship between man and nature. In this case, however, working with live animals moves her from passive observation to direct control over the natural environment.

Cardoso studied in both Colombia and the United States. Aware of contemporary artistic trends, she makes use of her country's rich natural sources and cultural heritage, employing elements from pre-Columbian, colonial, and present-day traditions. Her work, rich in color, texture, and form, provides a unique visual experience that captivates the spectator and makes him or her a participant in her new ritualistic reality.

—Francine Birbragher

CARO (LOPERA), Antonio (José)

Colombian painter and conceptual artist

Born: Popayán, 1939. **Education:** Universidad Nacional, Bogota. **Career:** Instructor, Taller Experimental, 1990s. Involved with artist group *Grupo Cayc.* **Award:** Bolsa Colcultura, 1972; fellowship, Guggenheim Foundation, *ca.* 1990s.

Selected Group Exhibitions:

1970 *Salón panamericano de artes gráficas,* Cali, Colombia
1971 Bouwncentrum, Bogota
 Museo de Zea, Medellín, Colombia
 Bienal americana de artes gráficas, Cali, Colombia
1972 *Nombres nuevos en el arte de Colombia,* Museo de Arte
 Moderno, Bogota
 III bienal de Coltejer, Medellín, Colombia
 Primer salón independiente, Jorge Tadeo Lozano
1999 *Global Conceptualism: Points of Origin 1950s-1980s,*
 Queens Museum of Art, New York

Publications:

On CARO: Book—*Nombres nuevos en el arte de Colombia,* exhibition catalog, text by Gloria Zea de Uribe and Eduardo Serrano, Bogota, Museo de Arte Moderno, 1972.

* * *

Considered part of the beginnings of conceptual art in Latin America (and as such he was included in the *Global Conceptualism: Points of Origin 1950s-1980s* exhibition at the Queens Museum of Art in New York City in 1999), Colombian artist Antonio Caro has developed a subtle and precarious work right from the margins of the periphery (he is marginal even in Colombia), working often with indigenous communities and with everyday people. Caro studied art at the Universidad Nacional in Bogotá, and while still a student he made his first appearance in both the art world and the public sphere: during the National Salon of 1970 he showed a bust made of salt of Alberto Lleras—the president of the country at the time—inside a glass case. There was an implicit critique of the connections between art and power in the precariousness of the material (salt) vis-à-vis the tradition of commemorative sculpture. During the opening of the exhibition Caro put water into the case; as the sculpture slowly dissolved, the salty water flooded the exhibition space (indeed, one of the first performance pieces ever made in Colombia), causing a stir and catapulting Caro into the public realm as the local newspapers reported on the event.

From the beginning Caro's oeuvre has dealt with sociopolitical matters. His work, which he described as "idea-based," makes use of everyday materials (such as cigarette boxes or photocopies) and artistic procedures and is often ephemeral in its duration. One interesting thing about Caro's work is that he repeats the same motifs and artistic moves year after year, historically re-inscribing the works in each version, as if to say that the iteration of the same work in a different (cultural, political) moment makes it completely new and still pertinent. Thus, five or six themes have been reworked over and over during the last three decades: *Colombia-CocaCola, Maíz, Homenaje a Manuel Quintín Lame, Todo esta muy Caro, Proyecto Quinientos,* and *Achiote.* Along with *Maíz,* the *Quintín Lame* piece is the one that has probably had the most versions, appearing in small-scale drawings, flyers, wall drawings, and several editions of prints. Manuel Quintín Lame was a self-taught Indian leader from the 1920s who learned law in order to defend his people against neglect and abuse by the Colombian government. He was tried several times and spent more than 18 years altogether in jail without a single charge being proved against him. In the1980s a guerrilla group that aimed to defend the interests of the Indian community named itself after Lame,

so the original history has been replaced by a recent fact, leaving Lame's name related to current political violence. Caro first developed an interest in Lame in the early 1970s, in the wake of similar attitudes toward minorities prevalent in those days. Learning by heart Lame's signature, Caro reinstated a presence that all official histories had systematically obliterated. Lame's signature in itself is highly symbolic: a syncretism of nineteenth-century calligraphy and Indian pictograms, it has a formal quality that goes beyond an individual, depicting the presence of two communities in uneasy coexistence.

Caro's best-known work, *Colombia* (1976), portrays the name of his native country written in Coca-Cola typeface, a gesture akin to some pop strategies—to which his work is sometimes likened—but with a totally different political agenda. While addressing the patronizing relationship between America and his country, Caro's move has proved premonitory of the drug-related events (coca-Colombia) that have marked binational relations for the last decade.

Since the early 1990s—while continuing his reworking of past themes—Caro has begun a series that involved local communities, financed in part by a Guggenheim scholarship. *Itinerancia del taller* ("Itinerant Workshops") departs from the idea that every person has an artistic drive that needs an outlet to be expressed. Caro has traveled to small cities and worked with the people in these artistic-expression workshops, the results of which were often exhibited in museum contexts.

—José Roca

CARRASCO, Barbara
American painter and muralist

Born: El Paso, Texas, 1955. **Education:** University of California, Los Angeles, B.A. 1978; California School of Fine Arts, Valencia, M.F.A. 1991. **Family:** Married Harry Gamboa, Jr., *q.v.* **Career:** Muralist, including mural for Luis Valdez's play, *Zoot Suit,* 1978, and a computer animation mural, *Pesticide,* displayed on big screen monitor, Times Square, New York, 1989. Also worked as an artist and muralist with César Chávez and the United Farm Workers Union, 1976–91; involved in fighting artistic censorship against Community Redevelopment Agency, Los Angeles, early 1980s. Member of art collectives and community groups beginning in 1976, including Public Art Center and *Chismearte* magazine. **Awards:** Getty Visual Arts fellowship, 1998; City of Los Angeles fellowship, 1999–2000.

Selected Exhibitions:

1988 B-1 Gallery, Santa Monica, California
1989 *Pinturaltura–Vermillion Blues Spilling Exhibition,*
 Galería de la Raza/Studio 24, San Francisco (with
 Juana Alicia)
1990 *Image and Identity: Recent Chicana Art from 'La Reina*
 del Pueblo de Los Angeles de la Porcincula,' Loyola
 Marymount Laband Art Gallery, Los Angeles
1991 *'Self-Help' Artists: Painting and Printmaking in East*
 L.A., Laguna Art Museum, Laguna Beach, California
1993 *The Chicano Codices: Encountering Art in the Ameri-*
 cas, Mexican Museum, San Francisco (traveling)
 Chicano/Chicana: Visceral Images, Works Gallery, Los
 Angeles

2000 *An American Leader—César E. Chávez,* Latino
 Museum of History, Art and Culture, Los Angeles
 *C.O.L.A. 2000: Recent Work from C.O.L.A. Fellowship
 Recipients,* Hammer Museum, University of Califor-
 nia, Los Angeles

Has exhibited at the MIT Visual Arts Center, Cambridge, Massachu-
setts; Los Angeles County Museum of Art; San Francisco Museum of
Modern Art; Museo Estudio Diego Rivera, Mexico City.

Collections:

Stanford University, California; Smithsonian Institution, Washington,
D.C.

Publications:

On CARRASCO: Books—*Barbara Carrasco* by Harry Gamboa,
San Francisco, Galería de la Raza, 1989; *Artistas Chicanas: A
Symposium on the Experience and Expression of Chicana Artists,*
Santa Barbara, California, University of California, 1991; *Chicano
and Latino Artists of Los Angeles* by Alejandro Rojas, Glendale,
California, CP Graphics, 1993. **Articles**—"Art with a Chicano
Accent. Historical and Contemporary Chicano Art in Los Angeles"
by Steven Durland, Linda Frye Burnham, and Lewis MacAdams, in
High Performance, 9(3), 1986, pp. 40–45, 48–57; "A Contemporary
Moralist" by Shifra M. Goldman, in *Artweek,* 19, 23 April 1988, p. 3;
"L.A. Chicano Art" by Kristina van Kirk, in *Flash Art,* 141, summer
1988, pp. 116–117; "Entering the Professional Art Market without an
MFA" by M. A. Greenstein, in *Artweek,* 25, 5 May 1994, p. 17.

* * *

In 1983 artist Barbara Carrasco was commissioned to create a
mural for the 1984 Olympic Games. She created an elaborate piece
called *LA History—A Mexican Perspective.* The piece shows violent
discrimination and lynchings and chronicles the displacement of
Japanese Americans in internment camps during World War II. The
piece was rejected by the committee for being too angry, too offensive
to perspective Japanese tourists (in spite of favorable letters from the
Japanese community). Carrasco was asked to alter her piece to make
it more palatable; she refused to do so. *LA History—A Mexican
Perspective* now belongs to the United Farm Workers Union.

This fierce independence and belief in her work—a refusal to
compromise—is typical of muralist Barbara Carrasco. Growing up in
the Mar Vista Gardens housing project in Culver City, California,
Carrasco was taunted by her peers for being "too white" (later she
would create a piece called *Images and Identity* that would focus on
the issue of skin color within the Hispanic community). As a first
grader she drew continually on her desk, which resulted in her being
held back a year. Her parents encouraged her art, while at the same
time they expected her to be a "good girl." She rebelled by wearing
combat boots and army jackets, although she did have a Catholic
education (later she would document this in *13 Stations of the Double
Cross*). In the 1970s she went to UCLA, where she studied sculpture,
painting, and graphic art, earning a bachelor's degree.

Her piece *LA History—A Mexican Perspective* shows the history
of Los Angeles as viewed from a unique, minority point of view. In 51
panels that weave in the hair of the Queen of Los Angeles, Carrasco
strives to demonstrate the complexity of the history of Los Angeles.
Panels include images of the first black mayor of Los Angeles, the
murdered *Times* reporter Ruben Salazar, and the *Zoot Suit* playwright
Luis Valdez, as well as 17 of Carrasco's helpers.

Other pieces created by Carrasco have also been controversial.
In 1989 she created a computer-animated mural called *Pesticide* for
Times Square in New York. This piece shows the harmful effects of
pesticides. In spite of the strong activist streak in her work, Carrasco
can also be witty and use elements of kitsch in her work. In an
installation called *Codex Carrasco,* which is, in a sense, a parody of a
self-portrait, Carrasco purposefully uses what Los Angeles critic
Cathy Curtis calls a "bland style" to ironically undercut the Ameri-
can dream. Mundane images—fake wood paneling, a daisy sticker,
the Flintstones, a ticket to Disneyland—rub against the reality of life,
exemplified by a photograph with the caption "still in the projects."
Carrasco's dark humor also gets highlighted in a piece in which
Casper the Friendly Ghost, who is the star, watches the world end on
television while a bag full of groceries—again mundane products,
such as bleach, are used—is displayed. The work of Barbara Carrasco
questions the way we live. Her fiery nature comes through in murals
that are about the discrimination of women and people of color. In a
bold, sometimes ironic way, she gets her message across.

—Sally Cobau

CARREÑO, Mario
Cuban painter

Born: Havana, 24 June 1913. **Education:** Academia de San Alejandro,
Havana, 1925–c. 1930; Academia de San Fernando, Madrid, 1932–35;
Ecole des Arts Appliqués, Paris, 1937–39. **Family:** Married 1) María
Luísa Gómez Mena in 1942; 2) Ida González, two daughters. **Career:**
Joined *Grupo Minorista,* a group of avant-garde artists, 1927. Illustra-
tor, *Revista de Havana* and *Diario de la Marina* magazines, 1927.
Lived in Spain, 1932–35. Instructor, Academia de San Alejandro,
Havana, 1935. Traveled to Mexico, 1936; lived in Paris, 1937–39,
and in Italy, 1939; returned to Havana, 1941; lived in New York,
1944–50. Instructor, New School for Social Research, New York,
1944–48. Moved to Santiago, Chile, 1957. **Awards:** Guggenheim
International Award; Annual Critics prize; National Prize for Art,
Santiago, 1982. **Died:** Santiago, 21 December 1999.

Individual Exhibitions:

1930 Sala Meras y Rico, Havana
1941 Perls Gallery, New York
1943 Institute of Modern Art, Boston
 San Francisco Museum of Art
1944 Perls Gallery, New York
1945 Perls Gallery, New York
1947 Pan American Union, Washington, D.C.
1950 New School for Social Research, New York
1951 Perls Gallery, New York

Mario Carreño: *Cuba Libre,* **1945. © Smithsonian American Art Museum, Washington, D.C./Art Resource, NY.**

Mario Carreño: *Nudes with Mangos,* 1943. © Christie's Images/ Corbis.

Selected Group Exhibitions:

1943	*The Latin American Collection of the Museum of Modern Art,* New York
1944	*Modern Cuban Painters,* Museum of Modern Art, New York
1946	Pan American Union, Washington, D.C.
1947	Morse Gallery, New York
1951	*Pittsburgh International Exhibition,* Carnegie Institute
1952	Pan American Union, Washington, D.C.
1956	*Pittsburgh International Exhibition,* Carnegie Institute
1959	*The United States Collects Latin American Art,* Art Institute of Chicago
1966	*Art of Latin America since Independence,* Yale University, New Haven, Connecticut, and University of Texas, Austin
1989	*The Latin American Spirit: Art and Artists in the U.S.,* Bronx Museum, New York

Collections:

Museum of Modern Art, New York; Musée d'Art Moderne, Ceret, France; Museum of Fine Arts, Chile; Metropolitan Museum, Miami; San Francisco Museum of Modern Art; Museum of Modern Art of Latin America, Washington, D.C.; Carroll Reese Museum, Nashville.

Publications:

On CARREÑO: Books—*Carreño,* exhibition catalog, by José Gómez Sicre, Washington, D.C., Pan American Union, 1947; *La soledad en dos pintores chilenos: Mario Carreño y Ricardo Yrarrázaval* by Alberto Pérez, Santiago, Editorial Fértil Provincia, 1992.

* * *

Mario Carreño was a member of the second generation of Cuban modernists. Born in 1913 in Havana, the precocious Carreño entered the Academy of San Alejandro at the age of 12. As a youth he worked as a newspaper illustrator in the capital city, and his prodigious talents were recognized in his first solo exhibition, in 1930. The show featured a series of drawings of heroic sugarcane workers rendered in a futuristic style that he must have learned from the Grupo Minorista, the first generation of modernists on the island, who began exhibiting in 1927. Carreño's emphasis on this subject was controversial since sugar was Cuba's principal export during the dictatorship of Gerardo Machado (1925–33), and the plight of peasants who worked in the industry was well documented. Many Cubans also resented the island's economic dependence on the United States and the cozy relationship between wealthy landowners, politicians, and the U.S. government, which set production quotas and prices. Carreño's early style in these drawings and later paintings was notable for a cubist fragmentation of form. His muscular males and voluptuous females seem to move with the agitated rhythms that characterize European futurist figural design.

From 1932 to 1935 Carreño lived in Spain, where he designed social and political posters, mostly in support of the Spanish Republic. He returned to Cuba in 1935, just before the start of the civil war, and taught at the Academy of San Alejandro in Havana. He went to Mexico the following year and was greatly impressed with the work of the muralists, particularly that of David Alfaro Siqueiros. He was especially responsive to dynamic and even aggressive figural compositions. In the years 1937–39 he returned to Europe, traveling extensively in France and Italy, where he studied the works of Picasso and the surrealists as well as the art of ancient Pompeii. He spent the early years of World War II in New York City, where he exhibited frequently at the Perls Gallery. Next to Wifredo Lam, he was the best known Cuban artist outside his homeland. In 1942 he married María Luísa Gómez Mena, the great patron of modern art. The couple hosted the American curators Alfred H. Barr and Edgar J. Kauffman from the Museum of Modern Art in New York City on their trip to Cuba during the war. Their visit culminated in the celebrated 1944 exhibition of Cuban modernists at the museum, in which Carreño exhibited.

In the 1940s and 1950s Carreño developed a distinctive style that approximated the work of the surrealists. His paintings became increasingly spartan in composition and geometric in design. He stated that in the 1960s he was increasingly preoccupied with issues of war and human suffering. In 1957, at the outset of the Cuban revolution and at the urging of his close friend the writer Pablo Neruda, Carreño left Cuba permanently and settled in Santiago de Chile. After the 1958 revolution he maintained an ambivalent relationship to his homeland, and he became perhaps the best known Cuban modernist living in exile.

—H. Rafael Chácon

CARRILLO, Charlie
American woodcarver and painter

Born: Charles Michael Carrillo, Albuquerque, New Mexico, 1 January 1956. **Education:** University of New Mexico, Ph.D. in anthropology 1996. **Family:** Married Debbie Barbara Eliza Trujillo; two children. **Career:** Created more than 6,000 religious objects. Since 1982 lecturer on New Mexican Santos and crafts. **Awards:** Second place, 1981, merit award, 1984, second place retablo, 1985, honorable mention, 1986, Hispanic Heritage award for in-depth research, International Folk Art Foundation, 1987, 1988, and 1989, grand prize best of show award, 1990, E. Boyd memorial award, 1991 and 1994, first place, gesso relief retablo, 1992 and 1993, and Florence Dibell Bartlett award, International Folk Art Foundation, 1994, all Spanish Market; second place, Santa Fe Festival of the Arts, New Mexico, 1981.

Selected Exhibitions:

1981	Santa Fe Festival of the Arts, New Mexico
1983	*The New Mexican Santero,* El Rancho de las Golondrinas, La Cienega, New Mexico
1986	Gallery One, Albuquerque
	Weyrich Gallery, New Mexico
1987	*From the Inside Out: Mexican Folk Art in a Contemporary Context,* Mexican Museum, San Francisco
1989	*El dia de los muertos,* Mexican Fine Arts Center Museum, Chicago
	Museum of International Folk Art, Santa Fe, New Mexico
	New Mexico Highlands University (individual)
	Charlie Carrillo, Ramón Móntee and Horacio Valdez, Móntez Gallery, Santa Fe, New Mexico
1990	*From Folk to Fine: Hispanic Artists of Northern New Mexico,* Center for the Arts of the Southwest, Santa Fe, New Mexico
1991	*Chispas!, Cultural Warriors of New Mexico,* Heard Museum, Phoenix (traveling)
	New Mexican Woodcarvers, University of California, San Diego
	Images of Penance, Images of Mercy: Southwestern Santos in the Late Nineteenth Century, Walters Gallery, Baltimore, Maryland (traveling)
1992	*American Encounters,* Smithsonian Institution, Washington, D.C.
1993	*Charles M. Carrillo: Santos,* Albuquerque Museum
1994	*Cuando hablan los santos: Contemporary Santero Traditions from Northern New Mexico,* Maxwell Museum of Anthropology, Albuquerque University of New Mexico
	Crafting Devotion: Tradition in Contemporary New Mexican Santos, Gene Autry Western Heritage Museum, Los Angeles (traveling)

Collections:

Regis University, Denver; Denver Art Museum; Albuquerque Museum; Heard Museum, Phoenix; Millicent Rogers Museum, Taos, New Mexico; Taylor Museum, Colorado Springs, Colorado; Mexican Fine Arts Center Museum, Chicago; Museum of International Folk Art, Santa Fe, New Mexico; National Museum of American History, Smithsonian Institution, Washington, D.C.

Publications:

By CARRILLO: Articles—"Colored Earth: The Tradition," in *Traditional Southwest,* fall 1989; "Traditional New Mexican Hispanic Crafts: Ayer y hoy—Yesterday and Today," in *1991–92 Wingspread Collector's Guide.*

On CARRILLO: Books—*Crafting Devotion: Tradition in Contemporary New Mexico Santos,* exhibition catalog, text by Laurie Beth Kalb, Albuquerque, University of New Mexico Press, 1994; *Charlie Carrillo: Tradition & Soul* by Barbe Awarlt and Paul Fisher Rhetts, Albuquerque, LPD Press, 1995. **Article—**"Charlie Carrillo: The Soul of a Contemporary Santero" by Paul Rhetts, in *Christianity and the Arts* (Chicago), 3(1), February 1995, pp. 43–45.

* * *

Santos have been made for centuries in former Spanish colonial territories. They are often based on early Christian iconography, and they are intended for public and private devotional purposes. The term santo, which means "saint" in Spanish, also refers, in the context of New Mexico, to an image of a saint or a bibilical event. The artists who make santos are known as *santeros.* Charlie Carillo has done more than any other *santero* to preserve the traditional methods of this centuries-old art.

The santos tradition began in New Mexico in the eighteenth century. Two of the earliest known *santeros* were Pedro Antonio Fresquis and an artist known as Molleno. The first *santeros* were trained in Mexico to provide devotional images to remote colonies in what is now New Mexico. Initially Franciscan priests were responsible for making santos, but gradually they passed this responsibility on to local artists, who adapted the tradition and made it something unique. *Santero* images often emphasize the humanity of a particular saint and downplay the centrality of Christ. They served as illustrations to help priests in the Spanish colonies explain the stories of the saints and the Bible to an illiterate audience. But the stories depicted in the santos are often different from traditional biblical stories seen in European religious art. They include visual elements drawn from the Native American cultures of the American southwest, blending European and Native American iconography.

It is not enough to simply create santos. The *santero* also carries on a tradition—in the materials and methods used and in the preservation of stories that describe the tradition of the santos. Carrillo makes his own pigments and gesso, often based on recipes that can be traced back as far as Fresquis and Molleno. With natural pigments and his own stains he achieves bright colors identical to those of the early colonial *santeros.*

Carrillo has created more than 6,000 devotional images during his career, including retablos, or flat pictures, and bultos, or three-dimensional statues. His primary materials are acrylic paint, woods such as pine and cottonwood, and gesso. Some of the bultos are made by molding the detailed features in gesso, allowing a level of detail that would be impossible in wood.

Carrillo's interest in santos did not stem from Catholic devotion; it developed while he was studying anthropology. In 1978 Carrillo

joined the Penitente Brotherhood, a group of lay Catholics whose practice emphasizes the redemptive power of suffering and death. The Penitente Brotherhood is a controversial and distinctively New Mexican phenomenon, and santos have a central place in the *morada*, the buildings where the Penitentes gather and pray.

Carrillo is part of a family of artists. His wife, Debbie, is a traditional potter while his children, Estrella and Roan, are also *santeros*. As an artist he continued to be at the forefront of a movement to discover, preserve, and communicate New Mexican folk traditions and to bring attention to santos as one of the longest-standing traditions in American folk art.

—Amy Heibel

CARRILLO, Lilia
Mexican painter

Born: Mexico City, 2 November 1930. **Education:** Escuela de Pintura y Escultura La Esmeralda, Mexico City, 1947–51; Académie de la Grande Chaumière, Paris, 1953–55. **Family:** Married 1) Ricardo Guerra in 1951, two sons; 2) Manuel Felguérez, *q.v.*, in 1960. **Career:** Worked at Galerías Chapultepec del INBAL, Mexico, 1956. Traveled to the United States, 1966; to Spain, 1967. Involved with avant garde artist group *Ruptura*, Mexico, 1950s; cofounder, *Salón independiente*, 1968. Also worked as a stage designer, 1960s, and a muralist. **Award:** Second prize, *Salón Esso*, Mexico City, 1965. **Died:** Mexico City, 6 June 1974.

Selected Exhibitions:

1956	Galería Carmel-Art, Mexico
1957	Galería de Antonio Souza, Mexico City
1958	*Primer salón nacional de pintura de bellas artes,* Mexico City
	Martin Schwerg Gallery, St. Louis, Missouri
	Galería de Antonio Souza, Mexico City
	Nuevos exponentes de la pintura mexicana, Museo de la Universidad, Mexico
	I bienal de jóvenes, Paris
1960	Pan American Union, Washington, D.C.
1961	Galería de Antonio Souza, Mexico City
	Instituto de Arte Contemporáneo, Lima, Peru
	VI bienal de Tokyo
	VI bienal de São Paulo, Brazil
	Galería Juan Martín, Mexico City
1962	Instituto de Arte Contemporáneo, Lima, Peru
1963	Galería Juan Martín, Mexico City
1964	Museo de Arte Moderno de Mexico, Mexico City
	II exposición anual de pintura panamericana, Barranquilla, Colombia
	Galería de la Casa del Lago, Mexico City (retrospective)
1965	*Actitudes plásticas,* Galería Aristos de la UNAM, Mexico City
	Pintura contemporánea de México, Casa de las Américas, Havana
1966	*Confrontación 66,* Palacio de Bellas Artes, Mexico City

	Casa de las Américas, Havana
1967	Galería Juan Martín, Mexico City
	Tendencias del arte abstracto en México, Museo de la Ciudad Universitaria, Mexico
	Museo de las Américas, Madrid
1968	Galería Juan Martín, Mexico City
1969	Galería Lepe, Puerto Vallarta, Mexico
	Palais des Beaux Arts, Paris
	Segundo salón independiente, Museo de Ciencias y Arte, Ciudad Universitaria, Mexico
1970	Galería Juan Martín, Mexico City
1974	Instituto Nacional de Bellas Artes, Mexico City
2001	*50 mujeres en la plástica de México,* Galería Metropolitana, Mexico City
	The Sixties in Mexican Art, Museo de Arte Moderno, Mexico City

Collections:

Museum of Modern Art, Mexico City; Museo de Arte de Sinaloa, Mexico; Mexican Museum, San Francisco.

Publications:

On CARRILLO: Books—*El corazón cae fuera del camino* by Armando Zárate, Mexico, Cuadernos del Viento, 1963; *Nueve pintores mexicanos* by Juan García Ponce, Mexico, Ediciones Era, 1968; *Homenaje a Lilia Carrillo,* exhibition catalog, Mexico, El Instituto Nacional de Bellas Artes y Literatura, 1974; *Lilia Carrillo,* exhibition catalog, Monterrey, Mexico, Museo de Arte Contemporáneo de Monterrey, 1992; *Lilia Carrillo: La constelación secreta* by Jaime Moreno Villarreal, Mexico, Ediciones Era, 1993. **Article**—"Lilia Carrillo (book review)" by Juan Villoro, in *Artes de Mexico,* 26, September/October 1994, pp. 88–89.

* * *

The mystical abstract style that Lilia Carillo developed in the 1950s was quite contrary to the dominant spirit of Mexican art of that time. The themes found in many of the prominent Mexican works of art reflected the history of Mexico, particularly the socialist spirit of the Mexican revolution. Thus the concept of incorporating national iconography into one's artwork was the dominant style taught at the Escuela Mexicana de Pintura (Mexican Painting School), which had inspired the well known muralists Diego Rivera, Jose Orozco, and David Siqueiros.

Carillo was part of a group of artists who rejected the Mexican Painting School style. Called *ruptura,* or the rupture movement, the group was formed in reaction to the predominant socially conscious art and instead focused on "pure painting." Of these maverick artists, some were united by their devotion to the human image, whereas others were primarily concerned with pure abstraction. Carillo, an abstractionist, was the only woman to have emerged from the rupture movement. Some critics claim that the movement was, in principle, opposed to socially relevant art. That, however, was not the case, as some rupture artists explicitly dealt with social issues. What the rupture did reject was the idea that artistic creativity should conform to state ideology. Artists identified with the rupture worked in a variety of styles. For example the Nueva Presencia, including Arnold

Belkin, Francisco Icaza, and Luis Cuevas, remained dedicated to representing the human image. In essence the fundamental idea behind the rupture was artistic freedom.

Like other rupture artists, Carillo believed that an artist expresses a personal world view and not the view of any group. Carillo, however, carried her personalism in art to an extremely high point of refinement, sophistication, and metaphysical depth, truly exemplifying the passionate quest for the spiritual essence of reality that Kandinsky had defined as the ultimate vocation of the artist. In her investigation of non-objective realities, Carillo, to use Fernando Gamboa's expression, created ''psychic images.'' These images, expressed through powerfully suggestive abstract forms, indicate emotional states—states of the soul evoked by a profound experience such as hearing a piece of music, reading a poem, or seeing something of beauty. Much of Carillo's work reflects what Racquel Tibol described as that which did not show the ''physical concept of material, but a poetic intuition of the immaterial.''

Carillo occupies an important position in modern art because she was one of the most accomplished and authentic representatives of abstract art, having established a distinct style and world view that inspired a whole generation of young artists. In a rare moment in which Carillo talked about her work, she explained that she did not use a particular method when she painted, and when she did use a method, she changed it.

—Christine Miner Minderovic

CARRINGTON, Leonora
Mexican painter, sculptor, and printmaker

Born: Chorley, Lancashire, England, 6 April 1917; moved to Mexico, 1943, Mexican citizen. **Education:** Chelsea School of Arts, London; Academy of Amédée Ozenfant, London, 1936. **Family:** Lived with surrealist painter Max Ernst, 1937–39. Married 1) Renato Leduc in 1941 (divorced 1942); 2) Emerico ''Chiki'' Weiss in 1946, two sons. **Career:** Involved with the Surrealists, Paris, late 1930s. Institutionalized following a nervous breakdown, Santander, Spain, 1940. Lived in New York, 1941–43. Worked as a novelist and playwright.

Individual Exhibitions:

1948	Pierre Matisse Gallery, New York
1950	Galería Clardecor, Mexico
1952	Pierre Loeb, Paris
1956	Galería de Arte Mexicano, Mexico
1957	Galería Antonio Souza, Mexico
1960	Museo Nacional de Arte Moderno, Mexico
1965	Galería de Arte Mexicano, Mexico
1969	Galería de Arte Mexicano, Florencia, Mexico
1976	Center for Inter-American Relations, New York (retrospective)
1979	Center for Inter-American Relations, New York
1988	Brewster Art Limited, New York
1991	*Leonora Carrington, Painting, Drawings and Sculptures 1940–1990,* Serpentine Gallery, London (traveling retropspective)

	Leonora Carrington, The Mexican Years, Mexican Museum, San Francisco
1994	Museo de Arte Contemporáneo, Monterrey, Mexico (retrospective)
1995	Brewster Arts Limited, New York
1996	Galería de Arte Mexicano, Mexico City
1997	Brewster Arts Limited, New York
1999	Brewster Arts Limited, New York (with Pablo Weis Carrington)

Selected Group Exhibitions:

1948	Pierre Matisse Gallery, New York
1961	*International Surrealist Exhibition,* D'Arcy Galleries, New York
1966	*Exposition internationale du surréalisme,* Galerie L'Oeil, Paris
1971	*Au coeur du surréalisme,* Baukunst Gallery, Cologne, Germany
1990	*La mujer en México,* National Academy of Design, New York
1997	*Crossing the Threshold,* Bernice Steinbaum Gallery, New York
1998	*ARTMIAMI '98,* Mary-Anne Martin/Fine Art, Miami

Collection:

Art Institute of Chicago.

Publications:

By CARRINGTON: Books—*En-Bas,* Paris, Fontaine, 1945; *Leonora Carrington,* with Juan García Ponce, Mexico, Ediciones ERA, 1974; *Le Cornet acoustique,* Paris, Flammarion, 1974; *La Porte de pierre,* Paris, Flammarion, 1976; *La Débutante/conte et pieces (1937–1969),* Paris, Flammarion, 1978; *Down Below,* n.p., Black Swan Press, 1983; *Pigeon vole,* Paris, Le Temps qu'il fait, 1986; *The House of Fear,* New York, Dutton, 1988; *The Seventh Horse & Other Tales,* New York, Dutton, 1988; *The Hearing Trumpet,* London, Virago, 1991; *El septimo caballo,* Madrid, Ediciones Siruela, 1992; *Libertad en bronce,* Lomas de Chapultepec, Mexico, Impronta Editores, 1999.

On CARRINGTON: Books—*Leonora Carrington, A Retrospective Exhibition,* exhibition catalog, New York, Center for Inter-American Relations, 1976; *Leonora Carrington, The Mexican Years,* exhibition catalog, San Francisco, Mexican Museum, 1991; *Leonora Carrington, Paintings, Drawings and Sculptures 1940–1990,* exhibition catalog, text by Andrea Schlieker, London, Serpentine Gallery, 1991; *Latin American Artists in Their Studios* by Marie-Pierre Colle, n.p., Vendome, 1994; *Leonora Carrington: Una retrospectiva,* exhibition catalog, text by Luis Carlos Emerich and Lourdes Andrade, Monterrey, Mexico, Museo de Arte Contemporáneo de Monterrey, 1994; *Leonora Carrington,* exhibition catalog, text by Mariana Pérez Amor and Alejandra Reygardas de Yturbe, Mexico City, Galería de Arte Mexicano, 1996; *Leonora Carrington: Il surrealismo al femminile* by Tiziana Agnati, Milan, Selene, 1997; *Leonora Carrington,* exhibition catalog, with text by Mia Kim, Whitney Chadwick, and others, New York, Brewster Arts Limited, 1997; *Leonora Carrington, historia en dos tiempos* by Lourdes Andrade, Mexico City, Consejo Nacional

Leonora Carrington: *Untitled.* **Photo by Carmelo Guadagno; © The Solomon R. Guggenheim Foundation, New York. Reproduced by permission.**

Leonora Carrington: *The Cockcrow*. © Christie's Images/Corbis. © 2002 Leonora Carrington/Artists Rights Society (ARS), New York.

para la Cultura y las Artes, 1998. **Articles**—"Leonora Carrington: Evolution of a Feminist Consciousness" by Whitney Chadwick, in *Women's Art Journal,* 7, spring/summer 1986, pp. 37–42; "Wo war Leonora Carrington?" by Monika Maron, in *Du* (Switzerland), 10, October 1988, p. 109; "Surrealism and Esoteric Feminism in the Paintings of Leonora Carrington" by Janice Helland, in *Revue d'Art Canadienne,* 16(1), 1989, pp. 53–61; "Leonora Carrington: The Mexican Years, 1943–1985" by Susan Aberth, in *Art Journal,* 51, fall 1992, pp. 83–85; "Leonora Carrington: Like a Messenger" by Santiago de los Monteros Espinosa, in *Art Nexus* (Colombia), 18, October/December 1995, pp. 80–82; "Leonora Carrington's Mexican Vision" by Clare Kunny, in *Museum Studies,* 22(2), 1996, pp. 166–179; "Leonora Carrington" by Salomón Grimberg, in *Art Nexus* (Colombia), 26, October/December 1997, pp. 62–65.

* * *

While studying painting at the Amédée Ozenfant Academy in London, the young Leonora Carrington met Max Ernst, and in 1937 they moved to Paris, where he introduced her to André Breton and his surrealist circle. Long interested in fairy tales, alchemy, and stories of the uncanny, Carrington found much in common with the surrealists and their explorations of myth and magic. Living with Ernst outside Paris in the village of Saint-Martin-d'Ardèche, she entered a two-year period of intense artistic growth and production, developing both a unique pictorial language and style of writing. She began exhibiting

with the surrealists, and two of her short stories–*La Maison de la peur* (1938) and *La Dame ovale* (1939), both illustrated by Ernst– were published.

In response to the stress of World War II and Ernst's incarceration in a concentration camp, Carrington suffered a nervous breakdown in 1940 and was placed in an asylum in Santander, Spain. She later recounted this painful experience in an extraordinary book titled *En bas* (1945; *Down Below*), which was highly praised by Breton and the surrealists for intermingling notions of madness with alchemical processes of transformation. Escaping a war-torn Europe, Carrington spent the next two years in New York City, where she participated in surrealist exhibitions and contributed stories and artwork to such surrealist journals as *View* and *VVV*.

In 1943 Carrington moved to Mexico, where she became part of the extensive European surrealist émigré community then residing in Mexico City. This included Luis Buñuel, Benjamin Péret, and the Hungarian photographer Emerico (Chiki) Weiss, whom she would marry in 1946. At this time she met the Spanish artist Remedios Varo, and the two formed a close friendship and artistic collaboration that would have lasting repercussions on both of their work. Together they explored Mexico's indigenous healing practices, read books on Jungian psychology, theosophy, and Eastern religions, and conducted alchemical experiments in their own kitchens.

Carrington's paintings, often intimate in scale, teem with mysterious creatures (humans, animals, and combinations thereof) who perform obscure ritualistic acts, at times bordering on the comic. As in

the works of Hieronymus Bosch, their fantastical terrains are embedded with arcane symbols that leave the viewer intrigued but confounded. Women are often the central protagonists, and sites of feminine domestic labor are transformed into arenas of occult drama: cauldrons are stirred in kitchens while incantations are drawn on the floor, ointments transform the nursery's children into animals, and hirsute crones wind their way through labyrinths. A mischievous sense of humor is evident throughout these meticulously rendered works, which in composition are reminiscent of the quattrocento Florentine painting the artist so admired. Using jewel-like, luminous color in a variety of media (including egg tempera), she created nuanced and liminal spaces that seem to possess a magical life of their own.

In Mexico Carrington continued to write stories, novellas, and plays, and she worked in the theater as a costume and set designer, eventually producing her own play, *Pénélope* (1957). Spicing her work with sly wit and a bit of black humor, as in novellas such as *The Hearing Trumpet* (first published in 1976), Carrington created strong female characters who navigate hidden realms, defy conventions, and find surprising solutions in order to maintain their freedom. In 1963 she completed her only mural commission, *El mundo mágico de los Mayas,* executed for the then newly constructed Museo Nacional de Antropolgía in Mexico City. Displayed in the Chiapas section of the museum, her mural presents a panoramic synthesis of the past and present belief systems of the indigenous population referred to as the "living Maya."

In addition to painting, Carrington explored a variety of media, including drawing, sculpture, tapestries, printmaking, metalwork, and book illustration and design. Reflecting a lifelong preoccupation with the occult and sacred practices of many different cultures, her work contains symbols from the cabala, Tibetan Buddhism, alchemy, Celtic goddess worship and mythology, Mexican shamanic healing, astrology, the tarot, and other esoteric movements. Eschewing overt political references in lieu of more subtle spiritual dimensions, her work also speaks to contemporary concerns such as vanishing nature, the plight of animals, and the complex positions of women in the world. Although of English origins, after spending roughly 75 years in her adopted country, Carrington is fully regarded as a Mexican artist.

—Susan Aberth

CARVALHO, Josely
Brazilian silkscreen, video, and installation artist

Born: São Paulo, 1942. **Education:** Studied architecture, Washington University, St. Louis, Missouri (on fellowship), B.A. 1967. **Family:** One son. **Career:** Founder and director, Silkscreen Project, a collective silkscreen printing project, New York, 1976–88; curator, Central Hall Gallery, New York, 1983–87; cofounder, exhibition group of Latin American women artists, New York, mid-1980s. Visiting professor, National University of Mexico, Mexico City, 1971–73; artist-in-residence, Arlington Public Schools, Virginia, 1974–75, St. Mark's Church, New York, 1978–82, Harvest Works, New York, 2001. Lecturer on art. **Awards:** Fellowship, Organization of American States, 1964–66; grant, National Endowment for the Arts, 1975–76, 1995–96; individual artist grant, New York Foundation for the Arts, 1986–87, 1999–2000; Massachusetts Council for the Arts award, Boston, 2000; fellowship, Rockefeller Foundation, Bellagio

International Study and Conference Center, 2000; grant, Creative Capital Foundation, 2000–04; Harvest Works artist-in-residence, 2001. **Address:** 124 East 13th St., New York, New York 10003. **Website:** http://www.joselycarvalho.net.

Individual Exhibitions:

1974	Museum of Contemporary Art, Curitiba, Brazil
1975	Casa del Lago, Mexico City
1976	Potter's House Gallery, Washington, D.C.
	Institute for Policy Studies, Washington, D.C.
1978	Diário Serigráfico, Galeria Portal, São Paulo
1981	Museum of Modern Art, Bahia, Brazil
1982	*In the Shape of a Woman,* Central Hall Gallery, New York
1983	*Memories,* Yvonne Seguy Gallery, New York
1985	*Smell of Fish,* Central Hall Gallery, New York (traveling)
1986	*Olor a pescado,* Casa de las Americas, Havana
	Cheiro de peixe, Paço das Artes, São Paulo
1988	*Diary of Images,* Franklin and Marshall College, Lancaster, Pennsylvania
	She Is Visited by Birds and Turtles, Terne Gallery, New York
1991	*It's Still Time to Mourn,* Hillwood Museum, Brookville, New York
	En el camino, Galería Bass, Caracas (with Ismael Frigerio)
	My Body Is My Country, Real Art Ways, Hartford, Connecticut
1993	*Diary of Images: Ciranda,* INTAR Latin American Gallery, New York
	Dia mater I, Art in General, New York, and Museu de Arte de São Paulo
1994	*Terceira ciranda,* Instituto de Arte, Universidade de Brasilia
	Segunda ciranda, Museu de Arte Contemporânea, São Paulo
1995	*In the Name of the Birds, the Fishes and the Holy Turtle,* Olin Gallery, Kenyon College, Ohio
1996	*Quarta ciranda,* Gallery North, Miami Dade Community College, Miami
1997	*Codex: Das sem teto,* Paço das Artes, São Paulo
1998	*Xetás,* Tyler School of the Arts, Philadelphia
2000	*Book of Roofs/Livro das telhas,* Museu de Arte Contemporânea do Paraná, Curitiba, Brazil

Selected Group Exhibitions:

1987	*Connections Project/Conexus: A Collaborative Exhibition Between 32 Women Artists from Brazil and the United States,* Museum of Contemporary Hispanic Art, New York
1989	*Hot Spots: Curator's Choice IV,* Bronx Museum of the Arts, Bronx, New York
	The Decade Show: Frameworks of Identity in the 1980s, New Museum of Contemporary Art, New York
1991	*Office Installations,* Hillwood Museum, C. W. Post College, Brookville, New York
	II International Biennial of Painting, Cuenca, Ecuador

Josely Carvalho: *Hatra,* **1993. Photo by Sarah Wells; courtesy of the artist.**

1993 *Ceremony of Spirit: Nature and Memory in Contemporary Latino Art,* Mexican Museum, San Francisco
1994 *Rejoining the Spiritual: The Land in Contemporary Latin American Art,* Maryland Institute, College of Art, Baltimore
1996 *A Woman's Place,* Monmouth Museum, New Jersey
1998 *Books,* Lower East Side Printshop, New York
1999 John Michel Kohler Center, Wisconsin

Collections:

Museo de Bellas Artes, Caracas, Venezuela; Bronx Museum of the Arts, New York; Museum of Modern Art, New York; Brooklyn Museum, New York; Seguros Sociais, Mexico; Museo de Arte Moderna de Bahia, Brazil; Museu de Arte de São Paulo; Museu de Arte Contemporânea, São Paulo; Museu da Gravura, Curitiba, Brazil.

Publications:

By CARVALHO: Books—*Connections Project/Conexus: A Collaborative Exhibition Between 32 Women Artists from Brazil and the United States,* exhibition catalog, with Sabra Moore, New York, Museum of Contemporary Hispanic Art, 1986; *My Body Is My Country,* with Lucy R. Lippard, Hartford, Connecticut, Real Art Ways, 1991; *Diary of Images: It's Still Time to Mourn,* Rochester, New York, Visual Studies Workshop Press, 1992. **Article**—"The Body/The Country," in *Heresies,* 7(3), 1993, p. 43.

On CARVALHO: Books—*Hot Spots: Curator's Choice IV,* exhibition catalog, Bronx, New York, Bronx Museum of the Arts, 1989; *En el camino,* exhibition catalog, text by Laura Hoptman, Caracas, Galería Bass, 1991; *Diary of Images: Circandas,* exhibition catalog, New York, INTAR Latin American Gallery, 1993; *Josely Carvalho: It's Still Time to Mourn,* exhibition catalog, New York, Art in General, 1993; *Ceremony of Spirit: Nature and Memory in Contemporary Latino Art,* exhibition catalog, by Amalia Mesa-Bains, San Francisco, Mexican Museum, 1993; *Rejoining the Spiritual: The Land in Contemporary Latin American Art,* exhibition catalog, text by Suzanne Garrigues, Inverna Lockpez, and Barbara Price, Baltimore, Maryland Institute, College of Art, 1994; "A Expansão dos Abrigos" by Katia Canton, *Books of Roofs,* Museu de Arte Contemporânea do Paraná, 2000. **Articles**—"The Women's Movement in Art, 1986," in *Arts Magazine,* 61, September 1986, pp. 54–57; "Josely Carvalho: Connected to Art" by Jon Amacker, in *The Brazilians,* April 1987, p. 11; "When You Think of Mexico: Latin American Women in the Decade Show" by Giulio V. Blanc, in *Arts Magazine,* April 1990, pp. 16–17; "Josely Carvalho" by Holland Cotter, in *New York Times,* 1993; "Defining Latino Art by Works not Culture" by Karin Lipson, in *Art Review,* 1994; "Views of Cultures, Exotic and near Home" by Helen A. Harrison, in *New York Times,* April 17, 1994; "Earth Tones" by John Dorsey, in *The Sun,* March 12, 1994; "Down and Dirt" by Mike Giuliano, in *City Paper,* March 9, 1994; "1993 in Review: Alternative Spaces," in *Art in America,* annual guide, 1994; "Josely Carvalho traz arte política ao MAC" by Katia Canton, in *Folha de São Paulo,* September 16, 1994; "Imagens de Violência" by Graça Ramos, in *Correio Brasiliense,* October 1, 1994; "Diário de Imagens de Josely Carvalho" in *Jornal de Brasilia,* November 14, 1994; "Josely Carvalko inaugura instalação" by Severino Francisco, in *Jornal de Brasilia,* November 20, 1994; "Carvalho quer fazer instalação no Brasil" by Katia Canton, in *Folha de São Paulo,* July 15, 1996; "Para folhear o Livro das Telhas" by Carlão, in *Gazeta do Povo,* April 2, 2000.

* * *

Over the past three decades Brazilian Josely Carvalho has assembled a body of work in a variety of media—everything from printmaking to video, the Web, and painting—that gives eloquent voice to matters of memory, identity, and social justice.

Carvalho's work consistently challenges the boundaries between artist and audience and between politics and art. During the late 1970s she established the Silkscreen Project at St. Mark's Church in the Bowery in New York City. By teaching inexpensive silk-screening techniques to various community groups, Carvalho helped them create banners and signs for rallies and demonstrations. She went on to do a similar workshop in the early 1980s in São Paulo, working with the Comunidades Eclesiásticas de Base and the Workers Party. In the mid-1980s Carvalho helped found an exhibition group of Latin American women artists in New York City. In 1985 she co-organized an exhibition, called *Choice,* that explored issues surrounding abortion. And in the late 1980s she participated in the Repo-History Project, a series of street signs that focused on the lost history of Lower Manhattan.

The artist referred to her body of work as a diary of images. Different chapters of the diary have addressed various themes and events, all of them related to issues of social justice. "The Smell of Fish," a chapter of Carvalho's work from the 1980s, explores cultural stereotypes about women and the exploitation and politicization of the female body. "My Body Is My Country," a series begun in the early 1990s, focuses on hybrid identity. A simultaneous work responding to the Gulf War was called "It's Still Time to Mourn"; in a finely made artist's book Carvalho responded to images of the war from the popular media and a fragment of an Iraqi soldier's journal that she came across in a newspaper article. Each chapter of Carvalho's work combines autobiographical and social narratives, using a combination of images and text. Carvalho's diary of images approaches history as a labyrinth of memory and its telling as a collective project that is both political and artistic.

Carvalho's evolving work from the late 1990s, entitled *Book of Roofs,* is a living text, part history, part metaphor. It brings together many of the themes that Carvalho has been developing for decades—shelter, as a political and metaphorical issue; displacement; and the intersections between personal recollection and collective consciousness. The work is a nonlinear compilation of personal histories, made up of fragments of individual pasts. Carvalho wrote in her introduction to the project: "I was walking on an island in Bahia, Brazil, where I saw hundreds of clay roof tiles stacked on the sand. Observing tile workers, I was mesmerized not only by the labor intensive process of their work (firing, carrying, piling, hoisting, installing) but the communal sense the work and the materials provoked. I saw their labor as art, and transposed it to a public art setting."

The work was first exhibited in 1997 as a video installation made up of three thousand clay roof tiles onto which digital video images were projected. It has since evolved to include an interactive website and various video installations. Visitors to the website can create their own "tile," such that the project becomes an infinite network of individual voices, an ever-changing, highly intuitive historical record. The image of a turtle, a symbol of time and wisdom and a creature whose shelter is an integral part of its being, navigates the site. In one sense *Book of Roofs* is a virtual dwelling. At the same time it

comments on geographically specific situations such as the problem of homelessness in Brazil, the eradication of indigenous homelands, and the displacement caused by ethnic wars. It is an extension of previous investigations, including the project Carvalho called *Cirandas,* which examines violence against children in the United States and Brazil.

—Amy Heibel

CASAS, Mel(esio)

American painter

Born: El Paso, Texas, 24 November 1929. **Education:** Texas Western College, El Paso, B.A. 1956; University of the Americas, Mexico City, M.F.A. 1958. **Career:** Instructor, University of Texas, El Paso; professor of art, San Antonio College. 1980s. Book reviewer, *Choice Magazine,* American Library Association. Cofounder, *Con Safo,* a group of Chicano artists, 1960s. **Awards:** Award, National Society of Arts and Letters, El Paso, 1956; award, University of the Americas Art Gallery, Seventh Exhibition, Mexico City, 1958; awards, *Annual Sun Carnival Exhibition,* El Paso Art Museum, 1959, 1964; award, *Thirty-sixth Annual Exhibition of San Antonio Art League,* Witte Memorial Museum, 1966; Outstanding Service award, *Seventh Annual Tribute to the Chicano Arts,* Our Lady of the Lake College, San Antonio, 1986; award, *Main Street Invitational,* Forth Worth Art Festival, 1986.

Individual Exhibitions:

1958 Galeria Genova, Mexico City
1961 Y.W.C.A., El Paso
1963 Mexican Art Gallery, Mexican American Institute of
 Cultural Exchange, San Antonio
1967 Trinity University, San Antonio
 Texas Lutheran College, Seguin
1968 Mexican Art Gallery, Mexican American Institute of
 Cultural Exchange, San Antonio
1973 Boehm Gallery, Palomar College, San Marcos,
 California
1976 *Mel Casas/Humanscapes,* Contemporary Arts Museum,
 Houston
1979 Koehler Cultural Center, San Antonio College
1982 Koehler Cultural Center, San Antonio College
1984 *Southwest Icons,* Koehler Cultural Center, San Antonio
 College
1988 Laguna Gloria Art Museum, Austin

Selected Group Exhibitions:

1963 Witte Memorial Museum, San Antonio
1964 Two Twenty Two Gallery, El Paso
1969 Oklahoma Art Center, Oklahoma City
1971 *Texas Painting and Sculpture: The 20th Century,*
 Pollock Galleries, Owen Arts Center, Southern
 Methodist University, Dallas (traveling)
1975 *1975 Biennial Exhibition of Contemporary American
 Art,* Whitney Museum of American Art, New York

1977 *Ancient Roots/New Visions,* Tucson Museum of Art,
 Arizona (traveling)
 Dalé Gas: Chicano Art of Texas, Contemporary Arts
 Museum, Houston
1983 *Chicano Expressions,* Intar Gallery, New York
 (traveling)
1987 *Third Coast Review: A Look at Art in Texas,* Aspen Art
 Museum, Colorado (traveling)
1989 *The Latin American Spirit: Art & Artist in the U.S.,*
 Bronx Museum, New York

Publications:

On CASAS: Books—*Mel Casas Paintings,* exhibition catalog, San Antonio, Mexican Art Gallery, Mexican American Institute of Cultural Exchange, 1968; *Mel Casas/Humanscapes,* exhibition catalog, Houston, Contemporary Arts Museum, 1976; *Mel Casas: An Exhibition,* exhibition catalog, Austin, Texas, Laguna Gloria Art Museum, 1988. **Articles**—"Mocking Myths, Nachos, Nostalgia" by Janet Kutner, in *ARTnews,* December 1975, pp. 88–92; "Twelve Days of Texas" by Roberta Smith, in *Art in America,* July/August 1976, pp. 42–48; "West Coast: Papers, documents, and interviews received" by Paul J. Karlstrom, in *Archives of American Art Journal,* 36(3–4), 1996, pp. 56–60.

* * *

On his way home from a Marc Chagall exhibition in the mid-1960s, the painter Melesio Casas passed a drive-in movie theater. He experienced the projected image as something of a revelation: "I looked up and saw gigantic heads on the screen above the trees. Cars were passing below on the freeway . . . I stopped and I just looked and it looked real, surreal! The few moments I sat there, I saw the head of a woman talking to someone hidden by the trees. She actually looked as if she were munching away at the tree tops, and cars were moving away. It was another reality. So I began to play with the idea and I began to refine it."

Casas developed this vision in an ongoing series of paintings he calls *Humanscapes.* The earliest works in the series focus on movie and television screens and their audiences. In *Humanscape No. 14* (1966), for example, the viewer looks through the rear window of a car parked in a drive-in. The windshield frames a fragment of a starlet's projected face—her perfectly arched brow and a bit of blond hair. Inside the car is her audience—a silhouetted, lone man in the driver's seat. He is a voyeur, and, under the circumstances, so is the viewer. The painting suggests a pop artist's fascination with mass culture and celebrity, but here, as elsewhere, Casas gives the image a more critical, politicized twist. "I so divide the picture plane of my painting so as to force the spectator into the role of 'voyeur,' thus acquiring an identity through participation . . . It is too difficult a task to witness and not react to the transformation of an audience from one world to another subliminally and without critical awareness. That's the reason the audience in my paintings acts as somnambulistic actors in a video space environment that projects sex-anxiety as a protection against nonbeing. Gone is the search for personal reality, and instead there is a collective reality." The picture plane of *Humanscape No. 14* is split into two zones—projection and audience. While the images in the zones have varied from painting to painting, the split picture plane has been one of the more consistent formal characteristics of the *Humanscape* series. Many of the underlying ideas are also consistent.

Other works in the *Humanscape* series deal directly with the problem of the Mexican-American as migrant worker, youth, and outsider. In No. 65 (*New Horizons,* 1970) farmworkers toil in the field that forms the painting's bottom zone, while the symbol of the Farm Workers Union of California's *huelga* (strike) stretches across the top. Around the time he painted this work, Casas exhibited with a group of Mexican-American artists called Con Safos and authored their politicized artistic statements and manifestos.

Con Safos broke up in 1975 because some of its members objected to the group's exclusive focus on social and political issues. Casas's work remained politically charged, and he continued writing highly engaged artist's statements, many of which were arranged as flow charts and in other graphic arrangements. These have the look of contemporary conceptual art but are more activist in content. One of the more graphically simple, an unpublished statement from 1983, reads:

- an act of *PROVOCATION*
- a point of *CONTENTION*
- visual *ABRASION*
WE ARE
- iconic *FRICTION*
- the *PRIMORDIAL ENGRAMS* of chicanismo
- the *VISUAL PROJECTIONISTS* for the chicanos
- *ARTISTSC/S*
- **CHICANO ART is not art for ART'S SAKE but ART for HUMAN SAKE•**

Beginning in the 1980s, Casas focused his attention on the barrio and Texas. Continuing to use a modified *Humanscape* format, with borders and split zones of attention, he also began building up a glossy surface with acrylic paint applied directly from the tube, giving the paintings an almost enameled quality. In *Slyboots* (1993) he puddled and caked the paint in imitation of leather, dust, and sand, using his pop aesthetic to focus on one of the stereotypical attributes of Texan culture.

—Anne Byrd

CASTELLÓN, Rolando

American sculptor

Born: Managua, Nicaragua, 1937; naturalized citizen of the United States. **Education:** San Francisco City College, A.A.1962. **Career:** Curator, Mary Porter Sesnon Art Gallery, University of California, Santa Cruz, 1990, San Francisco Museum of Modern Art, and Museum of Contemporary Art and Design, San José, Costa Rica, 1994–99. Cofounder, Galeria de la Raza, San Francisco, and TEOR/éTica, Costa Rica.

Individual Exhibitions:

1978	San Francisco Museum of Art
1985	Gallery White Art, Tokyo
1986	Academy of the Arts, Honolulu
1988	Gallery P'art, Freienbach, Switzerland
1990	Meridian Gallery, San Francisco (retrospective)
1994	SPACE, Los Angeles
	Meridian Gallery, San Francisco
1995	Theresa Mullen Gallery, San Francisco
1996	Museo de Jade Fidel Tristán, San José, Costa Rica
1997	Casa de América, Madrid, Spain
	Rolando Castellon: A Legacy of Mud, Post-Columbian Objects, 1981–1997, Art Institute of Chicago (retrospective)
1998	The Art Museum of Santa Cruz County, California
1999	IFA Gallerie, Bonn, Germany
	Centro Cultural de España, San José, Costa Rica
	Don Soker Gallery, San Francisco
	Meridian Gallery, San Francisco

Selected Group Exhibitions:

1989	*40 Years of Assemblage in California,* Wight Gallery, University of California, Los Angeles.
	Drawings from the Fourth World, Meridian Gallery, San Francisco
1995	*Barro América,* Centro de Arte, Maracaibo, Venezuela

Publications:

By CASTELLÓN: Books—*Aesthetics of Graffiti,* exhibition catalog, with J. Howard Pearlstein, San Francisco Museum of Art, 1978; *Leslie Reid: New Paintings and Drawings,* exhibition catalog, Santa Cruz, Mary Porter Sesnon Art Gallery and the University of California, 1991.

On CASTELLÓN: Articles—"Mysterious Talismans" by Mark Van Proven, in *Artweek,* 16, 23 February 1985, p. 4; "Connections with the Past" by Rebecca Solnit, in *Artweek,* 16, 20 April 1985, pp.4–5; "Drama of Space and Surface" by Mark Van Proven, in *Artweek,* 19, 2 April 1988, p. 4; "Reclaiming Cultural Discards" by Suvan Geer, in *Artweek,* 20, 6 May 1989, p. 9; "Softened by Time's Haze" by Charlotte Moser, in *Artweek,* 21, 10 May 1990, p. 12; "Meridian Gallery, San Francisco; Exhibit" by Gay Morris, in *Art in America,* 81, April 1993, p. 137; "Rolando Castellón" by Janet Cavallero, in *New Art Examiner,* 24, June 1997, p. 37; "San Francisco" by Carl Heyward, in *Art Papers,* 23(6), November/December 1999, pp. 61–62.

* * *

After his childhood days in his native Nicaragua, Rolando Castellón went to Costa Rica for a number of years and eventually traveled to the West Coast of the United States, where he spent most of his adult life as an artist and curator. Among his many activities, he acted as one of the founders of the Galeria de la Raza in San Francisco, worked as curator for contemporary art at the San Francisco Museum of Modern Art, and collaborated in laying down the principles of the Yerbabuena Gardens Art Center, which opened after his departure. Upon his retirement he returned to Central America and became the chief curator of the Contemporary Art and Design Museum of Costa Rica (MADC), which had opened in early 1994. After organizing more than 50 exhibitions at the museum, he left in early 1999. He keeps an exhibition and meeting space, called ARTEUM, in downtown San José and is one of the founders of TEOR/éTica, a project dealing with regional art practices.

Castellón is an artist who works around and through nature in its different manifestations and relations to humanity as an intimate

partner. In his gaze nature is not a subject of representation but becomes his personal research territory. In a position that contrasts with many artists who deal with nature, Castellón is not "inspired" by it. Rather, he makes use of nature in its material aspects for his own particular, individual purposes, which in a way are a subversion of the landscape genre. He helps himself from natural elements and uses them as the physical material for his pieces, mostly wall installations, small drawings with collage, and mud works on paper. Nature is a medium for Castellón, a medium by which he creates "real" still lifes and mural landscapes. It is interesting to note that, like some other Latin American artists of the twentieth century who are deeply moved by the essence of nature, his drawings and paintings have always been mostly abstract and are usually structured around the organic transformation of a geometric shape or are in some cases held together by an almost imperceptible grid.

Castellón is mostly a deeply intuitive artist who confers a poignant degree of poetry and shamanistic will in reordering the most humble materials of nature. He has worked since the 1970s in many media, from abstraction in drawing and painting to "doodles" and scratched books with canceled texts. Castellón enjoys picking up the poorest of support materials and reworking the surface until he constructs it to his convenience. The following drawing or painting is of a minimal character, and many of his pieces, mostly in medium to small formats, are done in series. In later years he has concentrated on mud works, which sometimes are done over kraft paper on mural installations and sometimes applied in layers to origami-like folded papers. The artist makes use of elements that draw him close to the *arte povera* movement, including the ritualistic attitude and symbolic weight this movement tried to convey. Castellón was strongly influenced by his childhood reminiscences of touching and feeling soil and mud, of watching compact mud floors being neatly swept in a simple home, of daydreaming while following the broom's traces on a barely wet surface.

Castellón's art picks up where nature closes its life cycle. If nature in Castellón's work means materials, it is also a reverent attitude. Wherever he goes, whether an open field or a mountain, the seashore, a city garden or the street, he always finds the doings and undoings of natural processes, and he accumulates, with the passion of the collector, beehives, seeds, thorns of all types, shells, pebbles, dry flowers, rough wooden branches, and cacti. He is obsessed by reordering the collected and barely intervened elements to re-create a lost primal state in small wall pieces, large mural installations, or small assemblages. Many of his pieces use mud as the support surface, with several layers of mud on paper, to which he adds various elements in what sometimes can seem a haphazard disposition but in fact reflects nature's harmonic chaos, what the artist has called a "post-columbian era." Thus, although extremely sophisticated and cosmopolitan, both in his thought and in his considerations on art, Castellón vindicates in some way his belonging to a race and a state of things broken by the Spanish conquest.

There is a strong sensual quality in Castellón's soil-covered surfaces. Some of them are worked over and over until they are heavy and smooth, giving the impression of rusted metal or heavy leather. In others the surface remains coarse and thick to allow for a "collage" of other natural elements. The idea of site/nonsite, while it does not dominate his mental discourse, is always perceptible. Castellón's intention is located more in the sensible aspects of the reconstruction. Among the myriad natural objects recontextualized in his works are delicate flat seeds that are wrapped in a kind of light, silky cover, larger than the seed it protects. These seeds, which are carefully collected, are delicately glued together in the most fragile of ways to create textilelike organic triangles, circles, and squares. The artist puts the unpredictable into a rational shape, following a certain geometric logic to order his reconstitution, and he has the feeling of being an instrument in the ordering of chaos or, even more, in the construction of another "natural" reality.

Castellón has organized hundreds of exhibitions of young artists who later became internationally recognized, and he has been active in promoting the inclusion of formerly excluded groups of minority artists, such as the Chicano movement, in the development of contemporary art in the United States. He also has been an important figure in the museographical concepts of the exhibition venues where he has worked, particularly at the MADC in San José from 1994 to 1999. He has a personal way of dealing with the installation of an exhibition that, in fact, reflects his own way of putting up his personal work. Castellón's work as a counselor to artists and particularly as an editor has also been important. Since 1979 he has produced 40 issues of *Cenizas* (Ashes), a small periodical publication in editions of 200 that is a poetical minijournal patiently done by hand, photocopied, and hand painted.

—Virginia Pérez-Ratton

CASTRO, Amílcar de
Brazilian sculptor

Born: Minas Gerais, 1920. **Education:** Studied design with Alberto de Veiga Guignard, 1942; Escola Parque, Belo Horizonte, Brazil, 1948–50. **Career:** Moved to Rio de Janeiro and became involved with the Neo-Concrete art movement, 1952; established newspaper *Jornal do Brasil;* publisher, with Ferreira Gullar, Neo-Concrete manifesto; lived in New Jersey, 1968–71; taught at Federal University of Minas Gerais. **Awards:** Bronze medal, *V salão de arte moderna do MEC,* Rio de Janeiro, 1947; prize, *Salão nacional de arte moderna da Bahia,* 1955; medalha de Prata, *IX salão nacional de arte moderna do MEC,* Rio de Janeiro, 1960; first prize, *Salão de arte moderna de Minas Gerais,* Belo Horizonte, Brazil, 1962; John Simon Guggenheim memorial fellowship, 1965, 1968, 1970; grand prize, Museu da Pampulha, Belo Horizonte, Brazil, 1974; prize, *Panorama da arte atual brasileira,* Museo de Arte Moderna de São Paulo, 1977, 1978.

Individual Exhibitions:

1969	Galeria Komblee, New York
1976	Museu de Arte Moderna do Rio de Janeiro
1978	Gabinete de Artes Gráficas, São Paulo
1980	Gravura Brasileira, Rio de Janeiro
1982	Galeria GB, Rio de Janeiro
	Gabinete de Arte Raquel Arnaud, São Paulo
	Museu de Arte Moderna do Rio de Janeiro and Museu de Arte de São Paulo
1983	Galeria Thomas Cohn de Arte Contemporanea, Rio de Janeiro
	Galeria de Arte Gesto Gráfico, Belo Horizonte, Brazil
1984	Galeria Pizza Massimo, Belo Horizonte, Brazil
	Galeria Rodrigo Melo Franco de Andrade, Rio de Janeiro

Espaço Alternativo da FUNARTE, Rio de Janeiro
1985 Galeria de Artes Gesto Gráfico, Belo Horizonte, Brazil
 VIII salão nacional de artes plásticas—Sala Especial,
 Rio de Janeiro
1986 Galeria Paulo Klabin e Gabinete de Arte, Rio de Janeiro
1987 Galeria Unidade Dois, São Paulo
 Galeria de Arte Fernando Paz, Belo Horizonte, Brazil
 Galeria Usina Arte Contemporanea, Espírito Santo,
 Brazil
1988 Galeria de Arte Paulo Vasconcelos, São Paulo
1989 Paço Imperial, Rio de Janeiro (retrospective)
 Gabinete de Arte Raquel Arnaud, São Paulo
1990 Galeria Cidade, Belo Horizonte, Brazil
 Paço das Artes Francisco Matarazzo Sobrinho, São
 Paulo
1991 Galeria Fernando Pedro Escritório de Arte, Belo
 Horizonte, Brazil
 Galeria de Arte do Espaço Cultural da CEMIG, Belo
 Horizonte, Brazil
1992 Gabinete de Arte Raquel Arnaud, São Paulo
 Galeria Macedo, Belo Horizonte, Brazil
 Museu de Arte de São Paulo (retrospective)
1994 Gabinete de Arte Raquel Arnaud, São Paulo
1998 Gabinete de Arte Raquel Arnaud, São Paulo

Selected Group Exhibitions:

1953 *II bienal internacional de São Paulo*
1960 *Konkrete Kunst,* Zurich
1966 *Artistas brasileiros contemporaneos,* Museu de Arte
 Moderna, Buenos Aires
1973 *Escultores: Amílcar de Castro, Ascânio MMM, Haroldo
 Barroso, Lúcia Fleury,Vlavianos,* Galeria de Arte
 Ipanema, Rio de Janeiro
1978 *Arte agora III: América latina,* Museu de Arte Moderna
 do Rio de Janeiro
1983 *XV salão nacional de arte,* Belo Horizonte, Brazil
1984 *Dez artistas mineiros,* Museo de Arte Contemporanea,
 São Paulo
1987 *Panorama da arte atual brasileira,* Museu de Arte
 Moderna, São Paulo
1989 *Cada cabeça uma sentença,* Museu de Arte Moderna,
 São Paulo (traveling)
1993 *4 x Minas,* Museu de Arte Moderna, Rio de Janeiro
 (traveling)
 *Brasil 100 años de arte moderna: Coleção Sérgio
 Fadel,* Museu National de Belas Artes, Rio de Janeiro

Publications:

On CASTRO: Books—*Amilcar de Castro,* exhibition catalog, by
Rodrigo Naves and others, São Paulo, Editora Tangente, 1991;
Precisão: Amilcar de Castro, Eduardo Sued, Waltercio Caldas,
exhibition catalog, by Irma Arestizábal and others, Rio de Janeiro,
Centro Cultural Banco do Brasil, 1994; *Dois estudos de comunicaçã
visual: Amílcar de Castro e a reforma do Jornal do Brasil* by
Washington Dias Lessa, Rio de Janeiro, Editora UFRJ, 1995; *Amilcar
de Castro,* exhibition catalog, by Rodrigo Naves and others, São
Paulo, Cosac & Naify Edições, 1997; *Brazilian Sculpture from 1920*

to 1990: A Profile by Vitor Brecheret, Washington, D.C., Inter-
American Development Bank, 1997; *Teodira dos valores: Amílcar de
Castro, Antonio Dias, Antonio Manuel,* exhibition catalog, by Marcio
Doctors and Paulo Herkenhoff, São Paulo, Museu de Arte Moderna
de São Paulo, 1998.

* * *

Along with other Brazilian artists, including Geraldo de Barros
and Lygia Pape, Amílcar de Castro helped establish the country's
importance in the international art scene of the 1940s and 1950s. The
connections of these artists to the modernist practices in Europe at
midcentury were critical to their identity, with their involvement in
concrete art in São Paulo being particularly important. Like the
Europeans, they believed that artistic progress and development
necessarily benefited the entire culture.

In 1942 de Castro studied design with Alberto de Veiga Guignard
and concurrently did figurative sculpture with the Austrian-born
master and major contemporary sculptor Franz Weissmann. Early in
the 1950s, influenced by the work of the Swiss abstract artist Max
Bill, de Castro shifted away from figuration and focused his attention
on the plane, transforming it by cutting and folding, a technique
modeled in paper and finalized in iron. He participated in exhibits of
the concrete movement in São Paulo, and in 1959 he was one of
numerous artists who signed the ''Manifesto Neo-Concreto,'' a
document that called for a revitalization of art practice, expressive
form, and individual experience as well as an intuitive response to the
creative act and the work of art. By the mid-1960s, working in Rio de
Janeiro, he had produced constructions that sought to redefine the
objective experience of space while intimately involving the viewer
as an engaged participant. He exhibited his sculptures as part of the
Konkrete Kunst show in Zurich in 1960 and exhibited in New York
City in 1969. After returning to Brazil, he began to give classes at the
Federal University of Minas Gerais.

De Castro has concerned himself with geometry and vigorous
divisions and foldings of the plane. The designs, pictures, and
ceramics he began to execute in 1991 reveal the same efficient and
rigorous technique. As a masterful layout artist, he transformed
Brazilian newspaper design by changing the layout of the *Jornal do
Brasil* in 1962. Later he turned his focus on the cubicle, compact iron
block, creating dense dovetailings of positive and negative, or on the
juxtaposition of pieces through linear cutouts. De Castro's relation-
ship to his raw material, iron, is also his commitment to the product of
his land, industrialized in its rigidity, yet simultaneously denuded of
any detestable regionalism.

—Martha Sutro

CASTRO-CID, Enrique
American painter

Born: Santiago, Chile, 1937; emigrated to the United States, 1962.
Education: Escuela de Bellas Artes, Universidad de Chile, Santiago,
1957–59. **Family:** Married Christophe de Menil. **Career:** Instructor,
Universidad de Chile, Santiago, 1960, New School for Social Research,
New York, 1962, School of Visual Arts, New York, 1970. Visiting
artist, University of Illinois, Urbana, 1968; guest lecturer, Cornell

University, Ithaca, New York, Vassar College, Poughkeepsie, New York, and Northwestern University, Evanston, Illinois, 1970. **Awards:** Fellowship, Organization of American States, 1962; fellowship, John Simon Guggenheim Memorial Foundation, 1964, 1965; William Copley award, 1966. **Died:** 1992.

Individual Exhibitions:

1960 La Libertad Gallery, Santiago
1963 Feigen-Palmer Gallery, Los Angeles
 Richard Feigen Gallery, New York
1964 Richard Feigen Gallery, New York
1965 *Robots,* Richard Feigen Gallery, New York
1966 *Compressed Air Sculptures,* Richard Feigen Gallery, New York
1968 *Anamorphoses and Mapping,* Richard Feigen Gallery, New York
 Krannert Art Museum, University of Illinois, Urbana
1969 *Electronic Sculpture,* Richard Feigen Gallery, New York
1971 *Paintings and Drawings,* Richard Feigen Gallery, New York
1973 Parris Art Museum, Southampton, Long Island, New York
1975 Galerie Alexandra Monet, Brussels
1978 *Conformal Mapping,* Droll/Kolbert Gallery, New York
1980 Lowe Art Museum, University of Miami
1981 Frank Kolbert Gallery, New York
 Gloria Luria Gallery, Miami
1984 Gloria Luria Gallery, Miami
1985 Barbara Greene Gallery, Miami
1988 Barbara Greene Gallery, Miami
1990 Dia Art Foundation, Bridgehampton, New York

Selected Group Exhibitions:

1961 Pan American Union, Washington, D.C.
1964 *Pittsburgh International,* Carnegie Institute
 Institute of Contemporary Arts, Washington, D.C.
1966 *Art of Latin America since Independence,* Yale University, New Haven, Connecticut, and University of Texas, Austin
 Smithsonian Institution, Washington, D.C.
1969 *New Sculptures,* Museum of Modern Art, New York
1984 *Myth and Reality, The Art of Modern Latin America, Selections from the Collections of the Guggenheim Museum,* San Antonio Museum, Texas
1985 *20th Century Latin American Art,* Metropolitan Art Museum, Miami
1988 *MIRA! The Canadian Club Hispanic Art Tour III,* Los Angeles Municipal Art Gallery (traveling)
 The Latin American Spirit: Art & Artists in the U.S., Bronx Museum of Art, New York

Collections:

Solomon R. Guggenheim Museum, New York; Lowe Art Museum, Miami; Museum of Modern Art, New York; Museum of Modern Art of Latin America, Washington, D.C.; Phoenix Art Museum; Des Moines Museum, Iowa.

Publications:

On CASTRO-CID: Books—*Painting and Sculpture 1966: Jean Art, Enrique Castro-Cid, Charles Hinman, Gerard Laing, Bridget Riley, William Tucker, Victor Vasarely, John Willenbecher,* exhibition catalog, Milwaukee, University of Wisconsin-Milwaukee Department of Art, 1966; *Enrique Castro-Cid,* exhibition catalog, Bridgehampton, New York, Dia Art Foundation, 1990. **Articles**—''The Art of Castro-Cid and the Transcendence of Will'' by Ricardo Pau-Llosav, in *New Orleans Review,* 1986; ''Castro-Cid's Art Is Matter of Space'' by Diane Monatne, in *Miami Herald,* 29 January 1987; ''The Oasis of the Infinite: Rafael Soriano and Enrique Castro-Cid,'' in *Drawing* (New York), 12(5), January/February 1991.

* * *

When Paul Valéry wrote of the aesthetic revolution that would inevitably follow from technological development, he might have been thinking of Enrique Castro-Cid:

> Our fine arts were developed, their types and uses were established, in times very different from the present, by men whose power of action upon things was insignificant in comparison with ours. But the amazing growth of our techniques, the adaptability and precision they have attained, the ideas and habits they are creating, make it a certainty that profound changes are impending in the ancient craft of the Beautiful. In all the arts there is a physical component which can no longer be considered or treated as it used to be, which cannot remain unaffected by our modern knowledge and power. For the last twenty years neither matter nor space nor time has been what it was from time immemorial. We must expect great innovations to transform the entire technique of the arts, thereby affecting artistic invention itself and perhaps even bringing about an amazing change in our very notion of art.

Castro-Cid's work challenged the way we perceive the physical world, introducing a concept of four-dimensional space and the representation of objects in four dimensions that defied conventions of perspective and representation. Over the course of a career in the United States that lasted almost 30 years, he pushed our perceptual boundaries and brought new instruments to bear on the making of contemporary art.

Castro-Cid arrived in New York City in 1962 from Chile and began making kinetic sculpture and robots shortly thereafter. (He designed the robot hound in the François Truffaut film *Fahrenheit 451*). He was among the first artists to link technology and art, working with computers, plotters, and digitizers to render representations of everyday imagery as it would appear in four dimensions. As one might expect, Castro-Cid was fascinated by Renaissance spatial representation and mathematical theory. He also drew on the theories of the British scholar D'Arcy Thompson and his concept of conformal mapping, which leads to a hyperspace of four to six dimensions. Castro-Cid was fascinated by technology and science, and his work investigated the bizarre metamorphoses of natural forms through the alterations of space, time, and natural processes.

Castro-Cid moved to Miami in 1980 to, as he said, ''recover my Latin culture.'' At the time the Latin American art scene in Miami

was beginning to transform what have been a resort town into a world-renowned center for Latino culture. Major exhibitions of Latino art traveled to Miami, and artists like Mario Bencomo, Maria Brito-Avellana, Gilberto Ruiz, Andrés Valerio, and Tony Mendoza lived and worked there. By the time Castro-Cid arrived in Miami, he was a two-time recipient of a Guggenheim Fellowship, with works in the collections of the Museum of Modern Art and the Guggenheim Museum, among others. He used the computers at the University of Miami and at Mount Sinai Medical Center to develop his paintings and drawings. In 1990 the Dia Art Foundation held an exhibition of his works. Curator Henry Geldzahler compared Castro-Cid's work to that of Francis Bacon: "Where [Bacon] distorts and collapses the face, Castro-Cid does the same for the space."

—Amy Heibel

CAVALCANTI, Emiliano di

Brazilian painter and illustrator

Born: Emiliano Augusto Cavalcanti de Albuquerque e Mello, Rio de Janeiro, 1897. **Education:** Studied under painter Gaspar Puga Garcia, 1906; Faculdade de Direito, 1916; Ranson Academy, Paris, c. 1923. **Career:** Illustrator, *Fon-Fon* magazine, 1914; co-organizer, *Semana de Arte Moderna* exhibition, São Paulo, Brazil, 1922; newspaper correspondent, Paris, 1923–25, 1935–40. Cofounder, Clube dos Artistas Modernos em São Paulo. **Awards:** Prêmio de melhor pintor nacional, Brazil, 1953; gold medal, *II bienal internacional do México,* 1960. **Died:** 1976.

Individual Exhibitions:

1916	Salão de los Humoristas, Rio de Janeiro
1917	George Fischer Elpons Gallery, Rio de Janeiro
1954	Museo de Arte Moderno, Rio de Janeiro
1964	Galería Relieve, Rio de Janeiro

Selected Group Exhibitions:

1922	*Semana de arte moderna,* São Paulo, Brazil
1951	*I bienal de São Paulo,* Brazil
1960	*II bienal internacional do México*

Publications:

By CAVALCANTI: Books—*Viagem da minha vida: Memórias,* Rio de Janeiro, Editôra Civilizacaõ Brasileira, 1955; *Reminiscências líricas de um perfeito carioca,* Rio de Janeiro, Editôra Civilizacaõ Brasileira, 1964. **Books, illustrated**—*A morte e a morte de Quincas Berro Dágua* by Jorge Amado, Rio de Janeiro, Sociedade dos Cem Bibliófilos do Brasil, 1962; *Poemas da negra* by Mario de Andrade, Rio de Janeiro, Edições Alumbramento, 1976.

On CAVALCANTI: Books—*Emiliano di Cavalcanti: 50 años de pintura, 1922–1971,* exhibition catalog, introduction by Luis Martins, São Paulo, Brazil, Gráficos Brunner, 1971; *Emiliano di Cavalcanti,* introduction by Luis Martins, São Paulo, Brazil, Gráficos Brunner, 1976; *Desenhos de Di Cavalcanti na coleção do MAC,* São Paulo, Brazil, Museu de Arte Contemporânea da Universidade de São Paulo, 1985; *Di Cavalcanti, desenhista: Uma coleção de 500 desenhos* by Lucien Finkelstein, Rio de Janeiro, Graphos Industrial Gráfico, 1986; *Emiliano di Cavalcanti, 1897–1976,* exhibition catalog, New York, The Society, 1987; *Di Cavalcanti,* exhibition catalog, Bogota, Colombia, and São Paulo, Brazil, Museo Nacional de Colombia and Universidade de São Paulo, Museu de Arte Contemporanea da USP, 1999. **Article**—"The Brazilian Imagery of Di Cavalcanti" by Lisbeth Rebollo Gonçalves, in *Art Nexus,* 33, August/October 1999, pp. 72–75.

* * *

By the time Emiliano di Cavalcanti organized and participated in the 1922 Semana de Arte Moderna in São Paulo, the founding moment of Brazilian modernism, he already had a promising career as an illustrator and caricaturist. A self-taught artist, he created paintings manifesting the triple influence of symbolism, impressionism, and fauvism. Spurred by his encounter with modern art, Di Cavalcanti traveled to Paris in 1923 as a newspaper correspondent and attended the Acadèmie Ranson. During his two years in Paris he not only became acquainted with and absorbed the lessons of Pablo Picasso, Fernand Léger, and Henri Matisse but also fell under the spell of expressionism, especially the work of Otto Dix and Georges Grosz. Their influence is evident in the overcrowded, vertically layered space, distorted anatomical proportions, and vibrant colors of *Five Girls from Guaratinguetá* (1930) and *Street Scene* (1931). The satirical tone that transpires in works from the 1920s depicting Rio de Janeiro's shantytowns and its underworld of prostitutes, pimps, and gangsters, such as *Mangue* (1929), echoes as well the impact of these German masters. Expressionism's pessimistic and anguished view of reality, however, was nowhere to be found in Di Cavalcanti's world. His was a painting imbued with the sensuality, luminosity, and festive atmosphere of the tropics.

Di Cavalcanti is widely considered the artist whose painting most distinctly and vividly acknowledged and exalted Brazil's multiracial makeup and heritage. His images of samba dancers and musicians and his dreamy, voluptuous *mulatas* are frequently regarded as touchstones of Brazilian national identity and emblems of pride in Brazil's African roots. Works like *Samba* (1928) celebrate the popular music of Brazil and allude to its most renowned cultural manifestation, Carnival. Dismissed as dissolute and backward by Brazil's upper classes, Carnival embodies in this and other works by Di Cavalcanti the very essence and artistic creativity of the popular classes. Di Cavalcanti's alluring women, on the other hand, have been construed as symbols both of the fertility of the tropics (*Women with Fruit,* 1932) and the warmth and sexual energy of its people.

In 1935 Di Cavalcanti returned to Paris for a five-year stay. During this sojourn he discovered the work of Eugéne Delacroix, whose exotic images of North African harems, mediated by Matisse's oriental odalisques, were to inspire his own erotic fantasies. Di Cavalcanti translated the formal and semantic complexity of European modernism into a personal and highly accessible language. Large-scale easel paintings successfully synthesized a wide range of influences: Paul Gauguin, Diego Rivera, Picasso's neoclassical phase, Matisse's Nice period. The fluid, simplified lines, pleasing color combinations, and decorative compositions of André Derain and Georges Braque's late cubism were also important points of reference

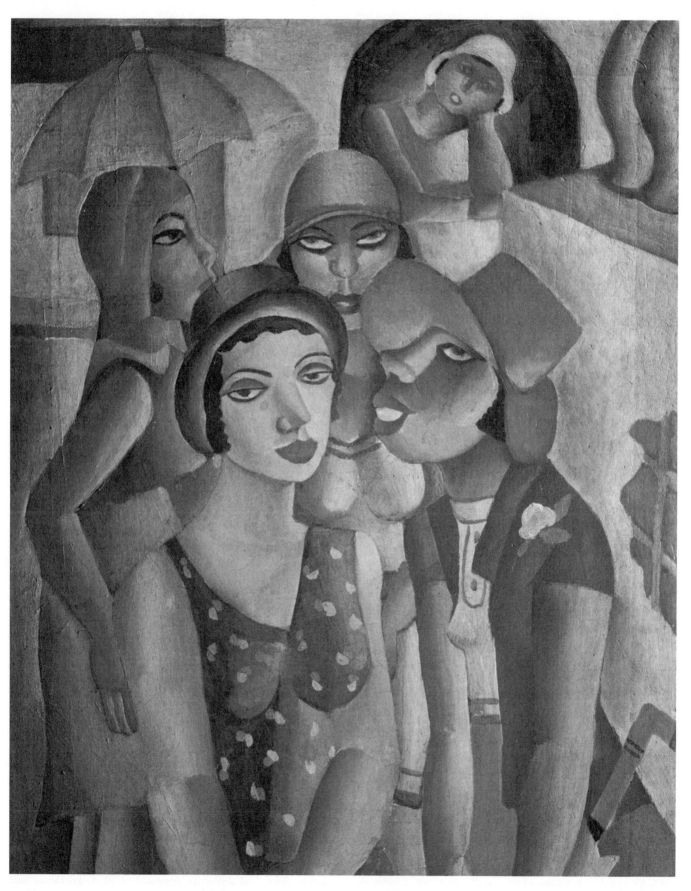

Emiliano di Cavalcanti: *Five Girls from Guaratingueta.* © Archivo Iconografico, S.A./Corbis.

for his mature style. As in the work of Matisse, women occupy a privileged position in Di Cavalcanti's pictorial universe. Although he cultivated still life and landscape painting throughout his career, the female nude remained the central motif of his vast output. Some of these pictures appear to be brothel scenes, while others feature sultry dark-skinned women sprawling on couches (*Woman with Fan,* 1937) or in the middle of a landscape in languid, provocative positions (*Recumbent Nude,* 1935) or posing on verandas engulfed in luxuriant tropical foliage (*Two Women on a Veranda,* 1961; *Woman, Birds, Flowers,* 1962).

In his later work Di Cavalcanti moved away from the social satire and fascination with marginal urban lifestyles of the 1920s to the domestic intimacy and solipsistic eroticism of the boudoir. Paintings such as *Woman with Guitar* (1932) exude a hedonistic abandon and an intense carnality. Ornate, curvilinear designs and shimmering colors, applied with increasing liberty after 1940, take precedence over the structuring function of line, often reduced to the most schematic of outlines. By the end of his career Di Cavalcanti settled for the excessive repetition of proven formulas, and his work suffered from a routine and mannered execution and a proclivity toward stereotypical representations of Brazilian femininity. At his best, however, he shaped a lyrical and dreamlike universe populated by seductive female icons that embodied in their bronzed, enticing flesh the sheer vitality and exuberance of Brazil and mirrored its ethnic and cultural diversity.

—Gerard Dapena

CHAGOYA, Enrique

American painter, printmaker, and mixed-media artist

Born: Mexico City; moved to the United States, 1977. **Education:** Studied economics, Universidad Nacional Autonoma de Mexico, 1972–75; San Francisco Art Institute, B.F.A 1984; University of California, Berkeley, M.A. 1986, M.F.A. 1987. **Family:** Married c. 1977. **Career:** Worked with migrant farm laborers, Texas, 1977; freelance illustrator and graphic designer, c. 1978. Director, Galeria de la Raza, San Francisco; curated exhibitions at the Drawing Center, New York, Mexican Museum, San Francisco, and others. Assistant professor of art, Stanford University, California, c. 2000. **Awards:** Eisner Prize, University of California, Berkeley, 1986; fellowships, National Endowment for the Arts, 1992, 1993; Eureka Fellowship, Fleishacker Foundation, 1996; Academy Award for visual arts, American Academy of Arts and Letters, New York City, 1997; Biennia Award, Louis Comfort Tiffany Foundation, New York City, 1997.

Individual Exhibitions:

1983 *Obra Grafica,* Galeria del Fonapas, Oaxaca
1984 *Drawings,* Galeria de la Raza, San Francisco
1985 *Etchings,* ASUC Studio, University of California, Berkeley

 Political Works, Martin/Weber Gallery, San Francisco
 The Work of Enrique Chagoya, Richard H. Reynolds Gallery, University of the Pacific Art Center, Stockton
 Enrique Chagoya, Installation, Artspace, San Francisco
1989 *Enrique Chagoya: When Paradise Arrived,* Alternative Museum, New York
1990 *Paintings and Installation,* De Saisset Museum, Santa Clara University
 Recent Work, Gallery Paule Anglim, San Franciso.
 Paintings on Metal, University of California Museum at Danville, Blackhawk Plaza, Behring, California
1992 *Paintings and Works on Paper,* Gallery Paule Anglim, San Francisco
1993 *Works on Paper-Installation,* Nelson Art Center, Arizona State University, Phoenix
 Re-inventing America, C.N. Gorman Musuem, University of California, Davis
 Power-Paradigm, Daniel Saxon Gallery, Los Angeles
1994 *Insulae Canivalium,* Gallery Paule Anglim, San Francisco
 Borders of the Spirit, M. H. de Young Memorial Museum, San Francisco
1995 *Enrique Chagoya, Drawings and Paintings,* Smith Center for the Arts, Ohlone College, Fremont
 Inner Boarders/Fronteras Internas, Sun Gallery, University of California, Hayward
1996 *The Big Little Book Series,* Smith-Andersen Gallery, Palo Alto
1996 *Beyond Boundaries,* Galeria de La Raza, San Francisco
1996–97 *Enrique Chagoya,* David Beitzel Gallery, New York
1997 *Insula Canibalium,* Stanford University, Stanford University
 The Politics of Humor, University of Colorado, Boulder
 Recent Works, David Beitzel Gallery, New York
 Recent Paintings, Gallery Paule Anim, San Fransco
1998 *Recent Work,* San Marco Gallery at Dominican, San Rafael
1999 *Doggie Doo Hopscatch,* Cité Internationale des Art, Paris
 Un-Noble Savage, Institute of Contemporary Art, San Jose
 utopiancannibal.org, Track 16 Gallery at Bergamot Station, San Jose
2000 *An American Primitive in Paris,* George Adams Gallery, New York
 Crocker Art Museum, Sacramento, California
 Enrique Chagoya: Locked in Paradise, Nevada Museum of Art, Reno
 Enrique Chagoya: Utopiancannibal.com, Gallery Paule Anglim, San Francisco
2001 *Utopian Cannibal: New Adventures in Reverse Anthropology,* Lisa Sette Gallery, Scottsdale
 From a Borderless World, Agustana College Art Gallery, Rock Island
 Adventures of the Reverse Anthropologist, Forum for Contemporary Art, St. Louis

Enrique Chagoya: *L'Arbre Généalogique,* **2000. Photo courtesy of George Adams Gallery; from the Collection of Susan A. and Charles M. Young.**

Selected Group Exhibitions:

1994	*The Chair Affair,* Oakland Museum, California
1996–97	National Academy Museum, New York
1997	*Diversity,* Bomani Gallery, San Francisco
1997–98	The Drawing Center, New York
1998	*Mouse: An American Icon,* Alternative Museum, New York
1999	*Saints, Sinners and Sacrifices: Religious Imagery in Contemporary Latin American Art,* George Adams Gallery, New York
2000	*Out of Time,* Galeria de la Raza, San Franciso
	Made in California, Los Angeles County Museum
2001	*Artists Respond: A Benefit Exhibition of Works by Gallery Artists and I Love New York Benefit,* George Adams Gallery, New York
	Magic Vision, Arkansas Art Center, Little Rock
	Contemporary Devotion, San Jose Museum of Art

Selected Collections:

Whitney Museum of Contemporary Art, New York; San Francisco Museum of Modern Art; M. H. de Young Memorial Museum, San Francisco; Centro Cultural de Arte Contemporaneo, Mexico City; Los Angeles County Museum; Di Rosa Foundation, St. Helena; National Museum of American Art, Smithsonian Institute, Washington, D.C.; Swigg Foundation, Honolulu; Galeria de la Raza, San Francisco; Santa Barbara Art Museum.

Publications:

By CHAGOYA: Books—*The Bread of Days: Eleven Mexican Posts* translated by Samuel Beckett, with Octavio Paz, Eliot Weinberger, and others, Covelo, California, Yolla Bolly Press, 1994; *Just Like Me: Stories and Self-Portraits by Fourteen Artists,* edited by Harriet Rohmer, with others, San Francisco, Children's Book Press, 1997. **Books, illustrated**–*Mr. Sugar Came toTown,* San Francisco and Emeryville, Artspace Books, 1989; *Friendly Cannibals* by Guillermo Gomez-Paz, San Francisco and Emeryville, Artspace Books, 1997; *Codex Espangliensis: From Columbus to the Border Patrol* by Guillermo Gómez-Peña, Santa Cruz, California, Moving Parts Press, 1998. **Article**–''Burning Desire: The Art of the Spray Can and a New Direction at the Mexican Museum,'' in *Shift,* Volume 5, Number 2, 1992.

On CHAGOYA: Books—*Enrique Chagoya: When Paradise Arrived,* exhibition catalog, text by Geno Rodriguez, New York, Alternative Museum, 1989; *Mixed Blessings; New Art in Multicultural America,*

New York, Pantheon Books, 1990; *The Chair Affair,* exhibition catalog, by Terrence McCarthy, Oakland, California, Oakland Museum Women's Board, 1994; *Here and Now: Bay Area Masterworks from the di Rosa Collections,* exhibition catalog, by Rene Di Rosa, Oakland, California, Oakland Museum, 1994. **Selected Articles—**"Thesis/Antithesis. Enrique Chagoya–Borders of the Spirit" by Anthony Torres, in *Artweek,* 25(20), 20 October 1994, p. 15; "Enrique Chagoya. M. D. de Young Memorial Museum, San Francisco" by Donald Goodal, in *Art Nexus* (Colombia), 16, April/June 1995, pp. 122–123; "'Diversity' at Bomani Gallery" by Debbie Koppman, in *Artweek,* 28, August 1997, p. 24; "Enrique Chagoya. University of Colorado at Boulder" by Joe Miller, in *New Art Examiner,* 25, October 1997, p. 57; "History, Unfolded" by Philip Krayna, in *Print* (New York), 53(1), January/February 1999, pp. 90–93; "Guillermo Gómez-Peña and Enrique Chagoya," in *Art On Paper,* 3(3), January/February 1999, p. 52; "Enrique Chagoya at the Crocker Art Museum" by Penelope L. Openshaw-Shackelford, in *Artweek,* 30(2), February 1999, p. 21; "Enrique Chagoya: George Adams" by Mary Schneider Enriquez, in *Art News,* 99(7), summer 2000, pp. 208–210; "Enrique Chagoya, Margaret Crane and Jon Winet at Gallery Paule Anglim" by John Rapko, in *Artweek,* 31(12), December 2000, p. 13.

* * *

Enrique Chagoya, a native of Mexico City who relocated to northern California in the late 1970s, was conversant in the iconography, politics, history, and culture of Mexico and the United States, a consequence of his binational and bicultural existence and identity. Proficient in the postmodern practice of appropriation, the artist was known for borrowing imagery from a wide range of sources, including but not limited to pre-Columbian religion and mythology, colonial Mexican illustrated codices, European painting, and U.S. comic book art. Chagoya described his work as "a conceptual fusion of opposite cultural realities . . . a product of collisions between historical visions, ancient and modern, marginal and dominant paradigms." Having studied both art and political economics, his work is resonant with a deep political consciousness, one that traverses cultural, historical, and artistic borders. By marrying ancient symbolism, art history, and modern politics, he created works that communicate to the viewer through a unique visual language rife with sardonic wit and an academic sensibility, one that rejects the notion of art for art's sake.

Chagoya often utilized the form of the pre-Columbian codex as a means of retelling the history of the invasion of the Americas from an indigenous perspective, one in which he gave voice not to the colonizer but to the colonized. This can be seen in works such as *Codex Espangliensis: From Columbus to the Border Patrol* (1998), an accordion-bound artist's book made from traditional Mexican bark paper, or *amate.* The result of a collaboration with Mexican-born writer and performance artist Guillermo Gómez-Peña, this work replaces the pictorial devices found in pre-Columbian codex with what Chagoya described as "stories of cultural hybrids, of political collisions of universal consequences," effectively recontextualizing the present through a reexamination of the past. By bringing together image and text, works such as this function as discursive tools for elucidating the inequities associated with cultural hegemony and colonialism within a global context. Such a strategy of historical

inversion elucidates the concept of *mestizaje,* or social, cultural, and biological hybridity, and reinscribes, in visual terms, the contemporary existence, experience, and identity of indigenous peoples.

In his work Chagoya also utilized a hierarchical visual system frequently found in Western art from the thirteenth through seventeenth centuries to show power imbalances, a system that employs variations in the scale and placement of figures to suggest power or subjugation. This is particularly evident in *Pocahontas Gets a New Passport (More Art Faster)* (2000), in which a tightly executed reproduction of a sixteenth-century portrait of Elizabeth of Austria by the French artist François Clouet (1510–72) ominously dwarfs the diminutive, crudely painted figure of Pocahontas. This artistic practice refers not only to the power struggle carried out for centuries between imperialistic and native cultures but it also pits aesthetic superiority against "primitive" incompetence, the privileged over the marginalized, particularly in regard to the mainstream art world (here indicated by the words "More Art Faster" contained within a cartoonist's speech balloon).

Chagoya has produced a body of work that casts its gaze not only at the United States-Mexican axis but also increasingly toward a more global perspective, moving away from a discrete form of political satirization toward works that take into account a broader range of cultural and aesthetic concerns.

—Kaytie Johnson

CHARLOT, Jean
Mexican painter

Born: Paris, France, 7 February 1898; moved to Mexico, 1921. **Education:** Studied drawing and painting, École des Beaux-Arts, Paris, 1915–21. **Military Service:** French Army, 1917–20, 1940: lieutenant. **Family:** Married Zohmah Day in 1939; one daughter and three sons. **Career:** Mural painter and assistant to Diego Rivera, Mexican government, Mexico City, 1921–24; staff artist in Yucatan, Carnegie Institute, Washington, D.C., 1926–30; instructor, Art Students League, New York, 1931–41; director, Colorado Springs Fine Arts Center, Colorado, 1947–49; professor, University of Hawaii, Honolulu, 1950–66. Artist-in-residence, University of Georgia, Athens, 1941–44. Painted 40 murals, including murals in the McDonough, Georgia, post office, University of Georgia, Athens, 1944, First National Bank, Waikiki and Honolulu branches, 1951–52, Tempe, Arizona, 1952, University of Hawaii, Honolulu, 1953. Also book illustrator. **Awards:** Fellowship, Solomon R. Guggenheim Foundation, 1945–47; Newbery Medals, American Library Association, 1953, for *Secret of the Andes,* and 1954, for *And Now Miguel;* Medal E oe Ka'uhane nona Kalei, state of Hawaii. D.F.A., Grinnell College, 1947; LL.D., St. Mary's College, Notre Dame, Indiana, 1957. Order of Distinction, state of Hawaii, 1976, for cultural leadership. **Died:** 1979.

Individual Exhibitions:

1951 Associated American Artists, New York

Jean Charlot: *Tortilla Maker,* **1937. © Smithsonian American Art Museum, Washington, D.C./Art Resource, NY.**

Jean Charlot: *The Sunday Dress,* 1947. © Smithsonian American Art Museum, Washington, D.C./Art Resource, NY.

1966 *Fifty Years, 1916–66,* Honolulu Academy of Arts
1968 *Obras pictoricas de Jean Charlot,* Museo del Arte
 Moderno, Mexico City (retrospective)
1976 *Paintings, Drawings and Lithographs by Jean Charlot,*
 Georgia Museum of Arts, University of Georgia,
 Athens

Selected Group Exhibitions:

1942 The Phillips Collection, Washington, D.C.,
 University of Louisiana, Baton Rouge
 Stendhal Gallery, Los Angeles
 Weyhe Gallery, New York

Collections:

Baltimore Museum of Art; Museum of Fine Arts, Boston; Cleveland
Museum of Art; Fine Arts Gallery, San Diego; Museum of Modern
Art, New York; Phillips Collection, Washington, D.C.

Publications:

By CHARLOT: Books—*The Temple of the Warriors at Chichen
Itzá, Yucaatan,* with Earl H. Morris and Ann Axtell Morris, 2 vols.,
Washington, D.C., Carnegie Institute of Washington, 1931; *A Pre-
liminary Study of the Ruins of Coba, Quintana Roo, Mexico,* with J.
Eric Thompson and Harry E. D. Pollock, Washington, D.C., Carnegie
Institute of Washington, 1931; *Picture Book: 32 Original Litho-
graphs,* New York, John Becker, 1933, reprinted, Dawson's Book
Shop, 1974; *Catalogue of Prints,* privately printed, 1936; *Pictures
and Picture Making* (lectures), Disney Studios, 1938; *Art from the
Mayans to Disney,* Sheed & Ward, 1939, reprinted, Books for
Libraries, 1969; *Charlot Murals in Georgia* (author of commentar-
ies), Athens, University of Georgia Press, 1945; *Guadalupe Posada:
100 grabados en Madera,* Arsacio Vanegas Arroyo, 1945; *100
Original Woodcuts by Posada,* Taylor Museum, 1947; *Art-Making
from Mexico to China,* New York, Sheed & Ward, 1950; *Dance of
Death: 50 Drawings and Captions,* New York, Sheed & Ward, 1951;
Choris and Kamehameha, Bishop Museum Press, 1958; *Mexican Art
and the Academy of San Carlos, 1875–1915,* Austin, University of

127

Texas Press, 1962; *Na'auao,* privately printed, 1962; *Mexican Mural Renaissance, 1920–1925,* New Haven, Connecticut, Yale University Press, 1963, reprinted, Hacker, 1979; *Three Plays of Ancient Hawaii,* Honolulu, University of Hawaii Press, 1963; *Posada's Dance of Death,* New York, Pratt Graphic Art Center, 1964; *Two Lonos* (play), privately printed, 1965; *An Artist on Art: Collected Essays of Jean Charlot,* Honolulu, University Press of Hawaii, 1972; *Picture Book II: 32 Original Lithographs and Captions,* Los Angeles, Zeitlin & Ver Brugge, 1973; *Cartoons Catholic: Mirth and Meditation from the Brush and Brain of Jean Charlot,* with F. J. Sheed, Huntington, Indiana, Our Sunday Visitor, 1978. **Books, illustrated**—*The Book of Christopher Columbus* by Paul Claudel, New Haven, Connecticut, Yale University Press, 1930; *Henrietta Shore* by Merle Armitage, New York, E. Weyhe, 1933; *La Légende de Prakriti,* Paris, Gallimard NFR, 1934; *The Sun, the Moon and a Rabbit* by Amelia Martinez del Rio, New York, Sheed & Ward, 1935; *Characters of the Reformation* by Hillaire Belloc, New York and London, Sheed & Ward, 1937; *Tito's Hats* by Melchor G. Ferrer, New York, Garden City Publishing Company, 1940; *Henry the Sixth, Part III,* by William Shakespeare, New York, Limited Editions Club, 1940; *Airports* by John Walter Wood, New York, Coward-McCann, 1940; *Digging in Yucatan* by Ann Axtell Morris, New York, Doubleday, 1940; *El Indio: Novela Mexicana* by Gregorio López y Fuentes, New York, Norton, 1940; *The Story of Chuan Yuc* by Dorothy Roads, Garden City, New York, Doubleday, 1941; *Carmen* by Propser Mérimée, New York, Limited Editions Club, 1941; *The Boy Who Could Do Anything & Other Mexican Folk Tales,* New York, William R. Scott, 1942, revised edition, Connecticut, Linnet Books, 1992; *Pageant of the Popes* by John Farrow, New York, Sheed, 1942; *Les Révélations de la Salette* by Paul Claudel, Paris, La Table Ronde, 1946; *The Tibetan Venus* by J. B. Morton, New York, Sheed, 1951; *45 Contemporary Mexican Artists: A Twentieth-Century Renaissance* by Virginia Stewart, Stanford, California, Stanford University Press, 1951; *Secret of the Andes* by Ann Nolan Clark, New York, Viking, 1952; *A Hero by Mistake* by Anita Brenner, New York, William R. Scott, 1953; *Martin de Porres, Hero* by Claire Huchet Bishop, Boston, Houghton Mifflin, 1954; *The Story of Thomas More* by John Farrow, New York, Sheed, 1954; *St. Germaine of Pibrac* by Joseph A. Keener, St. Joseph's Protectory Print, 1954; *Conversational Hawaiian* by Samuel H. Elbert and Samuel A. Keala, Honolulu, University of Hawaii Extension Division, 1955; *Our Lady of Guadalupe* by Helen Rand Paris, New York, Viking, 1955; *The Corn Grows Ripe* by Dorothy Rhoads, New York, Viking, 1956; *Selections from Fornanders Hawaiian Antiquities and Folk-Lore* by Samuel H. Elbert, Honolulu, University Press of Hawaii, 1959; *Conversational Hawaiian* by Samuel H. Elbert and Samuel A. Keala, Honolulu, University Press of Hawaii, 1961; *The Bridge of San Luis Rey* by Thornton Wilder, New York, Limited Editions Club, 1962; *The Art of Salad Making* by Carol Truax, New York, Doubleday, 1968; *Spoken Hawaiian* by Samuel H. Elbert, Honolulu, University of Hawaii Press, 1970; *Book of the Lord: Reflections on the Life of Christ* by William J. Borer, Huntington, Indiana, Our Sunday Visitor, 1978; *A First Book* by Zohmah Charlot, Honolulu, 1980. **Children's books, illustrated**—*Tawnymore* by Monica Shannon, Garden City, New York, Doubleday, 1931; *A Child's Good Night Book,* New York, William R. Scott, 1943, *Two Little Trains,* New York, William R. Scott, 1949, *Fox Eyes,* New York, Pantheon, 1951, *A Child's Good Morning,* New York, William

R. Scott, 1952, and *Seven Stories about a Cat Named Sneakers,* New York, William R. Scott, 1955, all by Margaret Wise Brown; *Atansio. Poema del Niño* by Vargas Pérez, Mexico, Arsacio Vanegas Arroyo, 1945; *And Now Miguel* by Joseph Krumgold, New York, Crowell, 1953; *When Will the World Be Mine?: The Story of a Snowshoe Rabbit,* New York, William R. Scott, 1953, and *Kittens, Cubs, and Babies,* New York, William R. Scott, 1959, both by Miriam Schlein; *The Poppy Seeds* by Clyde Robert Bulla, New York, Crowell,1955; *Hester and the Gnomes* by Marigold Hunt, New York, McGraw-Hill, 1955; *Julio* by Loretta Marie Tyman, New York, Abelard-Schuman, 1955; *Dumb Juan and the Bandits,* New York, Young Scott Books, 1957, *A Hero by Mistake,* New York, Young Readers Press, 1966, and *The Timid Ghost, or, What Would You Do with a Sackful of Gold?,* New York, William R. Scott, 1966, all by Anita Brenner.

On CHARLOT: Books—*Jean Charlot* by Paul Claudel, Paris, Librairie Gallimard, 1931; *Jean Charlot's Prints,* exhibition catalog, Honolulu, University of Hawai'i Press, 1976, and *Popular Art: The Example of Jean Charlot,* Santa Barbara, California, Capra Press, 1978, both by Peter Morse; *Jean Charlot: A Retrospective,* exhibition catalog, Honolulu, University of Hawaii Art Gallery, 1990. **Articles**—''The Theme of the Body in the Work of Jean Charlot: Two Stages, France and Mexico,'' in *Studies in Religion* (Waterloo, Ontario, Canada), 12(2), 1983, pp. 211–218, and ''The Source of Picasso's First Steps: Jean Charlot's First Steps,'' in *Zeitschrift für Kunstgeschichte* (Germany), 55(2), 1992, pp. 275–278, both by John Charlot; ''Art for All: Was Mencken Right?'' by Clinton Adams, in *Print Quarterly,* 12, September 1995, pp. 279–288.

* * *

Jean Charlot contributed to the history of Mexican art not only through his stylized depictions of the indigenous peoples of Mexico but also through his writings, most notably his important study *Mexican Art and the Academy of San Carlos,* which has been the sole monograph in English on that institution. His book, *The Mexican Mural Renaissance,* written in the 1950s, describes the development of muralism as the dominant art form in Mexico from 1920 to 1950, the years following the Mexican Revolution. Charlot, who had relocated to Mexico from Paris in 1921, played an important role in this development. He assisted Diego Rivera on the *Creacion* (''Creation'') mural in the Anfiteatro Bolivar in the Escuela Nacional Preparatoria in Mexico City. Charlot's own mural in the school's stairway, *Masacre en el templo mayor* (''Massacre in the Main Temple''), was the first in the Mexican mural movement executed in true fresco. The theme, drawn from the Spanish conquest of the Aztecs, set the precedent for Mexican historical subjects in subsequent murals. Charlot continued to assist Rivera on murals for the Secretaria de Educacion Publica (Ministry of Education), also in Mexico City, and was given three panels of his own to do for that monumental program, one of which Rivera later destroyed in order to paint one of his own in its place.

Charlot's style in the early murals most resembles that of Italian Renaissance artists updated by late cubism, with large solid figures that look more sculptural than naturalistic. His painting *Los cargadores* (''The Burden Bearers'') in the Ministry of Education may have

provided the inspiration for many of Rivera's paintings of similar themes, such as *The Flower Carrier* (1935). The importance of the subject matter outweighed stylistic concerns for Charlot. He believed that style and subject could work to elevate one another to convey meaning with greater effect than words. He had worked in the cubist mode earlier in his career, but he abandoned the avant-garde stylings of Paris as being superficially devoted to appearance. The political and cultural climate of Mexico in the 1920s provided ample material for Charlot's ideas, giving weighty subjects for his massive working figures.

Throughout the 1930s and '40s Charlot continued to paint murals, albeit now in the United States. He worked for the WPA programs and later received many commissions from educational institutions throughout the United States. His interest in indigenous themes continued, and when he moved to Hawaii in 1950 he worked on themes from Hawaiian culture, drawing parallels between Mexican pre-Hispanic traditions and Hawaii's precolonial past. In both cases he mourned the excesses of colonization and celebrated the link to nature that he saw the native peoples as having.

In the latter years of his life Charlot turned to creating large colorful sculptures in various mediums and techniques, chiefly ceramic and enamel on copper, fully realizing the solidity of his painted forms in three dimensions. The Christian religious themes of much of his late work may seem out of place within the context of his admiration for indigenous peoples but is actually of a piece with his spirituality and his belief in the power of plastic arts to convey the highest concepts and emotions. While he mourned the violence of the conquest of the Mexican and Hawaiian peoples, he did not demonize the Spanish clergy or religion as a whole, as many of the Mexican muralists had done. Despite having abandoned Europe and the stylistic avant-garde of early twentieth-century Paris, Charlot maintained European ideals about the nature and quality of art as belonging to a higher sphere of thought. His work has the characteristics of devotional art, perhaps derived from Renaissance principles along with his own beliefs.

Charlot's contributions to the art of Mexico fall mostly in the development of the mural projects initiated in the early 1920s, but his writings have helped to educate many readers about otherwise overlooked aspects of Mexican art. He helped to lay the foundation for the use of true fresco technique by Rivera and others, and his early emphasis on historical and indigenous subjects, while from a European perspective, provided added impetus to the populist art practices of the 1920s and '30s in Mexico.

—Laura J. Crary

CHÁVEZ MORADO, José
Mexican painter, muralist, and printmaker

Born: Guanajuato, 4 January 1909. **Education:** Chouinard School of Art, Los Angeles, beginning in 1930; Escuela Nacional de Artes Plásticas, Mexico City, 1931–32. **Family:** Married Olga Costa in 1935. **Career:** Migrant farm worker, California, 1925–30; drawing instructor, elementary and secondary schools, Mexico, 1933; director, Sección de Artes Plásticas del Departamento de Bellas Artes de la Secretaría de Educación Pública, 1935; professor of lithography, Escuela de Artes del Libro, 1945; director, Museo de la Alhóndiga de Granaditas, the late 1960s-1980. Completed more than 20 murals on public and private buildings in Mexico, including murals at the Universidad Nacional Autónoma, 1952, the Secretaría de Comunicaciones y Obras Públicas, 1954, and the Centro Médico Nacional, 1960. Member, League of Revolutionary Writers and Artists, beginning in 1936, and Taller de Gráfica Popular, 1938–41. Founding member, Galería Espiral, 1941, Sociedad para el Impulso de las Artes Plásticas, 1948, Salón de la Plástica Mexicana, 1949, Taller de Integración Plástica, 1950, Sociedad de Amigos de Cuba, 1953; founder of several museums. **Awards:** Third prize, Mexico City, 1949; Premio Nacional de Pintura, 1974. Honorary doctorate, National University of Mexico, 1985.

Selected Exhibitions:

1938 *El presente de la memoria: Encuentro de pintores,* San Miguel de Allende, Mexico
1959 San Antonio Museum of Fine Arts, Texas
1983 *José Chávez Morado, Olga Costa: Exposición homenaje,* Salón de la Plástica Mexicana, Mexico City
1988 Museo del Palacio de Bellas Artes, Mexico City
1989 *The Latin American Spirit: Art & Artists in the U.S.,* Bronx Museum, New York
1992 *Muestra de la colleción pago en especie: José Chávez Morado,* Secretaría de Hacienda y Crédito Público, Mexico City
1994 *Dr. Atl, David A. Siqueiros, José Chávez Morado, Pablo O'HIggins, Alfredo Zalce, Federico Cantú, Carlos Mérida y José Clemente Orozco,* Centro Cultural el Nigromante, San Miguel de Allende, Mexico
 Instituto Nacional de Bellas Artes, Mexico City
1996 *José Chávez Morado: Modernidad de ayer, tradición de hoy,* Museo de la Secretaria de Hacienda y Crédito Público, Mexico City
2000 Instituto Nacional de Bellas Artes, Mexico City (with Olga Costa; traveling)

Collections:

Museo de Arte Moderno, Mexico City; Colorado Springs Fine Arts Center; Museum of Fine Arts, Boston; Philadelphia Museum of Art; Museo de Arte Olga Costa y José Chávez Morado, Guanajuato, Mexico.

Publications:

By CHÁVEZ MORADO: Books—*Vida nocturna de la ciudad,* n.p., 1936; *Ge, erre, ene: Poesía bufa,* n.p., Talleres de la Tipografía Brenes, 1958; *Murales de José Chávez Morado,* Guanajuato, Mexico, Museo de la Alhondiga de Granaditas, 1974; *Apuntes de mi libreta,*

José Chávez Morado: *Carnaval en Huejotzingo (Carnival in Huejotzingo)*, 1939. Collection of Phoenix Art Museum; gift of Dr. and Mrs. Loyal Davis. © Jose Chávez Morado/Licensed by VAGA, New York, NY.

with Raquel Tibol, Mexico City, Ediciones de Cultura Popular, 1979.
Books, illustrated—*Cantos para soldados y sones para turistas* by Nicolás Guillén, Mexico, Masas, 1937; *Corrido de la expropiación petrolera,* with Alfredo Zalce, Mexico City, Taller de Gráfica Popular, 1938; *Amor, patria mía* by Efraín Huerta, Mexico City, Ediciones de Cultura Popular, 1980; *El mal de ojo: La cabeza de la gorgona* by Nathaniel Hawthorne, second edition, Mexico City, Consejo Nacional para la Cultura y las Artes, 1990; *El niño de mazapán y la mariposa de cristal: Cuento para niños* by Magda Donato, second edition, Mexico City, Consejo Nacional para la Cultura y las Artes, 1990; *Rin-Rin Renacuajo: Cuento sudamericano de Rafael Pombo* by Rafael Pombo, second edition, Mexico City, Consejo Nacional para la Cultura y las Artes, 1990.

On CHÁVEZ MORADO: Books—*José Chávez Morado* by Julio Prieto, Mexico City, Ediciones Mexicanas, 1951; *José Chávez Morado: Imágenes de identidad mexicana* by Raquel Tibol, Mexico City, Universidad Nacional Autónoma de México, 1980; *José Chávez Morado, Olga Costa: Exposición homenaje,* exhibition catalog, Mexico City, Salón de la Plástica Mexicana, 1983; *Chávez Morado: Vida,*

obra y circunstancias by José de Santiago Silva, Guanajuato, Mexico, Ediciones del Gobierno del Estado de Guanajuato, 1984; *José Chávez Morado: Su tiempo, su país,* exhibition catalog, Guanajuato, Mexico, Gobierno del Estado de Guanajuato, 1988; *José Chávez Morado: Para todos internacional* by Carlos Monsiváis, Mexico City, Banco Internacional, 1989; *Muestra de la colección pago en especia,* exhibition catalog, text by Raquel Tibol, Mexico City, Secretaría de Hacienda y Crédito Público, 1992; *José Chávez Morado: Modernidad de ayer, tradicón de hoy,* exhibition catalog, Mexico City, Museo de la Secretaria de Hacienda y Crédito Público, 1996; *Olga Costa y José Chávez Morado en lo íntimo,* exhibition catalog, with text by Gabriel Rodríguez Piña and Blanca Garduño, Mexico City, Instituto Nacional de Bellas Artes, 2000.

* * *

José Chávez Morado created socially concerned murals, prints, and easel paintings from the 1930s, often drawing his motifs from popular, indigenous, and folk imagery of Mexico. He was also instrumental in the creation and development of museums in

Guanajuato, Mexico. He was born in Silao, Guanajuato, where his father owned a grocery store, but as a child Chávez Morado studied art in books he encountered in his grandfather's extensive library. From 1925 to 1930 Chávez Morado worked in California as a migrant farm worker. He studied painting briefly in Los Angeles on a scholarship at the Chouinard School of Art at the same time that David Alfaro Siqueiros was painting his mural *Mitin Obrero* ("Workers Meeting") on the walls of the school. He also saw José Clemente Orozco's *Prometheus* at Pomona College while the mural was in progress.

In 1930 he returned to Silao where for a short time he managed a grocery store established by his father. This endeavor did not interest him, however, and in 1931 he moved to Mexico City. He entered the Escuela Nacional de Artes Plásticas (National School of Plastic Arts, the former Academy of San Carlos), supporting himself by selling caricatures he made of his friends and acquaintances. At San Carlos he studied printmaking with Francisco Díaz de León and Emilio Amero. In 1933 he met his wife, fellow student Olga Costa, who was studying painting with Carlos Mérida at San Carlos. They married in 1935, forming a lifelong artistic partnership. During this period he also attended the Centro Popular de Pintura Saturnino Herrán (Saturnino Herrán Popular Painting Center), where he worked with painter Fernando Leal and printmaker Leopoldo Méndez. In 1935 he began to teach drawing at San Carlos, and he also created backdrops and masks for the ballets *Clarín* and *Barricada*, which were performed at the Palacio de Bellas Artes in Mexico City. In 1951 Chávez Morado designed costumes and decorations for the ballet *La manda*.

In 1936 he joined the Liga de Escritores y Artistas Revolucionarios (LEAR; League of Revolutionary Writers and Artists). He had previously painted a LEAR-sponsored fresco mural in the Escuela Normal Veracruzana (Veracruz Normal School) in Jalapa Veracruz, *La lucha antimperialista* (1935; "The Anti-Imperialist Struggle"), with Francisco A. Gutiérrez and Feliciano Peña. While in LEAR Chávez Morado produced two portfolios of woodcut prints, *Estampas del Golfo* ("Prints of the Gulf") and *La vida nocturna de la ciudad* ("Nocturnal Life of the City"), both of which portrayed scenes of popular culture in a style that was influenced by German expressionism. In 1937 he went to Spain as a member of LEAR's delegation to the Congreso de la Alianza Internacional de Intelectuales Antifascistas (Congress of the International Alliance of Anti-Fascist Intellectuals). Their tour included an art exhibition, *Cien años de arte revolucionario mexicano* ("100 Years of Mexican Revolutionary Art"), and performances of musical compositions by Silvestre Revueltas. Chávez Morado joined the Communist Party of Mexico in 1937.

From 1938 to 1941 Chávez Morado belonged to the Taller de Gráfica Popular (TGP; Popular Graphic Arts Workshop), the collective printmaking studio founded in 1937 by Leopoldo Méndez, Pablo O'Higgins, and Luis Arenal. During and after his years with the TGP he created powerful graphic images in a variety of styles, often with elements of the grotesque. His lithograph *Danza de la muerte* ("Dance of Death") portrays three masked men dancing with swords raised against each other, while *El clero y la prensa* ("The Clergy and the Press") depicts the press as a crowd of fantastic beasts and the clergy as a malign warlock with an elf-like figure as his companion. During the late 1930s and early 1940s Chávez Morado created political cartoons for the Communist newspaper *La Voz de México* and leftist publications *Combate* and *El Eje-le*.

In the 1940s he and his wife established the Galería Espiral and Sociedad de Arte Moderno, two of the first independent art galleries in Mexico. They exhibited their work along with that of Germán Cueto, Gabriel Fernández Ledesma, Angelina Beloff, Carlos Alvarado Lang, and others. In 1945 he painted a mural in a school in the Centro Escolar Estado de Hidalgo, and in 1955 he created a mural on the stairway of the Alhóndiga de Granaditas in Guanajuato. In the 1950s and '60s he also created murals for the Secretaría de Comunicaciones y Transportes, the Torre de Ciencias of the Universidad Autónoma de México, the Centro Médico Nacional, and Ciba Laboratories in Mexico City. In 1964 he painted murals on the first floor of the National Museum of Anthropology and designed the carved surface of the massive column in the museum's courtyard.

Beginning in the 1940s Chávez Morado painted a number of ingenious and imaginative canvases with themes concerning political and social conditions. His critique of fascism, *México negro* (1942; "Black Mexico") is a Goyaesque image. An enormous skeleton of a bull is impelled forward by a crowd of Mexican peasants; overhead owls, skulls, and various creatures fly around on newspaper wings. *Río revuelto* (1949; "Rough River") is a complex composition depicting the multiple cultural and physical strata of Mexico City. A scaffold of a modern building is the backdrop for scenes from contemporary life, including construction workers, circus performers, crowds, cars, and advertisements, with a pre-Columbian sculpture of Quetzalcoatl in the lowest level. His 1961 painting *Tzompantli* ("Skull Rack") suggests the blend of ancient and modern Mexico, setting an image of an Aztec skull rack against a contemporary glass-and-steel building.

In 1966 Chávez Morado moved to the city of Guanajuato. In the 1970s, inspired by the surrounding region, he painted a number of semi-abstract landscapes. In Guanajuato Chávez Morado has been responsible for the creation of the Museo del Pueblo de Guanajuato, established in the colonial palace of the Marqués de Rayas. He was the director of the Museo de la Alhóndiga de Granaditas from the late 1960s until 1980. In 1993 the painter and his wife converted their house and studio in Guanajuato to the Museo de Arte Olga Costa-José Chávez Morado.

—Deborah Caplow

CHIESA, Wilfredo
American painter

Born: San Juan, Puerto Rico, 15 January 1952. **Education:** Escuela de Artes Plásticas de Puerto Rico, B.F.A. 1972. **Career:** Instructor, San Juan Art Students League, Puerto Rico, 1976–77. Since 1980 associate professor of art, University of Massachusetts, Boston. Artist-in-residence, Massachusetts Council for the Arts, 1980, and Artist Foundation, Boston, 1982; visiting professor, Wellesley College, spring 1987, and Art New England, Bennington College, summer 1996, 2000. **Awards:** First prize, 450 Anniversary of San Juan, 1973; honorary prize, Ateneo Puertorriqueño, 1973; first prize, print, United Federal Savings, San Juan, 1974; Martínez-Cañaz

Foundation fellowship, 1975; Fondo de Becas para las Artes Plásticas fellowship, 1976; first honorary prize, painting, UNESCO, San Juan, 1977; MacDowell Colony fellowship, 1981. **Member:** Academy of Art, Science and History of Puerto Rico, 1993. **Address:** 175 Purchase Street, Boston, Massachusetts 02110. **E-mail Address:** wilfredo.chiesa@umb.edu.

Individual Exhibitions:

1977	La Casa del Libro, San Juan
1978	Bell Book and Candle Gallery, San Juan
	Cayman Gallery, New York City
1979	Thorne's Gallery, Northampton, Massachusetts
1982	Liga de Estudiantes de Arte, San Juan
	Museo Rayo, Roldanillo, Colombia
1983	University of Massachusetts, Boston
1984	Ponce Art Museum, Puerto Rico
	Museo de Arte Moderno, Bogota
1985	Galería Arteconsult, Panama City
	Ricardo Barreto Fine Arts, Boston

Wilfredo Chiesa: *Principro y Fin,* 1993. Photo courtesy of the artist.

1986	Luigi Marrozzini Gallery, San Juan
1988	Luigi Marrozzini Gallery, San Juan
1990	Andrea Marquit Fine Arts, Boston
1991	Galería Rojo y Negro, Madrid
	Leonora Vega Gallery, San Juan
1992	*Augenweide,* Andrea Marquit Fine Arts, Boston
	Elite Gallery, Miami
1994	Andrea Marquit Fine Arts, Boston
1995	Elite Gallery, Miami
1997	Andrea Marquit Fine Arts, Boston
1998	Peter Findlay Gallery, New York
	Elite Gallery, Miami

Selected Group Exhibitions:

1973	*Reyes, Chiesa, Bonilla,* Museo de Bellas Artes de Puerto Rico, San Juan
1978	Center for Inter-American Relations, New York
1984	*Congreso de artistas abstractos,* Museo del Arsenal, San Juan
1986	*25 años de pintura puertorriqueña,* Ponce Art Museum, Puerto Rico, and El Museo del Barrio, New York
	First Latin American Annual, AARON Gallery, Washington, D.C.
1987	*Puerto Rican Painting: Between Past and Present,* Museum of Modern Art of Latin America, Washington, D.C., Squibb Gallery, Princeton University, New Jersey, and University of Puerto Rico, San Juan
1988	*Abstract Visions,* Museum of Contemporary Hispanic Art, New York
1989	*Above, Beyond, and Within,* Boston Center for the Arts
1996	*Chiesa, Hernández-Cruz, Irizarry, Suárez,* Art Museum of the Americas, Washington, D.C., Ponce Art

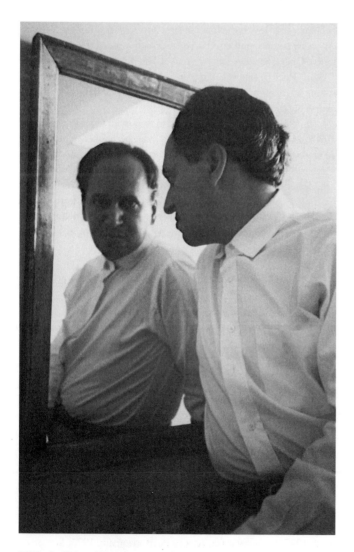

Wilfredo Chiesa. Photo courtesy of the artist.

Museum, Puerto Rico, and Instituto de Cultura
Puertorriqueña, San Juan
2000 *Tesoros de la pintura puertorriqueña,* Museo de Arte de
Puerto Rico, San Juan

Collections:

Lowe Museum of Art, Miami; University of Massachusetts, Boston; Museum of Fine Arts, Boston; Harvard University, Cambridge, Massachusetts; Boston Public Library; New York Public Library; Princeton University, New Jersey; Library of Congress, Washington, D.C.; El Museo del Barrio, New York; Metropolitan Museum of Art, New York; Museo de Arte Moderno, Bogota; Museo Rayo, Roldanillo, Colombia; Museo Vial, Roldanillo, Colombia; Colección Bienal de Arte, Medellín, Colombia; Museum of Modern Art, São Paulo, Brazil; Victoria and Albert Museum, London; Bibliotheque Nationale, Paris; International Print Museum, Fredrikstad, Norway; Instituto per la cultura e l'arte, Catania, Italy; Museo de Arte de Puerto Rico, San Juan; Ponce Art Museum, Puerto Rico; La casa del libro, San Juan; University of Puerto Rico, San Juan; Instituto de cultura puertorriqueña, San Juan; Inter-American University, San Juan.

Publications:

On CHIESA: Books—*Wilfredo Chiesa,* exhibition catalog, by Miguel González, Roldanillo, Colombia, Museo Rayo, 1982; *Pinturas, Wilfredo Chiesa,* exhibition catalog, text by Silvia Tennenbaum, Ponce, Puerto Rico, Museo de Arte de Ponce, 1984; *Chiesa, obra reciente,* exhibition catalog, text by Efraín Barradas, San Juan, Galería Luigi Marrozzini, 1986; *Wilfredo Chiesa,* exhibition catalog, text by Andrea Marquit-Clagett, Boston, Andrea Marquit Fine Arts, 1990; *Wilfredo Chiesa,* exhibition catalog, San Juan, Galería Lenora Vega/Ediciones Boinayel, 1991. **Articles**—''Wilfredo Chiesa: Un pintor que crea

Wilfredo Chiesa: *Arcos 50,* 1999. Photo courtesy of the artist.

construyendo el papel'' by Edda Pilar Duque, in *El Colombiano* (Medellín, Colombia), 22 May 1981; ''Chiesa,'' in *El Nuevo Día* (San Juan), 1 April 1984, and ''Wilfredo Chiesa 'Endurece' su pintura,'' in *El Nuevo Día* (San Juan), 27 March 1996, both by Samuel B. Cherson; ''Wilfredo Chiesa: Lo nuevo y lo viego'' by Marimar Benítez, in *El Reportero* (San Juan), 13 September 1986; ''Wilfredo Chiesa: A Good Artist Becomes Even Better'' by Myrna Rodríguez, in *Sunday San Juan Star* (San Juan), 14 September 1986; ''Sobriedad de Wilfredo Chiesa'' by Manuel Pérez-Lizano, in *El Nuevo Día* (San Juan), 5 September 1988; ''Wilfredo Chiesa,'' in *El Punto de las Artes* (Madrid), 12 December 1991; ''Wilfredo Chiesa, la apariencia luminosa del espacio'' by A. Meza, in *Exito!* (Bogota), 6 September 1995; ''Arcos: Recent Paintings by Wilfredo Chiesa'' by P. Parcellin, in *Art New England* (Boston), December/January 1997/1998.

* * *

Wilfredo Chiesa's paintings are most noted for their abstract minimalism. His work has typically featured spare geometric shapes and precise lines, with a particular concentration on rectangular forms. In his later work he came to explore the arc, a figure that he has sought to redefine symbolically. While Chiesa's work is generally spare, it is never simple. Working in mixed media and with self-imposed limits on palette, shapes, and composition, Chiesa crafts paintings that are tense, often hinting at hidden shapes and meanings. He has resisted the folkloric, fantastic, and figurative tendencies that are often seen as archetypal of Latin American art. For Chiesa painting is an intellectual exercise.

Chiesa's interest in abstract minimalism was fostered during his studies at the Instituto de Cultura Puertorriqueña's Escuela de Artes Plasticas. At the time Chiesa studied there in the 1970s, a number of Puerto Rican artists were practicing, teaching, and publicizing extreme abstractionism. Luis Hernandez Cruz, for instance, exerted a profound influence on the Puerto Rican arts community, launching Grupo Frente and the Congress of Abstract Artists, both of which promoted nonfigurative expression as a means to explore individual and collective identity. Chiesa's work has also been heavily influenced by the American abstract masters, whose oeuvre he first encountered on a trip to New York in the 1970s.

Chiesa's connection to American abstractionism was cemented when he was offered a teaching position at the University of Massachusetts in Boston. In his classes and on his canvases, Chiesa professed the idea that vision is abstract, that reality is present in abstraction, and that realism itself is abstract at its core. After he took a 1991 sabbatical in Germany, Chiesa's work became even more minimalistic. A solo exhibition, *Augenweide,* held in 1992 at Andrea Marquit Fine Arts in Boston, demonstrated this refinement in his approach. *Augenweide* featured a limited number of rectangles colored in graphite, pastel, or a combination of the two. The works' palettes were as limited as their composition—Chiesa used only black, white, and an umber gray. Despite their somber tones and set geometric compositions, though, the *Augenweide* works were complex. In *Augenweide Series No. 7,* for example, Chiesa balanced a large, dark, and centrally located rectangular form with light-colored space on the upper left-hand corner of the canvas, jagged gray edges on the upper right-hand corner, and a completely blank lower right corner. The painting's subtle and uneasy composition leaves the viewer with the sense of a presence trying to emerge from below the work's surface.

After exhibitions at Elite Gallery in 1992 and at Andrea Marquit again in 1994, Chiesa spent four years developing the works that would constitute his 1998 show, *Arcos: The Echo of Vision.* While he continued the minimalist exploration of geometric shapes evident in *Augenweide,* Chiesa introduced new elements to the paintings of *Arcos.* Although the rectangle reappeared in the *Arcos* paintings, it was joined there by the recurring shape of the ogival arch. "The square is the most neutral of formats," he explained in the exhibition's catalog. "It does not predispose any kind of image." For Chiesa the arches of the *Arcos* paintings transcended those of lines, circles, or even figures. The arch "allows us not to leap back and forth from one point to another, but to go on," he said. At their core the works are about the force of gravity and how the paintings liberate themselves from its confines. In *Solo lo Espiritual, Solo lo Verdadero,* for example, Chiesa combined graphite, charcoal, and pastel to create four overlapping rectangles, the corners of which form a square near the canvas's center. The overlapping forms are ambiguous, each seeming to exist both as space and as a solid plane. The *Arcos* paintings' use of color marks another stylistic shift in Chiesa's work. Deep blues and greens, brilliant reds, and pale yellows coexist with the familiar whites, blacks, and grays that dominated *Augenweide.*

—Rebecca Stanfel

CLARK, Lygia
Brazilian sculptor

Born: Lygia Pimentel Lins, Belo Horizonte, Minas Gerais, 23 October 1920. **Education:** Ecole Normale, Belo Horizonte, 1934–37, teaching certificate 1937; studied art under landscape architect Roberto Burle-Marx, Rio de Janeiro, 1947, under Fernand Léger, Paris, 1948–50, and under Arpad Sezenes, Paris, 1950–52. **Family:** Married Aloizio Clark in 1939 (died 1968); one daughter and two sons. **Career:** Lived in Paris and Stuttgart, 1964, in Venice and Paris, 1968, and in California, 1969. Instructor, Institute for the Deaf and Dumb, Rio de Janeiro, 1950–55; professor, Sorbonne, Paris, 1970–75. Cofounder, Neo-Concrete association MAM. **Awards:** Frederico Schmidt prize, Rio de Janeiro, 1952; prize, *Bienal,* São Paulo, 1957, 1961; Revelation Artistique de l'Année, Rio de Janeiro, 1962; grand prize, *Bienal,* Bahia, Brazil, 1966. Honorary doctorate and gold medal, Parma, Italy, 1980. **Died:** Rio de Janeiro, 1988.

Individual Exhibitions:

1952	Galerie de l'Institut Endoplastique, Paris
	Ministere de l'Education et la Culture, Rio de Janeiro
1960	Galeria Bonino, Rio de Janeiro
1963	Luis Alexander Gallery, New York
	Museu de Arte Moderna, Rio de Janeiro
1964	Technische Hochschule, Stuttgart
1965	Signals Gallery, London (retrospective)
1966	*Bienal,* Bahia, Brazil (retrospective)
1968	*Biennale,* Venice (retrospective)
	Museu de Arte Moderna, Rio de Janeiro
	Galerie M. E. Thelen, Essen
1970	Galerie Camargo, São Paulo
1971	Galerie Camargo, São Paulo
1980	Galeria Funarte, Rio de Janeiro

1982	Gabinete de Arte Raquel Arnaud, São Paulo
1984	Galeria Paulo Klabin, Rio de Janeiro
1986	Salão Nacional de Artes Plásticas de Funarte, Paço Imperial, Rio de Janeiro (retrospective)
1994	*São Paulo Bienal* (restrospective)

Selected Group Exhibitions:

1960	Museum of Modern Art, New York
1962	Pan-American Union, Washington, D.C.
1963	*Arte neoconcrete,* Museu de Arte Moderna, Rio de Janeiro
	Biennale, Venice
1964	*Festival of Modern Art in Latin America,* Signals Gallery, London
1966	*Art of Latin America since Independence,* Yale University, New Haven, Connecticut, and University of Texas, Austin
1965	*Mouvement 2,* Galerie Denise René, Paris
	Art et mouvement, Galerie Denise René, Paris (traveled to the U.K.)
1969	*Symposium of Survival Art,* International Tactile Sculpture Symposium, California State University at Long Beach
1970	Kunstmarkt, Cologne, Germany

Collections:

Museu de Arte Moderna, Rio de Janeiro; Museu de Arte Moderna, Sao Paulo; Museo de Arte Moderno, La Paz, Bolivia; Museum of Modern Art, New York; Arts Council of Great Britain, London; Centre National d'Art Contemporain, Paris.

Publications:

By CLARK: Articles—"Un Mythe moderne: La Mise en evidence de l'instant comme nostalgie du cosmos," in *Robho* (Paris), 4, 1965; several articles in *Signals* (London), April/May 1968; several articles in *Robho* (Paris), 4, 1968; "L'Homme, structure vivant d'une architecture biologique et cellulaire," in *Robho* (Paris), 5/6, 1969; "Le Corps est la mai'sm," in *Robho* (Paris), 5/6, 1971; "L'Art c'est le corps," in *Preuves* (Paris), 1973; "Tote Kultur–Lebende Kultur," with Adviniula, in *Heute Kunst* (Dusseldorf), 9, 1975; "De la suppression de l'object," in *Mácula,* 1976; "The Relational Object in a Therapeutic Context," in *Flue,* spring 1983.

On CLARK: Books—*Kinetic Art* by Guy Brett, London, 1968; *Lygia Clark: Obra-trajeto* by Maria Alice Milliet, São Paulo, Edusp, 1992; *Resignifying Modernity: Clark, Oiticica and Categories of the Modern in Brazil* (dissertation) by Paula Terra Cabo, Essex, England, University of Essex, 1997; *Lygia Clark* by Manuel J. Borja-Villel, Barcelona, Fundació Antoni Tapies, 1998; *Lygia Clark* by Paulo Herkenhoff, São Paulo, Museu de Arte Moderna de São Paulo, 1999. **Articles**—"La IX Biennale de Sao Paulo" by Pierre Restany, in *Domus* (Milan), 457, 1967; "Lygia Clark and Spectator Participation" by C. Barrett, in *Studio International* (London), 173, 1967; special issue of *Robho* (Paris), 1968; "De Kunst ur Lygia Clark" by Frans Haks, in *Vroumbiar Huis* (Hilversum, Netherlands), September 1969; "Lygia Clark: In Search of the Body" by Guy Brett, in *Art in America,* 82, July 1994; "Nostalgia of the Body: Life and Work of

Lygia Clark'' by Yve-Alain Bois and others, in *October* (Cambridge, Massachusetts), 69, summer 1994, pp. 85–109; ''Lygia Clark and Hélio Oiticica: A Legacy of Interactivity and Participation for a Telematic Future'' by Simone Osthoff, in *Leonardo*, 4, 1997, pp. 279–289; ''Eloge de l'oeil-corps: Lygia Clark'' by Arnauld Pierre, in *Cahiers du Musée National d'Art Moderne* (France), 69, autumn 1999, pp. 42–75.

* * *

Along with Hélio Oiticica, Lygia Clark is considered one of the most important Brazilian artists of the twentieth century who emerged in the late 1950s and early '60s and whose artistic legacy is still apparent today in the work of younger artists within Brazil and abroad. As one of the founders of neo-concretism in Brazil, Clark helped revolutionize an understanding of the monochrome and geometric abstraction by shifting them away from the consensus that they are emptied of meaning by their lack of iconographic association with the real world.

Unlike some of her European and North American contemporaries who emphasized a neo-Kantian hermeticism of pure abstraction, Clark articulated that form as well as color is imbued with significance. Whereas North America critics such as Clement Greenberg espoused a formalism that severed the art object from its social referent, Clark underscored the importance of the viewer in providing creative closure to the work of art. In doing so she undermined a conservative formalism and supplanted it with a rigorous critical practice that was as much densely philosophical as it was aesthetically sensuous. She would later take her critical formalism into many directions that converged on the notion that other senses should be used in the experience of art. Marcel Duchamp had observed that one of the key tenets of modernism was what he called its ''retinal-centrism,'' meaning that twentieth-century art had a bias for the optical. Taking Duchamp's observation only as a point of departure, then, Clark reworked the monochrome and reconfigured the ontology of the art object by making the viewer's participation a crucial aspect of the work.

This was realized in her sculptures as well as her vestiary work, or art worn by participants that made it interactive and that would later entail the participation of more than one person. In turn, this idea would be extrapolated further in Clark's collective performances that culminated in her ostensible abandonment of art for her work in psychotherapy. These disparate ideas and sources that covered such a wide intellectual and cultural spectrum, which she was able to cohere into a profound artistic project, situates Clark in a class all by herself whose work will need generations of critics and art historians in order to fully assess its impact.

Clark had first studied painting under the tutelage of Roberto Burle Marx in Rio de Janeiro, and it was not until 1950 that she went to Paris to continue her studies with Fernand Léger and Arpad Sezenes. Influenced by the pure and geometric abstraction of Piet Mondrian and Russian constructivism, Clark returned to Rio de Janeiro and began making small works that were planar and relief-like. It was not until the end of the 1950s with her *Unity* series and paintings such as *Egg* (1959) that Clark began to exhibit qualities that evinced a directional shift in reconverting the monochrome and pure abstraction back into the social field proper. While Ad Reinhardt's black paintings negated the world, for example, Clark's work of the same hue referenced the social as well as the corporeal by way of its oval format. As a transitional piece, *Egg* was an accomplished work that was gestational of how Clark was reconfiguring form in implying that it can never be divorced from the viewer/receiver and the world of which she or he is a part. This was further emphasized in geometric sculptures made up of hinged plates that she titled *Animals* (1962).

Animals were a radical proposition in and of themselves in that viewer/receiver manipulation was contingent for their artistic completion. Tactility as an aesthetic receptor evolved from physical interaction with the artwork, to where the artwork became a conduit for social intercourse between individuals. This became increasingly evident in works that needed to be worn by individuals in order for them to be artistically activated and to achieve formal closure. While her colleague Oiticica was working in a similar vein exemplified in the *Parangole,* which had a formal affinity to Clark's work, Clark's cloaks were conceptualized differently than Oiticica. Clark's vestiary when worn by one person was about stimulating interiority in an auto-dialogue of self-knowledge; when worn by two persons, her vestiary was about the work's ability to engender and mediate interaction between participants. Since this type of work was therapeutic by nature, Clark's art increasingly looked like psychotherapy. Yet this strategy needs to be seen in the context of two other international artists who where beginning to expand the role of the artist: Andy Warhol and Joseph Beuys. The former manipulated the artist into a popular culture star, and the latter reconfigured the role of the artist as shaman and political activist.

Clark transformed the role of the artist into wholly different registers: the artist as psychotherapist and healer. And it is in this final transformation from geometric abstraction to interactive work to experimental pieces that Clark has evinced her international importance in the history of twentieth-century art, both in Latin America and abroad.

—Raúl Zamudio

CLIMENT, Elena
Mexican painter

Born: Mexico City, 1955. **Education:** Studied in Mexico City, Valencia, Spain, and Barcelona, Spain; largely self-taught. **Family:** Married Claudio Lomnitz, c. 1980s; two children. **Career:** Moved to New York, c. 1988; returned to Mexico, 1998–99; moved to Chicago. **Agents:** Mary-Anne Martin/Fine Art, 23 East 73rd Street, New York, New York 10021, U.S.A.; and Galería GAM, Mexico City.

Individual Exhibitions:

1972	Galería Helen Lavista, Mexico City
1976	Galería Casa de las Campanas, Cuernavaca, Mexico
1977	Galería Helen Lavista, Mexico City
1978	Galería San Angel, Mexico City
1982	Galería Metropolitana, Mexico City
1983	Galería el Grillo y el Oso, Mexico City

Elena Climent: *Kitchen with View of Viaduct,* **1995. Photo courtesy of Phoenix Art Museum, Arizona/Mr. and Mrs. Gene Lemon in honor of Clayton Kirking/Bridgeman Art Library.**

1988 Museo del Palacio de Bellas Artes, Mexico City
1992 *Elena Climent, In Search of the Present,* Mary-Anne
 Martin/Fine Art, New York (traveled to Galería de
 Arte Mexicano, Mexico City)
1995 *Re-encounters,* Mary-Anne Martin/Fine Art, New York
1997 *To My Parents,* Mary-Anne Martin/Fine Art, New York
1998 *Antologia,* Museo Pape, Monclova, Coahuila, Mexico
 (traveling)
1999 *Windows from Here to Then,* Mary-Anne Martin/Fine
 Art, New York

Selected Group Exhibitions:

1984 *Bienal de dibujo,* Palacio de Bellas Artes, Mexico City
1991 *La mujer en México,* Centro Cultural de Arte
 Contemporaneo, Mexico City, and Museo de Monter-
 rey, Mexico
 Los Angeles County Museum of Art
1993 *Regards de femmes,* Musee d'Art Moderne, Liege,
 Belgium
1994 *Art Miami '94,* Miami Beach Convention Center, Miami
 Miradas femininas, Museo de Arte Contemporaneo,
 Aguascalientes, Mexico

1995 *Latin American Women Artists 1915–1995,* Milwaukee
 Art Museum (traveled to Phoenix Art Museum;
 Denver Art Museum; National Museum of Women in
 the Arts, Washington, D.C.; and Center for the Fine
 Arts, Miami)
1996 *Innata natura: Pintura mexicana contemporánea,* Feria
 Arco, Madrid (traveled to Galerie Rahn, Zurich,
 Switzerland)
 Lazos y Nexus: The Legacy of María Izquierdo,
 Mexican Fine Arts Center Museum, Chicago
 Salon de triumfadores: 30 años de arte joven, Museo de
 Aguascalientes, Mexico (traveled to Foro de Arte y
 Cultura, Guadalajara, Mexico; Antiguo Palcio del
 Arzobispado, Mexico City; and Museo de Historia
 Mexicana, Monterrey, Mexico)

Publications:

On CLIMENT: Books—*Elena Climent: El tiempo detenido,* exhibi-
tion catalog, text by José Torres Martinez, Mexico City, Galería
Metropolitana, 1982; *Elena Climent: Flor de asfalto,* exhibition
catalog, text by M. Saavedra, Mexico City, Palacio de Bellas Artes,
1988; *Elena Climent: In Search of the Present,* exhibition catalog,

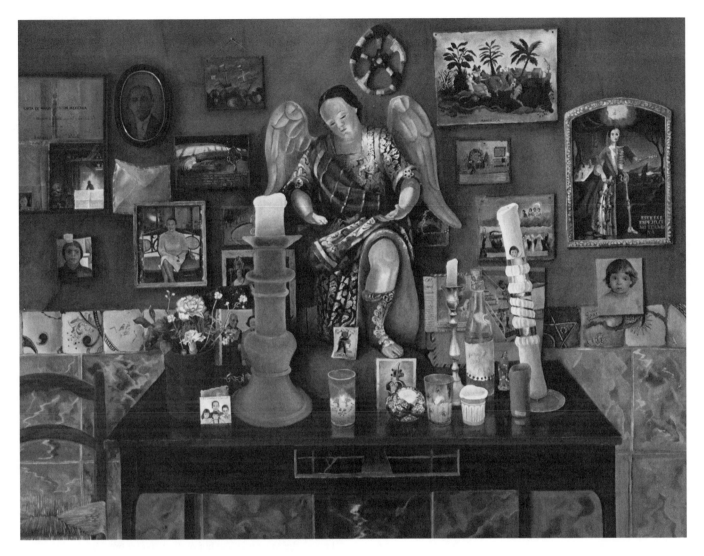

Elena Climent: *Table with Angel,* **1996. Photo courtesy of Mary-Anne Martin/Fine Art, New York.**

text by Edward J. Sullivan, New York, Mary-Anne Martin/Fine Art, 1992; *Re-encounters,* exhibition catalog, with text by Sara M. Lowe, New York, Mary-Anne Martin/Fine Art, 1995; *Innata natura: Pintura contemporánea mexicana,* exhibition catalog, with text by Luis-Martin Lozano, Mexico City, Galería de Arte Mexicano, 1996; *To My Parents,* exhibition catalog, text by Hayden Herrera, New York, Mary-Anne Martin/Fine Art, 1997; *Elena Climent,* exhibition catalog, by Ricardo Pozas Horcasitas, Mexico, Consejo Nacional para la Cultura y las Artes, 2000; *Elena Climent: Windows from Here to Then,* exhibition catalog, New York, Mary-Anne Martin/Fine Art, 2000. **Articles—**''Elena Climent at Mary-Anne Martin/Fine Art'' by Hayden Herrera, in *Art in America,* October 1992, p. 151 (illustrated); ''Lo humilde como identidad'' by Raquel Tibol, in *Proceso,* 1 February 1993, p. 52 (illustrated); ''The Persistence of Mexico'' by M. Schneider Enriquez, in *Artnews,* April 1995, p. 133 (illustrated); ''Elena Climent. Mary-Anne Martin Fine Art, New York'' by Clayton Kirking, in *Art Nexus* (Colombia), 26, October/December 1997, pp. 156–157; ''Elena Climent: Embracing Life's Objects'' by Caleb Bach, in *Americas,* 52(4), July/August 2000, pp. 18–27 (illustrated); ''Elena Climent: Mary-Anne Martin/Fine Art'' by Mary Schneider

Enriquez, in *Art News,* 99(9), October 2000, p. 181; ''Elena Climent: Mary-Anne Martin/Fine Art'' by Carol Damian, in *Art Nexus* (Colombia), 38, November 2000/January 2001, pp. 151–152.

* * *

Elena Climent's intimate still life paintings have earned her a reputation as one of the most influential contemporary Mexican artists. Her paintings, which are stylistically influenced by Flemish masters, are composed of the objects and artifacts with which people surround themselves. Although the people are absent, the paintings capture their personalities through the possessions they portray.

The daughter of the exiled Spanish painter Enrique Climent and his wife Helen, a Brooklyn Jew, Climent was born and raised in Mexico City. When she was 16, she expressed an interest in art, which her father supported, although he discouraged her from pursuing formal training. Climent began working in oils only after her father's death in 1980. Like other Mexican painters who came of the age in the 1980s, she wanted to escape the nostalgia that infused Mexican art, which tended to depict the country as it had existed during the time of

the so-called Mexican masters of the 1930s and 1940s. Climent instead wanted to portray the beauty of Mexico as it really was: industrialized, constantly growing and changing, and bombarded by American products.

To hone her vision, Climent took to wandering Mexico City, which attuned her to the Mexican aesthetic genius for arranging the objects of everyday life. She began to paint these urban landscapes, and although her mother and her late father's artistic friends derided her work as belonging to the *escuela de feismo* (school of ugliness), she persevered. In 1988 she held a well-received exhibition at the Palacio de Bellas Artes.

Climent's work progressed to a new level after she left her homeland in 1988. Living in New York City, she came to appreciate more fully the vibrant colors of her past, and she focused on portraying the everyday reality of middle-class Mexicans in still lifes that presented the trappings of contemporary Mexican life in a thoroughly antinostalgic way. These works were displayed at Climent's first one-woman show, *In Search of the Present,* held at Mary-Anne Martin/Fine Art in 1992. A particular highlight of the exhibition was her 1991 still life *Yellow Kitchen,* which depicted a portion of a kitchen counter. Like most of Climent's work, *Yellow Kitchen* is small and highly detailed, with a limited field of vision, and it melds a photo-realistic style with a knowing innocence. Arranged beneath a velvet painting of the Last Supper tacked to a yellow wall are the kitchen's contents: a package of dried peppers, a can of salsa verde, apples in a pink plastic bowl, boxed chocolate, lit candles, matches, and a spatula. The kitchen is clearly inhabited, and the objects are infused with the personality of their owner.

Climent's compositions shifted slightly following the success of *In Search of the Present.* Still living in the United States, Climent knew that she had more to say about Mexico, but she also realized that she was not just Mexican. She was part Jewish, part Catholic, and the daughter of an American. She began to explore her own identity in her

work, featuring her own possessions in still lifes. For example, in the 1995 painting *Altar of the Dead with Menorah,* Climent depicted a Mexican-style altar covered with brightly colored artificial flowers. A picture of a haloed saint is partially obscured by the top arch of the altar. Photographs of Climent's dead ancestors hang on the green wall behind the altar. A menorah and two candles illuminate the photographs. *Altar of the Dead with Menorah* was included in the 1995 exhibition *Re-encounters,* which reflected on personal history, the death of Climent's mother, the meeting of the past and the present, and spirituality.

These themes were more fully developed in Climent's next exhibition, *To My Parents,* which opened at Mary-Anne Martin/Fine Art in 1997. This exceptional show had its genesis in the death of Climent's mother in 1994, at which time Climent returned briefly to Mexico to memorialize her childhood home. The works of this period capture small scenes of the family home–parts of walls, a small space on a shelf, a few inches of a table–in a way that unites past and present. Many of the paintings contain family photographs, notes, and bundles of letters, and because the objects occupying these spaces are presented from a detailed vantage point only a few inches above the surface on which they are arranged, the perspective is that of a small child.

In 1998 Climent returned to Mexico for a yearlong sabbatical and began work on another collection of innovative paintings. These works, exhibited in the 2000 show *Windows from Here to Then,* introduced new elements to her oeuvre. In these paintings she arranged her meticulous still lifes in front of a vista of an external landscape, usually seen through a window. The inside and outside scenes exist in separate spacial and temporal frames, a meditation on the theme of time that Climent began to address in *Re-encounters* and *To My Parents.* In *Room with Landscape of Burgundy,* for example, the lower, interior half of the painting depicts a Mexican bedroom containing a window seat covered with an Indian blanket, a glass of juice, an apple, and a cordless phone. The top of the painting is viewed through the same window but portrays a vast French landscape.

—Rebecca Stanfel

COLLAZO, Carlos
American painter

Born: 1956. **Education:** Studied architecture, University of Auburn, Alabama, 1973–75; Liga de Estudiantes de Arte, San Juan, 1975–79. **Award:** Premio Unico, *VIII Salón de Pintura UNESCO,* Museo de la Universidad, 1983. **Died:** 1990.

Selected Exhibitions:

1983 *VII Salón de Pintura,* UNESCO, Museo de la
 Universidad
1989 *Autorretratos,* Chase Manhattan Bank, Hato Rey (with
 María Mater O'Neill)
 *Carlos Collazo, Jaime Suárez, Jaime Romano: Tres
 de Puerto Rico,* Museo de Arte Moderno, Cali,
 Colombia

Elena Climent. Photo courtesy of Mary-Anne Martin/Fine Art, New York.

1994 Museo de Arte Contemporáneo, San Juan

Collection:

University of Puerto Rico.

Publications:

On COLLAZO: Book—*Carlos Collazo, 1956–1990: Exposicion homenaje,* exhibition catalog, San Juan, Instituto de Cultura Puertorriqueña, 1994. **Article**—''Neurotic Imperatives: Contemporary Art from Puerto Rico'' by Marimar Benítez, in *Art Journal,* winter 1998, 1 December 1998. **Film**—*Un retrato de Carlos Collazo* by Sonia Fritz, 1994.

* * *

More than any other artist from Puerto Rico, Carlos Collazo was able to adapt avant-garde trends to a personal expression profoundly grounded in the visual arts of Puerto Rico. He worked in many media—drawing, printmaking, watercolor, assemblages, painting, and sculpture in clay—in a constant search for new forms of expression. Collazo's multifaceted production communicated a sense of freedom and a creative mastery of each medium. His architectural studies gave him a feeling for design and proportions that permeated his production.

Collazo's early work was abstract, based on the grid and the exploration of textures and formal elements. He never felt obliged to follow any one approach to art making and combined abstractions with allusions to landscape in an early synthesis of diverse elements. An excellent draftsman, Collazo then embarked on an exploration of realistic scenes, influenced by photo-realism of the 1970s. In contrast with the work of U.S. photo realists, Collazo's scenes are austere: there is no intention of rivaling the verism of photography. His portrayal of domestic settings becomes a means of symbolizing a time, a vital order. The art deco interiors constitute a mosaic of a simpler life in which religious prints, home altars, and the television set sustain the spiritual. These gave way to luscious still lifes that combine flowers and fruits with ceramic sculptures by other Puerto Rican artists, a combination that harkens back to the memento mori, the remembrance of death, the original inspiration of still lifes. The well-designed object or sculpture replaces the home altar or TV as source of spiritual solace. In the series *Still-life Scene of the Crime* (1985), Collazo portrayed collages of photographs, prints, knives, and jewelry with fruits and flowers in enigmatic compositions. The appropriation of photographs and the very process of working out the series—he would photograph the composition and project it onto the canvas or paper—recall Christian Metz's essay ''Photography and Fetish'' published in 1985 in the journal *October* and presage the relationship between death, fetish, and photography in the late *Self-Portraits. Still-life Scene of the Crime* is a Creole version of the postmodern discourse, of ambivalence, and of the different levels of illusion and reality.

Until 1986 the work of Collazo is characterized by sober, elegant masterly execution and an adaptation of international trends to depict or symbolize everyday life in Puerto Rico. Collazo's output partook of the Puerto Rican plastic arts tradition, in which *factura* (''rendering'') is awarded pride of place. A dramatic shift in his work can be observed in his latter production, which becomes passionate and frenetic, imbued with drama and expressive force. As the artist himself expressed, ''the Self-portraits are related to the death of a friend, which confronted me with the need to return to essentials.''

Beginning in 1986, Collazo experimented constantly with new media—cement, foam, encaustic—and produced an impressive number of paintings, sculptures in clay, three-dimensional objects, and drawings. In the exhibition *Male Female* of 1986, he first showed the series of images that combine symbols alluding to sex and death, themes that he worked until the end of his life. The forms recall penises, tombstones, nuclear missiles, and female genitalia, combined with twigs and broken branches. The genitals and allusions to truncated life form part of a visual vocabulary that expresses the tragic paradox of sex: symbol of potency and renewal of life that had become harbinger of death in the early stages of the AIDS epidemic.

Collazo referred to the *Self-Portraits* as ''fetishes'': they can be read both as objects imbued with supernatural power and as obsessive symbols in the Freudian interpretation of the term. His exploration of his own image has nothing to do with narcissism nor with aggrandizing his presence. On the contrary, Collazo portrayed himself bald, as he would have looked 20 or 30 years later. In some of the *Self-Portraits* the image invades the frame, reaching out to the real world; in others the semblance is spectral, ambivalent, as if making reference to the fact that he painted from images projected onto the canvas. The allusions to sex and death, Eros and Thanatos, and the expressive force of these works imbues them with the hypnotic power believers attribute to fetishes.

The work of Collazo, particularly the series of *Self-Portraits,* forms part of the international trend of the return to significance, of the postmodern discourse on appropriation, and of the paramount importance of photography. He employed these concepts in a corpus of works that stand out for their quality and force. Collazo was involved with the concept of the work of art as a fetish, a secular icon, a testimony of life and of the power of visual images.

—Marimar Benítez

COLLAZO, Guillermo
Cuban painter and sculptor

Born: Santiago, 7 June 1850. **Education:** Studied painting in New York under Napoleon Sarony. **Career:** Moved to the United States with his family to escape the revolution in Cuba, 1868. Opened a portrait studio, 1880. Returned to Cuba, 1883. Worked as an illustrator for magazines. Moved to Paris, 1888. **Died:** Paris, 26 September 1896.

Selected Exhibitions:

1890 Paris Salon
1933 Salones del Lyceum, Havana (retrospective)

Exhibited in New York after 1868, in Havana after 1883, and in Paris after 1888.

Publications:

On COLLAZO: Books—*La pintura y la escultura en Cuba,* Havana, Editorial Lex, 1952; *Pintores cubanos,* Havana, Instituto Cubano del Libro, n.d.; *Historia de la pintura en Cuba* by Alina Cardoza, Tampa, Florida, French Printing, 1978; *La Habana: Salas del Museo Nacional de Pintura de Cuba,* Havana, Museo Nacional, 1990.

* * *

Guillermo Collazo was an accomplished and successful Cuban realist in the last quarter of the nineteenth century. Born in 1850 in Santiago de Cuba, in Oriente province, Collazo began his art training in his hometown at an early age. As a youth he also became involved in the struggle for independence, and in about 1868 his parents, fearing detention by the Spanish authorities, sent him to New York City. There he worked with the artist Napoleon Sarony, the leading portrait photographer at the time. In Sarony's studio Collazo was primarily involved in touching up photographs, but on the side he also did illustrations for newspapers. During those years Collazo must have learned the conventions of classical portraiture from Sarony, who is known to have studied in France. He also began painting portraits and miniatures, and in 1880 he opened his own portrait studio. He returned to Cuba in 1883, however, to marry a wealthy heiress.

Collazo's best known works are portraits of Cuba's ruling class, the Spanish colonialists and their descendants known as Creoles, painted in the 1880s. His masterpiece from the period, *La siesta* (1886), depicts an upper-class woman on the patio of her Havana home. The image presents the woman seated at the left and looking languidly across her patio to the sea at the right. There is little tension in the luminous image. In spite of the loose handling of the pigments, the painting is classically composed, with a strong sense of design, and the details of the sitter, her clothing, the furniture, the architectural features of the colonial interior, and the natural elements and ornaments in the garden are carefully delineated. Afternoon light suffuses the room and glimmers on the sculpture and tropical plants in the backyard. Collazo's loose handling of paint and his mastery of light and color evoke the works of the contemporary American painters John Singer Sargent and William Merritt Chase. Although most of his works from this period were bland society portraits, he also painted dramatic landscapes. The latter were typically images of tranquil moments in gardens in the capital city or narrow views of tropical vegetation. He occasionally painted romantic scenes of storms in the jungle or the countryside, evoking the sublime power of nature.

In 1888 Collazo took a grand tour of European cities, and he eventually settled in Paris. His studio on Avenue Victor Hugo became a celebrated hub of artistic and political activity, particularly for the proindependence community of Cuban exiles living in Europe. There he exhibited his collection of art as well as his own work and hosted gatherings for intellectuals and activists, including the Comité Cubano de París, an organization formed specifically to support Cuban independence from Spain. Collazo died two years before the Spanish-American War and therefore never saw Cuba gain its independence. Ironically, in his late years he abandoned Cuban subjects altogether. Instead, in his Parisian exhibitions such as the Salon of 1890 he presented historicist images of romantic scenes set in France in the

eighteenth century. He also made some small figurative bronzes before his death in Paris in 1896. His work, though moderately successful, was ultimately *retardataire* in style and subject.

—H. Rafael Chácon

COLÓN MORALES, Rafael
American painter

Born: Trujillo Alto, Puerto Rico, 1941. **Education:** Universidad de Puerto Rico (scholarship), B.F.A. 1964; American University, Washington, D.C., 1965–66; Academia de San Fernando, Madrid (scholarship), 1966–67. **Career:** Moved to New York, 1970. Instructor, Universidad de Puerto Rico, Rio Piedras, 1968–70, Brooklyn Community College, New York, 1972–76, State University of New York, Albany, 1972–76, School of Art, El Museo del Barrio, New York, 1978–81. Curator, El Museo del Barrio, New York, 1984. Participated in artist's cooperative *Borinquen 12,* Puerto Rico, 1967–69.

Individual Exhibitions:

1962	Ateneo Puertorriqueño, San Juan, Puerto Rico
1963	Universidad de Puerto Rico, San Juan
1964	First Federal Gallery, New York
1965	Instituto de Cultura Puertorriqueña, San Juan
1968	Galería Santiago, San Juan, Puerto Rico
1969	Colegio Regional de Avecibo
1982	*Children of Darkness: Rafael Colón Morales,* El Museo del Barrio, New York
1999	Museum of the Americas, San Juan

Selected Group Exhibition:

1961	Universidad de Puerto Rico

Collections:

Ateneo Puertorriqueño, San Juan; El Museo del Barrio, New York; Instituto de Cultura Puertorriqueña, San Juan; Museo de Arte de Ponce, Puerto Rico; Museum of Modern Art of Latin America, Washington, D.C.; Universidad de Puerto Rico, San Juan.

Publications:

By COLÓN MORALES: Books—*Children of Darkness: Rafael Colón Morales,* exhibition catalog, New York, El Museo del Barrio, 1983; *Taller Puertorriqueño Presents the First Regional Invitational Hispanic Art Exhibition,* exhibition catalog, with Lois Johnson and John Ollman, Philadelphia, Taller Puertorriqueño, 1987. **Article**—"Puerto Rican Nationalist Art: A History, A Tradition, A Necessity," with Juan Sanchez, in *Art Workers News,* 11(9), May 1982.

On COLÓN MORALES: Article—"Rafael Colón Morales: Museum of the Americas" by Jose Antonio Perez Ruiz, in *Art Nexus* (Colombia), 34, November 1999/January 2000, pp. 137–138.

* * *

In 1982 the Puerto Rican artist Rafael Colón Morales wrote: " . . . the war between the children of light and the children of darkness rages on to eternity. Endowed with the power of God and their unprincipled scorn for chaos, the children of light are apt to win the battles. But the children of darkness are said to have many more alternatives; they surge from the void unto life–they are seekers of light." Throughout his painting career Colón Morales has been concerned with states of being in which subjects emerge from darkness and go in search of knowledge. Always seeking to extend the potential of painting, he has worked in a range of expressive forms, including surrealistic and abstract geometric representations, as well as culturally rooted biomorphic and mythological figures.

The art critic Walter Friedlander once wrote that two basic currents run throughout the history of French art, the rational and the irrational. If that description is applied more loosely to the art of all of Western civilization, then Colón Morales fits firmly into the irrational camp. His art, like that of the Flemish painter Peter Paul Rubens, is rich in the sensuality of color, movement, form, and spirit. His paintings are characterized by high energy and seeming chaos, and their articulation is not entirely the result of chance; they are carefully thought out. Such is the case with *Retorno a la tierra* (1979). In this painting a rich blue sky forms the backdrop. In the corner is a *bohío* (peasant shack), in front of which stands a figure that is half man and half animal. At a distance from the figure, in the form of a concentric circle, there are other references to animals, some, like a horse, real and others, like a dragon, mythological. Legends in Europe and in North and South America frequently use the white horse as a symbol of dignity and purity of intention. In *Retorno a la tierra,* however, the horse is viewed not as a strong conqueror but almost as a disinterested and tired participant; he turns away from the tranquility of the *bohío.* The dragon, meanwhile, is full of vitality, possibility, and purpose. The horse, not native to the New World, was introduced to the Americans through Spanish colonization, and in this painting the representation of the animal breaks with the tradition of depicting the horse as the common man's ally. In Colón Morales's world even the most fundamental loyalties have broken down.

Although Colón Morales's symbolic language is personal, it is steeped in the much older traditions of Europe and pre-Columbian America, particularly those of the Caribbean basin. Many of his paintings use Caribbean reality and specifically the Puerto Rican condition to assert truths about the nature of man. They often depict aggressiveness, but underlying the violence and trouble there is a comprehension of justice and humanity.

Among Colón Morales's most varied technical achievements are his *pellejos,* or skins. In making them he applies paint directly to glass of any shape or size. When the surface dries, he applies new layers of paint, using the same or different colors, until the desired consistency is reached. When he then peels the paint off the glass, it is transparent, like a stained glass window, and as flexible as delicate cloth. Some of these finished pieces have been transferred onto Plexiglas or canvas as parts of assemblages that incorporate small objects such as a razor blade, a paint tube, or a photograph. Colón Morales has also turned the *pellejos* into sculptures by mounting them on objects such as a wooden horse, a chair, or the metal frame of a folding cot. Through these experiments he express his interest in painting as an inventive and continuously evolving medium. The finished pieces, exemplified by *Lagartijos* (1974) and *El techo*

(1975), express his preoccupation with the mythology of the Taino people of Puerto Rico. The mythology of this early Indian culture is a tool for the formulation of his thought, with many of the works reflecting his personal vision, desires, anxieties, and needs. To Colón Morales the *pellejos* represent the shedding of skin that is the symbol of rebirth, a constant theme in the mythology of the pre-Columbian peoples of the Caribbean.

—Martha Sutro

COLSON, Jaime
Dominican painter

Born: Puerto Plata, 1901. **Education:** Escuela de la Lonja, Barcelona, 1919–24; graduated from Escuela Especial de San Fernando, Madrid; studied at the free academies of Montparnasse, Paris. **Career:** Lived in Paris, 1920. Professor, Escuela de Arte de Trabajadores, Mexico, 1928–32; director, Escuela Nacional de Bellas Artes, Santo Domingo. Traveled to Spain and France in the 1940s. **Awards:** Prize of Mexico, 1937; first prize in painting, *VII bienal de Santo Domingo,* 1950; first prize, *Exposición internacional celebrada,* Bilbao, Spain, 1954; primero del Ayuntamiento, *X bienal de Santo Domingo,* 1960; second prize, *XI bienal de Santo Domingo,* 1963. Order of Duarte, Sanchez, and Mella, 1969. **Died:** 1972.

Individual Exhibitions:

1996 UNESCO, Paris (retrospective)
2001 Museum of Fine Arts, Santiago, Chile (traveling
 retrospective)

Selected Group Exhibitions:

1950 *VII bienal de Santo Domingo*
1954 *Exposición internacional celebrada,* Bilbao, Spain
1960 *X bienal de Santo Domingo*
1963 *XI bienal de Santo Domingo*

Publications:

On COLSON: Book—*Jaime Colson: Pinturas,* Coral Gables, Florida, Palette Publications, ca. 1996. **Article—**"Jaime Colson" by Marianne de Tolentino, in *Art Nexus,* 22, October/December 1996, pp. 143–144.

* * *

Jaime Colson is considered one of the leading exponents of Dominican fine arts. His body of work testifies to the international range of influences and art movements he encountered over the course of a long career, as well as the extraordinary fertility of the various art worlds in which Colson participated. Anglo audiences— often reinforced by an Anglo-dominated gallery and museum world— have, for much of the twentieth century, expected Latino art to be

comprised mainly of folksy, figurative images characterized by flattened perspective and bright colors, with a strongly narrative content. The breadth and depth of Colson's career is a dramatic reminder that Latino artists have participated in virtually every modern art movement from cubism and abstraction to conceptual and performance art.

Born in the Dominican Republic in 1901 to a Dominican mother and a Spanish father, Colson immigrated to Spain when he was a young man, and it was there that he began to study painting. At the age of 20 he settled in Paris, where he encountered Pablo Picasso, Georges Braque, and Fernand Leger. In 1930 Colson moved to Mexico and worked with the great Mexican muralists Diego Rivera, José Clemente Orozco, and David Alfaro Siqueiros. Returning to Europe, he traveled through Italy and spent time in Barcelona during World War II.

In response to the influences that he encountered in Europe, Colson experimented with styles ranging from cubism to surrealism. In his earlier works the influence of the European avant-garde is clearly in evidence; his later paintings display a uniquely Caribbean character. His mature work achieves an artful blend of the European avant-garde of his youth, the social engagement of the Mexican muralists, the influence of the classical art he encountered on his travels in Italy, and the regional styles of his Caribbean homeland. Rather than being derivative or imitative, he developed a hybrid style entirely his own.

The relatively young tradition of a specifically Dominican art owes much to Colson's influence. It was only after gaining independence from Haiti in the late 1800s that the Dominican Republic began to develop its own unique art forms. From the beginning, Dominican painting reflected the art movements that were prominent in Europe, particularly in Spain—everything from neoclassicism to romanticism and impressionism. Colson's work, with its cosmopolitan influences, is often seen in contradistinction to a more regional style, exemplified by artists such as Yoryi Morel, whose idyllic landscapes and scenes of rural life are in sharp opposition to Colson's abstractions. The blend of European influences evident in Colson's paintings, however, indicates an important part of the history of art making in the Dominican Republic. Many European artists fled to the Dominican Republic in the 1940s, and around this time Colson returned to his homeland. In 1942 the first school for professional art education was established in the Dominican Republic, the Escuela Nacional de Bellas Artes, and many of its faculty were exiled Europeans. This was the period of dictator Rafael Trujillo, who welcomed foreign artists and intellectuals in order to cultivate a liberal image for his regime. Some of the exiles who arrived in the 1940s remained in the Dominican Republic and helped shape a subsequent generation of artists. In the 1960s, during the struggle for independence, Dominican art took a nationalist turn, and artists such as Elsa Nunez, Candido Bido, and Ramon Oviedo gained popularity and acclaim. In the period that followed, Dominican art continued to be influenced by developments outside the Caribbean, but, as is common in the history of Latin American art in general, abstraction was less popular than it was in Europe and among white American artists.

During the 1920s Colson and his Dominican colleagues anticipated an evolution in Dominican art that eventually became the movement known as *costumbrismo*. The movement continues to this day and is evident in the work of such Dominican artists as Guillo

Perez and Candido Bido. Literally meaning ''the art of customs and manners,'' *costumbrismo* is a type of genre painting that represents or imitates local customs, manners, and fashions.

A gifted teacher, Colson exerted an enormous influence on subsequent generations of Dominican and other artists, including the Chilean painter Mario Carreño, with whom he mounted joint exhibitions. Colson devoted the last 25 years of his life to teaching, passing along the techniques and influences he had assimilated over the course of an extraordinary lifetime. Despite his enormous influence, commercial success eluded Colson during his lifetime. When he died in 1972, his students paid for his burial.

—Amy Heibel

COSTA, Eduardo
Argentine painter, mixed-media artist, and sculptor

Born: Buenos Aires, 1940. **Education:** Universidad Nacional de Buenos Aires, 1958–65. **Career:** Editor, *Airón* magazine, 1959. Traveled to New York, 1966–70. Literacy advisor, Center for Inter-American Relations, New York, 1968; instructor, City University of New York, 1969–71. Performed in poetry and theatrical events, New York, late 1960s. Traveled to Europe and to New York, 1975; moved to Rio de Janeiro, 1978; settled in New York, 1981. Jewelry designer, 1980s; worked for designers Geoffrey Beene and Fabrice, 1982. Editor of children's books, Scholastic, Inc., 1995. Since 1993 writer, *Art in America,* and since 1995, *ArtNet* magazine. Traveled to Chile, 1994, and to Cuba, 1997. Cofounder, artist group *First Mass-Media Art Work,* 1966. **Award:** Universidad Nacional de Buenos Aires fellowship, 1972.

Individual Exhibitions:

1998 *Volumetric Paintings,* ICI, Buenos Aires
2000 Work Space, New York (with John Perreault)
 Museo de Arte Moderno, Buenos Aires (retrospective)
2001 *Volumetric Paintings: The Geometric Works,* Cecilia de
 Torres, Ltd., New York

Selected Group Exhibitions:

1967 *Fashion Fiction I,* Osvaldo Giesso Gallery, Buenos
 Aires
1970 *Art in the Mind,* Oberlin College, Ohio
1977 *Homenaje a Marcel Duchamp,* Galería Arte Nuevo,
 Buenos Aires
1987 *Fashion and Surrealism,* FIT, New York (traveling)
1989 *The Latin American Spirit: Art & Artists in the U.S.,*
 Bronx Museum, New York
1992 *Dissimilar Identities,* Scott Alan Gallery, New York
1995 *Group Show,* Elga Wimmer Gallery, New York
1999 *Global Conceptualism,* Queens Museum, New York
 (traveling)

En medio de los medios, Museo Nacional de Bellas
 Artes, Buenos Aires
2000 *Square Roots,* Cecilia de Torres, Ltd., New York

Collection:

Metropolitan Museum of Art, New York.

Publications:

By COSTA: Articles—"Art Mundo: International Latin America,"
with Patricia Isaza, in *Flash Art* (Italy), 173, November/December
1993, pp. 56–58; "Hélio Oiticica: The Street in a Bottle," in *Flash
Art* (Italy), 174, January/February 1994, pp. 75–77; "Allende Museum
in Santiago," in *Art in America,* 83, February 1995, p. 29; "Hélio
Oiticica at Marian Goodman," in *Art in America,* 83, July 1995, pp.
84–85; "Buenos Airs Cultural Center," with Laura Buccellato, in *Art
in America,* 83, October 1995, p. 31; "The Black Virgin," in *Art in
America,* March 1998; "Hélio Oiticica's Cocaine Works and Some
Thoughts on Drugs, Sex, Career, and Death," in *NY Arts,* May 2000;
"Kcho at Barbara Gladstone," in *Art in America,* 89(4), April
2001, p. 135.

On COSTA: Article—"New York: Eduardo Costa and John Perreault
at the Work Space" by Aruna D'Souza, in *Art in America,* 88(1),
January 2000, pp. 115–116.

* * *

Artists in Argentina participated in the "dematerialization of
art" craze that swept the world in the 1960s by examining the effect of
mass media on both art and society. Eduardo Costa was one of the key
players in the Argentine avant-garde circle that included Oscar
Masottta (a principal theoretician), Roberto Jacoby, and Raúl Escari.
Together the artists explored *arte de los medios* (mass-media art), a
strategy to place works of art within the systems of mass media. In
their 1966 manifesto they criticized mass media, suggesting that it
deprived the public of reality, offering them information consumption
instead: "'To distribute two thousand copies in a big modern city is
like shooting a bullet into the air and waiting for the pigeons to fall,'
said Nam June Paik. Ultimately information consumers are not
interested in whether or not an exhibition occurs; it is only the image
the media constructs of the artistic event that matters." They thus
proposed the appropriation and use of mass media as a new means for
dematerializing art objects.

Soon after publishing their manifesto, the artists put their plan
into action. They sent the press reports of an imaginary event—
Happening para un jabalí difunto ("Happening for a Dead Wild
Boar")—accompanied by fake photographs. The next year, in Buenos
Aires, Costa alone launched the first installment of his *Fashion
Fiction* series (1967–82): he produced sculptural body parts made
from 24-karat gold, touted them as wearable jewelry, and—over the
space of a year—placed articles about the pieces in various maga-
zines, including *Vogue* (New York, 1968), *Harper's Bazaar* (New
York, 1968), and *Caballero* (Mexico City, 1969).

Dan Graham's seminal *Works for the Pages of Magazines*
(1965–69) established the pages of major magazines as a site suitable

for displaying works of art. Graham used print media as an alternative
to the gallery system and the commodification it demands. In Gra-
ham's view printing art in magazines democratized the means of
producing and distributing art. Costa's *Fashion Fiction* series, how-
ever, was willfully conspicuous in a way that Graham's project was
not. Played out in high-profile fashion magazines such as *Vogue,* with
photographs by Richard Avedon and models such as Marisa Berenson
donning Costa's jewelry, *Fashion Fiction* assumed a total disguise.
The pieces looked just like any other fashion spread. The aptly titled
work reveals the power of mass media to turn fiction into reality
simply by publishing and circulating it as such. Costa's conceptual
project altogether co-opted both mass media and the media-driven
fashion industry.

In the late 1960s and the 1970s, dividing his time between New
York City, Buenos Aires, and Rio de Janeiro, Costa both rigorously
collaborated with a number of progressive artists and worked in such
media as poetry, photography, happenings, and interventions in the
city environment. In 1981 he settled in New York City and continued
to pursue variations on his *Fashion Fiction* series. Then, in the mid-
1990s he began working in representational forms, examining the
three-dimensional possibilities of traditional genres such as still life
and portraiture. Most recently he exhibited his series of *Volumetric
Paintings* (2000). They are solid, minimal geometric forms made
entirely from acrylic paint in primary colors. Neither carved nor
molded, these monochromatic three-dimensional paintings are meant
to "represent" the internal space of the objects. While seemingly a
backward leap from the artist's radical proto-conceptualist roots,
Costa's return to the practice of object-making synthesizes the
traditions of geometric abstraction. From constructivism, minimalism,
and neo-concrete art, as they evolved over the course of the twentieth
century around the world, Costa's work concerns the transformation
of color into material, elimination of painting's surface-support
relationship, and emphasis on shape and systematic structure.

—Hitomi Iwasaki

COVARRUBIAS, Miguel
Mexican painter and cartoonist

Born: Mexico City, 4 February 1904. **Education:** Escuela Nacional
Preparatoria, Mexico City. **Family:** Married Rosa Rolanda in 1930.
Career: Moved to New York, 1923. Illustrator, *Vanity Fair, Fortune,*
and *Harper's Bazaar,* 1923–36; curator of modern section of *Twenty
Centuries of Mexican Art,* Museum of Modern Art, New York, 1940;
instructor, Escuela Nacional de Antropología, Mexico, 1940; direc-
tor, Academia de Danca, Instituto Nacional de Bellas Artes, 1940.
Muralist, World's Fair, San Francisco, 1940, Museum of Natural
History, New York, c. 1950. Traveled to Bali, 1930s. Also worked as
a stage designer for the theatre and as a muralist. **Awards:** Grants,
Simon R. Guggenheim Foundation, 1930, 1933. **Died:** Mexico City,
6 February 1957.

Selected Exhibitions:

1924 Whitney Studio Club, New York

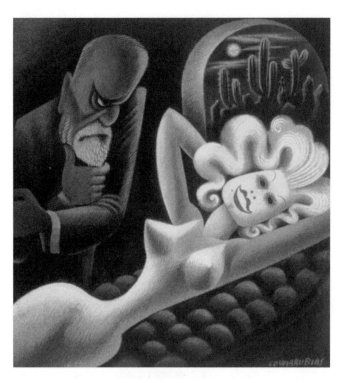

Miguel Covarrubias: *Sigmund Freud and Jean Harlow,* 1935. © Corbis.

1925	Dudensing Gallery, New York (individual)
1928	Valentine Gallery, New York
1932	Valentine Gallery, New York
1935	*Carnegie International Exhibition of Modern Painting,* Pittsburgh, Pennsylvania
1940	Museum of Modern Art, New York
1945	Nagional Gallery of Art, Mexico
1964	Museo de Ciencias y Arte, Ciudad Universitaria, Mexico
1966	*Art of Latin America since Independence,* Yale University, New Haven, Connecticut, and University of Texas, Austin
1981	*Miguel Covarrubias: Dibujos y pinturas,* Galería Metropolitana, Mexico
2000	*Covarrubias-The Rosa and Miguel Covarrubias Collection,* Mexican Museum, San Francisco

Collections:

Cleveland Museum of Art; Museum of Fine Arts, Boston; Museum of Modern Art, New York; Philadelphia Museum of Art; Seattle Art Museum; Mexican Museum, San Francisco.

Publications:

By COVARRUBIAS: Books—*The Prince of Wales and Other Famous Americans,* New York, Knopf, 1925; *Negro Drawings,* New York and London, Knopf, 1927; *Island of Bali,* with Rosa Covarrubias, New York, Knopf, 1937; *Pageant of the Pacific,* San Francisco, Pacific House, 1939; *La zona del pacifico,* New York, Knopf, 1946; *Mexico South, the Isthmus of Tehuantepec,* with Rosa Covarrubias,

New York, Knopf, 1946; *The Eagle, the Jaguar, and the Serpent: Indian Art of the Americas,* New York, Knopf, 1954; *Indian Art of Mexico and Central America,* New York, Knopf, 1957; *Arte indígena de México y Centroamérica,* Mexico, Universidad Nacional Autónoma, 1961. **Books, illustrated—***Método de dibujo* by Adolfo Best-Maugard, Mexico, Depto. Editorial de la Secretaría de Educación Pública, 1923; *Trimblerigg* by Lawrence Housman, New York, 1925; *Blues, an Anthology* by William C. Handy, New York, Albert and Charles Boni, 1926; *Adventures of an African Slaver* by Theodore Canot, New York, Albert and Charles Boni, 1928; *Meaning No Offense* by John Riddell, New York, John Day Company, 1928; *Born to Be* by Taylor Gordon, New York, Covici-Friede, 1929; *Frankie and Johnny* by John Huston, New York, Albert and Charles Boni, 1930; *The John Riddell Murder Case, a Philo Vance Parody* by John Riddell, New York, Scribner, 1930; *China* by Marc Chadourne, New York, Covici-Friede, 1932; *Batouala* by René Maran, New York, Limited Editions Club, 1932; *In the Worst Possible Taste* by John Riddell, New York, Scribner, 1932; *Peace by Revolution* by Frank Tannenbaum, New York, Columbia University Press, 1933; *Mules and Men* by Zora Neale Hurston, New York, J. B. Lippincott, 1935; *Typee* by Herman Melville, New York, 1935; *Green Mansions* by William H. Hudson, New York, Heritage Reprints, 1936; *Madame Flowery Sentiment* by Albert Gervais, New York, Covici-Friede, 1937; *Uncle Tom's Cabin* by Harriet Beecher Stowe, New York, Limited Editions Club, 1938; *The Discovery and Conquest of Mexico* by Bernal Díaz del Castillo, New York, Limited Editions Club, 1942; *A History of the Conquest of Mexico* by William Prescott, New York, Nuevo Mundo, 1942; *Arts of the South Seas* by Ralph Linton and S. Paul Wingert, New York, Museum of Modern Art, 1946; *All Men Are Brothers* by Shui hu Chuan, New York, Heritage Press, 1948; *John and Juan in the Jungle* by Yvan T. Sanderson, New York, Dodd, Mead and Co., 1953; *El pueblo del sol* by Alfonso Caso, Mexico, Fondo de Cultura Económica, 1953; *Las olmecas antiguos* by Román Piña Chan, Mexico, Conseo Editorial del Gobierno del Estado de Tabasco, 1982. **Articles—**''Voodoo Blackens the Night-Spots,'' in *Vogue,* 89(5), 1 March 1937, p. 71; ''Everyday Life in Bali,'' in *Asia,* April 1937, pp. 254–259; ''Good Food of Bali,'' in *Asia,* May 1937, pp. 334–339; ''Birth to Marriage in Bali,'' in *Asia,* June 1937, pp. 414–419; ''Theatre in Mexico,'' in *Theatre Arts Monthly,* 22(8), August 1938, pp. 555–623.

On COVARRUBIAS: Books—*Miguel Covarrubias Caricatures* by Beverly J. Cox and Denna Jones Anderson, Washington, D.C., Smithsonian Institution Press, 1985; *Miguel Covarrubias: Artista y explorador* by Sylvia Navarette, Mexico, Dirección General de Publicaciones del Consejo Nacional para la Cultura y las Artes, 1993; *Covarrubias* by Adriana Williams, et al., Austin, University of Texas Press, 1994.

* * *

Born in Mexico City, Miguel Covarrubias became enamored of the theater and cultural arts at an early age. Largely self-taught, the young artist sketched caricatures of himself, theater people, and artist friends such as Diego Rivera, José Clemente Orozco, and Rufino Tamayo. In 1923, on a government scholarship, Covarrubias moved to New York City, where he quickly became known as a brilliant

illustrator, stage designer, and caricaturist. He found regular work selling drawings, paintings, and caricatures to numerous publications such as the *New York Tribune, Herald, Evening Post,* and *Los Angeles Daily Times* and became a regular contributor to *Vanity Fair,* the *New Yorker,* and *Vogue.* Because of his charm and genuine interest in meeting people, Covarrubias promptly became friends with many of the rich of the day, as well as writers, artists, and actors. He is well known for his caricatures of the famous people he knew and met. His popular book, *The Prince of Wales and Other Famous Americans,* bound in handmade batik, includes 66 caricature portraits. In 1925 Covarrubias had a one-man exhibition at the Dudensing Gallery in New York City with many of the original works from *The Prince of Wales.*

Covarrubias was passionate about people and learning about their cultural traditions. His artwork often reflects influences from the various cultural traditions he studied. Soon after he moved to New York City, Covarrubias discovered the blues and jazz music of Harlem. As a gathering place for intellectuals, artists, and personalities, Harlem was much like the bohemian section of Mexico City in which he had grown up. Covarrubias created illustrations for books on the personalities of the Harlem scene and for numerous authors he met in Harlem, including Alice Walker and Zora Neale Hurston.

One of the most influential experiences in Covarrubias's artistic career was a trip to Bali in the 1930s, where he immersed himself in Balinese art, dance, and culture. He eventually created, after returning to New York City, dramatic and mysterious gouache paintings, such as *Procession of Women with Offerings at a Temple in Bali,* that are colorful, detailed visual accounts of the things he saw on the island. He later wrote and illustrated *Island of Bali,* which became a bestseller whose popularity caused a craze in New York City and elsewhere for all things Balinese. The book continues to be a handy resource for information about the island.

Covarrubias also became engrossed in the traditional and ancient art of Mexico. He studied and taught anthropology and archaeology of ancient Mexico, and he wrote and illustrated several important books on pre-Columbian art and Mexican folk art that are still used. Through his art and writing he became a champion of Mexican traditional culture.

Although Covarrubias tended to stay away from political statements (unlike his artist friends in Mexico), in 1935 he exhibited a painting entitled *The Bone* in the Carnegie International Exhibition of Modern Painting in Pittsburgh, Pennsylvania. It makes a stirring commentary on government bureaucracy of old Mexico. Depicting a man in a black suit and hat with a white shirt and tie who is seated in a green wicker chair, his hands crossed and resting on a black umbrella, the painting suggests that the man may have been given his easy government position due to his political support of the party in power.

In 1946 Covarrubias, Diego Rivera, and Roberto Montenegro were commissioned to paint murals for the elegant Hotel del Prado in Mexico City. Covarrubias created two large wall maps for the reception area, one of old traditional Mexico with points of interest and historical landmarks and the other of modern Mexico with its cities, railways, and airways. (Many of the murals were destroyed in the 1985 earthquake.) He also painted a large mural for the Ritz Hotel in Mexico City entitled *An Afternoon in Xochimilco.* This work depicts a boat full of Mexican men and women (including the same character in *The Bone*) enjoying the floating gardens of Xochimilco, while a typical American couple photographs them from another area.

The contributions of Covarrubias to the world of graphic arts, painting, anthropological studies, theater, and literature were numerous for such a short lifetime. His greatest achievement was opening people's minds to the beauty of unfamiliar cultures and places through his insightful and passionate admiration for all people as seen in his art.

—Andrea Kalis

CRAVO NETO, Mário
Brazilian painter, sculptor, and photographer

Born: Bahia, Salvador, 20 April 1947. **Education:** Art Students League, New York, 1968–70. **Family:** Son of sculptor Mário Cravo, Jr. **Awards:** Sculpture prize, *I bienal de artes plásticas de Bahia,* 1965; Governor of the State of São Paulo prize for sculpture, *IX bienal internacional de São Paulo,* 1971; Coruja de Ouro Embrafilme, for *Ubirajara,* Rio de Janeiro, 1976; second prize for sculpture, *Panorama 78,* Museu de Arte Moderna de São Paulo, 1978; best photographer of the year, Associação Paulista de Críticos de Arte, São Paulo, 1980, 1995; premio nacional de fotografia, Ministerio da Cultura, "FUNARTE," Rio de Janeiro, 1996; Prize Waterhouse, *Panorama da arte brasileira,* Museu de Arte Moderna de São Paulo, 1997.

Individual Exhibitions:

1965	Galeria Convivium, Salvador
1971	Museu de Arte Moderna da Bahia, Salvador
	Galeria Documenta, São Paulo
	XI bienal internacional de São Paulo
1972	Galeria Grupo B, Rio de Janeiro
	Galeria Documenta, São Paulo
1973	Galeria Documenta, São Paulo
	XII bienal de São Paulo
1974	A Galeria, São Paulo
1975	*XIII bienal internacional de São Paulo*
1976	Modern Art Galerie, Munich
1977	*XIV bienal internacional de São Paulo*
	Galeria Multipla, São Paulo
1979	Museu de Arte de São Paulo (with Pierre Verger)
	Museu de Arte da Bahia, Salvador (with Pierre Verger)
1980	Galleria II Diaframma, Milan
	Foto Galeria, São Paulo
1981	Galeria Monica Filgueiras, São Paulo
	Galleria La Parisina, Turin, Italy
1982	Brazilian American Cultural Institute, Washington, D.C.
1983	ECT Galeria de Arte, Brasilia
	XVII bienal internacional de São Paulo
	Arco Arte Contemporânea, São Paulo
	Museu de Arte de São Paulo
	Galleria II Diaframma, Milan
1984	Fotografia Oltre, Chiasso, Italy
	Museu de Arte Moderna, Rio de Janeiro
1985	Immagine Fotografica, Milan

Mário Cravo Neto. Photo courtesy of the artist.

1986	Arco Arte Contemporânea, São Paulo
1987	Billedhusets Galleri, Copenhagen
	Vision Gallery, San Francisco
1988	Pallazo Fortuny, Venice
	Suomen Valokuvataiteen Museo, Helsinki
1989	Arco Arte Contemporânea, São Paulo
	La Galeria Kahlo, Coronel, Mexico
	Galeria O Cavalete, Salvador
1990	Canon Image Center, Amsterdam
	Galerie Springer, Berlin
1991	Ada Galeria, Salvador
	Galeria del Teatro General San Martin, Buenos Aires
1992	The Witkin Gallery, New York
	Fahley/Klein Gallery, Los Angeles
	Galeria Módulo, Lisbon
	Houston FotoFest
1993	Fisher Gallery, University of Southern California, Los Angeles
	Kathleen Ewing Gallery, Washington, D.C.
	Vision Gallery, San Francisco
1994	The Witkin Gallery, New York
	Susan Spiritus Gallery, Costa Mesa, California
	Frankfurter Kunstverein, Frankfurt, Germany
	Museum of Photographic Art, San Diego
1995	Catherine Edelman Gallery, Chicago
	Kunstverein Steyr, Stein, Austria
	Museu de Arte Moderna, Rio de Janeiro
	Museu de Arte Moderna da Bahia, Salvador
	Museu de Arte de São Paulo Assis Chateaubriand, São Paulo

	Centro Cultural de Bélem, Lisbon
1996	Bohusläns Museum, Uddevalla, Sweden
	Borås Kunstmuseet, Borås, Sweden
	Solar do Barão, Curitiba, Brazil
	Museum für Photographie, Braunschweig, Germany
1997	The Witkin Gallery, New York
	Oldenburger Kunstverein, Germany
	Bentley Gallery, Scottsdale, Arizona
1998	Galerie Esther Woerdehoff, Paris
	Centro Cultural Recoleta, Buenos Aires
	Galeria Pierre Verger, Salvador
	Photo España 98, Madrid
	Fahey/Klein Gallery, Los Angeles
1999	Espaço Neogama, São Paulo
	Sicardi Sanders Gallery, Houston
	Centro de Fotografia, Universidad de Salamanca, Spain
	Galeria Visor, Valencia, Spain
	Galeria S-292, Barcelona, Spain
2000	Yancey Richardson Gallery, New York
	Nationalhistoriske Museum på Frederiksborg, Hillerød, Denmark
	Palacio de Aguirre, Cartagena, Spain
	5th biennale de Lyon, France
	Museu de Arte Moderna, Salvador
	Pinacoteca do Estado de São Paulo
2001	Galeria Buades, Madrid

Selected Group Exhibitions:

1965	*Primera bienal nacional de artes plásticas da Bahia,* Salvador
1978	*Subterranean Art, Architecture and Objects,* Galleria Huan Martin, Museo Carrillo Gil, Mexico City
1983	*O tempo do olhar: Panorama da fotografia basileira atual,* Museu Nacional de Belas Artes, Rio de Janeiro (traveled to Museu de Arte de São Paulo)
1985	*Panorama da arte atual brasileira: Formas tridimensionais,* Museu de Arte Moderna, São Paulo
1992	*Arte amazonas,* Museu de Arte Moderna, Rio de Janeiro (traveling)
1994	*Romper los margenes, encuentro de fotografia latino americano,* Museu de Artes Visuales Alejandro Otero, Caracas
	Tradition and the Unpredictable, the Allan Chasanoff Photografic Collection, Museum of Fine Arts, Houston
1997	*Panorama da arte brasileira 97,* Museu de Arte Moderna, São Paulo (traveled to Museu de Arte Moderna, Salvador)
1998	*Years Ending in Nine,* Museum of Fine Arts, Houston
2000	*Fotografía brasileña contemporánea,* Museu Nacional de Arte, La Paz, Bolivia

Collections:

Museum of Modern Art, New York; Princeton Art Museum, New Jersey; Stedelijk Museum, Amsterdam; Brooklyn Museum, New

Mário Cravo Neto: *Carlinhos Brown as Exu,* **1996. Photo courtesy of the artist.**

York; Museum of Fine Arts, Houston; Museet for Fotokunst, Odense; Museu de Arte Moderna, Rio de Janeiro; Wolfsburg Kunst Museum, Germany; Santa Barbara Museum of Art, California.

Publications:

By CRAVO NETO: Books—*A cidade da Bahia,* with others, Salvador, Aries Editora, 1984; *Os estranhos filhos da casa,* Salvador, Aries Editora, 1985; *Exvoto,* with others, Salvador, Aries Editora, 1986; *Angola,* Salvador, Fundação Odebrecht, 1991; *Mário Cravo Neto,* with Peter Weiermair, Frankfurt, Edition Stemmle, 1994; *Mário Cravo Neto,* exhibition catalog, Salvador, Aries Editora, 1995; *Espaço Cravo,* Salvador, Aries Editora, 1998; *Salvador,* with others, Salvador, Aries Editora, 1999; *Laróyè,* Salvador, Aries Editora, 2000. **Books, photographed**—*Bahia* by Jorge Amado, São Paulo, Raizes, 1980; *Cravo* by Mário Cravo Junior, Salvador, Aries Editora, 1983; *Esculturas,* exhibition catalog, text by Mário Cravo Junior, Rio de Janeiro, Patrocínio Cultural, 1987; *Giluminoso: A poética do ser* by Bené Fonteles, Gilberto Gil, and Pierre Verger, São Paulo, Imprensa Oficial, 1999.

On CRAVO NETO: Books—*Brasile,* exhibition catalog, text by Mário Cravo Junior, Milan, Idea Books, 1988; *Mário Cravo Neto,* exhibition catalog, text by Casimiro Xavier de Mendonça, Salvador, Ada Galeria de Arte, 1991; *Body to Earth: Three Artists from Brazil,* exhibition catalog, text by Susan M. Anderson, Los Angeles, University of Southern California, 1993; *Imagens da fotografia brasileira* by Simonetta Persichetti, São Paulo, Estação Liberdade, 1996; *Mário Cravo Neto,* exhibition catalog, Houston, Sicardi Sanders Gallery, 1999. **Articles**—"Mário Cravo Neto" by Amanda Hopkinson, in *Creative Camera,* 327, April/May 1994, pp. 40–43; "Mário Cravo Neto" by Peter Weiermair, in *European Photography* (Germany), 16, spring 1995, pp. 24–31; "Mário Cravo Neto" by Adriano Pedrosa, in *Artforum International,* 34, summer 1996, p. 114; "The Lasting Instant: Ruins and Duration in Latin American Photography" by Carlos Jiménez Moreno, in *Third Text* (United Kingdom), 39, summer 1997, pp. 77–86; "Through a Brazilian Lens" by Edward Leffingwell, in *Art in America,* 86(4), April 1998, pp. 78–85; "Mário Cravo Neto" by Paco Barragan, in *Art Nexus* (Colombia), 32, May/July 1999, pp. 50–55.

* * *

During the 1990s the growing prestige of photography as an eminently artistic medium could be seen, reaching the point where expressly documentary works were considered as aesthetic proposals. In Brazil the rise of photography, whether used as a resource within a varied media repertoire or as the main technique, has brought with it the appearance of figures of great relevance on the international plastic arts scene. Photographers such as Miguel Rio Branco and the documenter Sebastião Salgado or the appropriationist Rosângela Rennó illustrate the country's important position in contemporary photography.

Within this group of renowned Brazilian photographers, Mário Cravo Neto comes to the fore. In his work formal value is essential. He creates images, synthetic and monochromatic–in black and white or in shades of sepia–in which mysticism related to the ethnic question is evident through references to the syncretic religious beliefs of the Afro-Brazilian population. The symbolic nature of man in his photographs is related to the poetics of the divine that emanates fundamentally from Candomblé, a cult devoted to powerful gods, generically termed *orixá*s. The cult is practiced mainly in Salvador, the city that was the first capital of colonial Brazil and that was an important port for the slave trade.

Cravo Neto has concentrated on the interpretation of Bahia culture, using the body as an essential symbolic reference point. The black skin, the gestures of the hands, the ritual presence of symbolic elements in the form of animals or objects, the intense presence of the faces, and the general hieratism reveal his highly aestheticizing vision of Bahia culture. Even in his documentary work, in which he has recorded alcoholics, prostitutes, and street children, the general atmosphere of his photographs alludes to a vital energy that spills over or to a state of peaceful containment, far from a lugubrious view of misery.

The Bahia cultural component, with its complex sense of the body, also implies an associated animal symbolism that Cravo Neto adopts in his recurrent use of animals to provide metaphors of a mystical character. The relationship of human bodies with animals is a component he uses to convert the scene into a kind of allegory. In works such as *Lord of the Head* (1988), *Men with Bird Tears* (1992), and *Men with Two Fishes* (1992), Cravo Neto uses birds, turtles, and

fish, relating them to models whose faces are hidden. This is possibly reminiscent of the rites of spiritual possession and divine incarnation in Candomblé, rites in which divinities appropriate those in a trance to use them as instruments of communication with the world of mortals. Nevertheless, in the work of Cravo Neto allusions to classical mythology can also be found.

Within this ritualistic spirit sensuality is an element that makes evident the appreciation of corporeality as an expression of the divine. The satires, the images of the female, the portraits of expressive hands, and the taste for the contrast of human skins and animal coats or plumage all point to an eroticism very much associated with textures and pigmentations. Cravo Neto reaches abstraction when putting an extreme accent on texture and when concentrating on the element that perhaps most interests him in corporeality: the skin. From this formalistic impulse, which is the basis of his marvelous sense of textural contrast, both luminous and rhythmic, come works such as *Pituassu (Neck 1)* (1984) and *Geraldo (Neck 2)* (1987), with men looking toward the zenith, showing their throats and *Tinho (Head)* and *Tinho (Eyes)* (1990), with a man with his back to the viewer, also looking upward. In these works the treatment of light is fundamental. Working with subtle variations of tone, Cravo Neto melts the black bodies into dark, mysterious ambiences. But he also works in high contrasts, which participate directly in the poetics of the textures and symbolic references, as in *Shelter II* (1990), where we see a black hand holding a white baby.

Apart from working on his studio photographs, Cravo Neto has documented Bahia life in color photographs. He has depicted the gregarious multitudes of carnivals, the energy of sacred rites, the misery of the marginalized population of one of the poorest cities in Brazil, and the decisive presence of the sea, which is of great importance in Candomblé. On the other hand, he has also reactivated his interest in spatiality, which led him initially to work with installation before becoming interested in photography. Thus, he has come to exhibit large-scale format projections of his photographs.

—Vivianne Loría

CRUZ AZACETA, Luis
American painter

Born: Havana, Cuba, 1942; immigrated to the United States, 1960, granted U.S. citizenship, 1967. **Education:** School of Visual Arts, New York, 1966–69. **Family:** Married Sharon Jacques (second marriage); two children. **Career:** Worked in a factory assembling trophies, c. 1960; clerk in a button factory, c. 1963–66; library clerk, New York University, 1966–80. Instructor, University of California, Davis, 1980, Louisiana State University, Baton Rouge, 1982, University of California, Berkeley, 1983, and Cooper Union, New York, 1984. **Awards:** Fellowship, Cintas Foundation, 1972, 1975; fellowships, Guggenheim Memorial Foundation and New York Foundation for the Arts, both 1985; fellowship, National Endowment for the Arts, 1980, 1985, 1991–92.

Individual Exhibitions:

1978 Allan Frumkin Gallery, Chicago
 Cayman Gallery, New York

Luis Cruz Azaceta. Photo courtesy of the artist.

Luis Cruz Azaceta: *Central Station,* **1999. Photo courtesy of Galeria Ramis Barquet, New York.**

New World Gallery, Miami-Dade Community College, Miami

1979 Allan Frumkin Gallery, New York

1981 Richard L. Nelson Gallery, University of California, Davis
The Candy Store, Folsom, California

1982 Allan Frumkin Gallery, New York
Louisiana State University Gallery, Baton Rouge

1984 Allan Frumkin Gallery, New York
The Candy Store, Folsom, California

1985 Allan Frumkin Gallery, New York
Chicago International Art Exposition

1986 Allan Frumkin Gallery, New York
Museum of Contemporary Hispanic Art, New York
The Candy Store, Folsom, California
Anderson Gallery, Virginia Commonwealth University, Richmond

1987 Gallery Paule Anglim, San Francisco
Lisa Sette Gallery, Scottsdale, Arizona
Fondo del Sol, Washington, D.C.
Le Musee Francais, South Miami

1988 Kunst Station, Sankt Peter, Cologne, Germany
Allan Frumkin Gallery, New York
Frumkin/Adams Gallery, New York

1989 Opus Art Studios, Inc., Coral Gables, Florida
Lisa Sette Gallery, Scottsdale, Arizona
Frumkin/Adams Gallery, New York

1990 Georgia State University, Atlanta
Eugene Binder Galerie, Cologne, Germany
The Aids Epidemic Series, The John & Mable Ringling Museum of Art, Sarasota, Florida (traveled to Tweed Museum of Art, University of Minnesota, Duluth, and Cleveland Center for Contemporary Art, both 1992)
Broken Realities, Frumkin/Adams Gallery, New York

1991 Queens Museum of Art, New York
The Aids Epidemic Series, The John & Mable Ringling Museum of Art, Sarasota, Florida
Selected Works, Lisa Sette Gallery, Scottsdale, Arizona
Obras selectas: Trayectoria, Galeria Botello, Hato Rey, Puerto Rico
Trayectoria, Museo de Arte de Ponce, Puerto Rico
Diaspora, Frederic Snitzer Gallery, Coral Gables, Florida
Selected Paintings & Drawings, Opus Gallery, Coral Gables, Florida
New Drawings, Frumkin/Adams Gallery, New York

1992 *New Paintings,* Frumkin/Adams Gallery, New York
Day without Art, Rhode Island School of Design Museum, Providence
Picturing the World Turned Upside Down: Paintings by Luis Cruz Azaceta, Galeria Ramis Barquet, Monterrey, Mexico
Fragile Crossing, Smithsonian Institution, Washington, D.C. (traveled to Lisa Settle Gallery, Scottsdale, Arizona, 1994)
Selected Works, Fredric Snitzer Gallery, Coral Gables, Florida
Selected Works, Sylvia Schmidt Gallery, New Orleans
Luis Cruz Azaceta Works on Paper, J. Maddux Parker Gallery, Sacramento, California

1993 *Biting the Edge,* Contemporary Art Center, New Orleans
Identity and Chaos, Daniel Saxon Gallery, Los Angeles
In the Big Easy, Sylvia Schmidt Gallery, New Orleans

Luis Cruz Azaceta: *Wall 4.* **Photo courtesy of the artist.**

Crossing, Fredric Snitzer Gallery, Coral Gables, Florida
New Paintings from the New Orleans Series, Frumkin/
 Adams Gallery, New York
1994 *Luis Cruz Azaceta: Street Life in America, A Man*
 Caught between Two Cultures, A Survey of Northern
 California and Bay Area Collections, La Raza/Galeria
 Posada, Sacramento, California
 HELL: Luis Cruz Azaceta Selected Works from
 1978–93, Alternative Museum, New York
 Recent Works, J. Maddux Parker Gallery, Sacramento,
 California
 Diaspora, Fredric Snitzer Gallery, Coral Gables, Florida
1995 *Luis Cruz Azaceta: Dislocations,* Mills College, Oak-
 land, California
 Stripped Bare, Frumkin/Adams Gallery, New York
 Made on Tchoupitoulas, Sylvia Schmidt Gallery, New
 Orleans
 Luis Cruz Azaceta, Johnson Community College,
 Overland Park, Kansas
1996 *Luis Cruz Azaceta: Self As Another,* San Diego State
 University, California
 A Painter's Passage, New Jersey Center for Visual
 Arts, Summit
1997 *Dead Line,* Fredric Snitzer Gallery, Miami
1998 *Hybrid States,* Lisa Sette Gallery, Scottsdale, Arizona
 Susurro, Fredric Snitzer Gallery, Miami
 Breakout, Ramis Barquet Gallery, New York
 Bound, Mary-Anne Martin/Fine Art, New York
1999 *Back Streets,* George Adams Gallery, New York
2000 *Structuring Fear,* Ramis Barquet Gallery, New York
 NO/NY, Arthur Roger Gallery, New Orleans
2001 *Mapping,* Fredric Snitzer Gallery, Miami

Generous Miracles Gallery, Chelsea, New York
Arthur Roger Gallery, New Orleans

Selected Group Exhibitions:

1986 *Into the Mainstream: A Selection of Latin American*
 Artists in New York, Jersey City Museum
1987 *Hispanic Art in the United States: Thirty Contemporary*
 Painters and Sculptors, Museum of Fine Arts,
 Houston (traveling)
1988 *Committed to Print,* Museum of Modern Art, New York
 (traveling)
1990 *The Decade Show,* New Museum of Contemporary Art,
 Museum of Contemporary Hispanic Art, and Studio
 Museum, Harlem, New York
1991 *Mito y magia en America: Los ochenta,* Museo de Arte
 Contemporaneo de Monterrey, Mexico
1992 *Latin American Artists of the 20th Century,* curated by
 Museum of Modern Art, New York (traveled to
 Museo de Arte Contemporaneo, Seville, Spain, Centre
 George Pompidou, Paris, Ludwig Museum, Cologne)
 Ante America, Biblioteca Luis Angel, Bogota (traveled
 to Caracas, Venezuela, and the United States)
1996 *Point Counter Point: Two Views of 20th Century Latin*
 American Art, Santa Barbara Museum of Art,
 California
 Cuba siglo XX: Modernidad y sincretismo, Centro
 Atlantico de Art Moderno, Las Palmas de Gran
 Canaria, Spain (traveling)
 Thinking Print: Books to Billboards 1980–1995,
 Museum of Modern Art, New York
1997 *Breaking Barriers,* Ft. Lauderdale Museum of Art, Ft.
 Lauderdale
1998 *1998 New Orleans Triennial,* New Orleans
 Lion De Cuba, Musee Des Tapisseries and the Pavillon
 De Vendome, France
 Dream Collection: Part II, Miami Art Museum
1999 *Accounts Southeast Transience,* Southeastern Center for
 Contemporary Art, Winston-Salem
 Parody, Jack S. Blanton Museum of Art, University of
 Texas, Austin
2000 *Five Continents and Once City,* Third International
 Salon of Painting, Museo de la Ciudad de Mexico
 Contemporary Narrating in American Print, Whitney
 Museum of American Art at Champion, New York
2001 *Rembrant to Rauschenberg: Building the Collection,*
 Jack S. Blanton Museum of Art, University of Texas
 at Austin
 The Figure: Another Side of Modernis, The Human
 Figure in Painting from 1950 to the Present, Snug
 Harbor Cultural Center, New York

Collections:

Alternative Museum, New York; Arkansas Arts Center, Little Rock;
Crocker Art Museum, Sacramento, California; Delaware Art Museum,
Wilmington; Fine Arts Collection, University of California, Davis;
Fort Lauderdale Museum of Art; Greenville County Art Museum,
South Carolina; Houston Museum of Fine Arts; Huntington Gallery
Museum, University of Texas, Austin; Marco Museo de Arte

Contemporaneo de Monterrey, Mexico; Metropolitan Museum of Art, New York; Miami Art Museum; Museo de Barrio, New York; Museo de Bellas Artes, Caracas; Museum of Fine Arts, Boston; Museum of Modern Art, New York; New Orleans Museum of Art; Rhode Island School of Design, Museum Collection, Providence; Richard Brown Baker Art Collection, Yale University, New Haven, Connecticut; Rutgers State University of New Jersey, New Brunswick; Santa Barbara Museum of Art, California; Smithsonian Institution, Washington, D.C.; Tucson Museum of Art, Arizona; Whitney Museum of Art, New York; Allen Memorial Art Museum, Oberlin College, Ohio; Chemical Bank Collection, New York; Fulton Montgomery Community College, State University of New York, Johnstown, New York; Harlem Art Colleection, State Office Building New York; Lowe Art Museum, Coral Gables; Miami Public Library Art Collection; Milwauke Art Museum; Museum of Art, University of Missouri, Columbia; New School of Social Research; Philip Morris Collection, New York; Rene and Veronica DiRosa Foundation; Sidney & Frances Lewis Collection, Virginia Museum of Fine Arts, Richmond; South Campus Art Collection, Miami-Dade Community College; Sprint Art Collection; University of Arizona Art Museum, Tuscon.

Publications:

On CRUZ AZACETA: Books—*Luis Cruz Azaceta,* exhibition catalog, Allan Frumkin Gallery, New York, 1984; *Hispanic Art in the United States: Thirty Contemporary Painters and Sculptors,* exhibition catalog, by John Beardsley and Jane Livingston, Abbeville Press, New York, 1987; *The AIDS Epidemic Series,* exhibition catalog, by Susana Torruella Leval, Philip Yenawine, and Ileen Sheppard, Queens Museum, Queens, New York, c. 1990; *Hell: Luis Cruz Azaceta, Selected Works, 1978–1993,* exhibition catalog, essay by John Yau, Alternative Museum, New York, 1994; *Bound,* exhibition catalog, essay by Edward Sullivan, Mary-Anne Martin/Fine Art, New York, 1998; *Breakout,* exhibition catalog, Galeria Ramis Barquet, New York, 1998; essay by Gerardo Mosquera, in *Five Continents and One City,* Museo de la Ciudad de Mexico, 2000. **Articles—**''Painting His Heart Out: The Work of Luis Cruz Azaceta'' by Linda McGreevy, in *Arts Magazine,* 59, June/Summer 1985, pp. 126–28; ''Luis Cruz Azaceta'' by Francine Birbragher, in *Art Nexus* (Colombia), 25, July/September 1997, pp. 137–38; ''Homenaje s Luis Cruz Azaceta'' by Ivan De La Nuez, in *Encuentro de la Cultura Cubana,* Number 15, 1999–2000.

*

Luis Cruz Azaceta wrote on 4 November 1995:

Bang, Bang You Are Dead
One
Two
Three
An aids victim died
A B C
 Cuban refugees
 Alien across the fence,
 City bombers planning their
 next hit,
 A child cries for his mother,
 A crack-head breaks a glass
 window,

 A man builds a box–O.J. runs
in his bronco–the Menendez cried in
court–a lawyer points his finger–
a mother drowned her kids–a cop chased
a mugger–a woman holds a sign–Jesus
Saves–the air is polluted–my friend
hates his Father, his Father hates his
Mother, his Mother is leaving his Father–
the children are running away–the student
carries a gun–the drug addict stops a car–
the blind subway music-man kicks his
dog–a teenager drinks a beer–a
preacher stands in a corner, a soldier
shoots his rifle, a wedding takes place
in the park, a rich man counts his
money, a thirsty man asks for water,
a clown smiles, a sinner prays,
a dog barks, the train runs late,
the light switch don't work, the Museum
of Modern Art is free on Thursday
I look at my watch
I stretch a canvas
I mix some colors
I use a 2 ½ inch brush
I listen to Gregorian Chants and
 Cuban music
I change my style
I use acrylic paint
I nail plywood into the canvas
I look at myself in the mirror
I kill a roach
I make a painting of a barricade
I let it drip
I change the color
I don't like it
I answer the phone
I change the color again
I flip the CD
Tom Waits sings
Goya can't hear
Vincent cuts his ear
Picasso goes to Spain
Mondrian goes to Broadway
Beckman smokes a cigarette
Freda cut her hair
Bakelite upside down
Saul's Day-Go
Arneson picks his nose
Tomorrow is coming
Tomorrow is today
Today is now
Now is present.

* * *

The city of New York provided the inspiration for Luis Cruz Azaceta's early works, cartoonlike images rendered in bright, flat

colors with black outlines. Subways, graffiti, urban chaos, and brutality were themes that appeared often, frequently with self-portraits to represent humanity, especially the victims of violence and intolerance. The United States was not the picture of the American dream he expected to find when his family fled the political oppression of Cuba. Instead, he arrived in the era of civil unrest and political dissent of the 1960s and used his experiences as the subject of his work. A trip to Europe introduced him to the old masters, and the emotional expressionism of artists like Goya, Hieronymus Bosch, and Pieter Brueghel marked a turning point that resulted in works based on his own psychic reality. The self-referential works of the 1970s and 1980s featured the artist as either witness or victim of the anxiety of life in the modern city. He used his self-portrait to call forth social issues with a personal and confrontational power. The AIDS epidemic provided another theme of desperation. Dismembered bodies, barbed wire, ferocious dogs, and architectural fragments were painted in lurid colors, and the journey through the labyrinth of city life soon came to be associated with the journey of exile. Boats and rafts entered his artistic language, sometimes with the artist himself as the emaciated victim cast to sea.

In representing the plight of the many who have risked their lives to flee Cuba, Cruz Azaceta deals with issues of displacement, exile, identity, and faith that continue to have universal significance. He constantly reinvents himself as the artist and creates new processes and techniques to explore visual strategies for his social themes. He usually works in series and in large-format paintings with brash painterly surfaces and with found objects and other materials contributing to their vibrant textures. The use of the grid as a formal element, like a fence or barrier, organizes the surface of many of his works. Colors range from neon bright to brooding monochromatic tones, especially in the works of the late 1990s done after his move to New Orleans. These works have become decidedly minimal as he uses a wider range of materials, including wood, metal studs, photographs, and other objects, to deliver his messages and continue to explore themes of human emotions and relationships. He has long been fascinated by the inhumanity of people toward one another and the ways in which they often behave more like animals than civil beings. His subjects, human and animal, appear desperate in their efforts to survive. His interest in photography has encouraged him to explore new ideas and push the boundaries of what he had done previously. Themes of violence that occurred in his earlier work have come to expand beyond that of the human as victim to the effects of the media that encourage desensitivity and cruelty. The incorporation of photographs has brought an innovative sense of reality to his work.

The "object" type of work of the 1990s demonstrates a new physicality in which process and materials affect the final appearance of Cruz Azaceta's large pieces. While the old themes of social injustice, exile, and violence have continued to be of concern, he has also investigated sexuality, male/female relationships, taboos, and phobias. As comments on the often precarious nature of human relationships, the later works rely less on brash colors and harsh graffiti and more on objects and figures, particularly of himself and his wife, as the focal point of mixed-media compositions. He combines his own style of expressionism and abstractionism to expound on universal themes from a personal perspective and to create a symbolic, even spiritual, vocabulary for today's world.

—Carol Damian

Carlos Cruz-Diez: *Physichromie nā 506*. Photo by Philippe Migeat; © CNAC/MNAM/Dist. Réunion des Musées Nationaux/Art Resource, NY. © 2002 Artists Rights Society (ARS), New York/ADAGP, Paris.

CRUZ-DIEZ, Carlos
Venezuelan painter

Born: Caracas, 17 August 1923. **Education:** School of Plastic and Applied Arts, Caracas, 1940–45, diplomas in artistic education and manual arts 1945; studied advanced techniques of art and publicity, New York, 1947. **Career:** Publications designer, Creole Petroleum Corporation, 1944–45; art director, McCann-Erickson Advertising Agency, Venezuelan subsidiary, 1946–51; illustrator, *El Nacional*, Caracas, 1953–55; traveled to Barcelona and Paris to study physical qualities of color, 1955–56; designer of publications, Ministry of Education, and designer, *El Disco Anaranjado*, Caracas, 1957. Lived in Paris, 1960–80; returned to Caracas, 1980. Professor, Instituto Internacional de Estudios Avanzados, Caracas, 1986–93; teacher, 1953–55, and professor and assistant director, 1958–60, School of Arts, Caracas; professor, School of Journalism, Central University of Venezuela, Caracas, 1959–60; professor, 1972–73, and juror, 1973–80, Ecole Superieur des Beaux-Arts, Paris. Founder, Estudio de Artes Visuales, c. 1957. **Awards:** First prize, Alphabetization Poster Contest, Caracas, 1946; José Loreto Arismendi prize, 1950, Artistides Rojas prize, 1952, and Enrique Otero Vizcarrando prize, 1953, Official Exhibition of Venezuelan Art; Emilio Boggio prize, Ateneo de Valencia Exhibition, Venezuela, 1950; first prize, *Bienal*, Cordóba, Argentina, 1966; Subsecretaria de la Cultura award, Cordoba, 1966; international painting prize, *Bienal*, São Paulo, 1967; first prize, *Nacional de artes plasticas*, Venezuela, 1971; Premio de Intervención del Arte en la Arquitectura, *Bienal de arquitectura*, Venezuela, 1976; Carlos Raúl Villanueva prize, *XXXVI salón de arte Arturo Michelena*, Valencia, Venezuela, 1978; gold medal, Norwegian International Print Triennale, 1992. **Member:** Academia de Ciencias Artes y Letras de Mérida, Venezuela, 1998. **Agents:** Galerie Denise René,

Carlos Cruz-Diez: *Physichromie nā 506.* **Photo by Philippe Migeat;
© CNAC/MNAM/Dist. Réunion des Musées Nationaux/Art Resource,
NY. © 2002 Artists Rights Society (ARS), New York/ADAGP, Paris.**

124 rue de la Boetie, 75008 Paris, France; Galeria Adler Castillo,
Edificio Galipan Avenida Francisco de Miranda, Caracas 106, Vene-
zuela. **Address:** 23 rue Pierre Semard, Paris 75009, France.

Individual Exhibitions:

1947	Instituto Venezolana Americano, Caracas
1955	Museum of Fine Arts, Caracas
1956	Galeria Buchholz, Madrid
1960	Faculty of Architecture, Central University of Venezuela
	Museum of Fine Arts, Caracas
1965	Galleria La Polena, Genoa, Italy
	Galleria II Punto, Turin, Italy
	Signals Gallery, London
	Physichromies de Cruz-Diez: Oeuvres do 1954 a 1965, Galerie Kerchache, Paris
1966	Galerie M.E. Thelen, Essen, Germany
	Galerie Fundacion Mendoza, Caracas
1967	Galerie Corkright, Caracas
1968	Galerie Art Intermedia, Cologne, Germany
	Galerie Accent, Brussels
	Gallerie K.B., Oslo
	Museum am Ostwall, Dortmund, Germany
1969	*Cruz-Diez et les 3 etapes la couleur moderne,* Galerie Denise René, Paris
	Galerie Corkright, Caracas
1970	Galerie Ursula Lichter, Frankfurt, Germany
	Artestudio Macerata, Macerata, Italy
1971	*Physichromies, couleur additive, induction chromatique, chromointerferences,* Galerie Denise René, New York
	Galerie Corkright, Caracas
1972	Galerie Buchholz, Munich, Germany

	Galerie Formes et Muraux, Lyons, France
1973	Galleria Falchi, Milan
	Galerie Denise Rene, Paris
	Galleria Christian Stein, Turin, Italy
	Galeria Cadafe, Caracas
1974	Galleria Trinita, Rome
	Génesis, eclosión y absoluto del color, Galeria Corkright, Caracas
1975	Galeria Aele, Madrid
	Galerie Denise René, Paris
	Museo de Arte Contemporáneo, Bogota, Colombia
	Galeria Barbie, Barcelona
	Museo La Tertulia, Cali, Colombia
	Artiste et Ville, Caracas
1976	Galeria de Arte Mikeldi, Bilbao, Spain
	Museo de Arte Moderno, Mexico City
	Pabellón de Arte de la Ciudadela, Pamplona, Spain
	Galerie Denise René, New York
	Musée de la Chaux des Fonds, Switzerland
1977	Galerie Latzer, Kreuzlingen, Switzerland
	Allianza Francesa, Caracas
	Galerie Venezuela, New York
	Galerie Noroit, Arras, France
	Art in the Street, Imperial College, London
1978	Ausbildungszentrum USB, Wolfsberg, Switzerland
	Pavillon Werd, Zurich
	Umjetnik i Grad, Galerija Suvremene, Zagreb, Croatia
	Ibero-Amerikansiches Institut, West Berlin
1979	Arte Contacto, Caracas
	Galerija Zgraf, Sarajevo, Yugoslavia
1980	Universidad Simon Bolivar, Caracas
	Art in the Street, University of Liverpool, England
	Casa de las Americas, Havana
1981	*Didactica y diálectica del color,* at *Triennale,* Caens (traveled to the Museo de Bellas Artes, Pordenone, Italy; and Museo de Arte Contemporáneo, Caracas)
1984	Satani Gallery, Tokyo
	Museo La Tertulia, Cali, Colombia
	Galería Centro Arte El Parque, Valencia, Venezuela
	Galería Jairo Quintero, Barranquilla, Colombia
1985	Galeria Arte Autopista, Medellin, Colombia
	Museo de Arte Moderno, Bogota, Colombia
	Museo de Arte Moderno, Medellin, Colombia
	Interotoff Art Gallery, Frankfurt, Germany
	Hotel de Ville, Castres, France
1986	Galerie Denise Rene, Paris
1987	*Autonomie der Farbe,* Galerie Schoeller, Dusseldorf, Germany
	Gabinete de Arte Raquel Arnaud, São Paulo, Brazil
	Cruz-Diez, Frederiksberg Raadhus, Copenhagen
1988	Galerie Wack, Kaiserslautern, Germany
	Quadrat-Josef Albers Museum, Bottrop, Germany
	Ateneo de Valera, Venezuela
1989	*Aventuras de la optica: Soto y Cruz-Diez,* Granada, Spain (with Jesús Soto)
1990	Abbaye des Cordeliers, Chateauroux, France
	Galerie Hermanns, Munich, Germany
1991	Museum Moderner Kunst, Cuxhaven, Otterndorf, Germany
	Galerie Schoeller, Düsseldorf, Germany

Carlos Cruz-Diez, Arquitectura Centro Cultural
 Consolidado, Caracas
Museo de Arte Costarricense, San Jose, Costa Rica
Cruz-Diez inducciones cromáticas, Espacios Simonetti,
 Valencia, Venezuela

1992 Galleria Verifica 8+1, Venice
1993 Galeria Lauter, Mannheim, Germany
 35 años de gráfica, Venezuela (traveling)
 Espacios Simonetti, Valencia, Venezuela
1994 *Cruz-Diez, retrospectiva 1955/1994,* Galerie Denise
 Rene, Paris
 Museo de Arte Moderno, Santo Domingo, Dominican
 Republic
1995 Galerie Wack, Kaiserslauter, Germany
 Galería La Otra Banda, Universidad de Mérida,
 Venezuela
1996 Gabinete de Arte Raquel Arnaud, São Paulo, Brazil
 Galerie Schoeller, Düsseldorf, Germany
 Galería Li, Caracas
1998 Museo de Arte Moderno, Bogota, Colombia
 Cruz-Diez, und Gebe dem Raum die Farbe, Museo de
 Gelsenkirchen, Germany
 Museo de la Estampa y del Diseño, Caracas
 Museo de Arte Moderno Jesús Soto, Bolivar, Venezuela
 (retrospective)
1999 Museo de Arte Moderno del Zulia, Maracaibo, Vene-
 zuela (retrospective)
 Durban Segnini Gallery, Coral Gables, Florida

Selected Group Exhibitions:

1950 *Official Exhibition of Venezuela Art,* Caracas (and 1952,
 1953)
1953 *Bienal,* São Paulo, Brazil (and 1963, 1967, 1979)
1962 *Biennale,* Venice
1964 *Mouvement II,* Galerie Denise René, Paris
1965 *Anthology of Kinetic Sculpture and Perceptual Art,*
 Signals Gallery, London
1966 *Licht und Bewegung,* Kunstverein, Dusseldorf, Germany
1968 *Art vivant,* Foundation Maeght, St.-Paul-de-Vence,
 France
1972 *12 ans d'art contemporain en France,* Grand Palais,
 Paris
1977 *3 Villes, 3 Collections,* Centre Georges Pompidou, Paris
1979 *Modern Latin American Art,* Lowe Art Museum,
 University of Miami

Collections:

Museo de Bellas Artes, Caracas; Casa de la Cultura, Havana; Museum of
Modern Art, New York; Museum of Contemporary Art, Chicago;
Musée d'Art Contemporain, Montreal; Victoria and Albert Museum,
London; Städtisches Museum, Leverkusen, West Germany; Museum
des 20. Jahrhunderts, Vienna; Centre National d'Art Contemporain,
Paris, Musée d'Art Moderne de la Ville, Paris.

Publications:

On CRUZ-DIEZ: Books—*Physichromies de Cruz-Diez: Oeuvres
de 1954 a 1965,* exhibition catalog, with text by Frank Popper, Paris,
1965; *Carlos Cruz-Diez,* exhibition catalog, with text by Carlos
Dorante, Caracas, 1967; *Cruz-Diez et les 3 etapes de la couleur
moderne,* exhibition catalog, with text by Jean Clay, Paris, 1969;
Relief and 3-Dimensional Structures, London, 1970, and *An Intro-
duction to Opitcal Art,* London, 1971, both by Cyril Barrett; *The
Techniques of Kinetic Art* by John Tobey, New York, 1971; *12 Ans
d'art contemporain en France,* exhibition catalog, with text by Jean-
Luc Allerant, Paris, 1972; *Carlos Cruz-Diez: Génesis, eclosión y
absoluto del color,* exhibition catalog, with text by Roberto Guevara,
Caracas, 1974; *Cruz-Diez* by Alfredo Boulton, Caracas, 1975; *Cruz-
Diez: Didactia y dialectica del color,* exhibition catalog, with text by
Umbro Apollonio, Caracas, 1981; *Cruz-Diez: Homenaje al maestro
Carlos Cruz-Diez,* exhibition catalog, with text by Ninoska Huerta
and Bélgica Rodríguez, Caracas, PDV, 1998. **Articles**—''Carlos
Cruz Diez'' by Marianne de Tolentino, in *Art Nexus* (Colombia), 14,
October/December 1994, pp. 123–125; ''Carlos Cruz-Diez: A
Venezuelan in Paris'' by Valere Bertrand, in *Cimaise* (France), 41,
November/December 1994, pp. 67–70; ''Three Masters of Abstract
Art and Their International Impact'' by Germán Rubiano Caballero,
in *Art Nexus* (Colombia), 16, April/June 1995, pp. 80–82.

* * *

 Carlos Cruz-Diez is known as one of the main forces behind
kinetic art, a movement that included Jesús Raphael Soto and
Alejandro Otero, among others. These artists sought to create the
illusion of vibration or motion by careful manipulation of color and
form in their geometrically abstract paintings and sculptures. Kinetic
art was one of the most important movements in twentieth-century art
in Venezuela. It marked the beginning of artistic modernism in
Venezuela, where fine arts schools throughout the country were
previously dominated by nineteenth-century French academic paint-
ing. Kinetic art was fueled by the 1950s oil boom, which created a
great deal of prosperity and sources for artistic commissions. Kinetic
art has at times had right-wing associations because it developed
during a period of military rule and has been a favorite artistic style
for public and corporate art commissions. But this popularity was
perhaps due more to the fact that it was decidedly formless and
apolitical, possessing no specific ideology except that of the libera-
tion of Latin American art from outdated and figurative art forms.
Kinetic art expressed a great deal of optimism and at times was almost
utopian in its belief in modernism as a force to create change and
development in Latin America.

 Cruz-Diez began his career painting social realist works and
working as artistic director for the McCann Erikson advertising
agency in Caracas during the 1940s. On a trip to Europe in 1955–56
he became especially intrigued by the French painter Georges Seurat's
scientific studies of color as well as with geometric abstraction and
the artistic and theoretical program of the Bauhaus. Part of his work in
advertising had involved studies of how color affects the viewer's
reception. He also met Soto and the other kinetic artists in Paris who
were associated with the Galerie René. Upon returning to Venezuela,
he opened the Estudio de Artes Visuales, which was devoted to the
study of color theory. He drew from studies of physics, optics, and
philosophy to develop his own theories, finding that the reception of
color was not stable but rather influenced by a number of factors. He
created works that manifested this concept, changing their appear-
ance when viewed from various angles.

 In his *Physichromie* series, Cruz-Diez attached strips of tinted
plastic or metal, known as *laminae,* in parallel rows at right angles to

the painting's surface. The painting itself consisted of thin vertical bars of colors usually in complementary groupings that appeared to vibrate when placed next to each other. As the viewer looked at the work from different angles, the appearance of the colors changed. This effect was created by the reflections of color caused by the laminae, layering of colors created by transparent laminae, or the effect of retinal afterimages on color perception, something Cruz-Diez referred to as "additive color." For example, in the 1959 painting *Additive Yellow* he painted a thin red line against a green line on a black background. The two colors placed close together create a vibration that appears to be the color yellow. In these works he attempted to liberate color from the confines of representation and to create contrasts that would cause the colors to vibrate and float like a form of energy before the surface of the canvas.

While the form of the *Physichromies* remained constant, the materials used and the scale of the works varied a great deal. Cruz-Diez often experimented with *Physichromie* murals and sculptures that were integrated with the architecture of various sites. In 1974 he painted *Physichromies* on various areas of the Simón Bolívar International Airport, including the air control tower as well as certain walls and walkways. He also painted them on parts of a hydroelectric station in Venezuela in 1973, and he did a mural for the Venezuelan Embassy in Paris, where he lived from 1960. Cruz-Diez used different techniques to experiment with the physical experience of color in large-scale artworks. In 1968 he set up a *Chromosaturation* labyrinth in the Odéon metro station in Paris. This was an installation consisting of rooms painted entirely in red, green, or blue that created an all-encompassing, corporeal experience of color for the viewer. Each room was connected by a black hallway that allowed the viewer to recover from the experience of the previous room before entering the next. In these works he explored a bodily relationship with color that had connections to the phenomenological writings of French philosopher Maurice Merleau-Ponty, whom he had studied. Like Soto, Cruz-Diez often approached his art with a scientific rigor, transforming his work into a series of experiments on visual perception.

—Erin Aldana

CUETO, Germán
Mexican sculptor

Born: Mexico City, 9 February 1893. **Education:** Academy of San Carlos; self-taught sculptor. **Family:** Married Lola Cueto. **Career:** Instructor, Royal College of Art, London. Cofounder and member, muralists' union Sindicato de Obreros Técnicos, Pintores y Escultores, Mexico, 1923; member, artistic group Movimiento Estridentista, Mexico, 1921–27. Lived in Paris and Spain, 1927–32. Established puppet theaters in Mexico City public schools, Department of Education, Mexico City, 1932; codirector, with Lola Cueto, puppet theater Teatro Rin-rin, Mexico City, *ca.* 1932. Involved with Liga de Escritores y Artistas Revolucionarios, Mexico City, 1934–37. Cofounder, Teatro Guiñol, with Germán List Arzubide, 1930s. **Died:** Mexico City, 14 February 1975.

Selected Exhibitions:

1924 Stridentist Exhibition, Mexico City

1981 *Exposición Germán Cueto, 1893–1975: Homenaje a sus 60 años de labor artística,* Museo de Arte Moderno, Mexico City
2000 Museo Nacional de San Carlos, Mexico

Collection:

Museo de Aguascalientes, Mexico.

Publications:

On CUETO: Books—*Exposición Germán Cueto, 1893–1975: Homenaje a sus 60 años de labor artística,* exhibition catalog, Mexico City, Museo de Arte Moderno, 1981; *Germán Cueto, un artista renovador* by Teresa Bosch Romeu, Mexico City, Consejo Nacional para la Cultura y las Artes Dirección General de Publicaciones, 1998. **Article**—"The Stridentists" by Serge Fauchereau, in *Artforum International,* 24, February 1986, pp. 84–89.

* * *

Germán Cueto created semiabstract and abstract sculptures during a time when artistic realism was in its ascendancy in Mexico. He studied briefly at the Academy of San Carlos but was mainly self-taught as a sculptor. He spent a year in Europe in 1916, during a period when European avant-garde activities were at a high pitch. From 1921 to 1927 he participated in the Movimiento Estridentista (Stridentist Movement), the avant-garde literary and artistic group started by writer Manuel Maples Arce. Cueto created a number of clay portrait masks of his fellow Stridentists in a futurist- and cubist-inspired style. Among these masks are portraits of writer Germán List Arzubide and artist Leopoldo Méndez. Cueto also made remarkable, colorful masks out of painted cardboard and sheet metal. Their distorted, semiabstract forms are reminiscent of the African masks that inspired the European avant-garde. His *Mask 1* (1924) is a brilliantly painted cardboard face with dramatic geometric patterning. Active in Stridentist activities, he showed his sculptures in the 1924 Stridentist exhibition in Mexico City. He briefly lived in Jalapa, Veracruz, when the Stridentist Movement relocated there in 1925.

In 1923 Cueto joined the artists David Alfaro Siqueiros, Diego Rivera, José Clemente Orozco, Xavier Guerrero, Fermín Revueltas, Ramón Alva Guadarrama, and Carlos Mérida in the creation of the muralists' union Sindicato de Obreros Técnicos, Pintores y Escultores (Syndicate of Technical Workers, Painters and Sculptors; SOTPE). Cueto and his wife, Lola Cueto, also an artist, had a home on Mixcalco Street in Mexico City, which became an artists community. The Cuetos set up a collective workshop in a patio between several houses that they rented out. Rivera and his wife, Lupe Marin, were among the artists who lived there in the 1920s. The Cuetos experimented with handmade puppets and held puppet shows in the patio.

In 1927, after the Stridentists disbanded, Cueto and his wife lived in Paris and Spain. In 1930 he visited the studios of Constantin Brancusi and Jacques Lipchitz and exhibited with the group Cercle et Carré (Circle and Square), founded in Paris in 1930 to promote abstract art. In Paris the Cuetos pursued their interest in puppet theater and made both hand puppets and marionettes. Upon their return to Mexico in 1932 they worked with the Department of Education to establish puppet theaters in the public schools of Mexico City. The Cuetos directed the Teatro Rin-rin, which toured the public schools in and around Mexico City, presenting adaptations of popular stories

and legends and newly written puppet plays with leftist messages. From 1934 to 1937 Germán participated in the Liga de Escritores y Artistas Revolucionarios (League of Revolutionary Writers and Artists; LEAR).

In Paris Cueto created the cubist sculpture *Napoleon* (1931), which was carved from Reims stone; his subsequent work reflects his interest in abstract representation—in this respect he was out of step with Mexican realist art of the 1930s and '40s. His 1936 wooden model, *Maqueta para monumento a la revolución* ("Maquette for a Monument to the Revolution"), combines cubist form with the technological imagery of wheels and gears favored by the Stridentists. He often used nonprecious materials such as tin, aluminum, cement, or cardboard and painted his sculptures in bright colors. He also experimented with mosaics and enamel glazes on metal. The undated work *Tehuana* is an abstract portrayal of an indigenous woman of the Isthmus of Tehuantepec created from four metals. Cueto's undated bronze sculptures *Autoretrato* ("Self-Portrait") and *Forma barroca no. 2* demonstrate his characteristic eccentric, linear angularity, use of negative space, and playful rhythms. In 1968 Cueto created *El corredor* ("The Racer"), a large bronze sculpture near the stadium of the Universidad Autónoma de México. Although Cueto was relatively unknown, his experimental sculptures were an inspiration to the generation of abstract artists who emerged in Mexico in the 1950s.

—Deborah Caplow

CUEVAS, José Luis
Mexican painter and engraver

Born: Mexico City, 1934. **Education:** Primarily self-taught; attended one class, Escuela Nacional de Pintura y Escultura "La Esmeralda," Mexico City, 1944; studied graphic arts, Institución de Enseñanza Universitaria, Mexico City, c. 1948. **Career:** Instructor, Tamarind Workshop, Albuquerque, New Mexico, 1965, Poligrafa, Barcelona, Spain, 1981, and Taller Kyron, Mexico. Visiting artist, Philadelphia Museum School of Art, 1957–58, and San Jose State College School of Art, California, 1969–70. **Awards:** Drawing prize, *V Biennial of São Paulo,* Brazil, 1959; first prize, International Black and White Exhibition, Lugano, Switzerland, 1962; engraving prize, *Triennial of Graphic Arts,* New Delhi, India, 1968; first prize, *III Latin American Print Biennial,* San Juan, Puerto Rico, 1977; National Prize of Science and Art, Mexican government, 1981; international prize, World-Wide Council of Engraving, San Francisco, 1984; Gentleman of the Order of Arts and Letters, French government, 1991; named Creador Emérito of Mexico, 1993; Tomas Francisco Prieto award in engraving, Madrid, 1997.

Individual Exhibitions:

1953	Galería Prisse, Mexico City
1954	Pan American Union, Washington, D.C.
1957	Roland de Aenlle Gallery, New York
	Grass Gallery, Washington, D.C.
1959	Roland de Aenlle Gallery, New York
1960	Philadelphia Museum of Art
	Fort Worth Art Center, Texas
1961	University of Texas, Austin
	Santa Barbara Museum, California

José Luis Cuevas: *Self Portrait,* c. 1952. Photo courtesy of Phoenix Art Museum, Arizona/Gift of Mr. and Mrs. Orme Lewis/Bridgeman Art Library.

1962	Occidental College, Los Angeles
1963	Andrew Morris Gallery, New York
1965	Grace Borgenicht Gallery, New York
	Munson-Williams-Proctor Institute, Utica, New York
1967	Grace Borgenicht Gallery, New York
1970	San Francisco Museum of Art, California
1972	Museo de Arte Moderno, Mexico City
1974	Museo de Arte Contemporaneo, Caracas, Venezuela
1975	Phoenix Art Museum, Arizona
1976	Musee d'Art Moderne, Paris
1986	*Intolerance,* Museo de Bellas Artes, Bilbao, Spain
1994	Museo de Arte y Diseño Contemporáneo, San José, Costa Rica (retrospective)

Selected Group Exhibitions:

1954	Pan American Union, Washington, D.C.
1957	*Four Masters of Line,* Musee de la Napoule, France
1959	*V Biennial of São Paulo,* Brazil
1965	*The Emergent Decade,* Cornell University, Ithaca, New York, and Solomon R. Guggenheim Museum, New York
1968	*Triennial of Graphic Arts,* New Delhi, India
1977	*III Latin American Print Biennial,* San Juan, Puerto Rico
1982	*Venice Biennial*
2000	*Inner Self,* La Llorona Art Gallery, Chicago
2001	*International Offerings,* Jack Rutberg Fine Arts, Los Angeles

Collections:

José Luis Cuevas Museum, Mexico City, Latin American Art Collection, University of Essex, England; Metropolitan Museum of Art, New York; Solomon R. Guggenheim Museum, New York; Museo Rufino Tamayo, Mexico City; Brooklyn Museum, New York; Museum of Modern Art of Latin America, Washington, D.C.; Philadelphia Museum of Art.

Publications:

By CUEVAS: Books—*Cuevas por Cuevas: Notas autobiográficas,* prologue by Juan García Ponce, Mexico, Era, 1965; *Los signos de vida,* with Marta Traba and Francisco Toledo, Mexico, FCE, 1976; *Historias del viajero,* Mexico, Premia, 1987; *Cuevas antes de Cuevas,* Mexico, Bruguera Mexicana, 1990; *Cuevas: Unveiling the Secrets of the Vault,* Washington, D.C., Mexican Cultural Institute, Kimberly Gallery, 1991; *Gato macho,* Mexico, Fondo de Cultura Económica, 1994; *Municiones de caviar: Poemas a José Luis Cuevas,* Mexico City, Ediciones La Giganta, 1995; *Cuevario,* Colima, Mexico, Museo José Luis Cuevas, 1997; *Jose Luis Cuevas, el ojo perdido de dios,* with Jorge Toribio, Toluca, Universidad Autónoma del Estado de México, 1997; *Animales impuros,* Mexico, Impronta Editores, 1998; *José Luis Cuevas: El sexófago posmoderno,* with Willebaldo Herrera, Tijuana, Mexico, Consejo Nacional para la Cultura y las Artes and Museo José Luis Cuevas, 1998; *Memorias del tacto,* with Francisco León, Mexico, Nueva Imagen, 2000.

On CUEVAS: Books—*José Luis Cuevas,* exhibition catalog, New York, David Herbert Gallery, 1960; *Jose Luis Cuevas of Mexico,*

exhibition catalog, Washington, D.C., Pan American Union, 1963; *José Luis Cuevas* by Carlos Valdés, Mexico, UNAM, Dirección General de Publicaciones, 1966; *Confesiones de José Luis Cuevas* by Alaída Foppa, Mexico, FCE, 1975; *Revelando a José Luis Cuevas* by Daisy Ascher, Mexico, D. Ascher, 1979; *José Luis Cuevas, genio o farsante?: Charlas con el polémico pintor* by José Bernardo Ponce, Mexico, Signos, 1983; *El torno a Cuevas* by Jorge Mejía Prieto and Justo R. Molachino, Mexico, Panorama Editorial, 1985; *José Luis Cuevas: Su concepto del espacio* by Graciela Kartofel, Mexico, Universidad Nacional Autónoma de Mexico, 1986; *Ensayo sobre José Luis Cuevas y el dibujo* by Ida Rodríguez Prampolini, Mexico, Universidad Nacional Autónoma de Mexico, 1988; *El mundo desconocido de José Luis Cuevas* by María de los Angeles Cajigas R., Mexico, Claves Latinoamericanas, 1994; *Los sueños de José Luis Cuevas,* exhibition catalog, Mexico, Loteria Nacional para la Asistencia Pública, 1994; *José Luis Cuevas* by Eugenio Aguirre, Mexico City, Miguel Angel Porrúa, 1997; *José Luis Cuevas: Obra gráfica,* exhibition catalog, Madrid, Museo de la Casa de la Moneda, 1997; *José Luis Cuevas,* exhibition catalog, Madrid, Museo Nacional Centro de Arte Reina Sofía, 1998. **Articles**—"José Luis Cuevas: En el jardín de Narciso" by Francisco Leon, in *Artes de Mexico,* 39, 1995–1996, p. 91; "Una conversacion con Jose Luis Cuevas en Madrid" and "Jose Luis Cuevas, armado con su firma," both by Javier Arnaldo, in *Cuadernos hispanoamericanos,* 575, 1998.

* * *

The most polemical Mexican artist of his generation, José Luis Cuevas is reputed to be the greatest Latin American master of drawing of the twentieth century. A precocious artist, Cuevas gained instant notoriety in his native Mexico for his outspoken attacks on what he perceived to be the tyrannical monopoly of the muralist school over his country's artistic life. Artists who, like Cuevas, attempted in the early 1950s to develop new plastic languages free of overt politics or strident nationalism were bound to encounter the indifference of state art schools and museums and the antagonism of critics. To the monumental and romanticized indigenism of Diego Rivera, Cuevas opposed the intense spirituality and energetic forms of José Clemente Orozco and the satirical and macabre graphic work of José Guadalupe Posada, both of whom shaped his beginnings as an artist. Cuevas also expressed his admiration for the painting of Rufino Tamayo, whose fusion of cubism and surrealism represented the only visible alternative at the time to muralism's hegemony.

In contrast to the generally hostile reception at home, Cuevas met with rapid international recognition while he was in his early twenties. His first American exhibition, held at the Pan American Union in Washington, D.C., in 1954, sold out on opening night. The following year Cuevas had his first one-man show in Paris, where Pablo Picasso purchased two drawings, and saw the publication in France of the first monograph on his work. Thereafter Cuevas exhibited regularly across Europe, the United States, and Latin America, winning numerous awards and generating endless outrage and controversy. His drawings, watercolors, and prints conjure a highly personal and anguished view of human existence. At the age of 10 Cuevas fell gravely ill and was bedridden for many months, during which he took up drawing in earnest. Unsurprisingly Cuevas's art evinces a fascination with death and corruption. His is a phantasmagoric and nightmarish world of ugly, degenerate, and often monstrous characters trapped in desolate and absurd circumstances. Clowns (*La Farsa,* 1958), prostitutes, the crippled (*Yo en Coney island, observando*

un mutilado, 1962), and the mentally insane (*Loco,* 1954) were among the subjects of his first series of drawings.

For a while Cuevas aligned himself with the movement known as *Nueva Presencia,* a group of young Mexican artists from the 1960s committed to an expressionistic and sometimes gestural figurative painting that conveyed the alienation of the modern human condition. But his art evinces a rather generalized condemnation of war, violence, and social injustice, without any particular political agenda. As a whole Cuevas's position toward his subject matter remained detached and nonjudgmental but not altogether void of compassion or even tenderness. This attitude is more apparent in his erotic suites which, like Picasso's, depict the artist in sexual encounters with prostitutes or invoke the topos of the artist and his model. These images articulate the interrelatedness of sexuality and artistic creativity at the same time that they play off Cuevas's legendary amatory exploits.

Cuevas's style generally favors a broken, nervous line that isolates his figures from their shallow, blank backgrounds. Bodies often overlap in crowded, asymmetrical compositions. The art of Francisco de Goya, especially his series of engravings, served as a key source of inspiration. Cuevas's graphic work encompasses the fantastic mood and grotesque humor of Goya's *Caprichos* and the despair and cruelty of his *Desastres de la guerra.* The demonic hallucinations of Goya's *Black Paintings* foreshadow Cuevas's own horrifying visions of evil and vice, as in the witches and satanic rituals from the series *Intolerance* (1983). Cuevas's art bears as well thematic and formal similarities to that of the German expressionists. Renowned critic Marta Traba, one of Cuevas's staunchest champions, placed him alongside Francis Bacon, William de Kooning, and Jean Dubuffet, three contemporary artists whose work also reveled in subjective deformation and existentialist angst. Like them Cuevas created art that bespeaks the anxiety of living in the post-atomic age. He once admitted to drawing that which most terrified him, reminiscing in his autobiography about the wretched streetwalkers and infirm beggars who inhabited his neighborhood and found their way into his first childhood sketches.

Cuevas equally stated his debt to filmmakers such as Buster Keaton and Luis Buñuel and professed a wide range of literary influences: Fyodor Dostoyevsky, Edgar Allan Poe, Marquis de Sade, the seventeenth-century Spanish satirist Francisco de Quevedo, and most decisively Franz Kafka, whose work he illustrated in the 1957 series *The Worlds of Kafka and Cuevas.* (Cuevas designed covers and illustrations for more than 30 books.) His work may seem at times formally repetitive, solipsistic, and unbearably depressing, yet it was also sincere, lucid, and unapologetically defiant of norms, taste, and decorum. Through his maverick personality and iconoclastic practice, Cuevas opened the way for the renewal of Mexican art.

—Gerard Dapena

CÚNEO (PERINETTI), José
Uruguayan painter

Born: Montevideo, 11 September 1887. **Education:** Círculo de Bellas Artes, Montevideo; studied under Anton Mucchi, Turin, Italy, 1907–09; Academia Vity, Paris, 1912–13. **Career:** Traveled to Paris, 1917; visited Europe, 1922, 1927–30, 1938. **Awards:** Silver medal, *Exposición Panamá-Pacific,* 1915; bronze medal, *Exposición*

internacional de artes y técnicas, Paris, 1938; grand prize in painting, *Salón nacional de bellas artes,* Montevideo, 1942; first prize, *Primer salón nacional de acuarelas,* Montevideo, 1949; grand prize, *Primera bienal nacional de arte,* 1954; prize, *Bienal de arte,* Havana, 1955; prize, *Tercera exposición bienal hispanoamericana de arte,* Barcelona, Spain, 1956; prize, *Primer salón de pintura moderna,* Montevideo, 1964; grand prize in painting, *X bienal de arte de São Paulo,* Brazil, 1969; national prize, *Festival de pintura de Cagnes-sur-Mer,* France, 1974. **Died:** 1977.

Selected Exhibitions:

1910	Casa Moretti, Montevideo
1913	Salón Moretti, Montevideo (with Bernabé Michelena)
1914	Salón Moretti, Montevideo
1916	Galería Müller, Buenos Aires
1922	Salón Vda. Moretti, Montevideo
1925	*Salón de primavera del círculo de bellas artes,* Montevideo
1930	Galerie Zak, Paris
1931	Amigos del Arte, Montevideo
	Exposición de pintura uruguaya, Baltimore, Maryland
1932	Galería Postal, Montevideo
1933	Palacio de la Música, Escuela Taller de Artes Plásticas, Montevideo
1935	Galería Müller, Buenos Aires
1936	Galería Müller, Buenos Aires
1937	Amigos del Arte, Montevideo
	Biblioteca Popular Artigas, Colón, Montevideo
1938	Institutos Normales, Montevideo
	Galerie Jeanne Castel, Paris
	Exposición internacional de artes y técnicas, Paris
1939	Galería Casa d'Artisti, Milan
	Amigos del Arte, Montevideo
	Escuela Militar, Montevideo
1942	Amigos del Arte, Montevideo
1943	Salón Caviglia, Montevideo
1946	Ateneo de Salto, Uruguay
	Escuela República Argentina, Montevideo
1948	*Exposición internacional de arte,* Bogota, Colombia
1949	Galería Berro, Montevideo
1950	Galería del Este, Punta del Este, Uruguay
	Galería Moretti, Montevideo
1951	Institutos Normales de Montevideo
	Windsor Gallery, Montevideo
	Exposición de pinturas uruguayos, Galería Moretti, Montevideo
1952	Galería Moretti, Montevideo
	Amigos del Arte, Montevideo
1954	Galería AUDE, Montevideo
	XXVII bienal de arte de Venecia, Venice
	Galería Montevideo de Artes Plásticas, Montevideo
	Primera bienal nacional de arte, Montevideo
1955	*Bienal de arte,* Havana
1956	*Tercera exposición hispanoamericana de arte,* Barcelona, Spain
	Galería Montevideo, Montevideo
1958	*XXIX bienal de arte Venecia,* Venice
1959	Galería Montevideo de Artes Plásticas, Montevideo
	Círculo de Bellas Artes, Montevideo

1960	Galería Montevideo, Montevideo
	Salón municipal de artes plásticas, Montevideo
1961	*José Cuneo, 50 años de pintura,* Amigos del Arte, Montevideo
1962	Club Solís de Pando, Canelones, Uruguay
	Centro de Artes y Letras de "El País," Montevideo
	Galería Ulus, Belgrade, Yugoslavia
1964	*Primer salón de pintura moderna,* Montevideo
	Bienal de arte de Córdoba, Argentina
1966	*Art of Latin America Since Independence,* Yale University, New Haven, Connecticut, and University of Texas, Austin
	Salón del Subte, Montevideo (retrospective)
	Zak Gallery, Paris
1967	Galería Moretti, Montevideo
1969	*X bienal de arte de São Paulo,* Brazil
1971	Galería Karlen Guggelmeier, Montevideo
1972	*XXXVI bienal de arte de Venecia,* Venice
1975	Instituto Italiano de Cultura, Montevideo
1976	Club de Arte de Galería Bruzzone, Montevideo
1977	Sala Vaz Ferreira, Biblioteca Nacional, Montevideo
1987	Galería Moretti, Montevideo

Publications:

On CÚNEO: Books—*El pintor José Cúneo, paisajista del Uruguay* by José Pedro Argul, Montevideo, Editorial San Felipe y Santiago, 1949; *4 artistas sur americanos: Torres Garcia, Figari, Barradas, Cuneo,* exhibition catalog, Montevideo, Galería Sur, 1987; *José Cúneo: Retrato de un artista,* exhibition catalog, by Raquel Pereda, Montevideo, Edicion Galería Latina, 1988; *La lección del maestro,* exhibition catalog, by Alicia Haber, Montevideo, Galería Latina, 1990; *Catálogo de la exposición: José Cúneo-Bernabé Michelena,* exhibition catalog, by Gabriel Peluffo and others, Montevideo, Museo Juan Manuel Blanes, 1998. **Articles**—"Las lunas de Cúneo: El devenir cósmico en el paisaje uruguayo," in *Letras de Buenos Aires,* April 1983, pp. 43–49, and "La pintura uruguaya en Buenos Aires: José Cúneo," in *Artinf* (Buenos Aires), 1987, p. 9, both by Alicia Haber.

* * *

José Cúneo is considered to be among the most significant artists in the history of Uruguayan art. His long, prolific creative life can be divided into various stages. Most important were his planista-figurative stage, his expressionist rural landscapes, and his abstract series that he signed as Perinetti, and later as Cúneo Perinetti, upon fusing figurative and abstract elements. He traveled many times to Europe, where he was in direct contact with museums and artists, although he always lived in Uruguay.

Cúneo's European travels began when he was very young with his first visit to Italy in 1907, where he studied in Turin, first briefly with the sculptor Leonardo Bistolffi and then, between 1907 and 1909, with the painter Anton Mucchi. Between 1912 and 1913 he lived in Paris and attended courses given by Hormen Anglada Camarassa and Kees van Dongen at the Academia Vity, and in 1917 he was linked to La Grande Chaumière Academy and thus received, during his formative years, impressionist, postimpressionist, fauve, and then futurist influences. He continued incorporating diverse expressionist, abstract, and other influences during his numerous visits to Europe throughout his life.

As of 1914 Cúneo devoted the bulk of his life to capturing the Uruguayan landscape in different styles. His first contribution of great relevance was the painting he did within the Uruguayan movement called planismo ("planarism"), considered a Montevideo school of painting, which came into existence in the 1920s. It was based on attention to the local landscape rendered in planes of intense color that reveal a fauvist and postimpressionist inheritance. Cúneo was one of its great exponents, along with Humberto Causa, Manuel Rosé, Petrona Viera, Carmelo de Arzadun, Guillermo Laborde, Cesar Pesce Castro, Alfredo De Simone, Etchebarne Bidart, Alberto Dura, and Melchor Méndez Magarriños.

Cúneo began painting in planista style in 1918 with a major series. Cúneo's planismo is unique in its high color, its geometrization of the landscape, the euphoria expressed in the planes of exalted color, and the simplification and clarity of the forms highlighted by the exactness of their outlines with dense, vigorous impastos. He transmitted the joy of painting and a passionate delight in the native landscape. The large planes of color, the geometrization, and the control, inherited from Paul Cézanne, come into play in his studied composition, demonstrating the moderating rationalism typical of planismo. He also did an important series of portraits in planista language. His joyful discovery of Uruguay's landscape can be seen in *Paisaje de melo tacuari* (1918) and *Cerro largo/La aguada* (oil on burlap, 1918). Cúneo also used the same palette and style in dealing with portrait.

Another interesting and transcendent series from his figurative stage devoted to Uruguayan landscapes is *Lunas y ranchos* ("Moons and Ranches"), which he began in the 1930s and completed in the mid-1950s, although the bulk of his production involving these themes was done in the 1930s and '40s. Cúneo moved to the interior of the country (the department of Florida), whose landscape inspired him to begin the series in 1931.

Lunas y ranchos include diverse elements of the nocturnal Uruguayan countryside, but the dwellings and the land seem to sink into a cataclysmic movement, and a hypertrophied moon, sky, and clouds dominate the paintings' space. Cúneo melded the real, the perceived, and the imaginary. He made reality a malleable material, modifiable by his inner vision. Thus the land sinks under the pressure of cosmic dynamism, the country dwellings lurch in a dangerous equilibrium, the clouds and moon's halo take on tremendous expressive potential, and the majestic sky imposes itself over beings and things. This cosmic dynamism is expressed visually by abandonment of horizontals and verticals, the predomination of diagonal composition, the large areas of contrasts of light and shadow, and the profound rhythms generated by the forms of clouds and trees. Obliqueness lends a dynamic nature to the composition and everything appears to be shaken, while the forms acquire moving outlines. In turn, the heavy texturizing of the canvases, through the use of burlap, sand, plaster, and paste, step up the material's communicative potential. Some examples are *Luna nueva* (oil on canvas, 1933), *Ranchos del barranco* (oil on board), and *Luna y Osamehta* (oil on burlap).

Also important in his creative cycle was his abstract stage. Cúneo connected with the European informalist movements as of 1954 during a stay in Europe. When he returned to Montevideo in 1956, he decided he should adopt a new pictorial mode. Cúneo did his first major abstract works in 1957. The mutation was so intense for him that he felt the need to rebaptize himself, and for a long time starting then he signed using his mother's last name, Perinetti. He did abstraction of an expressionist ilk, linked to his earlier work, in large-scale paintings and in a series of works on paper painted between

1961 and 1965. In the first works there is a close linkage to Robert Delaunay's orphism and to geometry. Later he adopted the splotch, irregular brush strokes, texture, and elements that have links with abstract expressionism. Despite his decision to become an abstract painter, he did not break totally with his previous world, and the disassociation between Cúneo and Perinetti was not so radical or extreme, although it was a profound change. Visual reality reappears in different works. Later Cúneo decided to acknowledge that integration of the real in the abstract. He retained tints of telluric forms and links to the local countryside. In some of these paintings are yellow bats, evocations of insects and snails, animals, armadillos, wiggling serpents, anthropozoological elements, mythical masks, and figures that suggest clouds. He began signing his works Cúneo Perinetti and did so until his death.

—Alicia Haber

DAVIDOVICH, Jaime
American painter and video artist

Born: Buenos Aires, Argentina, 1936; moved to the United States, 1963, U.S. citizen, 1968. **Education:** Escuela Nacional de Bellas Artes, Buenos Aires, 1954–58; Universidad de la República Oriental del Uruguay, Montevideo, 1959–61, M.F.A. 1961; School of Visual Arts, New York, 1963. **Career:** Argentine representative, International Congress of Plastic Arts, United Nations, New York, 1965, and Art Center of the Instituto Torcuato di Tella of Buenos Aires. Host, as Dr. Videovich, television program *The Live! Show,* New York, 1976–84. Cofounder, Artists' Television Network, New York, 1976. **Awards:** Visual arts fellowships, National Endowment for the Arts, 1978, 1984, and 1990; awards, Creative Artists Public Service Program, 1975, 1982; grants, New York State Council on the Arts, 1975, 1982.

Individual Exhibitions:

1963	Art Institute, Canton, Ohio
1965	Spectrum Gallery, New York
1966	Spectrum Gallery, New York
1967	Spectrum Gallery, New York
1968	Spectrum Gallery, New York
1987	Diane Brown Gallery, New York
1989–90	*The Live Show,* American Museum of the Moving Image (retrospective)
1990–91	*Forces,* Exit Art, New York

Selected Group Exhibitions:

1976	Whitney Museum of American Art, New York
1978	*Intermedia,* Gallery of New Concepts, University of Iowa, Iowa City
1981	*Alternatives in Retrospect,* New Museum of Contemporary Art, New York
1984	*Cleveland Revisited,* New Gallery of Contemporary Art, Cleveland
1987	*The Debt,* Exit Art, New York
1989	*The Latin American Spirit: Art & Artists in the U.S.,* Bronx Museum, New York
2000	*An Independent Vision of Contemporary Culture 1982—2000,* Exit Art, New York

Collections:

Dayton Art Institute, Ohio; Museum of Modern Art, Buenos Aires; Everson Museum of Art, Syracuse, New York; H. Abrams Collection; Akron Art Institute, Ohio; Exit Art, New York; Museum of Art, University of Iowa, Iowa City.

Publications:

On DAVIDOVICH: **Books**—*Intermedia,* exhibition catalog, by Hans Breder and Stephen C. Foster, Iowa City, Gallery of New Concepts, University of Iowa, 1978; *Cleveland Revisited,* exhibition catalog, Cleveland, New Gallery of Contemporary Art, 1984. **Article**—Article by Ellen Handy, in *Arts Magazine,* 66, October 1991, p. 93.

* * *

A versatile artist, Jaime Davidovich was a painter and video artist who also worked in mixed media and created installations. In fact, Davidovich worked with such a large variety of media that it is difficult to clearly define his personal visual style. Therefore, when discussing Davidovich's work, one must focus on the motivating factors behind his art. One of his passions was making art accessible to all people. Another passion was the desire to communicate, through art, his views on the problems of the contemporary world. An artist with an essentially humanistic worldview, Davidovich observed the reality from the vantage point of a true citizen of the world, always striving to transcend cultural and national boundaries.

Davidovich was born in Argentina and moved to New York City in the early 1960s to study at the School of Visual Arts. In 1976 he helped create, and later became president of, the Artists' Television Network (ATN), a nonprofit organization devoted to developing television as a medium that would bring art to a larger audience. As a result of his efforts, television viewers gained immediate access to a rich variety of artistic and cultural events, including theater, dance, performances of contemporary music, video creations, lectures, seminars, and street happenings. Davidovich also had his own show, *The Live! Show,* featuring a broad spectrum of New York avant-garde, which he hosted under the name Dr. Videovich. Dr. Videovich conducted interviews, had phone-in discussions, presented news, and had guest appearances of well-known artists and performers, including Laurie Anderson, John Cage, Jean Dupuy, and Gregory Battcock. This project continued until 1984, when ATN came to an end.

Much of Davidovich's art directly addresses the phenomenon of globalization and its effect on individuals, groups, or society as a whole. Several exhibits shown at Exit Art in New York City have featured Davidovich's response to the social and economic consequences of globalization. In the late 1980s Davidovich took part in an exhibit called *The Debt,* which was an "invitational challenge" to several artists to create a work that would reflect their own understanding of the fact that many South American and Third World countries live with the overwhelming economic burden of astronomical debts to international bankers.

Sometimes the message of an artist's work can become more powerful when the public realizes how art can affect everyday existence. Intrigued by the concept of interactive art, where audience or viewer participation is an integral element of the piece of artwork,

Davidovich produced *Forces/Farces* (1990–91), a multimedia installation that combines his video expertise and his skill and originality as a painter. The installation features video work shot in Argentina, Germany, Japan, and Hong Kong and addresses global issues such as ecological crisis, overpopulation, media blackouts, rampant consumerism, and multinational economics. The installation is a visual play divided into seven acts, each act represented by its own free-standing tableau. People are free to walk among the tableaux and, after viewing, are invited to voice their reactions to the installation by answering questions that were formulated by Davidovich and a cultural anthropologist. The videotaped interviews about the exhibition are then screened, as an integral part of the installation, which enables visitors to simultaneously experience the work of art and its reception.

During the last decade of the twentieth century Davidovich focused on "the ideas of flesh, permanence, spiritual tradition and the new technologies." Raised as a Jew in a predominantly Catholic country, Davidovich felt singularly equipped to tackle the paradoxical clash of ancient spiritual traditions and vertiginous technological progress. His Cibachrome print *Inside and Between* (1996) is an unlikely combination of tiny television screens formed into the shape of a cross located above and below Psalm 49:17–18 ("For when he dies he will carry nothing away"), which is written in both Hebrew and Spanish. Davidovich's choice of this particular psalm is not accidental because the psalm talks about the ultimate emptiness and impermanence of worldly riches. The background of the print appears as a red shroud. Davidovich chose red because of its rich and ambivalent meaning. It is obvious that he wanted to convey the idea that his art exists in a symbolic context of not only strife and destruction but also hope. The crosses are instantly recognizable as such, but with closer scrutiny, the viewer realizes that the crosses are comprised of small television screens. The incongruity of the symbols and the languages is also instantly realized. This work exemplifies the concept of an "open work," an artistic creation that never allows the viewer to arrive at a definitive interpretation.

In 1995 Davidovich discussed another work with the same theme that was shown at an exhibition at El Museo del Barrio in New York City:

> As a Jew born and raised in Argentina, I was accustomed to seeing the image of Christ present everywhere, from the schools to all places of public activity. As an Argentinian living and working in the United States, the images of television are in my mind all the time. Since my childhood I have seen the image of Christ on the altar above human touch and here, in my installation, I place the television high up, out of reach with the Christ below eye level. In between these two images but separated by empty space, are images of the impermanence of flesh as well as icons of the Judeo-Christian tradition. These form the setting for a dialogue with the silent television, with a brick wall and a woodcarved Christ. This is a cyberspace dialogue not in real time but in a new time, a time without time, petrified by the wood and electronic pulses. Everything remains still."

—Christine Miner Minderovic

Juan Dávila. Photo courtesy of Kalli Rolfe Contemporary Art, Melbourne.

DÁVILA, Juan
Chilean painter and video performance artist

Born: Santiago, 1946. **Education:** Colegio Vergo Divino, Santiago, 1951–63; studied law, 1965–69, then fine arts, 1970–72, Universidad de Chile. **Career:** Moved to Australia, 1974. Editor, *Art and Criticism* monograph series, Melbourne. Member, Committee of Revista de Critica Cultural, Santiago. **Agents:** Kalli Rolfe Contemporary Art, 909 Drummond Street, North Carlton 3054, Melbourne, Australia; and Greenaway Art Gallery, 39 Rundle Street, Adelaide 5000, Australia. **Web Site:** http://www.juandavila.com.

Individual Exhibitions:

1974 *Latinamerican Artistic Coordination,* CAL Gallery, Santiago
1977 Tolarno Galleries, Melbourne
1979 *Latinamerican Artistic Coordination,* CAL Gallery, Santiago
1981 Tolarno Galleries, Melbourne
 Hot Art, Melbourne City Square
1982 Roslyn Oxley9 Gallery, Sydney
1983 *Fable of Australian Painting,* Tolarno Galleries, Melbourne
 Ned Kelly, Praxis, Fremantle, Australia
 Fable of Chilean Painting 1973/83, Sur Gallery, Santiago

Juan Dávila: *Lost Again,* 2000. Photo courtesy of Kalli Rolfe Contemporary Art, Melbourne.

1984 Adelaide Festival, Experimental Art Foundation,
 Adelaide, Australia
 Pieta, Performance Space, Sydney
 The Studio, Sydney College of the Arts
 Davila, Paintings 1980/84, Sur Gallery, Santiago
1985 Roslyn Oxley9 Gallery, Sydney
1986 Power Gallery of Contemporary Art, University of
 Sydney
 Picasso Theft, Avago Gallery, Arts Workshop, Univer-
 sity of Sydney
1987 Tolarno Galleries, Melbourne
 Bellas Gallery, Brisbane, Australia
1988 Roslyn Oxley9 Gallery, Sydney
 Centro Cultural de la Municipalidad de Miraflores,
 Lima
 Galeria Ojo de Buey, Santiago
1989 Tolarno Galleries, Melbourne
1990 *Large Prints,* Cannibal Pierce Gallerie Australienne, St.
 Denis, France
1991 *Mexicanismo,* Bellas Gallery, Brisbane, Australia
 Center for Contemporary Art of South Australia,
 Adelaide, Australia
 Tolarno Galleries, Melbourne
 Roslyn Oxley9 Gallery, Sydney
1992 Plimsoll Gallery, Tasmanian School of Art, Hobart,
 Australia
 Popular Art, graphic Work 1958–1992, Tolarno Galler-
 ies, Melbourne
1993 *Welcome to Australia,* Roslyn Oxley9 Gallery, Sydney

1994 *3-D Semblance,* Tolarno Galleries, Melbourne
 Joy Radio, Trish's Coffee Place, North Melbourne
 Imperfect Drawings, Greenaway Gallery, Adelaide,
 Australia
 Juanito Laguna, Chisenhale Gallery, London, and
 Tolarno Galleries, Melbourne
1995 *Juan Davila, Recent Jet Sprays,* Plug In Inc., Winnipeg,
 Canada
1996 *Rota,* Galeria Gabriela Mistral, Santiago (traveled to
 Tolarno Galleries, Melbourne, and Greenaway Gal-
 lery, Adelaide, Australia)
1997 *ARCO 97,* Greenaway Art Gallery, Madrid
1998 *Verdeja, Project Room, ARCO 98,* Greenaway Gallery,
 Madrid
1999 *Recent Drawings,* Kalli Rolfe Contemporary Art,
 Melbourne
2000 *Love's Progress,* Kalli Rolfe Contemporary Art, Mel-
 bourne Art Fair 2000
2001 *The Ruins of Adelaide,* Greenaway Art Gallery,
 Adelaide, Australia

Selected Group Exhibitions:

1972 *Leon, Davila, Borquez, Gana,* Latin American Art
 Institute, Santiago
1983 *From Another Continent: Australia, the Dream and the
 Real,* Museum of Modern Art, Paris
1984 *Three Artists, Three Rooms,* Australian Centre for
 Contemporary Art, Melbourne

1987 *Contemporary Art in Australia,* MOCA Museum of
 Contemporary Art, Brisbane, Australia
1993 *Cartographies,* Winnipeg Art Gallery, Canada
 (traveling)
1994 *Cocido y crudo,* Centro de Arte Reina Sofia, Madrid
 Don't Leave Me This Way, Art in the Age of AIDS,
 Australian National Gallery, Canberra
1995 *Aspects of Australian Printmaking 1984–1994,* National
 Gallery of Victoria, Melbourne
1998 *São Paulo biennale,* Brazil
1999 *A sangre y fuego,* EACC Espai d'Art Contemporani de
 Castelo, Spain

Collections:

Art Gallery of South Australia, Adelaide; Australian National Gallery, Canberra; National Gallery of Victoria, Melbourne; Museum of Contemporary Art, Sydney; Art Gallery of Western Australia, Perth; Museum of Modern Art at Heide, Melbourne; Metropolitan Museum of Art, New York; Art Gallery of New South Wales, Sydney; Monash University Collection, Melbourne; Waverley City Art Gallery, Melbourne; Queensland University of Technology, Brisbane; University of Sydney; Museo Extremeño e Iberoamericano de Arte Contemporaneo, Spain.

Publications:

By DÁVILA: Books—*Hysterial Tears: Juan Davila,* with Paul Taylor, London, GMP, 1985; *The Mutilated Pieta,* exhibition catalog, with Paul Foss, Surry Hills, New South Wales, Australia, Artspace, 1985; *Juanita Laguna,* exhibition catalog, London, Chisenhale Gallery, 1995. **Article**—"On Multiculturalism in the International Art Circuit," in *Art & Design,* 10, July/August 1995, pp. 17–19.

On DÁVILA: Books—*Unbound: Possibilities in Painting,* exhibition catalog, text by Adrian Searle and Linda Schofield, London, South Bank Centre, 1994; *Rota: Juan Davila,* exhibition catalog, text by Diamela Eltit and Carlos Pérez V., Santiago, Galería Gabriela Mistral, 1996. **Articles**—"Juan Davila at the Adelaide Festival" by Paul Taylor, in *Studio International,* 197(1006), 1984, pp. 20–21; "Brushes with the Law–Juan Davila: Painter As Comedian" by Ian Britain, in *Studio International,* 199, December/February 1986–87, pp. 30–31; "Sting Ray" by Peter King, in *Art and Australia,* 32, spring 1994, pp. 155–156; "Juan Dávila" by Michael Archer, in *Artforum International,* 33, February 1995, p. 101; "Juan Dávila: The Horror of Crossbreeding" by Catalina Mena, in *Art Nexus* (Colombia), 23, January/March 1997, pp. 96–97.

* * *

Born in 1946 in Santiago, Chile, Juan Dávila moved to Australia in 1974, where he has continued to live and work. Perhaps most notorious for his irreverent portrait of the South American independence hero Simón Bolívar (1783–1830), Dávila produced work that actually encompassed a broad range of historical references, which the artist used to undermine universal constructions of both historical and contemporary culture.

From the beginning Dávila has been interested in the history of art. The work with which he has become most associated are his paintings that layer and juxtapose highly sexualized imagery with references to art history, popular culture, mass media, and social criticism. In the late 1980s Dávila began to work on a series of images based on a fictional character, Juanito Laguna, created by the Argentine painter Antonio Berni (1905–81). Berni's character metaphorically stood for the impoverished and marginalized populations of Buenos Aires. Dávila took up this same figure in order to underline his own relationship to the history of Latin American art as well as to redefine an icon from this history. His three-part painting *Wuthering Heights* (1990) illustrates how he combined references to European literature and the history of Latin American art. In "The World Promised to Juanito Laguna," from *Wuthering Heights,* Dávila indiscriminately borrowed the stylized illustrative style of comic books and combined it with visual quotations from paintings by the Brazilian artists Tarsila do Amaral and Helio Oiticica and from the Mexican painter Frida Kahlo, adding stylistic and technical elements borrowed from abstract expressionism and surrealism. All these parts are then punctuated by references to pornography and by unexpected juxtapositions of a sexual nature. Dávila replaced Heathcliff, the ultimate symbol of masculine power and sexuality, with Juanito Laguna, a figure whose sexuality is ambiguous at best.

Dávila's work represents a postmodern critical standpoint that employs a battery of aesthetic approaches in order to develop the argument. The artist combined eclectic elements that seemed unrelated until the spectator closely examined each segment. References to the history of art were always present, acting as the foundation from which Dávila launched his narrative. Sexuality and sexual ambiguity also played major roles, as Dávila constantly questioned interpretations of sexual identity and sex roles in larger society. In addition to this questioning of a monolithic sexuality, Dávila was interested in exploring issues of race, racial mixing, identity, and the influence of colonialism on these phenomena. Characterizing himself as an "outsider" both in Chile and in Australia, Dávila used this uncertainty as a privileged position from which to observe society and culture at a distance.

Placing images of his narratives in individual boxes, in comic book and photo-novel fashion, Dávila undermined the concept of painting as a way to reveal "universal" narratives. By incorporating these stylistic traits culled from popular culture, the artist referenced pop art and the culture of mass-produced imagery, as well as the kind of overly romanticized, dramatic, extreme, and profane narratives contained in these kinds of images.

As an artist, Dávila was interested in criticizing and revealing modes of aesthetic production. He saw painting as a way to explore the revelation of truths instead of as a way to create new untruths. His methodology revealed his thinking about culture, its commodification, and the process of constant reproduction that informs its expression. The artist has stated, "I am interested in the process of replacement of what is real by its reproduction." He was interested in thrusting together the unexpected in order to reveal society's most blatant hypocrisies.

Dávila's work has been severely criticized for its irreverent representation of historical figures. By exploring this kind of imagery, however, Dávila hoped to reveal the contradictions endemic to our society. Significantly, and perhaps ironically, he sought to do this in the most accessible way possible. By integrating highly recognizable elements and rendering his images in a common narrative form (the comic), Dávila created a direct connection to the viewer's psyche.

The melodrama of his imagery strikes a resonant chord, bringing memories of soap-opera style narratives to mind.

—Rocío Aranda-Alvarado

de AMARAL, Olga
Colombian textile artist

Born: Bogotá, 1932. **Education:** Studied architecture, Colegio Mayor de Cundinamarca, Bogotá, 1951–52; Cranbrook Academy of Art, Bloomfield Hills, Michigan, 1954–55. **Career:** Founder, 1965, and director, until 1972, textile department, University of the Andes, Bogotá; directed textile workshops at crafts schools in the United States; operator, commercial textile atelier. **Awards:** First prize, *XXII salón de artistas nacionales,* Instituto Colombiano de Cultura, Museo Nacional, Bogotá, 1971; first prize, *III bienal de arte de Coltejer,* Medellín, Colombia, 1972–74.

Individual Exhibitions:

1958	Sociedad Columbiana de Arquitectos, Bogotá
1961	Galería El Callejón, Bogotá
1966	Museo de Bellas Artes, Caracas, Venezuela
	Glaería T.B.A., Bogotá
	Universidad Carabobo, Caracas, Venezuela
1967	Galería Jack Lenor Larsen, New York
	Gall's, Kansas City, Missouri
	Galería Skidmore, Saratoga Springs, California
1968	West Museum, San Francisco
1969	Banco de la República, Biblioteca Luis Angel Arango, Bogotá
1970	*Woven Walls,* Museum of Contemporary Crafts, New York (traveling)
1972	Museo de Arte Moderno, Bogotá
1973	Banco Nacional, Paris
	Andre Emmerich Gallery, New York
1974	Bonyton Gallery, Sydney, Australia
	South Yarra Gallery, Melbourne, Australia
	Andre Emmerich Gallery, New York
1975	Rivolta Gallery, Lausanne, Switzerland
	Artwave Gallery, New York
1976	Galería Belarca, Bogotá
1977	Florence Dull Gallery, New York
	Ruth Kaufmann Gallery, New York
	La Galería, Quito, Ecuador
1980	La Galería, Quito, Ecuador
	Holladuras, Galería Tempora, Bogotá
1983	Modern Master Tapestries Gallery, New York
1984	Allrich Gallery, San Francisco
1985	Gloria Luria Gallery, Miami
1987	Galería Bellas Artes, Santa Fe, New Mexico
1988	Galería Camino Real, Boca Ratón, Florida
1990	Allrich Gallery, San Francisco
	Bellas Arts Gallery, New York
1992	Johnson County Community College, Overland Park, Kansas
	Lost Images, Galería Bellas Artes, Santa Fe, New Mexico
1993	Allrich Gallery, San Francisco
	Elite Gallery, Miami
	Centro Cultural Avianca, Barranquilla, Colombia
	Museo de Arte Moderno, Bogotá
1994	*Sol y luna,* Galería Bellas Artes, Santa Fe, New Mexico
1996–97	*Nine Stelae and Other Landscapes,* Fresno Art Museum, California (traveling)
1997	Musee de la Tapisserie Contemporaine, Angers, France
	Olga de Amaral: Rétrospective 1965–1996, Musée d'Angers, France
	Peter Joseph Gallery, New York
1999	*Olga de Amaral: Woven Gold,* Albuquerque Museum
	Olga de Amaral: Estelas, bosques, umbras, Galería Diners, Santa Fe de Bogotá

Fiber As Medium, Los Angeles.

Selected Group Exhibitions:

1967	*Third International Tapestry Biennal,* Lausanne, Switzerland
1970	*Olga de Amaral, Else Bechteleym, Sheila Hicks,* Buchholz Gallery, Munich, Germany
1971	*Lausanne Biennale,* Lausanne, Switzerland
1974	*XXV salón nacional de artes visuales,* Instituto Colombiano de Cultura, Museo Nacional, Bogotá
1977	*Fiberworks,* Cleveland Museum of Fine Arts, Ohio
1981	*Foire internationale d'art contemporain—FIAC '81,* Museo de Arte Moderno, Paris
1983	*Colombia: Arte de taller—arte de la calle,* School of Fine Arts, Paris
1987	*The Elemental Fabric,* American Craft Museum, New York
1990	*XXXIII salón nacional de artistas,* Instituto Colombiano de Cultura, Corferias, Bogotá
1992	*15th Tapestry Biennal,* Lausanne, Switzerland
1995–96	*Mujeres artistas latinoamericanas 1915–1995,* Phoenix Art Museum (traveling)

Collections:

American Crafts Museum, New York; Art Institute of Chicago; Cleveland Museum of Art, Ohio; Craft and Folk Art Museum, Los Angeles; Cranbrook Academy of Art Museum, Bloomfield Hills, Michigan; Denver Art Museum; Metropolitan Art Museum, New York; Musee Cantonal des Beux Arts, Lausanne, Switzerland; Musee d'Art Moderne de la Ville, Paris; Museo de Arte Moderno, Bogotá; Museo de Arte Moderno La Tertulia, Cali, Colombia; Museum Bellerive, Zurich, Switzerland, Museum of Modern Art, New York; National Museum of American Arts, Washington, D.C.; National Museum of Modern Art, Toledo, Ohio; Rhode Island School of Design, Providence.

Publications:

On de AMARAL: Books—*Olga de Amaral–Muros tejidos y armaduras,* exhibition catalog, Bogotá, Museo de Arte Moderno, 1972; *Olga de Amaral: Woven Sculpture,* exhibition catalog, New

York, Andre Emmerich Gallery, 1974; *Olga de Amaral, desarrollo del lenguaje* by Galaor Carbonell, Bogotá, Litografía Arco, 1979; *Olga de Amaral: Tapestries from the Moonbasket and Montana Series,* exhibition catalog, text by Jack Lenor Larsen, San Francisco, Allrich Gallery, 1989; *Olga de Amaral,* exhibition catalog, text by Charles Talley, Jacques Leenhardt, and Jack Lenor Larsen, New York, Bellas Artes Gallery, 1990; *Olga de Amaral: Cuatro tiempos,* exhibition catalog, Bogotá, Museo de Arte Moderno de Bogotá, 1993; *Olga de Amaral: Nine Stelae and Other Landscapes,* exhibition catalog, text by Jacquelin Pilar, Fresno, California, Fresno Art Museum, 1996; *Olga de Amaral: Rétrospective 1965–1996,* exhibition catalog, Angers, France, Musée d'Angers, 1997; *A Woman's Gaze: Latin American Women Artists* by Marjorie Agosín, Fredonia, New York, White Pine Press, 1998; *Olga de Amaral: Estelas, bosques, umbras,* exhibition catalog, text by Sergio Trujillo Dávila and Manuel Hernández, Santa Fe de Bogotá, Galería Diners, 1999; *Pre-Columbian Textiles and the Tapestries of Olga De Amaral* (thesis) by Marianne Hogue, Richmond, Virginia, Virginia Commonwealth University, 1999. **Articles**—"Olga de Amaral" by Charles S. Talley, in *American Craft,* 48, April/May 1988, pp. 38–45; "Olga de Amaral: Four Periods," in *Art Nexus* (Colombia), 12, April/June 1994, pp. 76–79; "Fantasies of Fiber" by Juliana Soto, in *Art News,* 93, December 1994, pp. 112–113; "Olga de Amaral. Art Museum of the Americas and the Federal Reserve Board, Washington, D.C." by K. Mitchell Snow, in *Art Nexus* (Colombia), 25, July/September 1997, pp. 142–143; "Olga de Amaral: Luminous Transformations," in *Sculpture* (Washington, D.C.), 16, October 1997, pp. 12–13, and "Illuminating Vision: Materials and Meaning in the Work of Olga de Amaral," in *Surface Design Journal,* 23(2), winter 1999, pp. 32–36, both by Twylene Moyer; "Olga de Amaral: Indianapolis Museum of Art" by Jean Robertson, in *American Craft,* 58(5), October/November 1998, p. 96; "Olga de Amaral: Diners Gallery' by Marta Rodriguez, in *Art Nexus* (Colombia), 33, August/October 1999, pp. 136–137; "Olga de Amaral's Recent Work Transcends the Grid" by Kathleen McCloud, in *Fiberarts,* 26(2), September/October 1999, p. 10.

* * *

The career of Colombian textile artist Olga de Amaral spans more than four decades. Her abundant corpus, however, defies the singular categorization of fiber art. The multivalent aspects reflected in her work include architectonics, ceramics, colonial Latin American architecture, and ancient and contemporary peasant weaving. Although her tapestries have been compared to pre-Columbian artifacts, de Amaral maintains that any such relation is fundamentally subconscious rather than intentional.

Since the mid-1950s when she attended Cranbrook Academy of Art under the tutelage of master weaver Marianne Strengell, de Amaral has expanded the definition of fiber art in an ongoing evolution of surface and structure. She continues to transform the textile medium by combining and reassembling her own stylistic imperatives, with each stage in this development adding to the next as integrated parts of a whole that is yet to be finalized. In this vein de Amaral has stated: "One begins to know that each step is all right and that another step will follow . . . You make your own information and use it, and the more you use it, the more information it gives you. You create substance by using yourself."

Born in 1932 to a middle-class family in Bogotá, Colombia, de Amaral studied architectural design and drawing at the Colegio Mayor de Cundinamarca, where she later taught. Her first foray into the realm of textile design occurred in 1954 when she entered Cranbrook Academy of Art in Bloomfield Hills, Michigan. It was there that she extended her interest in architectonics vis-à-vis the structural characteristics inherent in weaving. In 1965, 10 years after leaving Cranbrook, she founded the textile department of the University of the Andes in Bogotá and served as its director until 1972. Throughout these years she directed textile workshops at crafts schools in the United States and participated in group and individual exhibitions such as the 1971 *Lausanne Biennale* and the *Fiber As Medium* show in Los Angeles. In addition to her production of exquisite fine art tapestries de Amaral has run a successful commercial textile atelier for more than three decades. This business has given her two great advantages: the financial freedom to create works unconstrained by economic dictates and the facilities and staff with which to realize her unique vision.

De Amaral's earliest creations were colorful two-dimensional woven tapestries that incorporated bright colors and patterns, but she soon began experimenting with the three-dimensional, sculptural capacity of fiber. During the 1970s she created large-scale works that were often installed in natural settings, blending into the scenery. The monumental *Hojarasca Blanca y Seca* (1971) is typical of this period with its rough, monochromatic surface composed of cascading woven rectangles. At this same time the artist began to use horsehair and plastic films to create optical effects that would add a translucent quality to her ever-changing tapestries.

A further development in de Amaral's corpus was the use of gold, said to have been inspired by the work of British ceramist Lucie Ries. By gilding the woven surfaces of her substantial wall hangings with gold and silver leaf, de Amaral paradoxically created works that appeared almost invisible and weightless because of their light-reflective properties.

The following decades witnessed another development in de Amaral's work. The artist employed the three primary colors—red, blue, and yellow—and the use of small rectangular linen tabs in a consistent format. She began to gesso the surfaces of the linen tabs and then applied rich saturated color to create art objects that harmoniously balanced structure and surface. *Imagen Perdida 2* of 1992, with its red, blue, green, gold, and silver color scheme, is exemplary of this particular stage in de Amaral's work. It is important to note that the painted surfaces of her tapestries never overshadow the complexity of their woven construction. In fact, it is absolutely essential to the integrity and intentionality of each piece that it clearly be perceived, first and foremost, as a fiber-art object.

The artist began to apply gesso more heavily to her textile creations, as in her first installation entitled *Nine Stelae.* Inspired by large boulders on her farm in Colombia, these stiff tapestries are suspended in space, on one side shining gold leaf and on the other side dark, muted silver leaf. Their weight is contradicted by the reflective properties of the metallic colors in much the same way that the brightness of the gold contradicts (and yet complements) the antique patina of the silver.

De Amaral's vision of fiber as art clearly transcends the usual boundaries of the medium. As she continues to produce unique and exquisite tapestries she will undoubtedly pioneer even more innovations that will have a lasting impact on the textile medium and will redefine the perception of what fabric art is.

—Marianne Hogue

DEIRA, Ernesto
Argentine painter

Born: Buenos Aires, 26 July 1928. **Education:** University of Buenos Aires, law degree 1950; studied under Leopoldo Torres Agüero, 1954–56, and Leopoldo Presas, 1956; studied in Paris on a scholarship from National Fund of the Arts, 1961. **Career:** Visiting professor, Cornell University, Ithaca, New York, 1966. Moved to Europe, 1975. **Awards:** Fulbright fellowship, 1965; Lozada prize, *Salón de acuarelistas y grabadores,* 1958; second prize, Poemas Ilustrados, 1965; prize, *Primer salón de artistas jóvenes de américa latina*; second prize, *Bienal de la academia de arte;* premio criterio, 1967; Palanza prize, Academia Nacional de Bellas Artes; Konex prize, 1982; Fortabat prize, 1984. Guest of honor, *XLVII National Salon,* Rosario. **Died:** 1986.

Individual Exhibitions:

1958 Rubbers Art Gallery, Buenos Aires
1961 Van Riel Gallery, Buenos Aires
1968 El Taller Gallery, Buenos Aires
1969 Museum of Fine Arts, Caracas
1973 *Imaginary Portraits,* Carmen Waugh Gallery, Buenos Aires
1977 Museum of Chartres, France
1985 Ruth Benzacar Gallery, Buenos Aires
 Galería Roosevelt, Paris

Also exhibited at Bonino Gallery.

Selected Group Exhibitions:

1960 *First International Exhibition of Modern Art,* Buenos Aires
1961 *Another Figuration,* Peuser's Gallery, Buenos Aires
1966 *The Emergent Decade,* Cornell University, Ithaca, New York, and Solomon R. Guggenheim Museum, New York
1974 *Within the Decade,* Solomon R. Guggenheim Museum, New York
1976 *Images of the Passion,* Buenos Aires

Publications:

On DEIRA: Books—*Argentine New Figuration* by Jorge Glusberg and others, Buenos Aires, Argentine Association of Art Critics, 1986; *Ernesto Deira: Mayo 1998: Retrospectiva: Obras, 1961–1985,* exhibition catalog, Buenos Aires, Centro Cultural Borges, 1998.

* * *

As a member of a group called *Otra Figuración,* which established a landmark in Argentine art production, Ernesto Deira, who studied law, came in touch with the art world in 1954 through Leopoldo Torres Agüero and Leopoldo Presas. From 1958, when he had his own exhibition (Rubbers Art Gallery), until after he was invited by Rómulo Macció to take part in an exhibition held by *Otra Figuración* (1961), Deira's style was to borrow the use of matter from the informalists and dramatic means from the expressionists, which gave way to a condensed and contained figuration where the outline of the figures gained great significance in that it strengthened the expressive force in his work.

During his first period Deira used matter in a fluid way by making use of drips and applying the paint straight from the tube. His strokes were violent and quick in order to crack and distort the figures to the point where the images seem to get lost in that imprecise and somewhat grotesque space. Deira depicted a sometimes pathetic, cruel, and deeply analytic human figure. One could say that during this first period Deira's human figure was disintegrated, deconstructed by an analytic eye that had gone crazy and had therefore lost all reference to limits. His attitude seemed obsessive and was not even destined to uncover the psychological contents of the image he created. While his works in ink and his drawings were within the limits that seem conventional, on his canvases he let the meaning of things seep through for what they really were. Matter erodes from the figure, the figure then disintegrates, oils or enamel, color or outlines become totally independent from the figure.

After a few experiences in which Deira suggested multiple angles of observation, among these *Desgalarizar la galería* at Bonino Gallery and *Rollos desenrollados* at the El Taller gallery (1968), where he covered the room from the floor up with strips of paper on which he had previously drawn numerous figures with different techniques (pencil, pastels, oils), he entered a period of decantation and slowed down noticeably, leading to a new figuration called ''organic'' to express his rhythmic and almost sensual outline and the distance that the intimate figures took.

A gallery of anonymous portraits appears: foreshortened bodies, legs, torsos, outlined figures, all placed between silent foregrounds, sometimes textured with an always dynamic brush stroke that does not alter the inner loneliness and quiet (*Tendida,* 1976; *Trasposición de la playa de Lanzarote,* 1979; *Aproximación,* 1980; all acrylic on canvas). Even when Deira needed to represent matter's undulating movement like that of a flowing liquid, his strong outlines retained all movement's excessive impact (*El tercero incluído,* acrylic on canvas, 1980). Deira said in 1979 that, ''in my case, to paint a picture is to unpaint it. Painting consists in adding or taking away less and less, so that only the essential remains. I'm not quite sure, but I think that my painting is now calmer. Yet this has not made me lose strength.'' Serenity, density, and expressive fulfillment portrayed all his work from that period until his death.

—Horacio Safons

DELANO, Irene
American painter

Born: Irene Esser, Detroit, Michigan, 1919. **Education:** Pennsylvania Academy of the Fine Arts, Philadelphia, 1933–37. **Family:** Married Jack Delano, *q.v.,* in 1940; one son and one daughter. **Career:** Assistant to muralist Anton Refregier, World's Fair, New York, 1939. Traveled to Puerto Rico with husband Jack Delano, 1941. Graphic designer of posters, booklets, magazines, and training manuals, United States Air Force, 1942–46. Established Motion-Picture and Graphic Arts Workshop, Commission of Public Recreation, Puerto Rico, 1946; director, Division of Community Education (DIVEDCO), Puerto Rico, 1949–52. Independent designer, San Juan, 1952–70. Editor, *Que Pasa* magazine, 1970–82. **Awards:** American

Institute of Graphic Arts prize, New York, 1948; National Endowment for the Arts grant (with Jack Delano), 1979. **Died:** 1982.

Individual Exhibitions:

1981 *Irene y Jack Delano en Puerto Rico,* Universidad de
 Puerto Rico (with Jack Delano)
1988 *Homenaje a Irene Delano,* Casa del Libro, San Juan

Selected Group Exhibitions:

1963 *Exposición de gráfica puertorriqueña,* Instituto de
 Cultura Puertorriqueña
1988 *Latin American Spirit: Art & Artists in the United
 States 1920–1970,* Bronx Museum, New York

Collections:

American Institute of Graphic Arts, New York; Brooklyn Art Books, New York; Division of Community Education, San Juan; UNESCO, New York.

Publications:

By DELANO: Books, illustrated (with Jack Delano)—*Stupid Peter, and Other Tales* by Helen Kronberg Oson, New York, Random House, 1970; *The Emperor's New Clothes* by Jean Van Leeuwen, New York, Random House, 1971.

On DELANO: Books—*Los cinco sentidos: Cuaderno suelto de un inventario de cosas nuestras con decoraciones de Irene Delano* by Enrique Tomás and Blanco y Geiger, San Juan, Instituto de cultural Puertorriqueña, 1968; *Irene y Jack Delano en Puerto Rico,* exhibition catalog, by Inés Mendoza de Muñoz Marín, Hato Rey, Puerto Rico, Ramallo Bros. Printing, 1981; *Homenaje a Irene Delano,* exhibition catalog, San Juan, Instituto de Cultura Puertorriqueña, 1988; *Visual Artists and the Puerto Rican Performing Arts: 1950–1990: The Works of Jack and Irene Delano, Antonio Martorell, Jaime Suárez, and Oscar Mestey-Villamil* by Nelson Rivera, New York, Lang, 1997.

* * *

Irene Delano and her husband Jack were instrumental in encouraging the creation of art with a defined social purpose aimed at a distinctly Puerto Rican audience. After World War II, Puerto Rico went through profound political, social, economic, and cultural changes. The Delanos, leading members of cultural government institutions, developed educational and cultural materials for the poor, illiterate majority of Puerto Ricans of the 1940s and '50s. They were particularly influential in their contributions to the cultural program of Governor Luis Muñoz Marín and his Popular Democratic Party (PPD). They also worked within the education division (DIVEDCO) and radio stations. Due to their association with government institutions, it was their work, and that done by other artists in their workshop, that became the most visible to a sizable audience, one composed mainly of country people ordinarily alienated from art. Whether it was through books, graphics, photographs, music, dance, theater, films, television, or radio, the Delanos' commitment to honor the Puerto Rican people and their culture was their top priority.

Irene Esser was born in Detroit, Michigan, in 1919. An excellent pianist and musician, she was a graduate of the Toronto Conservatory. Her mother encouraged Irene to do drawing, painting, and designs, enrolling her at the Royal Academy of Art in Toronto while she was also studying at the conservatory. After high school Irene decided to pursue a career in painting. She started at the Academy of Fine Arts in Philadelphia in 1933 and spent four years working strictly as a painter. Jack Delano was 19 years old and in his second year at the Royal Academy when he first met Irene, then 16. In 1937 Irene moved to New York City to set up a painting studio and work as an assistant to painter Anton Refregier at the New York World's Fair in 1939. Her paintings from that time concentrated mostly on human figures, using a realist approach. Jack also moved to New York City and worked in photography.

In 1941 Jack, through a photography position with the Farm Security Administration, traveled, with Irene, for the first time to Puerto Rico as part of a project that sought to document the conditions of people in North American territories outside the United States. After four decades (1898–1940) of North American rule, Puerto Rico in 1941 had been deprived of its political autonomy and economy. The Delanos stayed in Puerto Rico for three months, traveling throughout the whole island accompanied by an interpreter. During their visit more than two thousand photographs were taken.

Between 1942 and 1946 the Delanos were involved, as most North Americans were, in war-related activities. Jack was assigned to photograph the activities of people throughout the United States during the war, some of which were published in a book by James Valle called *The Iron Horse at War.* Irene designed posters, booklets, magazines, and training manuals for the Air Force. In 1946, after Jack was discharged from the Air Force photographic unit, the Delanos left for Puerto Rico with the intention of spending a year photographing the island. It was to become their permanent home. The Delanos undertook a photography project for the Puerto Rican government's Office of Information. The result was two thousand photographs that constitute the largest photographic documentation of Puerto Rico in the 1940s.

Besides photography, Irene took charge in the creation of a graphics workshop with the purpose of designing posters, leaflets, and other educational materials on a range of subjects aimed at the needs of rural communities that were developing health and social systems. Her workshop was enhanced by the presence of Puerto Rican artists who were invited to come and train with her. The Delanos' workshop, DIVEDCO, had a considerable impact not only for the communities for which it was created but also for a large sector of Puerto Rican artists.

Working with Irene at DIVEDCO were many of the most notable graphic artists and writers. Lorenzo Homar, Rafael Tufino, Carlos Raquel Rivera, and Julio Rosado del Valle, among others, created illustrations for the division; Rene Marques, Emilio Diaz Valcarcel, and Pedro Juan Soto were some of the writers. With Irene's vision large quantities of educational materials, distributed free to rural communities around the island, were produced, all written, illustrated, and designed by workshop members. Some illustrations that came out of this community, such as Tufino's coffee harvest linocut series, are highly regarded as some of the most outstanding graphics of the period.

In 1979, after years of working to initiate dance, ballet, and theater productions in Puerto Rico, the Delanos were awarded a National Endowment for the Arts grant to complete a long-coveted project: to re-photograph the people and places photographed in the

1940s in order to examine four decades of changes in Puerto Rican society after a period of rapid industrialization. With their 1940s photographs in hand, the Delanos covered the island searching for, and in many instances finding, the people they had met 40 years before. These photos became the basis for the exhibition *Contrastes: 40 anos de cambio y continuidad en Puerto Rico* ("Contrasts: 40 Years of Change and Continuity in Puerto Rico"). Irene was responsible for interviews that accompanied the exhibition as well as the editing.

—Martha Sutro

DELANO, Jack
American photographer

Born: Jack Ovcharov, Kiev, Russia, 1 August 1914; emigrated to the United States, 1923, naturalized U.S. citizen, 1928; adopted name Delano, 1940. **Education:** Pennsylvania Academy of Fine Arts, Philadelphia, 1932–37 (Cresson Travelling Scholar, 1936–37), diploma 1937. **Military Service:** United States Corps of Engineers, Air Transport Command, 1943–46: captain. **Family:** Married Irene Esser, *q.v.,* in 1940 (died 1982); one son and one daughter. **Career:** Began taking photographs in Europe, 1936–37; photographer, Works Progress Administration Project, New York, 1937–39; freelance photographer, New York, 1939–40; staff photographer, Farm Security Administration, Washington, D.C., and throughout the United States and Puerto Rico, 1940–43; photographer, government of Puerto Rico, 1946–47; director of motion picture services, government of Puerto Rico, 1947–53; independent filmmaker, San Juan, 1953–57; director of programming, Puerto Rican Educational Television, 1957–64; general manager, Puerto Rican Government Radio and Television Service, 1969; music teacher, Puerto Rico Conservatory, 1969–79; book illustrator and graphics consultant, Puerto Rico, 1969–79. Technical consultant, Puerto Rico Humanities Foundation, 1977. Taught film animation techniques, Sacred Heart University; designer, San Juan Children's Museum and Pablo Casals Museum. Also worked as a composer. **Awards:** Fellowship in photography, Guggenheim Foundation, 1945; travel fellowship, Unesco, Europe and Asia, 1960; Children's Art Books award, with Irene Delano, Brooklyn Museum, New York, 1973; grant, National Endowment for the Arts, 1979; Certificate of Merit, Casa Aboy, San Juan, 1983; Composers award, Institute of Puerto Rican Culture, 1984; ASCAP award for musical composition, 1987. **Died:** 12 August 1997.

Individual Exhibitions:

1938	*Anthracite Coal Miners,* Pennsylvania Railroad Station Gallery, Philadelphia
1977	Sonnabend Gallery, New York
1978	Art Students League, San Juan
1979	*Our Humility, Our Price,* Springfield Museum of Fine Arts, Massachusetts
1982	University of Puerto Rico Museum, San Juan
1983	Hostos Community College, New York
1984	University of Michigan, Ann Arbor
1985	Daytona Beach Community College, Florida

Jack Delano: *Henry Brooks, Ex-Slave,* 1941. © Corbis.

	Casa Aboy, San Juan
1986	*Before and After: The FSA,* Daytona Beach Community College, Florida (with Arthur Rothstein and Marion Post Wolcott)
1990	*Contrasts: 40 Years of Change and Continuity in Puerto Rico, Photographs by Jack Delano,* Smithsonian Institution, Washington, D.C. (traveling)
1992	*Retrospective,* Vigo, Spain
1998	*The Art of Jack Delano,* Smithsonian Institution, Washington, D.C. (traveling retrospective)

Selected Group Exhibitions:

1955	*The Family of Man,* Museum of Modern Art, New York (world tour)
1962	*The Bitter Years,* Museum of Modern Art, New York
1976	*FSA Photographers,* Witkin Gallery, New York
1977	*Documenta 6,* Kassel, Germany
1978	*Work,* Fine Arts Museum, San Francisco
1979	*Images de l'Amerique en Crise,* Centre Georges Pompidou, Paris
1980	*Les années amerees de l'Amerique en Crise,* Galerie Municipale du Chateau D'Eau, Toulouse, France
1981	*Farbe im Photo,* Josef-Haubrich-Kunsthalle, Cologne, Germany
1982	*Floods of Light,* Photographers' Gallery, London
	Lichtbildnisse: Das Porträt in der Fotografie, Rheinisches Landesmuseum, Bonn, Germany

Collections:

Library of Congress, Washington, D.C.; Smithsonian Institution, Washington, D.C.; New York Public Library; International Museum of Photography, George Eastman House, Rochester, New York; University of Louisville, Kentucky; Institute of Puerto Rican Culture, San Juan.

Publications:

By DELANO: Books—*The Iron Horse at War,* text by James Valle, Berkeley, California, Howell-North Books, c. 1977; *Puerto Rico Mío: Four Decades of Change,* Washington, D.C., Smithsonian Institution Press, c. 1990; *From San to Ponce on the Train,* Puerto Rico, 1992; *In Search of Maestro Rafael Cordero,* with Irene Delano, Puerto Rico, 1994; *That's Life,* San Juan, Editorial de la Universidad de Puerto Rico, 1996; *Photographic Memories: The Autobiography of Jack Delano,* Washington, D.C., Smithsonian Institution Press, 1997. **Books, illustrated (with Irene Delano)**—*Stupid Peter, and Other Tales* by Helen Kronberg Oson, New York, Random House, 1970; *The Emperor's New Clothes* by Jean Van Leeuwen, New York, Random House, 1971; **Articles**—"Educational TV in Puerto Rico," in *San Juan Star,* 1964; "Documentary Photography," in *Southern Exposure* (Chapel Hill, North Carolina), 1977.

On DELANO: Books—*Portrait of a Decade* by Jack Hurley, Baton Rouge, Louisiana, 1972; *In This Proud Land* by Roy E. Stryker and Nancy Wood, Greenwich, Connecticut, 1973; *A Vision Shared: A Classic Portrait of America and Its People 1935–43* edited by Hank O'Neal, New York and London, 1976; *Les années ameres de l'amerique en Crise 1935–1942,* exhibition catalog, by Jean Dieuzaide, Toulouse, France, 1980; *Farbe im Photo: Die Geschichte der Farbphotographie von 1861 bis 1981* by Fritz Binder and others, Cologne, Germany, 1981; *Floods of Light: Flash Photography 1851–1981,* exhibition catalog, by Rupert Martin, London, 1982. **Articles**—"Jack Delano: Clicking in Puerto Rico for 30 Years" by Erin Hart, in *Sunday San Juan Star,* June 1975; "FSA Color" by Sally Stein, in *Modern Photography* (New York), January 1979; "Jack Delano: Interview" by Ed Miller, in *Combinations: A Journal of Photography* (Greenfield Center, New York), July 1979; "The Serious Pleasures of Commitment: Jack and Irene Delano" by Marshall Morris, in *San Juan Star,* 11 January 1981; "La permanencia del pasado en las foto de Jack Delano" by Edgardo Rodriguez Julia, in *San Juan Star,* 6 December 1982.

* * *

During the Great Depression Jack Delano began to look for work as a musician or painter. He was eventually hired as a photographer by the Farm Security Administration (FSA) in Washington, D.C. His job was to record the plight of the displaced American farmer and the accomplishments of the Franklin Roosevelt administration in the area of agriculture. Little did Delano know how this assignment would change his life. It would also lead him to discover—and introduce to the public—the many facets of photography.

Roy E. Stryker, professor at Columbia University and project director, guided his staff toward a photographic approach of self-discovery and engagement that is remarkably similar to the documentary and journalistic work of today. Delano trained himself to focus both on details and general scenes, recording what may go unnoticed

to the untrained eye. It was a technique half a century ahead of its time. The photographs for the FSA project were intended for use in a variety of "practical" ways, as one would use statistics, and were not expected to be artistic. Delano, however, took his work on a journey of personal interpretation through a time of significant change in the history of a people.

In 1941 Delano was sent to Puerto Rico for a three-month assignment. Four years later a Guggenheim fellowship allowed him and his wife to return, and they embarked on a journey of documentation and a lifelong love affair with the island. His initial view of Puerto Rico was similar to that of any outsider: a small island with no infrastructure, visible poverty, no natural resources, and overcrowding. Its people had an identity that, at times, was difficult to define. As time passed, his personal regard for his subjects and firsthand experience of the diversity of the island gave his work a unique perspective.

Delano knew his subjects well and was in direct contact with them. He wanted them to know they were being photographed without losing the honesty of the moment. In the 1940s the social, economic, and political dynamics of the island would meet today's criteria of Third World. Delano's documentation of the transformation experienced by Puerto Rico and its people during the five decades since his arrival makes his work important to the worlds of art, academia, and history.

Delano could not ignore the problems of underdevelopment of the 1940s. The contemporary changes and contrast between underdevelopment and great abundance was difficult to bring to life in a meaningful way, presenting an exceptional challenge. Over time the social environment of the island and its people changed dramatically. The faces of his subjects during his early years on the island often look hungry, even emaciated. In contrast, in the 1980s he showed people who are well fed and healthy, with pleasant expressions that suggest they are enjoying themselves. At one time women appeared in Delano's photographs in the plantation environment, working with the tobacco leaves while taking care of children. Later one sees them working in modern factories, assembling electronic components or performing some other kind of technological or industrial function. Sometimes they are photographed pushing shopping carts through the supermarket or window-shopping at the local mall. One of the most remarkable aspects of Delano's work is his choice of what to record and under what circumstances. This unique talent distinguishes him from other contemporaries.

In his book *Puerto Rico Mio, Four Decades of Change,* Delano revisited his work, looking at his subjects a second time and placing them in a more updated environment. Dancing has long been an important part of island life, and Delano captured this favorite diversion in contrasting ways. He used the work of his early years as a point of departure for a more recent account of the same story about the same people. *Dance at the Escambron Beach Club, San Juan* (1941) shows a ballroom crowded with young white couples, dressed in formal attire, smiling and dancing in a polite embrace. In contrast *Dancing in the Street During the Patron Saint's Day in the Town of Loiza Aldea* (1981) introduces the viewer to a street corner with open doors to an establishment called La Esquina Caliente, as the painted sign shows. Other signs, advertising beer and a political candidate, are quite visible. These share space with an official Department of Transportation sign—a white arrow with black letters that read "Transito," indicating traffic flow. On the sidewalk and on the street, people of all colors and ages are engaged. Some are dancing, others are sitting, watching the dancers. The same diversion and the same people are viewed in contrasting situations reflective of the times.

In 1941 Delano photographed the façade of an abandoned movie theater in San Sebastian, which still featured old movie posters on the wall. One advertises a movie with Loretta Young, another with Maurice Chevalier. In 1989 he photographed a video rental store in Rio Piedras. The advertising movie posters there are quite different. The overlapping of subjects is remarkable not just for the quality of the work, but for the message it communicates. There is no need for text. This collection of works is a feast for the eyes. The less said the better. Lines and shapes, background and foreground all blend in a magnificent masterpiece that speaks of hardship, failure, success, and hope.

Delano's work is a walk down memory lane. In 1990 his book *Contrasts-Contrastes* was developed into an exhibition of the same name and later added to the permanent collection of the Smithsonian Institution. Delano's greatest achievement and the secret to his success is perhaps the result of combining three activities that rarely complement each other: documenting for the FSA, painting, and developing a deep affection for Puerto Rico and its people. All three merged to create an original: Jack Delano— artist, historian, and social commentator.

—Martha Gutiérrez-Steinkamp

de la VEGA, Jorge Luis
Argentine painter

Born: Buenos Aires, 27 March 1930. **Education:** Studied architecture, Universidad Nacional de Buenos Aires. **Family:** Married Marta Rossi in 1969. **Career:** Traveled to Europe, 1962; lived in the United States, 1965–67. Professor of art appreciation, Universidad Nacional de Buenos Aires, 1965–67. Visiting professor of painting, Cornell University, Ithaca, New York; instructor, Manuel Belgrano School, Buenos Aires, 1965–67. Member, artist group *Nueva Figuración,* 1960s. **Awards:** Fellowship, Spanish Fund for the Arts, 1962; Premio Especial para Pintor Argentino, *Bienal latinoamerica de arte,* IKA, Cordova. **Died:** 26 August 1971.

Individual Exhibitions:

1951	Salas del Banco Municipal, Buenos Aires
1961	Galería Lirolay, Buenos Aires
1962	Galería Lirolay, Buenos Aires
	Galería Bonino, Buenos Aires
1963	Pan American Union, Washington, D.C.
1968	Galería Bonino, Buenos Aires
1969	Galería Carmen Waugh, Buenos Aires

Selected Group Exhibitions:

1961	*Otra figuración,* Galería Peuser, Buenos Aires
1962	Pan American Union, Washington, D.C.
1964	*Pittsburgh International,* Carnegie Institute
	New Art of Argentina, Walker Art Center, Minneapolis
1965	*The Emergent Decade,* Solomon R. Guggenheim Museum, New York, and Cornell University, Ithaca, New York
1966	*Art of Latin America since Independence,* Yale University, New Haven, Connecticut, and University of Texas, Austin
1969	Bienal de San Pablo

Collections:

Solomon R. Guggenheim Museum, New York; Museum of Modern Art, New York; Museum of Modern Art of Latin America, Washington, D.C.; Oakland Museum, California; Rhode Island School of Design, Providence.

Publications:

On de la VEGA: Books—*Neo-figurative Painting in Latin America,* exhibition catalog, Washington, D.C., Pan American Union, 1962; *Jorge de la Vega,* exhibition catalog, text by Jorge Romero Brest, Buenos Aires, Centro de Artes Visuales de Instituto Torcuato di Tella, 1967; *Jorge de la Vega,* exhibition catalog, Caracas, Galería Conkright, 1973; *Jorge de la Vega, 1930–1971,* exhibition catalog, Buenos Aires, Museo Nacional de Bellas Artes, 1976; *Pintores argentinos de Siglo XX: de la Vega* by Guillermo E. Magrassi, Buenos Aires, Centro Editor de América Latina, 1981; *Argentine New Figuration,* exhibition catalog, text by Jorge Glusberg, São Paulo, 18th International Biennial, 1986; *La nueva figuracion-Deira-de la Vega-Maccio-Noe,* exhibition catalog, text by Jorge Glusberg, Buenos Aires, Ruth Benzacar Galeria de Arte, 1986; *Jorge de la Vega,* Madrid, Fundación Arte y Technología, 1996. **Articles**—''Argentina's New Figurative Art'' by Terence Greider, in *The Art Journal,* 24, fall 1964, pp. 2–6; ''New Art of Argentina'' by Jan Van Der Marck, in *Art International,* 8, October 1964, pp. 35–38.

* * *

Jorge de la Vega's father was a painter, and it was thanks to him that the son became an artist. Yet he considered himself self-taught. Before he was six, he was already painting, and at age 16 he took a prize in a sketch-and-botch competition. He also practiced music from the time he was very young and began studying architecture, although he did not take a degree in the field. Between 1946 and 1960 he concentrated on portraits (*Portrait of the Model Coloma, ca* 1949; *Portrait of His Father,* 1950; *Sentupery,* 1952) and on still lifes (*Estudio de un pejerrey,* 1947; *Calas,* 1951; *La plancha,* 1952) and then moved on to geometric abstraction (*Monocopia,* 1953; *Pintura,* 1956; *Sin titulo,* 1960).

In the early 1960s de la Vega's work changed, and he grew to become one of the outstanding Argentine artists of his time. Together with Luis Felipe Noé, Rómulo Macció, and Ernesto Deira, he became a member of the group Nueva Figuración (New Figuration). With their freely executed brush strokes and the particular way in which de la Vega treated paint, his 1960 works in oil, such as *La sonrisa roja, Personaje vegetal,* and *Los náufragos,* show a clear influence from the informalists. His figures are present but barely perceptible, and the surface of the canvas becomes part of the painting. These were the characteristics that defined de la Vega's work between 1960 and 1962, but in 1963 he began a series called *Bestiario,* which he worked on until 1966. He broke away from his own iconography and with that of Nueva Figuración. De la Vega's fantastical zoology was done using pieces of glass and plastic, stones, shreds of paper, draped fabrics, chips of various material, pieces from children's jigsaw

puzzles, religious medals or stickers, and various other objects. He searched for the objects he used purposely; they were not left to chance. The pieces were topped off with the paint and drippings that showed the absolute liberty with which he worked. He was also moved by a sense of play. As the artist has said, ''I painted unrealistic animals that floated in the sidereal space.'' The critic Mercedes Casanegra has remarked, ''Man underlies every character in his Bestiario.'' This can be seen in works such as *Los músculos de la memoria* (1963), *Conflicto anamórfico n°1–La medida* (1964), *Imagen,* (1966), and *Music Hall* (1967).

Beginning in 1967 and specifically during a stay in the United States, de la Vega abandoned the use of collage and oils and experimented with new techniques. He used drawings in ink and acrylics in black and white in a way similar to graphic design. His themes included contemporary urban life, masses of men and women who seem to form part of a deformed and deforming giant organism. Frivolous, trapped in their own fantasies, they represent an exacerbation of hedonism in a consumer society. It is a winding, twisted, and in some ways cathartic figuration. He produced a stereotype of the distance between life and its parody on a kind of Möbius strip. During this period de la Vega became capable of synthesis, and his work gained in strength and monumentality. This can be seen, for example, in *Nunca tuvo novio* (1966); *Relaciones públicas,* lost but illustrated in the March 1967 issue of *Art in America*; *La verdadera historia* (1968); and *Rompecabezas* (1969–70).

—Horacio Safons

De OBALDÍA, Isabel
Panamanian painter and sculptor

Born: Washington, D.C., 1957. **Education:** Studied architecture, University of Panama, 1975; studied drawing, École des Beaux Arts, Paris, 1976; Rhode Island School of Design, B.F.A. in graphic design and cinematography 1979; Art Students League, New York, 1982; Pilchuck Glass School, Stanwood, Washington, 1987. **Family:** Married; two sons. **Career:** Lecturer, Glass Art Society Conference, Tampa, Florida, summer 1999. **Awards:** First prize, Concurso Panarte, 1978; John Hauberg fellowship, Pilchuck Glass School, 1990; first prize for graphics, Concurso Instituto Nacional de Cultura, Panama, 1990; first prize, *I bienal de arte de Panama,* 1992. **Agent:** Mary-Anne Martin/Fine Art, 23 East 73rd Street, New York, New York 10021, U.S.A. **Website:** http://www.mamfa.com.

Individual Exhibitions:

1977 Galería Etcétera, Panama
1978 Galería El Sotano de Panarte, Panama
1980 Galería Arteconsult, Panama
1981 Museo de Arte Contemporáneo, Panama
1985 Galería Arteconsult, Panama
1986 *Marina y los amigos de Selba,* Museo de Arte
 Contemporáneo, Panama
1989 *Maniobras,* Museo de Arte Contemporáneo, Panama
1990 *Los veedores,* Galería Arteconsult, Panama
1993 *Vidrios,* Museo de Arte Contemporáneo, Panama
1994 *Los conjuros del silencio,* Galería Musem, Panama
1995 Centro Wifredo Lam, Havana

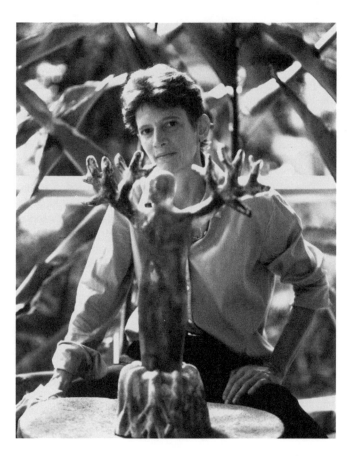

Isabel De Obaldía. Photo courtesy of Mary-Anne Martin/Fine Art, New York.

1996 *Recent Works,* Elite Fine Art, Coral Gables, Florida
1997 *Obras recientes, oleos y dibujos,* Galería Arte Consult,
 Panama
 Beasts and Men, Mary-Anne Martin/Fine Art, New
 York
1998 Elite Fine Art, Coral Gables, Florida
1999 *Captive Spirits,* Mary-Anne Martin/Fine Art, New York
2000 *The ADAA Art Show,* Mary-Anne Martin/Fine Art, New
 York
2001 *Art Palm Beach,* Mary-Anne Martin/Fine Art, West
 Palm Beach, Florida
 Art Miami, Mary-Anne Martin/Fine Art, Miami Beach,
 Florida
 The ADAA Art Show, Mary-Anne Martin/Fine Art, New
 York

Selected Group Exhibitions:

1983 *VI bienal de San Juan del grabado latinoamericano,*
 Puerto Rico
1991 *Nueva pintura bolivariana,* Museo La Tertulia, Cali,
 Colombia
1993 *Seven Panamanian Artists,* Museum of Modern Art,
 Dominican Republic
 Paintings of the Caribbean and Central America,
 Museum of the Arts of the Americas, Organization of
 American States, Washington, D.C.

Isabel De Obaldía: *Nazareno,* 1999. Photo courtesy of Mary-Anne Martin/Fine Art, New York.

1996 *Contemporary Art of Panama,* Casa de América, Madrid
 III bienal del Caribe y Centroamérica, Santo Domingo,
 Dominican Republic
1998 *Crosscurrents, Contemporary Painting from Panama,
 1968–1998,* Americas Society Art Gallery, New York
 (traveling)
 Primera bienal de pintura del Istmo Centroamericano,
 Guatemala (traveled to Duke University Museum of
 Art, Durham, North Carolina)
1999 *Mujeres en las artes,* Tegucigalpa, Honduras
 Holding Light: Contemporary Glass Sculpture, Austin
 Museum of Art, Texas

Collections:

Panama Museum of Contemporary Art; Rippl Ronai Museum, Kaposvar, Hungary.

Publications:

On De OBALDÍA: Books—*Isabel De Obaldia,* exhibition catalog, Panama, Museo de Arte Contemporáneo, 1981; *Vidrios,* exhibition catalog, Panama, Museo de Arte Contemporáneo, 1993; *Isabel De Obaldia: Recent Works,* exhibition catalog, Coral Gables, Florida, Elite Fine Art, 1996; *Isabel De Obaldía: Obras recientes,* exhibition catalog, Panama, Galería Arteconsult, 1997; *Isabel De Obaldia:*

Beasts and Men, exhibition catalog, text by Edward J. Sullivan, New York, Mary-Anne Martin/Fine Art, 1997; *Captive Spirits,* exhibition catalog, text by Carol Damian and René De Obaldía, New York, Mary-Anne Martin/Fine Art, 1999. **Articles**—"Isabel De Obaldia" by Mary Schneider Enriquez, exhibition review, in *Art News,* 97, January 1998, p. 132; "Isabel De Obaldia" by Matthew Kangas, review of the exhibition *Beasts and Men* at Mary-Anne Martin/Fine Art, in *Glass* (New York), 70, spring 1998, p. 57; "Isabel De Obaldía," in *Art & Antiques,* 23(2), February 2000, p. 65.

* * *

From the most fragile of media, Isabel De Obaldía has crafted sculptures that are both monumental and delicate. Like the history of her native Panama, De Obaldía's creations have fused the artistic traditions of Latin America, the United States, and Europe in a way that is both traditional and contemporary. She has used a thoroughly modern approach to make luminescent cast glass sculptures that are reminiscent of ancient stone statues and talismans. Although small, De Obaldía's sculptures–typically of male figures and animals–are highly detailed and incorporate significant amounts of color.

De Obaldía was born in 1957 in Washington, D.C., to French and Panamanian parents. After studying architecture at the University of Panama and drawing at the École des Beaux-Arts in Paris, she attended the Rhode Island School of Design, where she received a B.F.A. degree in graphic design and cinematography in 1979. From 1980 to 1987 De Obaldía focused on painting and drawing. Using large canvases, bold colors, and vigorous gestures, she created works that reflected both the neoexpressionist style that was popular in European and American art centers and the uncertainty and turmoil of Panamanian politics of the period. De Obaldía's drawings and paintings typically portrayed isolated single figures or small groupings. These human and animal images existed in their paintings outside any narrative framework.

In 1987 De Obaldía's artistic career shifted dramatically when she attended the Pilchuck Glass School in Stanwood, Washington. After studying under several renowned artists, including Bertil Vallien, a Norwegian expert in sand casting, and Jiri Harcuba, a Czech master glass engraver, De Obaldía returned to her studio in Panama City and began producing extraordinary sculptures. The shift from painting to sculpture was a bold step in itself. What made the move even more significant was the fact that Panama did not have a strong sculptural tradition from which she could draw support.

Although she continued to produce two-dimensional works of art, De Obaldía came to concentrate on perfecting the technically difficult craft of casting glass sculptures. To create her pieces, she first modeled figures in terra-cotta and used the results to make plaster molds. She then filled the molds with pieces of colored and clear glass and fired them. Finally, armed with drills and grinders, she created an array of designs and textures on the surfaces of the sculptures. The finished products appear to be lit from within. The colors–sometimes vibrant, at other times muted–emerge almost organically from the core of the works.

De Obaldía's three-dimensional work received international attention in 1997 when Mary-Anne Martin/Fine Art in New York City held an individual show of her sculptures. Entitled *Beasts and Men,* the show was comprised of cast glass sculptures of human (mostly male) figures and animals. Although none of the 16 pieces was larger than 20 inches in any direction, they evoked massive pre-Columbian

monuments. One of the more highly regarded sculptures from the exhibit was *Awakening,* a semiabstract male figure reclining on his back. Only the figure's head is raised. He cranes his neck to examine his own exposed genitals.

In 1999 De Obaldía held another solo exhibition at Mary-Anne Martin/Fine Art. Like *Beasts and Men,* the new show, *Captive Spirits,* featured small sculptures that hearkened back to ancient monuments. In these new works, however, De Obaldía explored the relationship between the physical and the spiritual worlds. In the remarkable *Tronco,* De Obaldía created a mythical being–half man, half tree. The male figure is an earthy red, and his feet meld into a rootlike base. His hands are branching green tree limbs, which he holds outstretched.

—Rebecca Stanfel

de SZYSZLO, Fernando

Peruvian painter and sculptor

Born: Barranco, Lima, 1925. **Education:** Escuela de Artes Plásticas, Pontificia Universidad Católica, Lima, 1946–48. **Career:** Lived in Paris and Florence, Italy, 1949–55. Cofounder, *Espacio,* group promoting contemporary art in Peru. Professor of painting, Escuela de Artes Plásticas, Pontificia Universidad Católica, Lima, 1955–1977; consultant, visual art section of Pan American Union, Washington, D.C., 1958. Visiting professor of art, Cornell University, Ithaca, New York, 1962, and Yale University, New Haven, Connecticut, 1965. **Awards:** Moncloa prize, 1955; honorable mention, *IV bienal de São Paulo,* Brazil, 1957.

Individual Exhibitions:

1947	Peruvian-North American Cultural Institute, Lima
1950	Galerie Mai, Paris
1953	Pan American Union, Washington, D.C.
1961	Institute of Contemporary Art, Boston
1964	Museo de Bellas Artes, Caracas, Venezuela
1973	Museo de Arte Moderno, Mexico City, and Museo de Arte Moderno, Bogotá, (retrospective)
1976	Petroperú, Lima (retrospective)
1977	Galería Virtual, Universidad de Lima
1985	Museum of Modern Art of Latin America, Washington, D.C. (retrospective)
1986	Cultural Center of the Municipality of Miraflores, Lima
1988	*El canto de la noche,* Museo Rufino Tamayo, Mexico City, and Museo de Monterrey, Mexico
1990	Galeria Durban, Caracas, Venezuela
1992	*Las puertas de la noche: Muestra antológica, 1967–1992,* Museo Nacional de Bellas Artes, Santiago, Chile (traveling)
1993	Iturralde Gallery, Los Angeles
1994	Durini Gallery, London
1995	Durban Segnini Gallery, Miami, and Galería Durbán, Caracas, Venezuela
1996	*Szyszlo in the Labyrinth,* Art Museum of the Americas, Washington, D.C.
2000	Museum of Latin American Art, Long Beach, California

Selected Group Exhibitions:

1958	XXIX Venice Biennial, Italy
	Pittsburgh International, Carnegie Institute
1959	*The United States Collects Latin American Art,* Art Institute of Chicago
1961	*Latin America: New Departures,* Institute of Contemporary Art, Boston
1962	*Bienal de São Paulo,* Brazil
1965	*The Emergent Decade,* Solomon R. Guggenheim Museum, New York, and Cornell University, Ithaca, New York
1966	*The Art of Latin America since Independence,* Yale University, New Haven, Connecticut, and University of Texas, Austin
1975	*XIII bienal de São Paulo,* Brazil
1989	*The Latin American Spirit: Art & Artists in the U.S.,* Bronx Museum, New York

Collections:

Institudo de Arte Contemporáneo, Lima; Museo de Arte, Lima; Museo del Banco Central de Reserva del Perú, Lima; Museo de Arte Moderno, Bogotá; Biblioteca Luis Angel Arango, Banco de la República, Bogotá; Museo Interamericano de Pinturo, Cartagena, Colombia; Museo de Bellas Artes, Caracas, Venezuela; Museo de Arte Contemporáneo, Santiago, Chile; Museo de Arte Moderna, São Paulo, Brazil; Casa de la Cultura, Quito, Ecuador; Museum of Fine Arts, Dallas; Solomon Guggenheim Museum, New York; Instituto Panameño de Arte, Panamá; Museo de Arte Moderno de América Latina, Washington, D.C.; Bienal de Coltejer, Medellín, Colombia; Archer M. Huntington Gallery, University of Texas, Austin; Casa de las Américas, Havana; Museo de Ponce, Puerto Rico; Museo de Arte de Maldonado, Uruguay; Herbert F. Johnson Museum of Art, Cornell University, Ithaca, New York; Museum of Herzelya, Israel; Museo Rufino Tamayo, México City, D.F.Galleria Degli Uffizzi, Florence, Italy; Galería de Arte Moderno, Santo Domingo, Dominican Republic; Museo La Terulia, Cali, Colombia; Lalit Kala Academy, New Delhi, India; Museo Forma, El Salvador; Lower Art Museum, University of Miami; Museo Contemporáneo de Arte Bolivariano, Santa Marta, Colombia; Museu de Arte Moderna, Rio de Janeiro; Museum of Art, Rhode Island School of Design, Nancy Sayles Day Collection, Providence; Galería de Arte Nacional, San José, Costa Rica; National Museum of Contemporary Art, Seoul, South Korea; Museo Paraguayo de Arte Contemporáneo, Asunción, Parauay; Museo de Arte Moderno, México City; University of Essex, Latin American Art Collection, Essex, England.

Publications:

By de SZYSZLO: Article—''Algunas reflexiones sobre la creación artística en América Latina,'' in *Vuelta* (Mexico), 136, March 1988.

On de SZYSZLO: Books—*Fernando de Szyszlo,* exhibition catalog, Washington, D.C., Pan American Union, 1953; *Poesía quechua y pintura abstracta* by Emilio Adolfo Westphalen, Lima, Casa de la Cultura del Perú, 1964; *Fernando de Szyszlo: Exposición retrospectiva,* exhibition catalog, Mexico City, Museo de Arte Moderno, 1973; *Exposición retrospectiva del artista peruano Fernando de Szyszlo,* exhibition catalog, Bogotá, Museo de Arte Moderno, 1973; *Szyszlo:*

Indagación y collage by Mirko Lauer, Javier Sologuren, and Emilio Adolfo Westphalen, Lima, Mosca Azul Editores, 1975; *Pintores peruanos: Fernando de Szyszlo* by Mario Vargas Llosa, Lima, Banco Popular del Peru, 1979; *Fernando de Szyszlo: First Retrospective Exhibition in the United States,* exhibition catalog, Washington D.C., Organization of American States, 1985; *El canto de la noche,* exhibition catalog, text by Judith Alanís, Mexico City, Visual Gráfica, 1988; *Fernando de Szyszlo,* exhibition catalog, text by Carlos Silva, Caracas, Venezuela, Gráficas Armitano, 1990; *Fernando de Szyszlo,* by Alfred Wild, New York and Bogotá, Ediciones Alfred Wild, 1991; *Puertas de la noche,* exhibition catalog, text by Ana Maria Escallón, Santiago, Chile, Ediciones Alfred Wild, 1992; *Profiles latinoamericanos de los '90* by Ela Navarrete Talavera, Panama, Impredisa Panamá, 1992; *Fernando de Szyszlo: Recent Paintings,* exhibition catalog, text by Mario Vargas Llosa, Los Angeles, Iturralde Gallery, 1993; *Fernando de Szyszlo* by Ashton Dore, New York, Associated American Artists, 1994; *Fernando de Szyszlo,* exhibition catalog, London, Durini Gallery, 1994; *Latin American Artists in Their Studios* by Marie-Pierre Colle, New York, Vendome Press, 1994; *Fernando de Szyszlo: "Habitación no. 23,"* exhibition catalog, Miami, Durban Segnini Gallery, 1995; *Perú mágico* by Cecilia Raffo, Lima, PromPerú, 1997; *Libertad en bronce,* Lomas de Chapultepec, México, Impronta Editores, 1999; *La construcción de un artista peruano contemporáneo* by Luis Rebaza Soraluz, Lima, Pontificia Universidad Católica del Perú, 2000. **Articles**—"La primera exposición de Fernando de Szyszlo" by Jorge E. Eielson, in *La Nación* (Peru), 17 May 1947; "La pintura moderna en el Perú" by Juan Acha, in Humbolt, 7, 1961; "Szyszlo: Una aproximación" by Sebastián Salazar Bondy, in *Proceso* (Peru), January 1964; "Fernando de Szyszlo: Una imagen de Latinoamerica" by Jesús Velasco Marquez, in *Revista de la Universidad de México,* 25(9), May 1971, pp. 41–45; "Encuentro y desencuentro con el arte peruano actual" by Damián Bayón, in *Plural* (Mexico), 4, January 1972; "Szyszlo en la pintura peruana" by Carlos Rodríguez Saavedra, in *Plural* (Mexico), 13, October 1972; "Arte combinatoria y trágica conjunción: Nieto y Szyszlo" by Jorge Alberto Manrique, in *Plural* (Mexico), 19, April 1973, pp. 36–37; "La obra gráfica de Fernando de Szyszlo" by David Sobrevilla, in *Cielo Abierto* (Peru), 10(25), July/September 1983; "Szyszlo's Abstract Nativism" by Robert A. Parker, in Americas, 37(6), November/December 1985, pp. 40–43; "Szyszlo: Misterio de la realidad" by Ana María Gazzolo, in *Oïga* (Peru), 5(309), 15 December 1986; "Conversation with a Peruvian Master: Fernando de Szyszlo" by Alice Thorson, in Latin American Art, 2(1), winter 1990, pp. 23–27; "Szyszlo" by Vicky Torres, in *Kantu* (Peru), 8, July 1990; "El lado oscuro de Szyszlo" by Angel Páez, in *Vea* (Peru), 1(7), 1993, pp. 17–20; "De Atahualpa al Museo de la Nacion: entrevista a Fernando de Szyszlo" by Luis Jaime Cisneros, in *Debate* (Peru), 16(75), December/January 1993–94, pp. 70–73; "Fernando de Szyszlo" by Alvaro Medina, in *Art Nexus* (Colombia), 11, January/March 1994, p. 60.

* * *

Inspired by the sheer beauty and the mystery of the Andes and by the rich cultural heritage of mythology and art that have been resident among the mountain peaks and valleys for hundreds of years, the Peruvian painter and sculptor Fernando de Szyszlo has created works that are recognized as virtual icons of Latin American art. For more than 50 years his combining of the methods of European abstractionism with pre-Columbian aesthetics, often distinguished by a similarly abstract approach to design, has resulted in dramatic images that capture the brilliant colors of ancient textiles, erupting volcanoes, golden ornaments, and blood sacrifices against azure skies. The sense of ritual that is pervasive in the art of the pre-Columbian peoples manifests itself in a contemporary language that is relevant for today yet definitely related to the sacred mysteries of the past. De Szyszlo constructs a universe of deep shadows and luminous chromatic effects in shapes that recall the artifacts of tombs, pyramids, and temples but are none of them. The contours of lonely stelae signify the plight of human existence, ever searching for meaning in the mysteries of time.

In paintings that situate art and archaeology against the vast expanse of the cosmos, de Szyszlo brings forth the hybrid creatures, amazing textile patterns, and unique pottery shapes of his ancestors. He weaves strokes of color that look like tapestries for an Inca noble and re-creates fantastic birds with allusive details of feathers, claws, and beaks to form his own private mythology. While painting was not part of the Inca past, he resurrects the ancient lore associated with mountain spirits and fanged deities to live in a vital new form. Each work is a dynamic appropriation of pre-Columbian motifs in rich pigments applied with a palette knife to create thick impastos and other interesting surface effects that mimic architectural reliefs and woven cloths, always against radiant backgrounds that speak of sacred environments. The consolidation of Peruvian traditions into abstract form is particularly evident in *De la serie Mar de Lurín* (1989), which features the shape of a monstrous deity in stages of metamorphosis against a horizon painted in long strips reminiscent of remnants of Chancay cloths and mummy wrappings.

The mythic tone found in the works of de Szyszlo echoes a particular direction in the art of abstraction that took place in Latin America beginning in the 1950s. Described as "lyric abstraction," it was far more subjective in expression than the abstraction being produced by the New York school or by European artists of the same persuasion and was used to infuse the canvas with a spiritual fervor, often derived from memories of the past. When a young de Szyszlo traveled to Paris in 1949, he was introduced to André Breton and the writers and artists of the Café Flor. He lived in Paris and Italy until 1955, when he returned to Lima to teach painting at Catholic University, the first of many academic appointments. The European experience was inspirational and affirmed his need to listen to his own intuition and to respect his own heritage. He continued to explore the elements of Andean art in a constant acknowledgment of its aesthetic and ritual concepts. The forms that emerge from the depths of color in *Cajamarca* (1960), for example, may be variously interpreted as the plastic elements that are the basis of nonobjective abstraction or as the synthesis of shapes inspired by the Andean condor as revealed in magnificent colors that capture the essence of flight and the transformative powers of ritual. His titles also emphasize his personal associations with the Andes and its people and places, legends, and heroic personalities. A consummate intellectual and student of art and history, de Szyszlo imbues his work with a cultural presence that gives each object astonishing substance.

Ancestral spirits also abide in de Szyszlo's sculpture with a similar sense of disquietude and inscrutability that is based on abstract composition. His work in three dimensions, done in stone and cast in bronze, allows him the opportunity to give volume and substance to his own symbolic repertoire while paying tribute to the monumental architectural forms of the Andes and to its distinctive stone carvings found as lintels, stelae, tenoned heads, and other sacred motifs. The inclusion of geometric signs such as circles, spirals, and squares

transcends the merely aesthetic. It refers to pre-Columbian iconography of almost 3,000 years duration.

—Carol Damian

de ZAYAS, Marius
Mexican painter, photographer, and caricaturist

Born: Veracruz, 13 March 1880. **Family:** Married 1) Francesca Kravchyk in 1912, two daughters; 2) Virginia Harrison Gross, one daughter and one son. **Career:** French portrait painter. Illustrator, *El Diario Illustrado* and *La Actualidad,* Mexico, 1906. Moved to New York, 1907. Contributor, *World,* New York, 1907–14; publisher, *As Others See Us,* New York, 1908. Traveled to Paris, 1910. Contributor, *Camera Work,* and art critic, beginning in 1911. Traveled to Paris and London, 1914. Founder and director, Modern Gallery, New York, 1915–18. Traveled to Paris, 1919. Founder and director, De Zayas Gallery, New York, 1919–21. Traveled to Paris, 1924; moved to Paris, 1927-ca. 1948. Involved in the New York Dada movement with Marcel Duchamp, Man Ray, and Francis Picabia. Also worked as an art dealer, curator, and filmmaker. **Died:** Greenwich, Connecticut, 10 January 1961.

Selected Exhibitions:

1909 Photo Secession Gallery, New York (with John Nilsen Laurvik)
1910 *Up and down Fifth Avenue,* Photo Secession Gallery, New York
1913 291, New York
 Photo Secession Gallery, New York
1981 *Marius de Zayas, Conjurer of Souls,* Spencer Museum of Art, University of Kansas, Lawrence (traveled to Philadelphia Museum of Art and Center for Inter-American Relations, New York)
1992 Universidad Veracruzana, Xalapa, Veracruz, Mexico

Publications:

By de ZAYAS: Books—*A Study of the Modern Evolution of Plastic Expression,* with Paul B. Haviland, New York, 291, c. 1900; *African Negro Art: Its Influence on Modern Art,* New York, Modern Gallery, 1916; *The Collection of Marius de Zayas of New York City,* New York, Anderson Galleries, 1923; *Exhibition of Greek Art,* exhibition catalog, New York, Whitney Studio, 1925; *How, When and Why Modern Art Came to New York,* Cambridge, Massachusetts, Massachusetts Institute of Technology, 1996; *Un nuevo punto de vista en la evolución del arte moderno: Escritos de divulgación, 1928,* Mexico, Breve Fondo Editorial, 1997. **Articles—**"Caricature: Absolute and Relative," in *Camera Work,* 46, October 1914; interview with Pablo Picasso, in *The Arts* (New York), May 1923, pp. 315–326; "How, When, and Why Modern Art Came to New York," in *Arts Magazine,* 1980. **Book, illustrated—***Vaudeville* by Caroline Scurfield Caffin, New York, Kennerley, 1914.

On de ZAYAS: Books—*Marius de Zayas, Conjurer of Souls,* exhibition catalog, text by Douglas Hyland, Lawrence, University of

Kansas, 1981; *The Aesthetics of Visual Poetry, 1914–1928* by Willard Bohn, Cambridge, Cambridge University Press, 1986; *Marius de Zayas, acopio mexicano,* exhibition catalog, by Luis Mario Schneider, Xalapa, Veracruz, Mexico, Universidad Veracruzana, 1992. **Articles—**"The Art of Marius de Zayas" by Craig R. Bailey, in *Arts Magazine,* 53, September 1978, pp. 136–144; "The Stridentists" by Serge Fauchereau, in *Artforum International,* 24, February 1986, pp. 84–89; Marius de Zayas issue of *Biblioteca de México,* 39, 1997.

* * *

Caricaturist, artist, and follower of developments in the European avant-garde, Marius de Zayas came to the United States from dictator-ruled Mexico in 1907. He quickly became a prominent personality in New York City and a key intermediary between that city and Paris, both the apex of avant-garde artistic expression at that time. De Zayas counted among his friends fellow artists Alfred Stieglitz, Guillaume Apollinaire, Pablo Picasso, Francis Picabia, and Marcel Duchamp. De Zayas did not only work with caricature; his drawings and paintings incorporated cubist abstraction and planar decomposition, also infused with a futurist dynamism and a proto-Dada humor.

De Zayas's most important work championed African tribal sculpture. An avid student of ethnology, de Zayas made a 1910 trip to the Salon d'Automne to inquire into the meaning of the new art in Paris. On his return, as a member of Stieglitz's "291" gallery, and later with his own gallery, he began tireless efforts to educate Americans about this new art. He presented his interpretation of African primitive art through a series of publications that began to appear in 1911 in the magazine *Camera Work* and other publications. He summarized his ideas in the monograph *African Negro Art: Its Influence on Modern Art,* published in 1916 and illustrated with photographs of carvings that had appeared at "291" two years earlier. De Zayas argued that triangles, rectangles, and circles are basic elements in primitive design and govern proportion. He sought to demonstrate this effect in his own work. For example, in *Francis Picabia,* one of his most severely abstracted drawings, he employed a series of curved lines for establishing arcs of varying proportions along a series of diagonals. These, in turn, were enhanced with algebraic symbols that appear to rest at key points within an apparently primitive approach to proportions.

In 1923 de Zayas wrote about the importance of African art as related to modern art with these words: "The artists who were in search of the new, trying to break away from the traditions of classic art, found in African sculpture a new standard of form and proportion, discovering a way to transpose the visual reality into an abstract and emotive form." This so-called primitive form influenced everything that de Zayas subsequently undertook, from the way in which he hung the African masks in "291" to the covers he created for future publications. His interest in "trying to break away from the traditions of classic art" also reflects the deep concern about the state of western civilization and the future that de Zayas shared with other artists and thinkers in the years surrounding 1914. Pessimistic about contemporary arts and culture, de Zayas wrote to Stieglitz in an undated letter, "I believe that this war will kill many modern artists and unquestionably modern art. It was time, otherwise modern art would have killed humanity. But what satisfies me is that at least we will be able to say the last word." In March 1915 the first issue of the proto-Dada publication *291* was published by its cofounders Picabia, Stieglitz, and de Zayas, with a cover design by de Zayas.

De Zayas also achieved notoriety for his graphic work. Informed by his caricaturist's accuracy, he incorporated cubist abstraction and planar decomposition in his art. Apollinaire praised his "incredibly powerful" drawings, seeing in them "very new techniques . . . in accord with the art of the most audacious contemporary painters."

—Martha Sutro

DIAS, Antonio
Brazilian painter

Born: Campina Grande, Paraíba, 1944. **Education:** Atelier Livre de Gravura da Escola Nacional de Belas Artes, Rio de Janeiro; studied in Paris on scholarship, 1966–67. **Career:** Lived and worked in Rio de Janeiro, 1960–66; moved to Milan, 1968; traveled to New York, 1970; returned to Brazil, 1978. Professor, Universidade Federal da Paraíba, 1978. Returned to Milan, 1981; moved to Germany, ca. 1984. Worked as a filmmaker and artist. **Awards:** Premio P. Favaro, Centro Cultural de San Fidele, Milan, 1968; John S. Guggenheim memorial fellowship, 1971.

Selected Exhibitions:

1962 Galeria Sobradinho, Rio de Janeiro
1964 Galeria Relevo, Rio de Janeiro
1965 Galerie Houston-Brown, Paris
 Biennale de Paris
 Jovem pintura, Museu de Arte Contemporânea, São Paulo
 Jovem desenho, Nacional Museu de Arte Contemporânea, São Paulo
 Opinião 65, Museu de Arte Moderna, Rio de Janeiro (traveling)
1966 Galeria Guignard, Belo Horizonte, Brazil
1967 Galeria Deita, Rotterdam
 Galeria Relevo, Rio de Janeiro
 Nova objetividade brasileiro, Museu de Arte Moderna, Rio de Janeiro
 Science Fiction, Kunstholle, Berlin
 Musée des Arts Décoratifs, Paris
 Stadtische Kunsthalie, Dusseldorf
1968 Galerie Hammer, Berlin
 Galerie Deita, Rotterdam
1969 Galleria ACME, Brescia, Italy
 Studio Marconi Grafica, Milan
 Galeria La Chiocciolo, Podava, Italy
 Dialogue between the East and the West, National Museum of Modern Art, Tokyo (traveling)
1970 Galerie Richard Foncke, Gent, Belgium
 Art Concepts from Europe, Bonino Gallery, New York
 Kunsthaus Hamburg
1971 Studio Marconi, Milan
 Galeria Breton, Milan
 Solomon R. Guggenheim Museum, New York
1972 Veste Sagrada, Rio de Janeiro
 Galeria da Vinci, Bolzano, Italy
 Galerie Stampo, Basei, Brazil
 Galerie Franco Toselli, Milan

1973 Galeria Ralph Camargo, São Paulo
 Galerie Albert Baronian, Brussels
 Galeria Bolsa de Arte, Rio de Janeiro
 Centro de Arte y Comunicación, Buenos Aires
 Galerie Stampa, Basei, Brail
 Biennale de Paris
 Expo-projeção grife, São Paulo
 Galeria Françoise Lambert, Milan
 Royal College of Art Gallery, London
1974 Nuovi Strumenti/Pierro Cavellini, Brescia, Italy
 Museu de Arte Moderna, Rio de Janeiro
 Galerie Rolf Ricke, Koln, Germany
 Kunstholle Koln, Germany
 Musée des Arts Décoratifs, Lausanne, Switzerland
 Kunstverein, Koln, Germany
1975 *Video Art,* Institute of Contemporary Art, Philadelphia
 Museum of Contemporary Art, Chicago
 Contemporary Arts Center, Cincinnati
1976 Galerie Albert Baronian, Brussels
 Galerie Lucia Amelio, Naples, Italy
 Nuovi Strumenti/Pierro Covellini, Brescia, Italy
 Galerie Eric Fobre, Paris
1977 *The Record As Artwork,* Fort Worth Art Museum, Texas
1978 Galeria Arte Global, São Paulo
 Galeria Gravura Brasileira, Rio de Janeiro
 Galeria Luisa Strina, São Paulo
 Art & cinema biennale di Venezia, Venice
1979 *Núcleo de arte contemporãneo,* Universidade Federal de Paraíba
 Galeria Saramenha, Rio de Janeiro
1980 Galerie Wolter Storms, Munich
 Monica Figueiras de Almeida Galeria de Arte, São Paulo
 Galeria Piero Cavellini, Brescia, Italy
 Biennale di Venezia
1981 Galeria Cesare Manzo, Pescara, Italy
 Galeria Luisa Strina, São Paulo
 Galerie Walter Storms, Munich
 Bienal de São Paulo
1982 Galeria Gravura Brasileira, Rio de Janeiro
 Galeria Walter Storms, Munich
1983 Galeria Piero Cavellini, Brescia, Italy
 Galeria Albert Boronian, Brussels
 Galeria Thomas Cohn, Rio de Janeiro
 Galeria Luisa Strina, São Paulo
 Galerie Beatrix Wilhelm, Leonberg, Germany
1984 Galerie im Lenbochhaus, Munich
 An International Survey of Recent Painting and Sculpture, Museum of Modern Art, New York
 Bienale of Sydney Australia
1985 Fine Arts Museum, Taiwan
 Galeria Saramenha, Rio de Janeiro
 Galeria Thomas Cohn, Rio de Janeiro
 Galeria Luisa Strina, São Paulo
 Galerie Tina Presser, Porto Alegre, Brazil
1986 Galeria Piero Cavellini, Brescia, Italy
 Galerie Beatrix Wilhelm, Stuttgart, Germany
 Galeria Luisa Strina, São Paulo
 Solomon R. Guggenheim Museum, New York

1987 Galerie Emmerich-Baumann, Zurich
 Studio Marconi, Milan
 Galeria Joan Prats, Barcelona, Spain
 Galeria Saramenha, Rio de Janeiro
1988 Stattliche Kunsthalle, Berlin
 Brazil Projects PS 1, New York Museum
1989 Galeria Luisa Strina, São Paulo
1990 Galerie Notheifer, Berlin
 Galerie Dr. Luise Krohn, Badenweiler, Germany
 Galerie Pulitzer, Amsterdam
1991 Galeria Luisa Strina, São Paulo
1992 Galerie Stohli, Zurich
 Artistas latinoamericanos del siglo XX, Museu de
 Gravura, Curitiba, Brazil
1993 Stadtische Galerie im Lenbachhaus, Munich
 Galeria Luisa Strina, São Paulo
 Galeria Paulo Fernandes, Rio de Janeiro
 Latin American Artists in the Twentieth Century,
 Museum Ludwig, Koln, Germany (traveling)
1994 Galeria Paulo Fernandes, Rio de Janeiro
 Paço das Artes, São Paulo (traveling)
 Bienal internacional de São Paulo
1997 *Transparencias,* Museu de Arte Moderne, Rio de
 Janeiro
1999 Centro de Arte Moderna, Lisbon
2001 *O país inventado,* Museu de Arte Moderna de São
 Paulo

Publications:

By DIAS: Books–*Antonio Dias,* exhibition catalog, New York, Brazilian Government Trade Bureau, 1969; *Some Artists Do, Some Not,* Brescia, Italy, Edizioni Nuovi Strumenti, 1974.

On DIAS: Books—*Antonio Dias,* exhibition catalog, Rio de Janeiro, Museu de Arte Moderno, 1974; *Antonio Dias,* exhibition catalog, text by Paulo Sérgio Duarte, Rio de Janeiro, FUNARTE, 1979; *Antonio Dias,* exhibition catalog, Rio de Janeiro, Galerie Thomas Cohn, 1985; *Antonio Dias: Arbeiten auf Papier, 1977–1987,* exhibition catalog, text by Achille Bonito Berlin, Staatliche Kunsthalle, 1988; *Antonio Dias: Trabalhos,* exhibition catalog, text by Paulo Sérgio Duarte and others, Ostfildern, Germany, Cantz, 1994; *Antonio Dias* by Lúcia Carneiro and Ileana Pradilla, Rio de Janeiro, Lacerda Editores, 1999; *Antonio Dias,* exhibition catalog, Lisbon, Centro de Arte Moderna, 1999. **Articles**—"Antonio Dias. Discurso amoroso" by Lisette Lagnado, in *Galeria,* 15, 1989, pp. 70–76; "Brasilianische Kunst" by Christian Huther, in *Kunstforum International* (Germany), 129, January/April 1995, pp. 305–306; "Transparencias" by Catherine Millet, in *Art Press* (France), 220, January 1997, p. 79.

* * *

The work of the Brazilian-born artist Antonio Dias defies categorization. At once cerebral and sensual, contained and magical, his work borrows elements from modernism, postmodernism, pop art, and conceptualism. Dias is interested in the physical properties of a painting or sculpture, the materials and paints used to create a piece. Color is not important in and of itself but rather is important as a

physical presence. Like an alchemist, Dias experiments with different materials, combining standard acrylic paints with graphite, malachite, iron oxide, and gold and copper leaf. By merging these various elements, he creates paintings and installations that have been described as "luminous," "pearly," and "iridescent." Although Dias resists giving meaning to a work, he believes that paintings have a "spirit." He has explained, "I wouldn't say exactly that the paintings have a soul, but there must be something like a 'spirit'. Otherwise it would be no more than a grammatical exercise. That was what irritated me about concept art. I did have a conceptual attitude, but not as far as the point at which one only speaks in footnotes."

During the 1960s, having left Brazil for Italy, Dias immersed himself in the conceptual art scene that was popular at the time. He worked in the conceptual style, creating heady pieces that were abstract and cooly conceived. His geometric paintings used his skills as an architectural draftsman. Some of Dias's works included a missing corner, which would become a signature for him.

In 1977, having arrived at a dead end with conceptual art and searching for a circular element that he could use for a project he had been planning for several years, Dias traveled to India and Nepal. Working with Tibetan artisans, he learned how to make the paper that became the material for *Niranjanirakhar,* an installation consisting of four round elements. After the first element was completed, the Tibetans named the piece *Golo,* meaning "round." When the entire piece was completed, they called the work *Niranjanirakhar,* a native word for God and a name that Dias continued to use. Although Dias did not see the work as mystical, he appreciated the way the native artisans created a meaning for themselves.

In 1986 Dias's painting *God/Dog* was included in an exhibition at the Guggenheim Museum. The work is startling in its simplicity: a black canvas with the words "GOD" and "DOG" placed neatly beside each other in the center. The starkness of the painting, combined with the subtle irony, creates a strange puzzle. When a critic asked for an explanation, Dias replied that the painting was about a man taking a dog for a walk. Of course, there is no picture of a dog and no mention or picture of a man. The piece is, rather, a sort of linguistic trick. In *God/Dog* Dias asks questions about the nature of things: the relationship between man and dog (after all, a man is a dog's god) and the relationship between words and meaning.

Although Dias sets up his own problems and creates his own answers in his work, essentially creating a distinct language, he also incorporates the archetypal. Drawing on Jungian philosophy, he creates pieces that float between the subconscious and conscious. His works fluctuate between macrocosms and microcosms. For instance, in *Caramuru* (1992) the "dots" in the painting can be seen as the solar system, leopard skin, or magnified pores. Dias is a master at creating a specific, unique world in his work, of mixing elements to create paintings that ask as many questions as they answer.

—Sally Cobau

DIAS, Cícero
Brazilian painter

Born: Cícero dos Santos Dias, Jundiá, Pernambuco, 5 March 1907.
Education: Studied architecture, Escola de Belas Artes do Rio de

Janeiro, 1925. **Career:** Moved to Rio de Janeiro, 1920; returned to Recife, 1932. Art instructor, Recife, 1935. Moved to Paris, 1937. Member, artist group *Grupo Espace,* 1945.

Individual Exhibitions:

1928	Rio de Janeiro
1929	Escada, Pernambuco
1938	Galeria Jeanne Castel, Paris
	Galeria Billet, Paris
1946	Museum of Modern Art, Paris
1947	Galeria René Drouin, Paris
	Musée National d'Art Moderne, Paris
1949	Museu de Arte Moderna de São Paulo
1952	Museu de Arte Moderna de São Paulo
	Museu de Arte Moderna do Rio de Janeiro
1957	Galeria Ranulpho, Recife
1959	Salvador, Bahia (retrospective)
1964	Musée d'Art Moderne de la Ville de Paris
1965	*Bienal de São Paulo* (retrospective)
1967	São Paulo Club
	Manchete, Rio de Janeiro
1970	Galeria Portal, São Paulo
	Galeria Ranulpho, Recife
1973	Galeria San Mamede, Lisbon, Portugal
1974	Galeria Portal, São Paulo
1975	Galeria Renot, Salvador
1976	Galeria Ranulpho, Recife
1978	Museu André Malraux, Le Havre
	Galeria Ranulpho, São Paulo and Recife
1982	Galeria Bellechasse, Paris
1987	Galerie Denise René, Paris
1988	Rio Design Center, Rio de Janeiro
1989	Redfern Gallery, London
1991	Simões de Assis Galeria de Arte, Curitiba
	Museu Nacional de Belas Artes, Rio de Janeiro
1993	*Cícero Dias: Os años 20,* Salão Copacabana Palace Hotel, Rio de Janeiro
1994	Galerie Marwan Hoss, Paris
1995	*Cícero Dias, pinturas e desenhos,* Galeria Multiarte, Fortaleza
1997	Casa França-Brasil, Rio de Janeiro

Selected Group Exhibitions:

1930	Museum Nicholas Roerinch, New York
1937	*Salão de maio,* São Paulo
1944	*Mostra da pintura moderna brasileira,* Royal Academy of Arts, London
1947	*Pinturas abstratas,* Galeria Denise René, Paris
1950	Venice Biennial
1954	*Artistas de vanguarda da Escola de Paris,* Museu de Arte Moderna de São Paulo
1962	*Arte latino-americana,* Museum of Modern Art, Paris
1974	*Tempo dos modernistas,* Museu de Arte Moderna de São Paulo
1985	*Rio, vertente surrealista,* Galeria de Arte Banerj, Rio de Janeiro

Publications:

By DIAS: Books, illustrated—*A ilha dos amores* by Luís de Camões, Lisbon, Portugal, Edições Atica, 1980; *Casa-grande & senzala: Formação de família brasileira sob o regime da economia patriarcal,* 28th edition, by Gilberto Freyre, Rio de Janeiro, Editora Record, 1992.

On DIAS: Books—*Profile of the New Brazilian Art* by P. M. Bardi, Rio de Janeiro, 1970; *Eu vi o mundo, ele começava no Recife: O painel de Cícero Dias* by Norma Carreira Peregrini, Rio de Janeiro, Museu Nacional de Belas Artes, 1982; *Cícero Dias e seu longo processo de morrer* by Osvaldo Della Giustina, São Paulo, Almed, 1983; *Cícero Dias: Pintures 1950–1965,* exhibition catalog, Paris, Galerie Denise René, 1987; *Cícero Dias: Anos 20* by Luis Olavo Fontes, Rio de Janeiro, Editora Index, 1993; *Cícero Dias: Images au centre du songe,* exhibition catalog, text by Philippe Dagen, Paris, Galerie Marwan Hoss, 1994; *Cícero Dias: O sol e o sonho* by Marcilio Lins Reinaux, Recife, Editora Universitaria UFPE, 1994; *Cícero Dias* by Antonio Bento and Mario Carelli, Rio de Janeiro, Icatu, 1997. **Articles—**"Cícero Dias" by Michel Faucher, review of an exhibition at Galerie Denise René, Paris, in *Cimaise,* 34, November/December 1987, pp. 93–96; review of an exhibition at Galerie Marwan Hoss, Paris, by Laurence Pythoud, in *L'Oeil* (Lausanne, Switzerland), 460, April 1994, p. 15.

* * *

Born in Brazil in 1907, Cícero Dias explored a number of styles throughout his career, including modernism, surrealism, and geometric abstraction, before returning to his early style in which he depicted daily life in elegant watercolors. In 1925 Dias moved to Rio de Janeiro, where he became acquainted with the modernist movement. His watercolor *I Saw the World: It Began in Recife* was displayed at the National Salon of Fine Arts, a place that exhibited avant-garde paintings. Although Dias was unfamiliar with surrealism, his painting had qualities of it with its heady, erotic portrayal of life in northeast Brazil. After moving to Paris in 1937, Dias discovered surrealism and worked in that style until he began experimenting with geometric abstraction. He joined the organization Group Espace, and in 1948 he painted an abstract mural in the Ministry of Finance in Recife.

Dias is best known for figurative art, a style he returned to after his exploration of abstract art. Painters have moved from other countries to Brazil because of its favorable light and rich colors, but as a native Dias captured life in Brazil with remarkable empathy and insight. Dias has been called "a delightful painter of Pernambucan life in scenes of pure and simple lyricism yet evocative of the most characteristic local color imaginable." One work that captures these qualities is *River Bathers* (1930).

In *River Bathers* two men in the foreground look at each other, while in the background a man puts his arms around his children. The heavy men's bodies are almost womanly—curved, yet strong. In a surreal way the upper man seems to float above his companion. Posed naked near a rock, he echoes formal nude portraits of women. The scene is charged with life and energy. Soon the men will jump into the water and the children will run away, but Dias has beautifully captured the moment.

—Sally Cobau

DÍAZ, Gonzalo

Chilean painter, photographer, and installation artist

Born: Santiago, 1947. **Education:** Escuela de Bellas Artes de la Universidad de Chile, 1965–69, degree in art 1969; Universitá Internazionale dell'Arte, Florence, Italy, 1980. **Career:** Faculty member, Talleres de Pintura de la Facultad de Artes, Universidad de Chile, Santiago, 1969–75; professor, Instituto de Arte Contemporáneo, 1977. **Awards:** Prize of merit, Concurso CRAV, Museo de Arte Contemporáneo, Santiago, 1974; first prize, Concurso El Arbol, Museo de Arte Contemporáneo, Santiago, 1975; Gran Premio del VI Concurso de la Colocadora Nacional de Valores, Museo Nacional de Bellas Artes, 1980; first prize, *II bienal de gráfica,* Universidad Católica, Santiago, 1982; second prize, Concurso Plástica Abierta, Plaza Mulato Gil de Castro, Santiago, 1982; Primer Premio concurso Chile-Francia, Instituto Chileno Francés de Cultura, 1983; Guggenheim fellowship, 1987; Premio Altazor, Museo Nacional de Bellas Artes, 2000.

Individual Exhibitions:

1984 *A que hacer? Chtó dielat?,* Galería Sur, Santiago
1985 *El kilómetro 104,* Galería Sur, Santiago
1986 *Reposición,* Glaería Visuala, Santiago
1988 *Banco-Marco de prueba,* Galería Arte Actual, Santiago
1989 Galería Ojo de Buey, Santiago
1991 *La declinación de los planos,* Universidad Católica de Chile
1995 Museo de Arte Moderno, Chiloé, Chile
1998 Museo Nacional de Bellas Artes, Santiago
 Galería Gabriela Mistral, Santiago

Selected Group Exhibitions:

1979 *XV bienal internacional de São Paulo*
1991 *Contemporary Art from Chile,* Americas Society, New York
1992 *Latin American Artists of the Twentieth Century,* Museum of Modern Art, New York
1993 *Arte latinoamericano actual,* Museo Municipal de Bellas Artes J.M. Blanes, Montevideo, Uruguay
 Cartographies, Winnipeg Art Gallery, Canada
1994 *VentoSul/II mostra de artes visuais integração do Cone Sul,* Argentina (traveling)
 V bienal de la Habana, Havana
1995 *Intervenciones en el espacio,* Museo de Bellas Artes, Caracas
1996 *Latinoamericano,* Museo Nacional de Bellas Artes, Buenos Aires
 Los límites de la fotografía, Museo Nacional de Bellas Artes, Santiago

Publications:

By DÍAZ: Books—*Modern Riddles: A Collaborative Work,* edited by Stephanie Brown, Sunderland, England, Artists' Agency and Diamond Twig Press, 1995; *Quadrivium: Ad usum delphini,* exhibition catalog, Santiago, Galería Gabriela Mistral, 1998. **Article**—"Statement against Censorship," with Eugenio Dittborn and Arturo Duclos, in *Art Monthly,* 179, September 1994, p. 24.

On DÍAZ: Books—*Sueños privados, ritos públicos,* exhibition catalog, by Justo Pastor Mellado, Santiago, La Cortina de Humo, 1989; *Contemporary Art from Chile,* exhibition catalog, by Fatima Bercht, New York, The Society, 1990; *Intervenciones en el espacio: Diálogos en el MBA* by María Elena Ramos, Caracas, Museo de Bellas Artes, 1998. **Articles**—"Contemporary Art from Chile" by Elizabeth Merena, in *Afterimage,* 19, September 1991, pp. 14–15; "Everyone Needs a Madonna" by Don Greenlees, in *Art News,* 90, October 1991, pp. 96–97; "Gonzalo Diaz" by Catalina Mena, in *Art Nexus* (Colombia), 28, May/July 1998, pp. 138–139.

* * *

Although Gonzalo Díaz, one of the foremost Chilean objectivists, launched his artistic career as a painter, he is best known for his elaborate installations. Díaz has synthesized images and texts in his work to question the meanings of everyday objects and assumptions. His installations incorporate Chilean political history, found objects, wordplays, appropriated advertising images, and even the exhibition sites themselves to create artistic spaces in which every object and its meaning(s) are called into question. At its core Díaz's work explores power in its myriad representations. His installations often contain scaffolding, which symbolizes the structural girding of power. Díaz's work is never bombastic though. Like other Chilean artists in the *avanzada* movement who faced intense censorship under the dictatorship of Augusto Pinochet, Díaz turned to abstractionism so that he could subtly express his often-subversive messages without risking official repression.

In 1982 Díaz unveiled his first high-profile installation, *Historia sentimental de la Pintura chilena* ("A Sentimental History of Chilean Painting"). Although he had trained as a painter and had won some attention in this medium, *Historia sentimental* emphatically announced Díaz's arrival to both the Chilean and international art communities and denoted his expansion beyond the confines of the canvas. The work presented a powerful yet understated critique of the history of Chilean painting. Employing the iconic image of a blond, glamorous housewife familiar to nearly every Chilean from the label of a popular cleaning powder, Klenzo, Díaz decried the shallowness of Chile's painting tradition, most particularly its neglect of the Virgin Mary as a subject. To this end Díaz juxtaposed the image from the cleaning powder container with the text "Dear Madonna: I have set . . . eyes over you, dear Chilean painting . . . I set, my dear, my eyes on you. Lost, I could love you too." *Historia sentimental* sarcastically suggested that the Klenzo woman could be Chile's Madonna.

Díaz broadened the scope of his work in the 1989 installation *Lonquen 10 años* ("Lonquen 10 Years"), which took as its theme the disappearance of Chilean citizens under the Pinochet regime. The title refers to the bodies of the disappeared that had been discovered in a lime mine in Lonquen, south of Santiago. The case was officially investigated in 1979 (during the sixth year of Pinochet's dictatorship). The judiciary established the names of both the victims and their murderers but then let the perpetrators go free under a series of amnesty acts. In *Lonquen 10 años* Díaz numbered and piled against a wall 200 Chilean river stones, which were supported by a scaffolding of wooden beams. The installation also marked the first time that Díaz

incorporated a version of the *Via Crusis* (''Way of the Cross'') into his work. The *Via Crusis,* which traditionally consists of 14 scenes representing events during the course of Jesus's crucifixion and resurrection, is an essential element of Catholic iconography and appears in almost every Catholic church. In *Lonquen 10 años* Díaz's *Via Crusis* included 14 paintings, each framed, lit, and covered, along with the words ''In this house / on January 12, 1989, / Gonzalo Díaz got the revelation / Of the secret of the dreams.'' Above each painting was a ledge containing a glass of water.

Díaz continued to explore both scaffolding and the *Via Crusis* in his later work. He also expanded the scope of his installations. In 1997's ambitious *Unidos en la Gloria y en la Muerte* (''United in Glory and Death''), for example, Díaz incorporated the exhibition site at the Museo Nacional de Bellas Artes into the installation itself. As in *Historia sentimental, Unidos* examined Chilean art, though *Unidos* problemized the cultural power of sanctioned and institutionalized art, as well as that of the state that supports it. *Unidos* took its title from the name of a statue, located across the street from the Museo Nacional, commemorating Icarus's ill-fated flight. Díaz emblazoned the phrase ''Unidos en la Gloria y en la Muerte'' in giant neon letters on the outside of the museum. In the exhibition room itself, he built a rough scaffold through which was woven the text of the Chilean Civil Code. The scaffold—representing the structural skeleton of power—literally supported the Civil Code.

—Rebecca Stanfel

DITTBORN, Eugenio
Chilean painter, engraver, video, and installation artist

Born: Santiago, 1943. **Education:** School of Fine Arts, Universidad de Chile, 1962–65; Escuela de Fotomecánica, Madrid, 1966; Hochschule für Bildende Kunst, Berlin, 1967–69; Ecole des Beaux Arts, Paris, 1968. **Career:** Cofounder, Escuela de Santiago, 1984. **Awards:** Prize in engraving, *Primer salón de gráfica,* Universidad Católica de Chile, 1978; first prize in engraving, *III bienal,* Universidad Católica de Chile, 1982; fellowship, John S. Guggenheim Foundation, 1985; second prize, Intergraphik, Berlin, 1987; fellowship, Fundación Andes, 1995.

Individual Exhibitions:

1974	Galeria Carmen Waugh, Santiago
	Museo Nacional de Bellas Artes, Santiago
1976	Galeria Epoca, Santiago
1977	Galeria Epoca, Santiago
1978	Centro de Arte Contemporáneo, Pereira, Colombia (traveling)
1980	Galeria Sur, Santiago
1981	Galeria Sur, Santiago
1984	Artspace, Sydney
	Museo de Arte Moderno de Cali, Colombia
1985	Chamaleon Gallery, Hobart, Tasmania, Australia
	Galeria Sur, Santiago
	Galeria Bucci, Santiago
	Geroge Paton Gallery, Melbourne
1987	Institute of Modern Art, Brisbane, Australia

1988	Centro Cultural de la Municipalidad de Miraflores, Lima, Peru
1989	Kinok Producciones, Santiago
	Center for Photography, Sydney
1990	Teatro Ana Julia Rojas, Caracas, Venezuela
	Kinok Producciones, Santiago
1993	Witte de With, Rotterdam, Netherlands
	Institute of Contemporary Art, London
1994	Center for the Fine Arts, Miami
	Wellington City Art Gallery, New Zealand
	Transmission Gallery, Glasgow
1996	Espacio 204, Caracas, Venezuela
	Estudio O'Ryan, Santiago
1997	New Museum of Contemporary Art, New York
1998	Museo Nacional de Bellas Artes, Santiago
	Instituto de Arte Contemporánea, Lisbon
	Alexander and Bonin, New York
1999	Galería La Sala, Santiago
	Château de Jau, Cases de Pène, France
2001	Blaffer Gallery, University of Houston
	The Foreseen and Unforeseen Position of Their Bodies, Alexander and Bonin, New York

Selected Group Exhibitions:

1992	*Latin American Artists of the Twentieth Century,* Museum of Modern Art, New York
1994	*Cocideo y crudo,* Museo Nacional Centro de Reina Sofia, Madrid
1995	*About Place, Recent Art of the Americas,* Art Institute of Chicago
2001	Espai d'Art Contemporaini, Castelló, Spain

Collections:

Museum of Contemporary Art, Antwerp; University of Texas, Austin; Museum of Contemporary Art, Brisbane, Australia; Château de Jau, Cases de Pène, France; Institute of Contemporary Art, Lisbon; Walker Art Center, Minneapolis; Museum of Modern Art, New York; Museo Nacional de Bellas Artes, Santiago; Moderna Museet, Stockholm; Museum of Contemporary Art, Sydney; Art Gallery of Ontario, Toronto, Canada.

Publications:

On DITTBORN: Books—*MAPA: The Airmail Paintings of Eugenio Dittborn, 1984–1992,* exhibition catalog, text by Guy Brett, Sean Cubitt, Roberto Merino, and others, London, Institute of Contemporary Art, and Rotterdam, Netherlands, Witte de With, 1992; *Remota: Eugenio Dittborn Animal Paintings,* exhibition catalog, text by Guy Brett, Dan Cameron, Sean Cubitt, and others, New York, New Museum of Contemporary Art, 1997; *Mundana: Eugenio Dittborn,* exhibition catalog, Santiago, Pública Editores, 1997. **Articles—**''Return to Sender'' by Dan Cameron, in *Artforum,* March 1993; ''Eugenio Dittborn'' by Simon Grant, in *Art Monthly* (London), June 1993; ''Eugenio Dittborn'' by Adrian Searle, in *Time-Out* (London), April-May 1993; ''Eugenio Dittborn: Travels on the Picture Plane'' by Sean Cubitt, in *Art & Design,* 9, July/August 1994, pp. 76–83; ''Distance of Memory: The Airmail Paintings of Eugenio Dittborn'' by Desa Philippi, in *Parachute,* 83, July-September 1996; ''Eugenio

Dittborn'' by Victor Zamudio-Taylor, in *Art Nexus* (Colombia), 25, July/September 1997, pp. 48–51; ''Eugenio Dittborn, rémotitudes'' by Catherine Millet, in *artpress,* 249, September 1999, pp. 26–29.

* * *

Along with Alfredo Jaar, Eugenio Dittborn is one of the foremost Chilean artists on the contemporary international scene. Although up to the mid-1980s Dittborn worked with painting, drawing, and diverse graphic techniques, his best-known works are his so-called airmail paintings. Since 1984 he has been producing these paintings, the main characteristic of which is that they travel through the international postal service, following pre-established routes and reaching various destinations. Dittborn has also worked with video since the start of the 1980s.

The airmail paintings show the graphic resources Dittborn was already exploring in the 1970s, including serigraphy, offset, and photo silk screen. In these methods of transfer images are applied to a paper medium or to fine fabric, which is then carefully folded so that it fits into an envelope specially designed by the artist. In his first formal explorations in this art Dittborn used kraft paper, but later, from 1986 onward, he used synthetic fabrics. From the start he used the envelopes as determining elements, designing them in blue with spaces in white for recording the route and information on the characteristics of the work. The envelopes are exhibited along with the airmail painting as the proof of and reference to their journey in space and time, which is normally a complex one. The emphasis put on a work's method of transportation, using standard express service, shows that it is a nomadic object within the system of international contemporary art. The relationship of the airmail paintings to so-called mail art is primarily the fact that in both cases the works take a journey through the postal system. The differences are found in the greater dimensions, the public nature (with museum and art galleries as destinations), and the complex routes that characterize Dittborn's works.

The airmail paintings refer to a general political discourse on forms of authoritarianism, social marginalization of diverse tones, and the ravages of colonialism. As a working method, Dittborn juxtaposes and intermixes photographs of native American Indians, criminals taken from police files, drawings of children and schizophrenics, images taken from television or magazines, and texts. He also reuses elements in different works, trying out different combinations of images. In his *History of the Human Face,* which covers several works, Dittborn exhibits some of the elements that make up his formal repertoire. *The 11th History of the Human Face (500 Years)* (1991) presents drawings of faces made by patients at the Santiago de Chile Psychiatric Hospital side by side with photographic portraits of criminals and mixed with drawings of children. An ironic vein may be discovered in some of these works. *El Crusoe* (1999–2001) is a work fragmented into two sections. In the first we see images that refer to the preparation of food and in the one next to it the caricature of a man shipwrecked on a small island.

The airmail paintings sometimes have embroidery and seams. They are usually presented as large, monochromatic surfaces that reveal themselves to be enormous documents, a kind of cadastre that keeps disturbing data on marginalization. Dittborn's concern for the marginalized inspired the work *The House of Erasmus from Rotterdam* (1993), for which he requested drug addicts of the city to paint their ideal house, at the same time asking them to describe the house they had lived in when they were 10 years of age. The texts and drawings

were sent to Chile so that Dittborn could incorporate them into his airmail paintings, in which he reflected upon the absence of home. The home as a place longed for, like an omnipresent desire or need in shadow, had appeared in Dittborn's first airmail paintings. In *To Dress (Airmail Painting Nº 56)* (1986–87) one could see simply drawn silhouettes of houses associated with portraits of criminals, along with allusive inscriptions to the images. These simply drawn houses have reappeared in several of his works

In general Dittborn's work denotes a constant formal experimentation within the pattern of the postal journey of the airmail paintings, which demand certain material requirements for the effective transportation of the work in its envelope. The conceptual aspect of the work is essential and refers to concerns regarding colonialism, authoritarianism, and marginalization in a sometimes surprising mixture of irony, scepticism, and humanism.

—Vivianne Loría

do AMARAL, Tarsila
Brazilian painter and sculptor

Born: Capivari, 10 September 1886. **Education:** Studied drawing and painting under Pedro Alexandrino and Elpons in São Paulo, 1916–17; Académie Julien, Paris, 1920–22. **Family:** Married 1) Andres Teixeira in 1906 (marriage ended), one son; 2) Oswalde de Andrade in 1922 (divorced 1929). Lived with Martin Luis, 1934-*ca.* 1954. **Career:** Lived in Paris, 1922–24. Became involved with the Modernist group, 1922; involved with Pau-Brasil movement, 1923–27. Traveled to Moscow, 1931. **Died:** São Paulo, 17 January 1973.

Individual Exhibitions:

1926	Galerie Percier, Paris
1928	Galerie Percier, Paris
1931	Museum of Modern Western Art, Moscow
1950	Museu de Arte Moderna, Sao Paulo (retrospective)
1963	*São Paulo bienal*
1969	Museu de Arte Moderna, Rio de Janeiro (traveling retrospective)
1970	*Tarsila 50 años de pintura,* Museu de Arte Moderna, Rio de Janeiro, and University of São Paulo (retrospective)

Selected Group Exhibitions:

1922	Salon des Artistes Francais, Paris
1951	*I bienal de São Paulo*
1963	*VII bienal de São Paulo*
1964	*XXXII bienal de Venice*
1987	*Art of the Fantastic: Latin America, 1920–1987,* Indianapolis Museum of Art (traveling)
1989	*Art in Latin America: The Modern Era, 1820–1980,* South Bank Centre, London
1993	*Latin American Artists of the Twentieth Century,* Museum of Modern Art, New York

Tarsila do Amaral: *Central Railroad of Brazil,* **1924. Photo courtesy of Museo de Arte Contemporaneo, Sao Paulo, Brazil/Index/Bridgeman Art Library.**

Publications:

On do AMARAL: Books—*Tarsila–Sua obra e seu tempo* by Aracy A. Amaral, 2 vols., São Paulo, Editore Perspectiva, 1975; *Revista de antropofagia* by Augustos de Campos, São Paulo, Cia Lithographica Ypiringa, 1976; *Tarsila* by Maros A. Marcondes, São Paulo, Arte Editora, 1986; *Tarsila–Sua obra e seu tempo* by Aracy A. Amaral, São Paulo, Tenege, 1986; *Tarsila do Amaral: A modernista* by Nádia Battella Gotlib, São Paulo, Editora SENAC, 1997; *Tarsila: Anos 20,* São Paulo, Página Viva, 1997; *Tuneu, Tarsila e outros mestres* by Ana Angélica Albano and others, São Paulo, Plexus, 1998; *Tarsila do Amaral: Projecto Cultural Artistas do Mercosul* by A. Aracy, São Paulo, Fundação Finambrás, 1998. **Articles**—''Manifesto Antropofago'' by Oswald de Andrade, in *Revista de Antropofagia,* 1, May 1928; ''Manifesto of Pau-Brasil Poetry'' by Oswald de Andrade, translated by Stella M. de Sá Rego, in *Latin American Literary Review,* 14, January-June, 1986, pp. 184–187; ''Tarsila do Amaral: A Brazilian Modernist'' by C. Damian, in *Woman's Art Journal,* 20(1), 1999, p. 3.

* * *

Tarsila do Amaral was born in 1886 on a farm in Capivari, in the interior of the Brazilian state of São Paulo, to a wealthy landowning family that often traveled to Europe. She began painting only in 1916 at the age of 30, and in 1920 she went to Paris to study at the Académie Julien with the conservative academician Emile Penard. Although do Amaral missed the celebrated *Semana de Arte Moderna* in February 1922 in São Paulo, itself a consequence of Anita Malfatti's exhibition of 1917, she was greatly influenced by the intellectual activity that emerged from it. This group of intellectuals, from all areas of the arts, was committed to the development of modernism in Brazil, which at the time was deeply conservative and dependent on foreign cultural influences.

Through Malfatti, do Amaral met the poet Oswald de Andrade, who became her companion until 1929. Together with others such as Sergio Buarque de Holanda, they formed the futurist group Klaxon in 1922. She also formed the short-lived Grupo de Cinco with Malfatti, Oswald de Andrade, Mário de Andrade, and Paulo Menotti del Picchia. Do Amaral returned to Paris in 1922–24, accompanied by de Andrade, in order to meet with the Parisian avant-garde. She took a studio there and mixed with many French and Brazilian intellectuals. Her impressionist-style nudes, portraits, and interiors, painted with spontaneous brushwork on textured canvases, gave way to more disciplined geometric forms. Do Amaral studied modernism in Paris and was particularly drawn to cubism, studying with Fernand Léger, Albert Gleizes, and André Lhote. Indeed, her paintings of 1924–27 reflect Léger's influence. Together with de Andrade she coined the term *Pau-Brasil* (from the highly symbolic brazilwood tree) to represent a specific Brazilian modernist aesthetic. The name lent itself to a poetry manifesto of 1924.

While she was in Paris, do Amaral befriended the French poet Blaise Cendrars, who later went to Brazil to give a talk on modern French poets. Afterwards a group of Brazilians, including do Amaral and de Andrade, traveled with Cendrars into the interior of Brazil. In the states of Minas Gerais, Bahia, and Pernambuco they rediscovered Brazil's Portuguese colonial baroque past and came into contact with the different popular arts synonymous with each region. Do Amaral celebrated the culture of these places in a series of paintings, including *Lagoa Santa* (1925), that contrasted with images of urban,

industrial Brazil in works such as *EFCB* (1924). The British art historian Dawn Ades has pointed out that these images suggest an industrial primitivism in which the buildings have flat facades with little or no perspective and remain devoid of people, whereas the images of interior towns and urban favelas are much more animated, with a greater use of color and movement.

Although Brazilian intellectuals were at this time highly educated, wealthy, and Europeanized, they resolved to change the consciousness of Brazilians by undertaking a reassessment of colonialism. They were not without their critics, however. One Brazilian commentator remarked on Do Amaral's return from Paris, dressed in the latest French fashions, to teach the people how to be Brazilian. The publication of the *Manifesto antropófago* in 1928, however, determined the direction in which this intellectual core was headed. Exhorting the artist to devour the colonizer through the ingestion and digestion of its culture, the manifesto urged the artist to produce a wholly new Brazilian form. Do Amaral's most influential period, the 1920s and early 1930s, coincided with these various manifestos, and she is seen as the painter who best represents the Brazilian aspirations for nationalistic expression in a modernist style during this period of great intellectual activity. Her masterworks include the celebrated *A negra* (1923) and *Antropófagia* (1929). She also illustrated the *Revista de antropófagia* with drawings and sketches that would serve as studies for her well-known work *Abaporu* (1928), which translates from Tupí-Guaraní as ''man who eats (himself)'' and which echoed images of the classic sciapod.

In 1931 do Amaral traveled to Moscow and on her return to Brazil became more interested in painting in a social realist style, producing, for example, *Segunda classe* (1933). During the 1950s and 1960s she reworked past themes, but do Amaral is best known for the work she produced in the 1920s in association with the anthropophagite movement. Consequently, she is seen as one of the great Latin American modernists who chose to reject European cultural influences in a bid to identify and celebrate the particular and rich culture of Brazil.

—Adrian Locke

DOWNEY, Juan
American video installation artist

Born: Santiago, Chile, 1940; moved to the United States, 1966. **Education:** Universidad Católica, Chile, 1957–61, B.A. in architecture 1961; Stanley Hayter's ''Atelier 17,'' Paris, 1963; Pratt Institute, Brooklyn, New York, 1967–69. **Family:** Married Marilys Lamadrid. **Career:** Instructor, Pratt Institute, Brooklyn, New York. Cofounder, artist collective *New Group,* New York. **Awards:** Scholarship, Fondart del Ministerio de Educación, Chile; video fellowship, Rockefeller Foundation, New York; fellowships, Guggenheim Memorial Foundation, New York, 1971, 1976; Prize for Excellence in Art, Science and Technology, 49th Venice Biennale ''Plateau for Mankind,'' 1986, for *About Cages;* awards, New York State Council on the Arts; awards, National Endowment for the Arts; award, Kaltenborn Foundation; award, Massachusetts Council for the Arts and Humanities. **Died:** 1993.

Individual Exhibitions:

1962 Galería Condal, Barcelona, Spain

1964	Galería Carmen Waugh, Santiago, Chile
1965	Pan-American Union, Washington, D.C.
	Casa de las Américas, Havana, Cuba
1968	Judson Church, New York
	University of Pennsylvania, Philadelphia
	Smithsonian Institution, New York
	Lunn Gallery, Washington, D.C.
	Marta Jackson Gallery, New York
	Galerie Jaqueline Ranson, Paris
1969	Corcoran Gallery of Art, Washington, D.C.
	Instituto de Arte Contemporáneo, Panamá City
1970	Howard Wise Gallery, New York
	Electric Gallery, Canada
1974	The Kitchen, New York
1975	Center for Inter-American Relations, New York
1976	Contemporary Arts Museum, Houston, Texas
1977	Galería Alder/Castillo, Caracas, Venzuela
	Everson Museum of Art, New York
	Anthology Film Archive, New York
1978	University Art Museum, Berkeley, California
1979	Mandeville Gallery, La Jolla, California
1982	Schlesinger-Boissante Gallery, New York
	Leo Castelli Gallery, New York
1984	Galería de Arte "Plástica 3," Santiago, Chile
1985	San Francisco Museum of Modern Art
1987	Ediciones Visuala Galería, Santiago, Chile
1989	Institute of Contemporary Art, Boston
1990	International Center of Photography, New York
1992	Galería Praxis, Santiago, Chile
1993	Festival de la Creación Vídeo, Clermont-Ferrand, France
	Lincoln Center, New York
1995	Museo Nacional de Bellas Artes Santiago, Chile
1998	Museum of Modern Art, New York

Selected Group Exhibitions:

1969–70	*Latin America: New Paintings and Sculpture,* Center for Inter-American Relations, New York
1975	*Biennial Exhibition,* Whitney Museum of American Art, New York
1977	*VI Documents of Kassel,* Germany
1987	*The Situated Image,* Mandeville Gallery, La Jolla, California
1989	*The Latin American Spirit: Art & Artists in the U.S.,* Bronx Museum, New York
1991	*Biennial Exhibition,* Whitney Museum of American Art, New York
2000	*An Independent Vision of Contemporary Culture 1982–2000,* Exit Art, New York

Collections:

Museum of Modern Art, New York; Whitney Museum of American Art, New York; Juan Downey Foundation, New York; Stedelijk Museum, Amsterdam; Casa de las Américas, Havana, Cuba; Bibliothèque Nationale, Paris; National Collection of Fine Arts, Washington Free Library of Philadelphia; Corcoran Gallery of Art, Washington, D.C.; Tel-Aviv Museum, Israel; Center for Inter-American Relations, New York; Museo Nacional de Bellas Artes, Santiago, Chile; Museo de Bellas Artes, Caracas, Venezuela; Everson Museum

of Art, Syracuse, New York; Library of Congress, Washington D.C.; Museo de Arte Contemporáneo, Caracas, Venzuela; Museo de la Solidaridad Salvador Allende, Santiago, Chile.

Publications:

On DOWNEY: Books—*Awareness of Love* by Rafael F. Squirru, Washington, D.C., H. K. Press, 1966; *Latin America: New Paintings and Sculpture,* exhibition catalog, New York, Center for Inter-American Relations, 1969; *Juan Downey: Dibujando con los yanomami,* exhibition catalog, Caracas, Venezuela, Galería Alder/Castillo, 1977; *Juan Downey: 20 años de dibujos, grabados, y videos,* exhibition catalog, Santiago, Chile, Galería de Arte "Plástica 3," 1984; *The Situated Image,* exhibition catalog, La Jolla, California, Mandeville Gallery, 1987; *Festival Downey: Video porque te ve,* exhibition catalog, Santiago, Chile, Ediciones Visuala Galería, 1987; *Juan Downey: Of Dream into Study* by John G. Hanhardt and Anne H. Hoy, Santiago, Chile, Lord Cochrane, 1989; *Illuminating Video: An Essential Guide to Video Art* by Sally Jo Fifer and Doug Hall, New York, Aperture with Bay Area Video Coalition, 1990; *Juan Downey: Instalaciones, dibujos, y videos,* exhibition catalog, Santiago, Chile, Museo Nacional de Bellas Artes, 1995; *Juan Downey: With Energy beyond these Walls* by Josephine Watson, Valencia, Spain, IVAM Centre del Carme and Generalitat Valenciana, 1998.

* * *

Juan Downey was one of the important figures of Latin American conceptualism in the 1960s and 1970s. His work articulated a critique of architectural utopias as well as of the relation between art and technology, while he maintained an acute awareness of his position as a Latin American within the art world. Born in Santiago, Chile, in 1940, he studied architecture and after graduation traveled to Barcelona and then to Paris, where he made the acquaintance of artists such as Roberto Matta, Takis, and Julio Le Parc, who exerted an important influence in his early work. While in Paris, Downey became interested in kinetic art and developed a particular vision that went beyond the op art tendencies of the time to a concern with creating objects in which modernist form, the machine, and human perception could be put in play.

Downey moved to the United States, first to Washington, D.C., in 1966 and then in 1970 to New York City, where he resided until his death in 1993. During this period he joined Douglas Davis to form the New Group, an artists' collaborative, and worked on his electronic sculptures, which stemmed not only from a concern with machine aesthetics but also with the idea of working with energy and engaging the public's participation in the work. His piece *Invisible Communication* (1967), consisting of three geometric volumes that interacted with one another through the emission of light and sound when spectators were in the vicinity, was one of the first such interactive sculptures. The work gave rise to a series of installations, performances, and related drawings bearing the title *Invisible Energies,* through which he continued to experiment with light, sound, and magnetic fields as crucial, although not always intrinsic, to the object. These works were also an investigation into the perception of space and how the work of art conditioned the spectator's awareness of the immediate and the urban surrounding space.

From the 1970s onward Downey's interest in technology became a driving force behind his work, and he began experimenting with video as one of the most advanced technological mediums of the

day. But soon his work in technology shifted to a political critique as the United States increasingly relied on its technological resources to foster warfare in Third World countries in order to sustain its economic and political interests. This was not only the case in Vietnam but also in Downey's homeland of Chile, where the United States purportedly supported the right-wing forces that contributed to the downfall of Salvador Allende Gossens's socialist government. The situation in Chile led Downey toward reflection on his identity and to an exploration of the more primeval roots of Latin American culture; after having been exposed to the Paris and New York art worlds, he wanted to "recuperate his culture." In the mid-1970s he began to work on the *Trans Americas* series, in which his critique of technology and his interest in video as a narrative and documentary medium would merge with an anthropological methodology. Video not only became the ethnographer's field instrument but also put the objective eye of film technology at the service of the poetics of the artist. *Trans Americas,* which started as a diary-like and documentary project that set out to explore the indigenous cultures of Latin America through their architecture and social forms as conditioned by the structure of their dwellings, constitutes Downey's most ambitious and extended body of work. He traveled to the Amazon, where he lived among the Guahibos and then the Yanomami for a period of nearly two years. The work carries out a strong critique of the effects of civilization on these societies, which now live on the margins of modern culture in Latin America, and posits them as an example of displacement and cultural shock and as a metaphor for the artist himself. In later works Downey continued to question the conventional anthropological perspective of the other, as in his 1979 work *The Laughing Alligator.*

In the 1980s Downey made another voyage, this time, however, a virtual one, to the roots of his European cultural heritage. He began to work on his other great series, *The Thinking Eye, Culture as an Instrument of Active Thought,* composed primarily of *The Looking Glass* (1981), *Information Withheld* (1983), *Shifters* (1984), *J.S. Bach* (1986), and the interactive videodisc *Bachdisc* (1988). In this series he employed systems of analytic interpretation to research myths and traditions of Western culture, also fundamental to his identity as a Latin American. In his own words the series represented "an attempt to decipher the self through cultural obsessions." In 1990 Downey began working on his last series of videos, entitled *Hard Times and Culture,* which were to explore the links between cultural creation and the social, political, and economic conditions of decadence. Before his death he had completed the first part of *Vienna, fin-de-siècle.*

Downey was a complex and multifaceted artist who considered his work more than art. He saw it, in the traditional art history sense, as an instrument of cultural communication that not only aroused in the public an awareness of context but that also engaged people in a critical examination of postmodern culture and society.

—Julieta Gonzalez

DUCLÓS, Arturo
Chilean painter

Born: Santiago, 3 May 1959. **Education:** Universidad Católica de Chile, M.F.A. 1984. **Career:** Cofounder, Escuela de Santiago, 1993.

Awards: Fellowship, Guggenheim Foundation, 1992; fellowship, Fondo Nacional para los Amigos del Arte, Santiago, 1993, 1994; first prize, Ciencias de Artes y Comunicación, Universidad UNIACC, Santiago, 1996.

Individual Exhibitions:

1985 *La lección de anatomía,* Bucci Gallery, Santiago
1989 *La isla de los muertos,* Ojo de Buey Gallery, Santiago
1990 Instituto Chileno Norteamericano, Concepción, Chile
1991 *Ora pro nobis,* Galería Espacio Arte, Santiago
1992 Galería Jean Marc Patras, Paris
 Centre d'Art Herblay, Paris
1993 Annina Nosei Gallery, New York
1994 Le Sous-Sol, Paris
 Annina Nosei Gallery, New York
1995 *El ojo de la mano,* Museo Nacional de Bellas Artes,
 Santiago (traveling)
 Leonora Vega Gallery, San Juan, Puerto Rico
 Ambrosino Gallery, Miami
 Annina Nosei Gallery, New York
 Pinturas ornamentales, Galería Tomás Andreu, Santiago
1996 Associazione Culturale Contemporanea, Milan
 Galería Tomás Andreu, Madrid
1997 *Les tables mises,* Annina Nosei Gallery, New York
 Sixth Havana Biennial
1998 *Caput corvi,* Ruth Benzacar Gallery, Buenos Aires
 (traveled to Galería Tomás Andreu, Santiago)
 Consulado Argentino, New York
 Alquimia en el trabajo de Arturo Duclos, Essex
 University Gallery, Colchester, England (traveling)
1999 *El lenguaje de los pájaros,* Galería DPM, Guayaquil,
 Ecuador
 Galería Tomás Cohn, São Paulo
 Sal+Azufre+Mercurio, Galería Frances Wu, Lima
 Alchemy in the Work of Arturo Duclos, Bolivar Hall,
 London
2000 *Armonía Chimica,* Sicardi Gallery, Houston
 Animal Gallery, Santiago

Selected Group Exhibitions:

1991 *IV bienal internacional de la Habana,* Havana
1992 *Anteamérica,* Museo Alejandro Otero, Caracas
 (traveling)
1994 *Ocho pintores chilenos,* Museo de Arte Moderno,
 Mexico City
1995 *La mythe tragique de la vedette en el night club:
 Pinturas recientes,* Galeria Gabriela Mistral, Santiago
1996 *Latinoamérica '96,* Museo Nacional de Bellas Artes,
 Buenos Aires
1998 *XXVI bienal de São Paulo*
 Cinco continentes y una ciudad, Museo de la Ciudad de
 Mexico, Mexico City
 Bienal de arte en 360˚, Santiago
1999 *Art Miami,* Miami Beach, Florida

I bienal mercosul, Porto Alegre, Brazil

Collections:

Museo Nacional de Bellas Artes, Caracas; Phoenix Art Museum; Museo de Arte Moderno, Santiago; Museo de Arte Contemporáneo, Santiago; Museo de Arte Contemporáneo, Valdivia, Chile.

Publications:

By DUCLÓS: Article—"Statement against Censorship," with Gonzalo Díaz and Eugenio Dittborn, in *Art Monthly* (United Kingdom), 179, September 1994, p. 24.

On DUCLÓS: Books—*Biothanatos: Pinturas de Arturo Duclós* by Claudia Donoso, Santiago, Mario Fonseca, 1990; *Ora pro nobis,* Santiago, F. Zegers Editor, 1991, and *El ojo de la mano,* exhibition catalog, Santiago, Osculum Infame Editores, 1995, both by Guillermo Machuca; *7 Latin American Artists,* exhibition catalog, New York, Annina Nosei Gallery, 1993; *Ocho pintores chilenos,* exhibition catalog, with text by Gabriel Barros, Mexico City, Museo de Arte Moderno, 1994; *Arturo Duclós: Opere recenti,* exhibition catalog, Milan, Associazione culturale Ciocca Raffaelli, 1996; *Arturo Duclós,* exhibition catalog, with text by Sofia Fan, São Paulo, Galeria Thomas Cohn, 1999. **Articles**—"Arturo Duclos" by Nena Ossa, in *Art News,* 92, May 1993, p. 117; "Arturo Duclós: Myths and Tombs" by Guillermo Machuca, in *Art Nexus* (Colombia), 11, January/March 1994, pp. 206–208; "Searching South: Two South American Artists" by Mario Flecha, in *Art & Design,* 9, July/August 1994, pp. 44–51; "Arturo Duclós" by Dan Cameron, in *Flash Art* (Italy), 182, May/June 1995, p. 100; "Arturo Duclós: Ornament and Representation" by Justo Pastor Mellado, in *Art Nexus* (Colombia), 21, July/September 1996, pp. 87–88; "Arturo Duclós" by Jorge Lopez Anaya, in *Art Nexus* (Colombia), 30, November 1998/January 1999, pp. 126–127; "Art Miami 99" by Carol Damian, in *Art Nexus* (Colombia), 32, May/July 1999, pp. 92–94; "Arturo Duclós," in *Art & Antiques,* 23(2), February 2000, pp. 67.

* * *

Arturo Duclós has become one of the most influential Chilean artists of his generation. His works reflect both the complex relationship between symbols and meaning in the postmodern world and the turbulent contemporary history of his native country. They challenge the viewer to make sense of the multitude of images, texts, textures, and signifiers on display, often with unsettling results. Duclós's primary medium has been painting, but he has also employed techniques and elements of printmaking, which he studied formally in the early 1980s, and design.

Duclós, who was born in Santiago in 1959, came of age during the turbulent years that followed the U.S.-backed military coup that overthrew Chile's elected government in 1973. In the late 1970s and early 1980s the Chilean art world was split into two warring camps, the critical-conceptualists, who valued a work's discourse over its aesthetics, and the proponents of so-called new painting, who strove to rejuvenate painting as a representational art form. Duclós quickly found a home with the critical-conceptualists, and he announced himself as an artist to be watched with his 1983 work *The Anatomy Lesson.* On display at Santiago's Bucci Gallery in 1985, this installation, the centerpiece of Duclós's first solo exhibition, featured a collection of human bones gathered from a Santiago morgue, painted with oil, and arrayed on a large towel.

As the 1980s unfolded and Chile began to recover from the trauma of the 1970s, Duclós became more open to representational painting. For example, the works in his 1989 solo exhibition, held at the Ojo de Buey Gallery in Santiago and entitled *La isla de los muertos,* incorporated texts and symbolic images. But instead of deploying them according to their commonly understood meanings, Duclós persistently problematized them, leaving them stripped of their familiar contexts and forcing them to sink or swim in their own hermeneutic universe. The work retained Duclós's austere, uncompromising style. In other works he continued to make use of unconventional materials, including sheets, curtains, burlap, textiles, printed materials, sleeping bags, blood, and bone.

By the mid-1990s Duclós was consistently producing dense multilayered works that pushed further at the meaning of symbolic systems. His 1993 piece *La mano loco,* for example, converted the Roman Catholic sign of the cross from a trinity to a quaternity and juxtaposed it with a fourfold figure consisting of a hammer and sickle, a cross, a star, and a pair of crossed daggers. Images of horse heads in ovals stand guard over each corner of the work, while a white plastic frame juts out from the center of the painting, housing a stylized picture of roses and lettered with the Latin word *verbum* (truth). Duclós has also retained his interest in depictions of the body. He caused a stir in 1995 by exhibiting a Chilean flag made entirely from 70 human femurs. In a 1997 installation at the Sixth Havana Biennial he ran tubing around the exhibition rooms and corridors of the site, through which he intended to circulate human blood. Customs regulations forced him to substitute pig blood at the last moment, but the piece nevertheless included pictures and biographical information about the people who had donated their blood for the work.

Duclós has continued to refine his conceptual paintings. His 2000 solo exhibition *Armonía Chimica,* at the Sicardi Gallery in Houston, Texas, featured a series of works called *Sefirot* and another entitled *Four Elements,* which further explored the relationship between man's search for meaning and the apparent meaninglessness–or at least indecipherability–of the world he inhabits.

—Rebecca Stanfel

EGAS, (Juan) Camilo
Ecuadoran painter

Born: Quito, 1889. **Education:** Escuela de Bellas Artes, Quito, 1904–11; Regia Scuola di Belle Arti, Rome (on government grant), 1911–14; Academia de San Fernando, Madrid (on government grant), 1919–20; Académie Colarrosi, Paris, 1923. **Career:** Drawing instructor, Escuela Normal de Señoritas, 1908; lithographer, Casa Danessi, Rome, 1912; professor of lithography, Ecuador, 1915; architect, Oficina de Fomento, Ecuador; commissioner of fine arts, Ecuadoran Pavilion, *Exposition internationale des arts décoratifs et industriels modernes*, Paris, 1925; art director, Teatro Nacional Sucre, Ecuador, 1925; founder, Egas Art Center, Quito, 1926; founder, art magazine *Hélice,* Quito, 1926. Moved to the United States, 1927. Professor of painting, 1929, and director of art, *ca.* 1935–62, New School for Social Research, New York; commissioner of fine arts, Ecuadoran Pavilion, 1939 New York World's Fair. Muralist, including murals at the New School for Social Research, New York, 1933, and Ecuadoran Pavilion, 1939 New York World's Fair. **Awards:** Gold medal, *Exposicion nacional,* 1916; Mariano Aguilera prize, 1918. **Died:** New York, 18 September 1962.

Selected Exhibitions:

1912 Amatorie Culturi delle Belle Arte, Rome
1915 *Exposicion nacional de Quito*
1924 Salon des Indépendents, Paris
 Salon d'Automne, Paris
1931 New School for Social Research, New York
1933 John Reed Club, New York
1939 World's Fair, New York
1946 Acquavella Gallery, New York
1952 Casa de la Cultura Ecuatoriana, Quito
1956 Museo Colonial de la Casa de la Cultura Ecuatoriana,
 Quito
1963 New School for Social Research, New York

Collections:

Museo Antropológico, Guayaquil, Ecuador; Banco Central del Ecuador, Quito.

Publications:

On EGAS: Book—*The Indian in the 1920's Painting of the Ecuadorian Painter Camilo Egas* (thesis) by María Trinidad Pérez, Austin, University of Texas, 1987.

* * *

Known primarily as the founder of indigenism in Ecuador, Camilo Egas worked in myriad styles during his artistic career. He received his education at the Escuela de Bellas Artes in Quito under the tutelage of the French artist Paul Bar and the Italian sculptor Luigi Casadio, the first instructor at the school to use indigenous models in life drawing classes. Through this exposure Egas began to employ the indigenous figure in native dress as a decorative motif in his paintings. His early works demonstrated a break from nineteenth-century images of attractive Indians in picturesque settings. In works such as *Las floristas* ("The Flower Sellers") he emphasized the ornate detailing of the costumes and added exotic tropical flora to the composition to create a colorful patterned surface. These works served as a precursor to the more socially conscious exploration of indigenous subjects that emerged in Ecuador in the 1930s.

As part of his studies Egas traveled to Rome on a government grant and later enrolled in the Academia de San Fernando in Madrid. In the early 1920s he spent several years in Paris, where he became acquainted with the work of the French avant-garde and incorporated current European trends into his work. The French fascination with the exotic as well as the postwar return to naturalism most likely guided the course of his development, encouraging his continued exploration of indigenous themes.

In 1925 the Ecuadorian government appointed Egas to represent the country in the international arena, placing him in charge of organizing the Ecuadorian exhibition at the *Exposition Internationale des Arts Décoratifs et Industriels Modernes* in Paris. His experience abroad led him to attempt to incite an avant-garde movement in Ecuador. Upon his return to Quito he established the Egas Art Center, which served as a meeting place for artists, and edited the country's first art journal, *Hélice* (Propeller), modeled after European avant-garde publications. The journal, which promoted social criticism and new artistic ideas, did not find an audience in Ecuador, however. The next year Egas abandoned the journal and moved to New York City in search of a more receptive artistic milieu. He took up permanent residence there, returning to Ecuador only infrequently.

In 1929 Egas took a position as an art professor at the New School of Social Research, and by 1935 he had been appointed director of the art school. Although his position at the New School took up much of his time, he continued to paint and to follow closely artistic developments in New York. His work in the 1930s clearly partook of Depression-era social realism. In works such as *Fourteenth Street* he painted the gritty reality of poverty and social isolation in New York. Also during his tenure at the New School, Egas befriended the Mexican muralist José Clemente Orozco, and he was greatly influenced by Orozco's bold expressionistic style. Orozco's impact is clearly evident in the mural Egas painted for the Caroline Bacon Room at the New School, in which he incorporated Orozco's use of anatomical deformations and monumental figures in a rendition of Indians laboring in the fields. Egas repeated this theme in his mural *La cosecha* ("The Harvest"), painted with Eduardo Kingman for the Ecuadorian pavilion at the 1939 New York World's Fair.

In the 1940s, as a result of the arrival of the European surrealists in New York, Egas began depicting grotesque figures in a nightmarish dreamworld while maintaining the Indian as his primary subject. In the 1960s his style metamorphosed once again, demonstrating the impact of abstract expressionism. He created powerful canvases coated with thick layers of gray and blue paint in a perpetual exploration of surface texture. The work of this diverse artist thus runs the gamut from social realism to abstraction, placing him among the most important figures of modern Ecuadorian art.

—Michele Greet

EIRIZ, Antonia
Cuban painter

Born: Havana, 1929. **Education:** San Alejandro National School of Fine Arts, Havana, degree in art 1958. **Career:** Involved with the Neo-Expressionist movement, Cuba, late 1950s. Professor, School for Crafts Instructors, Havana, 1962–64; art professor, Cubanacan National School of Art, Havana, 1965–69. Traveled to Italy, Spain, and France, 1966. Participated in artist exchange program with Germany and Russia, 1975. Art consultant, Foundation for Cultural Patrimony, Cuba, 1984–89. Judge, National Salon Competition, National Museum of Fine Arts, Havana, 1970, and Cuadrennial, Erfurt, Germany, 1982. **Awards:** First place, Alliance Française Poster, Havana, 1959; first place, "Towards the Revolution" contest, Havana, 1960; honorable mention, *Biennial VI,* São Paulo, Brazil, 1961; first place woodcut, First Competition of Latin American Prints, Casa de las Americas, Havana, 1963; travel fellowship, United Nations Educational, Scientific, and Cultural Organization, 1966; Contributions to Culture medal, 1981, Raul Gomez Garcia medal, 1982, Alejo Carpentier medal, 1983, and Order of Felix Varela, 1989, all Ministry of Culture, Cuba. **Died:** Miami, 1995.

Individual Exhibitions:

1964	Galería de la Habana, Havana
	National Museum of Fine Arts, Havana
	Del Lago Gallery, Mexico City
1967	*Thirty Illustrated African Poems,* Gliano Gallery, Havana
1985	Latin American Cultural Space Gallery, Paris
1986	Foundation for Cultural Patrimony Gallery, Havana
1987	Municipal Museum of Guanabacoa, Havana
	Angel Romero Gallery, Madrid
1991	*Reencuentro,* Galiano Gallery, Havana
1993	Duchess County Art Association Barrett House Gallery, Poughkeepsie, New York
	Weiss/Sor Fine Art, Coral Gables, Florida
1995	*Antonia Eiriz: Tribute to a Legend,* Florida International University, Miami

Selected Group Exhibitions:

1960	*National Salon,* National Museum of Fine Arts, Havana
1961	*Biennial VI,* São Paulo, Brazil
1962	*First Competition of Latin American Prints,* Casa de las Americas Gallery, Havana
1963	*50th Anniversary Exhibition,* National Museum of Fine Arts, Havana
	Sixth Anniversary of the Revolution, Galería de la Habana, Havana
1965	*Print Biennial,* Santiago, Chile
1966	*Homage to Escardo-Baragano,* Union of Writers and Artists Exhibition, Havana
1967	*Painters and Guerillas,* Casa de las Americas Gallery, Havana
1969	*Cuban Paintings Today,* United Nations, New York
1989	*Havana in Madrid,* Madrid

Collection:

National Museum of Fine Arts, Havana.

Publications:

On EIRIZ: Books—*Antonia Eiriz: Tribute to a Legend,* exhibition catalog, essay by Juan A. Martínez, Fort Lauderdale, Florida, Museum of Art, 1995; *Antonia Eiriz: Primer homenaje postumo, con obras nunca antes expuestas,* exhibition catalog, Fondo Cubano de Bienes Culturales, 1995. **Article**—"Antonia Eiriz: An Appreciation" by Giulio V. Blanc, in *Art Nexus,* 13, July/September 1994, pp. 134–136.

* * *

One of the most important artists to come of age during the Cuban revolution, Antonia Eiriz was a provocative, paradoxical figure. She never conformed to the officially prescribed social realist style or the officially acceptable subject matter. Much of her early work may be interpreted as ironic comments on the excess of demagoguery and as critical of the Cuban government. When abstraction was forbidden and her creative enterprises stifled in the days of cultural repression that marginalized so many Cuban intellectuals in the late 1960s, she ceased producing art in a silent and terrible protest against a policy that was hostile to culture. At the same time, she became a mythic figure, influencing a generation of artists. She was respected as a teacher at the Cubanacan National School of Art and the School for Crafts Instructors in Havana, received numerous awards and fellowships, and served in the 1980s as the art consultant for the Foundation for Cultural Patrimony in Cuba. She maintained her personal protest by not doing her own work until after she went into exile in 1993. She then resumed painting for the three short years before her death in Miami.

The early career of Eiriz was influenced by a group of abstract expressionists in Cuba known as *Las Once* ("The Eleven"), which existed from1953 to 1955. She shared with the group an interest in creating art that was intuitive, yet conscious of formal elements, and although she moved toward figuration, painterly expression persisted as basic to her work throughout her career. As she developed her own personal style, her imagery professed a tragic view of humanity, symbolic of the time in which she lived in revolutionary Cuba. There always seems to be hidden meaning in the painterly images of Eiriz, and her visual language often employs skulls, demons, phantasm, and irreverence to tell a story within a style that is neoexpressive and replete with existential content. Contorted figures occupy large canvases, with surfaces scarred by rough textures and mixed media. The tendency toward social content within abstraction is not unusual in Latin America, and Eiriz painted brutally grotesque characters that

reflected the power of the Cuban revolution in its early days. She also did some large-format prints and assemblages with found objects that were unique in Cuban artistic production in her day.

In Miami in 1993 Eiriz resumed painting her vision of humanity in all of its tragedy and pain. Large-scale canvases with screaming ghosts and haunting interpretations of religious and social significance appeared in sinister visions of resigned sadness. Images emerged out of the layers of thick pigment to confront the viewer with their agony. Poignant meditations of profound pessimism, these last works were dark and prophetic of the end of her life.

—Carol Damian

ELETA, Sandra
Panamanian painter and photographer

Born: Panama City, 4 September 1942. **Education:** Finch College, New York, 1961–64; New School for Social Research, New York; International Center for Photography, New York; Escuela de Arquitectura de la Universidad de Costa Rica. **Career:** Instructor of photography, Universidad de San José, Costa Rica, 1972–73. Since 1974 freelance photographer, Panama. Cofounder, Taller Portobelo, Panama. **Award:** Crystal Apple prize, New York Film Festival, 1985.

Individual Exhibitions:

1980	Consejo Venezolano de Fotografía, Caracas
1982	*Portobelo,* Museo de Arte Contemporáneo de Panama
1998	*XXIV bienal de São Paulo,* Brazil
	Galerie Agthe Gaillars, Paris
	Museo de Arte Moderno, Mexico City (traveling)
1999	*II bienal iberoamericana,* Lima

Selected Group Exhibitions:

1976	Galería Fotocentro, Madrid
1978	Museo de Arte Moderno de Mexico, Mexico City
1979	*Encuentros internacionales de fotografia,* Arles, France
1981	Kunsthaus de Zurich
1983	Centro Geroge Pompidou, Paris
	Museo de Arte Contemporáneo, Panama City
	Galerie Agathe Gaillard, Paris
1992	Photographers' Gallery, London
1999	*Mujeres en el arte: Cinco artistas de Panama,* Mujeres en las Artes, Tegucigalpa, Honduras

Publications:

By ELETA: Book, photographed—*Con Ernesto Cardenal: Un viaje a solentiname* by Gloria Guardia, n.p., Editorial Litográfica, 1974.

On ELETA: Books—*31 fotografías de Sandra Eleta,* exhibition catalog, Caracas, Consejo Venezolano de Fotografía, 1980; *Portobelo: Fotografía de Panama,* second edition, text by María Cristina Orive, Edgar Soberón Torchia, and Edison Simons, Buenos Aires, La Azotea, 1991; *Desires and Disguises: Five Latin American Photographers,* exhibition catalog, text by Amanda Hopkinson, London and New York, Serpent's Tail, 1992. **Article**—''Sandra Eleta: Portobelo Unseen'' by Nita M. Renfrew, in *Aperture,* 109, winter 1987, pp. 48–57.

* * *

Photographer Sandra Eleta first gained prominence in the 1970s with her extraordinary black-and-white images of the people of African descent who inhabit the town of Portobelo on Panama's Caribbean coast, where the artist has lived for many years. Trained in fine arts, social research, and photography in New York City, this well-traveled artist produced work from a broad base that reflected her international culture, technical ability, and communication with her subjects. Her view of the world was always humanistic and highly personal and often linked to her sense of spirituality and her attachment to Panama.

The image of *Putulungo, the Octopus Gatherer,* which over time has become an icon for Eleta's oeuvre, is only one of the many photographs produced in Portobelo between 1977 and 1981 that were included in her book *Sandra Eleta: Portobelo* (1985). The interaction with the subject that one perceives in her perturbing yet beautiful images of the child named *Dulce* or of the dignified *Catalina, Queen of the Congos* reveals the intimate relationship and sense of solidarity she developed with the townspeople as well as her artistic sensitivity and knowledgeable use of the lens. In the artist's own words, she ''seeks to penetrate as much as possible into the identity of the subjects she deals with: looking for a dialog rather than for the grasping of moments.''

Eleta was among the first Panamanian photographers to explore the possibilities of self-expression through multimedia creations. Her first audiovisuals include a work in color about *Portobelo* (1984) and the piece *Sirenata en B,* for which she was awarded the Crystal Apple award at the New York Film Festival in 1985. In *Sirenata en B* (the title is a wordplay that combines the Spanish words for mermaid and serenade) Eleta created a daring, dreamlike story based on a driver of one of Panama's colorful, hand-painted buses, reflecting the world of traffic, salsa music, and lively figures that characterize that form of urban transportation and Panama's capital itself. The artist, who was in charge of the script, the photographs, and the music for *Sirenata en B,* has described it as ''an explosion, an absolute freedom of color, a wild experience.''

In the early 1990s Eleta put together a video entitled *The Empire Visits Us Once Again,* an imaginary documentary about the U.S. invasion of Panama, and was commissioned to produce the audiovisual entitled *Abia Yala–Tierra Grande* (''Great Earth'') for the Panamanian Pavilion at ExpoSevilla, Spain, in 1992. Toward the end of the decade, on commission from the United Nations, Eleta created a new audiovisual named *Along the Byways of the Chagres: Emberás, Children of the River* that combined a softened personal worldview with an anthropological perspective. The work focuses on the Chagres River and the natives who inhabit its shores, portraying an idealistic view of their world and of this great waterway, which has played a major role in Panama's historical development. While recording the lives of the people in their communities, Eleta at times achieved images of artistic, and almost magical, quality, such as her photograph of a girl, crowned with crabs, whose name is *America.*

In addition to her work as a photographer, Eleta has been active as the promoter of workshops, such as the co-op she established for women in Portobelo in the 1980s, and her joint explorations, with designer Juan Dal Vera, of handmade artworks, such as tapestries or clothing that seek to perpetuate traditions of the Caribbean coast. She

has also worked with the painter Arturo Lindsay on an exchange program between art students from the United States and artists from Portobelo, triggering the creation of the Taller Portobelo de Pintura, a lively center for painting and sculpture that has brought about the establishment of a new group of Panamanian artists with a language of their own.

During 1999 and 2000 Eleta further explored collaborative work, photography, and multimedia art through a joint project with the Panamanian artist Brooke Alfaro. Together they produced a large installation entitled "Comanche" that incorporated photography, sound, video, texts, and three-dimensional form in an exploration of the life of a street dweller in Panama City whom they befriended and based on whom they created a work of valuable humanistic, political, and artistic dimensions.

—Monica E. Kupfer

ELSO (PADILLA), Juan Francisco
Cuban sculptor and installation artist

Born: Havana, 1956. **Education:** Escuela de Artes Plásticas San Alejandro, Havana, 1970s; Escuela Nacional de Arte, Havana, 1970s. **Family:** Married Magali Lara (second wife). **Awards:** Honorable mention, *I bienal de la Habana;* prize, Salón Nacional de Paisaje, Museo Nacional de Bellas Artes, Havana, 1982. **Agent:** George Adams Gallery, 41 West 57th St., New York, New York 10019. **Died:** Havana, 1988.

Individual Exhibitions:

1982	*Tierra, maíz y vida,* Casa de Cultura, Plaza de la Habana, Havana
1986	*Ensayos sobre América,* Havana
1990	*Por América,* Museo de Arte Cariillo Gil, Mexico City (retrospective)
1991	*Latin American Spirituality, the Sculpture of Juan Francisco Elso, 1984–1988,* M.I.T. List Visual Arts Center, Cambridge, Massachusetts
1995	*Premio nacional anual de pintura contemporánea Juan Francisco Elso,* Museo Nacional Vitol SA, Havana

Selected Group Exhibitions:

1981	*Volumen I,* Havana
1984	*I bienal de la Habana,* Havana
1986	*XLII bienal de Venecia,* Venice
1988	*Art Expo from Cuba,* Naris Gallery, New York City
1990	*No Man Is an Island: Young Cuban Art,* Pori Taidemuseo, Finland
1992	*Ante América,* Biblioteca Luis-Angel Arango, Bogotá; Spencer Museum, University of Kansas, Lawrence
1997	*Face a l'Historie: 1933–1996,* Centre Georges Pompidou, Paris
	Caballos Politicos: Political Animals: Azaceta, Bedia, Benedit, Elso, Roche, George Adams Gallery, New York City,
1997–98	*Esto es: Arte objeto e instalación de Iberoamérica,* Centro Cultural/Arte Contemporaneo, A.C., Polanco,

Juan Francisco Elso: *Por América,* 1986. Photo courtesy of George Adams Gallery, New York, and Hirshorn Museum and Sculpture Garden, Washington, D.C.

Mexico; Fundacion Cultural Hispano Mexicana, Madrid

Collections:

Hirshhorn Museum, Washington, D.C.; Centro Cultural Arte Contemporáneo, Mexico City; Museo Nacional, Havanna.

Publications:

On ELSO: Books—*Latin American Spirituality, the Sculpture of Juan Francisco Elso, 1984–1988,* exhibition catalog, by Luis Camnitzer, Cambridge, Massachusetts, M.I.T. List Visual Arts Center, 1991; *Premio nacional anual de pintura contemporánea Juan Francisco Elso,* exhibition catalog, Havana, Museo Nacional Vitol SA, 1995; *Por Amrica: La obre de Juan Francisco Elso* by Luis Camnitzer, Rachel Weiss, and others, México, Universidad Nacional Autónoma de México, 2000. **Articles**—"Juan Francisco Elso," in *Arte en Colombia,* 45, October 1990, pp. 114–115, and "Juan Francisco Elso: Sacralisation and the 'Other' Postmodernity in New Cuban Art," in *Third Text* (London), 41, winter 1997–1998, pp. 74–84, both by Gerardo Mosquera; "An Art of Secular Mysticism: The Legacy of Juan Francisco Elso Padilla" by Luis Camnitzer, in *New Art Examiner,* 18, November 1990, pp. 28–30.

* * *

The Cuban artist Juan Francisco Elso Padilla, who died in 1988 at the age of 32, was one of the major contemporary sculptors of Latin America. His mark on modern art has become indelible owing to some stunning sculptural projects, particularly a portrait of José Martí. A student at the Escuela de Artes Plásticas San Alejandro and at the Escuela Nacional de Arte during the 1970s, Elso Padilla emerged as a key figure of the generation of the 1980s in the legendary *Volumen 1* exhibition of new art in Havana in January 1981. The following year he had his first solo show, an installation entitled *Tierra, maíz y vida*, at the Casa de Cultura, Plaza de La Habana. Influenced both by prehistoric cultures and the most up-to-date contemporary art from the West, he produced a body of work that engaged visually with the genesis myths of ancient pre-Columbian culture about *hombres de maíz*.

Elso Padilla subsequently produced a multimedia sculpture that has come to rank among the finest ever produced by a Latin American artist. This was his singular and deeply stirring 1986 image of Martí called simply *Por América*. Part conquistador and part African deity, the figure was made from rough-hewn wood and gesso along with various other materials. Some aspects of the Martí sculpture, such as the head, stand out for their striking naturalism, while other aspects are engaging because of the half-transformed state of the natural materials used. This self-conscious interplay of tactile materials and a gripping naturalism makes the work at once visionary and blunt, simultaneously both lofty and earthy.

About this justifiably famed sculpture, the Cuban critic Gerardo Mosquera has written that Elso Padilla ''left us one of the most astounding images in the history of Latin American art: Martí sculpted in the manner of a popular saint, clothed in earth and with machete raised, as if offering himself to the soil . . . at once an icon with a revolutionary mystique and the locus of power in the African manner, in addition to being an exemplar of Baroque imagery.'' As such, Mosquera concluded that a lesson of Elso Padilla's artwork is ''I am the other,'' so that the capacity to act in favor of our own self-determination means to act on behalf of a considered dialogue with everyone else.

The rich lineage left by Elso Padilla can be seen in the subsequent sculpture from Cuba of Alexis Leyva Machado (Kcho), Los Carpinteros, and Alejandro Aguilera González, the latter of whom produced in 1988 a brilliant portrait of Che Guevara as part of his installation *En el mar de América* at the Centro de Artes Visuales in Havana. Aguilera González's visually compelling portrait of Guevara, like Elso Padilla's masterful one of Martí, took a predictable subject and turned it into the most unlikely sculpture one could imagine. Elso Padilla was unquestionably the stimulus for the later work and for indeed the revitalization of Cuban sculpture and installation art generally.

—David Craven

ENRÍQUEZ (GÓMEZ), Carlos
Cuban painter

Born: Zulueta, 3 August 1900. **Education:** Graduated from business school in Philadelphia; attended Pennsylvania Academy of Fine Arts, Philadelphia. **Family:** Married 1) Alice Neel in 1925 (divorced 1930), two daughters (one deceased); 2) Eva Frejaville in 1939 (divorced 1945); 3) Germaine in 1945. **Career:** Worked at the Independent Coal Company, c. 1926. Lived in New York, 1927–30, then in Paris and Madrid, 1930–33. Traveled to Mexico, 1943, to Haiti, 1945. Member, artist group *Grupo Minorista,* Cuba, 1920s. **Awards:** Purchase awards, National Salons, 1935, 1938, 1946. **Died:** 2 May 1957.

Selected Exhibitions:

1927	*Exposición de arte moderno,* Havana
	XII salón de Bellas Artes, Havana
1935	*Salón nacional de pintura y escultura,* Havana
1937	*Exposición de arte moderno,* Centro de Dependientes, Havana
1938	*II salón nacional,* Havana
1944	Palacio de Bellas Artes, Mexico City
1946	*III exposición nacional,* Havana
1951	Museum of Modern Art, Paris

Exhibited in Mexico, 1938, 1946; United States, 1939, 1943, 1944, 1946; Haiti, 1945; Guatemala, 1944; Argentina, 1946.

Collections:

National Museum of Cuba; El Huron Azul, Havana; Museum of Modern Art, New York; Cuban Foundation Museum, Daytona Beach, Florida; Cuban Museum of Art and Culture, Miami.

Publications:

By ENRÍQUEZ: Books—*Tilín García,* Havana, Dirección General de Cultura, Ministerio de Educación, 1960; *La vuelta del Chencho,* Havana, Dirección General de Cultura, Ministerio de Educación, 1960; *La feria de Guaicanama,* Havana, Dirección General de Cultura, Ministerio de Educación, 1960; *Dos novelas,* prologue by Félix Pita Rodríguez, Havana, Editorial Arte y Literatura, 1975.

On ENRÍQUEZ: Books—*Carlos Enríquez* by Félix Pita Rodríguez, Havana, Editorial Lex, 1957; *Carlos Enríquez* by Juan Sánchez, Havana, Editorial Letras Cubanas, 1996.

* * *

The writer and painter Carlos Enríquez was a major figure in the first generation of Cuban modernists. Born to a wealthy family in Zulueta in the province of Las Villas, Enríquez traveled to the United States to study engineering as a young man. Eventually he dedicated himself to the visual arts and enrolled at the Pennsylvania Academy of Fine Arts in Philadelphia. There he pursued a traditional academic curriculum but also encountered modern art. He also met the painter Alice Neel, whom he married.

In 1925 Enríquez returned to Havana and became an integral member of the avant-garde Grupo Minorista, a group of young artists who sought to end the emphasis on realism espoused by the faculty of the Academy of San Alejandro and supported by the upper-class system of patronage. Instead, they attempted to bridge the modernist values of European abstraction with progressive themes and nationalistic subjects. In 1927 Enríquez exhibited with other Cuban modernists that included Eduardo Abela, Víctor Manuel, and Amelia Peláez in the groundbreaking *Exposición de Arte Moderno,* put on by the *Revista de Avance* and the first major exhibition of modern art in

Cuba. Three years later Enríquez held his first solo exhibition in Havana, in which he showed a series of drawings.

In that year his marriage to Neel ended, and he embarked on a trip to Spain and France. From 1930 to 1934 he embraced modernist ideals and developed a semiabstract visual language. He was preoccupied with Cuban subjects, and in addition to painting he also wrote novels, developing what he called the *romancero guajiro* (peasant romance). His paintings from the decades of the 1930s and 1940s focused on scenes of campesinos, or peasants, often on horseback and engaged in violent battle. He depicted events that took place mainly during the Cuban struggle for independence from Spain at the close of the nineteenth century. His favorite protagonist in these works was the *bandolero,* a peasant Creole turned highwayman and a symbol of macho freedom, unfettered sexuality, and debauchery. His masterpiece, *El rapto de las mulatas* (''The Rape of the Mulatas''), from 1938, depicts two white *bandolero*s raping two women of mixed blood, who do not seem to resist the attack. It is a swirling composition of form and color, full of frenetic energy that has been characterized as a painterly hurricane or whirlwind.

Throughout the 1940s and 1950s Enríquez used surrealist devices such as X-ray vision, diaphanous films of color laid fluidly on the canvas, to create dreamlike spaces for his tropical landscapes and violent figures. These works alluded to the constant change and dynamism of nature and to his skepticism of human motivations. He generally focused on the themes of eroticism, machismo, violence, danger, and death, preoccupations that evoked dominant trends in European surrealism. The majority of his paintings, however, were grounded in Cuban historical subjects and nationalistic themes. Occasionally he painted images of heroic death, as in *Muerte de Martí* (1934), an allegorical rendering of the death of modern Cuba's founding father, a work that retains the grand qualities of history painting in spite of its surrealist style.

—H. Rafael Chácon

F

FÁDER, Fernando
Argentine painter

Born: Mendoza, 1882. **Education:** Royal Academy of Art, Munich, Germany, 1900–05. **Career:** Professor, Escuela Nacional de Bellas Artes, Buenos Aires, until 1916. Involved with artist group *Nexus,* early 1900s. **Awards:** Medalla de plata, *Exposición de Munich,* 1904; medalla de oro, *Exposición de San Francisco,* 1915. **Died:** Córdoba, 1935.

Individual Exhibitions:

1904	Club Español. Mendoza, Argentina
1905	Salón Costa, Buenos Aires
1906	Salón Costa, Buenos Aires
1916	Salón Müller, Florida
1917	Salón Müller, Florida
1918	Casa Corralejo y Cía, Montevideo, Uruguay
	Salón Müller, Florida
1919	Salón Müller, Florida
1920	Salón Müller, Florida (retrospective)
1922	Salón Müller, Florida
1923	Salón Müller, Florida
1924	Asociación Amigos del Arte, Florida
1926	Salón Müller, Florida
1927	Salón Müller, Florida
1930	Salón Müller, Florida
1932	Dirección Nacional de Bellas Artes, Posadas, Argentina
1932	Comisión de Bellas Artes de Rosario, Argentina
1933	Salón Müller, Florida
1935	Galeria Müller, Buenos Aires
	Museo Nacional de Bellas Artes, Buenos Aires
	Museo Municipal, Rosario, Argentina
1939	Sociedad Central de Arquitectos, Juncal, Argentina
1942	Museo de Bellas Artes, Córdoba, Argentina
1956	Museo Provincial de Bellas Artes ''Rosa Galisteo de Rodríguez,'' Santa Fé, Argentina (retrospective)
1957	Museo Provincial de Bellas Artes ''Emilio Carafa,'' Córdoba, Argentina
1988	Museo Nacional de Bellas Artes, Mendoza, Argentina
1994	*Fader en el Fader: 200 obras,* Museo Provincial de Bellas Artes Emiliano Guiñazú, Buenos Aires
1995	Zurbaran Gallery, Buenos Aires
2001	Museo Provencial de Bellas Artes, Buenos Aires

Selected Group Exhibition:

1907	Salón Costa, Buenos Aires

Collections:

Museo Nacional y Provincial de Bellas Artes, Buenos Aires; Museo Castagnino de Rosario, Buenos Aires; Galisteo de Rodriguez, Santa Fe, Argentina.

Publications:

On FÁDER: Books—*Fáder: Exposición posthuma,* exhibition catalog, Buenos Aires, Galeria Müller, 1935; *Catálogo de la exposición–homenage de Fernando Fader,* Córdoba, Imprenta de la Universidad Nacional de Córdoba, 1942; *Fernando Fader* by José González Carbalho, Buenos Aires, Editorial Poseidón, 1943; *Exposición retrospectiva de homenaje a Fernado Fáder,* exhibition catalog, by Horacio Caillet-Bois, Santa Fé, n.p., 1956; *Fernando Fader* by Antonio Lascano González, Buenos Aires, Ediciones Culturales Argentinas, 1966; *Fernando Fader: Museo Nacional de Bellas Artes,* exhibition catalog, Mendoza, Argentina, Ediciones Culturales Benson & Hedges, 1988; *El genio de Fader* by Ignacio Gutiérrez Zaldívar, Buenos Aires, Zurbaran Ediciones, 1993; *Fader en el Fader: 200 obras,* exhibition catalog, Buenos Aires, Museo Provincial de Bellas Artes E. Guiñazú, 1994; *Fernando Fader,* exhibition catalog, Buenos Aires, Zurbaran, 1995; *Fernando Fader* by Olga María Stirnemann de Moyano, Córdoba, Alción Editora, 1996; *Fernando Fader: Obra y pensamiento de un pintor argentino* by Rodrigo Gutiérrez Viñuales, Buenos Aires, Centro de Documentación de Arquitectura Latinoamericana, 1999. **Article**—''Fernando Fader (book review)'' by Adrian Gualdoni Basualdo, in *Goya* (Spain), 275, March/April 2000, p. 126.

* * *

Born into a wealthy family (his father owned a utility company), Fernando Fáder lived his early life in luxury. He was educated in Germany and France and studied painting in Munich at the Royal Academy of Art after being rejected from the school entrance several times. When his father died, his brother lost most of the family's money, and Fáder was left to provide for himself and his family by selling his paintings, a task that proved surprisingly and hugely successful for an Argentine painter. The success was mostly due to Fáder's excellent curator, Federico Müller.

Fáder's paintings displayed Fáder's true love of the country, as well as his connection to nature. In Córdoba, Fáder created eight canvases about farm life, including a piece called *Life of a Day.* These pieces are infused with light, and they beautifully show an entire day of life on a farm. They were displayed by Müller in his gallery in September 1917 to great acclaim. Many were sold. With his new wealth Fáder bought a house and several cars. He had a falling out with Müller, but eventually the two reconciled. Although criticized for not developing a unique style, Fáder—who created pieces ''for the

mother country'' and who worked relentlessly to capture the world he knew—still remains one of the great Argentine painters.

—Sally Cobau

FELGUÉREZ, Manuel
Mexican sculptor and painter

Born: Zacatecas, 12 December 1928. **Education:** La Esmeralda and Academia de San Carlos, Mexico City, 1948; Academy of the Grande Chaumier, Paris; studied under Osip Zadkine, 1949–50. **Career:** Worked as a muralist, 1960–70, Mexico, and as a ceramicist. Visiting professor, Cornell University, 1967; guest researcher, Harvard University, 1975. Helped promote the Salón Independiente, 1968; modified the curriculum of the National Institute of Fine Arts, 1968. **Awards:** Education scholarship, French government, 1958; second prize in painting, *First Triennial,* New Delhi, India, 1968; fellowship, Guggenheim Foundation, 1975; Gran Premio, *Biennial of São Paulo,* Brazil, 1975; Premio Nacional de Arte, Mexico, 1988; Creador Emérito, Sistema Nacional de Creadores de Arte, 1993.

Individual Exhibitions:

1959 Bertha Shaeffer Gallery, New York
1960 Bertha Shaeffer Gallery, New York
 Pan American Union, Washington, D.C.
1973–74 *Espacio multiple,* Museo de Arte Moderno, Chapultepec Park, Mexico City
1997 *Límite de una secuencia,* Museo de Arte Contemporáneo, Monterrey, Mexico traveled to Consejo Nacional para la Cultura y las Artes, Instituto Nacional de Bellas Artes, and Museo Rufino Tamayo, Mexico
 Galería Ramis Barquet, Garza García, Mexico, and New York

Selected Group Exhibitions:

1956 *Gulf-Caribbean Art,* Houston Museum of Fine Arts
1958 Brooklyn Museum, New York
1962 World's Fair, Seattle
1966 Gallery of Fine Arts, San Diego, California
 Portland Art Museum, Oregon
 University of Nebraska, Lincoln
 University of Texas, Austin
1989 *The Latin American Spirit: Art & Artists in the U.S.,* Bronx Museum, New York
1997 Ivanffy and Uhler Gallery, University of Texas, Arlington
1999 *Ocho pintores,* Museo de Arte Moderno, Mexico City

Collections:

Francisco Goitia Museum, Zacatecas, Mexico; Jack S. Blanton Museum of Art, University of Texas, Austin.

Publications:

By FELGUÉREZ: Book—*Libertad en bronce,* with Leonora Carrington, José Luis Cuevas, and others, Mexico, Impronta Editores, 1999.

On FELGUÉREZ: Books—*Carrillo, Coen, Corzas, Felguérez, García Ponce, Gironella, Orlando, Ramírez, Rojo, von Gunten,* Mexico, Galería Juan Martín, 1960; *Espacio múltiple,* exhibition catalog, Mexico, Instituto Nacional de Bellas Artes y Literatura, 1973; *La maquina del octavo piso* by Miguel Angel Torres Solís, Mexico, Confederación de Cámaras Industriales de los Estados Unidos Mexicanos, 1989; *Muestra de la colección pago en especie,* exhibition catalog, text by Raquel Tibol, Mexico, Secretaría de Hacienda y Crédito Público, 1992; *Manuel Felguérez* by Juan García Ponce, Spain, Ediciones del Equilibrista, 1992; *Manuel Felguerez,* exhibition catalog, Garza García, Mexico and New York, Galería Ramis Barquet, 1997; *Felguérez: Límite de una secuencia,* exhibition catalog, text by Beatriz Mackenzie and Miguel Cervantes, Monterrey, Mexico, Museo de Arte Contemporáneo, 1997; *Felguérez: Límite de una secuencia,* exhibition catalog, text by Adriana Balderas, Liliana Mata, and Delia Velázquez, Mexico City, Consejo Nacional para la Cultura y las Artes, Instituto Nacional de Bellas Artes, and Museo Rufino Tamayo, 1997; *Ocho pintores,* exhibition catalog, Mexico, Impronta Editores, 1999; *Libertad en bronce,* Mexico, Impronta Editores, 1999; *Felguérez,* exhibition catalog, Mexico, UAM, 2000. **Articles**—"Límite de una secuencia" by Juan Villoro, excerpt from exhibition catalog, in *Artes de Mexico,* 35, 1996, pp. 100–103; "Manuel Felguérez: Museo de Arte Contemporáneo" by Carlos-Blas Galindo, review of the exhibition *Límite de una secuencia,* in *Art Nexus* (Colombia), 25, July/September 1997, p. 132–133. **Video**—*Espacio múltiple* by Erika Zapata and Elías Calles, Mexico City, Consejo Nacional para la Cultura y las Artes, Coordinación Nacional de Medios_Audiovisuales, and Canal 22 Televisión Metropolitana, 1999.

* * *

Manuel Felguérez was one of the founding members of the *ruptura* movement of the 1950s that sought to make a stylistic and ideological break with the social realism of earlier Mexican art. Artists of earlier movements, including the Mexican muralists as well as the members of the Taller de Gráfica Popular, had become increasingly rigid and dogmatic in their explorations of Mexican identity. Felguérez, who had studied in Paris under the constructivist painter Ossip Zadkine, preferred European-inspired geometric abstraction to the figurative and folkloric Latin American social realism. Felguérez felt that artists should not feel obligated to adhere to specific national styles. He was joined by other artists, including Vicente Rojo, José Luis Cuevas, and his first wife, Lilia Carrillo, who, while stylistically different, were united in their desire for artistic independence. Felguérez became known as the strongest supporter of geometric abstraction in Mexico, although throughout his career he experimented with more painterly works based loosely on geometric compositions.

Felguérez made some of his most innovative breakthroughs in the field of mural painting from 1960 to 1970. He created several

murals at locations in Mexico City, including the first abstract mural in Mexico, at the Diana Cinema, and another at the headquarters of the Confederación de Cámaras Industriales, an association of businessmen. These enormous murals possessed aspects of architecture, painting, and sculpture all at the same time. They had no figurative subject matter but were rather an assembly of abstracted references to gears, screws, pulleys, and other mechanical parts. At this time Felguérez was especially interested in creating art for public settings, and he completed murals at schools, swimming pools, and theaters, as well as a monumental metal sculpture for the 1968 Olympics.

Around 1973 Felguérez developed his technique of combining elements of various artistic genres into a theory he dubbed *El espácio multiple*. He conceived of the multiple not as an art object that was identical to others in a series but as one that inspired other works that became variations on a theme. For instance, a painting entitled *Signo convexo* might inspire a sculpture with the same shape, based on a traffic sign, or other paintings with different color schemes. Just as he had done with his earlier mural works, in the *El espácio multiple* series Felguérez subverted the distinctions between painting, sculpture, and industrial design. He presented some of these works at the 13th São Paulo Biennial in 1975, and he became the first Mexican artist to win the grand prize.

Felguérez imagined being able to use computers to generate designs for future artworks. The computer would be programmed with several basic elements and would then rearrange them in an infinite number of ways, more than any artist would be able to do as an individual. He received a Guggenheim Fellowship in 1975 and, with the help of systems analysts and technicians, worked at Harvard University and at the Massachusetts Institute of Technology to realize his project, which he named *La máquina estética*.

Felguérez and the others of the *ruptura* movement have had a lasting effect on Mexican art by making it possible for artists to pursue individual styles without feeling obligated to use indigenous cultures, the plight of the poor, or the Mexican Revolution as subject matter. He felt no ideological conflict in making art that was inspired by industry and that used technology and materials that often could not be found in Mexico. He has also been an influential theoretician, having published a number of articles and assisted in changing the curriculum at the Escuela Nacional de Artes Plásticas. In addition, he promoted the Salón Independiente, an open forum for artists and discussions on art.

—Erin Aldana

FERNÁNDEZ, Agustín
American painter, sculptor, and mixed-media artist

Born: Havana, Cuba, 1928; left Cuba, 1959; moved to the United States, 1972. **Education:** Academia de San Alejandro, Havana, B.A. 1950; Art Students League, New York, 1949–50; studied philosophy, Universidad de Habana, 1950–52; Academia de San Fernando, Madrid, 1953. **Family:** Married; three children. **Career:** Traveled to Europe, 1952; lived in France, 1959–68, and in San Juan, Puerto Rico, c. 1970. **Awards:** Honorable mention, *Fourth Bienale of São Paulo,* Brazil, 1956; travel scholarship, Cuban government, 1959.

Agustín Fernández: *Oculus,* 1990. Photo courtesy of Anita Shapolsky Gallery, New York.

Individual Exhibitions:

1954 Pan American Union, Washington, D.C.
1956 Duveen Graham Gallery, New York
1958 Condon Riley Gallery, New York
1959 Bodley Gallery, New York
1993 Gary Nader Fine Art, Coral Gables, Florida
1999 Signal 66, New York

Selected Group Exhibitions:

1956 *Fourth Bienale of São Paulo,* Brazil
1959 *The United States Collects Latin American Art,* Art
 Institute of Chicago
1967 *Latin American Art: 1931–1966,* Museum of Modern
 Art, New York
1989 *The Latin American Spirit: Art & Artists in the U.S.,*
 Bronx Museum, New York
1998 *In Context,* 123 Watts, New York

Collections:

Detroit Institute of Arts; Library of Congress, Washington, D.C.; Museum of Modern Art, New York; Yale University, New Haven, Connecticut; Brooklyn Museum of Art, New York.

Agustín Fernández: *Star,* 1990. Photo courtesy of Anita Shapolsky Gallery, New York.

Publications:

By FERNÁNDEZ: Book, illustrated—*20th Year of the Cuban Diaspora* by José Martí, Miami, Metropolitan Museum & Art Centers, 1978.

On FERNÁNDEZ: Books—*15 Paintings,* exhibition catalog, Washington, D.C., Pan American Union, 1954; *Agustin Fernandez* by R. C. Kenedy, New York, Rapoport Printing Corp., 1973; *Agustín Fernández,* exhibition catalog, text by Anne Horton, Coral Gables, Florida, Gary Nader Editions, 1993. **Articles—**''Latin America's Magical Realism: The Legacy of Torres-García'' by Ricardo Pau-Llosa, in *Art International* (Switzerland), 12, autumn 1990, pp. 81–87; ''The Cubans Have Arrived: Artists Living in the U.S.'' by Giulio V. Blanc, in *Art & Antiques,* 15, December 1993, pp. 64–73.

* * *

In 1959 the government of Fidel Castro gave Agustín Fernández a scholarship to study in Paris. After the scholarship ended, he stayed for 10 years before moving to the United States, where he has lived in exile for more than 30 years and received recognition as one of the most important Latin American artists. In Paris he was encouraged by the independent surrealists and learned to explore the subconscious to conjure the metaphysical images that are so essential to his art. Themes of erotic obsessions and the unexpected juxtaposition of organic and metallic imagery have occurred in his work since the formative phase beginning in the 1950s in Cuba. They continued in his early years of surrealist experimentation in painting and the construction of object assemblages in Paris and through his mature phases in painting and sculpture in New York City. Throughout his career his work has been characterized by a sensuality that often erupts into the erotic.

The uncertainties of exile affected Fernández's work in the 1960s, and his experimentation was dominated by dark monochromatics and ambiguous, often disturbing, references to the body. Metals and leathers competed with soft, fleshy textures. Razor blades were introduced as a metaphor for pain. Breasts represented delicate sensuality. A short visit to Puerto Rico in 1970 introduced a white light to his palette that contributed to the sense of equilibrium that was as much a mastery of technique as it was essential to his methods of composition. The development of his now familiar aesthetic language that took place in the 1970s and 1980s demonstrated Fernández's concern with the precarious balance between hard and soft and with ambiguous forms that resembled breastplates, leather, and industrial materials, even vacuum cleaner hoses. Much of his imagery was inspired by the urban dynamics of New York City that transform humans and animals into mechanized creatures and monstrous forms wearing respirators and industrial armor.

Some work from this period recalls sculptures of pagan deities and serpents. *Figure in the Forest* (1980) features a fearsome image of a creature made from an armor plate with reptilian scales and torn pieces of pink paper that interrupt the dark contours of its breasts and other body parts. The fragility of the human condition is threatened by the anxiety of sexual repression and Freudian obsessions. Color became more prevalent in the 1990s, although the intensity of Fernández's imagery never abated, and even flowers were more metallic than delicate. Every image is presented as a confrontation that provokes the viewer to respond personally and complete the story, to retreat into the mythology of the ancients, the rituals of the Aztecs, or the medieval Crusades. His subjects are presented with an obsessive attention to technique in order to replicate surfaces of pristine details and convincing reality.

Fernández's concern with technical perfection applies to sculpture as well. Throughout his career he has created three-dimensional objects, many made of the same industrial materials that appear in his paintings and with a decidedly surrealist distortion. He also has embarked upon the production of monumental sculptural objects cast in bronze. His paintings, always descriptive of a volumetric objective quality, come to life in these large totemic pieces, especially in the multibreasted goddesses reminiscent of Diana. He has continued to be incredibly prolific and productive in the mature years of his career and has never lost sight of the direction of his artistic ambition to create works that express his own intellectual and philosophical vision.

—Carol Damian

FERNÁNDEZ, Arístides
Cuban painter

Born: Guines, 1904. **Education:** Academia de San Alejandro, Havana, 1924–25. **Career:** Began painting toward the end of his life and was not known in the art world until after his death. Also wrote short stories. **Died:** 1934.

Selected Exhibitions:

1935 Havana
1950 Havana

Publications:

On FERNÁNDEZ: Books—*Arístides Fernández*, Havana, Direcciên de Cultura, 1950, and *La cantidad hechizada . . . ,* Madrid, Júcar, 1974, both by by José Lezama Lima; *Arístides Fernández: Narrador y pintor*, Matanzas, Ediciones Matanzas, 1992, and *Transmutaciones relacionables en Arístides Fernández*, Havana, Editorial Letras Cubanas, 1994, both by Enrique Carreño Rodrígugez.

* * *

Arístides Fernández is an obscure and eccentric figure within the first generation of Cuban modernist painters. He studied briefly, for about a year (1924–25), at the San Alejandro Academy, where he received a minimal education in the basics of drawing and composition and practically nothing regarding the technique of painting. With the exception of his friendship with fellow painter Jorge Arche, Fernández worked in complete isolation. He never traveled abroad, and so it seems that his exposure to modern European art was through reproductions. These limitations are reflected throughout his modest pictorial production; his application of paint can be coarse and his drawing weak. Yet these very limitations give his paintings a folk art-like charm. In terms of style he developed a highly personal expressionist vocabulary.

Fernández's body of work consists of oils, watercolors, and a few pencil drawings. He also wrote a group of highly original short stories that in their mystery and strangeness recall the narratives of both Poe and Kafka. Thematically his paintings consist of portraits as well as rural and urban genre scenes. Practically all of his work is undated, but, according to Juan A. Martínez in *Cuban Art and National Identity,* most of the portraits were executed in the late 1920s and the genre scenes painted in the early 1930s.

Among the portraits of Fernández, *Retrato de la madre del artista* stands out. The woman is depicted in profile and at shoulder length, with the palette consisting of tans, browns, and white, as well as a pale flesh tone. A dark brown line outlines her entire figure and accentuates the collar of her dress. Throughout the surface the pigment is thinly applied. Her dignity and poise bring to mind early Italian Renaissance portraits, which the artist was probably familiar with through reproductions in books. Fernández's *Autorretrato,* painted toward the end of his life, depicts a close-up face in three-quarter view. The palette consists of darker earth tones with touches of blue, and unlike the portrait of the artist's mother here the paint is thickly applied, creating an evenly textured surface from the face to the background. In this work Fernández depicts himself staring straight at the viewer. Both of the portraits posses an intimacy of scale and outlook, yet they are also charged with a subtle psychology that gives evidence of the strength and intensity of the sitters.

Fernández's most ambitious works were the genre paintings *La familia se retrata*, *Batey*, and *El entierro*. The first two works depict the dismal social conditions found in the Cuban countryside of the 1920s and 1930s. Yet in these paintings, whether it is a group of women posing for a photo or taking clothes to wash at the river, the Cuban female peasant is depicted as strong and matriarchal. *El entierro* depicts the burial of Christ, or possibly of everyman. Women, and only women, weep, grieve, or carry the body of the only male in the composition. They inhabit a desolate landscape of hills, with a barren tree and a walled city in the distance. Coloristically the painting consists of dark blues, purples, browns, and grays. The flat, patterned drawing of both *Batey* and *El entierro* recalls the compositions of Gauguin, an artist much admired and imitated by other Cuban modernists such as Víctor Manuel.

Fernandez's paintings were first exhibited posthumously in 1934, and his short stories were not published until 1960. His achievement lies in the creation of a very personal, if sometimes awkward, expressionist style in which melancholic environments are balanced by the strength and dignity of his human subjects.

—Alejandro Anreus

FERNÁNDEZ, Lola
Costa Rican painter

Born: Cartagena, Colombia, 15 November 1926; moved to Costa Rica, 1930. **Education:** Universidad de Costa Rica, graduated 1948; Universidad Nacional de Bogota, Colombia, 1948–50, degree in painting 1950; Academia de Bellas Artes, Florence, Italy (on government scholarship), 1954–58. **Family:** Married Jean Pierre Guillermet. **Career:** Traveled to Paris, 1957. Professor, Universidad de Costa Rica, beginning in 1959; also taught at University of San Pedro, Costa Rica. Member, artist group *Grupo Ocho,* Costa Rica, 1962. **Awards:** UNESCO prize, 1961; gold medal, *Second Annual Salon of Plastic Arts,* 1973.

Individual Exhibitions:

1948	Museo Nacional de Bogota, Colombia
1949	Teatro Nacional de Costa Rica
1950	Museo Nacional, Universidad de Costa Rica
1951	Instituto Nacional de Panama
1957	Galería Bernard Chéne, Palais Royal, Paris
1958	Museo Nacional, Universidad de Costa Rica
1962	*Las arcadas,* San José, Costa Rica
1965	Galería de Artes y Letras, San José
1966	Museo de Arte Moderno, Bogota, Colombia
1967	Galería de Artes y Letras, San José
1968	Pan American Union, Washington, D.C.
1972	Galerie St. Louis, Morges, Switzerland
	Gallerie Vulpera, Switzerland
1973	Galería DIS/FORMA, San José, Costa Rica
	Facultad de Bellas Artes, Universidad de Costa Rica
1981	*Tapices,* Biblioteca Nacional, Sala Julián Marchea, Costa Rica
	Tapestries and Oils, Ana Sklar Gallery, Miami
	Tapestries of Lola Fernández, Inter-American Bank, Washington, D.C.
1984	Museo de Arte Costarricense, San José, Costa Rica (retrospective)

Selected Group Exhibitions:

1950	*Exhibición arte centroamérica,* Museo Nacional Universidad de Costa Rica
1958	*Primera bienal interamericana de pintura y grabado,* Instituto Nacional de Bellas Artes, Mexico City
1964	*Modern Artists of Costa Rica,* Pan American Union, Washington, D.C.

1965 *Primer salón panamericano de pintura y V festival
 nacional de arte,* Cali, Colombia
1973 *Pintores costarricenses en México,* Palacio de Iturbide,
 Mexico City
1974 Pan American Union, Washington, D.C.
1978 *Plástica contemporánea de Costa Rica,* Casa de las
 Américas, Havana
 Grabados y dibujos costarricenses, Museo Nacional de
 Costa Rica
1983 *Arte contemporáneo costarricense,* Museo Carrillo Gil,
 Mexico City

Collections:

Museo de Arte Moderno, Bogota, Colombia; Museum of Contemporary Latin American Art, Washington, D.C.; University of Indiana; University of Pennsylvania; Maison L'Unesco, Paris; Casa de las Américas, Havana; Museo de Arte Latinoamericano, El Salvador; Museo de Arte Costarricense, San José, Costa Rica; Galería Nacional de Arte Contemporáneo, San José, Costa Rica; Banco Central de Costa Rica, San José.

Publications:

On FERNÁNDEZ: Book—*Lola Fernández, retrospectiva,* exhibition catalog, San José, Costa Rica, Museo de Arte Costarricense, 1984.

* * *

Although Lola Fernández was born in Cartagena, on the Caribbean coast of Colombia, as a child she immigrated to Costa Rica, where she became a citizen. She received a traditional education in painting and art history in the Academia de Bellas Artes of the Universidad de Costa Rica, graduating in 1948. Realizing that her education in art was limited, however, she returned to Colombia, where she studied two more years in the Escuela de Bellas Artes of the Universidad Nacional de Bogotá. Prior to receiving a degree in painting in 1950, she exhibited her more modern paintings in the Museo Nacional de Bogotá with like-minded students who had formed the Grupo de los Seis. Following her return to Costa Rica, she began a teaching career at the Academia de Bellas Artes. In 1954 she was awarded a fellowship to study painting at the Academy of Fine Arts in Florence, Italy, from which she graduated in 1957.

Upon her return to Costa Rica via Paris and New York City, she arranged for a one-person exhibition in the Museo Nacional de Costa Rica, which opened 29 May 1958. It is generally credited as being the first show of abstract art in that country. One hall exhibited only abstract art, while a second displayed figurative paintings, prints, and drawings. Accompanied by her decorator husband Jean Pierre Guillermet, she traveled to China and Japan on a grant from UNESCO in 1961–62, resulting in a series of paintings collectively called *Serie Oriente,* in which biomorphic forms are scratched with gestural marks. Her next series, *Violencia,* was sadly inspired by the continuing violence in her native Colombia; one of these paintings was included in the landmark show of 1965, *The Emergent Decade: Latin American Painters and Painting in the 1960s,* at the Solomon Guggenheim Museum of Non-Objective Art in New York City. She avowed that after selecting the theme she painted intuitively upon approaching her canvas. Natural violence was the theme of her next series, *Serie Volcanes,* which alludes to the power and primordial energy of the internal geologic forces rampant in Central America, and her series *Serie Espacio* seems inspired by cosmic creation in galactic space. These works were accorded an individual exhibition in 1968 by the Pan-American Union Gallery in Washington, D.C., and praised by José Gómez Sicre, head of visual arts and gallery curator. It was he who classified her work as abstract expressionist, again in the retrospective exhibit held in the Museo de Arte Costarricense in 1984.

Fernández was invited to join El Grupo Ocho in 1962, which had been created the previous year by eight male artists, two of whom—Felo García and Manuel de la Cruz González—are considered cofounders of abstract art in Costa Rica. They each held one-man shows in San José just after Fernández's in that same watershed year 1958. The government began to support the arts by creating the Galería de Artes y Letras in downtown San José, in which Fernández exhibited her work in 1965 and 1967. Her work from the early 1970s incorporated textured prints of textiles and constructed reliefs, as in *Supervivencia* of 1971, which overlays patterns rendered in rich colors on woven cotton, suggesting a complex layering of memory. Work in this style won her the gold medal in the Second Annual Salon of Plastic Arts in 1973.

Since the late 1970s Fernández's work has been figurative with surrealistic overtones, as in her *Serie Arquetipos,* although it retains a strong sense of formal composition of flattened planes, use of texture, and expressive intensity of color and gestural brushstrokes, executed in large scale. It incorporates found material such as metal in collages to create a greater range of visual and tactile sensations.

—John F. Scott

FERNÁNDEZ, Teresita
American sculptor and installation artist

Born: Miami, Florida, 1968. **Education:** Florida International University, Miami, B.F.A. 1990; Virginia Commonwealth University, Richmond, M.F.A. 1992 **Awards:** National Endowment for the Arts fellowship, 1994–95; Cintas fellowship, 1994–95; CAVA Fellowship, National Foundation for Advancement in the Arts, 1995; Marie Walsh Sharpe Foundation fellowship, 1997–98; American Academy in Rome fellowship, 1999; Louis Comfort Tiffany Biennial Award, 1999.

Individual Exhibitions:

1995 Museum of Contemporary Art, Miami
1996 Deitch Projects, New York
 New Museum of Contemporary Art, New York
1997 Masataka Hayakawa Gallery, Tokyo
 Corcoran Gallery of Art, Washington, D.C.
1998 *New Works: 98.4,* ArtPace, San Antonio, Texas
 Masataka Hayakawa Gallery, Tokyo
1999 *Borrowed Landscape,* Deitch Projects, New York
 Institute of Contemporary Art, Philadelphia
 MATRIX: Teresita Fernandez, Berkeley Art Museum,
 California
2000 Site Santa Fe, Santa Fe
 James Kelly Contemporary, Santa Fe
 Hothouse, Musuem of Modern Art, New York

Teresita Fernández: *Precipice,* 2000. Photo courtesy of Deitch Projects and the artist.

2001 Galeria Helga de Alvear, Madrid
 Castello di Rivoli, Turin
 Bamboo Cinema, Madison Square Park, Public Art
 Fund, New York

Selected Group Exhibitions:

1993 *Thirty and Under,* Ground Level, Miami
1995 *New Orleans Triennial,* New Orleans Museum of Art
 Selections, Spring 95, The Drawing Center, New York
1996 *Defining the Nineties,* Museum of Contemporary Art,
 Miami
 Enclosures, New Museum of Contemporary Art, New
 York
1997 *X-Site,* Contemporary Museum, Baltimore, Maryland
1998 *Threshold,* The Power Plant, Toronto, Canada
 Seamless, De Appel, Amsterdam
 Arkipelag: Insertions, Stockholm
2000 St. Louis Art Museum, Missouri
 Paula Cooper Gallery, New York
 not seeing, Doug Lawing Gallery, Houston
2001 *Hortus Conclusus,* Witte de With, Rotterdam, The
 Netherlands
 Inside Space, MIT List Visual Arts Center, Cambridge
 Reading the Museum, National Museum of Modern Art,
 Tokyo

Publications:

On FERNÁNDEZ: Books—*Teresita Fernández,* exhibition cata-
log, Philadelphia, Institute of Contemporary Art, University of Penn-
sylvania, 1999; *Shared Roots: Sculpture by VCU Alumni,* exhibition
catalog, text by John Caperton and Amy Moorefield, Richmond,

Virginia, Virginia Commonwealth University, 1999; *Wonderland,*
exhibition catalog, text by Rochelle Steiner, St. Louis, Missouri, St.
Louis Art Museum, 2000; *Teresita Fernández,* exhibition catalog,
Rivoli, Castello di Rivoli, 2001; *Hortus Conclusus* exhibition catalog,
text by Tanja Elstgeest, Witte de With Center for Contemporary Art,
2001; *Inside Space; Experiments in Redefining Rooms,*.exhibition
catalog, text by Bill Arning, MIT List Visual Arts Center, 2001;
Reading the Art Museum, exhibition catalog, text by Mika Kuraya,
Tokyo; National Museum of Modern Art, 2001. **Selected Articles**—
''Teresita Fernández at Deitch Projects'' by Monica Amor, in *Art
Nexus* (Colombia), 23, 1997; ''Teresita Fernández'' by Owen Drolet,
in *Flash Art,* May 1997; ''The Crystal Stopper'' by Jan Avgikos, in
Artforum, September 1997, p. 124; ''X-Site '97'' by Carlos Basualdo
in *Artforum,* March 1998, pp. 104–05; ''Focus: Teresita Fernández''
by Anne Barclay Morgan, in *Sculpture* (Washington, D.C.), 18(1),
January/February 1999, pp. 8–9; ''Teresita Fernández: Intimate Immen-
sity'' by Jane Harris, in *Art/Text* (Australia), 64, February/April 1999,
pp. 39–41; ''Teresita Fernández'' by Melissa Ho, in *New Art Exam-
iner,* July/August, 1999, pp. 56–57; ''Teresita Fernández'' by Yukie
Kamiya, in *Bijutsu Techo Monthly Art Magazine,* January 2000, pp.
138–39; ''Home Is Where the Cliches Aren't'' by Joanne Silver, in
Boston Herald, Feburary 2, 2001; ''Inside Art–Art in the Park'' by
Carol Vogel, in *New York Times,* May 25, 2001, p. E26.

* * *

In the 1960s artists began experimenting with what sculpture
could be. Their work got bigger and more abstract, their materials less
traditional. Sculptural work began more than ever to call attention to
that from which it was made. A movement known as American
minimalism emerged, focusing on extremely simple geometric forms.
Space itself took precedence over form or subject matter. Minimalist
sculpture got rid of the pedestal—the work of art was now standing
directly on the ground, propped against the wall, or hanging from the
ceiling. But in every case it directly intervened in the space occupied
by the viewer. Partly in reaction to abstract expressionism, with its
emphasis on the artist's gesture, American minimalism celebrated
industrial materials and fabrication methods.

Artist Teresita Fernández's work owes a debt to artists such as
Richard Serra, whose minimalist sculptures serve as elegant interven-
tions in our visual landscape. They communicate a visceral experi-
ence of balance, weight, and proportion. But unlike that of her
minimalist predecessors, Fernández's work does not refer only or
strictly to the work of art itself. Her environments tug at the edges of
memory, calling up associations with other, often mundane, architec-
tural environments. They bring sculptural minimalism into dialogue
with a postmodern, feminist analysis of the body and its relationship
to social space.

Some of Fernández's works seem to hover, suspended in space
despite their apparent heaviness. The works cast shadows on the walls
and floors where they are installed. The arrangement of forms point to
the forces that constantly surround us—gravity, weight, motion—and
inspire a direct, physical awareness of the interaction of our bodies in
a physical environment. In one piece titled *Supernova* she installed six
round objects on the floor of the gallery. They appear like puddles or
holes in the ground, giving the illusion of great depth. They draw us,
invite us in, and produce a measure of anxiety by their seeming
limitlessness. They have as much physical presence as would a series
of six columns rising into the air, affecting us as much with the

Teresita Fernández: *Bamboo Cinema,* 2001. Photo courtesy of Deitch Projects and the artist.

illusion of a spatial absence as one could with a positive equivalent, a physical presence. Besides raw material Fernández also uses light, color, and sound to address and manipulate space.

Fernández's work at its best inspires a kind of childlike curiosity in the viewer. She has shown a particular fascination with swimming pools, often using mirrors and windows to evoke empty pools. In 1996 she installed an entire empty swimming pool in a gallery at Deitch Projects in New York. Visitors were entranced. Most approached the steps leading to the edge of the pool with trepidation and often a bit of embarrassment combined with real curiosity and a sense of intrigue. The enormous spatial presence it created—which was, because the swimming pool was empty, also an absence—moved many viewers to a wondrous silence. But it also called up ordinary associations with other everyday spaces and landscapes.

The displacement one experiences in front of Fernández's work suggests the fluidity of identity and reality and blurs the distinction between the familiar and the strange. Like Claude Monet, who spent his final years in an obsessive meditation on the subject of his pond at Giverny, Fernández returns again and again to her motif, creating immersive environments that envelop us in an alternate reality, one in which the usual boundaries between reality and illusion begin to dissolve.

—Amy Heibel

FERNÁNDEZ LEDESMA, Gabriel
Mexican painter and printmaker

Born: Aguascalientes, 30 May 1900. **Education:** Academia de San Carlos, Mexico City, 1917. **Family:** Married Isabel Villaseñor. **Career:** Worked as an artist for the Mexican government, c. 1920; editor, *Forma* art magazine, 1926–28; director, Departamento de Dibujo, Secretaría de Educación, Mexico City, c. 1930s. Involved with art movement *Estridentismo,* Mexico, 1920s. Cofounder, Escuela Libre de Escultura y Talla Directa and Centros Populares de Pintura, Mexico City, 1925, artist group *¡30–30! Group,* 1929, and League of Revolutionary Writers and Artists. **Died:** Mexico City, 26 August 1984.

Selected Exhibitions:

1981 *Gabriel Fernández Ledesma,* Centro de Artes Visuales, Saltillo, Mexico

1999 *History of Mexican Modern Art, 1900–1950,* Montreal Museum of Fine Arts

 Misiones culturales, Museo Casa Estudio Diego Rivera y Frida Kahlo, Mexico

2000 Museo Aguascalientes, Mexico

The Mexican Renaissance: Art in Post-Revolutionary Times, 1921–1934, National Gallery of Canada and Montreal Museum of Fine Arts

Collections:

Instituto Mexiquense de Cultura, Mexico; Museo Regional de Aguascalientes, Mexico; Museo de la Estampa del Estado de Mexico, Toluca; Museo de Arte de Sinaloa, Mexico.

Publications:

By FERNÁNDEZ LEDESMA: Books—*Calzado mexicano: Cactlis y huaraches,* Mexico, Secretaría de educación pública, 1930; *Juguetes mexicanos,* Mexico City, Talleres Gráficos de la Nación, 1930; *Plan de acción para el funciónamiento de una sección de artes plásticas populares,* Mexico City, Departamento Autónomo de Publicidad y Propaganda, 1937; *Los esmaltes de Uruapán,* with Francisco de P. León, Mexico, D.A.P.P., 1939; *Album de animales mexicanos,* Mexico, Secretaría de Educación Pública, 1944; *Canto a Mexico,* with Margarita Paz Paredes, Mexico, G.E.A.R., 1952; *Viaje aldredor de mi cuarto,* Mexico, Editorial Yolotepec, 1958; *Fernando Castillo, pintor popular, 1895–1940,* Mexico, UNAM, 1984; *Juegos plásticos y apuntes,* Mexico, Gobierno del Estado de Aguascalientes, Instituto Cultural de Aguascalientes, Aguascalientes, 1990. **Book, illustrated**—*Nervo* by Amado Nervo, Mexico, Ferrocarril mexicano, 1919.

On FERNÁNDEZ LEDESMA: Books—*Gabriel Fernández Ledesma,* exhibition catalog, Saltillo, Mexico, Centro de Artes Visuales & Investigaciones Esteticas, 1981; *Gabriel Fernández Ledesma* by Judith Alanís, Mexico City, Universidad Nacional Autónoma de México, 1985; *Carnaval en Huejotzingo* by Raquel Tibol, Mexico, Editorial Offset, 1986; *El eco de la imagen: Vanguardia y tradición en Gabriel Fernández Ledesma* by Benjamín Valdivia, Aguascalientes, Mexico, Instituto Cultural de Aguascalientes, 1992.

* * *

Gabriel Fernández Ledesma was a noted art educator as well as an accomplished artist who worked in various mediums, from painting and ceramics to printmaking, especially woodcuts. He left his native Aguascalientes in 1917 to study at the Academia de San Carlos with Saturnino Hernán. By 1920 he was working as an artist for the revolutionary government of Álvaro Obregón. A ceramic frieze was designed and produced by Fernández Ledesma for the Colegio de San Pedro y San Pablo, the renovation of which was being done under the leadership of Roberto Montenegro.

Fernández Ledesma soon assumed a more rebellious role among vanguard artists in Mexico with the foundation of Estridentismo in 1921. For this avant-garde movement, which was led by Manuel Maples Arce, he produced a number of noteworthy woodcuts: *New York* of 1922, *El tallador* (''The Workshop Artisan''), and *El soldado herido* (''The Wounded Soldier'') of 1926. The first print is obviously indebted to futurism, with a visionary sense of modernization registered through the angular field of skyscrapers. Conversely, the other two woodcuts are connected more clearly to *campesino* culture and its agrarian, pre-modern forms of image making. The natural texture of the wood grain is notably accented in the latter two prints. Each attests

to Fernández Ledesma's commitment, beginning in the mid-1920s, to the revitalization of artisanal forms of popular culture.

As significant to art education and art-world polemics as to artistic production, Fernández Ledesma was involved with several of the major art publications of the avant-garde. He helped edit the journal *Forma* (1926–28) and was a member of the group 30—30!. In the mid-1920s he cofounded the Escuela y Talla Directa and the Centros Populares de Pintor, which offered art instruction to working-class people. His prints from this period feature, not surprisingly, competing tendencies that alternate between an intentionally ''naive'' style that looks like the work of an autodidact, as is the case with his poster for the Talla Directa Escultura from the mid-1920s, and a more elegant, professional manner that self-consciously used the conventions for perspective, as is the case with *Cartel: una exposición de teatro* (1935). The former image shows a sculptor in a type of neo-Egyptian profile position with almost no foreshortening or overlapping and maximum visual intelligibility. The look is distinctly ''archaic,'' and it advertises an anti-academic art school seeking a fresh start aesthetically through the reclamation of popular culture. The latter composition features a staged figure who is in a mannered posed and pulls the strings of a puppet for a theatrical audience.

The intertwinement of artistic practice and art pedagogy remained a constant trait of his career in the following decades, when he was director of the Departamento de Dibujo in the Secretaría de Educación. In that capacity he actively aided such key groups as the Taller de Gráfica Popular (TGP), a print collective founded in 1937 by Leopoldo Méndez and Pablo O'Higgins. Indeed, the correspondence in the TGP Archives readily attests to the dual role of Fernández Ledesma as a printmaker and as an art-world impresario who backed exhibitions and workshops by Mexico's leading printmakers.

—David Craven

FERRER, Rafael
American painter and conceptual artist

Born: Santurce, Puerto Rico, 1933; emigrated to New York, 1966. **Education:** Staunton Military Academy, Virginia, 1948–51; Syracuse University, New York, 1951–52; University of Puerto Rico, Mayaquez, under E. Grannell, 1952–54. **Family:** Married Irene Alvarez in 1962; one daughter and one son. **Career:** Worked as a drummer in a Latin band, Syracuse, New York, 1951–52. Visited Europe; associated with Surrealist group, Paris, 1953. Worked as a drummer in Spanish Harlem, New York, 1957. Since 1959 full-time painter. Moved to Philadelphia, 1965; visited Germany, 1969, Amsterdam, Barcelona, and Cologne, 1970. First Body Art exhibitions, Amsterdam, 1970. Instructor, Philadelphia College of Art, 1967, and School of Visual Arts, New York, 1977–79. **Address:** c/o Nancy Hoffman Gallery, 429 West Broadway, New York, New York 10012, U.S.A.

Individual Exhibitions:

1964	University of Puerto Rico Museum, Mayaquez
1966	Pan American Union, Washington, D.C.
1968	Leo Castelli Gallery, New York
1969	Galerie M. E. Thelen, Essen

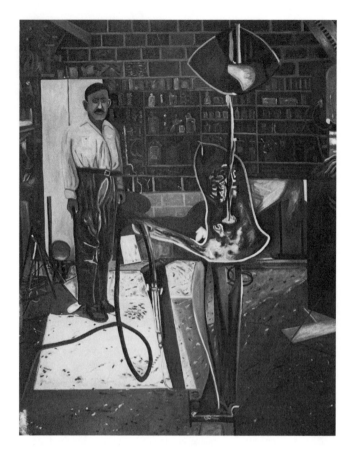

Rafael Ferrer: *Virgin Isle,* 1998–99. Photo courtesy of Nancy Hoffman Gallery, New York.

1969	Eastern Connecticut State College, Hartford
1970	Leo Castelli Gallery, New York
	Galerie Mickery, Amsterdam
	Philadelphia Museum of Art
	Galerie M. E. Thelen, Cologne, Germany
	University of Hartford, Connecticut
1971	University of Rhode Island Fine Art Center, Kingston
	University of Pennsylvania, Philadelphia
	Whitney Museum, New York
1972	Pasadena Museum of Art, California
1973	Contemporary Art Center, Cincinnati, Ohio
1974	Nancy Hoffman Gallery, New York
	Museum of Modern Art, New York
1975	Nancy Hoffman Gallery, New York
1977	Albright-Knox Art Gallery, Buffalo, New York
	Marianne Deson Gallery, Chicago
	Galerie Dorothea Speyer, Paris
	Fort Worth Art Museum, Texas
1978	Nancy Hoffman Gallery, New York
	The New Gallery, Cleveland
1980	Hamilton Gallery of Contemporary Art, New York
	Frumkin Struve Gallery, Chicago
1982	Nancy Hoffman Gallery, New York
1986	Nancy Hoffman Gallery, New York
1988	Nancy Hoffman Gallery, New York
1990	Nancy Hoffman Gallery, New York
1995	Nancy Hoffman Gallery, New York

Rafael Ferrer: *El Paseo (The Stroll),* 1984. Photo courtesy of Nancy Hoffman Gallery, New York.

Selected Group Exhibitions:

1970	*Whitney Annual,* Whitney Museum, New York
1971	*Depth and Presence,* Corcoran Gallery, Washington, D.C.
1973	*Whitney Biennial,* Whitney Museum, New York
1977	*Drawings of the 70s,* Art Institute of Chicago
	Narrative Arts, Contemporary Art Museum, Houston
	A View of a Decade, Museum of Contemporary Art, Chicago
1978	*Private Myths,* Queens Museum, New York
	Masks, Tents, Vessels, Talismans, Institute of Contemporary Art, Philadelphia
1980	*The Pluralist Decade: Venice Biennale,* Institute of Contemporary Art, Philadelphia

Collections:

Metropolitan Museum of Art, New York; Whitney Museum, New York; Museum of Modern Art, New York; Albright-Knox Art Gallery, Buffalo, New York; Philadelphia Museum of Art; Museum of Contemporary Art, Chicago; Lehmbruck Museum, Duisburg, Germany.

Publications:

On FERRER: Books—*Deseo: An Adventure,* exhibition catalog, with Carter Ratcliff, Contemporary Arts Center, Cincinnati, Ohio, 1973; *Drawing,* exhibition catalog, Nancy Hoffman Gallery, New York, 1995. **Articles**—"New York: Rafael Ferrer, Leo Castelli Gallery" by B. Vinklers in *Art International* (Lugano, Switzerland), March 1970; "A Different Drummer" by K. Levin in *Artnews* (New York), December 1971; "New York: Rafael Ferrer, Whitney Museum" by Kenneth Baker in *Artforum* (New York), March 1972; "Rafael Ferrer: An Interview," with Stephen Prokopoff, in *Art and Artists* (London), April 1972; "Rafael Ferrer" by J. L. Dunham in *Artweek* (Oakland, California), November 1974; "Ferrer's Sun and Shade" by Carter Ratcliff in *Art in America* (New York), March 1980; "Some Part of the World: New Paintings by Rafael Ferrer" by Larry Day, in *Arts Magazine,* 60, November 1985, pp. 26–28; "Rafael Ferrer" by Mike Hubert, in *Flash Art,* XXVI(170), May 1993; "Rafael Ferrer"

by Hearne Pardee, in *Artnews* (New York), 94, November 1995, p. 242; Rafael Ferrer issue of *Art Press* (Paris), 17, 1996.

* * *

Rafael Ferrer left his native home of Puerto Rico in 1951, at the age of 18, to attend Syracuse University. After returning home to study art at the University of Puerto Rico, Ferrer made a final move to New York City in 1966. By this time Ferrer had worked with a broad range of media including sculpture, painting, drawing, printmaking, and performance art.

Ferrer was first known for his inventive, loosely assembled temporary installations associated with process art. His installation environments included materials such as leaves, grease, hay, ice, neon, and corrugated metal. In the 1960s Ferrer's friendship with Robert Morris led to his participation in a process art show at the Castelli Warehouse, in which he exhibited a staircase covered with dried leaves raked from lawns. During the next decade Ferrer became well known for his outrageous installation pieces. In 1975 he created a room-size environment called *Celebes* for display in the Nancy Hoffman Gallery and later exhibited at the Museum of Modern Art in New York City. This work alludes to a specific tropical location and includes a jungle bedroom with primitive wall hangings and paper-bag masks, a plastic palm, a wondrous paint-splattered dresser, bedroom slippers, neon lights, and a gigantic mounted boa suspended above the room. He used a naive style and unusual materials to bring to mind the natural forces of a tropical place. These nontraditional installations suggest a good-humored view of place, race, and self-identity and encourage the desire to go to faraway places.

During the 1970s Ferrer began painting as well as creating sculpture. He painted expressive portraits and figures and experimented with materials such as raffia, paper, steel, latex, and acrylic in his sculptures. His success in the mid-1970s came out of the fact that he was not conforming to the established art movements of minimalism, pop, and conceptual art but was primarily a figurative artist whose distinctive style and use of color set him apart. His sculpture *Puerto Rican Sun* made the cover of *Art in America* in March 1980. On one side it depicts the hot orange Caribbean sun between two tropical palm trees and on the other side the cool moon. Erected in a predominately black and Puerto Rican neighborhood of the South Bronx, the bright *Puerto Rican Sun* sits in stark contrast to the deteriorating neighborhood it inhabits.

His works of the late 1970s and the 1980s seem to celebrate island life and allude to his Puerto Rican and American background, giving an expressive, colorful, and unique quality to images such as pineapples, palm trees, animals, and people. His painting *El sol asombra,* now at the Butler Institute, is a striking example of this Caribbean sensibility. It is dominated by brilliant light and vivid color that seems to capture the artist's poignant memories or dreams. The brushstrokes are thick, flowing, and dynamic, complimenting the visual imagery of the tropics. Ferrer's sculpture *The Night of Ruiz Belvis (A Kiosk for the Hotel Aubry in Valparaiso, Chile with a Sentry Owl),* at the Orlando Museum of Art in Florida, also exhibits the artist's reference to cultural history and his Hispanic roots. This sculpture is a rectangular columnar steel armature covered with canvas and painted colorfully. An owl sits on top of the column holding paintbrushes in its claws. Words painted down the sides of the column say either ''Valparaiso'' or ''Hotel Aubry.'' Ruiz Belvis, whose name is used in the title, was a Puerto Rican abolitionist of the nineteenth century who bought and freed slave children. Belvis

traveled to Valparaíso, Chile, and was mysteriously killed there. The sculpture gives a sense of place through the sentiment of a worn and glowing hotel sign and the suggestion of night through the sentry owl. Ferrer created an atmosphere of a shady coastal town that underlines the mystery of Belvis's death.

During the 1990s Ferrer made a series of large drawings in homage to Cuban painter Wifredo Lam, who had encouraged Ferrer in his early efforts. Additionally, Ferrer's interpretations of two Hiroshige prints revealed his love of bold patterns and details.

Ferrer's achievements as an artist have added a visual richness to basic forms through energetic painting, rhythmic flattened surfaces, light, and atmosphere. His impressive pictorial surfaces have a splendor of emotion and color. He was a master at making cultural connections while evoking the feeling of another time and place.

—Andrea Kalis

FIGARI, Pedro
Uruguayan painter

Born: Montevideo, 29 July 1861. **Education:** Universidad de la República, degree in law 1885; studied painting under Godofredo Sommavilla, 1886. **Family:** Married María de Castro Caravia in 1886; five children. **Career:** Served on the State Council, 1898–99; elected member, Chamber of Deputies, 1897–1905; president, Ateneo de Montevideo, 1903–09; director, Escuela Nacional de Artes y Oficios, 1915–17. Began painting, 1921. Traveled in Europe as Uruguayan diplomatic representative, c. 1927. Lived in Buenos Aires, 1921–25, and in Paris, 1925–33. Founder, *El Deber* newspaper, 1893, and art organization *Sociedad Amigos del Arte,* Buenos Aires, 1924; also founded *El Diario* newspaper. **Awards:** Gran Premio de Pintura, Salón del Centenario, Montevideo, 1930; gold medal, Exposición Iberoamericana, Seville, 1930. **Died:** Montevideo, 24 June 1938.

Individual Exhibitions:

1923	Druet Gallery, Paris
1933	Amigos del Arte, Montevideo
1946	Knoedler Gallery, New York
	Council for Inter-American Cooperation, New York
	Organization of American States, Washington, D.C. (retrospective)
1960	Musée National d'art Moderne, Paris
1996	Galeria Sur, Montevideo
1998	Museo Nacional de Bellas Artes, Buenos Aires

Selected Group Exhibitions:

1930	Zak Gallery, Paris
1942	Pan-American Fair, New York
1943	*Latin American Collection of the Museum of Modern Art,* New York
1945	San Francisco Museum of Art
1946	Pan American Union, Washington, D.C.
	Baltimore Museum of Art, Maryland
	Walker Art Center, Minneapolis

Pedro Figari: *Dance in the Courtyard.* © Art Resource, NY.

Seattle Art Museum

1966 *Art of Latin America since Independence,* Yale University, New Haven, Connecticut, and University of Texas, Austin

Collections:

CDS Gallery, New York; Museum of Fine Arts, Houston; Mary Anne Martin/Fine Art, New York; Museum of Modern Art, New York; Museum of Modern Art of Latin America, Washington, D.C.; National Cowboy Hall of Fame, Oklahoma City.

Publications:

By FIGARI: Books–*Essai de philosophie biologique, artes, estética, ideal,* Paris, Editions de la Revue de l'Amerique latine, 1926; *El arquitecto,* Paris, Editions Le Livre Libre, 1928.

On FIGARI: Books—*Exposition Pedro Figari,* exhibition catalog, Paris, Musée National d'art Moderne, 1960; *Pedro Figari* by Samuel

Oliver, Buenos Aires, Ediciones de Arte Gaglianone, c. 1984; *The Magic Line: The Drawings of Pedro Figari* by Alfredo Halegua, Washington, D.C., Monumental Sculptures, c. 1988; *Historia Kiria* by Jesus Caño-Guiral, Montevideo, Instituto Nacional del Libro, 1989; *Figari: XXIII bienal de São Paulo,* Buenos Aires, FINANBRAS, 1996; *Pedro Figari,* exhibition catalog, by Victoria Ocampo, Montevideo, Galeria Sur, 1996; *Pedro Figari en el Museo Nacional de Bellas Artes,* exhibition catalog, by Jorge Glusberg, Angel Kalenberg, and others, Buenos Aires, Museo Nacional de Bellas Artes, 1998. **Article**—''Pedro Figari: The Search for Roots'' by Ivonne Pini, in *Art Nexus,* 18, October/December 1995, pp. 64–68.

* * *

Pedro Figari was born in Montevideo, Uruguay, on June 29, 1861, to Genovese parents. He was trained as a lawyer and in 1885 was awarded a doctorate in jurisprudence. He enjoyed a long and distinguished career as a lawyer, journalist, and politician before dedicating himself to painting and writing. From 1895 to 1899 he represented an army officer, Lieutenant Almeida, falsely accused of

Pedro Figari: *Dancers in Haiti.* © Giraudon/Art Resource, NY.

murder. Although Almeida was released in 1899 because of a lack of evidence, Figari continued to fight to clear his name, and Almeida was finally vindicated in 1922. Figari's association with Almeida led to his being called the American Zola, after the French champion of Captain Dreyfus, although Figari always criticized the fact that the Dreyfus affair received more attention in Uruguay than did that of Almeida. Aside from the period 1898–99, when he served on the State Council, between 1897 and 1905 Figari served in the Chamber of Deputies as an elected member of the Colorado Party. He codirected the newspaper *El Deber* in 1893 and founded another newspaper, *El Diario*. In 1912 he published *Arte, Estética, Ideal* (translated into French and published in Paris in 1920), in which he expounded his theories on art education. Appointed the director of the School of Fine Arts and Crafts in Montevideo in 1915, he resigned in 1917 after he failed to push through radical reforms.

Despite maintaining an interest in the arts during his professional career, Figari seriously took up painting only in 1921 when, after turning down the ambassadorship to Peru and retiring from pubic life at the age of 60, he moved to Buenos Aires, accompanied by five of his children. There, in 1924, he was involved in the founding of Amigos del Arte, an organization dedicated to the defense of modern art. In 1925 he moved to Paris, returning to Buenos Aires in 1933.

Figari is widely accepted as being one of the first Latin American modernists, an accolade made by the Cuban novelist Alejo

Carpentier, among others. Although influenced by European expressionism, Figari advocated the formulation of a regional art that was distanced from the conventions and demands of Europe. Thus, Figari captured the landscapes, traditions, and customs of Uruguay and Argentina in his small, intimate paintings in oil on cardboard. He himself believed that his contribution to art was modest, but he consciously set out to capture characteristic scenes of the urban and rural life of the region. The Argentine poet and art critic Damián Bayón saw him as someone who inspired other Uruguayans to capture the essential elements of their culture without falling into folkloristic or tourist-oriented art. Figari's work is nevertheless deliberately nostalgic, demonstrating his preoccupation with preserving what he saw as the real aspects of Uruguayan culture but which other sectors of Uruguayan society perceived as the failure of their country. These visions recalled those that he witnessed as a young person in the 1860s and 1870s.

In his work Figari depicts the culture of the gaucho and life on the pampas, where the only landmark of significance is the large, fleshy *ombu* tree; the *candombe* and *cambacuá* religious rituals of the Afro-Uruguayan population; traditions of the European and Creole population such as the European dance *pericón*; and images associated with *conventillos* (low-rent boardinghouses). His images reflect the rural dimension of national identity, an aspect often lost in the European-influenced urban centers of Montevideo and Buenos Aires.

207

Indeed, his images of the urban Uruguayan bourgeoisie, with their European clothes and parlors, are largely seen as ironic. He later published *Historia Kiria* (1929), a description of a utopia that satirized the urban elites of La Plata. He has been criticized by the Uruguayan artist and critic Luis Camnitzer, however, as a paradigm of the colonial artist in spite of his own insights, as one whose self-perception became self-deception. Camnitzer sees Figari's work as doubly distant since he painted both from memory and from outside Uruguay. Figari also published *El arquitecto* (1928) and in 1930 was awarded a gold medal in painting at the Exposición Iberoamericana de Sevilla. He eventually returned to Montevideo, where he died in 1938.

—Adrian Locke

FONSECA, Ever

Cuban painter and sculptor

Born: Guantánamo, 1938. **Education:** Escuela Nacional de Arte, Havana, 1963–67. **Awards:** First prize in painting, *Salon 70,* National Museum of Fine Arts, Havana, 1970; International Prize of Drawing, Joan Miró, Barcelona, Spain, 1971–72; prize, *International Festival of Painting,* Cagnes-Sur-Mer, France, 1971–77; first prize, *National Salon of Professors and Instructors of Art,* Havana, 1973; prize of painting, *Juvenile National Salon of Fine Arts,* Havana, 1976; award, UNESCO, 1979–84; third prize, *First Carlos Enriquez Salon of Painting and Sculpture,* Havana, 1980; great prize and international prize of contemporary art, Monte Carlo, Monaco, 1982–83; first prize and Prize René Portocarrero, *UNEAC Salon,* 1988. Order 10th for the 1300 Years of Bulgarian Culture, 1984; Distinction for the National Culture, 1988. **Member:** Union of Writers and Artists of Cuba; International Association of Plastic Artists of UNESCO.

Individual Exhibitions:

1963 *Diecinueve mártires y un héroe,* Santiago, Cuba
1971 *Ever Fonseca: Oleos de 1968 a 1971,* Museo Nacional
 de Bellas Artes, Havana
1977 *Ever Fonseca,* Galería Habana, Havana
1985 *Poesía, realidad y otras fabulaciones,* Galería Plaza
 Vieja, Fondo Cubano de Bienes Culturales, Havana
1987 National Museum of Szozcsin, Poland
 Servando Cabrera Moreno Gallery, Havana
1988 Museo Nacional de Bellas Artes, Havana
1991 Galería Qualli, Mexico City
1993 *Pintura cubana,* Casa de la Cultura de Morclia,
 Michoacán, Mexico
1994 *Metamorfosis,* Galería Plaza Vieja, Fondo Cubano de
 Bienes Culturales, Havana
1996 *Exposición de pinturas, esculturas y cerámicas de Ever
 Fonseca,* Salón Vedado, Hotel Nacional de Cuba,
 Havana
 Ever Fonseca: Las fábulas de su mundo, Centro de
 Prensa Internacional, Havana
1997 *Ever Fonseca: Llegar para quedarse, VI bienal de la
 Habana,* Havana
2001 Barrio Museum, Havana

Selected Group Exhibitions:

1981 *6 artistas cubanos,* Museum of Modern Art, Paris
1984 *I bienal de la Habana,* Havana
1985 *Salón de artes plásticas UNEAC '85,* Museo Nacional
 de Bellas Artes, Havana
1988 *Plástica cubana 1980,* Galería L, Havana
1992 *Color de Cuba,* Expo '92, Seville, Spain
1993 *Cuba de hoy,* La Galería, Santiago, Chile
1995 *I salón de arte cubano contemporáneo,* Museo Nacional
 de Cuba, Havana
 Arte contemporáneo cubano, Museo de Arte Moderno,
 Dominican Republic
1997 *Art Beyond Borders,* TIMOTCA-UNESCO, United
 Nations, New York (traveling)
1998 *II salón de arte cubano contemporáneo . . . en tiempo,*
 Galería La Acacia, Havana

Publications:

On FONSECA: Book—*Pintura cubana* by Graziella Pogolotti, Havana, Galería La Acacia, 1991.

* * *

In the early 1960s some Cuban artists tried to create an epic form of art, inspired in large part by the politics of the time. Pop art emerged on the scene, and Raúl Martínez, who devised his own version of pop art based on imagery of the Cuban Revolution and daily life, was one of its greatest proponents. Martínez also led the resurgence of the graphic arts in Cuba; later, this form of expression was taken over by the government for its own propagandistic ends. Interest in photography, in psychedelic art and in New Figuration also grew in the 1960s, a departure from the abstract expressionism of the previous decade.

In the early 1970s the failure of the Cuban-backed guerilla movement in Latin America and the economic chaos of the nation led the Cuban government to abandon its independent position and more fully enter the sphere of the Soviet Union. This shift put an end to pluralism in art, and while no official style was dictated, the practice of using the arts to further ideology was required, along with a stereotyped form of nationalism. A culture of officialdom dominated these years. Some artists continued to paint in their own styles, but they could exhibit only rarely. A school of neoexpressionists arose, but strictures forced these artists to adapt to the dictates of official tastes. The widespread success of photo-realism in the mid-1970s signaled a change, and a number of artists turned to this style. At the close of the decade a more liberal atmosphere prevailed, and the founding of the Cuban Ministry of Culture in 1977 allowed for more freedom of experimentation and encouraged a revitalization of arts in general. The 1970s also saw more Cuban émigré artists in both Miami and New York beginning to come into prominence.

Among the artists who were active in Cuba during the 1960s and '70s was Ever Fonseca, who was born in 1938 in the interior of the island. After New Figuration was introduced in Cuba he explored a new, personal mythology based on peasant folklore. The restrictive period of the early 1970s, however, did not allow him to exhibit his work with any great frequency. Representative of his early work is *Los jigues del amor* (1975), a painting in which all things pictorial have been almost reduced to symbols. The painting appears to depict two figures embracing, but upon closer inspection one of the figures

seems to be nature or the landscape itself. The reduction of the imagery to recognizable symbols or pictographs has antecedents in the work of such artists as Rene Avila but is nonetheless very different. Fonesca's work is more surreal in feeling and looks back to the interest in surrealism expressed in many avant-garde artists' works from the 1930s and '40s. Simultaneously emphasizing flat planes and spatial recession, the dream-like image incorporates the beach, water, and the sun, three primary natural elements of life in Cuba.

Fonseca continued his interest in pictographic representation in the 1990s. In *Cabezes de jigues* (1993), for example, the canvas depicts a sea of eyes and vegetal forms. Are these forms multiple heads that have been superimposed? Or rather, do the eyes exist in nature, peering through the vegetal forms like hidden spirits? This sense of mystery pervades Fonseca's work, engaging the viewer to decode what is depicted on the canvas's surface.

Throughout his career, as was the case with many other Cuban artists, Fonseca explored various indigenous sources for visual imagery in his work. Cuba's traditional folklore provided a rich lode of ideas, and Fonseca succeeded in creating a unique visual language that tried to seek out what was ''Cuban'' in Cuban art.

—Sean M. Ulmer

FONSECA, Gonzalo
Uruguayan painter and sculptor

Born: Montevideo, 2 July 1922. **Education:** Studied architecture at Universidad de la República Oriental del Uruguay, 1939–41; studied painting under Joaquín Torres-García, Montevideo, 1942–49. **Career:** Traveled to Middle East, 1950–52; lived in Paris, 1952–57; lived in the United States, beginning in 1957; traveled to Italy, 1970; traveled to India, 1975. Sculptor, New School for Social Research, New York, 1959–61, Reston, Virginia, 1963–64, PS 46, New York, and Bronx, New York, 1968, Alza Laboratory, Palo Alto, California, 1970. **Died:** 10 June 1997.

Individual Exhibitions:

1952	*Gonzalo Fonseca Paintings,* Studio Claudio Matinenghi, Rome
1962	*Gonzalo Fonseca, Selected Works,* Portland Art Museum, Oregon
1970	*Gonzalo Fonseca, Recent Works,* Jewish Museum, New York
1974	Galería Conkright, Caracas
1976	Galería Adíer/Castíllo, Caracas
1977	*Sculturi di Gonzalo Fonseca,* Galería del Naviglio, Milan
1978	Fiera di Bologna, Italy
1986	*Gonzalo Fonseca: Sculpture,* Arnold Herstand, New York
1988	*Gonzalo Fonseca: Sculpture & Drawings,* Arnold Herstand, New York
1989	*Fonseca, Sculpture & Drawings,* Arts Club of Chicago
1991	*Gonzalo Fonseca: Sabbakhin Sculpture,* Arnold Herstand, New York
1994	*Mundos de Gonzalo Fonseca,* Museo de Bellas Artes, Caracas

Selected Group Exhibitions:

1954	*Bienal de Arte,* São Paulo
1956	*Exposición de Arte Plástico,* Museo San Martin-Artigas, Buenos Aires
1960	*4 Constructivist Works of the TTG,* New School, New York
1970	*Universalismo Constructivo,* Museo Nacional de Bellas Artes, Buenos Aires
1987	*Latin American Artists in New York since 1970,* Archer M. Huntington Art Gallery, Austin, Texas
1988	*Latin American Spirit: Art and Artists in the U.S., 1920–1970,* Bronx Museum, New York, Center for the Arts, Vero Beach, Florida, Institute of Culture, San Juan, and El Paso Museum of Art
1993	*Latin American Artist of the 20th Century,* Museum of Modern Art, New York, Centre Georges Pompidou, Paris, and Ludwig Museum, Dusseldorf
1994	*Torres-García y la Escuela del Sur,* Quinta Galería, Bogota
1996	*The Still Life,* Cecilia de Torres Gallery, New York (traveling)
1997	*Una estética permanente,* Galería Elvira González, Madrid

Collections:

Brooklyn Museum, New York; Solomon R. Guggenheim Museum, New York; University of Texas, Austin; Portland Art Museum, Oregon; Museo de Bellas Artes, Caracas.

Publications:

By FONSECA: Books—*Gonzalo Fonseca, Recent Works,* exhibition catalog, Portland, Oregon, Portland Art Museum, 1962; *Gonzalo Fonseca: Recent Works,* exhibition catalog, New York, Jewish Museum, 1970; *Gonzalo Fonseca,* exhibition catalog, with Angel Kalenberg and others, Montevideo, Uruguay, Ministerio de Educación y Cultura, 1990.

On FONSECA: Articles—''Gonzalo Fonseca'' by Mark Mennin, in *Arts Magazine,* 61, October 1986, p. 112; ''Gonzalo Fonseca'' by Katherine Chacon, in *Art Nexus* (Colombia), 14, October/December 1994, pp. 125–126.

* * *

Gonzalo Fonseca epitomizes Uruguay. A devoted artist, he was neither interested in exhibitions nor concerned with fame or the elites. Since childhood he was deeply attracted to art and archaeology. As a child he traveled frequently to Europe with his family, and the region's museums and archaeological sites defined his lifelong devotion. In 1939 he began studying architecture, having learned to carve stone two years earlier. For three years he was able to resist academic

studies, but soon his spirit started looking for more artistic venues. In 1942 he entered the Taller Torres-García, the nontraditional teaching premise created by Joaquín Torres-García. The impact that Torres-García had on his professional life was important but not as definitive as for some of his colleagues. Fonseca accepted being compared only to his master, not to his contemporaries.

With some of his classmates Fonseca also traveled to Peru and Bolivia, and the two countries continued to feed his already strong passion for sculpture, stone, and primitive cultures, in this case pre-Columbian civilizations. He kept in touch with Europe by living in Paris for a year while he conducted archaeological research, looking for ways to understand those powerful cultures of the past; to this end he also traveled to Jordan, Syria, and Egypt. In 1957 he moved to New York City, where he established his studio. New York adopted him and he adopted New York, but Carrara, Italy, would soon play a very important third party role. In 1970 Fonseca began to spend half a year in New York and Pietrasanta, Italy.

Fonseca was a polyglot and lived almost secluded, enjoying the rooms of the apartment where he also had his studio in New York, while at the same time longing for Carrara; when in Italy he often thought of New York. Though he chose to be a sculptor—a work in the public domain—he did not want to let many people know about his profession. He was even more restrictive about information concerning his personal life. Nevertheless, Fonseca is a significant figure in contemporary art because of the aesthetic language he developed. He wanted to carve the stones only up to a certain point, not looking for a perfect reproduction of something from the everyday life but allowing the secrets of the material to breath. He was devoted to relating iconographic elements that he could recall to those that he created, not just as objects but also in a metaphysical path. The holes, small caves, and irregularly paved surfaces that he discovered and created in huge marble blocks were always custodians of some secret inner power. As citylike remainings of the human era vanished, he conceived the huge and heavy cuts as vertical or horizontal self-standing pieces or wall reliefs. In spite of the fact that the forms left by the machinery when cutting each stone were a point of departure for the artist, he did drawings regarding the orientation and type of tombs, caves, and elements to be created. Fonseca's artwork is a mission toward the unknown world while not forgetting the existing cities.

Fonseca was not interested in the commonly named "success." He became renowned without his own impulse for it, and the magnificence of his secret messages survives the time when they were created. He was not interested in displaying at a gallery, although it has always been very much desired. Rarely has more than one of his pieces been seen in the public domain; the material he used was often very delicate, though bulky and heavy, all of which complicated the transportation of his pieces. He also worked with wood, clay, cement, and threads. Such materials reveal that his work has a clear relation with tribal roots. It is interesting to notice the small but empowering areas in which he settled a relation with primitive artifacts, structures, and techniques. Geography was unmentioned yet still present in the perception he had of volumes and textures, about which he learned early on through traveling and observing/absorbing silently. Each of Fonseca's pieces has an architectural approach, the perception of nature as a consequence of the materials that he used, and the consistent relation to origins—his Latin American ones or those of the different cultures that he often visited and carefully studied.

—Graciela Kartofel

FONTANA, Lucio
Argentine painter and sculptor

Born: Rosario de Santa Fe, 1899. **Education:** Instituto Tecnico Carlo Catteneo, Milan, 1914–15; Accademia di Brera, Milan, 1928–30. **Career:** Moved to Milan with family, 1905. Sculptor in his father's studio, Rosario de Santa Fe, 1922–24. Lived in Milan, 1928–34, in Paris, 1934–36, in Argentina, 1939–47. Member, artist group *Abstraction-Création,* 1934. Cofounder, Academia Altamira, Buenos Aires, 1946. Wrote first and third Spatialist manifestos, Milan, 1947, 1950. **Award:** International Grand Prize for Painting, *Venice Biennale,* 1966. **Died:** 1968.

Individual Exhibitions:

1930	Galleria de Milione, Milan
1937	Galerie Jeanne Bucher, Paris
1961	Martha Jackson Gallery, New York
	Wadsworth Atheneum, Hartford, Connecticut
1966	Walker Art Center, Minneapolis
1968	Marlborough Gallery, New York
1970	Martha Jackson Gallery, New York
1977	Solomon R. Guggenheim Museum, New York (posthumous retrospective)
1999	Galerie Pascal Retelet, Saint Paul de Vence, France
2000	Sperone Westwater, New York

Selected Group Exhibitions:

1949	Museum of Modern Art, New York
	Galleria del Naviglio, Milan
1950	*Venice Biennale*
1957	*Italian Art from 1910 to the Present,* Haus der Kunst, Munich
1958	*Venice Biennale*
1966	*Venice Biennale*
1967	*Latin American Art: 1931–1966,* Museum of Modern Art, New York

Collections:

Aquavella Galleries, New York; Solomon R. Guggenheim Museum, New York; Hirshhorn Museum and Sculpture Garden, Washington, D.C.; Museum of Modern Art, New York; Washington University, St. Louis.

Publications:

On FONTANA: Books—*Omaggio a Lucio Fontana* by Enrico Crispolti, Rome, B. Carucci, 1971; *Lucio Fontana* by Carla Schulz-Hoffmann, Munich, Prestel-Verlag, c. 1983; *Lucio Fontana: "Qui sait comment est dieu?": Biographie, 1899–1968* by Giovanni Joppolo, Marseille, Images en manoeuvres, c. 1992; *Lucio Fontana, Retrospektive* by Thomas M. Messer, Ostfildern-Ruit bei Stuttgart, Hatje, c. 1996; *Lucio Fontana: Teatrini* by Luca M. Barbero, Mantova, Italy, Casa del Mantegna, 1997; *Lucio Fontana* by Sarah Whitfield, Berkeley, University of California Press, 1999; *Lucio Fontana,* exhibition catalog, by Enrico Crispolti, Olivier Meessen, and others,

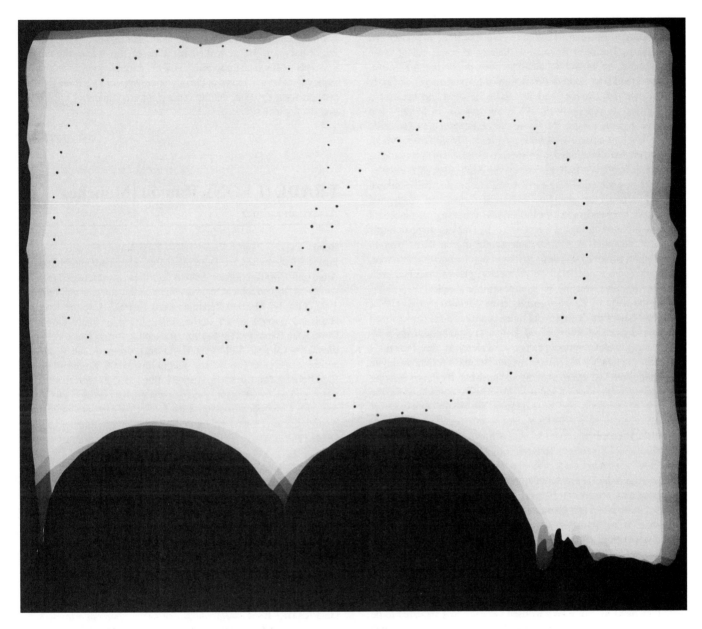

Lucio Fontana: *Spacial-Theatrical Concept,* **1965. © Archivo Iconografico, S.A./Corbis.**

Saint Paul de Vence, France, Galerie Pascal Retelet, 1999; *Lucio Fontana,* exhibition catalog, New York, Sperone Westwater, 2000. **Articles—**''Fontana's Post-Dada Operatics'' by Holland Cotter, in *Art in America,* 75, March 1987, pp. 80–85; ''Renovating the New: The Art of Lucio Fontana'' by Jole de Sanna, in *Artforum International,* 26, November 1987, pp. 109–113; ''Five Milanese Exhibitions and a Book Explore Anew the Cosmic Universe of Lucio Fontana's Art'' by Stefano Casciani, in *Abitare* (Italy), 386, July/August 1999; ''Lucio Fontana: My Friend Lucio Fontana'' by Giorgio Soavi, and ''The Door That Never Was: Lucio Fontana'' by Cecilia de Carli, both in *FMR* (Italy), 102, February/March 2000; ''From Matter to Light: Fontana's Spatial Concepts and Experimental Photography'' by Stephen Peterson, in *Art on Paper,* 4(4), March/April 2000, pp. 52–57.

* * *

Born in Argentina of Italian descent, Lucio Fontana was one of those rare artists who worked primarily in painting and sculpture and earned recognition in both mediums. Schooled as a classical figurative sculptor, Fontana used his training in the creation of purely abstract three-dimensional works. He is also historically important for his slashed and punctured monochrome paintings. His sculpture, painting, and installations were theoretically anchored in a concept that he called Spatialism. Spatialism was concerned with releasing energy innate in matter, but the energy that Fontana sought to make manifest was metaphysical in nature and, according to Spatialist philosophy, permeated the cosmos and could only materialize through a particular type of art.

The gestation of Spatialism can be found as early as 1931 in a group of sculptures called *Tavoleta grafita* (''Tablet with Graffiti''), in which Fontana deviated from the figurative works that established him as a highly gifted sculptor. These works paradoxically focused on

theoretical issues germane to both painting and sculpture and sought to erase the gulf between art and life by collapsing the structures that divide them. The most innovative strategy to come out of these investigations, in regard to painting, was dissolving the frame. Fontana would later address this notion in his violent yet elegantly slashed paintings, which used the space between the back of a painting and its support wall. While the impetus in literally and figuratively going outside the frame can be attributed to Fontana's Argentine contemporaries working collectively as Grupo Madi, *Tavoleta grafita* also alluded to another artistic problem that would be resolved in Fontana's later sculptures: the eradication of the sculptural base or pedestal. These early works are ontologically situated between painting and sculpture and are a formal and conceptual innovation. They underscore the limitations of painting's perspectival tradition, initiated during the Renaissance, by emphasizing painting's sculptural potential as a three-dimensional object. The *Tavoleta grafita* series achieved this through its rectangular horizontal format, which was constituted from polychromatic plaster inscribed with child-like gestures, creating an agitated sculptural relief.

In the wake of *Tavoleta grafita* came *Scultura astrata* (1934, "Abstract Sculpture"), in which Fontana continued his explorations into pure abstraction and resolved sculptural problems of space by undermining one of painting's most crucial elements: line. Fontana's emphasis on planarity in *Scultura astrata* became a formal analogue to the importance of line in painting and drawing. By deconstructing sculpture through line, an element historically considered in the province of painting, and by exploring the spatial dynamics of painting in relationship to its three-dimensionality and to what exists beyond the frame, Fontana was arriving at Spatialism. The catalyst for the realization of Spatialism, however, was *Manifesto blanco* ("White Manifesto"), a theoretical text written by Fontana and his students in 1946 in Argentina. The manifesto voiced ideas that would later be elaborated and refined into Fontana's violent aesthetic technique of slashing, puncturing, and tearing. As an attack on abstraction, figuration, rationalism, formalism, and aesthetics in general, *Manifesto blanco* was the theoretical linchpin that would underscore Fontana's works after 1951, which he collectively called *Conceto spaziale* ("Spatial Concept").

The first works under this rubric were a series called *Buchi* ("Holes"). These were Fontana's first monochromatic paintings and were punctured overall with a focused intensity that appeared to be randomly executed. The violence in this initial *Conceto spaziale* series has been couched in various frameworks. Some critics have read the *Buchi* and Fontana's other formal violations in psychoanalytic terms, where the canvas itself becomes the feminine receptacle of a masculine assault. Other critics, most notably Yve-Alain Bois, have read Fontana's work through Georges Bataille's concept of the *informe,* or formlessness, as well as what Bataille called the scatological. Fontana, in *Manifesto blanco,* offers a cosmological interpretation of his slashed and punctured canvases as an investigation into the "four dimensions of space." While Fontana's own reading of his work hints at a metaphysical undercurrent, his well-known *Conceto spaziale* series entitled *La fine di Dio* ("God Is Dead") engendered a new reading altogether.

Whereas his previous work was marked by an overt idealism figured through the cipher of metaphysics, *La fine di Dio* also alluded to concomitant philosophies such as existentialism and to Nietzsche's infamous proclamation that "God is dead." What may be the most interesting aspect of this series is not its complex theoretical thrust but its astute coupling of dense philosophical thought with a highly

elegant aesthetic. This combination is undoubtedly the most important contribution Fontana made to both Latin American and twentieth-century art. He reworked the idea of the frame beyond the concepts of his contemporaries, and his extrapolation of the philosophical realm that exists in the interstices between a painting and its support wall, evinced, among other things, complexity, originality, and intelligence.

—Raúl Zamudio

FRADE (LEÓN), Ramón (Monche)
American painter

Born: Cayey, Puerto Rico, 1875. **Education:** Escuela Normal, Puerto Rico; studied art, Dominican Republic; studied architecture, American Correspondence School, certificate in architecture, land surveying, topographical highway engineering, and master plumbing 1928. **Family:** Married Reparada Ortiz in 1907. **Career:** Lived in Haiti and opened an art studio, 1894. Lived in Santo Domingo, Dominican Republic, 1896–1902; traveled to Puerto Rico, 1897–99; traveled to Curaçao, Colombia, Costa Rica, Uruguay, and Venezuela before returning to Cayey. Traveled to Italy, 1907. Engineer, Puerto Rico Relief Administration, 1936–38. Illustrator, *El lápiz* newspaper. Also worked as an actor, land surveyor, and costume and scene designer. Cofounder, Society of the Lyre, Company of Comics, and Apollo Society; member, Club Revolutionnaire Betances, 1897. **Died:** 1954.

Selected Exhibition:

1900 Paris Salon

Collection:

Universidad de Puerto Rico.

Publications:

On FRADE: Books—*Ramón Frade León, pintor puertorriqueño: Un virtuoso del intelecto* by Osiris Delgado Mercado, San Juan, Centro de Estudios Avanzados de Puerto Rico y el Caribe, 1989; *El lugar de la memoria: Fotografías de Tulio Alvelo y Ramón Frade* by Marta Aponte Alsina, Cayey, Puerto Rico, Libroguiá, 1997.

* * *

Ramón (Monche) Frade is the early twentieth-century Puerto Rican painter who has possibly had the greatest influence throughout the Antilles. He was born in Cayey, a town in the center of the island of Puerto Rico, studied art in the Dominican Republic, began his career in Haiti, worked in Cuba, and returned to his native Cayey, where he spent his professional life. Quisquella as well as Haiti and Borinquen all claim him as their own.

His father, Ramón Frade Fernández, a photographer by profession and possibly artistically inclined, died within a year and a half of his birth. A prosperous Spanish businessman and neighbor of his family, Nemesio Laforga, and his wife convinced Monche's mother to let them adopt her fourth and youngest son. In 1877 the Laforga

family moved to Valladolid and three years later to Madrid, where Nemesio Laforga founded the Tivoli Theater, a business that led to his economic ruin. Laforga decided to move to the Dominican Republic, where his wife had influential family, and so Frade arrived there at 10 years of age. His adoptive father, recognizing his son's talent, enrolled him in the Escuela Municipal de Dibujo (the municipal drawing school) when he was 12.

During his youth the young Frade rubbed shoulders with the most notable intellectuals of the day. As he studied to be a teacher at the Escuela Normal (the grammar school), he spent his nights at the school for telegraph operators, where he also learned French, and frequented gatherings with educator and literary figure Eugenio María de Hostos, Dominican painter Luis Desangles, and various important Dominican intellectuals. Following the interests of his adoptive father, he joined several friends in founding the Society of the Lyre, the Company of Comics, and later the Apollo Society. He participated as an actor, designed costumes and scenery, and published his drawings and caricatures in the newspaper *El lápiz* ("The Pencil"). His indomitable spirit made it inevitable that many of his caricatures would cause him problems.

In 1892 he met the French painter Adolphen Leglande. Leglande, who was also a diplomat, had been sent to the Dominican Republic to mediate a problem between the National Bank and the French consulate. During his short stay on that island, he initiated a great friendship with the young artist. His lessons on color and technique were vitally important to Frade, who always remembered Leglande as his true teacher.

On finishing his university studies, Frade decided to seek his fortune, and in 1894 he moved to Haiti, where he opened his first studio in the capital. During his first two years there he offered painting classes to young Haitians and Cubans. Then, although he maintained a residence in Haiti, from 1896 to 1902 he spent time in Santo Domingo, where he painted the president, as well as in Jamaica and Cuba, where he was contracted to handle the decoration of the vestibule of the Teatro Tacón. He also was commissioned to design theater sets in Haiti. Preoccupied for the safety of his family with the advent of the Spanish-American War and the subsequent U.S. invasion, Frade traveled periodically to Puerto Rico from 1897 to 1899. On one of these trips he met Reparada Ortiz, who became his wife in 1907. One of his paintings, *La volteriana,* was accepted by the Paris Salon in 1900. He painted various historic works, among which are *Toussaint-Louverture en su celda de Fort de Joux* ("Toussaint L'Ouverture in his Cell at Fort de Joux"), *La Crete a Pierrot,* and the portrait of the Haitian president. Also in Haiti he became involved with the Cuban and Puerto Rican independence movements. He began a long friendship with Pachín Marín, the Puerto Rican revolutionary who struggled for Cuba's independence, and in 1897 he became a member of the Club Revolutionnaire Betances. He turned down the opportunity for a scholarship to study art in Europe when he was urged to become a Dominican citizen.

After a long voyage during which he visited Curaçao, Colombia, Costa Rica, and Uruguay, also spending a long time in Venezuela, he returned to Cayey, his native town. At that time it is known that Oller frequented the town since his nephew Ángel Paniagua lived there. Thus began the long friendship between the two painters.

In 1905 Frade painted his masterwork *El pan nuestro de cada día* ("Our Daily Bread"). This painting depicts a Puerto Rican peasant coming down from the mountains carrying a bunch of plantains, his only food. The monumental painting, approximately five feet in height, has become one of the principal icons of Puerto

Rican plastic arts. Together with Rafael Hernández's musical composition *Lamento Borincano* ("Borinquen Lament"), the two works represent the memory of a past steeped in poverty and need, only slowly forgotten. There remain more than a dozen studies of this painting as well as small replicas in oil and watercolor. It has also been the inspiration for principal contemporary artists. Carlos Irizarri, José Morales, María de Mater O'Neill, Arnaldo Roche, Antonio Martorell, Rosa Irigoyen, and Charles Juhasz have all appropriated Frade's work in order to reinterpret it within postmodernism.

For three years Frade kept trying for a scholarship until finally in 1907 he obtained sufficient funds to take himself to Rome for four years. He married and left alone for Europe, although what was planned as a prolonged stay lasted only four months. During that time he lived in Rome for two months and visited most of Italy. He struck up lasting friendships with such artists as Julio Romero de Torre. He was so impressed by Venice that he completed some 30 landscapes of the romantic city of canals.

Upon his return he became ill, and a little later his wife suffered a condition that kept her in bed for the rest of her life. Gone were his years of travel and adventure. To sustain himself he studied architecture by correspondence from the American Correspondence School, receiving in 1928 his certification for architecture, land surveying, topographical highway engineering, and master plumbing. He earned his living as a surveyor, and from 1936 to 1938 he worked as an engineer at the Puerto Rico Relief Administration.

The conditions of poverty and disinterest in the arts in Cayey slowly engulfed Frade, but he continued painting until his death in 1954. More than 600 works, including drawings and oil landscapes, allegorical paintings, still lifes, portraits, and genre paintings, are recognized. He never reproduced his success with another masterwork like *El pan nuestro de cada día*; nevertheless, *La planchadora* ("Ironing Woman"), *Caracolillo* ("Curl"), and *Jibara con chinas* ("Peasant Women with Oranges") are small jewels in which Frade displayed his talent, placing in the proper perspective the words he was often heard to utter: "All that is Puerto Rican is disappearing . . . in my desire to perpetuate it, I paint it."

—Haydee Venegas

FRASCONI, Antonio
American printmaker and woodcut artist

Born: Buenos Aires, Argentina, 28 April 1919; grew up in Montevideo, Uruguay; moved to the United States, 1945. **Education:** Circulo de Bellas Artes, Montevideo; studied architecture; Art Students League, New York (on scholarship), 1945; New School for Social Research, New York (on scholarship), 1946; studied lithography at Tamarind Workshop, California (on scholarship), 1962. **Career:** Since 1938 political cartoonist and graphic illustrator. Designer, U.S. postage stamp, 1963. Traveled to Italy, 1963, 1966. Instructor, New School for Social Research, New York; Pratt Institute, New York, and Brooklyn Museum School, New York. Since 1973 professor of visual arts, State University of New York, Purchase. Artist-in-residence, University of Hawaii, Honolulu, 1964. **Awards:** Award, Yaddo Foundation, 1952; fellowship, John S. Guggenheim Foundation, 1952; award, National Institute of Arts and Letters, New York, 1954; prize, American Institute of Graphic Arts, New York, 1954; grand prize for illustration, Limited Edition Club, New York, 1956;

Antonio Frasconi: *Duke Ellington, 29 Apr 1899–24 May 1974.* © Smithsonian American Art Museum, Washington, D.C./Art Resource, NY. © Antonio Frasconi/Licensed by VAGA, New York, NY.

grand prize, Festival de Cine de Venecia, 1960; grand prize, *Exposición de la Habana,* 1968; prize, *9 bienal internacional de arte grafica,* Tokyo, 1975; Governor's arts award, 1998; Printmaker Emeritus award, 2001.

Individual Exhibitions:

1939	Ateneo de Montevideo
1944	A.I.A.P.E., Montevideo
1946	Museum of Art, Santa Barbara, California
1947	Brooklyn Museum, New York
1948	Galeria Weyhe, New York
1949	Biblioteca Nacional, Mexico City
1952	Cleveland Museum of Art, Ohio (traveling retrospective)
1953	Smithsonian Institution, Washington, D.C.
1963	Baltimore Museum of Art, Maryland (retrospective)
1964	Brooklyn Museum, New York (retrospective)
1967	Galeria Penelope, Rome
1976	Jane Haslem Gallery, Washington, D.C.
	Antonio Frasconi—Obra grafica—1943–1975, Museo del Grabado Latinoamericano, San Juan, Puerto Rico
1987	*Involvement: The Graphic Art of Antonio Frasconi,* University of California, Los Angeles
1989	Dowd Fine Arts Gallery, State University of New York, Cortland
1996	*The Books of Antonio Frasconi: 50 Years,* Grolier Club, New York
1997	*Antonio Frasconi: Grabados,* Museo de las Américas, San Juan, Puerto Rico
2001	*Antonio Frasconi: Langston Hughes' ''Let America Be America Again,''* El Museo del Barrio, New York

Selected Group Exhibitions:

1949	Pan American Union, Washington, D.C.
1966	*Art of Latin America Since Independence,* Yale University, New Haven, Connecticut, and University of Texas, Austin
1967	*Salón nacional de bellas artes,* Montevideo
1968	*Exposición de la Habana,* Havana
1975	*9 bienal internacional de arte grafica,* Tokyo
1989	*The Latin American Spirit: Art & Artists in the U.S.,* Bronx Museum, New York

Collections:

Metropolitan Museum of Art, New York; Museum of Modern Art, New York; Fine Arts Museum of San Francisco; Smithsonian Institution, Washington, D.C.; University of Southern California, Los Angeles; University of Michigan, Ann Arbor; Frederick R. Weisman Art Museum, Minneapolis; Amon Carter Museum of Western Art, Fort Worth, Texas; University of Missouri, Colombia.

Publications:

By FRASCONI: Books—*Woodcuts,* with Joseph Blumenthal and Paul Bennett, New York, E. Weyhe, 1957; *See Again, Say Again: A Picture Book in Four Languages,* New York, Harcourt, 1964; *A Sunday in Monterey,* New York, Harcourt, 1964; *Kaleidoscope in Woodcuts,* New York, Harcourt, 1968. **Books, illustrated**—*12 Fables of Aesop* by Aesop, New York, Museum of Modern Art, 1954; *The House That Jack Built,* New York, Harcourt Brace, 1958; *The Cantilever Rainbow* by Ruth Krauss, New York, Pantheon, 1965; *Love Lyrics* by Louis Untermeyer, New York, Odyssey Press, 1965; *Bestiario: A Poem* by Pablo Neruda, translated by Elsa Neuberger, New York, Harcourt, 1965; *Elijah the Slave* by Isaac Bashevis Singer, translated by Singer and Elizabeth Shub, New York, Farrar Straus, 1970; *The Elephant and His Secret* by Doris Dana, based on a fable by Gabriela Mistral, New York, Atheneum, 1974; *One Little Room, an Everywhere: Poems of Love* edited by Myra Cohn Livingston, New York, Atheneum, 1975; *Beginnings: Creation Myths of the World* edited by Penelope Farmer, New York, Atheneum, 1978; *How the Left-Behind Beasts Built Ararat* by Norma Farber, New York, Walker, 1978; *The Little Blind Goat* by Jan Wahl, Owings Mills, Maryland, Stemmer House, 1981; *Leaves of Grass* by Walt Whitman, Franklin Center, Pennsylvania, Franklin Library, 1981; *The First Editor: Aldus Pius Manutius* by Theodore Low de Vinne, New York, Targ, 1983; *Two Tales* by Merce Rodoreda, translated by David Rosenthal, New York, Red Ozier, 1983; *Monkey Puzzle and Other Poems* by Myra Cohn Livingston, New York, Atheneum, 1984; *Prima che tu dica ''Pronto''* by Italo Calvino, Cottondale, Alabama, Plain Wrapper Press, 1985; *Sun at Midnight: 23 Poems* by Muso Soseki, translated by W. S. Merwin and Soiku Shigematsu, New York, Nadja, 1985; *Cuatro chopos* by Octavio Paz, translated by Elliot Weinberger, Purchase, New York, Center for Edition Works, 1985; *If the Owl Calls Again: A Collection of Owl Poems* selected by Myra Cohn Livingston, New York, McElderry Books, 1990; *At Christmastime* by Valerie Worth, New York, HarperCollins, 1992; *Friendship: An Emerson Homage in Remembrance of Joseph Blumenthal* by Ralph Waldo Emerson, New York, Kelly-Winterton Press, 1993; *Platero y yo* by Juan Ramón Jiménez, translated by Myra Cohn Livingston, New York, Clarion, 1994; *The Zoo at Night* by Martha Robinson, New York, McElderry Books, 1995.

On FRASCONI: Books—*The Work of Antonio Frasconi,* exhibition catalog, Cleveland, Ohio, Cleveland Museum of Art, 1953; *Frasconi: Against the Grain* by Nat Hentoff and Charles Parkhurst, New York, Macmillan, 1974; *Antonio Frasconi: A Bibliography* by Cornelia Corson, Purchase, New York, C. Corson, 1978; *Involvement: The Graphic Art of Antonio Frasconi,* exhibition catalog, edited by Edith A. Tonelli, Los Angeles, University of California, 1987; *Antonio Frasconi: Obra gráfica* by Ricardo E. Algría, San Juan, Puerto Rico, Museo de las Américas, 1996; *Antonio Frasconi: Grabados,* exhibition catalog, San Juan, Puerto Rico, Museo de las Américas, 1997. **Articles**—''Cries from the Heart'' by Henry Klein, exhibition review, in *Artweek,* 19, 13 February 1988, p. 4; interview with Antonio Frasconi by Robert Berlind, in *Art Journal,* 53, spring 1994, pp. 50–52; ''Going against the Grain'' by Caleb Bach, in *Americas,* 46(3), May 1994, p. 38. **Film**—*The Woodcuts of Antonio Frasconi* by Pablo Frasconi, Jersey City, New Jersey, Frasconi-Salzer Films, 1985.

* * *

An internationally known printmaker, Antonio Frasconi has been particularly esteemed for his woodcuts. Depicting a variety of topics including themes from fables, fairy tales, and nursery rhymes, Frasconi's works also portray prominent humanitarians, common laborers, and victims of political and social injustice.

Frasconi was born in 1919 in Buenos Aires into a family of Italian immigrants. The family moved to Uruguay when Frasconi was a child. Attracted by the printed image since early childhood, Frasconi stated that the work of Gustave Dore introduced him to the ''visual'' and inspired him to become a book illustrator. Frasconi learned the printing trade while working as a printer's apprentice in Uruguay during the 1930s. He was also interested in politics and used his artistic abilities to express his views. For example, as a teenager Frasconi produced antifascist posters upon which he signed the name ''Chico,'' and his political cartoons were published in weekly tabloids. Unlike some graphic artists who rely on advanced technology to create a print, Frasconi used simple printmaking tools: a block of wood, cutting tools, paper, and ink, and he acknowledged the fact that historically printmaking was an inexpensive means of reaching the masses.

While working as an apprentice, Frasconi became acquainted with the work of Honoré Daumier, Francisco Goya, Paul Gauguin, and George Grosz. As a young man Frasconi was fascinated by the United States and familiarized himself with American culture by listening to jazz, which to Frasconi represented ''freedom,'' and by reading Walt Whitman, Henry David Thoreau, Sinclair Lewis, Richard Wright, and John Dos Passos. When Frasconi learned that Grosz was a teacher at the Art Students League in New York City, he applied to the school. He received a one-year scholarship and moved to New York in the fall of 1945. When Frasconi arrived at the school, he was disappointed to find that Grosz was no longer teaching there but was delighted to meet his future wife, who was also an art student at the Art Students League.

Throughout his career Frasconi has been preoccupied with man's inhumanity to man. While living in Montevideo during World War I, he produced a series of 10 linocuts, *Los infrahumanos* (''The Subhumans''), which were inspired by race riots in Detroit, Michigan, in 1943. The prints, which addressed the oppression of black people in North America, were not shown in his country because the Uruguayan government did not want to appear critical of the United States at that time. American author Wright, however, endorsed Frasconi's work, stating, ''It is imperative that we artists seek and find a simpler, more elementary, and a more personal guide to the truth of experience and events than those contained in the mandates of frenzied politicians.''

In 1967 Frasconi produced a series of 20 woodcuts that display the horrors and destruction of Vietnam entitled *Viet Nam! Fourteen Americans* (1974). It is a series of portraits of prominent individuals who profoundly affected America, including Albert Einstein, Malcolm X, Cesar Chavez, Sitting Bull, Charles Ives, and Sacco and Vanzetti. During the 1980s the artist produced *Los desaparecidos,* a series that depicts people who were kidnapped, tortured, and killed during the repressive military regime in Argentina. Frasconi's portfolio *The Enduring Struggle: Tom Joad's America* contains prints that focus on 19 civil rights and labor struggles in the United States, including the killing of students at Ohio State by the National Guard, the uprising at Attica prison, the women's movement, and the march to Sacramento by the United Farm Workers.

A lover of jazz and American folk music, Frasconi has produced portraits of several musicians that he admired, including Bessie Smith, Duke Ellington, Charles Mingus, and Woody Guthrie. Frasconi also reveled in literature. He has produced a series of prints honoring many of the writers he most admired, including Whitman, Thoreau, Emerson, Edgar Allan Poe, Herman Melville, and Mark Twain. He also has illustrated the books of several of his favorite authors,

including Italo Calvino, Isaac Beshevis Singer, Gabriela Mistral, and Mario Benedetti.

Frasconi also has done collaborative works combining his prints with the work of other artists. Using Langston Hughes's poem ''Let America Be America Again,'' Frasconi created a series of woodcuts and relief prints in which Hughes's poem is intertwined with the printed images. Viewing Frasconi's images along with the poem, in simple typeface, either superimposed on the image or standing alone, is a powerful experience.

—Christine Miner Minderovic

FRIGERIO, Ismael

Chilean painter

Born: Santiago, 1955. **Education:** University of Chile, B.F.A. 1980. **Family:** Married twice; one daughter. **Career:** Worked as a carpenter, dishwasher, and furniture designer. Since 1981 has lived and worked in the United States. Director, School of Art, UNIACC University, Santiago, c. 2000. **Awards:** Painting scholarship, Sociedad Amigos del Arte de Santiago, 1981, 1982; Fondart fellowship, 1993.

Individual Exhibitions:

1983	Yvonne Seguy Gallery, New York
1985	Art Space, New York
1986	Museum of Contemporary Hispanic Art, New York
1989	Galería Plástica Nueva, Santiago
1990	Galería Botello, Hato Rey, Puerto Rico

Selected Group Exhibitions:

1983	*Contemporary Latin American Art,* Chrysler Museum, Norfolk, Virginia
1984	*Art and Ideology,* New Museum of Contemporary Art, New York
	Vision & Conscience, State University of New York, Binghamton
1987	*Hispanic Art in the United States: Thirty Contemporary Painters and Sculptors,* Museum of Fine Arts, Houston (traveling)
1991	*On the Road,* Galería Bass, Caracas
1993	*Ceremony of Spirit: Nature and Memory in Contemporary Latino Art,* Mexican Museum, San Francisco
1994	*Rejoining the Spiritual: The Land in Contemporary Latin American Art,* Maryland Institute, College of Art, Baltimore
1999	Museo Nacional de Bellas Artes, Santiago
2000	*Anatomía monumental,* Museo de Arte Contemporaneo, Valdivia, Chile

Collections:

Museo de Arte Contemporáneo de Puerto Rico; El Museo del Barrio, New York; Museo Nacional de Bellas Artes, Santiago.

Publications:

On FRIGERIO: Books—_Art and Ideology,_ exhibition catalog, essay by Nilda Peraza, New York, New Museum, 1984; _Vision & Conscience: Ismael Frigerio . . . Alfredo Jaar . . . Pat Steir . . . Steve Cagan,_ exhibition catalog, Binghamton, State University of New York, 1984; _Ismael Frigerio: The Lurking Place,_ exhibition catalog, essay by Susana Torruella Leval, New York, Museum of Contemporary Hispanic Art, 1986; _Hispanic Art in the United States: Thirty Contemporary Painters and Sculptors,_ exhibition catalog, by John Beardsley and Jane Livingston, New York, Abbeville Press, 1987; _Ismael Frigerio: Utopias 1989,_ exhibition catalog, essay by Amalia Mesa-Bains, Santiago, Galería Plástica Nueva, 1989. **Articles—** "Art: Political Subjects" by Michael Brenson, in _New York Times,_ 24 February 1984.

*　*　*

Ismael Frigerio is an émigré artist who works with the medium of memory. His paintings draw on specific historical events, often related to the collective past of his native Chile, and in so doing achieve a profundity that transcends specific cultural references. Since the early 1980s, he has developed a coherent body of work that addresses universal themes of loss, redemption, and remembrance. His painting style belongs to the new expressionist style of the 1980s, along with such artists as Roberto Juarez, Roberto Gil de Montes, Sandro Chia, and Georg Baselitz. Frigerio cites the influence of the German expressionists and the post-World War II American expressionists on his work.

Frigerio's 1985 painting, _The First Opportunity of Pain,_ was exhibited in the 1987 exhibition _Hispanic Art in the United States._ Although he was well known in Chile, this was his first significant exposure in the United States. The painting is made up of two panels, the first of which shows a close-up of the inside of what looks like a wooden rowboat or fishing boat; to the left hovers a solid brown shape. In the second companion panel, three fish are grouped together, completely vertical, as if they are rising into the air. Their gaping mouths and staring eyes are cast toward heaven, while their tails are drips of paint, giving the illusion that the fish are rising like rockets. The subject matter is more or less identifiable, and yet it is also mysterious. The influence of the expressionists Frigerio admires is much in evidence—the paint is sometimes roughly applied, with drips, spatters, and bold strokes of pure, primary colors. The shapes are simplified and monumental, with strong black lines defining the planks of the fishing boat and the outlines of the fish. Looking at the fish, the viewer cannot help but think of death and redemption, the Biblical story of the loaves and fishes, or the Holy Trinity.

Another work from 1985–86, _The Loss of Our Origin,_ features a wooden boat, inside of which is a recumbent nude figure—maybe dead, maybe paralyzed—wrapped in a blue serpent. There is no salvation in evidence; the boat points toward a horizon that appears to be engulfed in flame. The painting speaks of loss and a violent rupture between past and present, the experience of the colonized. The serpent is a recurring figure in Frigerio's work, symbolizing both sin and fecundity. In painting after painting, the serpent appears as the protagonist, like the Christian colonizers who came to the Americas, forever altering an Edenic existence. Another work from 1985–86, entitled _The Lust of Conquest,_ portrays a group of gray figures crowded inside what looks like a claustrophobic cage. Flames lick at their legs while a black serpent looks on. At one side of the canvas appears what looks like an ocean shore, with a black boat, unoccupied, pointing to the horizon. Speaking about _The Lust of Conquest_, Frigerio said, "When I went back to our history, to the Latin American history, to the Hispanic history, I found out how the people were killed. They never tell you how the people were, how the Indians died. . . The basic idea is to show how the conquerors sacrificed the people in America."

Although Frigerio has lived in New York since 1981, the themes he treats—often pertaining to experiences of dictatorship and conquest—are more relevant to Latin American artists than to U.S.-born artists of Latin-American descent. Frigerio is also interested in ecological history, particularly the impact of political events on nature. Water and fire, forces of creation and destruction appear repeatedly in his work. He explores the history of the land as a metaphor for the impact of colonization and political interruptions on human bodies and memories. _Ceremony of Memory_ presents an arrangement of images showing trees scorched as a result of a government decision. Similarly, works such as _Atacama_, part of the series entitled _Nature Our Neverending Witness_, juxtapose human and natural victims, showing images of land plundered by mining alongside the bodies of the miners assassinated at the turn of the twentieth century. The work incorporates small images, set into a layer of scattered salt like roadside shrines. In recent work Frigerio has turned to complex installations involving photography, sculpture, and painting. His multimedia works, such as _Monumental Anatomy_, done in collaboration with artist Felipe Zabala, use new technology to draw the viewer into a more intimate, shifting relationship with the work. Alienation figures prominently in all of his work, in whatever medium.

Frigerio studied philosophy and art at the University of Chile. In 1973, while he was in the midst of his university studies, the government of Salvador Allende was overthrown. Virtually all of the faculty were replaced overnight. Frigerio visited New York in 1979, returning to Chile to finish his degree in 1980. The next year, he moved to New York for good. His work is well known in Chile, where he is associated with a group of artists who rose to prominence in the 1980s. It took longer, however, for him to gain recognition in the United States. In a 1985 painting on burlap called _The Lurking Place_, Frigerio portrayed himself as a snake. The image is a metaphor for the experience of the artist, unsettled in a new land.

—Amy Heibel

G

Julio Galán: *Tenme (Tiziana),* **1997. Photo courtesy of Galeria Ramis Barquet, New York.**

GALÁN, Julio
Mexican painter and sculptor

Born: Múzquiz, Coahuila, 1959. **Education:** Studied architecture, Monterrey, Mexico, 1978–82. **Career:** Lived in New York, 1984–90; returned to Monterrey, Mexico. **Awards:** Second prize, Centro de Arte Vitro, Monterrey, Mexico, 1979; first prize of acquisition, *Salón anual de la plástica,* Mexico City, 1981; honorable mention, *Concurso nacional de artes plásticas,* Aguascalientes, Mexico, 1981.

Individual Exhibitions:

1980	Galería Arte Actual Mexicano, Monterrey, Mexico

1982	Galería Arte Actual Mexicano, Monterrey, Mexico
	Galería Arvil, Mexico City
1983	Galería Arte Actual Mexicano, Monterrey, Mexico
1984	Galería Uno, Puerto Vallarta, Mexico
	Galería Clave, Guadalajara, Mexico
1985	Consulado Mexicano, New York
	Art Mart Gallery, New York
1986	Galerie Barbara Farber, Amsterdam
	Paige Powell & Edit Deak, New York
1987	*Julio Galán,* Museo de Arte Moderno, Mexico City (traveling)
	Annina Nosei Gallery, New York
1988	Museo de Monterrey, Mexico
	Museo de Arte Moderno, Mexico City
	Galerie Barbara Farber, Amsterdam
1989	Annina Nosei Gallery, New York
1990	Annina Nosei Gallery, New York
	Galleria Gian Enzo Sperone, Rome
	Witte de With Center for Contemporary Art, Rotterdam
1991	Milagros Gallery, San Antonio, Texas
1992	Barbara Farber Gallery, Amsterdam
	Stedelijk Museum, Amsterdam
	Annina Nosei Gallery, New York
	Pabellón Mudéjar, Seville, Spain
1993	*Dark Music,* Pittsburgh Center for the Arts, Pittsburgh
	Julio Galán, exposición retrospectiva, Museo de Arte Contemporáneo de Monterrey, Mexico, and Museo de Arte Moderno, Mexico City
1994	Center for the Fine Arts, Miami
	Contemporary Art Museum, Houston
	Museo de Arte Moderno, Mexico City
	Museo de Arte Contemporáneo, Monterrey, Mexico
1995	Thaddaeus Ropac Gallery, Paris
1996	Barbara Farber Gallery, Amsterdam
	Annina Nosei Gallery, New York
1997	Galería Ramis Barquet, New York
	Robert Miller Gallery, New York
	Fundación Proa, Buenos Aires (retrospective)
1998	Galería Enrique Guerrero, Mexico City
	For Lissi, Timothy Taylor Gallery, London

Selected Group Exhibitions:

1982	*Salón anual de la plástica,* Palacio de Bellas Artes, Mexico City
1985	*De su álbum . . . inciertas confesiones,* Museo de Arte Moderno, Mexico City
1988	*Rooted Visions, Mexican Art Today,* Museum of Contemporary Hispanic Art, New York
1991	*The Bleeding Heart,* Institute of Contemporary Art, Boston (traveling)

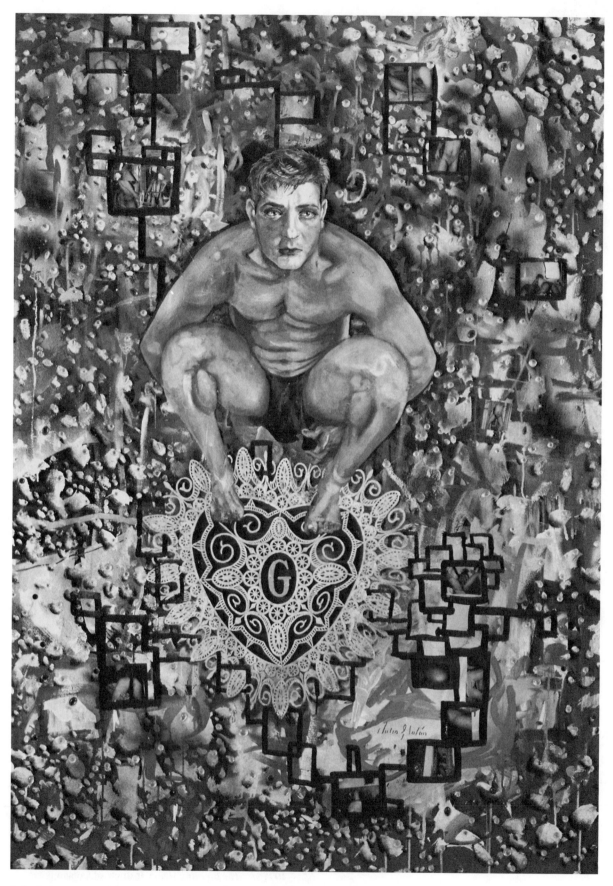

Julio Galán: *Manita de Gato,* **1999. Photo courtesy of Galeria Ramis Barquet, New York.**

1995 *The Muse?: Transforming the Image of Woman in*
 Contemporary Art, Thaddaeus Ropac Gallery and the
 Salzburg Art Festival, Austria
1997 Annina Nosei Gallery, New York
 Mexico Self-Portraits, Associated American Artists,
 New York
 Artistes Latino-Américains, Daniel Templon Gallery,
 Paris
2000 Galería Ramis Barquet, New York
2000–01 *20 Years/20 Artists,* Aspen Art Museum, Colorado

Publications:

On GALÁN: Books—*Julio Galán,* exhibition catalog, Barbara
Farber Gallery, Amsterdam, 1992; *Julio Galán: Dark Music,* exhibi-
tion catalog, text by Murray Horne, Pittsburgh Center for the Arts,
1993; *Julio Galán, exposición retrospectiva,* exhibition catalog,
Monterrey, Museo de Arte Contemporáneo, 1993; *The Muse?,* exhi-
bition catalog, text by Thaddaeus Ropac, Salzburg, Verlag A. Pustet,
1995; *Julio Galán,* exhibition catalog, text by Vanesa Fernandez,
Salzburg, Thaddaeus Ropac Gallery, 1995; *Oro poderoso,* exhibition
catalog, Galería Ramis Barquet with Robert Miller Gallery, New
York, 1997; *Mexico Self-Portraits,* exhibition catalog, Associated
American Artists, New York, 1997; *Julio Galán: Sculptures,* exhibi-
tion catalog, Galería Ramis Barquet with Robert Miller Gallery, New
York, 1997; *Julio Galán: Obras 1983–1997,* exhibition catalog,
Buenos Aires, Fundación Proa with Galería Ramis Barquet, 1997;
Julio Galán, exhibition catalog, text by Carlos Emerich, Galería
Enrique Guerrero, Mexico City, 1998; *Julio Galán: El juego de las
profanaciones* by Francisco Reyes Palma (part of series: *Teoría y
práctica del arte*), Mexico City, Consejo Nacional para la Cultura y
las Artes, 1998; *Julio Galán* by Mariuccia Casadio and Enrique
Badulescu, Paris and Salzburg, Thaddaeus Ropac Gallery, 1998;
Julio Galán: For Lissi, exhibition catalog, text by Greg Hilty,
London, Timothy Taylor Gallery with Galería Ramis Barquet, 1998;
20 Years/20 Artists, exhibition catalog, text by Suzanne Farver and
Robert Hobbs, Seattle, the University of Washington Press with the
Aspen Art Museum, 1999. **Articles**—''Julio Galán: Nostalgia for the
Unachievable'' by Jose Manuel Springer, in *Art Nexus* (Colombia),
13, July/September 1994, pp. 136–139; ''Julio Galán, Annina Nosei
Gallery, New York'' by Kristin M. Jones, in *Artforum International,*
35, November 1996, p. 98; ''At the Galleries: Julio Galán'' by
Charles Michener, in *The New Yorker,* 10 June 1996, pp. 60–64;
''Artistes Latino-Américains'' by Michel Nuridsany, in *Art Press*
(France), 224, May 1997, p. 78–79; ''Art Miami 99'' by Carol
Damian, in *Art Nexus* (Colombia), 32, May/July 1999, pp. 92–94;
''Universal Language'' in *Art and Antiques,* 23(2), February 2000,
pp. 61–67; ''Julio Galán and Ray Smith: Sotheby's (Fuller Building)
and Ramis Barquet'' by Alfred Mac Adam, in *Art News,* 99(2),
February 2000, p. 162; ''Julio Galaán and Ray Smith at Sotheby's and
Ramis Barquet'' by Eduardo Costa, in *Art in America,* 88(9), Septem-
ber 2000, p. 148–149.

* * *

Julio Galán was part of the group of Mexican painters that
emerged in the early 1980s that came to be known internationally as
the Neo-Mexicanists. These artists, including Nahum B. Zenil, artisti-
cally and thematically mined Mexico's rich cultural and artistic past
and meshed these sources with contemporary international aesthetic
idioms. These sources ran the gamut from religiosity and Catholi-
cism, to social and political critique, to indigenous traditions and the
popular arts, or what would in other contexts be called folk art.

Galán, however, broadened his artistic and narrative purview
through his working abroad, particularly in New York City. It is in
New York of the mid-1980s that Galán came into contact with its
burgeoning art scene, which was in a state of gestation and in the
height of what would historically be known as postmodernism. And
equally important for Galán, New York was where he met Andy
Warhol. Warhol's artistic influence, although minuscule, manifested
in the construction of Galán's theatrical persona, which in turn
became an inextricable part of his paintings. Galán's paintings
primarily focus on himself in that they are self-portraits in the
traditional sense of the word. The narratives that Galán has created in
his paintings that convey what he has called auto-iconography are
anything but traditional. And it is through the vehicle of self-
portraiture that Galán has been linked to his Mexican predecessors,
such as Frida Kahlo.

Whereas Kahlo focused on her personal life, which became a
mirror of the social world that she was a part, Galán has extended this
narrative strategy in myriad directions. This is evident in one of his
early paintings, titled *The Accomplices* (1987). In this picture Galán
dresses himself in *charro,* or cowboy, attire, and the protagonist of the
painting has an uncanny resemblance to Kahlo herself. It is evident
that it is Galán who is the one depicted as Kahlo cum *charro.* Apart
from the reference to Kahlo and *charro* culture, the conflation of
female with hyper Mexican masculinity also signifies another aspect
of Galán's narrative strategy: the ambiguity of sexuality and the
collapsing of genders within his paintings. This narrative quality is
further enhanced by the disparate formal elements that one finds in
The Accomplices that is emblematic of Galán's work overall.

The formal qualities of Galán's artistic style are evinced in such
things as the mixing of high and low culture, the claustrophobic sense
of pictorial space, intense hues and saturated colors, bits and pieces of
collaged detritus and ephemera, and the use of text or the written
word. All of theses aesthetic elements are cohered into his paintings
from a variety of sources that are rooted in the international impulses
of Galán's artistic milieu but also as far back as the baroque and
religious genres like the ex-voto.

Galán has also worked in sculpture that consists of found objects
reassembled into idiosyncratic configurations. These sculptures are
the three-dimensional equivalents to his paintings yet are a com-
pletely autonomous genre unto themselves. One thing that Galán has
adamantly contested in the critical appraisal of his work and that
seems to have been lost by a majority of his critics regardless of
geographic location is that he did not want to be associated with the
stereotype of Mexican art as innately surrealist. This perception of
Neo-Mexicanism, which was a vestige from André Breton's Eurocentric
perception of Mexico as naturally surrealist, has been seen by Galán
and his contemporaries as a condescension and misunderstanding of
their artistic practices. What is historically imperative in the assess-
ment of Julio Galán's oeuvre is that it attempted to work with and
against the strong painting tradition in Mexico. Thus, in a roundabout
way Galán has helped pave the road for the new artistic possibility of
going beyond painting and offering fresh options for Mexico's
succeeding generation of artists.

—Raúl Zamudio

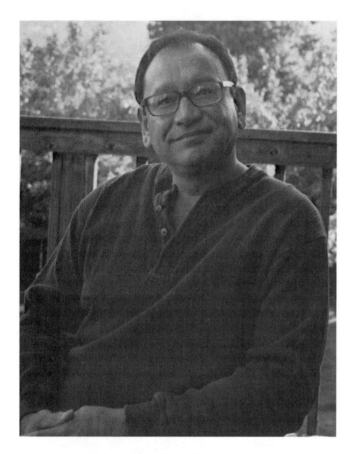

Daniel Galvez. Photo courtesy of the artist.

GALVEZ, Daniel

American painter and muralist

Education: Pacific University, 1971–73; California College of Arts and Crafts, Oakland, B.F.A. in painting 1975; San Francisco State University, M.F.A. 1979. **Career:** Muralist, including murals at Pearl Street Garage, Cambridge, Massachusetts, 1992, Police Activities League Center, Santa Monica, California, 1993, and Audubon Ballroom, New York, 1997. **Awards:** National Endowment for the Arts grant, 1985–86; Eureka fellowship in painting, Fleishhacker Foundation, San Francisco; creative artist fellowship, Cultural Arts Division, City of Oakland. **Address:** 3703 Rhoda Ave., Oakland, California 94602, U.S.A. **Online address:** galvezart@earthlink.net.

Individual Exhibitions:

1999 *Murals in the USA,* Kathrin Cawein Gallery of Art,
 Pacific University, Forest Grove, Oregon
 Made in Oakland, La Pena Cultural Center, Berkeley,
 California
2000 SOMARTS, San Francisco

Selected Murals:

1983 *Carnaval,* San Francisco Arts Commission, San
 Francisco
1985–86 Consortium of Local Arts Agencies of Massachusetts

1989 American Foundation for AIDS Research, Los Angeles
1991 *Vietnam Veterans Mural,* Pittsfield, Massachusetts
1993 Santa Monica Arts Commission, California
1995 Oakland/Alameda County Coliseum, California
1997 City of New York Department of Cultural Affairs, New
 York City
1999 General Services Administration, San Francisco
2000 United States Department of the Interior, Washington,
 D.C.
2001–02 City of Dublin, California
 Bay Area Rapid Transit and Mission Housing Develop-
 ment Corp., San Francisco

Selected Group Exhibitions:

1982 *In Progress,* Galería de la Raza, San Francisco
1984 Galería de la Raza, San Francisco
1996 *The Murals Project,* San Francisco Art Institute
1988–89 *Mano a Mano: Abstractuib/Figuration, 16 Latin Ameri-
 can Painters,* Art Museum of Santa Cruz County/
 UCSC/Oakland Museum
1990–92 *CARA/Chicano Art: Resistance and Affirmation,
 1965–1985,* Wight Art Gallery, University of Califor-
 nia, Los Angeles
1991–94 Oakland Coliseum, California
1992 *Beyond 1992,* Berkeley Art Center, Berkeley, California
1993 *Twelve Bay Area Painters: The Eureka Fellowship
 Winners,* San Jose Museum of Art, San Jose
 Sense of Place: Public Art Projects and Proposals,
 Richmond Art Center, Richmond
1995 *Urban Visions,* SOMAR Gallery, San Francisco
1996–97 *30+ East Bay Painters and Graphic Artists,* Oakland
 Museum/Oakland Coliseum
1998 *Freedom or Slavery: The Paul Robeson Portfolio,*
 Bomani Gallery, San Francisco
 Labyrinth: A Day of the Dead Exhibition, Yerba Buena
 Center for the Arts, San Francisco
1999 *Public Art: Private Vision,* The Art Foundry Gallery,
 Sacramento, California
2000 *La flor y la calavera: Altars and Offerings for the Days
 of the Dead,* Oakland Museum of California

Collections:

Audubon Ballroom, Department of Cultural Affairs, New York; Cambridge Arts Council, Massachusetts; Department of the Interior, Washington, D.C.; Mission Merchants Association, 21st Street Mural Project, San Francisco; Santa Monica Wallscapes, California; Galería de la Raza, San Francisco.

Publications:

By GALVEZ: Book, Illustrated—*It Doesn't Have to Be This Way* by Luis J. Rodriguez, n.p., Children's Book Press, 1999.

* * *

Muralist Daniel Galvez is known for the large-scale public murals that he has created throughout the United States. Enjoying a

Daniel Galvez: *Stewards for the Future,* **2000. Photo courtesy of the artist.**

wide range of sponsors, he has not only worked closely with his clients to express their values and public messages but has also been devoted to creating images that encourage people to strengthen their communities.

Most of Galvez's work depicts street scenes and people from various walks of life. His murals express the idea of a harmonious community. For example, the mural created for his *Crossroads* (1992) project on the cinder-block wall of the Pearl Street Garage in Central Square, Cambridge, Massachusetts, depicts people at work and at play and has a multicultural theme. In 1993 Galvez painted a mural at the Police Activities League Center in Santa Monica, California, which features positive interaction between adults and young people.

Another neighborhood project that Galvez participated in was the 21st Street Mural Project in San Francisco. It exemplified a new iconography that sought to capture the rich variety of life, including human relationships, the passage through the stages of life, as well as cultural and spiritual accomplishments. Youth involvement was a key element in this project; Galvez created the seventh mural, *Dream,* a 16-by-20-foot portable panel that featured a 2-foot border created by young people in the neighborhood. In his statement about the project, Galvez observed, "My intent as an artist has been to communicate through the arts the strength a dignity of individuals while seeking to generate a sense of community and respect for each other. By identifying who we are and who our neighbors are, an awareness can develop which reinforces our understanding of our differences, even as we become aware of our similarities. In painting public art, I have sought to give expression to others' tradition and ideals of themselves. In painting *Dream,* I wanted to give voice to the hope and dreams of our young people today as they work toward independence and individuality while honoring 20th century heroes."

Homage To Malcolm X (1997), a work that Galvez defines as the greatest achievement of his career, is an impressively sized, 12-by-64-foot mural located in the Audubon Ballroom in Manhattan. When looking at the mural, the viewer assumes that Malcolm X is entering a room through a Gothic arch; behind him, through the arch, is a brilliant blue but delicately clouded sky. On the ceiling of the room, above the archways, is an interesting arrangement of two circular objects. To Malcolm's left is a decorative rosette often found in Gothic cathedrals, and to his right is a foreshortened circular structure that resembles an arena, perhaps a courtroom. His clothing suggests traditional Islamic garb, and he is looking downward at a thick black book that rests in his hands. The mural also features images from television, film, and print media highlighting key events in Malcolm X's life, as well as images of the civil rights struggle. The historical images were executed with a special underpainting and glazing process that created the look of old news media. Overall, the mural imparts a sense of Malcolm's presence over a long period of time, including the present day. In 1997 Galvez stated, "I was grateful and proud to have been rewarded the honor to paint a mural of this great man. I feel this mural reflects the highest achievement of my career. I will continue to seek and to create innovative work which enhanced the human environment and is reflective of the aspirations, cultural richness, and values of people in our diverse society."

In addition to painting murals, Galvez also has worked as an illustrator. He created the artwork for Luis J. Rodriguez's *It Doesn't Have to Be This Way: A Barrio Story* (1999; *No tiene que ser asi: Una historia del barrio*), a bilingual children's book about a boy's encounter with a neighborhood gang.

—Christine Miner Minderovic

GAMBOA, Diane
American painter and photographer

Born: 1957. **Career:** Member of performance and visual arts group *Asco.*

Selected Exhibitions:

1992 *Image and Identity,* Los Angeles County Museum of
 Art
 San Diego State University, California
2000 Gallery of the Mexican Cultural Institute, New York
2001 Track 16 Gallery, Santa Monica, California

Publications:

On GAMBOA: Books—*Artistas Chicanas: A Symposium on the Experience and Expression of Chicana Artists,* Santa Barbara, California, University of California, 1991; *Chicano and Latino Artists of Los Angeles* by Alejandro Rosas, Glendale, California, n.p., 1993. **Article**—''Art with a Chicano Accent'' by Steven Durland, Linda Frye Burnham, and Lewis MacAdams, in *High Performance,* 9(3), 1986, pp. 40–45, 48–57.

* * *

A flamboyant survivalist spirit is at the core of Diane Gamboa's Latin identity. The East Los Angeles artist blends an amalgamation of urban toughness, pride, retaliation, and cuteness in the array of media she uses. These include paintings as well as designs for costumes, props, and makeup for video and live productions staged by the collaborative Asco (Spanish for ''disgust'' or ''repugnance''). Often ferociously expressionistic in style, her art melds both sinister and chic tones. Within a single, vital canvas viewers find a wild constellation of influences. Subtle suggestions of sexual alliance and conspiracy are set against backdrops of, for example, rich fabrics, overstuffed couches, and neobaroque chairs. Gentlemen with pompadours wearing satin-lapelled jackets jive with scarred, spike-haired gangsters. Whether she is working on a large or small scale, the emphasis is less on narrative and more on the precision of an ethnically coded aesthetic. Ominous, addictive, sumptuous, Gamboa's vision of sex, death, and weirdness carries with it aesthetic centrality and nuance.

Gamboa's incandescent palette, often reminiscent of that of Matisse, expresses an unequivocal passion for color. In many works every inch is covered with a figure or object, and every figure or object is covered with a pattern. In *Head Spin* the electric yellow and green stripes of a chair are juxtaposed to the ruby red roses of wallpaper. The bright purple of a necktie is echoed in purple hair, a purple necklace, and a purple-flowered dress. Colors and patterns are coordinated so tightly that the space flattens and figure definitions melt away, leaving a form derived from paint and color to emerge. Calling on both fantasy and surrealism, she produces an effect that is a kind of contemporary edginess bordering on rupture, even, at moments, on despair. Her overfull rooms seem to spin out of control, with chairs, pillows, and gargantuan statues (nearly gargoyles) loose and combustive. This *horror vacui* is evocative of a carnivalesque theater in which play and terror intermingle and where identities, always fluid, teeter on the brink of collapse and transformation.

Daydream, a series of small (5 by 7 3/4 inches) figurative drawings incised into inked aluminum, is a compression of Gamboa's monumental theatricality into the more raw contrasts of black and silver. The aluminum is fastened to wood and coated with a lush, penetrating black, on which the artist asserts her aggressive, boldly determined line. Agitated rivers of silver furrow into low black mounds, the result being at once tender, gritty, and anxious. In *Quivering Trance,* one of a number of compositions that set pairs of

figures in confrontation, an updated Leda and the swan sit side by side. Their coupling is implied by an undisguised devil incarnate and a woman sketched in a lower corner. *Man's Social Behavior* and *Particular Sensation* illustrate the perilous nature of confrontation between typical stereotypes of men and women. For Gamboa these stereotypes are seen in the unflattering roles of saw-toothed men, personifying aggression and threat, and in passive and posturing women who are overidentified with their bodies. The archetypal man's evil glare and the woman's objectified acceptance point blackly toward exploitation and victimization. In *In Memory* a female gazes serenely inward, with the object of her thinking materializing on her brow in the form of a barely etched male face. With their heart-shaped mouths and tender expressions, against the background of a floral pattern, Gamboa's expression of optimism seems nearly complete, but never, not even in this most mythically serene of forms, is her anxiety totally withheld.

—Martha Sutro

GAMBOA, Harry Jr.
American painter, photographer, mixed-media, performance, and video artist

Born: Los Angeles, 1951. **Career:** Visiting faculty member, California Institute for the Arts, Valencia, 1989, 1997, Otis Art Institute of Parsons School of Design, Los Angeles, 1991, University of California, Santa Barbara, 1993, University of California, San Diego, 1994, 1996, University of California, Riverside, 1995, 1997, California State University, Northridge, 1995, 1996, 1997, 1998, 1999, 2000, and University of California, Los Angeles, 1999. Artist-in-residence, La Jolla Museum of Contemporary Art, University of California, San Diego, 1988, 1999, Washington State University, Pullman, 1988, and University of California, Riverside, 1998, 1999. Editor, *Regeneración* magazine, Los Angeles, 1971–75. Cofounder and member, artist group *Asco,* Los Angeles, 1972–87; helped found Los Angeles Contemporary Exhibitions, 1978. **Awards:** Grants, National Endowment for the Arts, 1978, 1980, 1986, 1987; grant, Rockefeller Foundation, 1986; grant, Ford Foundation, 1989; Visual Artist fellowship, J. Paul Getty Trust Fund for the Visual Arts, 1990; Premio Mesquite, for best experimental video, San Antonio Cine Festival, 1992; documentary video production grant, Arizona Commission on the Arts, 1993; grant, MacArthur Foundation, 1994; curriculum development grant, California State University, Northridge, 1996; U.S. Latino Delegation fellowship, National Latino Communications Center, 1996; fellowship, Art Matters, 1996; visual artist fellowship, Cultural Affairs Department, Los Angeles, 1996; fellowship, California Arts Council, 1996; Mario Tamayo award, Los Angeles Contemporary Exhibitions, 1997; fellowship, Gluck Foundation, 1998, 1999; visual artist award, Flintridge Foundation, 2000; award, Durfee Foundation, 2001. **Agent:** Daniel Saxon Gallery, 552 Norwich Drive, Los Angeles, California 90048, U.S.A. **E-mail Address:** wordvision@yahoo.com.

Individual Exhibitions:

1981 *Gamboa 81,* Galeria Otra Vez, Los Angeles
1982 *Brown in Black and White,* California State University,
 Los Angeles

1984 *Gamboa 84,* Los Angeles Photography Center
1988 *L.A. Street Scenes,* Eastern Washington University,
 Cheney
1994 *The Urban Desert,* California State University, Los
 Angeles
1997 *Site Unscene,* Daniel Saxon Gallery, West Hollywood,
 California

Selected Group Exhibitions:

1974 *Asco,* Self Help Graphics, Los Angeles
1978 *Primer muestra de la fotografia latinoamericana
 contemporanea,* Museo de Arte Moderno, Mexico
 City
1979 *Artists As Social Critic,* Museum of Contemporary Art,
 Chicago
1990 *Chicano Art: Resistance and Affirmation,* Wight Art
 Gallery, University of California, Los Angeles
1992 *The Chicano Codices: Encountering the Art of the
 Americas,* Mexican Museum, San Francisco
1995 *1995 Biennial,* Whitney Museum of American Art, New
 York
1996 *From the West: Chicano Narrative Photography,*
 Mexican Museum, San Francisco
1997 *American Voices: Latino Photographers in the U.S.,*
 Smithsonian Institution, Washington, D.C.
1999 *Global Conceptualism: Points of Origin 1950s-1980s,*
 Queens Museum of Art, New York
2000 *Made in California: Art, Image, and Identity,
 1900–2000,* Los Angeles County Museum of Art

Collections:

Smithsonian Institution, Washington, D.C.; Mexican Museum, San
Francisco; Stanford University, California.

Publications:

By GAMBOA: Books—*Barbara Carrasco,* exhibition catalog, San
Francisco, Galería de la Raza, 1989; *Urban Exile: Collected Writings
of Harry Gamboa Jr.,* edited by Chon A. Noriega, Minneapolis,
University of Minnesota Press, 1998. **Articles**—Interview with Gronk
and Herrón, in *Neworld* (Los Angeles), 2(3), 1976; "El Dia de los
Muertos," work of fiction, in *Foco* (Los Angeles), 1(1), 1976; "Cruel
Profit," work of fiction, in *Grito del Sol* (Berkeley, California), 1(1),
1976; "Phobia Friend," work of fiction, in *Tin Tan* (San Francisco),
II(6), 1977; "Silver Screening the Barrio," in *Equal Opportu-
nity Forum* (Venice, California), 5(11), October 1977; "Cultural
Chicana: Los Angeles," in *La Opinion* (Los Angeles), 1980;
"Pseudoturquoiser," in *De Colores* (Albuquerque), 5(3–4), 1981;
"Ins and Outs," work of fiction, in *Corazon de Aztlan* (Los Angeles),
1(2), 1982; "A Rival Departure," work of fiction, in *201 Anthology*
(Los Angeles), 1982; "Taking People to the Wall in Mesa," perform-
ance text, in *Phoenix Exposure,* 1983, pp. 8–9; "Los mitos urbanos de
Carlos Almaraz," in *La Opinion* (Los Angeles), 131, 1983; "Urban
Exile," in *Artweek* (Oakland, California), 15(35), 1984, p. 3.; "Re-
flections on One School in East L.A.," in *L.A. Weekly* (Los Angeles),
6–12 February 1985; "The Chicano Inside and Outside the Main-
stream," in *LAICA Journal* (Los Angeles), winter 1987, pp. 20–29;

"Serpents in the City of Angels," in *Artweek* (San Jose, California),
20(37), 1988, p. 24; "Social Afterimages," in *High Performance*
(Santa Monica, California), 47, fall 1989, pp. 44–49; "Speakeasy,"
in *New Art Examiner,* 19, November 1991, pp. 13–14; "Past
Imperfecto," in *Jump Cut* (Berkeley, California), 39, 1994, pp. 93–95.

On GAMBOA: Books—*Harry Gamboa and ASCO: The Emergence
and Development of a Chicano Art Group, 1971–1987* (dissertation)
by S. Zaneta Kosiba-Vargas, Ann Arbor, University of Michigan,
1988; *Flintridge Foundation Awards for Visual Artists, 1999/2000,*
exhibition catalog, text by Noriko Gamblin, Karen Jacobson, and
others, Pasadena, California, Flintridge Foundation, 2000. **Articles**—
"Harry Gamboa Jr. and Asco" by Steven Durland and Linda Frye
Burnham, in *High Performance* (Los Angeles), 9(35), 1986, pp.
51–53; "Latino Dada: Savage Satire from Harry Gamboa Jr." by
Max Benavidez, in *L.A. Weekly* (Los Angeles), May 1986; "Survival
Stories" by Suvan Geer and Mary-Linn Hughes, in *Artweek,* 26,
April 1995, pp. 19–20; "Urban Exile: Harry Gamboa Jr." by Chon
Noriega, in *Cine Accion News* (San Francisco), 14(1), 1997; "Social
Unwest: An Interview with Harry Gamboa, Jr." by C. Ondine
Chavoya, in *Wide Angle,* 20(3), July 1998, pp. 54–78.

* * *

Harry Gamboa, Jr., has been highly influential in Chicano and
contemporary art, having worked in the areas of photography, per-
formance, video, and installation, in addition to writing poetry,
fiction, and critical essays. He is perhaps best known as the leader of
the artistic performance group Asco, whose members included Patssi
Valdez, Willie Herrón III, and Gronk. These artists met while
attending Garfield High School in East Los Angeles, the school with
the highest dropout rate in the United States and the setting for the
1988 film *Stand and Deliver.* Gamboa first became aware of the
politically subversive potential of art while helping organize the
"blowouts" that took place in several high schools in East Los
Angeles during the late 1960s, as students protested racism in the
classroom and inadequate education. He took up photography as a
means of empowering himself and counteracting the inaccurate
representation of Chicanos in the media.

Gamboa became editor of the artistic journal *Regeneración* in
1971 and invited Valdez, Herrón, and Gronk to contribute artwork.
Soon after, the group began working on collaborative projects that
protested the invisibility of Chicanos within the mainstream art world
as well as the extreme idealism and traditionalism to which many
Chicano artists had succumbed. Since other members of the Chicano
community complained that the artists' activities made them nau-
seous, they took the name "Asco," which means "nausea" in
Spanish, for their group.

Lacking substantial funding and wishing to subvert the status
quo by working from the margins, the members of Asco engaged in
street performances. These had aspects not only of artistic happen-
ings, but also of the political demonstrations that were a common
occurrence in Los Angeles during the early 1970s. In 1972 the
members of Asco asked the Los Angeles County Museum of Art
(LACMA) to include Chicano art in its exhibitions. After being
rejected they photographed themselves spray painting their names on

the walls of the museum like graffiti artists and entitled the work *Spray Paint LACMA.* In *Walking Mural,* performed the same year, the artists protested the static nature of murals, both as an artistic medium and in the nationalistic ideals portrayed in them. Valdez dressed in black as a fashionably up-to-date Virgin of Guadalupe, Herrón as a multiheaded heroic figure from a mural, and Gronk as a Christmas tree, while Gamboa filmed and photographed the procession. Asco staged other similar performances in which they targeted an army recruitment center in East Los Angeles as well as a Day of the Dead celebration.

Many of Asco's performances focused on Chicano's lack of visibility in the film industry. Gamboa developed the ''No Movie'' to protest this absence and the increasingly expensive and commercial nature of much filmmaking. In the ''No Movies'' the members of Asco posed in elaborately staged photographs that resembled film stills and hinted at a larger narrative. They often wore period costumes such as the zoot suits popular among Chicanos during the 1940s. Gradually these events began to include other artists such as Humberto Sandoval, Jr., and Gamboa's wife, artist Barbara Carrasco.

Gamboa's interests eventually grew beyond Asco's activities, and he began writing narrative plays and stories, in addition to producing videos. Although many of these projects involved members of Asco, the group grew apart and finally broke up in the late 1980s. Gamboa continued making his works, which combined genres such as video, photography, and drama and often had a humorous and irreverent style. The performance *Antizona* (1987) was typically multilayered and highly complex, featuring a video sequence of a street preacher inspired by the *fotonovela,* a genre of Spanish-language soap opera, and a live performance by Gamboa's son.

Much of Gamboa's work is more straightforward and serious in tone. During the 1990s he produced a series of photographic portraits, entitled *Chicano Male Unbonded,* that featured simple, full-length frontal images of Chicano men who had influenced his work. In 1978 he helped found the organization Los Angeles Contemporary Exhibitions, which established an institutional artistic presence in downtown Los Angeles that was the precursor to the Museum of Contemporary Art. He also contributed a critical essay on Asco to the catalog for the 1991 exhibition *Chicano Art: Resistance and Affirmation.*

Gamboa's work is theoretically challenging, and it is difficult to attach a single meaning to it, fitting for a body of work that has something of a guerilla sensibility. Gamboa has blurred the lines between various artistic mediums and genres and between performance and lived experience. In addition, he has opened up the possibility of a technologically complex Chicano art.

—Erin Aldana

GARAICOA, Carlos

Cuban architectural and freehand draftsman and photographer

Born: Havana, 1967. **Career:** Artist-in-residence, Paul Pozzoza Museum, Germany, 1993, city of Biel-Bienne, Pro Helvetia, and the

Canton of Berne, Switzerland, 1995, Art in General, New York, 1996, and Yaddo, Saratoga Springs, New York, 1998.

Individual Exhibitions:

1989 Investigations Center of the Ministry of Education,
 Havana
1992 Gallery Juan Francisco Elso, Havana
1994 Wifredo Lam Center, Havana
1995 Centre PasquART, Biel-Bienne, Switzerland
 Inside-Havana, Space Aglutinador of Art, Havana
1996 Carla Stellweg Gallery, New York
 Fototeca de Cuba, Havana
 Art in General, New York
1997 *VI Havana biennale,* Havana
2000 *La utopía, la ruina,* Biblioteca Luis Angel Arango,
 Bogotá
2001 Museum of the Bronx, New York

Selected Group Exhibitions:

1997 *Utopian Territories: New Art from Cuba,* Vancouver
1998 *Memorias intimas marcas,* Electric Workshop, Johan-
 nesburg (traveling)
 *Contemporary Art from Cuba: Irony and Survival on
 the Utopian Island,* Arizona State University, Tempe,
 Arizona (traveling)
1999 *Los mapas del deseo,* Kunsthalle Wien, Vienna

Collections:

National Museum of Fine Arts, Havana; Museum of Fine Arts, Houston; Southeast Museum of Photography, Florida; Metropolitan Savings Bank, Ohio; Centre PasquArt, Biel-Bienne, Switzerland; Leigh University Gallery, Bethlehem, Pennsylvania; Alex Rosenberg Fine Art, New York.

Publications:

On GARAICOA: Books—*Carlos Garaicoa: El espacio decapitado,* exhibition catalog, Switzerland, Centre PasquArt, 1995; *Utopian Territories: New Art from Cuba,* exhibition catalog, by Eugenio Valdés Figueroa, Vancouver, 1997; *Contemporary Art from Cuba: Irony and Survival on the Utopian Island* by Marilyn Zeitlin, Gerardo Mosquera, and Antonio Eligio, New York, Delano Greenidge Editions, Arizona State University Art Museum, 1999; *Los mapas del deseo,* exhibition catalog, by Eugenio Valdés Figueroa, Gerald Matt, Gerardo Mosquera, Achy Obejas, and others, Vienna, 1999; *La ruina, la utopía,* exhibition catalog, by José Ignacio Roca, Bogotá, Biblioteca Luis Angel Arango, 2000. **Articles**—''Reflections on Contemporary Photography in Cuba: Interview with J. A. Molina, Curator at Centro Wifredo Lam, Havana'' by Wendy Watriss, in *Aperture,* 141, fall 1995, pp. 16–29; ''The Cuban Quagmire: Carlos Garaicoa, Kcho, and Osvaldo Yero'' by Octavio Zaya, in *Flash Art* (Italy), 184, October

1995, pp. 95–97; "Carlos Garaicoa. Art in General; Carla Stellweg Gallery, New York; Exhibits" by Judd Tuly, in *Art Nexus* (Colombia), 22, October/December 1996, p. 154; "Cubaon: 11 Conceptual Photographers: Generous Miracles, New York" by Euridice Arratia, in *Flash Art* (Italy), 32(205), March/April 1999, p. 55; "Contemporary (Not Exactly Cuban) Art" by Cristina Vives, in *Art Press* (France), 249, September, 1999, pp. 34–39; "Garaicoa, Carlos: Biblioteca Luis Angel Arango" by Natalia Guiterrez, in *Art Nexus* (Colombia), 38, November/January 2000–01, pp. 133–135; "Carlos Garaicoa: Bronx Museum of the Arts" by Monica De la Torre, in *Art News*, 100(2), February, 2001, p. 158.

* * *

The Cuban artist Carlos Garaicoa employs architecture to enunciate a subtle but, at the same time, incisive critique of totalitarian regimes, particularly those of the Third World. Architecture and the city constitute the main vehicles of expression in his work, and the city of Havana and its dilapidated buildings are often the site and inspiration for his installations, photographs, and drawings. Garaicoa takes urban debris and elements of buildings and the city, such as street signs and plaques, that have long been abandoned or out of use and recontextualizes them so as to make a critique of the city's state of decay. In other works he places photographs, drawings, and commemorative plaques announcing the construction of one of his "utopian" projections on the site of a derelict building. According to the artist, his intention is to "set up a new reading of urban space, in which the object would act as a subject of narration." The use he makes of the site points to a critical history of the revolutionary process and of the way in which the city itself bears witness to this, however silently. His work gives a voice to the city, and as he himself has stated, "urban space becomes the protagonist of a 'new' writing."

In this sense allegory, along with its essential ambiguity, is the operation through which Garaicoa articulates his critique of political and economic systems. Two architectural and allegorical figures are particularly important in his work: the monument and the ruin. The monument is a recurring theme in his utopian architectural drawings and photo collages that depict the ambitions of the Cuban revolution, similar to the utopian aspirations of the Bolshevik revolution in Russia, which coincided with the modernist and constructivist avant-gardes. Garaicoa uses the language of modern architecture to design the invisible monuments that rise from the ruins of Old Havana. Unlike the monument, the ruin in Garaicoa's work is not of a projective nature but is a concrete fact that in turn emphasizes the paradox of the ruin as a representational strategy in allegorical constructs. His installations are sometimes precisely set within the ruins and at times also built over them in an attempt to make a statement about the failure of the revolution. His *Acerca de la construcción de la verdadera Torre de Babel* ("On the Construction of the True Tower of Babel"), an ongoing series of drawings and photographs, projects over the structure of a building in Old Havana an architecture that expresses the utopian aspirations originally animating the Cuban revolution. Over the actual edifice there is a precarious wooden structure, a sort of "useless scaffolding." The structure, which in the drawings and photographs contrasts with the projection of a clean and monumental architecture, is representative of the unfulfilled promises of the revolution.

Garaicoa's work is a commentary on the failure of utopian undertakings, not only of the Cuban revolution but also of modernist utopias in general. It attempts to remind us that all that remains of these utopian "projections" are the ruins of an ideology.

—Julieta González

GARCÍA, Rupert
American painter and printmaker

Born: French Camp, California, 1941. **Education:** Stockton College, California, 1959–62, A.A. in painting 1962; San Francisco State University, 1966–70, B.A. in painting 1968, M.A. in printmaking/silkscreen 1970; University of California, Berkeley, 1973–75, 1979–81, M.A. in art history 1981. **Military Service:** United States Air Force, 1962–66. **Career:** Lecturer, San Francisco State University, 1969–81; instructor, San Francisco Art Institute, 1973–80, Mills College, Oakland, California, 1981. Since 1988 professor of art, San Jose State University, California. Visiting lecturer, University of California, Berkeley, 1979–85; visiting assistant professor, Washington State University, Pullman, 1984; artist-in-residence, Mexican Museum, San Francisco, 1986–88, and Institute of Culture and Communication, East-West Center, Honolulu, 1987; adjunct lecturer, University of California, Berkeley, 1987; visiting artist, Illinois State University, Bloomington, 1988. **Awards:** Grant, California Arts Council, 1985; meritorious achievement award in graphics and illustration, Media Alliance, San Francisco, 1988; grant, National Endowment for the Arts, 1989; President's Scholar award, San Jose State University, California, 1992; Distinguished Artist award for lifetime achievement, College Art Association, New York, 1992; Artistic Achievement award, San Jose State University Institute for Arts and Letters, California, 1993; lifetime achievement award in art, National Hispanic Academy of Media Arts and Sciences, 1995. Honorary doctorate, San Francisco Art Institute, 1993.

Individual Exhibitions:

1970 Artes 6, San Francisco
 Oakland Museum, California
1971 Deganawidah-Quetzalcoatl University, Davis, California
1972 Center for Chicano Studies, University of California, Santa Barbara
 St. Mary's College, Moraga, California
 Universidad de Sonora, Hermosillo, Mexico
1978 *Rupert Garcia/Pastel Drawings,* San Francisco Museum of Modern Art
1980 *Poster and Silkscreen Art of Rupert Garcia,* Coffman Gallery, University of Minnesota, Minneapolis
1981 *Rupert Garcia: Portraits/Retreats,* Mexican Museum, San Francisco
 University Art Museum, State University of New York, Binghamton

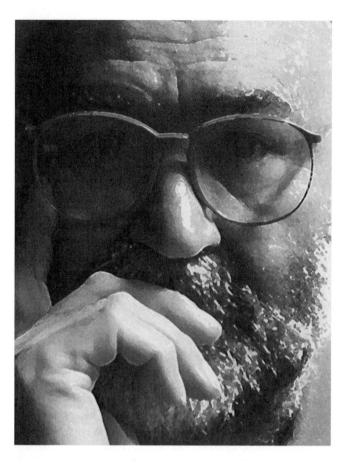

Rupert García. Photo courtesy of the artist; digital photo by Donald Farnsworth.

1982 *Rupert Garcia: Pastels,* Simon Lowinsky Gallery, San
 Francisco
 Evergreen Galleries, Evergreen State College, Olympia,
 Washington
1983 *Rupert Garcia: People in Pastels,* UPB Gallery,
 Berkeley, California
1984 *Rupert Garcia: Large Pastels,* University Art Museum,
 Berkeley, California
1985 *Rupert Garcia: Recent Pastels,* UPB Gallery, Berkeley,
 California
 Rupert Garcia: Paintings, Traver/Sutton Gallery, Seattle
 Harcourts Gallery, San Francisco
1986 *The Art of Rupert Garcia: A Survey Exhibition,*
 Mexican Museum, San Francisco
1987 *Rupert Garcia: New Pastel Paintings,* Galerie Claude
 Samuel, Paris
 Institute of Culture and Communication, East-West
 Center, Honolulu
 Vollum Center Gallery, Reed College, Portland, Oregon
 MARS Artspace, Phoenix
1988 *Rupert Garcia: New Work,* Iannetti-Lanzone Gallery,
 San Francisco
 Distinguished Artist Series: Rupert Garcia, Haggin
 Museum, Stockton, California
 *The Art of Rupert Garcia: Paintings and Pastels,
 1986–1988,* Saxon-Lee Gallery, Los Angeles

Rupert Garcia: New Work, Galerie Claude Samuel,
 Paris
1989 *Rupert Garcia: Peintre chican,* Zoo Galerie, Nantes,
 France
 Hearst Art Gallery, St. Mary's College, Moraga,
 California
 Iannetti-Lanzone Gallery, San Francisco
1990 *Apparitions and Emotions-Pastels 1983–1990,* Saxon-
 Lee Gallery, Los Angeles
 Resistance et affirmation, Galerie Claude Samuel, Paris
 Rena Bransten Gallery, San Francisco
 Rupert Garcia: Prints and Posters, 1967–1990, Fine
 Arts Museums of San Francisco (traveling)
1991 Allene Lapides Gallery, Santa Fe, New Mexico
1993 Rena Bransten Gallery, San Francisco
 Dominican College, San Marcos Gallery, San Rafael,
 California
 Aspects of Resistance: Rupert Garcia, Alternative
 Museum, New York (traveled to San Jose Museum of
 Art, California)
1995 Rena Bransten Gallery, San Francisco
1996 *Comunistas y calaveras: Monotypes by Rupert Garcia,*
 Aurobora Press, San Francisco
1997 Rena Bransten Gallery, San Francisco
1998 Sheppard Gallery, University of Nevada, Reno
1999 *Paintings and Works on Paper,* Galerie Claude Samuel,
 Paris

Selected Group Exhibitions:

1970 *Invitational Chicano Art Exhibit,* Sacramento State
 College, California
1975 *Chicanarte,* Los Angeles Municipal Art Gallery
 Images of an Era: The American Poster 1945–75,
 Corcoran Gallery of Art, Washington, D.C. (traveling)
1982 *Califas: Works on Paper,* Fondo del Sol, Washington,
 D.C.
1986 *II bienal de la Habana,* Centro Wifredo Lam, Havana
1988 *Committed to Print,* Museum of Modern Art, New York
 (traveling)
1989 *The Latin American Spirit: Art & Artists in the U.S.,*
 Bronx Museum, New York
1990 *Chicano Art/Resistance and Affirmation, 1965–1985,*
 Wight Art Gallery, University of California, Los
 Angeles (traveling)
1993 *The Art of the Other Mexico: Sources and Mean-
 ing,* Mexican Fine Arts Center Museum, Chicago
 (traveling)
2000 *Made in California, 1900–2000,* Los Angeles County
 Museum of Art

Collections:

Crocker Art Museum, Sacramento, California; Museum of Industrial
Arts, Copenhagen; University of Minnesota, Minneapolis; M. H. de

Rupert García: *Night Cap,* 1993. Photo courtesy of the artist; photo by M. Lee Fatherree, Oakland, California.

Young Memorial Museum, San Francisco; University of California, San Diego; Galeria de la Raza, San Francisco; St. Mary's College, Moraga, California; Mexican Museum, San Francisco; Institute of Culture and Communication, East-West Center, Honolulu; Mexican Fine Arts Center Museum, Chicago; El Museo del Barrio, New York; Museo Estudio Diego Rivera, San Angel, Mexico; Smithsonian Institution, Washington, D.C.; Oakland Museum, California; Palm Springs Desert Museum, California; Sonoma State University, Rohnert Park, California; San Francisco Museum of Modern Art; San Francisco State University Library; San Jose Museum of Art, California; University of Nebraska, Lincoln; University Art Museum, Berkeley, California.

Publications:

By GARCÍA: Books—*Láminas de la raza,* San Francisco, Laminas de la Raza Publications, 1975; *Recent Raza Murals in the U.S.,* with

Tim Drescher, Somerville, Massachusetts, Alternative Education Project, 1978; *Stories and Articles,* Austin, Texas, n.p., 1982; *Frida Kahlo, a Bibliography,* Berkeley, California, Chicano Studies Library Publications Unit, University of California, 1983; *Aspects of Resistance,* exhibition catalog, New York, Alternative Museum, 1994.

On GARCÍA: Books—*Rupert García,* exhibition catalog, San Francisco, Harcourts Gallery, 1985; *The Art of Rupert García: A Survey Exhibition,* exhibition catalog, text by Ramón Favela, San Francisco, Mexican Museum, 1986; *Rupert García: New Pastel Paintings,* exhibition catalog, Paris, Galerie Claude Samuel, 1987; *Rupert García,* exhibition catalog, Stockton, California, Haggin Museum, 1988; *Rupert García: Prints and Posters, 1967–1990,* exhibition catalog, San Francisco, Fine Arts Museums of San Francisco, and Mexico City, Centro Cultural Arte Contemporáneo, 1990; *Interface/ Innerface . . . Interpreting the Real,* exhibition catalog, Seattle, Cultural Affairs Division, Security Pacific Corporation, 1991; *Rupert García,* exhibition catalog, text by Linda Nochlin, San Francisco, Rena Bransten Gallery, 1997. **Articles**—''A Public Voice: Fifteen Years of Chicano Posters'' by Shifra M. Goldman, in *Art Journal,* 44, spring 1984, pp. 50–57; ''Rupert García: The Moral Fervor of Painting and Its Subjects'' by Peter Howard Selz, in *Arts Magazine,* 61, April 1987, pp. 50–53; interview with Rupert García by Michael M. Floss, in *Artweek,* 21, 27 December 1990, pp. 12–14.

* * *

Rupert García is a Chicano artist known for his pastel and silkscreen works that quote images from television and magazines and use them to make pointed political commentaries. García was one of the first Chicano artists to make cultural icons out of famous figures such as Mexican painter Frida Kahlo, freedom fighter Che Guevara, and the Virgin of Guadalupe. He used pop art, the visual language of consumerism, to subvert the cultural and economic hegemony of the United States. In doing so he developed a useful artistic strategy for Chicanos and other minority groups that commonly question dominant artistic practices.

García grew up in central California and at an early age became interested in art, copying images from magazines, books, and television. Many years later García joined the U.S. Air Force and was sent to Thailand, where he experienced firsthand the horrors of war. He returned in 1966 and studied at San Francisco State College, where he received a bachelor's degree and witnessed demonstrations by the Third World Liberation Front, an organization on campus that fought for minority rights. García's coming of age during the turbulence of the 1960s was to have a profound effect on his later work.

During the early 1970s García received a master's degree in art history from the University of California, Berkeley, but he felt that the curriculum there did not relate to his Chicano heritage. This experience, however, gave him a thorough knowledge of Western art, and he began to produce portraits of artists and images culled from famous politically charged artworks. García adapted the photograph *Striking Worker Assassinated* by Mexican photographer Manuel Alvarez Bravo and turned it into a powerful, brightly colored pastel that had a new context in the fight for minority rights. In addition García did portraits of artists, such as Kahlo, Diego Rivera, and David Alfaro Siqueiros, who were important to Chicanos not only for their Mexican identity but also because of their involvement in communism and devotion to social issues. García produced portraits of important figures who intrigued him, such as the nuclear physicist J.

Robert Oppenheimer, writer George Orwell, and film director Luis Buñuel.

Early in his career García used silkscreen to produce posters publicizing demonstrations and making political statements. The resulting flat, brightly colored graphic images were ideal for conveying political messages in a direct and effective manner. Wanting to work in a softer, more expressive style, García decided to combine pastels with silkscreen posters, filling in unprinted areas with gestural strokes of color. García used this technique in many of his works of the 1970s, such as *Political Prisoner* (1976), an homage to activist Angela Davis, as well as his portrait of Mao Zedong. But García rarely made paintings, and when he did, he did not silkscreen them, wishing to avoid comparisons with Andy Warhol. Instead he filled in the broad, flat areas of color completely by hand, as in his 1970 portrait of Rubén Salazar, a Chicano journalist killed in Los Angeles.

García took on other issues, including apartheid in South Africa, the war in Nicaragua during the late 1970s, and the plight of indigenous peoples in Australia. One of his most well known images, *El grito de rebelde,* which was featured on the cover of Shifra Goldman's book *Dimensions of the Americas,* was adapted from a photograph of a blindfolded and tied up political prisoner of the Shah of Iran crying out in protest, an image that transcends its historical context. García's work is distantly related to that of postmodern artists such as Sherry Levine, who appropriated famous artworks in order to address the issue of artistic originality. García's work, however, had much stronger ties to Third World politics than Levine's work, with a closer affinity to the Cuban poster artists of the 1960s and '70s who, in a similar fashion, used a pop art style to protest the Vietnam War in a deeply subversive manner.

—Erin Aldana

GARCÍA BUSTOS, Arturo
Mexican printmaker, painter, and muralist

Born: Mexico City, 8 August 1926. **Education:** Took drawing classes from landscape painter Armando García Nuñez; attended Academy of San Carlos, early 1940s; attended La Esmeralda, the National School of Painting, Sculpture and Engraving, 1943, where he studied under Augustín Lazo and Frida Kahlo and became an assistant to Diego Rivera. **Family:** Married Rina Lazo, late 1940s. **Career:** Contributed to magazine *1945,* 1945; cofounder, Jóvenes Artistas Revolucionarios, 1945; joined the Taller de Gráfica Popular, 1947; visited Europe, 1951; art instructor, Escuela de Bellas Artes, Guatemala City, 1952–54, School of Fine Arts, University Benito Juárez, Mexico City, until 1957, and La Escuela de Bellas Artes, Oaxaca, Mexico, 1957; visited Cuba, 1959, 1961; contributed to newsletter *Amigos de la Democracia Latinoamericana.* **Member:** Mexican Academy of Fine Arts, 1977. **Awards:** First prize, Salón de Plástica Mexicana, for *Mercado de Tlacolula;* first prize/gold medal, VI World Youth / Students for Peace Festival, Moscow, 1957, for *Mercado de Tlacolula.*

Individual Exhibitions:

1953 *Exposición de grabados de Arturo García Bustos:*
 Escuela Nacional de Artes Plásticas, Escuela
 Nacional de Artes Plásticas, Guatemala City

1974 Instituto Nacional de Bellas Artes, Mexico City
1998 *Nacionalismo y universalidad en la obra de Arturo
 García Bustos: Pintura y estampa,* Museo Mural
 Diego Rivera, Mexico City

Selected Group Exhibitions:

1986 Estación Zócalo, Mexico City
 *Diego Rivera y sus discípulos: Rina Lazo, Arturo
 Estrada, Arturo García Bustos,* Metro Zócalo, Mex-
 ico City
2001 Lazo and Bustos Gallery, Dallas

Collection:

Georgetown University, Lauinger Library, Washington D.C.

Publications:

On GARCÍA BUSTOS: Books—*Exposición de grabados de Arturo
García Bustos,* exhibition catalog, Guatemala City, Dirección Gen-
eral de Bellas Artes, 1953; *Diego Rivera y sus discípulos,* exhibition
catalog, Mexico City, Sistema de Transporte Colectivo, 1986; *Bustos:
Gráfica comprometida,* exhibition catalog, Mexico City, Instituto
Nacional de Bellas Artes, 1992; *Arturo García Bustos y el realismo
de la escuela mexicana* by Leonor Morales, Mexico, Universidad
Iberoamericana, 1992; *Nacionalismo y universalidad en la obra de
Arturo García Bustos,* exhibition catalog, Mexico City, Instituto
Nacional de Bellas Artes, 1998; *En tinta negra y en tinta roja; Arturo
García Bustos—Vida y obra* by Abel Santiago, Edición de la Fundación
Todos por el Istmo, 2000.

* * *

Arturo García Bustos is one of the second generation of Mexican
muralists, working as a politically motivated artist from the early
1940s. He was born in Mexico City and as a child saw Diego Rivera
creating his murals at the National Palace while José Clemente
Orozco painted the walls of the Supreme Court Building. García
Bustos attended the Academy of San Carlos in the early 1940s, and in
1943 he entered the Escuela de Pintura y Escultura de la Esmeralda.
There he studied first with the painter Augustín Lazo and then with
Frida Kahlo. He and a group of his fellow students became known as
Los Fridos, or ''followers of Frida.'' Kahlo took her students to paint
murals on the walls of a *pulquería* and a public laundry in Coyoacán
until ill health prevented her from working outdoors. After she could
no longer paint in public, Kahlo taught *Los Fridos* at her home
in Coyoacán.

During the 1940s García Bustos became a member of the
Mexican Communist Party. In 1945 García Bustos, along with artists
Pedro Coronel, Alberto Beltrán, and other young artists, founded the
Jóvenes Artistas Revolucionarios (Young Revolutionary Artists).
García Bustos provided illustrations for *1945,* a leftist periodical
created by David Alfaro Siqueiros.

In 1947 García Bustos joined the Taller de Gráfica Popular
(TGP; Popular Graphic Arts Workshop), the collective printmaking
studio founded in 1937 by Leopoldo Méndez, Pablo O'Higgins, and
Luis Arenal. At the TGP he learned printmaking and produced a

number of politically motivated images. In the late 1940s he married
the painter Rina Lazo. In 1950 he participated in the founding of the
Salón de la Plastica Mexicana, a gallery established to promote
contemporary art.

From 1952 to 1954 García Bustos worked at the Escuela de
Bellas Artes in Guatemala City, where he taught printmaking and
mural painting and established a graphic arts workshop modeled on
the TGP. During this time he produced a number of prints with
Guatemalan themes. He returned to Mexico after the violent over-
throw of the government of Guatemalan President Jacobo Arbenz.
His portfolio of linoleum prints, *Testimonio de Guatemala,* depicted
events from recent Guatemalan history.

During the 1950s García Bustos taught art in Mexico City and
participated in the group El Frente Nacional de Artes Plásticas
(National Front of Plastic Arts), a political and artistic association that
promoted muralism and politically motivated art. He and Rina Lazo
also taught at the Escuela de Bellas Artes (School of Fine Arts) of the
Universidad Autónoma Benito Juárez in Oaxaca. His print *Mercado
de Tlacolula,* created during this period, is a realistic portrayal of a
local weekly market. In 1959, following the Cuban Revolution,
García Bustos traveled to Cuba to lecture and to exhibit his Guatema-
lan prints. He visited Cuba again in 1961.

In the 1950s García Bustos and Rina Lazo created murals under
the auspices of the Mexican Communist Party. They explored agrar-
ian and historical themes at a school in Temixco, Morelos, and in a
rural agricultural cooperative in Atencingo, Puebla. In 1964 García
Bustos painted a mural in the ethnographic hall at the National
Museum of Anthropology in Mexico City, depicting the seven major
ethnic populations of the state of Oaxaca. In the 1960s and '70s
García Bustos also decorated the walls in the Palacio Municipal
(Municipal Palace) of Oaxaca. These works are painted in a realistic
style, portraying the history and culture of the region and of Mexico.
In 1989 García Bustos made a mural for the University Metro station
in Mexico City on the theme of the university in the twenty-first
century, and in 1999 he painted a mural for the Glaxo Wellcome
Company, portraying geneticists James Watson and Francis Crick.

From the 1940s García Bustos has promoted realist, socially
concerned art in the tradition of the earlier Mexican muralists.

—Deborah Caplow

GEGO
Venezuelan painter, printmaker, and sculptor

Born: Gertrudis Goldschmidt, Hamburg, Germany, 1 August 1912;
emigrated to Venezuela, 1939, granted Venezuelan citizenship, 1952.
Education: Studied architecture, Universität Stuttgart, Germany,
1938. **Career:** Associate professor, Universidad Central de Vene-
zuela, Caracas, 1958–67; sculpture instructor, Escuela de Artes
Plásticas y Aplicadas Cristóbal Rojas, Caracas, and Universidad
Central de Venezuela, Caracas; instructor, Instituto de Diseño, Cara-
cas, beginning in 1964. Traveled to the United States, 1958–59.
Awards: Grant, Tamarind Lithography Workshop, Los Angeles,
1966; National Plastic Arts of Venezuela award, 1979. **Died:** 17
September 1994.

Individual Exhibitions:

1955 Gurlitt Gallery, Munich
1958 Galeria de la Librería Cruz del Sur, Caracas
1961 Museo de Bellas Artes de Caracas
1964 Fundación Museo de Bellas Artes, Caracas
1968 Fundación Museo de Bellas Artes, Caracas
1969 Center for Inter-American Relations, New York
1977 Museo de Arte Contemporáneo, Caracas
1982 Galeria de Arte Nacional, Caracas
1984 Fundación Museo de Bellas Artes, Caracas

Selected Group Exhibitions:

1960 Museum of Modern Art, New York
 David Herbert Gallery, New York
 Betty Parsons Gallery, New York
1963 St. Paul Art Center, Minnesota
1964 Washington Square Gallery, New York
1965 *The Responsive Eye,* Museum of Modern Art, New
 York
1966 *Art of Latin America since Independence,* Yale Univer-
 sity, New Haven, Connecticut, and University of
 Texas, Austin
1967 *Latin American Art: 1931–1966,* Museum of Modern
 Art, New York
1969 Whitney Museum of American Art, New York
1970 Graphics Gallery, San Francisco

Collections:

Amon Carter Museum, Fort Worth, Texas; Art Institute of Chicago;
California Polytechnic State University, San Luis Obispo; University
of Iowa, Ames; La Jolla Museum of Art, California; Library of
Congress, Washington, D.C.; New York Public Library; pasadena
Museum, California; San Diego Museum, California; University of
Texas, Austin.

Publications:

On GEGO: Books—By Hanni Ossot, Caracas, Museo de Arte
Contemporáneo, 1977; *The Experimental Exercise of Freedom: Lygia
Clark, Gego, Mathias Goeritz, Hélio Oiticica, Mira Schendel,* exhibi-
tion catalog, text by Rina Carvajal, Alma Ruiz, and Susan Martin,
Los Angeles, Museum of Contemporary Art, 1999. **Articles**—
"Conversacion con Gego" with M. F. Palacios, in *Revista Ideas,*
May 1972; "Gego libre y abstracta" by Lourdes Blanco, in *El Diario
de Caracas,* 24 September 1994; "Gego and the Constructive Docil-
ity" by Victor Guédez, in *Art Nexus* (Colombia), 23, January/March
1997, pp. 58–62; "Do You Know Gego?–Billionaire Art Missionary
Patricia Cisneros Is Out to Prove There's More to Latin America than
Frida Kahlo" by Robert Goff, in *Forbes,* 6 July 1998, p. 286.

* * *

Gego was one of the most important figures of the Venezuelan
constructivist movement. Born Gertrud Goldschmidt in Hamburg,

Germany, in 1912, she moved to Caracas, Venezuela, in 1939, where
she lived until her death in 1994. She studied architecture and
engineering at the University of Stuttgart, where, despite her highly
technical training, she was influenced by De Stijl and the Bauhaus.
Once in Caracas, Gego worked as an architect and interior designer.
Her interest in industrial design led her to establish a furniture and
lighting design workshop. During her first decades in Caracas she
also began teaching architecture at the Universidad Central de Vene-
zuela and at the Cristobal Rojas School of Arts. She continued
teaching for many years, and several generations of Venezuelan
artists and architects studied with her.

During the 1950s Gego began developing her artistic work,
mainly drawings in which the line was her main object of study. In
1955 she had her first solo show at the Gurlitt Gallery in Munich, and
from then on she exhibited widely both in Venezuela and in other
countries. Most notably, she participated in the exhibition *The Respon-
sive Eye* at the Museum of Modern Art in New York City in 1965, a
landmark exhibition of kinetic and op art that included the work of
artists such as Victor Vasarely, Jesús Rafael Soto, Carlos Cruz-Diez,
and Bridget Riley.

Gego was a multifaceted artist who expressed herself through
drawings, engravings, graphic design, objects, and sculptures. She
was a prolific draftswoman, and her drawings accompanied every
stage of her work. Architecture was present in her investigations of
line and space and also in her sculptures conceived specifically for
buildings and public spaces. Her first sculptures were the series
Líneas paralelas ("Parallel Lines"), with a marked constructivist
influence, in which she made use of a system of parallel lines in order
to create virtual volumes. Her work then took a turn toward a more
intimate scale with the *Bichos,* the name of which is a reminder of the
homonymous works of Lygia Clark, who has been compared to Gego
by critics and scholars. Representative of this period are a series of
small-format sculptures in wire in which can be found the origins of
the later *Chorros* and *Reticuláreas,* which constitute Gego's most
significant body of work and which exemplify the idea of contempo-
rary sculpture's subversion of mathematical concepts by way of an
experiential rather than a scientific process. These sculptures, which
hang suspended in the air without any apparent support and in which
the grid appears to dissolve to become a formless net, seem to
undermine the constructivist influence on the geometrical abstraction
of the time in Latin America.

In her later years Gego concentrated on a series of works that
combined drawing with sculpture. *Dibujos sin papel* ("Drawings
without Paper"), a series of wire and mesh drawings installed on the
walls of the exhibition space, constituted a synthesis at the end of her
life of the formal and spatial investigations she had carried out in her
diverse body of work.

Within the context of the constructive movement in Venezuela,
clearly marked by a spirit of rupture and dissent, Gego's art stands
out, however silently and discreetly, as work that appeals more to the
spectator's senses than to the concept of a break with preceding
tradition. The fragility of structure, the simplicity of materials, and the
intimate scale that characterize the work are indicative of the idea of
contingency that is very much present in her art. The separation of the
sculptural object from its support, the treatment of the grid–which
denies the unique point of view of classical perspective–and above all
its strong perceptual and experiential orientation encourage the spec-
tator to become aware not only of the object but also of the space that

contains it, with all of its formal and conceptual implications. Thus, space is a fundamental element in Gego's work, starting with the first drawings–in which her spatial concerns are already clearly laid out–to literally arrive at the final "drawings without paper." She completely abandons the support of canvas or paper in *Chorros* and *Reticuláreas,* in which space becomes the substance of the work, framed by a nonstructural grid that takes the shape imposed by the very weight of the material from which it is made. The grid that gives way under the weight of matter, of air, and of space is emblematic of Gego's relationship with the constructivist tradition and of the independence of her work from theoretical and discursive frameworks. Her work acknowledges only space, and her grids seem to exist with the sole purpose of indicating the relativity and contingency of the objects within.

—Julieta González

GERZSO, Gunther
Mexican painter

Born: Mexico City, 17 June 1915. **Education:** Studied in Switzerland, *ca.* 1927; attended the German school, Mexico City, *ca.* 1931–34. Studied theater design and cinematography, Cleveland Playhouse, Ohio, *ca.* 1935. **Family:** Married Gene Rilla Cady *ca.* 1935; two sons. **Career:** Designed theater sets and costumes, Mexico, 1931–34; lived in the United States, 1935–41; set designer, Cleveland Playhouse, Ohio, 1936; art director for Mexican, French, and American film companies, Mexico, 1941–62. Visited Greece, 1959. **Awards:** Solomon R. Guggenheim fellowship, 1973; Premio Nacional de Artes y Ciencias, Mexico, 1978. **Died:** 21 April 2000.

Individual Exhibitions:

1950	Galeria de Arte Mexicano, Mexico City
1956	*Gunther Gerzso,* Galería Antonio Souza, Mexico City
1958	*Gunther Gerzso,* Galería Antonio Souza, Mexico City
1963	*Gunther Gerzso, Exposicion Retrospectiva,* Museo Nacional de Arte Moderno, Mexico City (retrospective)
1970	*Twenty Years of Gunther Gerzso,* Phoenix Art Museum
	Gunther Gerzso: Pinturas, dibujos, Galería de Exposiciones Temporales, Museo De Arte Moderno, INBA, Mexico City
1981	*Gunther Gerzso–Retrospectiva,* Museo de Monterrey, Mexico (retrospective)
1982	*Gunther Gerzso, One Man Show,* FIAC 1982, International Contemporary Art Fair, Paris
1984	*Gerzso. La centella glacial. Un dialogo plastico en la ciudad de Mexico,* Sala Ollin Yoliztli, Mexico City
	Gunther Gerzso Retrospective, Mary-Anne Martin/Fine Art, New York
1986	*Gunther Gerzso,* Museo Carrillo Gil, Mexico City
1990	*Gerzso,* Galería de Arte Mexicano, Mexico City
1993	*Gunther Gerzso. Pintura, grafica y dibujo, 1949–1993,* Museo de Arte Contemporaneo de Oaxaca, Mexico (traveling)

Gunther Gerzso. Photo courtesy of Mary-Anne Martin/Fine Art, New York.

1995	*Gunther Gerzso. Obra reciente,* Galería Lopez Quiroga, Mexico City
	Gunther Gerzso 80th Birthday Show, Mary-Anne Martin/Fine Art, New York
	Gunther Gerzso: Prints and Sculpture, Americas Society, New York
1996	*Gunther Gerzso,* Latin American Masters Gallery, Beverly Hills, California
2000	*Gunther Gerzso Remembered, 1915–2000,* Dallas Museum of Art (retrospective)

Selected Group Exhibitions:

1952	*Pittsburgh International Exhibition of Contemporary Painting,* Carnegie Institute
1956	*Gulf-Caribbean Art,* Museum of Fine Arts, Houston
1959	*Mexican Art, Pre-Columbian to Modern Times,* University of Michigan, Ann Arbor
1965	*Contemporary Mexican Artists,* Phoenix Art Museum
1966	*Art of Latin American Since Independence,* Yale University, New Haven, Connecticut, and University of Texas, Austin
1975	*12 Latin American Artists Today,* University of Texas, Austin
1978	*Seccion anual de invitados: Tamayo, Merida, Gerzso,* Salon Nacional de Artes Plasticas, Instituto Nacional de Bellas Artes, Mexico City

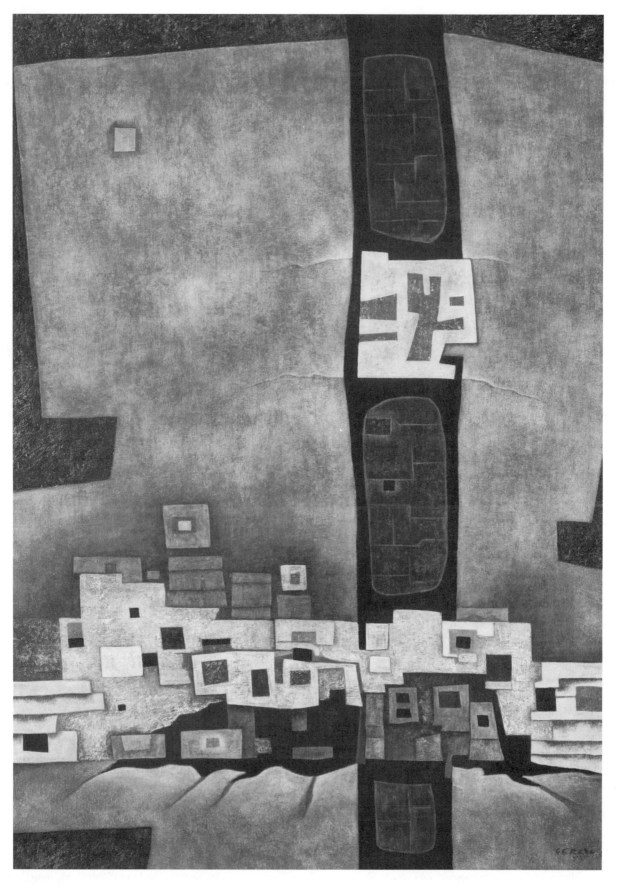

Gunther Gerzso: *Presence of the Past,* **1953. © Christie's Images/Corbis.**

Gunther Gerzso: *Ritual Place,* 1963. Photo courtesy of Mary-Anne Martin/Fine Art, New York.

Collections:

Agency for the Performing Arts, New York; Art of the Americas Collection, New York; Museum of Modern Art, New York; Museum of Modern Art of Latin America, Washington, D.C.; University of Texas, Austin.

Publications:

On GERZSO: Books—*Gunther Gerzso* by Luis Cardoza y Aragón, Mexico City, Universidad Nacional Autónoma de México, 1972; *La zona del silencio, Ricardo Martinez, Gunther Gerzso, Luis Garcia Guerrero* by Marta Traba, Mexico City, Fondo de Cultura Económica, 1975; *Gerzso, Mérida, Tamayo,* exhibition catalog, Mexico City, Instituto Nacional de Bellas Artes, 1979; *Gerzso,* Neuchâtel, Switzerland, Editions du Griffon, 1983; *Gunther Gerzso,* exhibition catalog, by Dore Ashton, Beverly Hills, California, and Mexico City, Latin American Masters and Galeria López Quiroga, 1996. **Articles**—''Gerzso, mago alquimista'' by Jorge Crespo de la Serna, in *Excelsior* (Mexico City), 14 May 1950; ''Gunther Gerzso'' by Paul Westheim, in *Novedades,* (Mexico City), 8 April 1956; ''Mexican Modernism'' by John Canaday, in *New York Times,* 25 April 1965; ''Pintura Actual: México'' by Justino Fernández, in *Artes de México* (Mexico City), 1966; ''Inconfundible lenguaje visual de Gunther Gerzso'' by Raquel Tibol, in *Excelsior–Revista dominical* (Mexico City), 15 March 1970; ''Artes plásticas: La obra mas reciente de Gerzso'' by Luis Cardoza y Aragón, in *El Día* (Mexico City), 6 April 1970; ''Gerzso: La centella glacial'' by Octavio Paz, in *Plural* (Mexico City), October 1972; ''La estratificación pictórica de Gunther Gerzso'' by Juan Acha, in *Plural* (Mexico City), July 1974, pp. 28–33; ''The Secret behind the Surface'' by David Ebony, in *Art in America,* 84(4), 1996; ''Gunther Gerzso'' by Jose Antonio Aldrete-Haas and Monica de la Torre, in *Bomb,* 74, winter 2001.

* * *

During his lifetime Gunther Gerzso distinguished himself as one of Mexico's most important and distinctive abstract painters. He came to the fine arts relatively late in his career after spending many

years as a highly successful set designer for the theater and films. Born in 1915 in Mexico City to European émigré parents, he was sent in 1927 to live with a wealthy uncle in Switzerland. The uncle, an art dealer, had been a student of the eminent art historian Heinrich Wöfflin and possessed a large art collection; this relation provided the young Gerzso with his only education in the fine arts. In Switzerland he met the painter Paul Klee as well as Italian stage designer Nando Tamberlani, who influenced his decision upon finishing school to pursue the field of set design. Gerzso returned to Mexico in 1931, but three years later he went to the United States, studied set design at the Cleveland Playhouse, and then became the company's set designer. After returning to Mexico in 1941, Gerzso designed sets for major films; in all, he worked on more than 150 motion picture productions during the era that has become known as the Golden Age of Mexican Cinema.

Gerzso began painting avocationally in the 1940s, a period in which he developed close friendships with artists Leonora Carrington, Remedios Varo, and Wolfgang Paalen, as well as with the poet Benjamin Péret, all Europeans affiliated with surrealism who found refuge in Mexico during World War II. In his initial years as a painter, Gerzso was influenced by surrealist tendencies. One of his major early works, *The Days of Gabino Barreda Street* (oil on canvas, 1944), shows a fantastical landscape inhabited by thinly disguised portraits of Varo, Carrington, Péret, and Esteban Frances, the Spanish painter then living in Mexico.

Despite his affinity for surrealism, Gerzso sought to develop his own artistic language, one that expressed a closer connection to native Mexico. Gerzso's work in film design afforded him much travel in the country, from which he gained a profound appreciation for Mexico's pre-Columbian cultures. By the 1950s this became a principal source of inspiration for Gerzso's increasingly abstract compositions. Works such as *Ancient Structures* (oil on Masonite, 1955) and *Archaic Landscape* (oil on Masonite, 1956) are highly abstracted, dreamlike interpretations of the timeworn facades of ancient Aztec or Mayan structures. Painted in such hues as muted golds, iridescent greens, and colors that evoke the earth, these compositions feature layered, interlocking elements in rhythmic patterns, suggesting architectural forms animated by some inner force.

In 1962 Gerzso retired from set design and finally devoted himself full time to painting. He developed the idiom of abstraction for which he has become best known, characterized by a strong sense of geometry and a purity of color and line. By the mid-1960s his palette became more vibrant, each rectilinear form in his compositions more precise and his surfaces almost glassy in appearance. *Figure in Red and Blue* (oil on canvas, 1964) is a characteristic canvas of this period. Multiple layers of planes are suggested by overlapping rectangular and trapezoidal forms; the illusion of deep space is created by painted shadows, by the intensely dark hues of the background, and by the faint suggestions of crevices breaking the purity of his flat planes. The monumental forms of Aztec and Mayan temples—as well as Mexico's dry, rugged landscape—may be points of departures for such works, but they also evoke the universal. These paintings become spaces to contemplate the metaphysical and infinities of time and space.

In describing his artistic process, Gerzso once stated that his style of painting could not be improvised. Rather, often applying the principals of the golden rule, he executed meticulous preparatory drawings for each painting. Later in his career, primarily in the 1980s and '90s, Gerzso produced sculptures in bronze and other metals. With these works he continued to draw inspiration from Mexico's

ancient cultures, creating totemic structures or reliefs consisting of overlapping planes that were clearly related to the compositional structures of his paintings.

—Elizabeth Ferrer

GOERITZ, Mathias
Mexican painter, sculptor, and architect

Born: Danzig, Prussia (now Poland), 4 April 1915; immigrated to Mexico, 1949. **Education:** Kaiserin-Augusta-Gymnasium, Charlottenburg, Berlin, 1924–34; Friedrich-Wilhelms-Universitat, Berlin, 1934–40, Ph.D. 1940; Kunstgewerbeschule, Charlottenburg, Berlin, 1937–39. **Family:** Married 1) Marianne Gast in 1942 (died 1958); 2) Ida Rodriquez Prampolini in 1960; one son. **Career:** Professor, Centro de Estudios Marroquies, Tetuan, Spanish Morocco, 1940–44; painter, Granada, Spain, 1945–47, and Guadalajara, Jalisco, Mexico, 1949–54. Founder and professor, Department of Basic Design, Universidad Nacional Autónoma de Mexico, Mexico City; founder and director, Escuela de Artes Plastics y Escuela de Diseno Industrial, Universidad Iboamericana, Mexico City, 1957–60; artist-in-residence, Aspen Institute for Humanistic Studies, Aspen, Colorado, 1970–72. Constructed El Eco, experimental museum, with Carlos Mérida and Rufino Tamayo, Mexico City, 1953. Founder, la Escuela de Altamira movement, Santillana del Mar, Santander, Spain, 1948; cofounder, Los Hartos movement, Mexico City, 1961. Editor, art section, *Arquitectura Mexico,* Mexico City, beginning in 1958; also worked as an art critic. Member, Group International d'Architecture Prospective, beginning in 1965. **Awards:** Zeev Rechter prize for architecture, Israel, 1987. Honorary fellow, Royal Academy of the Hague, 1976; honorary academician, Academia Nacional de Arquitectura, Mexico, 1984, Academia Mexican de Diseno, 1985, Academia de Artes, Mexico, 1986. Chevalier, Order des Arts et des Lettres, France, 1984. **Died:** 1990.

Individual Exhibitions:

1946	Sala Clan, Madrid
1948	Salon Alerta, Santander, Spain
1949	Galeria Palma, Madrid
1950	Galeria Camarauz, Guadalajara
	Galeria Clardecor, Mexico City
1952	Galeria Sapi, Palma de Majorca
	Galeria Jardin, Barcelona
	Galeria de Arte Mexicano, Mexico City
1953	El Eco Museo Experimental, Mexico City
1955	Galeria Proteo, Mexico City
1956	Carstairs Gallery, New York
1959	Galeria de Arte Mexicano, Mexico City (retrospective)
1960	Carstairs Gallery, New York
	Galerie Iris Clert, Paris
	Galeria de Antonio Souza, Mexico City
1961	Galeria de Arte Mexicano, Mexico City
1962	Carstairs Gallery, New York
1980	Israel Museum, Jerusalem
1984	Museo de Arte Moderno, Mexico City

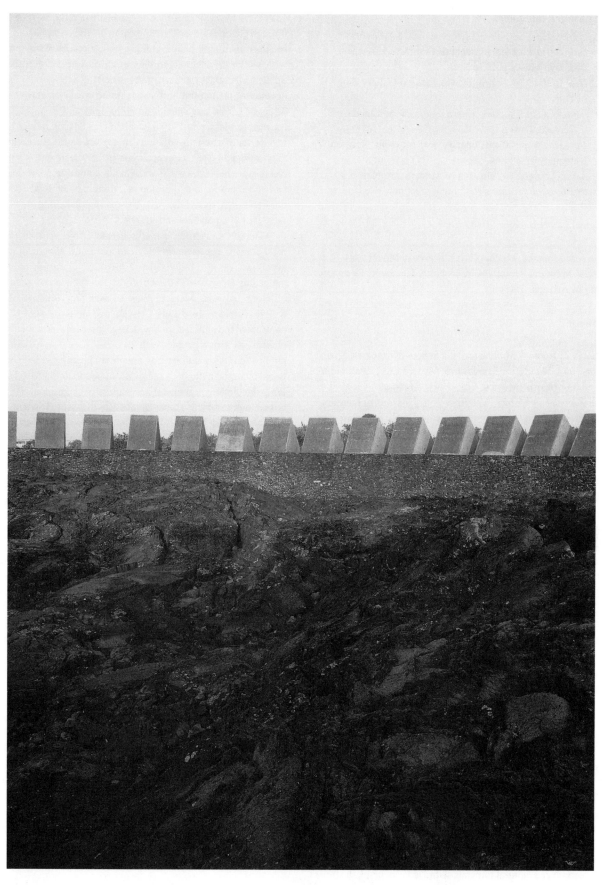

Mathias Goeritz, with Helen Escobedo Sebastian, Federico Silva, and Manuel Felguérez: *Ring of concrete blocks surrounding crater of volcano, Mexico City,* **1979–80. Photo courtesy of The Art Archive/Nicolas Sapieha.**

Selected Group Exhibitions:

1956 *Gulf-Caribbean Art,* Museum of Fine Arts, Houston
1959 Brooklyn Museum, New York
1960 *New Media/New Forms,* Martha Jackson Gallery, New York
 Aspects de la Sculpture Americaine, Galerie Claude Bernard, Paris
 New Europeans, Contemporary Arts Museum, Houston
1961 University of Illinois, Urbana
 Art of Assemblage, Museum of Modern Art, New York
 Pittsburgh International, Carnegie Institute

Collections:

Museo de Arte Moderno, Mexico City; Museum of Modern Art, New York; Israel Museum, Jerusalem; Kunsthalle, Hamburg, Germany; University of Arizona, Tucson.

Publications:

By GOERITZ: Books—*Manifesto of the School of Altamira,* Spain, Santander, 1948; *Manifesto: Estoy Harto,* Mexico City, 1960; *Manifesto: Estamos Hartos,* Mexico City, 1961; *Mathias Goeritz: Ein deutscher Künstler in Mexiko,* with Elke Werry, Marburg, Jonas, ca. 1987. **Articles—**''Manifesto arquitectura emocional,'' in *Cuadernos de Arquitectura* (Guadalajara), 1, 1954; statement in the exhibition catalog for his one-man show, Carstairs Gallery, New York, 1962.

On GOERITZ: Books—*Mathias Goeritz* by Oliva Zuniga, Mexico City and New York, 1963, 1964; *Mathias Goeritz* by Frederico Morais, Mexico City, 1982; *Mathias Goeritz* by Lily Kassner, Mexico City, Instituto Nacional de Bellas Artes, 1998. **Articles—**''El Eco: Ein Experimental-Museum in Mexico,'' in *Baukunst und Werkform,* 4, 1954; ''Architektur in Mexiko'' by Helmuth Borcherdt, in *Baumeister* (Munich), November 1959; ''Mathias Goeritz'' by Michel Ragon, in *Cimaise* (Paris), 106, 1972.

* * *

Mathias Goeritz, a plural artist, has to be defined as much for his ideas as for the art he created. He wrote ''Please, stop!'' and other significant manifestos as well as many prefaces for catalogs and articles for specialized magazines and books worldwide. He was also an editor and an art critic. His early interest in design, visual poetry, and photography demonstrate his involvement in providing new values and meanings to society. He kept private his deeply spiritual belief in religion. He would go fluently from painting into architecture and from writing into sculpture in the same way that he used several languages daily. Although neither devoted to handicraft nor to nature, he drew a personal approach to native cultures, not as a political statement but as a relation among human beings, respecting their value, power, and human rights.

Born to mixed-religion parents Goeritz grew up surrounded by a spirit of freedom and cultural thinking, with Dadaism being the most influential movement in his life. He fled the Nazis and went to Tangier, Morocco, and then to Spain, where he lived from 1945 through October 1949. There he painted—exhibiting under the name Mago—and taught his developing philosophical ideas. Intellectuals with whom he encouraged the strong movement of contemporary Spanish art collaborated when he created the School of Altamira after developing an admiration for the prehistorical elements of that area. There he taught free courses on philosophy and art appreciation. He traveled to Mexico in 1949 to teach in Guadalajara, where he created one of the earliest installations in the art world. Later in Mexico City he taught various generations of architects and visual artists. Never were his classes stiff academic readings. Impulse, motivation, and information and questioning, thinking out loud, considering nontraditional materials, and constantly awakening new thoughts were part of a personal anti-system.

Goeritz's emergence marks the departing point of one of the most important periods in Mexican and Latin American art. While muralism was declining Goeritz provided examples of what was happening elsewhere in the art world. He unfolded contemporary art relations between Mexico, Europe, and the United States. With Rufino Tamayo, Jose Luis Cuevas, and other artists his aesthetic confronted the muralist spell with new winds. He used regular mail to receive art from people such as Paul Klee for exhibitions and publication. Although he was not an architect he juried for international contests in the field and received honorary degrees. He built El Eco, the first experimental, or alternative, museum. He was the artistic author of the *Torres de Satélite* (Satellite Towers), a monumental group of urban sculptures for a new development. This space definition, a sign for a new city, was a team project with architects Mario Pani, Luis Barragan, and artist Chucho Reyes. For the cultural program of the 1968 Olympics Goeritz developed signs for isolated buildings in Mexico and abroad—using monumental concrete sculptures by artists from the participating countries—and arranged symposiums. He was the defining figure in the design field, introducing, teaching, and making room for it.

A free-spirited intellectual agitator, Goeritz was frequently heard to say such things as: ''When people wrote bad things about me, they gave me a wonderful publicity''; ''I was very lucky that people believed in me''; ''Only time will define what is art''; ''I like to credit all who participate in a project—there is enough work for everyone!''; ''I hope it is not boring'' (referring to whatever he was doing); ''I always had the complex of being a tower'' (tall and erect); and ''I made a big mistake not foreseeing how much and quickly Mexico City would grow.'' These comments reveal his natural leadership and organizational capacities and the sense of humor and self-criticism he displayed daily. Sharing, quality, and originality were his nonverbalized leitmotivs. His work was technically and creatively impeccable, but it avoided solemnity. In life and in art he simplified forms to enrich perceptions and emotions. New materials or different ways of using common materials was part of a personal challenge. As a European he admired the Mexican freedom for color. Crediting mainly Jesús (Chucho) Reyes for having shown him this strength, Goeritz would do an urban sculpture in pink, and when the time came to repaint he would turn to someone passing by and ask ''What color would you like it?'' This reflected a natural attitude and a serious desire to avoid boredom.

—Graciela Kartofel

GOITÍA (GARCIA), Francisco

Mexican painter

Born: Fresnillo, Zacatecas, 4 October 1882. **Education:** Academia de San Carlos (now Escuela Nacional de Artes Plásticas), 1896; studied under Francisco Galí in Barcelona, Spain, 1904. **Career:** Lived in Europe (primarily in Spain and Italy), 1904–12. Staff artist under General Felipe Angeles, army of Pancho Villa, Mexican Revolution, 1912. Researcher and illustrator, field work with anthropologist Manuel Gamol, 1918–25; teacher, Escuela Nacional de Artes Plásticas, late 1920s. Member, *Frente Nacional de Artes Plásticas.* **Award:** International prize, *Primera bienal interamericana de pintura y grabado,* Mexico City, 1958. **Died:** Xochimilco, 1960.

Selected Exhibitions:

1907	*V. exposición internacional de bellas artes e industrias artísticas,* Barcelona, Spain
	Salón Parés, Barcelona, Spain
1908	*Exposición internacional de bellas artes,* Rome
1924	Instituto Indigenista Interamericano, Washington, D.C.
1936	Instituto Indigenista Interamericano, Mexico City
1938	*International Exposition,* San Francisco
1939	Academia de San Carlos, Mexico City
1940	Palacio de Bellas Artes, Mexico City
1941	Escuela Nacional de Artes Plásticas, UNAM, Mexico City
1942	Instituto Autónomo de Ciencias y Artes, Oaxaca, Mexico
1943	Universidad de Yucatán, Mérida, Mexico
1945	*Salón de pintura,* Galería de Arte y Decoración, Mexico
1946	Biblioteca Cervantes, Zacatecas, Mexico (first individual exhibition)
	Pintura moderna mexicana 1911–1946, Havana
1947	*Exposición de la pintura contemporánea de México 1911–1946,* Universidad de Nuevo León, Monterrey, Mexico
	Instituto Nacional de Bellas Artes, Museo Nacional de Artes Plásticas, Mexico
1948	Universidad de Nuevo León, Monterrey, Mexico
1949	Instituto Nacional de Bellas Artes, Mexico City (retrospective)
1951	Galería Popular de Arte "José Clemente Orozco," Mexico City (group)
1952	Galerías Orozco, Mexico City
1953	Galería Orozco, Mexico City
	Museo Nacional de Artes Plásticas del Palacio de Bellas Artes, Mexico
	Museo Nacional de Arte Moderno, Mexico City
1954	*El paisaje de México en la plástica y la poesía,* Galería de Arte Contemporáneo, Mexico City
	Sala de Arte "El Cuchitril," Mexico City
1957	Gallery Las Pérgolas de la Alameda, Mexico City (retrospective)
	Salón de la Plástica Mexicana, Mexico City
1958	*Primera bienal interamericana de pintura y grabado,* Instituto Nacional de Bellas Artes, Mexico City
1959	Galería de Arte Mexicano, San Antonio, Texas
	Salón de la Plástica Mexicana, Mexico City
	V bienal de São Paulo, Brazil
1972	Salón Museo de Zacatecas, Mexico
1978	Museo de Arte Moderno de Chapultepec, Mexico

Collection:

Museo Francisco Goitía, Zacatecas, Mexico.

Publications:

On GOITÍA: Books—*Contemporary Mexican Artists* by Agustín Velázquez Chávez, New York, Covici-Friede, 1937; *Francisco Goitía: Seguido de un epistolario, notas técnicas y otros documentos importantes a su biografía,* Mexico, Editorial Cultura, 1958, and *Francisco Goitía,* Mexico City, Hachette Latinoamérica, 1992, both by Antonio Luna Arroyo; *Francisco Goitía, precursor de la escuela mexicana* by Alfonso de Neuvillate, Mexico City, Universidad Nacional Autónoma de México, 1964; *Goitía: Biografía* by José Farías Galindo, Mexico, Secretaría de Educación Pública, 1968; *Francisco Goitía Total* by Antonio Luna, second edition, Mexico City, Universidad Nacional Autónoma de México, 1987; *Goitía* by Beatriz L. Fernández and Mariana Yampolsky, Mexico, ISSSTE, 1988; *Francisco Goitía: Pintor del alma del pueblo mexicano* by María Teresa Favela Fierro, Mexico City, Fondo Editorial de la Plástica Mexicana, ca. 2000. **Article**—"Bilder aus Mexiko" by Erika Billeter, in *Du* (Switzerland), 3, 1988, pp. 16–53. **Film**—*Goitía, un dios para sí mismo* by Diego López and others, Mexico City, Consejo Nacional para la Cultura y las Artes, 1990.

* * *

Francisco Goitía was one of the most notable Mexican painters of the postrevolutionary period who did not participate in the Mexican mural movement. Working in artistic isolation throughout his career, he produced darkly expressive easel paintings focusing on the Mexican Revolution and Mexican culture, exploring themes of deprivation, death, and mourning. He was born in the state of Zacatecas the illegitimate son of a hacienda manager. In 1896 he began attending the Academy of San Carlos, where he studied with Germán Gedovius. Among his fellow students were Diego Rivera, Roberto Montenegro, and Alfredo Ramos Martínez. In 1904 he traveled to Europe, first to Barcelona and then to Italy and France. In Spain he was exposed to the paintings of Velázquez, El Greco, Francisco de Zurbarán, and Goya. Goitía was particularly impressed by Goya's *Disasters of War* etchings.

Goitía returned to Mexico in 1912 to take part in the Mexican Revolution. He worked as a staff artist under Gen. Felipe Angeles in the army of Pancho Villa. Always working from direct observation, Goitía based much of his work between 1914 and 1918 on scenes he witnessed during the revolution. He created nightmarish, disturbing images such as *The Witch* (1916), a gruesome depiction of a decaying face. He also painted macabre scenes of wartime hangings in his works *Landscape of Zacatecas I* (c. 1914) and *Landscape of Zacatecas II* (c.1914) and *Thea Hanged Man* (1918).

From 1918 to 1925 Goitía worked as a researcher and illustrator with the anthropologist Manuel Gamio in archaeological excavations and restorations at Teotihuacán and Xochimilco, outside Mexico City. He contributed illustrations to Gamio's monumental 1922 study of the Valley of Teotihuacán, *La Población de la Valle de Teotihuacán* ("The Population of the Valley of Teotihuacán"). Between 1928 and 1930 Goitía moved to Xochimilco; he lived simply among the poor

for the rest of his life. He never married and became increasingly eccentric and intensely religious. In the late 1920s he began to teach at the Escuela Nacional de Artes Plásticas (formerly the Academy of San Carlos); he also taught art in primary schools for many years. An independent in art, Goitía painted in his own expressive style. He worked separately from other Mexican painters of his time, although he was counted as an important figure in Mexican art. Anita Brenner devoted a chapter to him in her 1929 book *Idols Behind Altars*.

Goitía created what is perhaps his most notable work, *Tata Jesucristo* (1926; "Father Jesus"), during a visit to the village of San Andrés, Oaxaca. The painting is a dark, powerful work that expresses the sorrow of two indigenous women during the Days of the Dead. A candle and two marigolds in the foreground symbolize the traditions of mourning in Mexico. Two of Goitía's other significant works are *Man Seated on the Trash Heap* (1926–27), an enigmatic depiction of a impoverished old man, and *The Way to the Tomb* (1936), a surrealistic landscape inhabited by veiled skeletons. In about 1946 Goitía painted a lyrical, mysterious landscape, *Santa Mónica, Zacatecas, by Moonlight*, portraying sentinel-like rows of the unique, cone-shaped granaries of his home state.

Goitía held his first solo exhibition in the Biblioteca Cervantes in Zacatecas in 1946 and had a retrospective exhibition in 1957 at the gallery Las Pérgolas de la Alameda in Mexico City. In 1958 he received the international prize for *Tata Jesucristo* at the First Inter-American Biennale in Mexico City. He died at home in 1960. Interest in Goitía has grown in recent years, as shown by a number of monographs about his work and a film based on his life.

—Deborah Caplow

GÓMEZ-PEÑA, Guillermo
American installation and performance artist

Born: Mexico, 1955; moved to the United States, 1978. **Career:** Writer and editor for various publications, including *The Broken Line/La Lunea Quebrada, High Performance,* and *Drama Review.* Cofounder and member, Border Arts Workshop, 1984–90; contributed to radio program *Crossroads.* **Awards:** Prix de la Parole, International Theatre Festival of the Americas, 1989; Bessie prize, New York, 1989; fellowship, MacArthur Foundation, 1991.

Selected Exhibitions and Performances:

1990 *Authentic Cuban Santer and El Aztec High-Tech Welcome Columbus with Ritual Offerings* (performance with Coco Fusco), Mexican Museum, San Francisco

1992 *Two Undiscovered Amerindians Visit Spain* (performance with Coco Fusco), Columbus Plaza, Madrid
 Sydney Biennale, Australia

1993 *Whitney Biennale,* Whitney Museum of American Art, New York

1996 *Mexican Cowboys and Indian Lowriders,* Holter Museum of Art, Helena, Montana (with Roberto Sifuentes)
 Museum of Frozen Identity (performance-installation), Museum of Mexico City

1998 *BORDERscape 2000* (performance), New World Theater, University of Massachusetts, Amherst

Border Brujo, 1988–90.

Publications:

By GÓMEZ-PEÑA: Books—*Warrior for the Gringostroika,* St. Paul, Minnesota, Graywolf Press, 1993; *A Binational Performance Pilgrimage,* Manchester, England, Cornerhouse, 1993; *Temple of Confessions: Mexican Beasts and Living Santos,* with Roberto Sifuentes, Philip Brookman, and others, New York, PowerHouse Books, 1996; *New World Border,* San Francisco, City Lights, 1997; *Dangerous Border Crossers: The Artist Talks Back,* London, Routledge, 2000; *Codex Espangliensis: From Columbus to the Border Patrol,* with Enrique Chagoya and Felicia Rice, San Francisco, City Lights Books, 2000.

On GÓMEZ-PEÑA: Book—*An Art of Relationships: Defining the Artist as Public Intellectual in the Work of Guillermo Gomez-Peña, Rachel Rosenthal and Arts Unlimited* (dissertation) by Teresa M. Ter Haar, Bowling Green, Ohio, Bowling Green State University, 1999. Articles—"A Conversation with Guillermo Gomez-Pena and Coco Fusco" by Lane Barden, in *Artweek,* 24(20), 21 October 1993, p. 13; "Guillermo Gómez-Peña" by Carlos-Blas Galindo, review of the performance *Museum of Frozen Identity,* in *Art Nexus* (Colombia), 21, July/September 1996, p. 115; "Mexican Cowboys and Indian Lowriders. Holter Museum of Art, Helena, Montana" by Karen Kitchel, in *New Art Examiner,* 24, October 1996, pp. 51–52; "Artist's Book Beat" by Nancy Princenthal, in *On Paper,* 1, July/August 1997, pp. 38–39; "Cityscape San Francisco" by David Hunt, interview with Gómez-Peña, in *Flash Art* (Italy), 200, May/June 1998, pp. 61–63; "A Savage Performance: Guillermo Gomez-Pena and Coco Fusco's 'Couple in the Cage'" by Diana Taylor, in *TDR,* 42(2), summer 1998, p. 160; "Guillermo Gómez-Peña" by Jose Torres Tama, review of the performance *BORDERscape 2000,* in *Art Papers,* 23(3), May/June 1999, p. 46.

* * *

Guillermo Gómez-Peña is an interdisciplinary artist and writer who works in various genres and mediums, including performance art, installations, radio, video, poetry, literature, and computer art. As a Mexican artist who moved to the United States in 1978, he creates work that reflects on the idea of displacement and migration and deals with issues related to border culture and transcultural identities. The hybrid condition of the Latino immigrant, of Latin American culture penetrated by the globalizing influx from the North and the West, has been a constant concern in Gómez-Peña's work. This not only provides the subject matter but also gives the operational basis for a work that experiments between performance, installation, and many other genres as part of the hybrid state of the "border artist." From 1984 to 1990 he was a founding member of the Border Arts Workshop, an artists' collaborative project and visual branch of the Centro Cultural La Raza, whose aim is to address issues of cultural diversity and to work in close relation with frontier communities in the United States and Mexico. In addition, he actively collaborated with the radio program *Crossroads.* Gómez-Peña is also a prolific writer, the author of the books *Warrior for the Gringostroika* (1993) and *New World Border* (1997) and a contributor to several periodicals, including

High Performance and *Drama Review,* and to publications such as *Beyond the Fantastic: Contemporary Art Criticism from Latin America* (1995).

As part of his investigations into how Latin American culture is viewed by hegemonic discourse that drafts a representation of the other, specifically through the objective and scientific discipline of ethnography, Gómez-Peña set out at the beginning of the 1990s to conduct a "reverse ethnography." He staged a series of performances in collaboration with the Cuban-born American artist Coco Fusco, the first of which was *Undiscovered Amerindians* (1992), in which the artists displayed themselves in a cage as "two previously unknown specimens representative of the Guatinaui people." They dressed themselves as "natives," wearing outfits that recalled the hybridity of contemporary culture in the Americas and elsewhere, in which autochthonous elements coexist with Western and modern ones, and performed "the role of cultural other" for the public. The artists were fed by the museum guards, who also supplied the audience with additional fictitious information on the "specimens" and escorted them on a leash to the toilet when needed. The work not only made a critique of ethnographic practices and displays within the museum institution but also addressed one of the nineteenth-century sources of contemporary spectacle: the freak show. According to the artists, the idea was to make a "satirical commentary on the history of the ethnographic display of indigenous people" and also to situate the genre of the freak show as a precursor to the contemporary form of performance art. It also attempted to create an awareness in the spectator of the roles of the "domesticated savage" and the "colonizer."

Gómez-Peña and Fusco later collaborated in a second performance entitled *Mexarcane International,* in which they presented themselves as a multinational corporation that marketed and distributed exotic talent for special events. After submitting the audience of "prospective clients" to a questionnaire on their exotic tastes, Gómez-Peña did a performance to demonstrate what the buyers would get for purchasing their services. The performance was designed to be presented in shopping malls, which in American culture have come to constitute the public and social gathering space par excellence and where the artists could confront a more diverse public than the museum-going one.

Gómez-Peña has continued to work on the idea of the ethnographic display, experimenting with what he calls "the colonial format of the living diorama," which according to him subverts colonial practices of representation by employing such varied forms as the "ethnographic tableau vivant," the "Freak Show," the "Indian Trading Post," the "border curio shop," and the "porn window display." He has collaborated with the artists Roberto Sifuentes and James Luna in staging these live representations that call into question notions that are taken for granted about other cultures, especially so-called exotic ones.

Since the 1990s the issue of technology has also been an important element of Gómez-Peña's work. He perceives technology as an instrument of distinction between hegemonic and peripheral or marginal cultures that do not have access to it and are therefore labeled as culturally handicapped. He defines himself as an "information superhighway bandido," operating within the genre of "techno-razcuache," which, according to his definition, is "a new aesthetic that fuses performance art, epic rap poetry, interactive television, experimental radio and computer art; but with a Chicanocentric perspective and a sleazoid bent." He has found in the virtual space of the globalized and English-speaking World Wide Web an ideal place from which to undertake his critique of culturally homogenizing constructs and to "infect" it with the virus of diversity.

—Julieta González

GÓMEZ QUIRÓZ, Juan (Manuel)
Chilean painter and printmaker

Born: Santiago, 20 Feburary 1939; naturalized citizen of the United States, 1974. **Education:** Instituto Chileno Norteamericano, Santiago, 1958–61; Escuela de Bellas Artes, Universidad de Chile, 1957–62; Rhode Island School of Design, Providence (Fulbright fellow), 1962–63; Yale University, New Haven, Connecticut (Fulbright fellow), 1963–64; Pratt Graphic Arts Center, New York (Pan American Union fellow), 1964–65. **Family:** Married Judy Hand in 1965 (divorced 1973). **Career:** Lecturer, University of California, Santa Barbara, 1967, New York Community College, 1969–70, New York University, 1969–76, Summit Art Center, New Jersey, 1972–77. Director, New York University Photo-Etching Workshop, New York, 1969–70; president, H. H. Silverman Publication Co., 1986–88; curator and administrative assistant, Museum of Contemporary Spanish Art, New York, 1990. Coeditor, *Brujula/Compass* literary magazine, Hostos College, Bronx, New York, 1996, 2000. Member, Bronx Writers Corp, New York. **Awards:** First prize in painting, Salon de Alumnos, Escuela de Bellas Artes, University of Chile, 1960; prize, Salón Oficial de Chile, Museo de Bellas Artes, Santiago, 1960; second prize in painting, Salon de Primavera, Santiago, 1961; fellowship, John Simon Guggenheim Memorial Foundation, 1966; grant, National Endowment for the Arts, 1974; award, CETA Cultural Council Foundation, New York, 1977; grand prize, *VI bienal latinoamericana,* San Juan, Puerto Rico, 1979; Premio Adquisicion, *Segunda bienal del grabado de America Museo Municipal de Artes Gráficas,* Maracaibo, Venezuela, 1982. **Address:** 365 Canal Street, New York, New York 10013, U.S.A. **E-mail Address:** JGQuiroz@aol.com.

Individual Exhibitions:

1961	Sala Decor Facultad de Bellas Artes, Santiago
1964	Kie Kor Gallery, New Haven, Connecticut
	Ledesma Gallery, New York
1968	Alonzo Gallery, New York
1970	Alonzo Gallery, New York
1971	Ten Downtown, New York
1972	Alonzo Gallery, New York
	Summit Art Center, New Jersey
1975	Ars Concentra, Lima, Peru
1976	Galerie Balcons des Images, Montreal
	Galeria Pecanins, Mexico City
1977	Shubert Gallery, Marbella, Spain
1979	Museo del Grabado Latinoamericano, San Juan, Puerto Rico
1980	Sutton Gallery, New York
	San Sebastían Gallery, San Juan, Puerto Rico
1982	Held-Koupernikoff Gallery, Boston
1983	Sutton Gallery, New York
1984	Omar Rayo Museum, Rodalnillo, Colombia
1986	Todd Capp Gallery, New York

Juan Gómez Quiróz: *Portrait of an Actor.* **Photo courtesy of the artist.**

1986 *Euclidian & Non Euclidian Nudes,* Sutton Gallery, New York
1988 Sutton Gallery, New York

Selected Group Exhibitions:

1962 Associated American Artists, New York
1963 Weyhe Gallery, New York
1964 Brooklyn Museum, New York
 Magnet: New York, Bonino Gallery, New York
1965 Museum of Modern Art, New York
1966 *Art of Latin America since Independence,* Yale University, New Haven, Connecticut, and University of Texas, Austin
1967 University Gallery, University of California, Santa Barbara
1968 Britton Gallery, San Francisco
1969 Potsdam College, New York
1989 *The Latin American Spirit: Art & Artists in the U.S.,* Bronx Museum, New York

Collections:

Brooklyn Museum, New York; Cincinnati Art Museum; Center for Inter-American Relations, New York; Cornell University, Ithaca, New York; Everson Museum of Art, Syracuse, New York; Solomon R. Guggenheim Museum, New York; Instituto de Cultura Puertorriqueña, San Juan; Library of Congress, Washington, D.C.; Massachusetts Institute of Technology, Cambridge; Metropolitan

Museum of Art, New York; New York Public Library; New York University.

Publications:

By GÓMEZ QUIRÓZ: Books—*Not Black and White: Inside Words from the Bronx Writers Corps,* with others, edited by Mary Hebert, Austin, Texas, Plain View Press, 1996; *Cronica de la literatura hablada* (novella), n.p., Latino Press, n.d..

On GÓMEZ QUIRÓZ: Book—*The Latin American Spirit: Art & Artists in the U.S.,* exhibition catalog, New York, Bronx Museum, 1988. **Articles—**Review by Mary Steward, in *Arts Magazine,* June 1968, and March 1969; review by Gordon Brown, in *Arts Magazine,* April 1971, p. 94.

* * *

How to represent the curved nature of space, the fluidity of light and matter, and the movement of color through three dimensions are central questions posed by the work of the Chilean painter Juan Gómez-Quiróz. His substantial body of work, spanning more than 35 years and encompassing flat canvases, etchings and prints, shaped canvases, and ''topological'' paintings, maps the evolution of this artist as he pushes the limits of painting beyond its two-dimensional lexicon and engages the viewer in his multidimensional vision. The majority of his work, while drawing upon traditional subject matter–still life, portrait, and nude–consists of paintings that perceptually expand the image in a vibrating field of color, at times dreamlike and haunting, at times ironic and playful. At his best Gómez-Quiróz, who works almost exclusively in acrylics, displays a mastery of color and composition that renders both mathematical precision and an evocative sensuality.

Arriving in New York in the early 1960s, Gómez-Quiróz sought to ''break from the work of Jackson Pollack.'' Thus, his mature style developed in rebellion against the abstract expressionist, pop, and op art movements that characterized the New York scene of the 1960s and 1970s. Perhaps of greatest influence was the Chilean surrealist Roberto Matta, specifically his manipulation of perspective in landscape. Matta's influence can be seen in Gómez-Quiróz's early work, particularly in the mural-size *New York at Night* (1968), a highly charged, multiperspective abstract landscape.

For Gómez-Quiróz understanding the physics of space, how light moves through it, and what constitutes perception is primary to the making of his art. His first experiment with space and time was in *Totem Pole* (1965). This four-sided painting (acrylic on canvas) requires the viewer to walk around it, as its geometric composition changes perspective and mood. It was *Totem Pole* and the problem it presented–how to use color in three dimensions–that earned Gómez-Quiróz a Guggenheim Fellowship in 1966.

Wide recognition of the work of Gómez-Quiróz came with his *Bodegón* series, paintings and etchings that evolved in the 1970s. Drawing upon the motifs of the *bodegón* painters and European masters of domestic interiors–Chardin, Bonnard, and Morandi–Gómez-Quiróz discovered how to represent interior space in a way that reveals the fluid nature of physical matter. ''Still life'' seems a contradiction in terms for these paintings, which are alive with movement and which employ for the first time Gómez-Quiróz's technique of cross-hatching, overlapping fine lines of color and breaking down the geometry of objects into fluid waves. *Bodegón #40*

Juan Gómez Quiróz: *Bodegon #31,* 1977. Photo courtesy of the artist.

(1979) and *Red Bodegón* (1979), shown at New York's Sutton Gallery in 1983, portray the vibrancy of matter that one feels but cannot see with the naked eye. But it is in the earlier, dreamlike *Bodegón #31* (1977), in the permanent collection of New York's Guggenheim Museum, that the artist refines his technique, integrating his vision with an impressionist sensibility of color and light.

Drawing upon the success of his *Bodegón* works, Gómez-Quiróz moved on to landscapes, at the same time experimenting with shaped canvases that extended beyond the rectangular frame. Intensifying his palette with blues and reds, he evoked a kinetic sea of people, bicycles, and noonday heat in *Canal Street* (1989). His desire to break free of two-dimensional canvases altogether led him to study non-Euclidean geometry, quantum physics, and cosmology, and in 1989 he began painting on canvas curved into topological relief. In his topological portraits Gómez-Quiróz plays upon the distortion that occurs when an image is placed on a curved surface, which for him was a means of portraying the ''true'' multifaceted personality of his subjects. In *Gregorio, Portrait of an Actor* (1990), for example, the face, open and generous at one angle, turns sinister at another. In *Truman Capote* (1989) playful eyes turn steely and narrow. While these larger-than-life three-dimensional portraits succeed in proving their thesis, there is also a severity to the paintings that weighs them down.

Much more evocative and daring are Gómez-Quiróz's earlier topological studies of nudes, and it is here that his talents as a painter

and mathematician culminate. *Blue Non-Euclidean Interior with Figure* (1984), one of his few oils, and *Non-Euclidean Nude* (1984), both shown at the Todd Capp Gallery in 1986, are revealing, sensitively executed compositions, and his skill at utilizing the relief canvas draws the viewer into the contrary worlds of his beautiful subjects. In his series of ''mobile'' paintings Gómez-Quiróz takes his topology literally ''off the wall,'' suspending these closed ''spiral'' paintings between the floor and the ceiling with wire. Continuing with both portraiture and nude, these works-in-progress clearly draw upon the artist's earlier successes as he enters new territory, exploring how motion affects our perception of color and form in three-dimensional reality.

—Mary Hebert

GONZÁLEZ (ARANDA), Beatríz
Colombian painter

Born: Bucaramanga, 1938. **Education:** University of Los Andes, Bogotá, 1954, 1959–62, B.A. 1954, M.F.A. 1962; studied architecture, National University, Bogotá, 1954–56; studied engraving, Van Beeldend Kunsten Academy, Rotterdam, 1966. **Career:** Traveled to

Europe, 1956–59; to the United States, 1960. **Award:** Second prize in painting, *XVII salón de artistas nacionales,* 1965.

Individual Exhibitions:

1964 Museum of Modern Art, Bogotá
1976 Museo de Arte Moderno la Tertulia, Cali, Colombia
1977 *Los muebles de Beatriz González,* Museo de Arte Moderno, Bogotá
1984 Museo de Arte Moderno, Bogotá (retrospective)
1994 Museo de Bellas Artes, Caracas, Venezuela (retrospective)
 The Color of Death. Dreams As Investigations, Garcés Velásquez Gallery, Bogotá
1996 Biblioteca Luis Angel Arango, Bogotá (retrospective)
1999 *Beatriz González: What an Honor to Be with You at This Historic Moment,* El Museo del Barrio, New York

Selected Group Exhibitions:

1971 *XI bienal de São Paulo,* Brazil
1978 *XVIII bienal de Venice*
1987 *Art of the Fantastic: Latin America, 1920–1987,* Indianapolis Museum of Art (traveling)

Publications:

By GONZÁLEZ: Book—*Obras en prisión: Una estrategia para el traslado del colecciones,* exhibition catalog, with Martha Segura, Bogotá, Colcultura, 1996.

On GONZÁLEZ: Books—*Beatriz González: XI Bienal de San Pablo, Brasil,* exhibition catalog, text by Marta Traba, Instituto Colombiano de Cultura, Colombia, 1971; *Beatriz González: Apuntes para la historia extensa–Tomo I* by Jaime Ardila, Editorial Tercer Mundo, Bogotá, 1974; *Beatriz González,* exhibition catalog, text by Eduardo Serrano, Museo de Arte Moderno la Tertulia, Cali, Colombia, 1976; *Los muebles de Beatriz González,* exhibition catalog, text by Marta Traba, Museo de Arte Moderno, Bogotá, 1977; *Beatriz González: XVIII Bienal de Venecia,* exhibition catalog, text by Eduardo Serrano, Instituto Colombiano de Cultura, Colombia, 1978; *Reportajes a Beatriz González,* text by Juan Gustavo Cobo Borda, Ana Maria Cano, and Lucía Teresa Solano Berrío, Impresores Colombianos, Colombia, 1981; *Beatriz González: Exposicion Retrospectiva,* exhibition catalog, introduction by Gloria Zea, Museo de Arte Moderno, Bogotá, 1984; *Beatriz González: Una pintora de provincia* by Marta Calderón, Bogotá, C. Valencia Editores, 1988; *Beatriz González, retrospectiva,* exhibition catalog, Caracas, Venezuela, Museo de Bellas Artes, 1994; *La mirada cómplice: 8 artistas colombianos* by J. G. Cobo Borda, Cali, Colombia, Ediciones Universidad del Valle, 1994; *Treinta años en la obra gráfica de Beatriz González,* exhibition catalog, Bogotá, Banco de la República, 1996; *Beatriz González: What an Honor to Be with You at this Historic Moment,* exhibition catalog, text by Carolina Ponce de León, New York, El Museo del Barrio, 1998. **Articles**—"El lujo de Medellin" by José Hernan Aguilar, in *Revista,* 2(7), 1981, p. 51; "Beatriz Gonzalez. Bellas Artes Museum, Caracas" by Germán Rubiano Caballero, in *Art Nexus* (Colombia), 14, October/December 1994, pp. 126–127; "Beatriz González. Garcés Velásquez Gallery, Bogotá" by Natalia Gutiérrez, in *Art Nexus* (Colombia), 18, October/December 1995, pp. 109–110; "Beatriz Gonzalez: Taste & Taboo" by Juliana Soto, in *Art News,* 94, summer 1995, pp. 116–117; "Beatriz Gonzalez at the Museo del Barrio" by Nicolas Guagnini, in *Art Nexus* (Colombia), 29, August/October 1998, pp. 94–96.

* * *

Beatríz González Aranda, who was born in 1938, became one of the most influential personalities in Colombian art in the last half of the twentieth century. She has done multifaceted work as an artist, critic, and art historian (she has published extensively on nineteenth-century Colombian artists) and also through her groundbreaking role as the curator of art and history at the Museo Nacional de Colombia in Bogotá. Born in Bucaramanga, a provincial city in the northeast of the country, she studied art in Bogotá during the 1950s with Juan Antonio Roda and Carlos Rojas and was under the strong influence of the Argentine critic Marta Traba, who championed modern art in the midst of a very conservative context.

González's first works departed from the influence of European masters such as Velázquez and Vermeer, and she painted versions of *The Lacemaker* and *La rendición de Breda* in a style one critic described as "deliberately clumsy." González observed that so-called high art was known in the provinces through bleak reproductions such as those found in popular markets, and it was from these images–and later from the daily press–that she derived a rich iconography linking the local with the universal. In 1965 she won one of the prizes at the XVII National Salon with the painting *Los suicidas del Sisga,* which signified a departure for her work. Taking a news photograph of a couple holding hands before they committed suicide, González painted the scene with a discordant palette and in a simplified, flat-painting procedure that later became her trademark style. In an art scene heavily influenced by what was happening in Europe and the United States, her use of history and the everyday as a source for her artistic practice was at the same time controversial and refreshing.

González soon began to experiment with other techniques and with supports other than canvases for her paintings: found or popular furniture, everyday objects, curtains, works in which the relation between the base and the iconography became apparent through ironic titles. Thus, the Last Supper became a table in *La ultima mesa, 19,* Boticcelli's birth of Venus adorned a shell-shaped towel holder, and Simón Bolívar's deathbed–as portrayed in José María Espinosa's nineteenth-century painting–was interpreted in flat colors on the surface of a sheet metal bed with a painted fake veneer that González had bought in the popular markets of Bogotá. High art and official history coexist without uneasiness on unconventional bases through "bad taste" and what critics commonly regard as kitsch. González, however, has stated, "My work is not the search of a goal by means of ironical themes, but a painting with *temperature.* I don't make kitsch objects with the same morbidity that moves certain people to collect objects of so-called bad taste. I do not think that the society that I work in is kitsch, but overwhelming, in all proportions and senses."

Although often read as a "poor" version of pop, González's work is above all a powerful observation of Colombian society and its culture and an acid critique of institutions, both sociopolitical and artistic. Faced with international misunderstanding of her work–the context being made too precise–she has retorted, "I make under-developed painting for under-developed countries," and she has

termed her work ''regional art that can't be recognized universally except as a curiosity.''

In the late-1980s and in the 1990s González's subjects became more directly related to political matters. She returned to painting on canvas, while maintaining abundant work in several printing methods, but her palette became more colorful and her composition more complex. Taking as always her iconography from the daily press, she began constructing elaborate tableaux that incorporated subjects from different photographs, which resulted in multilayered and visually complex works. This is the case in the triptych *El altar* (1990), in which she juxtaposed figures of everyday events, a political murder, a local soccer star, and indigenous figures rowing, a modern-day altarpiece for the complex situation of the country. In this and later works political concerns have become more evident, while she has maintained the caustic humor that has always characterized her critical take on history and society.

In 1999 the Museo del Barrio in New York City organized *Beatriz González: What an Honor to Be with You in This Historic Moment, Works, 1965–1997,* a large retrospective curated by Carolina Ponce de León.

—José Roca

GONZÁLEZ, Juan Francisco
Chilean painter

Born: Santiago, 25 September 1853. **Education:** Escuela de Bellas Artes, 1869. **Career:** Traveled to Peru and Bolivia, 1877–79. Professor of drawing, Liceo de Hombres de Valparaíso, 1884–95. Traveled to Europe, 1887, 1896, 1904, 1907. Professor, Academia de Bellas Artes, Santiago, 1910; founder and president, Comité Ejecutivo de la Sociedad Nacional de Bellas Artes, 1918. **Awards:** Fourth medal, 1884, second medal and Premio de Paisaje de Certámen Edwards, 1892, premio de honor, 1898, first medal, 1900, Premio de Paisaje Certámen Edwards, 1901, and Premio de Honor Certámen Edwards, 1929, *Salón oficial de bellas artes;* second medal, *Exposición municipal de bellas artes,* Valparaiso, 1896; first medal, *International Exhibition of Paris,* 1900; second medal, *Exposición internacional de arte del centenario,* Buenos Aires, 1910; first prize, *Exposición de Sevilla,* 1929; diploma of honor, *Exposición internacional de Sevilla,* 1930. **Died:** Santiago, 4 March 1933.

Selected Exhibitions:

1884	*Exposición nacional,* Santiago
1889	*Salón oficial de bellas artes,* Santiago
1892	*Salón oficial de bellas artes,* Santiago
1894	*Salón de pintura,* Valparaiso, Chile
	Salón oficial de bellas artes, Santiago
1896	*Exposición municipal de bellas artes,* Valparaiso, Chile
1897	*Exposición municipal de bellas artes,* Valparaiso, Chile
	Salón oficial de bellas artes, Santiago
1898	*Salón oficial de bellas artes,* Santiago
1900	*Salón oficial de bellas artes,* Santiago
1901	*Salón oficial de bellas artes,* Santiago
1902	*Salón oficial de bellas artes,* Santiago
1903	*Salón oficial de bellas artes,* Santiago
1904	*Salón oficial de bellas artes,* Santiago
1906	*Salón libre,* Santiago
1910	*Exposición internacional de arte del centenario,* Buenos Aires
1912	Centro de Estudiantes de Bellas Artes, Santiago
1920	*Salón oficial de bellas artes,* Santiago
1927	*Exposición oficial de pintura,* Buenos Aires
	Salón oficial de bellas artes, Santiago
1929	*Salón oficial de bellas artes,* Santiago
1930	*Primer salón de primavera,* Santiago
	Salón oficial de bellas artes, Santiago

Exposición del centro de estudiantes de bellas artes, 1912 and 1913.

Publications:

By GONZÁLEZ: Book—*Texto de dibujo moderno,* Universidad de Chile, 1906.

On GONZÁLEZ: Books—*Juan Francisco González* by Alfonso Bulnes, Santiago, Talleres de la Editorial Nascimento, 1933; *Juan Francisco González, el hombre y el artista, 1853–1953,* Santiago, Ediciones de la Universidad de Chile, 1953, and *Juan Francisco González, maestro de la pintura chilena,* Santiago, Ediciones Ayer, 1981, both by Roberto Zegers de la Fuente; *Visión de la obra del maestro de la pintura chilena Juan Francisco González,* Santiago, Impresa Londres, 1963; *La pintura en Chile: Desde José Gil de Castro hasta Juan Francisco González* by Gaspar Galaz and Milan Ivelic, Santiago, Ediciones Extensión Universitaria, Universidad de Chile, 1975; *Juan Francisco González, 100 obras* by César Sepúlveda Latapiat, Santiago, Banco BHC, 1981; *Juan Francisco Gonzalez: Maestro de la pintura chilena,* exhibition catalog, text by Roberto Zegers de la Fuente, Santiago, 1981; *Juan Francisco González, maestro de la pintura de Chile* by Alicia Rojas Abrigo, Lo Barnechea, Chile, República de Chile, Ministerio de Educación, 1982.

* * *

Born in 1853, Juan Francisco González is notable for his prolific production of paintings—he created more than 4,000 works—as well as his dedication to creating a new style of painting in Chile. Moving away from the rigorous and academic constraints previously imposed on painters in Chile (the emphasis on technique over emotion), González drew from common experience, spontaneously drawing the people around him and using their very humanness as the core of his work. His use of warm colors and his subject matter—flowers, landscapes, and people—combined with his extraordinary ability to capture the light in the Central Valley of Chile make him one of the great Chilean painters.

González's parents, who ran an import shop, recognized their son's talent and sent him to work with Alexander Cicarelli. He traveled throughout Peru and Bolivia to search for subjects to draw before settling down to a drawing post at Liceo de Hombres de Valparaíso, a job he kept for 11 years. In 1989 he created a *Texto de dibujo moderno* (''Text of Modern Drawing''), which eventually got published by the University of Chile. Traveling to Paris, Germany, Spain, and North Africa enriched his works; especially influential

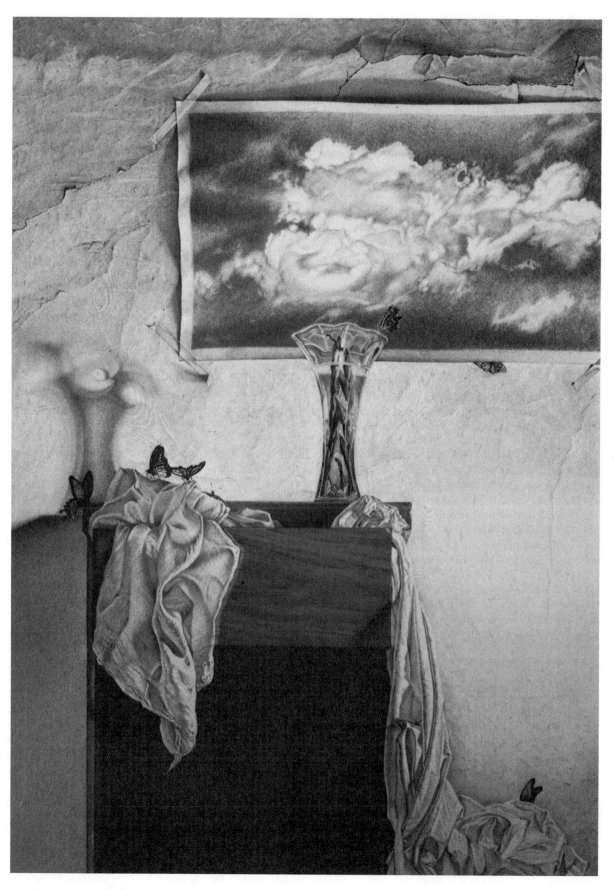

Juan Francisco González: *July 11, 1974,* **1974. Photo courtesy of Nancy Hoffman Gallery, New York.**

were the Japanese paintings that he saw in Europe. González belonged to *la Generación de los Grandes Maestros de la Pintura Chilena* ("the Generation of Great Teachers of Chilean Painting"), and he also belonged to *el grupo de Los Diez* ("the Group of Ten"), a selection of poets, writers, and artists chosen by the Chilean government to create a new style of art in Chile. With paintings such as *Landscape of Winter, Street of Limache, Picture of a Girl,* and *Bridge on the Tíber,* González was able to capture the beauty of common scenes.

—Sally Cobau

GONZÁLEZ, María Elena
Cuban sculptor and installation artist

Born: Havana, 1957. **Education:** Miami-Dade Community College, A.A. in art 1977; Florida State University, Florence-Italy program 1978; Florida International University, B.F.A. in sculpture 1979; San Francisco State University, M.A. in sculpture 1983. **Career:** Moved to the United States, *ca.* 1977. **Awards:** Cintas fellowship, Arts International, New York, 1989, 1994; grant, Art Matters, New York, 1990; grant, Pollock-Krasner Foundation, New York, 1991, 1998; individual artist grant, Artists Space, New York, 1991; grant, Louis Comfort Tiffany Foundation, New York, 1997; grant, Anonymous Was a Woman, New York, 1997; grant, Joan Mitchell Foundation, New York, 1998.

Individual Exhibitions:

1990	Fred Snitzer Gallery, Miami
1991	Art-in-General, New York
	Wall Works, Nuyorican Poets Café, New York
1992	*Works on Paper 1990–1992,* Art Windows at Port Authority Bus Terminal, New York
1994	Carla Stellweg Gallery, New York
1996	*In Our Faces* (installation), Miami-Dade Community College
	The Persistence of Sorrow (installation), El Museo del Barrio, New York
	Rotunda Gallery, New York
1998	*Illusory Nature of Control* (installation), HallWalls, Buffalo, New York
1999	The Project, New York

Selected Group Exhibitions:

1989	*Contemporaries: Juxtaposing Perceptions,* Museum of Contemporary Hispanic Art, New York
1990	*VII bienal iberoamericana de arte,* Instituto Cultural Domecq, Mexico City
1991	*Cadences: Icons and Abstraction in Context,* New Museum of Contemporary Art, New York
1993	*Cubana,* Cuban Museum of Arts and Culture, Miami
1994	*Encuentro interamericano de artistas plasticos,* Musel de las Artes, Universidad de Guadalajara, Mexico

1995	*Human/Nature,* New Museum of Contemporary Art, New York
	In Three Dimensions: Women Sculptors of the 90s, Snug Harbor Cultural Center, Staten Island, New York
1996	*Domestic Partnerships,* Art in General, New York
1997	*Material Girls,* Gallery 128, New York
1998	*Seven Year Itch,* Ambrosino Gallery, Miami

Publications:

On GONZÁLEZ: Books—*In Three Dimensions: Women Sculptors of the 90s,* exhibition catalog, text by Charlotte Streifer Rubinstein, Staten Island, New York, Snug Harbor Cultural Center, 1995; *Domestic Partnerships: New Impulses in Decorative Arts from the Americas,* exhibition catalog, text by Yasmin Ramirez, New York, Art in General, 1996; *The Persistence of Sorrow,* exhibition catalog, text by Fatima Bercht, New York, El Museo del Barrio, 1997. **Articles—**"La naturaleza sensual de Maria Elena Gonzalez" by Rodolfo Windhousen, in *El Nuevo Herald,* 23 November 1992, p. 3D; "Contemporary Lesbian Artists-Selected Works" by Patricia Cronin, in *Art Papers,* November/December 1994, p. 5; "Hispanas en las artes plasticas" by Marcia Morgado, in *Miami Herald,* 2 February 1995; "Maria Elena Gonzales" by John Angeline, in *Art Nexus* (Colombia), 20, April/June 1996, pp. 123–124; "The Latin Americanization of the United States" by Shifra M. Goldman, in *Art Nexus* (Colombia), 29, August/October 1998, pp. 80–84; "Abnormal Art Engages Hallwalls Patrons" by Jill Duffy, in *Spectrum,* 35, 2 December 1998.

* * *

The work of María Elena González has frequently been examined in architectural terms. This is particularly appropriate, as the artist's work often surrounds the viewer or occupies significant dimensions of space. At the same time, the artist has been consistently interested in the intimacy and sensuality of the object. Her sculptures are frequently covered with unexpected materials such as rubber, leather, or plastic. The tactile quality of these kinds of materials underscores her interest in creating an instant attraction between the spectator and the work of art by focusing on the materiality of the work and how it might feel to the human touch.

In her larger installations, such as *The Persistence of Sorrow* (1996), the artist occupied the entire gallery with her wall-size piece. In addition to touching on this architectural sensibility, the work has a sense of labor-intensive construction and careful craftsmanship that is reflected on its surface, where names of victims of AIDS are embossed in Braille. González paid close attention to the form as a space with strong, even overt, architectural possibilities. The flatness of the concept of a wall as an architectural construction is gently dissolved by the outward stretching and curving of the piece, as though to surround the spectator.

The artist continued to explore this relationship between architecture and sculpture in her project *Magic Carpet/Home* (1999), sponsored by the Public Art Fund in New York City. In this work González made the direct connection between the physical space of a home and a construction representing the sensual, undulating movement of a flying carpet. Installed in Coffey Park in the Red Hook neighborhood in Brooklyn, the work addresses a concept of home as

an ideal and lyrical place and also serves to reference its own physical and cultural environment. The juxtaposition of the private space of the home with the public park is reiterated in the placing together of disparate materials. The floor plan, based on the actual floor plan of apartment homes in the nearby Red Hook East Housing projects, is rendered in white paint on thick pieces of black rubber, mounted on wood.

Juxtaposition of a variety of materials has been one of the artist's central concerns, underscoring her interest in the contrast between the tactility of two different media, if only to the human eye. The contrast suggested by the use of disparate materials created a tension in the work, provoking the spectator to think about the contrast between materials—their function, texture, cultural significance, and meaning—when they are placed next to one another. González frequently contrasted the reflective surface of ceramic tile with the opacity of wood, the softness of leather with the hardness of metal, and, conceptually, the public with the private. This was evoked eloquently in her installation *Resting Spots* (1999), which functions both as a social space and as a place for remembering lost souls. Unique, small stools made of a variety of materials including ceramic tile, black grout, and soft black cushions invite groups of spectators to sit together. At the same time, a rubber strip above the stools acts as both decoration and signification, retaining the memory of the artist's dead parents, their names embossed in Braille. The cover of another stool can be lifted off to reveal an urn—further evidence of her approach to interpreting the act of remembering as a part of everyday life.

In her work from the early 1990s, González traversed the fine line between pleasure and pain. In *Audrey,* a work from 1994, a smooth tube that sprouts from a wooden object is painted red on one side. On the other side, perhaps intended to be read as the inside, the same smooth surface is lined with sharpened nails, underscoring again the close relationship and contradictions implied by interior and exterior and by the abrupt placement of seemingly incongruous materials next to one another. This paradoxical yet fascinating contrast of material and form combined with a strong allegiance to architectural space characterizes González's work.

—Rocío Aranda-Alvarado

GONZÁLEZ CAMARENA, Jorge
Mexican painter and sculptor

Born: Guadalajara, 24 March 1908. **Education:** Academia de San Carlos (now Escuela Nacional de Artes Plásticas), Mexico City, 1922–30. **Career:** Restored sixteenth-century frescoes, Huejotzingo monastery, 1930–32; graphic artist, Ministerio de Turismo. Muralist, Instituto Mexicano del Seguro Social, Paseo de la Reforma, Mexico City, 1950, Senate Chambers, Mexico City, 1958. Also painted murals at National Institute of Anthropology and History, Mexico City; Museo Nacional de Arquitectura, Mexico City. President, Asociación Mexicana de Artes Plásticas, 1972. **Awards:** Medalla J. Clemente Orozco, government of Jalisco, 1956; third prize, 1959, and second prize, 1962, *Salón anual de pintura del INBA;* Premio Nacional, Monumento a la Independencia, Dolores Hidalgo, 1960; Placa de oro, Guadalajara, 1964; medal of merit, government of Italy, 1967; Premio Nacional de Arte, 1970. **Member:** Academia de las Artes, 1972. **Died:** Mexico City, 24 May 1980.

Selected Exhibitions:

1956 *Pintores jalisciences,* Salón de la Plástica, Mexico City
1958 *Primera bienal interamericana de pintura y grabado,* Museo Nacional de Artes Plásticas, Palacio de Bellas Artes, Mexico City
 Exposición de arte mexicano contemporáneo, Secretaria de Relaciones Exteriores y el OPIC, Paris (traveled in France)
 Inauguración del Museo Nacional de Arte Moderno, Palacio de Bellas Artes, Mexico City
1959 *Primer salón nacional de pintura del INBA,* Museo Nacional de Arte Moderno, Mexico City
1962 *Salón anual de pintura,* Salón de la Plástica Mexicana, Mexico City
1963 *Arte de Jalisco,* Museo Nacional de Arte Moderno, Mexico City
1965 *Pintura contemporánea de México,* Havana
1970 Museo de Arte Moderno, Chapultepec, Mexico (retrospective)
 Pintura mexicana contemporánea, Galería Malintzincalli, Coyoacán, Mexico
1971 *20 aniversario de la Galería José Maria Velasco,* Galería José Maria Velasco, Mexico City
1972 *Juárez en el arte contemporáneo de México,* Museo de Arte Moderno, Mexico City
1974 *25 años de la plástica mexicana,* Salón de la Plástica Mexicana, Mexico City
1996 Museo del Palacio de Bellas Artes, Guadalajara
1997 Museo del Palacio de Bellas Artes, Mexico City (retrospective)

Collections:

El Palacio de Bellas Artes, Mexico City; Museo Nacional de Historia, Mexico City; Museo de Arte Moderno, Mexico City; University of New Mexico, Albuquerque.

Publications:

On GONZÁLEZ CAMARENA: Books—*Jorge González Camarena* by Mauricio Gómez Mayorga, Mexico City, Ediciones Mexicanas, 1951; *7 pintores: Carlos Orozco Romero, Jorge González Camarena, Raúl Anguiano, Fernando Castro Pacheco, Luis Nishizawa, José Reyes Meza, Trinidad Osorio,* Mexico City, Plástica de México, 1968; *Jorge González Camarena en la plástica mexicana,* Mexico City, Universidad Nacional Autónoma de México, 1981, and *González Camarena,* Mexico City, Ciencia y Cultura Latinoamérica, 1995, both by Antonio Luna Arroyo; *Universo plástico* by María Teresa Favela Fierro, Mexico City, Democracia Ediciones, 1995; *Jorge González Camarena: Antología,* exhibition catalog, text by María Teresa Favela Fierro, Mexico City, Museo del Palacio de Bellas Artes, 1996; *Arte y recreación: Grandes maestros mexicanos,* Mexico City, Fundación Cultural Televisa, 1998. **Article**—"Jorge González Camarena at Museo del Palacio de Bellas Artes" by Vincent Katz, in *Art in America,* 85, January 1997, p. 104.

* * *

Jorge González Camarena: Students look at González Camarena's *Liberacion, La Humanidad se Libera de la Miseria.* © Danny Lehman/Corbis.

Jorge González Camarena was a fairly prominent representative of the third phase of the Mexican mural movement, which lasted from the 1940s through the 1960s. He studied at the Academia de San Carlos from 1922 to 1930 and in 1930–32 helped to restore the frescoes in the sixteenth-century monastery of Huetjotzingo. After this apprenticeship in the fine arts, he worked as a graphic artist in the commercial wing of the Ministerio de Turismo. A telling example of this period in his career is the photo-offset poster *Visit Mexico,* from 1943, in the collection of the Zimmerman Library at the University of New Mexico.

In this bright representation of Mexico as a place of gracious pleasure, González Camarena used the alluring figure of a beautiful Mexican woman offering the spectator a plate of "native" fruits that clearly derives from Gauguin's painting *Tahitian Women with Mango Blossoms* (1899). Less indigenous looking than Gauguin's women, despite the fact that both images represent a "foreign" land, the González Camarena figure is also far more discreetly clothed, in a way that would make a middle-class visitor feel that the south was quite wholesome. The figure is a testament to the growing intrusiveness of Madison Avenue-style advertising even before the postwar boom in consumerism and tourism had taken off in the United States. As such, the poster represented less an image of Mexico in the minds of Mexicans than a view of Mexico as it was wrongly envisioned by Western tourists.

Beginning in the 1950s a very different conception of Mexico emerged from González Camarena's important series of public murals for prominent places in government buildings. These works secured him a place in the history of Mexican art, owing both to the distinctive pictorial language he originated in the 1950s and 1960s and also to the significance of the sites for which these imposing murals, done in either oil or acrylic, were commissioned. They included the Cámara de Senadores (National Senate), the Palacio de Bellas Artes–the unofficial pantheon of Mexico's greatest muralists–and the Castillo de Chapultepec, the former presidential residence and now a museum in Mexico City. The lofty thematic program of the murals included a tribute to a national leader, Belisario Domínguez, in the National Senate (1958); *La humanidad se libera a la misería* ("Humanity Emancipates Itself from Misery"), in the Palacio de Bellas Artes (1960); and *La conquista* (1960) and *Carranza con la constitución de 1917* (1967), both in the Castillo de Chapultepec.

The peculiar modernist style developed and used by González Camarena in these murals was marked by a *geométrica armónica* (harmonizing geometry) with a stringent structural logic. Yet the murals are also distinguished by a strikingly high-pitched color interaction that harbors deeply resonant shades. Moreover, the eclectic alternation of figuration with a semiabstract manner, derived from Rufino Tamayo, was a hallmark of González Camarena's style. He also employed passages of dramatically foreshortened forms in relation to resolutely structured ones. The net result was an unusual visual language that is restless without being dynamic and anguished without being unsettling structurally. In a certain sense González

249

Camarena's singular style and somewhat disjointed ''existential'' language for official buildings was in keeping with the type of dislocated modernization that prevailed in postrevolutionary Mexico after the late 1940s.

—David Craven

GONZÁLEZ PALMA, Luis

Guatemalan photographer

Born: Guatemala, 1957. **Education:** Studied architecture and cinematography, Universidad de San Carlos de Guatemala. **Family:** Married Delia Vigil. **Career:** Photographer of visiting ballet troupes, Guatemala, 1980s.

Individual Exhibitions:

1989 *Self-Confession,* Museum of Contemporary Hispanic Art, New York
1990 *The Dream Has Its Eyes Open,* Fotogaleria San Martin, Buenos Aires
1991 *Place without Rest,* El Cadejo Arte Contemporaneo, Antigua, Guatemala
 The Persistence of Pain, Galeria de Arte Contemporaneo, Mexico City
1992 Galeria Sol del Rio, Guatemala City
 FotoFest, Houston
 Persistence of Beauty, Persistence of Pain, Art Institute of Chicago
 Silence of the Stare, Schneider-Bluhm-Loeb Gallery, Chicago
 Gallery Image, Arhus, Denmark
 Simon Lowinsky Gallery, New York
 V Vigo Photo Biennial, Vigo, Spain
1993 *Luis Gonzalez Palma,* New Harmony Gallery of Contemporary Art, Indiana
 Stephen Cohen Gallery, Los Angeles
 A.B. Galleries, Paris
 Jane Jackson Gallery, Atlanta
 Schneider-Bluhm-Loeb Gallery, Chicago
 Fotofeis, International Festival of Photography, Scotland
 Scheinbaum and Russek, Santa Fe, New Mexico
 Moderna Museet, Fotografiska Museet, Stockholm
 Musee de la Photographie de Charleroi, Belgium
 Lowinsky Gallery, New York
 Minneapolis Institute of Art
1994 Royal Festival Hall, London
 Schneider Gallery, Chicago
 Cleveland Center for Contemporary Art
 Galeria Visor, Valencia, Spain
 Museo de Bellas Artes, Caracas
 Meadows Museum of Art, Southern Methodist University, Dallas
 Southeast Museum of Photography, Daytona Beach, Florida

Month of Photography, Bratislava, Slovakia
 Stephen Cohen Gallery, Los Angeles
 25th recontres de la photographie, Arles, France
1995 Galeria Il Diaframma, Milan
 Lisa Sette Gallery, Scottsdale, Arizona
 Photographers Gallery, Saskatoon, Saskatchewan, Canada
 Galeria Spectrum, Zaragoza, Spain
 Festival Internacional de Fotografia ''Tarazona Foto,'' Spain
 Galeria Antonio de Barnola, Barcelona, Spain
 Schneider Gallery, Chicago
 Mes de la Fotografia, Quito, Ecuador
 Southeast Museum of Photography, Daytona Beach, Florida
1996 Robert McClain & Co., Houston
 Schneider Gallery, Chicago
 Palacio de Bellas Artes, Mexico City
 Museo de Guadalajara, Mexico
 Museo de Arte Moderno de Medellin, Colombia
 Bilioteca Luis Angel Arango, Bogota
 Biuro-Wystaw-Artystycznych, Jelenia Gora, Osrodek Kultury, Poland (traveling)
 V bienal de Cuenca, Ecuador
 Galeria Tomas Andreu, Santiago
1997 James Danziger Gallery, New York
 Galeria Sergio Milliet, Rio de Janeiro
 Centro de Artes Visuales, Museo del Barro, Asuncion, Paraguay
 Massachusetts Institute of Technology, Cambridge
 Casa de las Americas, Havana
 Schneider Gallery, Chicago
 Lisa Sette Gallery, Scottsdale, Arizona
 Stephen Cohen Gallery, Los Angeles
 Martin Weinstein Gallery, Minneapolis
 Mes de la Fotografia, São Paulo, Brazil
1998 Photo & Col, Turin, Italy
 Lisa Sette Gallery, Scottsdale, Arizona
 James Danziger Gallery, New York
 Jane Jackson Fine Arts, Atlanta
 Barry Singer Gallery, Petaluma, California
 Schneider Gallery, Chicago
1999 Sicardi Gallery, Houston
 Stephen Cohen Gallery, Los Angeles
 Martin Weinstein Gallery, Minneapolis
 Galleries of Texas Tech, Lubbock, Texas
 Lisa Sette Gallery, Scottsdale, Arizona
 Mainsite Contemporary Art, Oklahoma
 Arts and Humanities Council, Lake Charles, Louisiana
2000 *New Works,* Sicardi Gallery, Houston
 Memphis College of Art, Tennessee
 Poetry and Passion, University of North Texas Art Gallery, Denton
 Throckmorton Fine Art, New York

Selected Group Exhibitions:

1988 *Angelogía,* Galería Imaginaria, Guatemala City

Luis González Palma: *El Silencio Flota en el Silencio,* 1998. Photo courtesy of dpm Arte Cotemporaneo, Guayaquil, Ecuador.

1989 *Presencia imaginaria,* Museo de Arte Moderno de
 Mexico, Mexico City, and Museo de Arte Moderno
 de Gautemala
1991 *Fotografia contemporánea de latinoamerica,* Museo de
 Huelva, Spain
1993 *Encuentro latinoamericano de fotografia,* Caracas,
 Venezuela
 *Canto a la realidad, fotografia latinoamericana
 1860–1990,* Casa de America, Madrid (traveling)
1994 *V bienal de la Habana,* Havana
 Indagaciones, Sol del Río, Arte Contemporánea,
 Guatemala
1995 *Traces: The Body in Contemporary Photography,* Bronx
 Museum, New York
1997 *Así está la cosa: Instalación y arte objeto de américa
 latina,* Centro Cultural de Arte Contemporáneo,
 Mexico City
1999 *10 años de Centro Cultural UFMG,* Belo Horizonte,
 Brazil

Collections:

Art Institute of Chicago; Berlin Museum; Bronx Museum of the Arts, New York; Centro Cultural de Arte Contemporaneo, Mexico City; Centro de Estudio Fotografico, Vigo, Spain; DePauw University, Greencastle, Indiana; Maison European de la Photographie, Paris; Fogg Museum, Harvard University, Cambridge, Massachusetts; High Museum of Art, Atlanta; Los Angeles County Museum; Maison de l'Amerique Latine, Paris; Minneapolis Institute of Arts; Museum of Art, New Orleans; Museum of Fine Arts, Houston; National Foundation for Contemporary Art, Paris; Santa Barbara Museum of Art, California; Arizona State University, Tempe; Musee de la Photographie, Charleroi, Belgium; Museo de Bellas Artes de Caracas, Venezuela;

Cleveland Center for Contemporary Art, Akron, Ohio; Center for Creative Photography, Tucson, Arizona; Museo de Bellas Artes, Buenos Aires;. Yale University, New Haven, Connecticut; Smith College, Northampton, Massachusetts; North Dakota Museum of Art, University of North Dakota, Grand Forks; Museo de Arte y Diseño Contemporaneo, San Jose, Costa Rica; Casa de las Americas, Havana; Biblioteca Luis Angel Arango, Bogota; Centro de Artes Visuales, Museo del Barro, Asuncion, Paraguay; Museo de Arte Moderno, Medellin, Colombia; University of Connecticut, Storrer; Akron Museum of Art, Ohio.

Publications:

By GONZÁLEZ PALMA: Books—*El silencio de los Mayas,* with Laura Leonelli, Mario Peliti, and Valerio Tazzetti, Barcelona, Spain, Lunwerg, 1998; *Poems of Sorrow,* Santa Fe, New Mexico, Arena Editions, 1999.

On GONZÁLEZ PALMA: Books—*Luis González Palma: La fidelidad del dolor,* exhibition catalog, Mexico City, Gallería Arte Contemporáneo, 1991; *Luis Gonzalez Palma,* introduction by Maria Cristina Orive, Buenos Aires, La Azotea, 1993; *Luis González Palma* by Sara Facio, Buenos Aires, Azotea Editorial Fotográfica, 1993; *Angeles mestizos,* exhibition catalog, Caracas, Museo de Bellas Artes, 1994; *Luis González Palma: Historias paralelas,* exhibition catalog, text by Camila Cesarino Costa, Bogota, Banco de la República, Biblioteca Luis Angel Arango, 1996. Articles—''Silence of a Look'' by Amanda Hopkinson, in *Creative Camera,* 325, December/January 1994, pp. 47–48; ''Luis Gonzalez Palma'' by Claudia Larraguibel, in *Art Nexus* (Colombia), 14, October/December 1994, pp. 127–128; ''A Conversation with Luis Gonzalez Palma'' by Natalia Gutiérrez, in *Art Nexus* (Colombia), 22, October/December 1996, pp. 88–91; ''Luis Gonzalez Palma at Stephen Cohen Gallery' by Laura Alvarez,

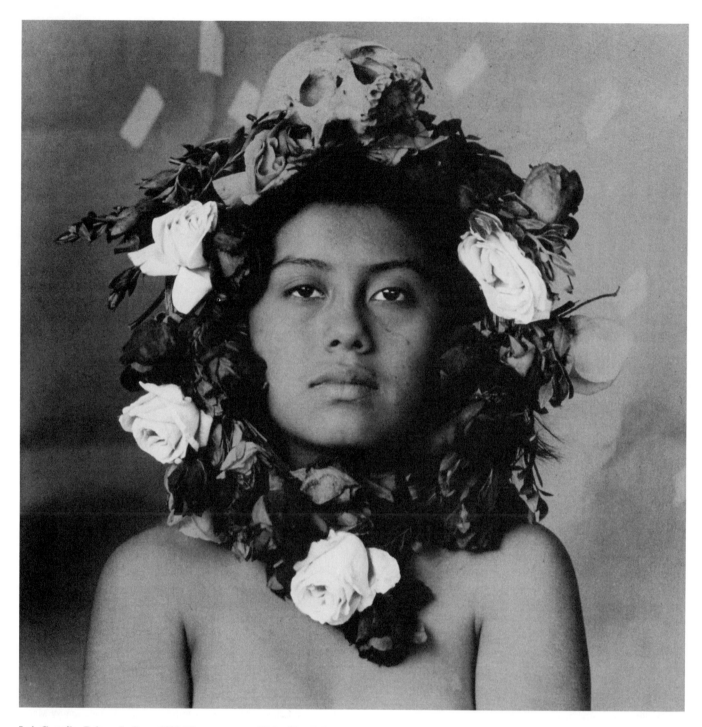

Luis González Palma: *La Rosa,* **1989. Photo courtesy of Schneider Gallery.**

in *Artweek,* 28, May 1997, pp. 24–25; ''Luis Gonzalez Palma'' by Mary Schneider Enriquez, in *Art Nexus* (Colombia), 36, May/July 2000, p. 152.

* * *

There is no doubt that Luis González Palma is one of the most relevant artists of the 1990s in Central America. Beyond the force of his work, which initially focused on a different gaze toward and from the ''other''—specifically the indigenous issue—and was tied to an unsaid desire for liberation from the historical burden of a repressive religion, he has taken the photographic medium to levels of legitimization formally reserved for traditional genres. The expansion of photography in Central America in the late 1990s is largely due to González Palma, whose work changed the reductive perspective, which until then had defined photography in the region as basically a documentation tool, and situated it as a language of the largest possibilities, where illusion and fiction could also be included.

Originally trained as an architect, González Palma possesses a strong sense of minimalistic design, which acts as a subtly poetic

balancing element to the extreme baroque origins of his images. His initial work tended toward the materialization of a different reading of the religious and vernacular iconography of a country where, although the indigenous traits prevail, their presence in the popular imaginary is not translated in the visual expressions other than the purely folkloric and neither is present in the religious representations. This first stage is the period of the well-known ''mestizo angels,'' exquisite images printed in black and white and altered with overtones of soft sepias, only interrupted by sudden details of absolute whiteness. The photographs are of an extreme elegance that masks the real intention of the artist, somehow sublimating a painful reality.

After this period of poetic visual reinterpretation of an environment through isolated figures, González Palma began creating large gridlike photomontages that, inspired by the ''games'' devised by the Spanish clergy to teach reading to the indigenous populations (such as *La Lotería*), juxtapose figures and objects. Although a kind of harmony seems to prevail in these austere compositions, the construction is based on fragments—a common practice in Guatemala and El Salvador—that prefigured the way in which a contradictory reality affected the vital space of the artist. In about the mid-1990s González Palma achieved a powerful dramatization of his images by progressively abandoning the kind of figuration and manipulation that had identified him up to then. Suddenly, a simple shirt hanging in the wind, with almost imperceptible orifices shooting through, could carry all the internal load of experimented violence. *The Simple Transparency of Faith* (Havana Biennale, 1997), a series of blind eyes disposed on many screens, led to a deep reflection on the essence of the gaze. At the same time, the visual and conceptual proposal decanted slowly, reinforced the configuration of the pieces by a voluntary serialization and the reduced visual information. Around this time González Palma constructed vertical sequences that speak of the human condition, where moments of celebration alternate with periods of sorrow and the ephemeral pleasure of naturally elapsing time confronts the drama of time interrupted by death and violence.

The experience of the body is one of the characters which defines a society. Within the Christian world, the physical body has created conflict, danger, guilt, and repression, becoming the place of suffering, punishment, and the forbidden. This is where González Palma's work takes root, as well as in the daily violence he has witnessed. In this way, the corporal memory and experience are more related to a state of pain than with pleasure, and luxury, comfort, and material excess appear clearly as what they really are: useless palliatives. It is within this context that one can inscribe the later works of González Palma, including *The Vision of the World* (1998; in the Museo de Arte Contemporáneo, San Jose), a photo-based installation put up with clinical and surgical material, in an aseptic environment, devoid of his former aesthetics. The piece functions, however, like the evidence of a body and soul in search for cure and salvation.

Some of González Palma's later work integrates earlier images into diptychs composed of a photograph and a square of baroque upholstery material into which the name of the figure is embroidered with care. Some of these deal with the impossibility of the indigenous population's integration into the rest of the Guatemalan society and the permanence and limits of an anthropological interest as the sole approach to these peoples.

—Virginia Pérez-Ratton

GONZALEZ-TORRES, Felix

American painter, sculptor, photographer, and installation artist

Born: Guáimaro, Cuba, 1957. **Education:** Whitney Museum Independent Study Program, New York, 1981–83; Pratt Institute, Brooklyn, New York, B.F.A. 1983; New York University, International Center for Photography, M.F.A. 1987. **Career:** Adjunct art instructor, New York University, 1987–89, 1992, CALARTS, Los Angeles, 1990. **Awards:** Artists fellowship, Art Matters, Inc., 1988, 1989; Cintas Foundation fellowship, 1989; Pollock-Krasner Foundation grant, 1989; National Endowment for the Arts fellowship, 1989, 1993; Gordon Matta-Clark Foundation award, 1991; Deutscher Akademischer Austauschdienst fellowship, Artists-in-Residence Program, Berlin, 1992. **Died:** 9 January 1996.

Individual Exhibitions:

1984	New York
1988	Rastovski Gallery, New York
	INTAR Gallery, New York
	New Museum of Contemporary Art, New York
1989	Brooklyn Museum, New York
1990	Andrea Rosen Gallery, New York
	University of British Columbia, Vancouver, Canada (with Donald Moffet)
	Neue Gesellschaft fur Bildende Kunst, Berlin (with Cady Noland)
1991	Luhring Augstine Hetzler, Los Angeles
	Massimo de Carlo, Milan
	Every Week There Is Something Different, Andrea Rosen Gallery, New York
	Julie Sylvester Editions, New York
	Museum Fridericianum, Kassel, Germany (with Cady Noland)
1992	*Magasin 3 Stockholm,* Konshall, Sweden
	Galerie Peter Pakesch, Vienna
	Andrea Rosen Gallery, New York
	Museum of Modern Art, New York
1993	Museum in Progress, Vienna
	Travel #1, Galerie Jennifer Flay, Paris
	Trave #2, Galerie Ghislaine Hussenot, Paris
	Migrateurs: Felix Gonzalez-Torres, Musee d'Art Moderne de la Ville de Paris
	Currents 22: Felix Gonzalez-Torres, Teweles Gallery, Milwaukee Art Museum
	Andrea Rosen Gallery, New York
1994	*Felix Gonzalez-Torres: Details from Twenty Sculptures,* Printed Matter, New York
	Traveling, Museum of Contemporary Art, Los Angeles (traveling)
	Fabric Workshop, Philadelphia
	Matrix Gallery, University of California, Berkeley
1995	Solomon R. Guggenheim Museum, New York
1996	Musee d'Art Moderne de la Ville de Paris

Selected Group Exhibitions:

1990	*The Rhetorical Image,* New Museum, New York

1991 *Variations on Themes: Prints Acquired for the Perma-*
 nent Collection, Whitney Museum of American Art,
 New York
1992 *From Media to Metaphor: Art About Aids,* Emerson
 Gallery, Hamilton College, Clinton, New York
 (traveling)
 Portraits, Plots and Places, Walker Art Center,
 Minneapolis
 *Felix Gonzalez-Torres, Albert Oehlen, Christopher
 Williams–Theatre Verite,* Margo Leavin Gallery, Los
 Angeles
 *Photoplay: Works from the Chase Manhattan Collec-
 tion,* Center for the Fine Arts, Miami (traveling)
1993 *Space of Time: Contemporary Art from the Americas,*
 America's Society, New New York (traveled to
 Center for Fine Arts, Miami)
 *Symptoms of Interference, Conditions of Possibility: Ad
 Reinhardt, Joseph Kosuth, Felix Gonzalez-Torres,*
 Camden Arts Centre, London
1994 *Latin American Art in Miami Collections,* Lowe Art
 Museum, University of Miami, Coral Gables, Florida
1995 *About Place: Recent Art of the Americas,* Art Institute
 of Chicago

Publications:

On GONZALEZ-TORRES: Books—*Felix Gonzalez-Torres,* ed-
ited by William S. Bartman, Los Angeles, A.R.T. Press, 1993; *Felix
Gonzalez-Torres,* exhibition catalog, Los Angeles, Museum of Con-
temporary Art, 1994; *Felix Gonzalez-Torres,* exhibition catalog, text
by Nancy Spector, New York, Solomon R. Guggenheim Museum,
1995; *About Place: Recent Art of the Americas,* exhibition catalog,
texts by Madeleine Grynsztejn and Dave Hickey, Chicago, Art
Institute of Chicago, 1995; *Felix Gonzalez-Torres,* exhibition cata-
log, text by Roland Wäspe, Andrea Rosen, and others, Hannover,
Germany, Sprengel Museum, 1997. **Articles**—"Felix Gonzalez-
Torres" by Catherine Liu, in *Flash Art,* October 1988; by Nancy
Spector, in *Contemporanea,* summer 1989, and in *Galeries Maga-
zine,* April/May 1991, pp. 80–81; by Pat McCoy, in *Tema Celeste,*
April/June 1990; "Felix Gonzalez-Torres: All the Time in the World"
by Robert Nickas, in *Flash Art,* November/December 1991, pp.
86–89; "This Is My Body: Felix Gonzalez-Torres" by Jan Avgikos,
in *Artforum,* Feburary 1991, pp. 79–83; "Felix Gonzalez-Torres" by
Marina Urbach, in *Art Nexus,* 6, October 1992, pp. 152–153, 212–213;
Felix Gonzalez-Torres issue of *Currents 22* by Dean Sobel, Milwau-
kee Art Museum, May/June 1993; "Felix Gonzalez-Torres: A Con-
versation with Strangers" by Brad Killam, in *Art Muscle,* 1993, p. 17;
"Gonzalez-Torres–On Photography" by A.D. Coleman, in *Juliet Art
Magazine,* 16, February/March 1993, pp. 56–57; "Gonzalez-Torres"
by Maria Campitelli, in *Juliet Art Magazine,* April/May 1993, p. 44;
Felix Gonzalez-Torres issue of *Parkett,* 39, 1994; "Politically Direct:
Felix Gonzalez-Torres: Traveling" by Claudia Mesch, in *Chicago
Reader,* 21 October 1994, p. 27; "Traveling Light: Installation Artist
Felix Gonzalez-Torres Shines at the Hirshhorn" by Jo Ann Lewis, in
Washington Post, 10 July 1994; "Voice Choices: Felix Gonzalez-
Torres at Printed Matter" by Kim Levin, in *Village Voice* (New
York), 22 November 1994; "Sweet Dreams on the Work of Felix

Gonzalez-Torres" by Gary Kornblau, in *Art Issues,* September/
October 1994, p. 52; "No Confidence: The Gorgeous Politics of Felix
Gonzalez-Torres" by David A. Greene, in *Los Angeles Reader,* 6
May 1994; "Felix Gonzalez-Torres: Entre un espioni" by Robert
Storr, in *artpress,* January 1995, pp. 24–32; "Gonzalez-Torres Spills
into the Guggenheim" by Sarah Schmerler, in *Art & Auction,*
February 1995, p. 98; "Felix Gonzalez-Torres at the Renaissance
Society" by Tim Porges, in *New Art Examiner,* January 1995, pp.
36–37; "Felix Gonzalez-Torres, towards a Postmodern Sublimity"
by Monica Amor, in *Art Nexus,* January-March 1995, pp. 56–61; "In
the Spirit of Felix Gonzalez-Torres" by Sue Spaid, in *Art Journal,*
58(1), spring 1999, pp. 84–85.

* * *

Felix Gonzalez-Torres was born in Guáimaro, Cuba, in 1957. In
1979 he moved to New York City, where he obtained a bachelor of
arts in philosophy from Pratt Institute School of Art Design in 1983
and a graduate degree from the International Center of Photography in
1987. He further pursued his academic training as a participant in the
Independent Study Program at the Whitney Museum of American Art
from 1981 to 1983. Gonzalez-Torres died in 1996 at the age of 39, but
throughout his relatively brief career he created a diverse body of
work ranging from billboards to interactive installations. He is best
known for his personal and intentionally engaged pieces, which
consistently involved themes of audience participation, process,
absence, and beauty, maintaining a dialogue between the visual arts
and community-based issues.

In the 1980s Gonzalez-Torres joined the New York–based artist
collective Group Material. Originally formed in 1979 by Julie Sult,
Mundy McLaughlin, and Tim Rollins, among others, the group
participated in social and cultural activism as well as community
education. Group Material participated in performances and rented
advertising spaces for artistic purposes in order to challenge the
institutional authority of museums, galleries, and auction houses by
focusing on process rather than the object and by taking visual art into
nontraditional places. Gonzalez-Torres later left this group, and in
1984 he received his first solo exhibition in New York. His work,
however, continued to involve social themes.

Although conscious of his Latino background, Gonzalez-Torres
sought to avoid any labels that would limit his work. Instead, he chose
to work in terms that revealed a broad range of human experiences.
Always provocative and poetic, his works expressed in-depth prob-
ings regarding the human condition in contemporary culture. Through-
out his career he installed stacks of paper or piles of candy from which
he asked that viewers take away a sheet of paper or a bit of candy. In
this process of subtraction and modification, the audience helped
create and shift the meaning of the works. By emphasizing a collabo-
rative element between the audience and himself, Gonzalez-Torres
created a link between the previously opposing realms of public
versus private, "high" versus "low" culture, and participation
versus contemplation. Much of Gonzalez-Torres's works—his light
pieces, billboards, clocks—were also portraits of the artist's per-
sonal life, his relationship with his lover, and his own struggle
with immortality.

—Miki Garcia

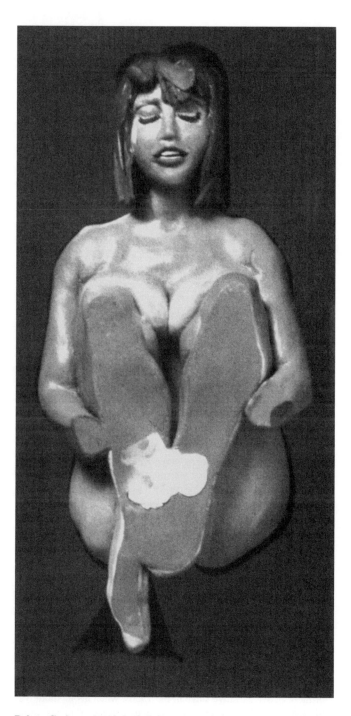

Robert Graham: *Untitled,* **1965. Photo courtesy of Hamburg Kunsthalle, Hamburg, Germany/Bridgeman Art Library.**

GRAHAM, Robert
American sculptor and installation artist

Born: Mexico City, 19 August 1938; naturalized U.S. citizen, 1950. **Education:** San Jose State College, California, 1961–63, B.A. 1963; San Francisco Art Institute, 1963–64, degree 1964. **Family:** Married Anjelica Huston. **Career:** Lived in Los Angeles and began making small art figures, 1964–69; lived and worked in London, 1969–70, then returned to Venice, California. Completed many public art installations, including the Olympic Gateway at the Los Angeles Coliseum.

Individual Exhibitions:

1964	Lanyon Gallery, Palo Alto, California
1966	Nicholas Wilder Gallery, Los Angeles
1967	Nicholas Wilder Gallery, Los Angeles
	Galerie Thelen, Essen
1968	Kornblee Gallery, New York
	Galerie Neuendorf, Hamburg, Germany
	Galerie Zwirner, Cologne, Germany
	Galerie Neuendorf, Cologne, German
1969	Kornblee Gallery, New York
	Nicholas Wilder Gallery, Los Angeles
1970	Galerie Neuendorf, Hamburg, Germany
	Galerie Neuendorf, Cologne, Germany
	Galerie Mollenhoff, Cologne, Germany
	Galerie Rene Block, Berlin
	Whitechapel Art Gallery, London
1971	Sonnabend Gallery, New York
	Kunstverein, Hamburg, Germany
1972	Galerie Herbert Meyer-Ellinger, Frankfurt, Germany
	Museum of Fine Arts, Dallas
	Courtney Sale Gallery, Dallas
1974	Nicholas Wilder Gallery, Los Angeles
	Galerie Neuendorf, Hamburg, Germany
	Galerie Zwirner, Cologne, Germany
	Felicity Samuel Gallery, London
	Galerie Neuendorf, Cologne, Germany
	Gimpel and Hanover Galerie, Zurich
	Texas Gallery, Houston
1975	Felicity Samuel Gallery, London
	Gimpel and Hanover Galerie, Zurich
	Texas Gallery, Houston
	Dorothy Rosenthal Gallery, Chicago
	Gimpel and Hanover Gallery, at the *Basel Art Fair,* Switzerland
	Nicholas Wilder Gallery, Los Angeles
1976	Greenberg Gallery, St. Louis
	Galerie Neuendorf, Hamburg, Germany
	Galerie Neuendorf, Cologne, Germany
	Gimpel Fils, London
1977	Nicholas Wilder Gallery, Los Angeles
	John Stoller Gallery, Minneapolis
	Robert Miller Gallery, New York
	Dorothy Rosenthal Gallery, Chicago, Illinois
1978	Robert Miller Gallery, New York
	Dorothy Rosenthal Gallery, Chicago
	Los Angeles County Museum of Art
1979	Robert Miller Gallery, New York
	Galerie Neuendorf, Hamburg, Germany
	Dag Hammarskjold Plaza, New York
1980	Dorothy Rosenthal Galllery, Chicago
1981	Los Angeles County Museum of Art
	Walker Art Center, Minneapolis

1981 Dorothy Rosenthal Gallery, Chicago
 School of Visual Arts, New York
1982 Norton Gallery, West Palm Beach, Florida
 Museum of Fine Arts, Houston
 Joslyn Art Center, Omaha
 Des Moines Art Center, Iowa
 San Francisco Museum of Modern Art
 Robert Miller Gallery, New York
1984 Gemini G.E.L., Los Angeles
 ARCO Center for Visual Arts, Los Angeles
1985 48 Market Street, Fragments Exhibition, Venice,
 California
1988 Los Angeles County Museum of Art
1989 Robert Miller Gallery, New York
1990 Galerie Neuendorf, Frankfurt, Germany
 Galerie Fahenmann, Berlin
 Earl McGrath Gallery, Los Angeles
 48 Market Street, Venice, California
 Mixografia Gallery, Los Angeles
 Robert Miller Gallery, New York
1991 John Berggruen Gallery, San Francisco
1992 Robert Miller Gallery, New York
 48 Market Street Gallery, Venice, California
1995 *Eight Statues,* Chac-Mool Gallery, Los Angeles
 (traveling)

Selected Group Exhibitions:

1966 *Whitney Biennial,* Whitney Museum, New York
1971 *3 Americans,* Victoria and Albert Museum, London
1972 *West Coast U.S.A.,* Kunstverein, Hamburg (toured
 Germany)
1974 *Biennial,* Art Institute of Chicago
1975 *Sculpture: American Directions 1945–1975,* National
 Collection of Fine Arts, Smithsonian Institution,
 Washington, D.C.
1976 *L.A. 8: Painting and Sculpture 76,* Los Angeles County
 Museum of Art
 Painting and Sculpture in California: The Modern Era,
 San Francisco Museum of Modern Art
1978 *Contemporary Artists Series, Number 1,* Rutgers Univer-
 sity Art Gallery, New Brunswick, New Jersey
1980 *Aspects of the 70's: Directions in Realism,* Danforth
 Museum, Farmington, Massachusetts
1986 *California Sculpture 1959–80,* San Francisco Museum
 of Modern Art

Collections:

Museum of Modern Art, New York; Whitney Museum, New York; Hirshhorn Museum and Sculpture Garden, Washington, D.C.; Los Angeles County Museum of Art; Kuntsmuseum, Cologne; Kuntsmuseum, Hamburg; Dallas Museum of Fine Art; Walker Art Center, Minneapolis; Museum of Modern Art, Paris; Victoria and Albert Museum, London; Museum of Art, Rotterdam; National Museum of Wales, Cardiff.

Permanent Public Installations:

Monument to Joe Louis, Cobo Hall, Detroit; City of San Jose.

Publications:

On GRAHAM: Books–*Robert Graham 1963–1969,* exhibition catalog, Cologne, Germany, Galerie Neuendorf, 1970; *Robert Graham: Statues* by Graham W. J. Beal and George W. Neubert, Minneapolis, Walker Art Center, 1981; *Robert Graham: Eight Statues,* exhibition catalog, text by Michael McClure, New York, Gagosian Gallery, 1994. **Articles–**"Through Western Eyes" by Leo Rubinfien, in *Art in America* (New York), September/October 1978; "Robert Graham: Ignoring the Lessons of Modern Art" by Barbara Isenberg, in *Art News* (New York), January 1979; "The Collectors: Contemporary Elan" by Peter Carlsen, in *Architectural Digest* (New York), March 1979; "ART: American Figurative Sculpture" by David Bourdon, in *Architectural Digest* (New York), November 1979; "Critic's Choice" by Grace Glueck, in *New York Times,* 23 November 1979; "Robert Graham" by Jon R. Friedman, in *Arts Magazine* (New York), January 1980; "Robert Graham" by Tomas Lawson, in *Flash Art* (Milan), January/February 1980; "'Local' Art Hits the Big Time" by Michael Tennesen and Richard B. Marks, in *Los Angeles Magazine,* February 1980; "Wheels and Deals Keep California Venice Spinning" by Charles Lockwood, in *Smithsonian* (Washington, D.C.), March 1980; interview with Robert Graham by Lane Barden, in *Artweek,* 24, 8 April 1993, pp. 24–25; "Dead or Alive: Molds, Modeling and Mimesis in Representational Sculpture" by Robert Taplin, in *Sculpture* (Washington, D.C.), 13, May/June 1994, pp. 24–31; "Robert Graham" by Pamela Hammond, in *Art News,* 94, April 1995, p. 155; Anjelica Huston and Robert Graham: The Artist Sculpts a Venice House for His Actor-Director Wife" by Joseph Giovannini, in *Architectural Digest,* 53, April 1996, pp. 128.

 * * *

The strength of Robert Graham's compelling bronzes derives from a series of subtle, overlapping oppositions. Although lifelike in detail if not in size, the women he depicts are imbued with a distinct element of the hallucinatory. The effect holds the viewer, who sees them as types rather than as individuals, at a psychological distance. With increasing accuracy Graham has transposed his studio model into a permanent form, maintaining that the sculptures serve not only as reproductions but also as "a metaphor for the human spirit." Nearly all of Graham's career has been devoted to the human figure. During his early narrative stage in the 1960s, when his medium was wax, the psychological tensions began to emerge from his work. Graham's miniature wax sybarites were applauded for their exquisite detail, yet covered by plexiglass from the viewer's world. They were kept in a vacuum, sealed from touch, offsetting the onlooker's sense of scale, forcing him into the role of voyeur. With the actual distance between sculpture and viewer indeterminate, the tiny personages were both approachable and distant.

Around 1970 Graham diverted his attention from narrative sculpture to experimenting with simultaneous views of the same figure. For the first time he employed a camera and a casting mold, two devices he found crucial for his subsequent work. Graham's first series of bronze pieces recalled the nineteenth-century Eadweard Muybridge photographs of figures in action. The figures were engaged in simple movements–walking, bending, arising–and Graham

strove to make every gesture as simple and as immediate as possible, thereby eliminating the ambiguity of the earlier works. Graham's deepening interest in fusing motion into his composition resolved into a lengthy series of reference photographs. After photographing different models, each one executing basic actions in different ways, he derived a master figure from which the mold of subsequent figures was made. Graham's wax figures progressed into bronze in 1971. With this came the departure of the plexiglass covers and the descriptive coloring he applied to the wax. The ambiguities returned, however. In his 1973 *Single Head,* Graham defiantly executed a "bust" whose portrayal of the face and shoulders is sensitive and veristic yet lacking in two important animating features: the head is hairless, and the eyes have no pupils.

Graham's 1973 *Eight Heads,* a piece in which each head bears a distinct facial expression, assumes classical overtones. With both hair and pupils still absent, the piece seems, paradoxically, complete within itself and, as one critic described it, "from another world." The plexiglass that once separated onlookers physically has been replaced by a psychological barrier. Again the spectator is forced to become a voyeur.

Graham abandoned his eerie, science fiction personages in the following years in pursuit of depicting specific individuals. This shift in focus necessitated a dramatic increase in scale. As his attention to detail heightened, the sense of real flesh and bone, of contours and dimples, intensified the reality of the bronze. Ironically, the soothing order is disrupted by the abrupt, almost brutal truncation of the figure. The viewer is thus trapped between the astonishing realism and the drastic editing.

In 1977 Graham returned to a convention he has continued to favor: a figure approximately three feet tall on a minimal geometric base. He introduced the anatomically precise *Lise* series, whose poses range from the passivity of *Lise I,* to the near swagger of *Lise II,* to the defiance of *Lise III.* For the first time the figures seem to be observing the viewer as he observes them. In this series Graham delicately shifted the literal interpretations of the statues to the metaphorical; by reducing the scale, he distilled the figure to its essence.

Graham uses oil paint to color his statues. Flesh color has become less important to him as he has moved to using his own black-and-white photos for research. His concern, instead, rests with tonal values, and thus he opts for a narrow range of purples, grays, and greens. The bloodless hues created by these colors disturb the realistic modeling of the nudes, further contributing to the emotional gap between viewer and figure.

—Carrie Barker

GRAU (ARAÚJO), Enrique
Colombian painter and sculptor

Born: Panama City, Panama, 18 December 1920. **Education:** Art Students League, New York (on Colombian government scholarship), 1940–43; Academy of San Marcos, Florence, 1955–56. **Career:** Instructor, Escuela de Bellas Artes de la Universidad Nacional, Bogotá, and Universidad de los Andes, ca. 1950s; director, Departamento de Escenografía de la Televisora Nacional, Bogotá, 1954. Visited the Galapagos Islands, 1992. Commissioned to paint the ceiling of the Heredia Theater, 1997. Also worked as a set designer for television and theatre. **Awards:** Mención de honor,

Primer salón de artistas nacionales, 1940; prize, *VII Annual Competitive Exhibition,* A.C.A. Gallery, New York, 1943; first prize, *Segundo salón de artistas colombianos costeños,* Barranquilla, Colombia, 1946; first prize, *Primer salón de pintura colombiana,* 1954; first prize in painting, *X salón de artistas colombianos,* 1957; first prize in drawing, *XI salón nacional de artistas colombianos,* 1958; first national prize, *Salón de arte latinoamericano,* 1959; first prize, *Salón nacional de pintura,* 1960; second prize, *Primer salón internacional de pintura,* 1960; second painting prize, *XIV biennial of São Paulo,* 1962.

Individual Exhibitions:

1945	Biblioteca Nacional, Bogotá
1948	Colombian Society of Architects, Bogotá
1951	Galería de Arte, Bogotá
1953	Galería "El Callejón," Bogotá
1954	Biblioteca Nacional, Bogotá
1955	Organization of American States, Washington, D.C.
	Museo de Arte Moderno, Bogotá (retrospective)
1956	Galería "L'Asterisco," Rome
1957	Pan American Union, Washington, D.C.
1960	Biblioteca Nacional, Bogotá
1962	Biblioteca Nacional, Bogotá
	Galería "Arte Moderno," Bogotá
1963	Museo La Tertulia, Cali, Colombia
1964	Jerrold Morris International Gallery, Toronto, Canada
	Pan American Union, Washington, D.C. (retrospective)
1965	Museo La Tertulia, Cali, Colombia
1966	Galería el Zaguán, Cartagena, Colombia
	Museo La Tertulia, Cali, Colombia
1967	Galería "La Casita," Medellín, Colombia
	Galería "Arte Moderno," Bogotá
1968	Galería "Arte Moderno," Bogotá
1969	Museo La Tertulia, Cali, Colombia

Enrique Grau: *La bella del Puerto,* **2001. Photo courtesy of the artist.**

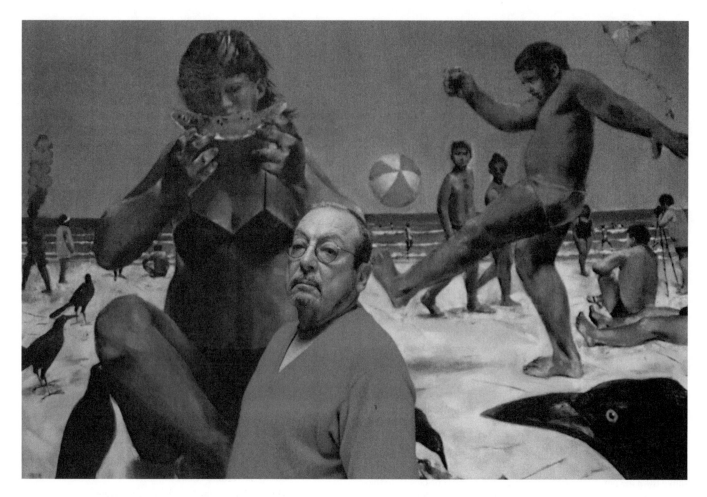

Enrique Grau standing in front of his artwork. Photo courtesy of the artist.

1971	Galería San Diego, Bogotá
1972	Museo Interamericano de Arte Moderno, Cartagena, Colombia
1973	Museo La Tertulia, Cali, Colombia
	Museo de Arte Moderno, Bogotá (retrospective)
1974	Biblioteca Piloto de la Unesco, Medellín, Colombia (retrospective)
1976	Country Club, Bogotá
	Centro de Arte Actual, Pereira, Colombia
1977	*Grau obra reciente,* Galería San Diego, Bogotá
1980	*El rey lear,* Galería 70, Bogotá
	Homenaje a Grau, Galería el Marqués, Cartagena, Colombia (retrospective)
1981	Aberbach Fine Art, New York
	Galería Atenea, Barranquilla, Colombia
1982	*Enrique Grau, otra tridimensional,* Museo de Arte Moderno, Bogotá
1983	*Enrique Grau, exposición retrospectiva,* Centro de Arte Actual, Pereira, Colombia
	Museo de Arte Moderno, Medellín, Colombia
1983	Museo de Arte Moderno, Cartagena, Colombia
1986	Museo de Arte Moderno, Bogotá
1987	*Los novios,* Aberbach Fine Art, New York
	Instituto de Cultura de Santander, Cúcuta, Colombia (retrospective)

	Casa de la Cultura, Tenjo, Cundinamarca, Colombia
1988	Galería Alfred Wild, Bogotá
	Galería Duque Vargas, Medellín, Colombia
	Enrique Grau años 80, Fondo Cultural Cafetero de Manizales, Colombia
1989	Galería El Taller, Pereira, Colombia (retrospective)
1990	Fundación para la Educación Superior, Cali, Colombia

Selected Group Exhibitions:

1940	*I salón de artistas colombianos,* Biblioteca Nacional, Bogotá
1954	*Exposición de artistas colombianos,* Biblioteca Nacional, Bogotá
1957	*IV biennial of São Paulo,* Brazil
1958	*Pittsburgh International,* Carnegie Institute
1965	*Art in America,* American Institute, Washington, D.C.
1967	*Art of Latin America since Independence,* Yale University, New Haven, Connecticut
1971	*I bienal americana de artes gráficas,* Cartón de Colombia, Museo La Tertulia, Cali, Colombia
1974	*Retrospectiva de los premios de los 25 salones de artistas colombianos,* Biblioteca Luis Angel Arango, Bogotá

Enrique Grau: *Homenaje a cartagena de Indias,* 2001. Photo courtesy of the artist.

1980 *Obra gráfica de los maestros,* Galería de Arte, Banco
 Ganadero, Cartagena, Colombia
1983 *Sexta bienal del grabado latinoamericano,* Instituto de
 Cultura Puertorriqueña, San Juan, Puerto Rico

Collection:

Colombian National Museum.

Publications:

By GRAU: Books—*El pequeño viaje del barón von Humboldt,* Colombia, Bolívar, 1984; *Las mariamulatas,* Santa Fe de Bogotá, Colombia, Banco de la República, Biblioteca Luis-Angel Arango, 1995; *Mujeres,* Bogotá, E. Michelsen, 1996. **Book, illustrated—** *Zoro* by Jairo Aníbal Niño, Bogotá, C. Valencia Editores, 1979.

On GRAU: Books—*Paintings and Drawings by Enrique Grau of Colombia,* exhibition catalog, Washington, D.C., Pan American Union, 1958; *Enrique Grau, exposición retrospectiva,* exhibition catalog, text by Eduardo Serrano, Bogotá, Museo de Arte Moderno, 1973; *Enrique Grau,* Bogotá, EDUFOTO, 1974, *Enrique Grau,* exhibition catalog, Bogotá, Fondo Cultural Cafetero, 1983, and *Enrique Grau: Esculturas,* exhibition catalog, Bogotá, Galería Fernando Quintana, 1994, all by Germán Rubiano Caballero; *Enrique Grau: Exhibition,* exhibition catalog, New York, Aberbach Fine Art, 1981; *Enrique Grau, Colombian Artist* by Donald B. Goodall, Santa Fe de Bogotá, Colombia, Amazonas Editores, 1991; *Galapagos Series: Iguanas,* exhibition catalog, Washington, D.C., Art Museum of the Americas, 1994. **Articles—** "Enrique Grau and Tradition" by Alfred MacAdam, in *Cimaise* (France), 33, July/September 1986, pp. 49–60; "Enrique Grau" by German Rubiano Caballero, in *Art Nexus* (Colombia), 22, October/December 1996, p. 138.

* * *

Enrique Grau was born in 1920 in Panama, although his family was from Cartagena, Colombia. When he was 20 years old, Grau, for

his most widely acclaimed piece, *Mulata Cartagenera,* was awarded the Mention of Honor in the first annual exhibition of Colombian national artists. This work, exemplifying Grau's natural technical ability, is of interest because of its ability to contextualize the underlying characteristics of the moment in the art of the country.

Shortly thereafter the Colombian government granted Grau a scholarship to study in New York at the Art Students League, where he remained until 1943. Upon his return to Bogotá, Grau, along with Alejandro Obregón and Eduardo Ramírez Villamizar, began to appear actively in the artistic circles, commercial halls, and galleries. One place particularly known for its interest in showing the works of Colombia's emerging young artists was the Colombian Society of Architects, where each artist exhibited his work individually in 1948.

The presence of the new generation of universally acclaimed talent in Colombia held an impressive character to the young people in the country. The paintings of this new generation of painters would influence practically the entire country. The early work that Grau showed is of varied influences, and for a short time the influence of the other young Colombians, including Obregón and Fernando Botero, was apparent. Although Grau's personal style, which would not begin to define itself until 1959, has doubtlessly become one of the most solid within the Colombian panorama of the twentieth century, it was predominantly his intent to contemporize the art world in Colombia at the time.

The national acclaim of Grau's work in Colombia did not go unnoticed in international circles. It is for this reason that between 1955 and 1957 the artist presented an individual exhibition in Washington, D.C., under the auspices of the Organization of the American States. In 1957 he helped to represent Colombia in the 4th Biennial of São Paulo. Naturally the list of national and international awards followed without interruption and continued until Grau's death. One of those awards, for example, was granted to Grau in 1962 for the painting *Great Swimmer.* The painting received the prize in the 14th Annual Exhibition of Colombian Artists at the Ministry of Education.

The work of Enrique Grau combines a specific figural vision with his association of figures and objects. Behind this premeditation in the purity of certain situations, the superficiality, the lightness, and the studied disorder that hides in the human core, are the artist's most complex feelings, desires, and rationalizations. This expression acquires the most peculiar of the materializations, defying the tepid nature of the human condition.

During the 1980s and until his death, Grau also practiced sculpture, and of this time *The Kiss* is one of the most important. Throughout his life Grau painted several murals, the most significant being a work in the cupola and the drop curtain of the stage of the Heredia Theater of Cartagena, the city in which he lived until his death in 1992.

—Daniel Lahoda

GRIPPO, Victor
Argentine painter

Born: Junín, Buenos Aires, 10 May 1936. **Education:** Studied chemistry, National University, La Plata, 1955–57, and National College of Junin, 1957–59; School of Fine Arts, National University,

La Plata, 1961–62, 1966–67. **Military Service:** Served in First Regiment, Argentine Army. **Family:** Married Ruth B. Klinger in 1967. **Career:** Private art tutor, 1955–72; staff member, Biological Institute, Buenos Aires, 1965–68; adviser in arts to sub-secretary of culture, Buenos Aires, 1968–71. Since 1968 freelance designer, Buenos Aires. Member, artist group *Grupo de los Trece (Grupo CAYC),* Argentina, beginning in 1975. **Awards:** First painting prize, National College, Junin, 1953; graphics prize, *Salon de Tandil,* Argentina, 1957; summer scholarship, Central University of Quito, Ecuador, 1959; first visual experiment prize, *Arts Festival,* Tandil, 1970; second Paolini Acrylics prize, Museum of Modern Art, Buenos Aires, 1972; first prize, U.N.O. 30, Unesco, Yugoslavia 1975; Gran Premio Itamaraty, *Bienal,* São Paulo, 1977. **Agent:** Jorge Glusberg, Centro de Arte y Comunicacion, Elpidio Gonzales 4070, Buenos Aires, Argentina. **Address:** Juncal 2170, Box 3, Buenos Aires, Argentina.

Individual Exhibitions:

1954 Museo Municipal Bellas Artes de Junin, Buenos Aires
1958 Salón Nueve Era, Tandil, Argentina
1959 Salón de Berisso, Buenos Aires
1966 Galeria Lirolay, Buenos Aires
1968 Galeria Lirolay, Buenos Aires
1992 Fawbush Gallery, New York
1995 Palais des Beaux Arts, Brussels (traveling retrospective)

Selected Group Exhibitions:

1969 *Biennale,* Musée d'Art Moderne, Paris
1970 *Festival de las artes,* Museo Provincial, Tandil, Argentina
1971 *Fotografia tridimensional,* Centro de Arte y Comunicacion, Buenos Aires
1972 *Bienal de arte coltejer,* Medellin, Colombia
 Encuentro internacional de arte, Pamplona, Spain
1973 *Hacia un perfil del arte latinoamericano,* Centro di Arte y Communicacion, Buenos Aires (toured Europe and the United States)
 Homenaje a Salvador Allende, Museo de Bellas Artes, Santiago
1974 *Arte de sistemas en latinoamerica,* International Cultureel Centrum, Antwerp (toured Europe)
 Tendencias actuales de la pintura argentina, Centre Artistique de Rencontres Internationales, Nice
1975 *El arte y la cultura de los paises del tercer mundo,* Espace Pierre Cardin, Paris

Collections:

Museo de Bellas Artes, Tandil, Buenos Aires Province; Museo de Bellas Artes, La Plata, Buenos Aires Province; Museo Nacional de Bellas Artes, Buenos Aires.

Publications:

By GRIPPO: Article—"Complementaridad de los pares opuestos" with others, in *Artinf 15* (Buenos Aires), November 1972.

On GRIPPO: Books—*Victor Grippo* by Jorge Glusberg, Buenos Aires, Centro de Arte y Comunicación, 1980; *Transcontinental: An Investigation of Reality* by Guy Brett, New York and London, Verso, 1990; *Victor Grippo,* exhibition catalog, text by Guy Brett, M. Catherine de Zegher, and Elizabeth A. Macgregor, Birmingham, Ikon Gallery, 1995; *Cantos paralelos: La parodia plástica en el arte argentino contemporáneo,* exhibition catalog, text by Mari Carmen Ramírez, Marcel Eduardo Pacheco, and Andrea Giunta, Austin, University of Texas, and Buenos Aires, Fondo Nacional de las Artes, 1999. **Articles**—"Carta de Valeno Ferreyra al pintor Victor Grippo" by Valerio Ferreyra in *Diario Nueva Era* (Tandil), April 1958; "Por las Galerias" by Cordoba Iturburu in *Diaro El Mundo* (Buenos Aires), August 1966; "Aspectos del Premino Ver y Estimar Modeladores de la Realidad" by Carlos Claiman in *Diario La Nacion* (Buenos Aires), April 1967; "A Noble Medium: Acrylics" by Kemble in *Buenos Aires Herald,* August 1972; "Las perfecciones acrilicas" by Horacio Safons in *Revista Primera Plana* (Buenos Aires), August 1972; "Vanguardias Artistics y Cultura Popular" by Nestor Garcia Canclini in *Transformaciones No. 90* (Buenos Aires) 1973; "Avantegarde et Fers de Lance" by Hugo Verlomme in *Quotidien de Paris,* February 1975; "Arte Popular y Sociedad en America Latina: Teorias esteticas y ensayos de transformacion" by Nestor Garcia Canclini in *Nueva Vision* (Buenos Aires) 1976; "Art of the Americas, the Argentine Project" by Ken Johnson, in *Art in America,* 80, April 1992, pp. 164–165; "A Quality of Light" by Valerie Reardon, in *Art Monthly* (United Kingdom), 207, June 1997, pp. 42–44.

*

Victor Grippo comments:

At present the artist has the possibility of playing a role which transcends the importance of his own work. Situated as he is between the social force that nurtures him and the social force that he can derive from his creative imagination, the artist will be obliged to take as a point of departure an ethical and genuinely progressive intention, transforming himself into the integrator of varied experiences. (Being in opposition to the continued fragmentation that oppresses our society.) In this way he can contribute to the conception of a more complete man.

My proposition is that of weakening the contradiction between art and science, through an aesthetic anchored in a complete chemical reaction between the logical-objective and the subjective-analogical, between the analytic and the synthetic. The imagination (not fantasy) is an instrument of creative knowledge no less rigorous than the one supplied by contemporary science.

Since 1970 I have completed a series of works, taking food (of Latin American origin) as the basic material. Through certain scientific approximations it was capable of provoking a reaction in the spectator's mind.

* * *

Born to Italian immigrant parents in Junín, Argentina, in 1936, Victor Grippo studied chemistry at the Universidad Nacional de la Plata and design at the Escuela Superior de Bellas Artes in Buenos Aires. Although he had worked as a painter and etcher since 1953, Grippo rose to prominence only in the 1970s when he became a leading member of the Grupo de los Trece (Grupo CAYC), founded

by the art critic Jorge Glusberg in 1971 and affiliated with the Centro de Arte y Comunicación at the Instituto Di Tella in Buenos Aires. Beginning in 1975, the group consisted of six members: Glusberg, Grippo, Jacques Bedel, Luis Fernando Benedict, Alfredo Portillos, and Clorindo Testa.

By combining his scientific knowledge with his artistic vision, Grippo produces conceptual works that challenge viewers' perceptions of art while deliberately questioning their knowledge. In this respect his work has sometimes been likened to that of the *arte povera* movement. Grippo takes recognizable objects and charges them with meaning that can be read on several different levels. Although his work explores the way in which language, art, and science work together, he can also be seen as commenting on political repression in Argentina, which culminated in the so-called dirty war (1976–82). His work is essentially organic and antitechnological, celebrating instead the commonplace. Indeed, this can be seen in his first openly political work, *Horno de pan* (1972), done with Jorge Gamarra and Rossi, a rural worker. They constructed a brick oven in Buenos Aires that produced bread for passersby before it was demolished by the authorities. This work underlined Grippo's desire to connect urban and rural populations, the modern with the traditional, a concept reinforced in *Algunos oficios* (1976), which celebrated the skills of three laborers largely unseen in an urban setting: the bricklayer, blacksmith, and farmer.

Grippo is best known, however, for a series of works entitled *Analogía,* in which the central object is the potato. *Analogía IV* (1972) juxtaposes two place settings at the same table, one real, the other synthetic. Similarly, *Analogía* (1975) places a real potato next to a stone. In *Analogía I (Energia)* (1977), 40 potatoes are wired with electrodes and connected to a voltmeter, demonstrating an unseen aspect of the potato, its ability to generate electricity. This is also revealed in *T.S.F. con papa* (1974). Grippo developed this process of transformation further by encasing pulses inside geometric lead flasks. In *Vida-Muerte-Resurrección* (1980) the addition of water made beans germinate and burst out of their containers, rupturing them in the process. The essence of these works is in revealing the inherent energy of common foodstuffs, which in turn power the consumer. Taking the potato and bean, as much symbols of the Andes and the New World as international food staples, Grippo unifies all sectors of Argentine society.

In *Serie de las valijas,* beginning the late 1970s, Grippo enclosed objects in transparent cases, enshrining them as if they were religious treasures or miniature portable art galleries. Some celebrate the ordinary, as with *Valajita de panadero* (1977), *Lead and Coal* (1984), and *Nest* (1984). Others, such as *Rose in a Vase* (1984), return to the theme of growth and germination, while still others commemorate famous people, as in *Pequeña valija para Le Corbusier* (1984).

Grippo celebrates the ordinary, and by doing so he creates a extraordinarily rich and diverse art. His work skillfully confronts Argentine society and its stark division between the urban, modern elite and rural, traditional communities. His *Analogía* series revealed new aspects of the potato but in doing so also evoked methods of torture and inequality to criticize political repression. Grippo's ability to take the commonplace and present it in a new light, as in *Tabla* (1978), where the surface of a table and its single drawer are covered with the same writing, challenges the preconceptions of the viewer. His ability to enshrine the ordinary serves to remind the viewer of shared origins and the wider implications of an integrated society.

—Adrian Locke

GRONK
American painter and performance artist

Born: Glugio Gronk Nicandro, Los Angeles, California, 1954. **Education:** Dropped out of high school; studied art, East Los Angeles College, c. 1970. **Career:** Cofounder and member, performance art group *Asco,* 1972–87. Artist-in-residence, Villa Montalvo, San Jose, California, 1996, and University of Rochester, New York, 1998. **Awards:** Artist of the Year, Mexican American Fine Art Association, Los Angeles, 1977; visual artist fellowship, National Endowment for the Arts, 1983.

Individual Exhibitions:

1984 Molly Barnes Gallery, Los Angeles
1985 *The Titanic and Other Tragedies at Sea,* Galerie Ocaso, Los Angeles
1986 *The Rescue Party,* Saxon-Lee Gallery, Los Angeles
1987 *Bone of Contention,* Saxon-Lee Gallery, Los Angeles
1988 *She's Back,* Saxon-Lee Gallery, Los Angeles
1989 *Grand Hotel,* Saxon-Lee Gallery, Los Angeles, and Iannetti-Lanzone Gallery, San Francisco
 King Zombie, Deson-Sauders Gallery, Chicago
1990 *China Is Near,* William Traver Gallery, Seattle
 Coming Home Again, Vincent Price Gallery, East Los Angeles College
 Hotel Senator, Saxon-Lee Gallery, Los Angeles
1991 *50 Drawings,* Daniel Saxon Gallery, Los Angeles
1992 *Hotel Tormento,* Galerie Claude Samuel, Paris
 Fascinating Slippers/Pantunflas fascinantes, Mexican Museum, San Francisco, San Jose Museum of Art, California, and Daniel Saxon Gallery, Los Angeles
1993 *A Living Survey,* Mexican Museum, San Francisco, Los Angeles County Museum of Art, and El Paso Museum of Art, Texas (retrospective)
1998 *Gronk X 3: Murals, Prints, Projects,* San Jose Museum of Art, California

Selected Group Exhibitions:

1975 *Chicanismo en el arte,* Los Angeles County Museum of Art
1982 *Asco '82,* Galeria de la Raza, San Francisco
1986 *Crossing Borders/Chicano Artists,* San Jose Museum of Art, California
1987 *Hispanic Art in the United States: Thirty Contemporary Painters and Sculptors,* Museum of Fine Arts, Houston (traveling)
1989 *Hispanic Art on Paper,* Los Angeles County Museum of Art
 Le Demon des Anges, Paris and Nantes, France, Barcelona, Spain, and Stockholm
1990 *Chicano Art/Resistance and Affirmation, 1965–1985,* Wight Art Gallery, University of California, Los Angeles (traveling)
1991 *Myth and Magic in the Americas: The Eighties,* Museum of Contemporary Art, Monterrey, Mexico

1992 *Chicano & Latino: Parallels and Divergence,* Kimberly
 Gallery, Washington, D.C., and El Paso Museum of
 Art
1993 *Chicano/Chicana: Visceral Images,* The Works Gallery
 South, Costa Mesa, California
 *Sin Frontera: Chicano Arts from the Border States of
 the U.S.,* Corner House, Manchester, England

Collections:

Denver Art Museum; Museum of Contemporary Art, Los Angeles; El
Paso Museum of Art; Corcoran Gallery, Washington, D.C.; Mexican
Museum, San Francisco; University of Texas, Austin; Fisher Gallery,
University of Southern California, Los Angeles.

Publications:

On GRONK: Books—*Hispanic Art in the United States: Thirty
Contemporary Painters and Sculptors,* exhibition catalog, by John
Beardsley and Jane Livingston, Abbeville Press, New York, 1987;
Gronk!: A Living Survey, 1973–1993, exhibition catalog, essay by
René Yañez, Mexican Museum, San Francisco, 1993. **Articles**—
"Chicanismo en El Arte" by Eduardo Fiaco, in *Artweek,* 6, 17 May
1975, p. 3; "Gronk and Herron: Muralists," in *Neworld Magazine,* 2,
April 1976, pp. 29–30, and "Gronk: Off-the-Wall Artists," in *Neworld
Magazine,* 4, July 1980, pp. 33–35, 42, both by Harry Gamboa; "Art
without Borders" by Tony Castro, in *Los Angeles Herald Examiner,*
4 May 1978; "Gronk and James Bucalo, Morning Becomes Electric-
ity" by Linda Burnham, in *Artforum,* 24, February 1986, pp. 110–111;
"Artist Won't Be Confined to Gallery" by Zan Dubin, in *Los Angeles
Times,* 6 June 1986; "Art for Eyes and Ears from Gronk" by David L.
Beck, in *San Jose Mercury News,* 18 September 1996, p. 3E. **Film**—
Gronk: A Work in Progress, produced by Debra Mims, Madison,
Wisconsin, Elvehjem Museum of Art, 1993.

* * *

Glugio Gronk Nicandro was a member of the Chicano perform-
ance group Asco who went on to produce his own drawings and
paintings, developing a reputation as an artist with a bold, individual
style. He has earned a great deal of mainstream acceptance for his
work and in 1993 had a career retrospective at the Los Angeles
County Museum of Art (LACMA). This event had a special irony
considering that some 20 years earlier the members of Asco had spray
painted their names on the front of the museum after they were told
that LACMA would not let them exhibit there.

Gronk first became interested in art as a child, fascinated by
shows on television and inspired by his school art classes. He made a
series of African-style ceramic masks and buried them throughout
East Los Angeles, thinking that archaeologists would find them
hundreds of years later and wonder what Africans had been doing
there. In high school he met Patssi Valdez and Willie Herrón III and
began working on artistic performances with them. He also contrib-
uted to the Chicano journal *Con Safos* and was invited by Harry
Gamboa, Jr., to submit work to the journal *Regeneración.* These
collaborations eventually led to the formation of Asco.

Gronk participated in Asco's performances and collaborated
with Herrón on several mural projects. The nightmarish, scowling
faces that Gronk added to the *Black and White Mural* (1979) prefigure
the expressionistic images that would later populate his paintings and
drawings. He performed in the 1985 play *Jetter's Jinx,* written by
Gamboa and co-starring Humberto Sandoval. Gronk also contributed
a large-scale, site-specific painting installation with Herrón to an
exhibition at the Museum of Contemporary Art in Los Angeles
entitled *Summer of 1985.* During this time he was developing his own
unique artistic style that was inspired by German expressionism and
the dark, brooding paintings of James Ensor, as well as by the bright
colors of Chicano and Mexican art and subjects adapted from film
noir and Raymond Chandler stories.

Gronk has usually worked in series, completing drawings,
paintings, and large-scale mural installations surrounding specific
themes. He has done series, including *Titanic, Grand Hotel,* and *Hotel
Senator,* that have references to Hollywood culture during the 1940s
and '50s and to cheap tabloid thrillers. Frequently in his work he
critiques the hypocrisy of the wealthy. His images, however, always
retain a certain mystery. A recurring theme in his work is "La
Tormenta," an image of a woman viewed from behind that is at the
same time glamorous and tragic. According to the artist, La Tormenta
was inspired by Ingrid Bergman in the film *Notorious* (1946), in
which she wore a dress with a dramatic V-back. In recent years he has
incorporated his work into performances that recall his years with
Asco. In 1995 he performed at the University of California, Los
Angeles, with the Kronos string quartet and an opera singer dressed as
La Tormenta. While music played he created an impromptu painting
that included an image of the femme fatale. Gronk often describes
himself as an urban archaeologist who excavates meanings from
below the surface of the urban environment. His work is a unique
synthesis of Chicano and southern California film cultures.

—Erin Aldana

GRUNER, Sylvia
**Mexican painter, sculptor, and video and
installation artist**

Born: Mexico City, 1959. **Education:** Betzalel Academy of Art and
Design, Jersualem, B.F.A. in art 1982; Massachusetts College of Art,
Boston, M.F.A. (honors) 1986. **Awards:** Jovenes Creadores, 1990,
and Coinversiones Culturales, 1993, both Fondo Nacional para la
Cultura y las Artes.

Individual Exhibitions:

1986 *Conversations with Loto Blue,* Thompson Gallery,
 College of Arts, Boston
1987 Alley of Beso, Boston
1990 *Silvia Gruner, instalaciones, dibujos, video,* Museo del
 Chopo, Mexico City
1991 *De las formas ancestrales o uno comiéndose su propia
 cola,* Curare, Mexico City

1992 *Destierro,* Centro Cultural Arte Contemporáneo, Mexico
 City (traveled to Itzamatitlan, Morelos, Mexico)
 Fetiches doméstico, Itzamatitlan, Morelos, Mexico
1993 *La expulsión del paraiso,* Ex-Convento de Tepoztlán,
 Morelos, Mexico
 Las justificaciones del placer, Galeria Nina Menocal,
 Mexico City
1994 *Azote,* Temistocles 44, Mexico City
 Reliquias, Instituto de Cooperación Iberoamericana de
 Buenos Aires
 Inventario, Museo Carrillo Gil, Mexico City
1996 *Cubiertos,* XXIV Festival Cervantino, Alhóndiga de
 Granaditas, Guanajuato, Mexico
1997 *Detalles arquitectónicos,* Galería de Arte
 Contemporáneo, Mexico City
 Collares, Centro de la Imagen, Mexico City
1998 Museum of Contemporary Art, San Diego
 Centro de la Imagen, Mexico City
1999 Espace d'art Ivonamor-Palix, Paris
2000 Museo Carrillo Gil, Mexico City

Selected Group Exhibitions:

1986 *La isla de Pandora,* Thompson Gallery, Boston
 Texto con lagartijas, North Hall Gallery, Boston
1989 *Tercera bienal de la Habana,* Havana
 Arte=Vida, Universidad Iberoamericana, Mexico City
 De la estructuración plástica en serie, Centro Cultural
 Santo Domingo, Mexico City
 A propósito, 14 obras en torno a Joseph Beuys, Ex-
 Convento del Desierto de los Leones, Mexico City
1990 *New Directions,* Galeria de la Raza, San Francisco
 The Face of the Pyramid, The Gallery, New York
1991 *El corazón sangrante,* Institute of Contemporary Art,
 Boston
1997 *Así esta la cosa: Instalación y arte objeto en
 latinoamérica,* Centro Cultural Arte Contemporáneo,
 Mexico City

Publications:

By GRUNER: Book—*Destierro,* n.p., 1992. **Films**—*Desnudo
desciende,* Mexico, 1986; *Desnudo con alcatraces,* Mexico, 1986;
Pecado original reproducción, Mexico, 1986; *In situ,* Mexico, 1995.

On GRUNER: Books—*Silvia Gruner, reliquias,* exhibition catalog,
Mexico, Consejo para la Cultura y las Artes, 1998; *Collares,* exhibi-
tion catalog, with text by Kellie Jones, Cuauhtémoc Medina Carrillo,
and Osvaldo Sánchez, Mexico, Consejo Nacional para la Cultura y las
Artes, 1998. **Articles**—"A Break in the Fence" by Timothy Nolan,
in *Artweek,* 25(21), 3 November 1994, p. 17; "The Labyrinths of
Mexican Art" by Rubén Gallo, in *Flash Art* (Italy), 186, January/
February 1996, pp. 52–53; "Silvia Gruner" by Magali Arriola, in *Art
Nexus* (Colombia), 24, April/June 1997, pp. 136–137; "Pequeñas
necesidades de la vida: Instalaciones de mujeres en los noventa" by
Kellie Jones, in *Las Palmas,* 19, January 1998, p. 82–89; "Silvia
Gruner" by Luz Maria Sepúlveda, in *Art Nexus* (Colombia), 28, May/
July 1998, pp. 146–147; "Silvia Gruner: Museum of Contemporary

Art" by Collette Chattopadhyay, in *Sculpture* (Washington, D.C.),
17(8), October 1998, pp. 56–57.

* * *

Sylvia Gruner has worked in any number of media—perform-
ance, video, film, photography, sculpture, found object, and site-
specific installation—but her conceptual work draws, first and fore-
most, on the visual, physical, and psychological properties of objects.
Artifacts, in particular, act as both an extension of and a surrogate for
the human body and psyche in her work.

A series of beaded necklaces created between 1995 and 1998
best exemplify Gruner's fascination with the concept of artifact.
Throughout the history of civilization necklaces have served as
conduits for a wide range of personal, mythical, and ethnological
symbolism. Gruner's necklaces represent an almost archaeological
search for forgotten continuity: the beads represent decontextualized
bodies, while the string links them together. Made from diverse and
unexpected materials—soap, chorizo, chewing gum, slingshots—and
in varying sizes, Gruner's necklaces are not ends unto themselves.
The artist situated them, either physically or virtually, in different
landscapes. In *Collar de Antigua* ("Antigua Necklace," 1995) Gruner
placed a large earthenware necklace in the ruins of a Guatemalan
convent, in *P+P* (1997) she digitally inserted a necklace into a
historical painting, and in *500kg de Impotencia (o plantear la
posibilidad)* ["500 Kilos of Impotence (Or Possibility of Doing So),"
1998] she submerged a King Kong-size necklace of boulders in the
San Diego Bay.

Dislocated from their normal context—adorning the neck of a
woman or man—the necklaces, with their circular form and stringed
units, take on a completely different meaning. Strung together, the
beads represent the accumulation of transitory information—wishes,
memories, and stories—thus mimicking the cyclical and repetitious
nature of history. The majority of these necklace projects are accom-
panied by a photographic/video documentation that often portrays
them in sections rather than in a complete view. One such portrait,
which shows a fragment of a necklace made of boulders, is blown up
as a billboard and placed high above the ground in a heavily trafficked
section of Mexico City (*Collar espectacular para el edificio Ermita*
["Spectacular Necklace for the Ermita Building"], 1997). Like the
absent presence of a body in the works of Felix Gonzales-Torres, the
photograph elicits an emotional response similar to that induced by a
portrait: the necklace is poignantly anthropomorphic.

In a manner similar to Ana Mendieta and Mierle Laderman
Ukeles, Gruner's work portrays the female body and domesticity as a
site where personal merges with social. She incorporated bodily
elements (e.g., hair), fixations (body weight), banal household objects
(scrub sponges), and even the nonquantifiable accumulation of labor
(*Reparar* ["Repair"], 1999). In Gruner's lexicon these corporeal
elements serve as stand-ins for human bodies. The traditional frame-
work of society continues to control aspects of private lives even over
a long span of time lived by several different generations.

In fabricating prehistoric figurines (*Don't Fuck with the Past,
You Might Get Pregnant,* 1995) and creating fictional goddesses out
of soap (*El Nacimeinto de Venus* ["The Birth of Venus"], 1995),
Gruner recycled Mexico's archaeological heritage and invested it
with new meanings and mythologies. "My work is always a frag-
mented place," she said. "It's a place that basically is filled with
tepalcates (fragments of pots and vessels), the little pieces of clay that
can be found everywhere. But cannot be constructed."

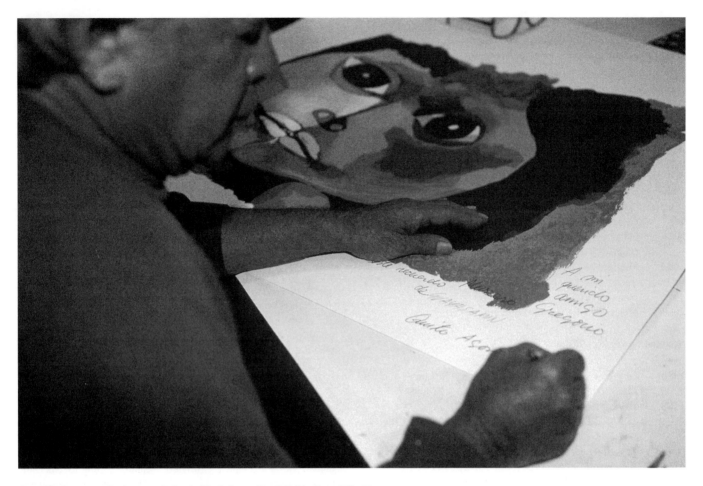

Oswaldo Guayasamín signs a painting in his Quito studio. © Pablo Corral/Corbis.

Inanimate objects that function as anthropomorphic surrogates have gradually replaced the performing bodies in Gruner's early work. Her video work *Lazy Susan* (2000) displays two water-filled glasses placed on a turntable to resemble a dancing couple, alluding to the ritualistic aspects of romance; in the video installation *Eclipse* (2000) cheap Chinese porcelain figurines performing inert sex acts were placed by a window. Such works indicated Gruner's interest in the I Ching and related philosophies that gave a Zen-like proclivity in her investigations of the transitory and of the multitudinous dimensions between the physical and metaphysical.

—Hitomi Iwasaki

GUAYASAMÍN, Oswaldo

Ecuadoran painter

Born: Quito, 6 July 1919. **Education:** Escuela de Bellas Artes, Quito, 1932–41, diploma 1941; studied fresco painting under José Clemente Orozco, Mexico, 1943. **Career:** Visited the United States by invitation of the U.S. Department of State, 1943. Muralist, including murals at Government and Legislative Palaces, Central University, and Provincial Council, all Quito, Barajas Airport, Madrid, UNESCO

Headquarters, Paris, and Latin American Parliament, São Paulo, Brazil. **Awards:** Grand award, Biennial of Spain, 1952; grand award, Biennial of São Paulo. **Died:** 10 March 1999.

Individual Exhibitions:

1952 Mortimer Brandt Gallery, New York
 Duveen-Graham Gallery, New York
1955 Pan American Union, Washington, D.C.
1995 Palace Museum of Luxemburg
 Glace Palace Museum, Buenos Aires

Selected Group Exhibitions:

1943 *The Latin American Collection of the Museum of
 Modern Art,* New York
1944 Art Institute of Chicago
1955 *Pittsburgh International,* Carnegie Institute
1959 *South American Art Today,* Dallas Museum of Fine Arts
1966 *Art of Latin America since Independence,* Yale Univer-
 sity, New Haven, Connecticut, and University of
 Texas, Austin
1969 Philbrook Art Center, Tulsa
1970 Center for Inter-American Relations, New York

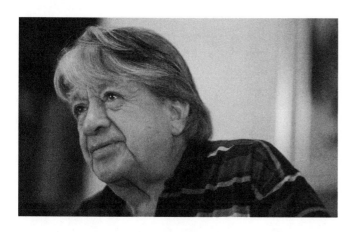

Oswaldo Guayasamín. © Pablo Corral/Corbis.

Collections:

Art Institute of Chicago; Museum of Modern Art, New York; Museum of Modern Art of Latin America, Washington, D.C.; San Francisco Museum of Modern Art.

Publications:

By GUAYASAMÍN: Books—*Guayasamín,* exhibition catalog, Paris, Musée d'Art Moderne de la Ville de Paris, 1973; *The Time That I Have Had to Live,* Guayaquil, Ecuador, Poligrafica Publishing Division, 1988; *Guayasamin: Oleos, dibujos, acuarelas y grabados,* Dominican Republic, Editora Cirripio, 1994; *Guayasamín,* exhibition catalog, Córdoba, Diputación de Córdoba, 1997; *Guayasamín: Yuelo de un ave blanca,* Quito, Universidad Católica del Ecuador, 1999.

On GUAYASAMÍN: Books—*Guayasamín Cuenca* by Gonzalo Humberto Mata, Cuenca, Ecuador, Editorial Biblioteca Cenit, 1969; *Oswaldo Guayasamín* by Jacques Lassaigne, Barcelona, Spain, Nauta, 1977; *Guayasamín* by Jorge Aravena, Música, Quito, Palabra e Imagen del Ecuador, 1978; *Oswaldo Guayasamín* by José Camón Aznar, Barcelona, Spain, Polígrafa, 1981; *Oswaldo Guayasamín, pintor* by Carlos D. Mesa G., La Paz, Bolivia, Periodistas Asociados Televisión, 1991; *Guayasamín: Una vida dedicada por entero a la creatividad* by Jorge Enrique Adoum, Rodrigo Villacis Molina, and others, Quito, Revista S.I.T.S.A., 1991. **Article**—"Oswaldo Guayasamín" by María José Ramírez, in *Art Nexus,* 32, May/July 1999, p. 38.

* * *

As one of the most renowned twentieth-century Ecuadoran artists, Oswaldo Guayasamín initiated a second wave of indigenism by stylistically renewing the themes originated by his predecessors. In his paintings he reinterpreted modernist visual syntaxes, modifying and applying them to socially critical subjects in a unique way.

As did most Ecuadoran artists of his generation, Guayasamín received his artistic training at the Escuela de Bellas Artes, where he studied with Pedro Leon Donoso. Guayasamín's early work dealt with indigenous themes and contemporary political events. *Los niños muertos* ("The Dead Children"), for example, depicted the innocent victims of a violent conflict over political succession in Ecuador. In

this piece he painted a heap of intertwined corpses in a thick mud-colored impasto, conveying a sense of tragedy through the distorted forms and harsh texture of the composition.

A visit by Nelson A. Rockefeller to Ecuador in 1942 altered the course of Guayasamín's career. Rockefeller was so impressed with the artist's work that he purchased five of his paintings. Upon his return home, Rockefeller convinced the U.S. State Department to invite Guayasamín to the United States as a guest of the government. In the United States Guayasamín had the opportunity to view for the first time numerous original paintings by American and European artists. He took particular interest in the works of Pablo Picasso and the Mexican artist Rufino Tamayo, later absorbing aspects of their styles into his own compositions. After several months of exhibiting throughout the United States, Guayasamín traveled to Mexico to assist José Clemente Orozco with his mural *Apocalypse* and to learn the technique of fresco painting.

Upon his return to Ecuador, Guayasamín began to incorporate into his paintings the formal innovations he had been exposed to while abroad, developing his own modern visual idiom for the depiction of socially critical themes. *Huacayñan* ("Trail of Tears"), created between 1946 and 1951, defined his future approach to painting. In preparation for this project he spent several years traveling in Peru, Chile, Argentina, Bolivia, Uruguay, and Brazil, making thousands of drawings of the peoples of South America and of the terrible poverty in which they lived. He conceived of *Huacayñan* as a series comprised of 103 individual paintings and unified by a common theme. Each painting included one or two figures delineated in a sharp angular style and painted in a restricted palette. The repetition of the same figure or figural type in a slightly altered pose emulated the visual experience of cinema. The series was based on the idea of racial identities in Latin America and was divided into three thematic groups: the Indian, the mestizo, and the black. Within each thematic group he used technical and chromatic variations as a signifying mechanism, associating each race with a particular style. He was thus able to explore racial typologies through the serial nature of his work.

After *Huacayñan*, Guayasamín began work on *La edad de la ira* ("Age of Anger"), a series that consisted of more than 300 paintings. In this series he broadened his worldview, dealing with the universal theme of crimes against humanity. For the project he traveled to the sites of World War II concentration camps and of numerous European conflicts, exposing through his paintings the suffering and anguish of war victims. The paintings demonstrate an increased severity of form and compositional simplicity. Characteristic of the series is the use of the fragment. He often isolated heads or hands in exaggerated gestures of pain and torment. In *La edad de la ira* he dealt with socially poignant subject matter in a distinctly modern visual idiom. His art thus served as a counterpart to the trend toward abstraction that emerged after World War II. As Katherine Manthorne has pointed out, his style places Guayasamín among neofigurative expressionists such as Willem de Kooning or Francis Bacon.

An extremely diverse artist, Guayasamín created numerous murals and sculptures in addition to oil paintings. He even worked in balsa wood and designed jewelry based on pre-Columbian motifs. His murals, unlike his paintings, depict complex historical narratives, often subverting official versions of events to expose patterns of exploitation.

Guayasamín's art clearly reflects his political consciousness. His philosophical outlook and involvement with human rights organizations indicate his leftist leanings. Consequently, Fidel Castro invited him to visit Cuba in 1959, and he was one of the first Western

artists to work in Mao Zedong's China. Guayasamín did not view his art as a means of creating a national identity but rather attempted through his painting to deal with universal issues. The Guayasamín Foundation in Quito continues the artist's legacy, housing numerous original paintings as well as his extensive collection of pre-Columbian and colonial art.

—Michele Greet

GUERRERO GALVÁN, Jesús

Mexican painter

Born: Tonalá, Jalisco, 1910. **Education:** San Antonio Art School, Texas, 1925–27; Escuela Libre de Pintura, Guadalajara, 1928. **Career:** Moved to Mexico City, 1930s. Portrait artist and instructor in elementary schools, Mexico City, 1925–38. Professor, La Esmeralda, Mexico City, 1939–42; deputy, Partido Popular political party, 1952. Artist-in-residence, University of New Mexico, Albuquerque, 1942. Traveled to the Soviet Union, 1960. Cofounder, Alianza de Trabajadores de Artes Plásticas, 1934, and Unión de Pintores y Grabadores de México, 1959. **Died:** Cuernavaca, Morelos, 1973.

Individual Exhibitions:

1942 Quinta Art Gallery, Albuquerque
 Art League of New Mexico, Albuquerque
1943 Julian Levy Gallery, New York
1959 Mexican Art Gallery, San Antonio, Texas
1977 Museo de Arte Moderno, Mexico (retrospective)
1994 Galería Fernando Gamboa, Mexico (retrospective)

Selected Group Exhibitions:

1939 World's Fair, New York
1940 *Twenty Centuries of Mexican Art,* Museum of Modern
 Art, New York
1989 *The Latin American Spirit: Art & Artists in the U.S.,*
 Bronx Museum, New York
1999 *Misiones culturales,* Museo Casa Estudio Diego Rivera
 y Frida Kahlo, Mexico

Collections:

Colorado Springs Fine Arts Center; Museum of Modern Art, New York; Philadelphia Museum of Art.

Publications:

By GUERRERO GALVÁN: Book—*A Mexican Painter Views Modern Mexican Painting,* Albuquerque, University of New Mexico Press, 1942.

On GUERRERO GALVÁN: Books—*Contemporary Mexican Artists* by Agustín Velázquez Chávez, New York, Covici-Friede, 1937; *La Quinta Gallery Catalogue,* exhibition catalog, by MacKinley Helm, Albuquerque, Quinta Art Gallery, 1942; *Jesús Guerrero*

Jesús Guerrero Galván: *Head of Woman,* **1940. © Christie's Images/Corbis.**

Galván (1910–1973): Visión poética de un gran pintor, exhibition catalog, with text by Bertha Taracena, Mexico, Museo de Arte Moderno, 1977; *Jesús Guerrero Galván (1910–1973): De personas y personajes,* exhibition catalog, with text by Olivier Debroise, Mexico, Museo de Arte Moderno, 1994.

* * *

The Mexican artist Jesús Guerrero Galván was born in 1910 of Tarascan parents in Tonalá in Jilisco state. He studied art in San Antonio, Texas, and then in 1928 at the Escuela Libre Pintura de Guadalajara. At the time the latter school was directed by Juan Ixaco Farías, a disciple of the French painter Adolphe William Bouguereau. While teaching art in primary schools in Mexico City from the late 1920s through the early 1930s, Guerrero Galván encountered the commanding public murals of the Mexican mural renaissance and was forced to rethink his neoacademic conception of art. By the mid-1930s he had developed the mature style for which he came to be known, a sort of poetic and semi-indigenous allegorical painting that has little to do with the overt political critiques otherwise associated with the modern Mexican school. As the patron MacKinley Helm once noted, the paintings of Guerrero Galván are distinguished more by a tone of ''passive tranquility than of active happiness.''

Guerrero Galván's oil paintings are at once formally compact, visually austere, and iconographically simple. Never a prolific artist, he evidently executed only eight to ten canvases a year. The titles of his works often encapsulate the thematic directness of his pictorial allegories, for example, *Fertilidad* (1931) or *Imágenes de México*

(1950). Each work avoids distractive elements or tangential parts as it addresses the main theme in a straightforward way that nevertheless gains in suggestiveness owing to the ambience of poetic reverie. One of the main traits of his paintings, as the Mexican scholar Justino Fernández once noted, is a distinctively rich texture that is marked by a broad range of pictorial effects, from densely impastoed parts to smooth areas and others of subtle gradations.

Despite his general concentration on easel painting, Guerrero Galván executed two major mural commissions in classic fresco, one in the United States and the other in Mexico City. These are *La unión de las Américas bajo la égida de la Libertad* (''The Union of the Americas under the Aegis of Liberty''), painted in 1942–43 in Scholes Hall at the University of New Mexico in Albuquerque, and *Alegoría de la electricidad* (''Allegory of Electricity''), painted in 1952 at the Comisión Federal de Electricidad in Mexico City.

The fresco in Albuquerque was executed while Guerrero Galván was an artist-in-residence at the university. Of all his works this rather large public image showcases the strengths of his visual language. The painting features figures that are approximately life-size in a spare setting with an uncomplicated iconographic program about the necessity of Pan-Americanism, an anti-Fascist theme of ethnic harmony that was particularly important to the Allies during World War II. The scene represents the friendship between two mothers and their infants, the group on the side on the fresco pointing north being Anglo and the group on the south side Mexican. (The Mexican woman is perhaps more Amerindian than mestizo.) Hovering above the scene is a dynamic personification of the classic figure of Liberty, who is connected to French art from Delacroix's painting *Liberty Leading the People* through Frédéric-Auguste Bartholdi's *Statue of Liberty*. Yet the Amerindian features of Liberty clearly link the personification not only with Old World cultural traditions but also with New World ethnicity.

The notable visual charge of the painting, however, comes less from the serene allegory of multiculturalism than from the more dramatic, as well as somber, visual language that Guerrero Galván has employed. The language, which is quite cohesive overall, entails an interesting synthesis of elements taken from the two greatest, but generally rather divergent, practitioners of Mexican muralism: Diego Rivera and José Clemente Orozco. The pictorial debts to Rivera's ''renovative classicism,'' to quote Fernández, include the calm symmetry of the main figurative motifs clearly located in the foreground along with an emotional restraint that links the culture of classical Greece with that of American Indians. The intracultural thematic commitment to intellectual harmony in antiquity has, however, been transformed here into one of transcultural racial harmony, which was a defining element of Rivera's mature manner.

Equally important debts to Orozco are registered in the Albuquerque fresco painting. There is a massive simplicity and stark palette with a somber range that are hallmarks of Orozco's most profound murals from 1926 at the National Preparatory School in Mexico City. Indeed, the somewhat dramatic light and dark contrasts, coupled with the somber earthy tones of limited value range, are more in keeping with Orozco's renovative baroque and its non-Apollonian debt to the peculiarly blanching chiaroscuro of El Greco. The result of this brooding Orozco-like palette, which was used by Guerrero Galván in conjunction with the neoclassical reserve of Rivera, is a painting with a complex mood. It is hopeful yet not untroubled.

Such a mood in *La unión de las Américas* deftly embodied several different things at once: the guarded optimism of the war effort, the sober future hopes of Mexico for greater parity with its imposing northern neighbor, and Guerrero Galván's own generally stoic, if also tender, attitude toward life as manifested in a similar way throughout his entire oeuvre. This achievement makes the fresco one of his most symptomatic and significant artworks. Moreover, the work helps one appreciate the critical assessment of Guerrero Galván by Fernández as ''one of the most well-formed Mexican artists, and one of the finest draftsman as well as colorists, which is to say, one of the most complete and meritorious of all his contemporaries.''

—David Craven

GUZMÁN de ROJAS, Cecilio
Bolivian painter

Born: Potosí, 24 October 1899. **Education:** Real Academia de San Fernando, Madrid (on scholarship), 1920s; Ecole des Beaux-Arts, Paris. **Career:** Returned to Bolivia, 1929. Director general and professor, Academia Nacional de Bellas Artes, Bolivia, and director general of the fine arts, Ministry of Education, Bolivia, both beginning in 1929. Traveled to London, 1945. **Awards:** Third prize, *Feria internacional de San Francisco,* 1939; first prize, *Salón oficial de bellas artes de Santiago;* first prize, *Salón oficial de Verano de Viña del Mar,* 1940; medal of honor, Universidad Técnica de Oruro; medal, ''Hijo Predilecto,'' Potosí. **Died:** La Paz, 14 February 1950.

Selected Exhibitions:

1929 *Salón de círculo de bellas artes,* Madrid
1930 Casa de la Moneda, Potosí
1939 *Feria internacional de San Francisco*

Publications:

On GUZMÁN de ROJAS: Book—*Mística y paisaje: Ensayos sobre la obra de Cecilio Guzmán de Rojas* by Marcelo Calvo Valda, La Paz, Librería Editorial ''Juventud,'' 1986.

* * *

Cecilio Guzmán de Rojas was born in 1899 in Potosí, Bolivia. He studied painting there under Avelino Nogales until 1920. He then traveled to Europe, where he studied with Julio Romero de Torres at the Escuela de Bellas Artes de San Fernando in Madrid. He stayed in Europe until 1929, also studying at Ecole des Beaux-Arts in Paris, France. He spent time visiting several countries and living in Spain, France, and Italy. His early education in Bolivia under Nogales provided him with an old-fashioned technique and attitude, so his time in Europe made for great exposure to European artistic trends. He developed a fondness for art nouveau and art deco from the region. This new style was apparent in Guzmán de Rojas's work upon his return to Bolivia in 1929.

Shortly after his arrival in Bolivia he was appointed director of the Escuela de Bellas Artes and director general of the fine arts in the Ministry of Education, where he renewed his artistic interests in his homeland. He aided in gaining widespread attention for the Bolivian indigenist style, first practiced by Arturo Borda and Nogales. Guzmán de Rojas combined his European education and stylistic interests with Bolivian indigenism, dubbing his style as indo-American. Through

Guzmán de Rojas's tenure at several official positions, this style of art was established as the official art of Bolivia. By the 1940s the art of the viceroyalty had been revived in Guzmán de Rojas's native village of Potosí, where due largely to his efforts the population began to embrace its own traditions and cultural values. Indigenism suddenly became popular among the high-society and wealthy classes, who continued to ignore the relevant social and economic implications that lay within this genre. Nevertheless, the indigenist style continued to slowly gain awareness for many social issues in Bolivia at the time. In 1945 Guzmán de Rojas began to focus more intently on his own painting and traveled to London with a grant to study restoration. Here he developed his coagulatory technique of painting, based on formulas he developed from ancient treatises on painting that he researched at the time.

Cecilio Guzmán de Rojas was a prolific painter. His oeuvre is usually separated into several periods. The earliest phase of Guzmán de Rojas's work was from Madrid in the 1920s and was done in a style he called *calidadismo,* which he perfected until the early '30s, when he began to adopt another style from his European experience. The second phase was characterized by a more expressionistic style influenced by the European art scene. Notably during this period he painted a series centered on the drama of soldiers in the Chaco War. A third period focused on figurative work, such as in *Aymara Christ* (1939). He also focused on many portraits during this time. Beginning in 1940 he traveled to Lake Titicaca and Machu Picchu in Peru. He painted a large series of landscapes of both places. From 1947 until his death in 1950 he focused solely on his coagulatory technique both in landscapes and semiabstract works. Among Guzmán de Rojas's most important accomplishments were his founding of the Museo Nacional de Arte and the assembly of the first collection of colonial Bolivian paintings now housed in the Museo Nacional de Potosí in Bolivia.

—Daniel Lahoda

H

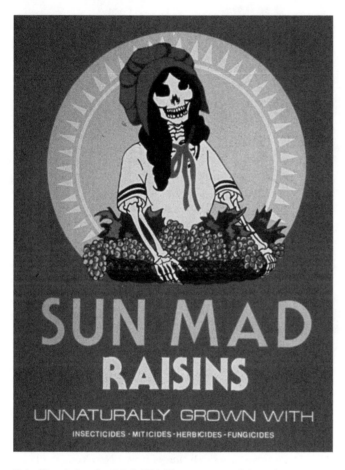

Ester Hernández: *Sun Mad,* 1981. Photo courtesy of the artist.

HERNÁNDEZ, Ester (Medina)
American painter, printmaker, graphic artist, and installation artist

Born: Dinuba, California, 3 December 1944. **Education:** Grove Street College, Oakland, California, 1973; University of California, Berkeley, B.A. in art practice 1976; California Community Colleges, art specialist lifetime credential. **Career:** Art instructor, Peralta Community Colleges, Oakland, California, 1980–81. Since 1987 art instructor, Creativity Explored of San Francisco. Visiting guest artist, Mills College, Oakland, California, 1979, 1980; visiting artist, Posada de Colores Senior Center, Oakland, California, 1983–84. Member, Latina artist collective *Las Mujéres Muralistas,* San Francisco, 1974-c. 1980s. **Awards:** Artist fellowship, Brandywine Institute, Philadelphia, 1990, 1996; grant, National Endowment for the Arts, 1992;

artist grant, Serpent Source Foundation, San Francisco, 1998; individual artist commission, San Francisco Art Commission, 2001. **Address:** P.O. Box 410413, San Francisco, California 94141–0413, U.S.A. **E-mail Address:** esterh@earthlink.net. **Website:** http://www.esterhernandez.com.

Individual Exhibitions:

1988 *The Defiant Eye,* Galeria de la Raza, San Francisco
1993 *Sun Mad Installation,* Mexican Museum, San Francisco
1995 *The Art of Provocation: Ester Hernandez,* Gorman Gallery, University of California, Davis (retrospective)
1996 *Day of the Dead,* CreArte Gallery, Minneapolis
1998 *Transformations: The Art of Ester Hernandez,* MACLA, San Jose Center for Latino Arts, California
2001 *Ester Hernandez,* Galeria de la Raza, San Francisco

Selected Group Exhibitions:

1980 *National Hispanic Feminist Art Exhibit,* Mexican Museum, San Francisco
1986 *Chicano Expressions,* Intar Latin American Gallery, New York
1987 *Latina Art Showcase '87,* Mexican Fine Arts Center Museum, Chicago
1990 *CARA-Chicano Art: Resistance and Affirmation,* Wight Art Gallery, University of California, Los Angeles (traveling)
1994 *Chicano Expressions,* Self Help Graphics, Los Angeles (traveling)
1998 *Posters: American Style,* National Museum of American Art, Smithsonian Institute, Washington, D.C. (traveling)
 The Role of Paper—Affirmation and Identity in Chicano-Boricua Art, Guadalupe Cultural Arts Center, San Antonio, Texas, and La Puntilla, San Juan (traveling)
1999 *Imagenes e historias/Images and Histories—Chicana Altar-Inspired Art,* Tufts University Gallery, Medford, Massachusetts, and DeSaisset Museum, Santa Clara University, California
2000 *Made in California,* Los Angeles County Museum of Art
2001 *Feminine Imagery,* Museo Santo Domingo, Oaxaca, Mexico (traveling)

Ester Hernández: *Frida & I*, 1998. Photo courtesy of the artist.

Collections:

Library of Congress, Prints and Photographs, Washington, D.C.; Stanford University, California; National Museum of Art, Smithsonian Institute, Washington, D.C.; Frida Kahlo Studio-Museum, Mexico City; Bronx Museum of the Arts, New York; Mexican Museum, San Francisco; San Francisco Museum of Modern Art; El Musel del Barrio, New York; Mexican Fine Art Museum, Chicago.

Publications:

By HERNÁNDEZ: Films—*Sun Mad—The Movie,* with Renee Moreno, San Francisco, Festival CineAccion, 1997; *The Fight in the Fields,* San Francisco, Tejada/Telles Productions, 1997.

On HERNÁNDEZ: Books—*International Women Artists,* exhibition catalog, London, Battersea Art Gallery, 1985; *Ester Hernandez-Artist Monograph Series,* exhibition catalog, San Francisco, Galeria de la Raza, 1988; *Yesterday and Tomorrow: California Women Artists* by Sylvia Moore, New York, Midmarch Arts Press, 1989; *Feminist Art Criticism: An Anthology* by Arlene Raven, Ann Arbor,

University of Michigan Research Press, 1989; *Mixed Blessings: New Art in Multicultural America* by Lucy Lippard, New York, Pantheon, 1990; *CARA-Chicano Art: Resistance & Affirmation,* exhibition catalog, Los Angeles, Wight Art Gallery, University of California, 1991; *Chicano Art* by Alicia Gaspar de Alba, Austin, University of Texas Press, 1998; *California Art: 450 Years of Painting & Other Media* by Nancy Moure, n.p., Dustin Publication, 1998; *Transformations: The Art of Ester Hernandez,* exhibition catalog, text by Holly Barnett, San Jose, California, MACLA, 1998; *Imagenes e historias/Images and Histories: Chicana Altar-Inspired Art,* exhibition catalog, text by Amalia Mesa Baines and others, Medford, Massachusetts, Tufts University, 1999. **Articles**—"A Mural Is a Painting on a Wall Done by Human Hands" by Victoria Quintero, in *El Tecolote* (San Francisco), 1974; "Ester, Lupe y La Chicana" by Dorinda Moreno, in *La Razon Mestiza II* (San Francisco), summer 1976; "Controversial Artist—Ester Hernandez" by Steven Harlow, in *En Frecuencia* (Santa Rosa, California), 1980; "The Art of Ester Hernandez" by Juan Felipe Herrerra, in *El Tecolote* (San Francisco), 1982; "La Exposicion Chicana en el MAMA" by Raquel Tibol, in *Proceso 890* (Mexico City), 1993; "Transformations: The Art of Ester Hernandez at MACLA" by Casey FitsSimmons, in *Artweek* (San Jose), October 1998; "California Muddles Along" by Kenneth Baker, in *San*

Francisco Chronicle, 15 November 2000; ''Retrieving Magic from the Vault'' by Holland Cotter, in *New York Times,* 5 January 2001.

*

Ester Hernández comments:

I was born and raised on the western slope of the Sierra Nevada in the central San Joaquin Valley of California, an area paradoxically known for its natural beauty and ongoing farmworker struggle. I was one of six children of farmworker parents. It was through family and community involvement that I learned to nurture and develop a great respect for, and interest in, the arts. My mother carried on the family tradition of embroidery from her birthplace in North Central Mexico; my grandfather was a master carpenter who made religious sculptures in his spare time; and my father was an amateur photographer and visual artist.

Equally important, the farmworking environment provided me with my first opportunities to explore the raw organic materials around me. This greatly affected my artistic sensibilities. My background has taught me that we Chicanos must continually strive for beauty and spirituality. This beauty—found in both nature and the arts—is the seed that uplifts our spirit and nourishes our souls.

For the past twenty years, I have also been committed to visually depicting the dignity, strength, experiences and dreams of Chicana/Latina women. As a Chicana artist, I believe it is important to produce and disseminate positive images of our varied lives; my work counteracts the stereotypes of Latina women as either passive victims or demonized creatures. My subjects range from grandmothers to folk singers to truck drivers, and in a very real sense, my artwork becomes a form of iconography. In honoring the experiences of these bold women, I gain a renewed understanding of myself.

My work has been exhibited throughout the United States, Latin America, Europe, Africa, and Russia. I have received numerous grant awards; taught art in elementary school, college, senior citizen centers; and presently teach at an art center for the developmentally disabled in San Francisco, California.

* * *

Ester Hernández, a Chicana of Yaqui and Mexican heritage, was born and raised in the agricultural town of Dinuba in the southern San Joaquin Valley of California. Her family, who worked as farm laborers, encouraged artistic expression throughout her childhood, a familial impetus that would profoundly influence her art. In 1965 Hernández witnessed an event that moved her profoundly: a United Farm Workers union march led by Cesar Chavez and Dolores Huerta. By the early 1970s Hernández had become progressively more politically active and began producing art that frequently explicated in visual terms the ideologies, goals, and protests of the Chicano civil rights movement.

In 1973 Hernández enrolled in courses at Grove Street College in Oakland, California, where she studied mural painting and silk-screen printing with Chicano artist and activist Malaquías Montoya. Known for teaching not only the importance of design but also the ability of art to raise social consciousness and function as a catalyst for social change, Montoya served as an early role model for the young artist. At

this time Hernández also came into contact with the politically charged prints of Rupert García, a California artist-printmaker known for appropriating images from consumer products and the mass media and subverting them by transforming them into satirical and iconic symbols of cultural and political activism. Hernández also engaged in the processes of reinscription and subversion in the print *Sun Mad* (1982), a biting visual parody in which she transformed the bonny, smiling Sun Maid raisin maiden into a skeletal, grim emblem that strongly expressed the physical dangers suffered by farm workers as a result of corporate negligence.

In 1974 she joined the first Latina artist collective, the San Francisco-based Las Mujéres Muralistas, a group that also included Patricia Rodríguez, Graciela Carrillo, Irene Pérez, and Consuelo Méndez. The artists joined together in order to lend a distinctively feminist viewpoint to the Chicano art movement, which until that point, they felt, had been deeply sexist. By 1977 the group had completed 11 murals in San Francisco's Mission District, giving Chicana artists not only visibility but also a voice, ultimately validating their significant role in the movement. For personal, professional, and economic reasons the group officially disbanded in the 1980s.

Although at times biting and acerbic, Hernández's art could also be tender and sentimental, especially when she created works that remembered and celebrated her personal heroines. Through her frequent depictions of women, including her mother, grandmother, Tejano singer Lydia Mendoza, Mexican artist Frida Kahlo, and anonymous women of color, Hernández explored and celebrated the Latina mystique. Strong, confident, and aggressive, the females that populate her work challenge the gender-specific roles normally assigned to Latinas and demolish stereotypes, asserting their rightful place within a traditionally patriarchal space. Rather than delving into feminist issues through the exploration of sexual politics, Hernández instead chose to cast her gaze at the role and status of women within the global community, a visual and conceptual strategy that is both emancipatory and empowering. She stated: ''As a Chicana artist, I believe it is important to produce and disseminate positive images of our varied lives: my work counteracts the stereotypes of Latina women as either passive victims or demonized creatures. My subjects range from grandmothers to folk singers to truck drivers, and in a very real sense, my artwork becomes a form of iconography. In honoring the experiences of these bold women, I gain a renewed understanding of myself.''

Like many Chicano artists, Hernández attested to a strong commitment to the community, a fact that is visually validated by her preferred medium—printmaking—one that allowed her ''to meet her artistic commitment to a popular expression for working class people.'' Yet, this preference of media has never limited her artistic output, for she has continually demonstrated her flexibility and depth as an image maker by working not only with printmaking but also painting, drawing, and, most recently, mixed-media installation. Hernández is known as one of the most important and respected artists in the Chicano art movement, a visual iconoclast responsible for producing some of its most potent and memorable images by marrying wit to sociopolitical commentary and autobiography. Her dedication to socially serving the community has continued, as has her desire and ability to continually expand both the stylistic and conceptual range of her work, in turn revealing not only her own depth and diversity as an artist but also that of women and artists on an international scale.

—Kaytie Johnson

HERNÁNDEZ CRUZ, Luis

American painter

Born: San Juan, Puerto Rico, 1936. **Education:** Universidad de Puerto Rico, San Juan, B.A. 1958; American University, Washington, D.C., M.A. 1959. **Career:** Art instructor, Escuela Superior Gabriella Mistral, Rio Piedras, Puerto Rico, 1960; instructor of humanities, 1961–63, and professor of fine arts, 1968, Universidad de Puerto Rico, San Juan; director of fine arts section, Ateneo Puertorriqueño, San Juan, 1966–71. Organizer, *Grupo Frente* and the Abstract Artists' Congress. **Awards:** First prize, Instituto de Cultura Puertorriqueña Urban Landscape Competition, 1963; first prize, ESSO Inter-American Competition, 1964.

Individual Exhibitions:

1958	Universidad de Puerto Rico, Rio Piedras
1961	Instituto de Cultura Puertorriqueña, San Juan
1962	Galería Campeche, San Juan
	Museo de la Universidad de Puerto Rico, Rio Piedras
1963	Galería Sol 13, San Juan
1964	Galería First Federal, San Juan
1965	Instituto de Cultura Puertorriqueña, San Juan
1966	La Casa de Arte, San Juan
1967	Instituto de Cultura Puertorriqueña, San Juan
1968	Instituto de Cultura Hispánica, Madrid
	La Casa de Arte, San Juan
1969	Universidad de Puerto Rico, Recinto de Mayagüez
1970	Museo de la Universidad de Puerto Rico
1971	Caravan House Gallery, New York
	Newark Museum, New Jersey
	Instituto de Cultura Puertorriqueña, San Juan
1973	Museo Español de Arte Contemporáneo, Madrid
	Departamento de Instrucción Pública, San Juan
	Museo del Grabado, San Juan
1975	*XIII bienal de São Paulo,* Sala Especial, Brazil
1976	Instituto de Cultura Puertorriqueña, San Juan
1978	Museum of Modern Art of Latin America, Washington, D.C.
	Galería Botello, San Juan
	Andes Gallery, Philadelphia
1980	Meeting Point Art Center, Miami
	Universidad de Puerto Rico, Río Piedras
	Galería Botello, San Juan
1981	Graphica Creativa, Jyvaskyla, Finland
	Centro de Bellas Artes de Puerto Rico, San Juan
1983	Artspace, Virginia Miller Galleries, Miami
	Coconut Grove Gallery, Virginia Miller Galleries, Miami
1984	Museo de Arte de Ponce, Puerto Rico (traveled to Chase Manhattan Bank, Hato Rey, Puerto Rico)
	Chase Manhattan Bank, Hato Rey, Puerto Rico
1986	Arsenal de la Puntilla, Instituto de Cultura Puertorriqueña, San Juan
1988	Arsenal de la Puntilla, Instituto de Cultura Puertorriqueña, San Juan
	Park Gallery, San Juan
1998	DLC Gallery, San Juan

Selected Group Exhibitions:

1967	Tibor de Nagy Gallery, New York
	Pan American Union, Washington, D.C.
1973	*Puerto Rico Heritage,* El Museo del Barrio, New York, and Metropolitan Museum of Art, New York
1975	*XIII bienal de São Paulo,* Brazil
1985	*VII bienal del grabado latinoamericano de San Juan*
1986	*Artistas abstractos de Puerto Rico,* Galería de Arte Moderno, Santo Domingo, Dominican Republic
1987	*Puerto Rico: Between Past and Present,* O.E.A., Washington, D.C.
1989	*The Latin American Spirit: Art & Artists in the U.S.,* Bronx Museum, New York
	XVIII bienal internacional de grabado, Ljubljana, Yugoslavia
2001	*Nuevos horizontes,* Biaggi Faure Fine Art, Puerto Nuevo, Puerto Rico

Collections:

American University, Washington, D.C.; Circulo de Bellas Artes, San Juan; El Museo del Barrio, New York; Instituto de Cultura Puertorriqueña, San Juan; Lowe Art Museum, Coral Gables, Florida; Museum of Modern Art, New York; Museum of Modern Art of Latin America, Washington, D.C.; Museo de Arte de Ponce, Puerto Rico; Universidad de Puerto Rico, Rio Piedras.

Publications:

On HERNÁNDEZ CRUZ: Books—*Luis Hernández Cruz: Pinturas, obra reciente,* exhibition catalog, San Juan, n.p., 1984; *Luis Hernández Cruz: Tiempos y formas de un itinerario artístico* by Marianne de Tolentino, P San Juan, ublicaciones Puertorriqueñas, 1989; *Luis Hernández Cruz, obra gráfica, 1962–1990,* exhibition catalog, text by Luigi Marrozzini, San Juan, Comisión Puertorriqueña para la Celebración del Quinto Centenario del Descubrimiento de América y Puerto Rico, 1991; *La transición de un espacio,* exhibition catalog, San Juan, Instituto de Cultura Puertorriqueña, 1994. **Articles**—''Luis Hernández Cruz,'' in *Art Nexus* (Colombia), 16, April/June 1995, pp. 119–120; ''Luis Hernández Cruz,'' in *Art Nexus* (Colombia), 28, May/July 1998, pp. 149–150, and ''Puerto Rico's Sculpture Park,'' in *Art Nexus* (Colombia), 32, May/July 1999, pp. 18–19, both by Manuel Alvarez Lezama.

* * *

The Puerto Rican artist Luis Hernández Cruz, born in 1936, has been a part of the abstract movement since his career began in the 1960s. He has been one of the principal figures of abstract painting in Puerto Rico as well as one of the most innovative and intrepid of abstract artists in Latin America.

In the painter's own words, ''an artist is someone who communicates a nation's past, present, and future through his art. Someone who, in the moment of creation, unifies these periods and the public with culture, leaving a legacy for the future.'' Based on this philosophy, the framework for the creation of the works of Hernández Cruz is simple: a focus on culture and on the concept under which

content and form are unified. The 1961 painting titled *Guajataca Landscape* exemplifies this principle. Large areas of color create a structure within the composition that evokes an abstract landscape. He integrates the geography that surrounds him as well as his social and collective vision with his sense of history, pre-Columbian cultures, and ancestral heritage. Guajataca is a town in the northeastern coast of Puerto Rico that dates to the time of the Taino, the inhabitants of the island at the time of the Spanish conquest. Regardless of its importance, however, subject matter does not appear to govern his lyrical compositions, and the themes within his work are secondary. What predominates in his abstraction is the pictorial aspect, in which the fundamental elements are color, light, pigments and their application, and the precise positioning of well-established forms.

During the 1960s Hernández Cruz created art in which he simplified his forms, accentuated his colors, and created strokes in thick impastos. This type of abstract expressionism has a strong presence in Puerto Rico, developed as a reaction against the nationalist aesthetic of the figuration of the 1950s. During this time pop art, op art, cybernetic art, Arte Povera, minimalist art, and other movements were being recognized by museums in the United States. Influenced by minimalist art, Hernández Cruz began creating geometric forms, as in *Composition with Ochre Shape* (1976), in which color and form, even within monochromatic compositions, take absolute control of the pictorial space. During the 1970s he dedicated himself to lyrical abstraction and integrated the concept of the landscape and colors of the tropics in compositions of a more organic nature.

By the end of the 1980s and the beginning of the 1990s Hernández Cruz approached figuration, and an evolution toward the representation of emotions became apparent. In his composition *Aquelarre at Sunrise* (1987) the human figures are reduced to silhouettes that move in empty, abstract spaces of vibrant colors and strong light, as if evoking that which is absent. The artist himself terms this figuration as ''anti-figure'' and describes it as follows: ''when the form disappears, when it is no longer a figure, what is left is the aura or the mere image of what was once a pseudo-structure. The *anti-figure* presupposes a figure, but is not its true nature.''

The system of signs Hernández Cruz used in his art of the 1960s and 1970s, as well as this less abstract work, varies in its application but is driven by essentially the same aesthetic and conceptual preoccupations. The figure undergoes a metamorphosis from the everyday to the festive, represented by the carnival, for instance, where the real personality is hidden behind a mask. This works of art are imbued with a magical and fantastic expressionism in which he interprets rather than describes.

The influence of Hernández Cruz within the visual arts has not been limited to painting but has also encompassed sculpture, printmaking, and drawing. Through teaching and the support of the arts at institutions such as the University of Puerto Rico, the Art Students League, and the Fine Arts School of the Puerto Rican Institute of Culture, he has promoted, inspired, and motivated many generations of artists in the search for and the understanding and appreciation of abstraction. As a part of his devotion to this cause, Hernández Cruz helped found and later became the president of the Abstract Artists' Congress. His also has taken on another role as a propagator of the arts throughout the directorship of the University of Puerto Rico Museum, a position he describes as ''a patriotic labor, because it is about helping, in any way one can, to create culture, and to do this for new generations.''

—Eliud Alvarado Rodríguez

HERNÁNDEZ-DIEZ, José Antonio
Venezuelan sculptor and multi-media artist

Born: Caracas, 26 April 1964. **Career:** Has lived in Barcelona, Spain, and Caracas.

Individual Exhibitions:

1991	*San Guinefort y otras devociones,* Sala RG, Caracas
1995	Galeria Camargo Vilaca, São Paulo
	Sandra Gering Gallery, New York
1996	Sandra Gering Gallery, New York
	Espacio 204, Caracas
1998	Sala RG, Caracas

Selected Group Exhibitions:

1988	*IX festival internacional de Super 8 y video,* Brussels
1990	*Los 80: Panorama de las artes visuales en Venezuela,* Galerie de Arte Nacional, Caracas
	III bienal de video arte, Museo de Arte Moderno de Medellin, Colombia
1991	*Venezuela/Nuevas cartografias y cosmogonias,* Galeria de Arte Nacional, Caracas
1992	*I bienal barro de America,* Museo de Arte Contemporáneo de Caracas Sofia Imber, Caracas
	Ante America, Biblioteca Luis Angel Arango, Bogota (traveling)
1993	*The Final Frontier,* New Museum, New York
1994	*Cocido y crudo,* Museo Nacional Centro de Arte Reina Sofia, Madrid
	Cuba Annual Benefit Auction, New Museum of Contemporary Art, New York
1996	*São Paulo biennial*
	Defining the Nineties, Museum of Contemporary Art, Miami

Publications:

On HERNÁNDEZ-DIEZ: Books—*Jose Antonio Hernández-Diez,* exhibition catalog, text by Jesus Fuenmayor, Galeria Camargo Vilaca, São Paulo, 1995; *Cocido y crudo,* exhibition catalog, text by Dan Cameron, Madrid, Museo Nacional Centro de Arte Reina Sofia, 1995.

Articles—''Jose Antonio Hernández-Diez'' by Jesus Fuenmayor, in *Poliester,* 7, fall 1993, pp. 48–51; ''Brincadeiras conceituais'' by Georgia Loacheff, in *Jornal de Tarde,* 4 September 1995; ''Jose Antonio Hernández-Diez at Sandra Gering'' by Yasmin Ramirez, in *Art in America,* September 1995; ''Hernández-Diez de andanzas expositivas por el mundo,'' in *Estilo,* 6(24), 1995, p. 14; ''Jose Antonio Hernández-Diez: Una vision dionisiaca y catonica de su obra'' by Ignacio Enrique Oberto, in *Universal,* 4 June 1995.

* * *

The Venezuelan multimedia artist José Antonio Hernández-Diez builds surprising, sometimes strange versions of the pop objects

of American adolescence that are pumped through the lines of commerce from the United States to his native land. In the 1970s an unprecedented number of American consumer goods began to appear in the market throughout Latin America, and the result was a generation brought up desiring everything American: skateboards, plastic figurines, video games, and so forth. Unlike their U.S. counterparts, however, Latin American teens lived in a social reality where class and economic divisions were ubiquitous and where blatant injustices went unchecked. This world became the backdrop for Hernández-Diez's artistic expressions. In the skateboards he made out of fried pigskin, a popular snack food in Venezuela, and in his photographs of plastic toys that had been chewed, he has studied and dissected this incompatibility between social suggestion and social reality.

The skateboards in Hernández-Diez's ironically titled *La Hermandad Brotherhood* (1995) were at once living and yet trapped in a static iconographical grasp, always torn between realities, continually desiring one thing while living another. The shapes and textures of the boards–a conflation of animal, food, toy, and social icon–were like the visceral architecture of a body turned inside out. When they were hung in the gallery, grease dripped from their wheels the way fluids drip from a body. The skin was tortured, revealing the secrets of the insides it protected and contained. The body of each piece became a kind of social map, explaining itself through metaphors.

Central to Hernández-Diez's work is its humor. Not deliberately ironic, it is a stylized, self-referential rhetoric, capable of implosion and explosion at once. At times his humor can arrive at a nonsense that itself arrives at a kind of meaning. In his second solo show in New York City, in 1996, the artist presented two sets of works consisting of the memory of an action or event. In a clear reference to minimalist painting, the main room of the gallery served as the setting for panels in neutral, everyday colors. Providing a contrasting, disturbing element that upset the initially tranquil sensation were various kinds of bites made by a large animal on the otherwise pristine surfaces of the monochromes. The scene was complemented by a table–a common symbol of everyday life–which itself was covered with teeth marks. In the adjacent room, which looked like a small chapel, there was a group of high-resolution photographs showing children's plastic dolls, all in bright, toylike colors. These little figures had also been bitten, but with smaller teeth marks. The compulsive, automatic gesture of taking something we have in our hands and biting it had been tenderly aestheticized. The victimized toys, which fit in the palm of a hand, were magnified in the photographs. The artist thus established a strange dialogue between the childlike, capricious, and logical bite with an equally childlike logic of scale.

In a similar project Hernández-Diez photographed street dogs devouring skateboards. This project is an example his trademark: to capture the absurd aspect of a casual event. The action is as compulsively causal as biting little dolls. A random event recorded by the artist becomes a testimony of his deliberately incidental, lateral position, his refusal to seek the obvious solution, thus closing the chain of meaning. His work, however, is sufficiently related to a set of cultural realities to exercise a subtle critical effect on them. The slightly crazy perception, tenderly dislocated from reality, inevitably establishes another reality, which is the intimate construction. A unique equation of wit and relevant eccentricities gives these pieces a certain fictional character and a strong sense of borne witness.

—Martha Sutro

HERRÁN, Saturnino
Mexican painter

Born: Aguascalientes, 9 July 1887. **Education:** Colegio de San Francisco Javier, Aguascalientes, 1895; studied drawing, 1897; Instituto de Ciencias de Aguascalientes, 1901; studied under Antonio Fabrés, Escuela de Bellas Artes, Mexico City, 1903–08. **Family:** Married Rosario Arellano in 1914; one son. **Career:** Professor of drawing, Escuela Normal de Maestros, Mexico City, 1910–14, Escuela Nacional de Maestros, Mexico City, 1915–18. **Awards:** Painting prize, Exposición de Bellas Artes, Mexico City, 1914. **Died:** 8 October 1918.

Selected Exhibitions:

1910 Mexican Centenary Exposition
1913 Spanish Pavilion, Mexico
1918 Ateneo Fuente de Saltillo, Mexico
 Palacio de los Azulejos, Universidad Nacional, Mexico

Collections:

Museo de la Ciudad, Aguascalientes; Instituto Nacional de Bellas Artes, Mexico City.

Publications:

On HERRÁN: Books—*Saturnino Herrán* by Fausto Ramírez, Mexico City, Universidad Nacional Autónoma de Mexico, 1976; *Exposición homenaje a Saturnino Herrán en los 60 años de su muerte, 1887–1918,* Mexico City, Instituto Nacional de Bellas Artes, c. 1978; *Saturnino Herrán, 1887–1987,* Mexico City, Instituto de Bellas Artes, 1987; *Saturnino Herrán,* text by Ramón López Velarde, Mexico City, Fondo Editorial de la Plástica Mexicana, 1988; *Saturnino Herrán* by Alfonso Reyes Aurrecoechea, Monterrey, Mexico, Estado de Nuevo León, 1988; *Saturnino Herrán: Jornadas de homenaje,* Mexico City, Universidad Nacional Autónoma de Mexico, 1989; *Herrán: La pasión y el principio,* text by Victor Muñoz, Mexico, Bital Grupo Financiero, 1994; *Saturnino Herrán* by Adriana Zapett Tapia, Mexico, Consejo Nacional para la Cultural y las Artes, 1998.

* * *

In 1914 Mexican painter Saturnino Herrán began designing a mural featuring, at its center, an image that brings together the most important elements of Aztec and Christian religious visual expression; the monumentality, brutality, and passion of each merge in *Coatlicue trasformada* ("Coatlicue Transformed"). To the left of this figure, showing the Aztec deity Coatlicue with the crucified Christ subtly superimposed upon her, are Aztec supplicants bringing offerings. To the right the Spanish conquistadores and clergy approach in a religious processional. In this one work Herrán effectively depicts the process of religious syncretism and cultural *mestizaje* (the mixing of Spanish and indigenous Mexican culture) that characterizes so much of Mexican culture and that formed the basis of the most powerful art created in twentieth-century Mexico.

Herrán's academic training in the early 1900s led him toward European modernist currents, particularly the symbolist movement. In *La leyenda de los volcanes* ("The Legend of the Volcanoes," 1910), a triptych, Herrán illustrated the tale of Popocatépetl and

Iztaccíhuatl, two doomed lovers who become volcanoes upon their deaths. The nudes drape across each other in tragic repose against the landscape of the Valley of Mexico, the volcanoes looming in the background. The heightened color of the paintings and outlined figures suggest the work of Paul Gauguin and other French symbolists. Although Herrán never traveled to Europe, his instructors at the academy, notably Catalan painter Antonio Fabres, brought these movements to the young artist's attention. Another painting from that year, *Los ciegos* ("The Blind Ones"), shows seminude men in various attitudes of despair and resignation, seemingly a metaphor for the human condition.

Beginning in 1912 Herrán began to paint single-figure Mexican genre scenes. These compositions follow nineteenth-century *costumbrismo* in their depictions of peasant types, but the artist employed techniques and styles from European modernism and academic painting to elevate the works beyond simple illustrations of Mexican characters. *Vendedor de platano* ("The Plaintain Vendor") from 1912 and *El gallero* ("The Cockfighter") from 1914 feature extreme close-ups, cropped figures, and the sharp diagonal perspective characteristic of Japonisme, combined with expressive brushwork and bright colors. His 1914 portrait of his wife, *Tehuana* ("Woman from Tehuantepec"), is one of the earliest uses of the image of the Tehuana for an elite audience. Unlike later paintings of women from the Isthmus of Tehuantepec, Herrán's Tehuana does not stand as a generalized symbol of indigenous Mexico nor does she carry the political weight she might later; rather, the elaborate headdress, exaggerated in size, that flows around her head and drapes down the front of her dress serves to frame the sensuality of her face, with her full lips and heavy-lidded eyes. Herrán's Tehuana stands on the bridge between a Mexican nationalist symbol and the femme fatale of symbolist works.

His last paintings, done while executing the studies for the mural *Nuestros dioses* ("Our Gods") featuring *Coatlicue trasformada,* turn back to Renaissance portraiture while retaining his interest in images of the Mexican people. His early death in 1918 at the age of 31 left his mural unrealized except in studies. His body of work contains many of the elements of Mexican nationalism combined with European modernism that would define the art of Mexico for decades after.

—Laura J. Crary

HERRÓN III, Willie

American mural painter

Born: Los Angeles, California, 1951. **Education:** As a high school senior attended classes at Otis Art Institute and Art Center College of Design, Los Angeles, c. 1970. **Career:** Member, artist group *Asco,* Los Angeles, 1970s and 1980s; co-owner, commercial design studio, Laguna Hills, California; member, punk rock band *Los Illegals.*

Individual Exhibitions:

1972 *The Wall That Cracked Open* (mural), 4125 City
 Terrace Drive, Los Angeles
 The Plumed Serpent (mural), City Terrace Drive and
 Miller, Los Angeles

1973 *Moratorium: The Black and White Mural,* 3221
 Olympic Blvd., Los Angeles (with Gronk)
1975 *Advancements of Man* (mural), Cesar Chavez Ave. and
 Soto St., Lost Angeles (with Alfonso Trejo, Jr.)
1976 *The Sorrow of Hidalgo* (mural), 4301 City Terrace
 Drive, Los Angeles
1984 *Struggles of the World* (mural), Hollywood Freeway
 (101) at Alameda, California
1994 *Only United Will One World Be Victorious* (mural), Los
 Angeles International Airport
1995 *No somos animales* (mural), Cesar Chavez Ave. and
 Soto St., Los Angeles (with Ralph Ramirez)

Selected Group Exhibitions:

1990 *Chicano Art: Resistance and Affirmation,* Wight Gal-
 lery, University of California, Los Angeles
1999 *Shadow Altars: The Last Chicano Day of the Dead
 Altar Show,* Social and Public Art Resource Center,
 Venice, California

Publications:

On HERRÓN: Books—*Summer 1985,* exhibition catalog, by Julia Brown and Jacqueline S. Crist, Los Angeles, Museum of Contemporary Art, 1985; *Chicano and Latino Artists of Los Angeles* by Alejandro Rosas, Glendale, California, CP Graphics, 1993. **Article**—"Art with a Chicano Accent" by Steven Durland, Linda Frye Burnham, and Lewis MacAdams, in *High Performance,* 9(3), 1986, pp. 40–45, 48–57. **Film**—*Latino Artists Pushing the Boundaries* by Juan Carlos Garza and Ray Santisteban, Princeton, New Jersey, Films for the Humanities and Sciences, 1995.

 * * *

Willie Herrón III is best known for the murals he painted during the 1970s and for his involvement with the Chicano performance group Asco. He grew up in East Los Angeles, attending Garfield High School with other Asco members Patssi Valdez, Harry Gamboa, Jr., and Gronk. Herrón received a scholarship to the Art Center College of Design and the Otis Art Institute. In 1972 he first began mural painting and embarked on collaborative projects with the members of Asco.

One of Herrón's most well-known murals is *The Wall That Cracked Open* (1972). He painted it on the night that his younger brother was stabbed in a gang dispute, in the same alley where the stabbing took place, which was near his home. The mural contains images of street youth fighting, a young man injured by gang members, and a grieving grandmother emerging through a crack. He incorporated the graffiti that already existed on the wall into the composition, and over the years many graffiti artists added their signatures to the work. While he accepted these additions as part of the work's natural evolution, it became a target for initiatives in the city of Los Angeles to eliminate graffiti, and the work was partially painted over. *The Wall That Cracked Open* is an important work in the history of the Chicano mural movement. It experiments both with the surface of the wall and with the mural itself as a medium, depicting figures breaking through the naturalistically painted crack. In addition, it investigates the relationship between the officially sanctioned

Willie Herrón III, with Gronk Herrón: *Moratorium: The Black and White Mural,* Estrada Courts, Los Angeles, 1973 and 1978. Photo by Jacinto Quirarte. Reproduced by permission.

work of muralism and the illegal, highly subversive work of graffiti artists.

Herrón's work in Asco often focused on critiques of the Chicano mural movement, which had stagnated into continual references to mythic figures in Chicano culture and to its pre-Columbian roots in Mexico. In *Walking Mural* (1972) he dressed as a multiheaded figure that was meant to represent Chicano *mestizaje,* or mixed racial heritage. He also collaborated on several projects with fellow Asco member Gronk, including a portable mural painted on fabric that could be moved from site to site and the *Black and White Mural* (1979), which is located at the Estrada Courts housing project in Los Angeles. The latter work was originally painted in black and white by the two artists, but Gronk later added color. It consists of nightmarish images taken from the streets of East Los Angeles, including a scene of demonstrators being beaten and a distorted image of Patssi Valdez in a screaming grimace. These images are depicted in succession, resembling a film strip or montage, creating an aesthetic decidedly different from many of the other Chicano murals being done at the time.

Herrón has continued to paint murals, both during his years in Asco and after the group's demise in the late 1980s. He created a mural of the Aztec deity Quetzalcóatl in 1972 and a mural entitled *The Sorrow of Hidalgo* in 1976. For the 1984 Olympics in Los Angeles, he completed a mural on the Hollywood Freeway entitled *Struggles of the World.* After leaving Asco he did not make murals for many years, instead focusing on his Chicano punk rock group, Los Illegals, which often combined aspects of rock music and artistic performance. He

eventually moved to Orange County with his family and started a design studio. Herrón has done murals for a number of commercial clients, such as the Sheraton Hotel and the Art Deco Lido Cinema, both in Newport Beach. He has also been involved in the restoration of his murals, many of which are from the early 1970s and suffering damage from graffiti artists and anti-graffiti workers painting over them.

—Erin Aldana

HOMAR, Lorenzo
American painter and printmaker

Born: San Juan, Puerto Rico, 1913. **Education:** Art Students League, New York, 1931; Pratt Institute, New York, 1940; Brooklyn Museum Art School, New York, 1945. **Military Service:** Drafted by the U.S. Army, 1940. **Career:** Design apprentice, Cartier jewelers, New York, 1937–40; artist and cartoonist, *Yank, Infantry Journal, Bell Syndicated,* and *El Mundo,* 1941–45. Returned to Puerto Rico from the United States, 1950. Book illustrator and designer, 1951, and director of graphic arts department, 1952–57, Division of Community Education, San Juan. Founder and director, Taller de Artes Gráficas, Instituto de Cultura Puertorriqueña, 1957–73; taught at Escuela de Artes Plásticas. **Awards:** Fellowship, John S. Guggenheim Memorial Foundation, 1956.

Individual Exhibitions:

1946	Brooklyn Museum, New York
1950	Ateneo Puertorriqueño, San Juan
1960	Instituto de Cultura Puertorriqueña, San Juan
	Universidad de Puerto Rico, San Juan
1970	*Primera bienal del grabado latinoamericano,* San Juan
1971	Wesleyan University, Connecticut
	Museo la Tertulia, Cali, Colombia
1975	Universidad de Puerto Rico, Recinto de Mayagüez
1977	Universidad de Puerto Rico, Recinto de Mayagüez
1978	Museo de Arte de Ponce, Ponce, Puerto Rico (retrospective)
1993	Galería Palomas, San Juan
1994	Casa Rectoría, Universidad del Turabo, Turabo, Puerto Rico
	Newark Public Library, Newark, New Jersey (retrospective)

Selected Group Exhibitions:

1959	*Bienal de México*
1964	*Bienal de Tokyo*
1969	*Bienal de Cali,* Colombia
1973	*Bienal del deporte en las bellas artes,* Barcelona, Spain
1989	*The Latin American Spirit: Art & Artists in the U.S.,* Bronx Museum, New York
2000	*Palabra en el tiempo,* La Casa del Libro, San Juan
	The Explosion of Puerto Rican Art, Museo de Arte de Puerto Rico

Collections:

American Institute of Graphic Arts, New York; Ateneo Puertorriqueño, San Juan; El Museo del Barrio, New York; Instituto de Cultura Puertorriqueño, San Juan; Museum of Modern Art, New York; Museum of Modern Art of Latin America, Washington, D.C.; Museo de Arte de Ponce, Puerto Rico; Princeton University Library, New Jersey; Universidad de Puerto Rico, San Juan.

Publications:

On HOMAR: Books—*Plenas* by Tomás Blanco, San Juan, Editorial Caribe, 1955; *Spiks* by Pedro Juan Soto, Mexico, Los Presentes, 1956; *Aquí en la lucha: Caricaturas de Lorenzo Homar* by José Antonio Torres Martinó, San Juan, Cuadernos de la Escalera, 1970; *Exposición retrospectiva de la obra de Lorenzo Homar,* exhibition catalog, text by Marimar Benítez, Ponce, Puerto Rico, Museo de Arte de Ponce, 1978; *Lorenzo Homar: A Puerto Rican Master of Calligraphy and the Graphic Arts* by Dale Roylance, Princeton, New Jersey, Graphic Arts Collection, Princeton University Library, 1983; *Lorenzo Homar a los 80 años,* exhibition catalog, San Juan, Galería Palomas, 1992; *Lorenzo Homar, artista ejemplar de la gráfica contemporánea de Puerto Rico* by Juan David Cupeles, San Juan, J.D. Cupeles, 1992; *Carteles de Lorenzo Homar: Una maestra,* exhibition catalog, text by Antonio Martorell and Arcadio Díaz Quiñones, Turabo, Puerto Rico, Universidad del Turabo, 1994; *Homar: An Appreciation of Lorenzo Homar and His Graphic Works, 1954–1994, Depicting the Culture, Art, and History of Puerto Rico,* exhibition catalog, with text by Magdalena Sagardia, William J. Dane, and Daniel Schnur, Newark,

New Jersey, Special Collections Department of the Newark Public Library, 1994; *El arte de bregar: Ensayos* by Arcadio Díaz Quiñones, San Juan, Ediciones Callejón, 2000. **Article**—''The Art of Lorenzo Homar'' by Dale Roylance, in *Calligraphy Review,* 11(1), 1994, pp. 34–37.

* * *

Lorenzo Homar and his family migrated to New York City in 1928, when he was 15 years old. He was a product of the rich cultural offerings, the opportunities for employment and study that would transform New York City into a magnet for artists from all over and into the locus of a large Puerto Rican community that migrated during the post-World War II boom. Upon his return to Puerto Rico in 1950, Homar would bring a solid training in the arts combined with a cosmopolitan cultural outlook.

Homar's first art classes were under Reginald Marsh in the Art Students League in New York City. In 1937 he began to work in Cartier as an apprentice. His formal studies took place at Pratt Institute (1940) and after World War II in the school of the Brooklyn Museum of Art. Gabor Peterdi, Rufino Tamayo, Arthur Osver, and Ben Shahn became teachers, friends, and mentors of this wiry youngster, who had been an acrobat in vaudeville.

Homar's most important output was in the graphic arts. Under Peterdi he had mastered intaglio and other means of engraving, but Homar's most significant works were done in woodcut, linoleum block, and silk screen, techniques that he learned from fellow artists in Puerto Rico. Homar's early paintings and poster designs show his debt to Shahn, evident in the rendering of the figure, with an emphasis on line. The lineal style gave way to the use of flat areas of color, as Homar was increasingly involved in the design of silk-screen posters for the Division of Community Education of the Department of Education and the Institute of Puerto Rican Culture's (ICPR) Graphic Arts Workshop. Homar organized and directed this workshop from 1957 to 1973, and there he formed two generations of printmakers. The ICPR workshops evolved into the Escuela de Artes Plásticas, a public university of the arts, where Homar also taught.

The design of posters led Homar into one of his passions—books and the design of letters—a passion he was able to follow, thanks to the important collection of rare books housed in La Casa del Libro in San Juan. Under Homar silk-screen printing became a major medium and the design of posters for cultural events a must. His series for the theater and ballet festivals, museum openings and special exhibitions at the Institute of Puerto Rican Culture, the Casals Festival, and the rare book exhibitions at La Casa del Libro are both a chronicle of major cultural events and a showcase of Homar's masterly designs and impeccable execution. Homar's apprentices and students absorbed his obsession for discipline, quality, and multifaceted cultural interests.

For his personal work, Homar turned first to linoleum-block prints, then to woodcut, a medium in which he produced exquisite miniatures as well as monumental images. He collaborated with Rafael Tufiño in the *Plenas portfolio* (1953–54), a collection of prints on this popular Afro-Puerto Rican dance form. Each image has the music and stanzas of a *plena* as well as a linoleum-block illustration. Homar produced many other prints, based on literature and poetry, a genre that became a benchmark in the graphic arts of Puerto Rico. He was also involved in caricature, particularly satires on political personages that display his wit as well as his commitment to the independence of Puerto Rico. After his retirement in 1973, he

continued producing silk screens, and in 1980 he returned to painting. The impact of many years' work in printmaking is evident in the flat-color treatment of the composition. His works are conceived as miniatures, regardless of their size, and harken back to Homar's early formation as a jewel designer. The formal quality of Homar's output and his work as a teacher and mentor of young artists has had a very strong impact on successive generations of Puerto Rican artists.

—Marimar Benítez

HUERTA, Salomón
American painter

Born: Tijuana, Mexico, 1965; moved to the United States, ca. 1969. **Education:** Art Center of Design, Pasadena, California, B.F.A. in illustration 1991; University of California, Los Angeles, ca. 1994–98, M.F.A. 1998. **Career:** Lecturer, Otis College of Art and Design, Los Angeles, ca. 2001.

Individual Exhibitions:

1998 Patricia Faure Gallery, Santa Monica, California
2000 Patricia Faure Gallery, Santa Monica, California
2001 Austin Museum of Art, Texas
 FACE, L.A. Artcore Center, Los Angeles (with Peter Liashkov)

Julie Rico Gallery, Santa Monica, California; Mexico City Museum; Armory Center for the Arts, Pasadena, California; Academie of Fine Arts Gallery, Munich, Germany.

Selected Group Exhibitions:

2000 *2000 Biennial,* Whitney Museum of American Art, New York
 Luminositá: Colori dalla California, Galleria Studio la Cittá, Verona, Italy
 Revealing & Concealing: Portraits & Identity, Skirball Cultural Center, Los Angeles
2001 *Capital Art,* Track 16 Gallery, Bergamot Station, Santa Monica, California
 Inspiring Heroes, Orange County Center for Contemporary Art, Santa Ana, California

Collection:

Whitney Museum of American Art, New York.

Publications:

On HUERTA: Articles—''Salomón Huerta at Patricia Faure'' by Gianna Carotenuto, in *Art Issues,* 56, January/February 1999, p. 42; ''Salomón Huerta: Patricia Faure Gallery, Santa Monica'' by Ken Gonzales-Day, in *Artext,* 72, February/April 2001, p. 85.

* * *

Born in Mexico and based in southern California, Salomón Huerta is one of several painters whose emergence in the 1990s acted to reinvigorate the genre of portraiture. The purpose of his portraits, however, is not so much to visually express a person's appearance or psychological outlook as to suggest how the mass media, advertising, and the current social landscape can shape our perceptions of ourselves and others. Huerta's small-scale, square-shaped images of heads, as well as his larger vertical compositions of standing full figures, are painted as seen from the back. By turning his subjects around, the artist offers scant clues to their identity, whether racial, cultural, or gender. Huerta has spoken of such compositions as ''mirror-images''–works upon which the viewer may project a certain identity, thus compelling reflection upon the values, and indeed the prejudices, they call forth. Reminiscent of mug shots or scenes of a police lineup, these works evoke the realm of civil authority and the racial profiling and stereotyping experienced by many African-American and Latino urban youth.

Huerta paints figures in a realistic style, even delineating the individual hairs and creases on a person's scalp. He places his subjects against plain, brightly colored backdrops, recalling the stylized, pop-inspired modes of contemporary fashion advertising. Initially trained as a commercial illustrator, Huerta deploys the bold and simple compositional approaches of print advertisements, not to sell products, but rather to immediately engage the viewer and his critical thinking.

Beginning in 1999, Huerta extended his exploration of the mood of contemporary urban society through a series of small paintings of suburban houses. Inspired by the modest bungalows and tract homes typical of working- and middle-class southern California neighborhoods, these houses suggest a numbing banality in the lives of their occupants. Huerta's approach in painting houses is similar to that he uses in portraying human subjects. Details are largely absent, leaving a generic image of ''house'' defined by blank walls and schematic doors and windows, framed by a flat expanse of green connoting a lawn in the foreground and a similarly flat field of blue representing the sky above. The banality of the houses is underscored by the colors in which Huerta renders them–pastel pinks, lime greens, and other hues suggestive of the ''candy-coating'' that the artist associates with artificially sanitized suburban environments. Huerta composes these paintings as if the houses were seen from across the street, creating the sense of a house under observation, despite the fact that they show no signs of life. Just as his standing figures resemble individuals in a police lineup, the houses become objects of similar scrutiny; these could be the views seen by a potential burglar or by the police at a crime scene.

Huerta's work has played a key role in the critical evaluation and redefinitions of Chicano art in the 1990s and into the 2000s. The earliest generation of Chicano artists arose in California, Texas, and other areas of the southwestern United States in the early 1970s as part of the Chicano civil rights movement. Inspired by the Mexican muralists as well as by artists of the African-American civil rights movement, young Chicano artists created numerous outdoor murals that promoted a new, more politicized and culturally aware identity for Mexican-Americans. Decades later, young Chicano artists, who may have had no actual experience of these social and political struggles, were confronted with the dilemma of how to examine issues relevant to their heritage while also having an impact on the broader art world. Huerta's work represents a radical departure from the sensibilities that have surrounded Chicano artistic production since the 1970s. The crisp, precise style he brings to his paintings, the

sense of detachment he has from his subjects, and the neutral spaces in which he places them reflect an artistic stance more aligned with the mainstream contemporary art world than with anything witnessed in Chicano art history. But Huerta maintains a deep commitment to eloquently examining an issue that remains central to Chicanos as well as to others outside the mainstream–how we in the United States think about and act upon questions of race, class, and gender. Particularly with his paintings of figures, who refuse the spectator a view of their face, Huerta transforms ambivalence into a strangely cathartic device, compelling us to question the terms by which we each negotiate the personal and social politics of identity.

—Elizabeth Ferrer

IRIZARRY, Carlos
American painter and graphic artist

Born: Santa Isabel, Puerto Rico, 1938. **Education:** School of Art and Design, New York. **Career:** Moved to the United States, *ca.* 1948. Member, atelier Friends of Puerto Rico; organizer of exhibitions of Puerto Rican artists, New York, *ca.* 1950s. Returned to Puerto Rico, 1963–68. Founder, Galería 63, San Juan, 1963.

Individual Exhibitions:

1963	Caravan House, New York
1967	Tibor de Nagy Gallery, New York
1983	Museo de Bellas Artes de Puerto Rico, San Juan
1989	Museo de Arte e Historia, San Juan
2000	*Carlos Irizarry: The '60s Plus Picasso,* Museo del Barrio, New York

Selected Group Exhibitions:

1967	*Latin American Art: 1931–1966,* Museum of Modern Art, New York
1968	Museo de la Universidad de Puerto Rico
1970	*Biennial of Latin American Graphics,* San Juan
1989	*The Latin American Spirit: Art & Artists in the U.S.,* Bronx Museum, New York
1999	*Pressing the Point,* Jack S. Blanton Museum of Art, University of Texas, Austin and Museo del Barrio, New York
2000–01	*Creo en Vieques,* Museo de Arte Contemporáneo de Puerto Rico, San Juan

Collections:

Museo de Arte Contemporáneo de Puerto Rico, San Juan; Museo del Barrio, New York; Ateneo Puertorriqueño, San Juan; Instituto de Cultura Puertorriqueña, San Juan; Museum of Modern Art, New York; Museum of Contemporary Hispanic Art, New York; Museo de Arte de Ponce, Puerto Rico; Universidad de Puerto Rico, San Juan.

Publications:

On IRIZARRY: Books—*La nueva abstracción: Domingo López, Luis Hernández Cruz, Carlos Irizarry,* exhibition catalog, El Museo de la Universidad de Puerto Rico, Puerto Rico, 1968; *Carlos Irizarry: Arte, política y números,* exhibition catalog, Instituto de Cultura Puertorriqueña, San Juan, 1983; *Carlos Irizarry: "Colección de coleccionistas,"* exhibition catalog, by Candido Ortiz, Museo de Arte e Historia, San Juan, 1989.

* * *

Carlos Irizarry received his training in New York's School of Art and Design. A painter and graphic artist, until the late 1970s he divided his time and output between San Juan and New York City. At both cities he organized exhibition spaces and groups of artists in an attempt to break through the conservative lack of interest in his early minimalist Plexiglas constructions and photo-silk screens (San Juan) and general apathy for things Puerto Rican (New York City). He was the first to use mechanical means of reproduction in his prints, techniques considered anathema to Puerto Rican printmakers. In *Biafra* (1970) Irizarry effectively used the grid and benday dots as an expressive means while asserting the very nature of mechanical reproduction. In the mural *Biafra* (1972) at the University of Puerto Rico's Mayagüez campus, Irizarry used silk screen on canvas, à la Andy Warhol, but its dramatic force is light-years away from the playful or cynical effects achieved by Warhol.

Irizarry used photography, appropriation, and the lack of interest in the materiality of paint that characterized the New York School after pop art in works that became gradually more involved with political protest art and a return to context and significance. His early masterpiece *The Transculturation of the Puerto Rican* (1975) makes a strong statement on cultural assimilation through the juxtaposition of the appropriated image of the *jíbaro* (''peasant''), from Ramón Frade's 1907 painting, and the spectral figure that symbolizes loss of identity.

One of his political protest conceptual works landed him in prison in New York City in 1977, where he served six years. It was during this time that he produced his most important works, dramatic paintings, and collages, as well as the masterful installation *Infinite Marx* (1982). His series of paintings/collages on the fictional political hero Alfonso Beal use the David and Goliath metaphor to symbolize the struggle for the independence of Puerto Rico. To portray the nationalist leader Lolita Lebrón, Irizarry used 30 small-scale panels painted with fragments of her image; hung separately, they seem to burst out into space and overwhelm the viewer.

Infinite Marx is Irizarry's most ambitious work; it combines large-scale papers laden with formulas from a treatise on economics the painter developed while in prison, over which he painted four monumental semblances of Karl Marx, set within a frame of facing mirrors. Upon his release from prison, Irizarry undertook a series of large-scale portraits of Puerto Rican personages such as poet Julia de Burgos, baseball player Roberto Clemente, political leader Pedro Albizu Campos, and painter José Campeche. In all, Irizarry included grids, elements that allude to color keys, and circles that recall his use of the benday dots in the late 1960s. The use of these elements in his early work was groundbreaking; in his latter paintings it became formulaic and seldom effective. The paintings were also reproduced

in photo-silk screens, on a smaller scale. In his most successful works, Irizarry adapted the New York School pictorial strategies to create powerful images of the political conflicts of Puerto Rico. From a fervent exponent of the New York avant-garde movements of the 1960s, Irizarry became a political artist and used the language of the vanguard to produce powerful images of Puerto Rico and its struggle to survive as an autonomous culture.

—Marimar Benítez

ITURBIDE, Graciela
Mexican photographer

Born: Mexico City, 16 May 1942. **Education:** Centro de Estudios Cinematográficos, Universidad Nacional Autónoma de México, 1969–72. **Family:** Married c. 1962; three children (one deceased). **Career:** Assistant to Manuel Alvarez Bravo, *q.v.,* 1970–71. Traveled to Panama, 1972; to Europe, 1970s. Worked for Instituto Nacional Indigenista, Mexico, 1970s. Founding member, Mexican Council of Photography, 1978. **Awards:** Prize, United Nations-International Labor Organization, 1986; award, W. Eugene Smith Memorial Foundation, 1987; fellowship, Guggenheim Foundation, 1988; grand prize, Mois de la Photo, Paris, 1988; Hugo Erfurth Award, Leverküsen, Germany, 1989; international grand prize, Hokkaido, Japan, 1990; award, *Recontres Photographiques,* Arles, France, 1991.

Selected Exhibitions:

1974	*Tres fotógrafas mexicanas,* Galería José Clemente Orozco, Mexico City
1980	*Graciela Iturbide,* Casa del Lago, Mexico City
1982	*Graciela Iturbide,* Museum of Modern Art, Georges Pompidou Center, Paris
1985	*Juchitán,* Casa de la Cultura de Juchitán, Mexico (traveled to Cantonal Museum of Fine Arts, Lausanne, Switzerland)
1987	*Graciela Iturbide,* Centro de Ricerca per l'Immagine Fotografica, Milan
1989	*Juchitán de las mujeres,* Galeria Juan Martín, Mexico City (traveling)
	Juchitán pueblo de nube, Side Gallery, Newcastle, England (traveling)
1990	*Neighbors,* Museum of Photographic Arts, San Diego, California
	Graciela Iturbide, Ernesto Mayans Gallery, Santa Fe, New Mexico
	External Encounters, Internal Imaginings: Photographs by Graciela Iturbide, Museum of Modern Art, San Francisco
1991	*Graciela Iturbide,* Museum of Photography, Seattle
	Recontres internationales de la photographie, Chapelle du Méjan, Arles, France (retrospective)
	Visiones: Graciela Iturbide, Le Mois de la Photo a Montreal Maison de la Petite Patrie, Montreal
1992	*Graciela Iturbide,* Fundacío ''La Caixa,'' Girona, Spain
	Graciela Iturbide, Galería Visor, Valencia, Spain
1993	*Graciela Iturbide,* Chicago Cultural Center

	Graciela Iturbide, Sala de Exposición de Telefónica, Madrid
	Graciela Iturbide, Musée de la Photographie, Centre d'Art Contemporaine de la Communauté Francaise de Belgique, Belgium
	En el nombre del padre, Galería Juan Martín, Mexico City (traveled to Galeria Foto Optica, São Paulo, Brazil, and Museo de Arte Moderno, Rio de Janeiro)
1994	*Graciela Iturbide,* Universidad de Salamanca, Spain
1995	*Graciela Iturbide,* I Kwangju Biennale, Korea
	Graciela Iturbide, Gallery of Contemporary Photography, Los Angeles
	Graciela Iturbide, Adair Margo Gallery, El Paso, Texas
1996	*Graciela Iturbide: La forma y la memoria,* Museo de Arte Contemporáneo de Monterrey, Mexico (retrospective)
1997	*Graciela Iturbide: Gil occhi che volano,* Castel dell'Ovo, Naples, Italy
1998	*Graciela Iturbide: Images of the Spirit,* Philadelphia Museum of Art (traveling retrospective)
2000	*Cuaderno de viaje,* Galeria Emma Molina, Monterrey, Mexico (traveling)

Collections:

University of California, Riverside; Throckmorton Fine Art, New York; Rose Gallery, Santa Monica, California.

Publications:

By ITURBIDE: Books, photographed—*Avándara,* text by Luis Carrión, Mexico City, Editorial Diógenes, 1971; *Los que viven en la arena,* text by Luis Barjau, Mexico City, INI-Fonapas, 1981; *Sueños de papel,* text by Verónica Volkow, Mexico City, Fondo de Cultura Económica, Colección Río de Luz, 1985; *Tabasco: Una cultura del agua,* text by Alvaro Ruiz Abreu, Villahermosa, Mexico, Gobierno del Estado de Tabasco, 1985; *Juchitán de las mujeres,* text by Elena Poniatowska, Mexico City, Ediciones Toledo, 1993; *En el nombre del padre,* text by Osvaldo Sánchez, Mexico City, Ediciones Toledo, 1993; *Fiesta und ritual,* text by Erika Billeter and Verónica Volkow, Switzerland, Benteli-Werd Verlags A.G., 1994; *Luz y luna, las lunitas* by Elena Poniatowska, Mexico City, Ediciones Era, 1994; *Imágenes del espíritu: Fotografias,* text by Roberto Tejada and Alfredo López Austin, Mexico City, Casa de las Imágenes, 1996.

On ITURBIDE: Books—*Graciela Iturbide,* exhibition catalog, San Francisco, Museum of Modern Art, 1990; *Graciela Iturbide: La forma y la memoria,* exhibition catalog, text by Carlos Monsiváis, Monterrey, Mexico, Museo de Arte Contemporáneo de Monterrey, 1996; *Graciela Iturbide: Gli occhi che volano,* exhibition catalog, Naples, Italy, Electa Napoli, 1997; *Graciela Iturbide,* exhibition catalog, text by José Ramón Docal Labaén, Carolina Martínez Gila, and Christian Caujolle, Galicia, Spain, Fundación Caixa Galicia, 1998; *Witness in Our Time: Working Lives of Documentary Photographers* by Ken Light, Washington, D.C., Smithsonian Institution Press, 2000. **Articles—**''Graciela Iturbide: Rites of Fertility'' by Macario Matus, in *Aperture,* 109, winter 1987, pp. 14–27; ''Juchitán'' by Erika Billeter, in *Du* (Switzerland), 3, 1988, pp. 58–65; ''Graciela Iturbide: Senses of Solitude'' by Veronica Volkow, in *Creative Camera* (United Kingdom), 10, 1988, pp. 26–32; ''Graciela Iturbide''

Graciela Iturbide: *Pescaditos de Oaxaca, Oaxaca,* 1986. Photo courtesy of the artist.

by Frederick Kaufman, in *Aperture,* 138, winter 1995, pp. 36–47; ''Graciela Iturbide: Normalizing Juchitán'' by Leigh Binford, in *History of Photography* (United Kingdom)k, 20, autumn 1996, pp. 244–249; ''The Performance of Everyday Life: Reflections on the Photography of Graciela Iturbide'' by Mark Alice Durant, in *Afterimage,* 24, September/October 1996, pp. 6–8; ''Dancing with the Iguanas'' by Frac Contreras, in *Art News,* 98(2), February 1999, pp. 96–97; ''Graciela Iturbide's Primal Scenarios'' by Max Kozloff, in *Art in America,* 87(11), November 1999, p. 122.

* * *

Graciela Iturbide is one of the most renowned contemporary Mexican photographers. She was an important participant in the photographic boom in Mexico during the 1970s and '80s and has continued to photograph and exhibit widely within Mexico and abroad. Her work follows the rich tradition of twentieth-century Mexican photographers who have focused on the diverse cultural, religious, and political experiences of Mexicans in urban and rural environments.

Iturbide began her career as a filmmaker. She studied film from 1969 to 1972 at the Centro de Estudios Cinematográficos of the Universidad Nacional Autónoma de México in Mexico. There she made a film about the life and work of the artist José Luis Cuevas. In 1970 and 1971 she worked as an assistant to photographer Manuel Alvarez Bravo, an inspiring teacher whose poetic images were a powerful influence.

In 1972 Iturbide traveled to Panama where she photographed Panama's indigenous people and the president of the country, General Omar Torrijos. In the 1970s while traveling in Europe Iturbide met French photographer Henri Cartier-Bresson, whose concept of the ''decisive moment'' had a great effect on her work. During this time she also worked for the Instituto Nacional Indigenista, documenting indigenous Mexican cultures.

In 1978 she was a founding member of the Mexican Council of Photography. From 1975 to 1981 she exhibited her work in group shows and participated in the first and second Colloquia of Latin American Photography held in Mexico City. In 1981 she published *Los que viven en la arena* (''Those Who Live in the Sand''), a photographic study of the Seri people of northern Mexico commissioned by the Instituto Nacional Indigenista. Her dramatic photograph *Mujer ángel* (''Woman Angel'') depicts cultural change—a Seri woman dressed in traditional clothing walks through the desert carrying a transistor radio by her side. By the mid-1980s she began to

publish her work extensively and held a number of one-person exhibitions in Mexico and abroad. In 1985 she produced *Sueños de papel* ("Dreams of Paper"), part of the *Rio de luz* ("River of Light") series of photography books.

In 1986 Iturbide took photographs of Chicano gang members in East Los Angeles, a project that coincided with her interest in ritual and custom. She received the W. Eugene Smith Photography Award in 1987 for her photographs of the people of Juchitán, a town in the Isthmus of Tehuantepec in the state of Oaxaca. She published these photographs in *Juchitán de las mujeres* ("Juchitán of the Women"), a lyrical visual study of the traditional Zapotec culture of the area, focusing especially on the strong women of Juchitán. *Nuestra Señora de las iguanas* ("Our Lady of the Iguanas"), perhaps Iturbide's most well known image, portrays a Juchitán market woman with a crown of live iguanas on her head. In 1988 Iturbide received a Guggenheim Fellowship for her photographic investigation *Fiesta y muerte* ("Fiesta and Death"), a study of the traditions of the Days of the Dead in Mexico.

In 1990 Iturbide had a major exhibition, *External Encounters, Internal Imaginings: The Photographs of Graciela Iturbide*, at the Museum of Modern Art in San Francisco, California. The same year the organization Médicins sans frontières asked her to work in Madagascar. In 1993 Iturbide held the first showing of her collection *En el nombre del padre* ("In the Name of the Father"), images of the ritualistic slaughtering of goats in the town of Huajuapan de León, Oaxaca. Her evocative photograph *El sacrificio* ("The Sacrifice") portrays an immaculately white unborn kid removed from its mother's belly, suggesting the biblical story of the sacrifice of Isaac.

A major retrospective of her work, *Graciela Iturbide: La forma y la memoria* ("Graciela Iturbide: Form and Memory") took place at the Museo de Arte Contemporáneo de Monterrey in 1996, and in 1998 the Philadelphia Art Museum sponsored another major retrospective, *Graciela Iturbide: Images of the Spirit*, that traveled to several American museums. Iturbide was living and working in Coyoacán, in Mexico City.

—Deborah Caplow

IZQUIERDO, María (Cenobia)

Mexican painter

Born: San Juan de los Lagos, 30 October 1902. **Education:** Academia de San Carlos, 1928; studied under German Gedovius and Manuel Toussaint, Escuela Nacional de Bellas Artes, Mexico City, 1928–29. **Family:** Married 1) Candido Posadas in 1917 (divorced 1927), three children; 2) Raul Uribe Castille in 1944 (divorced 1953). Lived with Rufino Tamayo, *q.v.,* 1929–33. **Career:** Became the first Mexican woman to have a solo exhibition in the United States, 1930; painting instructor, Escuela de Pintura y Escultura, Mexico City, 1931; art critic, *Hoy* newspaper, Mexico City, and writer of feminist articles for other publications; denied mural commission for National Palace, Mexico City, by Diego Rivera and David Alfaro Siqueiros, 1945. **Member:** Liga de Escritores y Artistas Revolucionarios. **Died:** Mexico City, 2 December 1955.

Individual Exhibitions

1929 Galeria de Arte Moderno, Mexico City

María Izquierdo: *Family Portrait (Mis Sobrinos).* © Schalkwijk/Art Resource, NY.

1930 Art Center, New York
1933 Galerie Rene Highe, Paris
1937 Galerie van den Berg, Paris
1938 Stanley Rose Gallery, Los Angeles
1939 Galeria de Arte Mexicano, Mexico City
1943 Sala del Seminario de Cultura Mexicana, Mexico City
1956 Galeriea de Arte Moderno, Mexico City (retrospective)
1971 *María Izquierdo y su obra,* Museo de Arte Moderno, Mexico City
1977 *María Izquierdo,* Museo Regional, Monterrey, California
1979 Palace of Fine Arts, Mexico City
1985 *María Izquierdo,* Gobierno de Jalisco, Guadalajara
1986 *María Izquierdo,* Casa de Bolsa Cremi, Mexico City
1988 *María Izquierdo,* Centro Cultural de Arte Contemporaneo, Mexico City

Selected Group Exhibitions

1930 *Mexican Arts,* Metropolitan Museum of Art, New York
1940 *Twenty Centuries of Mexican Art,* Museum of Modern Art, New York
 Golden Gate International Exposition, San Francisco
1951 *Art mexicain,* Musée d'Art Moderne de la Ville, Paris

1987	*Imagen de Mexico,* Museo Regional, Monterrey, California
1988	*Images of Mexico,* Dallas Museum of Art, Texas
1989	*Art in Latin America: The Modern Era, 1820–1980,* Hayward Gallery, London (traveling)
1992	*Art d'amerique latine, 1911–1968,* Musée National d'Art Moderne, Centre Georges Pompidou, Paris
1993	*Latin American Artists of the Twentieth Century,* Museum of Modern Art, New York
1995	*Latin American Women Artists, 1915–1995,* Milwaukee Art Museum

Collections:

Galeria de Arte Mexicano, Mexico City; Museo de Arte Moderno, Mexico City.

Publications:

By IZQUIERDO: Article—''A Letter to the Women of Mexico,'' in *Zocalo,* 1950.

On IZQUIERDO: Books—*A Guide to Mexican Art* by Justino Fernandez, Chicago, 1969; *María Izquierdo y su obra,* exhibition catalog, Mexico City, 1971; *María Izquierdo* by Margarita Michelana et al., Guadalajara, Mexico, 1985; *María Izquierdo* by Carlos Monsivais et al., Mexico City, 1986; *Latin American Artists of the Twentieth Century,* exhibition catalog, New York, 1993; *María Izquierdo: 1902–1955,* essays by Luis-Martin Lozano and Teresa del Conde, Chicago, Mexican Fine Arts Center Museum, c. 1996; *The True Poetry: The Art of Maria Izquierdo* by Olivier Debroise, Elizabeth Ferrer, and Elena Poniatowska, Tucson, University of Arizona Press, 1997. **Articles—**''La Pintura de María Izquierdo'' by Antonin Artaud, in *Revista de Revistas* (Mexico City), 23 August 1936; ''Le Mexique et l'esprit primitif,'' in *L'Amour de l'Art,* no. 8, 1937, and ''Mexico y el espiritu feminimo: María Izquierdo,'' in *Revista de la Universidad de Mexico,* 1968, both by Antonin Artaud; ''Surrealism in Mexico'' in *Artforum,* September 1986; ''María Izquierdo'' by Raquel Tibol, in *Latin American Art,* no. 1, 1989; ''Painting Mexican Identities: Nationalism and Gender in the Work of Maria Izquierdo'' by Robin Adele Greeley, in *Oxford Art Journal* (Oxford, England), 23(1), 2000, p. 51.

* * *

A pioneering modernist in Mexico, María Izquierdo painted exuberant circus scenes and colorful still lifes that evoked Mexican popular culture, as well as somber landscapes and allegories. Born in 1902, she was raised in small towns in northern Mexico and married at age 14. She had little exposure to the arts until she moved with her family to Mexico City in 1923, when she was 21. There she reveled in an environment utterly different from the intense conservatism that had circumscribed her earlier life, and it was partly her reluctance to conform to traditional social strictures that led to a divorce in 1927. Although she was a mother with young children, she took the unconventional step a year later of enrolling in art school, where she met the painter Rufino Tamayo, then a teacher. At the time the young Tamayo was experimenting with modernist idioms, inspired by a recent two-year sojourn in New York City. From 1929 to 1933 he and Izquierdo shared a studio as well as a life together. He helped her hone her artistic skills, and during this period both painted still lifes of commonplace objects that suggest the influence of European expressionism.

Izquierdo truly came into her own as an artist in the 1930s after a painful breakup with Tamayo. She concentrated on intimate depictions of the circus, a subject to which she returned frequently during her career. Her early circus compositions are often melancholic, picturing a closed, silent world in which an audience is rarely visible and performers appear suspended in motion. In *The Circus Performer* (1932) a woman seen from the rear rides standing one-legged atop a horse. The work has none of the animation or humor one would associate with the theme; rather, the scene conjures ritual, discipline, and control. Simultaneously with these works Izquierdo created a number of idiosyncratic small-scale allegories, all watercolors, that picture wholly imagined worlds: nude women or mermaids inhabiting such settings as classical ruins with arches and broken columns, primordial worlds suffused with the color of raw earth, or cosmic environments, as in *Saturn* (1936). Oddly, these works portray women either overcome by pathos or struggling with forces beyond their control, situations that countered Izquierdo's developing position as an independent and successful woman in Mexico. The allegories attracted the French poet and playwright Antonin Artaud, who visited Mexico in 1936 with the goal of experiencing a more authentic, spiritually attuned culture than he knew in Europe. Although Artaud's romantic notions of Mexico were largely disappointed, he was drawn to Izquierdo's elusive themes and passionately direct approach to painting and arranged for an exhibition of her work in Paris in 1937.

As she matured, Izquierdo embraced a broader range of subject matter, from the circus to still lifes, to portraits and landscapes. Especially in the 1940s and 1950s commentators noted the emphatically Mexican quality of her work. Izquierdo's *mexicanismo,* more than a reflection of the strident nationalism that dominated Mexican art of the 1930s and 1940s, was deeply felt and bound up in her sense of cultural and ethnic identity. It is seen in her exuberant approach to color, in the subjects she portrayed (especially in the 1940s), and in her clear affection for things Mexican. A group of still lifes Izquierdo created in the 1940s most directly conveys the spirit of *mexicanidad* central to her mature work. These include depictions of home altars featuring assemblages of popular art objects and images of a clearly mestizo Virgin Mary, as in *Altar de Dolores* (1943). With her bold colors, unrestrained sense of decoration, and tender evocation of the Virgin as a vital element of Mexican culture, these paintings reflect Izquierdo's profound connection to popular cultural traditions.

Beginning in the mid-1940s Izquierdo painted a series of landscapes that mark her artistic maturity. More metaphysical evocations than representations of real places, these works are characterized by deep vistas and empty spaces that recall compositions by the Italian Giorgio de Chirico. In works like *Naturaleza viva* and *Naturaleza viva with Red Snapper,* both from 1946, Izquierdo depicts lush still life arrangements in the foreground with barren landscapes receding into deep vistas. These vast, empty spaces recall the arid, open terrain of Mexico's northern provinces, where Izquierdo spent her youth, and anticipate the melancholy and nostalgia that were to pervade her later years. *Dream and Premonition* (1947) suggests a woman haunted by her past while foreboding the health problems that were to beleaguer her final years. It is a stoic portrait of the artist leaning out a window, holding her own decapitated head in her hands. Steeped in Christian symbolism, the composition suggests that the body is a receptacle for pain and that it must be sacrificed in the quest for redemption.

In the artistic creed she penned in 1947, Izquierdo called painting ''an open window to the human imagination.'' As she developed as an artist, she found evocative ways of melding dream, memory, premonition, life experience, and pure imagination in her painting. A singular figure in Mexican art, she forged a path that is linked to the nationally based cultural concerns of the Mexican muralists, who were her contemporaries, as well as to currents in European modernism but that expressed a deeply personal and eloquent exploration of the human spirit.

—Elizabeth Ferrer

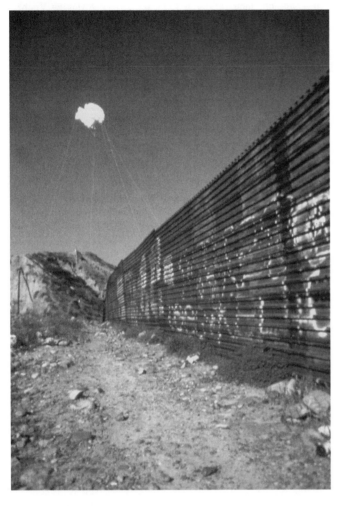

Alfredo Jaar: *The Cloud,* 2000. Photo courtesy of the artist and Galerie Lelong, New York.

JAAR, Alfredo
American photographer and installation artist

Born: Santiago, Chile, 1956; moved to the United States, 1982. **Education:** Studied film, Instituto Chileno Norteamericano de Cultura, 1979; studied architecture, Universidad de Chile, 1981. **Career:** Traveled to the Amazon rainforest, 1985. **Awards:** New York State Council of the Arts grant, 1985; Guggenheim fellowship, 1985; MacArthur Foundation grant, 2000.

Individual Exhibitions:

1979 Galeria CAL, Santiago

1985	Grey Art Gallery, New York
1988	Institute of Contemporary Art, Philadelphia
1989	Brooklyn Museum, New York
1990	*1+1+1,* La Jolla Museum of Contemporary Art, California
1991	Virginia Museum of Fine Art
	MVSEUM, Hirshhorn Museum, Washington, D.C.
1992	Galerie Franck + Schulte, Berlin
	The Aesthetics of Resistance, Pergamon Museum, Berlin
	Museum of Contemporary Art, Chicago
	Whitechapel Art Gallery, London
	New Museum of Contemporary Art, New York
1993	Center for the Fine Arts, Miami
	Tramway, Glasgow, Scotland
	Gesellschaft fur Akteulle Kunst, Bremen, Germany
1994	Galeria Oliva Arauna, Madrid
	Frankfurter Kunstverein, Frankfurt, Germany
	Institute fu Auslandsbeziehungen, Stuttgart, Germany
	A Hundred Times Nguyen, Fotografiska Museet and Moderna Museet, Stockholm
1995	Galerie Lelong, New York
	Museum of Contemporary Photography, Chicago
1996	City Gallery of Contemporary Art, Raleigh, North Carolina
1997	The Light Factory, Charlotte, North Carolina
	Galeria Franck + Schulte, Berlin
	Galeria Oliva Arauna, Madrid
	Todd Hosfelt Gallery, San Francisco
	Galeri Grita Insam, Vienna
1998	Koldo Mitxelena, San Sebastian, Spain
	Galeria Lelong, New York
	Stedelijk Museum Het Domein, Sittard, Netherlands
	Let There Be Light: The Rwanda Project, 1994–1998, Centre d'Art Santa Monica, Barcelona, Spain
1999	Museum of Art, Fort Lauderdale, Florida
	Lament of the Images, Massachusetts Institute of Technology List Visual Arts Center, Cambridge, Massachusetts
2000	*Alfredo Jaar: It Is Difficult,* Hosfelt Gallery, San Francisco

Selected Group Exhibitions:

1983	*In/Out: Four Projects by Chilean Artists,* Washington Project for the Arts, Washington, D.C.
1984	*Art & Ideology,* New Museum of Contemporary Art, New York
1987	*São Paulo biennale*
1989	*Magiciens de la terre,* Musee National d'Art Moderne, Centre George Pompidou, Paris

287

Alfredo Jaar: *Embrace,* **1996. Photo courtesy of the artist and Galerie Lelong, New York.**

1993 *Latin American Artists of the Twentieth Century,*
 Museum of Modern Art, New York
1995 *Ars 95,* Museum of Contemporary Art, Helsinki
1996 *The Luminous Image,* Alternative Museum, New York
 Thinking Print, Museum of Modern Art, New York
1998 *Crossings,* National Gallery of Canada, Ottawa
 Do All Oceans Have Walls?, Gesellschaft fur Aktuelle
 Kunst, Bremen, Germany

Publications:

By JAAR: Books—*Alfredo Jaar: Aprendendo a jogar,* exhibition catalog, São Paulo, 19th São Paulo International Biennial, 1987; *Two or Three Things I Imagine about Them,* exhibition catalog, London, Whitechapel Art Gallery, 1992; *A Hundred Times Nguyen,* exhibition catalog, Stockholm, Fotografiska Museet i Moderna Museet, 1994; *August 29, 1994,* Toronto, Canada, Art Metropole, 1997; *Let There Be Light: The Rwanda Project 1994–1998,* exhibition catalog, Barcelona, Spain, ACTAR, 1998; *It Is Difficult: Ten Years,* Barcelona, Spain, ACTAR, 1998; *Studies on Happiness 1979–1981,* with Adriana Valdés, Barcelona, Spain, ACTAR, 1999; *Face On: Photography As Social Exchange,* with others, edited by Mark Durden and Craig Richardson, London, Black Dog, 2000. **Article**—"Peripatetic Artist: 14 Statements," in *Art in America,* 77(7), July 1989, pp. 130–137.

On JAAR: Books—*Alfredo Jaar,* exhibition catalog, text by Madeleine Grynsztejn, La Jolla, California, La Jolla Museum of Contemporary Art, 1990; *Alfredo Jaar: Geography = War,* exhibition catalog, text by W. Avon Dranke and others, Richmond, Virginia,

Anderson Gallery, Virginia Commonwealth University, 1991; *Inferno and Paradiso,* text by Juan Goytisolo, Julia Kristeva, and others, Stockholm, Riksutställninger, 2000. **Articles**—"Alfredo Jaar, imágenes entre culturas" by Adriana Valdes, in *Arte en Colombia,* 42, December 1989, pp. 46–53; "Alfredo Jaar, the Body Maps the Other" by Patricia C. Phillips, in *Artforum,* 28(8), April 1990, pp. 134–139; "Pop into Agit-Pop" by Craig Adcock, in *Tema Celeste,* 30, March/April 1991, pp. 74–79; interview by Stephen Horne, in *Parachute,* 69, January/March 1993, pp. 28–33; "Making Visible: Difference and Representation in the Work of Alfredo Jaar" by Jon Bird, in *Art & Design,* 9, July/August 1994, pp. 34–43; "Alfredo Jaar" by Linda Johnson Dougherty, in *Art Papers,* 20, November/ December 1996, pp. 54–55; "Alfredo Jaar–The Dazzle of the Obvious" by Michele Cohen Hadria, in *Art Press* (France), 261, October 2000, pp. 42–43.

* * *

The work of the Chilean-born, New York-based Alfredo Jaar, considered by many to be one of the most important contemporary Latin American artists, is an outgrowth of a form of Latin American conceptual art that emerged in the 1980s, one that was profoundly political in nature. Much of Jaar's work examines the degrees of separation between the center and the margins, the polarity of North and South, and the power plays that result from control and subjugation, wealth and poverty, and power and powerlessness.

After he relocated to New York City in 1982, Jaar's work grew increasingly concerned with the inequities that exist in the tenacious, troubled relationship between wealthy industrialized nations, or the First World, and the so-called Third World, a term he is known to reject. His extensive travels have allowed him to witness these inequities firsthand and to utilize his work, particularly photographs, as a vehicle for facilitating a dialogue that expresses, in visual terms, a compassionately informed cartography of humanity that is socially, politically, and morally informed. Rather than functioning as detached documents of his extensive travels, his photographs instead serve a more conceptual and enlightened purpose, one that discloses, in humanistic terms, that which is all too frequently globally ignored and overlooked.

Jaar's interest in cartographic exactness, as well as his concern with regarding cultures and peoples with impartiality, is well illustrated in a work he completed in 1998 titled *Weltanschauung,* a foldout map of the world that utilizes a Peters projection, one that presents a human-scaled literal projection of the Earth's surface. This project, as Jaar has stated, "accurately portrays the relative size of all countries . . . and corrects the ethnocentric character of the most commonly used geographic representations." Not only does the work relate conceptually to Jaar's belief that the world is shaped by economic and political power, but it also alludes to his interest in creating artists' books, including *A Hundred Times Nguyen* (1994) and *Two or Three Things I Imagine about Them* (1992).

Jaar's background in architecture and film, with degrees from the Instituto Chileno Norteamericano de Cultura (1979) and the Universidad de Chile (1981), both in Santiago, is reflected not only in his photographs, which frequently express a cinematic narrative, but also in his spare, minimalist installations, where the interplay and dialogue between architectural space and object are emphasized,

explored, and exploited. These frequently large-scale works transcend modernist rhetoric in that their main component–the photograph–is an object highly contested and repeatedly rejected by Greenbergian notions of modernism.

Large-scale light boxes containing transparencies of Jaar's photographs are frequently the focal point of these projects, sites where the aesthetic and the ethical converge. *The Rwanda Project 1994–1998* is a moving, complex, and characteristically minimal example of his provocative installations, in which his awareness of design and a subtle theatricality are evident. In this work, a result of his photographic documentation of the assassination of an estimated million members of the Tutsi tribe by members of Hutu death squads in Rwanda in 1994, Jaar has created a memorial that is simultaneously a testimonial and an aide-mémoire, a tribute to the genocide victims and survivors, whom he visited in refugee camps, as well as a reminder of the atrocities that humankind is capable of committing.

—Kaytie Johnson

JIMÉNEZ, Luis (Alfonso, Jr.)
American sculptor and painter

Born: El Paso, Texas, 30 July 1940. **Education:** University of Texas, El Paso, then University of Texas, Austin, 1960–64, B.S. in art and architecture 1964; Ciudad Universitaria, Mexico City, 1964. **Family:** Married 1) Vicky Cardwell in 1961 (divorced 1966), one daughter; 2) Mary Wynn in 1967 (divorced 1970); 3) Susan Brockman in 1985, one son. **Career:** Recruiter, Headstart Program, New York, *ca.* 1966; studio assistant to Seymour Lipton, New York, 1965–67; program coordinator, New York City Youth Board, 1966–69; worked at his father's sign company, *ca.* 1971. **Awards:** Hassan Fund Purchase award, American Academy and Institute of Arts and Letters, 1977; fellowship, American Academy in Rome, 1979; fellowship, National Endowment for the Arts, 1979; Environmental Improvement award, American Institute of Architects in Houston, 1982. **Agent:** Hill's Gallery, 110 San Francisco, Santa Fe, New Mexico 87501, U.S.A.

Individual Exhibitions:

1969	Graham Gallery, New York
1970	Graham Gallery, New York
1972	O.K. Harris Gallery, New York
1973	Long Beach Museum of Art, Long Beach, California
1974	Contemporary Arts Museum, Houston
1975	Hills Gallery, Santa Fe, New Mexico
	O. K. Harris Gallery, New York
	Bienville Gallery, New Orleans
1977	University of North Dakota, Grand Forks
	University of Santa Clara, California
1978	Yuma Fine Arts Association, Arizona
1979	Plains Art Museum, Moorehead, Minnesota
	Landfall Press Gallery, Chicago
	New Mexico Museum of Fine Arts, Santa Fe, New Mexico
	Hills Gallery, Santa Fe, New Mexico
1980	Joslyn Art Museum, Omaha, Nebraska
1981	Franklin Struve Gallery, Chicago
	Sebastian-Moore Gallery, Denver, Colorado
1982	Hydt-Blair Gallery, Santa Fe, New Mexico
1983	Candy Story Gallery, Folsom, California
	Yares Gallery, Scottsdale, Arizona
	Laguna Gloria Art Museum, Austin, Texas
1984	Phyllis Kind Gallery, New York
	Alternative Museum, New York
	Hammarskjold Plaza, New York
	Sculpture Plaza, New York
	Barnsdall Junior Arts Center, Los Angeles
	Art Attack Gallery, Boise, Idaho
	Roswell Museum and Art Center, New Mexico
1985	Dallas Museum of Art, Texas
	Sette Gallery, Tempe, Arizona
	Art Network, Tucson, Arizona
	University of Arizona, Tucson
1986	University of Texas/El Paso Art Museum, Texas
	Adair Margo Gallery, El Paso, Texas
1987	Moody Gallery, Houston
	Marilyn Butler Fine Arts, Santa Fe, New Mexico
1997	Dallas Museum of Art (traveling retrospective)

Selected Group Exhibitions:

1969	*Human Concern/Personal Torment,* Whitney Museum of American Art, New York
1972	*Recent Figure Sculpture,* Fogg Art Museum, Harvard University, Cambridge, Massachusetts
1973	*Biennial Exhibition of Contemporary American Art,* Whitney Museum of American Art, New York
1977	*Dalé Gas: Chicano Art of Texas,* Contemporary Arts Museum, Houston
	Ancient Roots/New Visions, Tucson Museum of Art, Arizona (traveling)
1979	*The First Western States Biennial Exhibition,* Denver Art Museum (traveling)
1982	*Recent Trends in Collecting,* Smithsonian, Washington, D.C.
1983	*Showdown,* Alternative Museum, New York
1985	*Power of Popular Image,* Queens College, Pennsylvania
1987	*Hispanic Art in the United States: Thirty Contemporary Painters and Sculptors,* Museum of Fine Arts, Houston (traveling)

Collections:

Albuquerque Museum; Art Institute of Chicago; Denver Art Museum; Long Beach Museum, California; Metropolitan Museum of Art, New York; National Collection of Fine Art, Washington, D.C.; National Museum of American Art, Washington, D.C.; New Orleans Museum of Art; Phoenix Art Museum; The Plains Art Museum, Moorehead, Minnesota; Roswell Museum and Art Center, New Mexico; Sheldon Memorial Gallery, Lincoln, Nebraska; Witte Memorial Museum, San Antonio.

Publications:

On JIMÉNEZ: Books—*Luis Jiménez,* exhibition catalog, essays by Dave Hickey and Annette Carlozzi, Austin, Texas, Laguna Gloria Art

Luis Jiménez: *Fiesta Dancers,* 1985. Photo courtesy of ACA Galleries, New York. © 2002 Luis Jiménez/Artists Rights Society (ARS) New York.

Museum, 1983; *Luis Jiménez: Sculpture and Works on Paper,* exhibition catalog, New York, Alternative Museum, 1984; *Hispanic Art in the United States: Thirty Contemporary Painters and Sculptors,* exhibition catalog, by John Beardsley and Jane Livingston, New York, Abbeville Press, 1987. **Articles—**''New York Letter'' by Carter Ratcliff, in *Art International,* 16, May 1972, p. 46; ''Houston: Luis Jiménez at Contemporary Arts Museum'' by Jozanne Rabyer, in *Art in America,* 63, January/February 1975, p. 88; ''Signs: A Conversation with Luis Jiménez'' by Amy Baker Sandback, in *Artforum International,* 23, September 1984, pp. 84–87; ''Destined for a Public Place: The Art and Ideas of Luis Jiménez'' by Barbara Kingsolver, in *Tucson Weekly* (Tucson, Arizona), December 1985; ''Man on Fire: Sculpture of Luis Jiménez'' by Kathleen Whitney, in *Sculpture* (Washington, D.C.), 16, July/August 1997, pp. 20–25.

*

Luis Jiménez comments:

My main concern is creating an ''American'' art: using symbols and icons. Sources for the work come out of popular art and esthetic (cowboys, western Indians, the Statue of Liberty, motorcycles), as does the material-plastic (surfboards, boats, cars). I feel I am a traditional artist working with images and materials that are of ''my'' time.

* * *

The sculptor Luis Jiménez was born in El Paso, Texas, in 1940. He began his education at the University of Texas at El Paso but transferred to the University of Texas at Austin, where he received a B.A. in art and architecture in 1964. He later enrolled at the Cuidad Universitaria in Mexico City. Following a car accident—which temporarily paralyzed him—Jiménez abruptly left Austin to pursue a career in New York City in 1966, working there for five years producing his well-known fiberglass sculptures. In 1971 he returned to the Southwest, where he has continued to reside.

Much of the artist's works employ the use of fiberglass developed in an array of bright hues. Jiménez—whose maternal grandfather worked as a glassblower and paternal father was a carpenter—grew up with a deep respect for craftsmanship and artisan skills. His father worked in a sign painting shop creating neon signs and also had a profound influence on the artist's affinities to color and material.

Creating drawings, clay models, prints, and sculptures, the artist produced early works directly referencing the myriad social and political atmosphere of the late 1960s and early 1970s. As a Chicano artist, Jiménez specifically drew from themes regarding the Mexican-American experience, with particular focus on the culture of the American Southwest. Working in the realm of public sculpture, Jiménez was among the first generation of Chicano artists who sought to redefine and elevate the everyday world of Hispanic peoples.

The subjects represented in his works reflect the culture of the American West, often containing depictions of cowboys, buffalo, or cacti and other desert scenery. Jiménez, however, subverted common

Luis Jiménez: *Mesteño,* 1998. Photo courtesy of ACA Galleries, New York. © 2002 Luis Jiménez/Artists Rights Society (ARS), New York.

archetypes like the American cowboy and replaced them with the lesser known Mexican America vaqueros who established the cowboy culture of the American Southwest. Jiménez's *Honkey Tonk* (1981–86) uses billboard advertising methods to create a large tableau vivant of a cantina or bar that contains consciously exaggerated figures with a sense of satire and poignancy. Jiménez's father, an undocumented worker who crossed the border, bestowed a humanistic impression on the artist. In all his work Jiménez has continued to represent the dignity of working class people, consistently stimulating discussions regarding Mexican-American issues such as migrant labor, immigration, and social prejudice.

—Miki Garcia

JIMÉNEZ, Marisel

Costa Rican sculptor, assemblage artist, and installation artist

Born: 1947. **Education:** Universidad de Costa Rica; Universidad de las Américas, Mexico. **Awards:** Medalla de plata, Salón de Escultura, Banco Popular de Costa Rica, 1989; gold medal, *III salón nacional de escultura,* Museo de Arte Costarricense, San José, Costa Rica, 1989; first prize, *I bienal de escultura,* San José, Costa Rica, 1994; Premio Nacional de Escultura "Aquileo J. Echeverría," Ministerio de Cultura, Juventud y Deportes, San José, Costa Rica, 1994.

Individual Exhibitions:

1988 Sala Joaquín García Monge, Teatro Nacional, Costa Rica
1991 *El retablo de Maese Pedro,* Galería Itzcazú, Costa Rica
1993 *Las sábanas,* Museo de Arte Costarricense, San José, Costa Rica

Selected Group Exhibitions:

1990 *Arte costarricense hoy,* Dade Community College, Miami
 La animalística en la escultura costarricense, Museo de Arte Costarricense, San José, Costa Rica
1992 *Arte de Costa Rica,* Sprengel Museum, Hannover, Germany
1994 *Premios nacionales,* Museos del Banco Central, Costa Rica
 I bienal de escultura, San José, Costa Rica
1996 *Relaciones,* Museo de Arte y Diseño Contemporáneo, San José, Costa Rica
 MESOTICA II, Museo de Arte y Diseño Contemporáneo, San José, Costa Rica

Publications:

On JIMÉNEZ: Article—"Artistas hondureños participan en exposición colectiva en Europa" by Madrid Efe, in *La Prensa,* 4 June 1997.

* * *

Costa Rica is probably the Central American country with the strongest sculpture tradition, mainly in woodcutting but also in marble and stone. The animalistic thematic in particular has been overpowering, and in recent generations little renovation has come from sculptors trained in the classical techniques who have not been able to abandon the basic representation practices. Practically no abstract or geometrical work has developed, and there is a lack of a younger generation of sculptors. Among the few contemporary artists to have been able to bridge the gap between a formal academic training in woodcutting and modeling with a more conceptual discourse stemming from a deep personal experience is Marisel Jiménez. She is probably also one of the last artists to engage in all the production stages of her work before the use of objects and readymades entered the tridimensional art production in Costa Rica and the conceptual artists started to delegate the production of their pieces to local stonecutters and founders.

The personal body of work produced by Jiménez is a gradual path toward the analysis and exorcism of her internal ruptures. She also has produced several commemorative bronze works on commission that reflect her power of observation and her desire to convey darker or more hidden aspects instead of only rendering the more stereotyped and populist characteristics usually associated with venerated public figures: one of the most poignant busts is that of Yolanda Oreamuno, one of the country's most famous and most marginalized women writers, a self-exile who died tragically young far away from her native land. The artist has chosen to depict her as a decapitated head lying softly on its side, served on a platter, in reference to Saint John the Baptist, beheaded after Salome's dance.

Works done in the 1980s put together small birds and other frail animals, sometimes carved in wood, others done in terra-cotta, with pieces of simple furniture, broken windows, and plain wooden pallets. These were poetic exercises dealing with the pathos of the human condition, preparing her major work of 1993, the *Court of Don Carlos Jiménez*—her father. This installation, first-place winner of the Sculpture Biennale of 1994 and of the National Visual Arts prize of that same year, was definitely one of the most dramatic and daring approaches to her own intimacy and marked an entrance of the psychoanalytical discourse in local artwork. Several figures carved in wood hang from iron rods like a theater of marionettes, representing her father, her mother, her sister, her dog, and herself. All the figures are balancing over a large rustic wooden plank floor except for the figure of the artist, who is the only one with her feet on the ground. This is accompanied by an old cupboard in which the artist put away her heart carved in wood.

In 2000, at the invitation of the Contemporary Art and Design Museum in San José, Jiménez produced the large installation work *Ecce Homo.* This extremely complex work included a cell-like house made of chicken wire, several small ensembles of low furniture, cages, and fishing nets hanging from the ceiling or trailing on the ground, with the linking element a large production of terra-cotta marine birds. Many of the birds are wounded or dead, some are young creatures bundled together in a helpless bunch, others are hanging cruelly from what appears to be large fishing hooks, and others are simply sitting in half open cages, unable to even emerge from them. A low-lit atmosphere conveys an oppressive, extremely sad feeling to the whole installation. Part of this work was presented at the 2000 Havana Biennale.

Jiménez, although not a part of the younger generation of local artists and already having a large and strong production behind her, has still to produce some of her most powerful work, inasmuch as she has been gradually attaining the courage to delve into the darker depths of her own intimate world, to be able to put forth and express the unsaid, the unmentionable. Her contribution to the development of sculpture in Costa Rica has been important, and many younger artists have been indebted to her way of working around intimate themes and of adapting traditional techniques to a contemporary language and perception of art.

—Virginia Pérez-Ratton

JIMÉNEZ, Max
Costa Rican painter and sculptor

Born: San José, 16 April 1900. **Education:** Colegio Seminario, 1914–17; studied in England, 1919–21, and in Paris, 1922. **Family:** Married Clemencia Soto Uribe in 1926; two sons. **Career:** Traveled to Paris, 1922–25, to Europe, 1928–30; lived in Madrid, 1933; visited the United States, 1934, Chile and Cuba, 1936; lived in the United States and in Havana, 1939, 1943; lived in Santiago, 1946, and in Buenos Aires, 1947. Also worked as a writer and editor. **Died:** Buenos Aires, 3 May 1947.

Selected Exhibitions:

1924 Galerie Percier, Paris
1939 Galería M. M. Bernheim-Jeune, Paris

1940 Galería Georgette Passedoit, New York
1941 Galería Georgette Passedoit, New York
1942 Galería Zborowski, New York
 Lyceum, Havana
1943 Instituto de Cultura Americana, Havana
1944 Lyceum, Havana
1945 L'Atelier, Costa Rica
1999 Museo de Arte Costarricense, San José
2000 Museo de Arte Costarricense, San José (retrospective)

Publications:

By JIMÉNEZ: Books—*Ensayos,* prologue by J. García Monge, San José, Trejos, 1926; *Gleba,* Paris, Le Livre Libre, 1929; *Unos fantoches,* San José, Alsina, 1929; *Quijongo,* Madrid, Espasa Calpe, 1933; *Revenar,* Santiago, Nascimento, 1936; *Poesías,* San José, Círculo de Amigos del Arte, 1936; *Sonaja,* Madrid, Argis, 1936; *El domador de pulgas,* Havana, Hermes, 1936; *El Jaul,* Santiago, Nascimento, 1937; *Candelillas,* San José, Ed. Costa Rica, 1965; *Obra literaria de Max Jiménez,* San José, Studium, 1984.

On JIMÉNEZ: Books—*Narrativa de la crisis y crisis de la narrativa: Los jóvenes Max Jiménez y Marín Cañas, 1928–1931,* San José, Universidad de Costa Rica, 1996, and *Los textos de madurez de Max Jiménez: Carnaval, parodía y desencanto,* Ciudad Universitaria Rodrigo Facio, San Pedro de Montes de Oca, Centro de Investigación en identidad y cultura, 1997, both by Alvaro Quesada Soto; *Max Jiménez: Un artista del siglo,* exhibition catalog, with text by Ana Gabriela Sáenz Delgado, José Miguel Rojas González, and María Elena Masís Muñoz, San José, Museo de Arte Costarricense, 1999; *Max Jiménez: Aproximaciones críticas* by Alvaro Quesada Soto, San José, Editorial de la Universidad de Costa Rica, 1999; *Max Jiménez: Catálogo razonado* by Floria A. Barrionuevo and María Enriqueta Guardia, San José, Editorial de la Universidad de Costa Rica, 1999; *Max Jiménez* by Alfonso Chase, San José, Editorial Universidad Estatal a Distancia, 2000. **Articles**—"Carta de Costa Rica. El año del Max Jiménez" by Carlos Cortes, in *Cuadernos hispanoamericanos,* 594, 1999, p. 121; "Max Jiménez" by Belgica Rodriguez, in *Art Nexus* (Colombia), 35, February/April 2000, pp. 128–129.

* * *

Max Jiménez is, without doubt, the most interesting and complex figure of the historic Central American avant-garde movements. For a long time he was considered a dilettante, given the short and intense periods during which he devoted himself to different areas of art, as well as to his stylistic versatility in the writing of short naturalistic or absurdist novels, symbolist poetry, aphorisms, articles on politics and the economy, and so forth. Coming from a wealthy family, he had the opportunity to live in Europe in the early 1920s. He was sent off to London to study business but sneaked away to Paris, where he was to come into contact with avant-garde art movements, practically teaching himself to sculpt and possibly receiving a direct influence from local bohemians and particularly the works of Modigliani and Picasso. From then on he was characterized by a desire for experimentation, which in his works was to lead him to try nontraditional materials that have deteriorated over time.

Jiménez's sculptures include several of his key works, such as his magnificent granite heads, worked with great delicacy, in which he accentuated the smoothness of the carving and the appreciation of

roundness. With an insectlike appearance and with features that are clearly reminiscent of the native American Indian, these pieces are closely related to the figures his paintings are full of. His *Cabeza de negra* (1937; ''Black Woman's Head''), slender and rounded at the same time, is perhaps his most exquisite piece. It refers directly to the intense interest Jiménez was to show in his paintings from the end of the 1930s up to his death in 1947 in blackness, in part under the sensitive influence of his passion for the Costa Rican Caribbean. Other major works of sculpture include *Danaide* (1937), *Maternidad* (*ca* 1935; ''Maternity''), and one of his early works in bronze, *El beso* (1922; ''The Kiss'').

In his paintings Jiménez represented strange characters, tropical and melancholy or simply desolate and unclassifiable, lost in impossible beauty spots. With a clear tendency toward the deformed, which has often been attributed precisely to the influence of Picasso's classical period and to Modigliani's lengthened faces, Jiménez's pictorial work shows a special interest in the expressive stylization of monstrous hands and necks. As he did in his poetry, Jiménez constantly mixed sensuality and anguish, as in *Tierra cocida* (''Baked Earth''), one of his most significant paintings.

Because of Jiménez's powerful critical capacity many of his works, especially his writings, possess a bitter tinge, which came from his disenchanted view of humanity. This is accurately expressed in his anguished scenes of black characters sunk in desolation and misery, as in *Negro pobre* (''Poor Black Man'') and *Hambre bajo el sol* (''Hunger in the Sun''). But among his paintings voluptuous and indolent female nudes may also be found, not without an expression of profound melancholy. These paintings bear a mellow and expressive stamp or are at times strangely flat and synthetic, fluctuating between a palette of ochers, siennas, and somber greens and another of luminous pastel colors. Jiménez cultivated an atmosphere, both in his poetry and in his paintings, that was at the same time tropical and gloomy.

As a technique to illustrate his literary production, Jiménez embarked upon xylography. Wild lines and a symbolism that on occasion was especially twisted, as is revealed in his absurdist novel *The Flea Trainer* (1936), are constant features in his wood engravings. Of expressionist inspiration, the white lines can be seen as schematic profiles, often openly ''primitive.'' Jiménez's drawings, in contrast, are linear and of great subtlety. As a theme they also deal with the female nude, but they are far from the disquieting atmosphere of his paintings and sculptures and are divorced from the ''wild'' nature of his xylographs. The ideas that fed Jiménez's works in plastic, intimately related to his literary production, denote his tortured mood between a sensual attachment to life and the deception human nature inspired in him. In one of his most meaningful phrases, which make up his aphorisms, he expressed the depth of his pessimism: ''Upon so many misfortunes we put death as a limit, a limit which we almost finally wish for.''

—Vivianne Loría

JUÁREZ, Roberto

American painter

Born: Chicago, 1952. **Education:** San Francisco Art Institute, B.F.A. in 1977; University of California, Los Angeles. **Career:** Visiting artist,

Vermont Studio Center, October, 2001. **Award:** *Prix de Rome,* American Academy, Rome, Italy, 1996.

Individual Exhibitions:

1983	Robert Miller Gallery, New York
1985	La Mama's La Galleria, New York
	Robert Miller Gallery, New York
1986	Robert Miller Gallery, New York
1987	Robert Miller Gallery, New York
1988	Stephen Wirtz Gallery, San Francisco
1989	Robert Miller Gallery, New York
1990	Betsy Rosenfield Gallery, Chicago
1993	Robert Miller Gallery, New York
1995	*They Entered the Road,* Center for the Fine Arts, Miami
	Galeria Ramis Barquet, Garza García, Mexico
1996	*New Paintings,* Robert Miller Gallery, New York
1997	*Rome Paintings,* Robert Miller Gallery, New York
1997–98	*They Entered the Road,* Kemper Museum of Contemporary Art, Kansas City, Missouri
1998	Galerie Tobias Hirschmann, Frankfurt, Germany
2000	Robert Miller Gallery, New York
2001	David Floria Gallery, Aspen, Colorado

Selected Group Exhibition:

1985	Sheldon Memorial Art Gallery, University of Nebraska, Lincoln

Collections:

Brooklyn Museum of Art, New York; Metropolitan Museum of Art, New York; Museo del Barrio, New York; J. B. Speed Museum, Louisville, Kentucky; Newark Museum, New Jersey; Neuberger Museum of Art, Purchase, New York; St. Louis Art Museum, Missouri; Kemper Museum of Contemporary Art, Kansas City, Missouri.

Publications:

On JUÁREZ: Books—*Roberto Juárez: Spirit and Prism,* exhibition catalog, by Duncan Smith, Robert Miller Gallery, New York, 1983; *Roberto Juárez* by Gary Indiana, Bellport Press, New York, 1986; *Roberto Juárez: They Entered the Road,* exhibition catalog, text by César Trasobares and Lisa Liebmann, Center for the Fine Arts, Miami, 1995; *Roberto Juárez,* exhibition catalog, Galeria Ramis Barquet, Garza García, Mexico, 1995; *Roberto Juárez: One Year in Rome,* Robert Miller Gallery, 1997. **Articles—**''Blending Abstraction and Representation'' by Katherine Gregor, in *Artweek,* 19, 30 April 1988, p. 5; ''Roberto Juárez'' by Elisa Turner, in *Art News,* 94, September 1995, pp. 147–148; ''Roberto Juárez: They Entered the Road'' by Chris Hassold, in *Art Papers,* 19, November/December 1995, p. 40; ''Roberto Juárez: Robert Miller'' by Christopher Chambers, in *Flash Art* (Italy), 32(214), October 2000, pp. 105–106.

* * *

For more than 20 years Roberto Juárez has been a significant presence in contemporary art. Born in Chicago and trained at the San Francisco Art Institute and at the University of California at Los

293

Angeles, he has spent most of his professional career in New York City and Miami. After his first solo exhibition in 1981, he established an international reputation as a painter of large mixed-media compositions, often merging a distinctive color sensitivity with symbolic motifs. Over the next two decades he moved from an energetic expressionist style of "naive" figuration toward more contemplative abstraction. Exhibiting widely throughout the United States and Mexico during that period, he received several distinguished awards and public art commissions.

Juárez's paintings of the early 1980s featured highly personal symbolic motifs presented in a colorful painterly style, as seen in *Field of Eyes, Ojo,* and *Sun Woman*. Mayan deities, dice, disembodied eyes, birds, and tropical vegetation suggest associations with Latin traditions, often with particular reference to popular or folk culture. These brashly colored figurative images display affinities with new wave expressionism, graffiti, punk, and "bad" painting (i.e., exploiting a deliberate crudeness or naïveté). Critics observed, however, that, unlike the angst and alienation of most new wave expressionists, Juárez seemed to express a pure, animist joy in life with a "street kid primitivity." The critics also praised his early paintings for their positive affirmation of natural life forces and for revealing the "emotive power latent in things."

Around 1986 Juárez began to modify the extreme exuberance of his early expressionist style. Large iconic forms representing disembodied plants and sea life float above amorphous backgrounds in *Applepeppers* and *Dark Pond*. Critics saw "a new maturity" in the more introspective moods of these paintings, sometimes interpreted as "mindscapes." This trend continued into the early 1990s, when Juárez created a series of mixed-media collage paintings inspired by the experience of spending five winters in south Florida. Combining images of indigenous plant life with symbolic references to Seminole and Afro-Caribbean cultures, his series entitled *Miami Beach Paintings* explored connections between the region's past and present, along with its evolving multicultural identity.

In 1997, after receiving the Prix de Rome from the American Academy, Juárez spent a year in Italy. The experience inspired several series of lyrical, introspective paintings referring to the city's past and present. His large, softly colored paintings–sometimes interpreted as nostalgic reflections on the passage of time–contain eclectic references to classical sculpture at the Capitoline Museum, marginalia from medieval manuscripts in the Vatican collections, and an array of plant life from the city's numerous gardens. One series, *The Dormitories,* was intended to inspire individual meditation, like the paintings in the cells of medieval monks. Layers of rich color create a softly oscillating space without resorting to conventional systems of perspective. More personal meanings appear in the artist's elegiac series *They Entered the Road,* also from 1997, which commemorates the deaths of close friends and family members. The lush plant life in these poetic paintings seem to suggest the continual cycle of birth, death, and regeneration. Rich, glowing color and lush floral forms, created by mixtures of oil and pastel and floating over abstract grounds, invite comparison with the symbolist pastels of Odilon Redon. Juárez employed a similar style for his mural *A Field of Wild Flowers* at Grand Central Terminal in New York City.

Juárez has since moved further into abstraction. He created a series of paintings inspired by urban construction around his studio near Times Square that feature large semigeometric forms placed above abstract backgrounds. Brilliantly colored circles, rectangles, and other motifs–suggesting both organic and man-made structures–are depicted with free, improvisatory brushwork. The abstract forms are organized in patterns that suggest urban grids, plant cells, and neural systems. Juárez continued to develop this preoccupation with abstract form in another series, *A Taste for Home Decorating*. These paintings exhibit a new mastery of form and materials, as the surfaces exhibit unusual qualities of luminosity and transparency, achieved partly by combining peat moss, inks, acrylics, and water-based paints applied over rice paper and gessoed canvas. Critics have praised this new direction in Juárez's art, with its emphasis on strong abstract forms and patterns, apparently merging multinational and Latin influences with inventive decorative design.

—William H. Robinson

K

Frida Kahlo, 1931. © Bettmann/Corbis.

KAHLO, Frida

Mexican painter

Born: Magdalena Carmen Frida Kahlo y Calderón, Coyoacán, Mexico City, 6 July 1907. **Education:** Escuela Nacional Preparatoria, Mexico City, 1922–24; studied drawing and engraving under Fernando Fernández, Mexico City, 1925; Academia Oliver, 1925. **Family:** Married Diego Rivera, *q.v.,* in 1929 (divorced 1939; remarried 1940). **Career:** Teacher, Section of Painting and Handicrafts, Department of Fine Arts, Mexico, 1929; professor of painting, Escuela de Pintura y Escultura La Esmeralda, Mexico City, 1942. Traveled to the United States with Rivera, 1930–34; traveled to New York and Europe, 1938–39. Joined Mexican Communist party, 1928. **Awards:** Grant, Mexican government, 1946; prize, Secretaría de Educación Pública, 1946. **Died:** 13 July 1954.

Individual Exhibitions:

1938	Julien Levy Gallery, New York
1940	Museum of Modern Art, New York
1941	Philadelphia Museum of Art
	Institute of Modern Art, Boston
1943	Art of This Century Gallery, New York
1953	Galería de Arte Contemporaneo, Mexico City (retrospective)
1982	Whitechapel Art Gallery, London (with Tina Modotti)
1989	Meadows Museum, Southern Methodist University, Dallas (retrospective)
1990	Art Gallery of South Australia (retrospective)
1993	*The World of Frida Kahlo,* Schirn Kunsthalle Frankfurt, Germany, and Museum of Fine Arts, Houston (retrospective)

Selected Group Exhibitions:

1939	*Mexique,* Pierre Colle Gallery, Paris
1940	*International Surrealism Exhibition,* Gallery of Mexican Art
	San Francisco Golden Gate International Exhibition, San Francisco
	Twenty Centuries of Mexican Art, Museum of Modern Art, New York
1942	*Twentieth Century Portraits,* Museum of Modern Art, New York
1943	*A Century of the Portrait in Mexico (1830–1942),* Benjamin Franklin Library, Mexico City
	Mexican Art Today, Philadelphia Museum of Art
1947	*Forty-Five Self-Portraits by Mexican Painters,* National Institute of Fine Arts
1949	*Salon de la plástica mexicana,* Mexico

Collections:

Albright-Knox Art Gallery, Buffalo, New York; Museum of Modern Art, New York; Phoenix Art Museum, Arizona; San Francisco Museum; Window South, Palo Alto, California; Museo de Arte Moderno, Mexico City; University of Texas, Austin.

Publications:

By KAHLO: Books—*The Diary of Frida Kahlo: An Intimate Self-Portrait,* with an introduction by Carlos Fuentes and an essay and commentaries by Sarah M. Lowe, New York, Abrams, 1995; *The*

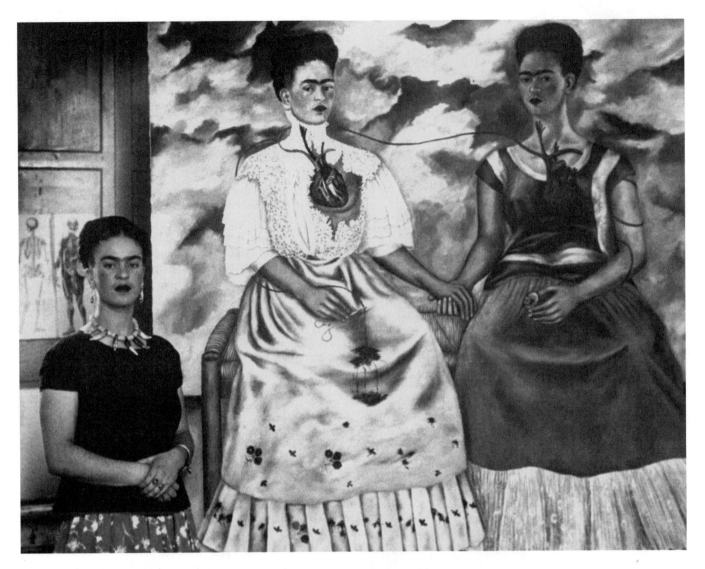

Frida Kahlo standing in front of her paining, *Las Dos Frida (Me Twice),* **1939. ©Bettmann/Corbis.**

Letters of Frida Kahlo: Cartas apasionadas, selected and edited by Martha Zamora, San Francisco, Chronicle Books, 1995.

On KAHLO: Books—*Frida: A Biography of Frida Kahlo,* New York, Harper & Row, 1983, London, Bloomsbury, 1989, and *Frida Kahlo: The Paintings,* New York, HarperCollins, 1991, both by Hayden Herrera; *Frida Kahlo: Autoportrait d'une femme* by Rauda Jamis, Paris, Presses de la Ranaissance, 1985; *Frida: El pincel de la angustia* by Martha Zamora, Mexico, La Herradura, 1987; *Frida Kahlo: La pintora y el mito* by Teresa del Conde, Mexico, Universidad Nacional Autónoma de Mexico, 1992; *Frida Kahlo: Una vida, una obra* by Carlos Monsiváis and Rafael Vázquez Bayod, Mexico, Ediciones Era, 1992; *The World of Frida Kahlo,* exhibition catalog, edited by Erika Billeter, Frankfurt, Germany, Schirn Kunsthalle Frankfurt, 1993; *Frida Kahlo* by Malka Drucker, Albuquerque, University of New Mexico Press, 1995; *Diego y Frida* by J. M. G. Le Clézio, Mexico, Editorial Diana, 1995; *Devouring Frida: The Art History and Popular Celebrity of Frida Kahlo* by Margaret A. Lindauer, Hanover, University Press of New England, 1999. **Articles—**''Frida Kahlo: The Palette, the Pain, and the Painter'' by Hayden

Herrera, in *Artforum,* March 1983, pp. 60–67; ''Frida Kahlo Mania!'' in *Interview,* XXII(10), October 1992, p. 62; ''Frida Kahlo: At the Altar of Pain Kahlo Became an Icon of Life'' by Erika Billeter, in *Southwest Art,* 23(3), August 1993, p. 94; ''The Kahlo Cult'' by Judd Tully, in *Artnews,* 93, April 1994, pp. 126–133; ''Diary of a Mad Artist'' by Amy Fine Collins, in *Vanity Fair,* September 1995; ''Frida Kahlo: A Self-Proclaiming Self-Portrait Artist'' by Kandace Steadman, in *School arts,* 95(5), 1996, p. 23; ''Dissociation, Repetition-Compulsion, and the Art of Frida Kahlo'' by Gail Carr Feldman, in *Journal of the American Academy of Psychoanalysis,* 27(3), 1999, p. 387; ''La escritura doble de Frida Kahlo'' by Esperanza Ortega, in *Quimera* (Barcelona), 191, 2000, p. 11.

* * *

The work of Mexican painter Frida Kahlo surged in popularity and market value in the 1980s, nearly 30 years after the artist's death in 1954. Kahlo achieved iconic significance during those years because her self-portraits, which comprise nearly 40 percent of her

total artistic output, explore multiple levels of gender, class, and cultural identities, which resonate strongly among many different communities. In her various artistic guises Kahlo presented startlingly brutal images of personal suffering on a physical and emotional level, as well as subtle renderings of the complicated cultural underpinnings of twentieth-century Mexico as they appeared in her life as the daughter of a German-Jewish immigrant father and a Mexican mother of Spanish-Indian ancestry.

Kahlo began painting in earnest while recuperating from a devastating bus accident that was to have lasting repercussions on her body and in her art. Many of her self-portraits focus on her injured body, often bleeding from wounds in her back or leg, mimicking her real injuries. Yet many of the wounds she depicted were metaphorical, symbolic of her own emotional distress or to convey ideas drawn from Christian and pre-Columbian religious iconography. Her earliest paintings exhibit none of the frank gore of these works but rather demonstrate an exploration of stylistic treatments ranging from Italian Renaissance portraiture to Mexican popular art to futurism and surrealism. Two works from that time, *Pancho Villa and Adelita* (ca 1927) and a self-portrait from 1929, show Kahlo's varied interests, which are clearly rooted in Mexican revolutionary politics and an awareness of the cultural movements of the time designed to promote Mexican indigenous culture. In the former Kahlo painted herself, presumably as "Adelita," a *soldadera* and heroine of a revolutionary ballad dedicated to Pancho Villa. Of the three other paintings within the scene, two depict Villa or his army, the other an enigmatic modernist space recalling Italian artist Giorgio di Chirico's work. The 1929 self-portrait utilizes motifs drawn from a drawing book by Adolfo Best Maugard that are meant to prescribe a curriculum of art instruction that would be inherently Mexican. In it Kahlo wears a pre-Columbian necklace and Spanish colonial earrings in a fashionable nod to her mixed cultural ancestry.

In 1929 Kahlo married the Mexican muralist Diego Rivera, and in 1930 she traveled with him to the United States. During the next four years Kahlo developed the themes that would form the basis of her paintings in the succeeding two decades of her art production. Kahlo's use of Mexican popular art forms and Mexican style of dress began while she lived in Mexico, but with her entry into international society and politics upon her marriage, her identification with Mexico and its people accelerated and became more pronounced in her art and life. In her paintings she explored further her own national and cultural identity and the European elements in her background and that of Mexico. *Self-Portrait on the Border of the United States and Mexico* (1932) illustrates the incongruities between the neighboring countries and the artist's ambiguous position in relation to them both. Kahlo balanced the impersonal industrialized landscape of the United States with the fertile agrarian landscape and monumental ruins of pre-Columbian Mexico. She stands between the two in formal dress, smoking a cigarette and waving a small paper Mexican flag as an uneasy bridge between the two cultures. The first of Kahlo's truly horrifying self-portraits, *Henry Ford Hospital* (1932), shows her abandoned on a hospital gurney in a barren landscape with the Detroit skyline behind her while she bleeds from a miscarriage. This small painting on tin takes the form of a *milagro* painting, a painting of a miracle, but no redemption occurs here, nor any miraculous intervention. Even with the autobiographical content, this painting makes political references to Kahlo's alienation within the United States and draws on many artistic traditions from Mexico.

After her return to Mexico in 1934, Kahlo's paintings exhibited an increasingly complex interplay of motifs and styles drawn from Mexican cultural history. Most notably, she favored the technique of oil on tin, drawn from *milagro* paintings. She also began to depict herself consistently wearing the dress of the Tehuana, to illustrate her alliance with the independent spirit of the indigenous Mexican peasantry. Her communist politics revealed themselves even more, so that by the time of her death she had an unfinished portrait of Stalin on her easel and a *milagro* painting entitled *Marxism Will Heal the Sick* showing herself casting aside crutches with the large face of Karl Marx looking on benevolently.

Kahlo has been looked at most often for her self-portraits fraught with graphic depictions of personal suffering. Looked at another way, they illustrate many of the debates going on in her lifetime about the nature of Mexican identity in the face of its colonial past and its continuing relationship with the United States.

—Laura J. Crary

KATZ, Leandro
Argentine and American photographer and filmmaker

Born: Buenos Aires, 1938 (originally Argentine: now holds dual Argentine and American citizenship). **Education:** Universidad Nacional de Buenos Aires, B.F.A. 1960; Pratt Institute, New York, 1965–67. **Career:** Lived in Peru, Ecuador, and Mexico, 1961–65; settled in New York, 1965. Instructor, School of Visual Arts, New York, 1970–90, Brown University, 1981–84, New School/Parsons, New York, 1986–87, and Department of Cultural Affairs of the City of New York, Artists in the Arts Apprenticeship Program, 1978–91. Since 1987 professor, William Paterson University, School of Arts and Communication, New York. Has participated in numerous film exhibitions. Created and broadcast radio pieces, WRVR, New York, 1966–70; coeditor, TVRT Press, New York, 1970. **Awards:** C.A.P.S. in filmmaking, 1976; National Endowment for the Arts fellowship in filmmaking, 1979, 1991, 1994; John Simon Guggenheim Memorial Foundation fellowship in visual arts, 1979; Jerome Foundation grant in filmmaking, 1982, 1992; Art Matters grant in filmmaking, 1987; New York State Council on the Arts grant in filmmaking, 1989, 1997; Rockefeller Foundation, Intercultural Film/Video fellowship, 1993; Nexus Press Artist Book residency, 1994; Arts International travel grant, 1994. **Address:** 25 East 4th Street, New York, New York 10003, U.S.A. **Website:** http://users.rcn.com/leandrok.

Selected Exhibitions:

1964 Betzalel Gallery, San Francisco
1965 Galería Sudamericana, New York
 Washington Square Gallery, New York
1967 Center for Cybernetic Research, Detroit
1972 Centro de Arte y Comunicación, Buenos Aires
 Museo Nacional de Bellas Artes, Caracas
1977 *Words,* Whitney Museum of American Art, New York
1978 *Artwords/Bookwords,* Los Angeles Institute of Contemporary Art
 Structure, John Gibson Gallery, New York
 Studio de Arte Canaviello, Milan
 The Ampitheatre, John Gibson Gallery, New York
1979 *The Altered Photograph*, P.S. 1, New York

Leandro Katz: *Lunar Typewriter,* "Lunar Alphabet" series, 1980. Photo courtesy of the artist.

1979 *Structure II*, John Gibson Gallery, New York
1980 *Film As Installation*, The Clocktower, New York
 The Lunar Alphabet, The Clocktower, New York
1982 *The Judas Window*, Whitney Museum of American Art,
 New York
 Metropotamia, P.S.l, The Institute for Art and Urban
 Resources, New York
1983 *Film As Installation II*, The Clocktower, New York
1984 *Orpheus Beheaded*, Rhode Island School of Design
 Museum, Providence (traveling)
1985 *The Milk of Amnesia*, C.E.P.A. Gallery, Buffalo, New
 York
1987 *This Is Not A Photograph*, Ringley Museum of Art,
 Florida (traveling)
 Latinamerican Artists in New York since l970, Univer-
 sity of Texas, Austin
1988 *Southern Novas, Northern Skies,* B.A.C.A., New York
1989 *The Latin American Spirit: Art and Artists in the U.S.,*
 Bronx Museum, New York
 A propos de l'international situationniste l957-l972,
 Musee National d'Art Moderne, Centre Georges
 Pompidou, Paris (traveling)
 Centro de Arte y Comunicación, Buenos Aires
 The Decade Show, New Museum of Contemporary Art,
 New York
1990 *Installations: Current Directions*, Museum of Contem-
 porary Hispanic Art, New York

1991 *SITEseeing*, Whitney Museum of American Art, New
 York
 Dissimilar Identity, Scott Alan Gallery, New York
1992 *The Catherwood Project*, Robert B. Menschel Gallery,
 Syracuse, New York
 Disorient, Gallery 400,University of Illinois at Chicago
 Americas, Expo '92, Andalucía Pavilion, Spain
 Cambio de Foco, Biblioteca Nacional Arango, Bogotá
 Remerica/Amerika, Hunter College Gallery, New York
1994 *Reclaiming History*, El Museo del Barrio, New York
 Two Projects, Galería Nina Menocal, Mexico City
 El desdoblamiento, el simulacro, el reflejo, I.C.I.,
 Buenos Aires
1995 *Latin American Book Arts*, Center for Book Arts, New
 York
 Two Projects/A Decade, El Museo del Barrio, New
 York
1996 *A Spiritual Journey: Photography in Latin America*,
 Brooklyn Museum, New York
1997 *Conceptual Photography* IV, John Gibson Gallery, New
 York
 VI bienal de la Habana, Havana
 Arts Annual Exhibition, Newark Museum, New Jersey
1998 *El arte de los libros de artista,* Instituto de Artes
 Gráficas de Oaxaca, Mexico
 Project for the Day You'll Love Me, Art Institute of
 Chicago

Leandro Katz: *Las Palomas, Uxmal,* Catherwood Project, 1993. Photo courtesy of the artist.

1999 *The Catherwood Project,* Photography Month Invita-
 tional, Quito, Ecuador (traveling)
2000 *Poetics, Politics, and Song,* Yale University, New
 Haven, Connecticut
2001 *Marking Time/Making Memory*, Miami University Art
 Museum, Oxford, Ohio

Collections:

Canadian Centre for Architecture, Montreal; Getty Center for the History of Art and the Humanities, Santa Monica, California; Museum of Modern Art, New York; Harvard University, Cambridge, Massachusetts; Brooklyn Museum, New York; El Museo del Barrio, New York; Museo de Arte Moderno, Buenos Aires; Yale University, New Haven, Connecticut.

Publications:

By KATZ: Books—*Puerto Verano,* Buenos Aires, Dondardo, 1960; *Urnas/Metal,* Buenos Aires, MBLK Editions, 1961; *Uampungo,* Tupiza, Bolivia, Nuevos Horizontes, 1961; *Las esdrujulas,* Lima, La Lengua Viperina, 1961; *Tres poemas,* Lima, Breve Follaje, 1961; *OOOO,* Iquitos, Peru, Alerta Gráfica, 1961; *Tzantzas,* Quito, Ecuador, Universidad Central, 1962; *Es una ola,* Buenos Aires, Editorial Sudamericana, 1968; *Ñ,* New York, Vanishing Rotating Triangle,

1970; *Latinamerica and I Have a Little Nest in Switzerland,* New York, Vanishing Rotating Triangle, 1970; *Dislocation & Relocation of Monuments,* New York Vanishing Rotating Triangle, 1971; *Self-Hipnosis,* New York, Vanishing Rotating Triangle, Viper's Tongue Books, 1975; *The Milk of Amnesia,* Buffalo, New York, C.E.P.A./The Visual Studies Workshop, 1985; *27 molinos,* New York, La Lengua Viperina, 1986; *Libro quemado/Burnt Book,* New York, privately printed, 1992; *El desdoblamiento, el simulacro y el reflejo,* with David Lamelas and Liliana Porter, introduction by Luisa Velenzuela, New York, 1994; *Che/Loro,* New York, Viper's Goneu Books, 1997; *Solidaridad,* edition of 25, New York, Viper's Tongue Books, 2000. **Article**—"El día que me quieras," in *Cinémas d'amérique latine,* March 1998. **Films**—*Crowd 7x7,* 1976; *Los Angeles Station,* 1976; *Twelve Moons (& 365 Sunsets),* 1976; *Moonshots,* 1976; *Fall,* 1977; *Paris Has Changed A Lot,* 1977; *Splits,* 1978; *Moon Notes,* 1980; *The Visit (Foreign Particles),* 1980; *Metropotamia,* 1982; *The Judas Window,* 1982; *The Visit,* 1986; *Reel Six, Charles Ludlam's Grand Tarot,* 1987; *Mirror on the Moon,* 1992; *El dia que me quieras,* 1997.

On KATZ: Books—*Structure,* exhibition catalog, text by Valentin Tatransky and Steven Poser, New York, John Gibson Gallery, 1978; *This Is Not a Photograph: Twenty Years of Large-Scale Photography,* exhibition catalog, Florida, John and Mable Ringling Museum of Art, 1987; *The Latin American Spirit: Art and Artists in the U.S.,* exhibition catalog, New York, Bronx Musuem of the Arts, 1988; *The*

Catherwood Project, exhibition catalog, text by Susana Torruella Leval, New York, LightWork, 1992; *Marking Time/Making Memory,* exhibition catalog, text by Linnea Dietrich and Edna Southard, Oxford, Ohio, Miami University Art Museum, 2001; *Twentieth-century Art of Latin America* by Jacqueline Barnitz, Austin, University of Texas Press, 2001. **Articles**—"Filmworks" by Carol Squiers, in *Artes Visuales,* August 1980; "Film As Installation" by Shelley Rice, in *Artforum,* September 1980; "Verbal Art Speaks Up" by Ted Castle, in *Flash Art,* November 1980; "Changing the Fantasmatic Scene" by Kaja Silverman, in *Framework,* November 1982; "How Latin American Artists in the U.S. View Art, Politics and Ethnicity in a Supposedly Multicultural World" by Shifra M. Goldman, in *Third Text* (London), 16/17, 1991; "Two Projects/A Decade" by Ana Tiscornia, in *Art Nexus,* June 1996; "Films by Leandro Katz" by Jonathan Rosenbaum, in *Chicago Reader,* March 1998; "The Profound Madness of Photography" by Jean Franco Montegna, in *Visual Culture,* 1998.

* * *

Argentine-born Leandro Katz is a photographer and filmmaker who has focused on the problem of historical memory in his films and installations. Beginning his career as a poet in Argentina, his work uses language as well as film and still photography to raise questions about political movements in Latin America. He has, for example, examined the mythic romanticism associated with political revolutionaries and the appropriation of popular images associated with their causes. Both in installations and film, Katz has looked at the final days of the Cuban guerrilla leader Che Guevara in a project called *Project for the Day You Love Me.*

Images of the cadaver of Guevara are featured in advertising throughout Latin America. In Katz's award-winning 16-mm film, he looks at the images critically, deconstructing the pathos and religious symbolism associated with the stark, artistically rendered shots taken after Guevara's execution. In 1965 Guevara left Cuba with 17 followers to organize an uprising in Bolivia. Months later he was captured and executed by the Bolivian army. Pictures of Guevara's body were released by the Bolivian army in hopes of relaying the message that the cause that Guevara fought for was dead. Rather than portraying Guevara as a failure, however, the pictures helped foster the idea of Guevara as a hero, a martyr. In a famous photograph of Guevara's cadaver, Guevara's eyes are open and he seems to be gazing at the sky. In *Project for the Day You Love Me* Katz returned to Bolivia to trace the source of this photograph. Long associated with photographer Hal Moore, the photograph was actually taken by a young Bolivian photographer, Freddie Alborta.

Alborta recalled taking the photograph of Guevara shortly after the rebel's death: "I had the impression I was photographing Christ . . . It was not a cadaver that I was photographing but something extraordinary . . . and that is why I took the photograph with such care." In his film Katz probes Alborta with questions, working toward the truth of Guevara's execution while dismantling the mythic quality of Guevara's death. He also shows disturbing photographs usually not seen that suggest the cruelty, violence, and even mundaneness of Guevara's death, releasing Guevara, in a sense, from the otherworldly perception of his execution. The famous photograph gets repeated in the film, bombarding the viewer with images in a way similar to advertising. Mixed within the still photographs is film footage showing scenes

such as Guevara's hand being sent to America for identification. The movement of the bodies in the film playing against the still photograph of Guevara's body create an eerie impression that Guevara is not really dead but between two worlds. The title song "The Day You Love Me" sung by Argentinean singer Carlos Gardel comes at the end of the film, when a picture of a young Guevara smiles hopefully at the camera.

In an art installation examining the Maya ruins, Katz has taken a similar critical gaze upon a subject. Using the drawings of British artist Frederick Catherwood, who visited the Yucatán in the 1830s, Katz asks questions about the very act of documenting an event. Like his deconstruction of the photograph of Guevara's death, Katz prompts the viewer to determine the authenticity of Catherwood's paintings. In his installation Katz uses his own photographs of the ruins done from similar angles to Catherwood. Taken at night, the photographs create a ghostly quality that suggests the absence of the Maya themselves in Catherwood's drawings.

By carefully redocumenting a previously documented event, Katz questions our perceptions and acceptance of the way things are. His artwork suggests that there are many ways to view a subject, for things are never merely what they seem—there is always an alternative story to uncover.

—Sally Cobau

KCHO
Cuban painter, sculptor, and installation artist

Born: Alexis Leyva Machado, Nueva Gerona, Isla de la Juventud, 1970. **Education:** Escuela Elemental de Arte de Nueva Gerona, Isla de la Juventud, 1983–86; Escuela Nacional de Artes Plásticas, Havana, 1984–90. **Awards:** Saiz Brothers Association prize, Salón Municipal de Artes Plásticas y Diseño, Nueva Gerona, Havana, 1990; National Salon of Art Professors prize, Centro Provincial de Artes Plásticas y Diseño, Havana; Ludwig Foundation scholarship, 1994; grand prize, Kwang-Ju Biennale, Unesco Prize for the Promotion of the Arts, Geneva. **Address:** c/o Barbara Gladstone Gallery, 515 West 24th Street, New York, New York 10011.

Individual Exhibitions:

1986 *Cacho expone fabelas,* Centro de Artes Plásticas de la Isla de la Juventud, Cuba
1990 *Paisaje popular cubano,* Galería de la Escuela Nacional de Artes Plásticas, Havana
1992 Museo Nacional Palacio de Bellas Artes, Havana
1993 *Kcho, Drawings and Sculptures,* Galería Plaza Vieja, Fondo Cubano de Bienes Culturales, Havana
 Galería de Arte Contemporáneo, Mexico City
1994 Galería Habana, Havana
1995 Fundación Pilar i Joan Miró, Mallorca, Spain
 Centro Wifredo Lam, Havana
1996 Barbara Gladstone Gallery, New York
 Studio Guenzani, Milan

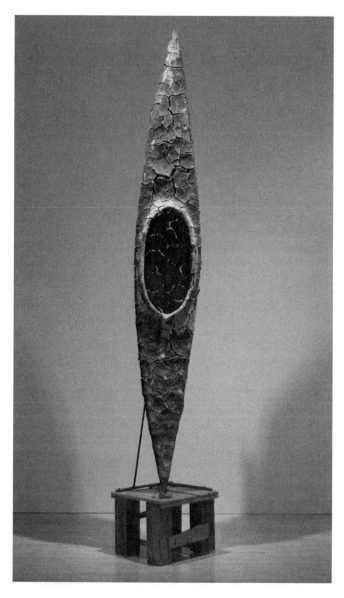

Kcho: *Untitled,* 1997. Photo courtesy of Barbara Gladstone Gallery.

Kcho: *Retrato (Ideas mojadas),* 2000. Photo courtesy of Barbara Gladstone Gallery.

1994 *Cocido y crudo,* Museo Nacional Centro de Arte Reina Sofia, Madrid
1995 *New Art from Cuba,* Whitechapel Art Gallery, London
1996 *Cuba siglo XX. Modernidad y sincretismo,* Centro Atlántico de Arte Moderno, Las Palmas de Gran Canaria, Spain (traveling)
1997 *no place (like home),* Walker Art Center, Minneapolis
1998 *Contemporary Art from Cuba: Irony and Survival on the Utopian Island,* Arizona State University, Tempe
1999 *Encounter,* Museum of Contemporary Art, Chicago
2001 *Locating Drawing,* Lawing Gallery, Houston

Publications:

On KCHO: Books—*Todo cambia,* exhibition catalog, essay by Alma Ruiz, Los Angeles, Museum of Contemporary Art, 1997; *Speaking of the Obvious Was Never a Pleasure for Us,* exhibition catalog, Jerusalem, Israel Museum, 1997; *Americana I Kcho,* exhibition catalog, Paris, Galerie National du Jeu de Paume, 1998; *Crossings,* exhibition catalog, text by Diana Nemiroff, Ottawa, National Gallery of Canada, 1998. **Articles**—"The Young and Restless in Havana" by Jay Murphy, in *Third Next Magazine* (London), 20, 1992, pp. 115–132; "Kcho" by Gerardo Mosquera, in *Arte en Colombia Internacional* (Bogota), 49, 1992, p. 160; "The Cuban Quagmire" by Octavio Zaya, in *Flash Art,* October 1995, pp. 95–98 (illustrated); "Art Is a Cuban's Vessel to Freedom" by Susan A. Davis, in *New York Times,* 17 March 1996; "KCHO" by Barry Schwabsky, in *Artforum,* summer 1996; by Carolina Ponce de Leon, in *Art Nexus* (Colombia), July/September 1996; "Castro's 'Approved' Artist?" by Richard Regen, in *SWING,* April 1997; "Kcho" by Soo Jin Kim, in *Art Issues,* 50, November/December 1997, p. 42; "Para Olvidar, Kcho" by Claude Gosselin, in *Les fiches du CIAC,* 27, 1997; "KCHO, Museum of Contemporary Art, L.A." by Adriano Pedrosa, in *Artforum,* February 1998; "Kcho y sus embarcaciones"

Centre International d'Art Contemporain de Montreal
1997 Museum of Contemporary Art, Los Angeles
Israel Museum, Billy Rose Pavilion, Jerusalem
Regen Projects, Los Angeles
1998 Galerie Nationale du Jeu De Paume, Paris
Studio Guenzani, Milan
2000 Barbara Gladstone Gallery, New York
Museo National Centro de Arte Reina Sofia, Madrid
Casa de las Americas, Galeria Latinoamericana, Havana
2001 Gallery 106, Austin, Texas

Selected Group Exhibitions:

1991 Centro Provincial de Artes Plásticas y Diseño, Havana
1992 *Un marco por la tierra,* Centro de Desarrollo de las Artes Visuales, Havana
1993 Centro Cultural Arte Contemporáneo, Mexico City

by Manuel Alvarez Lezama, in *El Nuevo Dia,* 18 July 1999; "KCHO" by Geraldine Bretault, in *Beaux Arts,* 15 December 1999; "KCHO" by Regina Barthel, in *Das Lied von der Erde,* June/October 2000; "Nature and the Solitary Self" by Simona Vendrame, in *Tema Celeste,* October/December 2000.

* * *

In the course of his career the Cuban-born artist Alexis Leyva Machado, known as Kcho, has moved from individual pieces of sculpture to paintings to site-specific installations inspired by the theme of emigration. His work incorporates the culture of the place or country in which the work is exhibited without ignoring its link to Cuban culture, specifically with the situation of the Cuban *balseros,* or sea refugees. By initiating his impulse with the tragedy of refugees at sea and moving outward, he has addressed the geopolitical situation of his birthplace and the larger question of escape from a predetermined reality of life, as well as the liberating, ever floating dream. Since the inception of his first works, he has seen the boat, often represented by the fundamental shape of the island of Cuba, as a symbol for departure. "To be born on an island is both a privilege and a call, everlastingly repeated, unending, towards elsewhere," he has written. "I believe that an islander is a man passing through." His works have been filled with the notion of Cubania: references to the island, to its shape, and to the objects, such as palm trees, Cubans use to identify themselves.

In his paintings Kcho has used various hues of conte crayon on paper of several colors. His line delivers a variety of energies, from relaxed and playful to quick and precise. The ephemeral nature of his colors, forms, and atmospheres creates the sense of bottles thrown into an ocean in search of a receiver. In a 2001 show in New York City he put together 14 drawings in an endless column, in the tradition of Constantin Brancusi and of African carvings. Instead of abstractions representing the repeated elements, however, Kcho used representational images, including ship propellers, inner tubes, and boats. The images may be understood as references to physical transportation. By piling them up to suggest infinity, however, a more philosophical transit is evoked: from today to tomorrow, one historic era to the next, one generation to the following.

Kcho's gigantic sculptures and installations are made up of actual stacks of boats, barrels, oars, bottles, and luggage and other accessories of travel. In his sculptures and installations the sensual beauty of old, found wood artifacts and of the small, precise boats that the artist carves combines to lend a physicality to the sense of travel. In his drawings he expands his discourse beyond the particular to the philosophical and the universal. Although some of the drawings are preliminary sketches for sculptures or are similar in their form to sculptures he has built, the dematerialization and synthesis of drawing make these works key to understanding Kcho's fundamental metaphysical discourse. In expanding his attention beyond the particular plight of Cuban refugees, Kcho has addressed the representation of the general laws that create the future. In his drawing titled *Portrait (The Endless Column),* the column does not end abruptly at the top like its predecessors but is crowned by several inner tubes that progressively dissolve into the paper, suggesting the infinitude of this migration and the matter with which it is articulated.

—Martha Sutro

KINGMAN (RIOFRÍO), Eduardo
Ecuadoran painter

Born: Loja, 3 February 1913. **Education:** Escuela de Bellas Artes, Quito, 1928–31; studied under Camilo Egas, New York. **Family:** Married Bertha Jijón in 1950. **Career:** Moved to Guayaquil, 1931–34; visited New York, 1938; lived in the United States, 1945–48. Staff member, San Francisco Museum of Art, c. 1945–47; director, Museo de Arte Colonial, Quito, 1948–68. Muralist, including Ecuadorean Stack of Arms, 1939 World's Fair, New York, Minister of Agriculture building, Military Geographic Institute, Fatherlands Temple, Municipal Palace, Loja. Founder, Caspicara Art Gallery, Quito, 1941. Cofounder, Casa de la Cultura Ecuatoriana, Quito, 1945. **Awards:** First prizes, *Salón nacional Mariano Aguilera,* Quito, 1936, 1959; national prize Honorato Vásquez, Ecuadoran government, 1944; first prizes, *Salón nacional de artes plásticas de la casa de la cultura ecuatoriana,* 1947, 1953; Eugenio Espejo prize for plastic art, 1986; Premio Rumiñahui, Municipio de Quito, 1991; Gabriela Mistral prize for plastic art, OAS, 1994. **Died:** 27 November 1997.

Individual Exhibitions:

1938 Galeria Actualidad Diaria, Bogota, Colombia
1942 Museo de Bellas Artes, Caracas, Venezuela
 Ministerio de Educación, Bogota, Colombia
1946 San Francisco Museum of Art
1948 *IV salón de mayo,* Quito
1949 Museo de Arte Colonial, Quito
1955 Casa de la Cultura, Núcleo del Guayas, Guayaquil
1956 Biblioteca Nacional Luis Angel Arango, Bogota, Colombia
 Museo de Bellas Artes, Caracas, Venezuela
1957 Museo de Arte Colonial, Quito
 Casa de la Cultura, Guayaquil
1966 Museo de Arte Colonial, Quito
1967 Galería Caspicara, Quito
1971 Banco Interamericano de Desarrollo, Washington, D.C.
1978 Galería Altamira, Quito
1981 Ministerio de Relaciones Exteriores, Quito (retrospective)
1982 Galería Unicentro, Guayaquil
1984 Galería La Manzana Verde, Guayaquil
1985 Casa de la Cultura, Cuenca, Ecuador
1990 Alianza Francesa, Quito
1991 Wharter West Museum, Kentucky
1993 Centro Civico de Guayaquil

Exhibited in Moscow, Paris, and Madrid, 1987; in Riobamba, 1992.

Selected Group Exhibitions:

1933 Society of Writers and Artists
1942 Newar Museum, San Francisco
1947 Pan American Union, Washington, D.C.
1966 *Art of Latin America since Independence,* Yale University, New Haven, Connecticut, and University of Texas, Austin

1987 Eastern Museum, Moscow
 Maison de l'Amerique Latine, Paris
 Salones Caja de Crédito de Madrid

Publications:

By KINGMAN: Books—*Arte de una generación,* Loja, Editorial Universitaria, c. 1972; *E. Kingman,* with photographs by Diego Falconí, Quito, Pintores Ecuatorianos, 1983.

On KINGMAN: Books—*E. Kingman* by Diego Falconí, Quito, Pintores Ecuatorianos, 1983; *Eduardo Kingman* by Hernán Castelo Rodríguez, Quito, La Manzana Verde, 1985; *Eduardo Kingman* by Lenín Oña, Quito, Dinediciones, 1994.

* * *

In the 1930s Ecuador not only endured the devastating affects of worldwide depression but also experienced nearly a decade of political turmoil. These years marked the rise of indigenism, an artistic strategy dedicated to critiquing the devastating social circumstances of the Indian in Ecuador. Eduardo Kingman Riofrío's paintings, marked by emotionally poignant renditions of Indians and laborers executed with minimal anatomical detail, established the predominant pictorial style of Ecuadorian indigenism.

Born in the southern province of Loja to a North American father and an Ecuadorian mother, Kingman moved to Quito to study at the Escuela de Bellas Artes under Victor Mideros. In Quito Kingman met artists such as Diógenes Paredes, Bolívar Mena, Luis Moscoso, and Leonardo Tejada, who, together with Kingman, decided to eliminate the picturesque from their paintings and to focus instead on the harsh reality of Ecuador's indigenous population. The work of these artists corresponded to the Latin American trend of boldly rendered, socially critical art by artists such as Cándido Portinari in Brazil and José Sabogal in Peru, which had its roots in Mexican muralism.

Kingman distinguished himself during the 1930s through his powerful renditions of indigenous workers depicted in a monumental style. The anatomical deformations and nonidealized depiction of a workingman in *El carbonero* ("The Charcoal Seller"), submitted in 1935 for Ecuador's prestigious Mariano Aguilera Prize, scandalized the conservative jury and was rejected from the competition. An outcry by Kingman's peers ensued, and for months the incident was debated in the press. Consequently, the next year a new, more liberal jury awarded the piece first place in the same competition. The event thus served to promote indigenism as the predominant style of visual expression in Ecuador.

Kingman's paintings exposed the poverty and toil of indigenous life. In *Los guandos* ("The Haulers") of 1941, for example, Kingman created a centripetal composition, visually simulating the entrapment of indigenous workers caught in a perpetual cycle of exploitation and suffering. More common, however, were his straightforward compositions of one or two figures, frequently a single laborer or an Indian mother and child. A prolific worker, he also painted various murals in Quito, including a series of four–*Industria, Agricultura, Turismo en la sierra,* and *Turismo en la costa*–painted for the 1944 Industrial Fair sponsored by the Ecuadorian Ministry of Industry and Agriculture.

In addition to painting Kingman produced woodcuts to illustrate contemporary novels. His album of prints *Hombres del Ecuador* ("Men of Ecuador") highlights the artist's expert draughtsmanship

and expressive figural style, recalling the prints produced by Mexico's Taller de Gráfico Popular (The People's Print Workshop). The distribution of Kingman's prints abroad opened the door to international exhibitions.

Unlike Ecuadorian artists of the previous generation, Kingman did not travel abroad until after he had come of age as an artist, most likely because of the unavailability of government scholarships. He made his first trip outside South America in 1938 to assist Camilo Egas with his mural for the Ecuadorian pavilion at the New York World's Fair. During the 1940s Kingman again traveled to the United States to work and exhibit at the San Francisco Museum of Art, and in 1947 he participated in an exhibition sponsored by the Pan-American Union in Washington, D.C. Upon his return to Quito in 1948, he was appointed director of the Museum of Colonial Art, where he worked for the next 20 years. The appointment did not, however, hinder his artistic production.

Kingman experimented with abstract painting during the 1950s. *Nave sideral* ("Space Ship"), for example, with its three-dimensional web of line and color, shares an affinity with nonfigural paintings by Wifredo Lam or Roberto Sebastian Matta. Critics who knew Kingman for his social realism, however, did not espouse this change. Thus, Kingman chose to produce mainly figural works for the remainder of his career.

Kingman's later paintings were marked by his exaggerated rendition of hands, a motif also employed by his contemporary Oswaldo Guayasamín. The hands in these works become the locus for the expression of emotion, most often anguish and despair. In the 1970s Kingman's palette changed dramatically. He infused his paintings with brilliant washes of translucent color, creating a sense of transparency akin to stained glass. Through his easel paintings and murals Kingman not only addressed critical social issues but also developed a powerful personal style to communicate the urgency of his subject matter.

—Michele Greet

KOSICE, Gyula
Argentine painter and sculptor

Born: Kosice, Czechoslovakia, 26 April 1924; emigrated to Argentina 1928. **Education:** Escuela Bellas Artes Belgrano, Buenos Aires, 1940–44, M.A. 1944. **Family:** Married Diyi Laan in 1945; two daughters. **Career:** Cofounder, *Arturo* magazine, 1944, and *Arte Concreto Invención* (Concrete Art Invention), 1945; founder, *Madi* art movement, and author of its manifesto, 1946; director, *Arte Madi Universal* magazine, 1946; Argentine commissioner for the *Bienal de São Paulo,* 1961, Venice *Biennale,* 1962, and *Biennale de Paris,* 1963. **Awards:** Bronze medal, *Exposición internacional y universal,* Brussels, 1958; first prize, *Premio nacional de escultura "Instituto Torcuato di Tella,"* Museo Nacional de Bellas Artes, Buenos Aires, 1962; prize, *Plástica con plásticos,* Museo Nacional de Bellas Artes, Buenos Aires, 1966; first prize in visual experience, *Casa Argentina en Israel—Tierra Santa,* Museo de Arte Moderno, Buenos Aires, 1966; premio a la mejor producción, Fondo Nacional de la Artes, Buenos aires, 1971; first prize, Sociedad Rural Argentina, Buenos Aires; Konex de Platino prize, Fundación Konex, Buenos Aires, 1983; medalla de plata, Accademia Internazionale Citta di Bonetto, Italy, 1985; first prize, Trofeo-Escultura tema

Gyula Kosice. Photo courtesy of the artist.

''Democracia,'' Municipalidad de la Ciudad de Buenos Aires, 1987; bronze plaque, Comité Olímpico Argentino, Buenos Aires, 1988; premio Miró, Montevideo, Uruguay, 1988; premio a la disciplina artística, Universidad Nacional de La Plata, 1990; Laurel de Plata, Rotary Club of Buenos Aires, 1991; Punta del Este prize, Intendencia de Maldonado, Uruguay, 1994; Recorrido Dorado prize, Sociedad Distribuidora de Diarios, Revistas y Afines, Buenos Aires, 1994; premio a la Trayectoria, Fondo Nacional de las Artes, Buenos Aires, 1994; arts prize, Fundación Tzedaka, Buenos Aires, 1995. **Member:** Honorario de la Sociedad Argentina de Artistas Plásticos, Buenos Aires, 1984. **Address:** República de la India 3135—6° A, Buenos Aires 1428, Argentina. **E-mail Address:** gyulakosice@usa.net. **Website:** http://www.kosice.com.ar.

Individual Exhibitions:

1947 Galerías Pacíficos, Buenos Aires
1953 Galería Bonino, Buenos Aires
1960 Galería Denise René, Paris
 Dryan Gallery, London
1963 Galería L'Oeil, Paris
1964 Galería La Hune, Paris
1965 Terry Dintenfass Gallery, New York
1966 Galería de Arte Moderno, Cordoba, Argentina

1967 Galería Bonino, Buenos Aires
1968 *100 obras de Kosice, un precursor,* Instituto Torcuato di Tella, Buenos Aires
 Galería Bonino, Buenos Aires
 150 metros de lluvia en la calle Florida, Buenos Aires
1969 Galería Lacloche, Paris
1970 Galería Estudio Actual, Caracas
1971 *La ciudad hidroespacial,* Galería Bonino, Buenos Aires (traveling)
1972 Galería de Arte del Banco Continental, Lima
 Museo de Arte Moderno, Buenos Aires
1973 Biblioteca Luis Angel Arango, Bogota
1974 Museo de Israel, Jerusalem
 Bijoux, Espace Cardin, Paris
1975 Galería Pozzi, Buenos Aires
1977 *Retrospectiva—relieves de aluminio,* Galería la Ciudad, Buenos Aires
1979 *Esculturas insólitas,* Galería Birger, Buenos Aires
 Obras hidrocinéticas, Galería Unika, Punta del Este, Uruguay
 Planetario de la Ciudad de Buenos Aires ''Galileo Galilei''
1982 Hakone Open Air Museum, Tokyo
1985 *Obras monumentales,* Centro Cultural Ciudad de Buenos Aires

Gyula Kosice: *Constelacíon.* **Photo courtesy of the artist.**

1991	*Retrospectiva, obras 1944–1990,* Museo Nacional de Bellas Artes, Buenos Aires
1994	*Homenaje a Kosice,* Museo de Arte Moderno, Buenos Aires
1999	*Anticipaciones,* Sala Cronopio, Centro Cultural Recoleta, Buenos Aires

1994	*Art from Argentina,* Museum of Modern Art, Oxford, England, and Royal College of Art, London
1998	*Vertientes contemporáneas de la escultura Argentina,* Museo Sívori, Buenos Aires
2000	*Heterotopías—Una mirada al sur,* Museo Nacional Centro de Arte Reina Sofía, Madrid

Selected Group Exhibitions:

1948	*La pintura y la escultura de este siglo,* Museo Nacional de Bellas Artes, Bueno Aires (traveling)
1963	*Arte argentino actual,* National Museum of Modern Art, Paris
1967	*Arte cinético, luz y movimiento,* Museum of Modern Art, Paris
1974	*Arte latinoamericano,* Organization of American States, Washington, D.C. (traveling)
1981	*I Bienal del Deporte,* Museo Nacional de Artes Plásticas, Montevideo, Uruguay
1991	*Escultura Argentina del siglo XX,* Salas Nacionales de Exposición, Galería A.M.C., Buenos Aires
1993	*Dibujos de escultores,* Fundación San Telmo, Buenos Aires

Collections:

Musée National d'Art Moderne, Paris; Museo Contemporáneo, Medellin; Museum of Contemporary Art, Seoul; Museo de Arte Moderno, Buenos Aires; Museum of Modern Art, Grenoble, France; Museum of Modern Art, Tel Aviv; Museo de Artes Plásticas, Montevideo, Uruguay, Museum of Israel, Jerusalem; Museo Municipal de Artes Plásticas Eduardo Sívori, Buenos Aires; Museo Nacional de Arte Moderno, Asunción, Paraguay; Museo Nacional de Bellas Artes, Buenos Aires; Museo Nacional de Bellas Artes, Montevideo, Uruguay; Museu da Arte Moderna do Rio de Janeiro; Museum of Fine Arts, Houston; New School of Reserach, New York.

Publications:

By KOSICE: Books—*Invención,* Buenos Aires, Ediciones Optimus, 1945; *Golsé-se* (poetry), Buenos Aires, Ediciones Madí, 1952; *Peso y*

Gyula Kosice: *Homenaje a la Democracia.* **Photo courtesy of the artist.**

medida de Alberto Hidalgo, Buenos Aires, Ediciones SIGLA, 1953; *Antología madí* (poetry), Buenos Aires, Ediciones Madí, 1955; *Art Madí international: Groupe argentin,* exhibition catalog, with Pierre Guéguen, Paris, Galerie Denise René, 1958; *Geocultura de la Europa de hoy,* introduction by Herbert Read, Paris, Ediciones Losange, 1959; *Poème hydraulique,* Paris, Editions Jean Naert, 1960; *Arte hidrocinético,* Buenos Aires, Ediciones Paidós, Buenos Aires, 1968; *La ciudad hidroespacial,* Buenos Aires, Ediciones Anzilotti, 1972; *Arte y arquitectura del agua,* Caracas, Ediciones Monte Avila, 1974; *Arte madí,* Buenos Aires, Ediciones de Arte Gaglianone, 1982; *Del arte madí a la ciudad hidroespacial,* Cordoba, Argentina, Ediciones Dirección General de Publicaciones de la Universidad de Cordoba, 1983; *Obra poética,* prologue by Adolfo de Obieta, Buenos Aires, Ediciones Sudamericana, 1984; *Entrevisiones,* Buenos Aires, Ediciones Sudamericana, 1985; *Teoría sobre el arte,* Buenos Aires, Ediciones EUDEBA, 1987; *Kosice,* prologue by Rafael Squirru, Buenos Aires, Ediciones de Arte Gaglianone, 1990; *Arte y filosofía porvenirista,* Buenos Aires, Ediciones de Arte Gaglianone, 1996. **Article—**''Arte y realidad virtual,'' in *La Nacion,* 19 December 1993.

On KOSICE: Books—*Kosice* by Guy Habasque, Paris, Collection Prisme, 1965; *G. Kosice,* exhibition catalog, Buenos Aires, Galería Bonino, 1971; *Reportaje a una anticipación* by Osiris Chiérico, Buenos Aires, Taller Libre, 1979; *La ciudad hidroespacial,* exhibition catalog, Buenos Aires, Banco Popular Argentino, 1979; *Kosice: Obras, 1944–1990,* exhibition catalog, Buenos Aires, Museo Nacional de Bellas Artes, 1991; *Kosice,* exhibition catalog, Argentina, El Ministerio de Relaciones Exteriores y Culto, 1993. **Articles—**''Gyula

Kosice: The Water Tamer'' by Bonnie Tucker, in *Comments on Argentine Trade,* June-July 1994; ''Kosice homenajeado en el Mam,'' in *Mensual,* 15 June 1994.

* * *

The work of Gyula Kosice, one of the forerunners in the renewal of abstract forms in the postwar years, has enlarged the field of kinetic research by the original use of water, an element virtually unexplored in plastic terms. The wide range of his interests, including sculpture and painting, poetry, and theoretical essays, the monumental and architectural quality of some of his works, and the cosmic implications he draws from the dynamics of the creative process all make Kosice a multifaceted artist for whom the liberating function of the imagination finds expression in the elaboration of a rational system.

Born in Czechoslovakia, Kosice was taken to Argentina at the age of four and received Argentine citizenship. He studied at the Academy of Fine Arts in Buenos Aires and stayed on in Buenos Aires to pursue his artistic career. From 1944 he became involved with a group of young artists who were rebelling against establishment trends in Argentina, still dominated by the epigones of the Paris school, and who drew their inspiration from the Bauhaus, constructivism, and Max Bill in an attempt to develop an abstract language that was ''pure and hard.'' With them Kosice founded the *madí* movement, becoming its leading theoretician and organizer. Bypassing the overly rigorous system of concrete art, he developed what was to become the theoretical basis for his own research: ''to invent objects for a classless society which liberates energy and dominates space and time in all its fullness, and matter as far as its ultimate consequences.'' It was around this time, too, that he met the Italo-Argentine sculptor Lucio Fontana and witnessed the publication of the first spatialist manifesto.

Open to all manner of technical experimentation, Kosice first exhibited a collection of paintings worked in blocks of color and with irregular mounts. But it was to sculpture that he was to turn definitively, forcing dynamic effects from matter in order to create an impression of movement. His preference was for nontraditional materials, frequently of industrial origin, such as aluminum, plexiglass, glass, and iron wire, and he executed two particularly innovative works at this time: one in wood, mobile, jointed, and transformable; the other a ''luminary structure'' of geometrical shape modeled out of a neon tube.

In 1948 Kosice exhibited with the *madí* artists at the *Salon des Réalites Nouvelles* in Paris. This exhibition marked the beginning of an international career that would lead him, a few years later, to show his first hydrokinetic works at the Denise René gallery. One particular quality can help us to define the aesthetic of these sculptures: transparency, proceeding from a desire to appropriate the space without disturbing its visual unity. From now on Kosice was to work principally with translucent materials (plexiglass, glass fibers) that asserted or effaced themselves under the spectator's gaze in a seductive play of appearances and reflections. The sculptures were composed in a subtle balance of fixed and mobile pieces.

But it was through the use of water that Kosice perfected the dynamism of his sculptural system. The element of chance deriving from the displacement of liquid masses and from the very nature of water, which is intrinsically mobile and transformable, disrupted the traditional relationships of fullness–emptiness, depth–leading Kosice to exercise scientific control over his materials. His formal language appropriated, by metaphorical transcriptions, the diverse forms water

can take. The bubbles, drops, jets, fountains, splashes, waves, and pools of the liquid part of the works became spheres, cylinders, or planes in their solid representations. Gradually the works were to expand in extent and complexity to become veritable polysensorial environments, bringing together over large surfaces, from the ground to the walls, luminous and sonorous elements that completed the hydraulic effects.

Naturally, Kosice also came to consider the architectural implications of his work and its capacity to intervene directly in the transformation of the social environment. He realized a number of fountains and urban sculptures in various Latin American cities, as, for example, his impressive *Water Tower* in Buenos Aires (1972), a hydraulic composition of monumental proportions that has as its base a long cylinder reaching up toward the sky.

Kosice's *Hydrospatial City,* shown in France in 1974, provided the synthesis of his architectural ideas. It consisted of the futurist projection in space of a revolutionary and liberating social structure so that "imprecise science becomes superhuman." Presented in the form of plans and models, the transparent cosmic city suppressed current divisions in living spaces, insisting on a necessary improvement in human relations. Its realization was scientifically plausible thanks to the energy potential contained in the hydraulic power of clouds. Through this work the Argentine artist developed, as Pierre Restany stated in the exhibition catalogue, "an invitation to take part in the supreme journey of technological humanism, an appeal to feel more acutely, to see higher and further, to live better."

—Dominique Liquois

KUITCA, Guillermo (David)

Argentine painter

Born: Buenos Aires, 1961. **Education:** Studied painting with Ahuva Szlimowics, 1970–79; Colegio Nacional Sarmiento, degree 1978; Universidad de Buenos Aires, 1980. **Career:** First exhibit age 13. Traveled in Europe, 1980–81. Playwright, director, and stage set designer, Buenos Aires, 1981–87. **Awards:** Grand prize, *Arché biennial,* 1982; Young Artist of the Year, Association Argentina de Críticos de Arte, 1982.

Individual Exhibitions:

1984 *Guillermo Kuitca: Pinturas,* del Retiro Galeria de Arte, Buenos Aires
1985 Elisabeth Franck Gallery, Belgium
1990 Annina Nosei Gallery, New York
 Gian Enzo Sperone, Rome
1991 Museum of Modern Art, New York
1992 Newport Harbor Art Museum, Newport Beach, California
 Corcoran Gallery of Art, Washington D.C.
 Contemporary Art Museum, Houston
1993 Museum of Contemporary Art, Montreal
 Institute of Modern Art Centre del Carme, Valencia, Spain
 Museo de Monterrey, Mexico
 Museo Rufino Tamayo, Mexico City

1994 *The Tablada Suite 1991–1993,* Sperone Westwater, New York
 Burning Beds: 1982–1994, Contemporary Art Foundation, Amsterdam (traveling)
 Thomas Cohn Contemporary Art, Rio de Janeiro
1995 *Puro teatro,* Sperone Westwater, New York
 Galería Ramis Barquet, Garza García, Mexico
 Center for the Fine Arts, Miami
 Whitechapel Art Gallery, London
1997 Nohra Haime Gallery, New York
 Poema pedagogico, Sperone Westwater, New York
 Timothy Taylor Gallery, London
1997–98 Museo Alejandro Otero, Caracas, Venezuela
1998 *Puro teatro,* Thaddaeus Ropac Gallery, Paris
1999 *Castle to Castle,* Sperone Westwater, New York
 L.A. Louver, Venice, California
 Beds, Theaters, and Drawings, The Arts Club of Chicago
 Centro de Arte Hélio Oiticica, Rio de Janeiro

Selected Group Exhibitions:

1985 *Bienal de São Paulo,* Brazil
1987 *Art of the Fantastic: Latin America, 1920–1987,* Indianapolis Museum of Art (traveling)
1989 *Bienal de São Paulo,* Brazil
1992 *IX Biennial of Kassel*
1995 *Kwangjiu Biennial,* South Korea
1997 Basilico Fine Arts and Lehmann Maupin, New York
 Joan Prats Gallery, New York
 Sperone Westwater, New York
 Artistes Latino-Américains, Daniel Templon Gallery, Paris
1998 ADAA Art Show, Sperone Westwater, New York

Collection:

North Carolina Museum of Art.

Publications:

On KUITCA: Books—*Guillermo Kuitca: Pinturas,* exhibition catalog, Buenos Aires, del Retiro Galeria de Arte, 1984; *Guillermo Kuitca,* exhibition catalog, text by Jorge Glusberg, Elisabeth Franck Gallery, Belgium, 1985; *Guillermo David Kuitca: Obras 1982–1988* by Sonia Becce, Buenos Aires, J. Lublin, 1989; *Kuitca,* exhibition catalog, text by Achille Bonito Oliva, New York, Annina Nosei Gallery, 1990; *Guillermo Kuitca,* exhibition catalog, text by Charles Merewether, Rome, Gian Enzo Sperone with Annina Nosei Gallery, 1990; *Guillermo Kuitca,* exhibition catalog, text by Lynn Zelevansky, Newport Beach, California, Newport Harbor Art Museum with New York Museum of Modern Art, 1992; *Guillermo Kuitca, May 1993,* exhibition catalog, New York, Sperone Westwater Gallery, 1993; *A Book Based on Guillermo Kuitca* by Martin Rejtman, Jerry Saltz, and Marcelo E. Pacheco, Amsterdam, Contemporary Art Foundation, 1993; *Guillermo Kuitca,* exhibition catalog, Montréal, Musée d'Art Contemporain de Montréal, 1993; *Guillermo Kuitca: The Tablada Suite 1991–1993,* New York, Sperone Westwater Gallery, 1993; *Guillermo Kuitca: Burning Beds: A Survey, 1982–1994,* exhibition catalog, Amsterdam, Contemporary Art Foundation, 1994; *SOLO*

Impression, Inc., exhibition catalog, text by Ruth E. Fine and Kathleen McManus Zurko, Wooster, Ohio, College of Wooster Art Museum, 1994; *Guillermo Kuitca: Obra recente*, exhibition catalog, Rio de Janeiro, Thomas Cohn Arte Contemporânea, 1994; *Guillermo Kuitca: The Tablada Suite 1991–1993*, exhibition catalog, New York, Sperone Westwater Gallery, 1994; *Guillermo Kuitca: Puro teatro*, exhibition catalog, New York, Sperone Westwater Gallery, 1995; *Guillermo Kuitca*, exhibition catalog, text by Ed Shaw, Garza García, Mexico, Galería Ramis Barquet, 1995; *Guillermo Kuitca: Poema pedagogico*, exhibition catalog, New York, Sperone Westwater Gallery, 1997; *Guillermo Kuitca: Obras 1982–1998* by Graciela Speranza and Sonia Becce, Santafé de Bogotá, Grupo Editorial Norma, 1998; *Guillermo Kuitca: Drawings 1981–1996*, New York, Sperone Westwater Gallery, 1998; *Guillermo Kuitca: Castle to Castle*, exhibition catalog, New York, Sperone Westwater Gallery, 1999. **Articles—** "La giovane generazione e il desiderio di vivere" by Jorge Glusberg, in *Domus*, 661, May 1985, pp. 84–87; "Guillermo Kuitca" by Josefina Averza, in *Flash Art*, 26(173), November 1993, p. 45; "Artful Mapper of the Modern Dilemma" by Caleb Bach, in *Americas*, 49(4), 1997, p. 20; "Artistes Latino-Américains" by Michel Nuridsany, exhibit review, in *Art Press* (France), 224, May 1997, pp. 78–79; "Guillermo Kuitca: Timothy Taylor Gallery, London" by Juan Cruz, exhibit review, in *Art Monthly* (United Kingdom), 208, July/August 1997, pp. 30–31; "Guillermo Kuitca" by Paul Ardenne, exhibit review, in *Art Press* (France), 233, March 1998, p. 73; "Kuitca's Stagecraft" by Robert Farris Thompson, in *Art in America*, 87(12), 1999, pp. 90–99; "Forum Art—Deciphering Plans," in *Interior Design*, 70(10), 1999, pp. 36–40; "Artist's Book Beat" by Nancy Princenthal, in *Art on Paper*, 3(3), January/February 1999, pp. 66–67; "Did Andy Warhol Really Die?" by Daniel Pinchbeck, in *Art Newspaper*, 10(92), May 1999, p. 70; "Guillermo Kuitca: L.A. Louver" by Jacqueline Cooper, exhibit review, in *New Art Examiner*, 26(8), May 1999, pp. 60–61; "Art Miami 99" by Carol Damian, in *Art Nexus* (Colombia), 32, May/July 1999, pp. 92–94; "Guillermo Kuitca: Body of Painting: Abstraction According to Kuitca" by Rosanna Albertini, in *Art Press* (France), 249, September 1999, pp. 30–33; "No Home at All: An Interview with Guillermo Kuitca" by Kathryn Hixson, in *New Art Examiner*, 27(5), February 2000, pp. 42–44; "Guillermo Kuitca: The Arts Club of Chicago" by Charmaine Picard, review of the exhibition *Beds, Theaters, and Drawings*, in *Art Nexus* (Colombia), 35, February/April 2000, p. 138; "Guillermo Kuitca: The Arts Club of Chicago" by Marcelino Stuhmer, review of the exhibition *Beds, Theaters, and Drawings*, in *New Art Examiner*, 27(5), February 2000, p. 50.

* * *

Born to Russian Jewish immigrant parents in Buenos Aires in 1961, Guillermo Kuitca took painting lessons at the Ahuva Szlimowicz workshop (1970–79) and studied theater and the cinema in secondary school. He was awarded a degree from the Colegio Nacional Sarmiento in 1978. In 1980 he entered the Facultad de Filosofía y Letras of the Universidad de Buenos Aires to study art history, a course he abandoned after the first term. He decided to travel to Europe instead, and while he was in Germany, he met the choreographer Pina Buasch.

On his return to Argentina in 1981, Kuitca became involved with the theater in Buenos Aires and founded his own company. As well as designing stage sets, in 1982 he codirected his first play, *Nadie olvida nada*, with Carlos Ianni. Another collaboration with Ianni, *El mar dulce*, followed in 1984. The close relationship between Kuitca's theater work and his art is revealed through the two series of paintings that share their titles with the theater pieces.

Since these two early groups of paintings Kuitca has produced additional series of major works: theater scenes (1981–87), maps (1987–93), and floor plans (begun in 1987). This body of large expressionistic paintings is dominated by similar themes that stress emptiness, loss, solitude, and a sense of not belonging. In many respects these issues reflect both Kuitca's personal experience as the son of immigrant parents and the turbulent political situation of Argentina during the 1970s and 1980s. His work has been likened to that of the Otra (also known as Nueva) Figuración movement in Argentina in the 1960s, which included the artists Luis Felipe Noé (born 1933) and Rómulo Macció (born 1931). Theater scenes such as *La busca de la felicidad* (1985) or the series *El mar dulce* (1983–86) depict large, open sets, often empty of people or with groups clustered together alongside stage props such as overturned chairs or paintings. There usually is little lighting, suggesting that the performance is over, and the stage is abandoned. Yet groups of people linger, often in apparently violent scenes. The viewer is not aware of what is happening, whether these are actors or other more sinister individuals involved in an unscheduled drama. The association of political repression with stage plays, in which the audience members watch spellbound, unable to intervene while the drama unfolds before their eyes, reflects an Argentine society dominated by the so-called dirty war (1976–82).

The body of work that represent maps is painted on canvas and ordinary single mattresses, which often form groups placed side by side or piled one on top of the other. These maps are seemingly accurate copies of geographic maps, although many actually repeat the names of cities or towns across the whole surface, making them more imaginary than real, as in *San Juan de la Cruz* (1992). Most are untitled, while others carry names such as *Hamburgo* (1988) or *The River* (1989). Kuitca likens the lines made by roads, rivers, and railways to the veins and arteries of the human body; both are networks, the lifeblood, of communication. By choosing mattresses, Kuitca is also referring to the contours and marks a human body leaves on the surface, creating its own imprint or map. In other cases, as in *Untitled* (1992), he uses hypodermic syringes to demarcate the streets of an unknown city. Yet, whereas in the theater scenes the audience is not seen, here the body itself is missing, emphasizing once more a sense of loss, displacement, and the inability to participate or intervene.

Kuitca returns to the theme of the theater in his seating plans, which include football stadia. In these works vast public spaces are presented through individually numbered and lettered seats. *The Tablada Suite* series (1991–93) and *Ein Deutsches Requiem* (1995), the latter with bold sweeps of color taken from the national flag of Germany, epitomize this group. The absence of the audience is now addressed, for the viewer looks directly out onto the empty seats. The unstated reference is to cultural censorship, the gathering of individuals into public spaces during repression, and above all the silence of emptiness. Kuitca, who has continued to live in Buenos Aires and work on the *Diarios* (begun in 1994) and *People on Fire* (begun in 1992), a series based on a family tree, addresses issues of identity, repression, and absence, reflecting the contemporary history of his own family and the experience of all people in Argentina.

—Adrian Locke

LAM, Wifredo
Cuban painter

Born: Wifredo Oscar de la Concepción Lam y Castilla, Sagua la Grande, 2 December 1902. **Education:** Academia San Alejandro, Havana, 1921–23; Academy of San Fernando, Madrid, 1926; studied in the studio of Fernando Alvarez di Sotomayor, Curator of the Prado, Madrid, c. 1928. **Military Service:** Fought with the Republicans in the Spanish Civil War, c. 1930s. **Family:** Married 1) Eva Piris in 1929 (died 1931); 2) Helena Holzer in 1944 (divorced 1950); 3) Lou Laurin in 1959; three sons. **Career:** Painter, Academia de Quatre Gates, Barcelona, 1936–37. Moved to Paris and joined the Surrealist movement, 1938; traveled to France, Martinique, St. Thomas, and Havana, 1940–41; lived in Paris, New York, and Havana, 1946–52; moved to Paris, 1952; settled in Italy, 1960. Founding member, artists' union *Agrupacion de Pintores y Escultores Cubanos,* 1949. **Awards:** First prize, *Salone Nacionale,* Havana, 1951; Gold Medal for Foreign Painters, Premio Lissone, Rome, 1953; fellowship, John Simon Guggenheim Memorial Foundation, 1964; Premio Marzotto, Milan, 1965. **Died:** Paris, 11 September 1982.

Individual Exhibitions:

1928	Galerie Vilches, Madrid
1939	Galerie Pierre, Paris
	Peris Gallery, New York (with Pablo Picasso)
1942	Pierre Matisse Gallery, New York
1944	Pierre Matisse Gallery, New York
1945	Galerie Pierre, Paris
	Pierre Matisse Gallery, New York
1946	Centre d'Art, Port-au-Prince, Haiti
1948	Pierre Matisse Gallery, New York
1950	Pierre Matisse Gallery, New York
1951	Ministry of Education, Havana
1952	Institute of Contemporary Arts, London
1953	Galerie Maeght, Paris
1955	Galerie Colibri, Malmo, Sweden
	University of Havana
	Museo de Bellas Artes, Caracas, Venezuela
	Instituto Venezuela-Francia, Caracas, Venezuela
1957	Palacio de Bellas Artes, Marcaibo, Venezuela
1959	Galleria Grattacielo, Milan
1961	University of Notre Dame, Indiana
	New York University, New York
	Galerie La Cour d'Ingres, Paris
	Galleria del Canale, Venice
	Galleria del Obelisco, Rome
	Albert Loeb Gallery, New York
1962	Salone Annunciata, Milan
1963	Galerie Krugier, Geneva

	Galeria de la Habana, Havana
	La Biblioteca Nacional, Havana
1964	Galleria Notizie, Turin, Italy
1965	Museo de Arte Moderna, Havana
	Galerie Anderson, Malmo, Sweden
	Galerie Christine, Aubry, Paris
1966	Kunsthalle, Basel (with Vic Gentils)
	Kestner-Gesellschaft, Hannover, Germany
1967	Galerie Albert Loeb, Paris
	Stedelijk Museum, Amsterdam
	Moderna Museet, Stockholm
	Palais des Beaux-Arts, Brussels
1968	Musée d'Art Moderne de la Ville, Paris (with Matta and Alicia Penalba)
	Galerie Villand et Galanis, Paris
1969	Kunstkabinett, Frankfurt, Germany
	Galleria Bergamini, Milan
1970	Galleria Arte Borgogna, Milan
	Galerie Krugier, Geneva
	Gimpel Fils, London
	Gimpel and Weitzenhoffer, New York
1971	Galerie Gimpel und Hanover, Zurich
1972	Galerie Tronche, Paris
	Studio Bellini, Milan
1978	Ordrupgaard Samlingen, Copenhagen
1979	Artcurial, Paris
1982	Pierre Matisse Gallery, New York
1987	Galerie Maeght Lelong, Zurich
1995	*Drawings: Interlude Marseille,* Latin American Masters, Beverly Hills, California
1996	Galerie Lelong, New York

Selected Group Exhibitions:

1947	*Exposition internationale du surrealisme,* Galerie Maeght, Paris
	Museum of Modern Art, New York
1958	*50 ans d'art moderne,* Palais des Beaux-Arts, Brussels
1959	*Documenta,* Kassel, Germany
	Solomon R. Guggenheim Museum, New York
1966	*Grands et jeunes d'aujourd'hui,* Musée d'Art Moderne de la Ville, Paris
	Art of Latin America since Independence, Yale University, New Haven, and University of Texas, Austin
1968	*Painting in France 1900–1967,* National Gallery of Art, Washington, D.C. (toured the United States)
	Dada, Surrealism and Their Heritage, Museum of Modern Art, New York, Museum of Fine Arts, Boston, National Gallery of Art, Washington, D.C., Museum of Fine Arts, Chicago, San Francisco Art Institute

Wifredo Lam: *Woman-Bird,* **1967. © Christie's Images/Corbis. © 2002 Artists Rights Society (ARS), New York/ADAGP, Paris.**

Wifredo Lam: *Bird,* c. 1982. © Christie's Images/Corbis. © 2002 Artists Rights Society (ARS), New York/ADAGP, Paris.

1970 *Pittsburgh International,* Carnegie Institute
1978 *Cuba: Peintres d'aujourd'hui,* Musée d'Art Moderne de la Ville, Paris

Collections:

Museum of Modern Art, New York; Museum of Modern Art of Latin America, Washington, D.C.; Solomon R. Guggenheim Museum, New York; Art Institute of Chicago; Rhode Island School of Design, Providence; Centre Georges Pompidou, Paris; Musée d'Art Moderne de la Ville, Paris; Moderna Museet, Stockholm; Tate Gallery, London; Nationalgalerie, Berlin; Musejm Boymans-van-beuningen, Rotterdam; Stedelijk van Abbemuseum, Eindhoven, Netherlands; Centro Medico, Havana.

Publications:

By LAM: Articles—"Lettre de Wilfredo Lam," in *Opus International* (Paris), September 1971; "Lam della Giungla," in *Bolaffiarte* (Turin), April 1974.

On LAM: Books—*Lam,* exhibition catalog, by André Breton, Port-au-Prince, Haiti, 1946; *Wifredo Lam y su obra vista a traves de significados criticos* by Fernando Ortiz, Havana, 1950; *Lam* by Jacques Charpier, Paris, 1960; *Lam* by Hubert Juin, Paris, 1964;

Wifredo Lam, edited by Alex Grall, Paris, 1970; *Servizi in porcellana decorati da Wifredo Lam* by M. V. Ferrero, Turin, 1970; *Wifredo Lam* by Michel Leiris, Fratelli Fabbri, Paris, 1970; *Lam* by Alain Jouffroy, Paris, 1972; *Wifredo Lam* by Max-Pol Fouchet, Ediciones Polígrafa, Barcelona, 1976; *Wifredo Lam* by Alain Jouffroy, Société International d'Art XX Siecle, Paris, 1979; *Wilfredo Lam* (sic), exhibition catalog, text by Daniel Abadie, Galerie Fabien Boulakia, Paris, 1985; *Wifredo Lam,* exhibition catalog, text by Nelson Herrera, Museo de Arte Moderno, Bogota, 1986; *Wifredo Lam,* exhibition catalog, with essay by Per Kirkeby, Zurich, 1987. **Articles—**"Wifredo Lam: S'aboucher a l'invisible" by Lucien Curzi, in *L'Oeil* (Lausanne, Switzerland), 363, October 1985, pp. 42–45; "Wifredo Lam: Transpositions of the Surrealist Proposition in the Post-World War II Era," in *Arts Magazine,* 60, December 1985, pp. 21–25, and "In Search of Wifredo Lam," in *Arts Magazine,* 63, December 1988, pp. 50–55, both by Lowery Stokes Sims; "Wifredo Lam: Return to Havana and the Afro-Cuban Tradition" by Julia Herzberg, in *Latin American Literature and Arts* (New York), 37, January-June 1987, pp. 22–30; "Wifredo Lam: Painter of Negritude" by Robert Linsley, in *Art History* (United Kingdom), 11, December 1988, pp. 528–544; "Dancing in the Dark" by Susana Torruella Leval, in *Art News,* 93, summer 1994, p. 153; "Lam and His Contemporaries" by Juan A. Martinez, in *Art Nexus* (Colombia), 11, January/March 1994, pp. 208–209; "Wifredo Lam" by Gerardo Mosquera, in *Art Nexus* (Colombia), 15, January/March 1995, pp. 72–79; "The Lam Plan" by Paige Bierma, in *Art News,* 99(5), May 2000, p. 70.

* * *

Two major factors characterize the life and work of Wifredo Lam, an important member of the surrealist movement and Cuba's best known modernist of the twentieth century. The first is Lam's integration of his ethnic identity and knowledge of Afro-Cuban religious themes into the mainstream of modern art. The second is his complex and sometimes tense relationship to his homeland and its modernist movement versus his loyalty to Europe and the avant-garde.

Wifredo Oscar de la Concepción Lam y Castillo was born on 2 December 1902 in Sagua la Grande, in the province of Las Villas. His father was a Chinese immigrant, probably a former railroad worker, and his mother had African and Spanish ancestry. In his youth Lam was greatly influenced by members of his family who practiced Santeria, the religion formed from the conflation of Spanish Catholicism and West African spiritual traditions.

His prodigious artistic abilities were recognized when he was a child, and he was encouraged to pursue studies in art. Between 1921 and 1923 he studied at the Academy of San Alejandro in Havana on a scholarship from his provincial government. In the early 1920s he painted and drew landscapes and portraits. He left for Spain in 1926 to study at the Academy of San Fernando in Madrid, but he soon tired of his academic lessons and rejected academism altogether. He supported the Republican cause during the Spanish Civil War and joined the Fifth Regiment. By 1936 he was designing posters for the Republic, and in 1937–38 he endured the siege of Madrid. There he met Helena Holzer, who became his partner.

In the late 1930s Lam was doing paintings in an Africanized cubist style, most likely the result of seeing the work of Pablo Picasso in an exhibition held in Barcelona in 1936. Lam's paintings were predominantly of figures with distorted proportions and masklike faces. In 1938 he went to Paris, where he met and befriended Picasso. He had direct contact with the surrealists, including André Breton,

Max Ernst, and Victor Brauner, and he was also drawn to the work of Fernand Léger and Henri Matisse. He was embraced by Breton and the surrealists and in 1939 had his first solo show at Pierre Loeb's gallery. Lam's drawings and paintings from this period address a personal symbology of abstract forms rendered in an idiosyncratic cubist style. Although much of his work was figurative and abstract, he also did works about the Spanish Civil War and the plight of refugees.

In 1940 he and other artists and intellectuals fled Paris, first for the port of Marseilles and then for the island of Martinique in the Caribbean. He was accompanied on the journey by Holzer, Breton, and Claude Lévi-Strauss, among others. Their trip included a stop in Haiti, where Lam met the writer Aimé Césaire, a major figure in the negritude movement, which inspired Lam to seek his own Afro-Cuban roots and to incorporate them in his modernist paintings.

By 1941 Lam had returned to Havana and reestablished his connections to the intelligentsia. Lydia Cabrera, the celebrated ethnologist of Afro-Cuban folklore, was counted among his closest friends, and she and Lam observed Santeria ceremonies. Although he had relations with the Cuban avant-garde and even intimate ties to modern artists like Teodoro Ramos Blanco, Carlos Enríquez, Fidelio Ponce de León, Amelia Peláez, and René Portocarrero, Lam was highly selective in his choice of exhibitions and refused being pigeonholed as a Cuban or Latin American artist. In the mid-1940s and the early 1950s he was active in the cutting-edge journal *Origenes* and joined an anti-Franco committee with other painters and sculptors, and in 1949 he helped found the Agrupacion de Pintores y Escultores Cubanos, an artists' union, and exhibited in its shows. He was curiously absent, however, from major exhibitions of Cuban art, preferring solo shows in New York City, Paris, and other cities.

In 1943 the Museum of Modern Art in New York City acquired what is considered Lam's masterpiece, his painting *The Jungle*. The work is characteristic of Lam's mature style, in which he created abstract environments that evoke Cuba's tropical landscape as well as the forces of nature as a whole. *The Jungle* is a dreamscape populated by figures, animals, and spirits that are simultaneously whimsical and menacing. Although none of the images are recognizable elements from Santeria, likenesses of the Catholic saints and African *orishas*, or deities, they evoke the powerful transformations that occur continuously in nature. Lam was interested in rendering the cycles of death and regeneration that characterize the jungle, indeed all of life's processes, in an abstract, open-ended visual language. His painterly style, loose compositions of flowing lines, vibrant color, and rich textures enhance the ideas of a universe in flux and subject to all sorts of elemental forces. While his works are comfortably perceived as surrealist, they are also Cuban in theme and inspiration, evoking not just Afro-Cuban traditions but also the national preoccupation with the power and beauty of the landscape.

Lam was well aware of the fact that African and other non-Western art had been important catalysts for the development of expressionism and abstraction in European art of the early twentieth century. He was also cognizant of the fact that, by unifying the goals of abstraction and an insider's knowledge of Santeria, he had made an enormous contribution to both Cuban and European modernism. But he rejected facile interpretations of his work as merely dependent on African art, Santeria imagery, and European abstraction. Moreover, he resisted the use of his art as ethnocentric or nationalist propaganda.

By 1952 Lam had returned to Paris and by 1960 had settled permanently in Italy. In the years after the 1958 revolution Lam maintained close ties to Cuba, even while living abroad. His last visit

took place in 1980, when he was in poor health. He died two years later in Paris.

—H. Rafael Chácon

LARRAZ, Julio
American painter and printmaker

Born: Havana, Cuba, 12 March 1944; emigrated to the United States, 1961. **Education:** Studied under Burt Silverman, David Levine, and Aaron Schickler, New York, 1968–70. **Career:** Cartoonist, New York, c. 1970. Traveled to Spain, 1976. **Awards:** Fellowship, Cintas Foundation, 1975; award, American Academy of Arts and Letters, New York, 1976; Purchase award, American Academy of Arts and Letters, New York, 1977.

Individual Exhibitions:

1971	Pyramid Galleries, Washington, D.C.
1976	Westmoreland County Museum of Art, Greensburg, Pennsylvania
1980	Hirschl & Adler Galleries, New York
1983	Wichita Falls Museum and Art Center, Texas
1984	Galería Iriarte, Bogotá, Colombia
	Nohra Haime Gallery, New York
1985	Galería II Gabbiano, Rome
	Nohra Haime Gallery, New York
1986	Museo de Arte Moderno, Bogotá, Colombia
1987	Museo de Monterrey, Mexico, and Nohra Haime Gallery, New York
	Galerie Ravel, Austin, Texas
1988	Nohra Haime Gallery, New York
1991	Nohra Haime Gallery, New York
1992	Nohra Haime Gallery, New York
	University of Illinois, Urbana
1995	*The Planets,* Ron Hall Gallery, Dallas
	Galerie Vallois, Paris
1996	Peter Findlay Gallery, New York
1998	Boca Raton Museum of Art, Miami
1999	Atrium Gallery, St. Louis, Missouri
2000	Marlborough Gallery, Boca Raton, Florida

Selected Group Exhibitions:

1981	*V bienal del grabado latinoamericano,* Instituto de Cultura Puertoriqueña, San Juan, Puerto Rico
1982	Galería Iriarte, Bogotá, Colombia
1984	Galería Arteconsult, Panama
1986	*V bienal de artes gráficas,* Museo de Arte La Tertulia, Cali, Colombia
1987	Hooks/Epstein Gallery, Houston
	Archer M. Huntington Art Gallery, University of Texas, Austin
1988	Kansas City Art Institute, Missouri
	Fuera de Cuba, State University of New Jersey, Rutgers, and University of Miami

Collections:

University of Texas, Austin; Miami-Dade Public Library, Florida; Museo de Arte Moderno, Bogotá, Colombia; Museo de Monterrey, Mexico; Pennsylvania State University Museum, Philadelphia; Vassar College of Art Gallery, Poughkeepsie, New York; Westmoreland Museum of Art, Greensburg, Pennsylvania.

Publications:

On LARRAZ: Books—*Julio Larraz: Recent Still-Lifes,* exhibition catalog, New York, Hirschl & Adler Galleries, 1980; *Julio Larraz: Recent Painting,* exhibition catalog, New York, Nohra Haime Gallery, 1985; *Larraz,* exhibition catalog, with text by Peter Frank and Lori Simmons Zelenko, Monterrey, Mexico, Museo de Monterrey, 1987; *Julio Larraz* by Edward J. Sullivan, New York, Hudson Hills Press, 1989; *Julio Larraz: Moments in Time,* exhibition catalog, New York, Nohra Haime Gallery, 1989; *Julio Larraz, Paintings,* exhibition catalog, text by Maarten van de Guchte, Urbana, Illinois, University of Illinois, 1992; *Julio Larraz: Witness to Silence,* exhibition catalog, New York, Nohra Haime Gallery, 1992; *Julio Larraz,* exhibition catalog, Paris, Galerie Vallois, 1995; *The Planets,* exhibition catalog, Dallas, Ron Hall Gallery, 1995; *Julio Larraz,* exhibition catalog, text by Edward Shaw, Buenos Aires, Der Brücke Ediciones, 1998. **Articles**—"Julio Larraz" by Lori Simmons Zelenko, in *American Artist,* 52, April 1988, pp. 45–51; "Julio Larraz" by K. K. Kozik, in *Art Nexus* (Colombia), 16, April/June 1995, pp. 48–52; "Julio Larraz at Peter Findlay" by David Bourdon, in *Art in America,* 84, February 1996, p. 91; "Julio Larraz. Boca Raton Museum of Art, Florida," in *Art Nexus* (Colombia), 29, August/October 1998, pp. 130–131, and "Julio Larraz: Marlborough Gallery, Boca Raton," in *Art Nexus* (Colombia), 37, August/October 2000, pp. 134–135, both by Carol Damian.

* * *

The career of the Cuban-American artist Julio Larraz began in New York City, without any formal training, and has developed in many places since he left Havana in 1961. He has devoted his time to both painting and sculpture, some accomplished on a grand scale. He began working as a caricaturist in New York, living on the Hudson River, where he was first inspired to paint the landscape. In the late 1970s he left New York to explore other environments and found places like New Mexico rich in the material sources and lighting so significant to his art. As he looked beyond the landscape, still lifes and provocative figures appeared in his work, all painted with meticulous attention to detail and infused with light that is as magical as it is lucid and believable. An astute observer of everything around him, from the seeds in a piece of fruit to the ephemeral nature of clouds and sky, he has constantly questioned their very existence from multiple perspectives while analyzing their plastic qualities and compositional relationships.

A serious approach to objective associations in time and space informs both Larraz's painting and sculpture. Always interested in exploring the properties of form, shape, and texture, he investigates how distorting shifts of size and scale affect the viewer's perception and sense of recognition. He maneuvers and choreographs the elements of his compositions in an environment of heightened reality

that resonates as a disturbing intrusion into a psychological realm that has no ordinary equivalent. He equates this disquieting effect with the view of an insect encountering the relative giants of vegetables, fruit, flora, and fauna that are common to us but that assume monumental, even threatening proportions to the miniature creature. In his paintings the contour of a squash becomes as vast as the curvature of the earth against the sky, cropped and realigned for monumental compositional consequences.

While his still life arrangements expose the true impact of Larraz's unique compositional aesthetic, his paintings of interior scenes with arcane characters involved in puzzling activities are especially provocative. Portrayed in a highly unusual and ingenious manner, these strange personalities appear in a world of bizarre associations and obtuse circumstances that defy explanation. Everything is painted with a masterful fidelity to detail, real and imagined, to further subvert the subjects' true meanings and force our attention to physical description enhanced by brilliant lighting and dark shadows. Disquieting references to real people involved in mysterious activities become intensified through such artful devices as abrupt cropping of the composition and oblique angles of vision. Larraz has long incorporated open windows looking onto barren landscapes or azure seas in his paintings, a strategy that opens interior spaces to the world afar and instills a sense of nostalgia or yearning, perhaps a reference to the loss of his island homeland. The addition of figures to these once empty interiors imparts different emotions and provokes new questions about his already puzzling scenes. Beautiful paintings become the catalyst for magical forays into the world of the imagination.

In both painting and sculpture Larraz adapts a realist approach to the production of art, but he does so only insofar as the real world is considered to be the vehicle for an intellectual investigation into the complexities of pictorial structure and the physical properties of the objective. His cryptic images are as elusive as they are suggestive of a strange world of reality and imagination.

—Carol Damian

LAZO, Agustín
Mexican painter

Born: Mexico City, 26 August 1896. **Education:** Studied painting with Alfredo Ramos Martínez; attended Academy of Fine Arts; Escuela al Aires Libre de Coyoacán, Mexico City; Escuela Nacional de Artes Plásticas, Mexico City; studied theatre stage design under Charles Dullin in Paris, 1928–30; also studied at Académie de la Grand Chaumière, Paris. **Career:** Lived in Paris, 1925–30. Stage designer, Teatro de Orientación, Mexico, 1931–32, and National University, Mexico; scenery creator, Teatro Mexicano, 1947. Also worked as a critic and playwright, 1930s and 1940s. Professor of oil painting, Esmerelda, Mexico, 1950s. **Died:** Mexico City, 28 January 1971.

Selected Exhibitions:

1935 Mexican Art Gallery, Mexico City
1936 Mexican Art Gallery, Mexico City
1940 *Exposición internacional surrealista,* Paris

Collections:

Museum of Modern Art, Mexico City; Museo de la Secretaría de Hacienda, Mexico City; Capilla Alfonsina, Mexico City.

Publications:

By LAZO: Books—*Toxiumolpia: El fuego nuevo: Ballet azteca* (ballet), with Carlos Chávez, Mexico, Secretaria de educación pública, 1921; *La huella,* Mexico, Sociedad General de Autores de Mexico, 1940; *Pablo Picasso,* with others, Mexico City, Sociedad de Arte Moderno, 1944; *Segundo imperio, pieza en cinco actos,* Mexico, Letras de Mexico, 1946; *El caso de Don Juan Manuel,* Mexico, Atenea, 1948; *La mulata de Córdoba* (libretto), with José Pablo Moncayo and Xavier Villarrutia, Mexico, Ediciones Mexicanas de Música, 1979.

On LAZO: Books—*Contemporary Mexican Artists* by Agustín Velázquez Chávez, New York, Covici-Friede, 1937; *Modern Mexican Artists Critical Notes* by Carlos Mérida, Mexico, Frances Toor Studios, 1937.

* * *

The Mexico City native Agustín Lazo was best known as an oil painter, although he was also widely recognized for his watercolors, graphic work, and stage designs. In the course of his career his work progressed from the realistic to the imaginative and, as with many of his contemporaries, on into the theater. He was considered by some to be a master of the grammar of the painter. He was also a proficient writer and dramatist.

Two clearly differentiated periods marked Lazo's career. The first began with his introduction to painting, when he studied in the shop of the impressionistic painter Alfredo Ramos Martínez and attended the Academy of Fine Arts. In these years of active experimentation and personal search, Lazo's preoccupations were essentially structural and technical, involving drawing, color, material, and construction.

Starting in 1928, Lazo began painting pictures of his own inner world. Unlike Diego Rivera, who intended his paintings to be for the people, Lazo painted for the intelligentsia. Although they were not great in number, the series of drawings he made during this period portray a dreamlike world. Innately aristocratic and restrained, Lazo never depicted the closed fists and orating mouths of his colleagues' paintings. There was always a gulf between the revolution-born Mexican backdrop against which Lazo lived and his own private yearnings and sensibilities.

Lazo's small drawing *Woman with Bird,* for example, illustrates in more modern terms a favorite nineteenth-century episode: the girl holds and comforts a sick dove in preternatural tenderness. The sotto voce creation of the story would be at home in the Victorian parlor, complete with melancholia, rocking chairs and antimacassars. It is almost a contradiction to the dramatic and violent times in which Lazo lived. In his stage plays the bustled, corseted, and padded ladies were most affected by their discreet longings. His paintings are brilliant in color, but throughout all of his pictorial work–including easel painting, engraving, gouache, watercolor, and ink–the strong continuity of his essential sensitivity and tranquility persist.

In the late 1940s several Mexico City painters worked together in dramatic efforts. The 1947 season of Teatro Mexicano, presented by the National Institute of Fine Arts, offered several plays written and created by Lazo and his contemporaries. *La huella* and *El caso de Don Juan Manuel* were written by Lazo, and he also created the scenery. Two other plays on the same bill involved painting colleagues. Julio Castellanos created the sets for *El pobre Barbazul,* and Antonio Ruiz designed the scenery for *El gesticulador.* In the 1950s Lazo worked as a professor of oil painting at Esmerelda, the Mexican national school of painting and sculpture.

—Martha Sutro

LEGORRETA (VILCHIS), Ricardo
Mexican architect

Born: Mexico City, 7 May 1931. **Education:** Universidad Nacional Autónoma de Mexico, B.A. in architecture 1953. **Career:** Architect, 1950s, then partner, 1955, José Villagrán García, Mexico City; principal, Legorreta Arquitectos, Mexico City, beginning in 1963. Founder and president, furniture and accessories design firm Legorreta Arquitectos Diseños. Instructor, Universidad Nacional Autonoma de Mexico, Universidad Iberoamericana, Harvard University, Cambridge, Massachusetts, University of California, Los Angeles, University of Texas, Austin. **Awards:** First prize, Banco de Mexico, 1981; gold medal, Tau Sigma Delta, 1983; prize, School of Architecture of Oaxaca, Mexico, 1983; gold medal, International Union of Architects, 1999; gold medal, American Institute of Architects, 2000; Premio Nacional de las Artes, Mexico; Architect of the Americas prize, Uruguay. **Address:** Legoretta Arquitectos, Palacio de Versalles 285 ''A,'' 11020 Mexico, or 3440 Motor Avenue, Floor 2, Los Angeles, California 90034, U.S.A.

Works:

1973 Hotel Camino Real, Cancun, Mexico
1998 Visual Arts Center, College of Santa Fe, New Mexico

Hacienda Cabo San Lucas Hotel; IBM, Mexico City; IBM Factory, Guadalajara, Mexico; Solana Complex, Dallas; Regina Hotel, Cancun, Mexico; Museum of Contemporary Art, Monterrey, Mexico; Metropolitan Cathedral, Managua, Nicaragua; Pershing Square, Los Angeles; Chapultepec Zoo, Mexico City; Monterrey Library, Mexico; Banker's Club, Mexico City; San Antonio Library, Texas; Mexican Museum, San Francisco; Children's Discovery Museum, San Jose, California; Fashion and Textile Museum, London; Tustin Market Place, California; Club Mediterranée, Huatulco, Oaxaca, Mexico; Las Fuentes, Camino Real, Ixtapa, Mexico; Gomez House, Mexico City; Molina House, Mexico City; Lomas Sporting Club, Mexico City; Automex Chrysler Factory, Toluca, Mexico; Renault Factory, Durango, Mexico.

Publications:

By LEGORRETA: Books—*Muros de Mexico* with Graziano Gasparini, Mexico, San Angel Ediciones, 1978; *The Architecture of Ricardo Legorreta* with Wayne Attoe, Sydney H. Brisker, and Hal Box, Berlin, Ernst & Sohn, and Austin, Texas, University of Texas Press, 1990; *Legorreta Arquitectos: Ricardo Legorreta, Victor*

Legorreta, exhibition catalog, with Victor Legorreta, Spain, Centro de Publicaciones, 1998; *Legorreta Arquitectos* with Lourdes Legorreta, Victor Legorreta, Noé Castro, and John V. Mutlow, second edition, Mexico, Gustavo Gili, 1998; *López Guerra: Architecture* with Pedro Ramírez Vázquez and Antonio Toca, Milan, L'Arca, 2000. **Book, edited**—*Modernity and the Architecture of Mexico,* with Edward R. Burian, Austin, Texas, University of Texas Press, 1997.

On LEGORRETA: Books—*Ricardo Legorreta, tradición y modernidad* by Louise Noelle, Mexico, Universidad Nacional Autonoma de Mexico, 1989; *La arquitectura de Ricardo Legorreta* by Wayne Attoe and others, Mexico, Noriega, 1993; *The Architecture of Ricardo Legorreta* by John V. Mutlow, London, Thames and Hudson, 1997; *World Architects in Their Twenties: Renzo Piano, Jean Nouvel, Ricardo Legorreta, Frank O. Gehry, I.M. Pei, Dominique Perrault,* Tokyo, TOTO Shuppan, 1999; *Ricardo Legorreta* edited by Yukio Futagawa, Tokyo, A.D.A. Edita, 2000. **Articles**—Interview with Ricardo Legorreta by James Steele, in *Mimar,* 43, June 1992, pp. 62–67; "Ricardo Legorreta: The Inspirations, Traditions and Humour in His Work," in *Architectural Design* (London), 64, July/August 1994, pp. 18–21; Ricardo Legorreta issue of *A + U* (Japan), 289, October 1994, pp. 6–73; "Fond Memories of Place: Luis Barragan and Ricardo Legorreta" by Wayne Attoe, in *Places* (Cambridge, Massachusetts), 9, winter 1994, pp. 34–43; "Legorreta e il populismo" by Richard Ingersoll, in *Casabella* (Italy), 59, March 1995, pp. 40–41; "Mexican Mysteries: A Choreography of Planes by Architect Ricardo Legorreta" by Joseph Giovannini, in *Architectural Digest,* 54, January 1997, p. 108; "Ricardo Legorreta: The Color of Conscience" by Penelope Rowlands, interview, in *Art News,* 97(4), April 1998, p. 137; "Legorreta's Gold Tops AIA Honors" by Michael J. O'Connor, in *Architecture,* 89(1), January 2000, pp. 21–22; "Using Ancient and Modern Tools, Legorreta Has Created a Powerful Architecture of Suggestion" by David Dillon, in *Architectural Record,* 188(5), May 2000, pp. 156–158.

* * *

The architect Ricardo Legorreta Vilchis was born in 1931 to a Mexico City banking family whose name is nationally known in association with finance. He was educated exclusively in Mexico and in 1953 graduated from the Escuela Nacional de Arquitectura of the Universidad Nacional Autónoma de México in Mexico City. He has specified his personal influences, saying, "My father taught me spirituality, social conscience, and a deep love for Mexico; José Villagrán the love for architecture. From [Luis] Barragán, Chucho Reyes, and Pedro Coronel, I learned about color and beauty." Early in his career he worked with José Villagrán García, before opening his own office in Mexico City in 1963. He later also came to maintain an office in Los Angeles.

Legorreta is known for a characteristic modern architectural style of massive walls, with high and expansive spaces defined by more walls, that reflect Mexican traditional and colonial building design. Entire wall surfaces are often covered with bright colors. His style also incorporates such qualities as thick walls of stone or adobe, unadorned but for occasional window or passageway openings, and an emphasis on plain geometric angles. In addition, he uses brilliant color accents, notably intense yellow, deep *rosa mexicana,* and cobalt blue, as illustrated prominently in such projects as the Hotel Camino Real in Ixtapa. This bold use of color creates visual excitement, volume, and an emphasis on oblique forms. Legorreta's buildings

may be ornamented with dynamic objects from the Mexican landscape–palm trees, cacti, ceramic jugs, ballast balls–that become icons by their symbolic placement. But the imposing presence of the buildings themselves, particularly those for public use that are large to begin with, is reminiscent of pre-Columbian public structures such as the Pyramid of the Sun.

Legorreta integrates into his work many of the characteristics initiated by the Mexican architect Luis Barragán (1902–88). Both draw from Mexican historical architecture, of which a great many buildings are still in use. Creations by pre-Columbian pyramid builders, Spanish colonial stone masons, and vernacular adobe builders clearly provided inspiration for both. Legorreta, however, plies his trade to encompass wide public audiences. The Camino Real hotels in Mexico City and Ixtapa; Pershing Square Park in Los Angeles; city libraries in San Antonio, Texas, and Monterrey, Mexico; and Managua's Metropolitan Cathedral are examples. In contrast, Barragán's creations reflect private, intimate concerns, particularly as highlighted in the Chapel for the Capuchinas Sacramentarias del Purísimo Corazón de María in Tlalpan, Mexico, where silence and tranquility are the overwhelming features. Legorreta's imposing public structures, such as libraries and children's museums, can accommodate large crowds while also allowing for movement and smaller gathering spaces. Often the structures are larger than the surrounding buildings, and because of their massive walls, attention-grabbing colors, and unusual placement of structural angles, they become unique, prominent features of the urban landscape.

The open architecture of Legorreta's public structures is ideal for Mexico's temperate weather and has been embraced across the country's borders in regions with similarly mild climates. Large, unencumbered patios and rooms with open, unglazed vistas are not appropriate for severe, snowbound winters. Thus, it is California, Texas, New Mexico, and Nicaragua that have been beneficiaries of the homegrown Mexican design. Plans have also been developed for construction in Honolulu, Hawaii.

—Susan N. Masuoka

LEIRNER, Jac(queline)
Brazilian sculptor and installation artist

Born: São Paulo, 1961. **Education:** College of Fine Arts at Fundação Armando Alvares Penteado, São Paulo, B.A. 1984. **Career:** Instructor, College of Fine Arts, São Paulo, 1987–89; visiting fellow, Oxford University, 1990; artist-in-residence, Walker Art Center, 1991.

Individual Exhibitions:

1991	Museum of Modern Art, Oxford
	Institute of Contemporary Art, Boston
1992	Walker Art Center, Minneapolis
	Hirshhorn Museum and Sculpture Garden, Smithsonian Institution, Washington, D.C.
1993	Galeria Camargo Vilaca, São Paulo
1997	Galerie Lelong, Miami
	Galeria Camargo Vilaca, São Paulo
1998	Sala Mendoza, Caracas
1999	Bohen Foundation, New York

2001 Galeria Helga de Alvear, Madrid

Selected Group Exhibitions:

1983 *Bienal,* São Paulo
1989 *Bienal,* São Paulo
1990 Venice Biennale
 Transcontinental: Nine Latin American Artists, Ikon
 Gallery, Birmingham, England
1991 *Viva Brasil viva,* Liljevalch Konsthall, Kulturhuset,
 Stockholm
1992 *Brasil: La nueva generación,* Fundación Museo de
 Bellas Artes, Caracas
 Documenta 9, Kassel
1993 *Latin American Artists of the Twentieth Century,*
 Museum of Modern Art, New York
1994 *Sense and Sensibility: Women Artists and Minimalism in
 the Nineties,* Museum of Modern Art, New York

Collections:

Walker Art Center, Minneapolis; Art Gallery of Ontario, Toronto.

Publications:

On LEIRNER: Books—*Transcontinental: Nine Latin American Artists,* exhibition catalog, edited by Guy Brett, London, 1990; *Jac Leirner,* exhibition catalog, with text by David Elliott, Oxford, 1991; *Jac Leirner,* exhibition catalog, São Paulo, 1993; *Jac Leirner: Nice to Meet You,* exhibition catalog, Galeria Camargo Vilaca, São Paulo, 1997; *Jac Leirner,* exhibition catalog, text by Ariel Jiménez, Sala Mendoza, Caracas, 1998. **Articles—**''Critics' Choice'' by Robin Cembalest, in *Artnews,* summer 1993; ''Women on the Verge of an Identity Crisis'' by E. Planca, in *Arte,* July/August 1994; ''Jac Leirner'' by Lissette Lagnado, in *Art Nexus,* July/September 1994.

* * *

Throughout her artistic career the Brazilian conceptualist Jac Leirner has been concerned with ordered accumulations. These accumulations have consisted of cutlery and blankets stolen from various aircraft and of bags from gift shops and bookshops and from some of the world's most famous museums. In a 1997 show her material consisted of calling cards of persons from the art world, including curators, collectors, museum directors, critics, and artists. What she formed was a kind of summary autobiography characterized by the obsessive and deliberate collecting of aspects of the world of art that ultimately comprised the narrative.

Leirner's brand of conceptualism accounts for the degree of self-referentiality implied by artistic practice as well as for the inherent ambiguity of language and the precarious nature of the possibility of communication. In the case of the calling cards, Leirner was examining the taste and influences that make up her sensibility. The way in which the cards were arranged in each of the 11 rooms was both randomly precise and casually specific and ultimately revealed the idiosyncrasy of the relationships among the persons represented by them. The autobiographical element was represented in the work, not by a calling card, but instead by an upside-down badge for entry into

the São Paulo Biennial, placed so as to indicate that Leirner was the installer of one of the rooms that contained work by another artist. The names and sequences continued to play out with each successive card in the horizontal line and, like a textual conversation, come to evoke a kind of precariousness of recognition and naming, of the futility of attempting to create order.

Leirner's site-variable 1998 work *HipHop* installed a circuitous montage of found color on the walls of the exhibition space. Blocks, bars, bands, and strips of brightly colored adhesive tape were placed side by side in a steady beat, expressing the artist's interest in the nature of circuits and recalling her 1992 project *Documenta 9, Corpus Delecti,* an arrangement of ashtrays from airline armrests that were strung together with a beaded chain. *HipHop* was about the notion of the circuit as a site, within which things are linked by observation and decision as well as by formal and metaphoric qualities. In the middle of the floor Leirner installed a serpentine line of devalued Brazilian currency, separately titling it *Blue Phase* (1991–98). She punched two holes in each bill and laced them together with cord in alternating groups of new and used, ultimately bookending and binding the 15-foot-long object with Plexiglas plates. The labor of collecting, classifying, and constructing a larger, more complete form is part of the situational integrity and the systematic aspect of her work.

In her 2001 series called *Adhesivos* (''Adhesives'') Lierner maintained her strategy of collecting similar objects that are later utilized as material for sculptures. In this case it was hundreds of decals from museums, art centers, fairs, airports, and even shipping crates, which Lierner arranged on the insides of pairs of windshields or bus windows. The series exposed the concepts and themes recurrent in her work: trips; the object-testimonial of personal experiences; art made from reality; the accumulation of ''circulating'' materials; the condensing and fixing in space of a prolonged period of time, throughout which she has collected, from very distant places, the components of the work; and the ordering of these elements according to simple, minimalist outlines.

—Martha Sutro

LEONILSON, (José)
Brazilian painter and mixed-media artist

Born: José Leonilson Bezerra Dias, Fortaleza, Ceará, 1 March 1957. **Education:** Fundação Armando Alvares Penteado, 1977–80; Aster art school, 1980. **Career:** Lived in Madrid, 1981; traveled to Italy, Germany, and Portugal, 1982; to Paris, 1985; to Europe, 1986; to Europe and New York, 1988–89, 1990; to the United States, 1991; and to Europe and New York, 1992. Illustrator, journal *Folha de São Paulo,* 1991–93; organizer of exhibition *Um olhar sobre o figurativo,* Casa Triângulo, São Paulo, 1992; committee member, committee to select portfolios, Centro Cultural São Paulo, 1992. **Awards:** Premio Brasília de Artes Plásticas, *Salão nacional,* 1990; prize, APCA, São Paulo Association of Art Critics, 1994. **Died:** São Paulo, 28 May 1993.

Individual Exhibitions:

1980 *Cartas a um amigo,* Solar do Unhão, Bahia
1981 Galeria Casa do Brasil, Madrid
1982 Galeria Pellgrino, Bolonha

1983 Galeria Luisa Strina, São Paulo
 Galeria Thomas Cohn, Rio de Janeiro
 Galeria Tina Presser, Porto Alegre, Brazil
1984 Arte Galeria, Fortaleza
1985 Galeria Luisa Strina, São Paulo
 Thomas Cohn Arte Contemporânea, Rio de Janeiro
 Espaço Capital, Brasília
1986 Galerie Walter Storms, Munich (with Albert Hien)
1987 *O pescador de palavras,* Galeria Luisa Strina, São Paulo
 Moving Mountains, Kunstforum, Munich
1988 Galeria Thomas Cohn Arte Contemporânea, Rio de
 Janeiro
1989 Galeria Luisa Strina, São Paulo
 Nada hás a temer, Gesto Gráfico, Belo Horizonte,
 Brazil
 Bombeiros não são corruptos, Espaço Capital, Brasília
1990 Gesto Gráfico, Belo Horizonte, Brazil
 Pulitzer Art Gallery, Amsterdam
1993 Galeria São Paulo and Thomas Cohn Arte
 Contemporânea, Rio de Janeiro
1994 Galeria São Paulo
1995 *Leonilson: São tantas as verdades,* Galeria de Arte do
 SESI, São Paulo
 Zé, Paço Imperial, Rio de Janeiro
1996 *Projects,* Museum of Modern Art, New York (with
 Oliver Herring)
 Galeria de Arte do Sesi, São Paulo
 Leonilson: São tantas as verdades, Centro Cultural
 Banco do Brasil, Rio de Janeiro (traveling)
 Randolph Street Gallery, Chicago
1997 Centro Cultural Light, Rio de Janeiro
 Doações recentes, Museu de Arte Moderna de São
 Paulo
 Leonilson: O solitário inconformado, Museu de Arte
 Contemporânea de Americana, Americana

Selected Group Exhibitions:

1979 *Desenho jovem,* Museu de Arte Contemporânea da
 Universidade de São Paulo
1980 *Panorama da arte atual brasileira,* Museu de Arte
 Moderna, São Paulo
1981 *Giovane arte internazionale,* Galleria Giuli, Lecce, Italy
1985 *XIII nouvelle bienale,* Paris
 Nueva pintura brasileña, Centro de Arte y
 Comunicación, Buenos Aires
 XVIII bienal internacional de São Paulo
1986 *A nova dimensão do objeto,* Museu de Arte
 Contemporânea, Universidade de São Paulo
 Transvanguarda e culturas nacionais, Museu de Arte
 Moderna, Rio de Janeiro
1987 *Ouverture brésilienne,* CREDAC, Ivry-sur-Seine, France
1989 *Panorama da arte atual brasileira/pintura,* Museu de
 Arte Moderna de São Paulo

Collections:

Museu da Gravura Cidade de Curitiba, Brazil; Museu de Arte
Moderna, Rio de Janeiro; Museu de Arte Moderna de São Paulo.

Publications:

On LEONILSON: Books—*Ouverture brésilienne,* exhibition cata-
log, Ivry-sur-Seine, France, CREDAC, 1987; *Leonilson: Use, é lindo,
eu garanto* by Ivo Mesquita, São Paulo, Cosac & Naify Edições,
1991; *Oliver Herring, Leonilson,* exhibition catalog, text by Starr
Figura, New York, Museum of Modern Art, 1996; *Contemporary
Brazilian Art,* exhibition catalog, São Paulo, Bayer S.A., 1996;
Leonilson: São tantas as verdades by Lisette Lagnado, Sã Paulo,
DBA Artes Graficas, 1998; *Imagem escrita,* edited by Renata Salgado,
Rio de Janeiro, Graal, 1999. **Articles**—"Oliver Herring and Leonilson"
by Marina Urbach, in *Art Nexus* (Colombia), 20, April/June 1996, pp.
120–121; "Leonilson" by Bill Hinchberger, in *Art News,* 95, June
1996, p. 162; "Oliver Herring/Leonilson" by Berta Sichel, in *Flash
Art* (Italy), 190, October 1996, p. 113.

* * *

One of the most important of the Brazilian artists who came
of age in that country's booming 1980s, José Leonilson made
autobiographically based drawings, paintings, and embroideries that
usually contained textual fragments or poems. His work addressed,
often with poignancy, his identity as a gay man and traced the
progression of his illness from AIDS. He died from AIDS-related
complications at the age of 36. Leonilson used domestic materials
such as buttons and embroidered dresses, shopping bags, and pillow-
cases made from translucent, softly colored material, and his finished
pieces often possessed the texture and chromatics of painting. The
mood of his sometimes disturbing work focused on quiet, personal
emotion, human fragility, and mortal loss.

Leonilson began his career as a painter, but sewing became the
focus of his creative activity while he was living with AIDS in his
later years. Fragmentary, overtly spiritual, the last pieces he made had
the tenderness and intimacy of bridal clothes, yet they were an effort
to articulate beforehand his own death, incorporating Roman Catholic
and corporeal iconography to suggest life's countless untold narra-
tives. *So Many Are the Truths* (1988) portrayed a list of cultural saints,
such as Marlon Brando, Andy Warhol, and Angela Davis, scrawled
beside roughly drawn figures and reflected both Leonilson's child-
hood Catholicism and influences from the international art world. *O
Penelope* is a large wall hanging sewn together from several pieces of
voile. Its highly irregular seams suggest the difficulty of joining two
lives or of piecing together the fragments of one's own existence. *O
Penelope* is one of two of his pieces that refer to the Homeric figure of
Penelope, who ceaselessly wove and unraveled her tapestry as she
awaited the return of her long absent husband and who for Leonilson
captured his suppressed impatience and longing. In the middle of *34
with Scars,* a small panel in white voile embroidered on the edges,
there are two tiny scars and the number 34, his age at the time he made
it. *The Island,* another square panel in white voile, portrays acute
physical and emotional fragility and feelings of alienation. In the
middle of the panel are the embroidered contours of a doll-like man
having his empty body filled with small metal objects. On the right
side, irregularly stitched in childlike letters, is the word "Island," and
at the bottom the same lettering forms the words "handsome"
and "selfish."

Leonilson was among the growing number of male artists with
direct roots in early feminist art, with its democratic, labor-intensive
aesthetic and its assumption that the political and the personal are
bound together. The mastery of Leonilson's work was in intricately

tying the fragility of his materials to his complex emotional ambitions. His most reverent work successfully mixes the sacred with the profane, the sophisticated with the primitive, and the emotional with the rational.

—Martha Sutro

Le PARC, Julio (Alcides)
Argentine painter

Born: Mendoza, 23 September 1928. **Education:** Studied under Lucio Fontana, School of Fine Arts, Buenos Aires, 1942–54. **Family:** Married Martha Garcia in 1959; three sons. **Career:** Since 1958 has lived and worked in France. Cofounder, *Groupe de Recherche d'Art Viseul (GRAV),* Paris, 1960–68; professor, arts plastiques et sciences de l'art, Université Paris I Pantheon/Sorbonne, 1972–73. **Awards:** Gold medal, with GRAV, *Biennale di San Marino,* 1963; Premier Prix Travail d'Equipe, with GRAV, *Biennale de Paris,* 1963; Special Di Tella prize, Buenos Aires, 1964; International Grand Prix for painting, *Biennale,* Venice, 1966. Chevalier, Ordre des Arts et Lettres, France. **Agent:** Galerie Denise René, 124 rue la Boetie, 75008 Paris. **Addresses:** 29 rue Couste, 94230 Cachan, France; and 41 rue des Rabats, 92160 Antony, France.

Individual Exhibitions:

1966	Galerie Denise René, Paris
	Howard Wise Gallery, New York
	Op Art Galerie, Esslingen, Germany
1967	Halfmannshof, Gelsenkirchen, Germany
	Galerie Francoise Mayer, Brussels
	Howard Wise Gallery, New York
	Galerie Saint-Laurent, Saint-Laurent-du-Pont, France
	Istituto di Tella, Buenos Aires
	Istituto General Electric, Montevideo, Uruguay
	Museo de Bellas Artes, Caracas, Venezuela
1968	Moderna Museet, Stockholm
	Galerie Buchholz, Munich
	Museu de Arte Moderna, Rio de Janeiro
	Museo de Bellas Artes, Mexico City
	Galleria del Naviglio, Milan
1969	Henie-Onstad Art Center, Oslo
	Galleria de Foscherari, Bologna, Italy
	Konsthallen, Gothenburg, Sweden
	Galleria del Cavillino, Venice
1970	Galerie Denise René, Paris
	Casa de las Americas, Havana
	Ulmer Museum, Ulm, Germany
1972	*Julio Le Parc, recherches 1959–1971,* Stadtische Kunsthalle, Düsseldorf, Germany (retrospective)
	Galerie Antanona, Caracas, Venezuela
	Galerie Denise René, Paris
	Galerie Francoise Mayer, Brussels
	Haus am Waldsee, Berlin-Zehlendorf
	Galerie Denise René-Hans Mayer, Dusseldorf, Germany
1973	Galleria La Polena, Genoa, Italy

	Denise René Gallery, New York
1974	Galerie Denise René, Paris
1975	Museo de Arte Moderno, Mexico City
	Galleria Lorenzelli, Bergamo, Italy
1976	*Le Parc: Pinturas recientes,* Museo de Arte Moderno, Mexico (traveling)
	Galeria Studium, Valladolid, Spain
	Galeria Rayuela, Madrid
	Modulations, Galerie Denise René, Paris
	Le Parc en la Coruna, Galeria Mestre Mateo, La Coruna, Spain Museo de Arte Moderno, Bogotá, Colombia
1977	*Festivals de Royan* at the *Quadriennale,* Rome
	Galeria Torques, Santiago de Compostela, Spain
1988	*Julio Le Parc: Experiencias, 30 años 1958–1988,* Salas Nacionales de Exposición, Buenos Aires
1996	*Les années lumière,* Espace Electra, Paris (traveling)
	Les alchimies, Galerie Dionne, Paris
	Salle de jeux, Galerie Municipale Julio Gonzales d'Arcueil, Paris
1997	Galeries du théâtre, Cherbourg, France
2000	*Second Mercosur Visual Arts Biennial,* Porto Alegre, Brazil
	Museo Nacional de Bellas Artes, Buenos Aires

Selected Group Exhibitions:

1965	*The Responsive Eye,* Museum of Modern Art, New York
	Lumie_e, mouvement et optique, Palais des Beaux-Arts, Brussels
1966	*Biennale,* Venice
1967	*Bienal,* São Paulo, Brazil
1968	*Kinetische Kunst,* Haus am Waldsee, Berlin-Zehlendorf
1970	*Kinetics,* Hayward Gallery, London
1971	*Multiples: The First Decade,* Philadelphia Museum of Art
1973	*Electric Art,* Kunsthalle, Hamburg, Germany
1976	*Creadores latinamericanos contemporaneos 1950–1976,* Museo de Arte Moderno, Mexico City
1977	*L'art et l'automobile,* Centre Georges Pompidou, Paris

Publications:

By Le PARC: Books—''Propositions sur le mouvement,'' with GRAV, in *Bewogen-Beweging,* exhibition catalog, Stockholm, 1961; text, with GRAV, in *Le Parc: XXXIII Biennale de Venise 1966,* Paris 1966; text, with GRAV, in *Lumière et mouvement,* exhibition catalog, Paris, 1967; text, with GRAV, in *GRAV,* exhibition catalog, Krefeld, Germany, 1968; *Julio Le Parc, recherches 1959–1971,* exhibition catalog, with Jürgen Harten, Düsseldorf, Germany, Stadtische Kunstahalle, 1972; *Historieta: Petite histoire en images interrogeant la face cachée de l'art, de l'artiste et de son contexte social,* exhibition catalog, with Jean-Louis Pradel, Nantes, France, Joca Seria, 1997. **Articles**—''L'art valeur bourgeoise au travail révolutionnaire'' and interview, with Frederic Chaleuil, in *Politique d'aujourd'hui* (Paris), 9, 1971; interview, with B. Breecken, in *Vendredi hebdo,* January 1971; ''Je me déclare incapable de prendre

Julio Le Parc: *Vibratory Effects,* **1974. Photo courtesy of Castilla de San Jose, Lanzarote, Canary Islands/Bridgeman Art Library. © 2002 Artists Rights Society (ARS) New York/ ADAGP, Paris.**

une décision pour accepter ou refuser l'invitation de M. Lassaigne,'' in *Les Lettres francaises* (Paris), April 1972.

On Le PARC: Books—*Julio Le Parc, entrevista grabada* by Marta Dujovne and Marta Gil Solá, Buenos Aires, Editorial Estuario, 1967; *Julio Le Parc* by Enzo Mari, Milan, Achille Mauri, 1969; *Le Parc, couleur 1959,* exhibition catalog, Paris, Galerie Denise René, 1970; *Julio Le Parc, Kinetische Objekte,* exhibition catalog, Ulm, Germany, Ulm Museum, 1970; *Le Parc: Pinturas recientes,* exhibition catalog, Bosque de Chapultepec, Museo de Arte Moderno, Mexico, Instituto Nacional de Bellas Artes, 1975; *Le Parc: Modulations,* exhibition catalog, Paris, Galerie Denise René, 1976; *Careaga, Le Parc, Soto, Vasarely,* exhibition catalog, Asunción, Paraguay, Galería Citroën, 1977; *Le Parc,* Madrid, Rayuela, 1978; *Le Parc,* exhibition catalog, Valencia, Spain, Excm. Ajuntament de València, 1986; *Julio Le Parc: Experiencias, 30 años 1958–1988,* exhibition catalog, Buenos Aires, Secretaría de Cultura de la Nación, Dirección Nacional de Artes Visuales, 1988; *Julio Le Parc* by Jean-Louis Pradel, n.p., Severgnini, 1995; *Alquimicias,* exhibition catalog, Murcia, Ayuntamiento de Murcia, 1996; *Julio Le Parc, arte e tecnologia,* exhibition catalog, with text by Leonor Amarante, Porto Alegre, Brazil, Fundação Bienal de Arts Visuais do Mercosul, 1999; *Julio Le Parc,* exhibition catalog, with text by Jorge Glusberg, Buenos Aires, Museo Nacional de Bellas Artes, 2000. **Articles**—''52 interventi sulla proposta di comportamento di Enzo Mari'' by Lea Vergine in *NAC* (Milan), August 1971; ''Julio Le Parc: Recherches 1959–1971'' by P. Kress in *Kunstwerk* (Baden-Baden), March 1972; ''Dusseldorf: Julio Le Parc'' by A. Pohribny in *NAC* (Milan), April 1972;''Szene Rhein-Ruhr'' by B. Kerber in *Art International* (Lugano, Switzerland), April 1972: ''Julio Le Parc: The Laws of Chance'' in *Studio International* (London), January 1973; ''Arte Programmata: a cura di Lea Vergine'' in *NAC* (Milan), March 1973; ''Le Parc en lumière'' by Denis Picard, in *Connaissance des Arts* (France), 527, April 1996, pp. 58–89; ''La recherche plastique de l'ouvrier Julio Le Parc'' by Anne LeGuy, in *Beaux Arts Magazine* (France), 144, April 1996, p. 36.

* * *

From being an artist interested in kinetics and light, Julio Le Parc gradually moved to environments and play and become more and more politicized into what he has called a ''cultural guerrilla.'' Going to Paris from Argentina on a scholarship in 1958, he joined with Victor Vasarely's son Yvaral and other like-minded artists the following year to found Groupe de Recherche d'Art Visuel (GRAV), one of the many kinetic groups formed in Europe during the late 1950s and early 1960s. It was a deliberate reaction against the fashion for informal tachism and was influenced by the ideas of Vasarely, with his belief in impersonality and the anonymity of the artist. These artists set up a communal studio and constructed some works under the group name alone.

At first the group's aim was scientific or pseudoscientific research into visual problems, but gradually, as Le Parc became more and more dominant, it was led toward the other main tendency of kinetic art, the ''game aesthetic'' of building environments for play and spectator participation. The group built complex environmental labyrinths through which the public had to crawl while playing visual games of many kinds. Le Parc aimed at instability, a situation in which any permanent form of a work became impossible to discern. His works are designed to disorient the spectator, and he uses all sorts

of devices, like distorting glasses and spring-loaded shoes, to achieve this disorientation. Play and entertainment are basic even to his more serious mobiles and kinetic light murals, which use simple, suspended metallic elements to produce a constantly shifting play of light and shade. Other games demonstrate velocity, vibration, or the way Ping-Pong balls are shot radially from a fast spinning pivot to the sides of the box. The increasingly polemical and political nature of his work was shown when, for a retrospective in Düsseldorf in 1972, he arranged a participative environment of large punch-me dolls with faces painted to represent the pillars of established society, typically for him not only policemen, politicians, priests, and journalists but also the artist.

Le Parc has remarked that kineticism ''runs the risk of becoming a new academicism,'' and he has become one of those artists who seek a new orientation for art as the direct manipulation of the environment. His own statements make clear the relationship of his political views to his earlier belief in artistic instability and disorientation: ''One must become a kind of cultural guerrilla against the present state of things and point out all the contradictions. One must create new situations in which people may rediscover their capacity to bring about changes; fight any tendency towards stability, permanence, lastingness; fight anything that heightens the state of dependence, apathy, passivity which is linked to habits, established criteria and myths.''

—Konstantin Bazarov

LINARES, Pedro
Mexican sculptor and papier-mâché artist

Born: Pedro Linares Jiménez, Mexico City, 29 June 1906. **Family:** Married Adela Mendoza Alcátars in 1930 (died 1973); three sons. **Career:** Creator, often with his sons, of phantasmagorical papier-mâché creatures and monsters known as *alebrijes*. Exhibited frequently with his sons. **Award:** Premio nacional de ciencias e arte, Mexico, 1991. **Died:** Mexico City, 26 January 1992.

Selected Exhibitions:

1968 XIX Olympiad, Diego Rivera Anahuacalli Museum, Mexico City
1977 Museum of Man, San Diego, California
1978 *Three Folk Artists from Mexico,* Craft and Folk Art Museum, Los Angeles
1987 *La muerte animada en la cartonería popular y sus raices antiguas: El arte de los Linares,* Palacio de Iturbide, Mexico City (traveled throughout Mexico)
 Pedro Linares and the Days of the Dead/MATRIX, Wadsworth Atheneum, Hartford, Connecticut
1989 *The Art of Mexican Papier-Mâché,* Mexican Fine Arts Center Museum, Chicago
1990 French Institute of Latin America, Mexico City
1991 New Gallery, Santa Monica, California
1994 *En Calavera: The Papier-Mâché Art of the Linares Family,* Fowler Museum of Cultural History, University of California, Los Angeles

Collections:

Anahuacalli Museum, Mexico City; Centre Georges Pompidou, Paris.

Publications:

On LINARES: Books—*Las artesanías tradicionales en México* by Carlos Espejel, Mexico City, SEP-Stenas, 1972; *Three Folk Artists from Mexico,* exhibition catalog, by Judith Bronowski, Los Angeles, Craft and Folk Museum, 1978; *Los artesanos nos dijeron . . .* by Rodolfo Becerril Straffon and Adalberto Ríos Szalay, Mexico City, FONART, 1981; *El imaginativo mundo de los Linares* by Victor Inzúa Canales, Mexico City, UNAM, 1987; *En Calavera: The Papier-Maché Art of the Linares Family,* exhibition catalog, Los Angeles, University of California, 1994. **Articles**—"Los alebrijes" by María Antonieta Barragán, in *Caminos del Aire,* 1990; "Funny Papiers," in *Southwest Art,* 24, December 1994, p. 22. **Films**—*Pedro Linares, Folk Artist* by Robert Trafur, Judith Bronowski, and Robert Grant, Santa Monica, California, Production Centre West, 1980; *La ofrenda* by Lourdes Portillo and Susana Muñoz, San Francisco, 1989.

* * *

Pedro Linares was a papier-mâché artist whose career bridged production of traditional fiesta fare and imaginative one-of-a-kind figures of artistic expression. As the patriarch, he taught and inspired male members of his family to join him in production, then to take over, and finally to surpass him creatively. Three younger generations of the family, including three of his sons and three of his grandsons, have participated in paper art making after having learned the skills purely within the family, passed down in the time-honored method. Youngsters of his great-grandchildren's generation have begun by playing with *engrudo* flour paste on paper, by helping with selected tasks, and by trying their hand, alone, at their own pieces.

The Linareses have been known for two basic genres: the expressive, gesticulating skeletons and *alebrije,* composite fantastic animals. While the genesis of both genres can be traced to traditional Mexican fiesta paper goods, two separate events marked their beginning. The word *alebrije* was invented by Linares, and it cannot be found in the dictionary. The story, as told by Linares, was that one night in the early 1950s he was overcome with a high fever. "I thought I died. No, I think I died. I died," he said, "when I saw these enormous, scary animals, with horns, and spikes, and in crazy colors. And, I was so scared I came back to this side, to the side of the living." After that he was cured and began making papier-mâché figures in the image of his vision.

Alebrijes did not, however, spring fully formed but have evolved over the course of more than 40 years. From Linares family examples collected since the late 1950s in the UCLA Fowler Museum collection, it has been possible to follow the development of the papier-mâché beasts. They have become more complex with time, with emphasis on bold sculptural forms and meticulous surface painting, often designating feathers, scales, or fur. Of the family artists, Pedro's son Miguel has practiced with the most precise hand. Some of his inventions include a lion-scorpion, a wild dog-dragon, and a feline-eagle, painted in the boldest puce, copper, carmine red, and cobalt blue.

There was also economic impetus for *alebrije* production. In 1957, when an illegal dynamite cache exploded in Mexico City just before the busiest time of the traditional papier-mâché market and a resulting ban prevented sales of "Judas" figures, the Linareses

turned to selling *alebrijes* to the tourist, decorators', and appreciative art market. Since this proved to be more lucrative than seasonal fare sold on the streets or in municipal markets, and the Linareses' artistic inventiveness in turn encouraged *alebrije* production, the two factors proved mutually beneficial to promote the art.

The Linares artists have regarded only papier-mâché fantastic animals made by Linares family members to be *alebrijes.* Since it was Pedro who invented the genre and other family members who evolved the style, they have considered it a family artistic privilege rather than part of the national heritage.

The 1968 International Olympics held in Mexico City marked the beginning of the large-scale Linares animated skeleton production. As photographs at the end of the nineteenth century revealed, gesturing human skeletal figures were a mainstay of Day of the Dead festivities. These three-dimensional figures, however, measured a maximum of 10 centimeters. The Linareses, too, made these small dancing, marching *calacas* when Pedro's three sons were young, to be sold in the local holiday market.

According to Pedro and his sons, in preparation for the 1968 Olympics, Dolores Olmedo approached them to fill some commissions. Olmedo, as Diego Rivera's executor, had asked them before to make Day of the Dead offerings for the memorial altar she constructed yearly at Anahuacalli, Rivera's studio. But this time her request had an Olympic theme: Could they make large-scale (about 120 centimeters) papier-mâché skeletons competing in a variety of Olympic events? Could they depict such sports as boxing, Greco-Roman wrestling, diving, and gymnastics? Pedro, aided by his sons Enrique and Felipe, took on the challenge.

Several years later Carlos Espejel of the government folk art support agency FONART dropped off a picture book featuring José Guadalupe Posada prints. Together they decided which grouping the Linareses would make, and for many years thereafter the Linareses made Posada-based animated skeletons in three dimensions for the government FONART Day of the Dead displays. Perhaps the most spectacular was the memorial in 1986, the year after the massive Mexico City earthquake, that depicts dozens of dressed skeletons in an earthquake rescue scene: firemen, policemen, army guards, emergency care workers, victims, and even a rescue dog with his trainer from France. The Linareses began by reproducing Posada skeleton figures in three dimensions. Then, at the point when a traumatic natural disaster effected the entire nation, the Linareses were inspired to create expressions of the earthquake's impact on their own.

The two Linares genres have infinite creative possibilities and promise to be the basis of elaboration far into the future.

—Susan N. Masuoka

LIRA, Benjamin
Chilean painter, photographer, and sculptor

Born: Santiago, 14 January 1950. **Education:** Studied architecture, Universidad Católica de Valparaíso, Chile, 1969; Instituto Cultural de las Condes, Santiago, 1970; Academia de San Fernando, Madrid, 1970; Byam Shaw School of Drawing and Painting, London, 1971–73; Pratt Institute, New York (on fellowship), 1977–79, M.F.A. 1979. **Family:** Married Francisco Sutil in 1977 (separated 1992); one

daughter. **Career:** Traveled to Europe, 1967. Lived in New York, 1977–92. **Awards:** Special prize, *Niños dibujan a Chile,* 1964; grand prize, Concurso de Pintura Interescolar del Colegio Villa María Academy, Santiago, 1966; first prize, Colocadora Nacional de Valores, Museo Nacional de Bellas Artes, Santiago, 1977; fellowship, Fulbright Foundation, 1977.

Individual Exhibitions:

1970 Instituto Cultural de las Condes, Santiago
1974 Galería Módulos y Formas, Santiago
1976 *Gráfica 76,* Galería Imagen, Santiago
1979 Pratt Institute, Brooklyn, New York
1982 *Benjamín Lira fotografías,* Museo Nacional de Bellas
 Artes, Santiago
1983 Ricardo Barreto Contemporary Art, Boston
 Galería Forum, Lima, Peru
1984 Leila Taghinia-Milani Gallery, New York
 Galería Plástica 3, Santiago
1985 *Benjamin Lira, Paintings 1981–85,* Frances Wolfson Art
 Gallery, Miami-Dade Community College, Miami
1987 *Benjamin Lira: Pinturas recientes,* Galería Epoca,
 Santiago
1988 Ruth Siegel Gallery, New York
1989 Galería Epoca, Santiago
1990 *New Paintings,* Ruth Siegel Gallery, New York
1991 *Benjamín Lira: Pinturas, 1985–1990,* Galeria de Arte de
 Jorge Carroza Lopez, Santiago
1996 Galería A.M.S. Marlborough, Santiago
 Galería el Caballo Verde, Concepción, Chile
1999 *Benjamín Lira: Treinta años en el arte,* Galería A.M.S.
 Marlborough, Santiago

Selected Group Exhibitions:

1976 Instituto Cultural de las Condes, Santiago
1982 *Drawing,* Inter-American Art Gallery, New York
1985 *Plástica chilena-horizonte universal,* Museo Nacional de
 Bellas Artes, Santiago
1986 *V bienal americana de artes gráficas,* Museo de Arte
 Moderno La Tertulia, Cali, Colombia
1987 *Latin American Artists in New York since 1970,*
 University of Texas, Austin
1990 *Figurative Perspectives, Six Artists of Latin American
 Background,* Rockland Center for the Arts, West
 Nyack, New York
 At the Edge, Laguna Gloria Art Museum, Austin, Texas
1992 *Colección ladeco de arte contemporáneo,* Centro
 Cultural Monte Carmelo, Santiago
1998 *Chile: Arte y cobre,* Museo Nacional de Bellas Artes,
 Santiago
2001 *Art Chicago 2001*

Collections:

Museo Nacional de Bellas Artes, Santiago; Museo Chileno de Arte Moderno, Santiago; University of Texas, Austin; Vassar College, Poughkeepsie, New York.

Publications:

On LIRA: Books—*Pintura y escultura de hoy,* exhibition catalog, text by Carmen Aldunate, n.p., Editorial Universitaria, 1976; *Benjamín Lira fotografías,* exhibition catalog, Santiago, Museo Nacional de Bellas Artes, 1982; *Drawing,* exhibition catalog, New York, Inter-American Art Gallery, 1982; *Ayer y hoy,* exhibition catalog, text by Lily Lanz, Santiago, Galería Epoca, 1984; *Benjamin Lira, Paintings 1981–85,* exhibition catalog, Miami, Miami-Dade Community College, 1985; *Benjamin Lira: Pinturas recientes,* exhibition catalog, text by Edward J. Sullivan, Santiago, Galeria Epoca, 1987; *Benjamín Lira: Pinturas recientes,* exhibition catalog, Santiago, Galería Epoca, 1990; *Benjamín Lira: Pinturas, 1985–1990,* exhibition catalog, Santiago, Galeria de Arte de Jorge Carroza Lopez, 1991; *Benjamín Lira: Pinturas y collages recientes,* exhibition catalog, text by Carlos Chávez, Santiago, Galería A.M.S. Marlborough, 1996; *Benjamín Lira: Treinta años en el arte,* exhibition catalog, text by Edward Shaw and Marcelo Maturana, Santiago, Ediciones A.M.S. Marlborough, 1999. **Article**—"Ruth Siegel Gallery, New York; Exhibit" by Elizabeth Hayt, in *Art News,* 87, November 1988, p. 180.

* * *

Benjamin Lira's dramatic use of color, texture, and abstract imagery has marked his paintings and collages as some of the most significant art being produced in contemporary Chile. Although Lira views himself as a Latin-American artist first and foremost, his eclectic influences include European masters and New York City architecture. Ultimately though, it is Lira's striking and unconventional ways that make his work unique.

Lira's distinctive style and his interest in revealing the hidden in the familiar were presaged by his early interest in collage. Encouraged by his maternal grandfather, Lira cut up picture books and magazines to provide the images he transmuted into his own work. These youthful explorations also familiarized him with the works of Joseph Cornell, Kurt Schwitters, Pablo Picasso and Robert Rauschenberg. Archaeology (another discipline focusing on the excavation of hidden meaning) was also a formative influence. Indeed, Lira contemplated becoming an archaeologist for a time, before he realized that his true passion was drawing.

At age 19 Lira enrolled in a course in architecture. His sketches, however, tended to resemble watercolors far more than drafting plans, and his professors told him that his talents were better suited to art. He then left Chile to study in various European schools, including the Royal Academy of San Fernando in Madrid and the Byam Shaw School of Drawing in London. He was also influenced by the more casual artistic studies he conducted independently on trips to Turkey, Greece, Italy, and France. Lira became captivated with representations of the human form after coming across the book *De human corporis fabrica,* which contained a series of plates, predating Leonardo da Vinci, that depicted the body as a machine. It inspired Lira to study medical illustrations and other anatomical drawings as well as representational works of the Old Masters.

Lira returned to Chile in 1973 and soon began sharing studio space with Gonzalo Cienfuentos. In this early period of his career, Lira worked mainly with pen and pencil on paper, though he retained his interest in collage as well. This work was centered on the line and the way that it could shape and reveal the human form. As the 1970s progressed, however, he expanded his use of media to include oil and acrylic on canvas and narrowed the focus of his artistic vision to

disembodied human heads and faces, which he rendered in an expressionistic and surreal way. The works of this period, which Lira referred to as his "Human Nature" series, show people abstracted in brutal isolation, screamingly dismembered and in anguish, set off from even the background on which they were painted. By cloaking the individuality of his figures in the garb of abstraction, Lira sought to capture the common stories of the human soul, those truths hidden behind the mask of daily life.

As his work matured, Lira continued to depict abstract figures, but his use of color became ever more vivid and convention shattering. He meticulously mixed his own paints and experimented with different techniques, including sand scraping, to give his pieces precise shades and tones. In this effort he sought to create hues reminiscent of Mayan murals and pre-Columbian ceramics. Lira also employed various strategies—including the use of sand, acrylic and marble dust—to alter the texture of his paintings, enabling him better to capture his visions of color and form. Indeed, it is these two aspects that Lira came to emphasize in his work, subordinating imagery to them.

Lira's reputation blossomed during the 1980s, and he was featured in solo exhibitions in the United States and Chile. By the early 1990s, he had returned to his early love of collage, producing intricate, multidimensional canvases that blurred the boundary between painting and sculpture. At the same time, he continued to explore the human form on canvas, creating pieces such as *Pulsamiento* (1995), in which human images are stranded amid vast spaces, abstract and seemingly muzzled, drawn into themselves. The paintings of this period employed mainly primary colors, mixed with white, as Lira sought to make his art more luminous.

—Rebecca Stanfel

LLINÁS, Guido
Cuban painter

Born: Cuba, 1923. **Career:** Traveled to the United States, early 1950s; to Europe, late 1950s. Moved to Paris, 1963. Cofounder and member, artist group *Los Once*, 1953–55; member, artist group *Los Cinco*, 1955–63.

Individual Exhibitions:

1997 *Guido Llinas and Los Once after Cuba,* Art Museum at
 Florida International University, Miami
1998 Altman Space, Clairegoutte, France

Selected Group Exhibitions:

1952 *Young Art,* Confederation of Cuban Workers, Havana
1953 *Eleven Painters and Sculptors,* La Rampa, Havana (with
 Los Once)
1997 *Breaking Barriers,* Museum of Art, Fort Lauderdale,
 Florida (traveling)
2000 *3 International Graphic Triennial,* Bitola, Macedonia

Publications:

By LLINÁS: Book, illustrated—*On déplore la* by Julio Cortázar, Paris, Brunidor, 1966.

On LLINÁS: Book—*Guido Llinás and Los Once after Cuba,* exhibition catalog, text by Dahlia Morgan, Juan A. Martínez, and Cristoph Singler, Miami, Art Museum at Florida International University, 1997.

* * *

In Cuba during the 1950s, many of the ideas introduced by avant-garde artists in the previous three decades had run their course. The representation of the noble peasant had, in some ways, seen its day, and many younger artists wanted to leave behind the sweetness and sentimentality of the older generation. The world's artistic capital had shifted from Paris to New York, and abstract expressionism was emerging as a dominant art form. During this period there was also a growing interest among Cuban painters in concrete art and geometric abstraction.

In 1953 several Cuban artists attracted to abstract expressionism, including the painter Guido Llinás, formed a group called *Los Once* ("The Eleven") and exhibited together for the next two years. Not only were *Los Once* artists responsible for introducing abstract art into Cuba, they were also social and political activists. *Los Once* members met frequently to discuss ideas and strategies. As had their predecessors, they often included literary artists in their discussions. They were antagonistic toward earlier artists, whom they saw as failing to break from European modernism, sometimes even claiming that there was no "movement" in the arts in Cuba before *Los Once.* Their rejection of earlier art had a political aspect and was a rebellion against the 1952 military coup in Cuba. Protesting against Batista's regime, *Los Once* artists refused to show in any official exhibitions and often organized their own "counterexhibitions."

The formal launching of the group occurred on 18 April 1953, with the exhibition *Eleven Painters and Sculptors* at La Rampa, a commercial center in Havana. The exhibition was organized by Llinás and the sculptor Tomás Oliva and included the painters René Avila, José I. Bermudez, Hugo Consuegra, Viredo Espinosa, Fayad Jamís, and Antonio Vidal and the sculptors Francisco Antigua, Agustín Cárdenas, and José A. Diaz Peláez. This exhibition received favorable reviews in the press, which led to six more group shows in the next two years. Bermudez left the group later in 1953 to live in the United States. He was replaced by Raúl Martínez, who became one of the group's most outspoken leaders.

Founding member Llinás was one of the most purely abstract artists in *Los Once.* Initially inspired as a young man by Wifredo Lam's exhibition in 1946, Llinás had previously been limited to what he had learned from the academies in his home province of Pinar del Rio, but participation in *Los Once* helped him to expand his horizons. The group had its beginnings in *Young Art,* a 1952 exhibition at the cultural center of the Confederation of Cuban Workers in which Llinás brought together a number of emerging artists like himself, including Antonia Eiriz, the brothers Manuel and Antonio Vidal, and Fayad Jamís. Llinás, Antonio Vidal, and Jamís went on to become part of *Los Once,* whereas Eiriz and Manuel Vidal followed different artistic paths but were made "honorary members" of the group. In the early 1950s Llinás traveled to New York, Washington, and Philadelphia, where he was exposed to the work of Rothko, Pollock, Motherwell, Kline, de Kooning, and Gottlieb. After the disbanding of *Los Once* in 1955, Llinás became a member of *Los Cinco* ("The Five"), which continued to show together until 1963. In the late 1950s Llinás traveled to Italy and France, and after a brief return to Cuba he settled in Paris permanently in 1963.

As reported in the unpublished memoirs of Hugo Consuegra, a fellow member of *Los Once* and *Los Cinco,* Llinás believed: ''In the philosophy of *Los Once,* a painting does not represent anything. It is direct expression. Something that must be felt through its color and form.'' His painting known as *Untitled* (oil on burlap, in the Jay and Anita Hyman Collection, 1953) is a perfect example of this philosophy. The work is totally devoid of figuration and thus was quite a radical departure from previous Cuban art.

Llinás's interest in abstract expressionism was later merged with his experience with the Afro-Cuban Abakuá religion. From the latter Llinás took symbols and pictographs, incorporating them into his canvases. His work in the 1990s used cross and arrow symbols, which were combined with his investigation of color as a means of expression. Examples of such work were found in the major retrospective entitled *Guido Llinás and Los Once after Cuba,* which was presented in 1997 by the Art Museum at Florida International University in Miami.

—Sean M. Ulmer

LOMAS GARZA, Carmen
American painter, printmaker, and sculptor

Born: Kingsville, Texas, 1948. **Education:** Texas Arts and Industries University (later Texas A&M University, Kingsville), Kingsville, B.S. in art education 1972; Antioch Graduate School, Juarez/Lincoln Center, Austin, Texas, M.E. 1973; Washington State University, Pullman, 1975–76; San Francisco State University, M.A. in art 1981. **Career:** Administrative assistant and curator, Galeria de la Raza, San Francisco, 1976–81. **Awards:** International Artist in Residence grant, Fondo Nacional para Cultura y las Artes and National Endowment for the Arts, 1996; two fellowships, National Endowment for the Arts; fellowship, California Arts Council.

Individual Exhibitions:

1984 Olive Hyde Art Gallery, Fremont, California
1985 Galería Posada, Sacramento, California
1987 Mexican Museum, San Francisco
1991 *Pedacito de mi corazón/A Piece of My Heart,* Laguna Gloria Art Museum, Austin, Texas (traveled to El Paso Museum of Art, Texas, Mexican Fine Arts Center Museum, Chicago, Oakland Museum, California)
1995 Hirshhorn Museum and Sculpture Garden, Smithsonian Institution, Washington, D.C.
1996 Steinbaum-Krauss Gallery, New York
1998 TAEA Conference, Corpus Christi, Texas

Selected Group Exhibitions:

1977 Mexican Museum, San Francisco
 Dalé Gas: Chicano Art of Texas, Contemporary Arts Museum, Houston
1978 Frank C. Smith Fine Arts Center, Texas Arts and Industries University, Kingsville
1980 Museum of Modern Art, San Francisco

1982 *Hispanics USA 1982,* Wilson Gallery, Lehigh University, Bethlehem, Pennsylvania
1984 *¡Mira!,* El Museo del Barrio, New York (traveling)
1986 *Chicano Expressions,* Intar Latin American Gallery, New York
1987 *Hispanic Art in the United States: Thirty Contemporary Painters and Sculptors,* Museum of Fine Arts, Houston (traveling)
1992 *The Chicano Codices: Encountering Art of the Americas,* Mexican Museum, San Francisco
1997 Steinbaum-Krauss Gallery, New York

Publications:

By LOMAS GARZA: Books—*Family Pictures/Cuadros de familia,* Children's Book Press, San Francisco, 1990; *Pedacito de mi corazón/A Piece of My Heart: The Art of Carmen Lomas Garza,* introduction by Amalia Mesa-Bains, New Press, New York, 1994; *In My Family/En mi familia,* Children's Book Press, San Francisco, 1996; *Ventanas magicas/Magic Windows,* Children's Book Press, San Francisco, 1999; *Making Magic Windows: Creating Cut Paper Projects with Carmen Lomas Garza,* Children's Book Press, San Francisco, 1999.

On LOMAS GARZA: Books—*Carmen Lomas Garza/Prints & Gouaches,* exhibition catalog, essay by Tomás Ybarra-Frausto, San Francisco Museum of Modern Art, San Francisco, 1980; *Carmen Lomas Garza,* exhibition catalog, Galeria Posada, Sacramento, California, 1985; *Hispanic Art in the United States: Thirty Contemporary Painters and Sculptors,* exhibition catalog, by John Beardsley and Jane Livingston, Abbeville Press, New York, 1987; *The Liberated Chicana: The Art of Carmen Lomas Garza and Yolanda M. Lopez* by Andreya Paula Hernández, 1999. **Articles**—''Not So Naive After All'' by Josef Woodard, in *Artweek,* 22, 11 April 1991, pp. 9–10; ''Storytelling'' by Collette Chattopadhyay, in *Artweek,* 23, 17 December 1992; ''Interview with Carmen Lomas Garza'' by Jennifer Easton, in *Art Papers,* 18, May/June 1994, pp. 2–6; ''Looking/Learning–Carmen Lomas Garza: A Universal Tribute to Family, Heritage, and Community'' by Nancy Walkup, in *School Arts,* 97(1), 1997; ''Ofrenda de Arte'' by Abel Salas, in *Hispanic,* 11(12), 1 December 1998, p. 32.

* * *

Carmen Lomas Garza was born in Kingsville, Texas, in 1948. At an early age Lomas Garza showed an interest in art and at age 13 decided to become a visual artist. In 1965, during the early period of the Chicano civil rights movement, Lomas Garza met a group of demonstrators from the United Farm Workers that had marched through her hometown protesting human rights abuses of Mexican-American laborers in the southwest United States. These activists not only disputed unfair wages and health conditions but also promoted a positive image that affirmed Mexican-American cultural life. Inspired by these principles Lomas Garza began to produce a body of work that portrayed the integrity of the Mexican-American people. In the spirit of other women artists such as Grandma Moses and Frida Kahlo, Lomas Garza took an autobiographical approach and used a naïve

Carmen Lomas Garza: *Loteria-Tabla Lena,***1974. Photo by Jacinto Quirarte. Reproduced by permission.**

style that borrowed from artisan and craft traditions to depict her memories of childhood. In style, composition, and color she rendered scenes of daily life such as birthdays, family gatherings, and Mexican customs like faith healing in loving detail drawn from her own experiences in southern Texas.

At Texas A&I University (later Texas A&M University) Lomas Garza studied art education and studio art, receiving a bachelor of science degree in 1972. She later earned a master's degree in education from Antioch Graduate School, Juarez/Lincoln Center in Austin, Texas, in 1973 and a master of art from from San Francisco State University in 1981. Lomas Garza then settled in San Francisco, where she has continued to work in a diverse array of media including painting, paper and metal cutouts, offerings or *ofrendas,* Day of the Dead altars, installations, children's books, and prints. Using her own memories of coming of age during the 1950s and '60s in Kingsville as starting points, Lomas Garza consciously focuses on the positive and humanizing qualities of Mexican-Americans. Her painting *Tamalada* (1987; ''Making Tamales'') portrays the artist's family during the annual ritual of making tamales during the Christmas season. The

practice of making tamales requires many steps and often involves several people. As in many Mexican-American homes the family customs surrounding the holidays become cherished events, and Lomas Garza rendered this scene with meticulous detail, careful to recall the traditional Mexican calenders hanging on the wall, the fruit crates used as stools, and the elaborate process of tamale production. Resisting any overtly political messages the artist instead chose to celebrate the lifestyles of a particular minority group in an effort to overcome harsh racial stereotypes and heal old wounds. Nevertheless the appeal of these paintings is one that creates profound commonalities between families and communities regardless of geography or ethnicity.

In 1984 Lomas Garza was commissioned to create a series of large-scale paintings by the San Francisco Water Department. The series, titled *Use of Northern California Water,* included eight works. The city of San Francisco recognized her again in 2000 when she was selected by the San Francisco International Airport to produce a large copper cutout titled *Baile* for the airport's inaugural festivities.

—Miki Garcia

325

LÓPEZ, Alma
American painter and digital artist

Born: Sinaloa, Mexico, 1966; raised in California. **Education:** University of California, Santa Barbara, B.A. 1988; University of California, Irvine, M.F.A. 1996. **Career:** Muralist. Program coordinator, Social and Public Art Resource Center, Los Angeles, 1991–94; director and cofounder, art collaborative *Homegirl Productions*; 1996; cofounder, Chicana artists' collective *L.A. Coyotas,* 1996; cofounder, webzine *Tongues.* Muralist, including six digital murals at Estrada Courts, Los Angeles. Book cover designer, University of Arizona Press. **Awards:** Design Excellence in Public Art award, City of Los Angeles, 1997; residency grant, California Arts Council, 1997–99; individual artist grant, City of Los Angeles, 1998; Brody fellowship for visual artists, 1998; IV Binational Visual Art award, Siquieros-Pollock Frontera-Ford, 1999. **Web site:** http://www.almalopez.net. **E-mail Address:** almalopez@earthlink.net.

Individual Exhibitions:

1999 *Mnescio/mnesic: Relativo a la memoria,* Both Sides of the Equator Gallery, Whittier, California
2000 *Alma Lopez: Digital Diva,* 18th Street Arts Complex Gallery, Santa Monica, California
2001 Galeria de la Raza, San Francisco

Selected Group Exhibitions:

1997 *Recuerdos Electronicos/Electronic Memories,* Galeria de la Raza, San Francisco
1998 *Obras de pintores chicanos y tlaxcaltecas,* National Association of Chicana/o Studies, Casa de la Representacion del Gobierno de Tlaxcala, Mexico City
 Close to the Border VII/Cerca de la frontera VII, University Art Gallery, New Mexico State University, Las Cruces
 Art by Numbers, Walt Whitman Cultural Arts Center, Camden, New Jersey
2000–01 *Hecho en Califas,* Plaza de la Raza, Los Angeles (traveling)
2000–03 *Just Another Poster? Chicano Graphic Arts in California,* University of California, Santa Barbara (traveling)
2001 *Cyber Arte: Tradition Meets Technology,* Museum of International Folk Art, Santa Fe, New Mexico
 Lifting the Veil: Liberating the Virgin Mary, Bernice Steinbaum Gallery, Miami
 Slippery When Wet, Advocate Gallery, Los Angeles
 Las malcriadas, Emanations Studio Gallery, Santa Fe, New Mexico

Publications:

On LÓPEZ: Articles—"The Original Digital Diva: An Interview with Alma Lopez" by A. Lorena Flores, in *BOCA,* October-November 1999; "Alma Lopez: Digital Diva," in *Tentaciones,* November

2000; "'Our Lady' Decision Appealed" by Morgan Lee, in *Albuquerque Journal,* 16 June 2001; "Santa Fe Madonna Sparks Firestorm" by Sarah S. King, in *Art in America,* 89(6), June 2001, pp. 23–25.

* * *

 Alma López, a Mexican-born mural painter and digital artist, has had a career fueled by controversy. By deconstructing religious icons including the "normalizing" of the Virgin Mary in her work *Our Lady* (López depicts the Virgin Mary strutting barefoot with belly button displayed), López has created a body of work that tests the beliefs and attitudes of the community where she grew up. Her work has been both attacked by the church for its "sacrilegious nature" and vandalized by men in the community. López, who grew up in northeast Los Angeles, was deeply influenced by the iconoclastic images she witnessed as a girl, images that would shape and define her work as an artist: "My visual world included wall-sized, meticulously painted graffiti lettering; bakery and market calendars of sexy Aztec princes, Ixta draped over the lap of strong warrior Popo; tattoos of voluptuous bare-breasted women with long feathered hair; cholas with burgundy lips and raccoon-painted eyes. . . . "

 As an honors art student at the University of California, Santa Barbara, López perfected her skills as a painter, but when she returned to Los Angeles, she realized that her early impressions fit with muralism. Collaborating with Professor Judith Baca, the UCLA Cesar Chavez muralism students, the Social and Public Art Resource Center, and the Estrada Courts Community, López created six digital murals, each eight feet by nine feet, for Estrada Courts, one of the oldest housing projects in East Los Angeles. López's murals each focus on a distinct theme relevant to the housing project, including male machismo, the development of the projects after World War II, and the migration from Mexico to California. Two of the murals are dedicated to women: *Maria de Los Angeles* and *Los four.* Whereas *Maria de Los Angeles* focuses on the matriarchs of the community, *Los four* depicts the project's young women. In the digital work the young women sit on the front steps of their houses and gaze into the future; behind them stand the figures of famous Hispanic females. The women talk of the ever-present fear of violence in the community, of the men they date (one woman did not want to be included because of a black eye given to her by her boyfriend), of their hopes and desires, and of their children. After the mural was hung up, *Los four* was immediately vandalized by men in the housing project who felt that some of the women who had posed were not suitable representatives of the community because they dated outside of the project.

 Undaunted by the vandalism of *Los four,* López went on to create the hugely controversial *Our Lady.* In *Our Lady* a saucy, scantily dressed Madonna (she wears only a bikini of roses) places her hands on her hips and lifts her chin in the air, creating the impression of an aloof, sensual, yet down-to-earth woman. Her hair is shiny black and her lips are painted red; her belly and feet are bare. This Mary could be a mother buying groceries or a young woman walking on the beach. Yet at the same time, López still infuses her Virgin Mary with religious significance as she surrounds her body in a halo of golden light. A bare-breasted angel holds Mary up, and the intricate red tapestry background glitters as a velvety impression of a cloth or curtain. Although this piece was displayed in both Mexico and

Cándido López: *Argentine Camp on the Other Side of the San Lorenzo River, Argentina,* 1865. Photo courtesy of Museo Historico Nacional, Buenos Aires, Argentina/Index/Bridgeman Art Library.

California, it did not receive a negative response until it was part of the *CyberArte* exhibition in Sante Fe at the Museum of International Folk Art in 2001. There, led by a vocal group who disapproved of the work including the Catholic church, objectors to *Our Lady* demanded that the piece be removed from the museum because of its sacrilegious nature. López defended her work by saying that the piece was in a museum rather than a church. Although the disagreement culminated in a rally that drew more than 200 people, the piece remained on display for several months. It seems ironic that some of the people who one would think would relate to López's work are her harshest critics. As López puts it, the Virgin Mary was everywhere when she was growing up—on bottles of air freshener and on the back of playing cards. The version of the Virgin Mary that she created seemed as natural to her as all the other depictions of the Virgin. When she was a young girl her family used to pile the kids in their red Thunderbird and head to Mexico for a few days. It was important to remain close to "the culture," just as López's work will surely remain close to the culture she grew up in, full of lush flowers and strong women.

—Sally Cobau

LÓPEZ, Cándido

Argentine painter, photographer, and engraver

Born: Buenos Aires, 29 August 1840. **Education:** Studied painting under Baldasarre Verazzi; studied photography and engraving under Carlos Descalzo. **Military Service:** Fought in the war against Paraguay, 1865. **Family:** Married Emilia Magallanes in 1872; eleven children. **Died:** Buenos Aires, 31 December 1902.

Selected Exhibitions:

1859 Museo Nacional de Bellas Artes, Buenos Aires
1861 Museo Mitre, Mercedes, Argentina
1885 Club Gimnasia y Esgrima, Buenos Aires (individual)

Collection:

Museum of Natural History, Buenos Aires.

Publications:

On LÓPEZ: Books—*Candido López: El sentido heróico de una vocación* by José León Pagano, Buenos Aires, Ministerio de Educación, 1949; *Cándido López* by Marta Gil Solá and Marta Dujovne, Buenos Aires, Asociación Amigos del Museo de Bellas Artes de Buenos Aires, 1971; *Cándido López,* exhibition catalog, text by Augusto Antonio Roa Bastos and Marta Dujovne, Parma, Italy, Franco Maria Ricci, 1976; *Fragments and Details* by Patricio J. Lóizaga and Jorge Glusberg, Argentina, Fundación Banco Credito Argentino, 1993; *Candido López: Proyecto cultural,* exhibition catalog, Buenos Aires, Banco Velox, 1998; *Cándido López, Florencio Molina Campos y Benito Quinquela Martín como paradigmas de la plástica argentina* by Elisabet Sánchez Pórfido, La Plata, Editorial de la Universidad Nacional de La Plata, 1998.

* * *

Cándido López was a late nineteenth-century Argentine artist who completed a series of paintings dealing with the war that Brazil, Argentina, and Uruguay declared on Paraguay in 1865. López followed a conventional path in pursuit of an artistic career, studying in

the workshops of the Argentine painter Carlos Descalzo and the Italian Baldassare Verazzi, where he learned the basic elements of perspective and drawing and worked from marble copies of Greek and Roman sculpture. Although he had had a great deal of academic training, on the occasion of his first exhibition in 1856 critics observed that his work had a certain flatness to it that seemed more typical of an untrained, or ''primitive,'' painter. One of his most important early commissions was his 1862 *Portrait of General [Bartolomé] Mitre*, an image of the leader who joined the Argentine Confederation with Buenos Aires upon being elected president.

After a failed attempt to further his artistic training by going to Europe, López traveled throughout the Argentine countryside. While visiting San Nicolás de los Arroyos in 1865, he decided to join a volunteer battalion and take part in the war against Paraguay. During the battle of Curupaytí, which took place in September 1865, his right hand was completely smashed by a mortar shell. Gangrene set in, and after a series of unsuccessful operations his right arm was amputated up to the elbow. Afterward, López spent several years learning how to paint with his left hand. He began painting his series of paintings on the war with Paraguay around 1870, eventually completing approximately 50 works with this theme.

López had his only individual exhibition at the Club Gimnasia y Esgrima de Buenos Aires in 1885. There he exhibited 29 of his battle paintings, receiving praise for the way he had so painstakingly preserved the memory of a war that was an important aspect of Argentina's history as a nation. It was on this historical basis, and not in terms of their artistic merit, that his paintings received recognition. The shape of the canvases was a long rectangle with a 1:3 proportion that was ideal for depicting panoramic landscapes, a format the Argentine painter Pridiliano Pueyrredón had also used. Paintings such as *Pasaje del Arroyo San Joaquín, el 16 de Agosto de 1865, Provincia de Corrientes* typically consist of a vast and heroic Argentine landscape upon which the antlike movements of groups of soldiers are depicted from a great distance. Although the scenes have a flatness and stiffness that make them at times appear more surreal than realistic, he was faithful to the factual details of each battle. According to the scholar Marcelo Pacheco, López created a visual model depicting the idea of the real instead of an illusion of reality.

After an extended series of negotiations, in 1887 López persuaded the Argentine government to purchase the 29 paintings for the newly formed Museum of National History, where they still reside. To support his family of 12, López briefly painted a series of still lifes of fruit and freshly killed animals that were sold to middle-class *porteño*s. In 1891 he began painting battle scenes again, and he continued to do so until his death in 1902. In recent years there has been a renewed interest in López's work as an important early manifestation of Argentine nationalism.

—Erin Aldana

LOPEZ, Yolanda M.

American painter, multimedia, and installation artist

Born: San Diego, California, 1942. **Education:** College of Marin, California, A.A. 1965; San Francisco State University, 1965; San Diego State University, B.A. in painting and drawing 1975; University of California, San Diego, M.F.A. in visual arts 1978. **Family:** One son. **Career:** Active in the Third World Liberation movements,

beginning in 1968. Community artist, *Los Siete de la Raza*, San Francisco, 1960s; lecturer on Chicano art; recruiter, *Census 2000*, U.S. Census Bureau, 1998–2000; instructor, Horace Mann Middle School, San Francisco; education director, Mission Cultural Center, San Francisco.

Individual Exhibitions:

1976 *Tres mujeres: Tres generaciones: Drawsings by Yolanda M. Lopez,* Galeria Campesina, La Brocha del Valle, Fresno, California
1978 *Yolanda M. Lopez, Works, 1975–1978,* Mandeville Center for the Arts, La Jolla, California

Cactus Hearts/Barbed Wire Dreams: Media Myths and Mexicans, MACLA Center for Latino Arts, San Jose, California; San Francisco State Student Union Association; La Raza Organization, San Francisco; Galería de la Raza, San Francisco; Galería Posada, Sacramento, California.

Selected Group Exhibitions:

1970 *First Annual Bay Area Chicanas Show,* Galeria de la Raza, San Francisco
1974 *Tres mujeres: Yolanda M. Lopez, Gloria Amalia Flores, Victoria Castillo,* Galeria Poxteca, San Diego, California
1975 *Exposicion chicanarte,* Chicano Arts Committee, Los Angeles Municipal Art Gallery
 An Exhibit of Portraits, Galeria de la Raza, San Francisco
1978 *Reflexiones: The Chicano/Latino Art Experience in California,* El Centro Cultural de la Raza, San Diego, California
 A Creative Space for Women, Self-Help Graphics, Los Angeles
1993 *Three Stories: Flo Wong, Jean LaMarr, Yolanda Lopez,* University Art Gallery, California State University, Chico
 La Frontera/The Border: Art about the Mexico/United States Border Experience, Museum of Contemporary Art, San Diego, California (traveling)
1994 *Mirror, Mirror . . . Gender Roles and the Historical Significance of Beauty,* San Jose Institute of Contemporary Art, California, and California College of Arts and Crafts, Oakland
1995 *Puro corazón,* Pomona College, Claremont, California

Publications:

By LOPEZ: Film—*When You Think of Mexico: Commercial Images of Mexicans,* n.p., 1986.

On LOPEZ: Books—*Yolanda M. Lopez, Works, 1975–1978,* exhibition catalog, La Jolla, California, Mandeville Center for the Arts, 1978; *3 Stories: Flo Wong, Jean LaMarr, Yolanda Lopez,* exhibition catalog, Chico, California State University, 1993; *Puro corazón: A Symposium of Chicana Art,* exhibition catalog, Claremont, California, Pomona College, 1995. **Article**—''Yolanda Lopez: Breaking

Chicana Stereotypes'' by Betty LaDuke, in *Feminist Studies,* 20(1), spring 1994, p. 117.

* * *

Yolanda M. Lopez is a nationally known multimedia video and installation artist. She has been one of the most dynamic participants in the Chicano arts movement since the 1960s. The progeny of two active Chicano communities–she was raised in the Logan Heights barrio of San Diego and settled as a young adult in the San Francisco Bay Area–Lopez has participated in Third World liberation movements since 1968. She began her career as a community artist in the San Francisco Mission District with a group called Los Siete de la Raza. Since that time she has produced paintings, posters, prints, videos, installations, and educational materials that critique racial and gender stereotypes. Lopez sees herself as an ''artistic provocateur'' committed to the Chicano cultural tenet that art can be a tool for political and social change. Her widely circulated posters and installations often draw upon images of her own communities, giving voice to marginalized people such as farmworkers, sweatshop seamstresses, and other working-class laborers.

Lopez has degrees in painting and drawing from San Diego State University and the University of California at San Diego. As a scholar and an artist, she has taught studio classes and has lectured on contemporary Chicano art at the University of California at Berkeley and at San Diego and at the California College of Arts and Crafts. Active as the educational director for the Mission Cultural Center, Lopez uses art to teach how public images sometimes reinforce racism and ignorance. She also reworks Mexican and indigenous icons, such as the Virgin of Guadalupe and an Aztec warrior, to signify contemporary cultural struggles. For example, her print *Who's the Illegal Alien, Pilgrim?* (1978), still widely circulated at national Chicano conferences, visually deconstructs traditional concepts of national, cultural, and geopolitical North American identity. In the print an indigenous male in tribal headdress assumes the aggressive stance of Uncle Sam and with pointed finger demands a rethinking of who is the alien to these lands.

Lopez is best known for her painted triptych *Our Lady of Guadalupe* (1978). These oil pastels on paper commemorate mothers, grandmothers, working-class women, and self-assertive Chicanas. The centerpiece of the triptych is a *Portrait of the Artist as the Virgin of Guadalupe.* Lopez depicts herself as an exuberant, powerful runner breaking out of the demure role typically projected by the Madonna image. She radiates the full-body halo (*mandorla*) and wears the blue cape of stars associated with the Virgin of Guadalupe, but gone are the downcast eyes and the immobile body posture. Instead, Lopez is active, in control of her own life, and displacing the quiet image of the ideal woman. The side panels of the triptych also recast her mother and grandmother as Guadalupe. Both radiate the *mandorla* as they work to serve their family and community. Her mother labors as a seamstress; her grandmother skins a snake. Lopez further illustrates female strength in several accompanying slide-illustrated lectures, including ''Connecting Art to Community'' and ''The Virgin of Guadalupe and Her Impact as a Role Model.''

Lopez's media series *Cactus Hearts/Barbed Wire Dreams* (1984–98) consists of several installations that explore identity, assimilation, and cultural change. It includes *Things I Never Told My Son about Being a Mexican,* with displays of advertisements, food wrappers, toys, souvenirs, and articles of clothing that reproduce notions of Mexicans as lazy, servile, alien, or meek. Along with the

installations Lopez created a 28-minute video, *When You Think of Mexico: Commercial Images of Mexican in the Mass Medi*a (1986), that offers the artist's analysis of the images and shows how symbols deliver their meaning. Lopez asserts that ''it is important for us to be visually literate, it is a survival skill. It is crucial that we systematically explore the cultural mis-definition of Mexicans and Latin Americans that is presented in the media.''

Women's Work Is Never Done (1995–99) includes a series of posters paying homage to women in their roles as community leaders. The series depicts the physical and intellectual risks that women take in fighting for social, political, and economic justice. One poster is a portrait of Sandra Hernandez, the doctor who headed San Francisco's public health department during the AIDS crisis. Another poster commemorates Delores Huerta, the cofounder and first vice president of the United Farm Workers of America. Many of the posters illustrate female laborers' efforts to organize in protest against unsafe working conditions. An accompanying installation, *The Nanny,* explores the invisibility of immigrant women as domestic workers. In this series Lopez presents women as agents of change who take the advance guard in promoting women's and workers' rights.

—Judith Huacuja Pearson

LORA READ, Marcos
Dominican sculptor and installation artist

Born: Santo Domingo, 1965. **Education:** Altos de Chaván, Rome, 1987–89, A.A.S. in fine arts 1989; Sculpture Centre, New York (Rubin scholarship), 1990–91; Ateliers Arnhem, Hogeschool voor de Kunsten, Arnhem, Netherlands, 1992–93. **Career:** Worked as a conceptual artist in Paris and Munich. Instructor, Ateliers Arnhem, Hogeschool voor de Kunsten, Arnhem, Netherlands, c. 1999. Artist-in-residence, Altos de Chaván, Rome, 1996.

Individual Exhibitions:

1996 Gallery Metis NL, Amsterdam
1997 *My House Is Your House, My Friend,* Van Reekum
 Museum, Apeldoorn, Netherlands (retrospective)
 Gallery Metis NL, Amsterdam
1999 *New Work–Marcos Lora Read: La casa del nomada,*
 Miami Art Museum
 Gallery Metis NL, Amsterdam

Selected Group Exhibitions:

1990 *XVII bienal de artes plásticas,* Museo de Arte Moderno,
 Santo Domingo
 The Book As Art, Barbara Fendrick Gallery, New York
1991 *IV bienal de la Habana,* Museo Nacional de la Habana,
 Havana
1992 *Archivos,* EXPO '92, Seville, Spain
1993 *V bienal de la Habana,* Havana
1994 *22 bienal international de São Paulo*
1995 1st Bienal of Johannesburg
1996 *Amsterdam Art Fair,* Gallery 20 x 2, Amsterdam
 ARCO '96, Berini Gallery, Madrid

Contemporary Dominican Art, Americas Society, New York

Collections:

Van Reekum Museum, Apeldoorn, Netherlands; Ludwig Museum, Aachen, Germany.

Publications:

On LORA READ: Book—*Marcos Lora Read: Works, 1992–1997,* exhibition catalog, Apeldoorn, Netherlands, Van Reekum Museum, 1997. **Articles—**''Marcos Lora Read'' by Antonia Maria Cerdo I. Ripoll, in *Art Nexus* (Colombia), 25, July/September 1997, pp. 66–69; ''Marcos Lora Read'' by Sherry Gaché, in *Sculpture* (Washington, D.C.), 18(2), March 1999, pp. 62–64.

* * *

Marcos Lora Read is part of a young generation of Dominican artists who have created an international presence for themselves through a combination of talent, ingenuity, and fortitude. Lacking sponsorship, Lora Read has been known to manage his own exhibition expenses by hand-carrying his work, thus avoiding shipping charges, and then, so as to avoid paying taxes, giving it away before he is required to declare it at customs. His work centers around made, found, and recycled material imbued with metaphorical significance. Everyday objects, modified and arranged in relation to one another, suddenly arrest the viewer's attention and suggest rich layers of meaning.

A whimsical and somewhat unnerving piece from 1993 includes a cue stick carved so that the end forms the shape of a pointing finger, installed alongside a cue ball painted with an eye, inside a glass jar. The piece, called *¿Quién crees que eres?* (''Who Do You Think You Are?''), suggests manipulation and confrontation, a poke, an accusation, an attack. Like other works by Lora Read, it is funny, a witty variation on a game. The component parts of the piece are frozen in an eternal moment of mutual regard, waiting to be acted upon, pawns in an inevitable, highly physical chain reaction. Perhaps both the pointing finger and the lone eyeball are the divided parts of the same subject, posing a question to itself, which gives the piece an existential humor. Or perhaps they represent subject and object, the action of one person upon another, which suggests a political dimension. Another installation piece by Lora Read, entitled *Nueva order,* includes a hammer that has been modified so that the striking end is a human tooth. The viewer winces, then stops to ponder the metaphorical significance of the hammer in relation to the other objects installed by its side. Both *¿Quién crees que eres?* and *Nueva order* provoke, at the same time, a visceral and a philosophical response.

From an art historical perspective, Lora Read's assemblage and installation works, like other postmodern conceptual art in a similar vein, owes a profound debt to Marcel Duchamp, who mounted a bicycle wheel on a stool in 1913 and called it art. Since then, and particularly in the 1970s and 1980s, artists further developed the possibilities of assemblage, experimenting with the unusual arrangement and manipulation of ordinary things as a medium for investigating memory and the way physical objects acquire personal and political significance.

It is not at all unusual for Dominican artists to participate in current movements in contemporary art, despite the general lack of support for their work. Lora Read, like many Dominican artists, from Jaime Colson to Freddy Rodriguez, has spent much of his time studying, exhibiting, and working abroad, and he is part of an international community of artists working in a conceptual mode. His 1992 installation *Cinco carrozas para la historia* (''Five Carriages for History'') was acquired by the Ludwig Museum in Aachen, Germany, after it had been exhibited at the Havana Biennial. The piece, comprised of five wooden dugouts decorated with symbolic references and text, is an implicit critique of colonialism. It carries forward the critical stance and political engagement of Dominican predecessors like Jorge de Severino and Tony Capellán, while achieving a unique lyricism and beauty.

Since the 1930s and 1940s, when a number of artists from Spain, as well as Dominican artists who had been studying or working abroad, settled in Santo Domingo, the Dominican Republic has been an interesting mix of international influences and Dominican innovations. Yet the work of Dominican and other Caribbean artists like Lora Read is often excluded from exhibitions and discussions of so-called Latin American art, especially in North America. This is unfortunate, both because it isolates Dominican artists and also because it overlooks the history of the Dominican Republic as a significant site for the evolution of modernism and artistic innovation.

—Amy Heibel

LOS CARPINTEROS
Three Cuban painters, sculptors, and mixed-media artists

Born: 1) Dagoberto Rodríguez Sánchez, Caibarién, Las Villas, 1969; 2) Alexandre Arrechea Zambrano, Trinidad, Las Villas, 1970; and 3) Marco Castillo Valdés, Camagüey, 1971. **Education:** All attended Instituto Superior de Arte, Havana, graduated 1994. **Career:** Began collaborating, 1991, and formed Los Carpinteros, 1994. **Award:** UNESCO prize for artistic excellence, 2000.

Individual Exhibitions:

1996 *Todo ha sido reducido a la mitad del original,* Castillo de los Tres Reyes del Morro, Havana
1997 Galería Angel Romero, Madrid
 New Museum of Contemporary Art, New York (with Bili Bidjocka)
1998 *Los Carpinteros,* Iturralde Gallery, Los Angeles
 Mecánica popular, Galería Habana, Havana
 Ludwig Forum, Aachen, Germany
2001 *Ciudad transportable,* P.S. 1 Contemporary Art Center, New York (traveled to Los Angeles County Museum of Art and São Paulo Biennial, Brazil)
 Grant Selwyn Fine Art Gallery, Los Angeles

Also exhibited at San Francisco Art Institute.

Selected Group Exhibitions:

1995 *New Art from Cuba,* Whitechapel Art Gallery, London
1996 *Domestic Partnerships: New Impulses in Decorative Arts from the Americas,* Art in General, New York
1997 *III bienal de Johannesburg,* South Africa

Utopian Territories: New Art from Cuba, Contemporary
Art Gallery, Vancouver
1998 *Contemporary Art from Cuba: Irony and Survival on
the Utopian Island,* Arizona State University Art
Museum, Tempe
2000 *7th Annual Havana Biennial,* Wifredo Lam Contempo-
rary Art Center, Havana

Collections:

New Museum of Contemporary Art, New York; Los Angeles County
Museum of Art; Ludwig Forum, Aachen, Germany; Museo Nacional
Centro de Arte Reina Sofia, Madrid; Centro Cultural de Arte
Contemporáneo, Mexico City; Museo Meiac, Badajoz, Spain; Museo
de Bellas Artes, Havana.

Publications:

On LOS CARPINTEROS: Books—*Utopian Territories: New Art
from Cuba,* exhibition catalog, text by Eugenio Valdés Figueroa,
Vancouver, Contemporary Art Gallery, 1997; *Los Carpinteros:
Provisorische utopien,* exhibition catalog, Aachen, Germany, Lud-
wig Forum, 1998; *Contemporary Art from Cuba: Irony and Survival
on the Utopian Island,* exhibition catalog, by Marilyn Zeitlin and
others, New York, Arizona State University Art Museum, 1999.
Articles—''Los Carpinteros: Iturralde'' by Suzanne Muchnic, in *Art
News,* 98(1), January 1999, p. 132; ''Contemporary (not exactly
Cuban) Art'' by Cristina Vives, in *Art Press* (France), 249, September
1999, pp. 34–39; ''The Object As Protagonist: An Interview with Los
Carpinteros'' by Rosa Lowinger, in *Sculpture,* 18(10), December 1999.

* * *

Los Carpinteros is a Cuban artist's collaborative comprised of
three members: Alexandre Arrechea, Dagoberto Rodríguez, and
Marco Castillo. Their work often combines found objects recycled in
witty installations that are part of the new Cuban aesthetic. The three
have been working together since 1991, and they began exhibiting as
a group in 1994. They were given their name because so much of their
early work was made of wood, but they took it as their own because
the fact that it had nothing at all to do with art (and more to do with
traditional craft) appealed to them. Their materials are often carefully
chosen to allude to different types of labor. In the summer of 2001, the
group exhibited a work called *Ciudad transportable* (''Transportable
City'') at P.S.1 Contemporary Art Center in New York City. Using
nylon canvas and aluminum tubing, they erected an imaginary city
that was part installation art, part sculpture, and part architecture.
Famous Cuban architectural monuments, including the state capital,
are represented abstractly in a series of 10 tents that can be installed
indoors or out. The shapes, which are large enough for an adult to
enter, draw on the recognizable forms of the factory, the church, the
home, and the apartment building, but they are lyrical shadows of real
buildings, stripped of architectural detail. The tents serve as meta-
phors for the way we live together in communities that are more
ephemeral than permanent. ''The original idea has to do with the
minimal basic space that any community needs to live, or the
environment in which life occurs,'' Rodríguez has said.

The tents have another meaning as well: they refer to the
transience of contemporary urban life and perhaps to the nomadic
lifestyle of the artists themselves. Los Carpinteros were part of a new

generation of Cuban artists that emerged in the 1990s who were, quite
literally, on the move. These artists have been living in Havana but
have shown most of their work outside Cuba. After decades of cold
war politics, the new Cuban art is a much-needed channel of open
communication between the United States and Cuba. Beginning in
the 1990s, Cuban artists have been allowed to live and work abroad,
traveling between their homeland and their place of residence. The
openness has brought an onslaught of Cuban dancers, musicians, and
artists to the United States, particularly to New York City, and
disrupted outdated myths about Cuban culture. But the exit-permit
policies that allow such cultural exchange are less a result of diplo-
matic idealism than economic necessity. The evaporation of Soviet
subsidies and the growing discontent of the Cuban elite have left the
government with few options other than to permit its artists and
performers to seek audiences outside Cuba. The result is a delicate
situation for Cuban artists: they are beholden to their sponsors in the
United States, who must obtain a special license and pay for transpor-
tation, food, and lodging, but on the other hand these artists must be
careful not to offend the Cuban government that hands out their exit
permits. Los Carpinteros's work, however, has not been devoid of
political content. An early series of paintings, called *Interior Habanero,*
comments on the changes in Cuban society after the dissolution of the
Soviet Union. Another work called *¿Provisionalismo?* consists of a
half-built house, a variation on the eternal question of the glass-half-
empty, a not-uncommon dilemma in contemporary Cuba.

—Amy Heibel

LOU, Richard A.
American painter and assemblage artist

Born: Tijuana. **Education:** Southwestern College, A.A.; University
of Southern California/Fullerton, B.A.; Clemson University, South
Carolina, M.F.A. **Career:** Professor of art and photography, San
Diego Mesa College, California. Member, artist collective Border Art
Workshop/Taller de Arte Fronterizo, 1980s; cofounder, with Robert
Sanchez, *q.v.,* conceptual artist duo *Los Anthropolocos,* 1991.

Selected Exhibitions:

1985 *Border Realities,* Centro Cultural de la Raza, San
Diego, California
1987 *Invitation to the Necropolis: The Death Dance,* Centro
Cultural de la Raza, San Diego, California
1989 New York Artist Space Gallery and Centro Cultural de
la Raza, San Diego, California
1991 *Traversing Borders,* Boehm Gallery, Palomar College,
San Marcos, California
1992 *3rd International Istanbul Bienal*
1994 *Los Anthropolocos New Digs at Mission Viejo: In
Search of the Colorless Hands,* Saddleback College
Art Gallery, Mission Viejo, California (with Robert
Sanchez)

Publications:

On LOU: Books—*La Reconquista: A Post-Columbian New World,*
exhibition catalog, by Patricio Chávez, San Diego, California, Centro

Cultural de la Raza, 1992; *American Visions=Visiones de las Américas: Artistic and Cultural Identity in the Western Hemisphere* by Mary Jane Jacob, Noreen Tomassi, and Ivo Mesquita, New York, Allworth Press, 1994. **Articles—**"Traversing Borders" by Victoria Reed, in *Artweek,* 22, 11 April 1991, p. 10; "Artists Writing in Public . . . Compilation of Artists Working with Language or Text in Public Spaces," in *Public Art Review,* 6, spring/summer 1995, pp. 15–17.

* * *

Born in Tijuana, Mexico, to a Mexican mother and Chinese father, Richard Lou is what artist David Avalos referred to as a "border phenomenon." Creating works that were as culturally paradoxical as the geographically, culturally, and sociopolitically syncretic area in which he was raised—the United States-Mexico border region—Lou frequently addressed issues of identity and border politics in his projects, installations, and performances, which were mediated through photography and video.

In the 1980s Lou joined the Border Art Workshop/Taller de Arte Fronterizo (BAW/TAF), a collective of artists and writers, including Guillermo Gomez-Peña, Michael Schnorr, Emily Hicks, Victor Ochoa, and Avalos, that formed in 1984 to collaboratively explore the problems and complexities of the border through performance, text, and other interdisciplinary vehicles. During that time Lou met and began collaborating with artist and fellow BAW/TAF member Robert Sanchez, a partnership to which he ascribed an importance equal to each artist's individual efforts. In 1991 the two artists began a sustained fictional narrative in which they assumed the guise of Los Anthropolocos, two futuristic Chicano anthropologists/archaeologists who discover and study white ethnicity. Within this fabricated context the artists carried out performances and projects that subverted and negated the superficial anthropologism that is often associated with the co-optation of the ethnic other in the mainstream art world, blatantly lampooning the contested notions of discovery and cultural hegemony.

Many of Lou's works existed within the tradition of Chicano conceptualism established in the early 1970s by collectives such as the East Los Angeles neo-dada group ASCO and also shared an affinity with the literal and visual objectification of the corporal that is characteristic of body art. This was particularly evident in the photographically and video-documented performance *Headlines: Voices from the Conquered—1992,* in which Lou ritually shaved his head once a month, creating a conceptual and physical "support" on which artists of color were invited to add graphics and text articulating issues relating to the conquest of the Americas. For the duration of the performance the physically bulky, bald, and illustrated artist went about his daily activities, allowing the piece to become actuated by the viewer, in turn activating the borders between artist/object and audience. This conceptually interactive work (in which Lou was frequently perceived as a threatening presence), by allowing the spectator to intervene in the aesthetic process, derived its content from the xenophobic response it incited in the viewer. By making himself the object of the viewer's gaze by transforming himself into a human ethnographic curiosity, Lou simultaneously exposed the negative stereotypes behind that gaze.

Through his work Lou constantly engaged in the analysis and deconstruction of cultural, social, and ethnic identity, a process that revealed how contemporary consciousness was profoundly shaped by negative stereotypes of people of color. In the work *Inner City Portraits/Self Portraits* (1985–90), Lou was photographed while

assuming the guise of 21 fictional, urban-dwelling characters that he created and impersonated; the photographs are also accompanied by narratives in which the characters discuss and describe their existence in the inner city. In this pseudo-social documentary/narrative, Lou transformed himself into human objects of derision that embody and express negative stereotypes assigned to those who are culturally, ethnically, and socially marginalized.

—Kaytie Johnson

LUJÁN, Gilbert "Magu"
American painter

Pseudonym: Magu. **Born:** Gilbert Sánchez y Flores Luján, French Camp, California, 1940. **Education:** East Los Angeles Junior College, Monterey Park, California, 1962–65; California State University, Long Beach, 1966–69, B.A. 1969; University of California, Irvine, 1971–73, M.F.A. 1973. **Military Service:** United States Air Force, 1958–62. **Family:** Married Mardi in 1973; one son and two daughters; has two daughters from a previous relationship. **Career:** Muralist, Los Angeles, early 1970s. Member, artist group *Con Safos;* art editor, *Con Safos* magazine; cofounder, artist group *Los Four,* 1973. Instructor, Rio Hondo Community College, 1973–76, and Long Beach City College, California, 1975; department chair, lecturer, and instructor, La Raza Studies department, Fresno City College, California, 1976–80; Barnsdall Junior Art Center, Los Angeles, 1983–84; faculty member, University of California, Irvine, 1990. Director, Magulandia, Pomona Art Colony, California, c. 2000. Artist-in-residence, University of Illinois, Bloomington, 1975, 1989. **Award:** Grant, California Arts Council, 1984–85. **Address:** 558 West Second Street, Pomona Art Colony, Pomona, California 91766, U.S.A. **E-mail Address:** Magu4u@hotmail.com.

Gilbert "Magu" Luján. Photo courtesy of the artist.

Gilbert ''Magu'' Luján in front of artwork. Photo courtesy of the artist.

Individual Exhibitions:

1983 Galeria Otra Vez, Los Angeles
1984 *Magulandia,* Galeria Posada, Sacramento, California
1990 *Cruzin' with Magu,* Galeria de la Raza, San Francisco
1991 *Magu, Artist-in-Residence,* Fresno Art Museum,
 California
1993 *Cruising the Redlands,* Peppers Art Gallery, Redlands
 University, California
2001 *Magu, Cruisin' Da Pomona,* dA center for the Arts,
 Pomona Art Colony, Pomona, California

Selected Group Exhibitions:

1976 *Los Four,* California State University, Sacramento
1987 *Hispanic Art of the U.S.A.: Thirty Painters and
 Sculptors,* Houston Museum of Fine Arts (traveling)
1994 *Pleasures of the Palette,* Scottsdale, Arizona
1997 *Arte sin limites,* Museo de Arte, Juarez, Mexico

1998 *Inaugural Museum Show,* El Paso Art Museum, Texas
2000 *Made in California: Art, Image and Identity,
 1900–2000,* Los Angeles County Museum of Art
 East of the River: Chicano Art Collectors Anonymous,
 Santa Monica Museum of Art, California
 El papel del papel, Guadalupe Center for the Arts, San
 Antonio, Texas
2001 *Road to Aztlan,* Los Angeles County Museum of Art
 Modern Masters, Modern Art Gallery, Los Angeles

Publications:

On LUJÁN: Books—*Los Four: Almaraz, de la Rocha, Luján,
Romero,* exhibition catalog, Irvine, University of California, 1973;
*Hispanic Art in the United States: Thirty Contemporary Painters and
Sculptors,* exhibition catalog, by John Beardsley and Jane Livingston,
Abbeville Press, New York, 1987; *Magulandia: The Work of Gilbert
Sanchez Luján* by Amalia Mesa-Bains, San Francisco, Galería de la
Raza/Studio 24, 1991; *Chicano and Latino Artists of Los Angeles* by

Alejandro Rosas, Glendale, California, CP Graphics, 1993. **Articles—** "Centro Preserves a Heritage" by Kay Kaiser, in *San Diego Union,* 13 October 1985; "Luján's Spiritual Quest" by Anne Mayor, in *Reader's Guide,* 14 March 1986; "Mesoamerica Meets California Pop: Gilbert Luján" by Elenore Welles, in *Visions,* 1(5), winter 1987; "Gilbert Luján: Style and Salsa" by Niana Linart, in *Reader's Guide,* 14 March 1987.

* * *

The son of Mexican immigrants, Gilbert Sánchez y Flores Luján, nicknamed "Magu," grew up in East Los Angeles in the 1940s and '50s, during the era of the zoot-suit riots. After serving in the U.S. Air Force, he entered college at Long Beach State and quickly became part of a Chicano cultural movement that was rapidly gaining momentum. For Latinos in southern California, the 1960s and '70s were a time of radical change and increasing self-determination, marked in the visual arts by a revival of muralism and the call for Chicano self-expression. While he was still a student at Long Beach and later at the University of California, Irvine, Luján began organizing exhibitions and making artworks that explored the Chicano experience. In doing so, he helped forge a Chicano art movement that declared its independence from the Anglo, New York-based art establishment and reflected a uniquely Chicano aesthetic and set of concerns.

In the 1970s Luján began exhibiting with fellow artists Carlos Almaraz, Frank Romero, and Beto de la Rocha. The collective, known as Los Four, grew out of a series of impassioned conversations about *Chicanismo,* art, and politics. Their first exhibition at the University of California, Irvine, in 1974 led to an exhibition that same year at the Los Angeles County Museum of Art and the Oakland Museum. The exhibitions heralded a new Chicano presence in the art world. Taking its vocabulary from a largely California-based culture of low riders, border politics, Catholicism, and strong family and community loyalties, the Chicano art movement was both political and aesthetic. Artists such as Luján created a hybrid style completely their own, one that tapped into pop, folk, and neo-expressionist art, as well as Mexican Catholicism, the Spanish baroque, and Aztec and Mayan iconography. Luján's 1985 work, *Our Family Car,* which was exhibited at the Corcoran gallery, paid homage to the Chicano car culture of southern California. A 1950 Chevy painstakingly detailed both inside and out, *Our Family Car* is decorated with images of Native American deities, jalapeños, Mexican jumping beans, and flames. The interior includes painted figures and upholstery as well as various ceramic objects. The car does not just look like a low rider, it is a low rider, in all its hydraulically adjustable glory.

Luján moves between and often merges different worlds—bringing the barrio to the museum, creating a poetry out of the vernacular of the Chicano experience. He cites European influences such as Alberto Giacometti, Pablo Picasso, and Henry Moore. Luján's playful sculpture, particularly collage works, recall the lyrical ceramics made by Picasso toward the end of his career. Appearing often in Luján's work is the mythic character of the trickster, a figure drawn from traditional mythologies but introduced, through the artist's vivid imagination, to the modern barrio. Luján uses humor deliberately in his work. In a 1997 interview with Jeffrey Rangel for the Archives of American Art, Luján said, "My humor is a device. It's very clearly a device to hide the fact that I'm talking about human dynamics, and all these little things that I do trying to get laughs are to soften people's

ideas about who we are—Chicanos—and it works." Luján also admires Mexican artists, including Diego Rivera and Francisco Zuñiga.

An activist as well as an artist, Luján chaired the La Raza Studies Department at Fresno City College in the 1970s. He also organized various Chicano community services there, and in the 1980s he returned to Los Angeles, where he taught at the Municipal Art Center at Barnsdall Park. He continues to live and work in southern California and New Mexico, teaching, lecturing, and doing community organizing.

—Amy Heibel

LUJAN, Pedro
American sculptor

Born: El Paso, Texas. **Education:** University of Mexico, Mexico City, 1963; University of Texas, El Paso, B.A. 1965; San Francisco Art Institute, 1966; Ann Halprin Dance Workshop, San Francisco, 1969; Norwich University/Vermont College, Montpelier, Vermont, M.A. 1973. **Career:** Artist-in-residence, Roswell Museum and Art Center, New Mexico, 1981–82. **Awards:** Service awards, Creative Arts Program, 1973, 1981; fellowships, National Endowment for the Arts, 1974, 1997; fellowship, John Simon Guggenheim Memorial Foundation, 1982; Art Awareness award, 1992; Coronado Studios award, 1999.

Individual Exhibitions:

1977 Soho Center for Visual Artists, New York
 Rabinovitch and Guerra Gallery, New York
1979 Cayman Gallery, New York
 Intar, Latin American Gallery, New York
1982 Roswell Museum, Roswell, New Mexico
 University of Northern Iowa, Cedar Falls, Iowa
1985 *Pedro Lujan: Wood Sculpture,* Exit Art Gallery, New
 York
1986 University of Delaware, Newark
1988 Fondo del Sol, Washington, D.C.
1992 Art Awareness, Lexington, New York
1993 Fondo del Sol, Washington, D.C.
 Psychic Hooks and Installations, Carla Stellweg Latin
 American & Contemporary Art, New York
1996 *Inframundo,* Blue Star Art Space, San Antonio, Texas

Selected Group Exhibitions:

1979 *NY/8,* Joe and Emily Lowe Art Gallery, Syracuse
 University, Syracuse, New York
 Wallworks, Alternative Museum, New York
1981 *5+5: Artists Introduce Artists,* City Gallery, New York
 Bienal de arte de Medellin, Colombia
1984 Bronx Museum of Art, New York
1989 *Juxtaposing Perceptions,* Museum of Contemporary
 Hispanic Art, New York
1993 *New Works,* Carla Stellweg Latin American & Contem-
 porary Art, New York
1995 *Made to Order,* Alternative Museum, New York
1997 *Emerging Latino Artists,* Queens Theater, New York

Dreams and Symbols, George Mason University,
Fairfax, Virginia

Publications:

On LUJAN: Books—*NY/8,* exhibition catalog, text by Jason D.
Wong and April Storms, Joe and Emily Lowe Art Gallery, Syracuse,
New York, Syracuse University, 1979; *5+5: Artists Introduce Artists,*
exhibition catalog, New York, City Gallery, 1981; *Pedro Lujan:
Wood Sculpture,* exhibition catalog, text by Jeanette Ingberman, New
York, Exit Art Gallery, 1985. Articles–"Tejano Technique" by
Michael Kernan, in *Washington Post,* 15 April 1980, p. 9; "Artist
Explores World of Dreams," in *San Antonio Express,* November 1995.

* * *

"What I do are symbols. I'll give you enough
symbols so that it looks like something you've seen
before, almost recognizable . . . I have a conversation
with the material and by the end it's a mutual agree-
ment." (Pedro Lujan, interview by Jeanette Ingberman,
February 1985)

Sculptor Pedro Lujan sculpts images, usually in wood, that are
familiar but not exactly recognizable. Like dream imagery they greet
the viewer at the edge of perception, teasing out wide-ranging
associations. Some of the sculptures are suspended from the wall or
ceiling, while others are very much earthbound, seeming almost to
spring from the ground itself. Lujan has also designed monumental
sculptures for large public spaces. The artist favors his more intimate
bird sculptures, which are based on studies of nature; he has traveled
to the Arctic and to the Andes Mountains, studying native species and
incorporating his observations into his art. A fellow bird-watcher
might be able to identify a particular characteristic, but the forms are
essentially abstract rather than representational.

Lujan has experimented with a variety of materials—including
concrete, metal, and plastic—but the main body of his work is made
of wood, often white oak, walnut, or ash. He is drawn to the
permanence and relative immutability of wood as a medium. Many of
the suspended works are kinetic. Other site-specific sculptures resem-
ble doorways, fences, or bridges—the threshold between one world
and another. Inspired by the Mexican baroque, Lujan sometimes
incorporates gold into his work as a way to manipulate light. He has
said, "I am very fascinated by Latin American Baroque Art. The huge
alter pieces called retablos always play between the lights, shadows,
movements, and the gold leaf. It picks up any little light. There is no
need to light it up, it has a glow. The gold leaf has its own quality. I use
it but I don't like to overwhelm the pieces with gold. Just enough so
that it becomes one of the elements." In addition to the baroque,
Lujan is influenced by artists such as Lagarda, Caspicara, and David
Smith, as well as by the funk movement. Lugan also attributes some
of his inspiration to the Southwestern landscape of his native El Paso,
with its stark light, rich colors, and organic shapes. In a 1985
interview Lujan said, "I see myself as a traditional artist, rather than a
modern one. For instance, I use a traditional material, wood, in a
traditional way, which basically means in a three dimensional format,
very unchanging. . . . Sculptors are always the odd man out and I
don't consider myself a modern artist."

—Amy Heibel

LUNA, James
American painter, installation, multimedia, video, and
performance artist

Born: Orange, California, 1950. **Education:** University of Califor-
nia, Irvine, B.F.A. in art 1976; San Diego State University, California,
M.Sc. in counseling 1983. **Career:** Counselor, Palomar Community
College, San Marcos, California, c. 2000. Commissioned by the City
of San Francisco to create a collaborative public sculpture and
performance area, 1993. **Awards:** Bessie Creator award, New York
Dance and Theatre Workshop, 1991; Best Short Subject award,
American Indian Motion Picture Awards, 1993, for *History of the
Luiseño People: La Jolla Reservation, Christmas 1990.*

Selected Exhibitions:

1989 *Two Worlds: James Luna,* INTAR Gallery, New York
(traveling)
1990 Washington Project for the Arts, Washington, D.C.
California Indian Conference, Riverside, California
San Francisco Camerawork
Atlanta College of Art, Georgia
The Decade Show, New Museum of Contemporary Art,
New York
1991 *Facing the Finish,* San Francisco Museum of Modern
Art
SITEseeing, Whitney Museum, New York
Shared Vision, Heard Museum, Phoenix
Disputed Identities, Presentation House, Vancouver,
British Columbia, Canada
Selected Works, 1990–91, Palomar College, San Marcos,
California
Indigenous America: Honoring Our Heritage, Univer-
sity of San Diego, California
1992 *Sites of Recollection: Four Altars and a Rap Opera,*
Williams College Museum of Art, Williamstown,
Massachusetts
Body Takes, Toronto Photographers Workshop, Ontario,
Canada
Land, Spirit, Power, National Gallery of Canada,
Ottawa, Ontario
Mary Porter Sesnon Art Gallery, University of Califor-
nia, Santa Cruz
1993 *As Public As Race: Margo Kane, James Luna, Paul
Wong,* Walter Phillips Gallery, Banff Centre, Alberta,
Canada
*Shared Experiences, Personal Interpretations: Seven
Native American Artists,* Sonoma State University,
Rohnert Park, California
1995 *Tribal Identity: An Installation by James Luna,* Hood
Museum of Art, Dartmouth College, Hanover, New
Hampshire
2000 *The Chapel of the Sacred Colors,* AKA Gallery,
University of Saskatchewan, Canada

Selected Performance Exhibitions:

1986 *The Artifact Piece,* Museum of Man, San Diego,
California

1991 *Contemporary American Indian Art,* San Bernardino
 County Museum, Redlands, California
1992 *As Public As Race,* Walter Phillips Gallery, Banff,
 Alberta, Canada
1998 Museum of Contemporary Art, San Francisco

Publications:

By LUNA: Articles—"Allow Me to Introduce Myself: The Performance Art of James Luna," in *Canadian Theatre Review,* 68, fall 1991, pp. 46–47; "I've Always Wanted to Be an American Indian," in *Aperture,* 139, spring 1995, pp. 38–41. **Film**—*History of the Luiseño People: La Jolla Reservation, Christmas 1990,* with Isaac Artenstein, 1990.

On LUNA: Books—*James Luna,* exhibition catalog, San Francisco, Rolando Castellon Gallery, 1981; *Sites of Recollection: Four Altars and a Rap Opera,* exhibition catalog, text by Julia Barnes Mandle and Deborah Menaker Rothschild, Williamstown, Massachusetts, Williams College Museum of Art, 1992; *James Luna: Actions & Reactions,* exhibition catalog, text by Andrea Liss and Roberto Bedoya, Santa Cruz, California, University of California, 1992; *As Public As Race: Margo Kane, James Luna, Paul Wong,* exhibition catalog, text by Joane Cardinal-Schubert, Kerri Sakamoto, and Larissa Laim, Banff, Alberta, Canada, Walter Phillips Gallery, Banff Centre, 1993; *Shared Experiences, Personal Interpretations: Seven Native American Artists,* exhibition catalog, text by Edward Castillo and Michael Schwager, Rohnert Park, California, Sonoma State University, 1993. **Articles**—"Call Me in '93: An Interview with James Luna" by Steven Durland, in *High Performance,* 14(4), winter 1991, pp. 34–39; "James Luna" by Collette Chattopadhyay, in *Sculpture,* November 1996, pp. 58–59; "Surreal, Post-Indian Subterranean Blues" by Lori Blondeau and Bradlee Larocque, in *Mix,* 23(3), winter 1997/1998, pp. 46–53.

* * *

The artist and activist James Luna, a member of the Luiseño-Diegueño Indian tribe in San Diego County, describes himself as a "hi-tech Indian storyteller," a California First Nations artist who works in a style he defines as "contemporary traditionalist." Although he began his artistic career as a painter, earning a degree in art from the University of California at Irvine in 1976, the bulk of Luna's oeuvre consists of video and multimedia installations and performance works. Many of these are conceptually autobiographical and formally minimalist, and they address themes such as Native American identity and the commodification of Native American culture, rampant alcohol abuse, and issues related to cultural property, in particular, ownership, exploitation and appropriation, and authenticity. By fusing humor, ritual, and social critique, Luna effectively deconstructs and subverts stereotypes of Native Americans and people of color in the Western imagination.

In 1986 Luna's *The Artifact Piece* was installed in San Diego's Museum of Man. It was a work that would prove to be seminal and definitive, one of his earliest dealing with Indians as ethnographic spectacle and representing a move from the natural history to the art museum. In this piece a sedated Luna lay prone on a bed of sand in a museum case, wearing only a loincloth, the scars on his body resulting from drunken brawls and marked with descriptive labels. Both Luna and his personal effects, which were also contained in glass cases, were displayed among artifacts related to the Kumeyaay Indians, who formerly resided in San Diego County and who were one of the most resistant of all California tribes to subjugation.

The film *History of the Luiseño People: La Jolla Reservation, Christmas 1990* was a project based upon Luna's "Indian Talks" performances, on which he collaborated with the writer-director Isaac Artenstein. In this work, a metaphor for the loneliness and alienation often experienced by Native Americans, Luna sits alone, watching television and drinking beer on Christmas Eve, calling his family and friends with excuses for why he is unable to attend their holiday celebrations. The film has been screened at the Museum of Modern Art and received the 1993 Best Short Subject Award of the American Indian Motion Picture Awards.

Luna's bicultural identity and ethnicity, which is attributed to being born to a Luiseño Indian mother and a Mexican father, is eloquently, yet simply addressed in *Half Indian/Half Mexican* (1991). A work consisting of three black-and-white photographs of Luna in profile and frontal views, it presents a view of the artist as he is perceived through the gaze of outsiders.

Luna's connection with and commitment to the Indian community, on both a personal and global level, is evident in the fact that he continues to reside on the La Jolla Reservation on which he was born and raised. As he has stated, "I do not separate myself or my art from conditions here on the La Jolla Reservation, where I live." There he assumes the role of a healer, in that he is employed as a counselor at Palomar College in San Marcos.

—Kaytie Johnson

MACCIÓ, Rómulo
Argentine painter

Born: Buenos Aires, 29 April 1931. **Education:** Self-taught. **Career:** Worked for publicity agencies, including J. Walter Thompson, beginning in 1945; worked in graphic design and stage decoration; since 1956 dedicated solely to painting. Member, artist group *Otra Figuración,* 1961. **Awards:** Second prize, 1961, international first prize, 1963, and grand prize, 1967, Torcuato di Tella, Buenos Aires; scholarship, French government, 1961; grand prize, *Salón nacional,* Buenos Aires, 1967. Diploma al Mérito, Artes Visuales, Fundación Konex, Argentina, 1982, 1992.

Individual Exhibitions:

1956	Galería Galatea, Buenos Aires
1957	Galería Pizarro, Buenos Aires
1959	Galería Witcomb, Buenos Aires
1961	Galería Van Riel, Buenos Aires
1964	Galerie Schoeler, Paris
1965	Galería Bonino, New York
	Salón de Mayo, Paris
	Buchholz Gallery, Munich
	Galería Edurne, Madrid
1966	Galerie Mathias Fels, Paris
1967	*Macció, 1963–1967,* Centro de Artes Visuales, Buenos Aires
	Instituto Torcuato Di Tella, Buenos Aires
1969	Center for Interamerican Relations, New York
	Casa de las Américas, Havana
	T. Gallery, Haarlem, Netherlands
1970	Galería Carmen Waugh, Buenos Aires
	Galería Iolas Velazco, Madrid
1971	Víctor Najmías Art Gallery International, Buenos Aires
1972	Sala Monzón, Madrid
1974	Galleria dell'Incisione, Milan
	Lefebre Gallery, New York
1976	Museo de Arte Moderno and Instituto Nacional de Bellas Artes, Mexico City
1977	Museum of Modern Art, Paris
1981	Galería Juana Mordó, Madrid
1982	Bernheim-Jeune, Paris
1987	Salas Nacionales, Buenos Aires
1990	Sala Saint-Jean, Hotel de la Ville, Paris
1991	Castello Sforzesco, Sala Viscontea, Milan
	Instituto Italo Latinoamericano, Rome
1996	Galería Rubbers, Buenos Aires
	Museo Cuevas, Mexico City
1997	*Pinturas de contaminación y olvido,* Fundación Proa, Buenos Aires
1999	*Retratos de dos ciudades,* Centro Cultural Recoleta, Buenos Aires

Selected Group Exhibitions:

1960–61	*Catorce pintores de la nueva generación,* Galería Lirolay, Buenos Aires
1963	*Otra figuración,* Museo Nacional de Bellas Artes, Buenos Aires
1965	*Otra figuración,* Museu de Arte Moderna, Río de Janeiro
1986	*Argentine 18th International Biennial,* São Paulo, Brazil
2000	Galería Arco Romano, Medinaceli, Spain
2001	Fundación Proa, Buenos Aires
	Re-Aligning Vision: Alternative Currents in South American Drawing, Huntington Art Gallery, University of Texas, Austin

Collections:

Jospeh H. Hirshborn Collection; Larry Aldrich Museum Foundation; Museum of Rhode Island School of Desing, Providence; Solomon R. Guggenhein Foundation, New York; Walker Art Center, Minneapolis; Musèe d'Art Moderne, Brussels; Musèe Cantonal, Lausanne, Switzerland; Museum des Zwanzigsten Jahrunderts, Vienna; Neue Pinakothek y Kunst-Verein, Munich; Museo de Arte Moderno, Museo Nacional de Bellas Artes and Instituo Torcuato Di Tella, Buenos Aires; Museo Nacional de Bellas Artes, Córdoba, Argentina; Museu de Arte Moderna, Río de Janeiro; Museo de Bellas Artes, Caracas, Venezuela; Museo de Arte Moderno, México City; University of Texas, Austin; First National Bank of Boston; Museo de Arte Contemporáneo, Madrid; Musèe d'Art Moderne, Paris.

Publications:

On MACCIÓ: Books—*Catorce pintores de la nueva generación,* exhibition catalog, Buenos Aires, Galería Lirolay, 1961; *Rómulo Macció: Paintings,* exhibition catalog, New York, Galeria Bonino, 1965; *Rómulo Macció,* exhibition catalog, text by Jean-Jacques Lévêque, Paris, G. Girard, 1966; *Macció, 1963–1967,* exhibition catalog, Buenos Aires, Centro de Artes Visuales, 1967; *Rómulo Macció,* exhibition catalog, text by Jacques Lassainge, Milan, Galleria dell'Incisione, 1974; *Macció, Recent Paintings,* exhibition catalog, New York, Lefebre Gallery, 1974; *Rómulo Macció: El gran pintor argentino neofigurativismo,* exhibition catalog, Mexico City, Instituto Nacional de Bellas Artes, 1976; *Rómulo Macció,* exhibition catalog, text by Jacques Lassaigne and Sanivlam Salsi, Paris, Bernheim-Jeune, 1982; *Argentine New Figuration,* exhibition catalog, text by Jorge Glusberg, Buenos Aires, Argentine Association of Art Critics, 1986; *Pinturas de contaminación y olvido,* exhibition catalog, text by

César Magrini, Buenos Aires, Fundación Proa, 1997; *Retratos de dos ciudades,* exhibition catalog, Buenos Aires, Gobierno de la Ciudad de Buenos Aires, 1999. **Article—**''Rómulo Macció'' by Alberto Collazo, exhibition review, in *Art Nexus* (Colombia), 22, October/December 1996, pp. 135–136.

* * *

The Argentinian Rómulo Macció, a self-taught artist, formed part of a group founded in 1961 called Otra Figuración, where, together with Felipe Noé, Ernesto Deira, and Jorge de la Vega, he sought to create a new kind of figuration based on freer and more up-to-date foundations. Before significantly practicing this new figuration, he went through stages of surrealism and abstraction. His work at the beginning is based on the spontaneity of the actual act of painting, feelings taken to an extreme by means of expressionist resources used to their limit and absolute liberty of action when facing the canvas. Figures seem to literally explode in his paintings: eyes, mouths, and noses are all dispersed fragments that seem somewhat grotesque and tense.

The artist has incorporated many means taken from very up-to-date movements and tendencies in painting as much as in design (since he was 14 he worked at publicity agencies), which he then used freely, and together with the change of canvas size (large-scale canvases that allow a broader space for contrasts and confrontations), he constructed a painting of great visual impact. In addition, he often abandoned the traditional idea of the painting's frame as comparable to a window frame and used circular or polygonal shapes so that the frame abandons its function as a mere medium and becomes a substantial element of the work as a whole. This method is used in *Vivir un Poco al Día* (''Live a Little Each Day''), an oil, and in his mixed technique *Encrucijada* (''Dilemma,'' 1963).

About 1964 Macció began a more rationalist period; he cleared his paintings from stroke outbursts and graphics and worked in a more schematic manner, bringing his art into a succession of interrelating spaces that causes a somewhat surrealist and monumental effect. He painted enigmatic faces lacking any kind of identity; in some cases he inverted the face's features—like the nose and mouth, as in his acrylic *Téngase incruenta*—juxtaposing them with huge, almost monochrome surfaces, put up against other irregular features in shape and surface (*Esquemas,* mixed technique).

Since 1974, Macció has shown more interest in the pictorial sense of working—in other words, the corpus of the painting itself. This is his technique of ''painting-painting,'' where he enhanced, in all possible ways, the potentiality of the senses and possibilities of matter and color above all thematic and formal considerations. Macció moved along this path in a consistent and decisive way, and his work expanded and heightened in pictorial terms. His ability to define a body, reveal the dramatic sense, introduce the dimensions of space or intensity of light, and reveal the poetic sense of his painting to the spectator allows the viewer to detect the singularity of his work.

From his painting *Momia* (with which he obtained the international first prize Torcuato di Tella in 1963), where the accumulation of matter, entangled graffiti, and the sensuality of the oil distributed with a spatula encapsulated it in a stentorian manner of seduction, through his later work, Macció has followed a path of research and risk that held him as one of the most representative artists of Argentinian art.

—Horacio Safons

MacENTYRE, Eduardo
Argentine painter

Born: Buenos Aires, 20 February 1929. **Education:** Studied technical drawing; started painting, late 1940s. **Family:** Married Maria Carmen Apicella; two sons and one daughter. **Career:** Cofounder, artist group *Generative Art,* 1959. Traveled frequently to the United States, beginning in 1967. **Awards:** First prize, UNESCO, 1961; first prize ''Plástica con los plásticos,'' Argentine Chamber of Plastic Products, National Fine Arts Museum, Buenos Aires, 1966; Codex first prize and Decoralia Latin American Painting prize, National Fine Arts Museum, Buenos Aires, 1968; first prize, *Salón del automóvil club argentino,* 1969; first prize, *Second Biennial Exhibition of Latin American Engraving,* Puerto Rico, 1972; second prize, *Salón plástico filatélico,* 1981; first prize, 50th Anniversary J. B. Castagnino Museum, Rosario, Argentina, 1987; Laurel de Plata, Rotary Club, Argentina, 1988; first prize of honor, *First Biennial of Painting ''Spirit of Greece,''* Praxis Foundation, Argentina, 1992.

Individual Exhibitions:

1958	Rubbers Gallery, Buenos Aires
1960	Rubbers Gallery, Buenos Aires
1965	Museum of Modern Art, New York
	Bonino Gallery, Buenos Aires
1967	Pan American Union, Washington, D.C.
1968	Foundation for the Arts, Lima, Peru
	J. Walter Thompson Argentina, Buenos Aires
1969	Sala Luis A. Arango, Bogota, Colombia
	La Tertulia Museum, Cali, Colombia, and Zea Museum, Medellin, Colombia
	R. y A. Bonnano, Buenos Aires
1970	Bonino Gallery, New York and Buenos Aires
1972	University of Puerto Rico Museum
	Dorival Gallery, Buenos Aires
	Fifth Dimension, Buenos Aires
	Austral Gallery, La Plata, Argentina
1973	*Variable Polyptych II,* Kennedy Center for the Performing Arts, Washington, D.C.
	Venezuelan-Argentine Centre, Caracas, Venezuela
	Rubbers Gallery, Buenos Aires
1974	Centre of Arts and Letters, Punta del Este, Uruguay
	Arte Contacto Gallery, Caracas, Venezuela
	Argentine Institute of Culture of the German Republic, Bonn
	Ipanema Gallery, Brazil
1975	Arvil Gallery, Mexico
	Rubbers Gallery, Buenos Aires
	Argentine Consulate, Colonia, Uruguay
	National Library, Montevideo, Uruguay
1976	Arte Contacto Gallery, Caracas, Venezuela
	Forma Gallery, El Salvador
1977	Rubbers Gallery, Buenos Aires
1978	Genesis Gallery, Rosario, Argentina
1979	Rubbers Gallery, Buenos Aires
1980	*20 Years of Generative Art,* Praxis Gallery, Buenos Aires
1983	Jacques Martínez Gallery, Buenos Aires
1984	Praxis Gallery, Lima, Peru

Eduardo MacEntyre: *Fuga,* **2000. Photo courtesy of Galeria Arroyo.**

Fine Arts Museum "Rosa Galisteo de Rodríguez,"
 Santa Fe, Argentina
Austral Gallery, La Plata, Argentina
1985 R. Real Gallery, Rosario, Argentina
1986 Centre National des Arts, Ottawa, Canada
Museum of Modern Art of Latin America, Washington,
 D.C.
Art Museum of Ponce, Puerto Rico
Acadia University, Nova Scotia
University College of Cape Breton, Sydney, Canada

1987 National Theatre, Terreo Gallery, Brasilia
Museum of Rio de Janeiro
1988 Praxis Gallery, Buenos Aires
1989 Magister Gallery, Paraguay
Elite Fine Art Gallery, New York
Casa del Angel Cultural Centre, Argentina
1991 *Imaginary Landscapes,* Praxis Gallery, Buenos Aires
1993 Praxis Gallery, Buenos Aires

Selected Group Exhibitions:

1954 *Five Argentine Artists,* Galería Comte, Buenos Aires
1960 Galería Peuser, Buenos Aires (with Generative Art
 group)
1962 Museum of Modern Art, Rio de Janeiro (with
 Generative Art group)
1965 *The Emergent Decade,* Solomon R. Guggenheim
 Museum, New York
1966 *Art of Latin America since Independence,* Yale Univer-
 sity, New Haven, Connecticut, and University of
 Texas, Austin
1967 *Latin American Art: 1931–1966,* Museum of Modern
 Art, New York
1968 *Four New Argentinian Artists,* Galería Bonino, New
 York
1969 *Latin American Painting,* Oklahoma Art Center, Univer-
 sity of Oklahoma, Norman
1989 *The Latin American Spirit: Art & Artists in the U.S.,*
 Bronx Museum, New York
1997 *La espiritualidad de la forma a partir de un
 pensamiento constructivo,* Fundación

Also exhibited at Andreani, Buenos Aires

Collections:

Albright-Knox Art Gallery, Buffalo, New York; Bonino Gallery,
New York; Fine Arts Gallery of San Diego, California; Fogg Art
Museum, Cambridge, Massachusetts; Solomon R. Guggenheim
Museum, New York; Museum of Modern Art, New York; Museum
of Modern Art of Latin America, Washington, D.C.; Philadelphia
Art Museum; Rockefeller University, New York; University of
Texas, Austin.

Publications:

On MacENTYRE: Books—*Four New Argentinian Artists,* exhibi-
tion catalog, New York, Galería Bonino, 1968; *MacEntyre: Paint-
ings,* exhibition catalog, New York, Galería Bonino, 1970; *Eduardo
MacEntyre* by Rafael Squirru, Buenos Aires, Ediciones de Arte
Gaglianone, 1981; *MacEntyre,* exhibition catalog, Buenos Aires and
New York, Praxis International Art, 1995; *La espiritualidad de la
forma a partir de un pensamiento constructivo,* exhibition catalog,
Fundación Andreani, Buenos Aires, 1997. **Article**—''Praxis Gallery,
Buenos Aires'' by Rafael Squirru, exhibition review, in *Art News,* 92,
October 1993, p. 176. **Slides**—*Eduardo MacEntyre: Generative Art,*
photographed by Albert J. Casciero and Annick Sanjurjo, selections
from an exhibition at the Musuem of Modern Art of Latin America,
part of the series *Contemporary Latin American Artists,* Newport,
Rhode Island, Budek Films and Slides, 1986.

* * *

Eduardo MacEntyre was one of the many Argentine artists
working during the 1960s in the area of geometric abstraction,
creating meticulously drafted abstract paintings of colored and white
lines on dark backgrounds. Born in Uruguay to a Scottish father and a
Belgian mother, he was interested in industrial design as a teenager
but eventually became a painter. His early works were still lifes
inspired by European modernists. Although these paintings were

traditional and realistic in their treatment of form, MacEntyre soon
found that he was fascinated by Georges Seurat's experiments in
optics and color, in addition to the work of the cubists. MacEntyre
made his own paintings that at first closely resembled those of the
artists he most admired. But he adopted a geometric style that became
increasingly refined until it consisted of nothing but perfectly circular
and straight lines.

Along with Miguel Angel Vidal and Ary Brizzi, MacEntyre was
a practitioner of generative art, the name given by the Argentine art
critic Ignacio Pirovano to paintings from the 1960s that created the
optical illusion of movement through the progression of forms in
space. All three artists used bright, prismatic colors and basic geomet-
ric shapes such as the circle and square. They often tilted a square
canvas on one of its corners to create a dynamic series of diagonals.
MacEntyre's work was somewhat distinct from that of his colleagues
in that he used a compass to incorporate circular shapes into his work,
while Vidal and Brizzi worked primarily with straight lines and
angles. The increasingly complex designs MacEntyre created pro-
gressed across dark backgrounds and appeared to glow with shifting,
rainbowlike colors. He gave many of his works titles, for exam-
ple, *Generative Painting* and *Vibration,* that referred to their
physical qualities.

Although it was not overt, MacEntyre's work possessed a strong
ideology in addition to its striking form. Generative art had its origins
in the concrete art that was so popular in Argentina during the late
1940s and early 1950s. In contrast to the rigid geometry and polemicism
of the concrete artists, however, the generative painters wanted to
create works that possessed an almost spiritual or cosmic signifi-
cance, seeming not only to glow with an inner light but also to make
references to a fourth dimension. The Argentine critic Rafael Squirru
referred to MacEntyre's art as ''the most spiritual and abstract (since
it rested and based itself in mathematical and geometrical develop-
ments of great precision resulting in increased abstraction) that the
human mind had as of yet conceived.''

The first exhibition of generative art took place in 1960 at the
Galería Peuser in Buenos Aires. Featuring the works of MacEntyre
and Vidal, it was followed by another exhibition at the Museum of
Modern Art in Rio de Janeiro in 1962. As interest in MacEntyre's
work increased, he was invited to the São Paulo Biennial several
times, and he exhibited his work throughout South America. At the
same time MacEntyre became one of the first Latin American artists
to be shown in the United States, participating in the exhibitions *New
Art of Argentina, The Emergent Decade,* and *Beyond Geometry.*
MacEntyre, Vidal, Brizzi, and the Argentine pop artist Rogelio
Polesello were invited to a roundtable discussion on generative art
that took place at the Organization of American States in 1968.
MacEntyre has continued to work in the area of geometric abstraction
throughout his career, gradually abandoning the rigid symmetry of his
generative work for a more flowing style with shapes composed of
arcs that suggest natural forms such as birds and flowers.

—Erin Aldana

MALDONADO, Estuardo
Ecuadoran painter, sculptor, and engraver

Born: Pintag, 1930. **Education:** Escuela de Bellas Artes de Guayaquil,
1947–53; Academia de Bellas Artes y el Instituto de Arte, Rome,

1957. **Career:** Instructor of drawing and history of art, American College, Guayaquil, 1953–55. Worked in Rome, New York, and Quito. Muralist and sculptor, including works in Montessori school, Rome, 1964, Bank of Rome, Paris, 1974, Museum of the Catholic University of Quito, 1976, Central Bank of Ecuador, Guayaquil, 1980, and Theater Santiago de Guayaquil, 1988. Member, artist group *Spacio Documento,* Rome, 1980. **Awards:** First international award, Artistic International Association, Rome, 1961; first national prize of the art students in Italy, 1962, first national prize of young artists, 1963, Palazzo delle Esposizioni, Rome; international prize, Terme Luigiane, Cosenza, Italy, 1964; first prize, *2nd Biennal of Sacred Art,* Celano, Italy, 1966; Termolo prize for graphics, Italy, 1968; Sarnano prize for graphics, Civitanuova, Italy, 1969; Premio di Pittura, *2nd Biennal of Sport,* Madrid, 1969; first Corciano international prize, Perugia, Italy, 1969; prize, *2nd International Festival of Painting,* Cannes, Frances, 1970.

Individual Exhibitions:

1952	Casa de la Cultura, Portoviejo, Ecuador
	Casa de la Cultura, Esmeraldas, Ecuador
1953	Asociación de Empleados, Bahia de Caráquez, Ecuador
1956	Casa de la Cultura, Quito
1957	Museum of Colonial Art, Quito, Ecuador
1961	Palazzo delle Esposizioni, Rome
1962	Gallery Artisti di Oggi, Rome
1963	Gallery Scorpio, Rome
1965	Gallery il Bilico, Rome
	Gallery II Caripine, Rome
1967	Casa de la Cultura, Quito, Ecuador
	Gallery of Contemporary Art, Casa de la Cultura, Guayaquil, Ecuador
	Gallery Twentieth Century, Quito, Ecuador
	Manhattan Hall, New York
	Pan American Union, Washington, D.C.
	Gallery Rome, Chicago
	Gallery Obelisco, Mexico City
	Museum of Modern Art, Bogota
1968	Institute of Contemporary Art, Lima, Peru
	Gallery Dinis, Rio de Janeiro
	Mediterranean Club, Aguion, Greece
1969	Gallery 88, Rome
1970	Gallery Al 2, Rome
	Gallery Send, Madrid
	Gallery Ramon Duran, Madrid
	Museum of Contemporary Art, Madrid
	Gallery Simson, Stockholm
	Gallery Albers, Buenos Aires
1971	Gallery Christian Stein, Turin, Italy
	First Review of National Contemporary Art, St. Vincent, Italy
	Museum of Fine Arts, Valencia, Spain
	Gallery Brussels Hilton
	Gallery L'Ecuyer, Brussels
	Gallery New Images, La Haya, Netherlands
	Canning House, London
1973	Gallery Kiev, Hamburg, Germany
1974	Gallery Michelangelo, Bergamo, Italy
	Gallery Marcom IV, Rome
	Art Center, Brescia

1975	*1st International Exhibition of Contemporary Art,* Bologna, Italy (traveling)
	International Exhibition of Contemporary Art, Dusseldorf, Germany
	Contemporary Art International, Cologne, Germany
1976	Municipal Museum, Guayaquil, Ecuador
	Museum of the Central Bank, Quito, Ecuador
	Carmelo Building, Casa de la Cultura, Cuenca, Ecuador
	Gallery Altamira, Quito, Ecuador
	Homage to Latin American Artists, Bari, Italy
1977	La Galeria, Quito, Ecuador
	Museum of Fine Arts, Caracas, Venezuela
1978	Casa de la Cultura, Guayaquil, Ecuador
1981	Picture Gallery of the Central Bank, Guayaquil, Ecuador
	Museum of Palazzo Braschi, Rome
1982	Museum of the Central Bank of Ecuador, Cuenca
	Museum of the Central Bank of Ecuador, Quito
	Museum "Banco del Pacífico," Guayaquil, Ecuador
1984	Gallery Madeleine Hollaender, Guayaquil, Ecuador
	Gallery Auriga, Quito, Ecuador
	Italian-Latin American Institute, Rome
	National Gallery of Modern Art, Santo Domingo, Dominican Republic
	Latin American Space, Paris
1987	Hispanic Museum of Contemporary Art, New York
	National Gallery of Modern Art, Santo Domingo, Dominican Republic
	The Gallery, Santo Domingo, Dominican Republic
	National Museum of Port au Prince, Haiti
1988	La Galería, Quito, Ecuador
	Museum of the Central Bank of Ecuador, Guayaquil
	Museum of Modern Art, Cuenca, Ecuador
1989	Museum Nahim Isaías, Guayaquil, Ecuador
	20th International Biennal, São Paulo, Brazil
1993	Kingman Foundation, Quito, Ecuador
	La Galería, Quito, Ecuador
	Art Forum, Quito, Ecuador
	Expresions Gallery, Guayaquil, Ecuador
	Centro Civico Foundation, Guayaquil, Ecuador
	Casa de la Cultura, Quito, Ecuador
	Puerto Rican Culture Institute, San Juan
1994	Real House, Casa de Bastidas, Dominican Republic
	Arte Narder Gallery, Santo Domingo, Dominican Republic
1996	Museum of the Central Bank, Guayaquil, Ecuador
	Municipal Museum, Guayaquil, Ecuador
	Museum Nahim Isaías, Guayaquil, Ecuador
	Museum Banco del Pacífico, Guayaquil, Ecuador
	Metal Museum, Cuenca, Ecuador
1998	Museum Filanbanco, Quito, Ecuador
	City Museum, Quito, Ecuador
	Italian Art Museum, Lima, Peru

Selected Group Exhibitions:

1953	*V National Salon of Plastic Arts,* Quito, Ecuador
1969	*Vision 12,* Latin American Institute, Rome
1973	*Cancer Tropic-Capricorn-Tropic,* Modern Art Museum, Boston

1975 *Mass and Light,* El Metacrillado, International Contem-
 porary Art Exhibition, Industrial Center, Milan
 International Constructivist Art Center Review, Modern
 Art Museum, Geisenkirchen, Germany
1977 *75 Years of Ecuadorean Painting,* Twentieth Century
 Gallery, Quito, Ecuador
 Ecuador Abstract Currents, Pan American Relations
 Center, New York
1984 *Four Artists of Latin America of Rome,* Latin American
 Space, Paris
1987 *First International Biennal of Painting,* Cuenca,
 Ecuador
1989 *20th International Biennal,* São Paulo, Brazil

Collections:

Spanish Museum of Contemporary Art, Madrid; Museum of Modern
Art, Bogota, Colombia; Museum of Fine Arts, Valencia, Spain;
Museum of Contemporary Art, Lima, Peru; Museum of Abstract Art,
Cuenca, Spain; Gallery of Contemporary Art of the Casa de la
Cultura, Guayaquil; Pan American Union, Washington, D.C.; Museum
of Modern Art, Columbus, Ohio; Museum of Fine Arts, Caracas,
Venezuela; Museum of Contemporary Art Omar Rayo, Roldanillo,
Colombia; Museum of Modern Art, Cuenca, Ecuador; Gallery of
Modern Art, Santo Domingo, Dominican Republic; National Mu-
seum, Port au Prince, Haiti.

Publications:

By MALDONADO: Book—*75 artistas contemporáneos: Colección
Estuardo Maldonado donada al Museo del Banco Central,* exhibition
catalog, Ecuador, El Banco, 1978. **Book, illustrated**—*The Road to
Paradise* by David Ogle, Ecuador, Andean Publications, 1988.

On MALDONADO: Books—*Estuardo Maldonado,* exhibition cata-
log, Madrid, Museo Español de Arte Contempóraneo, 1970; *Estuardo
Maldonado: Sculptures in Steel-Color,* exhibition catalog, New York,
Museum of Contemporary Hispanic Art, 1987; *Estuardo Maldonado:
Del símbolo al dimensionalismo,* exhibition catalog, by Guido Mon-
tana and Lenín Oña, Ecuador, Ediciones EM, 1989.

* * *

Estuardo Maldonado was born in a small highland village on
Ecuador's eastern flank of the Andes. He was an important man of the
pre-Columbianist movement of the 1950s generation of artists. He
became a master of constructivist works most commonly created of
steel. His tendencies to create industrialist art are balanced by the
apparent urge to use pre-Columbian motifs in his sculptures and
paintings. The constructivist sculpture and paintings are the direct
result of his search for balance and meaning in indigenous signs
and themes.

Maldonado passed his days as a youth digging for pre-Colum-
bian ceramics in a small Andean village. He was first exposed to
painting as a boy through a schoolteacher and his uncle, an engineer
and architect. Maldonado fled from the small village of his youth to
the larger city of Guayaquil in his teenage years. In Guayaquil he
enrolled at the School of Fine Arts and went on to win a number of
school awards. While at the school he became an acquaintance of
Enrique Tabara, whose work influenced Maldonado greatly at the

time. His first paintings were inspired by the indigenists Diego Rivera
and José Clemente Orozco and featured social themes. This point in
his life was spent centered on his Latin American heritage.

In 1951 Maldonado began to exhibit in Ecuador. In 1957 he went
to Rome with a grant from the Ecuadorean government. He studied
sculpture at the Academy of Fine Arts in Rome until he returned to
Ecuador. Maldonado's time was well spent in Europe. He became
affiliated with a number of Italian artist groups that were working
with industrial materials such as steel and aluminum. This industrial-
ized art was a revival of Bauhaus. While living in Italy he received
national and international prizes nearly every year. In 1961 he had his
first individual exhibition at the Palazzo Venezia in Rome, and two
years later he received a prize in an exhibition there. In the following
years he exhibited extensively and participated in the Venice Biennial
of 1966. In 1959 and '60 he traveled in Western Europe, where he saw
a wide spectrum of ancient to modern art. He was attracted to the
works of Piet Mondrian and Wassily Kandinsky and especially to the
primitivism in Paul Klee's work. He later encountered Tabara again
in Spain. Here he was introduced to informalism, a fundamental
search for primal roots and meanings. He began experimenting
further with geometric forms in his work, including circles, curved
shapes, and heavy texture. By 1967 the artist created a landmark
piece—*Constellaciones.* This included many informalist symbols and
signs etched into the surface of the painting.

The artist returned to Rome and was later influenced by the neo-
concrete sculptures that were evolving at the time. Before returning to
Ecuador in 1967 he toured the United States, exhibiting in Washing-
ton, D.C., Chicago, and New York. Shortly after he arrived in
Ecuador Maldonado exhibited at the Galeria Siglo XX, although he
did not belong to the Grupo VAN. He was chosen by the Casa de la
Cultura to select works from other Latin American countries for the
Quito Biennial of 1967.

His works remained informalist as he began to live in his home
country again. Shortly after his arrival, though, Maldonado recol-
lected the modular concrete forms that he saw developing in Italy and
set on a quest to incorporate some of those theories into his work.
Gradually he evolved a sign in the shape of an angular *S,* which first
covered whole surfaces of his paintings and then became a singular
object. Maldonado then began alternating two- and three-dimensional
pieces, each centering on the *S.* He began incorporating it into infinite
compositions of interlocking labyrinths of symbol. His three-dimen-
sional sculptures included tower-like structures, and particularly of
note are his circular works in spiraling arrangements. After his year in
Ecuador the artist returned to Rome to begin new work with optical
effects using wood and metal. In 1969 he engraved pre-Columbian
symbols into metal then polished the metal plates into both opaque
and brilliant surfaces. During the early 1970s Maldonado was told of
a process that existed for coloring metal. He subsequently joined a
research team at the Sillem Company in Brescia, Italy. By 1974
Maldonado could reproduce six different colors on stainless steel.
The brilliance or opaqueness depended on how he finished the metal
before a chemical soaking process. He developed an enamel sub-
stance to coat the portion of the metal not to be colored, similar to the
methods used in creating batik cloth or engraving copper. Maldonado
was the first artist to use this particular method in his work.

Maldonado's work since 1974 has been titled *Modular Structure
#. . .,* in what he calls ''acero-inox color,'' or ''colored steel.'' As a
result of his technical discoveries and his pioneering efforts in using
these new methods in his art, he inspired many invitations to partici-
pate in exhibitions internationally. Most of these exhibitions have

focused on works consisting of modern materials. He exhibited these constructivist steel sculptures in 1974 at the Art Center in Brescia, in 1975 at the International Center for Constructivist Art at the Museum of Modern Art in Germany, in 1976 at the international art festival in Basel, and in 1977 at the Museum of Modern Art in Caracas, Venezuela. His colored stainless steel pieces were not shown in Ecuador until 1976, when Maldonado had exhibitions within a short period at the Municipal Museum in Guayaquil and the Casa de la Cultura in Cuenca, Ecuador. At this point in Maldonado's career he was unable to continue living in Ecuador because of his reliance on industrial materials not found there.

—Daniel Lahodo

MALDONADO, Tomás
Argentine painter

Born: Buenos Aires, 1922. **Education:** Escuela Nacional de Bellas Artes, Buenos Aires. **Career:** Illustrator, *Arturo* magazine; director, *New Vision;* published *Inventionist Manifesto,* 1946; founder, Asociación Arte Concreto-Invención, 1946; member, Asociación de Artistas Modernas, beginning 1952. Moved to Germany, 1954. Professor, Hochschule für Gestaltung, Ulm, Germany, 1954–67; editor, *Casabella* magazine, 1977. Also taught at Politecnico di Milano. **Award:** Honorary degree, Politecnico di Milano, 2000.

Selected Exhibitions:

1946 *Arte Concreto—Invención,* Peuser Hall, Buenos Aires
 Sociedad Argentina de Artistas Plásticos, Buenos Aires (with Asociación Arte Concreto-Invención,)
 La Boca Popular Athanaeum, Buenos Aires (with Asociación Arte Concreto-Invención,)
1947 *New Art,* Payer Gallery, Buenos Aires
1948 *Realites Nouvelles,* Paris
 New Realities, Abstract, Concrete, Non-Figurative, Van Riel Gallery, Buenos Aires
1950 *Arte Concreto,* Instituto de Arte Moderno, Buenos Aires (with Alfredo Hlito and Enio Iommi)
1952 *Modern Artists of Argentina,* Viau Gallery, Buenos Aires

Publications:

By MALDONADO: Books—*Tomás Maldonado: Buenos Aires-Montevideo, 1964,* Montevideo, Instituto de Diseño de la Facultad de Arquitectura, 1964; *El Bauhaus ayer y hoy,* with Mario de Micheli, Claude Schnaidt, and others, Montevideo, Signo Editores, 1977; *Tre lezioni americane,* Milan, Feltrinelli, 1992; *Real and Virtual,* Milan, Feltrinelli, 1992; *Tomás Maldonado: Escritos preulmianos,* with Carlos A. Méndez Mosquera and Nelly Perazzo, Buenos Aires, Ediciones Infinitio, 1997; *Crítica de la razón informática,* Barcelona, Paidós, 1998.

On MALDONADO: Books—*Tomás Maldonado* by Max Bill, Buenos Aires, ENV, 1955; *El arte concreto en la Argentina en la década del 40* by Nelly Perazzo, Buenos Aires, Ediciones de Arte Gaglianone, 1983; *The Idea of Design* by Victor Margolin and Richard Buchanan,

Cambridge, Massachusetts, MIT Press, 1995. **Articles—**''Le ragioni di Tomás Maldonado,'' in *L'Architettura* (Italy), 33, May 1987, pp. 322–323; ''Verso una teoria unificata degli artefatti?: Maldonado, Eco, Diana, Brockman'' by Sergio Polano, in *Casabella* (Italy), 62(655), April 1998, pp. 91–92.

* * *

Tomás Maldonado was a painter and theorist of central importance in promoting concrete art in Argentina during the mid-1940s. The event that sparked the interest in geometric abstraction was the publishing in 1944 of the art journal *Arturo,* of which only one issue was ever produced. Maldonado designed the cover, which consisted of his nonfigurative but also highly gestural and expressionistic drawing reminiscent of the work of Joaquín Torres-García or Hans Arp. Inside, artists such as Camilo Arden Quin, Gyula Kosice, and Torres-García contributed manifesto-like essays and poems on the subject of constructivism and their belief in the ability of art to revolutionize human existence.

Maldonado's art, like much concrete work of the time, was marked by its stark geometry. Many of his compositions, such as the *Una forma y series* from 1950, consisted of black or dark lines in a series on a flatly colored background of geometric shapes. But even more than his art, his writings helped solidify the ideological basis on which the concrete artists worked. In 1946 he published *Inventionist Manifesto,* expressing his disfavor with representational art because he thought it weakened people by surrounding them with fictitious illusions of space and reality. In contrast, concrete art made viewers aware of their own cognitive and inventive powers by surrounding them with nonrepresentational objects that had no meaning or function other than as embodiments of that which was purely man-made. As previous European movements such as Bauhaus and Russian constructivism had attempted, Maldonado wanted art to place people in the world and spur them to change it, instead of encouraging escapism and romanticism.

Extending the struggle against representation even further, Maldonado and his contemporaries referred to themselves as concrete instead of abstract artists because they wanted to emphasize that their works were not abstractions of images from lived experience but rather consisted of pure invention. Thus, the works produced by these artists were rigidly geometric, full of straight lines and flat colors. In 1946, the same year he published *Inventionist Manifesto,* Maldonado also founded the Asociación Arte Concreto-Invención, which included artists such as Alfredo Hlito, Enio Iommi, and Raúl Lozza, while other concrete artists such as Kosice and Arden Quin split off and formed the Madí group.

One of the Concreto-Invención artists' main achievements from Maldonado's point of view was the liberation of the painting from a square or rectangular frame. For Maldonado and his followers such a frame always carried with it the implication of a windowlike illusion of the world and therefore needed to be abolished. According to Maldonado, a concrete painting should be integrated with its frame; breaking free from the square, both became geometric but irregular and dominated by triangular shapes. One example of such a work is his *Arte Concreto,* a collage done in 1946 that consists of a red rectangle and black trapezoid on a solid white background, surrounded by an irregularly shaped wooden strip frame. Later the Concreto-Invención artists freed the frame from the work of art entirely, creating brightly colored, jagged-edged frames that floated on the wall and encircled empty space. Maldonado was

unhappy with these compositions, for to him they became more sculptural than painterly, seeking three-dimensional solutions to two-dimensional problems.

In 1952, Maldonado became a member of the Asociación de Artistas Modernas, which was founded by the Argentine critic Aldo Pellegrini and which included artists such as José Antonio Fernández-Muro and Sarah Grilo. While this group was still devoted to promoting abstraction, many of its members were of a younger generation and were decidedly less dogmatic in their approach than the concrete artists had been. In 1954 Maldonado left Argentina for good, expanding his interests beyond painting. He was invited by the Swiss constructivist Max Bill to teach at the Hochschule für Gestaltung, an organization founded by Bill that was intended to continue in the areas of art, craft, and industrial design where the Bauhaus had left off. Maldonado taught there until 1967. In 1977 he became the editor of the Italian architectural design magazine *Casabella,* expressing his desire in his first issue to integrate architecture with the fine arts.

—Erin Aldana

MALFATTI, Anita (Catarina)
Brazilian painter

Born: São Paulo, 1896. **Education:** Mackenzie College, São Paulo; studied at the Museum of Dresden under Lovis Corinth and Bishoff Kulm; Academia de Belas Artes, Berlin, 1910–13; also studied at Art Students League and Independent School of the Art, New York, 1915–16. **Career:** Returned to Brazil, 1916. Instructor of drawing, Mackenzie College and American School, São Paulo, 1921–23; president, Sindicato de Artistas Plásticos, 1940. Lived in Paris, 1923–28. Participant, Semana de Arte Moderna, 1922. Co-founder, *Grupo dos Cinco.* **Died:** 1964.

Individual Exhibitions:

1914 Mappin Stores, São Paulo
1917 Salão Nacional de Belas Artes, Rio de Janeiro
 Líbero Badaró, São Paulo
1971 Museu da Arte Brasileira, Rio de Janeiro (retrospective)

Selected Group Exhibitions:

1951 Bienal de São Paulo
1957 *Modern Art in Brazil,* Buenos Aires (traveling)
1966 *Art in Latin America Since Independence,* Yale
 University, New Haven, Connecticut, and University
 of Texas, Austin

Collection:

Museu da Arte Brasileira, Rio de Janeiro.

Publications:

On MALFATTI: Books—*Anita Malfatti (1889–1964),* exhibition catalog, São Paulo, Museu de Arte Contemporânea da Universidade de São Paulo, 1977; *Anita Malfatti no tempo e no espaço* by Marta Rossetti Batista, São Paulo, IBM Brasil, 1985; *Mário de Andrade:*

Cartas a Anita Malfatti edited by Marta Rossetti Batista, Rio de Janeiro, Forense Universitária, 1989; *Anita Malfatti e seu tempo,* Rio de Janeiro, Centro Cultural Banco do Brasil, *ca.* 1996.

* * *

Anita Malfatti's European sojourn in 1910 was to have a profound and lasting impact on her art. Her training at the Berlin Academy under Fritz Burger and the expressionist painter Lovis Corinth was the first influence on her work. During this initial stay abroad she also had the opportunity to study French impressionism and postimpressionism and to observe firsthand the current trends of European modernism. Returning to Brazil with the outbreak of war, she remained only briefly before going to the United States in 1915. *The Lighthouse,* a painting from that year, depicts a landscape in which pattern and color emerge as the dominant elements. With its strong design orientation and exuberant brush strokes of bold, bright colors and shapes, it clearly demonstrates postimpressionist tendencies.

Malfatti's work in New York was further affected by her studies at the Art Students League and at the Independent School of Art under Homer Boss of the so-called Fifteen Group. Her introduction to Marcel Duchamp, who was in New York at the time, is said to have piqued her interest in cubism. In this vibrant atmosphere she absorbed the cutting-edge styles of both native-born North American and transplanted European modernists. Her paintings from the period, considered some of her strongest, reflect the multivalent aspects of cubism, fauvism, and expressionism. *Cubist Nude* and *The Idiot,* two of her most accomplished paintings from these years, exemplify her assimilation of these varied approaches. They can be described as giving an overall impression of cubist tendencies, combined with a fauvist use of color, rather than as being executed with expert technical mastery. Her early canvases appear to be an eclectic interpretation of distinct modernist styles.

Having fully embraced all aspects of European and North American modernism, Malfatti then returned to Brazil. In 1917 her solo exhibition at the Líbero Badaró in São Paulo was received with all the shock and disapproval that early impressionism had met with in Paris in the late 1800s. The cognoscenti in São Paulo, who were still firmly entrenched in nineteenth-century academicism as late as the 1920s, looked upon Malfatti's work as the emblem of revolt against all the tradition stood for. Osvald de Andrade and Graça Aranha's rebuttals in defense of her work and modernism in general, rather than focusing on its intrinsic aesthetic worth, applauded its ability to shock.

It has been reported that a scathing review of the exhibition by a widely respected art critic had a profoundly negative effect on Malfatti's artistic development. Later paintings, however, demonstrate a more sophisticated integration of modern styles. Her *Portrait of Mário de Andrade* (1921–22) is a blend of expressionist distortion and the protocubist sensibility of Cezanne. Malfatti's originality is rooted in the manner in which she combined the various modern art forms that she had absorbed while in Europe and the United States.

In 1922 Malfatti took part in the groundbreaking Modern Art Week along with other modernists, including Tarsila do Amaral, Emiliano di Cavalcanti, and Vincente do Rêgo Monteiro. It was a weeklong celebration of avant-garde visual and performing arts, poetry readings, and lectures intended to challenge mainstream academic traditions. That same year she joined other influential artists and writers in establishing the Grupo dos Cinco. They were staunch proponents of a new sense of progressive nationalism that revered Brazil's mixed heritage and rebelled against all things conservative.

Malfatti then went back to Europe but returned to São Paulo six years later.

During the next decade Malfatti participated in a number of exhibitions in Brazil and in 1940 was named president of the Syndicate of Plastic Arts. As a leading pioneer of modern Brazilian art, she produced work from 1915 through the 1920s that, given its time and place, was seen as radical. Even though contemporary critics of modern art might regard her as derivative, Malfatti, together with do Amaral, di Cavalcanti, and do Rêgo Monteiro, played a critical role in bringing modernism to Brazil.

—Marianne Hogue

MANGLANO-OVALLE, Iñigo
American installation artist

Born: Madrid, Spain, 1961; moved to the United States, 1980s. **Education:** Williams College, B.A. in art and art history, Latin American and Spanish literature 1983; Art Institute of Chicago, M.F.A .in sculpture 1989. **Career:** Artist-in-residence, ArtPace, San Antonio, Texas, 1997. **Awards:** Artist fellowship awards, Illinois Arts Council, 1992, 1993; Neighborhood Arts Program grants, City of Chicago, Department of Cultural Affairs, 1993, 1994; Visual Artist fellowship, National Endowment for the Arts, 1995; Orion fellow, University of Victoria, British Columbia, Canada, 1995; Great Cities fellowship, College Urban Planning, University of Illinois, Chicago, 1995; International Artist Residency fellowship, PACE Foundation, 1997.

Individual Exhibitions:

1991　*Assigned Identities,* Centre Gallery, Miami-Dade Community College, Miami
1992　*Aliens Who . . . ,* New Langton Arts, San Francisco
　　　University of Illinois, Chicago
1993　*Cul-De-Sac: A Street-Level Video Installation,* Museum of Contemporary Art, Chicago
　　　Tele-vecindario: A Street-Level Video Block Party, Sculpture-Chicago
1994　*Torch,* IMAGE Film and Video Center, Atlanta (traveling)
　　　Balsero, Thomas Blackman Associates, Atlanta (traveling)
1995　Feigen Inc., Chicago
1996　*Blooms,* Real Art Ways, Hartford, Connecticut
　　　Feigen Inc., Chicago
　　　Andrea Rosen Gallery, New York
　　　Human Technology, Revolution, Detroit
1997　*Woofer, Woofer,* Contemporary Art Center, Cincinnati, Ohio
　　　Ball and Jacks, Instituto Cultural Cabañas Museum, Guadalajara, Mexico
　　　Flora and Fauna, Rhona Hoffman Gallery, Chicago
　　　Galerie Froment & Putnam, Paris
　　　ArtPace, San Antonio, Texas
1998　*The Garden of Delight,* South-Eastern Center for Contemporary Art, Winston-

Salem, North Carolina*The El Niño Effect,* Christopher Grimes Gallery, Santa Monica, California
1999　Wexner Center for the Arts, Columbus, Ohio
2000　Henry Art Gallery, University of Washington, Seattle
　　　Max Protetch, New York

Selected Group Exhibitions:

1992　*The Year of the White Bear,* Walker Arts Center, Minneapolis
　　　Disorient: Perspectives on Colonialism, Gallery 400, University of Illinois, Chicago
1993　*Urban Masculinity,* Longwood Arts Gallery, Bronx, New York (traveling)
1994　*Correspondences/Korrespondenzen,* Berlinische Galerie Museum für Moderne Kunst, Berlin (traveling)
　　　Latin American Art in Miami Collections, Lowe Art Museum, University of Miami
1995　*Xicano Progeny: Investigative Agents, Executive Council and Other Representatives from the Sovereign State of Aztlán,* Mexican Museum, San Francisco
　　　Vision of American Culture, Mexican Museum, San Francisco
1996　*Art in Chicago 1945–1995,* Museum of Contemporary Art, Chicago
　　　Second Sight: Printmaking in Chicago 1935–1995, Block Gallery, Northwestern University, Evanston, Illinois
1998　*XXIV bienal internacional de São Paulo,* Brazil

Publications:

By MANGLANO-OVALLE: Articles—''Assigned Identities,'' in *White Walls,* 28, summer 1991, pp. 13–26; ''Bifocal Borders: An Artist Project,'' in *Art Papers* (Atlanta), 16(1), January 1992; ''Does the Public Work?'' in *Art Papers* (Atlanta), September-October 1992, p. 31; ''Who Made Us the Target of Your Outreach?'' in *High Performance,* winter 1994, p. 14.

On MANGLANO-OVALLE: Books—*Iñigo Manglano-Ovalle,* exhibition catalog, text by Doug Ischar, Berlin, Berlinishe Galerie Museum für Moderne Kunst, 1994; *Iñigo Manglano-Ovalle, The Garden of Delights,* exhibition catalog, text by Ron Platt, Winston-Salem, North Carolina, Southeastern Center for Contemporary Art, 1998; *Interventions: New Art in Unconventional Spaces,* exhibition catalog, text by Rineke Dijkstra and Dean Sobel, Milwaukee, Milwaukee Art Museum, 2000. **Articles**—''Iñigo Manglano-Ovalle'' by Laurie Palmer, in *Frieze,* November-December 1993; ''Manglano-Ovalle: The Poetics of Tolerance'' by Ana Sokoloff, in *Art Nexus* (Colombia), 31, February/April 1999, pp. 40–44; ''Iñigo Manglano-Ovalle: Southeastern Center for Contemporary Art'' by Linda Johnson Dougherty, in *Sculpture* (Washington, D.C.), 18(2), March 1999, pp. 66–68; ''Transparent Scenarios'' by Michael Rush, in *Art in America,* 88(10), 2000, p. 134; ''Iñigo Manglano-Ovalle'' by Paul Quinones, in *Flash Art,* 213, 2000, p. 113; ''Iñigo Manglano-Ovalle: Henry Art Gallery, University of Washington'' by Victoria Josslin, in *New Art Examiner,* 27(7), April 2000, p. 58; ''The Genetic Esthetic'' by Barbara Pollack, in *Art News,* 99(4), April 2000, pp. 134–137; ''The Artists,'' in *Art Newspaper,* 11(103), May 2000, p. 59; ''Iñigo

Manglano-Ovalle: Max Protetch'' by Michele C. Cone, in *Art News,* 99(6), June 2000, pp. 146–147.

* * *

Formally exquisite, Iñigo Manglano-Ovalle allows one to see his own multicultural experience in his work. He was the son of a Spaniard and a Colombian and has been a resident in the United States since the 1980s, and in his works we see the confluence of his concerns, which coincide in a profound humanistic contemplation of today's society. The effective presence of subjects with diverse ethnic features, but identifiable as belonging to a West that is increasingly more varied, appears associated with ambiences that in some way refer to the coldness of technology and the concept of contemporary comfort.

Through a refined aesthetics in which he usually intermixes different mediums, Manglano-Ovalle tackles themes that lead him to identify himself with discourses on identity, transterritoriality, migration, postcolonialism, and the new policies of power. The references to high technology are not limited to the elements implicit in an image or the action associated with communications. The same technical realization usually includes the presence of diverse specialities in the fields of social science, medicine, and technology. In this sense the works of Manglano-Ovalle exhibit a sophistication that has its roots in the complex material and logistic approach that some of his most refined works imply. This is evident in *Banks in Pink and Blue* (1999), which consists of banks of frozen sperm selected by gender. The complexity of the subject dealt with at the technical, medical, and ethical levels required specialized counseling in the different areas and careful control of the variables and of the stability of the work itself. Of a similar level of complexity, *Millenial Countdown Clock* (2000) involved a satellite controlling time and the rotation of the Earth to fractions of a second, expressed by Manglano-Ovalle through the installation of 16 screens on which faces were substituted for digits. These impavid faces, which substituted for the cold numerical system and which have continued active on an Internet page, were of diverse ethnic character, and the change from one to another was determined by the continuous change of the digits over the passage of time.

This multiethnic allegory draws attention to the artifices with which human beings abstract the phenomena of time and space. And the problem of time and place is simply the framework of existing and physically being in a place. Manglano-Ovalle centers on the chance occurrence of identity. The consideration of appearances as a determining element of the identity problem opens the way to a critical level in which the social roles are abstracted, or are elegantly stylized, to concentrate on the observation of the phenomenology of others. Thus, in *Banks in Pink and Blue* the abstraction of the genres in the schematic division into two containers of Y or X chromosome sperm reveals the absurd complexity of the problem of individual nature.

In his attractive cibachromes of DNA samples, true abstractionist displays of rhythm and composition, Manglano-Ovalle goes deeper into the insurmountable fact of common human nature. Consequently, with this fundamental concept of equality he has undertaken works in which communities of citizens participate in the aesthetic event from its realization. More than a nostalgic reference to the avant-garde romanticism of the fusion of art and life, this is an approach from an anthropological reflection upon the problem of the general invisibility of individuals and social groups within the megacities of today.

In *Climate* (2000) the structure that distributes and rationalizes invisibility is modern architecture, represented by a building by one of the myths of architectural rationalism of the twentieth century, Ludwig Mies van der Rohe. Expectant faces and an anonymous individual who loads and unloads a weapon are seen in opposing scenes that break with the convention of sequence. This is real simultaneity, the history of an event that never reveals itself to us. It is scarcely an enigmatic sequence of a suggested spectacular action. Part of the nature of these images is their total dependence on technical fact. Projected on large screens held up by a minimalist structure of aluminium of an architectural nature, they have a spatiality that is determined by the physical presence of the structure framing and distributing them, and their force is centered on the impressive visual impact, chromatic and luminous, and on the mysterious motive of the characters who make the climatic allegory into a riddle.

The constant emphasis on the subject of identity opaquely points to the process of Westernization throughout the world, given the technological environment that forms the framework for or justification of Manglano-Ovalle's iconography. Mies van der Rohe's architecture, the containers of semen, or the involvement of satellites and radar for the transmission and recording of data all make evident the sophistication of technological equipment and the formal effect it provides to the works of this artist of impeccable technical quality and of complex, multidisciplinary conceptual reference points.

—Vivianne Loría

MANUEL, Víctor
Cuban painter

Born: Manuel García Valdes, Havana, 31 October 1897. **Education:** Studied under Leopoldo Romañach, Academy of San Alejandro, Havana, 1910. **Career:** Teaching assistant, Academy of San Alejandro, Havana, c. 1911. Traveled to Europe, 1925–27. Member, artist group *Grupo de Montparnasse,* Paris, c. 1925. Returned to Havana, 1927. Cofounder and member, artist group *Grupo Minorista,* Havana, 1927; contributor to magazine *Revista de Avance,* 1927. Visited Europe, 1929. Professor, Estudio Libra para Pintores y Escultores, 1937. Founder, graphic arts workshop Taller Experimental de Gráfica de la Plaza de la Catedral, Havana, 1964. **Award:** First prize, Lyceum, 1935. **Died:** Havana, 1969.

Individual Exhibitions:

1924 Las Galleries, Havana
1927 Asociación de Pintores y Escultores, Havana
1931 Lyceum, Havana
1945 University of Havana
1952 Reporters' Association, Havana
1956 Galeria Lex, Havana
1969 National Museum, Havana (retrospective)
1994 Alfredo Martinez Gallery, Coral Gables, Florida

Selected Group Exhibitions:

1917 *Salón de Bellas Artes,* Havana
1927 *Exposicion de arte nuevo,* Havana

1934 *XVII salón de bellas artes,* Havana
1935 *Exposición nacional de pintura y escultura,* Secretaría
 de Educación, Dirección de Cultura, Havana
1937 *Primera exposición de arte moderno, pintura y
 escultura,* Salones del Centro de Dependientes,
 Havana
1938 *II exposición nacional de pintura y escultura,* Havana
1939 Riverside Museum, New York
1940 *El arte en Cuba,* Instituto Nacional de Artes Plásticas,
 Universidad de la Habana
1945 *Exposición de pintura cubana moderna,* Academia
 Nacional de Bellas Artes, Guatemala
1966 *IV exposición de litografías del Taller Experimental de
 Gráfica,* Casa de la Cultura Checoslovaca, Havana

Publications:

On MANUEL: Books—*El camino de los maestros* by Graziella
Pogolotti, Havana, Editorial Letras Cubanas, 1979; *Victor Manuel* by
Jorge Rigol, Havana, Cuba Editorial Letras Cubanas, 1990. **Article—**
Review of an exhibition held at Alfredo Martinez Gallery, Coral
Gables, Florida, by Giulio V. Blanc, in *Art Nexus* (Colombia), 11,
January/March 1994, pp. 241–242.

* * *

Considered the father of modern art in Cuba, Víctor Manuel was
the leading artist of the Grupo Minorista, the first avant-garde
movement of the twentieth century on the island. Traveling to Europe
as a young man, he championed abstraction in the 1920s and
subsequently founded the movement that challenged academic real-
ism in Cuba. He developed a personal style derived from the formal
advancements of postimpressionism, cubism, and surrealism while
celebrating Cuban subjects and themes.

Manuel was born Manuel García Valdés in Havana in 1897. The
son of the caretaker at the Academy of San Alejandro, the principal art
school in the capital, Manuel revealed prodigious artistic abilities as a
child and was taken under the wing of Leopoldo Romañach, professor
of painting at the academy and Cuba's leading realist at the turn of the
twentieth century. At the age of 14 Manuel was a teaching assistant in
drawing classes at the academy, and he held his first solo exhibi-
tion in 1924.

Manuel turned down a teaching offer at the academy and decided
to travel to Europe instead. In 1925 he went to France, where he
studied the art of the turn of the century, gravitating toward the
postimpressionists Cezanne, Gauguin, and van Gogh and the so-
called primitives of that generation. He rejected academic realism in
those years and adopted some of the formal concerns of cubism. He
also became involved with the Grupo de Montparnasse, the leading
group of Latin American intellectuals in Paris at the time. His friends
there encouraged him to change and simplify his name, a deliberate
act of self-transformation that seemed to preempt his vision for the
arts in Cuba.

In 1927 Manuel returned to his homeland and became involved
in the establishment of a modernist movement in the capital to
challenge the instruction at the academy, which favored academic
realism and sentimental subjects, and a system of patronage that
privileged wealthy Creoles, Cuban descendants of the Spanish ruling
class. Along with fellow painters Amelia Peláez and Eduardo Abela,
he founded the Grupo Minorista, which held its first major show, the

Exposicion de Arte Nuevo, and began publishing a mouthpiece
magazine, the *Revista de Avance,* in 1927.

In the late 1920s and 1930s Manuel developed his characteristic
style. He painted solidly modeled and balanced compositions of
flattened figures and landscapes that evoked the work of Cezanne,
Gauguin, and Picasso. The images are abstract, rendered in simple,
dark outlines, and are generally monochromatic. His paintings of
tranquil street scenes, lone *guajiro*s, or peasants, in tropical land-
scapes, and figures seated in spartan interiors are characterized by a
certain melancholic air that parallels the intensity of the work of the
Italian surrealist Giorgio de Chirico. Manuel's paintings, however,
are not without a Cuban sense of humor. Often his urban scenes
feature figures such as mulattoes, laughing and dancing, or young
males urinating on street corners, for example.

In the 1930s Manuel won numerous national prizes for his work,
and in 1937 he joined the faculty of the Estudio Libre para Pintores y
Escultores, an experimental year-long art school headed by Abela and
modeled after a Mexican institution created in the 1920s. It accepted
students free of charge, did not discriminate in terms of sex, race, or
class, and was guided by principles of artistic freedom and exploration.

Throughout the decades of the 1940s and 1950s, Manuel contin-
ued to paint, doing landscapes primarily. He was the first major artist
to exhibit after the 1958 revolution and was held in high regard by the
Communist government. In 1964 he established the Taller Experi-
mental de Gráfica de la Plaza de la Catedral, a graphic arts workshop
in Havana. A major retrospective of his work was held in the National
Museum in the capital after his death in 1969.

—H. Rafael Chácon

MARADIAGA, Ralph
American painter, printmaker, and photographer

Born: San Francisco, 27 October 1934. **Education:** San Francisco
City College, 1969; San Francisco State University, B.A. in printmaking
1972, M.A. in printmaking 1975; Stanford University, California,
M.A. in film 1975. **Career:** Worked for an engineering business and
an insurance agency. Founder with René Yañez, late 1960s, and
administrative director, curator, art director, and graphics coordina-
tor, 1970–83, Galería de la Raza, San Francisco. Instructor, silkscreen
workshop, San Francisco State University, 1973–74, poster design
classes, Galeria de la Raza/Studio 24, San Francisco, 1977–78, basic
drawing and art history, San Francisco City College, 1976–81, film
history and advanced filmmaking, Sacramento State College, Califor-
nia, 1979–80, animation, San Francisco elementary schools, 1975–81,
and filmmaking, Galeria de la Raza/Studio 24, 1980–82. Traveled to
Russia, 1984. Printmaker, Self-Help Graphics, Los Angeles, 1984.
Guest curator and lecturer, University of California, Berkeley, Museum,
and Pima Community College, Tucson, Arizona. Also worked as a
producer and director of documentary films. **Awards:** California Arts
Council grant, 1980–82. **Died:** 19 July 1985.

Selected Exhibitions:

1970 Casa Hispana, San Francisco
1973 *Posters and Society,* San Francisco Museum of Modern
 Art
 The Print Club, Philadelphia Open Competition

1976 *Images of an Era,* Smithsonian Institution, Washington, D.C.

De Young Museum, San Francisco

1977 *Ancient Roots/Visions,* Mexico (traveling)

1979 San Francisco Arts Festival

1981 *5th bienal del grabado latino americano,* San Juan, Puerto Rico

Chicanos in California, University of Santa Cruz, California

1982 *Califas Works on Paper,* Fondo del Sol Gallery, Washington, D.C.

California: Art on the Road, Laguna Beach Museum, California

12x12 Group Exhibition, Castellon Gallery, San Francisco

Stockton National Prints & Drawings, Haggin Museum, Stockton, California

1985 *Personal Reflection,* Galeria de la Raza, San Francisco

1990 Galeria de la Raza, San Francisco

2000 *Just Another Poster? Chicano Graphic Arts in California,* University of Texas, Austin

Collections:

Museum of Modern Art, New York; San Francisco Art Commission.

Publications:

By MARADIAGA: Films—*El tecolote,* 1973; *A Measure of Time,* 1975; *Incident at Downieville,* 1979; *La gente de California,* 1981.

On MARADIAGA: Book—*Homenaje a Ralph Maradiaga, 1934–1985* by José Antonio Burciaga, San Francisco, Galería de la Raza, 1990. **Article**—''Of Tradition and Reverence'' by Wendy Cadden, in *Artweek,* 21, 2 August 1990, pp. 13–14.

* * *

The San Francisco Bay Area artist Ralph Maradiaga came to silk screen printing from a background in graphics and was taught the hand-cut screen technique by Rupert García. His earliest poster in the silk screen medium was an announcement for a California-wide Mexican-American and Latin American traveling exhibit in 1969 called *Arte de los Barrios,* in which he limited himself to black silhouetted forms on colored paper. By 1970, for the second *Arte de los Barrios* exhibition, he was working in three inks on yellow paper. In 1974 he created the 13-color split-fountain (color-blend) screen *Colors of the Guatemalan Indians* for a Peruvian poster exhibition. After that his exhibition posters grew in richness and complexity.

Maradiaga was the cofounder in the late 1960s of La Galería de la Raza, a nonprofit community arts organization in the Latino Mission District of San Francisco. A crucial cultural force, the gallery exhibited Latin American, Caribbean, Chicano, and Raza art, promoted murals, and maintained an archive and a design studio. It functioned as a nucleus for many Bay Area artists. Since mainstream art galleries did not consider Chicano art to be a legitimate form of expression, Maradiaga played a significant role in helping artists establish careers. He helped set standards and guidelines both in the installation and in the quality of work that was shown at Chicano exhibits.

Aside from being an artist, Maradiaga was also a teacher, a filmmaker, an animator, a photographer, and a curator for many of the exhibits shown at La Galería de la Raza. As both an artist and a teacher, he worked with graphic design, photography, silk screening, printmaking, and filmmaking. His educational film *A Measure of Time* was narrated by Luis Valdez, a playwright and the founder of El Teatro Campesino.

As an artist, Maradiaga crossed many boundaries. When he began as a silk screen artist, he did not have the equipment to facilitate the work. Undaunted, he continued creating posters under rustic conditions, producing works that ultimately captured and expressed his own spirit as well as that of the community. Not until 1984, when he went to Self-Help Graphics in Los Angeles to work with the master screen printer there, did he have access to an advanced printmaking workshop. His silk screen work from that period, titled *Lost Childhood,* manifests a sense of loss for the changing nature of the neighborhood where he had grown up.

Maradiaga participated in his first show at San Francisco's Casa Hispana in 1970. Since then his prints have hung in the San Francisco Museum of Modern Art; in Washington, D.C.; in San Juan, Puerto Rico; and at various galleries in Mexico City. His work is also part of the permanent collection of the Museum of Modern Art in New York City. On the occasion of his participation in the 1985 exhibition *Personal Reflection,* Maradiaga said, ''The images I use in my work are a reflection of our culture, its people and its tradition. As artists we must all share our customs, lifestyles, and imagery with one another. It is only through artistic, social, and political ideologies that we ascertain and retain a place in history and document it for our children.''

—Martha Sutro

MARISOL
American sculptor, painter, and graphic artist

Born: Marisol Escobar, Paris, 22 May 1930. **Education:** École de Beaux-Arts and Academie Julian, Paris, 1949; Art Students League, New York, 1950; New School for Social Research and Hans Hofmann School, New York, 1951–54. **Career:** Grew up in Europe, the United States, and Caracas. Taught at Montana State University, Bozeman; designed sets for Martha Graham and Louis Falco dance companies. **Awards:** Represented Venezuela at *Venice Biennale,* 1968. Honorary doctorates: Moore College of Art, Philadelphia, 1969; Rhode Island School of Design, Providence, 1986; State University of New York, Buffalo, 1992. **Member:** American Academy of Arts and Letters, 1978. **Agent:** Marlborough Gallery, 40 West 57th Street, New York, New York 10019, U.S.A. **Address:** 427 Washington Street, New York, New York 10013, U.S.A.

Individual Exhibitions:

1958 Leo Castelli Gallery, New York

1962 Stable Gallery, New York

1964 Stable Gallery, New York

1965 Arts Club of Chicago

1966 Sidney Janis Gallery, New York

1967 Hanover Gallery, London

Sidney Janis Gallery, New York

1968 Boymans-van Beuningen Museum, Rotterdam

Marisol: *Untitled,* **1960. © National Museum of American Art, Smithsonian Institute, Washington, D.C./Art Resource, NY. © Marisol/Licensed by VAGA, New York, NY.**

1970	Moore College of Art, Philadelphia (retrospective)
1971	Art Museum, Worcester, Massachusetts (retrospective)
1973	*Prints 1961–1973,* Cultural Center, New York
	Sidney Janis Gallery, New York
1974	Estudio Actual, Caracas
1975	Sidney Janis Gallery, New York
	Makler Gallery, Philiadelphia
1977	Contemporary Arts Museum, Houston
1981	Sidney Janis Gallery, New York
1984	Sidney Janis Gallery, New York
1988	Boca Raton Museum of Art, Florida
1989	Sidney Janis Gallery, New York
	Galerie Tokoro, Tokyo
1991	National Portrait Gallery, Smithsonian Institution, Washington, D.C. (retrospective)
1992	Tenri Gallery, New York
1995	Hakone Open Air Museum, Japan (retrospective)
	Marlborough Gallery, New York
1998	Marlborough Gallery, New York

Selected Group Exhibitions:

1964	*Painting of a Decade,* Tate Gallery, London
1966	*Art of the U.S.A 1670–1966,* Whitney Museum, New York

1967	*International der Zeichnung,* Darmstadt
	American Sculpture of the 60s, Los Angeles County Museum of Art
1968	*Biennale,* Venice
1969	*Pop Art,* Hayward Gallery, London
1970	*Women Artists,* Skidmore College, Saratoga Springs, New York
1975	*The Nude in America,* New York Cultural Center
1976	*The Dada/Surrealist Heritage,* Clark Art Institute, Williamstown, Massachusetts
1979	*The Opposite Sex,* University of Missouri, Columbia

Collections:

Whitney Museum, New York; Museum of Modern Art, New York; Metropolitan Museum of Art, New York; National Portrait Gallery, Washington, D.C.; Albright-Knox Art Gallery, Buffalo, New York; Yale University Art Gallery, New Haven, Connecticut; Brandeis University, Waltham, Massachusetts; Arts Club of Chicago; Hadone Open-Air Museum, Japan; Wallraf-Richartz Museum, Cologne.

Publications:

On MARISOL: Books—*Marisol,* exhibition catalog, Chicago, 1965; *Pop Art* by Lucy R. Lippard, New York and London, 1966; *Marisol*

Marisol: *Portrait of Sidney Janis Selling Portrait of Sidney Janis by Marisol, by Marisol,* 1967–68. © 1999 The Museum of Modern Art, New York. The Sidney and Harriet Janis Collection. © Marisol/Licensed by VAGA, New York, NY.

by Jack Mitchell, Caracas, 1968; *Marisol* by José Ramon Medina, Caracas, 1968; *The Autobiography and Sex Life of Andy Warhol* by John Wilcox, New York, 1970; *Marisol,* exhibition catalog, Philadelphia, 1970; *Marisol,* exhibition catalog, Worcester, Massachusetts, 1971; *Marisol: Prints 1961–1973,* exhibition catalog, by John Loring, New York, 1973; *Marisol,* exhibition catalog, by Roberta Bernstein and Susan Hersch, Philadelphia, 1975; *Art Talk: Conversations with 12 Women Artists* by Cindy Nemser, New York, 1975; *Presences: A Text for Marisol* by Robert Creeley, New York, 1976; *Pop Art: The Critical Dialogue* by Carol Anne Mahsun, Ann Arbor, Michigan, 1989; *Marisol: Recent Sculpture,* exhibition catalog, Tokyo, 1989; *American Women Sculptors* by Charlotte Streifer Rubenstein, Boston, 1990; *Magical Mixtures: Marisol Portrait Sculpture*, exhibition catalog, Washington, D.C., 1991. **Articles—**''Marisol's Magic Mixtures'' by Lawrence Campbell, in *Artnews* (New York), March 1964; ''It's Not Pop, It's Not Op—It's Marisol'' by Grace Glueck, in *New York Times Magazine*, 7 March 1965; ''Die elf Gesange der Marisol'' by G. Guben, in *Kunst* (Mainz, West Germany), 1969; ''Marisol: Worcester Art Museum'' by J.T. Butler, in *Connoisseur* (London), January 1972; ''Marisol,'' in *Mizue* (Tokyo), June 1972; ''New York Letter'' by April Kingsley, in *Art International* (Lugano, Switzerland), October 1973; ''Pop Artist Marisol—20 Years after Her First Fame—Recalls Her Life and Loves'' by Jeff Goldberg, in *People,* 24 March 1975; ''Marisol As Portraitist: Artists and Artistes'' by Roberta Bernstein, in *Arts Magazine,* May 1981; ''Chers Maitres: Marisol's Homages to 20th Century Artists'' by Joan Simon, in *Art in America* (New York), October 1981; ''Marisol's Self-Portraits: The Dream and the Dreamer'' by Roberta Bernstein, in *Arts Magazine,* March 1985; ''Who Is Marisol'' by Paul Gardner, in *Art News,* 1989.

* * *

Marisol Escobar had two reasons for dropping her family name: not to depend on the patriarchal tradition and to stand out in a crowd. Being born in Paris to wealthy Venezuelan parents, she had to learn to travel extensively and to adjust to her mother's death when she was only 11 years old. She has declared that as a teenager, years after her mother passed away, she deeply embraced Catholicism to a point of self-inflicted physical and spiritual mortifications. Religion also inspired her. At some point in her life, she also believed in the supernatural. The personality structure of human beings is known to be formed by the importance of unconscious motivation and the active nature of repression. Both seem to have worked actively in her being—less in her younger years, but clearly later on, when she began to create her protruding sculptures and assemblages.

There are some patterns that one can admire in Marisol's artistic growth. After studying one year in Paris (1949) at the École des Beaux-Arts, she was oriented to follow mainly after Pierre Bonnard's painting. A year later she moved to New York City, where once again she went to study at a renowned institution, New York's Art Students League, with Yasuo Kuniyoshi, a decorative painter. Following those two course periods, she entered the New School for Social Research (1951–54), where she studied with Hans Hofmann, the so-called ''dean of abstract expressionism.'' This has to be considered the beginning of Marisol's most important formative path, and Hofmann should be considered her most influential teacher. She continued attending other schools in New York and Massachusetts where Hofmann taught. While this was taking place, she began to meet and mingle with strong new artists, most of whom were working solidly in abstract expressionism.

In 1951 Marisol learned of the existence of pre-Columbian artifacts; she also stepped aside from painting and started using terracotta, wood, and sculpture. Hofmann's guidance was a turning point in her formative years. The use of the ''push and pull,'' or ''pull back and pull forth'' method (also related to the Sigmund Freud's ''doing-undoing''), as well as her acquaintance with pre-Columbian art became the most crucial moment for the development of her professional career. It was at this point that Marisol was confronted with her Latin American origins. Consciously and unconsciously, and out of her encounters with clay artifacts as cultural icons, she began to incorporate mud as well as construction and decorative elements to her assemblages, giving birth to her own style. Marisol could thereafter create her concepts and compositions having taken her former decorative instruction a step further as a new tool in the encounter of material, technique, and expression. Those unique works of art developed a new aesthetic for the twentieth century.

The concept of ''grab and let go'' was reenacted in 1958 when she was in one of Leo Castelli's shows and presented totemic figures and animals carved as heirs of the pre-Columbian cultures. She still wanted to further solidify her artistic results and left for Italy, where for a year she devoted herself to studying the Renaissance period and matured along new personal and professional paths. At a time when abstract expressionism was established, conceptual art was already on the scene, and pop was catching people's eyes, Marisol's art was emerging into the best collections and museums. Some people say her work is pop; it is not, but it breathes as pop. She also took into consideration the ''lost and found objects'' and the popular culture of everyday life, even though she did not concentrate on that only. The carving and building up, the wood, the painting, and the drawing were there to pay homage to society. Coming out of the great period of abstract expressionism, she articulated the figures—human and animal ones—with stains, drawings, in isolated sculptures, and as assemblages, in an environmental scope. She began with self-portraits and never left them aside—little girls staring astonished at the adult world. Occasionally a sense of humor and more frequently altered proportions inhabit her work. She has been drawn to the dreamer and to minorities, to friends and families, those suffering and those admired. She incorporated new experiences, such as her discovery of and devotion for the environment under water. Not only did these enter her work as new images but also influenced her treatment of surfaces. Marisol grew up with the rough and the smooth, war and peace, reconceptualized abstract expressionism and pop, minimalism and cubism. These are embedded in the personal style that she has offered the world.

—Graciela Kartofel

MARTÍNEZ, César (Augusto)
American painter and photographer

Born: Laredo, Texas, 4 June 1944. **Education:** Laredo Junior College, Texas, A.A. 1964; Texas Arts and Industries University, Kingsville (later Texas A&M University, Kingsville), B.S. in art education 1968. **Military Service:** United States Army, 1969–71: radio operator. **Career:** Worked with Texas Institute for Educational Development, a Chicano activist group, ca. 1971; cofounder, *Caracol,* a Chicano

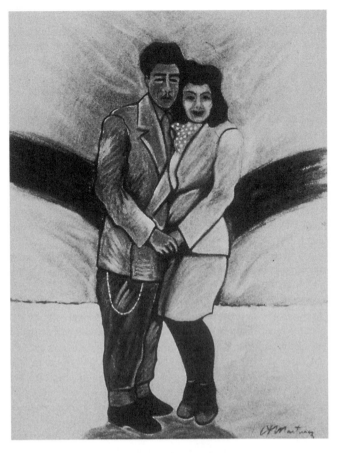

César Martínez: *La Pareja.* **Photo by Jacinto Quirarte; photo courtesy of the artist. Reproduced by permission.**

periodical; cofounder of artist group *Los Quemados.* Also affiliated with artist group *Con Safos,* ca.1971. Visual Arts visiting artist, University of Texas, San Antonio, 1999. **Awards:** Best painting of the exhibition award, *¡Mira!,* El Museo del Barrio, New York, 1984; artist-in-residence, ArtPace International Artist-in-Residence Program, 1997; artist of the year, San Antonio Art League Museum, 1999.

Individual Exhibitions:

1978	*New Paintings,* Xochil Art Center Gallery, Mission, Texas
1980	Dagen Bela Gallery, San Antonio, Texas
1987	Galeria Sin Fronteras, Austin, Texas
1988	*There's a Chicano in There Somewhere*, Guadalupe Cultural Arts Center, Guadalupe Theater Gallery, San Antonio, Texas
1990	*César A. Martínez: Mixed Media Paintings,* San Angelo Museum of Fine Arts, San Angelo, Texas
	Movimiento Artistico del Rio Salado, Phoenix
1991	*César A. Martínez: Three Major Series,* Ben P. Bailey Gallery, Texas Arts and Industries University, Kingsville, Texas
1993	*César Martínez: Recent Work,* Lynn Good Gallery, Houston
1994	*César Augusto Martínez: Reflejos mestizos,* El Paso Museum of Art, Texas

1997	ArtPace, San Antonio, Texas
1998	*César A. Martínez: Cultura de South Texas,* Art Museum of South Texas, Corpus Christi, Texas
1999	McNay Art Museum, San Antonio, Texas (retrospective)

Selected Group Exhibitions:

1977	*Dalé Gas: Chicano Art of Texas,* Contemporary Arts Museum, Houston
1979	*Fire: One Hundred Texas Artists*, Contemporary Arts Museum, Houston
1984	*¡Mira!,* El Museo del Barrio, New York (traveling)
1986	*¡Mira! The Tradition Continues,* El Museo del Barrio, New York (traveling)
	Chicano Expressions, INTAR Latin American Art Gallery, New York (traveling)
1987	*Hispanic Art in the United States: Thirty Contemporary Painters and Sculptors,* Museum of Fine Arts, Houston (traveling)
1990	*Chicano Art: Resistance and Affirmation, 1965–1985,* Wight Art Gallery, University of California, Los Angeles (traveling)
	15 Pintores y 3 Escultores Tejanos, Museo de Alvar y Carmen T. De Carillo-Gill, Mexico
1993	*La Frontera/The Border: Art about the Mexican/U.S. Border Experience,* Museum of Contemporary Art and Centro Cultural de la Raza, San Diego, California (traveling)
1994	*Ceremony of Spirit: Nature and Memory in Contemporary Latino Art,* Mexican Museum, San Francisco (traveling)

Collections:

Museum of Fine Arts, Houston; San Antonio Museum of Art, Texas; Colegio de la Frontera, Tijuana, Mexico; Mexican Fine Arts Center Museum, Chicago; El Paso Museum of Art, Texas; Art Museum of South Texas, Corpus Christi; Center for the Arts, Vero Beach, Florida; ArtPace, San Antonio, Texas.

Publications:

On MARTÍNEZ: Books—*Hispanic Art in the United States: Thirty Contemporary Painters and Sculptors,* exhibition catalog, by John Beardsley and Jane Livingston, Abbeville Press, New York, 1987; *César Augusto Martínez: Reflejos mestizos,* exhibition catalog, text by Jacinto Quirarte, El Paso, Texas, El Paso Museum of Art, 1994; *César A. Martínez: A Retrospective*, exhibition catalog, by Jacinto Quararte, Carey Rote, and others, Marion Koogler McNay Art Museum, San Antonio, 1999. **Articles**—"Martinez's Art Has South Texas Focus" by Ben Tavera King, in *Express-News* (San Antonio, Texas), April 1991; by Mark Frohman, in *Art News* (New York), October 1993, p. 172; "The Color of Culture" by Ellen Bernstein, in *Corpus Christi Caller-Times* (Corpus Christi, Texas), 4 October 1998; "Blending Cultures" by Dan R. Goddard, in *San Antonio Express-News* (San Antonio, Texas), 18 November 1998.

* * *

César Martínez is an artist who combines humor and irony with a serious exploration of Chicano issues. Growing up in the border town of Laredo, Texas, Martínez was struck by the images prevalent in his household—the family calendar, the tiny altar his grandmother always kept, and especially the family photographs. The photography of Richard Avedon would later influence his portraits, as would the artists Pablo Picasso, Mark Rothko, Francisco de Goya, Alberto Giacometti, and Norman Rockwell. This eclectic group of influences would shape both Martínez's work and philosophy: He admired Rockwell for his modesty and craftsmanship; Giacometti for the tiny figures he created. Looking in art history books proved a source of inspiration for Martínez.

Not only has Martínez reworked popular subjects—he created several portraits of the Mona Lisa—but also he has reworked his own images, perfecting and altering a subject through a series of paintings. For example, he painted a portrait of his high school friend in a painting called *Javier H.* The first *Javier H.* shows a man with a dark blue face and purplish shirt against a deep red background. Unhappy with his large signature in the painting, he redid the background, brightening the red. He then painted another picture of Javier H. Martínez similarly has painted several portraits of *Bato con Sunglasses* (''Bato with Sunglasses''). This delving into a theme, of exploring all facets of a subject, does not make Martínez's interest in creating series of paintings surprising. For a series to take shape, Martínez let an idea brew long before he actually began to work. Rather than working from images or sketches, Martínez worked from a mental space, conceptualizing an idea while finding a style to fit the theme. His work includes the *South Texas* series, the *Pachuco* series, and the *El Mestizo* series.

For the *South Texas* series Martínez worked to capture life in the predominantly Chicano area. Not being religious himself, he set about capturing the deep-rooted Catholicism of the people. In the 1970s he traveled throughout the Southwest, taking photographs of people involved in the Chicano movement. The photography would influence his later portraits as well as his series about Texas. In one painting that is representative of the *South Texas* series, he has used his friend El Cono as a model. El Cono is a hunter, and the piece is a shattering of hunter graffiti—not urban graffiti, but the type of graffiti a hunter could inscribe inside a hunting shack.

His series of paintings, although distinct, merge into one another. The hunter El Cono, for example, could appear in his series about pachucos (Mexican-American rebels). In the *Pachuco* series Martínez created portraits of men and women, of famous rebels and the man next door. Like Avedon photographs, Martínez sought an open gaze, a sort of flatness in his portraits: ''The idea of a very frontal and very emotion (less)—not emotionless, but almost expressionless—face just staring at you, that came from Richard Avedon's work.'' Although the portraits include found objects, such as wire or iron, the found objects work as paint rather than adding another dimension to the paintings. How he has created his portraits varies. Sometimes he has traced an enlarged photograph onto a canvas creating an exact resemblance, but perhaps his most successful portraits occur when he has worked from memory. Then real people from his past get transformed into characters and familiar archetypes. In one painting called *El hombre que le gustan las mujeres* (''The Man Who Liked Women''), Martínez merged a mechanic who had worked in front of his house when he was a child with an unemployed man who had also lived down the street. From the mechanic he got the character's thick arms and torso; from the unemployed man he got the

idea to place tattoos on the fleshy arms. Martínez decided to paint a tattoo of a pure, Mexican girl on one arm and a bad girl, a sort of prostitute, on the other. In the center of the character's chest he drew a tattoo of the Virgin Mary. Together the three women represent how many Chicano men view women. Martínez considered the work successful: ''It is in essence what I do with a series—combine characters into different people . . . and then it becomes a character that seems very real and very recognizable and very universal to the Chicano experience.''

Although Martínez has been criticized for not always portraying the Chicano experience in a positive light, he has, in fact, represented fairly both his Mexican and European heritage. After all, when he was a boy he wanted nothing more than to be a bull rider. When he was in grade school, he created a winning float that portrayed a bullfight. In his series *El Mestizo* he created pictures that elaborate the idea of the mestizo (person of mixed heritage, specifically Indian and Spanish). He created paintings that show the tension between the two cultures and used the jaguar (native to the Americas) and the bull (native to Spain) in a self-portrait to suggest the pull within himself.

—Sally Cobau

MARTINEZ, Daniel J(oseph)
American photographer, conceptual, and interdisciplinary artist

Born: Los Angeles, 1957. **Education:** California Institute of the Arts, Los Angeles, B.F.A. 1979; studied with Klaus Rinke, Germany, 1981–82. **Career:** Assistant professor of studio art, 1992–98, cochair, Graduate Studies Program, studio art, 1995–99, associate professor of studio art, 1998–2000, and acting chairman of studio art, 1999, University of California, Irvine. Cofounder, artist space Deep River, Los Angeles, 1996. Instructor, California State Summer School for the Arts, Mills College, Oakland, summer 1991, California State Summer School for the Arts, California Institute of the Arts, Valencia, summer 1992, Summer Youth Program, University of California, Irvine, summer 1992, and Summer Honors Program, University of California, Riverside, summer 1995. Visiting lecturer, studio art, University of California, Irvine, and Claremont Graduate School, California, 1991–92. Member, artist group *Asco*, Los Angeles, 1990–96; founding member, artist group *Favela*, Los Angeles, 1994. **Awards:** Inter Arts grant, Los Angeles Contemporary Exhibitions, 1986; Individual Artist fellowship, Brody Arts Fund, Los Angeles, 1988; Individual Artist fellowship, California Arts Council, 1988; fellowships, Art Matters, Inc., 1989, 1990; fellowships, National Endowment for the Arts, 1989, 1990, and 1996; Individual Artist fellowship, City of Los Angeles, 1990; fellowship, J. Paul Getty Trust Fund for the Visual Arts, 1997; Award for Teaching Excellence, School of the Arts, University of California, Irvine, 1998; award, Norton Family Foundation, Los Angeles, 1998–2001; Individual Artist fellowship, Flintridge Foundation, 1999–2000; first prize, *ES2000 Tijuana International Biennial of Standards,* 2000; C.O.L.A. Individual Artist grant, Cultural Affairs Department, City of Los Angeles, 2000.

Individual Exhibitions and Projects:

1981 Espace DBD Gallery, Los Angeles

1983	Guggenheim Gallery, Chapman College, City of Orange, California
1984	*The People of Los Angeles* (installation), Olympic Arts Festival, University of Southern California, Los Angeles
	Where Does All the Money Come from, Attitudes and Expressions (installation), Mills House Art Complex, Garden Grove, California
1985	*City of Lost Angels,* John Jannety/Tony Duquette Studios, Los Angeles
1986	*Forces of Enlightenment,* Natalie Bush Gallery, San Diego, California
1987	*The Human Condition* (installation), Abstraction Gallery, Los Angeles
	The End of Manifest Destiny, The Birth of a New Human Race (installation), M.I.T. List Gallery, Cambridge, Massachusetts
1988	*Fragments* (installation), B-1 Gallery, Santa Monica, California
	Big Fish Eat Little Fish (installation), Santa Monica Museum of Art, California
1989	*New Works and Video Generated Images,* On Metal, B-1 Contemporary, Santa Monica, California
	No More Mr. Nice Guy, Navia Gallery, Los Angeles
	Eagles Don't Catch Flies (installation), Gallery at the Plaza, Security Pacific Corporation, Los Angeles
1990	*Ignore the Dents* (opera), Los Angeles Festival, Million Dollar Theater, Los Angeles
1991	*Tight, White and Right* (installation), Center of Contemporary Art, Seattle
1992	*I Pissed on the Man That Called Me a Dog,* New Langton Arts, San Francisco
	Three White Rats Wearing Black Felt Hats, Mars Art Space, Phoenix, Arizona
1993	*23 Blows of the Dagger,* Randolph Street Gallery, Chicago
1995	*How to Teach the Former British Empire Manners . . . or The Last Grasp of Colonialism . . . (after hours),* Artspace, Teststrip, Auckland, New Zealand
	Study for Museum Tags, Robert Berman Gallery, Santa Monica, California
1996	*What Makes a Queen Apologize (or How to Start Your Own Country),* Artspace, Auckland, New Zealand
1998	*If Only You Could See What I have Seen with Your Eyes (an Event for Acoustic Obedience),* Three Rivers Arts Festival, Pittsburgh
	The Killer in Me, Is the Killer in You, Track 16 Gallery, Santa Monica, California
1999	*The Lure of Perfection (Hypersimulation in the Age of the Cyborg),* The Project, New York
2000	Museo de las Artes de la Universidad de Guadalajara
	God Made Me Do It (I Suppose You Know What You're Doing, but I Wonder if You Know What It Means), Orchard Gallery, Derry, Ireland
	Revenge for Being Born, Three Rivers Art Festival Gallery, Pittsburgh
2001	*More Human than Human,* The Project, New York
	Museo de Arte Contemporaneo Carrillo Gil, Mexico City

Selected Group Exhibitions:

1993	*Revelaciones/Revelations: Hispanic Art of Evanescence,* Cornell University, Ithaca, New York
	1993 Biennial, Whitney Museum of American Art, New York
1995	*Cultural Baggage,* Rice Media Center Gallery, Rice University, Houston
1997	*Distant Relations: A Dialogue Between Chicano, Irish, and Mexican Artists,* Museo de Arte Contemporaneo de Carrillo Gil, Mexico City
1998	*Double Trouble: The Patchett Collection,* Museum of Contemporary Art, San Diego, California (traveling)
2000	*Es 2000 Tijuana, International Biennial Eslandartes,* Centro Cultural Tijuana, Mexico
	Made in California, 1900–2000, Los Angeles County Museum of Art
	C.O.L.A. Exhibition, Hammer Museum, University of California, Los Angeles
2001	*Capital Art: A Group Show on the Culture of Punishment,* Track 16 Gallery, Santa Monica, California

Collections:

Smithsonian Institution, Washington, D.C.; Los Angeles County Museum of Art; Laguna Art Museum, Laguna Beach, California.

Publications:

By MARTINEZ: Books—*Ignore the Dents: A Micro Urban Opera,* Los Angeles, D. Martinez, 1990; *The Things You See When You Don't Have a Grenade!,* with David Levi Strauss and others, Santa Monica, California, Smart Art Press, 1996; ''Death in the Afternoon: A Dialogue in Sevilla,'' in *Manuel Ocampo, heridas de la lengua,* Los Angeles, Smart Art Press, 1997.

On MARTINEZ: Book—*Chicano and Latino Artists of Los Angeles* by Alejandro Rosas, Glendale, California, CP Graphics, 1993. **Articles**—'' Reframing a Movement'' by Allison Gamble, in *New Art Examiner,* 21, January 1994, pp. 18–23; ''Culture Is Action: Action in Chicago'' by Lisa G. Corrin and Gary Sangster, in *Sculpture* (Washington, D.C.), 13, March/April 1994, pp. 30–35; ''My Kind of Conversation: The Public Artworks of Daniel J. Martinez'' by Coco Fusco, in *Atlantica,* 15, 1996, pp. 145–151; ''Martinez Installation Finds Life on Both Sides'' by Graham Shearing, in *Pittsburgh Tribune-Review,* 14 June 1996; ''Daniel J. Martinez, Renée Petropoulos, and Roger F. White,'' in *Sculpture* (Washington, D.C.), 15, December 1996, p. 15; ''Launching Grenades of Art'' by Joe Brekke, in *Turlock Journal,* 4 April 2000; ''Art in Review: Daniel J. Martinez and Peter Rostovsky'' by Holland Cotter, in *New York Times,* 9 April 2000.

* * *

Daniel J. Martinez, who was born in 1957, grew up in a working-class neighborhood of Los Angeles. Although he never learned to speak Spanish, he was keenly aware of his minority status within the United States. This has been an ongoing issue explored in the

artist's work, which includes photographs, billboards, performances, and installations.

Martinez received a B.F.A. degree from the California Institute for the Arts in 1979. As a Mexican-American student there in the late 1970s, he became aware of underlying prejudices and feelings of alienation and began to examine notions of race and identity in his work. These investigations led to the artist's final graduation project, entitled *I HATE WHITE*, which consisted of several large white canvases with this text inscribed on them. The work may have been read as a formal affront to the history of painting and as a reaction to the anxiety a blank canvas could produce for a young artist, especially during the prominence of conceptual art. The work also alluded, however, to the politics of race and skin color.

In the early 1980s Martinez traveled and pursued his studies in Germany under the mentorship of Klaus Rinke. Martinez continued to focus on characteristic issues regarding race, ethnicity, and class in the United States. In the early 1980s he met Harry Gamboa, Jr., and began to collaborate with him and other members of the group Asco. According to Gamboa, the name Asco–a Spanish term meaning "nausea" or "disgust"–was chosen because it evoked the kind of response that young, university-educated Chicano artists had toward what traditional, stereotyped Chicano art should look like. Asco's antiestablishment tactics were not solely directed at homogenous Chicano art practices but also against the Eurocentric art systems that denied minorities equal presence.

Found throughout Martinez's entire body of work is a direct and confrontational posture, his purpose being to disrupt viewers' routine assumptions and to challenge them in hopes that they will look at issues of representation from another perspective. This strategy, however, has often garnered much controversy. His project for the 1993 Whitney Museum of American Art Biennial consisted of entrance tags with the words "I Can't Imagine Ever Wanting to Be White" printed on them in several variations. This caused a swell of controversy for its racial implications and even received public criticism from then New York Mayor Ed Koch. Throughout his work Martíínez has manipulated technology, incorporated literature and science, and appropriated nontraditional materials. The adoption of such varying strategies by the artist may stem from his *rasquachismo* sensibilities. This sense of not belonging to one country or another, commonly felt by Mexican-Americans, has given Martinez a syncretic perspective that affords him the ability to think in terms of montage, fragments, and accumulations.

—Miki Garcia

MARTÍNEZ, Raúl
Cuban painter, photographer, and graphic designer

Born: Raúl Martínez González, Ciego de Ávila, Camagüey, 1927. **Education:** Academy of San Alejandro, Havana, 1941; studied graphic design, Design Institute of Chicago, 1953. **Career:** Worked as a painter, photographer, and graphic designer. Worked for Agencia Publicitaria O.T.P.L.A., 1954–60; worked for El Taller de Artes Plásticas del Ministerio de Obras Públicas, 1960; artistic director, magazine *Lunes de Revolución*, 1960; instructor, University of Havana, 1961–65; worked at Taller de Grabados y Litografía de la UNEAC,

1976; artistic director, Instituto Cubano del Libro, 1979; worked at Instituto de Diseño de la Universidad Veracruzana, Mexico, 1981. Visited New York and Chicago, 1983. Member, artist group *Grupo de los Once,* Havana, 1954–55. **Awards:** Silver medal, *Exhibition of Cuban Painting,* 1960; first prize in photography, *Concurso carnaval,* Havana, 1960; bronze medal, *International Exhibition of Art,* Leipzig, Germany, 1965; grand prize, *I trienal de grabado,* Havana, 1979; prize, *Salón nacional Carlos Enríquez,* 1980; prize, *Salón UNEAC,* 1982; medalla Alejo Carpentier, 1983; grand prize, *Bienal de la UNEAC,* 1983. Medalla Felix Varela, Ministry of Culture, Havana, 1988. **Died:** 1995.

Individual Exhibitions:

1950 Galería Lyceum, Havana
1952 Galería Lyceum, Havana
 Galería Matanzas, Havana
1954 Galería Lyceum, Havana (with Agustín Cárdenas)
1957 Galería Lyceum, Havana
1958 Galería Color Luz, Havana
1962 Galería La Habana, Havana
 Galería Lyceum, Havana
1964 *Homenajes,* Galería Habana, Havana
1978 *La gran familia,* Galería Habana, Havana
1980 Galería La Habana, Havana
1981 *Los murales,* Galería 12 y 23, Havana
1983 Galería 12 y 23, Havana
1985 *Pinta mi amigo el pintor,* Galería Habana, Havana
1989 *La conquista,* Galeria de Arte Universal, Güines, Havana
1992 *Islas 90,* Galeria Juan David, Havana
 Museo Nacional de Bellas Artes, Havana

Selected Group Exhibitions:

1947 *XXIX salón del círculo de bellas artes,* Havana
1948 *XXX salón anual de pintura y escultura del círculo de bellas artes,* Havana
1950 *24 artistas cubanos ante la UNESCO,* Galería del Liceo, Havana
1955 *Contemporary Cuban Group,* Galería Sudamericana, New York
1960 *Segunda bienal internacional de Mexico,* Palacio de Bellas Artes, Mexico City
1965 *International Exhibition of Art,* Leipzig, Germany
1967 *Pintura contemporánea cubana,* Museo Nacional, Havana
1984 Biennale de Venice
1986 *Made in the U.S.A.: Art from Cuba,* Amelie Wallace Gallery, State University of New York at Old Westbury (traveling)
1991 *IV bienal de pintura,* Museo de Bellas Artes, Havana

Publications:

On MARTÍNEZ: Books—*Pintura, escultura: Raúl Martínez, Tomás Oliva,* Havana, 1958; *Antología de un artista: Raúl Martínez* by Gustavo César Echevarría, Havana, Casa Editora Abril, 1994. **Articles**—"Art & Politics: Cuba after the Revolution" by Eva Cockcroft, in *Art in America,* 71, December 1983, pp. 35–39; by

Gerardo Mosquera, in *Art Nexus* (Colombia), 18, October/December 1995, p. 42.

* * *

Raúl Martínez is one of the most celebrated Cuban artists of the last half of the twentieth century. Since the 1958 revolution that brought socialism to the island, his paintings and graphics have been intimately tied to the goals and policies of the Communist government of Fidel Castro. His popular works appear in venues as diverse as postage stamps, political posters, and traditional museum exhibitions.

Martínez was born in 1927 in Ciego de Ávila in Camagüey province. In the 1940s he studied at the Academy of San Alejandro in Havana for four years and then attended the Art Institute of Chicago. As a young painter in the decade of the 1950s, he joined the Grupo de los Once, 11 Cuban artists who accepted the values and styles of American abstract expressionism. He worked primarily with large fields of color. The movement, however, failed to connect with the traditions of the Cuban avant-garde, earlier generations who, in spite of their progressive styles, had retained the folk themes and narratives that were so vital to the construction of a modern national identity. In 1954 Martínez headed the O.T.P.L.A. advertising agency while continuing to paint. He became involved in the revolution that toppled the dictatorship of Fulgencio Batista in 1958.

In the 1960s Martínez rejected his earlier focus on individual expression and took on socialist norms of artistic production and the role of the artist as a cultural worker. He became a champion of the socialist regime, which initiated unprecedented government support for the arts during the decade. He also became involved in its numerous artistic organizations. In 1960 he edited the socialist publication *Lunes de Revolución* and directed the Insituto Cubano del Libro.

In 1964 Martínez exhibited his *Homenaje* (''Homage'') series, which broke with his earlier abstraction. The works included letters, photographs, and imagery drawn from billboards, advertising, and other popular sources. In all likelihood the change was inspired by the work of the contemporary American Robert Rauschenberg, but it also satisfied the need for content in the art of revolutionary Cuba. The success of the series led to a further simplification of forms taken directly from popular culture, more akin to the work of pop artists such as Andy Warhol and Roy Lichtenstein. Martínez's style was characterized by flat images based on photography but rendered with heavy black outlines and in brilliant primary colors. Some critics drew immediate formal connections with the work of Amelia Peláez, considered the mother of modern art on the island, as well as with the themes of the propagandistic and social realist art of the Soviet Union, eastern Europe, and China.

Martínez's graphic imagery was quickly put to use by the revolutionary government, which commissioned posters and billboards for a host of institutions and in its efforts to mobilize public support. His subjects included portraits of national heroes such as José Martí (1853–95) and others involved in the struggle for independence from Spain but also individuals who had led or taken part in the 1950s revolution, including Che Guevara (1928–67) and Fidel Castro, and figures from international Communism, including Marx and Lenin. His paintings also included repetition of symbols identified with socialism and Communism, the hammers, sickles, and stars that characterized official Soviet iconography. He received widespread attention as a result of his designs for postage stamps and for posters

for youth organizations, other governmental agencies, and international gatherings of the Soviet bloc and the Third World. His best known work, however, was done for the Cuban cinematographic industry, known as I.C.A.I.C. One of the best known images, a poster bearing the likenesses of three women across the course of Cuban history, was made for the popular film *Lucia*. Martínez's art survived accusations of sloganism and propaganda, and toward the end of his life, he continued to advocate for government support of the arts in Cuba.

—H. Rafael Chácon

MARTÍNEZ-CAÑAS, María
American photographer

Born: Havana, Cuba, 19 May 1960; raised in Puerto Rico, 1964–78; moved to the United States, 1978. **Education:** Philadelphia College of Art, 1978–82, B.F.A. in photography 1982; Art Institute of Chicago, M.F.A.1984. **Career:** Photography instructor, New World School of the Arts, Miami. Traveled to Spain, 1983, 1985–86, 1989. **Awards:** Fellowship, Fullbright-Hays Foundation, 1985; individual artist fellowship, Division of Cultural Affairs, Florida Department of State, 1987; fellowship, National Endowment for the Arts, 1988; visual and media artists fellowship, South Florida Cultural Consortium, Metro-DadeCultural Affairs Council, Miami, 1992.

Individual Exhibitions:

1983 Museo de la Universidad de Puerto Rico, Rio Piedras
1984 *XV rencontres internationales de la photographie,* Arles, France
1987 Key Biscayne Library, Florida
1988 Marianne Deson Gallery, Chicago
1991 *Fragmented Evidence,* Catherine Edelman Gallery, Chicago
 Encounters 1: María Martínez-Cañas, Center for Creative Photography, Tucson, Arizona
1992 *Nuevos Rumbos,* Catherine Edelman Gallery, Chicago
 Recent Works, Visual Studies Worshop, Rochester, New York *Fragmented Evidence,* Chrysler Museum, Norfolk, Virginia *Rumbos,* Barbara Gillman Gallery, Miami
1993 *Accounts Southeast: María Martínez-Cañas,* Southeast Museum of Photograhy, Dayton Beach
1994 *Cronologías: 1990–93,* Iturraide Gallery, Los Angeles
1995 *Imagen Escrita,* Catherine Edelman Gallery, Chicago
 Totems Negros: Constructed Photographs by María Martínez-Cañas, Southeast Museum of Photograhy, Daytona Community College
1997 *4 Series/4 Years: 1992–1996,* Julie Saul Gallery, New York
 Robert B. Menschel Photography Gallery, Syracuse University, New York
 Piedras, Iturraide Gallery, Los Angeles and Catherine Edelman Gallery, Chicago
1999 *Shadow Gardens,* Fredric Snitzer Gallery, Miami
 Traces of Nature, Julie Saul Gallery, New York

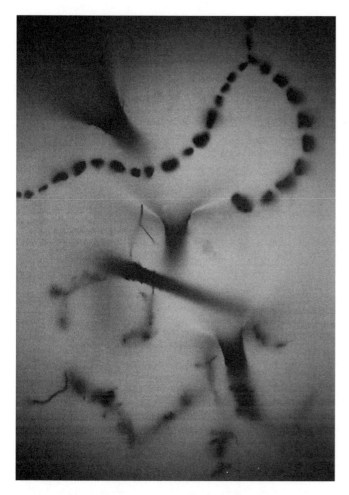

María Martínez-Cañas: *Traces of Nature: 19,* **1999. Photo courtesy of Julie Saul Gallery, New York.**

María Martínez-Cañas: New Work, Catherine Edelman Gallery, Chicago

María Martínez-Cañas: Quince Sellos Cubanos, The Phillip and Muriel Berman Museum of Art, Ursinus College, Collegeville, Pennsylvania

Años Continuos: An Installation by María Martínez-Cañas, Southeast Museum of Photography, Daytona Community College, Daytona Beach, Florida

2000 Catherine Edelman Gallery, Chicago

Jardines de Sombra/Shadow Gardens, Galeria Arte X Arte, Buenos Aires

National Museum of Women in the Arts, Washington, D.C.

Selected Group Exhibitions:

1982	Museum of Modern Art of Latin America, Organization of American States, Washington, D.C.
1985	Museo de la Universidad de Puerto Rico, Rio Piedras
1986	Chicago International Art Expo
1988	*Fuera de Cuba,* State University of New Jersey, Rutgers, and University of Miami
	Contemporary Art Center, New Orleans

1990	*Personal Odysseys,* Intar Gallery, New York
1995	*Points of Entry: Tracing Cultures,* Ansel Adams Center, Friends of Photography, San Francisco (traveling)
1998	*Cubazon: 11 Conceptual Photographers,* Generous Miracles Gallery, New York
1999	*Night and Day,* Centro Cultural Espanol, Miami
2000	*Cuban Allure: Photography and Video,* Light Factory, Charlotte, North Carolina, and Sibell Wolle Fine Arts Building, University of Colorado, Boulder
	Departing Perspectives, Site-Specific Installation, Spirito Santo Bank, Miami
	Abundant Invention, Wave Hill, Bronx, New York

Selected Public Collections:

Bibliotheque Nationale, Paris; Center for Creative Photography, Arizona; International Museum of Photography, George Eastman House, Rochester, New York; Museum of Modern Art, New York; Museum of Modern Art of Latin America, Organization of American States, Washington, D.C.; Asociación Puertorriqueña de la UNESCO, San Juan; Cintas Foundation, New York; Los Angeles County Museum of Art; Museé d'Art Moderne de la Ville de Paris; Museé du Cenre George Pompidou, Paris; National Museum of American Art, Smithsonian Institution, Washington, D.C.; Palacio de Bellas Artes, Mexico City; San Francisco Museum of Modern Art; Visual Studies Workshop, Rochester, New York.

Publications:

On **MARTÍNEZ-CAÑAS: Books**—Personal Odysseys, exhibition catalog, text by Moira Roth, New York, Intar Gallery, 1989; *Tracing Cultures* by Rebecca Solnit, San Francisco, Friends of Photography, 1995; *Criticizing Photographs: An Introduction to Understanding Images* by Terry Barrett, Mayfield Publishing, 1999. **Selected Articles**—"Photography: Jorge García Garcia and María Martínez-Cañas" by Félix Bonilla Norat, in *San Juan Star Magazine,* December 4, 1977; "Photographers Bring New Views to Gillman Show" by Helen L. Kohen, in *Miami Herald,* April 30, 1982; "Everything's Fine in Puerto Rico As It Is" by Myrna Rodriguez, in *San Juan Star,* October 13, 1985; "Away from Home, A New Generation Refines Style" by Diana Montané, in *Miami News,* September 30, 1988; "Latin American Artists of the South East Coastal Region" by Leslie J. Ahlander, in *Arte En Colombia Internacional,* spring 1990; "María Martinez-Cañas: Profile" by Elisa Turner, in *Latin American Art Magazine,* June 1993; "From Diversity Come Struggles" by Vicky Goldberg, in *New York Times,* November 27, 1994; "Emotions of Life in Exile Animates Artist's Work" by Elisa Turner, in *Miami Herald,* September 14, 1997; "María Martínez-Cañas" by Justin Spring, in *Artforum,* November 1999; "Art at Work" by Elisa Turner, in *Miami Herald,* May 23, 2000.

* * *

The medium of photography has afforded María Martínez-Cañas the opportunity not only to explore the use of the camera to go beyond the merely documentary but also to create images that become part of a unique symbolic vocabulary based on personal issues and experiences. Using maps, the archaeological record, art history, and

other visual references and combining them with her own photographs in a complex collage of negative images and drawing, she has developed a distinctive technical process to incorporate past and present, real and imagined, in a single work. Over the years her art has evolved from a concern with geography and personal identity used to trace her own voyage of exile and reminiscences to exquisite designs based on new journeys and natural forms that are statements about the aesthetics of black-and-white compositional interrelationships fundamental to the art of photography itself.

As a Cuban artist living in exile, Martínez-Cañas has used her art as a means of connecting to the land of her birth, a place she could only imagine through the memories of her family, who kept its beauty and culture alive. Over the years stamps, maps, and the ruins of time and place have appeared as symbols of nostalgia and reminiscence in numerous series. Her journey of self-discovery began with a research trip to the General Archive of the Indies in Seville, Spain, in 1985–86. The information in the archive provided physical contact with her heritage and the history of her homeland for the first time and inspired her to create images that combined photographs of maps with drawings cut out of plastic film that could be developed as part of the photographic process. Taking advantage of positive/negative effects, she creates elegant compositions that transcend mere reproductions or photographic documents. Utilizing the repetition of ''conventional negatives'' of places, landscapes, and other objects, she creates a pattern that is unique rather than a record of exact locations. As the images are cut apart and reorganized in a puzzle of shapes and forms, she reframes them within graceful designs of black and white. Their delicacy mingles with the pattern of forms to create complex scenarios that function like road maps through a time and place that are familiar yet nowhere recognizable.

In her late works Martínez-Cañas has continued her efforts to explore paths of personal identity, now derived from the plants, grasses, and flowers found in the garden of her Miami home. The garden serves as a metaphor for her innermost feelings and as a location of tranquility amid the chaos of modern life. Florida offers an abundance of tropical flora with exotic descriptions that the photographer dissects and isolates before she captures them with her camera so that she can restructure the microscopic elements into refined compositions.

—Carol Damian

MARTINS, Maria
Brazilian sculptor

Born: Maria de Lourdes Alves, Minas Gerais, 7 August 1900.
Education: Studied art, Academie des Beaux-Arts, Rio de Janeiro, and Academie des Beaux Arts, Paris; studied sculpture under Oscar Jespers, Belgium, 1939; also studied under Catherine Barjanski and Jacques Lipchitz. **Family:** Married Carlos Martins Pereira e Sousa in 1926, three daughters; involved with artist Marcel Duchamp, c. 1945. **Career:** Traveled to Ecuador, 1926, and to Japan; lived in the United States, c. 1942–50. Newspaper columnist, *Correio de Manha,* Rio de Janeiro. Organizer of first São Paulo Biennial, 1951. Cofounder, Fundação do Museu de Arte Moderna do Rio de Janeiro. Member, Surrealist movement, c. 1940. **Awards:** Second prize, 1953, and first prize, 1955, São Paulo Biennials. **Died:** Rio de Janeiro, 26 March 1973.

Individual Exhibitions:

1951	Corcoran Art Gallery, Washington, D.C.
1942	Valentine Gallery, New York
1943	Valentine Gallery, New York
1944	Valentine Gallery, New York
1946	Valentine Gallery, New York
1947	Julien Levy Gallery, New York
1949	Galerie Rene Drouin, Paris
1950	Museu de Arte Moderna, Sao Paulo
1956	Museu de Arte Moderna, Rio de Janeiro (retrospective)
1959	São Paulo Museum of Modern Art

Selected Group Exhibitions:

1940	*Pittsburgh International,* Carnegie Institute
	Latin American Exhibition of Fine Arts, Riverside Museum, New York
1942	Bucholz Gallery, New York
1944	Dayton Museum, Ohio
1946	*Origins of Modern Sculpture,* City Art of St. Louis, Missouri
1947	*International Surrealist Exhibition,* Paris
1953	*São Paulo Biennial*
1955	*São Paulo Biennial*

Collections:

Metropolitan Museum of Art, New York; Philadelphia Museum of Art.

Publications:

By MARTINS: Books—*Asia Major: O planeta china,* Rio de Janiero, 1958; *Deuses malditos: I. Nietzsche,* Rio de Janiero, 1965.

On MARTINS: Books—*Maria 1946,* exhibition catalog, New York, 1946; *Maria: Recent Sculptures,* exhibition catalog, New York, 1947; *Le Surrealisme en 1947: Exposition international du surrealisme,* exhibition catalog, Paris, 1947; *Maria,* exhibition catalog, Rio de Janeiro, 1956; *Painting and Sculpture in the Museum of Modern Art, 1929–1967* by Alfred H. Barr, Jr., New York, 1977; *Imaginarios singulares,* São Paulo, Bienal de São Paolo, 1987; *The Latin American Spirit: Art and Artists in the United States, 1920–1970,* New York, 1988; *Maria Martins: Mistério das formas* by Katia Canton, São Paulo, Ed. Paulinas, 1997; *Maria: The Surrealist Sculpture of Maria Martins,* exhibition catalog, New York, André Emmerich Gallery, 1998. **Articles**—''Brazilian Sculpture: A Very Vague Outline'' by A. C. Callado, in *The Studio,* 126, 1943; ''Maria Martins: A juventude sempre tem razao'' by Clarice Lispector, in *Manchete,* 21 December 1968; ''Sculpture surrealiste: Premiere explication suivie d'un repertoire'' by Sarane Alexandrian, in *Connaissance des Arts,* July 1972; ''The Bachelor's Quest'' by Francis Naumann, in *Art in America,* September 1993.

* * *

In a catalog presentation of Maria Martins's retrospective exhibition at the Museu de Arte Moderna in Rio de Janeiro in 1956, the Brazilian poet Murilo Mendes wrote, ''To create a Surrealist atmosphere is the goal of [Martins's] work. As system and doctrine,

Surrealism may indeed be considered a thing of the past, but does it not, by definition, escape any attempt [at] systematization? In fact, Surrealism subsists as [an] element for the creation of poetic atmospheres. Here resides its power. And as such, Surrealism has always existed, since the beginning of the world, contributing to the themes and to the development of many works of art. We live in a Surrealist country. I usually say that the frontiers of logic and . . . psychology disappear in Brazil. Indeed, how would one account, except by means of a Surrealist code, for what has happened, for instance, in Brazil these last years in politics and in the economy?''

The logic of surrealism is a logic of excess, of the breaking of barriers between reality and the dream, a logic of desire or of the very essence of reality as desire, the subject's desire revealing itself as the desire of desire (the very essence of desire's otherness) and disclosing itself here as the familiar shadow of the unfamiliar at the term of the artist's quest. According to Mendes's observation, in the case of Martins the surrealist artist's "descent" into the individual sources of the dream, toward the origins of imagination–or imagination as origin–in the end discovers itself in close proximity to the realities of the Brazilian social, political, and cultural universe, where logic and psychology find themselves unable to master the structures of being.

Aspects of the surreal in Brazilian reality and in the imaginary were reflected in early Brazilian avant-garde art, for instance, in the *antropofagia* series of Tarsila do Amaral in the late 1920s, with its oneiric, fabulous, and ancestral visions of the "primitive." And yet, at the time when Mendes wrote his fine commentary on Martins's works, Brazilian art had already started to embark, after a couple of decades of expressionistic affiliations, cultural identity searching, and sociopolitical commentary, on a path of technological commentary and inspiration, toward a formal, constructive art. This reflected the prospects of a decade in the making of advances in dependent capitalist development with its corollary of rapid industrialization, the creation of concentrated wealth and industrial poverty, mass urbanization, modernization, free markets, and social and political tensions.

From the point of view of the "will to the functionally modern," Martins's work was already becoming "out of time," out of joint with the ideological realities and ideological demands of the new time. The sculpture prizes she received in the São Paulo Biennial in 1953 and 1955 signaled both the recognition of the work of the artist (whose formative and productive years developed outside Brazil in close contact with the French and the American avant-gardes) and, by the close of the decade, the beginning of a long period of neglect that would end only in the 1990s.

In its own radical aspects, however, it is possible to say that the work of Martins reflected the surrealist project to the point at which surrealism as artistic doctrine and established procedure could be deflected and turned against itself. In his short essay Mendes underscored the paradox of Martins's use of the surrealists' method of automatism in sculpture with hard, resisting, slow-working materials. As if doubling the works of nature itself, growth and decay, forms that interpenetrate, develop, arrest, and devour each other, abundance and poverty, novelty and repetition, all are fused in these sculptural objects, organic, superorganic, and visionary, that speak also of the paradoxical reflections of the artist's reality in the work of art. In this sense the works can be seen as embodiments of primary processes, as if demonstrating again and again the fragility of all secondary elaborations.

"The spirit nowadays is blowing from the warm lands," wrote André Breton about Martins's works, for it is where nature is at its most exuberant that the true life of the mind can assert itself against the poverty of all intellectualism. "Possession by the soul of Nature," he wrote, "bring us close to the source of the Sacred." In the baroque excesses and repetitions of their forms and themes, the works of Martins echo something of that experience of beauty as *terribilitá*. All art is a form of expectation, of gestation, and to expect is to die a little with anticipation at every moment, to die a slow, burning death in a process of which only the corpses and carcasses, as memorials and monuments of conception, will finally remain. In the end the work of art is the empty shell of dreams lying always a little below or a little beyond the efforts of creation and the efforts of being.

Pointed out by many contemporary and later critics, the formal irresolutions and repetitions of Martins's works may present us with the final paradox of a truly deformative vision, a consciously degenerative artistic process, one that, thematizing origin and end, birth and death, the power and fragility of being, frustration and desire, succeeds precisely when (or because) it fails.

—Marcelo Guimarães Lima

MARTORELL, Antonio

American painter, printmaker, illustrator, and installation artist

Born: Santurce, Puerto Rico, 1939. **Education:** Taller de Julio Martín, Spain; Printmaking Workshop, Instituto de Cultura Puertorriqueña; studied engraving with Lorenzo Homar and Rafael Tufiño, Puerto Rico. **Career:** Director, Escuela de Artes Plásticas; teacher, Academia San Alejandro. Artist-in-residence, Universidad de Puerto Rico, Cayey. Member, Talleres Artes Graficás, Instituto de Cultura Puertorriqueña, 1962–65. Founder, print collective Taller Alacrán, San Juan, early 1960s.

Individual Exhibitions:

1964	New York Art Director's Club
1968	Galería Colibrí, San Juan
1981	Museo de Arte Moderno, Mexico City
1986	*Antonio Martorell: Obra grafica, 1963–1986,* Instituto de Cultura Puertorriqueña, San Juan
1994	National Building Museum, Washington, D.C.
	El Museo del Barrio, New York
1995	PS 48, New York
1997	Hostos Center for Arts and Culture, New York
	La casa letrada, El Museo del Barrio, New York
	Objetos del ausente, University Art Museum, University of Albany, New York
2000	*Reunión,* Museo de las Américas and Petrus Gallery, San Juan

Selected Group Exhibitions:

1964	Galería Colibrí, San Juan
1965	Randolph Gallery, Houston
1968	Galerie San Juan
1969	Galerie San Juan

1970 Galerie San Juan
1989 *The Latin American Spirit: Art & Artists in the U.S.,*
 Bronx Museum, New York
1992 Museo de Arte de Ponce, Puerto Rico, and El Museo
 del Barrio, New York
1997 *1997 Biennial Exhibition,* Whitney Museum of Ameri-
 can Art, New York
1999 *Dead Time = Tiempo muerto: Three Artists Exhibiti,*
 Taller Boricua Gallery, New York

Collections:

El Museo del Barrio, New York; Whitney Museum of American Art, New York; American Institute of Graphic Arts, New York; Art Institute of Chicago; Ateneo Puertorriqueño, San Juan; Casa del Libro, San Juan; Instituto de Cultura Puertorriqueña, San Juan; Metropolitan Museum of Art, New York; Museum of Modern Art, New York; Museo de Arte de Ponce, Puerto Rico; Universidad de Puerto Rico, Rio Piedras; Princeton University Library, New Jersey.

Publications:

By MARTORELL: Books—*La piel de la memoria,* Puerto Rico, Ediciones Envergadura, 1991; *Brincos y saltos: El juego como disciplina teatral: Ensayos y manual de teatreros ambulantes,* with Risa Luisa Márquez and Miguel Villafañe, Cayey, Puerto Rico, Ediciones Cuicaloca, 1992; *José Morales: Obra reciente,* exhibition catalog, with Verna Rosado, Hato Rey, Puerto Rico, Galería Raíces, 1993; *Carteles de Lorenzo Homar: Una muestra,* exhibition catalog, with Arcadio Díaz Quiñones, Turabo, Puerto Rico, Universidad del Turabo, 1994; *La Canción del coquí y otros cuentos de Puerto Rico,* with Nicholasa Mohr, New York, Viking, 1995; *El libro dibujado: El dibujo librado,* Cayay, Puerto Rico and New York, Ediciones Envergadura, 1995. **Books, illustrated**—*ABC de Puerto Rico* by Rubén del Rosario and Isabel Freire de Matos, Sharon, Connecticut, Troutman Press, 1968; *Oda a la lagartija* by Pablo Neruda, Campo Rico de Canóvanas, P.R. Martorell, 1974; *The Rainbow-Colored Horse* by Pura Belpré, New York, F. Warne, 1978; *Andando el tiempo* by Eraclio Zepeda, second edition, Mexico City, Martín Casillas, 1983; *F. Manrique Cabrera,* San Juan, Instituto de Cultura Puertorriqueña, 1984; *Allá donde florecen los framboyanes* by Alma Flor Ada, Miami, Alfaguara, 2000.

On MARTORELL: Books—*Album e familia: Exposición de Antonio Martorell, dibujos, collages y grabados,* exhibition catalog, Mexico City, Museo de Arte Moderno, 1981; *Antonio Martorell: Obra grafica, 1963–1986,* exhibition catalog, San Juan, Instituto de Cultura Puertorriqueña, 1986; *Los carteles de Martorell,* exhibition catalog, Bronx, New York, Hostos Culture & Arts Program, 1987, and *Visual Artists and the Puerto Rican Performing Arts, 1950–1990: The Works of Jack and Irene Delano, Antonio Martorell, Jaime Suárez, and Oscar Mestey-Villamill,* New York, Peter Lang, 1997, both by Nelson Rivera; *Exposición, la casa de todos nosotros: Antonio Martorell y sus amigos,* exhibition catalog, edited by Susana Torruella Leval, New York, Museo del Barrio, 1992; *Reunión,* exhibition catalog, San Juan, Museo de las Américas, 1999. **Articles**—''Martorell and the Graphical Work'' by Gloria Ines Daza, in *Spectator* (Bogota), October 1972; ''Teatristas en el museo: 'Huellas de hojalata' de Antonio

Martorell'' by Priscilla Melendez, in *Latin American Theatre Review,* 25(1), fall 1991, pp. 157–160; ''The Houses of Antonio Martorell: With Caribbean Sensualism by Mari Carmen Ramírez,'' in *Art Nexus* (Colombia), 11, January/March 1994, pp. 214–216; ''Antonio Martorell'' by K. Mitchell Snow, in *Latin American Art,* 5(4), 1994, p. 72; ''Antonio Martorell'' by Octavio Zaya, in *Flash Art* (Italy), 187, March/April 1996, p. 101; ''Antonio Martorell at the Hostos Center for Arts and Culture'' by Jonathan Goodman, in *Art in America,* 85, December 1997, p. 89; ''Antonio Martorell: Museum of the Americas and Petrus Gallery'' by Manuel Alvarez Lezama, in *Art Nexus* (Colombia), 35, February/April 2000, pp. 135–136.

* * *

Antonio Martorell has carried the multifaceted interests and skills that characterize his teacher, Lorenzo Homar, to ever-expanding areas. Installation artist, printmaker, portrait painter, book illustrator, set designer, actor, and writer, he constantly tackled new media to renew his interventions in the art world. Upon his return to Puerto Rico in 1962, after studying in Spain with painter Julio Martín Caro, Martorell apprenticed in the Printmaking Workshop of the Instituto de Cultura Puertorriqueña under Homar. Woodcut was the first medium he used to produce dramatic and somber images; he has used woodcut extensively throughout his career, in print portfolios and for his installations. Silk screen became another important medium to produce posters and wallpaper designs, notably in the Taller Alacrán, a workshop Martorell established in the early 1960s aimed at creating graphic work at prices that would facilitate a wide distribution. The Taller Alacrán provided work and training to other young artists and led to the establishment of other workshops in the late 1960s.

Martorell's profound sense of irony is present in his political prints, especially the *Barajas Alacrán* (''Scorpion Playing Cards'') of 1968, in which he satirized the elections in large-scale prints and in sets of cards. In the 1970s and early 1980s he produced a notable number of print portfolios based on the poetry of Ernesto Cardenal (*Psalms,* 1971; *Prayer for Marilyn Monroe,* 1972), Pablo Neruda (*Ode to the Lizard,* 1973), Antonio Machado (*Flies,* 1975), and Mario Benedetti (*Office Poems,* 1982). Armed with his portfolios, Martorell traveled throughout South America in the 1970s and settled in Mexico, where he taught at the Academia San Alejandro and even starred in a television production in which he drew illustrations based on stories told by Eraclio Zepeda.

Back in Puerto Rico in the early 1980s, Martorell became a ''public intellectual'' insofar as his writings, exhibitions, designs for theater sets and wardrobe, costumes for the Ponce Carnival, and installations became widely known. He turned to performance-installations, beginning with *Mano-Plazo* in 1985, based on the forced entry of his residence and destruction of his art by the FBI. As artist in residence at the University of Puerto Rico in Cayey since 1985, Martorell collaborated extensively with the troupe Teatreros de Cayey. In Cayey he turned to painting and portraiture, but his major production since then has been as an installation artist, a medium he has used to produce elaborate environments that combine found objects with prints and paintings and feature the artist's extraordinary calligraphic writing. His outspoken and profound critiques, his amazing capacity for undertaking large-scale productions, and the quality of his output in many media have made Martorell widely known and respected in Puerto Rico.

—Marimar Benítez

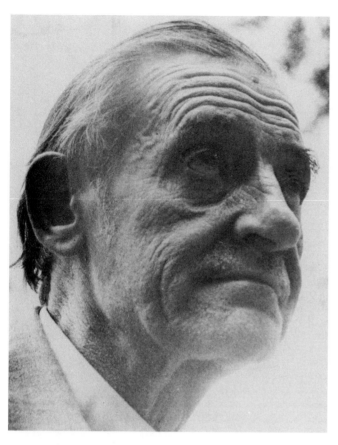

Roberto Matta. Photo courtesy of Private Collection/Lucien Herve/ Bridgeman Art Library.

MATTA, Roberto (Sebastian Antonio Echaurren)

French painter and sculptor

Born: Santiago, Chile, 11 November 1911; Chilean nationality stripped by Pinochet government. **Education:** College of the Sacred Heart, Santiago, c. 1928; studied architecture, Catholic University, Santiago, 1929–31, Dip. Arch., 1931. **Family:** Married Germana Matta in 1940; four sons and two daughters. **Career:** Interior decorator, Santiago, 1928; merchant seaman, Compagnie Transatlantique ship to Europe, 1933; architectural assistant, Le Corbusier studio, Paris, 1935–36. Independent painter, Paris, 1938–39, New York, 1939–48, Rome, 1948–54. Since 1955 painter, Paris. Visiting instructor, Minneapolis School of Art, 1966. Member, with Federico Garcia Lorca, André Breton, Salvador Dali, and Marchel Duchamp, *Surrealist Group Paris,* 1937–48, 1959—; founder, *Etrusculudens,* Etruscan crafts artisan group, 1972. President, Cultural Congress, Havana, 1968. **Award:** Premio Marzoto, Rome, 1962. **Address:** 145 Boulevard Saint-Germain, 75006 Paris, France.

Individual Exhibitions:

1940	Julien Levy Gallery, New York (with Pavel Tchelitchew)
1942	Pierre Matisse Gallery, New York (regularly until 1948)
	Art of This Century, New York
1944	Art of This Century, New York
1945	Sidney Janis Gallery, New York
1947	Galerie René Drouin, Paris
	Hugo Gallery, New York
1948	William Copley Gallery, Beverly Hills
1950	Galleria del'Obelisco, Rome
	Galleria Schneider, Rome
	Galleria del Cavallino, Venice
	Galleri del Naviglio, Milan
	Sidney Janis Gallery, New York (regular showings)
1951	Institute of Contemporary Arts, London
1952	Allan Frumkin Gallery, New York
1953	Sala Napoleonica, Venice
	Alexander Iolas Gallery, New York
1954	Museo de Arte Moderno, Lima
	Museo de Arte Moderno, Santiago
	Galleria del Cavallino, Venice
1955	Galerie du Dragon, Paris
	Galleri Colibu, Malmo, Sweden
	Pan American Union, Washington, D.C.
	Alexander Iolas Gallery, New York
1956	*Matta: Terres nouvelles,* Galerie du Dragon, Paris
1957	Museum of Modern Art, New York (retrospective)
	Ruth Moskin Gallery, New York
1958	Galleria Galatea, Turin
1959	Moderna Museet, Stockholm
	Galerie Daniel Cordier, Frankfurt
	Galerie Daniel Cordier, Paris
1960	Galleria del Naviglio, Milan
1961	Gimpel Fils Gallery, London
	Cordier and Warren Gallery, New York
1962	Galleria L'Attico, Rome
	Galerie Le Point Cardinal, Paris
	Gimpel Fils Gallery, London
1963	Allan Frumkin Gallery, New York
	Alexander Iolas Gallery, New York
	Galleria Schwarz, Milan
	Museo Civico, Bologna
	Galerie Edwin Engelberts, Geneva
	Casa de la Americas, Havana
	Auslander Gallery, New York
	University of Chicago
	Frank Perls Gallery, Los Angeles
	Kunsthalle, Dusseldorf
	Robert Fraser Gallery, London
	Museum des 20. Jahrhunderts, Vienna
	Galerie Le Point Cardinal, Paris
1964	Palais des Beaux-Arts, Brussels
	Stedelijk Museum, Amsterdam
	Städtische Kunsthalle, Mannheim, Germany
	Galerie Michael Hertz, Bremen, Germany
	Casa de la Americas, Havana
	Galerie Van de Loo, Munich
	Gimpel und Hanover Galerie, Zurich
1965	Kunstmuseum, Lucerne
	Galeria del Techo, Caracas
	Gimpel Fils Gallery, London
1966	Institute of Contemporary Arts, Lima
	Galerie Alexander Iolas, Paris
1967	Walker Art Center, Minneapolis

Roberto Matta: *Psychological Morphology,* **1939. Photo courtesy of Art Gallery of Ontario, Toronto, Canada/Purchased with donations from AGO Members and V.C. Fund, 1991/Bridgeman Art Library. © 2002 Artists Rights Society (ARS), New York/ADAGP, Paris.**

	Palais de Mutualité, Paris		Galeria Aele, Madrid
	Galleria Senior, Rome		Museo de Arte Moderno, Mexico City
	Galleria S. Luca, Rome		Museo de Arte Moderno, Bogota
	Casa de las Americas, Havana		Museo de Bellas Artes, Caracas
	Musée d'Art et d'Histoire, Saint-Denis, France	1975	Andre Crispo Gallery, New York
1968	Alexander Iolas Gallery, New York		Alexander Iolas Gallery, New York
	Musée d'Art Moderne de la Ville, Paris		*L'Homme descend du signe: Mattapastelli,* Galleria
	Galleria La Medusa, Rome		dell'Orca, Rome
1970	Nationalgalerie, Berlin		Palazzo della Loggia, Brescia, Italy
	Maison de la Culture, Ameins (with Claude Parent)		Kettles Yard Gallery, Cambridge
	Centre Culturel Municipal, Villeparisis, France		Hodel de Ville, Venissieux, France
	Galerie Michael Hertz, Bremen, West Germany	1976	Casa de las Americas, Havana
1973	Galleria Il Fauno, Turin	1977	Palazzo degli Alessandri, Viterbo, Italy
	Palazzo di Diamanti, Ferrara, Italy (toured Italy)		*Coigitum,* Hayward Gallery, London
	Alexander Iolas Gallery, New York	1978	Kettles Yard Gallery, Cambridge
	Museo Civico, Bologna		Galerie du Dragon, Paris
	Pinacoteca Comunale, Ravenna, Italy	1979	Stamperia della Beauga, Florence
	Centro Storico, Livorno, Italy		Centre Culturel Municipal, Villeparisis, France
1974	Belle Ciao, Terni, Italy		Universita di Urbino, Italy
	Kestner-Gesellschaft, Hannover (toured Germany)	1980	Palazzo degli Alessandri, Viterbo, Italy
	Office Culturel, St. Etienne du Rouvray, France		Galerie Kinge, Paris

Roberto Matta: *The Fruit,* **1965. Photo courtesy of Hamburg Kunsthalle, Hamburg, Germany/Bridgeman Art Library.© 2002 Artists Rights Society (ARS), New York/ADAGP, Paris.**

Paintings and Drawings 1971–79, Tasende Gallery, La Jolla, California (traveled to Blanden Memorial Art Gallery, Fort Dodge, Iowa)

1982 *Roberto Matta: Architecte du temps,* Theatre d'Ivry, Ivry-sur-Seine, France
Riverside Studios, Hammersmith, London

1983 Palacio de Cristal, Madrid

1984 City Museum and Art Gallery, Plymouth, Devon (traveled to Oxford, Swansea, Sheffield, Bolton, and Newcastle-upon-Tyne)

1995 *Roberto Matta: Chilean Surrealist,* Sindin Galleries, New York

1997 *Roberto Matta: Paintings and Drawings,* Andre Emmerich Gallery, New York
Roberto Matta: Paintings and Drawings: 1937–1959, Latin American Masters, Beverly Hills, California
MATTA 1940s-1990s: Following the Footsteps of a Giant, Sindin Galleries, New York

Selected Group Exhibitions:

1937 *Surrealisme,* Galerie Wildenstein, Paris
1938 *Exposition internationale du surrealisme,* Galerie des
 Beaux-Arts, Paris
1940 *Second International Surrealist Exhibition,* Mexico City
1946 *5 Big Paintings,* Museum of Modern Art, New York
1948 *Venice Biennial*
1964 *The Emergent Decade,* Solomon R. Guggenheim
 Museum, New York, and Cornell University, Ithaca,
 New York
1968 *Dada, Surrealism and their Heritage,* Museum of
 Modern Art, New York
1981 *A New Spirit in Paintings,* Royal Academy of Art,
 London
1997 *Surrealistic Pillow,* Nolan/Eckman Gallery, New York
1998 *Latin American Artists: Paintings and Drawings,* CDS
 Gallery, New York

Collections:

Musée National d'Art Moderne, Paris; Nationalgalerie, Berlin; Stedelijk Museum, Amsterdam; Baltimore Museum of Art; City Art Museum, St. Louis, Missouri; Lawrence Art Museum, Williamstown, Massachusetts; Walker Art Center, Minneapolis; Art Institute of Chicago; University of Chicago; Allan Frumkin Gallery, New York; Solomon R. Guggenheim Museum, New York; Maxwell Davidson Gallery, New York; Museum of Modern Art, New York; Museum of Modern Art of Latin America, Washington, D.C.; Pierre Matisse Gallery, New York; San Francisco Museum of Modern Art.

Publications:

By MATTA: Books—*Duchamp's Glass,* with Katherine S. Dreier, New York, Société Anonyme, 1944; *Come detta dentrovo signifiando,* Lausanne, 1962; *Dialogo con Tarquinia,* Tarquinia, 1975.

On MATTA: Books–*Matta: Terres nouvelles,* exhibition catalog, by E. Glissant, Paris, 1956; *Matta,* exhibition catalog, by L. Hoctin, New York, 1957; *Matta,* exhibition catalog, by I. Gustafson, Stockholm, 1959; *Histoire de la peinture surrealiste* by Marcel Jean, Paris, 1959; *Matta,* exhibition catalog, by Werner Hofmann, Vienna, 1963; *Un revolution du régard* by Alain Jouffroy, Paris, 1964; *Matta: Le Multiplicateur de progrès* by José Pierre, Paris, 1967; *Catalog raisonne de l'oeuvre gravée de Matta,* compiled by Ursula Schmitt, Silkeborg, 1969; *Developpements sur l'infrarealisme de Matta* by Jean Schuster, Paris, 1970; *Matta,* exhibition catalog, introduction by Ursula Schmitt, Berlin, 1970; *Matta,* exhibition catalog, by Wieland Schmied, Hannover, 1974; *L'Homme descend du signe: Mattapastelli,* exhibition catalog, by Giuliano Briganti, Rome, 1975; *Matta: Catalog raisonné de l'oeuvre gravée,* compiled by Roland Sabatier, Stockholm and Paris, Georges Visat et Editiones Sonet, 1975; *Matta: Opere dal 1939 al 1975* by Luisa Laureati, Rome, 1976; *Matta: Coigitum,* exhibition catalog, by André Breton, London, Arts Council of Great Britain, 1977; *Matta: Index dell'opere grafica dal 1969 al 1980,* edited by Germana Farrari, Viterbo, Italy, 1980; *Roberto Matta: Paintings and Drawings 1971–1979,* exhibition catalog, by Peter Selz, J. M. Tasende, and André Breton, La Jolla, California,

1980; *Roberto Matta: Architecte du Temps,* exhibition catalog, by Thierry Sigg and Jean-Pierre Faye, Ivry, France, 1982; *Matta: The Logic of Hallucination,* exhibition catalog, by Paul Overy, London, 1984; *Matta,* Paris, Centre Georges Pompidou, 1985; *Matta: Conversaciones* by Eduardo Carrasco, Santiago, Ediciones Chile et America, 1987; *Matta: Uni Verso,* Santiago, Museo Nacional de Bellas Artes, 1991; *Matta* by Wieland Schmied, Germany, Ernst Wasmuth Verlag, 1991; *Matta: Corpo a corpo,* exhibition catalog, by Germana Ferrari, Milan, Feltrinelli, 1993; *Roberto Matta: Paintings & Drawings 1937–1959,* exhibition catalog, by Martica Sawin, Beverly Hills, California, Latin American Masters, 1997; *Matta: Surrealism and Beyond,* exhibition catalog, edited by Curtis L. Carter and Thomas R. Monahan, Milwaukee, Haggerty Museum of Art, 1997; *Matta,* Madrid, Museo Nacional Centro de Arte Reina Sofia, 1999. **Articles—**''The Mobile Matter of Roberto Sebastian Matta'' by Alvaro Medina, in *Art Nexus* (Colombia), 17, July/September 1995, pp. 68–75; ''Roberto Matta'' by Mary Schneider Enriquez, in *Art News,* 96, June 1997, p. 124; ''Roberto Matta'' by Celia Sredni de Birbragher, in *Art Nexus* (Colombia), 27, January/March 1998, pp. 56–59; ''Roberto Matta: Borges Cultural Center'' by Cristina Carlisle, in *Art News,* 98(2), February 1999, p. 124.

* * *

Born in 1911 in Santiago, Chile, Roberto Sebastian Matta Echaurren has spent the majority of his life outside his home country. Matta studied architecture at the Catholic University of Chile from 1929 to 1931 and eventually went to Europe to work under Le Corbusier in 1935. His subsequent contact with the surrealists led him to begin painting, which would become his principal expression for the remainder of his career.

In 1937 Matta began his earliest experiments in painting, encouraged by his friend and fellow artist Gordon Onslow-Ford. They collaborated on a series of works based on automatism, a surrealist technique that involves automatic drawing, or drawing by subconscious impulse. That same year André Breton declared Matta a surrealist. He exhibited his work at the 1938 International Surrealist exhibition in Paris and again at the Second International Surrealist exhibition in Mexico City in 1940.

The majority of Matta's works make reference to a narrative form, particularly poetry. The titles of the works are significant, bearing witness to a creative process that begins with an introspective study of signs. Early in his artistic career, Matta was deeply influenced by the work of Federico García Lorca, Pablo Neruda, and Gabriela Mistral. Their vision, a mixture of primitivist romanticism and psychological associations, infused his imagery with a sense of lyricism. In 1936, upon hearing of García Lorca's assassination, Matta wrote scripts for 162 short film scenes, titled *La terre est un homme,* about life and death in a world filled with tragedy and political turmoil. These would become the basis for a series of drawings and paintings by the same title.

Matta's painting technique has been consistent throughout his career. He would begin with a spot of paint that has been rubbed with a cloth, creating a nearly translucent effect. He then drew forms over this with a paintbrush or directly from the tube. During the 1930s Matta developed his concept of psychological morphology and created his first inscapes, which the artist thought of as landscapes of the inner mind. Futuristic in their form, these inscapes often juxtaposed a barren, futuristic vision of an indefinable landscape with abstract

forms drawn from basic organic shapes and conceived as the aesthetic form of the artist's own psychological state. Matta's psychological morphology similarly represented his concept of an introspective mental state that also drew its forms from organic substances such as clouds, rocks, water, microscopic organisms, and other natural forms. The surrealists believed that organic forms were particularly successful in creating associations in the mind of a viewer, as they were part of the natural environment. By creating work that was steeped in vaguely recognizable forms, Matta hoped to catalyze visual associations with the workings of the viewer's own inner mind.

In the early 1940s Matta began to increase his scale significantly, perhaps due in part to his contact with the abstract expressionists in the United States. In Mexico he painted *Invasion of the Night* (1941), which illustrates his early interest in pre-Columbian culture and his articulation of the concept of the land in the Americas as a primordial space that constantly evolved through volcanic irruptions and seismic activity. This period of Matta's interest in surrealism and pre-Columbian culture marked the gradual internationalization of his work. At the same time the horrors of World War II influenced his growing interest in scale and abstraction as universalizing characteristics, which he combined with organic forms to express social suffering. Here, watery areas of blue mingle with a plateaued landscape of burning yellow, as prehistoric creature-like forms occupy the earth and skies. In later works, such as *Wound Interrogation* (1948), anthropomorphic figures combine erotic and aggressive qualities, fiercely occupying the canvas. The tumultuous images force the viewer to confront human brutality and its assaults on life. The figures in the works multiply, becoming automatons that take over the space with military-like force.

Matta lived in New York City until about 1948, when he moved to Italy. That year marked his first participation in the Venice Biennial as well as his expulsion from the surrealist group by Breton. Since then, he has divided his home between France and Italy. In the early 1970s Matta became increasingly interested in ceramics. In Tarquinia he organized a group called Etrusculens, whose work combined ceramics, carved pieces, and metal sculpture; the group's work with ceramics influenced his own production. He has remained involved in ceramic work and has begun to translate his large-scale surrealist landscapes to ceramic tiles, which he has installed on a wall, mimicking a canvas. This was perhaps a most appropriate medium for an artist who deeply admired pre-Columbian art of the Americas. In deference to this legacy Matta believed that the job of the contemporary artist was to use the work of pre-Columbian artists as a model and to reinvigorate their contribution with contemporary signs taken from science, psychology, and political history.

—Rocío Aranda-Alvarado

MAZÓN, Alejandro

Cuban painter

Born: Havana, 25 May 1962. **Education:** Studied under Juan Gonzalez, School of Visual Arts, New York, 1980–83. **Career:** Moved to Madrid, 1964; to the United States, 1974. Since 1991 professional painter. **Agent:** George Billis Gallery, Wolf Building, 508 West 26th Street, 9th Floor, New York, New York 10001, U.S.A. **Website:** http://www.boksayfinearts.com.

Alejandro Mazón: *When Dolls Play,* 1999. Photo courtesy of the artist and George Billis Gallery, New York.

Individual Exhibitions:

1993 *Images of God,* Faulty Beagle Gallery, Kunkletown, Pennsylvania
 Icons for an Age of Consent, Chetwynd Stapylton Gallery, Portland, Oregon
1994 *The Spirit and the Flesh, A Walk through the Tarot,* Virginia Miller Gallery, Coral Gables, Florida
1995 *Ancient Echoes,* Chetwynd Stapylton Gallery, Portland, Oregon
1996 *Heaven and Hell: Images between Two Gardens,* Faulty Beagle Gallery, Kunkletown, Pennsylvania
 Carnival, Handsel Gallery, Santa Fe, New Mexico
 Walking in Dorothy's Shoes, Bucheon Gallery, San Francisco
1997 *Ghosts and Memories,* Virginia Miller Gallery, Coral Gables, Florida
1998 *At the Center of the Universe,* Faulty Beagle Gallery, Kunkletown, Pennsylvania
 Riverdale Skies, Handsel Gallery, Santa Fe, New Mexico
2000 *Orchids and other Monsters,* Borinken Gallery, New Paltz, New York
 Directions to My House, Galeria Borinken, New Platz, New York
 George Billis Gallery, New York

Selected Group Exhibitions:

1992 *Latin American Selections,* Virginia Miller Gallery, Coral Gables, Florida
1996 *Latin Visions: Works by Emerging Young Artists,* Thomas Center Gallery, Jacksonville, Florida
1996 *Art Miami '96,* Miami Beach Convention Center, Miami
1997 *For the Birds,* Bucheon Gallery, San Francisco
 Emerging Art, Handsel Gallery, Santa Fe, New Mexico
 Art Americas '97, Miami Convention Center

Alejandro Mazón: *In the Room Next Door,* 2000. Photo courtesy of the artist and George Billis Gallery, New York.

1998 *Latin American Art in the 90s,* St. John's University,
 Queens, New York
 Texas National Exhibition, SFA Gallery, Nacogdoches,
 Texas
1999 *Image of Latin America, Part I & II,* Monique
 Goldstrom Gallery, New York
2000 *Sweet, Sassy, Sordid, Sexy, Sordid,* Jan Baum Gallery,
 Los Angeles

Collections:

Austin Museum of Fine Arts, Laguna Gloria, Texas; Southern Alleghenies Museum of Art.

Publications:

On MAZÓN: Articles—"Alejandro U. Mazón" by Beth Hanson, exhibition review, in *Latin American Art,* 6(1), 1994, p. 72; "Artist's Surreal 'Circus' Crosses Good and Evil" by Myra Yellin Goldfarb, in *The Morning Call,* 3 July 1994; "Las cartas tiradas de Alejandro Mazón" by Armando Alvarez Bravo, in *El Nuevo Herald,* 9 November 1994; in *Art Calendar,* January 2000; in *Northeast Art & Auction,* April 2000; in *Tiqqun,* June-July 2000; in *Art Nexus* (Colombia), July 2000.

*

Alejandro Mazón comments:

My work echoes some of the main themes commonly found in "Latin American Art": the power of memory, the need to preserve, the urgency to find maturity and grace in a universe that seems totally impersonal, and an obsession to reconcile the world of opposites.

Since I began painting in 1990, I have searched for ways of turning the subconscious into the familiar. I am often called a surrealist, but I have considered myself an "outsider" long before the term became a trend. I am outside the system not because my talent is untrained but because I have consciously kept away from an Art World I poorly navigate. My iconography purposely hangs between tradition and modernism; there is a tension between these two philosophies that assures my paintings are never quiet and always exploratory on a multitude of levels.

I approach a new idea believing that art is nothing without painting, that painting is nothing without color, and color nothing without courage. My paintings are always figurative, often narrative, and never planned. Abstractions bore me; folklore fascinates me. My talent moves between folk and memory, constantly fighting for recognition in an establishment where spiritual searches are not the common theme and folkloric imagination is considered "unacademic."

I am Cuban by birth, Spanish by blood, and American by necessity. This mix of identities is always conflicting. Reconciliation lies somewhere between remembrance and imagination, and so do my paintings.

* * *

Born in Cuba but raised in Spain and New York, Alejandro Mazón has explored his personal and cultural history in his art, which is dominated by a Latin-American aesthetic. Employing vibrant colors, he has created emotional works that mine the depths of his subconscious. These small and highly detailed paintings typically incorporate images that are at once personal and universal.

Mazón was born in 1962, when Cuba was at the height of its communist fervor. His childhood was an itinerant one, as Mazón's family resettled in Madrid, Spain, in 1964 and then moved to New York a decade later. This second transition proved difficult for Mazón. He felt too European to identify as Hispanic, too American to be Cuban, and too Cuban to be a Spaniard. He dealt with his isolation and disorientation through his drawing.

Mazón was a poor student and was only admitted to the School of Visual Arts in New York because an instructor, Juan Gonzales, happened to see Mazón's portfolio and lobbied the administration to accept him. Although Mazón developed a close relationship with Gonzales, he often rebelled against his teacher's methodical and disciplined style. When Gonzales expressed his frustration at Mazón's inability to follow direction and focus on his work, Mazón left the School of Visual Arts without his degree.

For the next 10 years Mazón turned away from his art, even after his former instructor told him he could likely "make it" as a painter. It was only after Mazón discovered that his roommate, a close friend, was HIV positive that he felt compelled to paint once again. On the evening of 7 July 1990, he brought out his art supplies from the back of his closet and began to paint a portrait of his roommate on a piece of masonite he found under the bathroom sink. Once this barrier was broken, paintings poured out of Mazón. He often created two or three works in a single day. His first exhibition took place at one of Miami's premier galleries in 1991 (though only after another artist had backed out of the group show at the last minute). His work was well received,

and Mazón went on to hold his first solo exhibition at the same gallery three years later.

Mazón's paintings have often been compared to those of Frida Kahlo. Like her, Mazón has melded the personal and the political in a unique and vibrant style. In a 1998 acrylic painting entitled *So You Can Walk on Water,* for instance, he dealt with the death of his friend from AIDS. Inspired by a dream in which his dead friend asked him why he was painting his portrait and to which Mazón responded ''so you can walk on water,'' Mazón blended Christian iconography with the image of his friend. The colors are as rich as the painting's symbolism. A white bird's wing rises from a green field into a bold, blue sky, while a red lily shoots up from a tile floor.

Some of Mazón's other paintings are more traditionally Latin-American. The *White Dress* (1999), for instance, uses elements reminiscent of Mexican folk art to convey the loss of childhood innocence. That painting also illustrates another of Mazón's tendencies—to build a painting from a single phrase (a practice also evidenced in *So You Can Walk on Water). The White Dress* was inspired by a friend who had told him that she had lost everything in a fire except for one white dress. In this painting Mazón's childhood—represented as a small boy almost entirely covered by a white dress—leaps away from the adult Mazón, who stands caught in a barbed-wire fence.

—Rebecca Stanfel

MEIRELES, Cildo (Campos)

Brazilian painter and mixed-media artist

Born: Rio de Janeiro, 1948. **Education:** Escola Nacional de Bellas Artes, Rio de Janeiro, c. 1963; also studied engraving, Museu do Arte Moderno, Rio de Janeiro. **Career:** Lived in New York, 1971–73. **Award:** Grand prize, *Salão Bússola,* Rio de Janeiro, 1969. **Agent:** Galerie Lelong, 20 West 57th Street, New York, New York 10019, U.S.A. **E-mail Address:** art@galerielelong.com. **Web Site:** http://www.artnet.com/lelong.html.

Individual Exhibitions:

1967 Museu de Arte Moderna, El Salvador (traveled to Bahia, Brazil)
1975 *Eureka/Blindhotland,* Mseu de Arte Moderna, Rio de Janeiro
 Blindhotland/Ghetto and Virtual Spaces: Corners, Galeria Luiz Buarque de Hollanda e Paulo Bittencourt, Rio de Janeiro
1977 *Casos de sacos,* Museu de Arte e Cultura Popular, Cuiaba, Brazil
 Cildo Meireles Drawings, Pinacoteca do Estado, São Paulo
1979 *The Sermon of the Mountain: Fiat Lux,* Centro Cultural Candido Mendes, Rio de Janeiro
 Definitives Articles, Galeria Saramenha, Rio de Janeiro
1981 Galeria Luisa Strina, São Paulo

1983 *Obscure Light,* Galeria Luisa Strina, São Paulo, and Galeria Saramenha, Rio de Janeiro
1984 *Red Shift,* Museu de Arte Moderna, Rio de Janeiro (traveling)
 Two Collections, Sala Oswaldo Goeldi, Brazil
 Museum of Contemporary Art of the University of São Paulo
1986 *Cinza,* Galeria Luisa Strina, São Paulo, and Petite Galerie, Rio de Janeiro
1989 *Campos de Jogo,* Galeria Luisa Strina, São Paulo
1990 *Projects,* Museum of Modern Art, New York, and Institute of Contemporary Art, London
1992 *Metros I,* Galeria Luisa Strina, São Paulo
1994 *Volatile and Entrevendo,* Capp Street, San Francisco
1995 *Volatile,* Galerie Lelong, New York
 Cildo Meireles, IVAN, Centro Julio Gonzalez, Valencia, Spain (traveling retrospective)
 Ouro e paus, Joel Edelstein Arte Contemporoanea, Rio de Janeiro
 Two Trees, Laumeier Sculpture Park, St. Louis
1996 Le Creux de l'Enfer, Centre d'Art Contemporain, Thiers, France
1997 Galerie Lelong, New York
1998 *Camelô,* Galeria Luisa Strina, São Paulo
 XXIV São Paulo Biennial
1999 *Ku Kka Ka Kka,* Galeria Lelong, New York
 Cildo Meireles, New Museum of Contemporary Art, New York, Museum of Modern Art, Rio de Janeiro, and Museum of Modern Art in São Paulo (retrospective)

Selected Group Exhibitions:

1970 *Information,* Museum of Modern Art, New York
1975 *Venice Biennial*
1987 *Modernidade—Art brésilien du 20 siècle,* Musée d'Art Moderne de la Ville de Paris and Museu de Arte Moderna de São Paulo
1988 *The Latin American Spirit: Art and Artists in the U.S.,* Bronx Museum, New York (traveling)
1989 *Magiciens de la terre,* Musée National d'Art Moderne, Paris
1992 *Latin American Artists of the Twentieth Century,* Plaza de las Armas, Spain (traveling)
 Documenta IX, Kassel, Germany
1998 *Out of Actions: Between Performance and the Object 1949–1979,* Museum of Contemporary Art, Los Angeles (traveling)
1999 *Global Conceptualism: Points of Origin, 1950s-1980s,* Queens Museum of Art, New York (traveling)
2000 *No es sólo lo que ves: Pervirtiendo el minimalismo,* Museo Nacional Centro de Arte Reina Sofía, Madrid

Collections:

University of Texas, Austin; Art Institute of Chicago; University of Essex, Colechester; Stedelijk Museum voor Actuele Kunst, Germany; Los Angeles County Museum of Art; New Museum of

367

Cildo Meireles: *Entrevendo (Glimpsing),* 1970/1994. Photo courtesy of the artist and Galerie Lelong, New York.

Contemporary Art, New York; Fonds National d'Art Contemporain, Paris; Museu de Serralves, Porto, Brazil; Kiasma Museum of Contemporary Art, Helsinki; Museu de Arte Moderna, Rio de Janeiro; Museu de Arte Contemporanea, São Paulo.

Publications:

On MEIRELES: Books—*Cildo Meireles* by Paulo Herkenhoff, Gerardo Mosquera, and Dan Cameron, Harrisburg, Pennsylvania, Phaidon, 1999; *No es sólo lo que ves: Pervirtiendo el minimalismo,* exhibition catalog, Madrid, Museo Nacional Centro de Arte Reina Sofía, 2001; *Marking Time/Making Memory,* exhibition catalog, Oxford, California, Miami University Art Museum, 2001. **Articles**— "Cildo Meireles" by Adriano Pedrosa, in *Poliester,* fall 1995, pp. 50–53; "Cildo Meireles" by Santiago Olmo, in *Art Nexus,* 17, July-September 1995, pp. 56–61; "Exchanging Values" by Juan Vicente Aliaga, in *Frieze,* 22, May 1995, pp. 43–45; "Cildo Meireles: From Brazil, Interactive Works, Metaphors, and Talcum Powder" by Holland Cotter, in *New York Times,* 28 March 1997, p. 28; "Cildo Meireles" by Monica Amor, in *Art Nexus,* 24, April-June 1997, pp. 98–99; "Cildo Meireles: Memory of the Sense" by Charles Merewether, in *Grand Street,* 64, March 1998, pp. 216–223; "Mixed Metaphors, Cildo Meireles Is Brazil's Greatest Artist, but Does His Message Travel Well?" by Linda Yablonsky, in *Time Out New York,*

1999; "Through the Labyrinth: An Interview with Cildo Meireles" by John Farmer, in *Art Journal,* fall 2000, pp. 25–43; "Stepping into the Same Stream Twice" by John Perreault, in *NY Arts,* 5(2), February 2000.

* * *

The visual artist Cildo Campos Meireles was born in Rio de Janeiro in 1948. He began art studies in 1963 and exhibited in 1965 at the II Salon of Modern Art in Brasilia. In 1969 he participated in the Paris Biennial and received the Grand Prize of the Salão Bússola of Rio. In 1970 he was part of the exhibition *Do Corpo à Terra* at the Palácio das Artes in Belo Horizonte and of the exhibition *Information* at the Museum of Modern Art in New York City. After this Meireles moved to New York City, where he worked from 1971 to 1973 and where he developed his series *Inserções em circuitos antropofágicos* (1971–73).

Meireles is widely regarded as one of the most important Brazilian artists of the postwar period. He has been a pivotal bridge between the generation of the neoconcretists of the early 1960s–Helio Oiticica, Lygia Clark, and Ligia Pape–and his own generation of artists devoted to installation and conceptual art, mediums in which he was a pioneer in Latin America. Meireles's interest in addressing political and social concerns through seductive, but also disorienting,

Cildo Meireles: *Volátil (Volatile)*, **1980/1994. Photo courtesy of the artist and Galerie Lelong, New York.**

1967–84 work *Desvio para o vermelho* (''Red Shift''), an installation of three red rooms that culminates in an encounter with a sink in which red water, suggesting blood, is openly pouring. The piece is anecdotally linked with the civilian killings during Brazil's military dictatorship.

Meireles's installations and environments are truly multidimensional experiments that incorporate smell, touch, and sound, but they also are often experienced through time. They are powerful and eloquent statements with multilayered tensions and, ultimately, a profound questioning of the limitations of communication and systems of understanding.

—Pablo Helguera

MEJÍA, Xenia
Honduran painter and printmaker

Born: Xenia Florencia Mejía Padilla, Tegucigalpa, 20 May 1958. **Education:** Escuela de Musica y Bellas Artes de Parana, Brazil, 1984–87, superior pintura 1987; Escuela de Bellas Artes de Berlin Hochschule Der Künst, Berlin, 1994–96, M.F.A. 1996. **Family:** Married Donaldo Altamirano in 2001. **Career:** Graphic designer, Universidad Jose Cecilio del Valle, Tegucigalpa, 1988–99; freelance designer, Mujeres en Las Artes y Fundacion San Juancito, Tegucigalpa, 1997–2001; product designer, Anthropologie Institut, Tegucigalpa, 1998–2001. **Address:** Apartado Postal 30277, Toncontín,

visual means has been described by the curator and critic Paulo Herkenhoff, as a ''poetic theory of society.''

From his earliest works Meireles showed an interest in manipulating space, beginning with his sketches of the late 1960s titled *Espacios virtuais: Cantos* (''Virtual Spaces: Corners''). The artist made three-dimensional representations of the corners of domestic rooms, adding some sort of extension or interjection of space at each corner. His interest in Euclidean geometry led to the creation of works with formal simplicity but complexity of meaning. Meireles's inquisitive temperament, being willing to break codes and infiltrate the system, is shown in the seminal series of 1970 entitled *Inserções em circuitos ideologicos* (''Insertions into Ideological Circuits''), an investigation of society's mechanisms for circulating goods and information. His works from this series consisted of messages inserted into objects that normally are recirculated in the market, such as glass Coca-Cola bottles or paper currency. The project was featured by the curator Kynaston McShine in the landmark exhibition *Information* (1970) at the Museum of Modern Art in New York City. Since that point Meireles has developed a body of work that successfully counterbalances a poignant sociological message with a seductive environment, an embracing of all of the senses while denouncing with elegance and eloquence the severe political and social maladies in contemporary Brazil's status quo. Such is the case with the

Xenia Mejía: *Alerta Permanente II,* **2000. Photo by Evaristo Lopez Rojas; courtesy of the artist.**

Xenia Mejía: *Alerta Permanente I,* 2000. Photo by Evaristo Lopez Rojas; courtesy of the artist.

Comayagüela, Honduras. **E-mail Address:** mejiapaxeniaflo@hotmail.com.

Individual Exhibitions:

1991 *Desnudos,* Alianza Francesa, Tegucigalpa
1995 *Carnes,* Galería Portales, Tegucigalpa
2000 *Trastornos de una lectura,* Centro de Artes Visuales
 Contemporáneo, Tegucigalpa

Selected Group Exhibitions:

1994 *II bienal de pintura del Caribe y Centro America,* Santo
 Domingo Museo, Dominican Republic
1995 *IV bienal de Cuenca,* Ecuador Museo de Arte, Cuenca
1996 *Geografias,* Aktions Galery, Berlin
1997 *Mesotica II,* Museo de Arte y Diseño de Costa Rica,
 San Jose
 III bienal de pintura del Caribe y Centro America,
 Santo Domingo Museo, Dominican Republic
1998 *Iberoamerica pinta,* Casa de America, Madrid
 I bienal de pintura del Istmo Centroamericano, Centro
 Cultural Miguel Angel Asturias, Guatemala
1999 *Four Honduran Artists,* Fleming Museum, University of
 Vermont, Burlington
 *Contemporary Art from Costa Rica, El Salvador,
 Guatemala, Honduras, Nicaragua,* Taipei Fine Arts
 Museum, Taiwan
2000 *Women of the World,* White Columns, New York

Collections:

Taipei Fine Arts Museum, Taiwan; Escuela Nacional de Bellas Artes, Tegucigalpa.

Publications:

On MEJÍA: Books—*Muestra de pintura latinoamericana,* exhibition catalog, Nagoya, Japan, InterAmerican Development Bank, 1991; *Mesótica II,* exhibitino catalog, San Jose, Costa Rica, Museo de Arte y Diseño Contemporáneo, 1997; *Four Honduran Artists,* exhibition catalog, text by William Mierse, Burlington, Robert Hull Fleming Museum, University of Vermont, 1999. **Articles**—"Aproximación al arte de Centroamerica II" by Belgica Rodriguez, in *Art Nexus* (Bogota), May 1991; "Mesótica II" by Dermis P. León, in *Art Nexus* (Bogota), April/June 1997, pp. 88–91; by Joseina Alvarez Quioto, in *El Heraldo,* 26 February 2000.

* * *

Xenia Mejía is part of an intermediate generation in Honduras, one of the first artists to engage in experimental work from painting to installation and one who has gradually introduced local audiences to international languages, new discourses, and aesthetics linked more to local realities than to the imported parameters applied until recently. She was trained in Germany in the early 1990s, and her initial paintings were heavily indebted to neoexpressionism, both in their painterly treatment and in their themes. Close to the less privileged in her own country and having a keen sense of observation and a sense of belonging to a particular reality, she has been driven to develop themes related to social issues and tragedies. Strange "street" animals, crudely depicted on shapeless canvases in aggressive yet almost human attitudes, populated a series of paintings shown in Honduras shortly after her return. Very early on, she began to include material references to these animals, mostly in the form of skins, and turned progressively toward installation media. Around 1995 the artist directly pointed to the dramatic situation of deprived children in the streets of Tegucigalpa.

One of Mejía's major works was a medium-sized installation included in *MESÓTICA* (1996), the first contemporary Central American exhibition. It reproduced what could be a backstreet area or squalid living quarters, a typical urban situation in an underdeveloped country. The installation focused, however, on a Central American context through the use of silk-screened corn "tortillas" strewn around the floor on top of round *comales*–the flat iron skillet used to cook them on the fire–each depicting the image of a child. In the back of the room were cans of prepared milk formula and a series of used, dirty baby bottles with leftover milk, an image of the substitution of expensive imported milk for natural breast feeding, which can be extrapolated to all imported culture. An old pair of women's shoes were thrown around the floor. The installation was constructed of remnants of construction material and effectively reconstituted its despairing urban reality while also appealing directly to a completely different aesthetics in Honduran art. It originated in daily life and struggles and was no longer related to an idealized, nostalgic vision of blue-green landscapes and tiled roofs.

Since then Mejía has produced paintings and photo-based works related to the consequences of the devastation of Hurricane Mitch in 1998 and in general to a despairing social and economic situation in which "hope" is just a word. Unlike former artists who in fact tried to integrate international trends by simply copying styles, Mejía has been able to combine foreign training with a local awareness of the personal and social realities in her country. She has continued her installation work parallel to her pictorial and photographic research and travels frequently between Berlin and Tegucigalpa.

—Virginia Pérez-Ratton

MÉNDEZ, Leopoldo
Mexican painter and printmaker

Born: Mexico City, 30 June 1902. **Education:** Academia de San Carlos, Mexico City, 1917–19; Escuela de Pintura al Aire Libre, Chimalistac, Mexico, 1920–22. **Career:** Collaborator, *Horizonte* magazine, Vera Cruz, Mexico, 1920s; illustrator, *Norte* magazine, 1928. Traveled to the United States, 1930. Director, Departamento de Bellas Artes de la Secretaría de Educación Pública, Mexico, 1932; illustrator for the films *Rio escondido,* 1947, *El rebozo de soledad,* 1949, *Memorias de un Mexicano,* 1950, *La rebelión de los Colgados,* 1953, and *La perla.* Cofounder, Stridentist Group, 1921, League of Revolutionary Writers and Artists, 1933, and Taller de Gráfica Popular, 1937. Founder, Fondo Editorial de la Plástica Mexicana, 1959. **Awards:** John Simon Guggenheim memorial fellowship, 1939; Primer premio Nacional de Grabado, 1946; Premio Internacional de la Paz, Russia, 1952; Premio de Grabado en el Salón de Invierno del INBA, 1952; Posada prize for printmaking, *Second InterAmerican Biennial of Painting, Printmaking, and Sculpture,* Mexico City; International Peace prize, Vienna. **Died:** Mexico City, 8 February 1969.

Selected Exhibitions:

1930 Jeke Zeitlan Bookshop, Los Angeles
1930 Milwaukee Art Institute
1932 Galería Posada, Mexico City
 Milwaukee Art Institute (with Carlos Mérida)
1934 San Francisco Museum of Art
1944 San Francisco Museum of Art
1945 San Francisco Museum of Art
 Art Institute of Chicago
1966 *Art of Latin America since Independence,* Yale University, New Haven, Connecticut, and University of Texas, Austin
1969 *Grabados mexicanos: Homenaje a Leopoldo Méndez,* University of Havana
1970 *Leopoldo Méndez 1902–1969,* Instituto Nacional de Bellas Artes, Mexico City
1979 Museo Nacional de Cuba
 Exposición homenaje a Leopoldo Méndez, San Luis Potosí, Instituto Potosino de Bellas Artes, Mexico City

1981 *Leopoldo Méndez: Homenaje a un grabador revolucionario,* Foro de Arte, Mexico City
1982 National Museum of Modern Art, Mexico City (retrospective)
 Leopoldo Méndez: Un revolucionario de nuestro tiempo, Universidad Obrera de México, Mexico City
1989 *The Latin American Spirit: Art & Artists in the U.S.,* Bronx Museum, New York
1999 Orme Lewis Gallery, Phoenix Art Museum
 Codex Méndez: Prints by Leopoldo Méndez, Arizona State University, Tempe (retrospective)
2001 *Leopoldo Méndez: Hacedor de imágenes de un pueblo,* Mexican Fine Arts Center Museum, Chicago

Collections:

Mexican Fine Arts Center Museum, Chicago; Museo Nacional de las Artes, Mexico City; Museo Nacional del Arte Moderno, Mexico City; Museo de la Estampa, Mexico City; Instituto de Arte Grafico de Oaxaca, Mexico; Chicago Art Institute, Library of Congress, Washington, D.C.; Museum of Modern Art, New York; Art Museum of the University of New Mexico.

Publications:

By MÉNDEZ: Books—*El nombre de Cristo,* Mexico, J.P. Valdes, 1939; *25 grabados de Leopoldo Méndez,* with Juan de la Cabada, Mexico, La Estampa Mexicana, 1943. **Articles**—"La estética de la revolución: La pinturamural," in *Horizonte* (Jalapa, Mexico), 1(8), November 1926; "Leopoldo Méndez dice . . . ," in *Anthropos,* 1(1), April-June 1947; "Testimonios de su viaje a la URSS," in *Cultura Soviética* (Mexico City), 93, July 1953. **Books, illustrated**—*Emiliano Zapata: Exaltación* by Germán List Arzubide and Gonzalo Humberto Mata, n.p., 1930; *The Gods in Exile* by Heinrich Heine, New York, Haldeman-Julius, 1931; *Con una piedra se matan muchos párajos-nalgones* by Lázaro Cárdenas, Mexico City, Taller de Gráfica Popular, 1940; *Corrido de don Chapulín,* Mexico City, Taller de Gráfica Popular, 1940; *Incidentes melódico del mundo irracional,* Mexico City, La Estampa Mexicana, 1944; *Ansina María* by Berta Domínguez D., Mexico City, Talleres de Bartolemé Costa-Amic, 1945; *Oratorio menor en la muerte de Silvestre Revueltas* by Pablo Neruda, with Mariana Yampolsky, Mexico City, Colaboración del Taller de Gráfica Popular, 1949; *Feliz año nuevo,* Mexico City, Taller de Gráfica Popular, 1956.

On MÉNDEZ: Books—*Los 60 años de Leopoldo Méndez* by Elena Poniatowska, Mexico City, Artes de México, 1963; *Leopoldo Méndez* by Manuel Maples Arce, Mexico, Fondo de Cultura Económica, 1970; *Leopoldo Méndez, 1902–1969,* exhibition catalog, Mexico City, Instituto Nacional de Bellas Artes, 1970; *Exposición Leopoldo Mendez en el X aniversario de su muerte,* exhibition catalog, text by Zarza, Havana, Ministerio de Cultura de Cuba, 1979; *Leopoldo Méndez: Artista de un pueblo en lucha,* exhibition catalog, Mexico City, Centro de Estudios Económicos y Sociales del Tercer Mundo, 1981; *Tres artistas del pueblo: José Guadalupe Posada, Leopoldo Méndez, Alberto Beltran* by Ricardo Cortés Tamayo, Mexico City, Edición de El Día, 1981; *Leopoldo Mendez: Dibujos, grabados, pinturas,* exhibition catalog, text by Rafael Carrillo Azpeitia, Mexico, Fondo Editorial de la Plástica Mexicana, 1984; *El Taller de Grafica*

Popular en Mexico 1937–1977 by Helga Prignitz-Poda, Mexico City,
Instituto Nacional de Bellas Artes, 1992; *Leopoldo Méndez: El oficio
de grabar* by Francisco Reyes-Palma, Mexico City, Consejo Nacional
para la Cultura y las Artes, 1994; *Codex Méndez: Prints by Leopoldo
Méndez,* exhibition catalog, text by Jules Heller and Jean Makin,
Tempe, Arizona State University Art Museum, 1999; *Leopoldo
Méndez, Revolutionary Art, and the Mexican Print: In Service of the
People* (dissertation) by Deborah Caplow, Seattle, University of
Washington, 1999. **Articles—** ''Los 60 años de Leopoldo Méndez''
by Elena Poniatowska, in *Artes de México* (Mexico City), 45, July
1963; ''The Stridentists'' by Serge Fauchereau, in *Artforum Interna-
tional,* 24, February 1986, pp. 84–89.

* * *

Leopoldo Méndez took part in a wide variety of artistic endeav-
ors in Mexico between 1920 and 1969. Because Méndez worked
primarily in the print medium with the idea that artists should work
anonymously and collectively, he has not achieved a level of fame
appropriate to his contributions to twentieth-century art. He has been,
however, greatly admired in Mexico, where he is often referred to as
the heir of José Guadalupe Posada, whose satirical prints of skeletons
and other folk motifs have influenced Mexican artists since the 1920s.

Méndez studied at the Academy of San Carlos in Mexico City
from 1917 to 1919. In 1921 he had his first exposure to printmaking
through the works and teaching of the muralist Jean Charlot at the
open-air art schools at Chimalistac and Coyoacan. In 1921 Méndez
joined the estridentistas, or stridentists. The stridentist movement was
inspired by the cubists, Italian futurists, and Dadaists, paralleling the
Mexican mural movement in the 1920s. Méndez contributed cubist-
inspired images for *Horizonte,* the stridentist magazine. In 1926 he
illustrated Germán List Arzubide's *Emiliano Zapata: Exaltación,* the
first book about Emiliano Zapata. When the stridentists disbanded in
1927 Méndez began to work with political groups, joining the
Communist Party in 1929.

Méndez was the first artist after Posada to utilize the full
potential of printmaking for political commentary. He also had an
affinity for the work of José Clemente Orozco, whose murals in-
cluded grotesque parodies of religious, political, and social inequities.
The 1932 print *Concierto de locos* (''Concert of Crazies'') is Méndez's
first important satirical work. The print depicts an Old Testament
figure of God with well-known cultural figures. Diego Rivera is
portrayed as an Aztec shaman, beating on a pre-Columbian wooden
drum, while David Alfaro Siqueiros plays a harp, like his namesake
King David. Here Méndez lampooned the arts in Mexico, focusing on
the relationship between Rivera and Siqueiros, whose public disa-
greements had become increasingly contentious.

In 1933 Méndez, Siqueiros, Pablo O'Higgins, and others formed
the Liga de Escritores y Artistas Revolucionarios (LEAR; League of
Revolutionary Writers and Artists). Méndez's woodcut *Concierto
sinfónico de calaveras* appeared on the cover of the first issue of
LEAR's newspaper, *Frente a frente* (Face to Face), in November
1934. Méndez used *calaveras* in the style of Posada to criticize the
inauguration of the Palacio de Bellas Artes. He again caricaturized
Rivera, who had been expelled from the Communist Party and had a
commission to paint murals in the National Palace. Méndez also
attacked Carlos Chávez, who wrote the music for the concert. The
image was one of the first uses of the *calavera* in post-revolutionary
prints; Méndez's sophisticated reworking of Posada's prints consti-
tuted a new genre in Mexican art.

In 1936 LEAR artists Méndez, O'Higgins, Alfredo Zalce, and
Fernando Gamboa painted murals at the Talleres Gráficos de la
Nación (National Printers Workshops) depicting the struggle against
fascism in Mexico. The murals strove for an immediacy unusual in
Mexican mural painting. The painters used the printers as models, for
the first time portraying workers in their own workplace.

When LEAR dissolved in 1937 Méndez, Luis Arenal, and
O'Higgins formed the Taller de Gráfica Popular (TGP; Popular
Graphics Workshop), a collective printmaking studio in Mexico City.
The TGP grew to a membership of about 25 printmakers, producing
high-quality graphic work. Méndez's encouragement of his fellow
artists and his dedication to the TGP were essential to its success. His
own style was influenced by the graphic work of Honoré Daumier,
Käthe Kollwitz, and Frans Masereel as well as by Posada, Mexican
folk artists, and the Mexican muralists. Méndez and other members of
the TGP focused on injustice, poverty, and exploitation in Mexico and
imperialism and fascism in Europe, the United States, and Mexico.

From the mid-1930s to the end of World War II the TGP
produced numerous anti-fascist images. Méndez's linocut for the
cover of *Das Siebte Kreuz* (*The Seventh Cross*) by Anna Seghers
depicts Nazi brutality in Germany. His 1942 *Deportation to Death*
portrays a train carrying Jewish prisoners to a concentration camp.
This is one of the earliest artistic images of the Holocaust to be
produced by someone not interned in the camps. His prints appeared
in *El libro negro del terror nazi* (''The Black Book of Nazi Terror''),
a remarkable collection of essays, photographs, drawings, and prints
that documented Nazi atrocities throughout Europe. In 1944 Méndez
collaborated with the writer Juan de la Cabada on *Incidentes melódicos
del mundo irracional* (''Melodical Incidents of the Irrational World'').
Their award-winning book blends Mayan folktales, rituals, and
fantasy with symbols from pre-Columbian art. In 1945 Méndez
created the allegorical self portrait *Visión* (''Vision''). He combined
his image with a deconstruction of the Mexican symbol, the eagle on
the cactus with a snake, against a backdrop of the Valley of Mexico.
The image addresses the existential dilemma in which artists found
themselves at the end of the war.

Méndez's work often has a cinematic quality. His print *Calaveras
Aftosas con Medias Naylon* (1947; ''Calaveras with Foot and Mouth
Disease in Nylon Stockings'') portrayed an anthropomorphized cow
as a cowgirl shooting a rifle, evoking images from Western movies.
He created prints for the backgrounds of credits in films by producer
Emilio Fernández and cinematographer Gabriel Figueroa during the
1940s and '50s, the golden age of Mexican cinema. His dramatic
images for films such as *Río escondido* (''Hidden River'') and *La
perla* (*The Pearl*) were enlarged to the size of murals on movie screens.

In 1959 Méndez founded the art-book publishing company the
Fondo Editorial de la Plástica Mexicana. Méndez's major projects
were three works, *La pintura mural de la Revolución Mexicana*
(*Mural Painting of the Mexican Revolution*), *José Guadalupe Posada,*
and *Lo efímero y eterno del arte popular mexicano* (''The Ephemeral
and the Eternal in Mexican Popular Art''). These books were compre-
hensive surveys of three significant aspects of Mexican culture.

When Méndez died in 1969 he was honored by many articles in
newspapers and journals. A retrospective exhibition of his work took
place in 1970 at the Palace of Fine Arts. His prints are frequently used
by grassroots groups in Mexico for political events and publications.
Méndez's powerful imagery continues to exert an influence today.

—Deborah Caplow

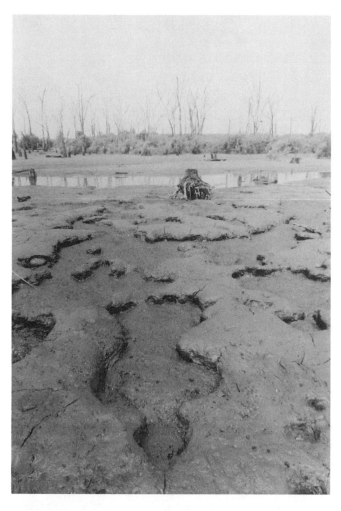

Ana Mendieta: *Untitled (Silueta Series),* **1979. Photo by Geoffrey Clements; Collection of Whitney Museum of American Art, Purchase, with funds from the Photography Committee. Reproduced by permission.**

MENDIETA, Ana

American painter, sculptor, photographer, and performance artist

Born: Havana, Cuba, 18 November 1948; Cuban exile: immigrated to the United States, 1961, granted U.S. citizenship, 1970. **Education:** University of Iowa, B.A. 1969, M.A. in painting, 1972, M.F.A. in multimedia and video art, 1977. **Family:** Married Carl Andre in 1985. **Career:** Lived in New York City. Began experimenting with performance art, documenting performances with photographs and video, 1970; visited Cuba, 1979; curator of an exhibition of third world female artists called *The Dialectics of Isolation,* 1980. **Award:** Fellowship, American Academy in Rome, 1983. **Died:** New York, 8 September 1985.

Individual Exhibitions:

1971	Iowa Memorial Union, University of Iowa, Iowa City
1976	112 Greene Street, New York
1977	*Corroboree,* University of Iowa, Iowa City
1979	A.I.R. Gallery, New York

1980	Colburn Gallery, University of Vermont, Burlington
	Kean College, Union, New Jersey
	Museo de Arte Contemporáneo, São Paulo
1981	A.I.R. Gallery, New York
1982	Douglas College, Rutgers University, New Brunswick, New Jersey
	Lowe Art Museum, University of Miami, Miami
	University Art Museum, University of New Mexico, Albuquerque
	Yvonne Seguy Gallery, New York
1983	Museo Nacional de Bellas Artes, Havana
1984	Primo Piano, Rome
1985	Gallery AAM, Rome
1987	New Museum of Contemporary Art, New York
1988	Los Angeles Contemporary Exhibitions, Los Angeles
	Terne Gallery
1989	Carlo Lamagna Gallery, New York
1990	Aspen Arts Museum, Aspen, Colorado
	Pat Hearn Gallery, New York
	Ana Mendieta: The Silueta Series, Galerie Lelong, New York (traveling)
1992	Laura Carpenter Fine Art, Santa Fe
1993	Centre d'Art Contemporain, Ile de Vassiviere, France
1994	*Ana Mendieta: The Late Works,* Cleveland Center for Contemporary Art
	Ana Mendieta: Burial of the Nanigo, Ruth Bloom Gallery, Santa Monica, California
	Ana Mendieta, Artotheque de Caen, France
	Ana Mendieta, Linease, 1980–1983, Galerie Lelong, New York
1995	*Ana Mendieta,* Galeria DV, San Sebastian, Spain
	Ana Mendieta, Helsinki City Art Museum, Helsinki (traveling)
	Ana Mendieta, Barbara Gross Gallery, Munich
1996	*Ana Mendieta,* Centro Galego de Arte Contemporanea, Santiago, Spain (traveling)
1997	*Ana Mendieta: Body Imprints and Transformations,* Galerie Lelong, New York
1998	Elba Benitez Galeria, Madrid
	Museum of Contemporary Art, Los Angeles
1999	Blum and Poe, Los Angeles
	Bernard Toale Gallery, Boston
	Museo Rufino Tamayo, Mexico City

Selected Group Exhibitions:

1980	*Women/Image/Nature,* Temple University, Philadelphia (traveled to Institute of Technology, Rochester, New York)
1981	*Latin American Art: A Woman's View: Maria Brito-Avellana, Ana Mendieta, Elena Presser,* Frances Wolfson Art Gallery, Miami-Dade Community College, Miami, Florida
1982	*Ritual and Rhythm: Visual Forces for Survival,* Kenkeleba House, New York
1983	*Contemporary Latin American Art,* Chrysler Museum, Norfolk, Virginia
1984	*Aqui: Latin American Artists Working and Living in the United States,* Fisher Gallery, University of Southern

Ana Mendieta: *Untitled (Silueta Series),* **1980. Photo courtesy of the Estate of Ana Mendieta and Galerie Lelong, New York.**

1984 California, Los Angeles (traveled to University of
 California, Santa Cruz)
1986 *In Homage to Ana Mendieta,* Zeus-Trabia Gallery, New
 York
1989 *Lines of Vision: Drawings by Contemporary Women,*
 Museum of Contemporary Hispanic Art, New York
 (traveled to Museo de Bellas Artes, Caracas)
1991 *Cuba-USA,* Fondo Del Sol Visual Art and Media
 Center, Washington, D.C. (traveling)
1993 *The Subject of Rape,* Whitney Museum of American
 Art, New York
1996 *Latin American Women Artists, 1915–1995,* Milwaukee
 Art Museum (traveling)

Collections:

Art Institute of Chicago; Dallas Museum of Fine Art; Art Gallery of
New South Wales, Sydney, Australia; For Lauderdale Museum of
Art; Fogg Art Museum, Harvard University, Cambridge, Massachu-
setts; Helsinki City Art Museum; Hirshhorn Museum and Sculpture
Garden, Washington, D.C.; Metropolitan Museum of Art, New York;

Milwaukee Art Museum; Museum of Contemporary Art, Chicago;
Museum of Contemporary Art, Miami; Museum of Fine Arts, Boston;
Museum of Modern Art, New York; National Museum of American
Art, Washington, D.C.; Philadelphia Museum of Art; Rhode Island
School of Design, Providence; San Francisco Museum of Modern
Art; Toledo Museum of Art; University of Iowa, Iowa City; Whitney
Museum of American Art, New York.

Publications:

By MENDIETA: Book, edited—*Dialectics of Isolation: An Exhibi-
tion of Third World Women Artists of the United States,* n.p.,
Publishing Center for Cultural Resources, 1980. **Film**—*Selected
Filmworks: 1972–81,* New York, Electronic Arts Intermix, ca. 1995.

On MENDIETA: Books—*Latin American Art: A Woman's View:
Maria Brito-Avellana, Ana Mendieta, Elena Presser,* exhibition
catalog, Miami, The Gallery, 1981; *The Ohio State University Gal-
lery of Fine Art Presents Rape: Dedicated to the Memory of Ana
Mendieta, Whose Unexpected Death on September 8 1985, Under-
scores the Violence in Our Society,* exhibition catalog, by Stephanie

K. Blackwood, Columbus, Ohio State University, 1985; *Ana Mendieta: A Retrospective,* exhibition catalog, by Petra Barreras del Rio, John Perreault, and others, New York, New Museum of Contemporary Art, 1987; *Naked by the Window: The Fatal Marriage of Carl Andre and Ana Mendieta* by Robert Katz, New York, Atlantic Monthly Press, 1990; *Ana Mendieta: The "Silueta" Series,* exhibition catalog, by Mary Jane Jacob, New York, Galerie Lelong, 1991; *Ana Mendieta: A Book of Works* edited by Bonnie Clearwater, Miami Beach, Grassfield Press, 1993; *The Unbaptized Earth: Ana Mendieta and the Performance of Exile* (dissertation) by Jane Blocker, Chapel Hill, University of North Carolina, 1994; *Ana Mendieta 1948–1985,* exhibition catalog, by Tuula Karjalainen, Mikko Oranen, and others, Helsinki, Helsingin kaupungin taidemuseo, 1996; *Ana Mendieta,* exhibition catalog, by Gloria Moure, Donald B. Kuspit, and others, Barcelona, Ediciones Poligrafa, 1996; *Ana* Mendieta by Gloria Moure, New York, Rizzoli, 1997; Where *Is Ana Mendieta?: Identity, Performativitiy, and Exile* by Jane Blocker, Durham, North Carolina, Duke University Press, 1999; *Vivencias,* exhibition catalog, Vienna, Generali Foundation, 2000. **Articles—**"Ana Mendieta" by Nancy Morejon, in *Michigan Quarterly Review* (Ann Arbor, Michigan), XXXIII(3), summer 1994, p. 618; "Ana Mendieta and the Politics of the Venus Negra" by Jane Blocker, in *Cultural Studies* (London), 12(1), 1998; "Tracing Mendieta" by Michael Duncan, in *Art in America,* 87(4), April 1999, pp. 110–113; "Ana Mendieta's Sphere of Influence" by Collette Chattopadhyay, in *Sculpture* (Washington, D.C.), 18(5), June 1999, pp. 34–41; "Car & Ana: Ten Years + One After" by Judd Tully, in *New Art Examiner,* 26(8), May 1999, p. 70.

* * *

Ana Mendieta, who, more than most artists, intimately linked her art with her life, proved to be an indispensable name at a time of revising art in the 1970s and '80s, especially in terms of performance art, video performance, body art, ephemeral art, and land art. In honor of satisfying a thirst for roots that she recognized in herself, she constantly explored the morphology and meaning of her works through materials that nature offered, though she also used photography and video with the same efficacy in a unique way to reveal her perceptions and interventions. From the beginning there was always something absent in what she exhibited, some unknown part not visible: the man who appeared stuck in the beard of a friend; the bird incorporated into a woman's figure, covered with chicken feathers; the raped woman; the dead woman; and the tied woman who for a moment pretends to be bound. Nothing of this existed. What truly occurred involved rituals that the artist brought about in her series and in her states, which she also brought forth in earth, in air, and in fire.

In using her own body she experimented and directly felt. She was converted; she traveled by way of sensation. She dissolves in the condition she imitates. We only see the outcome, but we know the process has been the most important thing.

Her work exists in the traces of this evolution, of this pact with the other. In this way her work becomes more interesting because it remains open; there is a space to fill that is of the absent moment. This element is the artist evolving like a ritual that is inseparable from her own life and that we never participate in her climax. The previous act remains absent before the observer's eye, which is also that of the camera. From this process the traces transpire, but the the outcome does not. The traces go on slowly until nothingness.

From there the blood running down the sidewalk beneath the door, the invitation to friends to see her raped or dead, the suitcase of bones and blood also left in the street all generate curiosity and captivate us because they conceal something that we have to imagine. By means of simulation of consequence she makes believe in—and she creates—her reason.

In *Glass on Body* she presses her nude body against a piece of glass. With *Facial Cosmetic Variation* the work involves her first foray into using her body, discovering its limits, exploring with abandon where it is possible to deform it. And in certain ways her work consists of different ways in which she abandons herself. The silhouette was the best way for her to encounter the power of vanishing, of biologically dissolving in nature in order to arrive at really being a part of it, at maintaining some corporal reference to her self. In this way the silhouette symbolized the total absence of subject, of organs, and it offered a certain impersonality that contributes to spatial dissolution.

Through her evolution she connects with this universal fluid that she constantly references. Thus, she survives, she deterritorializes in order to inhabit for a moment lacking identity, gender, nationality. It was in natural landscape that she discovered the ideal conditions (solitude and purity) for her transmutations. Each time she dissolved in nature, she walked closer to the divine, toward the imperceptible, in a regression of essence, in questing for solutions for her being uncomfortable in the world.

Finally, as part of this uneasiness with herself, Mendieta evolved into nothing, and she left herself absent forever.

—Glenda Leon

MENDIVE (HOYO), Manuel
Cuban painter, sculptor, and performance artist

Born: Havana, 15 December 1944. **Education:** Academia de San Alejandro, Havana, 1959–62, degree (honors) in painting and sculpture 1962. **Awards:** Premio Escultura, Círculo Bellas Artes, Havana, 1962; Premio Adam Montparnasse XXIV, Salón de Mayo, Paris, 1968; prize, *1 bienal de la Habana,* 1984; Premio Galería Espacio Latinoamericano, 1984; Premio Internacional, *II bienal de la Habana,* 1986; Medalla Alejo Carpentier del Consejo de Estado de la República de Cuba, 1988. Orden Felix Varela del Consejo de Estado de la República de Cuba, 1994.

Individual Exhibitions:

1964	Centro de Arte, Havana
1975	Museo Nacional, Tanzania
1981	Glaería Arte, Moscow
1982	Galería Orth Nuremberg
	Gallery Mpapa, Lusara, Zambia
1984	Galería Plaza Vieja, Havana
1986	Galería Espacio Latinoamericano, Paris
1987	Museo Nacional de Bellas Artes, Havana
	Museo de Arte Contemporáneo, Panama
1988	October Gallery, London
	Museo Etnográfico, Budapest
	XLIII bienal Venicia, Venice
1989	Galería Nesle, Paris
	Grupo Seibu, Shibuya, Tokyo
1990	Galería Civica Plaza Cavour, Padua, Italy

1991	*21a bienal internacional de São Paulo,* Brazil
1992	Galería le Monde de l'Art, Paris
1995	Galería Expositum, Mexico City
	Galería Fernando Quintana, Bogotá, Colombia
1996	Galería Nacional de Jamaica
	Galería Arte Actual, Santiago, Chile
	Galería La Acacia, Havana
1997	Galería Joan Gualta Art, Palma de Mallorca, Spain
	Galería El Mundo del Arte, Paris
1999	Gary Nader Fine Art, Miami

Selected Group Exhibitions:

1975	Instituto Nacional de Bellas Artes, Mexico City
1978	Museo de Arte Contemporáneo, Mexico City
1980	Museo Carillo Gil, Mexico City
1984	*Bienal de la Habana,* Wifredo Lam Museo de Bellas Artes, Havana
1988	Salón Mayo Grand Palais, Paris
1989	Hayward Gallery, London
1991	Galería Civica Arte Contemporáneo, Sicily, Italy
	Museum of Modern Art, San Diego, California
1996	*Feria ARCO '96,* Madrid
1997	*Sexta bienal de la Habana,* Centro Wifredo Lam, Havana

Collections:

Museo Nacional de Bellas Artes, Cuba; Museo de Arte Moderno, Panama; Museo de Arte Moderno, Cartagena, Colombia; Museo Etnográfico, Budapest; Museum of Modern Art, Paris; Museo Nacional de Tanzania; Mpapa Gallery, Lusaka, Nigeria; Galería Nacional, Kingston, Jamaica.

Publications:

By MENDIVE: Books—*Mendive: Un pintor de lo real-maravilloso,* n.p., Impr. André Voisin, n.d.; *Variations sur un théme: Conversation avec les poissons,* n.p., Espace Culturel Latino-Américain, 1986; *Water, Fish, Men: An Exhibition of New Work,* exhibition catalog, London, October Gallery, 1988.

On MENDIVE: Books—*Para el ojo que mira de Manuel Mendive,* exhibition catalog, text by Nancy Morejón, Havana, Museo Nacional de Bellas Artes, 1987; *Manuel Mendive,* exhibition catalog, text by Junji Ito, Kyoto, Japan, Kyoto Shoin, 1989; *Mendive, obara meji,* exhibition catalog, text by Giorgio Sagato, São Paulo, Bienal Internacional, 1991. **Articles**—"Mendive's World' by Robert Knafo, in *Connoisseur,* 216, April 1986, p. 28; "Manuel Mendive" by Klaus Steinmetz, exhibition review, in *Art Nexus* (Colombia), 17, July/ September 1995, pp. 114–115; "Manuel Mendive: Gary Nader Fine Art" by Carol Damian, in *Art Nexus* (Colombia), 33, August/October 1999, pp. 149–150.

* * *

Manuel Mendive was born in Havana in 1944 and graduated from the Academia de San Alejandro there in 1962. His works can be

seen as part of a pervasive change in the art of Cuba. Called by some a "Cuban Renaissance," the period of from the 1960s through the 1980s witnessed a growth in new artists emerging from the middle and lower classes. In celebrating their social backgrounds these artists fostered an increased popularity in folklore and traditional social values. The most radical was the imagery and ideas from the Afro-Cuban religions that many artists reclaimed. Cuba possessed four primary religious-cultural complexes of African origin: Santería (Yoruba), the Palo Monte (Kongo), the Regla Arará (Ewe-Fon), and the secret society Abakuá (cultures of Calabar). Unlike earlier artists who sometimes borrowed African religious motifs, these new artists often were more immersed in the religious practice itself.

Mendive's work of the 1960s incorporated images from the religious cults and Santería. During this time he often painted and carved deities on rough wooden planks, and his works were sometimes extensions of the ceremonies. In the 1980s he also painted the bodies of dancers participating in the Yoruba rituals, one such performance receiving a prize in the Second Biennial of Havana. Initiated in the rights of Santería himself, Mendive was one of the first artists to project his interpretation of the mythical elements of the world into his art. Using a conscious "primitive" vocabulary he started by presenting Yoruba mythology but later connected it to historical themes, everyday subjects, and finally his own mythology. He was one of the best-selling Cuban artists of his day and represented Cuba at the prestigious Venice Biennale of 1988.

In a work such as *Primitive African* (1988) Mendive's visual vocabulary is readily apparent. Colorful, flat, and decorative, the canvas is filled with fish, peacocks, butterflies, and plants. The center is devoted to a Janiform, or two-face, fish atop which balances a human head and above that a pineapple. The style, in which the forms are depicted with a series of decorative and colorful dots, is typical of Mendive. The overall sense is one of mystery and energy. This same sense of mystery can be found in his *Conversation with a Fish* (1984), where the viewer is confronted with figures that are half-human and half-fish or a human form who has an additional face depicted on his chest. These hybrid creations stem from the Santería deities who watch over the processes of life and death, good and evil. Work of the 1990s often finds more subtle gradations of form. The same spiritually energized figures appear but their environments appear more unsubstantial and ethereal. They remind the viewer of the surrealist tendencies sometimes found in other Cuban artists of the twentieth century.

In all of his works this magical vision is both captivating and mysterious. As Gerardo Mosquera accurately stated: "If Wifredo Lam had opened up modernism as a space for the expression of Afro-Cuban cultures, and Cárdenas introduced an African sensibility into abstraction, Mendive was the first to express a non-Western vision of the cosmos."

—Sean M. Ulmer

MÉRIDA, Carlos
Guatemalan painter and muralist

Born: Guatemala City, 2 December 1891. **Education:** Studied art in Guatemala, 1902–05; studied ethnomusicology in Quetzaltenango, 1907; studied art under Kees Van Dongen in Paris, 1912–14. **Family:**

Carlos Mérida: *Tepepul the Fortune Teller,* 1972. © Christie's Images/Corbis. © Estate of Carlos Mérida/Licensed by VAGA, New York, NY.

Carlos Mérida: *Deer Dance,* 1935. © Philadelphia Museum of Art/
Corbis. © Estate of Carlos Mérida/Licensed by VAGA, New York, NY.

Married Dalila Gálvez in 1919. **Career:** Lived in the United States,
1917–19; moved to Mexico, 1919. Assistant to Diego Rivera on
mural project, Simón Bolívar Amphitheater of Escuela Nacional
Preparatoria, Mexico City, 1922; Pintor Decorador of the Edificio de
la Secretaría de Educación Publica, Mexico City, 1925. Lived in
Paris, 1927–29. Director, Escuela de Danza de la Secretaría de
Educación Pública de México, 1932. Visiting professor of art, North
Texas Teachers College (now University of North Texas), Denton,
1941–42. Designed mural for San Antonio Convention Center, Texas,
1968. **Died:** 22 December 1984.

Individual Exhibitions:

1926	Valentine-Dudensing Gallery, New York
1930	Delphic Studios, New York
	John Becker Galleries, New York
1932	John Becker Galleries, New York
1935	Katherine Kuh Gallery, Chicago
1936	Stendhal Gallery, Los Angeles
1940	Stanley Rose Gallery
1951	Pan-American Union, Washington, D.C.
1957	Passedoit Gallery, New York
1962	Marion Koogler McNay Art Museum, San Antonio, Texas
1964	Gallery of Modern Art, Scottsdale, Arizona
1966	Martha Jackson Gallery
1983	*Carlos Mérida: A Retrospective,* B. Lewin Galleries, Beverly Hills, California

Selected Group Exhibitions:

1964	World's Fair, Queens, New York
1966	*Art of Latin America since Independence,* Yale University, New Haven, Connecticut, and University of Texas, Austin
1967	*Latin American Art: 1931–1966,* Museum of Modern Art, New York

Collections:

Museum of Fine Arts, Boston; Cleveland Museum of Art; Museum of
Modern Art, New York; Phoenix Art Museum; San Francisco Mu-
seum of Modern Art; Seattle Art Museum.

Publications:

By MÉRIDA: Books—*Modern Mexican Artists: Critical Notes,*
Freeport, New York, Books for Libraries Press, 1968; *Carlos Mérida
en sus 90 años,* edited by Mario de la Torre, Mexico City, Cartón y
Papel de México, 1981; *Carlos Mérida: A Retrospective,* exhibition
catalog, Beverly Hills, California, B. Lewin Galleries, 1983.

On MÉRIDA: Books—*Carlos Mérida, una expresión americana* by
Enrique Noriega, Guatemala, Ediciones Acento, 1981; *Carlos Mérida:
Color y forma* by Luis Cardoza y Aragón, Mexico City, Ediciones
Era, 1992; *Carlos Mérida: Un artista integral* by Eduardo Espinosa
Campos, Mexico City, Círculo de Arte, 1997.

* * *

Carlos Mérida was born in Guatemala City on 2 December 1891.
His parents, Serapio Santiago Mérida and Guadalupe Ortega Barnoya,
were natives of the city Quetzaltenango, where the artist moved in
1907 to begin his studies in music with ethnomusicologist Jesús
Castillo. Mérida later had to abandon these studies due to an
auditory sclerosis.

In 1909 Mérida returned to Guatemala City. He began gathering
a group of intellectuals, marginalized writers, and artists who found
themselves outside the official circles of the dictatorship of President
Manuel Estrada Cabrera. Mérida's contact with this collective and
especially with Jaime Sabartés, secretary and personal friend of Pablo
Picasso, was of grand importance to Mérida's interest in European
artistic movements of the time. In 1912 he traveled to France with his
friend and colleague Carlos Valenti, who committed suicide four
months after their arrival. This blow could have made Mérida to
return to Guatemala, but he remained in Paris. He made contact with
artists such as Kees Van Dongen, Hermenegildo Anglada Camarasa,
Madeo Modigliani, and Piet Mondrian as well as with Mexican artists
such as Angel Zárraga and Diego Rivera.

After two years of residence in Europe Mérida returned to
Guatemala in 1914 and with Guatemalan sculptor Rafael Yela Günter
began an important period that involved a return to the landscape of
Quetzaltenango, to its indigenous and folkloric elements. In this
period he relied on formal experimentation that characterized modern
art. Without a doubt this experience was seminal in its consolidation
of his aesthetic philosophy, especially the elaboration of avant-garde
theories in Latin America, which reverberated with the creation of
modern American forms and similarly the formation of local identi-
ties in art.

In 1919 Carlos Mérida married Dalila Gálvez and moved to Mexico City, where he settled. With the exception of brief trips to foreign countries, he would always return to Mexico City. At this time sculpture was dominated by the leaders of the first period of muralism. The magnitude of this artistic phenomenon displaced some artists and absorbed others. In Mérida's case in 1922 he began to approach the Mexican movement as an assistant to Diego Rivera, creating the murals of the Bolívar Ampitheater in the Escuela National Preparatoria. This period stimulated Mérida's decoration of public buildings with murals. In 1923 José Vasconcelos commissioned two murals from Mérida in the Biblioteca Infantil from the Secretaría de Educación Pública Building, and in 1925 he was named Pintor Decorador of the Edificio de la Secretaría de Educación Publica.

A strong desire for an autonomous and European art influenced and coincided with many of the muralists' ambitions. Nevertheless, six years later Mérida recognized the impossibility of conceiving of an art that transcends European references to visual art. This act marked the beginning of the break from his aesthetic theories and from the revolutionary ideas cultivated by social realism in the works of the muralists. After 1927, when he made another trip to Paris, his work underwent a significant change. The artist began a new incursion into abstraction and surrealism. Influenced by artists such as Jean Arp, Paul Klee, and Joan Miró he was inspired to transform his work to synthesize all recognizable objects in order to create amorphous beings inhabiting unreal spaces.

In accordance with his beginnings Mérida was destined to return to music. In 1932 he was designated as director of the the Escuela de Danza de la Secretaría de Educación Pública de México, an experience that prompted a series of drawings representing designs of dressing rooms and scenographies. With his increasing interest in treating dance with the same technical and conceptual tendencies as his painting, he developed new choreographic elements that reflected discussions and themes of that period.

During the post-war 1940s, which was marked by an unprecedented period of construction, Mexican artists and architects became protagonists in a polemic over the integration of painting and sculpture with new arquitecture. Mérida collaborated in mural decoration in the projects of architects such as Mario Pani, Enrique del Moral, and Salvador Ortega. These collaborations were principally in constructing multi-family complexes.

At that time Mérida's plain and linear style was already recognized, especially in his incursion into architecture, glazing techniques, mosaics, and other mural styles. In 1954 he received a commission to make four murals in the Palacio Municipal in Guatemala (1962–68). By then the work of Mérida had acquired the characteristics that best defined him: formal equilibrium, purity of line, and depuration of color and texture. He died in 1984 at 93 years of age.

—Rosina Cazali

MESA-BAINS, Amalia
American installation artist

Born: Santa Clara, California, 1943. **Education:** San Jose State University, California, B.A. in painting 1966; San Francisco State University, M.A. in interdisciplinary education; Wright Institute, School of Clinical Psychology, Berkeley, California, Ph.D. in clinical psychology 1983. **Career:** Art instructor, California State University, Monterey Bay; director, Institute for Visual and Public Art, California State University, Monterey Bay. **Awards:** Golden Palm award, Hispanic Arts Center, 1991; MacArthur fellowship, John D. and Catherine T. MacArthur Foundation, Chicago, 1992; Distinguished Service to the Field award, Association of Hispanic Artists of New York, 1992.

Individual Exhibitions:

1981 Mexican Museum, San Francisco
1987 *Grotto of the Virgins,* Intar Latin American Gallery,
 New York
1990 M.A.R.S., Phoenix, Arizona
1993 Whitney Museum of American Art, New York
1997 *Cihuatlampa, The Place of Giant Women,* Bernice
 Steinbaum Gallery, New York

Selected Group Exhibitions:

1984 Galería Posada, Sacramento, California
1986 *Chicano Expressions,* Intar Latin American Gallery,
 New York
1987 *El día de los muertos,* Galería de la Raza, San Francisco
1992 *III International Istanbul Biennial,* Turkey
 Ante America, Biblioteca Luis Angel Arango, Bogota,
 Colombia
1993 *Revelaciones/Revelations: Hispanic Art of Evanescence,*
 Herbert F. Johnson Museum of Art, Cornell University, Ithaca, New York
1996 Bernice Steinbaum Gallery, New York
1997 Bernice Steinbaum Gallery, New York
1998 *Memorable Histories and Historic Memories,* Bowdoin
 College Museum of Art, Brunswick, Maine
 (traveling)
2000 *Mi alma, mi tierra, mi gente: Contemporary Chicana
 Art,* Saint Mary's College, Notre Dame, Indiana

Publications:

By MESA-BAINS: Books—*A Study of the Influence of Culture on the Development of Identity Among a Group of Chicana Artists,* dissertation, Berkeley, Wright Institute, 1983; *Ester Hernández,* exhibition catalog, San Francisco, Galería de la Raza, 1988; *Ismael Frigerio: Utopías 1989,* exhibition catalog, Santiago, Chile, Galería Plástica Nueva, 1989; *Magulandia,* exhibition catalog, San Francisco, Galería de la Raza, 1991; *Mildred Howard: Ten Little Children Standing in a Line (One Got Shot, and Then There Were Nine),* with Judith Bettelheim, Adaline Kent Award Exhibition, San Francisco Art Institute, 1991; *Ceremony of Spirit: Nature and Memory in Contemporary Latino Art,* San Francisco, Mexican Museum, 1993; *Chicano Expressions,* Los Angeles, Self-Help Graphics and Art, 1993; *Facilitator's Guide to Diversity in the Classroom,* with Judith Schulman, Hillsdale, New Jersey, Research for Better Schools and L. Erlbaum Associates, 1994; *Another Life Up Inside Her Head,* exhibition catalog, San Francisco, Galería de la Raza, 1995; *Patssi Valdez:*

A Precarious Comfort, with Terezita Romo, exhibition catalog, San Francisco, Mexican Museum, 1999.

On MESA-BAINS: Books—*Ofrendas,* exhibition catalog, Sacramento, California, La Raza Bookstore and Galería Posada, 1984; *Offerings: The Altar Show,* by Linda Kaun, Venice, California, Social and Public Arts Resource Center, 1984; *Grotto of the Virgins,* exhibition catalog, text by Tomás Ybarra-Frausto, New York, Intar Latin American Gallery, 1987; *Artistas chicanas: A Symposium,* Santa Barbara, University of California, 1991; *La reconquista: Third International Istanbul Biennial,* by Patricio Chávez, San Diego, Centro Cultural de la Raza, 1992; *Revelaciones,* by Celia Alvarez Muñoz, Chon A. Noriega, and others, Ithaca, New York, Hispanic American Studies Program, Cornell University, 1993; *Signs from the Heart: California Chicano Murals* by Eva Sperling Cockcroft and Holly Barnet-Sánchez, Albuquerque, University of New Mexico Press, 1993; *Amalia Mesa-Bains,* exhibition catalog, text by Thelma Golden, New York, Whitney Museum of American Art, Philip Morris, 1993; *Voices from the Battlefront: Achieving Cultural Equity* by Marta Moreno Vega and Cheryll Y. Greene, Trenton, New Jersey, Africa World Press, 1993; *States of Loss* by Gary Sangster, New Jersey, Jersey City Museum, 1993; *Division of Labor: ''Women's Work''* in Contemporary Art, New York, Bronx Museum of the Arts, 1995; *Women of Hope: Latinas abriendo camino* by Noni Mendoza Reis, Irene McGinty, and others, New York, Bread and Roses Cultural Project, 1995; *Contemporary Art and Multicultural Education* by Susan Cahan and Zoya Kocur, New York, New Museum of Contemporary Art, Routledge, 1996; *Siting Histories: Material Culture and the Politics of Display in the Work of Fred Wilson, Pepon Osorio, and Amalia Mesa-Bains* by Jennifer A. González, dissertation, Santa Cruz, University of California, 1996; *Art on the Edge and Over* by Linda Weintraub, Arthur Coleman Danto, and Thomas McEvilley, Litchfield, Connecticut, Art Insights, Inc., 1996; *Interzones* by Octavio Zaya and Anders Michelsen, Copenhagen, Tabapress, 1996; *Home Altars of Mexico* by Ramón A. Gutiérrez, Sal Scalora, William H. Beezley, and others, Albuquerque, University of New Mexico Press, 1997; *Memorable Histories and Historic Memories,* exhibition catalog, Brunswick, Maine, Bowdoin College Museum of Art, 1998; *Arte Latino Treasures from the Smithsonian American Art Museum,* Washington, D.C., Smithsonian American Art Museum, 2000; *State of the Arts: California Artists Talk about Their Work* by Barbara Isenberg, New York, W. Morrow, 2000. **Articles**—''A Conversation with Amalia Mesa-Bains'' by Meredith Tromble, in *Artweek,* 23(25), 8 October 1992, p. 27; ''Amalia Mesa-Bains'' by Anne Barclay Morgan, in *Art Papers,* 19(2), March 1995, p. 24.

* * *

Amalia Mesa-Bains, one of the most accomplished Chicana artists working in the United States, is also an educator, a cultural critic, and an art historian. She holds a Ph.D. in clinical psychology and degrees in painting and interdisciplinary education. Her large-scale art installations focus on reinterpreting traditional Chicano altars by synthesizing religious traditions, family heritage, and Mexican-American culture with contemporary formal concerns. Through her altar installations she re-creates lush ceremonial spaces that raise critical issues about gender, race, and culture. By combining cultural activism, educational outreach, and artistic production, she has pioneered the documentation and interpretation of Chicano culture while expanding the formal parameters of American sculpture and painting.

The director of the Institute for Visual and Public Art at California State University at Monterey Bay, Mesa-Bains is the author of numerous scholarly articles and is a nationally known lecturer on Chicano art. As an educator and a community advocate, she has served numerous educational and cultural organizations. She has written on multicultural teaching strategies, student learning modalities, and diversity in the classroom. Her curricular publications as well as her literature on art history are of significant cultural relevance to students of color. Since 1967 she has brought this commitment to outreach into her art, creating environments that combine the fields of painting, sculpture, literature, and history.

In the words of Mesa-Bains, ''My art is always about self *and society.* I am a social activist who happens to be an artist. The teaching, the writing and the art are intimately intertwined.'' Her art engages critical issues as it intersects private concerns. For example, her altar devoted to the Mexican film star Dolores Del Rio (1983) offers adoration while questioning notions of ageless beauty and racial stereotypes. The altar to the seventeenth-century Mexican nun Sor Juana Inés de la Cruz (1981) honors both quiet patience and salient intellectual tenacity. Her homage to Frida Kahlo (1978) acknowledges the sorrows of being unable to bear a child yet scrutinizes society's gender expectations.

As a Chicana artist of immigrant parents, Mesa-Bains developed her art from the Mexican practice of making home altars. Her materials include personal artifacts displayed on tables and in niches. The environments are enhanced with candles, fragrant flowers, and herbs. Her table-sized *ofrenda*s (spaces for offering thanks), which dated to the period from 1975 through 1987, addressed female narratives, domestic spaces, ceremonies, and critiques. The altars offered an exuberant mix of vernacular materials, bicultural icons, and hybrid images situated in temporary sites. By focusing on gendered subjects and stereotypes, Mesa-Bains expanded Chicano *rasquache* aesthetics, defined by Tomas Ybarra-Frausto as ''an aesthetic of abundance and of display,'' to include *domesticana.* Mesa-Bains has defined *domesticana rasquache* aesthetics as ''the Chicana woman's use of satire, reversals, and play with traditional imagery in order to subvert restrictive cultural and gender roles.''

By 1987, with the *Grotto of the Virgin,* Mesa-Bains was building large-scale environments that drew audiences into interactive spaces in which viewers participated with the materials. She brought text into her multiroom installations, referencing specific archaeological and museological critiques of knowledge. Her intent was to have the installations create a cultural ''third space'' between the First World Anglo culture and Third World marginalized communities. Her rooms unfold history through a participatory model of art, one that she notes is ''not exclusionary, not simply celebratory, [but] rather engages the viewer in a critical dialogue about culture, gender and race.''

Mesa-Bains's trilogy *Venus Envy* has been her largest undertaking. *Venus Envy, Chapter 1: The First Holy Communion Moments before the End* (1993) creates a sanctuary for women. It is a beauty salon, a museum hall, and a history classroom that inaugurates the end of innocence and the beginning of physical love through metaphors of sexuality, spirituality, and death. *Venus Envy, Chapter 2: The Harem and Other Enclosures* (1994) explores physical, mental, and spiritual spaces that delineate, define, and constrict women. The work is lush with material comforts, as Mesa-Bains creates a haven of fabrics and scents for the body, a library of wide-reaching historical treatises for the mind, and an earthly garden of texture and color for the spirit.

Erotic images articulate issues of desire and control. The installation points to the life forged from within enclosures. Ironically, independence and community emerge within those parameters.

Venus Envy, Chapter 3: Cihuatlampa, the Place of the Giant Women (1997) continues to reflect women's struggles with self and society. For Mesa-Bains the hybrid Amazon-like female Aztec warriors called Cihuatlampa express the physical discomfort felt through the zealous scrutiny of women's bodies. The primary site is a ceremonial burial ground for the ancient Cihuatlampa, women who died in childbirth, forever large, pregnant, destined to labor as the bearers of the sun. Mesa-Bains dissects the burial ground with an archaeological dig, investigating the irony of cultures that grant heroism only to women who struggle against their bodies. Ceremony, rupture, violence, separation, and scrutiny thus become the main themes in Mesa-Bains's many reading and discussion-filled rooms.

—Judith Huacuja Pearson

MEYER, Pedro
Mexican photographer and digital artist

Born: Madrid, Spain, 1935; immigrated to Mexico, 1937, Mexican citizen, 1942. **Education:** Self taught photographer. **Career:** Organizer, Colloquium of Latin American Photography, Mexico City, 1979, 1981, and Havana, 1984. Since 1995 founder and editor, digital photography web site *Zone Zero.* Founder, Mexican Council of Photography, Mexico City, 1977. **Awards:** Purchase prize, Bienal of Photography award, Instituto Nacional de Bellas Artes, Mexico City, 1980, 1983; Premio Internazionale di Cultura Citta di Anghiari, Italy, 1984; fellowship grant, John Simon Guggenheim Foundation, 1987; award, National Endowment for the Arts, 1992; U.S./Mexico Fund for Culture award; first prize, Organización Internacional del Trabajao, Santiago, Chile. **Website:** http://www.zonezero.com.

Individual Exhibitions:

1978 *El retrato contemporáneo en Mexico: Pintura y fotografia,* Museo Carrillo Gil, INBA-SEP, Mexico City
 Testimonios sandanistas, Galería de Fotografía de la Casa del Lago de la UNAM, Mexico City
 Casa de las Américas, Havana
1979 *Testimonios sandanistas–parte II,* Salón de la Plástica Mexicana, Mexico City
1980 *De minha terra: Realidades lendas e mitos,* Museu da Imagem e do Som, São Paulo, Brazil (traveling)
1981 *Photographs by Pedro Meyer,* CityScape Foto Gallery, Pasadena, California
1982 *Fotografías de Pedro Meyer,* Fachhochschule Bielefeld, Germany, and Galeria 666, Paris
1983 *Tres fotógrafos mexicanos,* Museo Nacional de Bellas Artes de Cuba, Havan (traveling)
 Fotografía de Pedro Meyer, Nikon Gallery, Zurich, Switzerland, and Galeria Spectrum-Cannon, Zaragoza, Spain
 Juchitán: Retrato de un pueblo, Casa de Cultura, Ecuatoriana, Quito, Ecuador
1984 *Images of Pedro Meyer,* Palazzo Pretorio, Anghiari, Italy (traveled to Centro Ricerca Aperta, Naples, Italy, and June's Gallery, Yuma, Arizona)
1985 *Juchitán,* Casa de la Cultura of Juchitán, Oaxaca, Mexico
1986 *Los otros y nosotros,* Museo de Arte Moderno, Bosque de Chapultepec, Mexico City
 Pedro Meyer, Photographe mexicain, Douchy-les-Mines, Hotel de Ville, Centre Regional de la Photographie Nord-Pas de Calais, France
 Teimpos de America, Sasso di Castalda-Edificio Scolastico, Comune di Sasso di Castalda, Potenza, Italy
 Planket 86, Centre for Photography, Stockholm
1987 *Photographs by Pedro Meyer,* San Francisco Museum of Modern Art
1988 *Pedro Meyer: Mexican Photography,* Rantagalleria Photo Gallery, Oulu, Finland
1989 *Pedro Meyer: Contemporary Mexican Photography,* Massachusetts College of Art, North Gallery, Boston
 Photographs of Pedro Meyer, Visions Gallery, San Francisco
1993 *Truths and Fictions,* Museum of Photography, Riverside, California (traveling)
 Museo de Artes Visuales Alejandro Otero, Caracas, Venezuela

Selected Group Exhibitions:

1976 *The Photographers Choice,* Witkin Gallery, New York
1977 *Salón Nacional de Artes Plásticas,* Sección Bienal de Gráfica, Palacio de Bellas Artes, INBA, Mexico City
1978 *Contemporary Mexican Photographers,* Center for Creative Photography, Tucson, Arizona, Meridian House International, Washington, D.C., and Nexus Gallery, Atlanta
1979 *Hecho en latinoamérica 1,* Palacio de San Giovani, Turin, Italy, and Giardinni de la Biennale, Venice
1982 *La photographie contemporaine en amerique latine,* Musee National d'Art Moderne Centre Georges Pompidou, Paris
1986 *Eight Mexican Photographers,* San Francisco Camerawork Gallery
 39 Mexican Photographers, Houston Center of Photography
1987 *Latin American Photography,* Burden Gallery, New York, Society for Photographic Education, San Diego, California,, and Los Angeles Art Association Gallery
1989 *La memoria del tiempo: 150 Years of Mexican Photography,* Museum of Modern Art, Mexico City
1990 *Between Worlds: Contemporary Mexican Photography,* Impressions Gallery, York, England, Camden Arts Centre, London, University of East Anglia, England, and International Center of Photography, New York

Collections:

Addison Gallery of American Art, Andover, Massachusetts; Bert Hartkamp Collection, Amsterdam; Bibliotheque National de Paris,

Paris; Boston Museum of Fine Arts, Boston; Center for Creative Photography, Tucson, Arizona; Coleccion de Franco Fontana, Milan, Italy; Comuna di Anghari, Palazzo Preorio, Anghiari, Italy; Museum of Modern Art, Mexico DF; Grunwald Graphic Arts Center, University of California at Los Angeles, Los Angeles; International Museum of Photography, George Eastman House, Rochester, New York; International Center of Photography, New York; Museum of Modern Art, New York; Musee Nationale d'Art Moderne, Centre Georges Pompidou, Paris; Riverside Museum of Photography, Riverside, California; San Francisco Museum of Modern Art, California; The Museum of Fine Arts, Houston, Texas; Universidad de Parma, Parma, Italy; Los Angeles County Museum of Art, California; Victoria and Albert Museum, London.

Publications:

By MEYER: Books—*Negromex en blanco y negro,* Mexico City, 1977; *Hecho en latinoamerica,* Mexico City, 1978; *Hecho en latinoamerica 2,* with Lazaro Blanco and others, Mexico City, 1981; *Pedro Meyer, fotografía,* with an introduction by Carlos Monsivais, Mexico City, Museo de Arte Moderno, 1986; *Tiempos de America,* Potenza, Italy, Comune di Sasso di Castalda, 1985; *Planket 86,* exhibition catalog, Sweden, 1986; *Espejo de espinas,* Mexico City, Fondo de Cultura Económica, 1986; *Los trabajos y los días,* exhibition catalog, with Victor Flores Olea, Mexico City, Instituto Nacional de Bellas Artes, 1987; *Los cohetes duraron todo el dia,* Mexico, Petróleos mexicanos, 1988; *Verdades y ficciones,* exhibition catalog, Mexico, Casa de la Imágenes, 1995. **Articles**—"Dignidades," in *Revista Arquitecto* (Mexico City), 1978; "Ernesto Cardenal entre Rifles M-1," in *Uno Mas Uno* (Mexico City), November 1978; in *Symposium uber Fotografie* (Graz, Austria), 1980; "Letter from Nicaragua," in *American Photographer* (New York), January 1980; "Sobre la fotografia cubana," in *Semena de Bellas Artes* (Mexico City), July 1980; "La fotografia latinoamericano," in *Fototecnica* (Havana), January/March 1984; "Nuevos espejismos," in *Nexis* (Mexico City), July 1985; "Inside the USA," in *American Art* (Oxford, England), 5(3), 1991; "La revolución digital," in *Luna Cornea,* 2, 1993; "Los desafios de la tecnología a la creación fotográfica latinoamericana," in *La Jornada Semenal,* 267, July 1994. **CD-ROMs**—*I Photograph to Remember,* New York, Voyager Company, 1990; *Truths and Fictions,* New York, Voyager Company, 1994.

On MEYER: Books—*Contemporary Photography in Mexico: 9 Photographers,* exhibition catalog, text by Terence Pitts and Rene Verdugo, Tucson, Arizona, The Center for Creative Photography, 1978; *Retrospectiva de Pedro Meyer,* exhibition catalog, text by Carlos Monsivais, Mexico City, 1980; *7 portafolios mexicanos,* exhibition catalog, Mexico City, Universidad Autónoma de México,1980; *Los otros y nosotros,* exhibition catalog, text by Vicente Lenero, Mexico City, 1986; *A Shadow Born of Earth, New Photography in Mexico* by Elizabeth Ferrer, New York, American Federation of Arts, 1993. **Articles**—"Interview with Artist Pedro Meyer" by Jesse Lerner, in *Latin American Art,* 5(4), 1994, pp. 65–66; "Pedro Meyer's Documentary Fictions" by Jonathan Green, in *Aperture,* 136, summer 1994, pp. 32–37; "Visions of the Future" by David Schonauer, Carol Squiers, and Sue Alexander, in *American Photo,* 5, May/June 1994, pp. 60–71; "Pedro Meyer: Truths & Fictions" by Mark Little, exhibition review, in *Creative Camera,* 333, April/May 1995, p. 36; "You Can't Believe Your Eyes" by Scott Rosenberg, in *Wired,* 3(12), 1995; "Río de Luz," in *Aperture,* 153, fall 1998, pp. 2–75.

* * *

The Mexican photographer Pedro Meyer, who was born in Madrid, was only 13 years old when he began to practice photography seriously, and he is completely self-taught. Working as a documentary photographer and using traditional technology, he has produced images that have appeared in more than a hundred exhibitions in galleries and museums throughout Latin America, the United States, and Europe, including the Palacio de Bellas Artes in Mexico City and the International Center for Photography in New York City. His photographs form part of the permanent collection of more than 20 major museums, including the Museum of Modern Art in New York and the International Museum of Photography in Rochester, New York. He has also experimented with the application of computers to photography and has become a leading proponent of digitally altered processes. Integrating his early work with computer technology, he created a CD-ROM entitled *I Photograph to Remember* that combines black-and-white images of his parents' illness and death with narration and music. In all of his work Meyer's images wryly challenge the essential truths and myths surrounding the documentary aesthetic. His work also illuminates the transition of the photographic medium from its photochemical origins to its new electronic foundation and direction.

In many of his photographs Meyer presents serious messages with tragicomic undertones. Using closely controlled digital techniques, he illustrates provocative, often humorous fables that reveal his ironic messages. As a Mexican who has lived in Los Angeles, he is intensely conscious of the cultural divide separating the two cultures. In *Mexican Serenade,* for example, a toy-sized ceramic mariachi band serves as a yard ornament at a trailer park. Meyer's digital skill enters the commentary, with the Anglo trailer owner reduced to the size of a toy as well. *Plantation, El Centro* is one of Meyer's subtle, powerful commentaries on minorities in the United States. On close scrutiny the photograph of the black child reveals tire treads burned into his head and back, as if he had been run over and permanently marked. Behind him is the image of row upon row of crops in which he has toiled. Meyer sees America from a heightened perspective that shows the way in which myth, tradition, and values are subverted and distorted.

Meyer has also made innovations in his photographic series by inserting into them single straight, unaltered photographs. *Monumental Chair* (Washington, D.C., 1989), for example, is a parody of scale that looks more obviously altered than most of his digital photographs. The alteration, however, comes from the perspective on the landscape, which is reduced to miniature by the angle from which the photograph was taken.

Meyer has photographed the streets of New York City, the deserts of Arizona, and the training camps of Sandinista armies in Nicaragua. In his photographs it is human beings, usually rendered in epiphanic moments of worship, war, sex, pain, celebration, or sorrow, who are almost exclusively his subject. A Pemex oil worker is exalted by a seemingly infinite cloud and sky for a backdrop; a groom's unreadable but cold gaze into the camera lens implies the dubious future of his marriage; and a monumental Francisco Zúñiga-inspired female bends over to wash her hair. It is not surprising that Meyer would also experiment with producing combinations of photo and text. Some of his portraits have been both enhanced and refracted,

depicting a reality that is divided into many individual parts and then reassembled again. One portrait, with many sections composed of patterns of black-and-white dots, is realigned against the black-and-white squares of a tiled floor. In one corner the enlarged text becomes visible: ''We do not, of course, see atoms with the naked eye, even though they are what form us and give us substance. We are nothing more than a collection of small dots in search of a modicum of experience.''

—Martha Sutro

MINUJÍN, Marta
Argentine painter and sculptor

Born: Buenos Aires, 1943. **Education:** Escuela Nacional de Bellas Artes, Buenos Aires, 1953–59; Escuela Superior de Bellas Artes, Buenos Aires, 1960–62, doctorate in sculpture and painting; studied in Paris. **Career:** Lived in the United States, 1965–69, 1970–74. Guest artist, Corcoran School of Art, Washington, D.C., 1972–73. **Awards:** Scholarship, French Embassy, 1960, 1962; prize, Torcuato Di Tella Foundation, 1964; fellowship, Guggenheim Foundation, 1966; fellowship, Fairfield Foundation, New York, 1967; fellowship, Rockefeller Foundation, 1968. **Address:** Humberto 1° 1957, 1229 Buenos Aires, Argentina.

Individual Exhibitions:

1959	*8 dibujos de Marta Minujín,* Teatro Agón, Buenos Aires
1961	*Marta Minujín,* Galería Lirolay, Buenos Aires
1962	*Marta Minujín,* Galería Lirolay, Buenos Aires
	La pieza del amor, Tokyo
1963	*Casa de colchones,* Atellier Delambre, Paris
	Eróticos en technicolor, Instituto Di Tella, Buenos Aires
1966	*El batacazo,* Bianchini Gallery, New York
	Three Countries Happening, Instituto Di Tella, Buenos Aires
1967	*Minuphone,* Howard Wise Gallery New York
1968	*Minucode,* Center for Inter-American Relations, New York
	Importación/Exportación, Instituto Di Tella, Buenos Aires
1972	*Minusquires,* Rivkin Gallery, Washington, D.C.
1973	*Serie erótica,* Arte Nuevo Galería de Arte, Buenos Aires
1974	Hard Art Gallery, Washington, D.C.
1975	*La academia del fracaso,* CAYC, Buenos Aires
1976	Goethe Institute, Buenos Aires
	Comunicando con tierra, CAYC, Buenos Aires
1978	Gordon Gallery, Buenos Aires (retrospective)
1981	*La venus de queso,* CAYC, Buenos Aires
1982	*La cama,* Teatros de San Telmo, Buenos Aires
1983	*Extasy/Arte,* Galería del Buen Ayre, Buenos Aires
	Mary Anne Martin Fine Arts, New York
	Taghinia-Milani, New York
1984	*Marta Minujin. Recent Sculptures,* Yvonne Séguy Gallery, New York
	Museo de Arte Moderno, Cali, Colombia
1986	*Nuevas esculturas de Marta Minujin,* Galería Ruth Benzacar, Buenos Aires
1988	*Músculos y nieve,* Estudio Giesso, Buenos Aires
1989	*Hacia una invención de lo inextricable,* Galería Rubbers, Buenos Aires
	Marta Minujín. La multiplicación de Hércules, Centro Cultural Casa del Angel, Buenos Aires
1990	*Marta Minujín. Redimensioning the Past into the Future,* Gallery at Turnberry, Florida
	Plataia y los millones, Instituto de Cultura Iberoamericana, Buenos Aires
	Harrods en el Arte, Buenos Aires (retrospective)
1991	Banco Interamericano de Desarrollo, Washington, D.C.
	Marta Minujín. Arte fragmentado-esculturas y pinturas '80/90, Sala de Conferencias de Prensa Presidencial, Casa Rosada, Buenos Aires
1993	*Tiempo relativo,* Galería Rubbers, Buenos Aires
1994	Golden Shopping, Buenos Aires
1997	Centro Cultural Borges, Buenos Aires
1998	Galería Ruth Benzacar, Buenos Aires
1999	*Vivir en arte,* Museo Nacional de Bellas Artes, Buenos Aires
2000	Centro de España, Rosario, Argentina

Selected Group Exhibitions:

1957	*VIII exposición de artes plásticas,* Centro Cultural y Biblioteca Popula Juan B. Alberti, Buenos Aires
1970	*Information,* Museum of Modern Art, New York
1977	*Poeticas visuais,* Museu de Arte Contemporanea da Universidade de São Paulo, Brazil
1983	*XVII bienal de São Paulo,* Brazil
1989	*The Latin American Spirit: Art & Artists in the U.S.,* Bronx Museum, New York
1991	*Painting and Sculpture. New Acquisitions 1990–1991,* Art Museum of the Americas, Organization of American States, Washington, D.C.
1996	*Maestros latinoamericanos,* Tomás Andreu Galería de Arte, Santiago, Chile
	Modernidade e contemporaneidade nas artes plasticas, Centro Cultural São Paulo, Espaço Caio Graco, São Paulo, Brazil
1998	*Figuración, abstracción, fusiones,* Palais de Glace, Buenos Aires
	Out of Actions: Between Performance and the Object, Museum of Contemporary Art, Los Angeles

Selected Collections:

Solomon R. Guggenheim Museum, New York; United Nations, New York; Museo de la Tertulia de Cali, Colombia; Walker Art Center, Minneapolis; Museo de Arte Moderno de Medellín, Colombia; Museo Nacional de Bellas Artes, Buenos Aires; Museo de Arte Moderno, Buenos Aires; Chase Manhattan Bank Collection, New York; Parque Olimpico de Seoul, Korea; Art Museum of the Americas.

Publications:

By MINUJÍN: Article—''Los inútiles crónicos,'' in *La Nación* (Buenos Aires), 10 May 1993.

Marta Minujín: *El Patenón de libros,* **1983. Photo courtesy of the artist.**

On MINUJÍN: Books—*Marta Minujín,* exhibition catalog, Galería Lirolay, Buenos Aires, 1961; *Marta Minujín,* exhibition catalog, text by Rafael Squirru, Buenos Aires, Galería Lirolay, 1962; *Panorama de la Pintura Argentina Contemporánea* by Aldo Pellegrini, Buenos Aires, Paidós, 1967; *El Pop-Art* by Oscar Masotta, Buenos Aires, Columba, 1967; *Arte en la Argentina: Ultimas Décadas,* Buenos Aires, Paidós, 1969; *Dos Décades Vulnerables en las Artes Plásticas Latinoamericanas, 1950/1970* by Marta Traba, Mexico, Siglo XXI, 1973; *Marta Minujín,* exhibition catalog, text by Jorge Glusberg, Buenos Aires, Museo Nacional de Bellas Artes, 1983; *Marta Minujín: Esculturas recientes,* exhibition catalog, Buenos Aires, Galería del Buen Ayre, 1983; *Nuevas esculturas de Marta Minujin*, exhibition catalog, Buenos Aires, Galería Ruth Benzacar, 1986; *Marta Minujín esculturas,* exhibition catalog, text by Jorge Glusberg, Buenos Aires, Galería Rubbers, 1989; *Marta Minujín. Arte fragmentado-esculturas y pinturas '80/90,* exhibition catalog, Buenos Aires, Sala de Conferencias de Prensa Presidencial, Casa Rosada, 1991. **Selected Articles**—"Reportaje a Marta Minujín: A Profile" by Alvaro Torres de Tolosa, in *En Vuelo* (Buenos Aires), 5, January/March 1988; "Connections" by Ellen Lee Klein, in *Arts Magazine,* 60, September 1985, p. 38; "A Convergence of Visual Cultures" by Ricardo Pau-Llosa, in *Art International* (Switzerland), 6, spring 1989, pp. 17–23; "Marta Minujín muestra su taller" by Viviana Andón, in *Caras* (Buenos Aires), 12 August 1993; "Marta Minujín. Vivir a mil" by Graciela Cravino, in *Clarín* (Buenos Aires), 3 October 1993; "Alicia Penalba and Marta Minujin" by Alberto Collazo, in *Art Nexus* (Colombia), 12, April/June 1994, pp. 178–179; "Salvador Dalí, Marta Minujín y los pobres comían caviar" by Hernán Ameijeiras, in *La Maga* (Buenos Aires), May 31, 1995; "Entre la Performance y el Object" by Rodrigo Alonso, in *La Maga* (Buenos Aires), February 25, 1998.

* * *

Marta Minujín became one of the best known practitioners of Argentine pop art through a series of performances that transformed

Marta Minujín: *Catedreal del Pensamiento Vacío,* **1993. Photo courtesy of the artist.**

the urban environment into a site of spectacle, often engaging the interest of bystanders in the process. Her early career was promoted by the critic Jorge Romero Brest, director of the visual arts division of the Instituto Torcuato di Tella in Buenos Aires, an organization devoted to promoting Argentine art during the 1960s. Minujín was one of the few Latin American artists who had a well-established reputation in the United States and Europe, owing to her remarkable skill in creating unforgettable artistic happenings. At times she was dubbed the queen of pop art and compared to Andy Warhol, a connection reinforced by her posing with Warhol for a 1986 photograph in which both artists wore black and sported platinum blonde hair.

Minujín produced art objects primarily as vehicles and props for her performances. In 1962 she received an award from the French government to travel to Paris. At the end of her stay she decided to destroy all of the work that she had completed rather than surrender it to what she viewed as the crass commercialism of the gallery scene. She set fire to her paintings in a Paris vacant lot, attracting the curiosity of bystanders. Through this experience Minujín learned how to create a public spectacle and manipulate the artistic happening to maximum effect, skills she would use often throughout her career.

In 1965 Minujín collaborated with a group of Argentine artists that included Pablo Suárez and Rubén Santantonín to create *La menesunda* (''The Challenge''), an artistic environment that induced sensory overload. Observers were required to walk through passageways that presented a series of confrontational situations, including the smells of fried food, a room with walls that resembled the inside of an intestinal tract, and another in which two people were actually making love. In 1966 she received a Guggenheim Fellowship to travel to New York, where at the Bianchini Gallery she constructed a similar environment entitled *El batacazo* (''The Long Shot''). There observers walked through environments that included a room with live flies trapped inside clear plastic walls, cages of rabbits, and a long slide that viewers went down, landing on an inflatable vinyl replica of the actress Virna Lisi. In these works Minujín constructed situations in

385

which the observer's senses were bombarded and overwhelmed, an experience similar to the chaos of the urban environment.

Minujín's actions in Paris early in her career set the tone for her later series *Los mitos y la ley de la gravidad* (''Myths and the Law of Gravity''). Here she constructed various monumental art objects and then destroyed them, at the same time symbolically toppling the icons and myths of society. In 1980 she built the *Obelisco de Panetone* (''Obelisk of Sweet Rolls'') in downtown Buenos Aires. The 105-foot-tall wire framework covered with a popular brand of Argentine sweet rolls was a replica of an obelisk located elsewhere in the middle of the city. She raised and lowered the towering sculpture and then distributed the rolls one by one to approximately 50,000 people. In 1981 Minujín set fire to a monumental wire and cotton effigy of the Argentine tango idol Carlos Gardel that she had built for the Medellín Biennial.

Minujín linked sensationalism with the art world long before it was fashionable to do so and, like Warhol, was acutely aware of the artist's status as a celebrity. Like the Paris-centered artist groups GRAV (Groupe de Recherche d'Art Visuel) and the Situationist International, Minujín conceived of the city as the ideal location in which normally complacent viewers could be engaged through her performances. Minujín was greatly inspired by Marshall McLuhan's writings on the role of the communications media in modern society. In 1969 she created what she called a ''Minuphone,'' which bombarded the senses with loud noises and flickering lights when a ''call'' was made, reinforcing the connection between the technological apparatus and the nervous system. Latin American artists such as Hélio Oiticica wanted to make art relevant to popular audiences. In contrast, Minujín's work, like that of McLuhan, is concerned primarily with the means through which messages are conveyed and less with the message itself.

—Erin Aldana

MODOTTI, Tina

Mexican photographer

Born: Assunta Adelaide Luigia Modotti, Udine, Italy, 17 August 1896. **Education:** Studied under photographer Edward Weston in San Francisco, early 1920s. **Family:** Married Roubaix de l'Abrie Richey in 1917 (died 1922); had a relationship with Edward Weston, c. 1921–26; involved with Cuban rebel Julio Antonio Mella, 1928–29. **Career:** Moved to San Francisco, 1913. Actress in Hollywood films, Los Angeles, 1920–21; worked with Edward Weston, San Francisco and Mexico, 1922–26; contributing editor and photographer, *Mexican Folkways* magazine, 1924–29; photojournalist, with contributions to *New Masses, Creative Art, Vanity Fair,* and Mexican Communist Party newspaper *El Machete,* 1927–29. Exiled from Mexico for political reasons, 1930; moved to Moscow and joined the Soviet Communist Party, 1930. Worked for Comintern, Europe, 1931; helped political prisoners by carrying out undercover missions, Paris, 1932–33; worked for the International Red Aid during the Spanish Civil War, 1935–39. Returned to Mexico incognito, 1939. Affiliated with the Mexican Artists Union and Mexican Communist Party, 1920s. **Died:** Mexico City, 6 January 1942.

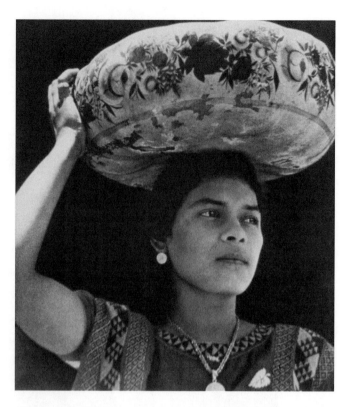

Tina Modotti: *Woman of Tehuantepec,* c. 1929. Photo courtesy of Throckmorton Fine Art, Inc.

Individual Exhibitions:

1929 Biblioteca Nacional, Mexico City
1930 Studio of Lotte Jacobi, Berlin
1942 Galeria de Arte Mexicano, Mexico City
1977 Museum of Modern Art, New York
1982 *Frida Kahlo and Tina Modotti,* Whitechapel Art
 Gallery, London
1983 *Frida Kahlo, Tina Modotti,* Museo Nacional de Arte,
 Mexico City
1995 Philadelphia Museum of Art
 Tina Modotti: Photographs 1923–29, Throckmorton
 Fine Art, New York
1996 *Tina Modotti: Photographs,* San Francisco Museum of
 Modern Art (traveling retrospective)
1997 *Tina Modotti: Vintage Photographs,* Robert Miller
 Gallery, New York
2000 *Tina Modotti and the Mexican Renaissance,* Moderna
 Museet, Stockholm (traveling)
2001 *Tina Modotti: The Mexican Light,* Galleria Photology,
 Milan

Selected Group Exhibitions:

1924 Palacio de Mineria, Mexico City
1927 *Tenth International Salon of Photography,* Los Angeles
 Museum
1990 Crocker Art Museum, Sacramento, California
1992 Galleria d'arte moderna, Udine, Italy
1993 Carla Stellweg Gallery, New York

1995 Houston Museum of Fine Arts (traveling)
1996 University of San Diego, California
1997 Maison de la culture Côtes-des-Neiges, Montreal
1998 Biblioteca Luis Angel Arango, Bogota
 Mexicana: Fotografía moderna en México, IVAM
 Centre Julio González, Valencia, Spain

Publications:

On MODOTTI: Books—*Tina Modotti,* Milan, Gruppo editoriale Fabbri, 1953; *Tina Modotti, Photographs* by Maria Caronia and Vittorio Vidali, New York, Idea Editions, 1981; *Perché non muore il fuoco* by Riccardo Toffoletti, Udine, Italy, Edizioni arti grafiche friulane, 1992; *Tina Modotti: Photographer and Revolutionary* by Margaret Hooks, London, Pandora, 1993; *Tina Modotti: A Fragile Life* by Mildred Constantine, London, Bloomsbury, 1993; *Tina Modotti in Carinzia e in Friuli* by Gianfranco Ellero, Pordenone, Italy, Cinemazero, 1996; *Tina Modotti, vanguardia y razón* by José Antonio Rodríguez, Mexico City, Sistema Nacional de Fototecas, 1998; *Tina Modotti: Vivir y morir en México* by Antonio Saborit, Mexico City, Consejo Nacional para la Cultura y las Artes, 1999; *Tina Modotti,* Germany, Koenemann Verlags GMBH, 1999; *Tina Modotti: A Life* by Pino Cacucci, New York, St. Martin's Press, 1999; *Shadows, Fire, Snow: The Life of Tina Modotti* by Patricia Albers, New York, Crown, and London, Hi Marketing, 1999; *Tina Modotti: The Mexican Renaissance,* exhibition catalog, text by Patricia Albers and Karen Cordero, Paris, Jean-Michel Place Editions, 2000; *Tina Modotti: Image, Texture, Photography* by Andrea Noble, Albuquerque, University of New Mexico Press, 2000. **Articles**—"Assignment Mexico: The Mystery of the Missing Modottis" by Margaret Hooks, in *Afterimage,* 19, November 1991, pp. 10–11; "Tina and Edward" by Gary Higgins, in *Creative Camera* (United Kingdom), 314, February/March 1992, pp. 20–23; "Who Was Tina Modotti?" in *Art & Antiques,* 9, September 1992, pp. 58–63; "The Immutable Still Lifes of Tina Modotti: Fixing Form" by Sarah M. Lowe, in *History of Photography* (United Kingdom), 18, autumn 1994, pp. 205–210; "Tina Modotti" by Natalia Gutierrez, in *Art Nexus* (Colombia), 30, November 1998/January 1999, pp. 129–130; "Romancing Edward: Love Letters to Edward Weston" by Susan Morgan, in *Aperture,* 159, spring 2000, pp. 20–25; "Unseen: Tina Modotti" by Mary Panzer, in *American Photo,* 11(5), September/October 2000, pp. 62–64, 107.

* * *

Despite her oeuvre's "fundamental paucity," to quote Jorge Luis Borges on the modest size of his own literary output, Tina Modotti was one of the most innovative and challenging photographers of the twentieth century. Her photographic work, all of which was done in a short but intensely productive period from 1923 through 1929, is inextricably linked to Mexico through her chosen subjects as well as her political choices and despite the fact that she was born in Italy. She was at once a cutting-edge early modernist, who was trained by the great Edward Weston, and an engagé artist in the most profound sense. Thus, she represented in an unusually compelling way the modernist as a political activist, so that her work was at once aesthetically austere and ideologically dense.

There are several exemplary photographs that demonstrate Modotti's uncommon combination of early modernism with political militancy. These remarkable images include *Huelga* (*Parade* or *Strike*) *of Workers* (1926), *Hands Resting on a Tool* (1927), *Bandolier, Maize, Guitar* (1927), *Campesinos Reading* El Machete (1928), and *Woman with Flag* (1928). What distinguishes these images from virtually any other photograph of the early twentieth century, outside those from the Soviet Union, is the sincere yet nonsentimental focus on basic vernacular components–a gun belt, a guitar, and a head of maize, say–to capture a rich range of competing associations. In *Bandolier, Maize, Guitar,* Modotti does this in a way that recalls the landmark "alternative modernist" artworks of Diego Rivera's cubist period, such as *Zapatista Landscape: The Guerrilla.* Her image surpresses any readily didactic rhetoric about the political significa-tion in question, yet the lean forms signify a rich range of things.

Similarly, *Woman with Flag* shows a *soldadera,* a camp fol-lower, deromanticized. The photo both recalls Delacroix's *Liberty Leading the People* (1830) and yet denies any connection with the mass surge around her that seems unstoppable. Instead, the viewer sees a lone militant cadre in classical profile with a resolute, if elegant, stance who occupies a modernist pictorial space as flat as any found in a Manet painting. The *soldadera* has no wave of popular combatants to envelop her. As such, her abstract political resolve gains in intensity owing, ironically, to the nondistractive, modernist austerity of the visual setting. There can be no doubt that this image articulates part of Modotti's own vanguard political vision as a militant of the Communist Party for most of her adult life (1924–42). Conversely, the language used is not just autobiographical. The photo is polyvalent in terms of its various meanings, since the compositional logic is hardly reducible to Modotti's own single-minded sense of political purpose.

Aside from these now classic photographs embodying a self-consciously politicized modernism, Modotti produced at least five other identifiable sets of images: (1) icons of industrial moderniza-tion, as in *Telephone Lines* (1925) and *Tank, No. 1* (1927); (2) images of women both *criollo* and indigenous, as in *Dolores del Río* (1925) and *Woman of Tehuantepec Carrying Jecapixtle* (1929); (3) indige-nous flora and fauna, as in *Calla Lily* (1925) and *Roses* (1925); (4) staged vignettes of puppets with a surreal air, as in *Hands of the Puppeteer* (1929) and *Police Puppets* (1929); and (5) photographs of the muralists and their works, as in *Pacheco Painting a Mural* (1927) and *Orozco at Work* (1927). Significantly, the first group of images dates from the mid-1920s and was linked to the neofuturist avant-garde movement called Estridentismo in a publication for which her photo *Telephone Lines* was made. The last group was intended as a collection of documentary photographs about the renaissance in Mexican mural painting at a time when it enjoyed international acclaim. Central to all of these series, however, is their anchorage in the popular culture of the working classes, plus an engagement with high art of the most subtle kind.

Some of Modotti's photographs are among the freshest of the first half of the twentieth century, and in their concentrated focus they rival the images from the 1920s of major Russian artists like Alexan-der Rodchenko or Dziga Vertov. According to conventional histories, Modotti's position in the history of photography at first seemed minor. Yet the profundity of her photographs has received increasing acknowledgment, and her position is now certainly held to be a major one. In 1991 her Gertrude Stein-like photograph *Roses,* from 1925, was purchased for the then record-setting price of $165,000. It is revealing that at the same Sotheby's auction a major photograph by her teacher Weston went for his top price of $154,000.

Because Weston was her mentor in photography and she was his model for a striking series of images, Modotti always found herself

compared with Weston, one of the great names in the history of photography. The standard early view, which survived through the 1950s, was summed up by the poet Octavio Paz, who in 1963 dismissed Modotti's photos as merely ''derivative.'' Subsequently, feminist commentators such as Laura Mulvey, Amy Conger, Sarah Lowe, Margaret Hooks, and Andrea Noble have rightly argued against this unflattering contrast, but sometimes they have simply inverted the comparison. Yet, unavoidable as this comparison of Modotti and Weston is owing to their student/teacher relationship, little is gained by the denigration of one in order to inflate the position of the other.

In fact, the contribution of both was of fundamental importance, however much one assesses the standing of either relative to the other. A fine example of how not to dismiss either figure while emphasizing the respective and divergent achievements of both can be found in a landmark 1926 essay by the best-known artist in Mexico at the time, namely, Rivera. In his review essay for *Mexican Folkways* magazine about their joint show, Rivera astutely observed the following: ''I believe that people like Weston and Tina, his student, are, on a parallel plane, equal to painters and other artists of the highest caliber . . . Edward Weston now embodies best the artist of the Americas, namely, one whose sensibility contains the extreme *modernidad* (modernity) of Northern Art and the vital tradition born out of art of the Southland. Weston's student, Tina Modotti, has achieved marvels of sensibility on perhaps an even more abstract or intellectual plane.''

—David Craven

(ORTIZ) MONASTERIO, Pablo

Mexican photographer

Born: Mexico City, 2 June 1952. **Education:** Instituto Patria, Mexico City, 1958–70; studied economics, Universidad Nacional Autonoma, Mexico City, 1970–73; studied photography, Ealing Technical College, London, 1974–75, and London College of Printing, 1975–76. **Career:** Photographer, Rhigetti Audio-Visual Company, Mexico City, 1972–74; editor and designer, photographic collection of books *México Indígena,* 1978–82; editor and codesigner, photographic collection of books *Río de luz,* Fondo de Cultura Económica, Mexico City, 1983–91. Photography instructor, Universidad Autonoma Metropolitana, Mexico City, 1977–84. Cofounder, Consejo Mexicano de Fotografía, 1977; founder, Centro de la Imagen; founder and director of photography magazine *Luna Córnea,* Mexico City, 1992–98. **Awards:** Prize, *Primer bienal de fotografía,* Mexico City, 1980; premio Ojo de Oro, Festiva Tres Continente, Nantes, France, 1997, and Premio al Mejor Libro Fotográfico de 1996–1997, Festival la Primavera Fotográfica, Barcelona, Spain, 1998, both for the book *La última ciudad.*

Individual Exhibitions:

1976	Creative Camera Gallery, London
	La Photogalerie, Paris
1977	Carlton Gallery, New York
1978	*3 jovenes fotografios,* Galeria Juan Martin, Mexico City (with Gabriel Figueroa Flores and Julieta Gimenez Cacho)
1979	*50 fotografias,* Teatro del Estado, Veracruz, Mexico
1980	Photographers Gallery, Santa Fe, New Mexico
1984	Casa de la Cultura, Quito, Ecuador
1986	Centre Culturel du Mexique, Paris
1989	Hospicio Cabañas, Guadalajara, Mexico
1991	*I Photography Biennial,* Tenerife, Spain
1992	Tropenmuseum, Amsterdam
	La Regoleta, Buenos Aires
	Museo de Arte, São Paulo, Brazil
1993	*Photography Biennial,* Tenerife, Spain
	Museo de Monterrey, Mexico
	Fotogaleria Imago Lucis, Lisbon, Portugal
1994	Instituto Cultural Cabañas, Guadalajara, Mexico
1996	*The Last City,* Gallery of Contemporary Photography, Santa Monica, California
1997	*Idolatrías,* Museo de Arte Moderno, Mexico City (traveling)
1998	*Arreglos,* Galería OMR, Mexico City
1999	*La ultima ciudad,* Galerie Photo, Montepellier, France

Selected Group Exhibitions:

1975	*Four Letter World,* Weavers Hall Museum, Norwich, England
1978	*Primera muestra latinoamerica de fotografia,* Museo de Arte Moderno, Mexico City
	Triennale de photographie, Musée d'Art e d'Histoire, Fribourg, Switzerland
1979	*Primera bienal de rito y magia,* Museo de Arte, São Paulo, Brazil
	Amnesty International, Museo Carrillo Gil, Mexico City
1980	*7 portafolios mexicanos,* Centre Cultural du Mexique, Paris (traveled to Picasso Museum, Antibes, France)
	Primera bienal de fotografia, Galeria del Auditorio, Instituto Nacional de Bellas Artes, Mexico City
1981	*Hecho en latino america 2,* Palacio de Bellas Artes, Mexico City
1982	*La photographie contemporaine en amerique latine,* Centre Georges Pompidou, Paris
2000	*Es espíritu del siglo,* Museo de Arte Moderno, Mexico City

Collections:

Instituto Nacional de Bellas Artes, Mexico City; Consejo Mexicano de Fotografia, Mexico City; Casa de las Américas, Havana; Biblioteque Nationale, Paris; Museum Georges Pompidou, Paris; Museum of Fine Arts, Houston.

Publications:

By MONASTERIO: Books—*El mundo interior,* Mexico City, 1979; *El desnudo fotografico,* Mexico City, 1980; *Los pueblos del*

viento, with text by Jose Manuel Pintado, Mexico City, INI-FONAPAS, 1981; *Testigos y cómplices,* Mexico City, MCE, 1982; *Tierra de bosques y árboles,* Mexico City, Jilguero, 1988; *Tiempo acumulado,* Spain, Centro de Fotografía Isla de Tenerife, 1991; *Corazón de venado,* Mexico, Casa de las Imágenes, 1992; *La última ciudad (The Last City),* Mexico, Twin Palms/Casa de las Imágenes, 1996; *Idolatrías,* Mexico, Museo de Arte Moderno, 1997; *Sexo y progreso,* Spain, Mestizo, 2000. **Books, edited—***La casa en la tierra,* Mexico City, 1980; *Los que viven en la arena,* with Graciela Iturbide, Mexico City, 1981. **Articles—**"Pablo Monasterio," in *British Journal of Photography* (London), July 1975, and July 1976; "El mimo," in *Revista de Bellas Artes* (Mexico City), July 1976; "Pablo Monasterio," in *Creative Camera* (London), November 1976; "Pablo Ortiz Monasterio," in *British Journal of Photography Annual* (London), 1977; "Pablo Ortiz Monasterio," in *Picture Paper* (Santa Fe, New Mexico), 10, 1980.

On MONASTERIO: Books—*Bienal de fotografía,* exhibition catalog, Mexico City, Instituto Nacional de Bellas Artes, 1980; *7 portafolios mexicanos,* exhibition catalog, Mexico City, Universidad Nacional Autonoma de Mexico; *Hecho en latino america 2,* exhibition catalog, with text by Pedro Meyer, Lazaro Blanco, and others, Mexico City, Palacio de Bellas Artes, 1981; *La photographie contemporaine en amerique latine,* exhibition catalog, text by Alain Sayag, Paris, Centre Georges Pompidou, 1982; *Between Worlds: Contemporary Mexican Photography,* exhibition catalog, edited by Trisha Ziff, New York, New Amsterdam, 1990. **Articles—**"Pablo Monasterio," in *Nueva Lente* (Madrid), September 1976; "Predomino de lo formal" by Chely Zarate, in *Semana de Bellas Artes* (Mexico City), March 1980; "Mexican Photography," in *Camera 35* (New York), February 1981; "Pablo Ortiz Monasterio," in *Creative Camera* (London), 5, 1989, pp. 14–15; "Pablo Ortiz Monasterio: Una cierta ciudad" by Eduardo Vázquez Martin, in *Artes de Mexico,* 36, 1997, pp. 96–97.

* * *

Whether it is the forgotten and dangerous backstreets of Mexico City, the sacred sites and rituals of the Huichol Indians, or the fragile villages on the slopes of the Istaccihuatl and Popocatepetl volcanoes, Pablo Ortiz Monasterio uses his camera as a "mechanism" for entering places he "wouldn't normally go" and for seeing things he would not normally see. Monasterio has played a critical role in the development of contemporary Mexican photography. He helped to create the Centro de la Imagen (Image Center) and served as editor in chief of the bilingual photography magazine *Luna Córnea.* His work is overwhelmingly documentary, but at times he has varied his approach. *Idolatrías: A Project for Monumental Sculptures* was a collection of collages that can loosely be defined as idol worship with a classical intent. According to Monasterio, the constructed photograph was a reaction against significant amounts of time devoted to "otherness" and an attempt to experience a more intimate form of expression.

Volcano Villages, a project using both color and black-and-white photography, combined myth, metaphor, and geography in landscape and straight documentary work to illustrate the ancient and complex reality of villages on the sides of Mexican volcanoes. Much of the area is now dangerous, with particular volcanoes in the process

of erupting and with the economies of several of the villages dependent on marijuana cultivation. This attracts a volatile mix of drug traffickers, army personnel, and impoverished peasants. In juxtaposition to his photography, he also displayed pottery from the villages.

Monasterio's 1996 book *The Last City* is a portrait of Mexico's capital that he spent 10 years composing. It shows a kaleidoscope of dynamic images evoking the apocalyptic atmosphere of the impoverished areas of the vast metropolis, one of the world's largest urban centers. In his project with the Huichol, Monasterio not only penetrated their world through pictures, but while he worked and lived among them, he initiated the construction of an intricate swinging bridge that became a vital link in a mountainous area enabling children to attend a local school. His other publications include *Testigos y cómplices* and *Los pueblos del viento,* a book on a fishing community in the south of Mexico.

Monasterio was also involved in the design and editing of the 1987 series *Río de luz* ("River of Light"), a major 15-volume series of photographic books published in Mexico City. In commenting on the process of constructing the series and its relevance to Mexican culture, Monasterio said, "I have a strong impression that black-and-white photography better suits our reality, which is painful and dramatic. Somehow, black and white is a more symbolic language than color. Color is closer to how we experience reality."

—Martha Sutro

MONGE, Priscilla

Costa Rican painter, sculptor, and mixed-media, performance, and installation artist

Born: San José, 1968. **Career:** Lived in Gent, Belgium.

Individual Exhibitions:

1995	Galería Jacobo Karpio, San José
1996	*A Radical Complicity,* Gandy Gallery, Prague
	Vereniging voor het Museum van Hededaagse Kunst Gent, Belgium
	Thomas Cohn Arte Contemporánea, Rio de Janeiro
	The Soap Factory, Athens
1999	*Polisemia/Ambigüedad,* Sala MAC, Museo de la República Antigua Casa Presidencial, Tegucigalpa, Honduaras

Selected Group Exhibitions:

1991	*V bienal de Lachner & Sáenz,* Museo de la Plaza de la Cultura, San José
1993	*Juguetes por artistas,* Museo de Arte y Diseño Contemporáneo, San José
	Costa Rica en las bienales, Museo de Arte y Diseño Contemporáneo, San José
	VI bienal de Lachner & Sáenz, Museo del Niño, Costa Rica

1994 *Arte contemporáneo costarricense,* Museo Mario Abreu,
 Maracay, Venezuela
1996 *Relaciones,* Museo de Arte y Diseñoño Contemporáneo,
 San José
 Mesótica, Casa de América, Madrid
1997 *Instalación y arte objeto en América Latina,* Centro
 Cultural de Arte Contemporáneo, Mexico City
1998 *XXIV bienal de São Paulo,* Brazil
2000 *Perverting Minimalism,* Museo Nacional Reina Sofía,
 Madrid

Publications:

On MONGE: Books—*El enigma de lo cotidiano,* exhibition catalog, text by Rosa Olivares, Alfredo Bryce Echenique, and others, Madrid, Casa de América, 2000; *Territorios ausentes,* exhibition catalog, text by Carlos Amorales and Gerardo Mosquera, Madrid, Casa de América, 2000. **Articles**—''Priscilla Monge. Jacob Karpio Gallery'' by Dermis Pérez León, in *Art Nexus* (Colombia), 17, July/September 1995, pp. 120–121; ''Priscilla Monge: At Loggerheads with Cliché and Taboos'' by Maria Lluisa Borras, in *Art Nexus* (Colombia), 30, November 1998/January 1999, pp. 44–48.

* * *

Priscilla Monge emerged as one of the key young promises of the contemporary art scene in the early 1990s in Costa Rica. Since then the continuous and coherent development of her work has made its presence on younger local artists as well as throughout the Central American region. One of the most clearly conceptual artists, she has structured her work since the beginning upon a discourse of ambiguity. Her first paintings, done on precisely chosen upholstery material, depict players in what seems to be a football field, in sets of two, evolving on the field in confusing movements that could be interpreted as sports clinches, sexual encounters, or wrestling. Her use of football mainly as a way of referring to power and violence has been recurrent throughout her work, but she has also focused on boxing, boomerang throwing, and Greco-Roman wrestling.

Since her eruption in and from the regional contemporary art scene toward a growing recognition in the international arena, the discourse from and about ''the feminine'' has been transferred to a level in which it is no longer possible to assume victimization without admitting complicity and implicating a more complex and less linear, gender-biased interpretation of feminine or masculine artistic expression. One could say that Monge´s polymorphous body of work not only determined a conceptual change in the process of artistic production as well as a less complacent attitude toward a discourse too often working on a self-serving structure but that she also initiated or has at least contributed strongly to a visible process of feminization in the Central American art of the last decade.

Monge has chosen to articulate her discourse around the ambiguity that hovers over society without excluding herself from this ambiguity and by accepting her own contradictions. She repeatedly departed from the iconography of sports as a metaphor for the strange rules that direct a subtly coercive coexistence. Another essential aspect of her work was in the semantic transformation she conferred to everyday objects: this is possible through her perception of the unsaid power of everyday life to generate the deepest horror and the capacity it can have of unleashing our fears and fantasies.

Monge has engaged in painting, drawing, sculpture, object making or reconfiguring, mixed-media installations, performance, and video. Her work stemmed from a minimalistic discipline, both in the bareness of the objects and the reiteration of many of her austere and direct pieces. These acquire power in the permanent disconcertion she provoked through her choice and association of opposite materials and the simultaneous implications of delicateness and violence, irony and gravity, and humor and sorrow. This allowed her to align, in a semiotic dynamic, contrary concepts that in fact end up enriched within that opposition and are sustained through subtle counterpoints. One of her major works, *Death Sentences* (1994), consists of six small pieces of embroidered linen on stretchers, each one with a text inspired from Costa Rica's nineteenth-century penal code. The piece she presented for the VI Havana Biennale, called *Shut Up and Sing,* offers a series of aggressive, black leather boxing masks on the wall, each one with a small music box in its mouth that the spectators could turn on and listen to light children's tunes. *Boomerangs* is another major project that has taken several forms. Started in 1996, and initially made of wood, each boomerang has an insult painted or inscribed on it. The series implies a virtual capacity of ''flying'': once the insult is thrown by the first emitter, the vicious circle of violence is established. She subsequently has produced the boomerangs in marble, namely the large series Gerardo Mosquera chose for the show *Perverting Minimalism* at the Museo Nacional Reina Sofía in Madrid in late 2000.

In 1998 Monge produced her first video, called ''Make Up Lesson'' from her series *The Lessons,* for the São Paulo Biennale of that year. This short three-minute video is a reflection on aggression toward women, on established beauty canons and the pressure they exert on women everywhere, and on the intimate relations between seduction and aggression. This video was followed by two other lessons, ''How to (Un)dress'' and ''How to Die of Love,'' both from 2000. In each one she subverted the common ideas and practices that are accepted around stereotyped behavior in relation to seduction, striptease, and sexiness as well as in relation to the romantic attitude of letting oneself die of amorous despair.

The dichotomies of violence and tenderness, life and death, and creation and destruction were dismembered only to be rebuilt, reinserted, and enriched by the semantic density Monge attained in reflecting on the state of confusion established between the victim and the victimizer by the continuous and quotidian experience of the seduction-violence-aggression-victimization cycle. It was really around the very concept of ambiguity, however, and with an insertion of humor, that the artist produced images and objects of a great structural complexity and with great ambiguity.

—Virginia Pérez-Ratton

MONTENEGRO, Roberto
Mexican painter

Born: Guadalajara, 1885. **Education:** Academia de Bellas Artes de San Carlos, 1905; Academia de San Fernando, Madrid (scholarship

Roberto Montenegro: *Mayan Women.* © Archivo Iconografico, S.A./Corbis.

from the Mexican government), 1906; Ecole des Beaux Arts, Paris, 1907. **Career:** Worked as an illustrator in Europe, 1906–19. Organizer, arts festival in Mexico, 1921; director, Museo de Artes Populares de Bellas Artes, 1934. Muralist, including Colegio Máximo de San Pedro y San Pablo, 1922, Secretaría de Educación Pública, Biblioteca Hispanoamericana, Escuela Nacional de Maestros, Escuela Benito Juárez, Palacio de las Bellas Artes, 1922–27, Hotel del Prado, 1947–48. Founder and director, Museo de Arte Popular, 1930. Worked as a portrait artist, set designer, and choreographer. **Award:** Premio Nacional de Artes Plásticas, 1967. **Died:** 1968.

Selected Exhibitions:

1912 Salon d'Automne, Paris
1921 Academia de Belles Artes de San Carlos
1965 Palacio de Bellas Artes, Mexico City (retrospective)

Madrid, 1918; Madrid and Mallorca, Spain, 1919.

Collections:

Palacio de Bellas Artes, Mexico City; Instituto de la Artesanía Jalisciense, Guadalajara; Museo de Arte Moderno, Mexico City.

Publications:

By MONTENEGRO: Books—*Pintura mexicana del periodo 1800–1860,* Mexico, Oficina da publicaciones y prensa, 1934; *Museo*

de artes populares, Mexico, Ediciones de Arte, c. 1948; *Retablos de mexicanos,* Mexico, Ediciones Mexicanas, 1950; *Planos en el tiempo,* Mexico, Arana, 1962.

On MONTENEGRO: Books—*Roberto Montenegro* by Justino Fernández, Mexico City, Universidad Nacional Autónoma de Mexico, 1962; *Roberto Montenegro, 1885–1968: Dibujos, grabados, óleos pinturas murales,* exhibition catalog, Mexico City, Instituto de Bellas Artes, 1970; *Entre dos mundos: Los murales de Roberto Montenegro* by Julieta Ortiz Gaitán, Mexico City, Universidad Nacional Autónoma de Mexico, 1994; *Roberto Montenegro: Ilustrador* by Esperanza Balderas, Mexico City, Dirección General de Publicaciones, 2000.

* * *

Roberto Montenegro's long, eclectic career included forays into many European artistic styles and various media, from printmaking to muralism. The styles he embraced included an aestheticism that borrowed from Aubrey Beardsley and Japanese prints, Renaissance naturalism and mannerism, and even surrealism. Montenegro also participated in the promotion of Mexican arts and culture in the period following the Mexican Revolution, painting a mural in the chapel of the former monastery of San Pedro y San Pablo in Mexico City, working on the first exhibition of popular arts in Mexico, along with Dr. Atl, Jorge Enciso, and Adolfo Best-Maugard, and directing the Museum of Popular Arts in Mexico City.

Montenegro never developed a clear stylistic trajectory, instead moving from style to style within a vast array of interests. His early studies in Mexico led him to the work of Julio Ruelas, whose late nineteenth-century modernism most resembled the German symbolists. Montenegro's drawing *Le Paon blanc* of 1908, complete with a French title, resembles Beardsley's art nouveau illustrations of the era. A dark-haired woman, naked except for a veil wrapped around her arm and flowing around her feet, arcs backward in the sensuous curve favored by the art nouveau. Above her head is the large form of a large white peacock, behind and surrounding her a shadowy landscape suggestive of German pine forests. Montenegro's travels to Europe during much of the next decade and a half informed his work throughout the rest of his life. As late as 1942, in his *Self-Portrait,* now in the Museo de Arte Moderno in Mexico City, he clearly invoked the *Self-Portrait in a Convex Mirror* by Parmigianino, although Montenegro located himself in a modern painter's studio. His hand reaches forward, toward the surface of the mirror, the deep field showing him at work on a larger canvas. It is impossible to look at the work without recalling other European paintings, such as Jan van Eyck's so-called Arnolfini wedding portrait or Velazquez's *Las Meninas,* both of which also include the artist's self-portrait within a larger context.

Despite his clear interest in European art styles of various epochs, Montenegro frequently returned to Mexico for indigenous subjects and executed several works that fit consistently within the context of *mexicanidad,* the creation and promotion of distinctly Mexican forms in art. In the exhibition of indigenous Mexican art organized by Dr. Atl to celebrate the centennial of the country's independence from Spain, Montenegro entered a work representing a contemporary Mexican peasant. Like many Mexican artists during

the first half of the twentieth century, Montenegro frequently depicted the Tehuana, a woman from the Isthmus of Tehuantepec in southern Oaxaca state. The Tehuana had come to represent the strength of native Mexico in the face of foreign intervention and the beauty of the Mexican peasantry. In such works as *Tehuana llorando a su muerto* (''Tehuana Mourning Her Dead'') from 1935 and the better-known *Tehuana,* which is undated, Montenegro turned to the Tehuana as a pictorial motif to illustrate his affiliation with *mexicanidad.* In the latter work the Tehuana appears almost as an abstract form in a still life, with her skirt spread out before her in regularized sculptural folds.

Montenegro's name appears in many chapters of twentieth-century Mexican art history, yet because his work did not hold to any particular style or pattern of production, it never formed a strong presence. Without as commanding a presence as Diego Rivera or even Dr. Atl, Montenegro nonetheless helped to carve the course of Mexican culture in the twentieth century through his support and promotion of indigenous popular arts in addition to his own painting.

—Laura J. Crary

MONTOYA, José

American painter, serigrapher, and woodcut artist

Born: José Ernesto Montoya, Escoboza, New Mexico, 28 May 1932. **Education:** San Diego City College, California, A.A. in art 1956; California College of Arts and Crafts, Oakland, B.A. 1962; California State University, Sacramento, M.A. 1971. **Military Service:** United States Navy, 1951–55. **Family:** Married 1) Mary Ellen Prieto in 1954 (divorced 1974), one daughter and five sons; 2) Juanita Jue in 1979, two daughters and one son. **Career:** Instructor, Wheatland High School, California, 1962–69, Yuba College, Marysville, California, 1964–69, and Universidad Anahuac, Mexico City, 1974. Assistant professor, 1970–74, associate professor, 1974–81, full professor, 1981–97, and since 1997 professor emeritus, department of art education, California State University, Sacramento. Founder, Mexican Concilio for Yuba-Sutter Counties, Marysville, California, 1968; founding member, Royal Chicano Air Force, 1970; founder, Barrio Art Program, 1970; cofounder, Centro de Artistas Chicanos, Sacramento, California, 1972; founder of musical group Trio Casindio, 1983. **Awards:** Best in Show award, Mid-Valley Annual Art Show, Marysville, California, 1968; National Endowment for the Arts writing fellowship grant, 1981; City of Sacramento Mayor's Award for Poetry, 1995; California Arts Council award, 1997, for the Pachuco Project. **Address:** 2119 D Street, Sacramento, California 95816.

Individual Exhibitions:

1977 *Pachuco Art de José Montoya: An Historical Update,* Art Space Gallery, Sacramento, California (traveling)
1981 *Pachuquismo,* I.C.C. People's Gallery, Sonoma, California
1985 *Chucos and cholos,* Lunas Café/Galeria, Sacramento, California

José Montoya: *Our Lady of the Valley,* 1997. Photo courtesy of the artist.

1996 *El Profe: José Montoya Chicano Arte, 1964–1996,* Robert Else Gallery, California State University, Sacramento
1998 *Hermanos Montoya: The Art of José and Malaquias Montoya,* La Raza Galeria Posada, Sacramento, California (with Malaquias Montoya)
1999 *Montoya y Montoya,* Self-Help Graphics, Los Angeles (retrospective; with Malaquias Montoya)

Selected Group Exhibitions:

1972 Galeria de la Raza, San Francisco
1974 *Baby Light My Enchilada,* California State University, Sacramento
1976 *Chicanarte,* Los Angeles Municipal Art Gallery
1977 *Raices antiguas/visiones nuevas,* Tucson Museum of Art, Arizona (traveling)
1980 *Chicanacan: Semana de arte y cultura chicana,* Institut Nacional de Bellos Artes, Mexico
1983 *Centro de Artistas Chicanos–Progressive Mural Installation and Poster Exhibition, 1969–1980,* Tempo Gallery, Crocker Art Museum, Sacramento, California
1986 *Chicano Literature and Arts Conference,* Université Paris VII, Institut Charles V, Paris
 Chicano Expression—A New View in American Art, Latin American Gallery, New York (traveling)

José Montoya in his studio. Photo by Szabo Photography; courtesy of the artist.

El Barrio–Primer espacio de la identidad cultural,
 Centro Cultural de Tijuana, Mexico
1989 In Search of Mr. Con Safos, Langford and Cook
 Gallery, Sacramento, California (traveling)

Collections:

Yale University, New Haven, Connecticut; California State Library,
Sacramento, California; Academia de San Carlos, Mexico City.

Publications:

By MONTOYA: Books—*El sol y los de abajo and Other R.C.A.F.
Poems,* San Francisco and Austin, Texas, Pocho-Che, 1972; *Pachuco
Art: An Historical Update,* n.p., Royal Chicano Air Force, 1977;
Thoughts on la Cultura, the Media, Con Safos and Survival, San
Francisco, Galeria de la Raza/Studio 24, 1979; *New Blood* (poetry),
Boulder, Colorado, New Blood Press, 1982; *Twin Double-Barrel
Shogun* (poetry), Sherman Oaks, California, Ninja Press, 1990;

José Montoya: *Awelita/Hawk,* 2000. Photo courtesy of the artist.

Information: Twenty Years of Joda, San Jose, California, Chusma House, 1992. **Articles**—"Rupert Garcia at the San Francisco Museum of Modern Art," in *Rayas,* 1(8), 1978; "Zoot Suit Riots of 1943, the Making of the Pachuco Myth," in *Somos,* 1(2), July 1978; "Cantos en cantinas, poetry at the Reno Club," in *Phantasm,* 4(1), 1979; in *Imagine,* III (1 & 2), summer/winter 1986. **Musical recording**—*A Pachuco Portfolio* (with Trio Casindio), 1997.

On MONTOYA: Books—*Three Contemporary Chicano Poets: Antecedents and Actuality* (dissertation) by Tomás Ybarra-Frausto, Seattle, University of Washington, 1979; "Jose Montoya: Vision of Madness on the Open Road to the Sun" by Olivia Castellano, in *De Colores,* edited by Bernice Zamora, Albuquerque, Pajarito Publications, 1979. **Articles**—"Portfolio Number Five, Jose Montoya," in *El Grito,* 1(3), spring 1970; "El Pachuco Arte de Jose Montoya," edited by C. Almaraz, in *Chismearte* (Los Angeles), 3, spring 1978; "Serious Group of Activists Takes Off with Name of Royal Chicano Air Force" by Mary Gage, in *Sacramento Bee* (Sacramento, California), 7 November 1979; "Jose Montoya–The Trilogy," edited by Lorna Dee Cervantes, in *Mango,* 11, fall/winter 1979/1980. **Film**—*Montoya, vata loco–Street Artist, Scholar/Philosopher* by Jose Camacho, 1980.

*

José Montoya comments:

I do Chicano art to insure the heroic struggle of the Mexicans who are not from Mexico is recorded accurately by us and does not depend on the media and the historical biases depicted in text books. I create Chicano art so that the worldview is appreciated, respected, and not misunderstood. And I choose to do that from right here—from my barrio. It's what inspires me. It is here where I find the true stories of what we have been subjected to. And it is here that I discover the courageous combinations that embody our indigenous tenacity for survival against the staggering odds of racial and political oppression without succumbing to victimization: we are not dirty and lazy and pachucos; we're not reefer smoking draft dodgers; and chocols and cholas aren't all gang bangers.

* * *

Artist, poet, teacher, and labor activist, José Montoya has dedicated his career to giving voice and definition to Chicano art. He has defined a Chicano as "a Mexican not from Mexico." One of the architects of the Chicano movement in California's Central Valley, Montoya worked with Cesar Chavez and started an art group in Sacramento known as the Royal Chicano Air Force. The farm fields of northern California have provided the palette, the backdrop, and the concerns of Montoya's Chicano consciousness. His concerns have ranged from the rights of farm workers to violence in the barrios, but Montoya has said that all of his expression goes back to his cultural roots, the harsh but rich environment of New Mexico during the Depression. In the mountainous region where he and his family lived, storytelling and artifacts defined the cultural voice. Beginning with the struggle of the United Farm Workers of America, Montoya joined other artists, writers, and community people in what was to become for him a lifelong endeavor of artistic provocation. Throughout his 40 years of teaching, painting, and writing, Montoya has sought to dispel images of Mexicans as lazy or as bandidos and to give them their imagery, color, and imaginative valence with assertiveness and power.

Like Francisco de Goya in eighteenth- and nineteenth-century Spain and José Guadalupe Posada in early twentieth-century Mexico, Montoya has used art to expose political and human atrocities. His series on the Pachuco, which included a historical update with photos and newspaper articles from the 1940s, and his later portrayals of the casualties of gang violence in *No More Drive By's* are as revelatory to Chicanos as images of atrocities by Napolean's army were to Goya's contemporaries. Humor became an important creative and inspirational force in Montoya's work after he and fellow artist Esteban Villa cofounded an artists' collective with their students. The Rebel Chicano Art Front (later Royal Chicano Air Force, or RCAF) was to be a major force in Montoya's career for more than 25 years. He served as a mentor and an educator to a younger generation of Chicano artists, providing them with knowledge about their artistic and cultural heritage. As a professor of art education at California State University in Sacramento, Montoya sought to infuse future educators with the same energy for creating social change through art that he had demonstrated. In 1970 he created the Barrio Art Program, which provides art to the youth and elderly of the Washington neighborhood of Sacramento.

Montoya's artistic themes have ranged from Chicano women and *Cholos* (male Chicanos) to the Mexican Revolution to matters of life and death, represented by *calaveras,* or skulls. He injects wry,

sometimes wacky tones and attitudes into his serious subjects. His watercolors show people on the streets of his neighborhood, commuters, and those affected by crises and tragedies such as drive-by shootings. In larger murals he has satirized the foibles of bureaucracy, with images of politicos under a capitol dome. Other work includes posters and silk screens depicting Pachucos in zoot suits and Chicano heroes such as the literary critic Luis Leal, who introduced Chicano literature to academia. The loosely drawn figures in *Calacas del barrio* attempt to characterize life itself. The 18 drawings of skeletons animate an entire wall, with singing minstrels and masked *comparsas* roaming the streets and chasing the dead back to their graves on the last day of Los Días de Muertos.

—Martha Sutro

MONTOYA, Malaquías
American painter and printmaker

Born: Albuquerque, New Mexico, 21 June 1938. **Education:** Reedley Junior College, California, 1960–62; Santa Clara County School for Bartenders, San Jose, California, certificate 1965; San Jose City College, California, 1966–68; received State of California Adult Teaching Credential 1969; University of California, Berkeley, 1968–70, B.A. (honors) in art 1970. **Military Service:** United States Marine Corps, 1957–60: honorable discharge 1960. **Family:** Married 1) JoAnna Kerby in 1963 (divorced 1976), two sons and one daughter; 2) Lezlie Salkowitz in 1976, two sons. Brother of José Montoya, *q.v.* **Career:** Worked as a farm laborer and cannery worker, San Joaquin Valley, California, 1948–62; commercial artist and silkscreener, Pranger Commercial Art & Advertising Company, San Jose, California, 1962–68; foreman of silkscreen department, Circo Incorporated, Mountain View, California, 1963–66; bartender, Cameo Room, San Jose, California, 1965–66; lecturer, Chicano Studies department, University of California, Berkeley, 1972–74; faculty member, University without Walls, Berkeley, California, 1974–76; lecturer, 1978–83, associate professor, 1983–84, full professor, 1984–89, California College of Arts & Crafts, Oakland, California. Since 1990 professor, Chicano Studies department, and since 1996 cooperating faculty member, department of art, University of California, Davis. Art instructor, Laney College, Oakland, California, 1969–70, and Contra Costa College, Richmond, California, 1971; guest lecturer, Mills College, Oakland, California, 1977; art workshop director, Alameda County Neighborhood Arts Program, Oakland, California, 1974–81; artist-in-residence, Ethnic Studies department, Stanford University, California, 1980; guest artist, Department of Art & Institute for Latino Studies, University of Notre Dame, Indiana, 2000. Founding member, Mexican American Liberation Art Front (MALA-F), Oakland, California, 1969. Also worked as an art consultant and curator. **Awards:** Life on the Water award, 1987; Heritage Scholarship Fund honoree, California College of Arts and Crafts, 1993; Community Commitment award, 1993, Dedicated Service award, 1995, and Excellence award, 1996, Clinica Tepati, University of California, Davis, School of Medicine, 1993; Recognition award, Murals Faculty Member Project, University of California, Davis, 1995, 1996, 1997, and 1998; Outstanding Chicano Artist, Centro Cesar Chavez, Solano County Health & Social Services, 1996;

Malaquías Montoya. Photo courtesy of the artist.

Distinguished Artist award, Vacaville Unified School District, 1997; honoree, Art as a Hammer, Center for the Study of Political Graphics, 1997; Adaline Kent award, San Francisco Art Institute, 1997. **Address:** P.O. Box 6, Elmira, California 95625, U.S.A. **E-mail Address:** mmontoya@ucdavis.edu.

Individual Exhibitions:

1971 Student Union, San Jose State University, California
 De Anza College, Cupertino, California
1973 Galeria Sotano, San Jose, California
1975 Merritt College, Oakland, California
 Centro Cultural de la Gente, San Jose, California
 La Pena Cultural Center, Berkeley, California
1977 *Cinco de Mayo,* Humboldt State University, Arcata, California
 Santa Ana Public Library, Santa Ana, California
1978 Casa Zapata, Stanford University, California
 Notre Dame College, Belmont, California
1981 Foothill College, Los Altos Hills, California
 Si se puede, Pro Arts Gallery, Oakland, California
1983 University of Texas, Austin
1984 San Jose City College Gallery, California
1985 California State University, Hayward
 Del muralismo revolucionario al arte chicano, Centro Cultural Tijuana, Mexico

Malaquías Montoya: *Untitled,* 1996. Photo by Lezlie Salkowitz-Montoya; courtesy of the artist

Malaquías Montoya: *Memories,* 1992. Photo by Lezlie Salkowitz-Montoya; courtesy of the artist.

Mexic-Arte Museum, Austin, Texas
ConfrontARTE, Galeria Sin Fronteras, Austin, Texas
Hermanos Montoya: The Art of José and Malaquias Montoya, La Galeria Posada, Sacramento, California (with José Montoya)

1988	Galeria Sin Fronteras, Austin, Texas
1989	*Malaquias Montoya and the Chicano Poster,* Galeria Esquina de la Libertad, San Francisco
	Galeria Posada, Sacramento, California
1990	Works Gallery, San Jose, California
	Arte de protesta, C. N. Gorman Museum, University of California, Davis
	Grand Oak Gallery, Oakland, California (with David Bradford)
1992	California State University, Bakersfield
	Galeria Sin Fronteras, Austin, Texas
1995	*Malaquias Montoya: Prints and Drawings,* Crocker Art Museum, Sacramento, California
1997	*Malaquias Montoya: 1997 Adaline Kent Award Exhibition,* San Francisco Art Institute
	Malaquias Montoya: The Creative Process, La Peña Center, Berkeley, California
	The Art of Protest: The Posters of Malaquias Montoya, MACLA, San Jose Center for Latino Arts, San Jose, California
1998	*Art within the Context of Struggle,* Hispanic Research Center, Arizona State University, Tempe
	LuchARTE, Guadalupe Cultural Arts Center, San Antonio, Texas

1999	*Montoya y Montoya,* Self Help Graphics/Galeria Otra Vez, Los Angeles, and La Galeria at the Mexican Heritage Plaza, San Jose, California (retrospective; with José Montoya)
	Laney College Art Gallery, Oakland, California
2000	University of Notre Dame, Indiana

Selected Group Exhibitions:

1981	*Califas,* Mary Porter Sesnon Art Gallery, University of California, Santa Cruz
1983	*A traves de la frontera,* Centro de estudios economicos y sociales del Tercer Munco, Mexico City
1988	*The Other America,* Der Neuen Gesellschaft fur Bildende Kunst, Im Haus der Kulturen der Welt, Berlin (traveled through Germany, Switzerland, and Italy)
1990	*CARA: Chicano Art, Resistance and Affirmation,* Wight Art Gallery, University of California, Los Angeles (traveling)

1991 *Mutual Influences/Influencias mutuas,* Guadalupe Cul-
 tural Arts Center and the Instituto Cultural Mexicano,
 San Antonio, Texas

1992 *Imagenes de la frontera: Monotipia, Monoprint Images
 of the Border,* Festival Internacional de la Raza,
 Tijuana

 Smith Anderson Gallery, Palo Alto, California

1998 *The Role of Paper, el papel del papel,* Sala Central of
 the Antiguo Arsenal de la Marina Espanola, La
 Puntilla, San Juan, Puerto Rico (traveling)

2000 *Pressing the Point: Parallel Expressions in the Graphic
 Arts of the Chicano and Puerto Rican Movements,* El
 Museo del Barrio, New York (traveled to Jack S.
 Blanton Museum of Art, University of Texas, Austin)

 Made in California: 1900–2000, Los Angeles County
 Museum of Art

Collections:

Galeria de las Americas, Institute for Latino Studies, University of
Notre Dame, Notre Dame, Indiana; Jack S. Blanton Museum of Art,
University of Texas, Austin; Mexican Fine Arts Center Museum,
Chicago; Smithsonian Institute, Washington, D.C.; Los Angeles
County Museum of Art.

Publications:

By MONTOYA: Book—*A traves de la frontera,* exhibition catalog,
with Lezlie Salkowitz-Montoya, Instituto de Investigaciones Esteticas,
Mexico, UNAM, 1983. **Articles**—"Malaquías Montoya–Why I Do
What I Do," in *Unity for Peace, Justice, Equality & Socialism,*
11(19), 19 December 1988, pp. 8–9; "A Critical Perspective on the
State of Chicano Art," with Salkowitz-Montoya, edited by Catherine
Clark, in *Cambio* (Oakland, California), 5(15), July 1991.

On MONTOYA: Books—*Malaquías Montoya,* exhibition catalog,
San Francisco, San Francisco Art Institute, 1996; *Valley Grown:
Mexican-American Visions and Voices from the Central Valley,*
exhibition catalog, Turlock, California State University Stanislaus,
1998. **Articles**—"Malaquías Montoya Exhibition Opens at La Pena"
by Linda Gomez, in *El Mundo,* XV(90), 29 October 1975; interview
with Montoya by Ning Su, in *Arte* (Berkeley, California), fall 1977;
"Malaquías Montoya, Habla del arte en la comunidad" by Alberto
Ampuro, in *La Cronica Latina,* 4 August 1978; "Art and Revolution:
A Discussion with Malaquías Montoya" by Nazri Zacharia, in *Third
World Forum* (Davis, California), 3 December 1990; "Montoya:
What Is Art without Social Responsibility?" by Elizabeth Sherwin,
in *The Davis Enterprise* (Davis, California), 9 December 1990;
"Malaquías Montoya: Raza Artist," in *Arriba* (Austin, Texas), 12(6),
27 March 1992; "The Vibrant Art of Politics, Malaquías Montoya
Fights Injustice with Silkscreens, Drawings" by Victoria Dalkey, in
Sacramento Bee (Sacramento, California), 3 December 1995; "Por-
trait of an Artist with a Mission" by Vicky Elliott, in *San Francisco
Chronicle* (San Francisco), 6 July 1997; "ENFOQUE: Malaquías
Montoya, Creating Awareness through the Beauty of Art" by Mayra
E. Sánchez, in *La Palabra* (Davis, California), 2(8), 23 September

1997; "Pa Malaquías, homenage a Malaquías Montoya," in *La
Oferta Review* (San Jose, California), XIX(8), 25 February 1998;
"Enlightening, Sad Time for Montoyas" by Richard Bammer, in
Reporter (Vacaville, California), 4 August 2000; "Art as a Hammer:
Malaquías Montoya's Social Serigraphy" by Ruthe Thompson, in
Screenprinting Magazine, September 2000, pp. 34–38.

*

Malaquías Montoya comments:

In terms of my artistic philosophy, it is important to note that my
other "voice" is the poster/mural. I am much more articulate and able
to express myself more eloquently through this medium. It is with this
voice that I attempt to communicate, reach out and touch others,
especially to that silent and often ignored populace of Chicano,
Mexican, and Central American working class, along with other
disenfranchised people of the world. This form allows me to awaken
consciousness, to reveal reality and to actively work to transform it.
What better function for art at this time? A voice for the voiceless.

My personal views on art and society were formed by my being
born into that silent and voiceless humanity. Realizing later that it was
not by choice that we remained mute but by a conscious effort on the
part of those in power, I realized that my art could only be that of
protest–a protest against what I felt to be a death sentence.

As a Chicano artist I feel a responsibility that all my art should be
a reflection of my political beliefs–as an art of protest. The struggle of
all people cannot be merely intellectually accepted. It must become
part of our very being as artists; otherwise we cannot give expression
to it in our work. I am in agreement with Pedro Rodrigues when he
said, "Fundamentally, artistic expression, or culture in general,
reaches its highest level of creation when it reflects the most serious
issues of a community, when it succeeds in expressing the deepest
sentiments of a people and when it returns to the people their ideas and
feelings translated in a clearer and creative way."

Through our images we are the creators of culture, and it is our
responsibility that our images are of our time and for our contempo-
raries and that they be depicted honestly and promote an attitude
toward existing reality, a confrontational attitude, one of change
rather than adaptability. We must not fall into the age-old cliche that
the artist is always ahead of his/her time. No, it is most urgent that we
be on time.

It is these tenets that guide my work and of course my life. My
inspirations come from that struggling collective. My work is a
collaborative one. Although I address many issues, there are three
prominent themes that run through my work. They are injustice,
empowerment, and international struggle. In my images of struggle
for justice, I try to illuminate with clarity the defects of social and
political existence. The art historian Dr. Ramon Favela has said of my
work, "With strident forms of great simplicity and power the message
conveyed by Montoya's posters are exceedingly clear . . . his images
are of a dispossessed humanity restrained and shackled by an incom-
prehensible and nefarious political condition."

My images of empowerment are intended to confront the multi-
tude of images of disempowerment given to us by our daily media.
Images that disguise reality, manipulate consciousness, and lull the
creative imagination to sleep. In my images I pay tribute to those who
struggle on a daily basis. I pay homage to the workers, and I
aggrandize their efforts. I celebrate small and large victories of the
human spirit. I depict people in control of their lives working together

to change and transform their reality. As Bertol Brecht said, "Art should not be a mirror of reality but a hammer with which to shape a new reality."

Images of international struggle are important to our community. They bring solidarity, and for this reason my work is replete with international themes. My work attempts to serve as a bridge between our struggle and those of other countries. This helps to give us a better understanding of the world we live in and show us that we are not an isolated culture that failed but that we have a common antagonist that makes it necessary for us to unite. From Angola to Central America, from Palestine to the barrio, I have created images that speak to the disenfranchised. In this sense my work bears the imprint of contemporary Chicano art that "reaches beyond the confines of the barrio." However, it does so in a more dramatic sense, traveling through the continents as well.

I must say my work is often referred to as propaganda art. I don't mind being labeled as such since I feel all work is propagandist in nature; it just depends who you want to propagandize for. From cave painting to the present, art has always spoken on someone's behalf.

* * *

The posters and murals of the American artist Malaquías Montoya emerge directly from the Chicano movement. In the mid-to-late 1960s, the migrant workers of California, New Mexico, and the rest of former Mexico began to fight for their right to fair wages and acceptable working conditions. Led by Cesar Chavez, the United Farm Workers embarked on a well-publicized strike—la huelga. Chavez encouraged a strong cultural component to la huelga, resulting in El Teatro Campesino and a number of poster artists and muralists—among them Montoya.

Montoya himself was the son of migrant farmers and was intimately aware of the struggle going on in the San Joaquin Valley. He became involved in the movement in 1968 while studying in the art department at the University of California, Berkeley. In 1969 he founded the Mexican-American Liberation Front (MALA-F) with René Yañaez, Esteban Villa, and Manuel Hernandez Trujillo. They held regular meetings to discuss the definition and philosophy of Chicano art. Their first exhibition celebrated the Mexican-American's Mayan heritage, modeling the imagery on a young poet named Manual Gomez. Montoya later said in an article in Screen Printing Magazine that Gomez "had a face like . . . one of the images of Mayan sculpture. So the entire show was about this new young face. It focused on our pride in this face that we had once thought ugly, and it suggested that we should be proud of how we looked." MALA-F later moved to Sacramento and—under the leadership of Montoya's brother, José—became the Rebel Chicano Art Front (RCAF). Due to confusion surrounding its acronym, the group was wryly renamed the Royal Chicano Air Force.

These movements reflected the philosophy behind El plan espiritual de Aztlán ("The Spiritual Plan of Aztlán"), a manifesto adopted by a huge Chicano Youth Conference in Denver in 1969. The plan called for a reclamation of Aztlán, the lands European Americans had taken from Mexico in the nineteenth century. But MALA-F and the RCAF were also motivated by the struggles of other oppressed peoples, particularly the Vietnamese. With the United States' invasion of Cambodia, the Berkeley art department became a veritable factory for antiwar posters. One of the most notable is Montoya's Vietnam/Aztlán (1973), a graphically powerful image of a tense-looking Vietnamese man and a defiant Chicano framed above and

below by Asian and Mexican-American hands locking together in a powerful gesture of solidarity. Unidos venceran, it proclaims, "together we will overcome." And at the bottom of the poster is, simply, FUERA ("OUT"). The poster effectively communicates the extreme urgency of both of these oppressed populations and memorably links their causes.

Much of Montoya's work has to do with immigrants and migrant and undocumented workers. In Abajo con la migra: cesen las deportaciones (1972) the Statue of Liberty wields a meat cleaver, and a migrant worker slumps impaled on the spikes of her crown. He has continued addressing these issues and others in posters such as Los ojos de Zapata (1995), A Free Palestine, and, more recently, work in support of the movement to free Mumia Abu-Jamal, an ex-Black Panther who has been accused—some believe wrongly—of having killed a Philadelphia policeman. His style is generally hard-edged with closely interlocking forms, though in later works he used tursche for more painterly effects.

When the Chicano movement began to fragment in the mid-1970s—with more Chicanos entering the middle class and establishing a stake in the status quo—Montoya admonished artists not to shift their focus from liberation to validation. "There's a lot of so-called political art that is part of the mainstream in galleries today. My feeling is that as long as it stays within the art community, it doesn't have an effect on anything but the artists themselves. I always feel that action has to come from the bottom up," he said in Screen Printing Magazine. Montoya has continued making posters, and he exhibited almost exclusively in public places, such as hospitals and clinics, university galleries, and community centers.

—Anne Byrd

MORALES, Armando
Nicaraguan painter

Born: Granada, 1927. **Education:** Escuela de Bellas Artes, Managua, 1948–53; Pratt Graphic Center, New York, 1960–64. **Family:** One son. **Career:** Traveled to New York, 1957, and to Italy, 1965. Instructor, Cooper Union, New York, 1972–73. Lived in New York, Princeton, New Jersey, and in Costa Rica, 1970s; traveled to Venezuela and Mexico, 1970s. Nicaraguan alternate delegate to UNESCO, Paris, 1982. **Awards:** Travel grant, American Council of Education, 1957; Ernest Wolf award for Latin America, Fifth Biennale of São Paulo, 1959; fellowship, John Simon Guggenheim Memorial Foundation, 1960; fellowship, Organization of American States, 1962.

Individual Exhibitions:

1957	Pan American Union, Washington, D.C.
1959	Institute of Contemporary Art, Lima, Peru
1962	Angeleski Gallery, New York
	Organization of American States Headquarters, Washington, D.C.
1963	Lee Ault and Company, New York
	Instituto Panameño de Arte, Panama City

Armando Morales: *Tropical Rainforest I (Selva Tropical I)*, 1987. © Christie's Images/Corbis. © 2002 Artists Rights Society (ARS), New York/ADAGP, Paris.

1964	Carnegie International, Pittsburgh
	Bonino Gallery, New York
1966	Bonino Gallery, New York
	Biblioteca Luis Angel Arango, Bogota, Colombia
	L. L. Hudson Gallery, Detroit
1967	Museo de Bellas Artes, Caracas, Venezuela
1968	Bonino Gallery, New York
	Palacio de Bellas Artes, Mexico City
1969	Park College, Kansas City, Missouri
1971	Bonino Gallery, New York
1973	Lee Ault Gallery, New York
1976	Lee Ault Gallery, New York
	Estudio Actual, Caracas. Venezuela
1978	Lee Ault Gallery, New York
	Estudio Actual, Caracas, Venezuela
1979	Ravel Gallery, Austin, Texas
1981	CDS Gallery, New York
1983	Jorge Belcher Gallery, San Francisco
1984	Galerie Claude Bernard, Paris
1986	*Armando Morales: Peintures,* Galerie Claude Bernard, Paris
	Ravel Gallery, Austin, Texas
1987	Galerie Claude Bernard, Paris
1990	Museo de Arte Contemporáneo Internacional Rufino Tamayo, Mexico City
	Galerie Claude Bernard, ARCO, Madrid

	Museo de Monterrey, Mexico
1991	Galerie Claude Bernard, Paris
1992	Galerie Claude Bernard, Paris
	Art Miami 1992, Miami
1993	The Americas Collection Gallery, Coral Gables, Florida
	CODICE, Galería de Arte Contemporáneo, Managua
1997	Gary Nader Gallery, Miami (traveling)

Selected Group Exhibitions:

1956	*Gulf-Caribbean Art,* Museum of Fine Arts, Houston
1957	Museum of Modern Art, New York
1958	*Pittsburgh International,* Carnegie Institute
1961	*Latin America: New Departures,* Institute of Contemporary Art, Boston
1964	*Pittsburgh International,* Carnegie Institute
1965	*The Emergent Decade,* Solomon R. Guggenheim Museum, New York, and Cornell University, Ithaca, New York
1966	*Art of Latin America since Independence,* University of Texas, Austin, and Yale University, New Haven, Connecticut
1968	*Pittsburgh International,* Carnegie Institute
1970	Center for Inter-American Relations, New York
1987	*Art of the Fantastic: Latin America, 1920–1987,* Indianapolis Museum of Art (traveling)

Collections:

Museum of Modern Art, New York; Solomon R. Guggenheim Museum, New York; Museum of Modern Art, São Paulo; Museo de Bellas Artes, Caracas; Institute of Hispanic Culture, Madrid; Cincinnati Art Museum; Detroit Institute of Arts; Institute of Contemporary Arts, Boston; Museum of Fine Arts, Houston; Museum of Modern Art of Latin America, Washington, D.C.; University of Texas, Austin.

Publications:

On MORALES: Books—*Morales: Paintings,* exhibition catalog, New York, Bonino Gallery, 1964; *Armando Morales,* exhibition catalog, text by Thomas M. Messer, Lee Ault & Company, New York, 1973; *Armando Morales,* exhibition catalog, CDS Gallery, New York, 1981; *Armando Morales: Peintures,* exhibition catalog, text by Dore Ashton, Galerie Claude Bernard, Paris, 1986; *Art of the Fantastic: Latin America, 1920–1987,* exhibition catalog, by Holliday T. Day and Hollister Sturges, Indianapolis Museum of Art, 1987; *Armando Morales,* exhibition catalog, Museo de Arte Contemporáneo Internacional Rufino Tamayo, Mexico City, 1990; *Armando Morales,* exhibition catalog, Coral Gables, Florida, Gary Nader Editions, 1993; *Morales* by Lily S. de Kassner, Italy, Américo Arte Editores, 1995. **Articles—**"Armando Morales: Southern Visions of the Mind" by Edward J. Sullivan, in *Arts Magazine,* 62, November 1987, pp. 62–65; "Armando Morales" by Jose Manuel Springer, in *Art Nexus* (Colombia), 13, July/September 1994, pp. 168–169; "Twelve Artists from Nicaragua" by Belgica Rodriguez, in *Art Nexus* (Colombia), 14, October/December 1994, pp. 112–113; "Armando Morales" by

Armando Morales: *Man and Woman III (Homage to Vesalio),* 1988. © Christie's Images/Corbis. © 2002 Artists Rights Society (ARS), New York/ADAGP, Paris.

Francine Birbragher, in *Art Nexus* (Colombia), 25, July/September 1997, pp. 136–137; ''Heading toward the Mainstream'' by Marí Gainza, in *Art News,* 99(6), June 2000, pp. 74–76.

* * *

Armando Morales began to paint at an early age, defying his prosperous merchant family's desire that he study engineering or law. In 1948 he moved to Managua from his native Granada to study at the Escuela de Bellas Artes with Rodrigo Peñalba. Under Peñalba's guidance Morales acquired a thorough understanding of color relationships and tonal variations, elements of which are present throughout his mature body of work. Peñalba also introduced Morales to the work of Bonnard, Morandi, Soutine, and other modern artists concerned with the painterly exploration of the craft. Morales concluded his studies with Peñalba in 1953.

After receiving a travel grant from the American Council of Education in 1957, Morales visited the United States for the first time. In New York City he discovered the work of the abstract expressionists and was particularly influenced by the use of color and poetic forms found in the works of Mark Rothko and Theodoros Stamos. In 1960 Morales received a Guggenheim Fellowship, which allowed him to settle permanently in New York City.

Throughout the 1960s Morales's paintings consisted of abstractions – the sources of these were to be found in the landscape and the figure – made up of broad forms. His colors are somber combinations of white, gray, and black with occasional touches of blue, brown, and red. The series *Guerillero Muerto* dates from this period.

Morales studied lithography at the Pratt Graphics Center in New York from 1960 to 1964 and started to work in this graphic medium. By the early 1970s his paintings became more figurative, focusing on the female nude and introducing still-life elements (such as phonographs and bicycles), a palette of blues and earth colors, and a more perspectival depiction of space. By the 1980s Morales's return to figuration was complete, his palette became richer, evoking the colors of his native Nicaragua. Important works from this time are *Bañistas,* the series *Bosques tropicales*, still lifes with tropical fruits, and portraits of César Augusto Sandino, the 1930s leader of Nicaraguan independence. These works mark a return to a national identity (closely connected with the Sandinista revolution of 1979) through the depiction of themes that evoke not just the environment and colors of the artist's native Nicaragua, but also the recovery of childhood memories and forgotten episodes of the country's history. Color lithography and pastels became Morales's favored mediums during this decade. Throughout the 1990s he continued to work and expand the mature visual vocabulary he had established in the 1980s. A devout practicing Catholic, he returned to the religious Christological themes of some of his early student work, and he also painted portraits of leading Latin American writers, including Carlos Fuentes and Gabriel García Márquez.

The forms in Morales's paintings and drawings are always defined by a meticulous handling of color as well as by tonal values that are rich in substance. His substantial contribution to the art of Latin America consists of an impressive and consistent body of work that ignores passing fashion in favor of a metaphysical view of the world. This view is sustained by his extraordinary powers as a ''painter's painter.''

—Alejandro Anreus

MORALES, José
American painter and sculptural installation artist

Born: New York, 25 July 1947. **Education:** Art Students League, New York; Academia de Peña, Madrid; Ecole de Beaux-Arts, Paris, 1961–68. **Career:** Lived in Sweden, 1968–73. **Awards:** First prize, Fine Arts Competition, New York National Bank, 1986; BRIO award, New York City Cultural Affairs, 1991; International Association of Art Critics award, *II bienal de internacional de pintura del Caribe y Centroamérica,* Santo Domingo, 1994; Best Solo Painting Exhibition of the Year, 1994, 1997, and Best Installation of the Year, 1999, International Association of Arts Critics, San Juan, Puerto Rico; first prize, *Certamen nacional de artes plásticas,* Museo de Arte Contemporáneo, San Juan, Puerto Rico, 1995; third prize, *V bienal internacional de pintura,* Cuenca, Ecuador, 1996; New York Foundation for the Arts fellowship, 1997, 2001; International Honor prize, Fundación Arawak, Santo Domingo, 1997; painting award, Instituto de Cultura Puertorriqueña, New York, 1998; first prize, *III salón internacional de estandartes,* Tijuana, Mexico, 1998. **Address:** 159 East 104 Street, New York, New York 10029, U.S.A.

Individual Exhibitions:

1968	Galleri Bengtsson, Stockholm
	Gallerie Jean Camion, Paris
1970	Marks Kontsgille, Kinna, Sweden
	Borås Art Museum, Borås, Sweden
1972	Galleri 54, Göteborg, Sweden
	Jose Morales: Peintures 1970–1972, Nagasaki Art Museum, Japan (traveling)
	Kinna Kommunalhaus, Sweden
1979	*Jose Morales: Paintings and Drawings,* El Museo del Barrio, New York
	Alternative Museum, New York
1980	Vorpal Gallery, New York
1981	Vorpal Gallery, New York
1985	Bronx Museum of the Arts, New York
1992	Galería Raíces, Hato Rey, Puerto Rico
1993	Bronx Museum of the Arts, New York
	Galería Raíces, Hato Rey, Puerto Rico
1994	Museo de Arte Contemporáneo, San Juan, Puerto Rico
	Galería Raíces, Hato Rey, Puerto Rico
1995	*Four Corners/Cuatro esquinas, Recent Paintings and Drawings by Jose Morales,* El Museo del Barrio, New York
1997	Central Fine Arts Gallery, New York
	Instituto de Cultura Puertorriqueña, San Juan, Puerto Rico
	Galería Sin Titulo, San Juan, Puerto Rico
1999	Casa de las Américas, Havana
	Galería de Arte, Universidad Sagrado Corazón, San Juan, Puerto Rico
2000	New Jersey City University

Selected Group Exhibitions:

1994	*II bienal internacional de pintura del Caribe y Centroamérica,* Museo de Arte Moderno, Santo Domingo

José Morales: *Carrusel*, 1999. Photo by José Luis Lopez; courtesy of the artist.

1995 *III International Biennial of Graphic Arts,* Municipal
 Museum of Arts, Györ, Hungary
1996 *V bienal international de pintura,* Museo de Arte
 Moderno, Cuenca, Ecuador
1997 *V salón de dibujo,* Museo de Arte Moderno, Santo
 Domingo
1998 *XXX international bienale de la peinture,* Musee
 d'Gagnes, Cote d'Azur, France
 III salón internacional de estandartes, Centro Cultural
 Tijuana, Mexico
2000 *Mitos en el Caribe,* Casa de las Américas, Havana
 Los tesoros de la pintura puertorriqueña, Museo de
 Arte de Puerto Rico, San Juan
 Puerto Rico/Rico Puerto/Que Puerto, Instituto de
 América, Grenada, Spain
2001 *Marks of the Soul,* Florida Atlantic University, Boca
 Raton

Collections:

Bronx Museum of the Arts, New York; Casa de las Américas,
Havana; Center for the Arts, Vero Beach, Florida; Centro Cultural
Tijuana, Mexico; City University of New York; Compañia de Turismo,
San Juan, Puerto Rico; Museo de Arte Contemporáneo, San Juan,
Puerto Rico; Museo de Arte Moderno, Cuenca, Ecuador; Museo de
Arte de Ponce, Puerto Rico; Museo de Arte de Puerto Rico, San Juan;
El Museo del Barrio, New York.

Publications:

On MORALES: Books—*José Morales Paintings & Drawings,*
exhibition catalog, New York, El Museo del Barrio, 1979; *José*

Morales: Obra reciente, exhibition catalog, text by Antonio Martorell
and Verna Rosado, Hato Rey, Puerto Rico, Galería Raíces, 1993; *José
Morales: Pintura y borradura,* exhibition catalog, San Juan, Museo
de Arte Contemporáneo de Puerto Rico, 1994.

* * *

José Morales creates large paintings that are emotionally rich,
enigmatic, and forceful. A painter who believes in painting from an
emotional rather than an intellectual source, Morales creates works
that may focus on violence or eroticism. Artist Antonio Martorell
writes of Morales's work, ''Large canvasses and fragmented planes
of paper; notes, sketches that are actually finished works; paintings
that preserve the freshness of a sketch . . . his percussive gray and
wide swath of chromatic saturation—lend his varied production
conceptual and technical coherence behind which hide his discreet
signature and his modest self.''

Having spent his childhood in the Bronx, Morales, of Puerto
Rican descent, left the United States to train as an artist in Madrid and
France. He then moved to Sweden, a place where his painting style
was embraced. He lived there for six years. When he returned to the
Bronx he set up a studio in a factory with artist Moral Rafael
Columbus. For a span of about seven years, however, Morales did not
paint at all. When he did begin to paint again, his work evolved around
the themes he had always been interested in: violence and the barriers
people have to put up with. In Sweden he had painted pieces that
showed tied figures surrounded by boxes. He would continue with
these motifs. In many of his works Morales adds a linen cloth, which
allows him to break with his original idea. For example, in *Keeping
the Pyramids* he began with a small picture done of a friend and added
first one and then two pieces of linen cloth, which transformed the

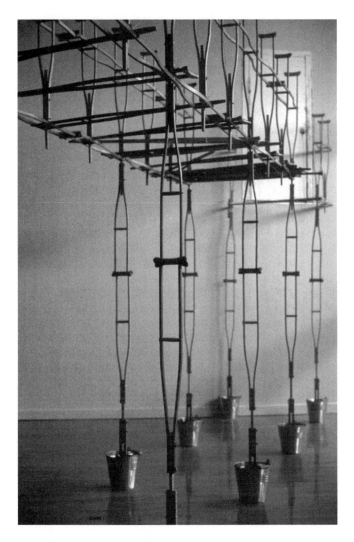

José Morales: *Puente,* **2001. Photo courtesy of the artist.**

painting into something entirely new. This spontaneity, this willingness to follow through with an idea, makes Morales's work both fresh and distinct.

—Sally Cobau

MUNIZ, Vik
Brazilian photographer

Born: São Paulo, Brazil, 1961; moved to the United States, *ca.* 1985.
Career: Since 1989 curator. Cofounder and associate editor, *Blindspot Magazine.* Visiting assistant professor of photography, Bard College, Annandale-on-Hudson, New York, 2001. Artist-in-residence, Frick Art and Historical Center, Pittsburgh, 2000.

Individual Exhibitions:

1988 Stux Gallery, New York
 PS 122, New York

1989 *Fluxus, Moment and Continuum,* Stux Gallery, New York
1990 Stux Gallery, New York
 Meyers/Bloom Gallery, Santa Monica, California
 Stephen Wirtz Gallery, San Francisco
1991 Gabinete de Arte Rachel Arnaud, São Paulo
 Galerie Claudine Papillon, Paris
 Galeria Berini, Barcelona, Spain
 The Best of LIFE, Stux Gallery, New York
 Kicken-Pausebach, Cologne, Germany
1992 Gallerie Beaumont, Luxembourg
 Galeria Claudio Botello, Turin, Italy
1993 *Equivalents,* Grand Salon, New York, and Ponte Pietra Gallery, Verona, Italy
 Individuals, Stux Gallery, New York
1994 Galeria Claudio Botello, Turin, Italy
1995 Brent Sikkema Gallery, New York
 The Wire Pictures, Galeria Camargo Vilaça, São Paulo
 Representations, Wooster Gardens, New York
1996 Rena Branstein Gallery, San Francisco
1998 International Center of Photography, New York
 Vik Muniz: Photographs, Rena Bransten Gallery, San Francisco
1999 Caisse des Dépôts et Consignations, Paris (traveled to Centre National de la Photographie, Paris, and Galerie Xippas, Paris)
 Vik Muniz: Seeing Is Believing, Museum of Contemporary Photography, Columbia College, Chicago (traveling)
2000 Ubu Gallery, New York
 Frick Art and Historical Center, Pittsburgh
 Earth Works, Rena Bransten Gallery, San Francisco
 Brent Sikkema Gallery, New York
2001 *The Things Themselves: Pictures of Dust by Vik Muniz,* Whitney Museum of American Art, New York
 Museu de Arte Moderna do Rio de Janeiro

Selected Group Exhibitions:

1990 *On the Edge between Sculpture and Photography,* Cleveland Center for the Contemporary Arts, Ohio
1991 *The Neighborhood,* A.I.R., Amsterdam
 The Encompassing Eye, Photography As Drawing, University of Akron, Ohio
1992 *Life Size: Small, Medium, Large,* Museo d'Arte Contemporaneo Luigi Pecci, Prato, Italy
1993 *The Alternative Eye: Photography for the 90's,* Southern Alleghenies Museum, Loreto, Pennsylvania
1994 *Single Cell Creatures,* Katonah Museum of Art, New York
1995 *Panorama da arte contemporanea brasileira,* Museu de Arte Moderna, São Paulo and Rio de Janeiro
 The Photographic Condition, San Francisco Museum of Modern Art
1999 *From Brazil: Alchemies and Processes,* Luis Angel Arango Library
2000 *Group Show,* Brent Sikkema Gallery, New York

Collections:

Metropolitan Museum of Art, New York; Art Institute of Chicago; Museum of Fine Arts, Boston; Los Angeles County Museum; San Francisco Museum of Modern Art; Museum of Modern Art, Dallas; Museum of Fine Arts, Houston; Museo de Arte Luigi Pesce, Prato, Italy; Museo de Arte Moderna do Rio de Janeiro; Maison Europeene de la Photographie, Paris.

Publications:

By MUNIZ: Books—*Making It Real: A Traveling Exhibition,* exhibition catalog, with Luc Sante, New York, Independent Curators Incorporated, 1997; *Clayton Days: Picture Stories by Vik Muniz,* with text by Andy Grundberg and Linda Benedict-Jones, Pittsburgh, Frick Art and Historical Center, 2000. **Articles**—"Vik Muniz," in *European Photography* (West Germany), 21(67), spring/summer 2000, pp. 20–21; "Clayton Days," in *Artforum International,* 39(2), October 2000, pp. 122–123.

On MUNIZ: Books—*Fluxus, Moment and Continuum,* exhibition catalog, New York, Stux Gallery; *Vik Muniz,* exhibition catalog, with text by Joshua Decter, New York, Stux Gallery, 1990; *Seeing Is Believing,* exhibition catalog, with text by Mark Alice Durant, Charles Stainback, and James Crump, Santa Fe, New Mexico, Arena Editions, 1998; *Vik Muniz: After Warhol,* exhibition catalog, Paris, Galerie Xippas, 1999. **Articles**—"Vik Muniz Interview" by Francesco Bonami, in *Flash Art* (Italy), 158, May/June 1991, pp. 166–167; "The Cunning Artificer: An Interview with Vik Muniz" by Vincent Katz, in *On Paper,* 1, March/April 1997, pp. 26–31; "Sweet Illusion: Meanings in Vik Muniz's Use of Chocolate and Other Materials in His Work" by Andy Grundberg, in *Artforum International,* 36, September 1997, pp. 102–105; "Through a Brazilian Lens" by Edward Leffingwell, in *Art in America,* 86(4), April 1998, pp. 78–85; "Vik Muniz: Photographs" by Jori Finkel, in *On Paper,* 2(6), July/August 1998, pp. 47–48; "Vik Muniz" by Katy Siegel, in *Artforum International,* 37(4), December 1998, p. 122; "Sweet Deception" by Susie Linfield, in *Art News,* 98(2), February 1999, pp. 90–91; "Vik Muniz: Seeing Is Believing" by Charmaine Picard, in *Art Nexus* (Colombia), 33, August/October 1999, pp. 104–105; "Artiste du mois: Vik Muniz" by Anne Kerner, in *Beaux Arts Magazine* (France), 187, December 1999, p. 313; "A Thousand Words: Vik Muniz" by Saul Anton, in *Artforum,* 39(2), 2000; by Bénédicte Ramade, in *Parachute* (Canada), 98, April/June 2000, pp. 49–50; "Vik Muniz" by Robert Mahoney, in *Art on Paper,* 5(1), September/October 2000, p. 83; "New York" by Dana Mouton Cibulski, in *Art Papers,* 24(5), November/December 2000, p. 44; by Vince Aletti, in *Artforum International,* 39(4), December 2000, pp. 130–131; "Dust to Dust" by Jean Dykstra, in *Art on Paper,* 5(4), March/April 2001, pp. 22–23. **Film**—*Worst Possible Illusion: The Curiosity Cabinet of Vik Muniz,* n.p., Mixed Greens, 2001.

* * *

Brazilian artist Vik Muniz has said of his work, "I prefer representations of representations to the things themselves." In keeping with that philosophy he presented a work at the Whitney 2000 Biennial entitled *Raft of the Medusa,* part of a series called *Pictures of Chocolate* begun in 1997. Muniz copied Theodore Gericault's painting *Raft of the Medusa* using chocolate syrup and a

needle, then he exhibited a photograph of that work. A piece like this one might be passed off as mere gimmickry were it not for the astonishing quality of Muniz's draftsmanship and the oddly expressive quality of his medium. His heavy, regular lines achieve a dramatic contrast between the dark chocolate and the very light untreated areas of the underlying surface. The qualities of the chocolate lend the whole thing a comic air, but at the same time they re-create—albeit in crude terms—some of the painterly effects accomplished by the romantic master. Rendered in glistening chocolate syrup the image is oddly true to the original subject. Gericault's painting recounts the story of the *Medusa,* a French ship that sank off the west coast of Africa. Of the 150 who tried to escape on a raft, only 15 survived. By the time they were discovered they had been at sea for 13 days with only human flesh and a bit of wine to sustain them. Gericault's painting (and Muniz's copy) depicts the survivors at the moment that they spotted the rescue ship. Gericault reputedly went to great pains to achieve authenticity, interviewing survivors and reconstructing their raft and visiting the corpses in the morgue. Muniz's copy of Gericault's painting, by contrast, is an artful tribute to fakery. In Muniz's *Raft of the Medusa* the chocolate syrup looks a bit like blood. Muniz himself has noted that Hitchcock used chocolate syrup in lieu of blood in his movies because the syrup photographed better, giving the scene a grisly, repulsive quality appropriate to the subject. Muniz said of this work: "Most of my work bets on what the viewer knows about the image that is in front of him. I think the power of images resides in the power of their being underestimated." While his subject is borrowed from the master of French romanticism, Muniz's method also pays tongue-in-cheek tribute to the abstract expressionists and especially Jackson Pollock, who revolutionized painting by dripping paint on canvas in a most unconventional way. Like Pollock, Muniz works rapidly, and the finished image captures the spontaneity and expressiveness of his gesture.

In perhaps his most enchanting work Muniz hired a crop duster to fly over Manhattan and "draw" outlines of clouds in the sky. He wrote of this enterprise: "The watching of clouds, whether as a method of forecasting or a form of amusement, has been going on for centuries; what one person sees as a chariot, another may see as a bear or as a gathering of angels. Visualization comes from within the observer." Muniz's work, with its undoubtedly whimsical quality, also makes serious commentary on the politics of representation and re-representation. We live in an environment of deliberately constructed imagery, but Muniz allows us to see that with new eyes. The effect of his cloud work is like suddenly chancing upon a cardboard cutout of a tree in the midst of a forest. We look at the line drawings of clouds hanging in the sky then look back at the landscape of the city and are newly aware of the images that surround us. Muniz, who calls his work "low-tech illusionism," reminds us of the constructed and ephemeral nature of our visual world.

—Amy Heibel

MUÑOZ, Óscar
Colombian painter, sculptor, and graphic artist

Born: Popayán, 1951. **Awards:** First prize and Special Prize of the Public, *V Salon of Young Art,* Zea Museum, Medellin, 1976; special

Óscar Muñoz: *9,* "Narciscos" series, 2000. Photo courtesy of Jean Albano Gallery and the artist.

mention, *National Salon of Visual Arts,* Bogota, 1982; gold medal, *Intergraphic 76,* Berlin, 1982; jury prize, *VI Norwegian International Print Biennial,* Fredrikstad, Norway.

Individual Exhibitions:

1979 Museo de Arte Moderno La Tertulia, Cali, Colombia
1981 *Carbones,* Galería Garcés Velásquez, Bogotá
 Galería 7, Lima, Peru

Museo de Arte Moderno de Panamá
1982 Centro de Arte Actual, Pereira, Colombia
1983 Cámara de Comercio, Cali, Colombia
1985 Museo de Arte Moderno La Tertulia, Cali, Colombia
1986 Galeria Quintero, Barranquilla, Colombia
 Arco '86, Galeria Quintero, Madrid
 Galeria Arte Autopista, Medellin, Colombia
 Galeria Garcés Velásquez, Bogotá
1987 Fundación Banco del Estado, Popayán, Colombia

1987 *Oscar Muñoz: 15 años,* Cámara de Comercio de Cali,
 Colombia
 Segundo festival de arte 1987, Cali, Colombia
 Galeria Epoca, Santiago
 Oscar Muñoz, Centro de la Municipalidad de
 Miraflores, Lima, Peru
1990 *Superficies al carbón,* Sala Suramericana de Seguros,
 Medellin, Colombia (traveled to Muse de Arte
 Moderno La Tertulia, Cali, Colombia, and Galeria
 Garcés Velásquez, Bogotá)
1993 *Estudios y proyectos,* Galeria de Bellas Artes, Cali,
 Colombia
1994 *Narcisos,* Ledisflam Gallery, New York (traveled to
 Galeria Garcés Velásquez, Bogotá, and Museo de
 Arte Moderno La Tertulia, Cali, Colombia)
1996 Museo de Arte Moderno, Bogotá
1997 Galeria Metropolitana de Barcelona, Spain
 Museo de Arte de Pereira, Colombia
1998 Centro Cultural MEC, Ministerio de Educación y
 Cultura, Montevideo, Uruguay
1999 Throckmorton Fine Arts, New York

Selected Group Exhibitions:

1986 *V bienal de artes gráficas,* Museo de Arte Moderno La
 Tertulia, Cali, Colombia
1987 *Arte colombiano, mito, sueno y realidad,* Inter-American
 Development Bank, Washington, D.C.
1990 *Sculpture of the Americas into the Nineties,* Museum of
 Contemporary Art of Latin America, Washington,
 D.C.
1991 *Colombia arte 80,* Museo de Bellas Artes, Lima, Peru
1993 *Pulsiones,* Museo de Arte La Tertulia, Cali, Colombia
1996 *Relaciones,* Museo de Arte y Diseño Contemporáneo,
 San José, Costa Rica
 V bienal de arte de Bogotá, Museo de Arte Moderno,
 Bogotá
1997 *Realigning Vision,* El Museo del Barrio, New York
 (traveling)
1998 *La generación intermedia,* Biblioteca Luis Angel
 Arango, Bogotá
 Amnesia, Christopher Grimes Gallery, Track 16 Gallery,
 Los Angeles (traveling)

Publications:

On MUÑOZ: Books—*Seis artistas colombianos: Octubre 1975,*
exhibition catalog, Cali, Colombia, Museo de Arte Moderno La
Tertulia, 1975; *Sculpture of the Americas into the Nineties,* exhibition
catalog, Washington, D.C., Museum of Modern Art of Latin America,
1990; *Óscar Muñoz,* exhibition catalog, Bogotá, Museo de Arte
Moderno, 1996; *Óscar Muñoz: Narcisos, aliento,* exhibition catalog,
text by Mónica Amor, Montevideo, Uruguay, Centro Cultural Mec,
1998. **Articles**—''Ócar Muñoz'' by Monica Amor, in *Art Nexus*
(Colombia), 14, October/December 1994, pp. 110–111; ''Óscar

Muñoz'' by María Teresa Guerrero, in *Art Nexus* (Colombia), 17,
July/September 1995, p. 114; ''Óscar Munoz'' by Marta Rodriguez,
in *Art Nexus* (Colombia), 23, January/March 1997, pp. 124–125;
'''Amnesia' at Christopher Grimes & Track 16'' by Michael Darling,
in *Art Issues,* 54, September/October 1998, p. 37; ''Óscar Muñoz'' by
Jonathan Goodman, in *Art on Paper,* 4(5), May/June 2000, pp. 82–83.

* * *

Born in Popayán, Colombia, in 1951, Óscar Muñoz first became
known through his large-scale drawings that portrayed the sordid
aspects of urban life. These works, done in pencil on paper, depicted
the derelict interior spaces of such places as whorehouses or shelters
for the poor and were often based on photographs by fellow Colom-
bian Fernell Franco. Muñoz's technique was impeccable, and the
subject matter was related to social concerns that were at the core of
cultural discussions in the 1970s in Colombia. His interest in the
figure in relation to architectural space took a step forward in
Cortinas, which consisted of nude figures drawn on the backs of
shower curtains that were then hung at a distance from walls in
various configurations. These visually deceiving works suggested the
actual human presence in the space.

The relation between drawing and photography in Muñoz's first
works was developed further in the *Narcisos* series of the 1990s, for
which he has become more widely known. After preparing a silk
screen frame with his self-portrait, as if he were going to make a print,
Muñoz delicately sifted graphite powder through it onto shallow
containers filled with water so as to produce a black-and-white image
that rested on the surface in unstable equilibrium. As the water
evaporated, the powder gradually settled and, responding to the
changes in the environment–heat, vibrations, and the occasional
bump by a passerby–became distorted. On the bottom of the contain-
ers the artist placed either plain paper or printed matter–maps,
newspapers, or old letters–so that when the powder finally settled the
portrait formed a symbolic relationship with the base. *Simulacros,* a
later variation of this series, included a drop of water that fell on the
surface every 10 seconds, gradually destroying parts of the image
while allowing its integrity as a whole to be preserved.

Time has always been a major issue in photography: the pro-
longed sittings required in early photographs, the lapse of time it takes
for images to become infused on light-sensitive surfaces, and the time
it takes to develop and fix the image. Muñoz's use of time in his
drawing-as-photography procedures results in heavily charged im-
ages that take a long period to become stabilized and that require the
viewer's interaction as part of their formation. This is also the case in
his *Aliento* series. A row of metallic mirrors protrudes from the wall in
a line slightly below the viewer's height. They appear devoid of any
image until a spectator breathes on them. A ghostly image of a face
then appears for a few seconds, only to disappear again. The images
are, in fact, portraits of those who have disappeared, people who have
been killed in violent circumstances related to Colombia's contempo-
rary political situation. In Muñoz's work the image reacts to the
viewer's interaction, forcing us to acknowledge our passivity in
relation to the events that mark our collective consciousness.

—José Roca

NEGRET, Edgar
Colombian sculptor

Born: Popayan, 1920. **Education:** Escuela de Bellas Artes, Cali, Columbia, 1938–43; studied with Jorge de Oteiza, Popayan, 1944–46, and in Madrid, 1953; studied at Clay Club Cultural Center, New York, 1948–50; influenced by Henry Moore. **Career:** Visited Bogota, then traveled to Europe, 1950; lived in Paris, 1950–52; traveled in Spain and Mallorca, 1953, in Paris and the United States, 1955. Instructor, New School for Social Research, New York, 1958. Painted original posters, graphics, and sets for La Mama Theatre, New York, 1963; founder, La Mama Bogota Theatre, Colombia, 1970. Museo Negret founded by the Colombian Government, Popoyan, 1986. **Awards:** First prize, 1949, and grand prize, 1967, *Salon nacional,* Bogota; travel fellowship, Paris, 1958; silver medal, *Bienal,* São Paulo, 1965; David E. Bright Foundation prize, *Biennale,* Venice, 1968; fellowship, Guggenheim Foundation, 1975. **Agent:** Humphrey Fine Art, New York City. **Addresses:** c/o Humphrey Fine Art, 242 East Fifth Street, New York, New York 10003, U.S.A.; and 37 East 7th Street, New York, New York 10003, U.S.A.

Individual Exhibitions:

1943	Palacio de Bellas Artes, Cali, Colombia
1944	Convento de San Francisco, Popayan
1946	Biblioteca Nacional, Bogota
1948	*Edgar Negret/Eduardo Ramirez,* Sociedad de Ingenieros, Bogota
1950	Peridot Gallery, New York
1951	Galeria de Arte, Bogota
	Galerie Arnaud, Paris
1953	Museo de Arte Contemporaneo, Madrid
1955	Peridot Gallery, New York
1956	Pan-American Union, Washington, D.C.
1957	*Edgar Negret/Jack Youngerman,* Gres Gallery, New York
1958	Biblioteca Nacional Bogota
1959	David Herbert Gallery, New York
1962	Museo de Bellas Artes, Caracas, Venezuela
	Biblioteca Luis-Angel Arango del Banco de la Republica, Bogota
1963	Galeria de Arte El Callejon, Bogota
1964	*Edgar Negret/Eduardo Ramirez,* Graham Gallery, New York
1965	Museo de Arte Moderno, Bogota
1966	Graham Gallery, New York
	Museu de Arte Moderna, Rio de Janeiro
	Galeria Siglo XX, Quito, Ecuador
	Casa de la Cultura, Guayaquil, Ecuador
	Museo de Zea, Medellin, Colombia

1967	Richard Demarco Gallery, Edinburgh
	Axiom Gallery, London
	Negret/Rojas, Galeria Nacional, Cali, Colombia
1968	Biblioteca Nacional, Bogota
	Negret/Cicero, Galerie Simone Stern, New Orleans
1969	Museo La Terulia, Cali, Colombia
1970	Stedelijk Museum, Amsterdam
1971	Galerie Buchholz, Munich, Germany
	Städtische Kunsthalle, Dusseldorf, Germany
	Museo de Arte Moderno, Bogota (retrospective)
1972	Galerie Bonino, New York
	Arts Club of Chicago
1974	Galeria Bonino, New York
	San Juan Museum of Fine Arts, Puerto Rico
	Corcoran Gallery of Art, Washington, D.C.
	Negret, Ramirez, Rojas, Galeria Monte Avila, Bogota
1975	University of Texas, Austin
	Museo d'Arte Moderno, Bogota
1976	Galeria Belarca, Bogota
	Center for Inter-American Relations, New York (retrospective)
	Sala de Exposiciones, Caracas, Venezuela
1977	Galeria San Diego, Bogota
1978	La Galeria, Quito, Ecuador
1979	Galeria Garcés Velásquez, Bogota (retrospective)
	Museo de Arte Moderno, Bogota
	Galeria San Siego, At *FIAC 79,* Grand Palais, Paris
1980	Galeria Quintero, Barranquilla, Colombia
	Galeria 9, Lima, Peru
1981	Fondacion Joan Miro, Barcelona, Spain
	Sala Caja de Ahorros, Alava, Vitoria, Spain
1982	Galeria Atenea, Barranquilla, Colombia
	Contemporary Sculpture Center, Tokyo
1983	Museo Espanol de Arte Contemporaneo, Madrid
	Galeria Casa Negret, Bogota
1984	Galeria Avianca, Barranquilla, Colombia
1985	Museo Casa Negret, Popayan, Colombia
1986	Humphrey Fine Art, New York
1987	Museo de Arte Moderno, Bogota (retrospective)
	Humphrey Fine Art, New York

Selected Group Exhibitions:

1950	*Sculptures and Paintings from Colombia,* New School for Social Research, New York
1952	*Salon des réalites nouvelles,* Paris
1956	*Carnegie International,* Carnegie Institute, Pittsburgh
1958	*Biennale,* Venice
1961	*Geometrics and Hard Edge,* Museum of Modern Art, New York
1968	*Documenta,* Kassel, West Germany

1975 *Latin American Artists Today,* University of Texas at
 Austin
1976 *El arte colombiano a traves de los siglos,* Palacio de
 Velázquez, Madrid
1979 *Twenty-Five Years Afterwards: Nevelson, Kelly, Negret,*
 Museo de Arte Moderno, Bogota
1985 *Works of Botero, Grau, Negret,* Museum of Modern Art
 of Latin America, Washington, D.C.

Collections:

Museo Casa Negret, Popayan, Colombia; Museo de Arte Moderno, Bogota; Museo de Arte Moderno, Caracas; Museo de Arte Moderno, Santiago, Chile; Museum of Modern Art, New York; Albany Institute of History and Art, New York; Pan-American Union, Washington, D.C.; University of Nebraska, Lincoln; Guggenheim Museum, New York; Stedelijk Museum, Amsterdam.

Publications:

By NEGRET: Books—*Nada que ocultar,* with Daniel Samper Pizano, Bogota, E. Negret, 1983; *Edgar Negret: The Andes,* New York, Humphrey Fine Art & Design, 1987.

On NEGRET: Books—*Negret: Magic Machines,* exhibition catalog, text by Franklin Konigsberg, New York, David Herbert Gallery, 1959; *Negret: Las etapas creativas* by Galaor Carbonell, n.p., Fondo Cultural Cafetero, 1976; *Negret: Retrospectiva,* exhibition catalog, Bogota, Garcés Velásquez Galería, 1978; *10 artistas y un museo,* exhibition catalog, by Germán Rubiano Caballero, Cartegena, Colombia, Museo de Arte Moderno de Cartagena, 1979; *Casa Museo Negret,* exhibition catalog, text by Galaor Carbonell, Cali, Colombia, Museo de Arte Moderno La Tertulia, 1985; *Negret: A Retrospective Catalog,* exhibition catalog, by Eduardo Serrano, Bogota, 1987; *Negret: Esculturas,* exhibition catalog, Santiago de Chile, Galería Arte Actual, 1990; *Edgar Negret: 1957–1991: De la máquina al mito,* exhibition catalog, text by José María Salvador, Monterrey, Mexico, Museo de Monterrey, 1991; *Negret: Diálogo con lo sagrado,* exhibition catalog, Caracas, Fundación Corp Group Centro Cultural, 1998. **Articles**—"Reviews and Previews: Negret" by Frank O'Hara in *Artnews* (New York), November 1955; "Reflexiones sobre la edad de los metales" by Marta Traba in *Vinculo Shell* (Buenos Aires), 1957; "Reviews and Previews: Edgar Negret" by Lawrence Campbell in *Artnews* (New York), November 1959; "News and Views from New York: Edgar Negret at the David Herbert Gallery" by Marvin D. Schwartz in *Apollo* (London), December 1959; "The World of Art, Pan-America: Five Contemporary Colombians" by Marta Traba in *Art in America* (New York), spring 1960; "The Sculpture of Edgar Negret" by Douglas Hall in *Studio International* (London), September 1967; "Reviews and Previews: Edgar Negret" by Rosalind Brown in *Artnews* (New York), April 1969; "Der Bildhauer Edgar Negret" by E. Trier in *Art International* (Lugano, Switzerland), summer 1970; "Twisting, turning, and binding" by Juliana Soto, in *Art News,* 93, December 1994, pp. 114–115; "The Enthusiasm of Edgar Negret" by Carlos Jiménez, in *Third Text* (United Kingdom), 30, spring 1995, pp. 85–88; "Three Sculptors," in *Art Nexus* (Colombia), 17, July/September 1995, pp. 117–118.

* * *

Edgar Negret is a Colombian sculptor who, the more he was introduced to modern idioms and nonobjective concepts, the more he seemed paradoxically to reflect in his work something of the silent dialogue between ancient monolithic style and a communal memory not yet overlaid by the superfluous data of intervening civilizations. He was slow in maturing, although by 1949, while relating to the figurative tradition, he had assimilated Henry Moore's penetration of the mass. From 1954 he switched his attitude toward metal constructions, and from this point they assumed the open situation, rising from flat ground rather than the top of a pedestal. This integration with the environment nonetheless concentrated the axis on a central base, and profiles strongly marked by cutout shapes–signals, arms, slots, and brackets–set up a system of iconic semaphores. As an admirer of both Gaudí and Calder, he simulated a style of metallic rococo, and the illumination of his flat metal by bright reds and oranges instilled a note of carnival to static constructions while breaking up the tonal mass in light.

Emblem for an Aquarium (1954) has an abstract simplicity, while its polychrome shells project unstressed affinities with fish. In the 1960s Negret operated with large structures of sheet metal, chiefly aluminum, symbolizing the mechanical power of screws and propellers as they might be embodied in entities of morphological character. He found an apt concrete weight to his formal syntax, placing the sheer planes and flanged girders as physical embodiments of abstract relationships that were the sums of simplified complexity. They took poetic solidities economically in reduced dimensions of architectural scope. In works such as *The Bridge* and *Stanchion 2* of 1968–70 the massive riveted and bolted girders are patterned by the repetition of the fastening nuts and heads in the way a cathedral is ornamented by its functional buttressing, the Gothic effects being heightened by the lozenge-shaped holes.

This identification with architecture continues alongside the airborne spirit of much of Negret's metaphoric imagery. *Cape Kennedy* (1966) has its obvious connection with space travel in its crude simplicity yet by that fact implying untold energy in its suggestion of upward-angled thrust. *Navigators* combines the helmeted astronaut image with the centrifugal spirit of automotive power. *Temple* (1971) is a structure conceived in voided grandeur, defining impressive proportions of space and converting straight-edged girders into contemporary capitals bearing measured architectural decoration on their flanges and bolt heads.

Negret is singularly outstanding for his affirmation of contemporary man-released power transfigured to optimistic paraphrase in organic poetry. His complex yet simple monoliths celebrate man's capacity to evolve for good instead of evil, for exploration rather than for destruction. His clean-cut constructions stand for classical order of tensed proportion and inhabited dignity.

—G. S. Whittet

NERI, Manuel
American painter and sculptor

Born: Sanger, California, 12 April 1931. **Education:** San Francisco City College, 1949–50; University of California, Berkeley, 1951–52; California College of Arts and Crafts, Oakland, 1951–56; California School of Fine Arts (later San Francisco Art Institute), San Francisco, 1956–58. **Military Service:** United States Army, 1952–55. **Family:**

Manuel Neri: *Red Legs,* **1979. Photo by M. Lee Fatherree; courtesy of Anne Kohs & Associates, Inc., Portola Valley, California.**

Married 1) c. 1953 (divorced c. 1955); 2) Joan Brown in 1962 (divorced); 3) Kate in 1983; two children. **Career:** Art instructor, San Francisco Art Institute, 1959–65, University of California, Berkeley, 1963–64, University of California, Davis, 1965–90. **Awards:** First award in sculpture, 1953, and Purchase award in painting, 1957, Oakland Art Museum, California; Nealie Sullivan award, California School of Fine Arts, San Francisco, 1959; 82nd Annual Sculpture award, San Francisco Art Institute, 1963; National Art Foundation award, 1965; fellowship, Guggenheim Foundation, 1979; Visual Artist fellowship, National Endowment for the Arts, 1980; Award in Art, American Academy and Institute of Arts and Letters, 1982; Award of Honor for Outstanding Achievement in Sculpture, San Francisco Arts Commission, 1985. Honorary doctorates: San Francisco Art Institute, 1990; California College of Arts and Crafts, Oakland, 1992; Corcoran School of Art, Washington, D.C., 1995. **Agent:** Anne Kohs & Associates, 115 Stonegate Road, Portola Valley, California 94028, U.S.A. **Web site:** http://www. artistforum.com.

Individual Exhibitions:

1957	The 6 Gallery, San Francisco
1959	Spatsa Gallery, San Francisco
1960	Dilexi Gallery, San Francisco
1963	*Neri Sculpture,* New Mission Gallery, San Francisco
1964	Berkeley Gallery, California
1966	Quay Gallery, San Francisco
1968	Quay Gallery, San Francisco
1969	Louisiana State University, Baton Rouge
1970	St. Mary's College, Moraga, California
	San Francisco Art Institute
1971	Quay Gallery, San Francisco
	San Francisco Museum of Art

Manuel Neri: *Carriona Figure No. 3,* **1981. Photo by M. Lee Fatherree; courtesy of Anne Kohs & Associates, Inc., Portola Valley, California.**

1971 University of Nevada, Reno
1972 Sacramento State College Art Gallery
 Manuel Neri: New Sculpture, Davis Art Center,
 California
1974 San Jose State University, California
 Manuel Neri: Sculpture and Installations, Stephens
 College, Columbia, Misouri
1975 Quay Gallery, San Francisco
1976 *Manuel Neri, Sculptor,* Oakland Museum, California
 (traveling)
 Neri Sculpture, Braunstein/Quay Gallery, New York
 The Remaking of Mary Julia: Sculpture in Process, 80
 Langton Street, San Francisco
1977 *Manuel Neri: Recent Sculpture and Drawings,*
 ArtSpace/Open Ring, Crocker Art Gallery, Sacra-
 mento, California
1979 Gallery Paule Anglim, San Francisco
1980 Whitman College, Walla Walla, Washington
 Richmond Art Center, California
 Grossmont College Gallery, El Cajon, California
1981 Seattle Art Museum
 Charles Cowles Gallery, New York
 Mexican Museum, San Francisco
 John Berggruen Gallery, San Francisco
 Manuel Neri: Drawings and Bronzes, Redding Museum
 and Art Center, California (traveling)
1982 Charles Cowles Gallery, New York
1983 Middendorf Gallery, Washington, D.C.
1984 John Berggruen Gallery, San Francisco
 *The Human Figure: Sculpture and Drawings by Manuel
 Neri,* California State University, Chico
 Middendorf Gallery, Washington, D.C.
 Gimpel-Hanover and André Emmerich Galerien, Zurich
1985 California State University, Sacramento
1986 Charles Cowles Gallery, New York
1987 Fay Gold Gallery, Atlanta
 San Antonio Art Institute, Texas
1988 College of Notre Dame, Belmont, California
 John Berggruen Gallery, San Francisco
 James Corcoran Gallery, Santa Monica
1989 Sheppart Fine Arts Gallery, University of Nevada, Reno
 Charles Cowles Gallery, New York
 San Francisco Museum of Modern Art
 Greg Kucera Gallery, Seattle
 Riva Yares Gallery, Scottsdale, Arizona
1990 John Berggruen Gallery, San Francisco
 Manuel Neri: Bronzes, Crocker Art Museum, Sacra-
 mento, California
 Bingham Kurts Gallery, Memphis
 San Marco Gallery, Dominican College, San Rafael,
 California
1991 *Manuel Neri: Works on Paper,* Bingham Kurts Gallery,
 Memphis
 Margulies/Taplin Gallery, Coconut Grove, Florida
 Charles Cowles Gallery, New York
 Manuel Neri: Drawings, Part I, 1953–1974, Richard L.
 Nelson Gallery, University of California, Davis
 Eve Mannes Gallery, Atlanta
 Riva Yares Gallery, Santa Fe, New Mexico
1992 John Berggruen Gallery, San Francisco

 Morgan Gallery, Kansas City, Missouri
 Margulies/Taplin Gallery, Boca Raton, Florida
 She Said: I Tell You It Doesn't Hurt Me, Fresno Art
 Museum, California
1993 Bingham Kurts Gallery, Memphis
 *Manuel Neri: New Work: Marbles, Bronzes and Works
 on Paper,* Charles Cowles Gallery, New York
 Riva Yares Gallery, Scottsdale, Arizona
 Manuel Neri–Drawings and Sculpture, University of
 Alabama Art Gallery, Tuscaloosa
 Manuel Neri: Painted and Unpainted, Dia Center for
 the Arts, Bridgehampton, New York
 Campbell-Thiebaud Gallery, San Francisco
1994 Margulies/Taplin Gallery, Boca Raton, Florida
 Manuel Neri: Master Artist Tribute III, Hearst Art
 Gallery, St. Mary's College, Moraga, California
 Morgan Gallery, Kansas City, Missouri
1995 *Manuel Neri: Sculptures et Dessins,* Galerie Claude
 Samuel, Paris
 Charles Cowles Gallery, New York
 Manuel Neri: Recent Drawings, Campbell-Thiebaud
 Gallery, San Francisco
 Manuel Neri: Bronze Sculpture and Drawing,
 Robischon Gallery, Denver
 Nevada Institute for Contemporary Art, Las Vegas
 (traveling)
1996 *Manuel Neri: Recent Drawings and Sculpture,* Lisa
 Kurts Gallery, Memphis
 Manuel Neri: A Sculptor's Drawings, Corcoran Gallery
 of Art, Washington, D.C. (traveling)
1997 *Manuel Neri: Early Work 1953–1978,* Corcoran Gallery
 of Art, Washington, D.C. (traveling)
 Manuel Neri: Recent Marble Sculpture, Corcoran
 Gallery of Art, Washington, D.C.
 Manuel Neri, San Marco Art Gallery, Dominican
 College, San Rafael, California
 Charles Cowles Gallery, New York
 Manuel Neri: Recent Works, Palo Alto Cultural Center,
 California
 Anne Reed Gallery, Ketchum, Idaho
1998 Galerie Simonne Stern, New Orleans
 Palm Springs Desert Museum, California
 Riva Yares Gallery, Scottsdale, Arizona
 Charles Cowles Gallery, New York
1999 Galerie Simonne Stern, New Orleans
 Campbell-Thiebaud Gallery, Laguna Beach, California
 Robischon Gallery, Denver
 Stremmel Gallery, Reno
2000 Campbell Thiebaud Gallery, San Francisco
 Anne Reed Gallery, Ketchum, Idaho
 Charles Cowles Gallery, New York
2001 Galerie Simonne Stern, New Orleans

Selected Group Exhibitions:

1987 *Hispanic Art in the United States: Thirty Contemporary
 Painters and Sculptors,* Museum of Fine Arts,
 Houston (traveling)
1990 *The Expressionist Surface: Contemporary Art in Plaster,*
 Queens Museum, New York

Collections:

Crocker Art Museum, Sacramento, California; Honolulu Academy of Arts; Mexican Museum, San Francisco; Oakland Museum, California; San Francisco Museum of Modern Art; Seattle Art Museum; Corcoran Gallery of Art, Washington, D.C.; Denver Art Museum; Hirshhorn Museum and Sculpture Garden, Washington, D.C.; Fresno Art Museum, California; Memphis Brooks Art Museum; National Museum of American Art, Smithsonian Institution, Washington, D.C.; Orange County Museum of Art, Newport Beach, California; Palm Springs Desert Museum, California; San Diego Museum of Art, California; San Jose Museum of Art, California; Tampa Museum of Art, Florida; Whitney Museum of American Art, New York.

Publications:

On NERI: Books—*Manuel Neri, Sculptor,* exhibition catalog, text by George Neubert, Oakland, California, Oakland Museum, 1976; *Manuel Neri: Drawings and Bronzes,* essay by Jan Butterfield, San Francisco, Western Association of Art Museums, 1981; *Manuel Neri: Sculpture and Drawings,* exhibition catalog, essay by Joanne Dickson, Seattle, Seattle Art Museum, 1981; *Manuel Neri,* exhibition catalog, text by Pierre Restany, San Francisco, Anne Kohs & Associates, and New York, John Berggruen Gallery, 1984; *Hispanic Art in the United States: Thirty Contemporary Painters and Sculptors,* exhibition catalog, by John Beardsley and Jane Livingston, New York, Abbeville Press, 1987; *Manuel Neri,* exhibition catalog, text by Thomas Albright, San Francisco, John Berggruen Gallery, 1988; *Manuel Neri: Plasters,* exhibition catalog, by Carolina A. Jones and others, San Francisco, San Francisco Museum of Modern Art, 1989; *She Said: I Tell You It Doesn't Hurt Me,* San Diego, California, Brighton Press, 1991, and *Territory,* San Diego, California, Brighton Press, 1993, both by Mary Julia Klimenko; *Manuel Neri: Sculpture, Painted and Unpainted,* exhibition catalog, text by Henry Geldzahler, Bridgehampton, New York, Dia Center for the Arts, 1993; *Manuel Neri: A Sculptor's Drawings,* exhibition catalog, text by Jack Cowart and Price Amerson, Washington, D.C., Corcoran Gallery of Art, 1994; *Working Together: Joan Brown and Manuel Neri, 1958–1964,* exhibition catalog, by Charles Strong, Whitney Chadwick and others, Belmont, California, Wiegand Gallery, College of Notre Dame, 1995; *Manuel Neri: Early Works, 1953–1978,* exhibition catalog, text by Jack Cowart, Price Amerson, John Beardsley, and others, Washington, D.C., Corcoran Gallery of Art, 1996; *Manuel Neri: Recent Marble Sculpture,* exhibition catalog, by Jack Cowart, Washington, D.C., Corcoran Gallery of Art, 1997. **Articles**—"Manuel Neri: A Kind of Time Warp," in *Current,* 1, April-May 1975, pp. 10–16, and "Manuel Neri's Survivors: Sculptor for the Age of Anxiety," in *Artnews,* 80, January 1981, pp. 54–59, both by Thomas Albright; "Ancient Auras–Expressionist Angst: Sculpture by Manuel Neri" by Jan Butterfield, in *Images and Issues,* spring 1981, pp. 38–43; "Manuel Neri: Cast from a Different Mold" by Hilton Kramer, in *New York Times,* 27 February 1981, p. C17; "A Sculptor Captive to Body Language of the Female Form" by Phyllis Tuchman, in *Newsday,* 16 February 1986, p. 15; "Innovations with the Figure: The Sculpture of Manuel Neri" by Mark Mennin, in *Arts Magazine,* 60, April 1986, pp. 76–77; "Manuel Neri" by Margarita Nieto, in *Latin American Art,* 1(2), fall 1989, pp. 52–56 (illustrated); interview by Meredith Tromble, in *Artweek,* 24, 8 April 1993, p. 20; "The Making of Manuel Neri" by Robert L. Pincus, in *Sculpture* (Washington, D.C.), 13, January/February 1994, pp. 34–37 (illustrated); "Manuel Neri: Early Works 1953–1978" by Sarah Tanguy, in *Sculpture* (Washington, D.C.), 16, May/June 1997, pp. 64–65.

* * *

During the 1950s and early 1960s, when the American art world was focusing on East Coast abstract expressionism and the advent of pop art, Manuel Neri established himself as a figurative sculptor. In fact, Neri is the only sculptor to have emerged from the critically acclaimed San Francisco Bay Area group of figurative artists that included Elmer Bischoff, Joan Brown, Richard Diebenkorn, and David Park. The Bay Area was an exciting place during the time Neri was developing his characteristic style. A student of Mark Rothko, Neri also taught painting, and Jerry Garcia was among his students. As an active participant in the Bay Area's cultural life, Neri arranged for Allen Ginsberg to perform his first full-length reading of his poem *Howl.*

Neri has sculpted in plaster, marble, and bronze. He has often treated whatever sculpting medium he is using as a surface upon which to paint. He has worked with marble as if it were as pliable as plaster and has not limited his forms to be confined to a compact chunk of material. Thus he has joined pieces of marble with reinforced steel and has continued sculpting. Characteristically Neri has left a thumbprint on clay, gouged marks into hard stone, and chiseled off smooth edges. Trained among painters whose brush strokes and choice of color was essential to the image, Neri has painted his sculptures, enriching the surface with vibrant colors. Like a painter, Neri believes that the artist's choice and application of color is an integral element of sculptural form. Neri also, however, has experimented with the absence of color and has focused on the plain white surfaces he can create out of plaster. He has manipulated the surface of a figure to enhance light and deepen shadows. Critic Roberta Carasso described Neri's work as "delicious poetry in the round."

Best known for his figurative sculpture, Neri has also created figurative works on paper and has painted on canvas. Female figures predominate in his work, but he also has worked with the male figure and some animals. Much of his sculpture clearly has been inspired by ancient sculpture. Resembling figurative relics found in ruins, Neri's human figures may lack limbs, or the suggestion of a figure may appear to emerge out of a stone block, as exemplified by *Odalisque II.* His *Ostrakon No. 2,* a small plaster female torso mounted on a wooden base, features a rough, textured, oblong convexity, painted red, on the side of the torso. Without the addition of color the viewer

would not be able to determine if the convexity represents erosion, as seen in ancient sculptures, or if it suggests a violent act. Because Neri painted the area red, the obvious suggestion is violence. Some critics have said that this technique suggests violence against women, but it is difficult to determine whether the visual effect evokes aggressive violence or the violence inherent in a creative act, such as giving birth.

Critic Mark Daniel Cohen, like many reviewers, appreciated the conceptual richness of Neri's art. "The subtlety of his method is the blending of the categories—many of the marks are indefinite and might be read as either signs of the making of the work or signatures of the ruination of time," Cohen wrote. "They become the same, past and future look alike and the work withdraws to a silence in which time stands still." Cohen likened Neri's sculpture to H.G. Wells's thoughts on ancient monuments. Cohen observed that Wells, in his *Outline of History,* "noted that ancient buildings, broken and bleached white by time, have an austere magnificence that could never have been theirs when they were new, whole, and gaudy. Stonehenge, the Parthenon, the remains in the Roman Fora seem more complete now than they could have [been] when they were complete. They seem to have taken on their true characters, become perfectly themselves with time. They loom in perpetual moonlight--harsh, serene, untouchable, formidable of form."

Neri's work, Cohen concluded, "like much of the best art, reminds us that the only timelessness is in the moment, that the now is the only eternity we will have as long as we are creatures on the earth, as long as we are natural. It lets us know that the past and the future are ideas, and all of life is in the present."

It is interesting to note that Neri has used the same model, Mary Julia Klimenko, who also has been his muse and collaborator, since 1972. She has read her poetry to Neri for most of the years that she has served as his model. At a master class held at Boston University in 1999, Neri asked Klimenko to read some of her poetry to the students while they worked on their sculptures. "I want to encourage more cross-pollination--music, poetry, and other kinds of writing, acting, dance," Neri explained. "There should be a give and take between disciplines. We should get to know other artists and expose ourselves to their work."

—Christine Miner Minderovic

NETO, Ernesto (Albequerque)

Brazilian sculptor

Born: Rio de Janeiro, 1964. **Education:** Escola de Artes Visuais Pargua Lage, Rio de Janeiro, 1994, 1997; Museu de Arte Moderna, Rio de Janeiro, 1994–96. **Family:** Married Lili Neto; one son. **Agent:** Tanya Bonakdar Gallery, 521 W. 21st Street, New York, New York 10011, U.S.A.

Individual Exhibitions:

1988 Petit Galerie, Rio de Janeiro
1989 FUNARTE, Rio de Janeiro
1990 Galeria Millan, São Paulo
1991 Galerie de Arte do IBEU, Rio de Janeiro
 Centro Cultural São Paulo
1992 Museu de Arte Moderna de São Paulo
1993 Desenhos, Espaço, Cultural Sergio Porto, Rio de Janeiro

Ernesto Neto: *Crossing over, over . . . over,* **2001. Photo courtesy of Tanya Bonakdar Gallery.**

1994 Galeria Camargo Vilaça, São Paulo
1996 Zolla/Lieberman Gallery, Chicago
 Elba Benitez Galeria, Madrid
 Paço Imperial, Rio de Janeiro
 Espacio 204, Caracas
 Christoper Grimes Gallery, Santa Monica
1997 Tanya Bonakdar Gallery, New York
 Galeria Pedro Oliveira, Porto
 Christopher Grimes Gallery, Los Angeles
 Galeria Camargo Vilaça, São Paulo
 Fundação Cultural do Distrito Federal, Brasilia
1998 Museo de Arte Contemporaneo Carrilo Gil, Mexico City
 Bonakdar Jancou Gallery, New York
1999 *Navedenga and the Ovaloids,* Bonakdar Jancou Gallery, New York
 Ernesto Neto 1998–1999: Naves, céus, sonhos, Galeria Camargo Vilaça, São Paulo
 Ernesto Neto: Nhó nhó nave, Contemporary Arts Museum, Houston
 Contemporary Arts Museum, Houston
 James Van Damme, Brussels
2000 Institute of Contemporary Art, London (traveled to Dundee Centre for Contemporary Arts, Scotland)
 SITE Santa Fe, New Mexico
 Wexner Center for the Arts, Columbus
 Galeria Elba Benitez, Madrid
 Dundee Contemporary Art, Scotland
2001 Art Gallery of New South Wales, Australia
 Matrix, University of California, Berkeley, Art Museum
 Centro Galego de Arte Contemporaneo, Santiago de Compostela
 Tanya Bonakdar Gallery, New York
 Laura Marciaj, Rio de Janeiro

Ernesto Neto: *Cosmovos,* **2001. Photo courtesy of Tanya Bonakdar Gallery, New York.**

Ernesto Neto: *É ó Bicho!,* **2001. Photo courtesy of Tanya Bonakdar Gallery, New York.**

Centro per Le Arti Contemporanee, Rome
Kolnisher Kunstverein, Cologne
Kiasma Museum of Contemporary Art, Helsinki
Espelho cego, Paco Imperial, Rio de Janeiro
Museu de Arte Moderna, Rio de Janeiro
2002 Centro per Le Arte Contemporanee, Roma
Hirshhorn Museum and Sculpture Garden, Washington, D.C.

Selected Group Exhibitions:

1991 *Brasil, la nueva generacion,* Fundação Museu Bella Artes de Caracas
1994 *Escultura carioca,* Paco Imperial, Rio de Janeiro
1995 *Entre o desenho e a escultura,* Museu de Arte Moderne de São Paulo
1996 *Sin fronteras/Arte latinoamericano actual,* Museo Alejandro Otero, Caracas
1997 *Esto es: Arte objeto e instalacion de piberoamerica,* Centro Cultural Arte Contemporaneo, Mexico City
1998 *Lygia Pape and Ernesto Neto,* Carrillo Gil Museum of Contemporary Art, Mexico City
 Amnesia, Track 16 Gallery and Christopher Grimes Gallery, Santa Monica (traveling)
2000 *Skin,* Cranbrook Art Museum, Bloomfield Hills, Michigan
 Wonderland, St. Louis Art Museum
2001 Guggenheim Museum, New York
 Space-Jack!, Yokohama Museum of Art, Yokahama, Japan
 Bodyspace, Baltimore Museum of Art
 Vantage Point, Irish Museum of Modern Art, Dublin
 Kunsthalle Basel, Basel

New South Wales Museum, Australia
New Art Gallery, Walsall
Montemedio Arte Contemporanea, Cadiz

Publications:

On NETO: Books—*Ernesto Neto 1998–1999: Naves, céus, sonhos,* exhibition catalog, São Paulo, Galeria Camargo Vilaça, 1999; *Ernesto Neto: Nhó nhó nave,* exhibition catalog, Houston, Contemporary Arts Museum, 2000; *Wonderland,* exhibition catalog, by Rochelle Steiner, St. Louis, St. Louis Art Museum, 2000; *Ernesto Neto,* exhibition catalog, London, ICA, 2000. **Articles**—"Ernesto Neto" by Carlos Basualdo, in *Artforum International,* 33, January 1995, p. 93; "Ernesto Neto at Zolla/Lieberman" by Sue Taylor, in *Art in America,* 84, December 1996, p. 108; "Ernesto Neto" by Adriano Pedrosa, in *Art/ Text* (Australia), 59, November 1997/January 1998, pp. 87–88; "Lygia Pape and Ernesto Neto" by Ana Isabel Perez, in *Art Nexus* (Colombia), February/April 1999, pp. 88–89; "Ernesto Neto" by Sylvie Fortin, in *Parachute,* 94, April/June 1999, pp. 48–49; "Ernesto Neto" by Ruben Gallo, in *Flash Art,* 204, 1999; "Ernesto Neto: ICA, London," by Gilda Willimas, in *Art Monthly,* 238, July/August 2000, pp. 46–47; "Skin" by David D. J. Rau, in *New Art Examiner,* 27(7), April 2000, p. 55.

* * *

One's immediate impression of Ernesto Neto's sculpture and installations is often primarily sensual—they are rather voluptuous and give the invitingly tactile impression of bodily tissue. As he said in a *Bomb Magazine* interview, "I don't want to make work that depicts a sensual body—I want it to *be* a body, exist as a body or as close to that as possible."

The series of works that perhaps most overtly focuses one's attention on sensuality are the *Ovaloids* Neto constructed in the late 1990s. Made of white Lycra and filled with tiny cream-colored Styrofoam pellets, they are about a meter high and invite the viewer's touch—and even penetration, as some of them have orifices into which one can insert a hand or arm.

At the same time that Neto began exhibiting the *Ovaloids,* he also made the *Naves* (''Ships''), such as *Navedenga* (1998). For this installation Neto stretched huge swaths of lycra from floor to ceiling, creating a kind of room within a room that visitors could walk into once they had removed their shoes. The effect of the interior was hushed, meditative—a feeling that was enhanced by the light coming in from a skylight and being diffused by the translucent lycra. ''When someone decides to get inside of a piece, they have another level of experience through the atmosphere created by these unexpectedly organic bodies. I believe that as living human beings we have a particular body in time, a kind of island in a cultural-physical world with skin as the border or limit. I like to work at that limit. That is my master plan. At this border is the place of happiness, the field of events where the relationship between the individuality of men and their world occurs—physical, psychological and mental.''

Neto's words hinted that these sculptures and installations, while sensual, were not just sweetness and light. They also played with ideas of consuming and being consumed by a work of art—ideas that have been important in Neto's native Brazil since the 1920s, when the idea of ''anthropophagy,'' or cultural cannibalism, gained currency as a metaphor for the experience of people whose indigenous culture was wiped out by sixteenth-century invaders. Neto's work shared these overtones with those found in the work of two of the most important artists to come out of Brazil in the 1960s, Hélio Oiticica and Lygia Clark. Like the *Naves,* Oiticica's *Penetrables* were meant to be entered without shoes and centrally featured the process of penetrating. And Neto's *M.E.D.I.T.* (1994), a series of photographs showing Neto's face being tightly—and somewhat demonically—wrapped in a piece of string, referred to Clark's 1973 *Cannibal Spit,* which excreted an expectorant substance. Neto's interest in sensualism and colonialism merged in 1997 pieces onomatopoeically titled *Piff, Paff,* and *Puff*—referring to silky, stocking-like materials filled with the savory spices of Latin America and Asia. Visitors to the gallery would smell the exhibition before they saw it and would encounter in the silk and spices an inherent, if somewhat gentle, critique of colonialism.

—Anne Byrd

NOÉ, Luis (Felipe)
Argentine painter

Born: Buenos Aires, 26 May 1933. **Education:** Studied art with Horacio Butler, Buenos Aires, 1950–52; studied law, University of Buenos Aires, 1951–1955. **Career:** Journalist, *El Mundo,* Buenos Aires, 1955–61; taught art, 1970–75; art critic. Cofounder, with Ernesto Deira, *q.v.,* Jorge Luis de la Vega, *q.v.,* and Rómulo Macció, *q.v.,* and member, artist group *Otra Figuración,*1961–66. **Awards:** Scholarship, French government, 1961; Palanza prize, 1962; national prize, Instituto Torcuato Di Tella, Buenos Aires, 1963; fellowship, Guggenheim Memorial Foundation, 1965, 1966; honorable mention,

Biennial of Engraving, Tokyo, 1968; diploma of merit, painting, Fundación Konex, Argentina,1982; artistic trajectory prize, Argentine Association of Art Critics, 1985; Fortabat prize, 1986; diploma of merit, painting, Fundación Konex, Argentina, 1992; diploma of honor, art theory, Fundación Konex, Argentina, 1994; Arlequín de Oro prize, Pettoruti Foundation, 1996, Chandon prize, Fondo Nacional de las Artes, Buenos Aires, 1997.

Individual Exhibitions:

1959 Galería Witcomb, Buenos Aires
1965 Museo de Arte Moderno, Buenos Aires
1966 Galería Bonino, New York
1969 *Saldos: Liquidación por cambio de ramo,* Galería Carmen Waugh, Buenos Aires
 Instituto de Arte Latinoamericano, Santiago, Chile
1975 *La naturaleza y los mitos* and *Conquista y destrucción de la naturaleza,* Galería Carmen Waugh, Buenos Aires
1985 Galería Ruth Benzácar, Buenos Aires
1987 Museo de Artes Plásticas Eduardo Sívori, Buenos Aires (retrospective)
 Galería Ruth Benzácar, Buenos Aires
1988 Arte Actual, Santiago, Chile
 Gooijer Fine Arts, Amsterdam
1989 Museo de Arte Moderno, Bogotá, Colombia
 Galería Ruth Benzácar, Buenos Aires
 ARCO, Madrid
 Galería Camino Brent, Lima, Perú
1990 Galería David Pérez Mac-Collum, Guayaquil, Ecuador
1991 Centro Cultural Recoleta, Buenos Aires
1995 Museo de Bellas Artes, Buenos Aires (retrospective)
1996 *Pinturas 1960–95,* Museo del Palacio de Bellas Artes, Mexico City
1998 Centro Cultural Borges, Buenos Aires
1999 Galería Rubbers, Buenos Aires
2000 Fondo Nacional de las Artes, Buenos Aires

Selected Group Exhibitions:

1960–61 *Catorce pintores de la nueva generación,* Galería Lirolay, Buenos Aires
1963 Museo Nacional de Bellas Artes, Montevideo, Uruguay
 Otra figuración, Museo Nacional de Bellas Artes, Buenos Aires
1965 *Otra figuración,* Museu de Arte Moderna, Río de Janeiro
1967 Riverside Museum, New York
1986 *Argentine 18th International Biennial,* São Paulo, Brazil
1993 *Latin American Artists of the Twentieth Century,* Museum of Modern Art, New New York
1997 *Re-Aligning Vision: Alternative Currents in South American Drawing,* Huntington Art Gallery, University of Texas, Austin (traveling)
1999 Bryggens Museum, Norway

Luis Noé: *La Ultima Ola,* **1985. Photo courtesy of dpm Arte Cotemporaneo, Guayaquil, Ecuador.**

2001 *Colecciones de artistas,* Fundación Proa, Buenos Aires

Collections:

Solomon Guggenheim Museum, New York; Metropolitan Museum, New York; Nancy Sayies Day Collection, Rhode Island School of Design; Archer Huntington Art Gallery, University of Texas, Austin; Museums of Fine Art of Buenos Aires, Caracas, Venezuela, Managua, Nicaragua, Santa Fe, New Mexico, San Juan, Puerto Rico, and General Roca, Argentina; Museums of Modern Art of Buenos Aires, Río de Janeiro, Bogotá, and Cuenca, Ecuador; Museums of Contemporary Art of Asunción, Paraguay, and Buenos Aires; Salvador Allende, Santiago, Chile; Center of Contemporary Art Chateau Carreras, Córdoba, Argentina.

Publications:

By NOÉ: Books—*Antiestética,* Buenos Aires, Ediciones Van Riel, 1965; *Una sociedad colonial avanzada,* Buenos Aires, Ediciones de

la Flor, 1971; *Códice rompecabezas sobre Recontrapoder en Cajón Desastre,* Buenos Aires, Ediciones de la Flor, 1974; *Oriente por Occidente,* Bogotá Dos Gráfico, 1992; *El Otro, la Otra y la Otredad,* Buenos Aires, IMPSAT, 1994.

On NOÉ: Books—*Catorce pintores de la nueva generación,* exhibition catalog, Buenos Aires, Galería Lirolay, 1961; *Luis Felipe Noé: Paintings,* exhibition catalog, New York, Galería Bonino, 1966; *Environments/Permutations,* exhibition catalog, New York, Riverside Museum, 1967; *Noé: Liquidación por cambio de ramo: Saldos,* exhibition catalog, Buenos Aires, Galería Carmen Waugh, 1968; *El arte de América Latina es la revolución* by Rojas Mix, part of the series *Cuadernos de arte latinoamericano,* Santiago, Chile, Editorial Andrés Bello, 1973; *Argentine New Figuration,* exhibition catalog, text by Jorge Glusberg, Buenos Aires, Argentine Association of Art Critics, 1986; *Noé: El color y las artes plásticas,* Buenos Aires, 1988; *Luis Felipe Noé: Pinturas 1960–95,* exhibition catalog, Mexico City, Instituto Nacional de Bellas Artes, 1996; *Re-Aligning Vision: Alternative Currents in South American Drawing,* exhibition catalog, by Mari Carmen Ramírez, Austin, Archer M. Huntington Art Gallery, University of Texas, 1997; *Noé: Mirada a los '90,* exhibition catalog, by Guillermo Whitelow, Buenos Aires, Fondo Nacional de las Artes, 2000; *Colecciones de artistas,* exhibition catalog, Buenos Aires, Fundación Proa, 2001. **Articles**—"Luis Felipe Noé: National Museum of Fine Arts" by Alberto Collazo, exhibition review, in *Art Nexus* (Colombia), 19, January/March 1996, p. 108; "Luis Felipe Noé: Centro Cultural Borges" by Alberto Collazo, exhibition review, in *Art Nexus* (Colombia), 29, August/October 1998, p. 116; "Buenos Aires: Luis F. Noé at Centro Cultural Borges and Galeria Rubbers" by Laura Buccellato and Eduardo Costa, exhibition review, in *Art in America,* 87(3), March 1999, p. 126–127.

* * *

Luis Felipe Noé's work has undergone various changes but has always maintained a close relation with figurative art, which, added to the concept of chaos, has led him to create a very particular and irreplaceable pictorial philosophy. During his presentation at the Van Riel Gallery (November 1960), Noé said, "my painting is centered around connections." Connections are opposed to chaos, as much as movement is opposed to stillness. Therefore, what kind of connections are these to which Noé refers? They are the connections with that that is confronted, not the connections with what is similar.

Noé's career as an artist began in the late 1950s and early '60s, during the somewhat libertarian atmosphere caused by the informalist movement, from which he took the use of matter and strokes. In *Serie Federal* (1961) —in which he refers to a specific period in Argentine history but without the intention of creating a historical record—Noé used oils and asphaltic paint made for industrial use, which generate abundant, almost liquid matter, to obtain shiny surfaces. Practically the only reference to constructive formalism is the use of black and red as contrasting colors. Here the viewer can already detect the importance given to matter as well as its corpus and direction, random strokes, and importance given to the figurative theme (*La anarquía del año 20, Convocatoria a la barbarie*), characteristics that Noé has used during his career with increasing emphasis.

Between 1961 and 1966 Noé, a member of the group known as Otra Figuración (other members include Rómulo Macció, Ernesto Deira, and Jorge de la Vega), introduced the idea of "divided painting," which broke the traditional idea of a unified canvas not only in the sense of its composition, but also in the identification of its images. This concept is consistent with the development of his idea of chaos in his painting. He does away with the sense of unity in his paintings and causes a strong play on surface tension that goes beyond the traditional format and foreground without abandoning it (*Mambo, Introducción a la Esperanza, Así es la vida, Señorita, Vernissage*) or abandoning it altogether (*Introducción al desmadre*). Noé's divided canvas is a separation-confrontation between two expressive needs, in which it is not structures that oppose each other, but different costumes of the same creative impulse. The artist calls it "cracked vision," and such works present diverse levels of analysis: the simultaneous, the emerging, the expelled, the taking of possession from the inside, the pictorial display, accumulation, and recurrence.

In 1966 Noé abandoned painting yet continued to meditate on it by writing two books (*Una sociedad colonial avanzada* ["A Very Advanced Colonial Society"] and *Códice rompecabezas sobre recontrapoder en cajón desastre* ["Jigsaw Codix on Ultimate Power in Disaster Box"]) and a self interview "De por qué Luis Felipe Noé no es más pintor y sin embargo hace una exposición de pintura" ("On Why Luis Felipe Noé Is No Longer a Painter, and Yet Holds a Painting Exhibition"). In 1969 he exhibited for the last time during his non-painting period, displaying *Noé. Liquidación por Cambio de Ramo. Saldos* in Carmen Waugh´s art gallery. He took up painting again in 1975, creating the series "*La naturaleza*" and "*Mitos y conquistas y destrucción de la naturaleza,*" which he exhibited in the same gallery. His theme is related to America and the Aborigines, with a mythical sense of paradise lost, after his trip to the Amazons in 1979. Explaining his interest in writing, Noé has said: "When I think about the world—that abstraction with concrete elements—I paint; when I think about painting, I write. These are two ways of thinking about painting."

Noé has always painted with a sense of discovery and inquiry, pushing the limits a little further. No immensity is enough; matter and color are set free and expand continuously. The origin, nature's forces, the mythical reason, all human aspects in relation to the universe—of which the biggest detail is infinite—maintains the validity of his painting and the significance of his work.

—Horacio Safons

NÚÑEZ (del PRADO), Marina
Bolivian sculptor

Born: La Paz, 17 October 1910. **Eduation:** Escuela Nacional de Bellas Artes, La Paz, 1927–29. **Family:** Married Jorge Falcon. **Career:** Professor of art anatomy and sculpture, Escuela Nacional de Bellas Artes, La Paz, 1930–38. Traveled through South America, the United States, Europe, and Egypt, 1938–40. Worked in the United States, 1940–48; returned to Bolivia, 1948; moved to Peru, 1972. **Awards:** Gold medal, best exhibition of the year, La Paz, 1930; gold medal, first prize foreign artist, Buenos Aires, 1936; gold medal, International Exhibition in Berlin, 1938; first prize sculpture, Annual Hall of the National Association of Women Artists of New York, 1946; first prize sculpture, *I bienal hispanoamericana de arte,*

Madrid, 1951; Condor de los Andes, La Paz, 1954; grand prize–sculpture III, National Hall of Bolivian Art, 1960; Orden de San Carlos medal, Colombia, 1961; medal of merit, Ministry of Culture, Bolivia, 1967; International grand prize sculpture, *Bienal interamericana de Mexico,* 1969; Pedro Domingo Murillo medal, La Paz, 1975; Gran Premio Pedro Domingo Murillo for lifetime achievement, Bolivia, 1983; gold medal, Manuel Vicente Bolivian foundation, 1985; medal of merit, Junta del Acuerdo de Cartagena, Lima, 1988; Premio Extraordinario de Cultura, La Paz, 1990. Honorary degree: Universidad Mayor de San Andres, La Paz, 1972. Great cross of the order "El Sol del Peru y Medalla Civica de la Ciudad," Lima, 1986; conferred Coat of Arms of the City of La Paz, Mayoralty of La Paz, 1993; conferred "Bandera de oro," 1993. **Died:** 9 September 1995.

Selected Exhibitions:

1930 Club de La Paz
1934 Salón de Arte Cuzeo, Peru
 Salón del Club Militar, La Paz
1936 Galería Witcomb, Buenos Aires
 Museo de Bellas Artes, Buenos Aires
1937 Galería Müller, Buenos Aires
 Amigos del Arte, Montevideo, Uruguay
 Galería de Arte, Rosario, Argentina
 Depiel Gore, Galería de Arte, Tucumán, Argentina
1938 Ministerio de Relaciones Exteriores, La Paz
 Salón Oficial, Santiago, Chile
1941 Grand Central Art Gallery, New York
 Art Cincinnati, Ohio
 Pan American Union, Washington, D.C.
 University of Tennessee, Chattanooga
 Art Gallery of Sweet Briar College, Virginia
 Newark Museum of Art, Norfolk, Virginia
1942 Art Center Association, Louisville, Kentucky
 University of Minnesota, Minneapolis
 Minneapolis Institute of Art
 San Francisco Museum of Art
 Joslyn Memorial, Omaha, Nebraska
 Rollings College, Winter Park, Florida
 National Museum, Washington, D.C.
 Sculptors Guild, New York
1943 Hackley Gallery of Art, Muskegon, Michigan
 Art Institute of Zenesville, Ohio
 Brooks Memorial Art Gallery, Memphis
 University of Delaware, Newark
 Society of Four Arts, Palm Beach, Florida
1945 Associated American Artists Galleries, New York
1946 National Association of Women Artists, New York
1947 Whitney Museum, New York
 Toledo Museum, Ohio
1949 Ministerio de Relaciones Exteriores, La Paz
 Universidad de San Javier, Sucre, Bolivia
 Prefectura de Potosí, Bolivia
 Universidad Técnica de Oruro, Bolivia
 Congreso Indigenista, Cuzco, Peru
1950 Club Social de Cochabamba, Bolivia
 Ministerio de Relaciones Exteriores, La Paz
 Asociación de Artistas, Lima, Peru
1951 Museo de Arte Moderno, São Paulo, Brazil
 Museo Nacional de Bellas Artes, Rio de Janeiro

Publications:

By NÚÑEZ: Books—*Color y piedra,* Lima, Ediciones Sol, 1950; *Eternidad en los Andes: Memorias,* n.p., A. Flaño, 1973.

On NÚÑEZ: Books—*Eternidad en los Andes: Memorias de Marina Núñez del Prado,* edited by Lord Cochrane, Santiago, 1973; *Jardín de esculturas de Marina Núñez del Prado* by Barbara Duncan, Lima, Libería Editorial "Minerva" Miraflores, 1989; *Casa Museo Núñez del Prado,* La Paz, Fundación Núñez del Prado, 1993; *Marina Núñez,* Salamanca, Spain, Ediciones Universidad de Salamanca, 1997.

* * *

Bolivian sculptor Marina Núñez del Prado used black granite, alabaster, basalt, and white onyx as well as Bolivian wood to create rolling, curving pieces that were influenced by Indian art. Born in 1910, Núñez del Prado at a young age showed promise in art and studied at the Fine Arts Academy in La Paz. Following her graduation she taught classes at the academy, and eventually she went on to become the first woman to be chair of sculpture and artistic anatomy. Later she traveled throughout Bolivia, Peru, Argentina, the United States, and Europe, exhibiting her works to great acclaim.

Her most famous piece is called *White Venus* (1960), a piece made of white onyx, which honors the female body. Another piece that focuses on women is called *Mother and Child.* This piece is also made of white onyx. She won a gold medal in New York for her work called *Miners Revolt,* which is about the miners' revolt in Bolivia's Potosí area. In the 1970s she relocated to Peru, where she lived with her husband, a Peruvian writer. Beloved by her fellow Bolivians, Núñez del Prado showed her love of her country in her work, in her heavy, earthy pieces. She died in 1995.

—Sally Cobau

OBREGÓN, Alejandro
Colombian painter

Born: Barcelona, Spain, 4 June 1920; moved to Columbia. **Education:** Stonyhurst College, England; Middlesex School, Concord, Massachusetts; Museum of Fine Arts, Boston, 1937–41. Also studied in Spain and France. **Family:** Four children. **Career:** Lived in France, 1949–54. Director, Movimento Nacional de Artes, Bogotá, 1955, Barranquilla, Colombia, 1956–57. **Awards:** First prize, *Gulf-Caribbean Art,* Museum of Fine Arts, Houston, 1956; Guggenheim International prize, 1959; National Grand prize, Salón Nacional of Colombia, 1962; prize, São Paulo Biennial, 1967. **Died:** 1992.

Individual Exhibitions:

1955	Pan American Union, Washington, D.C.
1970	Center for Inter-American Relations, New York (retrospective)
1973	Museum of Modern Art, Bogotá
1979	Museo la Tertulia de Cali
1981	El Salón Cultural de Avianca, Barranquilla, Colombia La Galería Esede, Bogotá
1982	Metropolitan Museum, Coral Gables, Florida (retrospective)
1985	*Alejandro Obregón: Pintor colombiano,* Museo Nacional de Bogotá and Maison de l'Amérique Latine, Paris
1986	Museum of Modern Art, Bogotá
1987	Garcés Gallery Velásquez
1988	Aberbach Fine Art Gallery, New York
1989	Gallery Duke Vargas, Medellin
1990	Galería El Museo de Bogotá Museo de Monterrey, Mexico (traveling retrospective)

Selected Group Exhibitions:

1955	*Pittsburgh International,* Carnegie Institute
1956	*Gulf-Caribbean Art,* Museum of Fine Arts, Houston
1959	*South American Art Today,* Dallas Museum of Fine Arts
1961	*Latin America: New Departures,* Institute of Contemporary Art, Boston
1966	University of Miami
1965	*The Emergent Decade,* Solomon R. Guggenheim Museum, New York, and Cornell University, Ithaca, New York
1966	*Art of Latin America since Independence,* Yale University, New Haven, Connecticut, and University of Texas, Austin

Collections:

Dallas Museum of Fine Arts; Solomon R. Guggenheim Museum, New York; Museum of Modern Art, New York; Museum of Modern Art of Latin America, Washington, D.C.; Museo Nacional, Bogotá; Institute de Arte Contemporaneo, Lima; Museo de Arte Moderno, Bogotá; Museo Nacional, La Paz, Bolivia; Galerie Creuze, Paris; Galerie Buchholz, Munich; Vatican Museum, Rome; Galeria Profili, Milan; Institute Cultura Hispanica, Madrid.

Publications:

On OBREGÓN: Books—*Obregón* by J.G. Cobo Borda, Bogotá, Editorial La Rosa, 1985; *Alejandro Obregón–A la visconversa!: Conversaciones junto al mar* by Fausto Panello, Bogotá, Ediciones Gamma, 1989; *Alejandro Obregón: Cinco decadas,* exhibition catalog, Bogotá, Museo de Arte Moderno, 1990; *Alejandro Obregón: Colombian Painter and Innovator* by Eileen Patricia McKiernan González, Norton, Massachusetts, Wheaton College, 1992; *Las mujeres de Obregón* by Camándula, Bogotá, Elektra, 1993; *Obregón: Fue siempre un genio?* by Pedro Obregón, Bogotá, Grijalbo, 1994.

* * *

Alejandro Obregón almost single-handedly modernized Colombian painting in the 1950s. Obregón was raised in the seaport of Barranquilla, on the Caribbean coast of Colombia—this tropical environment would always be reflected in his best paintings. Obregón studied painting at the Boston School of Fine Arts with the American expressionist painter Karl Zerbe from 1937 to 1941. Later, while pursuing his art studies independently in Alba, France (1949–54), he met and was influenced by the work of both Antoni Clavé and Graham Sutherland. His mature visual vocabulary was evident by the mid- to late 1950s. His stylistic traits included exuberant color, emphasis on the horizontal in his compositions, structurally articulated yet fragmented forms, and a painterly handling of both glazing and scumbling. All throughout his work Obregón drew on the fauna, flora, and landscape of Colombia.

Obregón's tragic reflections on the wave of violence that overtook his country in the late 1940s and early 1950s were evident in paintings such as *Desenso de la cruz* (1952), *El velorio* (1956), and *Velorio para un estudiante muerto* (1958). Perhaps Obregón's most seminal painting was the 1962 oil *Violencia: Detalle de un genocidio.* This work depicts a pregnant woman who has been brutally murdered. Her body dissolves into the earth below, while above it a blinding, whitish yellow covers the rest of the canvas. The body, a tonal variation of yellow ochre, white, brown, and touches of red, is painted with a bravura brushwork bringing to mind the painterly virulence of abstract expressionism. Obregón transformed the dead woman's body into the horizon line of the composition, through the formal eliminating the anecdotal aspect of the subject.

Obregón's work can be thematically divided according to geography: his condors, volcanoes, and bulls belong to a vast and arid Andean environment, while his iguanas, jungle flowers, and barracudas inhabit the Caribbean coast. In the late 1960s Obregón started working with acrylic, and this medium, together with market pressures for greater production, affected his painting negatively. His work became flat and repetitive with some exceptions (for example, *Homenaje al Che Guevara,* 1968). In the1980s he recovered some of the painterly vigor of his early work in a series of self-portraits.

Obregón's contribution rests in his revolutionary influence on Colombian painting of the 1950s and '60s: before Obregón Colombian painting was stalled in a nationalistic version of academicism. He affected this change with a visual vocabulary that synthesized a post-cubist structure with an intense and expressionistic palette at the service of a Colombian ethos.

—Alejandro Anreus

O'GORMAN, Juan
Mexican painter, muralist, and architect

Born: Mexico City, 6 July 1905. **Education:** Universidad Nacional Autonoma de Mexico, graduated 1927; apprentice to Carlos Obregón Santacilia, 1927. **Family:** Married Helen Fowler in 1941. **Career:** Architect, firm of José Villagrán García, Carlos Tarditi, and Carlos Contreros, Mexico City, 1927–29; chief draftsman, office of Carlos Obregón Santacilia, 1929–32; chief architect, Mexico City Department of Building Construction, Ministry of Public Instruction, 1932–34; private practice, Mexico City, 1934–82. Painted frescoes, Mexico City Airport, 1937–38. Cofounder, School of Architecture, 1932, and professor of architecture and architectural composition, 1932–48, National Polytechnic Institute, Mexico City. Founder, Workers' Housing Study Group, Mexico City, 1936. **Died:** 18 January 1982.

Works:

1929–30 Juan O'Gorman House I, Mexico City
1931 Diego Rivera House and Studio, San Angel
 Tomás O'Gorman House, Mexico City
1932–34 Technical School, Mexico City
 28 primary schools throughout Mexico
1934 Castellaños House, Mexico City
1936 Electricians' Union Building, Mexico City
1944–45 Museo Anahuacalli, Mexico (as consultant; with Diego Rivera)
1949 O'Gorman's personal residence, San Angel
1951–53 National Library, State University of Mexico, Mexico City
1953–56 Juan O'Gorman House II, Mexico City

Publications:

By O'GORMAN: Book—*El arte util y el arte artistico,* Mexico City, 1932.

On O'GORMAN: Books—*Mexico's Modern Architecture* by I.E. Myers, New York, 1952; *Juan O'Gorman: February 12 through April 3, 1964,* exhibition catalog, Los Angeles, San Fernando Valley

Juan O'Gorman: *The March of Loyalty (La marcha de la lealdad),* **detail of mural. © Schalkwijk/Art Resource, NY.**

State College, 1964; *Builders in the Sun: Five Mexican Architects* by Clive Bamford Smith, New York, 1967; *Autobiografia, antologia, juicios criticos y documentation exhuastiva sobre su obra* by Antonio Luna Arroyo, Mexico City, Cuadernos Populares de Pintura Mexicana Moderna, 1973; *Juan O'Gorman: Arquitecto y pintor* by Ida Rodríguez Prampolini, Mexico City, Universidad Nacional Autónoma de Mexico, 1982; *La palabra de Juan O'Gorman: Selección de textos,* Mexico, UNAM, 1983; *Sobre la encáustica y el fresco,* Mexico City, Colegio Nacional, 1987; *O'Gorman,* Mexico City, Bital Grupo Financiero, *ca.* 1999. **Articles**—''Juan O'Gorman'' by Mathias Goeritz, in *Arquitectura* (Mexico City), December 1960; ''The Death of Juan O'Gorman'' by Esther McCoy, in *Arts and Architecture,* August 1982.

* * *

Juan O'Gorman was native to Mexico, although his father was Irish and his Mexican mother was of Irish descent. He did not begin to paint until 1935, working first as an avant-garde architect for nearly a decade. He studied architecture at the Universidad Nacional Autonoma de Mexico, graduating in 1927. Early in his career he adhered to the functional theories of the French architect Le Corbusier. By the late 1930s, however, O'Gorman abandoned this functionalist approach in favor of a more organic one, very much under the influence of Frank Lloyd Wright. His best-known buildings are the home-studio for Diego Rivera in San Angel (1931); his own mosaic-covered home, also in San Angel (1949, destroyed 1969); and, at the Universidad

Juan O'Gorman: *Panel of the Independence-Hidalgo,* **left detail of mural.** © Schalkwijk/Art Resource, NY.

Nacional Autonoma de Mexico, the library (1951), whose mosaic-covered facade resembles a pre-Columbian codex. Throughout the early 1930s, when O'Gorman was appointed chief architect to the Secretaria de Educación Publica, he renovated 33 public schools and built another 20 using a simple modular design.

Shortly after graduating college, O'Gorman joined the Mexican Communist party, and his art, from his early functionalist architectural projects to his later satirical and anticlerical easel paintings and murals, always reflected his Marxist politics. By the late 1940s O'Gorman adopted a more critical and distant approach to the Communist party while remaining a Marxist.

As a painter O'Gorman was influenced by the work of fellow Mexicans Antonio Ruíz, Diego Rivera, and Frida Kahlo, as well as the early Flemish masters. Stylistically his work consists of solid drawing and a bright palette. His compositions, whether easel or mural works, are layered and complex yet organized with clarity for the legibility of the viewer. Textual references throughout his work are frequent, with the artist reproducing manuscripts as well as his own texts. All of O'Gorman's work was painted with a minute attention to detail, which endows his paintings with an almost hallucinatory quality. O'Gorman's preferred mediums were fresco for murals and egg tempera for easel works. His favored subjects were landscapes, historical and allegorical themes, and portraits. His fantastic landscapes are more flowing than the rest of his work, which at times seems a bit rigid, yet these are also filled with an obsessive amount of detail.

O'Gorman's most significant murals are *Historia de la aviación* (1938), *Historia de Michoacán* (1942), and *El altar de la independencia* (1959–61). Among his most significant easel paintings, the urban landscape *La ciudad de México* (1942) stands out for its fusion of an objective depiction of the growing metropolis, fantastic allegorical elements, a homage to the working class in the figure of an Indian bricklayer, and a partial self-portrait of the artist's hands in the

foreground holding a map of the city. O'Gorman's *Autorretrato* (1950) depicts the artist five times: as subject, model, architect, painter, and right hand holding a brush. The painstaking detail of this work brings to mind the paintings of Van Eyck, Memling, and other Flemish masters much admired by O'Gorman.

O'Gorman's greatest achievement as a painter lies in his continuation of the tradition of clear narrative mural painting started by Rivera and his enhancement of that tradition with his own detail-obsessed sensibility.

—Alejandro Anreus

O'HIGGINS, Pablo
Mexican painter and muralist

Born: Salt Lake City, Utah, 1 March 1904; Mexican citizen 1961. **Education:** Studied painting, School of Fine Arts, San Diego, 1922. **Career:** Moved to Mexico, 1924. Mural assistant to Diego Rivera, *q.v.,* 1924–28; contributor, 1926, and member of editorial board, 1927, magazine *Mexican Folkways;* instructor on cultural missions, Ministry of Education, Mexico, 1928–29; contributor, *Daily Worker,* newspaper of the American Communist Party, 1931–32. Muralist, including murals at Abelardo Rodríguez Market, Mexico City, Ship Scalers Union Hall, Seattle, International Longshoreman's Union Hall, Honolulu, and Universidad Michoacana, Morelia, Mexico. Cofounder and member, *Liga de Escritores y Artistas Revolucionarios,* 1934–37, and Taller de Gráfica Popular, a printmaking workshop, 1937-*ca.* 1960; cofounder, art gallery Salón de la Plástica Mexicana, 1949. Member, Mexican Communist Party, late 1920s. **Awards:** Primer premio, Salón Anual de Grabado, 1958; premio nacional de arte Elías Sourasky, 1970. **Died:** 16 July 1983.

Selected Exhibitions:

1962 *Congreso latinoamericano de artes gráficas,* Cuba
1976 *Pablo O'Higgins, cincuenta años de labor artística,*
 Museo Diego Rivera (retrospective)
1985 Instituto Nacional de Bellas Artes, Museo del Palacio de
 Bellas Artes, Mexico
1987 Mexican Fine Arts Museum, Chicago
1995 *Pablo O'Higgins: Un compromiso plástico,* Museo
 Dolores Olmedo Patiño, Xochimilco, Mexico
1997 *Pablo O'Higgins: 20 apuntes,* Plaza Ley Dorian, Baja
 *Pablo O'Higgins: Man of the Twentieth Century, A
 Print Retrospective,* Godwin Ternbach Museum,
 Queens College, New York
 Instituto de Artes Gráficas de Oaxaca, Mexico
1998 Instituto de Bellas Artes, Mexico City
 Mexico, delirios e ilusiones, Stanford University,
 Stanford, California
1999 *Three Generations of Mexican Masters,* Mexican
 Cultural Institute, Washington, D.C.

Publications:

By O'HIGGINS: Books—*Veinte apuntes,* with Diego Rivera, Mexico, Talleres de Impresora Santo Domingo, 1971; *Pablo O'Higgins,*

421

exposición, Monterrey, Mexico, Gobierno del Etado de Nuevo León, 1975.

On O'HIGGINS: Books—*Pablo O'Higgins,* exhibition catalog, by Elena Poniatowska and Gilberto Bosques, Mexico, Fondo Editorial de la Plástica Mexicana, 1984; *Un compañero de Diego: Pablo O'Higgins,* Mexico, Museo Estudio Diego Rivera, 1987; *Pablo O'Higgins: Hombre de siglo XX* by Gonzalo Celorio and Teresa del Conde, Mexico, Difusión Cultural, 1992; *Pablo O'Higgins: Un compromiso plástico,* exhibition catalog, Mexico, Museo Dolores Olmedo Patiño, 1995; *Pablo O'Higgins: Tetimonio del trabajo del pueblo,* exhibition catalog, Oaxaca, Mexico, Instituto de Artes Gráficas de Oaxaca, 1997; *Pablo O'Higgins: De estética y soberanía* by Francisco Reyes Palma, Mexico, Fundación Cultural María y Pablo O'Higgins, 1999. **Article**—"Border Crossings" by Aime Brandauer, in *Art in America,* July 1994.

* * *

Pablo O'Higgins was one of the most significant foreign-born artists of the Mexican mural movement and of Mexican political art in the twentieth century. Born in Salt Lake City as Paul O'Higgins, he moved with his family to San Diego, California, as a child. Encouraged in his interests in music, art, and literature, he studied the piano and at an early age discovered the work of Rembrandt. Through his contact with his Mexican-American neighbors, he learned to appreciate Mexican culture. In 1922 O'Higgins gave up his musical studies for visual art, and he established a studio in San Diego with Kenneth Slaughter and Miguel Foncerrada. In 1924 O'Higgins traveled to Guaymas, Mexico, where he wrote to muralist Diego Rivera, who promptly invited him to Mexico City. Almost immediately after his arrival, O'Higgins became one of Rivera's assistants. Rivera taught him the fundamentals of fresco painting and welcomed him into the world of the Mexican cultural renaissance. Between 1924 and 1928 O'Higgins worked with Rivera on the murals at the Ministry of Education and the National Agricultural School in Chapingo.

In 1926 O'Higgins began to contribute prints to the magazine *Mexican Folkways,* which was directed by Frances Toor, and in 1927 became a member of its editorial board. In 1930 O'Higgins, Toor, and French artist Jean Charlot wrote and published *Monografía, las obras de José Guadalupe Posada, grabador mexicano,* the first collection of Posada's largely forgotten prints. In 1928–29 O'Higgins participated in the cultural missions of the Ministry of Education, traveling with a team of educators to train rural schoolteachers. He taught drawing and painting, designed open-air theaters, and painted a mural on the walls of a community center in La Parilla, Durango.

In 1931 O'Higgins, with writer Juan de la Cabada and artist Leopoldo Méndez, started the organization Liga Intelectual Proletaria (LIP; Intellectual Proletarian League), a short-lived radical group whose purpose was to unite intellectuals, artists, and workers. He began an enduring association with Méndez, and they collaborated on numerous political and artistic projects from the 1930s to the '60s. In 1931–32 O'Higgins, who had joined the Mexican Communist Party in the late 1920s, produced illustrations for the *Daily Worker,* the newspaper of the American Communist Party. He was invited to Moscow as a guest of the Moscow Academy of Art, but disagreements over the Soviet adherence to socialist realism led him to leave the academy and work independently. During his stay in Moscow O'Higgins spent much time with the exiled photographer Tina Modotti.

In 1934 O'Higgins, with Méndez, David Alfaro Siqueiros, Luis Arenal, and others, formed the Liga de Escritores y Artistas Revolucionarios (LEAR; League of Revolutionary Writers and Artists). The organization, which grew to include more than 500 writers, artists, musicians, and actors, produced the periodical *Frente a frente* and sponsored a number of mural projects. With the help of Rivera, O'Higgins secured a commission for a group of LEAR artists to decorate the walls of the Abelardo Rodríguez Market in Mexico City. Located in a working-class neighborhood, the paintings and Isamu Noguchi's wall relief were the first truly accessible large-scale murals in post-Revolutionary Mexico. O'Higgins's work depicts the production of food, its nutritional qualities, and the oppression of agricultural workers, as well as the harmful effects of capitalism and fascism in Mexico.

In 1937, when LEAR dissolved because of political infighting, O'Higgins, Méndez, and Arenal started the Taller de Gráfica Popular (TGP; Popular Graphic Arts Workshop) as a continuation of the Plastic Arts Division of LEAR. They conceived of the workshop as a collective endeavor and produced prints collaboratively for a variety of political events and activities. From the late 1930s to 1945 much of their work was strongly antifascist. O'Higgins created several powerful prints for a series of posters advertising anti-Nazi lectures in 1938. His *Franco* (1938) depicts the Mexican followers of Spanish dictator Francisco Franco as vultures engaging in black-market speculation. In 1943 he created images for the book *El libro negro del terror Nazi* ("The Black Book of Nazi Terror"), a document produced by the German community in exile in Mexico City. In *Jude* ("Jew") he portrayed the persecution of Jews in Europe. His 1939 lithograph *Hombre del siglo XX* ("Man of the XX Century"), a depiction of a solitary man in rags, is a profound evocation of poverty and alienation. In the late 1940s O'Higgins was invited by the Ship Scalers Union in Seattle to create a mural for their union hall, and in 1952 he painted a mural on union solidarity in Honolulu, Hawaii, for the International Longshoreman's Union.

O'Higgins produced easel paintings and prints, mainly lithographs, throughout his career. Like his murals these works often focus on Mexican workers, portraying farmers, bricklayers, and workers in factories, shipyards, and oil fields, with an emphasis on shared labor. His 1945 lithograph *Ladrillero y su hijo* ("Bricklayer and His Son"), for example, conveys a sense of unity and activity as it portrays a father and child working together. His painted and graphic images display his distinctive line, nervous and expressive, along with simple, semiabstract compositions. O'Higgins also painted and made prints of landscapes, especially the arid countryside with maguey cactuses—lyrical studies of twisted, dramatic forms. He participated in the joint portfolios of the TGP, creating historical images for its 1947 collection, *Estampas de la Revolución Mexicana* ("Prints of the Mexican Revolution"), and *calaveras* for the Days of the Dead in November of each year.

In 1949 O'Higgins helped organize the Salón de la Plástica Mexicana, a collaborative nonprofit art gallery founded to promote Mexican art. In 1958 he began to experiment in the use of ceramic material for a mural in Poza Rica, Veracruz. He created a fresco mural for the Universidad Michoacana in Morelia called *Tenochtitlán libre* (1960; "Free Tenochtitlan"), and in 1963 and 1964 he produced four fresco mural panels for the ethnography hall of the National Museum of Anthropology.

Around 1960 O'Higgins, along with a number of other members, left the TGP due to internal dissention. During the 1960s

O'Higgins, who became a Mexican citizen in 1961, traveled extensively, and while in the Soviet Union he offered a course on mural painting. In the 1970s he had several major exhibitions of his work in Mexico. He created a large number of easel paintings of Mexican workers, campesinos, and rural landscapes between 1970 and 1983. At the time of his death he was planning a mural for the Universidad de Colima, in the state of Colima. Efforts to promote his art resulted in the formation of a government-sponsored foundation, Fundación Cultural María y Pablo O'Higgins, in Coyoacán.

—Deborah Caplow

OITICICA, Hélio

Brazilian painter, sculptor, performance artist, and installation artist

Born: Rio de Janeiro, 26 July 1937. **Education:** Studied under painter Ivan Serpa, Museu de Arte Moderna, Rio de Janeiro, 1954. **Career:** Dancer, Magueira Samba School, Rio de Janeiro, 1963–65. Lived and worked in New York, 1970–80. Member, artist group *Frente,* Rio de Janeiro, 1955–59, and Neo-Concrete movement, Rio de Janeiro, 1959. **Died:** 1980.

Individual Exhibitions:

1964 *Environment of Nuclei and Bodies,* Galerie G4, Rio de Janeiro
1967 *Collective Parangole,* Aterro Park, Rio de Janeiro
1968 *Apocalipopotesis,* Aterro Park, Rio de Janeiro
1969 Whitechapel Art Gallery, London
1980 Galeria Chaves, Porto Alegre, Brazil

Selected Group Exhibitions:

1965 *Opinion 65,* Museu de Arte Moderna, Rio de Janeiro
1967 *Brazilian New Objectivity,* Rio de Janeiro
1970 *Information,* Museum of Modern Art, New York
1989 *Art in Latin America: The Modern Era: 1820–1980,* Hayward Gallery, London
1991 *Experiancia neoconcreta, Rio de Janeiro 59/60,* Museu de Arte Moderna, Rio de Janeiro

Publications:

By OITICICA: Book—*Carlos Vergara,* exhibition catalog, Rio de Janeiro, 1978. **Article**—"On the Discovery of Creleisure," in *Art and Artists* (London), April 1969.

On OITICICA: Books—*Projectos de Hélio Oiticica,* exhibition catalog, by Mario Pedrosa, Rio de Janeiro, 1960; *Kinetic Art* by Guy Brett, London, 1967; *A invenção de Hélio Oiticica* by Celso Favaretto, São Paulo, FAPESP, *ca.* 1992; *Cartas, 1964–1974* by Lygia Clark and others, Rio de Janeiro, Editora UFRJ, 1996; *Hélio Oiticica: Qual é o parangolé?* by Waly Salomão, Rio de Janeiro, Relume Dumará, 1996; *Resignifying Modernity: Clark, Oiticica and Categories of the Modern in Brazil* by Paula Terra Cabo, n.p., 1997. **Articles**—"Arte Moderna, Arte Pos-Moderna, Hélio Oiticica" by Mario Pedrosa, in *Correio da Marha* (Brazil), July 1966; "Oiticica Talks to Guy Brett,"

in *Studio International* (London), March 1969; "Hélio Oiticica's People" by Jacqueline Barnitz, in *Arts Magazine* (New York), September/October 1972; "Hélio Oiticica: Reverie and Revolt" by Guy Brett, in *Art in America,* 77, January 1989; "Homage" by Waly Salomão, and "Hélio Oiticica: Autonomy and the Limits of Subjectivity" by Sonia Salzstein, both in *Third Text,* 28/29, autumn/winter 1994; "Hélio Oiticica" by Carla Stellweg, in *Art Nexus,* 12, April/June 1994; "Hélio Oiticica: The Street in a Bottle" by Eduardo Costa, in *Flash Art,* 174, January/February 1994, pp. 75–77. **Films**—*Arte Publica* by Sirito, Rio de Janeiro, 1965; *Apocalipopotese* by Raimundo Amado and Leonardo Bartucci, Rio de Janeiro, 1968.

* * *

Hélio Oiticica's importance in the history of twentieth-century art is manifold. His exemplary work primarily in sculpture and painting and later in performance and installation was supported by his original ideas that engendered a new way of thinking of art within his native Brazil and abroad.

Along with Lygia Clarke, who with Oiticica was a key initiator of neo-concretism in Brazil, Oiticica also emerged as a crucial innovator in reconceptualizing the monochrome, the use of geometry in art, the function of art in relation to the larger social world, and the ontological status of the art object. The impetus of this reconfiguration focused on shifting away the experience of a work of art from an optical one to one that involved the body. This new experiential modality was culled from a variety of artistic and philosophical sources, though the most prominent influence on Oiticica's ideas was the phenomenological existentialism of Maurice Merleau-Ponty. Oiticica's concepts derived from these sources manifested in various works that he called *Bolides* ("Fireballs"), *Parangoles, Penetrables,* and *Ninhos* ("Nests"), to name just a few.

Oiticica's early artistic endeavors about 1959 exhibited the gestation of his future artistic legacy and were inspired by wanting to resolve problems confronted by painters and sculptors alike. Questions of space and the relationship of sculpture to its exhibition context were addressed by Oiticica, but paradoxically through the medium of painting. His *Monocromaticos* ("Monchromatics," 1959) consisted of planar geometric paintings that were dependent on the viewer for artistic closure via their idiosyncratic presentation. Strategic to the works' creative completion was their placement that exemplified the importance of the viewer. This brought attention to the notion that art is never divorced from the viewer or the larger social world that the viewer is a part. Such emphasis on the reciprocity of art and its consumption was a concern of the historical avant-garde in general, specifically in their desire to collapse art into life. Yet this impulse to dissolve art into the real world was already under way in Latin America with Oiticica's Brazilian and Argentine predecessors.

Oiticica, however, would take these ideas much further in literally taking his work into the streets as evinced in his *Parangoles* that were worn in public. To arrive at the direct intervention of art into the social world and vice versa, he first explored art and its convergence with the viewer by implicating him or her as crucial for the work's artistic resolution. After *Monocromaticos* Oiticica made works that attempted to merge art and life. *Relevo espacial* ("Spatial Relief," 1959) hangs from the ceiling and is a type of painting-in-the-round that strategically forces the viewer's interaction with it. The spatial referred to in the title is literally the space the work occupies, with the relief actually being polygonal planes painted in hot colors. His *Nucleo* ("Nucleus," 1960) series also hangs from the ceiling but

incorporates mirrors placed on the floor that expand the relationship between artwork and viewer into a room-size installation. This move to encompass architectural space implied that art could never separate itself from the viewer, and in turn the viewer would enrich the work because he or she would bring to it a variety of interpretations filtered through varied social, cultural, and individual histories. The artistic emphasis on the social and cultural dynamics of the viewer was even more pronounced in the *Bolides* (1964).

The *Bolides* oscillated from associations with the vernacular or quotidian materials that constituted them to what Oiticica had argued as another element of their ontology that he called ''trans-object.'' The trans-object as embodied in the *Bolides* implies a metaphysical dimension, yet the *Bolides* were made to be handled literally by the viewer. Making the term ''viewer'' obsolete by virtue of the work's physical engagement in real time, the *Bolides* became a trans-object. Although the *Bolides* are theoretically contingent on the viewer, and the *Ninhos* necessitate interaction by the public in that they serve as makeshift shelters in the exhibition context, it was the *Parangole* that dismantled the authorial voice of the artist and became the culmination of Oiticica's attempt to fuse art and life.

The *Parangole* took many forms, but resembled capes, shrouds, and banners. In being partially constructed by the persons who wore them, the viewers became ''participants'' as they were ''exhibited'' in the public sphere. Thus, according to Oiticica, the *Parangole* ''aspire[d] to an 'environmental art' par excellence, which may or may not arrive at a characteristic architecture.'' The *Parangole* ultimately eradicated the gulf between art and life and like Oiticica's work in general were characterized by innovation and a dense theoretical undercurrent. This was a major contribution to the history of recent international art and evinced the importance of Oiticica and assured his perpetual reassessment for generations to come.

—Raúl Zamudio

OLLER (Y CESTERO), Francisco

American painter

Born: Bayamón, Puerto Rico, 17 June 1833. **Education:** Real Academia de Bellas Artes de San Fernando, Madrid, 1851–53; Ecole Impériale et Spéciale de Dessin and Académie Suisse, 1858–63. **Family:** Married; two daughters. **Career:** Traveled to Spain, 1851; lived in Paris, 1858–65, where he worked as a sacristan, singer in an Italian opera company, and artist. Instructor, Academie Suisse. Returned to Puerto Rico, *ca.* 1865. Court painter, King Amadeo I of Spain, 1873. Traveled to Paris, 1873; moved to Madrid, 1877; returned to Puerto Rico, 1884. Founder of a school of drawing and painting for young women. Visited Paris, 1893. Professor of drawing and painting, Escuela Normal (now University of Puerto Rico), *ca.* 1895. **Awards:** Silver medal, *Primer feria exposición de Puerto Rico*, 1854; silver medal and mention, *Segunda feria exposición de Puerto Rico*, 1855; gold medal, Puerto Rico Exhibition, 1893; gold medal, Ateneo Puertorriqueño, 1908. **Died:** 17 May 1917.

Selected Exhibitions:

1854 *Primer feria exposición de Puerto Rico*

1855 *Segunda feria exposición de Puerto Rico*
1864 Salón, Paris
1865 Salón, Paris
1867 *Exposición universal de Paris*
1868 *Las fiestas de San Juan*, Puerto Rico
1873 Viennese Exhibition
1875 *Salon des Refusés*, Paris
1878 *Exposición nacional de bellas artes*, Madrid
1881 *Exposición nacional de bellas artes*, Madrid
1883 *Exposición Francisco Oller*, Palacio de ''La Correspondencia de España,'' Madrid
1893 Puerto Rico Exhibition
1895 Salón, Paris
1896 Salón, Paris
1908 Ateneo Puertorriqueño, Puerto Rico
1929 Universidad de Puerto Rico
1931 *Segunda exposición de arte e historia*, Universidad de Puerto Rico
1933 *Segunda exposición de arte e historia*, Universidad de Puerto Rico
1935 *Exposición de cuadros restaurados de la Colección Degetau*, Universidad de Puerto Rico
1940 *José Campeche, Francisco Oller*, Ateneo Puertorriqueño, Puerto Rico
1948 *Francisco Oller*, Museo de la Universidad de Puerto Rico
1959 *Francisco Oller*, Museo de la Universidad de Puerto Rico
1962 *Dos siglos de pintura puertorriqueña*, Instituto de Cultura Puertorriqueña, Puerto Rico
1964 *Francisco Oller*, Instituto de Cultura Puertorriqueña, Puerto Rico
1973 *The Art Heritage of Puerto Rico from Pre-Columbian to Present*, Metropolitan Museum of Art and El Museo del Barrio, New York
1983 Museo de Arte de Ponce, Puerto Rico (retrospective)

Collections:

University of Puerto Rico Museum; Museo de Arte de Ponce, Puerto Rico.

Publications:

On OLLER Y CESTERO: Books—*4 pintores puertorriqueños: Campeche, Atiles, Oller, Pou*, San Juan, Instituto de Cultura Puertorriqueña, 1967; *Francisco Oller, un realista del impresionismo*, exhibition catalog, essays by Albert Boime, Edward J. Sullivan, and others, Ponce, Museo de Arte de Ponce, 1983; *Francisco Oller y Cestero: Pintor de Puerto Rico* by Osiris Delgado Mercado, San Juan, Centro de Estudios Superiores de Puerto Rico y El Caribe, 1983; *Oller maestro* by Haydée Venegas, Universidad Católica de Puerto Rico, 1985. **Articles**—''Paris/San Juan: Francisco Oller'' by Edward J. Sullivan, in *Arts Magazine*, 58, May 1984, pp. 120–124; ''A Friend of Cézanne,'' in *Apollo* (London), 120, September 1984, p. 203; ''Francisco Oller and the Image of Black People in the Nineteenth Century'' by Albert P. Boime, in *Horizontes* (Ponce), 28, April 1985.

* * *

Francisco Oller: *The Student.* © Erich Lessing/Art Resource, NY.

Francisco Manuel Oller y Cesteros was born in 1833 in Old San Juan to a well-off family. His grandfather was a doctor who introduced the smallpox vaccine in Puerto Rico, and his father was a merchant. From his early childhood he showed great interest in drawing. By age 14 he had copied Jose Campeche's portrait of his grandfather, in which he demonstrated a precocious control of the technique of painting.

At age 18 he worked as clerk in the royal treasury in San Juan. He was soon dismissed, however, when he was found caricaturing the superintendent and the head of the department. Later he became an art teacher at the college of Saint Thomas. During those years he was also interested in music and joined the Puerto Rico Philharmonic Society. He later sang the role of the Indian Taboa in Puerto Rico's first opera, *Guarionex*.

In 1851 Oller went to Spain, where he enrolled in the Academy of San Fernando under Federico de Madrazo y Kuntz. In 1853 he returned to Puerto Rico, where he kept painting portraits, copies of Campeche's works, and won a silver medal in the First and Second Puerto Rican Exhibitions.

In 1858 he finally was able to raise enough money to go to Paris. There he enrolled in the studio of Thomas Couture, where he learned anatomy and mastered perspective. Later he was a constant visitor to his professor Gustave Courbet's studio, where with Claude Monet, Jean-Frédéric Bazille, and Alfred Sisley he came in contact with realism. He attended night courses at the Ecole Imperiale es Spécial de Dessin and in the mornings went to the Académie Suisse with Antoine Guillemet and Armand Guillaumin. It was there that Oller brought Camille Pissarro to meet Paul Cézanne, and the three became lifelong friends.

Oller was accepted to the Salon in 1864 and '65. After his second acceptance in the Salon, he returned to Puerto Rico, published a book on perspective, opened a painting academy, was appointed painter-in-ordinary to the king (1872), and presented a major exhibition with 45 paintings, a self-portrait, portraits, landscapes, still lifes, and religious paintings. One of his most important accomplishments, however, was to introduce the ''plain-aire'' technique in Puerto Rico. Two landscapes using this technique, dated 1865, have survived. No other painter in the Americas had used this technique on an earlier date.

In 1873, after visiting the Vienna Universal exhibition, Oller returned to Paris, where he reaffirmed his friendship with Cézanne and Pissarro. The latter sent a letter to Théodore Duret to help sell some paintings by Pissarro that Oller had bought in the 1860s. It is now believed that the paintings were painted by Oller and signed by Pissarro to help Oller secure money to stay in Paris. Soon Oller's palette underwent a drastic change, and he started incorporating impressionist techniques in his work. He participated in the 1875 Salon des Refussés with seven paintings. By the end of 1877 he was back in Madrid, where he is known to have introduced impressionism into Spain. He stayed until after he closed an exhibition in 1883. The exhibition was highly successful and received excellent reviews; even the royal family bought two paintings.

After this momentous triumph Oller returned to Puerto Rico; the next 12 years of his life would be of great inner struggles. He resumed his teaching and began painting commissioned portraits, as well as studying the exuberant tropical landscape and its intense light. For many years he worked on his masterpiece *El velorio* (1893; ''The Wake''). This enormous painting was done with didactic purposes and an out of the ordinary symbolism, and it can be understood as possessing the germ of two of the most important twentieth-century Latin American movements: muralism from painting and fantastic realism from literature.

Oller took *El velorio* to Cuba and Paris. In Cuba he received great reviews, but Pissarro and Cézanne found it passé. This trip only lasted a year and a half (1895–96) but helped Oller to embark upon a deeper study of how light affects objects. He painted various French landscapes, his palette becoming brighter and lighter throughout the rest of his life. His last landscapes, still lifes, and portraits were imbedded with a serene ambiance, a complicated zigzagging perspective, and a light that seems to surface from inside the painting. Until his death in 1917, he remained an art teacher and taught people to see the real Puerto Rico, its fruits, its men, and its landscape.

Oller was a person of great intellectual curiosity; he kept up-to-date with scientific developments, especially those concerning light and color. An avid reader, he was interested in philosophy, literature, the occult sciences, geometry, geography, anatomy, grammar, and languages but especially art and artistic theory. He fought for the abolition of slavery; his paintings documented the horrors of this brutal institution. But most of all he was a visionary, an artist who was part of the intellectual creation of the most important artistic movement in the nineteenth century, and he used all his advanced knowledge to create his own style with Creole roots. In fact, Oller brought modernism to America decades before the Latin American modernist movements were established in the 1920s; he was the first artistic ''anthropophagus.''

Oller studied his country intensively and gave the world his interpretation of what Puerto Rico was like during his lifetime without ever falling into the trap of the picturesque. He rejected the academy and even while in Puerto Rico, far from all the avant-garde movements and lacking the stimulus of contact with other painters, he was able to maintain his own strong style—the style that has been named *boriquismo*.

—Haydee Venegas

O'NEILL, María de Mater
American painter

Also known as Mari Mater O'Neill. **Born:** San Juan, Puerto Rico, 9 March 1960. **Education:** Cooper Union School of Arts and Science, New York, 1978–84, B.F.A. 1984. **Career:** Drawing professor, Universidad Politéchnica, San Juan, 1999. Painting professor, 1991–94, and since 2000 design professor, Escuela de Artes Plásticas, San Juan; since 1995 webmaster, *El cuarto del quenepón,* San Juan; since 1999 Internet consultant, Instituto de Cultura Puertorriqueña, San Juan. **Awards:** Second prize, *Certamen de la revista sin nombre,* 1983; first prize, experimental video, *Ateneo puertorriqueño,* 1988, 1991; first grand prize in painting, *III bienal internacional de pintura,* Cuenca, Ecuador, 1991; first prize, computer-generated publication design, *Publish Magazine,* San Francisco, 1993; Federal Design Achievement award, 1995; second prize, *Certamen Museo de Arte Contemporáneo de Puerto Rico,* 1995; UNESCO medal, 1999. **Agent:** Maud Duquella, Galería Botello, Avenue F. D. Roosevelt, #314, Hato Rey 00918, Puerto Rico. **Website:** http://www.botello.com.

Individual Exhibitions:

1985 *Teatro,* Liga de Estudiantes de Arte, San Juan

María de Mater O'Neill: *El cementerio pequeño de Culebra,* 1990. Photo by John Betacourt; courtesy of the collection of Ileana Font.

1989	*Autorretratos,* Chase Manhattan Bank, Hato Rey (with Carlos Collazo)
1991	*Paisajes en tiempos de ansiedad,* Museo de Arte e Historia and Galería Botello, San Juan
1993	*Isla,* Galería Botello, San Juan
1994	*Mapas,* Museo de Arte Contemporáneo, Panama
	Paisaje en fuego, IV bienal internacional de pintura, Museo de Arte de Cuenca, Ecuador
1995	*Azul,* Galería Botello, San Juan
1996	*Obra reciente,* Museo de Arte de Ponce
2000	*Fin de juego,* Galería Botello, San Juan

Selected Group Exhibitions:

1994	*Otro país: Escalas africanas,* Centro Atlántico de Arte Moderno, Mallorca, Spain
1995	*Latin American Women Artists: 1915–1995,* Milwaukee Art Museum (traveling)
	Un marco por la tierra, Museo de Arte Moderno Sofía Imber, Caracas, Venezuela
	Caribean Visions: Contemporary Painting and Sculpture, Center for Fine Arts, Miami
1997	*The Richeness of Diversity: Contemporary Puerto Rican and Mexican Artists,* Susquehanna Art Museum, Harrisburg, Pennsylvania

1999	*Litografía Argentina contemporánea,* Museo de Artes Plásticas Eduardo Sivori, Buenos Aires
2000	*Latin Caribbean: Cuba, Dominican Republic and Puerto Rico,* MOOLA, Los Angeles
	Women of the World: A Global Collection of Art, White Columns, New York (traveling)
2001	*XIII bienal de San Juan,* Arsenal de la Puntilla, San Juan
	Muestra nacional de arte puertorriqueña año 2001, Instituto de Cultura Puertorriqueña, San Juan

Collections:

Cooper Union School of Arts and Science, New York; Museo de Antropología, Historia y Arte, University of Puerto Rico, San Juan; Museo de Arte de Ponce; Museo de Arte Contemporáneo, San Juan; Museo de Arte Contemporáneo, Panama; Museo de Arte Moderno, Cuenca, Ecuador; Museum of Fine Arts, Springfield, Massachusetts; El Museo del Barrio, New York; National Design Museum, New York.

Publications:

By O'NEILL: Books—"Sobre imágenes, signos y otras mentiras," in *Teatro Doméstico,* exhibition catalog, San Juan, Liga de Arte, 1992; "Identidad y control," introduction to *Nuestro Autorretrato:*

María de Mater O'Neill: *Ella, la más artista de todos,* **1999. Photo by John Betancourt; courtesy of the collection of José B. Andreu y Sra.**

La mujer artista y la autoimagen en un contexto multicultural, San Juan, Mujeres Artistas de Puerto Rico, 1993; ''Testimonio,'' in *Homenaje a Carlos Collazo,* exhibition catalog, San Juan, Instituto de Cultura Puertorriqueña, 1994; *Fin de juego,* exhibition catalog, San Juan, Galería Botello, 2000. **Articles**—''Carlos Collazo: Breves notas de una compañera de trabajo,'' in *Revista Plástica,* 1(21), September 1993; ''Chase Exhibit an Exercise in Choosing, Not Telling,'' in *San Juan Star,* 5 December 1993; ''Participación de Puerto Rico en IV Bienal Internacional de Pintura en Ecuador,'' in *Revista Cupey,* Universidad Metropolitana, San Juan, 1994.

On O'NEILL: Books—*Mixed Blessings* by Lucy R. Lippard, New York, Pantheon Books, 1990; *Otro país, escalas africanas,* exhibition catalog, text by Marimar Benítez, Mallorca, Spain, Centro Atlántico de Arte Moderno, 1994; *Caribbean Visions,* exhibition catalog, text by Shifra Goldman, Miami, Center for Fine Arts, 1995; *Puerto Rico: Arte e identidad* by Dwight García, Río Piedras, University of Puerto Rico Press, 1997; *Caribbean Art* by Veerle Poupeye, Thames and Hudson, New York, 1998; *Images of Ambiente* by Rudy C. Bleys, London, Continuum Press, 2000. **Article**—''Puerto Rican Art Moves Outward, and More Inward'' by Luisita López Torregrossa, in *New York Times,* 2001. **Films (documentaries)**—*Puerto Rico: Arte e identidad,* 1991, and *Un retrato de Carlos Collazo,* 1994, both by Sonia Fritz, San Juan, Hermandad de artistas gráficos; *ArteBorinken* by Graig Martin, 1994; *Discurso con analisís* by Edmundo H. Rodrígiuez, San Juan, 1995.

*

María de Mater O'Neill comments:

I believe good art is determined by history. In my case, it is the history of Puerto Rico. I am a local artist, in the sense that my work is directed toward my community (Puerto Rico). My work does not deal with the Puerto Rican community in the U.S.A.

In order for the ''reader'' to profoundly experience my work, they must be versed in the sociopolitical and cultural history of my country.

I am also an oil painter, which for me implies corporal action. I stress craft on myself and students, because the act of painting not only has to do from where you paint (history and culture) but also with ideas (theory) and hands (craft).

It comes as no surprise that I stress the corporal and that my main body of work deals with self portraiture; as a Puerto Rican woman, I think the body itself is identity, a true statement in Caribbean societies.

* * *

When in 1988 at 28 years old María de Mater O'Neill returned permanently to her native Puerto Rico, after completing studies at the Cooper Union School of Arts and Science, she faced a jolting reality. Her years of study in New York City had not prepared her to understand her own rich roots. It was then that she embarked on an intense search in painting. Using self-portraits and then landscapes as subjects, she aimed for her own diagnosis of Puerto Rico. Her process has been persistent, logical, and consistent.

O'Neill presented primarily sociopolitical problems and the affirmation of identity, both personal and sexual, at the same time as she made an accurate diagnosis. With the intense exploration of artist/ Puerto Rican, she delved into and searched the history, the landscape, and her imagination for the basis of her own complicated being as well as the complicated being that is a Puerto Rican. She scrutinized the symbols of Puerto Rico to understand and internalize them and to offer a lucid vision of the country.

Her first works, from 1986 to 1989, were principally self-portraits, with a satiric image of a being with long and deconstructed extremities in which sometimes only the eye could be distinguished; a vigilant eye, an artist's eye, an eye that searches for definitions, alternatives, knowledge—in short, an eye that elucidates the mysteries of a culture previously unexplored, alien and distant, but its own. During this period she shared a studio with her friend and fellow artist Carlos Collazo. Her works were filled with superimposed images and chaotic appearances that offer keys to the complexity and profundity of the multicultural Caribbean lands.

From these first works she demonstrated great strength of expression, strong brushwork, and powerful images wrapped in vivid coloring. For all this she had been affiliated with neo-expressionism prevalent at the beginning of her career. Nevertheless, her work contains many elements that separate it from recognized American, German, or Italian neo-expressionists and makes her a Caribbean expressionist. All the elements of ''Caribbeanism'' appear in her

works: imbroglio, multiplicity, impurity, musicality, rhythm, warmth, color, joy, dynamism, revelry, and passion.

By the end of the 1980s, O'Neill began to study her environment with the series *Paisajes en tiempos de ansiedad* (''Landscapes in Anxious Times'') and in works such as *Pequeño cementerio de Culebra* (''Small Cemetery in Culebra''), at once a defense of ecology and a portent of the death of a culture she revisited. In 1981 her painting *Donde moran los terribles* (''Where the Terrible Dwell'') garnered first prize at the Third International Painting Biennial of Cuenca, in Ecuador. This work was a tribute to her companion Collazo, who had died of AIDS at a time when patients of this illness were treated inhumanely. O'Neill has been the youngest artist to win this prize and the only woman.

The series *Paisajes en fuego* (''Landscapes on Fire'') followed, presented in 1994 as an exhibition in tribute of the Fourth Cuenca Biennial. In *Paisaje en fuego #6: El Castillo del Morro* (''Landscape on Fire #6: Morro Castle''), the old defense works, a major tourist attraction, are presented as a rural U.S. landscape. In the later landscapes her figure, now more defined, appears and dominates the action. In these paintings O'Neill is represented as a goddess capable of pacifying the forces of nature. After 1993–94 she produced a series of maps of Puerto Rico, interpreted by Efraín Barradas as self-portraits. And in 1995 she painted a series, *Suite del Caribe* (''Caribbean Suite''), consisting of 26 miniatures that are close-ups of the transparencies, reflections, and profundities of the Caribbean Sea. In the first 10 years of her career, she moved from the micro to the macro, to the being, and back from the macro to the micro.

As O'Neill made these paintings, she also worked in theater making sets, organized children's camps, collaborated with contemporary dance choreographers, produced videos and prize-winning graphic designs, and participated in important exhibitions around the world. Among her achievements in this epoch were the 1995 Federal Design Achievement award for the catalog of the Collazo retrospective and her participation in the itinerant exhibition *Latin American Women Artists 1915–1995*. Her work *Landscape on Fire 2* was used for the posters and promotion of this important exhibition. She also began to work on Web page design for both cultural and commercial institutions. She was a pioneer in cyberspace with the creation of her Internet hyper-magazine, *El cuarto del quenepón* (roughly translated as ''The Large Ackee Fruit's Room'').

In the late 1990s O'Neill dedicated herself almost exclusively to developing cybernetic projects, collaborating in the creation of the Image and Design Department of the School of Plastic Arts while continuing her vital sociocultural research. In these years and with great sacrifice and frequent interludes she has converted *El cuarto del quenepón* into a nonprofit corporation (June 2000) and the repository for the most important historic, graphic, and theoretical information for arts and culture in the country. The forum section of this hyper-magazine appeared at the beginning of 2001 and rapidly created a transcendental debate and interchange of information, ideas, and theory among local artists and critics and Puerto Ricans living in the United States.

In 1999–2000 O'Neill decided to return to dedicating the major part of her time to painting. She also taught at the School of Plastic Arts. For her first exposition in five years, *Fin de juego* (''End of the Game'') in March 2000, she prepared a series of paintings, drawings, and lithographs with images of comic nonentities that were a far cry from children's cartoons. In these she presented a heroine who is imaginary and, according to the artist, her alter ego. With a grand sense of both humor and severity, her heroine/mercenary tramples

and destroys the principal icons of Puerto Rican plastic arts (including her own), institutions dedicated to promoting the arts, and other social taboos. The imaginary, created principally by male artists, is demolished by a lesbian heroine. This series, the start of a new cycle, was short-lived, as it had fulfilled its mission of liberating the artist from her discourse on identity, both cultural and sexual. O'Neill has emerged completely from the closet. Gone are the ties and the taboos; she has embarked on a new voyage. She worked freely without attachments. At the same time that she designed doors, windows, and ironwork to reconstruct her house, she painted a series of canvases that reflect the interior of her studio, her home, and her cats. She no longer looked for who she is; she showed us who she is.

—Haydee Venegas

OROZCO, Gabriel
Mexican photographer, sculptor, and installation artist

Born: Jalapa, Veracruz, 1962. **Education:** Escuela Nacional de Artes Plásticas, U.N.A.M., Mexico, 1981–84; Círculo de Bellas Artes, Madrid, 1986–87. **Career:** Lived in New York, early 1990s. Artist-in-residence, DAAD, Berlin, 1995.

Individual Exhibitions:

1993	Museum of Modern Art, New York
	Kanaal Art Foundation, Kortrijk, Belgium
	Galerie Crousel-Robelin BAMA, Paris
1994	Museum of Contemporary Art, Chicago
	Marian Goodman Gallery, New York
1995	Monica de Cardenas, Milan
	DAAD Galerie, Berlin
	Migrateurs, Musée d'Art Moderne de la Ville de Paris
	Galerie Micheline Szwajcer, Antwerp, Belgium
1996	Marian Goodman Gallery, New York
	Art Gallery of Ontario, Toronto, Canada
	Institute of Contemporary Arts, London (traveled to Kunsthalle, Zurich)
	The Empty Club, Artangel Project, London
1997	DAAD Galerie, Berlin
	Staatliche Museum am Kulturforum, Berlin
	Stedelijk Museum, Amsterdam
	Anthony d'Offay Gallery, London
	Carambole avec pendule, Centre de la Vieille Charité, Musées de Marseille, France
1998	Marian Goodman Gallery, New York
	Musée Nationale d'Art Moderne de la Ville de Paris
	St. Louis Museum of Art
	Centro Fotográfico Alvarez Bravo, Oaxaca, Mexico
1999	*Museum Studies 5: Gabriel Orozco,* Philadelphia Museum of Art
	Galerie Chantal Crousel, Paris
	Centre pour l'Image Contemporaine, Geneva
	Portikus, Frankfurt-am-Main, Germany
2000	Museum of Contemporary Art, Los Angeles (traveling retrospective)

Selected Group Exhibitions:

1983 *Salón nacional de artes plásticas,* Instituto Nacional de
 Bellas Artes, Mexico City
1990 *Installations: Current Directions,* Museum of Contem-
 porary Hispanic Art, New York
1994 *Cocido y crudo,* Museo Nacional Centro de Arte Reina
 Sofía, Madrid
1996 *Everything That's Interesting Is New,* Deste Foundation,
 Athens, and Museum of Modern Art, Copenhagen
1997 *Biennial Exhibition,* Whitney Museum of American Art,
 New York
 Documenta X, Kassel, Germany
1998 *XXIV bienal de São Paulo*
 Berlin Biennial
1999 *Carnegie International 1999/2000,* Carnegie Museum of
 Art, Pittsburgh
2000 *Let's Entertain,* Walker Art Museum, Minneapolis

Collection:

Philadelphia Museum of Art; Museum of Modern Art, New York;
Musées de Marseille, France.

Publications:

By OROZCO: Book—*Gabriel Orozco Photogravity,* exhibition
catalog, Philadelphia, Philadelphia Museum of Art, 1999. **Article**—
"A Thousand Words: Gabriel Orozco Talks about His Recent Films,"
in *Artforum International,* 35(10), summer 1998, pp. 114–115.

On OROZCO: Books—*Gabriel Orozco,* exhibition catalog, New
York, Museum of Modern Art, 1993; *Real Time,* exhibition catalog,
London, Institute of Contemporary Arts, 1993; *Empty Club,* exhibi-
tion catalog, text by James Lingwood, Jean Fisher, and others,
London, Artangel, 1996; *Gabriel Orozco,* exhibition catalog, text by
Benjamin H. D. Buchloh and Bernhard Bürgi, Zurich, Kunsthalle,
London, Institute of Contemporary Arts, and Berlin, Deutscher
Akademischer Austauschdienst Berliner Künstlerprogramm, 1996;
Gabriel Orozco, exhibition catalog, text by Francesco Bonami, Paris,
Musé Nationale d'Art Moderne de la Ville de Paris, 1998; *Gabriel
Orozco,* exhibition catalog, text by B. H. D. Buchloh and Alma Ruiz,
Los Angeles, Museum of Contemporary Art, and Mexico City,
Museo Internacional Rufino Tamayo, 2000. **Articles**—"The Os of
Orozco" by M. Catherine de Zegher, in *Parkett* (Germany), 48, 1996,
pp. 54–79; "Like a Rolling Stone: Gabriel Orozco" by Jean-Pierre
Criqui, in *Artforum International,* 34, April 1996, pp. 88–93; "Ga-
briel Orozco: The Power to Transform" by Robert Storr, in *Art Press,*
225, June 1997, pp. 20–27; "Sudden Death: Roughs, Fairways and
the Game of Awareness" by Francesco Bonami, in *Parachute*
(Canada), 90, April/June 1998, pp. 26–32; "Gabriel Orozco" by
Damien Sausset, in *L'Oeil* (Lausanne, Switzerland), 497, June 1998,
pp. 58–61; "Gabriel Orozco: Museum of Contemporary Art, Los
Angeles" by David Joselit, in *Artforum International,* 39(1), Septem-
ber 2000, pp. 173–174; "Gabriel Orozco's Game Gets Real" by Tim
Griffin, in *Art on Paper,* 4(3), January/February 2000, pp. 51–55;
"Gabriel Orozco" by Christopher Miles, in *Art Nexus* (Colombia),
November 2000/January 2001, pp. 44–48.

* * *

Conceptual in nature, the artwork of Gabriel Orozco examines
broad-based cultural and political perspectives while looking at the
role of art itself. Like Duchamp, the artist Orozco is most often
compared with, Orozco has created installations where found objects
are either reproduced or photographed. (He reinvigorated Duchamp's
famous bicycle wheel with his piece *Four Bicycles/There Is Always
One Direction,* which shows an impossible eight-wheel cycle.) By
"flattening" an object in photography and collapsing a three-dimen-
sional object onto a flat surface, Orozco comments on the way we
perceive things. Orozco also asks us to look at familiar objects in a
new way, documenting such common things as bicycles, cars, and
even popsicles. A perpetual nomad, having lived in Italy, the United
States, Germany, and England, Orozco captures a certain time and
place in his photographs, documenting a specific cultural phenome-
non such as the ubiquitous yellow scooter in Germany. In his
photograph *Until You Find Another Schwalbe* (1995), Orozco allows
the viewer to determine the relevance of the yellow scooter. In
another work, *Melted Popsicle* (1993), Orozco photographs a popsicle
melting on asphalt—a scene that could be shot in any country that
has refrigeration. The piece recalls the work of Robert Smithson,
who created *Asphalt Rundown* and *Glue Pour.* Smithson depicted
the everyday in his work, creating meaning out of the most
mundane occurrences.

Orozco's work questions the role of museums in modern art. His
pieces suggest that the role of the museum is similar to the role of
advertising agent, as both try to pitch a certain idea or philosophy. For
example, a museum could be pitching surrealism or modernism
depending on the current trend. While Orozco's installations can
create serious debate, there is also, however, a sense of fun, of play, in
his work. Critic Collette Chattopadhyay writes in *Sculpture:* "Spin-
ning, turning, and revealing 'ideas in things' as William Carlos
Williams once put it, Orozco's best works change and challenge the
generally accepted rules of engagement in art and life."

Growing up in Mexico, Orozco was not exposed to American
culture like many of his peers. His father forbade English to be spoken
at home, and he did not listen to American rock songs or imitate
American fashions. Instead of joining the Boy Scouts, Orozco for two
summers participated in communist camps in the Soviet Union and
Cuba. Unlike other artists who wanted to achieve a sort of rock-star
status, Orozco even after coming to the United States maintained a
low-key approach. Rather than seeking a style of art where the voice
of the artist was prevalent, Orozco's beliefs compelled him to form a
conceptual, nonautobiographical style.

In his work *Photogravity* (1999) for the Philadelphia Museum of
Art, Orozco deconstructs and comments on the permanent Arensberg
collection housed there. The Arensberg collection can essentially be
divided into two categories: pre-Columbian objects, primarily from
Africa and North American Indian cultures; and twentieth-century
paintings, mostly from France, including work by Duchamp, Picasso,
Kandinsky, Klee, and Miro. Walter and Louise Arensberg, who were
good friends of Duchamp, were some of the first collectors of so-
called primitive art. In the 1950s two separate catalogs of the
Arensberg collection were printed, one describing the French paint-
ings, the other listing the primitive works. In *Photogravity* Orozco
explores the relationship between the two types of art. He uses the
catalogs themselves to comment on the categorization. By tak-
ing photographs of the primitive art catalog—photographs of
photographs—and blowing them up, Orozco raises questions about
the appropriation of objects: Do modern paintings imitate the formal
qualities of primitive pieces? Is it valid to place primitive objects in

museums, even if the original use of the object has become secondary to its "aesthetic value"? The original catalog does not go beyond a very basic description of an object; for example, one reads, "Mask. Granite. Guerrero?" This lax classification is troubling to Orozco. Formally the installation consists of the blown-up photographs of the pre-Columbian objects pasted on iron stands. It also features some of Orozco's previous works, including *Until You Find Another Yellow Schwalbe.*

Orozco is constantly challenging the expectations of contemporary art. In a post-Duchamp way, he makes the conceptual side of his work playful with his innovative distortion of the familiar.

—Sally Cobau

OROZCO, José Clemente
Mexican painter and lithographer

Born: Zapotlán el Grande (now Ciudad Guzmán), Jalisco, 23 November 1883. **Education:** Agricultural College of San Jacinto, 1899–1904; Academia de Bellas Artes de San Carlos, Mexico City, 1900–04; National Academy of Fine Arts, Mexico City, 1908–14; also attended National University, Mexico City. **Family:** Married Margarita Valladares in 1923; three children. **Career:** Architectural draftsman, Mexico City, 1904–09; cartoonist, *El Imparcial* and *El Hijo del Ahuizote* newspapers, Mexico City, 1911; illustrator, *La Vanguardia Mundial,* Mexico City, 1914–17. Began working with Diego Rivera and David Alfaro Siqueiros as a muralist, Mexico, 1922; muralist, National Preparatory School, Mexico City, 1923–24, Pomona College, Claremont, California, 1930, New School for Social Research, New York, 1930, Dartmouth College, Hanover, New Hampshire, 1934, Palace of Fine Arts, Mexico City, 1934, Guadalajara, 1936–39, Gabino Ortiz Library, Jiquilpan, Michoacán, 1940, Supreme Court Building, Mexico City, 1941, Hospital de Jesús Nazareno, Mexico City, 1942–44, Museum of Modern Art, New York, 1945–46, National School for Teachers, Mexico City, 1948, Government Palace, Guadalajara, 1949. Founder, National College, 1943. Exiled to the United States, 1917–20; lived in New York, 1927–34; traveled in Europe, 1932. **Awards:** National Prize in the Arts and Sciences, 1946. **Died:** 7 September 1949.

Selected Exhibitions:

1929 Art Students League, New York
1930 Delphic Studios, New York
 Museum Exposition Park, Los Angeles
1931 Downtown Gallery, New York
 Grace Horne Galleries
1934 Civic Auditorium, La Porte, Indiana
 Arts Club of Chicago
1940 *Twenty Centuries of Mexican Art,* Museum of Modern
 Art, New York
1943 *The Latin American Collection of the Museum of
 Modern Art,* Museum of Modern Art, New York
1952 Pan American Union, Washington, D.C.
1953 Institute of Contemporary Art, Boston (retrospective)
1961 Museum of Modern Art, New York

José Clemente Orozco, a self-portrait. Library of Congress.

1966 *Art of Latin America since Independence,* Yale University, New Haven, Connecticut, and University of Texas, Austin
1967 Museum of Modern Art, New York

Collections:

Museo Orozco, Guadalajara; Baltimore Museum of Art, Maryland; Museum of Fine Arts, Boston; Fogg Art Museum, Cambridge, Massachusetts; Museum of Fine Arts, Houston; Metropolitan Museum of Art, New York; Museum of Modern Art, New York; Museum of Modern Art of Latin America, Washington, D.C.; Philadelphia Museum of Art; San Francisco Museum of Modern Art.

Publications:

By OROZCO: Books—*Textos,* edited by Justino Fernández, Mexico City, 1955, 1983; *Autobiografía,* Mexico City, 1945, as *An Autobiography,* translated by Robert C. Stephenson, Austin, Texas, 1962; *The Artist in New York: Letters to Jean Charlot and Unpublished Writings 1925–29,* Austin, Texas, 1974.

On OROZCO: Books—*Man of Fire, J. C. Orozco: An Interpretive Memoir* by MacKinley Helm, Boston, Institute of Contemporary Art, 1953; *¡Orozco! 1883–1949: an exhibition,* exhibition catalog, Oxford, England, Council of the Museum of Modern Art, 1980; *José Clemente Orozco: Antología crítica* by Teresa del Conde, Mexico, UNAM, 1983; *José Clemente Orozco, una vida para el arte: Breve*

José Clemente Orozco: *Mujer grávida.* © Geoffrey Clements/Corbis. © Licensed by Orozco Valladares Family through VAGA, New York, NY.

historia documental by Raquel Tibol, Mexico, Fondo Cultural Economica, 1996; *José Clemente Orozco: La pintura mural mexicana* by Renato González Mello, Mexico, Consejo Nacional para la Cultural y las Artes, 1997; *José Clemente Orozco: Mexican Artist* by Barbara C. Cruz, Springfield, New Jersey, Enslow, 1998; *Mexican Muralists: Orozco, Rivera, Siqueiros* by Desmond Rochfort, San Francisco, Chronicle Books, 1998; *Mural Painting and Social Revolution in Mexico, 1920–1940: Art of the New Order* by Leonard Folgarait, New York, Cambridge University Press, 1998; *Orozco in Gringoland: The Years in New York* by Alejandro Anreus, Albuquerque, University of New Mexico Press, 2001. **Articles–**"If I Am to Die Tomorrow–Roots and Meanings of Orozco's Zapata Entering a Peasant's Hut" by John Hutton, in *Museum Studies,* 11, Fall 1984; "Diego Rivera and Mexican Art" by Ivor Davies, in *Studio International,* 200, November 1987; "Orozco's American Epic" by Charles Giuliano, in *Art News,* 88, November 1989; "José Clemente Orozco" by Donna Gustafson, in *Art News,* 96, March 1997; "Transformed Face: Orozco's Guadalajara" by Renato González Mello, in *Artes de Mexico* (Mexico), 41, 1998; "New York: Pollock, Orozco and Siqueiros at Washburn" by Richard Kalina, in *Art in America,* 86(9), September 1998.

* * *

José Clemente Orozco was one of the twentieth century's leading expressionist painters. As a young man he wanted to become an engineer, but this plan was thwarted after a chemistry experiment gone wrong left the artist with poor eyesight and without a left hand. Orozco attended the Academia de Bellas Artes de San Carlos, and while a student there was influenced by the work of José Guadalupe Posada, a popular engraver of broadsides. Another early influence were the drawings, prints, and paintings of the morbid symbolist Julio Ruelas, in particular his depictions of women as sinister, vampirelike creatures. From the very beginning of his career, Orozco earned his living as a political cartoonist and caricaturist, and this practice always endowed his work with a grotesque and satirical dimension.

Orozco's earliest works, produced during the mid- to late 1910s, were watercolors and pen-and-ink drawings that depict prostitutes, pimps, and other urban dwellers. The best work from this period is the series *La casa del llanto*, which consists of such brothel scenes as *La desesperada*, *Récamara*, and *Desolación*. When these works were exhibited in Mexico City in 1916, they were not well received by the public due to the subject matter and the artist's harsh expressionist style.

In 1922 Orozco—with Diego Rivera, David Alfaro Siqueiros, and other painters—was invited to paint murals on the walls of the Escuela Nacional Preparatoria San Ildefonzo. With other young artists, the three men, known as Los Tres Grandes, revived mural painting with a narrative, monumental figuration. From a technical point of view the muralists also revived the mediums of fresco, encaustic, and mosaic. A political viewpoint was evident in Mexican murals from the very beginning; Rivera and Siqueiros were Marxists, while Orozco maintained an iconoclastic position rooted in the anarchism of his youth. Orozco's murals at San Ildefonzo are monumental in form (bringing to mind Michelangelo), sober in color, and emotionally intense. His subjects in this mural cycle range from the clash of the conquest (*Cortés y la Malinche, Franciscano*) to the struggles, promises, and failures of the revolution (*La trinchera, La trinidad revolucionaria, La destrucción del viejo orden*). After completing the murals at San Ildefonzo (1923–26), Orozco executed the murals *Omnisciencia* at the Casa de los Azulejos in Mexico City and

Revolución social at the Escuela Industrial in Orizaba, Veracruz. From 1927 to 1934 Orozco lived in self-imposed exile in the United States, where he painted the murals *Prometheus* (1930; Pomona College, Claremont, California), *A Call for Revolution and Universal Brotherhood* (1930–31; The New School for Social Research, New York, New York), and *An Epic Interpretive Narrative* (1932–34; Baker Library, Dartmouth College, Hanover, New Hampshire).

The *Prometheus* mural continues the use of the heroic nude as seen in some of the San Ildefonzo panels, while in The New School murals Orozco failed in his use of the theory of dynamic symmetry. It is in Dartmouth where Orozco's mature style is crystallized in a series of dynamic compositions that integrate a rich palette, bold drawing, and most particularly a view of the world and its history that is anarchic and apocalyptic.

While in the United States Orozco also took up the medium of lithography, producing 19 lithographs. In addition, he painted significant easel pictures, including *Zapatistas* of 1931, a work filled with intense colors, dramatic angles, and an air of doom.

Orozco returned to Mexico in 1934 and in the years 1936–39 painted his most important murals in his native Guadalajara. These murals, spread out between three buildings—the Governor's Palace, the Hospicio Cabañas, and the university—range in subject from *Hidalgo* to a retelling of the conquest of Mexico, to the chaos of the 1930s and man's aspirations of enlightenment. Stylistically these murals are a fusion of diagonal compositions, an agitated yet structured drawing and color schemes that range from deep browns with cool blues to fiery reds with gray-greens, all applied with an open, vigorous brushwork. Although Orozco produced several murals after the Guadalajara cycle, these are without a doubt his most significant works and some of the most powerful paintings of the first half of the twentieth century.

Orozco's last great body of work is the series *Los teúles* (1947–48), a group of large easel paintings painted in a variety of mediums (pyroxiline, oil, tempera) on Masonite.

Thematically they depict the encounter between pre-Columbian natives and the Spanish conquerors in an eschatological light, where both are seen as brutal and oppressive. Stylistically these paintings are Orozco at his most abstract, approaching at times the surface quality and painterliness of abstract expressionism, without abandoning the figure.

Without a doubt Orozco's greatest achievement is his creation of a Latin American expressionism that reflects the social and political turmoil of his time without being topical or illustrative. In the end, his passionate and at times tormented paintings belong in the same pantheon as those of Matthias Grünewald, El Greco, and Goya.

—Alejandro Anreus

OROZCO RIVERA, Mario
Mexican painter, muralist, and sculptor

Born: Mexico City, 1930. **Education:** Escuela de Pintura y Escultura La Esmeralda, Mexico City, 1952. **Career:** Muralist, University of Veracruz, 1959; professor, UNAM and Universidad Veracruzana; muralist, 1959–64; assistant to David Alfaro Siqueiros, *q.v.,* 1964–65; head of assistants, Cuernavaca workshop of Siqueiros, 1964; director and overseer of mural production at National History Museum, Chapultepec Castle, Office of Public Education "Ex-Aduana," and

Polyforum Cultural Siquieros, David Alfaro Siquieros Mural Workshop, beginning in 1966. **Awards:** Premio adquisición, *Nuevos valores,* Salón de la Plástica Mexicana, 1955; third place, *Concurso internacional de pintura,* Moscow, 1957. **Died:** 20 November 1998.

Individual Exhibitions:

1953	Círculo de Bellas Artes, Mexico City
1981	Hotel de México
1997	*Mario Orozco Rivera: Master Painter,* Mexic-Arte Museum, Austin, Texas
1999	*Ultima pintura mural y de caballete,* UNAM, Mexico City
	Metropolitan Museum of Monterrey, Mexico

Publications:

By OROZCO RIVERA: Book—*Mario Orozco Rivera: De caballete y mural,* Mexico, n.p., 1981.

* * *

"Art that is not subversive is not art."
—Mario Orozco Rivera

Mario Orozco Rivera is considered the main disciple of David Alfaro Siqueiros, and throughout his career he continued Siqueiros's legacy of politically engaged public art projects. Orozco Rivera created more than 40 mural projects and a body of work that included numerous paintings before his death in 1998. A student of Jose Orozco (to whom he was also related), Diego Rivera, and Siqueiros, Orozco Rivera developed a painting style that reflected the influence of his teachers. His figures are monumental, often painted in acrylic on a wood background. During his lifetime Orozco Rivera emphasized the impact of his friendship with Siqueiros but downplayed the influence Siqueiros had on his artistic style. There is an apparent difference in their styles, most notably in their use of color. Diego Rivera said of Orozco Rivera, "The truth is presented in his work in a way which is both rich and joyful, without losing touch with the quality of pain manifested both inwardly and outwardly in Orozco Rivera's women. He is an excellent colorist, managing multiple color harmonies by means of large masses which bring out the tones in smaller areas, making them essential elements in a color composition on a monumental scale." In addition to mural projects and paintings, Orozco Rivera's body of work includes sculpture in mixed media, done in a modernist style. He was also a composer, poet, musician, and set designer.

Orozco Rivera entered the National Fine Arts School of Painting and Sculpture, La Esmeralda, in 1952 and studied with Manual Rodriguez Lozano and Carlos Orozco Romero. At the time Mexican art was in the midst of a transformation. A new generation of artists had grown frustrated with the dogmatism and political feuding of the muralists who had reigned during the 1920s and '30s. This new generation was eager to experiment with avant-garde styles, including abstraction. The 1960s, however, saw a resurgence of explicitly political art and a renewal of the muralist movement as a vehicle for social transformation.

Beginning in 1959 Orozco Rivera painted a series of murals at the University of Veracruz. He became an assistant to Siqueiros, and in 1966 he was appointed director of the David Alfaro Siqueiros Mural Workshop and oversaw the production of the murals at the National History Museum, the Chapultepec Castle, and Polyforum Cultural Siquieros. Throughout his career Orozco Rivera echoed some of the main tenets of the muralist movement, including the rejection of art for private consumption despite the fact that Mexican art in general, especially during the 1970s and '80s, turned increasingly toward more conventional formats appropriate for a commercial gallery setting.

Orozco Rivera remained sharply critical of the Mexican government for virtually all his career, sometimes at great cost. For example, in 1962 one of his works was removed from exhibition because it alluded to political suppression of the muralist movement. Along with Siqueiros, Orozco Rivera was active in the Mexican Communist Party, and later, in the Unified Socialist Party of Mexico. Because of his uncompromising dedication to social justice and his refusal to act as a mouthpiece for the state, he was denied certain public mural projects in Mexico that he might otherwise have obtained. As an activist in the Communist Party and in various artists' unions, Orozco Rivera fought for many improvements for artists—including state subsidies, mural preservation, and lower taxes on sales of art—without compromising the political and intellectual independence of contemporary Mexican artists.

—Amy Heibel

(MONTAÑEZ) ORTIZ, Rafael

American video installation artist, painter, sculptor, and performance artist

Also known as Raphael Montañez Ortiz and Ralph Ortiz. **Born:** New York, 1934. **Education:** Pratt Institute, Brooklyn, New York, 1960–64, B.S., M.F.A. 1964; Columbia University Teacher's College, New York, Ph.D. 1967. **Career:** Instructor, New York University, 1968; adjunct professor, Hostos Community College, New York, 1970. Cofounder, El Museo del Barrio, New York, 1969; artist-in-residence, Toronto, 1996; lives and works in Highland Park, New Jersey. **Awards:** John Hay Whitney fellowship, 1965–66.

Individual Exhibitions:

1960	Artists' Gallery, New York
1965	Barrett's Candy Store, Provincetown, Massachusetts
1967	Fordham University, Bronx, New York
1995	*Behind It All,* Electronic Bar, Buenos Aires
1996	*The Conversation,* Glasgow Museum of Modern Art, Scotland
	Piano Deconstruct Concert, Whitney Museum of American Art, New York
1997	*Raphael Montanez Ortiz: Early Destruction, 1957–67,* Whitney Museum of American Art, New York
	Dance No. 22, Guggenheim Museum, New York

Selected Group Exhibitions:

1962	School of the Museum of Fine Arts, Boston
1963	Washington University, St. Louis

1964	Park Palace Gallery, New York
	Detroit Institute of Arts
1965	Whitney Museum of American Art, New York
1967	*Latin American Art: 1931–1966,* Museum of Modern Art, New York
1968	*Destruction Arts Symposium,* New York
1989	*The Latin American Spirit: Art & Artists in the U.S.,* Bronx Museum, New York
1993	*Revelaciones/Revelations: Hispanic Art of Evanescence,* Herbert F. Johnson Museum of Art, Cornell University, Ithaca, New York
2000	*Speed of Vision,* Aldrich Museum of Contemporary Art, Ridgefield, Connecticut

Collections:

Museum of Modern Art, New York; Whitney Museum of American Art, New York.

Publications:

On ORTIZ: Books—*Rafael Montañez Ortiz: Years of the Warrior, Years of the Psyche* by Kristine Stiles, New York, El Museo del Barrio, 1988; *Outside the Frame: Performance and the Object: A Survey History of Performance Art in the USA Since 1950* by Gary Sangster, Cleveland, Ohio, Cleveland Center for Contemporary Art, 1994.

* * *

Beginning in the late 1950s, Rafael Montañez Ortiz emerged as one of the central players in destructivism, an international movement that attempted to redress what it saw as the social detachment of the postwar avant-guard. He worked in all genres, producing recycled films as well as works in painting, sculpture, installation, and performance. His role in the destructivist movement was to shift the domain of destruction from the realm of society to the realm of art, where its manifestation would become symbolic instead of real. Ortiz worked to show that destruction did not become art; rather, art constituted an arena within which destruction was itself transformed into a sacrificial process. This process sought to release both the man-made object and the human subject from the constrained, rationalized form and self of Western culture. In the 1960s a collection of archaeological works–in which he peeled away the outer layers of such things as mattresses, chairs, sofas, and pianos–was made part of the permanent collections of such museums as New York's Museum of Modern Art and Whitney Museum of American Art.

In the early 1970s Ortiz's acts of physical violence and animal sacrifice could not be contained within a symbolic art context, thereby appearing to represent yet another manifestation of actual destruction. Combining elements of psychoanalysis, physiology, philosophy, and maternal spiritualism, Ortiz developed a theory he coined ''Physio-Psycho-Alchemy.'' He also turned away from the practice of destruction in his art. In a mix of performance, therapy, meditation, and ritual, Ortiz addressed the body, encouraging participants to serve as both art and artist through their own ''inner visioning'' or ''authenticating communion'' of body, mind, and spirit. He sought a space within which art could transform social relations.

Ortiz also turned to the computer, digital imaging systems, and video, shifting his attention to the deconstruction of Hollywood texts.

His recycled films are unique within the tradition of avant-guard cinema. Using ritual sacrifice to, in his words, ''redeem the indigenous wound'' effected by the West, Ortiz used a tomahawk to hack apart 16 mm prints of films, place the fragments in a medicine bag, and shake it while issuing a war chant. When he had released the evil, he arbitrarily pulled out pieces and spliced them together, regardless of their orientation. Two that he created were *''Cowboy'' and ''Indian'' Film,* a recycling of Anthony Mann's *Winchester '73* (1950), and *Newsreel,* which featured the pope's blessing of a crowd, the Nuremberg trials, and the explosion of an atomic bomb in the Pacific. The effect from these random imagistic sequences and sound fragments was a disruption of the very genres and forms from which the art was constructed. In his film *Golf,* Ortiz used a punch to make random holes in an instructional golf film. The effect was both an elaborate pun on a symbol of upper-middle-class leisure and passivity and also a theoretical study of space: ''Golf was the result of my attempt to make space in the frame, space that was on-film space, that would take over the film space. With each random hole punch, I chanted, 'Emptiness is fullness.'''

In the 1980s Ortiz turned to the computer as a mode for further exploring theoretical concerns about space. His work involved 1-to-10-second passages of Hollywood films on laser disc that he manipulated through a computer program by using joysticks, allowing him to accelerate and decelerate at different speeds, sometimes as slow as a frame at a time, while he watched on a monitor. He used a waveform generator to further affect the sound, sometimes fracturing words and producing new words. He transferred the finished pieces, some of which took six months to produce, to video. He has described the finished effect as a ''holographic'' articulation within the Hollywood text but as also being outside the perceptual field and linear practice of the mass media.

In 1969 Ortiz founded El Museo del Barrio, the first Hispanic art museum in the United States. Although he faced criticism from many peer artists-activists who placed their emphasis on encouraging community-based cultural centers, alternative spaces, and vernacular aesthetics, Ortiz asserted that the need to intervene within the institutional space of the art world was also vital. In his own work, however, he challenged that space and its traditional definition of art in illuminating and representing ritual, performance, and contemporary social activities as art objects. Still, as if in opposition to a postmodern breakdown of categories, he has continued to articulate the need for his work to be contained within an art context rather than being disseminated loosely in the broader world. Both because of and in spite of its being housed within an artistic context, his work excites and falls between the categories he has engaged: modernism and postmodernism, the avant-guard and mainstream, a racial minority and the dominant culture.

—Martha Sutro

OSORIO, Pepón
American sculptor, painter, and installation artist

Born: Benjamín Osorio Encarnación, Santurce, Puerto Rico, 1955. **Education:** Universidad Inter-Americana, Rio Piedras, Puerto Rico, 1974; Herbert H. Lehman College, Bronx, New York, B.S. 1978;

Pepón Osorio: *Father's Prison Cell,* "Badge of Honor," detail, 1995. Photo by Sarah Wells; courtesy of Ronald Feldman Fine Arts, New York.

Columbia University, New York, M.A. in art education 1986. **Career:** Worked as a social worker and as a stage designer for the theatre, New York, early 1980s. Artist-in-residence, El Museo del Barrio, New York, 1989–91, Park Avenue Shelter for Homeless Women, 1993, Museum of Contemporary Art, Los Angeles, 1993, Walker Art Center, Minneapolis, 1994, Center for the Arts at Yerba Buena Gardens, San Francisco, 1996, Manchester Craftsmen's Guild, Pittsburgh, 1997, Center for Innovative Print & Paper, Department of Visual Arts, Rutgers University, New Brunswick, New Jersey, 1998; visiting faculty member, Rhode Island School of Design, Providence, 1993, Cleveland Art Institute, 1993; visiting artist, Skidmore College, Saratoga Springs, New York, 1995, California State University at Monterey Bay, California, 1996, Tyler School of the Arts, Temple University, Philadelphia, 1996, Skowhegan School of Painting and Sculpture, Maine, 1998, University of Hawaii, Honolulu, 1998. Also worked as a dance performer and costume designer. **Awards:** New York Dance and Performance Bessie award, 1985; fellowship, National Endowment for the Arts, 1988; fellowship, Krasner Pollack Foundation, 1988; fellowship, Theatre Communications Group and National Endowment for the Arts, 1990; Intercultural Film/Video fellowship, Rockefeller Foundation, 1993; Lila Wallace Arts Partners International Artist Program, 1993; Louis Tiffany Comfort award, 1993; artist fellowship in sculpture, New York Foundation for the Arts, 1995; Lynn Blumenthal Memorial Fund, 1996; Mid-Atlantic Arts Foundation residency award, Fabric Workshop, Philadelphia, 1996; International Association of Art Critics award, 1996; artist's fellowship, Joan Mitchell Foundation, 1996; Cal Arts/Alpert award for visual arts, 1999; fellowship, MacArthur Foundation, 1999; Skowhegan medal for sculpture, 2001. **Address:** c/o Ronald Feldman Fine Arts, 31 Mercer Street, New York, New York 10013.

Individual Exhibitions:

1985 *Ah, Great Power of God!,* Hostos Center for the Arts and Culture, Hostos Community College, Bronx, New York

1991 *Pepón Osorio: Con to' los hierros,* El Museo del Barrio, New York (retrospective)

1992 *The Wake: Aids in the Latino Community,* Pennsylvania Academy of Fine Arts, Philadelphia
 Historias, University of the Arts, Samuel S. Fleisher Art Memorial, Philadelphia

1993 *Scene of the Crime (Whose Crime?),* Cleveland Institute of Art

1994 *No Crying Allowed in the Barbershop,* Real Art Ways, Hartford, Connecticut

1995 *Project 5: Pepon Osorio-Badge of Honor,* Storefront, Newark, New Jersey (traveled to Newark Museum, New Jersey)

1996 *Bi-lingua-lismo,* Museo de Pedro Albizu Campos, Chicago *Pepon Osorio,* Galerie OZ, Paris
 Badge of Honor, Ronald Feldman Fine Arts, New York (traveling)
 En la barberia no se llora, Tyler School of Art, Temple University, Elkins Park, Pennsylvania

1997 *Pepon Osorio,* Otis Gallery, Otis College of Art and Design, Westchester, California
 El cab, South Bronx and Manhattan, New York (traveling art project)

1998 *Las Twines,* Las Twines Storefront and Hostos Art Gallery, Bronx, New York
 Pepon Osorio, Espacio Uno, Museo Nacional Centro de Arte Reina Sofia, Madrid
 Sala seis: Pepón Osorio, Museo Alejandro Otero, Caracas

1999 *Transboricua,* RISD Museum, Providence, Rhode Island
 Fear and Denial & Las Twines, Ronald Feldman Fine Arts, New York
 Pepon Osorio: Transboricua, El Museo del Barrio, New York

2000 *Pepón Osorio: Door to Door,* Escuela de Artes Plásticas, Museo de San Juan, Museo de Arte Contemporáneo de Puerto Rico, and Museo de Arte de Puerto Rico

Selected Group Exhibitions:

1995 *Ceremony of the Spirit,* Mexican Museum, San Francisco (traveling)
 Reclaiming Popular Culture, El Museo del Barrio, New York
 Art at the Edge: Social Turf, High Museum of Art, Atlanta
 Archeological Urban Data, Whitney Museum of American Art, Champion, Stamford, Connecticut

1996 *American Kaleidoscope: Themes and Perspectives in Recent Art,* Museum of American Art, Smithsonian Institution, Washington, D.C.

1997 *VI Cuban Bienniale,* Havana
 American Stories–Amidst Displacement and Transformation, Chiba City Museum of Art, Chiba, Japan (traveling)

1999 *Urban Mythologies: The Bronx Represented since the 1960s,* Bronx Museum of the Arts, New York
 The Rescue: Eight Artists in an Archive, International Center of Photography Midtown, New York

2000 *Representing: A Show of Identities,* Parrish Art Museum, Southampton, New York

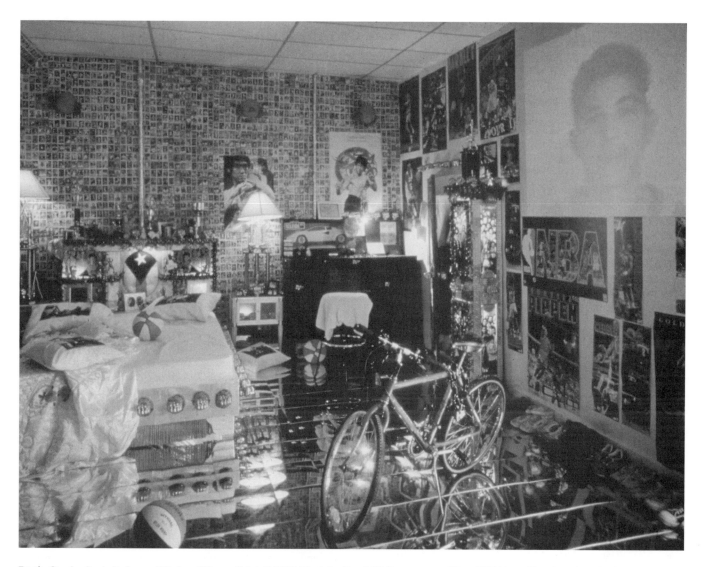

Pepón Osorio: *Son's Bedroom,* "Badge of Honor," detail, 1995. Photo by Sarah Wells; courtesy of Ronald Feldman Fine Arts, New York.

Collections:

El Museo del Barrio, New York; Bronx Museum of the Arts, New York; National Museum of American Art, Washington, D.C.; Newark Museum, New Jersey; Walker Center for the Arts, Minneapolis; Wadsworth Atheneum, Hartford, Connecticut; Whitney Museum of American Art, New York; Smithsonian National Museum of American Art, Washington, D.C., Museo de Arte de Puerto Rico.

Publications:

On OSORIO: Books—*Con to' los hierros: A Retrospective of the Work of Pepón Osorio,* exhibition catalog, text by Petra Barreras del Rio and others, New York, El Museo del Barrio, 1991; *American Kaleidoscope: Themes and Perspectives in Recent Art,* exhibition catalog, Washington, D.C., National Museum of American Art, Smithsonian Institution, 1996; *Pepón Osorio: Badge of Honor,* exhibition catalog, text by Luis Aponte-Parés, Joseph Jacobs, and Berta M. Sichel, Newark, New Jersey, Newark Museum, 1996;

American Stories: Amidst Displacement and Transformation, exhibition catalog, text by Yukiya Kawaguchi and others, Tokyo, Setagaya Art Museum, 1997; *Do It,* exhibition catalog, text by Bruce Altshuler, New York, Independent Curators, 1997; *Representing: A Show of Identities,* exhibition catalog, Southampton, New York, Parrish Art Museum, 2000; *Contemporary Puerto Rican Installation Art* by Laura Roulet, San Juan, University of Puerto Rico, 2000. **Articles**— "Pepón Osorio: Otras voces, otros ambientes" by Juan Bujan, in *La voz hispana,* May 1981; "Un artista informalista," in *El diario/La prensa,* June 1982, and "Pepón Osorio: Un puertorriqueño en Nueva York," in *El diario/La prensa,* 14 May 1991, both by Dora Rubiano; "Pepón Osorio" by Celeste Olalquiades, in *MAS,* 1989; "Broken Hearts: Views Puerto Rican Soul" by Marc Shugold, in *Rocky Mountain News,* July 1991; "Pepón Osorio" by Hovey Brock, in *ARTnews,* 90, October 1991; "Pepón Osorio" by Jennifer P. Borum, in *Artforum,* November 1991; "La guerra de las nostalgias: Pepón Osorio con to' los hierros" by Caledonio Abad, in *Claridad en rojo,* October 1991; "Extravagance and Sadness: The Nuyorican Art of Pepón Osorio" by Jonathan Mandell, in *New York Newsday,* 20 June 1992, pp. 68–69; "Pepón Osorio," in *Art Nexus* (Bogota), January

1995, "Nova arte altera relacoes entre paises," in *O estado de São Paulo,* 5 November 1995, and interview, in *Atlántica,* 12, winter 1995–96, all by Berta Sichel; "Imagine Community, Video in the Installation Work of Pepón Osorio" by Ana Tiffany Lopez, in *College Art Journal,* winter 1995; "Pepón Osorio" by Thad Ziolkowski, in *Artforum,* XXXV(3), November 1996, pp. 97–98; "Pepón Osorio" by Kim Levin, in *Village Voice,* 7 May 1996; "Pepón Osorio: Mas is More" by Anna Indych, in *Grand Street 62,* 16(12), fall 1997, pp. 112–117; "Pepón Osorio" by David Blatherwick, in *Parachute* (Montreal), 85, January-March 1997, pp. 65–66; "Neurotic Imperatives: Contemporary Art from Puerto Rico" by Marimar Benítez, in *Art Journal,* 57(4), winter 1998, pp. 74–85; "Yes, We Have Pepón" by Maximillian Potter, in *Philadelphia,* November 1999; "El genio de Pepón" by Luz Martinez, in *El diario,* 1 July 1999, pp. 24–25; "Artist Pepón Osorio Speaks at RISD about His Latest Work" by Bobbi Iervolino, in *Herald Sphere,* 3 March 1999; "The Secret of His Excess" by Nancy Hass, in *ARTNews,* 98(6), June 1999, pp. 96–99; "Granted, He's a Genius But Artist Shies from Saying So" by Carolina Gonzalez, in *Daily News,* 26 June 1999; "Pepón Osorio: Redefining the Boundaries for Installation" by Julia A. Herzberg, in *Art Nexus,* 35, May-July 2000, pp. 56–63; "Pepón Osorio" by Manual Alvarez Lezama, in *Art Nexus,* 39, February-April 2001, pp. 144–145.

* * *

Pepón Osorio was born Benjamín Osorio Encarnación in 1955 in Santurce, Puerto Rico. He acquired the nickname Pepón from his schoolmates before moving to New York City in 1975. Collaborating with artists Patti Bradshaw and Merián Soto, Osorio began producing his first installations in the form of stage sets for dance performances in 1979. From 1981 to 1985 he continued his work in stage design and began exhibiting abstract work in both San Juan and New York City. During the same period Osorio served as a social worker for children and pursued a degree in art education at Columbia University Teacher's College, receiving an M.A. in 1986. His combined interests in social justice, community activism, history, and cultural identity can be seen in the elaborate installation art for which he is best known today.

Osorio's art reached a turning point in 1985 when, abandoning early experiments with abstraction, he developed a highly iconographic aesthetic of assemblage. His first ornamental work, *La Bicicleta* (1985), appeared as a prop in the performance *Cocinado,* for which Osorio received a New York Bessie award in stage design. Childhood memories inspired the artist to adorn a working bicycle with plastic palm trees, flowers, fish, garlands of pearls, ribbons, and toys, covering every surface with vibrant colors and decorative motifs. A symbol of youthful fantasies and a transformation of cast-off consumer culture, *La Bicicleta* reflects the artist's interpretation of a working class capacity to make something from nothing. Moreover, the work initiated the artist's historical and conceptual investigation into Puerto Rican and Nuyorican popular culture. For subsequent works, such as *El Chandelier* (1987) and *La Cama* (1987), the artist employed the same aesthetic of decorative elaboration to create more explicitly autobiographical and narrative works. A mix of mass-produced objects, personal relics, and religious symbols, Osorio's work was occasionally misread by the mainstream art press as "postmodern kitsch." Instead, the work is comparable to that of other Carribean, Mexican, and Latino artists who seek to represent a complex, hybrid cultural reality through a carefully calculated display of artifacts.

Combining the visual and material elements of his early sculptural work with his knowledge of set design, Osorio developed highly elaborate room-size installations that comprise his major works to date. In the context of a postconceptual resurgence of installation art in the 1990s, Osorio's work was uniquely positioned among innovations in gallery art and new genre public art. *Scene of the Crime (Whose Crime?),* the first of these installations, exhibited at the Whitney Museum of American Art Biennial in 1993. Osorio's installation criticizes the social construction of Latino stereotypes in the "scenes" of mass media and Hollywood cinema, while also implying that these cinematic fantasies result in real domestic violence. For the works that followed, including *En la Barbería No Se Llora* (1994), *Badge of Honor* (1995), and *Las Twines* (1998), Osorio worked collaboratively with Puerto Rican communities in the conception, design, and construction of installations that were shown first in local neighborhoods before being exhibited in museums and galleries. *En la Barbería No Se Llora* explores the reproduction of masculinity in the context of a traditional barbershop setting, complete with barber chairs and free haircuts for visitors off the street. *Badge of Honor,* depicting a father's prison cell and a son's bedroom, offers a stark contrast between institutional and private spaces. Exploring the effect of incarceration on family relations, the artist videotaped a real son at home and his father in prison, projecting their poignant dialog so that each appears to be speaking from his own room. For *Las Twines* Osorio presented a haunting video installation and sculptural portrait of orphaned twin sisters, one black and one white, revealing the social complexities of racial mixing and paternal anonymity.

Like his sculptural works, Osorio's large-scale installations contain a rich repertoire of visual references. The colors red, white, yellow, and blue that dominate the decor in several installations are also meant to recall, for example, the Puerto Rican flag or the Santeria deities Obatala, Ogun, Oshun, and Yemaya. The furniture and walls come alive with silk-screen photographs of faces or expressive video projections. Because Osorio's installations stage "scenes" that are both familiar and surreal, densely packed with *chucherías* ("knick-knacks"), historical artifacts, and visual puns, viewers are invited to decipher layers of semiotic detail while also considering the larger social and political issues the work raises concerning daily life in their own communities.

Osorio was the recipient of the prestigious MacArthur Fellowship in 1999. His sculptures and installations have been collected by Whitney Museum of American Art, Smithsonian National Museum of American Art, Museo de Arte de Puerto Rico, and Walker Art Center. After working 25 years in his studio in the South Bronx, New York, Osorio has been living and working in Philadelphia, Pennsylvania.

—Jennifer Gonzalez

OSPINA, Nadín

Colombian sculptor

Born: Bogota, 1960. **Education:** Universidad Jorge Tadeo Lozano, Bogota, 1979–82, M.A. 1984. **Family:** Married Mirella Cabrera in 1984; one daughter. **Awards:** Honorable mention, *Salón Arturo y*

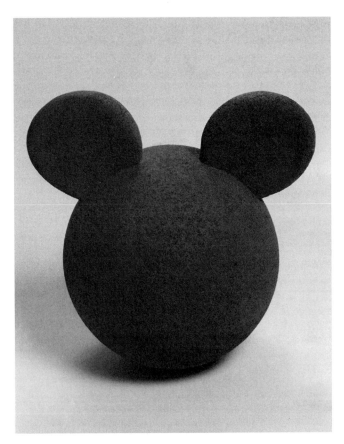

Nadín Ospina: *Idolo con calavera,* 1998. Photo by Luis Cruz; courtesy of the artist.

Nadín Ospina: *Esfera del Diquis,* 2000. Photo by Luis Cruz; courtesy of the artist.

Rebeca Rabinovich, Museo de Arte Moderno de Medellin, 1981; first prize, *Salón nacional de artistas,* 1992; fellowship, Guggenheim Foundation, 1997. **Agent:** Luis Fernando Pradilla, Cra 11, No. 93A-43, Bogota, Colombia, or Galería Arsnova XXI, Zurbano 11, Madrid, Spain. **Address:** Transversal 33C, #113–27, Bogota, Colombia. **E-mail Address:** Nadinospina@yahoo.com. **Website:** http://www.geocities.com/nadinospina/Nadin_Ospina.html.

Individual Exhibitions:

1992	*Nadín Ospina,* Galería Astrid Paredes, Caracas
1993	*Bizarros y críticos,* Galería de Arte 19, Bogota (traveling)
	Fausto, Galería Arte 19, Bogota
1996	*El gran sueño americano,* Galería Arte Contemporáneo, Mexico City
1998	*Instinto caribe,* Galería Nina Menocal, Mexico City
1999	*Trayectos visibles,* Museo de Arte de Pereira, Pereira, Colombia
	Viaje al fondo de la tierra, Museo de Arte Moderno de Bogota
2000	*Arqueología y turismo,* Galería El Museo, Bogota
	Arqueología y Mass Media, Galería Arsnova XXI, Madrid
2001	*Nadín Ospina,* Fabien Fryns Gallery, Marbella, Spain
	POP Colonialismo, Fundación Teorética, San Jose, Costa Rica

Selected Group Exhibitions:

1989	*XX bienal de São Paulo,* Parque do Ibirapuera, São Paulo, Brazil
1992	*Encountering the Others,* Halle K18, Kassel, Germany
1995	*II bienal de barro de América,* Museo de Arte Contemporáneo, Caracas, Venezuela
	Por mi raza hablará el espíritu, Museo del Chopo, Mexico City
1997	*Así está la cosa,* Centro Cultural Arte Contemporáneo, Mexico City
1998	*Transatlántico,* Centro Atlántico de Arte, Las Palmas de Gran Canaria, Spain
	The Garden of Forking Paths, Kunstforeningen, Copenhagen
2000	*Partage d'exotismes: 5a Biennale d'art contemporain de Lyon,* Halle Tony Garnier, Lyon, France
	XII bienal de la Habana, El Morro, Havana
2001	*XXXIX bienal de Venecia,* La Venezie, Venice

Collections:

Ludwig Forum, Aachen, Germany; Universidad de Essex, Colchester, England; Art Gallery of Western Australia, Perth; Museo de Bellas Artes, Caracas, Venezuela; Bass Museum, Miami; Fundacion Teoretica, San Jose, Costa Rica; Museo de Arte Moderno, Bogota; Museo de

Arte Contemporáneo, Bogota; Museo de Arte Moderno, Medellin; Biblioteca Luis Angel Arango del Banco de la República, Bogota.

Publications:

By OSPINA: Book—¿Mestizo yo?, Bogota, Universidad Nacional, 2000. **Article—**''Cumbre artistica en la habana,'' in Periodico El Espectador (Bogota), 5 June 1994.

On OSPINA: Books—Los criticos y el arte de los 90, exhibition catalog, text by Eduardo Serrano, Medellin, Museo de Arte Moderno, 1990; Constelaciones y trofeos emba/sanados, exhibition catalog, text by Axel Stein, Caracas, Galería Astrid Paredes, 1992; Fausto, exhibition catalog, text by Carlos Salas, Bogota, Galería Arte 19, 1993; La simulacion de Nadín y Simpson, exhibition catalog, text by Gil Javier, Bogota, Galería Arte 19, 1993; Domestic Partnerships, exhibition catalog, text by Carla Stellweg, New York, Art in General, 1996. **Articles—**''The End of the Solitude'' by Edward Shaw, in Art News (New York), October 1990; ''Mefistofeles y Fausto'' by Alvaro Medina, in El Espectador (Bogota), March 1994; ''Nadín Ospina. Galería Arte 19'' by Natalia Gutierrez, in Art Nexus (Bogota), April 1994; ''Novismo arte precolombino'' by Ruben Wisotzki, in Revista Estilo (Caracas, Venezuela), September 1995; ''Precolombino Postmoderno'' by Carolina Ponce de Leon, in Poliester (Mexico City), January 1995; ''Nadin Ospina'' by Ana Sokoloff Gutiérrez, in Art Nexus (Bogota), 22, October/December 1996, pp. 92–95; ''Nadín Ospina. Sincretismo estetico y cultural'' by Marcela Echavarria, in Harper's Bazaar (Mexico City), October 1998; ''Cultura canibal'' by Patricia Ruan, in Buen Vivir (Bogota), October 1998; ''Nadín Ospina–Mickey au pays des amérindies'' by Fabienne Fulcheri, in Fiac la Quotidien (Paris), September 1999; ''Nuevos Artistas,'' in Gatopardo (Bogota), August 2000; ''El exotismo pop'' by Eduardo Perez Soler, in Lapiz (Madrid), March 2001; ''(Per)versiones de Nadín Ospina'' by Tamara Diaz Bringa, in Ancora (San Jose, Costa Rica), April 2001.

* * *

The contemporary culture of globalization makes people share the same visual referents, and nowhere is this more evident than in consumer goods and in the icons of popular culture. Leaving apart ideological readings of such cartoon characters as Mickey Mouse or Bart Simpson, it remains true that they have exercised a persistent capacity to penetrate the global visual culture and that they have succeeded in incorporating themselves within daily life so that they are no longer experienced as signifiers of an ''alien'' culture. It is within this context that the Colombian artist Nadín Ospina, born in 1960, has worked.

After a period of working with sculptures in polyester resin–vividly colored and textured pieces, mostly of animals in stylized, geometrical arrangements–Ospina's art took a radical shift. At the National Salon of 1992 he presented In partibus infidelium, a museum-like environment in which he showed fake pre-Columbian artifacts in the mode of display normally used by archaeological museums. It was the beginning of a large body of work for which he has gained international attention. Ospina hired forgers of pre-Columbian pottery to make his pieces. He used not just artisans but real forgers of fake pieces, that is, people with practice in making pieces out of the same clay, with the same iconography, and with the same age-old procedures as those by pre-Columbian Indians. Providing them

with small plastic images of cartoon characters, he asked them to integrate some of the characters' salient features into the fake pieces. This body of work, what the Colombian critic Carolina Ponce de León has appropriately termed ''pre-Columbian postmodern,'' raises important questions with regard to the contemporary status of the original versus the copy, popular versus high art, and art objects versus artifacts, as well as appropriation and authorship.

For Viaje al fondo de la tierra, with research sponsored in part by a Guggenheim Fellowship, Ospina enlarged the scope of his project, hiring professional artists to help him construct a verisimilar context for his fake pieces. The departing point was an exhibition on the German voyagers Wilhelm Stübbel and Alphons Reiss, who went to South America at the end of the nineteenth century, following in the path of Alexander von Humboldt. Ospina was fascinated with the fact that the draftsmen and engravers who had made the detailed drawings and printing plates for the books that Stübbel and Reiss published after their return to Europe had never seen the original objects or landscapes they depicted with such accuracy. The idea was to reverse the procedures of archaeology: to infer a reality (in this case, nonexistent) from its (fake) representations. Giving them only very general guidelines, Ospina let the artists develop their own works in several techniques (oil painting, drawings, digital prints), the results of which were shown at the Museo de Arte Moderno de Bogotá in 1999.

Ospina's work also raises the question of ideological colonialism and the resistance to it by means of cultural cannibalism, eating the other in order to assimilate him in the process. As Ospina has stated, ''Beyond the aesthetic admiration and archaeological interest that I have for these pieces of unquestionable value, what really interests me are manifestations such as grave digging and forgeries that reveal contemporary cultural and social phenomena: mechanisms of surviving in the midst of misery, abuses of power and corruption that permit the external flow of pieces, simulations and tricks to fool tourists desperate for cultural souvenirs, pillage and depredation on the part of collectors and international institutions, a loss of the patrimony and identity of a society that is replaced by the most mediated consumer goods.''

Ospina's work has been shown extensively, and he has represented Colombia in the São Paulo and Havana biennials. He had a large museum-like installation in the Fifth Biennale de Lyon under the broad title Partage d'exotismes, curated by the French critic Jean-Hubert Martin.

—José Roca

OSSORIO, Alfonso
American painter

Born: Manila, Philippines, 2 August 1916; immigrated to the United States, naturalized citizen, 1939. **Education:** St. Richard's School, Malvern, Worcestershire, England, 1924–30; Portsmouth Priory, Providence, Rhode Island, 1930–34; Harvard University, Cambridge, Massachusetts, 1934–38, B.A. 1938; Rhode Island School of Design, Providence, Rhode Island, 1938–39. **Military Service:** United States Army, 1943–46. **Family:** Married Bridge Hubrecht in 1940. **Career:** Lived in Taos, New Mexico, 1940–42, then settled in New York; traveled to Paris, 1949; spent summers in Greece and Turkey, beginning in 1964. Installed l'Art Brut collection in his East Hampton

Alfonso Ossorio: *Double Portrait,* 1944. © Smithsonian Art Museum, Washington, D.C./Art Resource, NY.

home, 1952; organized exhibition series at Executive House, New York, 1956–58; cofounder, Sigma Gallery, East Hampton, New York, and organizer of summer exhibitions there, 1957–60; exhibited l'Art Brut collection at Cordier and Warren Gallery, New York. **Died:** 6 December 1990.

Individual Exhibitions:

1941	Wakefield Gallery, New York
1943	Wakefield Gallery, New York
1945	Mortimer Brandt Gallery, New York
1951	Studio Paul Facchetti, Paris
1951	Betty Parsons Gallery, New York
1953	Betty Parsons Gallery, New York
1956	Betty Parsons Gallery, New York
1958	Betty Parsons Gallery, New York
1959	Betty Parsons Gallery, New York
1960	Galerie Stadler, Paris
1961	Betty Parsons Gallery, New York
	Galerie Stadler, Paris
	Selection, Cordier and Warren Gallery, New York
	Galerie Cordier-Stadler, Frankfurt, Germany
1963	Cordier and Eckstrom Gallery, New York
1965	Cordier and Eckstrom Gallery, New York
1967	Cordier and Eckstrom Gallery, New York
1968	Cordier and Eckstrom Gallery, New York
1969	Cordier and Eckstrom Gallery, New York
1972	Cordier and Eckstrom Gallery, New York
1980	Guild Hall Museum, East Hampton, New York
1984	Oscarsson Hood Gallery, New York

Selected Group Exhibitions:

1958	*International Sky Festival,* Osaka, Japan
1968	*The Door,* Museum of Contemporary Crafts, New York
1976	*14 Paintings: De Kooning, Dubuffet, Ossorio, Pollock, Still,* Thomas GibsonFine Art, London

Collections:

Museum of Modern Art, New York; Whitney Museum, New York; Solomon R. Guggenheim Museum, New York; Metropolitan Museum of Art, New York; New York University; Wadsworth Atheneum, Hartford, Connecticut; Brandeis University, Waltham, Massachusetts; Philadelphia Museum of Art; International Center of Aesthetic Research, Turin, Italy; Boymans-van Beuningen Museum, Rotterdam.

Publications:

By OSSORIO: Books—*Poems and Wood Engravings,* London, 1934; ''Jackson Pollock,'' in *Pollock,* exhibition catalog, New York, 1951, reprinted in *Pollock,* exhibition catalog, Paris, 1952, and in *15 Americans,* exhibition catalog, New York, 1952, and in *The New American Painting,* exhibition catalog, New York, 1959; *Exhibition of Recent Paintings by Lee Krasner,* exhibition catalog, New York, 1960; *John Little Paintings,* exhibition catalog, New York, 1961; *Art Brut,* exhibition catalog, New York, 1961; ''Michael Lekakis,'' in *Americans 1963,* exhibition catalog, New York, 1963; ''Notes,'' in *14 Paintings: De Kooning, Dubuffet, Ossorio, Pollock, Still,* exhibition catalog, London, 1976. Articles—''One Man's Art U.S.A.,'' in *Artnews* (New York), October 1956; ''The House of the Hourloupe,'' in *Artnews* (New York), May 1968.

On OSSORIO: Books—*Les Peintures initiatiques d'Alfonso Ossorio* by Jean Dubuffet, Paris, 1951; *Ossorio* by Michael Tapie, Turin, 1961; *Ossorio: A Selection,* exhibition catalog, New York, 1961; *Art in Progress: The Visual Development of a College by Alfonso Ossorio* by B. H. Friedman, New York, Abrams, 1973. Articles—''We Visit the Artist Alfonso Ossorio'' by Louise Elliot Rago, in *School Arts* (Worcester, Massachusetts), April 1960; ''Alfonso Ossorio: A Biography, Mostly of His Work,'' in *Art International* (Zurich), April 1962, and ''Alfonso Ossorio,'' in *Art International* (Lugano, Switzerland), February 1967, both by B. H. Friedman; ''Ossorio'' by Simone Frigerio, in *Aujourd'hui: Arts et architecture* (Paris), May 1963; ''The Artist as Collector: Alfonso Ossorio'' by Kenneth B. Sawyer, in *Studio International* (London), March 1965; ''The Diabolic Craft of Alfonso Ossorio'' by Richard Howard, in *Craft Horizons* (New York), January/February 1967; ''Ossorio the Magnificent'' by Francine de Plessix, in *Art in America* (New York), March/April 1967; ''Alfonso Ossorio: La mia collezione e una fabbrica di idee,'' in *Bolaffiarte* (Turin, Italy), January 1974; ''Ossorio'' by Peter Blake, in *Architecture Plus* (London), January/February 1974. Films—*Galaxy* by Gregory Markopoulous, 1966; *The Artist: His Work and His Studio* by Terry Krumm, 1969.

* * *

During a career that spanned four decades, Alfonso Ossorio had his work approached critically from two viewpoints, neither of which was incorrect but which, rather, were overlapping. First, he has been historically placed among the first generation of abstract expressionists, a view supported by Ossorio's close, enduring friendship with Jackson Pollock, whose influence can indeed be seen in the surrealist ink drawings Ossorio produced during the 1940s. Second, much has been rightly made of his relationship with the French artist Jean Dubuffet, whose abiding fascination with *art brut* (raw art) closely paralleled Ossorio's if it did not precisely influence it. Ossorio's development incorporated these elements into his work, but it was not, as has been suggested, derivative of them.

In fact, Ossorio occupied a unique position, one that frequently aroused controversy no matter what medium or style he engaged: combinations of wax, watercolor and collage, and white lead and plaster; diagrammatic, neoconstructivist paintings that used and twisted the physical pigment itself into ropelike reliefs; and, from the 1950s, complex sculptural wall constructions and freestanding pieces incorporating such specialized detritus as bones, glass eyes, pieces of tree trunks, and mirrors. The work has been described as ''primitive,''

''barbaric,'' ''voodoo-like.'' The critical emphasis has been placed almost entirely upon the materials themselves–not by the artist, although he was well aware of their connotations of violence, mutilation, and death–rather than on the iconography, frequently anthropomorphic, that subsumes them.

When Ossorio used the term ''congregated imagery,'' he did so advisedly to separate his work from the more popular and possibly inaccurate genre of assemblage, or relief construction. The term implies a cerebral gathering of materials, not a celebration of the found object. These congregations are often highly decorative but are motivated by an intellectual, even mystical concern rather than a purely visual one. If his colors are violent and his use of materials visceral, it is because he was attempting to give, in Dubuffet's words, ''body to conceptual ideas–to the point of making them pass completely into the field of material objects–and at the same time preventing the real things he wants to represent from materializing too much.'' The final product was, of course, frequently horrifying, although presenting more declarations of hope than are often seen in such work.

Ossorio's is also an immensely sophisticated body of work, ''borrowing'' from oriental art, sometimes testing new industrial materials like the plastic sheeting he experimented with in 1968, at others reinterpreting the Christian and pagan myths of death and resurrection. Although bearing similarities to the best of *art brut* as practiced by the insane and the imprisoned, Ossorio's work indicates a calculated thoughtfulness that can come only from a professional draftsman and an artist learned in mythic and formal history. The content is demanding, compelling. It is not automatic at all but complicated, difficult to ''read,'' frequently relying on a combination of a visual vocabulary specifically chosen to evoke atavistic responses and an ordered control that ''marks'' these very emotive elements through complicated design.

Although Ossorio's style and materials altered throughout the years, these concerns bound all of the different phases of his work indissolubly. In fact, he frequently used elements from earlier pieces in new ''congregations,'' a ''reclamation'' as he termed it. He returned from time to time to generalized figuration, using a piece of a tree trunk or a glass eyeball from another, earlier piece; similar components echo each other from separate periods of his evolution as an artist. Starfish, bones, feathers, fragments of anatomical photographs emerge, disappear, and reemerge from work to work. Past, present, and even future combine, dissipate, and reassemble in an esoteric yet somehow recognizable fashion in an insinuating blend of repulsion and attraction.

—Jane Bell

OTERO, Alejandro
Venezuelan painter and sculptor

Born: Manteco, Bolivar, 7 March 1921. Education: Studied architecture, Maracay State, Paraguay; Escuela de Artes Plásticas y Aplicadas Cristóbal Rojas, Caracas, 1939–45; traveled to Paris on Venezuelan government scholarship, 1945–52. Career: Worked as an art instructor, c. 1950; coordinator, Museo de Bellas Artes, Caracas, 1959–60. Traveled to Paris, 1960–64. Vice president, National Institute of Culture and Bellas Artes, Caracas, mid-1960s. Helped establish the Gallery of National Art, Caracas, 1976. Member, artist

group *Los Disidentes,* Caracas, 1950s. **Awards:** National Painting prize, *XIX annual official hall Venezuelan Art,* 1958; fellowship, John Simon Guggenheim Memorial Foundation, 1971. **Died:** Caracas, 13 August 1990.

Individual Exhibitions:

1948	Pan American Union, Washington, D.C.
1949	Museo de Bellas Artes, Caracas
1966	Signals Gallery, London (retrospective)
1976	Museo de Arte Moderno, Mexico City (retrospective)
1986	Museo de Arte Contemporáneo, Caracas (retrospective)
1987	Museo de Arte Moderno Jesús Soto, Bolívar, Venezuela
1994	Museo de Artes Visuales Alejandro Otero, Caracas

Selected Group Exhibitions:

1939 *Latin American Exhibition of Fine Arts,* Riverside Museum, New York

1955 *Pittsburgh International,* Carnegie Institute

1957 Museum of Modern Art, New York

1959 *South American Art Today,* Dallas Museum of Fine Arts
 The United States Collects Latin American Art, Art Institute of Chicago

1961 *Latin America: New Departures,* Institute of Contemporary Art, Boston

1964 Solomon R. Guggenheim Museum, New York

1966 *Art of Latin America since Independence,* Yale University, New Haven, Connecticut, and University of Texas, Austin

1967 *Latin American Art: 1931–1966,* Museum of Modern Art, New York

1989 *The Latin American Spirit: Art & Artists in the U.S.,* Bronx Museum, New York

Collections:

University of Arizona, Tucson; Dallas Museum of Fine Arts; Museum of Modern Art, New York; Museum of Modern Art of Latin America, Washington, D.C.; National Air and Space Museum, Washington, D.C.; Museum of Modern Art, Bogota; Museum of Contemporary Art Sofia Imber, Caracas.

Publications:

On OTERO: Books—*Alejandro Otero* by Francois Sego, Paris, G. Lévis Mano, 1948; *I Bienal Nacional de Arte de Guayana: Homenaje a Alejandro Otero,* exhibition catalog, Bolívar, Venezuela, Museo de Arte Moderno Jesús Soto, 1987; *Lineas de luz: Escultural virtuales de Alejandro Otero,* exhibition catalog, Caracas, Museo de Artes Visuales Alejandro Otero, 1994.

* * *

Alejandro Otero was one of the most important artists of the kinetic art movement that took place in Venezuela during the 1950s and '60s and included artists such as Jesús Rafael Soto and Carlos Cruz-Diez. These artists were interested in creating optical illusions of vibration and movement through careful juxtapositions of colors in their work. Otero was one of several Venezuelan artists who visited Paris during the mid-1940s in search of modern artistic styles. Inspired by the cubist work of Pablo Picasso, he began painting a

series of coffeepots and other household objects that attempted to capture the reflections on their shiny surfaces, in the process focusing more and more on light and color until the form was lost completely. Upon returning from Paris in 1949, Otero exhibited his coffeepot series at the Museo de Bellas Artes in Caracas. Here his paintings provoked a great deal of controversy because the objects depicted had been abstracted to the point where they consisted only of a few lines and patches of color.

About 1950 several of the Venezuelan artists who studied in Paris, including Omar Carreño, Rubén Nuñez, Mateo Manaure, and Otero himself, began referring to themselves as Los Disidentes after they returned to Venezuela. They produced a journal of the same name that was circulated in Venezuela and Paris, and they published the *Manifesto de los NO,* in which they declared their opposition to conservatism in Venezuelan art. They specifically targeted the Escuela de Artes Plásticas in Caracas for its reliance upon outdated teaching methods based on nineteenth-century European artistic practices. Such ideas came out of Otero's writings, which were published in the *Los Disidentes* journal, creating the group's ideological focus. Eventually Los Disidentes were successful in influencing the modernization of Venezuelan art, particularly as precursors to the kinetic art movement. When the architect Carlos Raúl Villanueva was selected to design the new University City in Caracas, he chose many of the artists of the dissident group, including Otero, to create smaller artistic projects for individual sites.

On a trip to New York, Otero came in contact with the work of Piet Mondrian for the first time. The painting *Broadway Boogie Woogie* was especially influential in inspiring Otero to embrace a more geometric abstraction. In 1951 Otero began experimenting with colored strips of paper that he glued onto a square background, achieving brightly colored gridlike formations. These collages gradually evolved into the *Colorritmos,* which consists of vertical parallel black and white bands with interspersed blocks of color that were painted on long rectangular sheets of wood. By placing them between strips of dark and light, Otero made the colors in these works appear to be vibrating. Unlike the carefully formulated scientific studies of color perception conducted by Cruz-Diez and Soto, Otero's *Colorritmos* are informal and intuitive.

While Soto and Cruz-Diez concerned themselves with the illusion of movement through juxtapositions of color, Otero created a wide variety of sculptures and even stained-glass works that function in harmony with nature and often actually move instead of just appearing to do so. Inspired by Villanueva's ideas about integrating the fine arts with architecture, Otero wished to do the same, going one step further and integrating the arts with nature. He made a series of sculptures that incorporate aspects of industrial design and have parts that move in response to changes in the weather. These sculptures are often colossal in scale and consist of metal frameworks or towers that have plates or blades mounted on them that rotate in the wind or rain. Many of these projects were public art commissions that were gifts from the Venezuelan government to other countries, such as *Abra solar* (''Solar Wing,'' 1981), a gift to Colombia. In 1977 Otero created *Delta solar,* a triangle-shaped grouping of modules mounted over a reflecting pool that was a gift to the Smithsonian Air and Space Museum to commemorate the U.S. bicentennial. By placing his sculptures outdoors and subjecting them to the elements, Otero created a technologically inspired art that worked with nature instead of in opposition to it.

—Erin Aldana

PACHECO, María Luisa
Bolivian painter and mixed-media artist

Born: María Luisa Dietrich Zalles, La Paz, 22 September 1919. **Education:** Academia de Bellas Artes, La Paz, 1934; Academia de San Fernando, Madrid, 1951–52. **Family:** Married 1) Victor Pacheco Iturrizaga in 1939 (divorced), one son and one daughter; 2) Fred Bernard in 1961 (divorced 1975). **Career:** Illustrator, *La Razon* newspaper, La Paz, 1948–50; painting instructor, Academia de San Fernando, Madrid, 1951–52, and Escuela de Bellas Artes, La Paz, c. 1953; illustrator, *Life* magazine, New York, c. 1956; textile designer, New York, 1959. Traveled in Africa, 1952; lived in New York, 1956–82. Cofounder, Ocho Contemporaneos, 1953. **Awards:** First prize, *Municipal Salon,* La Paz, 1953; painting award, *Hispano-American Biennial,* Havana, 1954; fellowship, John S. Guggenheim Memorial Foundation, 1957, 1959, 1960; painting award, *São Paulo bienal,* 1959. **Died:** New York, 21 April 1982.

Individual Exhibitions:

1953	Galeria Nascimento, Santiago, Chile
1954	Galeria Plástica, Buenos Aires
1956	Galería Sudamericana, New York
1957	Pan American Union, Washington, D.C.
1958	Galería Sudamericana, New York
1961	Instituto de Arte Contemporáneo, Lima
1962	Rose Fried Gallery, New York
1965	Bertha Shaefer Gallery, New York
1966	Instituto de Arte Contemporáneo, Lima
1967	Bertha Shaefer Gallery, New York
1968	Zegri Gallery, New York
	Sala Mendoza, Eugenio Mendoza Foundation, Caracas
1971	Lee Ault Gallery, New York
1974	Lee Ault Gallery, New York
1976	Museo Nacional de Arte, La Paz
1977	Lee Ault Gallery, New York
1980	Lee Ault Gallery, New York
	Galería Buchholz, Bogota, Colombia
1986	Museum of Modern Art of Latin America, Washington, D.C. (retrospective)
1993	Museo Nacional de Arte, La Paz

Selected Group Exhibitions:

1958	Dallas Museum of Fine Arts
1959	Pan American Union, Washington, D.C.
	South American Art Today, Dallas Museum of Fine Arts
1960	*The United States Collects Latin American Art,* Art Institute of Chicago
1963	Institute of Contemporary Arts, Washington, D.C.
1965	*Magnet: New York,* Bonino Gallery, New York
	The Emergent Decade, Solomon R. Guggenheim Museum, New York, and Cornell University, Ithaca, New York
1966	*Art of Latin America since Independence,* Yale University, New Haven, Connecticut, and University of Texas, Austin
1969	*Latin American Paintings,* Philbrook Art Center, Tulsa
1970	*Latin American Paintings from the John and Barbara Duncan Collection,* Center for Inter-American Relations, New York

Collections:

Dallas Museum of Fine Arts; Solomon R. Guggenheim Museum, New York; Massachusetts Institute of Technology, Cambridge; Museum of Modern Art of Latin America, Washington, D.C.; University of Texas, Austin.

Publications:

On PACHECO: Books—*María Luisa Pacheco: Retrospectiva,* exhibition catalog, Bolivia, 1976; *Tribute to María Luisa Pacheco of Bolivia, 1919–1982,* exhibition catalog, Washington, D.C., 1986; *The Latin American Spirit: Art and Artists in the United States,* exhibition catalog, New York, 1988; *María Luisa Pacheco, pintora de los Andes,* exhibition catalog, La Paz, La Papelera, 1993. **Articles**—"Bolivia salida a tierra" by Marta Traba, in *Ultima Hora,* 9 December 1980; "María Pacheco Dies: Painter of Abstracts of Andes Childhood," in *New York Times,* 23 April 1982; "Abstract Landscapes of María Luisa Pacheco" by A. S. Casciero, in *Americas,* 39, 1987; "SIART '99: La Paz Inaugurates an International Art Salon" by Lisbeth Rebollo Goncalves, in *Art Nexus* (Colombia), February/April 2000, pp. 110–111.

* * *

María Luisa Pacheco was one of the most important contemporary artists from Bolivia. Her abstract paintings, based on the mountains and landscapes of her homeland, contributed to the popularization of abstract art in the Andean country, which had long been dominated by figurative painting. Indigenism, considered one of the highest expressions of the country's national identity, had been the most prevalent artistic movement during the 1930s and '40s but had slowly grown stagnant and uninteresting. Pacheco attended the National Academy of Fine Arts in La Paz, where she studied with Cecilio Guzmán de Rojas and Jorge de la Reza, two artists who sought, with little success, to bring modernism to Bolivian art. After having studied several years in Europe, she returned to Bolivia in 1952. Her arrival coincided with the election of Bolivian president Víctor Paz

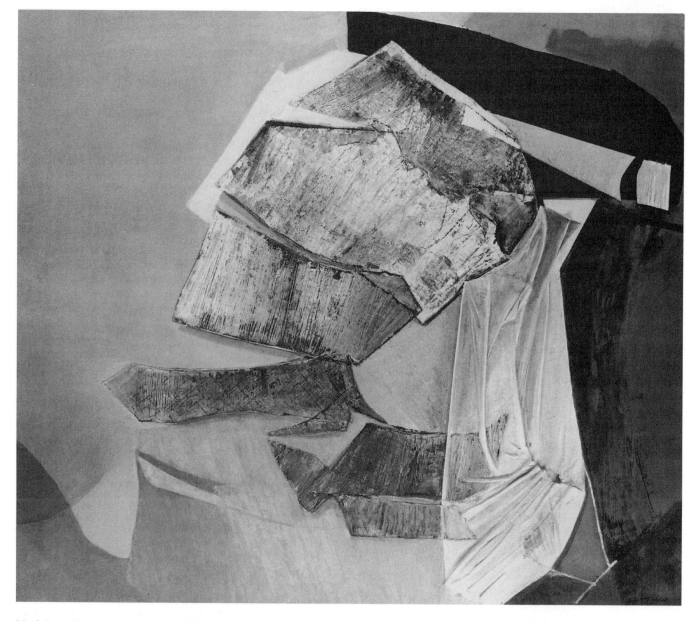

María Luisa Pacheco: *Anamorphosis,* **1971. Photo by Carmelo Guadagno; © The Solomon R. Guggenheim Museum, New York.**

Estenssoro, who enacted many political reforms. The environment in the country was suddenly receptive to abstract art, and Pacheco began showing her work. She and seven other artists united in their commitment to artistic modernization came to be known as the Eight Contemporaries.

Pacheco's work during the mid- to late 1950s was still recognizably figurative, although the forms she painted had a certain angularity already suggestive of abstraction. Typical of this period is *Tihuanacu* (1956), in which the steep hillsides of the Andean landscape are easily recognizable, as well as *Dos Figuras* (1957), which shows an increasing movement toward abstraction and is painted in reds, ochres, and grays, the colors that would dominate her later work. Critics have suggested that her work from this period has an architectural and sculptural quality that can be attributed to the influence of her father, who was an architect, and to the sculptures at Tiahuanaco, a pre-Columbian archaeological site in Bolivia. Another influence

was the Spanish painter Daniel Vásquez Días, whose studio Pacheco had visited while in Europe. Días was a member of the cubist generation and an acquaintance of Pablo Picasso, Georges Braque, and Juan Gris.

In 1953 Pacheco worked briefly as a painting instructor at the National Academy of Fine Arts, but teaching did not suit her, and she left the position. She began to exhibit her work throughout South America, giving her career a much more international scope. In 1956 she moved with her two children to New York, where abstract expressionism was at the height of its popularity and became a strong influence in her work. Pacheco received three Guggenheim Fellowships (1958–60), giving her the financial freedom to experiment stylistically. She began using a monochromatic palette of blacks, grays, and whites and eliminated any semblance of figurative painting entirely, instead basing compositions on a series of diagonals and roughly geometric forms.

From the late 1960s to early 1970s Pacheco created what is now considered to be her most developed and mature work. In these paintings she emphasized the texture of the paint, mixing in substances such as sand and newspaper, scratching its surface with a brush, and masking off sections to create sharply defined lines and angles. She continued to make references to the Bolivian landscape, but these were much more abstract, suggesting the forms of rocks and steep hillsides without being overtly figurative. Typical of this period is the painting *Catavi* (1974), a triptych done in earth tones and grays and consisting of abstract forms that strongly resemble rocks and mountains. Instead of depicting a literal landscape, Pacheco painted a sort of interior landscape suggestive of her own emotions and nostalgia for her homeland. The title of the work was a word in Aymará, an indigenous language of Bolivia, for the name of a town in the Andes. She eventually began to express herself with increasing physical force, at times working the canvas so much that she had to place a board behind it until the paint dried to prevent the fabric from wearing out under the pressure.

Pacheco lived in New York for 26 years, becoming one of the most important Bolivian artists despite not having lived in her native country for some time. For the last 10 years of her life, she worked exclusively for the Lee Ault and Company gallery, which resulted in her work being purchased for important collections such as the Solomon R. Guggenheim Museum and the Mobil Corporation. In the few years before she died she returned to the figurative painting of her early career.

—Erin Aldana

PAPE, Lygia
Brazilian sculptor, installation artist, and mixed-media artist

Born: Nova Friburgo, Rio de Janeiro, 1929. **Education:** Universidade Federal, Rio de Janeiro, B.A. in philosophy; Universidade Santa Ursula, Rio de Janeiro, M..A. in philosophical aesthetics 1980. **Family:** Married Gunter Pape; two daughters. **Career:** Coproducer of two neoconcrete ballets, 1958–59; director of avant-garde films, 1970s; instructor, Universidade Santa Ursula, Rio de Janeiro, 1972–85. Founder and member, *Grupo Frente,* 1954–56, and *Neoconcrete Group,* 1959–61. **Awards:** First prize, Sul América, Brazil, 1952; award, Salão Nacional de Arte Moderna, Rio de Janeiro, 1955; bronze medal, Salão de Arte Moderna, 1955; fellowship, Guggenheim Foundation, 1980; fellowship, Vitae Foundation, 1990; Mário Pedrosa prize, ABCA-AICA, 1990; best exhibition prize, Instituto Brasil-Estados Unidos, 1992.

Individual Exhibitions:

1975 Maison de France, Rio de Janeiro
1976 Museu de Arte Moderna, Rio de Janeiro
 Galeria Arte Global, São Paulo
1977 Pinacoteca do Estado, São Paulo
1984 Galeria do Centro Empresarial, Rio de Janeiro
1985 Galeria Arte Espaço, Rio de Janeiro
1988 Galeria Thomas Cohn, Rio de Janeiro
1990 Galeria Thomas Cohn, Rio de Janeiro
1991 Galeria Instituto Cultural Brasil-Estado Unidos, Rio de Janeiro
1992 Kunsthaus, Zurich
 Galeria Camargo Vilaça, São Paulo
1993 L'Onorabile Galleria, Milan
1994 Museo Nacional de Belas Artes, São Paulo
1995 Galeria Universidade do Espirito Santo, Brazil
1998 Carrillo Gil Museum, Mexico City (with Ernesto Neto)
2001 *Forma Brazil: Concrete and Neo-Concrete Art,* Americas Society, New York (with Geraldo de Barros)

Selected Group Exhibitions:

1955 Museu de Arte Moderna, Rio de Janeiro
1956 *Exposição de Arte Concreta,* Museu de Arte de São Paulo
1988 *Art in Latin America: The Modern Era, 1820–1980,* South Bank Centre, London (traveling)
1993 *Brasil: Segni d'arte: Librei e video, 1950–1993,* Fondazione Scientifica Querini-Stampalia, Venice
 Ultramodern: The Art of Contemporary Brazil, National Museum of Women in the Arts, Washington, D.C.
1995 *São Paulo bienal,* São Paulo

Publications:

On PAPE: Books—*Lygia Pape: 40 gravuras neoconcretas,* exhibition catalog, Rio de Janeiro, 1975; *Lygia Pape* by Mario Pedrosa et al, Rio de Janeiro, 1983; *Art in Latin America: The Modern Era, 1820–1980,* exhibition catalog, London, 1989; *Lygia Pape,* exhibition catalog, São Paulo, 1992; *Ultramodern: The Art of Contemporary Brazil,* exhibition catalog, Washington, D.C., 1993; *Lygia Pape* by Lúcia Carneiro and Ileana Pradilla, Rio de Janeiro, Lacerda Editores, 1998. **Article**–"Lygia Pape and Ernesto Neto" by Ana Isabel Perez, in *Art Nexus* (Colombia), 31, February/April 1999, pp. 88–89.

* * *

Born in Nova Friburgo, in the state of Rio de Janeiro, in 1929, the Brazilian artist Lygia Pape graduated in philosophy from the Universidade Federal do Rio de Janeiro and later earned a master's degree in philosophical aesthetics (1980) from the Universidade Santa Ursula in Rio de Janeiro. A founding member of the Groupo Frente (1954–56), which espoused geometry and abstraction over the re-creation of nature, she exhibited a series of woodcuts, *Tecelares,* in a collective show at the Museu de Arte Moderna in Rio de Janeiro in 1955 and in the *Exposição de Arte Concreta* at the Museu de Arte de São Paulo in 1956. These early woodcuts explored the relationship between inorganic geometric design and the natural marks left by the wood. Pape was also a founding member of Grupo Neoconcreto (1959–61), being a signatory of the *Manifesto Neo-Concreto* of the poet Ferreira Gullar in 1959 and participating in the *Primeira*

Exposição Neoconcreta. She produced various books, including *Livro da Criação* (1968), in which the reader interacted with the folded and cut pages, each turn of a page revealing a new aspect of the work. In collaboration with Gilberto Mota and Reynaldo Jardim, Pape also produced two neoconcrete ballets (1958–59) in which geometric shapes containing hidden dancers seemingly moved unaided.

After the military seized power in Brazil in 1964 and the Grupo Neoconcreto was disbanded, Pape became interested in film. She worked with two directors of the Cinema Novo generation: Nelson Pereira dos Santos on *Vidas Secas* (1963), and Glauber Rocha on *Deus e o diabo na terra do sol* (1964). She then went on to direct her own films in the 1970s, including *Catiti Catiti* (1978), whose Tupi-Guaranian title and subject matter refer to the *Manifesto antropófago* (1928) of Oswald de Andrade and the Brazilian modernist movement associated with such artists as Anita Malfatti and Tarsila do Amaral.

In the 1960s Pape worked on collective art projects that were presented in the streets of Rio de Janeiro, away from the confines of the art gallery, and that involved group participation. *O divisor* (1968) used a huge white sheet, measuring 20 by 20 meters, in which carefully positioned holes allowed participants to poke their heads through. The viewer saw a divided body, from above numerous heads and from below the body acting as a metaphor for the political and social situation of Brazil at the time. The conceptual work *Egg* (1968) consisted of three chambers through which participants had to pass. Moving through the chambers, called "Conception," "Gestation," and "Birth," participants experienced the different conditions in each before reemerging into a space in which they were confronted with reflections of themselves in several mirrors and were metaphorically "born again." Pape also liked to challenge people's perception of art and the self. *Nova objectividade brasileira* (1967) placed dead cockroaches and live ants in two acrylic boxes with mirrored bottoms. Horrified viewers thus saw their own images reflected amid the insects, symbols not so much of life and death but of filth and decay juxtaposed with industry and progress.

In the 1970s Pape produced installations, environments, and video art, and she returned to sculpture in the 1980s. In 1990 she revisited ideas begun in the 1968 book *Livro da Criação* in a series of metal wall sculptures entitled *Amazoninos*. These refer to the beauty of Amazonian flowers whose visual lightness and organic quality is undermined by their physical weight.

Pape is one of a generation of Brazilian artists, including Helio Oiticica and Lygia Clark, who have challenged artistic conventions in order to create a new artistic language confronting the political and social challenges of the country. No doubt fueled by the ambitious Brasília project, conceived in 1955 and inaugurated in 1960, and the subsequent state censorship of the military dictatorship, artists moved away from a figurative artistic language toward new forms of installation works and conceptual art that encouraged the viewer to participate directly. The convention that art was something seen and not experienced was thus broken. Consequently, the view that art was the preserve of the elite at the expense of the poor was eradicated. Indeed, this division was directly challenged through the participation of the urban working classes whose presence helped create Pape's work. Despite rejecting the conventional art world, she has been at the forefront of Brazilian art both as an innovator and a practitioner. Her work has been immensely influential in charting the course of Brazilian art since the 1950s.

—Adrian Locke

PAREDES, Diógenes
Ecuadoran painter

Born: Quito, 1910. **Career:** Lived in Paris, 1948. **Awards:** Second prize for painting, 1942, and first prize for painting, 1947, *Salon Mariano Aguilera,* Quito; first prize, *First National Salon of Fine Arts,* Quito, 1945; gold medal, *Atelier de Arte,* Quito. **Died:** Quito, 1968.

Selected Exhibitions:

1942	*Salon Mariano Aguilera,* Quito
1945	*First National Salon of Fine Arts,* Quito
1947	*Third National Salon of Fine Arts,* Quito
	Salon Mariano Aguilera, Quito
1967	*Testimonio plastica de Ecuador,* Quito
1968	Casa de la Cultura, Quito (retrospective)

Also exhibited in New York, Mexico, Paris, Buenos Aires, Lima, Peru, Madrid, San Francisco, Caracas, Venezuela, Bogota, Colombia, and Guatemala City.

Collection:

Museo de Arte Moderno Ecuatoriano, Quito.

* * *

Diógenes Paredes began painting in the indigenous realist style. Later he united with the more generational expressionists such as Oswaldo Guayasamin. This group of artists worked as social realists for years. The works were often gloomy and depicted the cruelties of indigenous life. Paredes is well known for his works of great force and dramatic feelings.

During the 1940s Paredes celebrated a period of rhetoric expressionism. The artist reached his audience with paintings of tense dramatism, featuring humanist gestures and political climates. Paredes also used somber colors to impart feelings of oppression to the viewer. His works *The Bad News, Torment,* and *Frozen* all exemplify these sentiments. In *Torment* one sees terrifying indigenous people with resigned faces, like stupefied refugees inside a small cave, while outside the torment destroys the earth. The coloring consists of livid grays creating a sense of fixed time for the viewer to contemplate. This painting triumphed at the first salon of the Casa de la Cultura in 1945. During this salon Paredes' paintings lent the show a somber impression.

After this landmark exhibition, with the approval of critics and his audience, Paredes painted 10 new severe pieces. He won a prize with *Girl of the Rock,* which symbolizes the solitude and silence of the most blank of social landscapes, that of the Indian. It's the live image of the an Ecuadorean Indian, blind and nude between the blank rocks of Paramo, Ecuador.

But the artist had works that were even more striking than *Girl of the Rock.* Especially *Torment*—anguish and pain envelop and dishearten a frozen time. Outside the cave are petrified humans painted a furious gray that relates the rigor of the torment, creating a tone of all the rigors of nature and man.

For Paredes the challenge seemed to be in drawing. Despite this Paredes drew the nudes that won him the prize for the Salon Mariano

Aguilera of 1947. The works that he created in 1948 and afterward offered a changed position, as if he were in a transition or simply tired from painting the emotionally driven landscapes of his early works. He painted landscapes of poor villages and scenes of indigenous life in Ecuador. Paredes continued painting these scenes; a few paintings stand out: *Inundation* (1950) and *Bricklayers* (1950), which was the artist's ultimate vigorous effort of indigenism for this period. These works were what the artist felt would fit into the genre at that time.

In the later 1950s Paredes's paintings had lost force and gave indigenism a new more decorative look. The most well known paintings of this era in the artist's career were *Playing Hide and Seek* (1954), *Wax Candles* (1954), *Small Settlements* (1956), and *Esmeraldas* (1956).

In a final attempt the artist tried to infuse some of the old expressionistic force behind many of his early works into this new decorative style. In making this final attempt he began developing his decorative style further and began working a new geometric style that was very humanist, resulting in some of Paredes's greatest works, including *Curiquingas* (1963) and *Dancers* (1965). In *Curiquingas* the livid symbols return; like masks, the faces have a certain magical-realist air and are impregnated with a profound grief.

In 1968 Paredes suffered a horrible accidental death. This prematurely cut the life of one of Ecuador's most influential indigenist artists. He seemed to be in a moment of transition and reflection and in search of the next work that he would develop. It is unfortunate that we will never see the next work from this champion artist of the indigenous people. Paredes's final exhibition was a retrospective of his life's work at the Casa de la Cultura in Quito, Ecuador. This exhibition included works from the artist's entire oeuvre, including the most memorable expressionist works along with the most insecure and coarse paintings.

—Daniel Lahodo

PAREDES, Luis

Salvadoran and Mexican photographer and mixed-media artist

Born: Luis Alfredo Paredes Trigueros, San Salvador, El Salvador, 25 August 1966; emigrated to Mexico, 1971. **Education:** Self-taught photographer. **Family:** Lives with Rebecca Bailey. **Career:** Photography teacher, Tesrup Højskole, Aarhus, Denmark, 1992–96. Since 1987 freelance photographer. **Address:** Brohusgade 16, 2 T.V., 2200 Copenhagen N., Denmark. **E-mail Address:** pared@worldonline.dk.

Individual Exhibitions:

1993 *Las marias,* Mala Galeri/Centre for Contemporary Art, Warsaw
 Two Portfolios, Galeria F. F., Lodz, Poland
 Rusticas, Galeria Sztuki BWA, Jelenia Góra, Poland
1994 *Works,* Luther Kirche/Internationale Photoszene, Cologne, Germany
1995 *Revelaciones,* Galleri IMAGE, Aarhus, Denmark, and The Traverse, FOTOFEIS, Edinburgh
2001 *Escapes,* CONTEXTO, Guatemala
 Fragmentos, TEOR/eTica, San Jose, Costa Rica

Luis Paredes: *Enfragmento I,* 1988. Photo courtesy of the artist.

Selected Group Exhibitions:

1995 *Cruzando caminos,* Museo de Arte, Lima, Peru
1996 *ArtGenda,* Øksnehallen, Copenhagen
 Review, Konsthallen, Göteborg, Sweden
 Mesotica II, Museo de Arte y Diseño Contemporaneo, San Jose, Costa Rica (traveling)
1997 *VI bienal de la Habana,* Fototeca de Cuba, Havana
 XLVII bienal de Venezia, Paviglione del I.I.L.L.A., Venice
1998 *El cuerpo en /de la fotografía,* Museo de Arte y Diseño Contemporaneo, San Jose, Costa Rica
 XXIV bienal de São Paulo, Parque Ibirapuera, São Paulo, Brazil
2000 *La huella de Europa,* Sala Nacional, San Salvador
2001 *III bienal iberoamericana de arte,* Lima, Peru

Collections:

Fototeca de Cuba, Havana; Centro Wilfredo Lam, Havana; Center for Contemporary Art, Warsaw; Museo de Arte y Diseño Contemporaneo, San Jose, Costa Rica; TEOR/eTica, San Jose, Costa Rica.

Publications:

On PAREDES: Books—*Fotofeis 95,* exhibition catalog, text by Pablo Swezey, Edinburgh, Fotofeis 95, 1995; *Mesotica II,* exhibition catalog, text by Dermis P. Leon, San Jose, Costa Rica, Museo de Arte y Diseño Contemporaneo, 1996; *XXIV bienal de São Paulo,* exhibition catalog, text by Virginia Perez-Ratton, São Paulo, Brazil, Fundaçao Bienal de São Paulo, 1998; *La Huella de Europa* by Janine Janowski, San Salvador, European Community, 2000. **Articles**—"El arte de la fotografia" by Claudia Rousseau, in *El Diario de Hoy* (San Salvador), 18 December 1994; "Om Luis Paredes Udstilling: Revelaciones" by Henrik Kristensen, in *Institut for Idéhistorie* (Aarhus, Denmark),

Luis Paredes: *Enfragmento II,* **1988. Photo courtesy of the artist.**

October 1995; ''Aarhusiansk Kunst i Kulturbyen'' by Mette Mari Rasmussen, in *AGENDA* (Aarhus, Denmark), April 1996.

* * *

The photography of Luis Paredes could be said to be an experience in fragmentation. Together with Luis González Palma, he is one of the contemporary Central American photographers who have experimented with intervention in the photographic image and who have distanced themselves from the tradition of orthodox documentary photography that prevailed up to the late 1980s. In one of his first series, realized around 1994, the artist departed from the nude as a theme and used naked bodies in frontal positions, with visible cuts and scratches that appeared to rip the surface and with other elements and textures surrounding and superimposed on the figures. He accomplished this by direct intervention with the negatives themselves in order to be able to print the prealtered images, fragments that reflected a strange violence against the human body. In later, more sedate works he assembled extraordinarily subtle photographs of body fragments, printed in soft, warm colors, to produce a complete puzzle in which the definition of the classic rectangular print contrasted with the sensual roundness of the bodies, further enhanced by a uniform, soft black background.

Entering a period of growing gloominess, Paredes produced for the Havana Biennale of 1997 a large-scale installation of burned photographs assembled in sets. The title *Burnt Garden* was directly related to the subject of flowers. The piece was a reminiscence of his days in the Salvadorean war, when he witnessed the blasting of mined fields while documenting the peace process after the end of the war. Upon approaching the site, the artist could observe the wild flowers still fresh and alive but burnt by the blast. He felt his country to be like a burnt garden. The contrast between beauty and danger, peace and threat, drove Paredes to do several pieces with this idea. He proceeded by printing close-ups of garden flowers in brilliant sepia tones and then burning the prints to various extents and assembling them one on top of the other as reconfigured petals, thus constructing monstrous flowers for the burned garden. He subsequently used this process for

his installation in the Venice Biennale of 1997, this time applying smaller ensembles of burned petals on the bottom of nine *bateas*, wooden washing boards typically used in the countryside of Central America. The work presented at the São Paulo Biennale of 1998 was a smaller mural piece, a triptych of squares made up of superposed layers of burned flowers but with the burning this time taking place with the finished ensemble. In this wall installation a new element was included–the Roman Catholic religion imposed on the indigenous population after the Spanish conquest–symbolized by the suggestion of a charred cross that eventually ended up cutting the assemblage into four pieces, an image of the divisions and fragmentations caused by the cultural impositions of a colonial history.

Paredes has lived in Copenhagen for several years and after the São Paulo Biennale underwent a difficult personal period in which he accomplished little work. In 2000, however, he showed the first series of new works, which turned away from the intervention with negatives and photo installations and toward more classical black-and-white prints of a minimalist character. His reflection on fragmentation has continued to be present, however, and these photographs constitute an essay on landscape, this time the flat landscape of the Danish countryside, in sharp contrast to the irregular, rugged surface of Central American geography. In these works Paredes has photographed nature in its simplest horizontal lines and produced modular works in which each photograph is the antecedent of the next. They are extremely fine ''suites'' of blurred images, successive glimpses of an absolutely regular, eternally flat horizon of evocative emptiness. The images were shown in several countries of Central America in 2001, in one of his most important exhibitions since 1998.

—Virginia Pérez-Ratton

PARRA, Catalina
Chilean collage and paper artist

Born: Santiago, 1940. **Education:** Pedagogico, Santiago. Self-taught. **Family:** Married 1) Francisco Soler, *ca.* 1958 (divorced), three children; 2) Ronald Kay (separated *ca.* 1979). **Career:** Lived in Germany, 1968–72. Cover designer, *Manuscritos* magazine, 1975. Since 1980 has lived and worked in New York. Instructor, Museo del Barrio, New York, and State University of New York. **Award:** Fellowship, Guggenheim Foundation, New York, 1980.

Individual Exhibitions:

1971 Gallerie Press de Konstanz, Germany
1977 Epoca Gallery, Santiago, Chile
1981 Museum of Modern Art, New York
 Henry Street Settlement, New York
1988 Terne Gallery, New York
1990 Gallerie Zographia, Bordeaux, France
1991 Intar Latin American Gallery, New York
1992 Lehman College Art Gallery, Bronx, New York and
 Universidad de Chile, Museo de Arte Contemporáneo
2001 *It's Indisputable*, Jersey City Museum, New Jersey

Selected Group Exhibitions:

1987 *The Debt*, Exit Art, New York

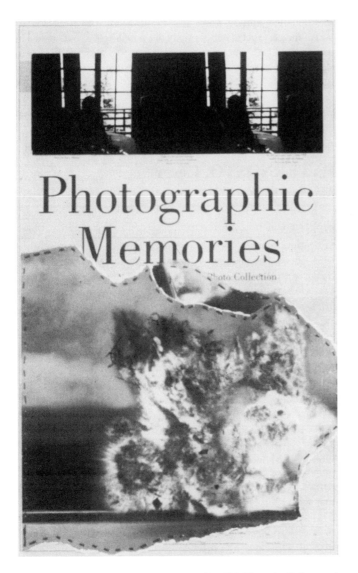

Catalina Parra: *Photographic Memories, #3,* 1998. Photo by Robert and Ida Mates; courtesy of Jersey City Museum; collection of the artist.

1990 *The Decade Show*, New Museum of Contemporary Art,
 New York
1993–94 *States of Loss*, Jersey City Museum, New Jersey
1994 *Rejoining the Spiritual*, Maryland Institute College of
 Art, Baltimore
1995 *Without Frontiers, Johannesburg Biennial*, South Africa
1997 *Across Borders*, A-Space, Toronto, Ontario
1998 *The Latina Artist: The Response of the Creative Mind to
 Gender, Race, Class, and Identity*, Mason Gross
 School of the Arts Galleries, Rutgers University, New
 Brunswick, New Jersey

Publications:

On PARRA: Books—*Positions: Reflections on Multi-Racial Issues in the Visual Arts* by Cassandra L. Langer, New York Feminist Art Institute/Women's Center for Learning, New York, 1989; *Catalina Parra in Restrospect*, exhibition catalog, text by Julia P. Herzberg, Bronx, New York, Lehman College Art Gallery, 1991; *Catalina*

Parra, exhibition catalog, Intar Latin American Gallery, New York, 1991; *Las hacedoras, mujer, imagen, escritura* by Marjorie Agosín, Santiago, Chile, Editorial Cuarto Propio, 1993; *States of Loss*, exhibition catalog, text by Gary Sangster, New Jersey, Jersey City Museum, 1993; *Rejoining the Spiritual*, exhibition catalog, text by Barbara Price, Baltimore, Maryland Institute College of Art, 1994; *American Visions: Artistic and Cultural Identity in the Western Hemisphere* by Mary Jane Jacob, Noreen Tomassi, and Ivo Mesquita, New York, ACA Books and Allworth Press, 1994; *English Is Broken Here: Notes on Cultural Fusion in the Americas* by Coco Fusco, New York, New Press, 1995. **Articles**—''Three South American Women Artists'' by Robert C. Morgan, in *High Performance*, 9(3), 1986, pp. 58–62; ''Terne Gallery, New York'' by Robert C. Morgan, exhibition review, in *Arts Magazine*, 62, January 1988, pp. 105–106; ''Portfolio'' by Inverna Lockpez, in *Heresies*, 7(3), 1993, p. 84.

* * *

Born in 1940 in Santiago, Catalina Parra lived in Chile until she moved to Germany in 1968. She returned to Chile in 1973 and then settled in New York City in 1980 after being awarded a Guggenheim fellowship. The influence of these vastly different locations and their cultural, social, and political legacies are constantly at work in Parra's art. The artist herself has acknowledged the extensive influence that Dada aesthetics, in particular the work of Max Ernst, have had on her work during her years in Germany and in subsequent periods. It is this influence that is evident in the work she created upon her return to Chile in the 1970s.

In a pivotal exhibition of 1977, Parra showed a series of collages and an untitled installation at Santiago's Galería Época. The installation consisted of a brain suspended in formaldehyde and displayed inside a chicken wire cage, a covert reference to the violence and oppression visited upon Chilean society under the dictatorship. Through this exhibition Parra's work became an important part of Chilean art history. Her stealthy criticism of the military regime, which had taken over in 1973, became an important example of political counterdiscourse in Chile under Pinochet's rule. Parra's work reflects both her concern for the trajectory of this particular political history as well as her engagement with larger issues surrounding media culture and its influence on the public at large.

It was also during the early 1970s that Parra began to work seriously on the collages with which she has become most frequently associated. Using an advertisement from *El Mercurio*, the most prominent Chilean newspaper, she began to undermine the authority of the newspaper's text through one of its own advertisements. In her work *Diariamente necesario* (1977; ''Necessary Daily'') Parra alludes to the newspaper's questionable journalistic practices. By juxtaposing obituaries with the central image of the daily slice of bread, she underlines the way in which the news stories are cut into pieces and reconfigured in an attempt to present incomplete and perhaps even falsified accounts of the atrocities committed by the military regime. The layers of text emphasize how similar layers are used in the construction of ''truth.'' In creating these collage works, Parra uses a variety of techniques, including tearing, cutting, pasting, and sewing. The stitches she uses to sew together the parts of the collage first appeared in her work of the 1970s. In the exhibition *Imbunches*, Parra showed works stitched together under the title *Los Imbunches*, referring to a myth from the Mapuche, the native Americans in Chile from the island of Chiloé.

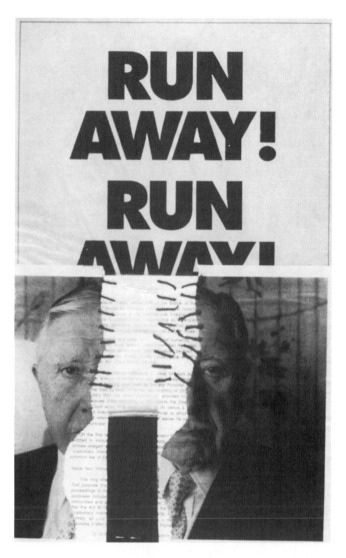

Catalina Parra: *Run Away, #8,* **1999. Photo by Robert and Ida Mates; courtesy of Jersey City Museum; collection of the artist.**

selection of significant words and phrases and her subsequent addition of imagery that is only partially discernible add to our interest in deconstructing the meaning of the image. She asks the viewer to excavate the various layers of imagery in order to understand fully her meanings.

—Rocío Aranda-Alvarado

PATERNOSTO, César

American painter

Born: La Plata, Argentina, 1931; moved to the United States in 1969. **Education:** Studied law at Universidad Nacional de Buenos Aires, 1951–58; studied painting at Escuela de Bellas Artes, Universidad Nacional de Buenos Aires, 1957–61. **Career:** Visiting scholar, New York University, 1981. **Awards:** First prize, *III Biennial of American Art,* Cordoba, Argentina; John S. Guggenheim memorial fellowship, 1972; Rockefeller Foundation grant, 1991.

Individual Exhibitions:

1962	Galería Rubbers, Buenos Aires
1964	Lirlay Gallery, Buenos Aires
1965	Center for Freedom of Culture, Buenos Aires
1966	Bonino Gallery, Buenos Aires
1968	AM Sachs Gallery, New York
1969	AM Sachs Gallery, New York
1970	AM Sachs Gallery, New York
1971	Camen Waugh Gallery, Buenos Aires
1972	Galerie Denise René, Paris
	Hans Mayer, Düsseldorf, Germany
1973	Galerie Denise René, Paris
1974	Galerie Denise René, Paris
1975	Galerie Denise René, Paris
1976	Galerie Denise René, Paris
1977	Artemúltiple Gallery, Buenos Aires
1978	Artemúltiple Gallery, Buenos Aires
1979	Sandiego Gallery, Bogotá
1981	*Paintings, 1969–1980,* Americas Society, New York
1982	Fuji Television Gallery, Tokyo
1984	Mary-Anne Martin Fine Arts, New York
	Galería del Retiro, Buenos Aires
1986	*Works on Paper, 1961–1986,* Foro de Arte Contemporáneo, Mexico City (traveled to Rayo Museum and Diners Gallery, Colombia)
1987	Fundación San Telmo Gallery, Buenos Aires (retrospective)
1989	*Formas simbólicas andinas,* Ruth Benzacar Gallery, Buenos Aires
1993	Exit Art, the First World Gallery, New York
	Galería Durban/César Segnini, Caracas
1995	Cecilia de Torres, Ltd., New York
1997	Galería Rubbers, Buenos Aires
	Museo Nacional de Bellas Artes, Buenos Aires
1998	*North and South Connected, an Abstraction of the Americas,* Cecilia de Torres, Ltd., New York

Parra has continued to appropriate the discourse of the mass media through the memorable quotes she uses as titles. Later bodies of work all draw their significance from a line in an advertisement published in the *New York Times.* By appropriating these phrases for her art, Parra infuses the original text with a new, loaded message. In these images authoritative phrases such as ''It's Indisputable'' lose their authority due to Parra's deconstructive approach, which is developed through her methodology. Beginning with an attractive tag line, she takes 10 or more copies of the same advertisement and creates a whole series of collages simultaneously. Tearing, cutting, stitching, taping, and gluing the disparate elements, Parra at once fractures and reunites the composition, creating seams, joining that which is hopelessly severed, separating those images that serve as masks, covers, or illusions. Her fractured images ask us to see what authorities, whether in politics or the media, attempt to hide.

Most evident in Parra's aesthetic is her preference for engaging language and its various meanings. She is interested both in language's ability to signify and in its powerfully seductive, persuasive faculties. Because the power of the media is in the text, Parra's careful

Selected Group Exhibitions:

1966 *Art of Latin America Since Independence,* Yale
 University, New Haven, Connecticut, and University
 of Texas, Austin
1977 *Lines of Vision: Recent Latin American Drawings,*
 Americas Society, New York
1986 *I bienal,* Havana
1987 *Latin American Artists in New York Since 1970,* Archer
 Huntington Museum, Austin, Texas
 Abstract Visions, Museum of Contemporary Hispanic
 Art, New York
1989 *The Latin American Spirit: Art & Artists in the U.S.,*
 Bronx Museum, New York
1991 *The School of the South, El Taller Torres-García and
 its Legacy,* Museo Reina Sofia, Madrid (traveling)
1992 *Latin American Artists of the 20th Century,* Seville
 EXPO, Spain (traveling)
1996 *Argentinien: Ursprünge und Erbe,* Giessen Museum,
 Germany (traveling)
1998 *North and South Connected: An Abstraction of the
 Americas,* Cecilia de Torres, Ltd., New York

Collections:

Museum of Modern Art, New York; Solomon R. Guggenheim
Museum, New York; Hirshhorn Museum & Sculpture Garden, Washington, D.C.; Albright-Knox Gallery, Buffalo, New York; University of Texas, Austin; Museo Nacional de Bellas Artes, Buenos
Aires; Museo de Arte Contemporáneo, Buenos Aires; Museo Provincial de Bellas Artes, La Plata, Argentina; Museo de Arte
Contemporáneo, Caracas, Venezuela; Museo de Arte Moderno,
Fundación Soto, Ciudad Bolivar, Venezuela; Museo del Banco Central, Guayaquil, Ecuador.

Publications:

By PATERNOSTO: Books—*Piedra abstracta: La escultura inca,
una visión contemporánea,* Mexico, Fondo de Cultura Económica,
1989; *The Stone and the Thread: Andean Roots of Abstract Art,*
Austin, Texas, University of Texas Press, 1996; *North and South
Connected, an Abstraction of the Americas,* exhibition catalog, New
York, Cecilia de Torres, Ltd., 1998.

On PATERNOSTO: Books—*César Paternosto,* exhibition catalog,
Paris, Galerie Denise René Rive Gauche, 1974; *César Paternosto,
Paintings, 1969–1980,* exhibition catalog, text by Lucy R. Lippars
and Ricardo Martín-Crosa, New York, Center for Inter-American
Relations, 1981; *César Paternosto: Obras 1961/1987,* exhibition
catalog, Buenos Aires, Fundación San Telmo, 1987. **Articles**—
''César Paternosto: Paternosto's Place in Latin American Art'' by
Alvaro Medina, in *Art Nexus* (Colombia), 19, January/March 1996,
pp. 52–55; ''César Paternosto'' by Alberto Collazo, in *Art Nexus*
(Colombia), 25, July/September 1997, pp. 121–122.

* * *

César Paternosto's most important contributions as an artist do
not end with his abstract paintings on canvas and on paper. He also
has conducted and published research on pre-Columbian art and its
relation to the contemporary aesthetic. This led him to successfully
and responsibly enter the curatorial arena. By the time that he went to
the United States, his work had been shown in Buenos Aires and had
been shared with a strong international artistic movement that was
already present there. Among the diverse movements that coexisted at
that time, the one that interested Paternosto the most was abstraction.
Paternosto lived in La Plata, a sophisticated city where he was able to
develop a solid artistic background before becoming a professional
artist. His consistent and risky forays into noncommercial artistic
territories are clearly conveyed by his use of fibers, materials that
were either for women or for arts and crafts. He continued to pursue
this and to work and research with the aid of threads. He stressed the
importance of abstract expression in pre-Columbian art that was
ignored by much of the contemporary art world.

The artist began in a nonrepresentational trend, deeply devoted
to the quasi-anonymous and perfect use of color on canvas. In his
work hard-edge coincided with abstraction; a logical color field,
contemplation, and concentration versus distraction were part of this
dialogue as well. As years passed he headed in a stronger, neater
direction in which research and integration positioned this hard-edge
artist in a sensitive geometry and as supporter of the pre-Columbian
cultures. In the late 1960s the young Paternosto motivated the public
to be active in front of his paintings by dealing with the sides of the
pieces as much—or even more—as their frontal surfaces. Each art
movement has its fans and its detractors. In the kind of work described
here expressions of admiration took place as frequently as did
complaints. In front of this apparently simple art detractors who did
not understand the originality and deepness of the approach misunderstood it as ''easy.'' Time is a precious judge, and those wrong
interpretations have been corrected through the years. People recognized that he worked the surfaces and the environment and provided
for an active participation from the viewer. ''The Oblique Vision''
was the title of the successful attempt to address art from a personal
angle. It was the time when critics were dealing with the participation
triangle that consisted of artist, public, and gallery. Paternosto agreed
with it and had an inner conviction: artwork was not a static ''thing''
to just have in front of the eyes. Paintings had grown out of the frame,
the canvas was wrapping the stretcher (he used thick stretchers that
allowed him to continue painting beyond the edge of the front of the
canvas to the sides), and painting meant neither tons of oil nor evident
brush strokes. The relation between the materials, the artist, and the
people took on a different and much more active interaction.

When Paternosto arrived in New York in 1969, he was on that
track of once and again creating those presences that related painting
to what is architectonic. Ten years later, not denying his previous path
but opening himself up to new directions, the importance of the
paintings as three-dimensional objects with fronts and sides prevailed, but light, presented as changes in color, activated the surface.
He was set for neat paintings—devoid of details, in a subtle geometry
on shaped canvases—even at the time he worked with thicker
painting, and one could find some traces of this on the surfaces. He
also had an admiration for Peru and the Andes, and the time came
when he began traveling to that region, getting closer to the history of
the continent and being able to confirm the power and grandeur of
those civilizations. He worked on that from different points of view,
always reaffirming that the center of civilization is in the Americas.
Latin American artists have been taught to look up to Europe; in doing
that, however, most of them forgot to look to their own roots and
origins. In the late 1990s the artist decided to curate an exhibition that

would put forth his concepts; he included artists who were not born in Latin America but whose art was related to what he was trying to convey. Argentina is a country where almost none of the pre-Columbian cultures existed, where the Indians were exterminated by a military campaign and the European upbringing eluded respect for what was native. It is a fact that far away one gets better insight from history, and Paternosto could do that while living in the most avant-garde city in the world. His findings apply not only to Argentine art but also to art throughout the world. History is always done in fractions; no one person can address all time periods in detail. Paternosto went back into history, chose one area on which to concentrate, and tried to set the record straight. Paternosto's call for the acknowledgment of the origins of Latin American art is one of his significant contributions to the art world. Throughout history there has been an attempt to obliterate the abstract roots of Latin America, but Paternosto has made it clear that they are indeed standing and in good health.

—Graciela Kartofel

PELÁEZ (del CASAL), Amelia
Cuban painter and ceramicist

Born: Yaguajay, 5 January 1896. **Education:** Escuela de Bellas Artes de San Alejandro, Havana, 1916–24, 1926–27; Art Students League, New York, 1924; Academie de la Grande Chaumière, L'École des Beaux-Arts, L'École de Louvre, and under Alexandra Exter, Academie Moderne, Paris, 1927–34. **Career:** Traveled to Spain, Germany, Italy, Czechoslovakia, and Hungary, 1927–34. Set up studio, Havana, 1934; set up ceramic workshop, 1955. Instructor, Escuela de Bellas Artes de San Alejandro, Havana, and at a public school, Havana, beginning in 1937. **Awards:** Cuban government grant for study in France, 1927; prizes, *Exposicion nacional de pintura y escultura,* Havana, 1935, 1938, 1956, 1959; first prize, *Pintura moderna cubana,* Galeria Sudamericana, New York, 1956. **Died:** Havana, 8 April 1968.

Individual Exhibitions:

1933 Galerie Zak, Paris
1935 Lyceum, Havana
1941 Gallería Norte, New York
1943 Institucion Hispano-Cubana de Cultura, Havana
 (retrospective)
1957 Lyceum, Havana
1959 Instituto Municipal de Cultura Marianao, Havana
1960 Lyceum, Havana (retrospective)
1964 Galeria de la Habana, Havana
1967 Museo de Arte Moderno, Bogota, Colombia
 Lyceum, Havana
1968 Museo Nacional, Palacio de Bellas Artes, Havana
 (retrospective)
1979 Museo de Arte Moderno, Mexico City (retrospective)
1987 Museo de Arte Moderno, Universidad Nacional, Bogota,
 Colombia
1988 Cuban Museum of Art and Culture, Miami, Florida
 (traveling retrospective)

1991 *Amelia Peláez: Exposicion retrospectiva, 1924–1967,*
 Funcacion Museo de Bellas Artes, Caracas,
 Venezuela

Selected Group Exhibitions:

1934 *Exposition de Livres Manuscrits,* Galerie Myrbor, Paris
1939 *Latin American Exhibition of Fine Arts,* Riverside
 Museum, New York
1943 Brooklyn Museum, New York
 Museum of Modern Art, New York
1947 Institute of Modern Art, Boston
 Pan American Union, Washington, D.C.
1952 Institute of Contemporary Art, Boston
1956 American Federation of the Arts, Washington, D.C.
1959 *The United States Collects Latin American Art,* Art
 Institute of Chicago
1967 *Latin American Art: 1931–1966,* Museum of Modern
 Art, New York

Collections:

Museum of Modern Art of Latin America, Washington, D.C.; Museum of Modern Art, New York; Museo Nacional de la Havana.

Publications:

On PELÁEZ: Books—*Amelia Peláez,* exhibition catalog, Havana, 1935; *Amelia Peláez* by Alejo Carpentier, Havana, 1960; *Amelia Peláez: Exposicion retrospectiva,* exhibition catalog, Havana, 1968; *Amelia Peláez* by Marisol Trujillo, Havana, 1973; *La gran pintora cubana Amelia Peláez,* 1896–1968, exhibition catalog, Mexico City, 1979; *Amelia Peláez* by Alejandro G. Alonso, Havana, Editorial Letras Cubanas, 1988; *Amelia Peláez, 1896–1968: A Retrospective,* exhibition catalog, Miami, Cuban Museum of Arts and Culture, c. 1988; *Amelia Peláez: En el centenario de su nacimiento,* Havana, Centro Wifredo Lam, 1996; *Amelia Peláez, 1896–1968,* Havana, Caixa de Balears, 1999. **Articles**—"Amelia Peláez" by Jose Lezama Lima, in *El Arte en Cuba,* 1940; "Amelia Peláez o el absolutisimo plastico" by Jorge Manach, in *Revista de la Habana,* September 1943; "Modern Cuban Painters" by Alfred H. Barr Jr., in *Museum of Modern Art Bulletin,* April 1944; "El arte cubanisimo de Amelia Peláez" by Lolo de la Torriente, in *Bohemia* (Havana), 7 September 1962; "Amelia Peláez: Version clasica del barroco cubano" by Graziella Pogolotti, in *Cuba,* January 1965; "Amelia Peláez y la Cultura Cubana" by Beatriz González, in *Re-Vista,* vol. 2, 1980; "Amelia" by Jose Lezama Lima, in *Imagen y Posibilidad,* Havana 1981; "Apuntes sobre Amelia Peláez y el arte latinoamericano" by Belgica Rodriguez, in *Plastica,* March 1988; "Amelia Peláez" by Carol Damian, in *Latin American Art,* spring 1991: "Amelia Peláez: The Artist as Woman" by Giulio V. Blanc, in *Art Nexus,* August 1992; "Pilgrimage to France: The Cuban Painters" by Lourdes Gil, in *Michigan Quarterly Review,* 33, fall 1994, pp. 716–722; "Kahlo et consoeurs" by Manuel Jover, in *L'Oeil* (Lausanne, Switzerland), 485, May 1997, p. 18.

* * *

Amelia Peláez is considered by many as the "mother of modernism" in Cuba. A member of the generation of artists known as the

Grupo Minorista, which also included Eduardo Abela, Carlos Enríquez, Fidelio Ponce de León, and Víctor Manuel, Peláez and her colleagues questioned the elite taste for folkloric and nationalistic themes and academic realism in Cuban painting in the early twentieth century. From the 1920s until her death in 1968, her paintings were characterized by a popular synthesis of cubist pictorial ideas and forms with native imagery and themes.

Peláez was born to an upper-class family in Yaguajay, in the province of Las Villas, in 1896 and entered the Academy of San Alejandro in Havana in 1916. After 1923 she became involved in promoting the progressive agenda of the Grupo Minorista at the academy. In 1924 she had her first solo exhibition and also studied at the Arts Students League in New York City. Three years later she received a scholarship to study at La Grande Chaumière at the École des Beaux-Arts and the Louvre in Paris. In the late 1920s she embraced the cubism of the Spaniard Pablo Picasso, the Frenchmen Georges Braque and Fernand Legér, and most importantly the Russian modernist Alexandra Exter, who became her teacher. She held successful exhibitions in Paris in the early 1930s and returned to Cuba in 1934. By then her definitive style and approach to painting was responsive to modernist values and unsentimental ideas about Cuban national culture and identity.

Two major streams unite in the painting of Peláez: the dominant visual language of the Parisian avant-garde in the 1920s, and Cuban themes and subjects, particularly those drawn from her roots in colonial creole culture. Until her death Peláez's paintings were consistently characterized by opulent still lifes of tropical fruit and architectural ornament and pattern that were rendered in heavy black outlines with diaphanous planes of bright colors. She initially painted fruit and flowers, but by the late 1930s she had begun to introduce familiar elements from Cuban baroque and neoclassical architecture as well as the domestic interiors of her upper-class world: balusters, wrought iron grills, wicker caning, stained-glass lunettes, or fanlights, known as *medio punto*s. She merged brilliant tropical light with the rich patterns and colors from plants in her family garden or from the colonial furniture in her home. This imagery became almost instantly popular and took on an iconic power to represent modern Cuba. It was eventually identified with Caribbean modernism and imitated both in Cuba and elsewhere.

Though personally shy and reclusive, Peláez taught at the academy in Havana after 1937 and in a public school in the Havana neighborhood of El Cerro. Throughout her long career she also painted numerous public murals, illustrated books, and worked with ceramics and watercolors. Less well known are her drawings and paintings of women in almost cloistered settings that reflect the reclusive life she led with her widowed mother and sisters in the Havana neighborhood of La Vibora.

—H. Rafael Chácon

PEÑA, Amado M(aurilio) Jr.
American painter and printmaker

Born: 1943. **Education:** Texas A&I University, Kingsville, B.A. in art 1965, M.A. in art and education 1971. **Family:** Married J.B. Peña. **Career:** Art instructor, Laredo Independent School District, Texas, 1964, 1965–70, Crystal City Independent School District, Texas, 1972–74, L C. Anderson High School, Austin, Texas, 1974–80, and

Amado M. Peña, Jr. © Jim Arndt. Photo courtesy of the artist.

Idyllwild School of Art, California, 1988; founder and art instructor, Alexander High School, Laredo, Texas, 1994–98. Artist-in-residence, Penn State University, State College, Pennsylvania, 1989, Austin Community College, Texas, 1990–92, and Laredo Community College, Texas, 1997. Founder, El Taller Inc. and El Taller galleries. **Awards:** Citation award, Laguna Gloria Art Museum, Austin, Texas, 1982; Native American Artist of the Year award, Dine Be Keyah Museum, Page, Arizona, 1987; Purchase award, Cherry Creek Arts Festival, Colorado, 1993; second place in mixed media and in printmaking, Laredo Art League, Texas, 1997; first place in mixed media, 1999, first place in painting, 2000, first place in printmaking, 2001, Southwest Arts Festival, Indio, California; first place in painting, Bayou City Art Festival, Houston, 2000; first place in paper cast, second place in painting, and second place in drawing, Gallup Inter-Tribal Ceremony, New Mexico, 2000; first place in painting and in printmaking, Castle Rock Arts Festival, Colorado, 2000. Honorary degree, Austin Community College, Texas, 1992. **Address:** 236 Don Gaspar, Santa Fe, New Mexico 87501, U.S.A. **Website:** http://www.penaofficial.com.

Individual Exhibitions:

1969 Dos Patos Art Gallery, Corpus Christi, Texas
 Texas A&I University, Kingsville
 University of Corpus Christi, Texas
1970 Dos Patos Art Gallery, Corpus Christi, Texas
 Texas A&I University, Kingsville
1971 Estudio Rio, Mission, Texas

Amado M. Peña, Jr.: *Manton Morado,* from "Mestizo" series, 2001. Photo courtesy of the artist.

1971	Dos Patos Art Gallery, Corpus Christi, Texas
1972	Dos Patos Art Gallery, Corpus Christi, Texas
	Estudio Rio, Mission, Texas
1973	Estudio Rio, Mission, Texas
	New Mexico Highlands University
1975	6th Street Gallery, Austin, Texas
	American Bank, Austin, Texas
1976	Kerby Lane Galleries, Austin, Texas
	Migrant Conference, Austin, Texas
	Tuthill Galleries, Dallas
1977	Kerby Lane Galleries, Austin, Texas
	Wagner Galleries, Austin, Texas
1978	Nuevo Santander Museum, Laredo, Texas
	Wagner Galleries, Austin, Texas
1979	Casa Adobe Gallery, El Paso, Texas
	Kerby Lane Gallery, Austin, Texas
	Los Llanos Gallery, Santa Fe, New Mexico
1980	Casa Adobe Gallery, El Paso, Texas
	Dagen Bela Gallery, San Antonio, Texas
	El Taller Gallery, Austin, Texas
	Gallery 26 East, Tulsa, Oklahoma
	Hanging Tree Gallery, Midland, Texas
	Hobar Gallery, Santa Barbara, California
	Laguna Gloria Art Museum, Austin, Texas

	Quail Hollow Gallery, Oklahoma City
1981	Brush Gallery, Houston
	Casa Adobe Gallery, El Paso, Texas
	Dagen Bela Gallery, San Antonio, Texas
	El Taller Gallery, Austin, Texas
	Enthios II Gallery, Albuquerque, New Mexico
	Galeria Elena, Newport Beach, California
	Gallery 26 East, Tulsa, Oklahoma
	Hobar Gallery, Santa Barbara, California
	Houshang's Gallery, Dallas
	Inter-American Development Bank, Washington, D.C.
	Julia Black Gallery, Taos, New Mexico
	Kemper Galleries, Colorado Springs
	Lake Gallery, Tahoe City, California
	Los Llanos Gallery, Santa Fe, New Mexico
	Westwood Gallery, Portland, Oregon
	White Buffalo Gallery, Wichita, Kansas
1982	Adagio Gallery, Palm Springs, California
	Albatross Gallery, Boulder, Colorado
	American West Gallery, Chicago
	Brush Gallery, Houston
	Byrne-Getz Gallery, Aspen, Colorado
	Casa Adobe Gallery, El Paso, Texas
	Dagen Bela Gallery, San Antonio, Texas
	El Taller Gallery, Austin, Texas
	Galeria Capistrano, San Juan Capistrano, California
	Gallery 26 East, Tulsa, Oklahoma
	Gekas-Nichols, Tucson, Arizona
	Hobar Gallery, Santa Barbara, California
	Houshang's Gallery, Dallas
	Julia Black Gallery, Taos, New Mexico
	Kemper Galleries, Colorado Springs
	Los Arcos Art Gallery, Laredo, Texas
	Los Llanos Gallery, Santa Fe, New Mexico
	Westwood Gallery, Portland, Oregon
	White Buffalo Gallery, Wichita, Kansas
1983	Adagio Gallery, Palm Springs, California
	American West Gallery, Chicago
	Canyon Gallery, Fort Lauderdale, Florida
	El Taller de Taos, New Mexico
	El Taller Gallery, Austin, Texas
	El Taller on the Plaza, Santa Fe, New Mexico
	Gallery at Hogg Hollow, St. Louis, Missouri
	The Graphic Image, Milburn, New Jersey
	Houshang's Gallery, Dallas
	Impressions Gallery, Tucson, Arizona
	Joy Tash Gallery, Scottsdale, Arizona
	La Brea, San Jose, California
	La Tienda Tlaquepaque, Sedona, Arizona
	Quintana's Gallery, Portland, Arizona
	Squash Blossom, Vail, Colorado
	Sterling Fine Arts, Laguna Beach, California
	Vis-A-Vis Gallery, New Orleans
1985	Adagio Gallery, Palm Springs, California
	American West Gallery, Chicago
	Andrews Gallery, Albuquerque, New Mexico
	Byrne-Getz Gallery, Aspen, Colorado
	El Taller de Taos, New Mexico
	El Taller Gallery, Austin, Texas
	El Taller on the Plaza, Santa Fe, New Mexico

Amado M. Peña, Jr.: *Pueblo en Azul,* **from ''Mestizo'' series, 2001. Photo courtesy of the artist.**

Galeria Capistrano, San Juan Capistrano, California
Houshang's Gallery, Dallas
Joy Tash Gallery, Scottsdale, Arizona
Kauffman Gallery, Houston
Lincoln Square Gallery, Arlington, Texas
Museum of Native American Art, Spokane, Washington
Parke Gallery, Vail, Colorado
Squash Blossom Gallery, Denver
1986 Adagio Gallery, Palm Springs, California
Americana Museum, El Paso, Texas
The Artisan's Shop and Gallery, Ruidoso, New Mexico
El Taller Gallery, Austin, Texas
El Taller on the Plaza, Santa Fe, New Mexico
Galeria Capistrano, San Juan Capistrano, California
Houshang's Gallery, Dallas
Joy Tash Gallery, Scottsdale, Arizona
Squash Blossom Gallery, Denver
Squash Blossom Gallery, Colorado Springs
1987 Adagio Gallery, Palm Springs, California
American West, Chicago
Americana West Gallery, Washington, D.C.
Avanti Gallery, San Antonio, Texas

Dagen Bela Gallery, San Antonio, Texas
El Taller de Taos, New Mexico
El Taller Gallery, Austin, Texas
El Taller on the Plaza, Santa Fe, New Mexico
Galeria Capistrano, San Juan Capistrano, California
Houshang's Gallery, Dallas
Joy Tash Gallery, Scottsdale, Arizona
Squash Blossom Gallery, Denver
Scottsdale Center for the Arts, Arizona (retrospective)
Xochil Art Museum, Mission, Texas
1988 Adagio Gallery, Palm Springs, California
American West, Chicago
Americana West Gallery, Washington, D.C.
Avanti Gallery, San Antonio, Texas
El Taller de Taos, New Mexico
El Taller Gallery, Austin, Texas
El Taller on the Plaza, Santa Fe, New Mexico
Galeria Capistrano, San Juan Capistrano, California
Hendrix Collection, Coconut Grove, Florida
Houshang's Gallery, Dallas
Joy Tash Gallery, Scottsdale, Arizona
Kemper Gallery, Colorado Springs
Lincoln Square Gallery, Arlington, Texas
McLaren and Markowitz Gallery, Boulder, Colorado
Sante Fe Style, Madison, Wisconsin
Sierra Gallery, Tahoe City, California
Texas A&I University, Kingsville
Tower Gallery, Sacramento, California
Xochil Art Museum, Mission, Texas
1989 Adagio Gallery, Palm Springs, California
Avanti Gallery, San Antonio, Texas
El Taller de Taos, New Mexico
El Taller Gallery, Austin, Texas
El Taller on the Plaza, Santa Fe, New Mexico
Galeria Capistrano, San Juan Capistrano, California
Hendrix Collection, Coconut Grove, Florida
Joy Tash Gallery, Scottsdale, Arizona
Lincoln Square Gallery, Arlington, Texas
Sierra Gallery, Tahoe City, California
Syd Entel Gallery, Tampa, Florida
1990 Adagio Gallery, Palm Springs, California
Avanti Gallery, San Antonio, Texas
El Taller de Taos, New Mexico
El Taller Gallery, Austin, Texas
El Taller on the Plaza, Santa Fe, New Mexico
Galeria Capistrano, San Juan Capistrano, California
Hendrix Collection, Coconut Grove, Florida
Joy Tash Gallery, Scottsdale, Arizona
Lincoln Square Gallery, Arlington, Texas
Santa Barbara Ranch, Clewiston, Florida
Santa Fe Style, Madison, Wisconsin
Sierra Gallery, Tahoe City, California
Sunset Mesa Gallery, Dallas
1991 Adagio Gallery, Palm Springs, California
Avanti Gallery, San Antonio, Texas
Dagen Bela Galeria, San Antonio, Texas
El Taller de Taos, New Mexico
El Taller Gallery, Austin, Texas
El Taller on the Plaza, Santa Fe, New Mexico
Joy Tash Gallery, Scottsdale, Arizona

1991	Lincoln Square Gallery, Arlington, Texas
	Sierra Gallery, Tahoe City, California
1992	Adagio Gallery, Palm Springs, California
	Adobe East Gallery, Milburn, New Jersey
	Allard's Gallery, Fresno, California
	Buffalo Gallery, Alexandria, New Mexico
	Byrne-Getz Gallery, Aspen, Colorado
	Caldwell-Snyder Gallery, San Francisco
	Canyon Road Gallery, Denver
	The Craft Place, Waco, Texas
	El Taller de Taos, New Mexico
	El Taller Gallery, Austin, Texas
	El Taller on the Plaza, Santa Fe, New Mexico
	Framecraft/Lampros Gallery, The Woodlands, Texas
	The Galeria, Norman, Oklahoma
	Galeria Capistrano, San Juan Capistrano, California
	Joy Tash Gallery, Scottsdale, Arizona
	Mercado Gallery, Albuquerque, New Mexico
	Santa Fe Style, Madison, Wisconsin
	Santa Fe Trails Gallery, Sarasota, Florida
	Silver Shadows Gallery, Breckenridge, Colorado
	Southwestern Art Gallery, Coral Gables, Florida
	Sunbird Gallery, Los Altos, California
	Thomas Charles Gallery, Las Vegas
	Phoenix Gallery, Coeur d'Alene, Idaho
	Rainbow Warrior, Dallas
	Webb Gallery, Amarillo, Texas
1993	Adobe East Gallery, Milburn, New Jersey
	The Craft Place, Waco, Texas
	Dagen Bela Galeria, San Antonio, Texas
	Deborah Hudgins Fine Art Gallery, Santa Fe, New Mexico
	El Taller de Taos, New Mexico
	El Taller Gallery, Austin, Texas
	Framecraft/Lampros Gallery, Woodlands, Texas
	Loma Luna, Dallas
	M. Martin Galleries, Richmond, Texas
	Santa Fe Trails Gallery, Sarasota, Florida
	Sierra Gallery, Tahoe City, California
	Southwestern Art Gallery, Coral Gables, Florida
	Sunbird Gallery, Los Altos, California
	Ultimate Impact Galleries, Decatur, Georgia
1994	Arts, Etc., Victoria, Texas
	Deborah Hudgins Fine Art Gallery, Santa Fe, New Mexico
	El Taller de Taos, New Mexico
	Framecraft/Lampros Gallery, Woodlands, Texas
	Galeria Capistrano, San Juan Capistrano, California
	Lazar Creative Framing and Fine Art Gallery, Canton, Ohio
	Post Road Framers Gallery, Rowley, Massachusetts
	Rainbow Warrior Gallery, Galveston, Texas
	Santa Fe Trails Gallery, Sarasota, Florida
	Sierra Gallery, Tahoe City, California
	Studio W Gallery, El Paso, Texas
1995	Arts, Etc., Victoria, Texas
	Brent Thompson Gallery, Boulder City, Nevada
	Chief Dodge Gallery, Scottsdale, Arizona
	El Taller de Taos, New Mexico
	Jean Winker Gallery, Wheaton, Illinois

	Lazar Creative Framing and Fine Art Gallery, Canton, Ohio
	Marathon Gallery, Tucson, Arizona
	Peña Studio/Gallery, Santa Fe, New Mexico
	Rainbow Warrior Gallery, Galveston Island, Texas
	Santa Fe Trails Gallery, Sarasota, Florida
	Sierra Gallery, Tahoe City, California
	Vargas Gallery, Scottsdale, Arizona
1996	Anasazi Gallery, Dallas
	Bazaar del Mundo Gallery, San Diego, California
	El Taller de Taos, New Mexico
	Galería Sol y Luna, San Antonio, Texas
	Gallery Southwest, Portland, Oregon
	Harvest Maiden Gallery, Albuquerque, New Mexico
	High Peaks Gallery, Breckenridge, Colorado
	Nizhoni Dream Catchers, Naples, Florida
	Shared Visions Gallery, Delray, Florida
	Sierra Gallery, Tahoe City, California
	Touch of Santa Fe, Waco, Texas
	Vail Arts Council Show, Colorado
1997	Gomes Gallery, St. Louis, Missouri
	Peña Studio/Gallery, Santa Fe, New Mexico
1998	Peña Studio/Gallery, Austin, Texas
	Sangre de Cristo Center for the Arts, Pueblo, Colorado

Selected Group Exhibitions:

1975	Institute of Mexican Culture, Hemisfair, San Antonio, Texas
1976	Inter-American Development Bank, Washington, D.C.
1978	Everson Museum of Art, New York
	Los Angeles County Art Museum
1980	Smithsonian Institution, Washington, D.C.
1981	Organization of American States, Washington, D.C.
	Santa Fe Festival of the Arts: National Invitational Exhibit of Native American Arts, New Mexico
1990	*Chicano Art: Resistance & Affirmation 1965–1985,* Wight Art Gallery, University of California, Los Angeles (traveling)
1993	*Chicano Social Revolution,* Expression Art Gallery, San Antonio, Texas
1995	*Covering the West–The Best of Southwest Art,* Tucson Museum of Art, Arizona (traveling)

Collections:

National Museum of American Art, Smithsonian Institution, Washington, D.C.; Texas A&I University, Kingsville; California State University, Long Beach; University of Kentucky, Louisville; University of Texas, Austin; Whitney Museum, San Antonio, Texas; Historical and Creative Arts Center, Lufkin, Texas; Museum of Nuevo Santander, Laredo, Texas.

Publications:

By PEÑA: Book—*Peña on Peña,* Waco, Texas, WRS Publishing, 1995. **Book, illustrated**—*Calor: A Story of Warmth for All Ages* by Juanita Alba, New York, Lectorum Publications, 1995.

On PEÑA: Books—*Tierra, familia, sociedad: Amado Peña's Themes,* exhibition catalog, Austin, Texas, Laguna Gloria Art Museum, 1980; *Amado Maurilio Peña, Jr.* by Howard L. Anderson, Robert S. Young, and Andrew Kilgore, Albuquerque, New Mexico, R.S. Young, 1981; *A Retrospective Show,* exhibition catalog, Austin, Texas, El Taller Publishing, 1987. **Articles**—"A Public Voice: Fifteen Years of Chicano Posters" by Shifra M. Goldman, in *Art Journal,* 44, spring 1984, pp. 50–57; "Amado Maurilio Peña. Interview" by Annie Osburn, in *Southwest Art,* 20, August 1990, pp. 88–93; "Patrones en colores," in *Southwest Art,* 25, October 1995, p. 180; "Serigraphs: Amado Peña's Hands-On Approach" by Sally Eauclaire, in *Southwest Art,* 25, April 1996, pp. 72–75.

* * *

Amado Maurilio Peña, Jr., has become one of the most popular artists of the American Southwest. His pieces, which typically involve a chiseled figure set against a backdrop of stereotypical features of the Southwest, have not always won critical acclaim; indeed, he has been accused of mass-producing art for the sake of profit. Nevertheless, Peña has become virtually a household name. His work–drawings, paintings, etchings, serigraphs, monotypes, lithographs, and posters–has become wildly popular. His style, which synthesizes elements of pre-Columbian, Native American, and Mexican folk art, is instantly recognizable. Using bright colors, contours, and patterns, Peña contrasts stony profiles with the rugged terrain of the Southwest. Indian blankets, pottery, and geometric shapes also accent his works. He has spoken publicly of his mestizo roots (he is descended from Spanish and indigenous North American people) and has asserted that his work tells the story of his heritage.

Peña did not pursue art full-time until 1978. Before then he was a high school teacher in Austin, Texas, who painted when he had time. In his early works from the 1970s he used bold colors and heavy gestures in a style more reminiscent of postimpressionism than of the crisp lines that characterized his later work. Like other Mexican-American artists of that decade, Peña used his art as a space to explore his political and cultural identity. For example, in a series of small prints from the mid-1970s he combined simple illustrations in fluorescent colors with sharp words. He also painted bleeding heads of lettuce and protesters carrying signs.

After he quit his teaching job, Peña's style shifted dramatically. He met another artist, Encarnación Peña (no relation), with whom he toured the Southwest. The muted colors, desert landscapes, and Native American influences of the region began to appear in his work. Peña's work found immediate popular success as he built his reputation at art and craft shows across the region. His goal was to reach the largest number of people with his work, and so rather than focus on individual paintings, he produced thousands of reproductions of each work. Peña immersed himself not only in the practice of art but also in the business of the art world. To this end he founded El Taller Inc. and El Taller galleries, through which he could showcase his work.

By the time *Southwest Art* featured him in 1979, Peña had developed his distinctive style. Using line as the dominant feature, he portrayed a figure in profile set against a backdrop of Native American motifs–pueblo architecture, woven zigzags, and Indian pottery and blankets. At its core Peña's paintings and serigraphs are rooted in line drawing. For example, his self-portrait from the mid-1990s, *El pintor como modelo,* contains a variety of line types. Jagged zigzag patterns act as a backdrop; steady lines carve out the face, hands, and clothing; and wispy lines decorate the surface. The similarities in his work, especially the repetitive left-facing angular profile, serve a specific function, to simplify the form and to allow the picture's inner story to emerge.

Peña has not limited himself to one artistic discipline, instead exploring similar themes in a variety of media. He has become best known, however, for his serigraphs, which he produces in limited runs of about 40 prints. This format, with its bright, flat color, clean lines, and crisp graphics, is particularly suited to his style. In his 1995 serigraph *Año nueva,* for instance, two figures face each other in profile. The serigraph enables Peña to emphasize the details of the blankets that wrap the figures and the pots in the foreground and background.

Although Peña has been derided for the popular appeal of his work, he has never equated selling his work with selling out. The fact that his paintings and prints have adorned hotel rooms and McDonald's restaurants has been a source of pride for him, a sign that he has touched thousands of people with his work.

—Rebecca Stanfel

PEÑA, Umberto
Cuban painter and printmaker

Born: Havana, 1937. **Education:** Academia de San Alejandro, Havana, 1955–58; Instituto Superior Politécnico, Mexico City, 1960. **Career:** Director of graphic arts, Casa de las Américas publishing house, Havana; designed 120 magazine issues of *Casa de las Américas* journal, about 2,000 book designs, and other publications, 1963–84. Moved to the United States, 1994. **Awards:** Acquisition prize, *National Salon of Painting,* Fine Arts Palace, Havana, 1962; Especial prize, *Third Latin American Print Competition,* Casa de las Américas, Havana, 1964; prize, *Fifth Paris Young Painting Biennial,* France, 1967; prize, *Second International Print Biennial,* Cracovia, Poland, 1968; La Palma Espinada, Instituto Cultural Cubano-Americano.

Individual Exhibitions:

1960	Contemporary Mexican Art Center, Mexico City
1964	Cuba Culture House, Prague, Czechoslovakia
1971	Doktor Glas Gallery, Sweden
1980	*Trapices,* National Capitol, Havana
1988	Museo Nacional de Bellas Artes, Havana (retrospective)

Selected Group Exhibitions:

1960	*Second Interamerican Biennial,* National Modern Art Museum, Mexico City
	National Print Salon about Revolution Subject, Fine Art Palace, Havana
1965	*Tokyo Print Biennial*
1971	*Cubaanse affiches,* Stedelijk Museum, Amsterdam
1977	*L'affiche contemporaine,* National Center of Art and Culture Georges Pompidou, Paris
1980	*VII Festival Internacional de Ballet de la Habana,* Havana
1986	*Cuban Craftsmanship,* Museo Nacional de Bellas Artes, Havana

1997 *Breaking Barriers,* Museum of Art, Fort Lauderdale, Florida
2000 *7th Havana Biennial*

Collection:

Museo Nacional de Bellas Artes, Havana.

Publications:

By PEÑA: Books, illustrated—*Primitivos relatos contados otra vez: Héroes y mitos amazónicos* by Hugo Niño, Havana, Casa de las Américas, 1978; *Vindicación de Cuba* by José Marti, Havana, Centro de Estudios Martianos, 1982; *Tres estudios Martianos* by Emilio Roig de Leuchsenring and others, Havan, Centro de Estudios Martianos, 1983.

On PEÑA: Books—*Trapices,* exhibition catalog, text by Reynaldo González, Havana, Impr. De la Dirección de Divulgación del Ministerio de Cultura, 1980; *Umberto Peña,* exhibition catalog, text by Nelson Herrera Ysla, Havana, Museo Nacional de Bellas Artes, 1988; *Breaking Barriers,* exhibition catalog, text by Carol Damian, Fort Lauderdale, Florida, Museum of Art, 1997. **Article**—''Umberto Peña expone'' by Antonio Eligio Tonel, in *Revolucion y Cultura,* 9, September 1988, p. 28.

* * *

Umberto Peña is a highly regarded, semiabstract painter who has, nevertheless, become best known for his subtle graphic designs at Casa de las Américas, where he has had a decisive influence on the international ''look'' of this noteworthy publishing house. Between 1963 and 1984 he designed 120 issues of the journal *Casa de las Américas,* countless catalogues produced by the same publisher, and some 2,000 book designs. As such, he helped forge the distinctive aesthetic of sophisticated simplicity for which Cuban silk screens and photo-offset posters have been known since the 1960s.

Peña studied at the Academia de San Alejandro in Havana (1955–58) and then in Mexico City at the Instituto Superior Politécnico (1960). He first worked as a painter and slowly gained a strong, if at times controversial, reputation for his semiabstract works, including *Buey desollado #8* (1964; ''Skinned Ox''), which is on display at the Museo Nacional de Bellas Artes in Havana. A painting that only obliquely suggests its bloody theme, à la Chaim Soutine and Rembrandt, it features numerous shimmering, tightly faceted structures that are notably animated throughout the entire expanse of the canvas. Although Peña exhibited little as a painter in the 1960s and '70s, he produced hundreds of book designs that made him well known in Cuba. Nonetheless, he was given a large retrospective exhibition by the Ministerio de Cultura at the Museo Nacional de Bellas Artes in 1988. Predictably, the show was sharply criticized by writers for *Bastión,* the periodical of the Cuban armed forces, while being eloquently defended by Roberto Fernández Retamar of Casa de las Américas in the pages of *Granma.*

In 1976 Peña made a series of 20 fabric mosaics that became a touchstone for the Volumen I exhibition that introduced the ''new'' artists of the 1980s. He called these works ''trapices,'' a neologism derived from the fusion of *trapo* (rag) with *tapiz* (tapestry). The multimedia character of these images, which were at once ''decorative'' and iconographically loaded, along with the striking shift of

textures back and forth between those of fibers and pigments, made his series notable to such younger artists as Rubén Torres Llorca and José Bedia. At the same time, Peña created an entirely different constructivist-based aesthetic at Casa de las Américas that highlighted limitations of the graphic media in which he worked as a designer. This design aesthetic made a virtue of color-separation and austere formal elements that were in keeping with the lean publishing budget at Casa de las Américas. Painterly in his paintings and hard-edged in his prints, Peña was remarkably experimental in both areas. For breadth of aesthetic engagement, there are few modern artists from Latin America who can match his range.

—David Craven

PEÑALBA, Alicia
Argentine sculptor and lithographer

Born: San Pedro, Buenos Aires, 9 August 1918. **Education:** Escuela Superior de Bellas Artes, Buenos Aires; studied engraving, Ecole Nationale Supérieure des Beaux-Arts, Paris (on scholarship), 1948; Academie de la Grande Chaumière, Paris, 1949; studied under sculptor Ossip Zadkine, 1950. **Career:** Lived and worked in Paris. **Awards:** Prize, Salón Nacional, Argentina, 1947; international sculpture prize, *6th Bienal of São Paulo,* Brazil, 1961; Gulbenkian prize in sculpture, 1974; Konex prize, 1982.

Individual Exhibitions:

1952 Salon de Mai, Paris
1957 Galerie du Dragon, Paris
1960 Otto Gerson Gallery, New York
 Fine Arts Associates Gallery, New York
 Galerie Claude Bernard, Paris
1962 Devorah Sherman Gallery, Chicago
 Museo de Arte Moderno, Rio de Janeiro
1964 Rijksmuseum Kroller Muller d'Otterlo, Germany (traveling retrospective)
1965 Galerie Henri Creuzevault, Paris
1966 Bonino Gallery, New York
 Phillips Collection, Washington, D.C.
1969 Galerie Nuovo Cárpine de Roma, Rome, and Galerie Toninelli Arte Moderno, Milan
1971 Galerie d'Art Moderne, Basel, Switzerland
1974 Galería Aele, Madrid
1975 Artel Gallery, Geneva, Switzerland
 Galerie de France et du Benelux, Brussels
1976 Galería Arte/Contact, Caracas, Venezuela
1977 Musée d'Arte Moderne de la Ville de Paris
 Villand-Galanis Gallery, Paris
1978 Museo de Arte Contemporáneo, Caracas, Venezuela
1982 Musée de Beaux Arts, Chaux de Fonds, France
1984 Galería Rubbers, Buenos Aires

Selected Group Exhibitions:

1958 Solomon R. Guggenheim Museum, New York
1959 *Sculpture internationale,* Galerie Claude Bernard, Paris
1960 Cleveland Museum of Art, Ohio

1961 *Drawings by Sculptors,* Smithsonian Institution, Washington, D.C. (traveling)
1962 Solomon R. Guggenheim Museum, New York
1964 *Pittsburgh International,* Carnegie Institute
 Aldrich Museum of Contemporary Art, Ridgefield, Connecticut
1970 *Pittsburgh International,* Carnegie Institute
1973 *Jewelry As Sculpture, Sculpture As Jewelry,* Institute of Contemporary Art, Boston
1989 *The Latin American Spirit: Art & Artists in the U.S.,* Bronx Museum, New York

Collections:

Albright-Knox Art Gallery, Buffalo, New York; Carnegie Institute, Pittsburgh; Cleveland Museum of Art, Ohio; Dallas Museum of Fine Arts; Isaac Delgado Museum of Art, New Orleans.

Publications:

On PEÑALBA: Books—*Peñalba: Sculptures 1960–1965,* exhibition catalog, Paris, Galerie Creuzevault, 1965; *Peñalba: Sculptures,* exhibition catalog, New York, Galeria Bonino, 1966; *Peñalba,* exhibition catalog, Basel, Switzerland, Galerie d'Art Moderne, 1971; *Peñalba,* exhibition catalog, Brussels, Galerie de France et du Benelux, 1975; *Une approche en 8 points de l'oeuvre sculptée* by Jorn Merkert, Paris, Galerie Michele Broutta, 1977; *Peñalba,* exhibition catalog, Paris, Musée d'art moderne de la ville de Paris, 1977; *Alicia Peñalba: O de la cadencia musical en la escultura* by Tomás Alva Negri, Buenos Aires, Ediciones de Arte Gaglianone, 1986. **Article**—"Alicia Peñalba and Marta Minujin. Galería Rubbers, Buenos Aires" by Alberto Collazo, in *Art Nexus* (Colombia), 12, April/June 1994, pp. 178–179.

* * *

Alicia Peñalba was an influential post-World War II abstract sculptor whose work was exhibited alongside Henry Moore and Étienne Hadju. Although she was born in Argentina, Peñalba spent most of her adult life in Paris, where her sculptures were critically and popularly acclaimed. Her work was frequently monumental in both its dimensions and its spirit. She worked primarily in clay, and although her work was cast in metal, concrete, or polyester, the finished product retained the earthy essence and textural quality of the original material. In addition to her renowned sculptures, Peñalba created lithographs, collages, designs for jewelry and vases, and tapestries.

Peñalba was born in Buenos Aires but lived in Chile and in the Patagonian region of Argentina for a significant part of her childhood. The cordillera landscape of her youth would inform much of her sculptural work. In 1948 she won a scholarship from the French government and enrolled at the École Nationale Supérieure des Beaux-Arts to study printmaking. After entering the studio of Ossip Zadkine in 1950, however, she decided to focus exclusively on sculpture. In 1951 she created her first nonfigurative work, destroyed her more conventional previous work, and wholeheartedly embraced abstraction.

Peñalba's work in the early 1950s was vertically oriented. Her sculptures consisted of faceted modules superimposed in layers or organized into groups. Because each module remained distinct from the others but simultaneously existed in concert with them, her work had an inner dynamism and intensity. For instance, *Middle Totem,* a 1954 piece, had modular forms clustered around a central axis. Peñalba's sculptures from this period, which she would later describe as encompassing the years between 1952 and 1957, were often named for animals, vegetable matter, or natural forces. *Ancestor Butterfly, Vegetal Liturgy, Sea Fawn,* and *Black Forest* emerged during this time. While critics were quick to assume that these pieces were meant to portray–albeit in an abstract fashion–the names she had given them, Peñalba was explicit that the works were instead an effort to spiritualize the symbols of eroticism, which for her was the source of creation. The works were vertical, she explained, not to emulate the trajectory of limbs or branches but rather to suggest that the procreative force reached toward the sky.

In the 1960s Peñalba's focus shifted. Having exhausted her earlier theme, she turned to the exploration of what she termed "the perfection of sculptural means." Her works of this era were typically horizontally oriented and used curved forms. *Great Winged Creature* (1963) featured a curved arc from which triangular shapes jutted. Like other pieces from the 1960s and 1970s, *Great Winged Creature* allowed light to pierce it from multiple entry points.

Throughout her career Peñalba demonstrated a commitment to massive public sculptures. One of her better-known works was *Grand Double* (1971), which was commissioned to adorn the MGIC Plaza in Milwaukee, Wisconsin. Comprised of looming bronze figures, *Grand Double* was 28 feet high, one of the largest works ever created by the lost-wax process. *Winged Field* (1963) was another classic Peñalba piece. She constructed more than a dozen giant concrete forms that were placed among the buildings of the School of Economic and Social Studies at Sankt Gallen, Switzerland.

Although Peñalba was best known for her sculpture, she pursued other artistic interests as well. She constructed various types of public works, including wall reliefs and fountains. Her lithographs and jewelry were also well received.

—Rebecca Stanfel

PÉREZ BRAVO, Marta María
Cuban photographer

Born: Havana, 1959. **Education:** Academia de Artes Plasticas San Alejandro, Havana, 1975–79; Instituto Superior de Arte, Havana, 1979–84. **Family:** Married Flavio; two daughters. **Career:** Moved to Monterrey, Mexico. Artist-in-residence, Institute of Contemporary Art, Portland, Oregon, 1996, and Vinalhaven Press, Vinalhaven, Maine, July 1997. **Awards:** First Prize in Photography, Fototeca of Havana, March 1996, for *Nudi'96*; Premio artista revelación de ARCO'97, Feria de Arte Contemporáneo, Madrid, 1997.

Individual Exhibitions:

1982 Casa de la Cultura de Plaza, Havana
1985 Casa de la Cultura de Plaza, Havana
1989 Museum of Art, Pori, Finland
 Hippolyte Gallery, Helsinki
 Fotogram Gallery, Jyvaskyla, Finland

Marta María Pérez Bravo: *Mas fuertes nos protejen mejor,* **1995. Photo courtesy of Galeria Ramis Barquet.**

	Titanic Gallery, Turku, Finland
1990	Museum of Art, Pori, Finland
1992	*Integración 92*, Galería Valenzuela y Klenner, Bogotá
	Le Lieu Gallery, Centre en Art Actuell, Quebec
	Basta Gallery, Hamburg Germany
	The Patio Gallery, Bremen, Germany
1994	*Divine Utterances,* Throckmorton Gallery, New York
1995	Espacio Aglutinador, Havana
	Galería Ramis Barquet, Monterrey, Mexico
	Centro Wifredo Lam, Havana
1996	Galería Ramis Barquet, Monterrey, Mexico
1997	Galería Luis Adelantado, Valencia, Spain
1998	Throckmorton Gallery, New York
	Museo Jose Luis Cuevas, Mexico City
	IFA Gallery, Bonn, Germany
	Thomas Cohn Gallery, São Paulo, Brazil
	Photographs do not Bend Gallery, Dallas
1999	*Todo viene de tierra ajena*, Museo Alejandro Otero, Caracas, Venezuela
	Ramis Barquet Gallery, New York

	Todo viene de tierra ajena, Casa de las Americas, Havana
	Paolo Curti Gallery, Milan
2000	Annina Nosei Gallery, New York
	Galería Luis Adelantado, Valencia, Spain
2001	Iturralde Gallery, Los Angeles
	Universidad de Salamanca, Spain
	Project Room, ARCO, Madrid
	Basta Gallery, Hamburg, Germany

Selected Group Exhibitions:

1988	*Raices en accion,* Museo Carrillo Gil, Mexico City
1990	*The Nearest Edge of the World: Art and Cuba Now,* Massachusetts College of Art
1992	Ludwig Forum, Aachen, Germany
1993	*Cartographies,* Winnipeg Art Gallery, Manitoba
1996	*The Image As Object,* Portland Institute of Contemporary Art, Oregon
1999	*Mirror Images, Women, Surrealism, and Self-Representations,* San Francisco Museum of Modern Art
2000	*Latin American Still Life, Reflection of Time and Place,* Museo del Barrio, New York
	Estética Iberoamericana, Museo Sofía Imber, Caracas, Venezuela
	Kwangju *Biennale,* Korea
2001	*Shifting Tides: Cuban Photography after the Revolution,* Los Angeles County Museum of Art

Collections:

Museum of Art, Pori, Finland; Museo Nacional de Bellas Artes, Havana; Ludwig Forum, Aachen, Germany; Museo Nacional Centro de Arte Reina Sofia, Madrid, Spain; Throckmorton Gallery, New York; Galería Ramis Barquet, Monterrey, Mexico; Museo Español e Iberoamericano de Arte Contemporáneo, Badajoz, Spain; the Norton family collection, United States; Fondo Fotográfico de la Colección de Arte ARCO, Madrid, Spain; Galería Luis Adelantado, Valencia, Spain; Fondo de la Colección del Centro de Arte Contemporáneo de Guadalajara, Mexico; Colección Cisneros, Mexico; Centro Andaluz de Arte Contemporáneo, Isla de la Cartuja, Seville, Spain; Fototeca of Havana.

Publications:

On PÉREZ BRAVO: Books—*Made in Havana,* exhibition catalog, text by Charles Merewether, Art Gallery of New South Wales, 1988; *Kuba OK,* exhibition catalog, text by Osvaldo Sanchez, Städtische Kunsthalle Dusseldorf, 1990; *The Nearest Edge of the World,* exhibition catalog, text by Rachel Weiss, Massachusetts College of Art, 1990; *No Man Is an Island,* exhibition catalog, text by Osvaldo Sanchez, Museum of Art, Pori, Finland, 1990; *The Children of Guillermo Tell,* exhibition catalog, text by Gerald Mosquera, Alexander Knoll Museum, Caracas, Venezuela, 1991; *Cartographies* by José Bedia, Alison Gillmor, and Batsleer Étienne, Winnepeg, Winnepeg Art Gallery, 1993; *American Visions: Artistic and Cultural Identity in the Western Hemisphere* by Mary Jane Jacob, Noreen Tomassi, and Ivo Mesquita, New York, Allworth Press, 1994; *Cruzando caminos,* exhibition catalog, text by Fernando Castro, Lima, Museo de Arte de Lima, 1995; *Me pongo en tus manos,* exhibition catalog, text by

Marta María Pérez Bravo: *Kini Kini,* **1999. Photo courtesy of Galeria Ramis Barquet.**

Orlando Hernández, Mexico, Galería Ramis Barquet, 1996; *Latin American Art of the 20th Century* by Edward Sullivan, London, Phaidon Press, and Madrid, Nerea Editings, 1996; *Marta María Pérez Bravo,* exhibition catalog, text by Juan Antonio Molino, New York, Galería Ramis Barquet, 1999; *Afro-Cuba, 'Woman,' and History in the Works of Ana Mendieta, María Magdalena Campos-Pons, and Marta María Pérez Bravo* by Robin Greeley, Storrs, Connecticut, William Benton Museum of Art, University of Connecticut, 2000; *Photographing Identity: The Self-Portraits of Marta María Pérez Bravo,* thesis, by Kay V. Grissom-Kiely, the Art Institute of Chicago, 2000. **Articles**—''Made in the USA: Art from Cuba'' by Lucy Lippard, in *Art in America,* April 1986; ''Made in Habana'' by Sebastian Lopez, in *Lápiz,* May 1992; ''Marta Maria Pérez: Pictures of the Cosmos'' by Gerald Mosquera, in *Art Nexus,* July-September 1995.

* * *

Among Cuban artists there is a long-standing tradition of using Afro-Cuban imagery in works of art, whether or not the artist is a practitioner of Afro-Cuban religion. During the 1950s and '60s Cuban artists such as Wifredo Lam and Manuel Mendive incorporated symbolic elements of Afro-Cuban religion into their paintings, performances, and mixed-media works of art. Heavily influenced by these modernist Cuban artists, Marta María Pérez Bravo and other young Cuban artists started experimenting with hybrid aesthetics, combining Western techniques and influences with their religious

and/or cultural heritage. A contemporary photographer, Pérez Bravo has used her own nude body, combined with Afro-Cuban religious symbols, to indicate her personal transformation—both physical and psychological—undergone in various stages of her life.

Pérez Bravo was born in Havana, Cuba, during the triumph of the Cuban Revolution in 1959. In her 20s she enrolled at the Instituto Superior de Arte (ISA), a distinguished art institution located outside Havana. During the four-year program, her primary interest was photography, but paper, chemicals, film, and other supplies were not very accessible on the island. This gave her the opportunity to master ideas before production and to explore other art media. Pérez Bravo began creating installations within natural landscapes, and she documented the final product with silver gelatin photographs.

During the mid-1980s Pérez Bravo stopped creating installations and focused solely on photographs, using a leitmotiv that had never been explored in Cuban art—her own body as subject matter. She effectively blended the personal with Afro-Cuban myths and rituals and with avant-garde experimentation, breaking from the social-realist photographic tradition in Cuba. Her first series of photographs, *Para concibir* (1985–86; ''To Conceive''), launched her photographic career and earned her notoriety in Cuba, Mexico, Europe, and the United States. Pérez Bravo's photographs brought extensive prestige to photography in Cuba as an artistic medium.

For *Para concibir* Pérez Bravo staged self-portraits relating to the physical and psychological transformations involved in maternity, birth, and motherhood. According to Cuban critic Gerardo Mosquera, ''Marta María Pérez was the first Cuban artist to work with her own body and in the immediate context of her experience as woman. She is also the only artist to use photographs for this purpose, using her own image.'' From this point forward, Pérez Bravo began to use art as a way to process her personal experiences at a more profound and trenchant level than that of her earlier work. As a result, these photographs, autobiographical in content, can be interpreted as self-portraits. She started to look inward and focus on the personal, rather than placing so much emphasis on the ideological.

In the early 1990s Pérez Bravo left Cuba to join her husband in New York City while he completed a Fulbright fellowship. They then relocated to Monterrey, Mexico, but made frequent visits to Cuba. For Pérez Bravo this relocation provided her more access to photography supplies, allowing her to concentrate on the medium that she preferred most.

Though not a practitioner of Afro-Cuban religion, Pérez Bravo has referenced Afro-Cuban religious imagery in most of her works. Santería and other Afro-Cuban religions act as metaphors for her personal expression. Although the Cuban government has not officially recognized Afro-Cuban religions, their myths and ritual have permeated Cuban culture. The African animist religions, brought to Cuba through slavery in the sixteenth century, have become part of the cultural infrastructure, influencing music, film, dance, and the visual arts. The three main Afro-Cuban religious images that Pérez Bravo has incorporated are Santería, derived from Yoruba religion and influenced by Catholicism; the Palo Monte, derived from the Bantu, who rely heavily on magic; and the Abakua secret societies that practice ancient African warriors' rituals.

Weighted Afro-Cuban religious symbols play a fascinating and important role in her work, and Pérez Bravo juxtaposed them next to her body to construct carefully premeditated compositions. She stated, ''Sometimes it's difficult for me to find the image with which to represent my idea; but once I've found it, that's it, and there's no other: it has no variants.'' In all her photographs, Pérez Bravo relates

to Afro-Cuban myths and rituals by embracing symbols that speak of her actual life, symbols that provide her with a vocabulary in which to express herself. For instance, in her photograph *Proteccion* (1990; ''Protection''), thorns or needles from a cebia tree (silk-cotton tree) are attached to her breasts, her face is shielded by her raised shirt, and her head is turned away. The thorns of ceiba—the sacred tree of Chango and the Taino cultures—are used to protect her from any external force that might harm her breast milk as she attempts to preserve her physical bond with her twins.

Pérez Bravo's knowledge of Afro-Cuban religions also allowed her to build a concrete, formal vocabulary based on the body. Her formal strategies corresponded to those used by surrealists. Male artists such as Hans Bellmer, René Magritte, and Brassaï rendered the female form nude, using the technique of cropping, which is commonly interpreted as violent and disrespectful toward women. Pérez Bravo has also used the cropping technique, symbolically inflicting violence on herself in her photographic self-portraits. Her fragmented body parts, always floating and positioned against the same white background, create a mysterious or somewhat surreal image. In the photograph *Tres exvotos* (1995; ''Three Offerings''), there are three isolated anatomical limbs: a hand, leg, and foot. Pérez Bravo takes objects (such as her body parts) that are familiar and makes them unfamiliar or strange, through cropping and fragmentation, to connote the physical transformations she experienced during pregnancy, birth, and motherhood—the unglorified aspects that are seldom discussed. Her face is usually distorted, covered up, or cropped out of most of her photographs altogether, and her photographs often include two plastic dolls that represent her twins, fragmenting the body in such a way that her identity is portrayed as lost.

It is important to realize that the process through which Pérez Bravo's photographs are constructed—like a performance or a photographic act. Her photographs are carefully constructed and posed, with her body facing the camera. Stylistically, there is a performative element to her work that becomes frozen at the snap of the camera.

—Kay Grissom-Kiely

PETTORUTI, Emilio

Argentine painter

Born: La Plata, 1 October 1882. **Education:** Academia de Bellas Artes, La Plata, c. 1913; Accademia Internazionale, Florence, Italy (on scholarship from province of Buenos Aires), c. 1915; also studied in Rome and Milan. **Career:** Traveled and studied in Europe, 1915–1924. Director, Museo Provincial de Bellas Artes de La Plata, 1930–47. Traveled to the United States by invitation of Committee of Inter-American Artists, 1942. South American representative, First Guggenheim International, 1957. Lived in Paris, 1952–71. Member, Futurist movement, Milan, 1913. **Award:** Fellowship, John S. Guggenheim Memorial Foundation, 1956. **Died:** 16 October 1971.

Individual Exhibitions:

1916	Galleria Gonelli, Florence
1922	Casa díArte, Rome
1926	Galería Fasce, Cordoba, Spain
1927	Museo Municipal de Bellas Artes de Rosario
1942	San Francisco Museum of Art

1943	National Academy of Design, New York
	City Art Museum, St. Louis
	Nelson Gallery, Kansas City
	Hatfield Galleries, Los Angeles
1944	Portland Art Museum, Oregon
	Seattle Art Museum
	San Francisco Museum of Art
1947	Pan American Union, Washington, D.C.
1950	Museo Nacional de Bellas Artes, Chile (retrospective)
1952	Galleria del Milione, Milan
1953	Galería San Marco, Rome

Witcomb Salon, Buenos Aires.

Selected Group Exhibitions:

1941	San Francisco Museum of Art
1955	Pan American Union, Washington, D.C.
1957	Solomon R. Guggenheim Museum, New York
1959	*Pittsburgh International,* Carnegie Institute
	South American Art Today, Dallas Museum of Fine Arts
1960	Contemporary Art Center, Cincinnati
	Art Club of Chicago
1961	Walker Art Center, Minneapolis
1966	*Art of Latin America since Independence,* Yale University, New Haven, Connecticut, and University of Texas, Austin
1967	Center for Inter-American Relations, New York

Collections:

Museum of Modern Art of Latin America, Washington, D.C.; San Francisco Museum of Modern Art.

Publications:

On PETTORUTI: Books—*Pettoruti* by Angel Osvaldo Nessi, La Plata, Buenos Aires, Instituto de Estudios Artísticos, 1962; *Pettoruti: Cinquante ans de peinture, 1964–1965,* exhibition catalog, Paris, Galerie Charpentier, 1964; *Un pintor ante el espejo,* Buenos Aires, Solar, 1968; *Pettoruti* by C. Córdova Iturburu, Buenos Aires, Academia Nacional de Bellas Artes, c. 1980; *Pettoruti: Un recorrido de la mirada,* exhibition catalog, Buenos Aires, El Museo, c. 1982; *Emilio Pettoruti: 1995, Salas Nacionales de Exposiciones, Palais de Glace,* exhibition catalog, Buenos Aires, Fundación Pettoruti, 1995; *Emilio Pettoruti* by Fermín Fevre, Buenos Aires, Editorial El Ateneo, 2000. **Articles**—''Protecting Pettoruti'' by Cristina Carlisle, in *Art News,* 93, October 1994, p. 36; ''Emilio Pettoruti'' by Miguel Angel Muñoz, in *Art Nexus* (Colombia), 34, November 1999/January 2000, pp. 76–83.

* * *

The two events that brought the avant-garde to Argentina were the publishing of the artistic and literary journal *Martín Fierro* and Emilio Pettoruti's first one-man show of paintings at the Witcomb Salon in Buenos Aires upon his return from nine years spent traveling in Europe. The *porteño* public had never before seen art that, in the cubist style, consisted of flat planes of color and forms simplified into geometric shapes. As a result, people reacted so violently to Pettoruti's work that his paintings had to be covered in glass for decades

afterward to protect them from being spat upon. In spite of the negative response, Pettoruti's artistic career survived, largely because of the support of the writers who contributed to *Martín Fierro*, including the well-known critic Alberto Prebisch, who supported artistic innovation and criticized the traditional art of the National Salons in Buenos Aires.

The formative event of Pettoruti's career was his trip to Europe, made possible by a government scholarship. Unlike many Latin American artists, who traveled to Paris when given such an opportunity, Pettoruti went instead to Italy because it was the home of his forefathers. He spent his first years in Florence, studying at the Accademia Internazionale with the Swiss painter Augusto Giacometti, and later traveled to Rome and Milan. It was also at this time that Pettoruti first made contact with futurist artists such as Giacomo Balla, Humberto Boccioni, and Hugo Severini. The drawing *Dynamic of the Wind* from 1915 has an obvious futurist influence, owing to the fact that Pettoruti was inspired by the futurists' desire to capture motion and light in their work. Pettoruti himself, however, is often erroneously associated with the movement simply because of his having met the futurists while in Italy.

Although Pettoruti denied being a member of any artistic group, his work shares many traits with that of artists who worked in cubism, incorporating elements of collage in addition to the cubistic treatment of form. His painting *The Siphon* from 1915 includes a cutting from an Argentine newspaper and a postcard of Florence in a still life of bottles and glasses on a table. How exactly Pettoruti learned of cubism is a question of much speculation, since he denied having come in contact with the movement until he traveled to Munich in 1921. Evidence of the influence of cubism, however, is present in his work starting in 1914. Pettoruti attributed the flattened perspective of his pre-Munich paintings to his studies of quattrocento artists such as Giotto. By the late 1920s Pettoruti's work showed the obvious influence of Picasso, for he completed a series of harlequins and tango musicians that bore a strong resemblance to paintings such as Picasso's *Three Musicians*.

Pettoruti never achieved a great deal of recognition as an artist in Argentina, for it was thought that his later career did not live up to the potential his early work had manifested. From 1930 to 1947 he served as director of the Museo Municipal de Bellas Artes in La Plata, his birthplace, and in 1957 he was the South American representative to the First Guggenheim International. He completed a series of still lifes in front of open windows that included *Argentinian Sun* of 1941. Critics, however, often thought of these paintings as rehashing his earlier, more innovative work. Pettoruti lived his last decades in Paris, from 1952 until his death in 1971.

—Erin Aldana

PINEDA, Jorge
Dominican installation artist and printmaker

Born: Barahona, 1961. **Education:** Studied architecture, Universidad Autónoma, Santo Domingo; Atelier de Lithographies Bordas, Paris, 1987–88; Tamarind Institute, University of New Mexico, Albuquerque, 1995. **Career:** Magazine and newspaper illustrator. Also worked

as a stage designer. Codirector, vanguard theatre group *Teatro Simarron,* Santo Domingo.

Individual Exhibitions:

1995 *The Hurricane's Eye,* Museum of Modern Art, Santo
 Domingo
1998 *Circo antillano,* Casa de Bastidas, Santo Domingo
 El Caribe: exclusión, fragmentación, paraíso, Badajoz,
 Spain
2000 Casa de Bastidas, Santo Domingo

Iradac Institute, New York; Galería Larrama, Santo Domingo.

Selected Group Exhibitions:

1996 Altos de Chavon Gallery, La Romana, Dominican
 Republic
1999 *A View of the Contemporary: Latin American Artists,*
 Galería Larrama, Santo Domingo, and Art and
 Culture Center of Hollywood, Florida
2001 *Affinities/Links,* Casa de Francia, Santo Domingo

Collections:

Trillana House, Bulacan, Phillipines; Jorge B. Vargas Museum & Filipiniana Research Center, University of the Philippines, Quezon City.

Publications:

On PINEDA: Book—*Personajes populares dominicanos,* Santo Domingo, Biblioteca Taller, 1986. **Article**—''Jorge Pineda'' by Marianne de Tolentino, in *Art Nexus* (Colombia), 18, October/December 1995, p. 116–117.

* * *

The Eighties Generation of artists of the Dominican Republic includes the key figures of Tony Capellán (born in 1955), Martin López (1955), Belkis Ramírez (1957), Jorge Pineda (1961), and Marcos Lora Read (1965), among others. This wave of young artists represents a trend toward the utilization of nonconventional visual vocabularies to address their aesthetic and social concerns. They have sought to liberate artistic production from previously constrained definitions and from Dominican society's traditional expectations of what art should be. For this group of artists, countering the norms of their social environment is an ongoing process. By adopting a flexible visual language such as installation, they challenge the art establishment, while creating room for diverse approaches to art production. Another commonality shared by these artists is their critical focus on social reality, particularly the plight of disenfranchised people in developing countries.

Pineda is an exemplary artist of his generation. His humane observations on child abuse, illiteracy, prostitution, and the daily struggles of impoverished people in his homeland materialize in his

skillfully executed prints, drawings, and installations. Known primarily for creating mixed-media installations that incorporate local issues with mundane objects such as shoe shine boxes, rag dolls, and plantain presses, Pineda draws attention to life's harsh realities. He employs everyday objects to facilitate the interpretive possibilities of his installations by the public at large. His engagement with the public is manifold. He addresses social concerns and strives to communicate precisely with those affected by the injustices represented in his work. Furthermore, through the use of nonconventional methods he offers alternative ways for the public to experience art.

Born in Barahona in 1961, Pineda studied architecture at the Universidad Autónoma de Santo Domingo. From 1987 to 1988 he lived in France, where he attended the Atelier de Lithographies Bordas. While there, he completed printmaking courses in wood engraving, serigraphy, and lithography. During this period Pineda immersed himself in the rich cultural milieu of Paris, where a visit to the Pompidou Centre of the National Museum of Modern Art proved to be an eye-opening experience. It was there he saw European avant-garde art as if for the first time. Pineda has described his experience as a ''dramatic'' revelation, and he has recalled being astonished by the artistic innovations that appeared before his eyes, although he was aware that the art he was standing in front of dated back 25 years. Armed with a renewed perspective, he returned home, where he would become a major figure in the development of his country's contemporary art scene.

An accomplished draftsman and printmaker, Pineda was awarded a residency grant in 1995 at the internationally recognized Tamarind Institute at the University of New Mexico in Albuquerque, which is known for training master printers. He is a multifaceted artist whose talents coalesce in his installations and public art. His creative endeavors have expanded to the world of theater, and he has become known for his set designs. He also devotes time to codirecting Teatro Simarron, a vanguard group based in Santo Domingo.

Whether the medium is graphite drawings, prints, or installations, Pineda's portrayals of humanity can be at once poignant, satirical, and humorous. The cluttered picture fields of works that depict caricature-like figures with grotesque features symbolize life's bizarre nature. The figures also remind us that humor plays an important role in surviving life's adversities. In one of his installations a playful arrangement of colorful rag dolls with their eyes taped over offers comments on issues such as child labor and the fragility of children. Pineda's culture watching enables him to express not only his preoccupations but also those of the greater society while fulfilling his need for artistic exploration.

—Elena Pellegrini

POGOLOTTI, Marcelo

Cuban painter

Born: Havana, 1902. **Education:** Art Students League, New York, 1923. **Career:** Visited France and Spain, 1924; traveled to Europe and lived in Italy and France, 1928–38. Lost his eyesight, 1938. Returned to Cuba, 1939. Also worked as an art critic and writer. **Died:** 25 August 1988.

Selected Exhibitions:

1934 *Asociación de escritores y artistas revolucionarios de Paris*
1938 Paris
1940 Lyceum, Havana
1975 Palacio de Bellas Artes, Havana (retrospective)
1986 Museo Nacional de Bellas Artes, Havana

Publications:

By POGOLOTTI: Book—*Del barro y las voces* (autobiography), Havana, Ediciones UNEAC, 1968.

On POGOLOTTI: Books—*Marcelo Pogolotti* by Felipe Cossío del Pomar, Havana, Dirección de Cultura, Ministerio de Educación, 1961; *Dibujos y publicaciones de Marcelo Pogolotti desde octubre 9/64,* Havana, Biblioteca Nacional José Martí, 1964; *Marcelo Pogolotti: Retrospectiva oleos, temperas y dibujos,* exhibition catalog, Havana, Palacio de Bellas Artes, 1975; *Contemporáneos: Noticia y memoria* by Juan Marinello, Havana, Unión de Escritores y Artistas de Cuba, 1975; *Marcelo Pogolotti,* exhibition catalog, text by Roberto Fernández Retamar, Havana, Imprenta de Divulgación, Ministerio de Cultura, 1986; *Hijos de su tiempo: Once pintores mayores de Cuba* by Juan Sánchez, Havana, Publicigraf, 1994.

* * *

Marcelo Pogolotti's entire body of work as a painter was produced during an 11-year period, from 1927 to 1938. His artistic education consisted of one year of study at the Art Students League of New York City in 1923. In 1924 Pogolotti visited France and Spain, and he then returned to Cuba, where he renewed his friendship with fellow painter Carlos Enríquez. In 1928 Pogolotti visited Europe for a second time, living in Italy and France for 10 years. Shortly after his arrival in Paris, he started experimenting with both geometric abstraction and surrealism. The first works in which he dealt with social or political subject matter were a series of drawings entitled *Nuestro tiempo* that were completed in 1931. Between 1931 and 1934 he was active in the Italian futurist movement, living in Italy and participating in various exhibitions in Turin. In 1934 he changed his political orientation from the Fascism of the futurists to the Marxism of the Association des Escrivains et Artistes Revolutionnaires in Paris. He adapted the machine aesthetics of Fernand Léger, and Léger's stylistic influence is evident in Pogolotti's paintings. The colors in Pogolotti's paintings are applied in a flat manner, while the forms are usually delineated and contained by dark outlines.

Paisaje cubano (1933) and *El cielo y la tierra* (1934) are among Pogolotti's best known paintings. These depict the exploitation of the working classes by the wealthy in cahoots with the clergy. Less successful works such as *Fábrica, Obreros,* and *Evasión* are too Léger-like and European in theme. A constant criticism of Pogolotti's work is that his style did not adapt itself to a more authentically Cuban visuality and that his themes of social exploitation and turmoil are more European than Latin American.

By the end of 1938 Pogolotti had gone blind and stopped painting. He returned to Cuba in 1939 and dedicated himself exclusively to literature, publishing novels, short stories, art criticism, and

his autobiography. In 1940 his artistic production of the years 1928 through 1938 was exhibited in a one-person show at the Lyceum in Havana. His contribution lies in being among the first Cuban modernists to create an art dealing with social conflict, yet his shortcomings as a painter are evident in his poor pictorial technique and inability to synthesize European influences into a personal style.

—Alejandro Anreus

PONCE (de LEÓN), Fidelio
Cuban painter

Pseudonym for Alfredo Fuentes Pons. **Born:** Camagüey, 1895. **Education:** Academia de San Alejandro, Havana, 1913–18. **Career:** Taught art to children and worked as a commercial artist. Traveled to New York, late 1930s. **Awards:** Painting prize, *El salon nacional;* prize, *El salon de arte moderno,* Havana, 1937. **Died:** Havana, 19 February 1949.

Selected Exhibitions:

1934 Lyceum, Havana
1938 Lyceum, Havana
1949 Lyceum, Havana
1993 *Four Cuban Modernists: Mario Carreño, Amelia Pelaez, Fidelio Ponce, Rene Portocarrero,* Javier Lumbreras Fine Art, Coral Gables, Florida
1995 Museo Nacional, Palacio de Bellas Artes, Havana

Delphis Studio, New York.

Collection:

Museum of Modern Art, New York.

Publications:

On PONCE: Books—*Fidelio Ponce* by Juan Sánchez, Havana, Editorial Letras Cubanas, 1985; *Four Cuban Modernists: Mario Carreño, Amelia Pelaez, Fidelio Ponce, Rene Portocarrero,* exhibition catalog, revised edition, with text by Carlos M. Luis, Coral Gables, Florida, Javier Lumbreras Fine Art, 1993; *Hijos de su tiempo: Once pintores mayores de Cuba* by Juan Sánchez, Havana, Publicigraf, 1994; *Fidelio Ponce de León: 1895–1949,* exhibition catalog, Havana, Museo Nacional, 1995; *La celosía* by Carmen Paula Bermúdez, Havana, Casa Editorial Abril, 1996; *Fidelio Ponce en San Juan de los Yeras* by José Seone Gallo, Santa Clara, Cuba, Ediciones Capiro, 1996.

* * *

The painter Fidelio Ponce de León is considered a member of the Cuban avant-garde that developed in the second decade of the twentieth century, although he was a reclusive figure who was mostly self-taught and directed. His art was in some ways the most unusual for this generation, mixing modernist ideas with traditional subject matter and academic conventions. Moreover, the somber mood of much of his painting and his eccentric lifestyle distinguish him from other painters of the period.

Fidelio Ponce de León was the pseudonym of Alfredo Fuentes Pons, who was born to an upper-class family in the city of Camagüey in 1895. He studied art briefly at the Academy of San Alejandro in Havana in the 1910s but did not participate in the avant-garde movement of the 1920s. He exhibited his paintings for the first time at the Lyceum in Havana in 1934. Ponce developed a style of loose figural compositions, rendered in heavy impasto, that hearken back to the work of Cuban academic painter Leopoldo Romañach, to whom he was devoted, as well as to El Greco and Bartolomé Esteban Murillo, Spanish baroque painters of the sixteenth and seventeenth centuries. In sharp contrast to the other members of the Cuban avant-garde, Ponce retained a dark, almost monochromatic, palette of grays, browns, and blues, with occasional whites and a little admixture of warm tones. The reduction of color to this dour palette evokes works from Picasso's so-called Blue Period early in the twentieth century. Ponce's psychological themes also evoke the work of the Spaniard Ignacio Zuloaga, while the heavy black outlines and abstracted figures recall the paintings of the Frenchman Georges Rouault or even the work of the German expressionists. Ponce's compositions became increasingly surrealistic, juxtaposing figures and simple objects in hallucinatory, dreamlike environments.

Although Ponce rejected the tropical colors and vibrant patterns of the Grupo Minorista, including fellow modernists Eduardo Abela, Cundo Bermúdez, Carlos Enríquez, Víctor Manuel, Amelia Peláez, and René Portocarrero, he was no less nationalistic in his themes and subject matter. Recalling his teacher's melodramatic subjects of the turn of the century, Ponce's paintings dealt with themes of pain, loneliness, poverty, oppression, and the stifling social values of postcolonial Cuban society. He approached these subjects with critical distance and obvious disdain, however. He was particularly interested in depicting the excesses of religious hypocrisy and pious ignorance within a Spanish Catholic society. His tense and conflicted figures from the decades of the 1920s to the 1940s certainly addressed broad human and religious themes, but they may also have addressed the squalor of life and the social unrest under dictator Gerardo Machado, who ruled Cuba from 1925 to 1933. Ponce's work may also be revelatory of his bohemian lifestyle, characterized by personal poverty, illness, and alienation. A member of Havana's demimonde, Ponce died of tuberculosis in 1949, but his achievements as a largely self-directed artist with his own inner vision were much appreciated by other artists and critics.

—H. Rafael Chácon

PORRO, Ricardo
Cuban architect

Born: Ricardo Porro Hidalgo, 3 November 1925; emigrated to Paris, 1966. **Education:** Universidad de la Habana, Havana, degree in

architecture 1949; studied in Paris, c. 1950–52, and in Venice, 1951. **Family:** Married; one son. **Career:** Traveled to Mexico to meet Luis Barragán, *q.v.,* 1954; traveled to Venezuela, 1958–60. Established architecture practice, Paris, 1966. Has worked as an architecture professor, Paris. Visited Cuba, 1996, 1997, 1998.

Individual Exhibition:

1990 Institut français d'architecture, Paris (traveled to Museo de Artes Visuales Alejandro Otero, Caracas)

Selected Group Exhibition:

1947 *Quema de los viñola,* Universidad de la Habana, Havana (with Frank Martínez and Nicolás Quintana)

Works:

1949 Casa Armenteros, Havana
1953 Casa García, Havana
1954 Casa Villegas, Havana
1957 Casa Ennis, Havana
1961–65 National Art Schools, Havana (with Roberto Gottardi and Vittorio Garatti)
1990 Collège Elsa Triolet, Paris

Banco Obrero, Venezuela, c. 1950s (with Gottardi and Garatti)

Publications:

By PORRO: Books—raicardo Porro oeuvres 1959–1993, exhibition catalog, with Sabine Fachard and Patrice Goulet, Paris, Institut français d'architecture, 1993; *Ricardo Porro: Architekt,* Klagenfurt, Germany, Ritter, 1994. **Articles—**"El sentido de la tradición," in *Nuestro Tiempo,* 16(IV), 1957; "Ricardo Porro—École d'Art a la Havane," in *L'Architecture d'Aujourd'hui,* 119, March 1965, pp. 52–56; "Cinq aspects du contenu en architecture," in *PSICON,* 2(3), January/June 1975, pp. 153–169; "Couleur et architecture, une longue histoire," in *Architecture Intérieure CREE,* 171, May 1979, pp. 64–68; "Cuba y yo," in *Escandalar–Cuba Otra,* 17–18, January/June 1982, pp. 152–156; "Fabien College, Montreuil: The Harmony of Opposites," with Renaud de La Noue, in *L'Architettura* (Italy), 39, September 1993, pp. 620–630; "An Architectural Autobiography of Ricardo Porro," in *A + U* (Japan), 282, March 1994, pp. 60–75.

On PORRO: Books—Ricardo Porro & Renaud de La Noue, Architectes* by Anne Favret and Patrick Manez, Paris, Editions du Demi-Cercle, 1990; *Ricardo Porro,* exhibition catalog, text by François Barré and Isabelle Cazès, Paris, Institut Français d'Architecture, 1991; *Ricardo Porro* by Patrice Goulet, two volumes, Paris, Institut Français d'Architecture, 1993; *Revolution of Forms: Cuba's Forgotten Art Schools* by John A. Loomis, New York, Princeton Architectural Press, 1999. **Articles—**"Les leçons de Venise," in *L'Architecture d'Aujourd'hui* (France), 234, September 1984, pp. 36–39; "Porro: Rue Paul Eluard a Saint-Denis" by Marie-Jeanne Dumont, in *L'Architecture d'Aujourd'hui* (France), 270, September 1990, pp. 82–85;

"Treating Children like Princes," in *L'Architettura* (Italy), 37, September 1991, pp. 740–741; Ricardo Porro issue of *A + U* (Japan), 282, March 1994; "Regards croisés," in *L'Architecture d'Aujourd'hui* (France), 295, October 1994, pp. 70–71; "Arquitectura: Hallar el marco poético" by Maria Elena Martin Zequeira, interview with Ricardo Porro, in *Revolución y Cultura,* 5, 1996, pp. 44–51; "Expressionniste," in *L'Architecture d'Aujourd'hui* (Paris), 325, 1999.

* * *

The young Ricardo Porro Hidalgo exalted the extreme sensuality of the Cuban people as their most prominent characteristic. He intended to express this sensuality in his Schools of Modern Dance and Plastic Arts, part of Fidel Castro's 1961 commission for a large campus to house the National Art Schools. Porro invited the Italian architects Vittorio Garatti and Roberto Gottardi to collaborate on the project, the three having worked together on the Banco Obrero in Venezuela in the 1950s.

Porro emphasizes the primacy of a poetic frame for human action and therefore advocates a close study of the genius loci prior to building. Before Porro's National Art Schools, Cuban academic architecture had concerned itself overwhelmingly with the white aristocracy. Porro sought to address Cuban negritude and eroticism in his designs for the Schools of Modern Dance and Plastic Arts. For example, he planned the School of Plastic Arts in the spirit of an African village, "a city seized by a negritude that had never before had a presence in architecture," as Porro has said. The organic shape of the complex reflects female power and sexuality, in homage to "the mystical mother." Catalan vaults become visible in the landscape as metaphorical breasts; similarly, Porro's sculptural fountain in the shape of a papaya alludes to female genitalia. Porro has likened the vaults to the form of many African dwellings.

Porro also found inspiration for the School of Plastic Arts in Paul Valery's poem "Eupalinos," about a temple design based on the proportions of a woman's body. This mode of finding inspiration in other arts evolved in Porro's practice through a permanent quest for a nexus between poetry, painting, and architecture that has remained evident in his contemporary work.

After moving permanently to Paris in 1966, Porro continued his early interest in education. In France he had an extended career as a professor, and he has continued to contribute to works for French universities and schools. With Renaud de la Noue, his partner for more than a decade, Porro prepared an audiovisual guide to their Cantonnement des Compagnies Républicaines de Sécurité in Vélizy, France. Porro and de la Noue elucidated the generative images for the project, including Paolo Ucello's *Battle of St. Romano,* Umberto Boccioni's *Charge of the Knights,* and Le Corbusier's Villa Savoye.

The Collège Elsa Triolet, which exemplifies the sculptural architecture of Porro and de la Noue, has made a significant contribution to the restoration of Saint Denis north of Paris. The secondary school, which was built in 1990, also formed the basis for an inspired collaboration between the architects and the photographers Anne Favret and Patrick Manez. They interpreted six elements of architecture in the Collège Elsa Triolet. Porro himself has recognized five aspects of architecture and has proposed to add a sixth: immediate content, persuasion, tradition, the superposed image, the mediated content, and the creator's fantasy. For him the whole interior richness

of the artist's spirit should be expressed in the work of art, and architecture must be a work of art or it is not architecture.

—Lola McDowell

PORTER, Liliana
Argentine painter and photographer

Born: Buenos Aires, 1941. **Education:** Escuela Nacional de Bellas Artes, Buenos Aires, 1953; Universidad Iberoamericana, Mexico City, 1958–64. **Family:** Married Luis Camnitzer, *q.v.,* in 1965 (divorced 1978). **Career:** Moved to New York, 1964. Cofounder and full-time etching instructor, Studio Camnitzer-Porter, Lucca, Italy, 1974–77; adjunct lecturer, State University of New York, Old Westbury, 1974–76; etching instructor, Porter-Wiener Studio, New York, 1979–81; adjunct lecturer, State University of New York, Purchase, 1987; etching instructor, Printmaking Workshop, New York, 1988. Since 1991 professor, Queens College, City University of New York. Artist-in-residence, University of Pennsylvania, Philadelphia, 1968. **Awards:** Purchase award, *Print Biennial,* Santiago, 1965; Foreign Ministry award, *International Print Biennial,* Cracow, Poland, 1968; first prize, *First Latin American Print Biennial,* San Juan, Puerto Rico, 1970; graphic design award, *Print Biennial,* Cali, Colombia, 1971; Purchase award for drawing, *Biennial,* Cali, Colombia, 1973; Purchase award, *4th International Print Biennial,* Bradford, England, 1974; first prize, *Arte Argentino 78,* Museo de Bellas Artes, 1978; Guggenheim fellowship, 1980; Purchase prize, *14th International Print Biennial,* Ljubljana, Yugoslavia, 1981; Edition Purchase award, *World Print 4,* Museum of Modern Art, San Francisco, 1983; first prize, *First Iberoamerican Graphics Biennial,* Montevideo, Uruguay, 1983; Prix Ex Aequo, *10th Graphics Biennial,* Cracow, Poland, 1984; New York Foundation for the Arts fellowship, 1985; grand prix, *XI International Print Biennial,* Cracow, Poland, 1986; first prize, *Latinamerican Graphic Arts Biennial,* Museum of Contemporary Hispanic Art, New York, 1986; first prize, *VII Latin American Print Biennial,* San Juan, Puerto Rico, 1986; National Endowment for the Arts and Arts International travel grant, 1994; Mid Atlantic/National Endowment for the Arts regional fellowship, 1994; PSC-CUNY Research award, in visual arts-photography, 1994, 1995, in visual arts-video, 1997, in visual arts-multimedia, 1999, 2000; Premio Leonardo, Museo Nacional de Bellas Artes, Buenos Aires, 1998, 1999; Women's Studio Workshop award, New York, 1999; Civitella Ranieri Foundation fellowship, Umbertide, Italy, 1999; New York Foundation for the Arts fellowship, 1999. Diploma al Merito, Fundación Conex, Buenos Aires, 1992. **Address:** c/o Annina Nosei Gallery, 530 West 22nd Street, New York, New York 10011, U.S.A.

Individual Exhibitions:

1969 Museo de Bellas Artes, Caracas, Venezuela
Museo de Bellas Artes, Santiago, Chile
Instituto Torcuato di Tella, Buenos Aires
1972 Galleria Diagramma, Milan
Libreria Einaudi, Milan
1973 Hundred Acres Gallery, New York
Museum of Modern Art, New York

Galleria Conz, Venice
1974 Hundred Acres Gallery, New York
Galeria Conkright, Caracas, Venezuela
Galerie Stampa, Basel, Switzerland
Museo de Arte Moderno, Bogota, Colombia
1975 Hundred Acres Gallery, New York
Galeria Belarca, Bogota, Colombia
1976 Galleria della Villa Schifanoia, Florence, Italy
Galleria Ariete Grafica, Milan
1977 Hundred Acres Gallery, New York
Galeria Arte Multiple, Buenos Aires
Galleria Arte Comunale, Adro, Brescia, Italy
1978 Museo de Arte Moderno, Cali, Colombia
Galeria Arte Multiple, Buenos Aires
1979 Barbara Toll Fine Arts, New York
1980 Center for Inter-American Relations, New York
Galeria Arte Nuevo, Buenos Aires
1982 Galeria Garces-Velasquez, Bogota, Colombia
Barbara Toll Fine Arts, New York
1983 Galerie Jolliet, Montreal
Galeria-Taller, Museo de Arte Moderno, Cali, Colombia
1984 Museo de Arte Contemporaneo, Panama City
Galeria Garces-Velasquez, Bogota, Colombia
Centro de Arte Actual, Pereira, Colombia
Barbara Toll Fine Arts, New York
1985 University of Alberta, Edmonton, Canada
Dolan/Maxwell Gallery, Philadelphia
1986 Galeria Luigi Marrozzini, San Juan, Puerto Rico
1987 Galeria-Taller, Museo de Arte Moderno, Cali, Colombia
Galeria Diners, Bogota, Colombia
1988 Galeria Krysztofory, Cracow, Poland
Galeria Latinoamericana, Casa de las Americas, Havana
The Space, Boston
1989 The World Gallery, Syracuse University, New York
1990 *Selection of Works: 1968–1990,* Fundacion San Telmo, Buenos Aires (traveling)
1991 Weatherspoon Art Gallery, University of North Carolina, Greensboro
Galeria-Taller, Museo de Arte Moderno, Cali, Colombia
Galeria Diners, Bogota, Colombia
1992 *Fragments of the Journey 1968–1991,* Bronx Museum of the Arts, New York, and University of Texas, Austin
1993 *Liliana Porter: A Retrospective of Graphic Art 1968–1993,* Reading Public Museum, Pennsylvania
Liliana Porter-Simulacrum, Steimbaum Krauss Gallery, New York
1994 *Illusion/Fragments/Reality,* Gallery of Contemporary Art, Sacred Heart University, Fairfield, Connecticut
Liliana Porter, Galeria Ruth Benzacar, Buenos Aires
1995 *Liliana Porter: Poetry and Paradox,* University Art Gallery, New Mexico State University, Las Cruces
1996 *Them,* Monique Knowlton Gallery, New York
1997 *Fotografias,* Ruth Benzacar, Buenos Aires
Dialogos, Museo de Bellas Artes Juan Manuel Blanes, Montevideo, Uruguay
1998 *Ellos y algunos otros,* Espacio Minimo, Murcia, Spain
Arte poetica, University Art Gallery, State University of New York, Stony Brook

Liliana Porter: *Deer/Dear*, 2001. Photo courtesy of Annina Nosei Gallery, New York.

1999	*For You,* Projects, ARCO, Madrid (traveling)
2000	Espacio Minimo, Murcia, Spain
	Ruth Benzacar, Buenos Aires
	Sicardi-Sanders, Houston
	Annina Nosei, New York
	The Space inside the Mirror, Center for Photography, Woodstock, New York
	Emiso Art Center Gallery, DePauw University, Greencastle, Indiana

The Secret Lives of Toys: Liliana Porter Photographs, Phoenix Art Museum

Drum Solo/Solo de tambor, Galeria Espacio Minimo, Madrid

Selected Group Exhibitions:

1970 *Information,* Museum of Modern Art, New York

Liliana Porter: *Goucho,* **2000. Photo courtesy of Annina Nosei Gallery, New York.**

1976 *Printmaking New Forms,* Whitney Museum of American Art, New York
1978 *Variations on Latin Themes in New York,* Center for Inter-American Relations, New York
1986 *V bienal americana de artes graficas,* Museo de Arte Moderno, La Tertulia, Cali, Colombia
1987 *Latin American Artists in New York since 1970,* University of Texas, Austin
1989 *The Latin American Spirit: Art and Artists in the U.S.,* Bronx Museum, New York
1992 *IV muestra de pintura y escultura latinoamericana,* Galeria Espacio, San Salvador, El Salvador
1993 *Latin American Artists of the Twentieth Century,* Museum of Modern Art, New York (traveling)
1995 *Latin American Women Artists 1915–1995,* Milwaukee Art Museum (traveling)
1997 *Re-Aligning Vision: Alternative Currents in South American Drawing,* Archer M. Huntington Art Gallery, Austin, Texas (traveling)

Collections:

Museo de Bellas Artes, Caracas; Museum of Modern Art, New York; Museo de Bellas Artes, Buenos Aires; Philadelphia Museum of Art; La Biblioteque Nationale, Paris; New York Public Library; Museo del Grabado, Buenos Aires; Museo de Arte Moderno, Buenos Aires; Museo Universitario, Mexico City; Museo de Bellas Artes, Santiago;

Museo de Arte Moderno, Cali, Colombia; Museo de Arte Moderno, Bogota; University of Texas, Austin; Museo del Barrio, New York; Instituto de Cultura, San Juan, Puerto Rico; Museum of Contemporary Graphic Art, Fredrikstad, Norway; Hunter Museum of Art, Chattanooga, Tennessee; Metropolitan Museum of Art, New York; Musee d'Art, Lodz, Poland; Musee d'Art Contemporaine, Montreal; Collection of Ministry of Culture Francaise, Belgium; Casa de las Americas, Havana; Instituto Wifredo Lam, Havana; Museo de Arte Moderna do Rio de Janeiro; Museo de Arte Contemporaneo, Panama City; Bronx Museum for the Arts, New York; University of North Carolina, Greensboro; Museo Tamayo, Mexico City; Museu da Gravura, Curitiba, Brazil; Museo de Monterrey, Mexico; Museo de Arte Contemporaneo de Monterrey, Mexico; Center for Photography at Woodstock, New York; Museo Nacional Centro de Arte Reina Sofia, Madrid; Museo Extremeo e Iberoamericano de Arte Contemporaneo, Badajoz, Spain; Boras Konstmuseum, Sweden; Smithsonian American Art Museum, Washington, D.C.

Publications:

On PORTER: Books—*New York Graphic Workshop: Luis Camnitzer, José Guillermo Castillo, Liliana Porter,* exhibition catalog, with text by Gerd Leufert and Donald H. Karshan, Caracas, Museo de Bellas Artes de Caracas, 1969; *Liliana Porter,* exhibition catalog, Bogota, Museo de Arte Moderno, 1974; *Liliana Porter: Recent Work,* exhibition catalog, Boston, The Space, 1988; *Selección de obras 1968–1990,* exhibition catalog, with text by Shifra M. Goldman, Angel Kalenberg, and Florencia Bazzano Nelson, Buenos Aires, Fundación San Telmo, 1990; *Liliana Porter: Obra gráfica 1964–1990,* exhibition catalog, San Juan, Puerto Rico, Comisión Puertorriqueña, 1991; *Liliana Porter: Fragments of the Journey,* exhibition catalog, Bronx, New York, Bronx Museum of the Arts, 1992; *Liliana Porter: Photographs,* exhibition catalog, New York, Monique Knowlton Gallery, 1996. **Articles**—''Liliana Porter'' by Ruben Gallo, in *Art Nexus* (Colombia), 23, January/March 1997, pp. 139–140; ''Weighing in on Feminism'' by Carey Lovelace, in *Art News,* 96, May 1997, pp. 140–145; ''Liliana Porter: Shaking Hands with Mickey'' by Gerardo Mosquera, in *Third Text,* 42, spring 1998, pp. 71–77; ''Liliana Porter: The Poetry of Communication'' by Luis Camnitzer, in *Art Nexus* (Colombia), 35, February/April 2000, pp. 68–71; ''Liliana Porter,'' in *Art on Paper,* 4(6), July/August 2000, p. 52; ''The Subconscious of Civilization: An Interview with Liliana Porter'' by Pablo Baler, in *Sculpture* (Washington, D.C.), 20(1), January/February 2001, pp. 36–41. **Films**—*Diverse Roots, Diverse Forms,* Dick Young Productions, 1993; *Liliana Porter: Fragments of the Journey,* A. Geovision, 1993.

* * *

In the work of Liliana Porter one can see the interest in the limits and transfer between illusion and reality and between triviality and transcendence. In her works from the 1960s and 1970s she paid special attention to illusory constructions spurred by the work of art. Preferring the use of graphic techniques, which she related with three-dimensional objects, she experimented with forms of perversion of the dichotomy between reality and illusion. In this way she questioned the very effectiveness of the representative fiction of art by subjecting it to the principles of reality–the objects–that give it meaning. The paper-based trompe l'oeil in which she simulated

crumpled paper through drawing tackled the problem of representation in an obvious way. From these drawings Porter achieved interesting proposals in which she produced shadows to be completed by the spectator-receiver, placing the real object, which was similar to the one that had produced them, in relation to the image. Such is the case with *Sombra para un vaso* (1969; "Shadow for a Glass").

In the 1970s Porter furthered her research into perspective, undertaking impressions of illusory effects on walls as well as superimposing photography and drawings in which ambiguous relationships were established between real elements photographed in perspective, flat drawings, and three-dimensional objects. The open appropriation of images in this period announced the renewed significance of objects that would be the main method of work adopted by Porter in the 1990s.

From the 1980s onward Porter began to concentrate on childhood references, on objects in which anthropomorphism, understood formally or sentimentally, became a subtle metaphor of the ramifications of illusion. Working from an objectivism reminiscent of pop, Porter explored the anecdotal and expressive possibilities of small games, souvenirs, and ceramic figurines. These icons of popular culture and the masses, preferred by Porter, involve themselves in the spirit of entertainment that inspires part of the object-based work of artists in Latin America.

With respect to figurines, Porter makes these bibelots acquire an unusual, dramatic character. The staging she uses is simple; she limits herself to the purity of white or to neutral colors. The scale is upset by the effect of the figurines' protagonism, obtained from the visual cleanliness that surrounds them and the variation in the usual perspective from which they are looked at. The concentration on dialogues between pairs of objects or on the monologues of solitary bibelots, with suggestive titles on the action that has taken place, confers an air of profundity to scenes that are rapidly transformed into an ingenious stimulus to smile. Porter's scenes maintain a difficult balance between the jocular and the poetic, which in the last instance can be summed up as the childish delight of the onlooker in the benign color and warm forms of the plastic, ceramic, or wood kitsch figures.

In Porter's photographs we see the elements that make her little creatures take on life in these curious static dramatizations. The cleanliness that surrounds them is one of the elements, with the neutrality of ambience that avoids distractions and contributes to concentration on the figurines transforming their futility into mysterious eloquence. The mere fact of making a careful photographic register of the bibelots confers meaning upon the images, giving them a story. The air of posturing the figures show, or the takes *in fraganti* of the dramatic scenes they interpret, is seen to have an air of transcendence through the monumentality the photography infuses them with.

In the works *For You* (1999) and *Solo de Tambor* (2000; "Drum Solo")–16 mm films transferred to video–Porter uses the protagonism of the little dolls to the full, disturbing their scale with close-ups and revealing their secret power and unusual potential for humor. The short sequences that make up these works exhibit with great clarity Porter's poetic symbolism, within which the humanization of the curious and the seductive fauna of bibelots are taken to the extreme by using a dramatic approach.

—Vivianne Loría

PORTINARI, Cándido
Brazilian painter

Born: São Paulo, 1903. **Education:** Escola Nacional de Belas Artes, Rio de Janeiro, 1918; studied figure drawing under Lucilio de Albuquerque and painting under Aoedo and Batista da Costa, Rio de Janeiro, 1921. **Family:** Lived with Maria Victoria Martinelli, beginning in 1930; one son. **Career:** Traveled on Premio de Viagem travel fellowship to France, Great Britain, and Italy, 1928; lived in Paris, 1929–31; traveled to the United States, 1940. Instructor, Universide do Distrito Federal, Rio de Janeiro, 1936–39. Muralist, Library of Congress, Washington, D.C., 1941–42, and United Nations, New York, 1952–56. Book illustrator, Gallimard, Paris. **Awards:** Legion of Honor medal, 1946; Guggenheim National first prize, 1957; Hallmark Art award, 1957. **Died:** 1962.

Individual Exhibitions:

1929	Palace Hotel, Rio de Janeiro
1930	Palace Hotel, Rio de Janeiro
1931	Palace Hotel, Rio de Janeiro
1932	Palace Hotel, Rio de Janeiro
1933	Palace Hotel, Rio de Janeiro
1934	Palace Hotel, Rio de Janeiro
1935	Palace Hotel, Rio de Janeiro
1936	Palace Hotel, Rio de Janeiro
1940	Pan American Union, Washington, D.C.
1947	Pan American Union, Washington, D.C.
1950	Pan American Union, Washington, D.C.
1959	Wildenstein Gallery, New York

Selected Group Exhibitions:

1935	*Pittsburgh International,* Carnegie Institute
1939	Brazilian pavilion, World's Fair, New York
1939	*Latin American Exhibition of Fine Arts,* Riverside Museum, New York
1940	Museum of Modern Art, New York
1947	Pan American Union, Washington, D.C.
1949	Pan American Union, Washington, D.C.
1953	Pan American Union, Washington, D.C.
1959	*The United States Collects Latin American Art,* Art Institute of Chicago
1966	*Art of Latin America Since Independence,* Yale University, New Haven, Connecticut, and University of Texas, Austin
1967	Museum of Modern Art, New York

Collections:

Carnegie Institute, Pittsburgh; Jewish Museum, New York; Library of Congress, Washington, D.C.; Museum of Modern Art, New York; Museum of Modern Art of Latin America, Washington, D.C.

Publications:

By PORTINARI: Books—*Portinari,* Buenos Aires, Peuser, 1947; *Poemas de Cándido Portinari,* Rio de Janeiro, J. Olympio, 1964;

Cándido Portinari standing next to his painting, *A Baia Negress,* 1946. © Bettmann/Corbis.

Portinari, o menino de Brodósqui, Rio de Janeiro, Livroarte Editora, 1979.

On PORTINARI: Books—*Portinari: His Life and Art* by Josias Leão, 1940; *Portinari* by Carlos Drummond de Andrade, São Paulo, Cultrix, 1962; *Portinari* by Flávio de Aquino, Buenos Aires, Editorial Codex, 1964; *A infância de Portinari* by Mário Filho, Rio de Janeiro, Bloch, 1966; *Cándido Portinari* by Victor Civita, São Paulo, Abril Cultural, 1967; *Un Cándido pintor Portinari* by Flávio Damm, Rio de Janeiro, Ed. Expressão e Cultura, 1971; *Cándido Portinari* by Marcos Moreira, São Paulo, Editora Três, 1974; *Portinari* by Antônio Bento, Rio de Janeiro, Léo Christiano Editorial, 1980; *Portinari Leitor* by Annateresa Fabris, Cacilda Teixeira da Costa, and others, São Paulo, Museu de Arte Moderna de São Paulo, 1996; *Cándido Portinaro: Proyecto Cultural Artistas del Mercosul* by Antonio Callado, São Paulo, Finambrás, 1997.

* * *

Many of Cándido Portinari's paintings reflect his humble origins. He was born on the Santa Rosa coffee plantation in Brazil in 1903 of Italian immigrant parents. The second of twelve children, he left home at the age of fifteen for Rio de Janeiro to attend the National School of Fine Arts for three years. In 1928 his *Portrait of Olegario Mariano* garnered him a fellowship that enabled him to study art in Europe. Returning to Rio de Janeiro, he became a much sought-after portraitist in diplomatic circles. The 1935 *Portrait of Paulo Osir* is typical of these beautifully crafted studies, comparable to those of Amedeo Modigliani and other European modernists. He also produced many canvases that depict various types of individuals, as in *The Mestizo.* It is Portinari's genre paintings of Brazilian life, however, that are the most profoundly moving. One such painting, entitled *Café,* was the subject of much controversy when it won second prize at the Carnegie International Exhibition in 1935. It depicts powerfully muscular workers toiling in the coffee bean fields. It is a sensitive study in blues and browns reminiscent of the monumental classical figures of Pablo Picasso and the regionalism of Thomas Hart Benton.

In addition to being a prolific easel painter, Portinari was also a well-known muralist. Muralism as an artistic movement remained popular throughout the 1930s and '40s in both North and South America. Whereas the Mexican muralists Diego Rivera and José Clemente Orozco painted images of Indians and mestizos, heroic portrayals of Afro-Brazilians dominated many of Portinari's most moving paintings. And while images of South American blacks were accepted by the North American audience, the white Brazilian elite rejected such imagery as emblematic of their nation. At the time, artists and their works were perceived as their countries' cultural representatives who bore the responsibility of bringing to the Western world a broader understanding and acceptance of other cultures.

Paz y guerra, a large mural commissioned by Brazil for the General Assembly of the United Nations in New York City, installed in 1953, has been described as Portinari's most ambitious and political work. It is a visual condemnation of war and its destructive excesses, and, in spite of the political implications of such a work, Portinari declared that he had no partisan intent in its creation. Rather, he maintained that he was decrying war on behalf of all humanity and in terms of its negative impact on free expression.

His extensive mural output, including those at the Ministry of Education in Rio de Janeiro and the *Discovery of the New World* in the Library of Congress in Washington, D.C., led critics to regard him as the Brazilian Rivera. While both artists created images of agrarian workers, miners, and laborers, Portinari's work was devoid of Rivera's didactic polemics. Instead of paintings that set rich and poor in stark opposition to one another, Portinari painted images of Brazilian peasants taken directly from his own experience. His workers possess strength and dignity without the socialist propaganda that made Rivera's murals so controversial in the United States. It was said that Portinari eschewed politics, concerning himself only with artistic expression never subordinated to social issues. By the end of his long career, he had created an extensive corpus, both on canvas and in murals, in which the figure, portrayed in a sophisticated, painterly way, simultaneously expressed the human condition, social realism, and modernism.

—Marianne Hogue

PORTOCARRERO, René
Cuban painter and sculptor

Born: Havana, 24 February 1912. **Education:** Attended Villate and Academia de San Alejandro, Havana, 1924–26; largely self-taught. **Career:** Professor, Estudio Libre de Pintura y Escultura, 1937; drawing teacher, Havana penitentiary, 1943. Traveled to Europe and the United States, *ca.* 1940s. Created a ceramic mural, Palacio de la Revolucion, Havana, 1968. Also worked as a book illustrator and a designer of sets for theatrical productions. **Award:** Sambra International prize, *VII Biennial,* São Paulo, Brazil, 1963. **Died:** Havana, 7 April 1985.

Selected Exhibitions:

ca. 1930	Salon de Bellas Artes, Havana
1934	Lyceum, Havana
1945	Julian Levy Gallery, New York
1963	*VII Biennial,* São Paulo, Brazil

Collections:

Museum of Modern Art, São Paulo; Museum of Modern Art, Rio de Janeiro; Museum of Modern Art, New York; Museum of Modern Art, San Francisco; Bellas Artes, Caracas; Milwaukee Art Center; Pan American Union, Washington, D.C.; Museum of Fine Arts, Houston; Art Museum of Indianapolis; Museo de Bellas Artes, Montevideo; Museo de Bellas Artes, Buenos Aires; Instituto de Arte Contemporaneo, Lima; Museo Nacional, Havana.

Publications:

By PORTOCARRERO: Book, illustrated—*Paradiso* by José Lezama Lima, Mexico City, 1968.

On PORTOCARRERO: Books—*El sueño,* Havana, Biblioteca Nacional José Marti, 1960; *Cuba: René Portocarrero,* exhibition

catalog, Paris, Ministère des relations extérieures, 1984; *René Portocarrero* by Graziella Pogolotti and Ramón Vázquez Díaz, Berlin and Havana, Henschel and Letras Cubanas, 1987; *25 años de color de Cuba: René Portocarrero*, Havana, Ministerio de Cultura, 1988; *Four Cuban Modernists: Mario Carreño, Amelia Pelaez, Fidelio Ponce, Rene Portocarrero*, exhibition catalog, Coral Gables, Florida, Javier Lumbreras Fine Art, 1993. **Article**—''René Portocarrero'' by Gerardo Mosquera, in *Art Nexus* (Colombia), 19, January/March 1996, pp. 76–80.

* * *

An influential member of the second generation of Cuban modernists of the early twentieth century, René Portocarrero followed in the footsteps of the Grupo Minorista, particularly Amelia Peláez, in addressing themes and imagery from Cuba's baroque and colonial past in a modern semiabstract pictorial language. Portocarrero developed his own distinctive style, based on dense patterns and brilliant colors, that was celebrated on the island and abroad.

Portocarrero was born in 1912 in the old Havana neighborhood of El Cerro. Though much decayed at the beginning of the century, this colorful neighborhood, with its narrow streets and eclectic architecture of ornate columns and angled rooftops, its piety, feasts, and popular carnivals, provided much inspiration for the artist. In the years 1924–26 Portocarrero briefly attended art classes at Villate and at the Academy of San Alejandro in Havana. He was, however, mostly self-taught. An admirer of the ideas of the Cuban avant-garde in the 1920s, he rejected academic realism early on and embraced figurative abstraction. He was an avid drawer and illustrated modernist books and journals. He held his first solo exhibition at the Lyceum in Havana in 1934.

Three years later Portocarrero took part in an important experiment in visual arts education on the island. He joined the faculty of the Estudio Libre de Pintura y Escultura, directed by Eduardo Abela in 1937. This experimental year-long school was modeled after a Mexican institution. The school accepted students free of charge. It did not discriminate in terms of sex, race, or class and was guided by principles of artistic freedom and exploration. The school was guided by both the progressive aesthetics and the politics of the Mexican muralist movement of the 1920s and 1930s. Indeed, Portocarrero took a great interest in the style of the muralists. His paintings were characterized by a flattened picture plane with large blocks of color containing recognizable figures of distorted and generally squat proportions. His compositions were nevertheless classically composed and harmoniously balanced.

In his paintings Portocarrero followed the chromatic richness of Peláez as well as the intentional primitivism and figural distortions of Abela, Carlos Enríquez, Víctor Manuel, and other members of the first generation of modernists in Cuba. Nevertheless, he developed his own pictorial language of short, animated strokes of color laid in thick impasto on the canvas to form a rich mosaic-like pattern. The figures are sometimes lost in the dense color and surface of his paintings. Like Peláez, he indulged himself in painting the *barroquismo*, or florid baroque qualities, of the interiors and furnishings of upper-class homes in Havana. His paintings allude to the turned wood fixtures and the caning of the furniture, the ornate patterns of art nouveau screens, the brilliant stained glass of the lunettes known as

medios puntos, and the stone balusters and wrought iron gates of colonial architecture. To a certain extent he also emulated Manuel's solitary street scenes and quiet interiors. His work, however, radiates an exuberant pictorial quality and a lighthearted spirit. He took delight in painting Cubans of all classes, races, and professions and often recorded popular scenes, including Santeria rituals that encompassed the veneration of both Roman Catholic saints and powerful West African deities.

Portocarrero was a well-rounded artist, designing sets for theatrical productions, doing book illustrations and ceramics, and writing novels in addition to painting. In 1943 he taught a drawing class in a prison in Havana and in 1968 did the illustrations for *Paradiso,* José Lezama Lima's greatest novel. By the time of his death in 1985, Portocarrero had become a celebrated artist in Communist Cuba and had exhibited widely around the world, particularly in the former Soviet bloc, where he received numerous honors.

—H. Rafael Chácon

POSADA, José Guadalupe
Mexican engraver and lithographer

Born: Aguascalientes, 2 February 1852. **Education:** Academia Municipal de Dibujo de Aguascalientes, 1867; studied lithography and engraving under printer Jose Trinidad Pedroza, Aguascalientes. **Family:** Married Maria de Jesus Vela in 1875; one son out of wedlock. **Career:** Illustrator, Pedroza's political newspaper *El Jicote*, 1871; book illustrator and wood engraver, 1872, then manager, 1873, Pedroza's lithograph and print shop, León, Mexico; established own print shop, León, Mexico, 1876; illustrator, *La Gacetilla* newspaper; instructor of printmaking and bookbinding, Escuela de Instruccion Secundaria de León, 1884–88. Moved to Mexico City and established print shop, 1888; began metal engraving, 1889; editorial illustrator and lithographer, Don Antonio Vanegas Arroyo publishing house, 1890–1913. Estimated to have produced more than 20,000 engravings. **Died:** 20 January 1913.

Individual Exhibitions:

1943 Palacio de Bellas Artes, Mexico City (traveling retrospective)
1963 National Institute of Fine Arts, Mexico City (retrospective)

Collections:

Jean Charlot Collection, University of Hawaii, Honolulu; Bellas Artes National Institute, Mexico City; Biblioteca Nacional de Mexico; National Library of Anthropology and History; Mexico City; Municipal Archive, León, Mexico; Museo Aguascalientes; Museo de Arte Moderno, Mexico City; Taller de la Gráfica Popular, Mexico City; Universidad Nacional Autónoma de Mexico, Mexico City; Amon Carter Museum of Western Art, Fort Worth, Texas; Art

José Guadalupe Posada: *Don Chepito torero.* © Giraudon/Art Resource, NY.

Institute of Chicago; University of California, Berkeley; Colorado Springs Fine Arts Center; Denver Art Museum; Metropolitan Museum of Art, New York; Museum of Modern Art, New York; Philadelphia Museum of Art; Tulane University, New Orleans; University of Texas, Austin; Yale University, New Haven, Connecticut.

Publications:

By POSADA: Books—25 Prints of José Guadalupe Posada, Mexico, La Estampa mexicana, 1942; *36 grabados,* Mexico City, Arsacio Vanegas Arroyo, 1943; *Las calaveras, y otros grabados,* Buenos Aires, Editorial Nova, 1943; *100 Original Woodcuts by Posada,* foreword by Jean Charlot, Mexico City, Arsacio Vanegas Arroyo and Colorado Springs, Colorado, Taylor Museum, 1947.

On POSADA: Books—Monografia: Las obras de Jose Guadalupe Posada, grabador mexicano, edited by Frances Toor, Pablo O'Higgins, and Blas Vanegas Arroyo, Mexico City, Mexican Folkways, 1930; *José Guadalupe Posada* by Luis Cardoza y Aragón, Mexico City, Universidad Nacional Autónoma de México, 1963; *Posada's Popular Mexican Prints,* edited by Stanley Appelbaum and Roberto Berdecio, New York, Dover Publications, 1972; *The Works of José Guadalupe Posada,* edited by Hannes Jähn, Frankfurt, Zweitausendeins, 1976; *Posada's Mexico,* edited by Ron Tyler, Forth Worth, Texas, Amon Carter Museum of Western Art, 1979; *Tres artistas del pueblo: José Guadalupe Posada, Leopoldo Méndez, Alberto Beltran* by Ricardo Cortés Tamayo, Mexico, Edición de El Día, 1981; *Posada:*

Messenger of Mortality by Julian Rothenstein, London, Redstone Press, 1989; *Jose Guadalupe Posada: Mexican Popular Prints,* edited by Julian Rothenstein, Boston, Shambala, 1993; *Posada: El novio de la muerte* by Rius, Mexico City, Grijalbo, 1996; *Posada's Broadsheets: Mexican Popular Imagery, 1890–1910* by Patrick Frank, Albuquerque, University of New Mexico Press, c. 1998. **Articles—**''Un presursor del movimiento de Arte Mexicano'' by Jean Charlot, in *Revista de Revistas,* 1925; ''Jose Guadalupe Posada'' by Diego Rivera, in *Universidad,* December 1936; ''Posada's Prints as Photomechanical Artefacts,'' in *Print Quarterly* (United Kingdom), 9, December 1992, pp. 334–56, and ''Posada and the 'Popular': Commodities and Social Constructs in Mexico before the Revolution,'' in *Oxford Art Journal,* 17(2), 1994, pp. 32–47, both by Thomas Gretton; ''Jose Guadalupe Posada Yet Again'' by J. Leon Helguera, in *Studies in Latin American Popular Culture,* 12, 1993, p. 203; ''Gallery for Eloquent Skeletons'' by Trudy Balch, in *Américas,* 52(5), 2000, p. 48.

* * *

The Mexican draftsman and printmaker José Guadalupe Posada began his career early in childhood, when he showed a remarkable interest in drawing. He attended the Academy of Aguascalientes under the tutelage of the draftsman Antonio Varela. Posada was then apprenticed with the lithographer Jose Trinidada Pedroza and began to create illustrations reflecting the political and social character of Mexican society for the periodical *El Jicote.* In 1872, after political

José Guadalupe Posada: *La Calavera du dandy (La Mort et le dandy)*. © Giraudon/Art Resource, NY.

threats, Posada and Pedroza were forced to flee to León, in Guanajuato state. In León, Posada taught lithography and began to create wood engravings in earnest.

In 1888 Posada relocated to Mexico City and the following year began working as a drafter and engraver in the printing atelier of Antonio Venegas Arroyo. The association between Venegas and Posada would spark a friendship that lasted until the latter's death. While at Venegas's workshop, Posada abandoned lithography in favor of the lower priced, more accessible medium of printmaking. In collaboration with Venegas, Posada illustrated news items for papers that were distributed as *corridos gráficos*. Using zinc, wood, and typeset engravings, Posada was able to mass-produce more than 20,000 copies at a time. Such materials were particularly important at a time when illustrations were the main source of conveying the news to a largely illiterate public. Posada's repertoire of images documented scenes from daily life and popular culture, as well as depicting religious iconography and political heroes like Emiliano Zapata and Benito Huerta. Posada also was credited with the creation of Don Chepito, a character reflecting popular social views. Posada's *calaveras*, or costumed skeleton figures, were perhaps his best-known figures.

The artist's inflammatory renderings of political and social life repeatedly led to prison terms throughout his career. By no means, however, did he renounce his views, and he contributed to several periodicals, including *La Patria Ilustrada, El Teatro,* and *El Centavo Periódico,* that dealt with the social and political situation in Mexico. Throughout his life Posada's creations gained extraordinary popularity, and they became inspirational sources for later artists such as Diego Rivera and Frida Kahlo and for contemporary artists like Nahum Zenil.

—Miki Garcia

POU, Miguel
American painter

Born: Ponce, Puerto Rico, 1880. **Education:** Studied under Pedro Clausells, Luis Desangles, and Santiago Meana; Instituto Provincial, Ponce, B.A. 1898; studied education, Normal School, Hyannis, Massachusetts, 1906; Art Students League, New York, 1919–20; Pennsylvania Academy of the Fine Arts, Philadelphia, 1935. **Career:** Teacher, then superintendent, Department of Public Education, Puerto Rico, 1900–22; founder, Miguel Pou Academy, Puerto Rico, 1910. Traveled in the United States, 1901–07; traveled to New York City, 1944. **Died:** 1968.

Individual Exhibitions:

1957 Instituto de Cultura Puertorriqueña, San Juan
 (retrospective)
1980 Museo de Arte de Ponce, Puerto Rico (retrospective)

Selected Group Exhibitions:

1901 *International Exposition,* Buffalo, New York
1902 Charleston, South Carolina
1926 Independents Salon, New York
 Aristas Gallery, New York
1938 *National Exposition of Art,* New York

Collections:

Ateneo Puertorriqueña, San Juan; Instituto de Cultura Puertorriqueña, San Juan; Museo de Arte de Ponce; Universidad de Puerto Rico, San Juan.

Publications:

On POU: Books—*Miguel Pou: Su vida y su obra* by Ana Valdejulli de Pou, Santurce, Estado Libre Asociado de Puerto Rico, 1973; *Exhibición retrospectiva con motivo del centenario de Miguel Pou,* exhibition catalog, San Juan, Instituto de Cultura Puertorriqueña, 1980.

* * *

Miguel Pou is one of the most prolific and multifaceted of the Puerto Rican art masters of the first half of the twentieth century. He was born in Ponce, the island's so-called "noble city," in 1880. His father, a pharmacist, was Juan Bautista Pou, and his mother was Margarita Becerra Julbe. Pou was descended from one of the founders of the town of Ponce known as "the Portuguese." He began to study drawing at age 11 with Pedro Clausells, and from ages 15 to 18 he studied painting with Spanish artist Santiago Meana, who was staying in Ponce.

His first works date from 1894. During the more than 70 years of his long career it is believed that he painted more than 800 works, 634 of which were catalogued by his widow, and participated in more than 85 exhibitions. Pou painted landscapes, portraits, nudes, regional characters, religious paintings, genre paintings, still lifes, flowers, and animals; produced murals, wall hangings, and posters; decorated furniture; illustrated books; and restored works of art and photographs.

Under instruction from his early teachers, Pou began copying primarily religious works. When the Spanish-American War was over, his professor returned to his native country. Pou then took the opportunity to complete a series of Puerto Rican landscapes, which he sold to American soldiers, and he began to study from books on art history and technique.

The painting *Lavanderas en el patio de Ponce* ("Washer Women in a Ponce Yard"), a work dating from the end of 1898, is the first in which his affinity for the impressionist style can be perceived, and for a number of years he continued making copies of famous paintings, both portraits and landscapes. In 1900 he was named art teacher for the Puerto Rico Department of Public Education. For the next 22 years he devoted himself to teaching. During the first decade of the

twentieth century he traveled periodically to the United States where he took courses in art education and photograph restoration techniques. On these visits he also took the opportunity to visit museums and universities as well as to participate in exhibitions.

At age 39 he applied for leave and went to study for a year at the Art Students League of New York City, and it could be said that it was upon his return that his career as a professional truly began. The painting of a child with an orange, *De la tierra triste* ("From the Sorrowful Land," 1921), demonstrates the great change in his palette. The use of light, the strong impasto, and the bravura of his brush stroke are elements that remained constant in his work until the 1940s.

In 1922 he renounced his position as superintendent of the Department of Instruction and dedicated himself fully to painting. Thereafter he earned his living from the private lessons he had begun giving in his home in 1910 and from the sale of his works, a highly privileged position in a poor country. He also opened what he called the Pou Academy. Most of Ponce's young ladies attended this academy, which closed in 1950, and it trained a number of artists: among the students who became recognized artists were Jose Alicea, Horacio Castaing, and Epifanio Irizarry.

Halfway through the 1940s his impastoed and luminous palette began to change. Primary colors began to blend and disappear. His oil landscapes and genre paintings became increasingly softer, and pastel colors appeared, which at first glance looked as if they were painted with oil crayons. From one painting to another he developed the style that would characterize him during the last 30 years of his artistic career. His relevant vision of the southern landscape faithfully reflected this area where the dry air makes the mountains sharper and their surfaces acquire a brown color that flattens their depth.

Pou painted Ponce society and the country's principle heroes on commission. Landscapes were his favorite subject and of them he said, in an interview published in *Alma Latina,* "I paint landscapes because I am enchanted by the brilliance and transparency of my country." He accumulated an impressive inventory of almost all the southern plantations—*Barrio de Mameyes* (1921), *Barrio Guaraguao* (1932), *Floresta Tropical* (1932), *Vista de la Central Mercedita* (1943), and *Barrio Anón* (1948)—and he painted the island's principal beaches, Luquillo, el Escambrón, and Rincon. He also completed a series of urban landscapes in which he painted the plazas and cathedrals of Ponce, Aibonito, and Barranquitas. And he painted a series of washerwomen in the river. All these works offer valuable information about life in Puerto Rico in the first half of the twentieth century.

Nevertheless, Pou often said his greatest wish was to reflect the soul of his people, and perhaps that is why his regional characters and genre paintings are deemed his best work. "The Shoemaker," "The Gardener," "The Hammock Vendor," "The Promise," and his various versions of the "Daily Bread" theme are his most impressive paintings.

In 1953, for reasons of health, he moved to San Juan, where his son worked as a doctor. His palette curiously recovered much of the brilliance, color, and depth of his early years. This phenomenon perhaps shows that the loss of color and the iron gray so typical of his work were not a product of a loss of vision. One hypothesis is that this change was a product of an intense observation of the phenomenon of the southern lights. As soon as Pou moved north, mountains became green again, and his perspectives regained depth. The northern skies are more filled with clouds, and the Sun is less punishing. The green mountains and their rounded tops allow for a greater depth of field. This phenomenon was captured by the old painter.

At Pou's death in 1968, his son donated most of his paintings, sketch books, manuscripts, and even his drawing implements to the Ponce Art Museum.

—Haydee Venegas

PUJOL, Ernesto
Cuban installation artist and photographer

Born: Havana, 1957. **Education:** University of Puerto Rico, B.A. in humanities, specialty in fine arts, 1979; St. John Vianney Seminary, Miami, theology certification, 1980; Pratt Institute, Brooklyn, New York, graduate in art therapy, 1987; Hunter College, New York, graduate in communication and media, 1990. **Career:** Monk, 1980–84. Visiting artist, Cooper Union, New York, and Art Institute of Chicago; lives and works in New York. **Awards:** Fellowship, Mid-Atlantic Arts Foundation; fellowships, Pollock Krasner Foundation, New York, 1993, 1998; fellowship, Joan Mitchell Foundation, New York, 1997; fellowships, Cintas Foundation, New York, 1991, 1997.

Individual Exhibitions:

1995 *The Children of Peter Pan*, Casa de las Américas, Havana, Cuba
 Taxonomies, Galería Ramis Barquet, Nuevo Leon, Mexico
 Collapses, Fredric Snitzer Gallery, Coral Gables, Florida
1996 *Saturn's Table*, Ludwig Foundation of Cuba, Havana
 Winter, Iturralde Gallery, Los Angeles
1997 *The Picnic*, Bronx Museum of the Arts, New York
 Ernesto Pujol, Linda Kirkland Gallery, New York
 Games, Joan Guaitia Gallery, Palma de Mallorca, Islas Baleares, Spain
1999 *Memory of Surfaces*, R.I.S.D. Art Museum, Providence, Rhode Island
 Whiteness, Linda Kirkland Gallery, New York
 Hagiografia, Galería Ramis Barquet, New York
 Pori Photography Center, Finland
2000 *Conversion of Manners*, El Museo del Barrio, New York
 Hagiografia, Museo Rufino Tamayo, Mexico City
 El cuerpo de la fe, Galería Pancho Fierro, Lima, Peru
 Hagiografia, Galería Ramis Barquet, New York
2001 *Conversion of Manners*, Allentown Art Museum, Pennsylvania

Selected Group Exhibitions:

1994 *Inquisitive Art: Three Contemporary American Artists of Latino Heritage,* Douglas F. Cooley Memorial Art Gallery, Reed College, Portland, Oregon
1995 *Division of Labor*, Bronx Museum of the Arts, New York
 The House Project, Museum of Contemporary Art, Los Angeles
1996 *Cuba Twentieth Century,* La Caixa Foundation, Palma de Mallorca, Islas Baleares, Spain

Ernesto Pujol: *Veiled Nun, 1999.* **Photo courtesy of Galeria Ramis Barquet.**

1997 *VI Biennial of Havana, Cuba*
 II Biennial of Johannesburg, South Africa
 This Is How It Is, Centro Cultural Arte Contemporáneo, Mexico City
1998 *Spaces in Transition,* Museo de Arte, San Juan, Puerto Rico
1999 Paris Arts Fair, France
 Cuba: Maps of Desire, Kunsthalle Wien, Vienna, Austria

Collections:

Linda Kirkland Gallery, New York; El Museo del Barrio, New York.

Publications:

On PUJOL: Books—*Taxonomías*, exhibition catalog, text by Gerardo Mosquero, Neuvo Leon, Mexico, Galería Ramis Barquet 1994; *Inquisitive Art: Three Contemporary American Artists of Latino Heritage,* exhibition catalog, text by Inverna Lockpez, Portland, Oregon, Douglas F. Cooley Memorial Art Gallery, Reed College, 1994; *Winter,* exhibition catalog, Los Angeles, Iturralde Gallery, 1996; *Hagiography,* exhibition catalog, text by Octavio Zaya, New York, Galería Ramis Barquet, 1999. **Articles**—''Ernesto Pujol'' by Jose Antonio Perez Ruiz, in *Art Nexus*, 26, October/December 1997, pp. 150–151; ''Ernesto Pujol'' by Miriam Basilio, in *Art Nexus*, 27, January/March 1998, p. 133; ''Ernesto Pujol'' by Lawrence Hegarty,

Ernesto Pujol: *Nun in Profile,* **1999. Photo courtesy of Galeria Ramis Barquet.**

in *Art Papers*, 22(3), May/June 1998, pp. 51–52; "Ernesto Pujol: The Formal Structure of a Classic" by Maria Lluisa Borràs, in *Art Nexus*, pp. 44–48; "Art Miami 99" by Carol Damian, in *Art Nexus*, 32, May/July 1999, pp. 92–94; "Art 1999 Chicago" by Charmaine Picard, in *Art Nexus*, 33, August/October 1999, pp. 98–101; "Ernesto Pujol: Little Man" by Jane Harris, in *Sculpture*, 18(5), June 1999, p. 10–11; "Good Business Is the Best Art" by Graciela Kartofel, in *Art Nexus*, 38, November/January 2000–2001, pp. 107–108.

* * *

Born in Havana, Cuba, in 1957, Ernesto Pujol lived in Spain and Puerto Rico before settling in the United States in 1979. Working with painting, mixed-media installation, and photography, Pujol's broad range has illustrated his versatility with a variety of media. Understated would perhaps be the best adjective for much of his work, which takes difficult concepts such as racial purity and impurity, memory, absence, loss, religious identity, or gender contradiction and uses them as the framework through which his imagery is constructed.

In the 1990s Pujol became increasingly interested in the concept of whiteness and the ethnicity either implied by or unrecognized within this term. He created a series of works, titled *Whiteness,* based on his explorations of this concept. Gathering a variety of both found and created white objects, including baby shoes, porcelain plates, and plaster casts, Pujol created an installation, *Still Life* (1999), from the *Whiteness* series, that was both serene and disquieting at the same time. This was true in much of Pujol's work, as he was often interested in creating objects and installations featuring imagery that was perturbing at the same time as it was beautifully simple. He was particularly interested in examining the dark side of memories, those thoughts that may haunt the individual. Placed with one another, the objects the artist chose become metaphors for the presences and reminiscences that Pujol called forth. For Pujol each found object contained memories that enriched the installation immeasurably; each object came with a history and narrative that added to the completion of the finished project. The juxtaposition of found objects such as bird cages, knives, and other household objects with created ones such as plaster casts of youthful penises and scrotums underlines incongruous messages that reflect the often contradictory nature of life.

Within the varied nature of the objects seen in Pujol's installations, an element of the personal is inevitably present. This was an important point for Pujol, who frequently credited feminist theory with helping him to see the realm of the personal within the arena of the political. By taking personal narratives as the basis for his work, Pujol was able to enhance the story of the particular and create a universalizing epic. For example, using children's shirts and blouses, as in the installation *The Children of Peter Pan* (1995), the artist was able to evoke issues of political oppression, forced migration, and physical violence. The installation was a response to Operation Peter Pan, a U.S.-sponsored program that brought Cuban children to foster homes and orphanages in the United States during the early years of the revolution. Scale, in this instance, was significant, underlining the vulnerability of those who might occupy these small garments. Also important to Pujol was an unfettered examination of the process of socialization and how it serves to construct rigid gender roles and influence social expectations. Pujol's work bears witness to the extent of the control of social confines and of the legacy of patriarchy on the human psyche.

His interest also extended to more esoteric themes, such as the preservation and revelation of knowledge. In an installation called *Memory of Surfaces* (2000) at the Rhode Island School of Design, Pujol combined objects borrowed from local libraries to make a statement about what he referred to as the fragile commodity that knowledge has been, both historically and currently. He conceived of the installation as a conversation, between the nineteenth and twentieth centuries, about access to knowledge. By bringing together books, maps, furniture, and other artifacts, Pujol commented on how knowledge is gathered, presented, and (narrowly) disseminated.

In 1979 Pujol entered a cloistered Catholic monastery, an experience that has marked his work, perhaps forever. Some of his photographs feature the artist himself dressed in the habits and robes of a variety of holy orders of monks and nuns, including Carmelites, Capuchins, Jesuits, and Sisters of the Sacred Blood. An enormous body of work, these photographs present traditional portrait poses and many more intimate details that focus on different parts of the body and their relationship to the robes that cover them. Pujol saw parts of this series also as an examination into "disappearance." In these images the figure gradually turns away from the camera lens and becomes increasingly introspective. The austerity of the photographs plays an important role, as each one becomes, in its essence, a kind of devotional image.

—Rocío Aranda-Alvarado

QUIJANO, Nick
American painter, installation artist, and woodcarver

Born: New York, 1953; moved to Puerto Rico, 1967. **Education:** Studied architecture, University of Puerto Rico, 1970–72; resumed architecture studies, 1995. **Career:** Also worked as a furniture designer.

Selected Exhibitions:

1988 Museum of Contemporary Hispanic Art, New York
 (with Arnaldo Roche)
1990 *The Decade Show: Frameworks of Identity in the 1980s,*
 Museum of Contemporary Hispanic Art, New York
 (traveling)
 New Art from Puerto Rico, Springfield, Massachusetts

Collections:

Museo de Arte de Puerto Rico, San Juan; Galería Matices, Hato Rey, Puerto Rico.

Publications:

On QUIJANO: Book—*La ciudad infinita: Versiones de San Juan,* San Juan, La Comisión Puertorriqueña para la Celebración del Año 2000, 2000. **Film**—*Builders of Images: Latin American Cultural Identity* by Juan Mandlebaum, 1992.

* * *

Born and raised in New York City during the 1950s and '60s, Nick Quijano spent summers in Puerto Rico with his grandmother. In 1967 his family decided to return to Puerto Rico to live. His first years there were spent gathering objects, rescuing memories and stories, and filling his senses with the greenness of the tropics while learning to play various musical instruments. At the age of 17, in 1970, Quijano began to study architecture at the University of Puerto Rico, a career he abandoned two years later in order to dedicate himself to painting.

Quijano's first works were an inventory of Puerto Ricans as a people. He re-created scenes of the past transported to the present. These works, of a deceptively primitive appearance, are small paintings on paper with frames painted by hand: scenes of daily life, boys and girls playing, self-portraits with his grandmother, dances and life in the bars. They are joyful works, sonorous, charged with a sensuality typical of the tropics. Thanks to his talent for music, his works possess a special rhythm that can be perceived with more than one sense. His success was instantaneous: these small works captured the public with their sensuality, color, and unprecedented musicality.

They were intimate works that burst into memories and established a dialog with the spectator's own longings and remembrances, an innovative form of awakening memories without resorting to worn-out clichés. Later he exchanged paintings for installations, where the objects he had painted in his works are presented on pedestals, creating a connection between the real object and the painted one.

Along with these works Quijano completed a number of unique and bizarre dolls, put together from flotsam scavenged from deserted beaches, objects made with craft techniques that were a far cry from handicrafts. The ability to give life to these entities and to convert pieces of rubber, sandals, and glass, as well as stones, into extravagant looking beings and country hicks impressed a group of museum directors visiting the country in 1986.

At the end of 1988 Quijano's career went in a new direction. Together with Arnaldo Roche he exhibited 25 of his paintings and installations at the Museum of Contemporary Hispanic Art in New York (MOCHA). Two years later he was selected to appear as part of the exhibition the *Decade Show,* which summed up artistic activity for the 1980s in New York, as well as the exhibit *New Art from Puerto Rico* in Springfield, Massachusetts.

The playful sensuality exhibited in his small early paintings took a new turn at the beginning of the 1990s. He began to paint gigantic tropical fruits on canvas, the smallest of which measured four square feet. The new inventory features enormous tropical fruits that cover the entire surface of the composition. For *Musa paradisíaca* (''Heavenly Muse'') he was inspired by, but did not copy, Francisco Oller's *Plátanos amarillos* (''Yellow Plantains''), using the suggestive scientific name of the fruit that is a staple of the Puerto Rican diet. He made a *Mango* into a fruit of desire and was also capable of painting erotic *Pimientos* (''Peppers''), and he turned a *Guanábana* (''Sour Sop'') into an explosive artifact. This last was a tribute to the island of Vieques, completed eight years before the presence of the U.S. Navy was openly challenged by the Puerto Ricans.

But it was in Quijano's series of tropical leaves and flowers that he unleashed sensuality. The paintings of his series called *Tropical* carry an erotic charge as intense as that of Robert Maplethorp's erotic photographs of the same themes. These are flowers transported from their habitat, enlarged and painted with their vivid colors on a dark background. In some, such as *Gardenia, Bromelia, Heliconia, Anthurium,* and *Orchid,* we see only details, flowers that provoke and at the same time subjugate the spectator. The same occurs with the leaf of the *Yagrumo.* This form of seduction, impacting the spectator, has always been present in Quijano's work.

Quijano also has had a prestigious market for furniture that he has designed and fabricated in Central America. Enormous wardrobes carved with details of pineapples, four-poster beds, also carved with tropical motifs, tables, and desks formed part of the collection of organic and tropical furniture that he designed. Constructed from excellent wood with great precision, his furniture sold at high prices and became fashionable additions to the best residences, hotels, museums, and churches of the capital city.

After an eminently successful career as a painter and artist, Quijano made the decision in 1995 to quit and dedicate his time to finishing his training as an architect, whereupon he received a degree. But painting as his true vocation called him back. He began painting large canvases that were syntheses of all the subjects he has already worked on and manifestations of his deepest sentiments: solitude, joy, sadness, love. He once again has presented the excesses and the lust of what he called the Caribbean condition.

—Haydee Venegas

QUIRÓZ, Alfred J(ames)
American painter

Also known as A. J. Quiróz. **Born:** Tucson, Arizona, 9 May 1944. **Education:** San Francisco Art Institute, 1968–71, B.F.A. in painting 1971; Rhode Island School of Design, Providence, 1973–74, M.A.T. in art education 1974; University of Arizona, Tucson, 1982–84, M.F.A. in painting 1984. **Military Service:** United States Navy, 1963–67: assistant navigator; National Defense Medal, Armed Forces Expeditionary Medal, Vietnam Service Medal, Vietnam Campaign Medal. **Family:** Married Marcia D. Duff in 1977; two sons. **Career:** Visual arts and film specialist, Rhode Island State Council on the Arts, 1974–77; film instructor, Roger Williams College, Bristol, Rhode Island, 1975; arts coordinator, School One, Providence, Rhode Island, 1975–77; instructor of drawing and painting, Alternate Learning Project, Providence, Rhode Island, 1975–78; project director, ESAA Special Arts, Central Falls, Rhode Island, 1978–79; illustrator, Lisa Frank Inc., Tucson, Arizona, 1981–84; instructor of drawing and painting, City of Tucson Parks & Recreation, Arizona, 1981–86. Adjunct lecturer, 1988, assistant professor of art, 1989–93, associate professor of art, 1993–98, and since 1998 full professor of art, University of Arizona, Tucson. Artist-in-education, Arizona Commission on the Arts, 1985–89; muralist and art coordinator, *Aces: Iron Eagle III* (film), 1990–91; set artist, *The Lightning Incident* (film), 1991. **Awards:** Artist grant, National Endowment for the Arts, 1977; best of show, *Arizona Biennial,* Tucson Museum of Art, 1986; Arizona Arts Award fellowship, Tucson, 1988; travel grant, 1989, visual arts fellowship, 1989, 1995, and professional development grant, 1991, Arizona Commission on the Arts; materials grant, Phoenix Art Museum, 1992; research incentive grant, 1992, Excellence in Teaching award, 1995, and College of Fine Arts small grant, 1995, University of Arizona; Wakonse fellowship, 1995; visual arts fellowship, Tucson/Pima Arts Council, 1996, 2000; Clinton King purchase award, Museum of Fine Arts of Santa Fe, 1996. **Address:** 2726 East Winchester Vista, Tucson, Arizona 85713. **E-mail Address:** ajquiroz@email.arizona.edu.

Individual Exhibitions:

1972 Student Union Gallery, University of Arizona, Tucson
1973 Pima Community College, Tucson, Arizona
1976 School One Gallery, Providence, Rhode Island
1978 School One Gallery, Providence, Rhode Island
1986 Ohio State University, Newark
 MARS Gallery, Phoenix
1988 Gorman Museum, University of California, Davis
 SOMAR Gallery, San Francisco

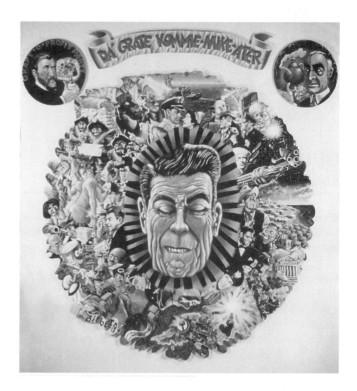

Alfred J. Quiróz: *Da Grate Kommie-Nuke-Ater,* 1997–98. Photo by Damian Johnson; courtesy of the artist.

 Centro Cultural de la Raza, San Diego, California
1989 University Art Gallery, California State University, Stanislaus
1992 *Alfred J. Quiróz: Contemporary Narrative Paintings,* Donna Beam Fine Art Gallery, University of Nevada, Las Vegas
1994 *Alfred J. Quiróz: Hystorical Narratives,* New Directions Gallery, Scottsdale Center for the Arts, Arizona
1996 Temple Gallery, Tucson, Arizona
1997 La Galeria de la Casa de la Cultura de Nogales, Sonora
1999 Gallery B.A.I., Barcelona

Selected Group Exhibitions:

1991 *Counter Colo-nialismo,* Centro Cultural de la Raza, San Diego, California (traveling)
1992 *Year of the White Bear,* Walker Art Center, Minneapolis (traveling)
 Chicano Codices, Mexican Museum, San Francisco (traveling)
1993 *La Frontera/The Border*, Museum of Contemporary Art, San Diego, California (traveling)
 In/Out of the Cold, Center for the Arts, San Francisco
1994 *Works on Papers,* Galeria Mesta Bratislava, Bratislava, Slovakia
1997 *Borders, Barriers & Beaners,* SPARC Gallery, Venice, California
1998 *Same Difference,* Guggenheim Gallery, Chapman College, Orange, California
1999 *Arizona Biennial,* Tucson Museum of Art, Arizona
2000 *Chispa,* Apex Gallery, New York

Alfred J. Quiróz: *Novus Ordo,* **1993. Photo by Bob Hsiang; courtesy of the artist.**

Collections:

Tucson Museum of Art, Arizona; Scottsdale Museum of Contemporary Art, Arizona; Museum of Fine Arts, Santa Fe, New Mexico; Davis Dominguez Gallery, Tucson, Arizona.

Publications:

On QUIRÓZ: Books—*Ventanas: Visiones culturales,* exhibition catalog, Moorhead, Minnesota, Plains Art Museum, 1992; *Counter Colo-nialismo,* exhibition catalog, San Diego, California, Centro Cultural de la Raza, 1992; *Alfred J. Quiróz: Contemporary Narrative Paintings,* exhibition catalog, Las Vegas, Donna Beam Fine Art Gallery, University of Nevada, 1992. **Articles—**''Since Vietnam: The War and Its Aftermath'' by Jeff Kelley, in *Artforum International,* 23, April 1985, p. 101; ''Report from Tucson: The New West'' by Ann Wilson Lloyd, in *Art in America,* 80, October 1992, pp. 54–61. **Film—***Alfred Quiróz: The Big Picture, Tucson's Murals* by K. T. Good, Tucson, Arizona, Good Productions, 1993.

* * *

Alfred J. Quiróz hailed from Tucson, Arizona, a second-generation descendant of Mexican-American lineage. As a young man in high school he began what would become a lifelong interest in art linked to a curiosity in history. Even after serving two tours of duty in Vietnam while in the U.S. Navy, he held on to his passion for art and completed formal university training in the visual arts. The experiences of his youth, his fascination with history, time spent in the Navy during the Vietnam War, his encounters with the occult, and his keen observations and overall inquisitiveness helped to frame the foundation from which his paintings developed. His heritage became the

mechanism for catching and then communicating the truths underlying events, personalities, and attitudes.

The work of Quiróz may not fit into what has been identified as Chicano art. He is accused of not addressing ethnic Hispanic concerns and therefore of not being part of Chicano expression. The issues he chooses to pursue lean toward a broader examination of human nature and its course in history. The tools Quiróz uses to make these explorations are what tie him to his Hispanic roots: boldly colorful subjects, exaggerated forms, cartoonlike presentations. Although he finds himself in Hispanic culture, he does not consider himself to be solely of the culture. The work of Quiróz penetrates notions and attitudes of popular history to make strong, often satirical, political statements. If one examines his comic book images, vibrant colors, and exaggerated actions, one sees the hypocrisy and the irony, the terror and the inhumanity, the evidence of the human condition given to self-gratification and the events that come of it.

Quiróz pursues a number of themes in his work. His more noted series include *Quincentenary, Presidential, Past Lives, Chicano/ Meso-Centric History, New-Cleer,* and *AZTECA TV.* These serial studies present well-researched historical events, they illustrate legitimate personalities, and they astutely examine human nature. His characters are portrayed in *Mad* magazine fashion, sometimes as cutout shapes and sometimes as three-dimensional, freestanding forms fronting large-format paintings. Colliding cultures are found in paintings layered with references to ancient American civilization and to contemporary cultural artifacts. The approach Quiróz takes in handling his subjects gives him the freedom to push his narratives beyond the dignified, respectable, and acceptable tradition of history painting. The core subject matter may hearken to ancient origins, but the handling of it, the design elements, and the manner of presentation heed the practice of artistic appropriation, borrowing from one source to fulfill his objectives with another. The exaggerated action of

seemingly humorous or irreverent situations, the bold and garish colors, the shaped canvases–all pull the work out of the entrenched hierarchy of painting and plant it squarely at the end of the twentieth and the beginning of the twenty-first century.

Quiróz's paintings take the veneer off popular perceptions of people and events, both current and historic. He irreverently peels the veneer away to reveal the truths we may be uncomfortable in viewing, perhaps of atrocious events, the inhumanity of the participants, or the hypocrisy of political figures. The comic book imagery serves to soften the blow of the message that Quiróz is sending. However camouflaged it may be, the message is still there for those who have the eyes to see.

—Jerry A. Schefcik

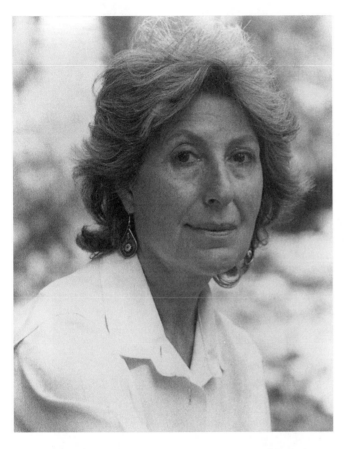

Raquel Rabinovich. Photo by Mariana Eliano; courtesy of the artist.

RABINOVICH, Raquel
American painter and sculptor

Born: Buenos Aires, Argentina, 30 March 1929; emigrated to the United States, 1967, naturalized American citizen, 1973. **Education:** Universidad de Cordoba, Argentina, 1950–52; La Sorbonne, Paris, and Atelier Andre Lhote, Paris, 1956–57; University of Edinburgh, Scotland, 1958. **Family:** Married Jose Luis Reissig in 1956 (divorced 1980), two daughters and one son; resumed living with Reissig in 1987. **Career:** Lecturer in art, Long Island University, Brookeville, New York, 1976–77, Port Washington Library, New York, 1976–77, College of New Resources, New York, 1978–79, Metropolitan Museum of Art, New York, 1982, Brooklyn Museum, New York, 1982, Whitney Museum of Art, New York, 1983–86, and Marymount Manhattan College, New York, 1984–91. **Awards:** Grant, CETA, 1978; grant, Artists Space, 1980, 1982, 1986; residency, Cummington Community of the Arts, Massachusetts, 1989; fellowship, National Endowment for the Arts, 1991, 1992; grant, New York State Council

on the Arts, 1995; grant, Pollock-Krasner Foundation, 2001. **Agent:** Joseph Szoecs, Director, Trans Hudson Gallery, 416 West 13th Street, New York, New York 10014, U.S.A. **Address:** 141 Lamoree Road, Rhinebeck, New York 12572–3013, U.S.A. **E-mail Address:** raquelrabinovich@aol.com. **Website:** http://www.sculpture.org.

Individual Exhibitions:

1973 Benson Gallery, Bridgehampton, New York
1974 Henscher Museum, Huntington, New York
1975 Susan Caldwell Gallery, New York
1978 *Cloister, Crossing, Passageway, 1.32,* City University of
 New York (traveling)
1980 *Shelter,* Institute for Art and Urban Resources, New
 York
1981 Galeria Garces Velasquez, Bogota
1983 Kouros Gallery, New York
 The Map Is Not the Territory, Center for Inter-American
 Relations, New York
1985 C Space, New York
1986 *Invisible Cities 1986, Sculptures and Drawings,* Bronx
 Museum of the Arts, New York
1996 *Raquel Rabinovich: Drawings 1978–1995,* INTAR
 Gallery, New York
 Trans Hudson Gallery, Jersey City, New Jersey
 Lehigh University Art Galleries, Bethlehem,
 Pennsylvania
1998 Trans Hudson Gallery, New York
2000 Trans Hudson Gallery, New York

Selected Group Exhibitions:

1979 *The Language of Abstraction,* Betty Parsons Gallery,
 New York
1981 Museo de Arte Moderno de Cartagena, Colombia
1984 *An Exhibition of Contemporary Sculpture,* Anderson
 Center Gallery, Hartwick College, Oneonta, New
 York
1986 *25th Anniversary Commemorative Art Exhibition,* City
 University of New York
1990 *Beyond the Surface,* Americas Society, New York
1992 *The Persistence of Abstraction,* Edwin A. Ulrich
 Museum of Art, Wichita State University, Kansas
1996 *In This Time and Place,* State University of New York,
 New Paltz, New York
1997 *Re-Aligning Vision: Alternative Currents in South
 American Drawing,* University of Texas, Austin
 (traveling)
2000 *Toward the New,* Hillwood Art Museum, Long Island
 University, New York

Raquel Rabinovich: *Temples of the Blind Windows, #3,* 1978–83. Photo by Doug Baz; courtesy of the artist.

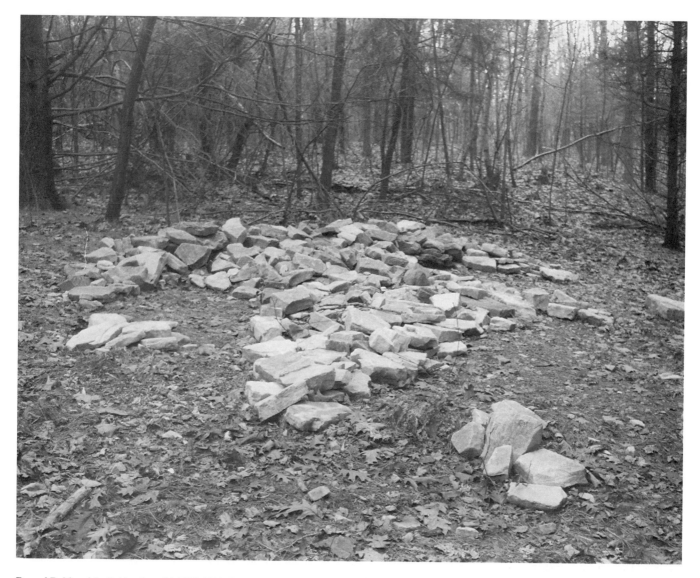

Raquel Rabinovich: *Pabhavikas, #4,* 1995–2000. Photo by Isabel Carlota Rodriguez; courtesy of the artist.

2000 Trans Hudson Gallery, New York

Collections:

Museo de Arte Moderno, Buenos Aires; Suffolk Museum, Stonybrook, New York; El Museo del Barrio, New York; Museo de Arte Moderno, Bogota; Cincinnati Art Museum; Fondo Nacional de las Artes, Buenos Aires; Museo Genaro Perez, Cordoba, Argentina; University of Texas, Austin; Hartwick College, Oneonta, New York; Banco de la Provincia de Buenos Aires, New York; New Jersey State Museum, Trenton; Walker Art Center, Minneapolis; Reading Public Museum, Pennsylvania; Museo de Arte Abstracto, Zacatecas, Mexico; Miami Art Museum.

Publications:

On RABINOVICH: Books—*Raquel Rabinovich: Invisible Cities 1986, Sculptures and Drawings,* exhibition catalog, by Barry Schwabsky, Bronx, New York, Bronx Museum of the Arts, 1986;

Raquel Rabinovich: The Dark Is the Source of Light, exhibition catalog, text by Linda Weintraub and George Quasha, Barrytown, New York, Station Hill Arts, 1996. **Articles**—''Beyond the Surface'' by William Zimmer, in *Arts Magazine,* 65, October 1990, p. 100; ''Tom Wolf and Raquel Rabinovich at Trans Hudson'' by Nicole Krauss, in *Art in America,* 87(7), July 1999, p. 98. **Film**—*The Time of the Gazing: A Glance at Raquel Rabinovich* by Camilo Rojas, 2001.

*

Raquel Rabinovich comments:

For me, art is an indirect language. I create metaphors to better access this indirectness. My art probes the unsaid, the trapped text that is the nature of the universe. Through my creative process I unfold what is enfolded, accessing that which is hidden, ''freeing'' this text.

Entering the darkest space allows light to be unfolded. This is the paradox I probe whether I am painting, drawing, or creating sculptures. The dark and the light are metaphors for hidden realms and spiritual emergence. They are not tangible. They are not visible. But

they can be known and experienced. I strive to make them knowable by accumulating countless layers of charcoal, pastel, and graphite in my drawings; of oil, pencil, and wax in my paintings; and of natural stones in my sculptures. In each medium, the layers conceal in order to reveal what is unsaid, unspoken. My art originates in the place of not knowing.

The process of creating paintings and drawings continues until the ground becomes groundless and the surface dissolves into that groundlessness. The stone sculptures, on the other hand, never attain completion. The pieces are constructed outdoors, in the woods. They occupy a space of constant becoming, remaining perpetually in the present, interacting with the circumstances of light, and temperature, and season, and weather. I call these site-specific works "Pabhavikas," a Pali word that means arising from or emerging from. Since my sculptural compositions reflect natural processes, the stones belong to both zones of being, they are visible and invisible, present and absent, finished and unfinished.

The two-dimensional work that I produce within my studio and the three-dimensional work that I create out of doors share an engagement with the interchangeability between inner and outer.

* * *

Through her strikingly spare paintings, drawings, and sculptures, artist Raquel Rabinovich has questioned the human ability to perceive and understand lived experience. Having studied at the Sorbonne and the University of Edinburgh and traveled throughout South Asia, Rabinovich has not defined herself in terms of belonging to a specific movement or regional artistic style. Rather she has incorporated the epistemological concerns inspired by various strains of philosophy to create works that destabilize the viewer with their complete lack of figuration of any sort. By paring her works down to the simplest elements, she examines the viewer's ability to "know" the work of art merely through sensorial perception. Although Rabinovich has not officially been associated with other artistic movements, her work is similar to that of a number of artists such as Kasimir Malevich, Lucio Fontana, and Ad Reinhardt, which assumed a quality of extreme simplicity and emptiness, often as the result of pursuits of spirituality or mysticism. Like Brazilian artist Mira Schendel, Rabinovich has created works named by their series that emphasize gesture and process, delving into philosophical questions influenced by Eastern thought.

In her early career Rabinovich created lyrical geometrically abstract paintings that resembled the art of the predominant movements in Argentina during the early 1960s. Rabinovich's work from this time, however, stands out for its early preoccupation with metaphysical issues. For instance, one series of paintings created around 1963 is entitled *The Dark Is Light Enough.* In this title she upsets the clear distinction made in Western thought between darkness and light, with light serving as a metaphor for awareness or enlightenment. For Rabinovich darkness is also an appropriate point of contemplation, for it symbolizes emptiness, space, and the eternal.

One of Rabinovich's most important series of drawings is *Invisible Cities* (1984–85), named after the book by Italo Calvino on Marco Polo's travels throughout the empire of Kublai Khan. In describing Polo's role as mediator in embellishing or leaving out information on the cities he had visited, Calvino writes, "The eye does not see things, but images of things that mean other things." This quotation is stamped at the top of drawings that consist of thin

graphite washes and smudged pencil marks on paper. In creating her drawings Rabinovich goes through a complex and lengthy process of applying layers of pigment. The different materials used often do not layer perfectly, as in the case of hard shiny graphite and dark powdery charcoal. In the case of Rabinovich's glass sculptures, the layers become a metaphor for the imperfection of human perception. In these works sheets of gray tinted glass are arranged in buildinglike formations. When one is walking through the works or looking at them from a distance, the sheets of tinted glass create layers that sometimes completely obscure what can be viewed through them.

Rabinovich was greatly inspired by a trip she took to South Asia in 1987. She named one of her series of drawings *Chhodrtens* (1989–90) after the Buddhist practice that she observed in Nepal of sealing sacred objects inside round mounds of brick or stone that then serve as centers of prayer and devotion. Similarly, Rabinovich named another series *Garbhagrihas* (1991–92) from a Sanskrit word meaning "inner sanctuary." In these drawings the artist's process of choosing pigments and materials, as well as the type of paper, and then carefully layering them onto the paper becomes like a devotional act in which the process almost takes on more significance than the finished product.

—Erin Aldana

RAMÍREZ, Belkis
Dominican painter, printmaker, and installation artist

Born: Santiago Rodríguez, 1957. **Education:** Studied graphic arts, Universidad Autónoma de Santo Domingo, Dominican Republic, 1978, 1986, degree in architecture 1986; Talleres de Grabado, Santo Domingo y Altos de Chavón, Dominican Republic, 1982; studied photography, Universidad de San José, Costa Rica, 1985; studied in Moscow, 1985. **Awards:** Beca Organización de Estados Americanos, Universidad de San José, Costa Rica, 1985; third prize, Concurso de Grabado, FAO, Dominican Republic, 1986; second prize in drawing, *XVII bienal nacional de artes visuales,* Dominican Republic, 1990; first prize in installation, *XVIII bienal nacional de artes visuales,* Dominican Republic, 1992; first prize in installation, *XIX bienal nacional de artes visuales,* Santo Domingo, Dominican Republic, 1994.

Individual Exhibitions:

1987	*La tercera edad,* Centro de Arte Nouveau, Dominican Republic
1991	*Dibujos y grabados,* Museo de Arte Moderno, Dominican Republic
1993	*Historias ajenas,* Museo de Arte Moderno, Dominican Republic
1994	*Instalaciones y grabados,* Altos de Chavón, Dominican Republic
1995	*Miedo ambiente,* Museo de Arte Moderno, Dominican Republic
1997	*Al derecho y al revés,* Centro Cultural Hispánico, Dominican Republic
2000	*Belkis Ramírez, caribe inexplorado,* Sala Naranja, Valencia, Spain

Selected Group Exhibitions:

1983 *VI bienal de San Juan del grabado latinoamericano,* San Juan, Puerto Rico
1987 *Artistas dominicanos,* Casa de la Cultura, New York
1990 *XVII bienal nacional de artes visuales,* Museo de Arte Moderno, Dominican Republic
1992 *Exposición homenaje a Julia de Burgos,* Ateneo Puertorriqueño, San Juan, Puerto Rico
1994 *XIX bienal de artes visuales,* Museo de Arte Moderno, Dominican Republic
1995 *Ain't I A Woman?,* ArtSpace, New Haven, Connecticut
1996 *Arte moderno y contemporáneo de la República Dominicana,* Americas Society, New York, and Bass Museum, Miami
1997 *VI bienal de la Habana,* Havana
1998 *XII bienal de San Juan del grabado latinoamericano,* San Juan, Puerto Rico
1999 *Colectivo-colectiva,* LARRAMA Arte Contemporáneo, Santo Domingo, Dominican Republic

* * *

In the latter part of the 1980s and in the early 1990s, Dominican artists recognized the potential for broadening visual discourse through the use of installations. With installation art becoming a lingua franca practiced virtually everywhere, Dominican artists from the Eighties Generation embraced its experimental possibilities to articulate timely political, social, and economic issues. Belkis Ramírez, an exemplary artist known for integrating printmaking with installation, is a key figure in the contemporary art milieu of her country. Born in Santiago Rodríguez in 1957, Ramírez studied at the Escuela de Artes of the Universidad Autónoma de Santo Domingo, where she obtained a degree in architecture in 1986. She has also studied various printmaking techniques, including metal engraving, intaglio, and lithography, in the Dominican Republic, Costa Rica, and Russia.

The convergence of printmaking and installation is central to understanding Ramírez's process of making art. Her graphic work draws upon various printmaking techniques, architecture, and everyday objects to create the large-scale installations for which she has become recognized. The woodblock panels she uses in printmaking are often recycled as fundamental components of her installations. The woodcut, which was the major form of relief printing in the 1960s, is the main technique used by Ramírez to create prints and installations that scrutinize the social fabric of her environment. The subjugation of women and issues concerned with nature, such as deforestation, are among the concerns she explores in her work.

Ramírez infuses the hybrid visual discourse of installations with her own blend of cultural influences, woodcut panels, and quotidian objects. Her trajectory as an installation artist began in the early 1990s, during a visit to La Bienal de La Habana, where she was inspired by the work of non-Dominican installation artists. This was a decisive moment in her career, as she considered the opportunities installation could provide her as a graphic artist and architect. Consequently, in 1992 she created *Reloj no marques la hora,* exhibited at the Bienal Nacional de Artes Visuales in Santo Domingo, where it was awarded first prize in the freestyle category. The title of the work derives from a popular romantic Spanish-language ballad whose title alludes to the longing for time to stand still.

Reloj no marques la hora and the installations that followed have possessed a physicality designed to engage the viewer. According to Ramírez, '' . . . the installation is the best way to allow the public to become a part of the work of art. Because the installation [has] three-dimensions [this] lets the spectator [get] inside of it.'' Her architectural background enables her to make three-dimensional connections among the physical attributes of the space, the work, and the viewer.

The success of Ramírez's first installation led to the creation of *De la misma madera,* which was awarded first prize at the Bienal Nacional de Artes Visuales in 1994. One of her most ambitious installations, it consisted of six woodcut panels, presented in two rows of three, that depicted generic members of society. Several stones of varying sizes lay strewn before the panels, as though they had been shot at the portraits. This massive configuration of images, facing an imposing 10-foot slingshot constructed from a reclaimed tree and supported by a mound of large stones collected from local rivers, was a metaphor about humankind that was open to interpretation. The relationships set up by Ramírez among the components of the installation–the portraits, slingshot, stones, and viewer–created ambiguity. The work might have been suggesting that society can be both the aggressor and the victim. On another level it was a reminder that humankind is not separate from nature and that our survival depends on its preservation. The menacing slingshot might be interpreted as a weapon not only of destruction but also of nature's wrath against mankind.

The marriage of the woodcut and the installation is a unique and integral characteristic of Ramírez's visual language. When she presents the woodcut with other objects in the context of an installation, the printmaking block exudes new meaning. She involves the viewer through her use of large-scale or exaggerated objects and materials, such as imposing woodcuts eight feet by five feet or blocks presented individually or in groups, as well as thick ropes or a colossal slingshot. The heavy, dark incisions of her woodcuts reveal disembodied figures whose heads, hands, and feet portray the duality of the absence and presence of the human body. The physical fragmentation of the figures and the strong gestural quality of the woodcuts and composed blocks indicate that the artist or the artist's hand is ''in'' the work. The next time viewers ''enter'' her installations, they may notice Ramírez's presence.

—Elena Pellegrini

RAMOS, Mel(vin John)
American painter

Born: Sacramento, California, 24 July 1935. **Education:** Studied under Wayne Thiebaud at Sacramento Junior College, California, 1953–54; San Jose State College, California, 1954–55; Sacramento State College 1955–58, B.A. 1957, M.F.A. 1958. **Family:** Married Leta Alice Helmers in 1955; two sons and one daughter. **Career:** Teacher, Elk Grove High School, California, 1958–60, Mira Loma High School, California, 1960–66, Sacramento State College, California, 1965–66, and Arizona State University, Tempe, 1967. Associate professor of painting, 1966–80, and since 1980 professor of painting, California State University at Hayward. Artist-in-residence, University of Southern Florida, Tampa, 1970, and Syracuse University, New York, 1970; visiting artist, University of Wisconsin,

Mel Ramos: *Girl on a Burger,* **1965. Photo courtesy of Wolverhampton Art Gallery, West Midlands, UK/Bridgeman Art Library. © Mel Ramos/Licensed by VAGA, New York, NY.**

Madison, 1973, and Pacific Lutheran University, Tacoma, Washington, 1973. **Awards:** Purchase prizes, San Francisco Museum of Art, 1948, and Oakland Art Museum, 1959; artist fellowship, National Endowment for the Arts, 1986. **Agent:** Louis Meisel, 141 Prince Street, New York, New York 10012. **Addresses:** 5941 Ocean View Drive, Oakland, California 94618, U.S.A.; or Moragrera 38, Horta de San Juan, Tarragona, Spain. **Web Site:** http://www.melramos.com.

Individual Exhibitions:

1964	Bianchini Gallery, New York
1965	Bianchini Gallery, New York
	David Stuart Gallery, Los Angeles
1966	Galerie Ricke, Kassel, Germany
1967	San Francisco Museum of Art
	Berkeley Gallery, San Francisco
	Galerie Tobies-Silex, Cologne, Germany
1968	Mills College Art Gallery, Oakland, California
	David Stuart Gallery, Los Angeles
1969	David Stuart Gallery, Los Angeles
	Gallery Reese Palley, Los Angeles
	Stadtsmuseum, Aachen, Germany
1970	Artists Contemporary Gallery, Sacramento, California
1971	French and Co., New York
	Graphics Gallery, San Francisco
	Galerie Bruno Bischofberger, Zurich
	Galerie Richard Foncke, Ghent, Belgium

1972	Utah Museum of Fine Arts, Salt Lake City
1973	Dickinson College, Carlisle, Pennsylvania
	Madison Art Center, Wisconsin
	Pacific Lutheran University, Tacoma, Washington
1974	Meisel Gallery, New York
	David Stuart Gallery, Los Angeles
1975	Museum Haus Lange, Krefeld, West Germany (retrospective)
1976	Meisel Gallery, New York
1977	Morgan Gallery, Shawnee Mission, Missouri
	Oakland Museum, California (retrospective)
1978	University of Nevada at Reno
1979	California State University, Chico
1981	Meisel Gallery, New York
	Modernism, San Francisco
	California State University at Chico
1982	Route 66 Gallery, Philadelphia
	Melinda Wyatt Gallery, Venice, California
1985	Louis K. Meisel Gallery, New York
1986	Hokin Gallery, Chicago
1987	Studio Trisorio, Naples
1988	James Corcoran Gallery, Los Angeles
1994	Kunstverein Lingen, Germany (traveling retrospective)

Selected Group Exhibitions:

1969	*Pop Art Revisited,* Hayward Gallery, London
1975	*3 Centuries of the American Nude,* New York Cultural Center
1976	*California Painting and Sculpture: The Modern Era,* San Francisco Museum of Modern Art
1978	*Art about Art,* Whitney Museum, New York
1981	*American Drawings in Black and White 1970–80,* Brooklyn Museum, New York
1983	*Modern Nude Painting 1880–1980,* National Museum of Art, Osaka, Japan
1984	*Automobile and Culture,* Museum of Contemporary Art, Los Angeles
1985	*Pop Art 1955–70,* Art Gallery of New South Wales, Sydney (traveled to Brisbane and Melbourne)
1992	*Pop Art,* The Royal Academy, London
	Hand Painted Pop, Museum of Contemporary Art, Los Angeles

Collections:

Museum of Modern Art, New York; University Museum, Potsdam, New York; Chrysler Museum of Art, Norfolk, Virginia; San Francisco Museum of Modern Art; Oakland Museum, California; Museem der Stadt, Aachen, West Germany; Kaiser Wilhelm Museum, Krefeld, West Germany; Solomon R. Guggenheim Museum, New York; Whitney Museum of American Art, New York; Smithsonian Institution, Washington, D.C.; Seattle Art Museum, Washington; National Gallery of Art, Washington, D.C.

Publications:

By RAMOS: Books—*The Girls of Mel Ramos,* with Elizabeth Claridge, Chicago, Playboy Press, 1975; *Mel Ramos,* with Elizabeth

Claridge, London, Mathews Miller Dunbar, 1975; *Mel Ramos: Six Girls,* Milan, Plura Edizioni, 1979; *Mel Ramos, Watercolors,* Berkeley, California, Lancaster-Miller, 1979; *Mel Ramos: Pop Art Images,* with Robert Rosenblum, Köln and New York, Taschen, 1997.

On RAMOS: Books—*Mel Ramos,* exhibition catalog, introductory essay by Klaus Honnef, Aachen, Germany, Zentrum für aktuelle Kunst, 1969; *Mel Ramos: Paintings, 1959–1977,* exhibition catalog, by Harvey Jones, Oakland, California, Oakland Museum, 1977; *Mel Ramos,* exhibition catalog, Los Angeles, David Stuart Galleries, 1978; *Mel Ramos: A Twenty Year Survey,* exhibition catalog, with text by Carl Belz, Rose Art Museum, Waltham, Massachusetts, Brandeis University, 1980; *Figurative Options: Jack Ogden, Mel Ramos, Wayne Thiebaud,* exhibition catalog, Sacramento, California, The Gallery, 1984; *Mel Ramos: The Artist's Studio 1986–1989,* exhibition catalog, New York, Louis K. Meisel Gallery, 1989; *Mel Ramos: The Heroines of 1962–64,* exhibition catalog, New York, Louis K. Meisel Gallery, 1991; *Mel Ramos,* exhibition catalog, with text by Walter Guadagnini, Corte Madera, California, Gingko Press, 1999.

*

Mel Ramos comments:

The subject of my painting is the figure. The object of my painting can be anything and usually is. I sometimes think that everything is instantaneous except my work, and I get the feeling that the best figuration is in the movies. Nevertheless, despite the rampant self-consciousness about "formal" concerns that seems to characterize twentieth-century art, the best painting still announces itself in this manner, and I am not particularly interested in becoming an exception. I am for an art that hangs on the wall and asserts itself.

* * *

Mel Ramos's new landscapes, introduced in New York in the 1980s, ostensibly seemed to represent a major departure from the blunt, figurative pop paintings that brought him fame in the 1960s. In reality, however, the fundamental issues that formed the basis of his earlier aesthetic investigations–exploration of forms, a search for complete objectivity in representation–also informed the new work. "I have never been interested in dealing with art from an esoteric point of view," he has said. "I do not think of objects as symbols, but as temporal, formal entities, as shapes to be explored purely on a formal basis."

A major California figure of the first generation of pop artists, Ramos came to the attention of the art world when pop art was at its apogee. He participated in a movement that in celebration of the banal, the commonplace, the vulgar often gently parodied familiar icons of American popular culture. His first mature works were a sort of hard-edged figurative painting that documented as well as mimicked comic book heroes and *Playboy* sex symbols, using a limited palette of flat colors and hard, precise drawing. Then, in a series of salutes to art history executed in the 1970s, Ramos turned his attention from the lowly to the mighty with reconstructions of traditional and modernist masterpieces that he infused with a new eroticism drawn from the heroic images of contemporary folklore. Unfortunately, because of the notoriety fostered by their subject matter–beautiful nude bodies, mostly female–the ideas behind the

works from these two decades were overshadowed by journalistic sensationalism and often misunderstood. Central to Ramos's aesthetic are the modernist principles of both "objectness" and the autonomy of the painted surface that depersonalize a subject. Thus, for him the figures were never anything but objects–plastic shapes to be studied and re-created with paint on canvas or paper according to his particular vision–and to regard them as anything else was to miss the point of the art entirely.

Ramos's approach to the landscape is a similar one. His images may have changed to monuments, cacti, bridge supports, and palm trees, but they are treated with a like impersonal neutrality. That they are an outgrowth of the artist's art historical *Homage Series* of the 1970s, particularly Willem de Kooning's, is evident from the lushly brushed surfaces and what he has called "the gesticulated backgrounds." In allegiance to Morris Louis's famed unfurled canvases, they are organized around a central void flanked by angled rows of colored travel-related objects depicted in a worm's-eye perspective, the way a tourist would look at those objects. "The landscape came about mainly through my travels," Ramos has explained, "and the way one looks at things, as tourists look at the facades of buildings, as palm trees." In keeping with his preference for the mundane, the iconography of these paintings is derived from postcards, travel posters, and other popular media images, thus marking the opening of a new chapter rather than a change in the narrative.

"My primary concern has always been ART; I am interested in ART, and the subject matter of my work is, and will always be, ART." With these words Ramos recapitulated two very successful decades. On the strength of the interest generated by the landscapes, one might have hazarded the prediction that the third would be important. When Ramos showed his landscapes for the first time in 1982, a controversy that had simmered for two decades was put to rest. Ramos, his critics proclaimed, might not be a male chauvinist painter after all; he might just have been a misunderstood artist who was manipulating the female form to satirize the worst aspect of American advertising. Speculations were rife about the cause of the switch from figures to landscapes, but the move was a good one, everyone agreed, and as one Los Angeles reviewer declared, "Sex's loss [was] art's gain."

In point of fact, Ramos was not then, nor has he ever been, a male chauvinist or a satirist or anything but an artist concerned with art and its history. "Although I have been accused of being a sexist, or of exploiting women, I really have never had any politics," he has said. With a perspective of three decades, despite assertions to the contrary, it became clear that militancy was never Ramos's posture and that the change in subject matter was but another means of exploration, of research into new ways to make the same individualistic statement in as many forms as possible.

And where did Ramos's research into the landscape lead to? As demonstrated by his series *The Artist in the Studio,* right back to the figure and the history of art. In this series and its corollary, *The Drawing Lesson,* de Kooning and Manet make way for Ingres and Matisse. A "nude descending a staircase" takes on a new look; soft-focus mirror reflections and family memorabilia are added to the repertoire; and, most importantly, Ramos was now drawing from his own past, as in the restated *Kellog* painting, which he turned into a composition centered around a drawing by Ingres. "My new paintings are more narcissistic," he said during an interview. "I use some of my old works in my compositions, showing them reflected in mirrors, and this is what I mean by narcissistic. This is not a new device: artists have shown mirror-reflected images for ages, ever

since the mirror was invented in the fifteenth century, when Jan van Eyck painted *Giovanni Arnolfini and His Bride* (1434).''

The significance of the *Studio* series goes far beyond reconsideration of imagery, however. In his art historical *Homage* works of the 1970s, Ramos relied upon well-known modernist masterpieces that he recast according to his own aesthetic vocabulary, parodying or celebrating as the cases may have been. In the *Studio* paintings and drawings he continued to pay tribute to the heroes from the past, but the prototypes are less obvious. Matisse, Ingres, Bonnard, and Duchamp are all part of the cast of characters, but there is no question as to the identity of the protagonist. In addition, the images from which he drew are not as renowned, and if they are rendered just as faithfully, they are now but one segment of a complex compositional scheme. This, in turn, gives the works an irrefutable stamp of Ramos authenticity that establishes them firmly within the stream of art history, lending truth once more to the timeless French adage ''The more things change, the more they stay the same.''

—Andree Maréchal-Workman

RAMOS, Nelsón
Uruguayan painter

Born: Dolores, 19 December 1932. **Education:** Escuela Nacional de Bellas Artes, Montevideo, 1951; Museu de Arte Moderna, Rio de Janeiro (on grant), 1959; studied in Italy, France, and Spain on Uruguayan Cultural Ministry grant, 1962–63. **Career:** Textile designer and illustrator for newspapers, *O Estado de São Paulo* and *Diario de São Paulo,* early 1960s; professor, Escuela de Artes Aplicadas de Uruguay, 1967–77, College of Art and Design, Minneapolis, 1981. Artist-in-residence, Massachusetts College of Art, Boston, 1992. Founder, Centro de Expresión Artística, 1971. **Awards:** Premio adquisición, *Salón municipal,* Montevideo, 1956, 1958, 1959, 1962, 1967; honorable mention, *Salón internacional de Punta del Este,* Uruguay, 1959; beca itamarati, Brazil, 1959; prize, *I bienal de jóvenes,* Montevideo, 1961; third prize in drawing, *Salón nacional de bellas artes,* Montevideo, 1962; first prize, *Exposición arte actual de América y España,* 1963; Premio Blanes, *Exposición premio Blanes,* Montevideo, 1964; second prize in painting, *Salón nacional de artes plásticas,* Montevideo, 1965; gran premio adquisición, *XXXI salón de arte plásticas,* Montevideo, 1967; grand prize, *2 salón General Electric,* Montevideo, 1967; second prize, *Exposición premio Codex de pintura latinoamericana,* Buenos Aires, 1968; grand prize in painting, *2 salón de artes plásticas,* Punta del Este, Uruguay, 1968; prize, Mid-American Arts Alliance; prize, Eco-Art, Rio de Janeiro; premio fraternidad, Montevideo; premio figari, Banco Central del Uruguay; grand prize, *Bienal interparlamentaria de pintura del Mercosur,* Montevideo.

Individual Exhibitions:

1956 Galeria ''Arte Bella,'' Montevideo
1958 Galeria ''Arte Bella,'' Montevideo
1960 Galeria ''Arte Bella,'' Montevideo
 Galeria ''Arte Bella,'' Punta del Este
1962 Galeria ''Columbia,'' Montevideo
1963 Instituto de Cultura de Valladolid, Spain
 Museo de Arte Moderno, Madrid

1964 Instituto General Electric, Montevideo
 Galeria ''Amigos del Arte,'' Montevideo
1965 Galeria ''Amigos del Arte,'' Montevideo
 Galeria ''Lirolay,'' Buenos Aires
 Centro de Promoción Cultural, Montevideo
1966 Galeria ''Lirolay,'' Buenos Aires
 Galeria ''Amigos del Arte,'' Montevideo
1967 Galeria ''Guernica,'' Buenos Aires
1968 Departmento Cultural Banco Caja Obrera, Montevideo
 Galeria ''Amigos del Arte,'' Montevideo
1975 Galeria ''Losada,'' Montevideo

Selected Group Exhibitions:

1955 Galeria ''Amigos del Arte,'' Montevideo
1958 *I salón panamericano,* Porto Alegre, Brazil
1961 *I bienal de pintores jóvenes,* Montevideo
1964 *Pintura uruguaya de hoy,* Museo de Arte Moderno, Buenos Aires
1965 Guggenheim Museum, New York
1969 *X bienal de São Paulo,* Brazil
1970 *II bienal de arte,* Medellín, Colombia
1996 Museo Nacional de Bellas Artes, Montevideo
1997 *XLVII biennale de Venezia,* Venice
 Galería Gustavo Tejería Loppacher, Punta del Este, Uruguay

Collections:

Central Bank of Uruguay, Montevideo; Museo Municipal Juan Manuel Blanes, Montevideo; Museo Nacional de Artes Visuales, Montevideo; Museo de Arte Contemporáneo, Santiago; Museo de Arte Moderno, Buenos Aires; Museo de Arte Moderno, Madrid; Museo de Arte Contemporáneo, São Paulo; University of Texas, Austin; Museo de Bellas Artes, Caracas.

Publications:

By RAMOS: Book—*Nuevas formas: Nelsón Ramos,* exhibition catalog, with Alfredo Torres and Olga Larnaudie, Punta del Este, Uruguay, Galería Gustavo Tejería Loppacher, 1997.

On RAMOS: Books—*Nelsón Ramos: Blanco, negro, negro, blanco, blanco, blanco,* Montevideo, Ediciones Aletheia, 1975, and *Nelsón Ramos,* exhibition catalog, Montevideo, Museo Nacional de Artes Visuales, 1997, both by Angel Kalenberg; *Antonio Berni, Virginia Jones, Eduardo MacEntyre, Francisco Matto, Manuel Pailos, Nelsón Ramos* by Ernesto Heine and Antonio Berni, Montevideo, Imprenta Rosgal, 1986. **Article**—''Nelsón Ramos,'' in *Art Nexus* (Colombia), April/June 1995, pp. 121–122.

* * *

The dynamic and impressive trends of twentieth-century Uruguayan art are represented in the work of Nelsón Ramos, an artist who has confirmed the reflections of Angel Kalenberg, director of the National Museum of Uruguay, that as the center of an art movement dies the energy moves to the periphery and the transformative ideas

are developed there. In 1934, when Joaquín Torres-García left Europe to return to his homeland in Uruguay, he did so as European constructivism was losing momentum. Taller Torres-García, a workshop school founded on a doctrine of universal constructivism, focused on creating from the European core an art for all of the Americas that was based on the rich tradition of symbols and religions of pre-Columbian civilizations.

Ramos, born in 1932, was educated in Montevideo during this historic moment in the plastic arts tradition of Uruguay. While he was the product of the classic formal training of the Escuela Nacional de Bellas Artes de Montevideo (1951), his artistic contribution has always had a basis in defining that which was Uruguayan, rejecting imported art forms and the stereotypes of color, myth, and folklore that have characterized much of Latin American art. His early travels on study grants to the Museum of Modern Art in Rio de Janeiro (1959) and to Spain, Italy, and France (1962–63) on a grant from the Uruguayan Cultural Ministry gave him an external perspective and the resolve to strive toward a new, uniquely Uruguayan visual language.

Ramos has a number of distinct epochs in his work, which, taken as a whole, reflect a coherent vision. In the early 1960s he produced expressive drawings, and this was followed by a period of expressionistic, informalist painting. The evolution of his work progressed to a focus on meditation on simple objects, which then led to a decade of monochromatic painting with emphasis on a vertical line.

The construction of wooden boxes in the late 1970s began a period that lasted for almost two decades, until the mid-1990s, and through which Ramos defined himself as a master of materials. The boxes, which reflect the geometric principles of Torres-García and the use of the simple found materials of Joseph Cornell, have come to signify an important period of Ramos's work. They initially were meditations about the objects enclosed in them, but they soon evolved into elegantly beautiful tributes to the skylights of the quickly disappearing architecture of the Montevideo horizon. The boxes were constructed, like the kites of his youth, from thin pieces of wood and transparent paper in the subdued palette of the Río de la Plata, and the geometric forms became characteristic of Ramos's artistic language.

Ramos established the Centro de Expresión Artística in 1971 and has continued to nurture another generation of young artists in their pursuit of a universal voice with an Uruguayan spirit. Times were particularly difficult during the 10-year dictatorship, unusual in the history of this strong democracy, that dominated the 1970s, when political affiliation mattered, artistic expression was repressed, and public exhibitions were rare. He emerged in the XVIII São Paulo Bienal of 1985 with works of much more expressive content, such as *Después del silencio*. After the silence of the repressive regime passed to a government that embraced the open expression of artistic heritage, Ramos was emboldened to express a memory of the colonization of the Americas in a series of boxes for the quincentennial in 1992. These boxes, which have been likened to the *vanitas* of the Dutch and Spanish colonists, express a melancholy suggesting the fragility of life and the memory of what was lost to the world in the process of colonization. Skulls, twisted cadavers, and vampire bats, formed with impeccable craftsmanship from the simple materials of wood, paper, and unfired clay, characterize the boxes, which can barely contain their anecdotes of historic horrors.

Ramos continued producing works throughout the 1990s that represented a variety of themes, including the devastation of the global environment and even the genocide of the Indians of the American Southwest, the latter inspired from a travel and teaching grant he received in 1992 from the Mid-American Arts Alliance through the United States Information Agency. His craftsmanship forces the artist and the viewer to slow the information explosion of an industrialized technical society and to meditate upon the strange beauty and power of these visual images.

With these images Ramos returned to the expressionism of his early career, one that has achieved a dialogue between the internal signs and the concrete symbols of an Uruguayan voice. His art, although original and at times humorous, is always elegantly crafted, as can be seen in those works exhibited in the 1997 Venice Biennial. Ramos's work reflects a thoughtful and deliberate contribution to a Latin American vernacular of handworked materials that use iconographic symbols communicating layers of meaning and that are structured around geometric forms in the tradition of Torres-García.

—Linda A. Moore

RASCÓN, Armando
American painter and installation artist

Born: Calexico, California, 1956. **Education:** University of California, Santa Barbara (Hazel S. Lagerson scholarship), B.A. in fine arts 1979. **Career:** Cofounder, director, and curator, Terrain Gallery, San Francisco, 1988–99. Organizer, *Border Metamorphosis: The Binational Mural Project,* a 2.5-mile-long mural, Calexico, California, 2001. Guest faculty, University of California, Davis, 1988, California College of Arts and Crafts, Oakland, 1991, University of California, Berkeley, 1995, Real Alternatives Program High School, San Francisco, 1996, Artworks/Consortium for Elders & Youth in the Arts, San Francisco, 1997–98. Artist-in-residence, La Casa de la Raza, Santa Barbara, California, 1979, and Contemporary Art for San Antonio—Blue Star Art Space, San Antonio, Texas, 1998. Guest curator at various museums, including Museum of Modern Art, New York, and Mexican Museum, San Francisco. Commissioner, San Francisco Art Commission, 1995–97. **Awards:** Visual Artists Fellowship Grant in Painting, National Endowment for the Arts, 1987; Goldie award, San Francisco *Bay Guardian,* 1994; Adaline Kent award, San Francisco Art Institute, 1994; Artists' Projects grant, Artists' Projects Regional Initiative, New Langton Arts, San Francisco, 1996; Artist Resource Bank award, Washington State Arts Commission, Olympia, Washington, 1996–98; Visual Arts fellowship, Artists Fellowship Program, California Arts Council, 1998; Organization grant, Rockefeller Foundation, 1998; Art Program grant, Lannan Foundation, 1998; Project grant, U.S.-Mexico Fund for Culture, Mexico City, 1998.

Individual Exhibitions:

1987 *Decay and Resurrection,* MEDIA, San Francisco
1991 *The Multicultural Reading Room: Center for Research and Information,* Randolph Street Gallery, Chicago, and New Langton Arts, San Francisco
 Existential Monochrome, Randolph Street Gallery, Chicago, and Southern Exposure, San Francisco
1992 *Counterweight,* public art project, Santa Barbara Contemporary Arts Forum, California
1994 *Xicano Anesthetic,* INTAR Gallery, New York
 Occupied Aztlán, Walter/McBean Gallery, San Francisco Art Institute

1995 *Institute of Xicano Relations: Reading the Treaty of*
 Guadalupe Hidalgo, Los Angeles Center for Photo-
 graphic Studies
1997 *Postcolonial CALIFAS,* Museum of Contemporary Art
 and Centro Cultural de la Raza, San Diego, California
1998 *Latina Postcolonial Photobureau,* Blue Star Art Space,
 San Antonio, Texas

Selected Group Exhibitions:

1992 *Tattoo Collection,* Centre Contemporain Regional d'Art,
 Nantes, France (traveled to Galerie Jennifer Flay,
 Paris; Daniel Bucholz, Cologne, Germany; and
 Andrea Rosen Gallery, New York)
 Mistaken Identities, University Art Museum, University
 of California, Santa Barbara
1994 *Cultural Identities and Immigration: Changing Images*
 of America in the 90's, Oliver Art Center, California
 College of Arts and Crafts, Oakland
1997 *Identity/Identidad,* Museum of Contemporary Art, San
 Diego, California
 Expansion Arts: Artists of Our Times, Alternative
 Museum, New York
1998 *Original Accounts of the Lone Woman of San Nicholas*
 Island, Side Street Projects, Santa Monica, California
1999 Museum of Contemporary Art, San Diego, California
 Photography Salon, Elizabeth Cherry Contemporary Art,
 Tucson, Arizona

Collections:

Museum of Contemporary Art, San Diego, California; Museum of
Modern Art, New York.

Publications:

By RASCÓN: Books—*Art after Eden: An Un-Natural Perspective,*
San Francisco, Southern Exposure Gallery, 1986; *Xicano Progeny:*
Investigative Agents, Executive Council, and Other Representa-
tives from the Sovereign State of Aztlán, San Francisco, Mexican
Museum, 1995.

On RASCÓN: Books—*Armando Rascon: An Inter-Cultural Cross-*
Disciplinary Project, exhibition catalog, with text by Victor Zamudio-
Taylor, New York, Intar Gallery, 1994; *Occupied Aztlán,* exhibition
catalog, with text by Norma Alarcón, San Francisco, San Francisco
Art Institute, 1994; *Aztlán hoy: La posnación chicana* by Berta M.
Sichel, Madrid, Comunidad de Madrid, 1999. **Articles**—''Armando
Rascon'' by Mark Van Proyen, in *Artweek,* 18, 18 April 1987, p. 7;
interview with Armando Rascón by Steven Jenkins, in *Artweek,*
22(31), 26 September 1991, p. 20; ''Uneasy Rider'' by Steven
Jenkins, in *Artweek,* 25(9), 5 May 1994, p. 26; ''Armando Rascon''
by Harry Roche, in *San Francisco Bay Guardian,* 28(50), 14 Septem-
ber 1994, p. 46; ''Antilinear: Redefining Text with Technology'' by
Berta M. Sichel, in *Flash Art,* 193, March/April 1997, pp. 71–72.

* * *

Armando Rascón was born in 1956 in Calexico, California, a
city on the U.S.-Mexican border opposite Mexicali, Mexico. Raised

amid the influences of both Mexican and American traditions, Rascón
developed a hybrid sensibility that resulted from the daily exchanges
of border culture. These experiences inform the artist's work. In his
photographs, installations, and curatorial exhibitions, Rascón exam-
ines contemporary issues regarding the history of colonization and
subsequent legacy of Mexican Americans, particularly those commu-
nities along the U.S.-Mexican border.

Rascón received his B.A. in fine arts from the University of
California, Santa Barbara. After that he moved to San Francisco,
where he became an active member of the arts community.

Part of a generation that followed an intense period of Chicano
civil rights activism and cultural movements that began in the late
1960s, Rascón has continued the legacy of artists within the Chicano
movement of the late '60s and early '70s who saw a need for social
and political activism in the arts. He therefore inherited a politically
conscious awareness that found a voice in his visual practices. As a
contemporary artist using new media and conceptual strategies,
Rascón has helped to shift the concerns of Chicano art into a
postmodern and digital age.

As an artist and curator Rascón has used interdisciplinary art
methods to probe notions of meaning and identity shaped by politi-
cal and cultural forces within U.S. society in particular. Both in
his visual art and his curatorial investigations he has drawn on
themes that deal with cultural and sociopolitical history of Mexican
Americans, including affirmation, representation, pedagogy, and
information distribution.

Rascón has been a guest curator for such institutions as the
Museum of Modern Art in New York and the Mexican Museum in
San Francisco, among others. In 1988 he founded and served as
codirector of Terrain, a gallery devoted to contemporary art in
downtown San Francisco. In 2001 Rascón worked on a two-mile
mural in his homeland on the border of Calexico and Mexicali.

—Miki Garcia

RENNÓ, Rosângela
Brazilian photographer and installation artist

Born: Belo Horizonte, 1962. **Education:** Escola de Arquitetura,
Universidade Federal de Minas Gerais, Belo Horizonte, 1986; studied
art, Escola Guignard, Belo Horizonte, 1987; Escola de Comunicações
e Artes, Universidade de São Paulo, Brazil. **Career:** Fashion photog-
rapher. Artist-in-residence, Civitella Ranieri Foundation, Umbertide,
Italy, 1995–96. **Awards:** Acquisition prize Empresa Cautos, *XXXIX*
salão de artes plásticas de Pernambuco, 1986; second prize, 1988,
and acquisition prize ''Cidade de Ribeirão Preto, 1991, *Salão de artes*
plásticas de Ribeirão Preto; acquisition prize Hoescht do Brasil, *XX*
salão nacional de arte, Belo Horizonte, 1988; prêmio fotoptica, *VII*
salão paulista de arte contemporânea, 1989; prêmio Marc Ferrez de
Fotografia, IBAC/Funarte, 1992; acquisition prize, *II salão paraense*
de arte contemporânea, 1993; acquisition prize, *13 salão nacional de*
artes plásticas, IBAC/Funarte, 1993.

Individual Exhibitions:

1989 *Anti-cinema—Veleidades fotográficas,* Sala Corpo de
 Exposições, Belo Horizonte

1991–92 *A identidade em jogo,* Centro Cultural São Paulo e
 Pavilhão da Bienal de São Paulo, Brazil (traveling)
1994 *Humorais,* Galeria de Arte do IBEU-Copacabana, Rio
 de Janeiro
 Realismo fantástico, Galeria de Arte do IBEU-
 Madureira, Rio de Janeiro
 Centro Cultural, São Paulo, Brazil
 Instituto Brasileiro de Arte e Cultura, Río de Janeiro
1995 *Hipocampo,* Galería Camargo Vilaça, São Paulo, Brazil
 In oblivionem, De Appel Foundation, Amsterdam
1996 *Cicatriz,* Museum of Contemporary Art, Los Angeles
1997 Galería Luis Adelantado, Valencia, Spain
1998 Lombard Freid Fine Arts, New York
1999 Australian Centre for Photography, Sydney
1999–00 Museum of Contemporary Art, Los Angeles

Selected Group Exhibitions:

1991–92 *Apropriações 91,* Paço das Artes, São Paulo, Brazil
1992 *Space of Time: Contemporary Art from the Americas,*
 Americas Society, New York
1993 Aperto section, *XLV Biennale di Venezia,* Italy
1994 Centro de Arte Reina Sofia, Madrid
 XXII Bienal de São Paulo, Brazil
1995 *Fotografia brasileira contemporânea,* Centro Cultural
 Banco do Brasil, Rio de Janeiro
1996–97 Van Abbemuseum, Eindhoven, Holland
1997 *II Johannesburg Biennial,* South Africa
 II Kwangju Biennale, Japan
1998 *Investigations of Contemporary Art,* Centrum für
 Gegenwartskunst, Linz, Austria

Collections:

Museum of Contemporary Art, Los Angeles; Museo Nacional Centro
de Arte Reina Sofia, Madrid; Museu de Arte Moderna, São Paulo,
Brazil; Museu de Arte Moderna, Río de Janeiro; Museo Alejandro
Otero, Caracas, Venezuela.

Publications:

On RENNÓ: Books—*Apropriações 91,* exhibition catalog, text by
Tadeu Chiarelli, São Paulo, Brazil, Paco das Artes, 1991; *Travaux
publics,* exhibition catalog, Eindhoven, Holland, Peninsula Founda-
tion and Van Abbemuseum, 1996; *Cicatriz,* exhibition catalog, Los
Angeles, Museum of Contemporary Art, 1996; *Rosângela Rennó,*
São Paulo, Brazil, Imprensa Oficial, 1997; *Archiv X: Ermittlung der
Gegenwartskunst,* exhibition catalog, text by Elisabeth Madlener and
Elke Krasny, Linz, Austria, Centrum fur Gegenwartskunst, 1998.
Articles—''Rosângela Rennó'' by Kate Bush, in *Flash Art* (Italy),
26(173), November/December 1993, p. 83; ''Latin America's Heat
Wave: Rosângela Rennó: Photo Opportunities'' by Bill Hinchberger,
in *ARTnews,* 93(6), Summer 1994, p. 145; ''Cicatriz'' by Adriano
Pedrosa, exhibition review, in *Artforum International,* 35, January
1997, p. 90; ''Aperto Brazil'' by Ruben Gallo, in *Flash Art* (Italy),
31(202), October 1998, p. 83–84.

* * *

In the 1990s photography in Latin America finally came to form
part of the world of contemporary art. With this definitive irruption
within the plasticity of a medium traditionally conceived of as
excessively technical, the formal strategies of photography began to
be confused with those of contemporary art, which obscured the limits
of the different techniques. The use, already extensive since the
beginning of the twentieth century, of photography as works of art, as
a visual recourse made possible by the principle of collage that also
permitted the inclusion of objects and waste products found within a
plastic composition, led the practice of photography at the end of the
century to include the resources of the pastiche of contemporary art.
The appropriation of preexisting ideas and images today forms a
normal and accepted part of photography as a special field in itself.

Within this broad concept of photography, in which the technical
realization of the photographic image itself is no longer determinant,
the work of Rosângela Rennó becomes especially attractive because
of its consistent use of preexisting photographs, which for her serve as
a general rehearsal on social and individual identities. She appropri-
ates old photographs, in which the very quality of their being past and
the anonymity of their protagonists bring a disquieting opaqueness.
Nevertheless, elements of unquestionable eloquence invest these
phantomlike presences with perturbing meanings in their recent
production as transformed into minimalist patterns of grounds of color.

From the end of the 1980s Rennó appropriated photographic
material from family albums, institutional archives, and press rec-
ords. Initially she centered on pure photography, introducing text as a
fundamental element of the meaning. During the first half of the
1990s her work was characterized by three-dimensional research.
Both with the introduction of textures through the use of resins and
with her desire to take photography to the object level, Rennó
formulated an interpretation of the fact of photography in which the
element of ''memory'' was doubly questioned. On the one hand, the
appropriation of photographs of anonymous subjects and situations
long forgotten attempts to call attention to the amnesia lurking in the
background. The photographic register, against the backdrop of the
intention she stimulates to undertake it, does not ensure commemora-
tion. The overproduction of images conspires with general historical
anonymity so that the social memory eliminates from its records the
great unimportant majority that has insisted in its vain attempt to
become immortal through the photographic medium. On the other
hand, Rennó recovers and reinserts these traces in the present visual
panorama, although she is unable to reactivate the individuality of
those who have been photographed, except through the singularity of
the artist's proposal. These rescued portraits continue to be prisoners
of anonymity and of the absence of references, although they are
socially reaccepted as art. They become transformed into signs,
symbols, or allegories, depending on the artist's handling of the
document and on the context in which she expounds her reinterpretation
of the original images.

The photographic negatives that formed a substantial part of the
disturbing ghostlike projections and recompilations of faces of people
of the past in the work of Rennó at the start of the 1990s is a key part of
her working material. In her works the handling of formats is
characteristic, a mixture of mediums and of the construction of
objects with the photographs themselves, as in the case of *Las
afinidades electivas* (1990; ''Elective Affinities''), a kind of small
bubble containing the photograph of a couple; *Puzzles* (1991), two
puzzles made up of photographs of a man and woman, respectively;
and *Private Collection* (1995), hundreds of photographs making a
block, with text that serves as a sculpted title.

In her later works Rennó has moved on to a kind of pictorialism. Her *Red Series* (2000) is particularly pictorial. Old photographs, mainly of men dressed in military uniform and even children, were digitally handled. Rennó blew them up and made them into large and pleasant red surfaces that hide, as if behind a thick glaze, the disquieting shadow of men in uniform. In the series *Blind Wall* (2000) padded panels house old photographs, almost totally obscured by the chromatic veil, strangely filtered into modules of an abstract appearance in which the photographs appear as compositional elements of rhythm and texture.

—Vivianne Loría

RESENDE, José

Brazilian sculptor

Born: São Paulo, 1945. **Career:** Cofounder, *Malasartas*, an alternative art journal, 1975; architecture instructor, Catholic University, Campinas, Brazil. **Awards:** Prêmio Aquisição, *I Jovem Arte Contemporânea*, São Paulo, 1967; fellowship, Guggenheim Foundation, New York, 1984.

Individual Exhibitions:

1974	Museu de Arte, São Paulo
1980–81	Espaço Arte Brasileiro Contemporânea, Río de Janeiro
1988	Subdistrito Comercial de Arte, São Paulo
1991	Joseloff Gallery, Hartford, Connecticut
1994–95	Centro Cultural Banco do Brasil, Río de Janeiro
1998	Centro de Arte Hélio Oiticica, Río de Janeiro
2001	Centro de Arte Hélio Oiticica, Río de Janeiro

Selected Group Exhibitions:

1980	*Paris Biennale,* Galerie Debret, France
1989	Gabinete de Arte Raquel Arnaud, São Paulo
1992	*Documenta 9,* Kassel, Germany
1998	*XI Sydney Biennial*, Australia
	XXIV Bienal de São Paulo
2000	*I Liverpool Biennial of Contemporary Art,* England

Collection:

Gabinete de Arte Raquel Arnaud, São Paulo.

Publications:

On RESENDE: Books—*José Resende,* exhibition catalog, São Paulo, Museu de Arte, 1974; *Biennale de Paris 11ème,* exhibition catalog, text by Jacob Klinbowitz, Paris, Georges Pompidou Center, 1980; *José Resende,* exhibition catalog, text by Ronaldo Brito, Río de Janeiro, Espaço Arte Brasileiro Contemporânea, 1980; *José Resende,* exhibition catalog, São Paulo, Subdistrito Comercial de Arte, 1988; *10 esculturas*, exhibition catalog, São Paulo, Gabinete de Arte Raquel Arnaud, 1989; *José Resende, New Sculpture from Brazil,* exhibition catalog, text by Elaine Barella, Hartford, Connecticut, University of Hartford, 1991; *José Resende,* exhibition catalog, text by Ronaldo

Brito, Río de Janeiro, Demibold, 1992; *José Resende,* exhibition catalog, text by Ronaldo Brito, Río de Janeiro, Centro Cultural Banco do Brasil, 1995; *Brazilian Sculpture from 1920 to 1990: A Profile* by Vítor Brecheret, Washington, D.C., Inter-American Development Bank, 1997; *José Resende*, exhibition catalog, Río de Janeiro, Centro de Arte Hélio Oiticica, 1998; *José Resende* by Lúcia Carneiro and Ileana Pradilla, interview, Río de Janeiro, Lacerda Editores, 1999. **Articles**—"An Insidious Reticence: The Sculptures of José Resende" by Reynaldo Laddaga, in *Art Nexus* (Colombia), 31, February/April 1999, pp. 36–39; "Rio de Janeiro: José Resende at the Centro Oiticica" by Edward Leffingwell, in *Art in America*, 87(4), April 1999, p. 153.

* * *

Materials in José Resende's sculptures are constantly under tension. Whether thick leaden strands or silken cloth, the various parts of his works are assembled in accord with their structural properties. Since the early 1970s Resende has shown a growing interest in spatial qualities of matter. By unusual architectural logic, derived from a balance of opposing qualities, his works extract poetic intensity from banal elements and achieve a discreet inner sense. The unlikely cohesion of different sorts of matter, such as soft and rigid, opaque and transparent, liquid and solid, is used to suggest the suspension of an imminent happening. The 1980s series of body-size glass ampoules filled with fluids of different densities explores the precariousness of improbable liquid sculptures. As only a tiny leather string sustains it diagonally in between wall and ground, the ampoule from 1983 containing water and oil constantly threatens to fall apart.

Resende's sculptures are free of expressive content, although they activate the viewer's anxiety for freezing expected incidents. No matter how diverse the materials used, each piece is provided with solid internal cohesion. Opening over the ground, as *Venus* (1992); supported on the walls, from where they are projected out; or tensing a delicate nylon cloth to hang heavy paraffin blocks between ground and wall, his sculptures establish structural relations from which their freedom of expansion in space derives. The internal unity of Resende's pieces allows him to transcend the regular perception of space, traditionally rooted on the horizon line. Based in constructive principles, they are deeply rooted in Brazilian tradition but dialogue with European modern sculpture.

One such piece was installed in 1994 at Largo da Carioca, downtown Rio de Janeiro. A long two-walking-legs-like sculpture on Cor-Ten steel soberly plays with the eroded figures of Alberto Giacometti. Known as *Passante* ("Passerby") for its resemblance to the people who daily cross the plaza, the work hooks up with the sculptures of seminal neoconcretist artists. Some of them, such as Amilcar de Castro and Franz Weissman, explored cuts and folds on industrial steel plates, transforming the gap between different planes into a virtual volume. *Passante* is one of a series of pieces in which Resende revisits neoconcretism for the spatial possibilities of flat surfaces. Rather than unfolded volumetric surfaces, however, it consists of a linear, compressed shape that cuts urban landscape.

Resende's sculptures verge opposite bodies of work in the late 1980s. Taking materials such as paraffin, plumb, felt, nylon, and leather simultaneously as mold and molded shapes, the artist reframes European sculpture tradition in terms of process. Precarious materials, largely used by artists such as Josef Beuys for questioning art's objecthood, are used in the object-based practice of modeling. Leading and learning about transformation processes, such as melting,

solidification, folding, hanging, or stretching, Resende injects the course of time into sculpture's veins.

The prevalence of aesthetic experience in contemporary societies constantly questions the borders of the visual arts. Contrary to what early modernists believed, the unity between art and life seems now to be accomplished by the dissipation of both in the uncontrolled flow of information. Images, then, do not refer to the real but erase it with veiling fetishism. It is difficult to recognize in this process a synthesis of life in art, which would give the viewer a genuine aesthetic experience. The labyrinthine scheme of urban space, the excess of visual devices, from street video screens to the throbbing virtual world on the Internet, can only be experienced as fragmentary. The claustrophobic density of information threatens the very pleasure of art.

But the assumed and necessary risk in Resende's work is that of seeking volatile aesthetic experience via formal investigation. Resende explores instability as well as the very density of the work; he seeks transformational processes but keeps a calculated proximity to certain paradigms of modernism. Well-positioned within the object-based exhibition Documenta IX in which he participated in 1992, he drew away from the polemical Documenta X, whose curator radically addressed art's crisis.

By recognizing but resisting the precariousness of contemporary subjectivity, Resende formulates an unorthodox constructive system. It is, however, moved by the transitory and the fine irony of an eroticism at first unnoticed then obvious. The audacity of Resende's work is that it touches on the precarious unity of contemporary art and does it in such a way that brings unexpected pleasure into the world.

—Luiza Interlenghi

REVERÓN, Armando

Venezuelan painter

Born: Armando Julio Reverón Travieso, Caracas, 1889. **Education:** Academia de Bellas Artes, Caracas, 1908–11; Escuela de Artes y Oficios y Bellas Artes, Barcelona, Spain, 1911; studied under Antonio Degrain and Manuel Martin, Academia de San Fernando, Madrid, 1912–13. **Family:** Lived with Juanita Ríos beginning in 1920, married in 1950. **Career:** Went into isolation, Macuto, Venezuela, 1920. Suffered from a nervous breakdown, 1945; institutionalized, San Jorge Sanatorium, 1953. Member, Impressionist painter group *Círculo de Bellas Artes,* Venezuela. **Award:** First prize, Official Salon of Venezuela, 1940. **Died:** 1954.

Individual Exhibitions:

1933	Galerie Katie Granoff, Paris
1949	Taller Libre de Arte, Caracas
1950	Venezuelan-American Center
1954	Caracas Museo de Bellas Artes (retrospective)
1956	Museum of Contemporary Art, Boston (retrospective)
1989	Galería de Arte Nacional, Caracas

Selected Group Exhibition:

1987	*Art of the Fantastic: Latin America, 1920–1987,* Indianapolis Museum of Art

Publications:

On REVERÓN: Books—*Armando Reverón,* exhibition catalog, text by Diggory Venn, Boston, Institute of Contemporary Art, 1956; *La obra de Armando Reverón* by Alfredo Boulton, Caracas, Ediciones de la Fundación Neumann, 1976; *Armando Reverón* by Juan Calzadilla, Caracas, Ernesto Armitano, 1979; *Armando Reverón a la luz,* exhibition catalog, by Victoriano de los Ríos, Rafael Arráiz Lucca, and others, Caracas, Galería de Arte Nacional, 1989; *Mirar a Reverón* by Alfredo Boulton, Caracas, Macanao Ediciones, 1990; *Aproximación didáctica a la obra de Armando Reverón,* Caracas, Museo Armando Reverón, 1991; *Los objetos de Reverón,* Caracas, Fundación Museo Armando Reverón, 1993; *El erotismo creador de Armando Reverón* by Juan Liscano, Caracas, Fundación Galería de Arte Nacional, 1994; *Armando Reverón: Luz y cálida sombra del Caribe,* exhibition catalog, by Katherine Chacón, Rafael Arráiz Lucca, and others, Caracas, Consejo Nacional de la Cultura, 1996. **Articles**—''Reverón, the Hermit of Macuto'' by James B. Lynch, in *Americas,* 32, February 1980, pp. 19–25; ''Armando Reverón'' by German Rubiano Caballero, in *Art Nexus* (Colombia), 23, January/March 1997, pp. 123–124.

* * *

Armando Julio Reverón Travieso was born in Caracas, Venezuela, in 1889, the only child of a wealthy Creole family, although he was brought up by a foster family in Valencia in the province of Carabobo. At the age of 12 he contracted typhoid fever, and the illness left him shy and withdrawn. His family encouraged him to paint, and in 1908 he returned to Caracas, where he enrolled in the Academia de Bellas Artes. The academy was very conservative, and, following a student strike in 1909, he was expelled for a period of several months. He graduated in 1911 with distinction. Following his first exhibition, which revealed him to be a gifted colorist, Reverón was awarded a stipend by the Caracas city council to study abroad.

At the age of 22 Reverón traveled to Spain, where he enrolled in the Escuela de Artes y Oficios in Barcelona (1911) before moving to the Academia de San Fernando in Madrid (1912–13), where he was attracted to the work of Diego Velásquez, Francisco Goya, and the Spanish modernist Ignacio Zuloaga. This time in Europe was a period of discovery and growth for the young artist, whose work became marked by an atmosphere of mystery, unreality, and fantasy. During an interlude in Paris (1914) Reverón was able to study the work of Paul Cezanne. He returned to Caracas in 1912 for a short visit and then returned to Venezuela permanently in 1915.

In 1916 Reverón joined a group of intellectuals, called the Círculo de Bellas Artes, who aimed to regenerate art in the oppressive political climate of Venezuela. To this end French impressionism offered them a way to challenge academic limitations. Reverón met the Romanian Samys Mützer, the Franco-Venezuelan Emílio Boggio, and the Russian Nicolas Ferdinandov, all of whom were resident in Venezuela at the time. From this group of artists Reverón learned the pointillist technique. By 1919 he had entered his so-called blue period, in which the canvases, epitomised by *The Cave* (1919) and *Figure beneath the Uvero Tree* (1920), were dominated by different shades of blue.

Influenced by Ferdinandov, who had a passion for the sea, Reverón left Caracas in 1920 for the small village of Macuto, on the Caribbean coast, with his companion Juanita Ríos, an indigenous Venezuelan whom he met in 1918 and eventually married in 1950. Ríos helped Reverón in his search for a purer and less material

existence in Macuto, where they turned their backs on Western materialism. They constructed two simple thatch huts with a perimeter stone wall, with one of the huts, called El Castillete de las Quince Letras, serving as Reverón's studio. There he painted on canvases that were either unprimed or prepared with textured grounds, preferring highly absorbent or heavily woven material such as burlap or agave fibers. In addition, Reverón eliminated all strong color from his work, reducing the images to a monochromatic purity during what became known as his white period (1926–36), in which he approached pure abstraction. These images leave ghostlike traces on the canvas, capturing the blinding light of the sea and sand. Good examples are *Coconuts on the Beach* (1926) and *White Landscape* (1934).

While living at Macuto, Reverón adopted an extraordinary ritual. Seeking purity through his work, he painted in a state of almost total isolation, one in which the image was all-important. In order to eliminate all outside influences, he filled his ears with cotton, wore only the minimal clothing, and insisted on being barefoot so that he could retain contact with nature. He also bound his waist with a leather belt in order to remove all sexual desire from his mind. Likewise, he refused to touch metal objects and constructed all of his own paintbrushes and furniture from local materials.

In the 1940s Reverón entered what is known as his sepia period. This was dominated by landscapes (1940s), including the port of La Guira, and figure painting (1936–39), during which he gradually reincorporated color into his work. The shortage of models, other than Juanita, was overcome by the construction of near life-size mannequins, which they made together. Each mannequin had a distinct personality, complete with a name, hair, painted expressions, and even genitalia, and they were incorporated into his work. Reverón also constructed various objects, such as a telephone and a birdcage, with which he decorated his house. He began to blur reality and fiction, however, and during the final decade of his life he suffered two major mental crises. He was confined to the San Jorge sanatorium in Caracas for three months in 1945 and for nearly a year in 1953. Reverón died in 1954.

Reverón is seen as a Latin American modernist who, despite his self-imposed isolation, produced an extraordinary body of work mirroring that of the American abstract expressionists. His work, filled with a deep-rooted sensitivity for the people and landscape of Macuto, celebrates the beauty of Venezuela with an evocative and ethereal quality. By contrast, his portraits of himself and others reflect a world of desire and veiled eroticism that, through the presence of the mannequins, drift in and out of reality. With time Reverón's work became more self-obsessed and introspective, reflecting his inability to distinguish his own existence from the fantasy world he and his wife had created for themselves.

—Adrian Locke

REVUELTAS, Fermín
Mexican painter

Born: Santiago, Papasquiaro, Durango, 7 July 1902. **Education:** Jesuit College of San Edward, Austin, Texas, 1910–13; Art Institute

Fermín Revueltas: Detail of mural fresco of woman in red at National Preparatory School, San Idelfonso, Mexico City. Photo courtesy of The Art Archive/Nicolas Sapieha.

of Chicago, 1919; Escuela de Pintura al Aire Libre, Chimalistac, Mexico, 1920. **Career:** Returned to Mexico from studies abroad, 1920. Director, Escuela de Pintura al Aire Libre José María Velasco, Villa de Guadalupe, Mexico, 1920; established Escuela de Pintura al Aire Libre, Milpa Alta, Mexico, 1921; director, Escuela de Pintura al Aire Libre Guadalupe Hidalgo and Colegio de San Pedro y San Pablo, Mexico City, 1925; established Escuela de Pintura al Aire Libre, Cholula, Mexico, 1927; painting teacher, Department of Fine Arts of the Ministry of Education and Escuela Industrial de Insurgentes, Mexico City, late 1920s. Muralist, including murals at National Preparatory School, 1922, Technical Industrial Institute, 1927, and Railroad Men's School. Also worked as a stage designer for the theatre, a stained glass artist, and as an illustrator, *Crisol* magazine, Mexico. Member, artistic movement *estridentistas;* Painters' Syndicate; and Communist Party of Mexico, 1928. Founding member, muralists' union *Sindicato de Obreros Técnicos, Pintores, y Escultores,* 1922; artist group *¡30–30! Group,* 1928; *Bloque de Obreros Intelectuales,* 1929. **Died:** Mexico City, 9 September 1935.

Selected Exhibitions:

1922 Academia de San Carlos, Mexico City (group)

American Federation of Arts and the College Art Association, 1934.

Collections:

Antiguo Colegio de San Ildefonso, Mexico; Biblioteca Central de la Universidad Autonoma de Sinaloa, Mexico; Museo Nacional de Arte, Mexico City; Museo de Arte Moderno, Mexico City.

Publications:

By REVUELTAS: Books, illustrated—*Umbral* by René Tirado Fuentes, n.p., 1931; *5 poemas sobre cinco viñtas de Fermín Revueltas* by Arnulfo Martínez Lavalle, Mexico City, Imprenta Mundial, 1934.

On REVUELTAS: Books—*Contemporary Mexican Artists* by Agustín Velázquez Chávez, New York, Covici-Friede, 1937; *Fermín Revueltas: Colores, trazos y proyectos*, exhibition catalog, Mexico City, Universidad Nacional Autónoma de México, 1983; *Fermín Revueltas* by Judith Alanís, Mexico City, Celanese Mexicana, 1984; *Fermín Revueltas, 1902–1935: Muestera antológica*, exhibition catalog, Mexico City, Museo de Arte Moderno, 1993.

* * *

Fermín Revueltas participated in the first phase of the Mexican mural movement, producing realist and allegorical works that focused on revolutionary subject matter. He also created modernist, cubist-inspired easel paintings, drawings, and prints. Revueltas was born into a creative family. The eldest son, Silvestre, became one of Mexico's most esteemed composers; Fermín's younger brother, José, gained considerable renown as a prolific writer and a political activist; his sister Rosaura was an actress and a writer; and another sister, Consuelo, was also an artist. Recognizing the young Fermín's artistic inclinations, his father arranged for him to take drawing classes in Guadalajara. In 1910, to protect them from possible involvement in the Mexican Revolution, their father sent Silvestre and Fermín to board at the Jesuit College of San Edward in Austin, Texas, where they remained until 1913. From there the brothers went to Chicago. Fermin studied art on his own, using as a resource the Art Institute of Chicago, while Silvestre had violin lessons.

In 1920 Fermín Revueltas returned to Mexico. He began to attend the Escuela de Pintura al Aire Libre (Open-Air Painting School) in Chimalistac, one of the experimental art schools headed by Alfredo Ramos Martínez. Within the year Revueltas was appointed director of the Open-Air Painting School José María Velasco at the Villa de Guadalupe, and in 1921 he started an open-air school in Milpa Alta. In 1925 he managed the open-air schools of Guadalupe Hidalgo and the Colegio de San Pedro y San Pablo in Mexico City. In 1927 Revueltas founded an open-air school in the state of Puebla, the Escuela de Pintura al Aire Libre of Cholula. He was also appointed painting teacher in the Department of Fine Arts of the Ministry of Education and gave classes at la Escuela Industrial de Insurgentes (Insurgentes Industrial School) in Mexico City. He continued to be involved in arts education throughout the rest of his career.

In 1921 Revueltas joined the estridentistas (stridentists), the avant-garde literary and artistic movement recently inaugurated by the writer Manuel Maples Arce. His paintings, drawings, and prints illustrated stridentist publications, and he took part in stridentist events, such as the Stridentist Exhibition of 1924 in Mexico City. He experimented with woodcut prints and painting. His cubist-inspired watercolor *Andamios exteriores* (1923) was based on a book of poetry of the same name by Arce.

In 1922 the secretary of education, Jose Vasconcelos, hired Revueltas, Diego Rivera, Jose Clemente Orozco, Fernando Leal, Jean Charlot, and Amado de la Cueva to paint murals at the National Preparatory School. Revueltas painted an encaustic mural, *Allegoría de la Vírgen de Guadalupe* (''Allegory of the Virgin of Guadalupe''), in the vestibule of the building. That year Revueltas helped found the muralists' union, the Sindicato de Obreros, Técnicos, Pintores, Escultores, Grabadores y Artistas Revolucionarios (Union of Revolutionary Workers, Technicians, Painters, Sculptors, Printmakers and Artists).

In 1928 Revueltas was a founding member of 30–30, a group of artists opposed to the conservative policies of the Academy of San Carlos. At this time he also joined the Communist Party of Mexico. The following year he, along with Rivera, Arce, and others, formed the Bloque de Obreros Intelectuales (Intellectual Workers Bloc), and Revueltas illustrated the bloc's journal, *Crisol*, with woodcuts and drawings. In the late 1920s he participated in the cultural missions organized by the Ministry of Education to train rural schoolteachers. He also designed and painted stage sets in the Cathedral of Villahermosa and organized open-air theaters in the towns of Caquini and Macuspana, Tabasco.

Revueltas was very active as a mural painter in the early 1930s. He painted walls at the Instituto Técnico Industrial de México (Technical-Industrial Institute of Mexico), in the church of Guadalupita in Cuernavaca (now destroyed), and at the house of General Almazán in San Angel, D.F. Revueltas also painted murals in the library of the house of General Lázaro Cárdenas in Pátzcuaro, Michoacán, and the Palacio de Gobierno de Morelia (Government Palace of Morelia, now the University of San Nicolás). His murals in Morelia centered on the themes of the Congress of Apatzingán and the execution of Gertrudis Bocanegra, a hero of the Mexican War of Independence. In 1932 he

painted murals at the building of the newspaper *El Nacional Revolucionario* on the theme of work and at the Escuela Gabriela Mistral (Gabriela Mistral School) (both now destroyed). In 1934 he painted a mural on the allegory of production for the Banco Nacional Hipotecario (the National Mortgage Bank, now Banco Serfin). He also produced numerous illustrations for leftist newspapers and magazines. In 1931 he created cubo-futurist-inspired illustrations for the book *Umbral.* His images incorporate words, numbers, and symbols.

In 1933 Revueltas began to make stained-glass windows. His windows for the offices of the Partido Nacional Revolucionario (Revolutionary National Party) in Culiacán, Sinaloa, and for the Centro Escolar Revolución (Revolution Educational Center) in Mexico City depicted the history of Mexico. He also created stained-glass windows for the Casa del Pueblo (House of the People) in Sonora on the theme of the collectivization of Mexico and for the Hospital Colonia, Mexico City. These windows, representing Mexican history, Mexican workers, and the revolution, were the stained-glass equivalents of murals such as those painted by Rivera during the 1920s and '30s. As narrative works with revolutionary content, they are unique in the history of twentieth-century Mexican art.

Throughout his career Revueltas painted oil paintings and watercolors, but between 1932 and 1935 he produced an especially large number of paintings. These were simple, pastoral scenes of Mexican rural life or abstract landscapes in muted colors. In 1935 Revueltas won a contest for the decoration of the monument to General Obregón, but before he could complete this project, he died suddenly of an aortic aneurysm in September 1935.

—Deborah Caplow

RIESTRA, Adolfo

Mexican painter and sculptor

Born: Tepic, Nayarit, 1944. **Education:** Studied under Dwite Albisson, Guadalajara, 1955–56; studied law, Universidad de Guanajuato, and painting, Taller del Maestro Jesús Gallardo, Mexico, 1962–66; Portrero Hills Graphics Workshop, San Francisco. **Career:** Worked as a judge. Traveled to San Francisco, 1968. **Died:** Mexico City, 10 October 1989.

Individual Exhibitions:

1976	Teatro Degollado, Guadalajara, Mexico
1979	*Islas tristes y negras,* Casa del Lago, Mexico City
1980	Centro Cultural Teotihuacan, Mexico City
1982	Galería Sloane-Racotta, Mexico City
1984	Galería OMR, Mexico City
1986	*Barro nuevo,* Galería OMR, Mexico City
1987	*Escultura en barro,* Galería Enrique Romero and Galería OMR, Mexico City
1988	Galería OMR, Mexico City
1989	*El canto,* Galería Florencia Riestra, Mexico City
	El mar, Galería OMR, Mexico City
1991	*Obra inédita,* Galería OMR, Mexico City
	Homage to Adolfo Riestra, Wenger Gallery, Los Angeles
1994	Galería OMR, Mexico City
1998	*Adolfo Riestra: Dibujante, pintor y escultor,* Museo de Arte Contemporáneo de Monterrey, Mexico (retrospective)

Selected Group Exhibitions:

1978	*I bienal iberoamericana de arte,* Museo Carrillo Gil, Mexico City
1984	*I bienal la Habana,* Havana
1986	*Encuentro de ceramistas contemporáneos de Latinoamérica,* Museo de Arte de Ponce, Puerto Rico
1988	*Rooted Visions: Mexican Art Today,* Museum of Contemporary Hispanic Art, New York
1990	*Through the Path of Echoes: Contemporary Art in Mexico,* University of Texas, Austin (traveling)
1992	*I bienal barro de América,* Museo Sofía Imber, Caracas, Venezuela
	ARCO '92, Madrid
1994	*Escultura, pequeño formato,* Galería de Arte Mexicano, Mexico City
1999	*México Eterno: Arte y permanencia,* Museo del Palacio de Bellas Artes, Mexico City
	Visual Voices of Mexico, Museum of Latin American Art, Long Beach, California (traveling)

Collections:

Centro Cultural/Arte Contemporáneo, Mexico City; Metropolitan Museum of Art, New York; Museo de Monterrey, Mexico.

Publications:

On RIESTRA: Books—*10 artistas de Mexico,* exhibition catalog, New York, Grace Borgenicht Gallery, 1993; *Adolfo Riestra,* exhibition catalog, text by Erika Billeter, Mexico City, Galería OMR, 1994; *Adolfo Riestra: Dibujante, pintor y escultor,* exhibition catalog, text by Edward J. Sullivan and Alberto Ruy Sánchez, Monterrey, Mexico, Museo de Arte Contemporáneo de Monterrey, 1998. **Articles—**"OMR Gallery, Mexico City" by Mary Schneider Enriquez, in *Art News,* 93, September 1994, p. 186; "Adolfo Riestra: Marco" by Patricia García Cavazos, review of an exhibition at the Museum of Contemporary Art of Monterrey, Mexico, in *Art Nexus* (Colombia), 30, November 1998/January 1999, pp. 138–139.

* * *

Although he produced a significant body of drawings and paintings, Adolfo Riestra is best known for his monumental sculptures. Using earthen clay and primitive pre-Columbian techniques, Riestra created life-size works reminiscent of the ancient figures that populated the temples of Mesoamerica, particularly the religious statuary of ancient Mayan civilization.

Riestra came to art later in life. Although he had long painted as a hobby (and even took classes with Dwite Albisson in Guadalajara), he was a lawyer by training, having attended the University of Guanajuato

Law School. He was making a living as a judge in Mexico when he abandoned the law in 1968 to take an extended trip to San Francisco. He was associated there with the Portrero Hills Graphics Workshop, where he honed his drawing technique.

After returning to Mexico, Riestra spent the next 14 years concentrating on two-dimensional art. In his paintings and drawings he reinterpreted human and animal figures by abstracting the forms, giving expression to the animal figures, and stylizing key elements of the subjects. Riestra's paintings had the primitive feel that would later come to mark his sculptures. In *Hombre chango,* for instance, a painting that stylistically resembles pre-Columbian religious art, Riestra depicted a black monkey on a brilliant blue background. The monkey's tail curls insouciantly, and its legs are elongated. Shining out of the monkey's blackness are its bright red lips–full, feminine, and human.

Riestra became interested in sculpture in the early 1980s and studied traditional sculptural techniques with the artisans of Metepec. From them he learned to construct his figures out of layered clay disks. The result of this technique is that Riestra's statuary is as simple as the pre-Columbian work from which he drew his inspiration. He portrayed breasts, for example, as small mounds with holes and legs as massive, solid tree trunks. Although spare, his work is nevertheless monumental. His 1989 sculpture *Bombonera chica* (''Small Candy Jar'') typifies his style. Using a form based on a pre-Columbian vessel, Riestra shaped a round body for the jar's base, with the lid doubling as a head

Although Riestra's sculptures were made using the age-old techniques of Mexican craftsmen, his work has a distinctly contemporary feel. In *Torso con brasos tubulares* (1989; ''Torso with Tubular Arms'') he depicted a crudely formed triangular torso topped by an enigmatic slit-eyed head. Biceps protrude directly from the figure's chest, while the lower arms and hands are drawn in relief. Another well-known piece is *Giganta con caballito* (1989; ''Giantess with Small Horse''). The towering, eight-foot-tall women wears a horse as a headdress.

During his lifetime Riestra received a good deal of recognition for his work, particularly his sculpture. He held several solo exhibitions at Galeria OMR. It was not until after his death in 1989, however, that Riestra gained international attention. The Wenger Gallery in Los Angeles held *Tribute to Adolfo Riestra* in 1991.

—Rebecca Stanfel

RIOS, Miguel Angel
American painter, printmaker, and installation artist

Born: Catamarca, Argentina, 2 August 1943; moved to New York, 1976, United States citizen, 1982. **Education:** Academia Nacional de Bellas Artes de Buenos Aires, 1960–65, M.F.A. 1965; studied art in France, Spain, and Italy, 1974–76. **Career:** Professor of art, National Universities of Tucumán and Catamarca, Argentina, 1966–72. **Award:** Fellowship, Guggenheim Foundation, 1998. **Agent:** Trans Hudson Gallery, 416 West 13th Street, New York, New York 10014, U.S.A. **E-mail Address:** mrios2000@hotmail.com.

Individual Exhibitions:

1966	Galería Estimulo de Bellas Artes, Buenos Aires
1976	Ocean Song Gallery, Del Mar, California
1980	Gallery Ueda, Tokyo
1983	Gallery Ueda, Tokyo
1984	Allen/Wincor Gallery, New York
1985	Allen/Wincor Gallery, New York
1988	Galeria de Arte Mexicano, Mexico City
1989	Vrej Baghoomian Gallery, New York
1991	Vrej Baghoomian Gallery, New York
	Arco International, Vrej Baghoomian Gallery, Madrid
1992	*Repackaging the Gulf War,* Galería de Arte Mexicano, Mexico City
	Galería Ramis F. Barquet, Mexico City
	Museo de Arte Moderno and Galería der Brücke, Buenos Aires
1993	*Así en la tierra como en el cielo: Exposición retrospectiva de Miguel Angel Ríos, 1979–1993,* Museo de Monterrey, Mexico
	John Weber Gallery, New York
1995	John Weber Gallery, New York
	Drawings, Galerie Wohn Maschine, Berlin
1996	Oddi Baglioni Gallery, Rome
1998	*Los vientos del sur,* Ruth Benzacar Gallery, Buenos Aires
1999	*Manhattan Codice,* Museo Carrillo Gil, Mexico City (traveling)
2000	*The Discovery of the Amazon: An Interpretation of the Chronicle of Fray Gaspar de Carvajal,* CRG, New York (with Sergio Vega)

Selected Group Exhibitions:

1993	*Trade Routes,* New Museum of Contemporary Art, New York
1994	*Mapping,* Museum of Modern Art, New York
1997	*6th Havana Biennial*
1998	*The Edge of Awareness,* P.S.1 Contemporary Art Center, New York
	Transatlantica, Museo de Arte Contemporaneo, Canary Islands, Spain
	Amnesia, Christopher Grimes and Track 16, Los Angeles
1999	*Peintures et sculptures d'amérique latine,* Museo de Bellas Artes, Caracas, Venezuela
2000	Trans Hudson Gallery, New York
	7th Havana Biennnial
	Kwangju Biennial, Korea

Collections:

Santa Barbara Museum of Art, California; University of Texas, Austin; Museum of Monterrey, Mexico; Museum of Modern Art, New York; Museo de Bellas Artes, Caracas, Venezuela; Museo Alejandro Otero, Caracas, Venezuela; Museo de Extremadura, Badajoz, Spain; Museum of Modern Art, Tokyo.

Miguel Angel Rios: *Los niños brotan de noche (The Children That Spring Out at the Night),* from "Mapping with the Mind" series, 2001. Photo courtesy of the artist.

Publications:

By RIOS: Book—*Dreams from the Heights,* exhibition catalog, New York, Vrej Baghoomian, 1989. **Book, illustrated**—*El libro de vidrio* by Tilo Wenner, Buenos Aires, Ediciones Mediodía, 1963.

On RIOS: Books—*Miguel Angel Rios: Earth Paintings,* exhibition catalog, Tokyo, Gallery Ueda, 1980; *Miguel Angel Rios,* exhibition catalog, text by John Yau, New York, Vrej Baghoomian Gallery, 1991; *Miguel Angel Ríos,* exhibition catalog, text by Meyer Raphael

Rubinstein, Mexico City, Galería de Arte Mexicano, 1992; *Así en la tierra como en el cielo: Exposición retrospectiva de Miguel Angel Ríos, 1979–1993,* exhibition catalog, text by Elizabeth Ferrer and John Yau, Monterrey, Mexico, Museo de Monterrey, 1993. **Articles**—"Miguel Angel Rios: Epics from the Earth" by Frederick Ted Castle, in *Artforum International,* 27, November 1988, pp. 122–125; "Mapping & Identity. Miguel Angel Ríos," in *Art in America,* 82, January 1994, p. 88, and "New York: Miguel Angel Rios and Sergio Vega at CRG," in *Art in America,* 88(2), February 2000, p. 133, both by Raphael Rubinstein; "Miguel Angel Ríos," review of an exhibition

Miguel Angel Rios: *Los niños brotan de noche (The Children That Spring Out at the Night),* **from ''Mapping with the Mind'' series, 2001. Photo courtesy of the artist.**

at John Weber Gallery in New York, in *Art Nexus* (Colombia), 12, April/June 1994, pp. 189–190, and ''Dis-mapping America: Miguel Angel Rios' Maps,'' in *Third Text* (United Kingdom), 34, spring 1996, pp. 23–36, both by Mónica Amor.

*

Miguel Angel Rios comments:

The Children That Spring Out of the Night reproduces the hallucinogenic experience as well as tries to destabilize, spatially and conceptually, the certainties that the White Cube implies. The audio-video not only reproduces the hallucinogenic experience but also destroys, within a conceptual framework, the context created by the White Cube. I want to use the space (in the darkness, where the observer will be confronted by the acoustic experience separated from the visual one).

In Huatla de Jimenez, Oaxaca, Mexico, *The Children That Spring Out of the Night* stands for mushrooms. These bodies come from the earth to initiate a search connected to a type of knowledge that goes beyond the one that we are used to recognize. Therefore, my proposal is to break with the White Cube not architecturally but through a more profound way, a deeper one, trying to create a ''psychography'' that situates itself ''beyond.'' That is to say, in the first place, mixing the installation's form with its theme and then with the ''breaking of the White Cube,'' not in its own terms, but

503

architecturally as well as institutionally (not even by the idea of a room inside another room), but by using the METAPHOR of the trip, one that will take us outside of our daily existence.

* * *

Miguel Angel Rios's oeuvre is an eclectic mix of sculpture, painting, mixed-media works, and installation, video, and sound pieces. His work from the early 1980s concerned itself primarily with formal issues. Yet Rios's approach to form was more often than not infused with the notion that materiality is already charged with social signification. Exemplary of this strategy are his two-dimensional ceramic pieces as well as sculptures made of clay and wood that are coupled with an iconography that freely culled from the pre-Hispanic past. Because in pre-Hispanic cultures form was embedded with meaning, Rios's artistic endeavors in this early stage of his career must be seen as engaging form but from a concept of the aesthetic as ideologically inflected.

This exploration of form and iconography through the prism of indigenous cultures engendered Rios to begin thinking of how other cultures outside Europe and North America perceived the world and articulated it in art and visual culture. One of the most basic categories crucial to art either formally or thematically concerns space. Thus the question of space as a formal endeavor and how it becomes politically loaded when it is depicted or represented is one of the main areas toward which Rios directed his artistic focus. The culmination of Rios's ideas concerning space is evinced in works that have brought him international renown: three-dimensional wall pieces that can be characterized as maps.

Rios's maps, although formally complex, visually elegant, and conceptually driven, address such themes as dislocation, the writing of history by its victors, and how cartography in particular and representation in general help shape perception of reality along particular ideological lines. Before arriving at this aesthetic and idiosyncratic personal style, Rios had begun a series of works that consisted of drawings on ready-made maps. The drawings themselves were reminiscent of animation and addressed through parody biographical and historical themes. The relationship between the formal execution of line on ready-made maps is an astute interplay between geography and the hand of the artist. Rios's formal and conceptual strategies of intervention onto existing systems of classification prompted an exploration of historical cartography realized in works that exist somewhere between painting, photography, and relief sculpture.

One of his early forays into this artistic practice was *A 500 años de la conquista* ("At 500 Years of Conquest"; 1992). Coinciding with the 500th anniversary of Christopher Columbus's discovery of the New World, the work consists of corrugated cardboard strips that were accentuated by what could be called quipus that resemble cords with knots. A quipu is an Inca notational device that was used to document trading transactions as well as being a mnemonic tool used to trigger cultural memories by the *quipucamayoc*, or quipu, reader, which would aid him in the enunciation of oral histories. Rios's use of this ancient Andean technology was not only an innovative formal trope but it also addressed the epistemological differences between Western cartography as a positivist undertaking and the pre-Hispanic Andean notion of space and history as being an interpretive endeavor. Rios would further expand these ideas in his installations that evinced his artistry and intellectual depth in developing complex themes into a

myriad of innovative and complicated formal directions that merged cutting-edge technology with *arte povera*-like aesthetics. In his video work and installations Rios continued to question the ideological underpinnings of representation but also began to address the possibility of adapting other senses in experiencing art.

Rios's installation *Tolache* (2000) incorporates his previous interests in indigenous cultures but also begins to focus on sound as well as the body as experiential receptors for the work of art. As one enters the installation, architectural destabilization produced by a skewed floor emphasizes the viewer's corporal relationship to the work; this is coupled, moreover, with an audio track of a native Mexican healer chanting in Nahuatl. Rios's use of other formal elements than the visual was an undermining of modernity's fixation with the optical that became a point of contention with other artists such as Hélio Oiticica, Lygia Clark, and Ernesto Neto. Rios's installations and video work, such as *The Children That Spring Out of the Night* (2001), continue with some of his previous themes and are further evidence of the expansion of an already broad formal and conceptual repertoire. In his perpetual exploration of various media that began early in his career with painting, and then sculpture, installation, sound pieces, and video work, Rios has exhibited through his protean artistic personality a highly sharp artistic intelligence that situates his historical importance in Latin America and abroad.

—Raúl Zamudio

RIVERA, Carlos Raquel
American painter, printmaker, and graphic artist

Born: Barrio Río Prieto, Yauco, Puerto Rico, 1923. **Education:** Edna Coll Academy, San Juan, 1947–49; Art Students League, New York, 1950. **Career:** Worked in the workshop of Juan Rosado, Puerto Rico, ca. 1950; with Division of Community Education, Puerto Rico, ca. 1955. Member, Centro de Arte Puertorriqueño. **Awards:** Premio de las Naciones, *I bienal iberoamericana de México;* Premio en el Certamen Annual del Ateneo Puertorriqueño, 1954; Premio Nacional de la Cultura, Instituto de Cultura Puertorriqueña, 1992. **Died:** 1999.

Individual Exhibitions:

1956	Unión General de Trabajadores, Santurce, Puerto Rico
1958	Sala de Exposiciones, Universidad de Puerto Rico
1964	Galeria Colibri, San Juan
1972	Instituto de Cultura Puertorriqueña, San Juan
1980	El Museo del Barrio, New York
1993	*Carlos Raquel Rivera, obra gráfica 1941/1990,* Instituto de Cultura Puertorriqueña
2001	*Carlos Raquel Rivera: Una visión personal,* Universidad del Sagrado Corazón, Puerto Rico

Selected Group Exhibitions:

1957	Riverside Museum, New York
1962	*Dos siglos de pintura puertorriqueña,* Instituto de Cultura Puertorriqueña, San Juan

1964 Museo de Arte de Ponce, Puerto Rico

1977 *Pintura puertorriqueña,* Museo de la Universidad de Puerto Rico, Rio Piedras

1985 *Pintura y gráfica de los años 50,* Arsenal de la Puntilla, Instituto de Cultura Puertorriqueña, San Juan

1986 *25 años de pintura puertorriqueña,* Museo de Arte de Ponce, Puerto Rico (traveled to Museo de Bellas Artes del Instituto de Cultura Puertorriqueña, San Juan)

1989 *The Latin American Spirit: Art & Artists in the U.S.,* Bronx Museum, New York

1998 *100 años después . . . cien artistas contemporáneos,* Arsenal de la Puntilla, Puerto Rico

Collections:

Ateneo Puertorriqueño, San Juan; El Museo del Barrio, New York; Instituto de Cultura Puertorriqueño, San Juan; Museo de Arte de Ponce, Puerto Rico; Universidad de Puerto Rico, San Juan.

Publications:

On RIVERA: Books—*Spiks* by Pedro Juan Soto, Mexico, Los Presentes, 1956; *C.R. Rivera,* exhibition catalog, with text by Pedro Juan Soto, San Juan, Galeria Colibrai, 1964; *Carlosraquel,* exhibition catalog, San Juan, Instituto de Cultura Puertorriqueña, Convento de Santo Domingo, 1972; *"Con su permiso–,"* exhibition catalog, New York, El Museo del Barrio, 1980; *Carlos Raquel Rivera, obra gráfica 1951/1990,* exhibition catalog, with text by Teresa Tío, San Juan, Instituto de Cultura Puertorriqueña, 1993. **Articles—**"Carlos Raquel Rivera, pintor de ideas," in *Urbe,* 2(6), September 1963, pp. 46–52; "Carlos Raquel Rivera" by Ernesto Ruíz de la Mata, in *San Juan Star* (San Juan), 10 December 1972; "Carlos Raquel Rivera Our Own Fantasist" by Domingo García, in *San Juan Star* (San Juan), 24 October 1976, pp. 6–7.

* * *

A native of a rural sector of Yauco, Puerto Rico, Carlos Raquel Rivera studied at the Edna Coll Academy in San Juan and at the Art Students League in New York City under Reginald Marsh and John Corbino. He was a member of the Centro de Arte Puertorriqueño, an association formed by the principal artists of the 50s Generation. Until 1955 he worked at the Community Education Division of the Department of Education as a book illustrator and as a designer of sets for movies and the posters to announce them. But his forte was not design, and many of the images he produced for hire lack the passion and intensity of his signature works.

A painter and graphic artist, Rivera produced the most forceful images of the themes and genres favored by artists in Puerto Rico in the 1950s and '60s. He was able to give visual form to complex ideas and subjects. His prints were mostly in linoleum block and range from celebratory images of rural life to empathic portrayals of poverty to fierce political satires and allegories on colonial oppression. Although the influence of Leopoldo Méndez and the Mexican Popular Graphics Workshop is present in Rivera's prints, such as in *Marea alta* (1959; "High Tide"), his idiosyncratic and highly original images express a unique artistic voice.

Rivera's paintings, often poetic, can also convey mystery and terror. Changes of scale, the blend of the commonplace and the bizarre, and the surprising coexistence of incongruent images (tiny figures, broad strokes, and indecipherable forms) have earned the artist the label of surrealist, not an altogether mistaken designation. Rivera effectively combined meticulous rendering with broad, sure splotches of color, as in *Paisaje de la Jurada* (1965; "The Jurada Landscape"), and the concrete and the fantastic in images that convey the viewer into the realm of mystery. His urban scenes of demonstrations or night conflagrations, populated by incongruent characters, coexist with the explicit representation of the United States colonial regime, as in *Diplomacia* (1957; "Diplomacy"). *La madre patria* (1959; "Fatherland") is a picaresque satire of the Spanish conquest—humor and the meticulous rendering balance the scatological character of the scene.

Rivera's extraordinary paintings of the early 1960s, such as *Mala entrañita* (1961–62), *La enchapada* (1962–63), or *Paroxismo* (1963), reflect the acute identity conflicts of Puerto Rican society. His scenes are populated by fantastic vignettes in which money and dependency articulate the process of assimilation and by spectral images that recall the potent incongruity of nightmares. In *Niebla* (1961–65; "Fog"), his most ambitious work, Rivera opted for an ambivalent image in which he exalted the beauty of tropical vegetation. The fog hides the community built on the hill, and the tropical paradise is full of spines, of dissonant and menacing scenes.

Although severely deformed by arthritis, Rivera kept on painting and producing prints until the end of his life. In the 1970s, '80s, and '90s his work became strange, at times extravagant. Rivera's aim was to make each painting completely different from any he had painted before; any exhibition of his work or a visit to the studio produced a feeling of disorientation upon seeing disparate works in dissimilar color keys. The element of surprise and shock at the outrageous and incongruent scenes in his paintings had been a constant through Rivera's artistic output. Beginning in the 1970s, the bizarre images within each painting moved out into the realm of the viewer, faced with an array of seemingly discordant works. To the end Rivera's disquieting creations were images/symbols of the complex reality of Puerto Rico.

—Marimar Benítez

RIVERA, Dhara

American sculptor and installation artist

Born: Vega Baja, Puerto Rico, 1952. **Education:** Universidad de Puerto Rico, Río Piedras, B.A. 1973; Pratt Institute, New York, B.A. 1979; Hunter College, New York, M.F.A. in sculpture 1983. **Career:** Faculty member, La Escuela de Artes Plásticas, San Juan, Puerto Rico. **Awards:** First prize for ceramics, Ateneo Puertorriqueño, 1974; first prize for drawing, *Sin Nombre* magazine, San Juan, Puerto Rico, 1979; D.C. Horowitz award, Hunter College, New York, 1985; *Casa Candina Ceramics Biennial* award, 1988.

Individual Exhibitions:

1980 Hunter College, New York

1982	Liga de Estudiantes de Arte, San Juan, Puerto Rico
1985	Hunter Arts Gallery, New York
1992	*Amor y terror de la palabra,* Museo de Arte e Historia, San Juan, Puerto Rico
1997	*Inflexions,* Luiggi Marrozzini Gallery, San Juan, Puerto Rico

Selected Group Exhibitions:

1988	*Casa Candina Ceramics Biennial,* San Juan, Puerto Rico
1991	*Casa Candina Ceramics Biennial,* San Juan, Puerto Rico
1993	*Cerámica puertorriqueña hoy,* Museo de Arte e Historia, San Juan, Puerto Rico
1995	Museo Sofía Imbert, Caracas, Venezuela
1996	*Direcciones,* Museo de Arte de Ponce, Puerto Rico
1998	*Exclusión, fragmentación y paraiso,* Museo Extremeño e Iberoamericano de Arte Contemporáneo, Spain
2000	*7 bienal de la Habana,* Havana

* * *

In her sculptures and installations Dhara Rivera uses craft to undermine the conservative bent of the many traditions and media she works in. Raised by an artisan mother, Rivera absorbed the discipline imposed by materials and turned to devising ways to go beyond it. She was educated at the University of Puerto Rico and, in New York City, at the Pratt Institute and in the Whitney Museum Independent Study Program for Young Artists and the M.F.A. program at Hunter College. For her prizewinning installation at the 1988 Casa Candina Ceramics Biennial, she used diverse materials and unfired clay in a work that expressed the primacy of the artistic voice over the strictures of the well-crafted object that often has pride of place in sculpture in clay.

Rivera's works are simultaneously neat and explosive, primitive and conceptual. Walking into one of her installations, the viewer is aware of the expert handling of materials and, at the same time, of her statement on the limitations and possibilities of the very materials she is using. The artistic voice and the concept that animates her work are always more than the sum of the parts and strategies employed.

Rivera worked in prints and drawings in the 1970s and undertook three-dimensional media after her studies and sojourn in New York. For a 1992 solo exhibition, the multimedia installation *Amor y terror de la palabra* ("Love and Fear of Words"), she created a series of "books" that invited the viewer to take an inner journey of reminiscence on the various effects of reading. Rivera's pieces, be they cement teddy bears, fishing hooks, glass pigeonholes, or stacks of folded pieces of cloth, refer to everyday objects transformed by the artist to convey an alternative reading or view. She excels in the capacity to open the viewer's imagination to explore the meaning and sense of her familiar yet strange objects. Perhaps her art can best be described as conceptual, inasmuch as the physical presence or aspect of each piece provokes reflection on the intellectual process the work expresses. The glass pigeonholes, with empty birds' nests, induce the viewer to ponder the fragility of life while absorbing the minimalist beauty of the object itself.

Inflexions, the term Rivera used for a 1997 solo exhibition, can be read as a reflection on the self, an inner journey to one's soul. The

high stacks of white folded cloth referred to the traditional world of women, diapers, and laundry; tilted precariously, they also evoked hospitals and the contingent nature of life. Her work *Bucarabú* (2000), a children's park on the oceanfront in San Juan, makes reference to various elements related to the sea. Some forms recall hulks of imaginary sunken ships washed ashore in the playground; others refer to deck chairs and life buoys, while others are striking for their forms and sinuous lines. Rivera has combined the functional and the aesthetic in objects destined for physical play or for romping or to be used for rest and to stimulate the imagination. Her delicate objects and sturdy playground are the product of a refined imagination, of a poetic syntax used to create metaphors out of the commonplace. In her hands everyday objects are transformed into poetic images.

—Marimar Benítez

RIVERA, Diego
Mexican painter and muralist

Born: José Diego Maria Rivera, Guanajuato, 13 December 1886. **Education:** San Carlos National Academy of Fine Arts, Mexico City, 1898–1905; studied in the studio of Eduardo Chicharro, Madrid, 1907–08. **Family:** Married 1) Angelina Beloff in 1914, one son; 2) Guadalupe Marin in 1932, two daughters; 3) Frida Kahlo, *q.v.,* in 1929 (divorced 1939; remarried 1940); 4) Emma Hurtado in 1955; also had a daughter by Marevna Vorobev-Stebelska. **Career:** Lived in Paris, 1911–21. Muralist, U.S. Stock Exchange Luncheon Club, San Francisco, 1930–31, California School of Fine Arts, 1931, Sterne Home, California, 1931, Detroit Institute of Arts, 1932–33, Rockefeller Center, New York, 1933, New Worker's School, New York, 1933, Golden Gate International Exposition, San Francisco City College, 1940. Director, Academy of San Carlos, 1929–30. **Died:** 24 November 1957.

Individual Exhibitions:

1927	Worcester Art Museum, Massachusetts
1928	Weyhe Gallery, New York
1930	California Palace of the Legion of Honor, San Francisco
1931	Detroit Institute of Arts
	Museum of Modern Art, New York
1932	Society of Arts and Crafts, Detroit
1940	San Francisco Museum of Art
1942	International Ladies Garment Workers Union, New York
1943	Hackley Art Gallery, Muskegon, Michigan
1951	Museum of Fine Arts, Houston

Selected Group Exhibitions:

1916	Modern Gallery, New York
1928	The Art Center, New York
1940	*Latin American Exhibition of Fine Arts,* Riverside Museum, New York
	Twenty Centuries of Mexican Art, Museum of Modern Art, New York

Diego Rivera, 1940. Photo by Fritz Henle. © Corbis.

1945	San Francisco Museum of Art
1948	Dallas Museum of Fine Arts
1963	Los Angeles County Museum of Art
1966	*Art of Latin America since Independence,* Yale University, New Haven, Connecticut, and University of Texas, Austin
1967	*Latin American Art: 1931–1966,* Museum of Modern Art, New York
1970	Metropolitan Museum of Art, New York

Collections:

Academy of San Carlos, Mexico City; Amherst College, Massachusetts; Art Institute of Chicago; Baltimore Museum of Art; Brooklyn Museum, New York; Carrillo Gil Museum, Mexico City; Cleveland Museum of Art; Colorado Springs Fine Arts Center, Colorado; Columbus Museum of Art, Ohio; Des Moines Art Center, Ioew; Detroit Institute of Arts; Fogg Art Museum, Cambridge, Massachusetts; Frida Kahlo Museum, Mexico City; Hood Museum, Dartmouth College, Hannover, New Hampshire; Honolulu Academy of Art; Los Angeles County Museum of Art; Meadows Museum, Southern Methodist University, Dallas; Milwaukee Art Museum; Minneapolis Institute of Arts; Museum of Fine Arts, Houston; Museum of Modern Art, New York; Museum of Modern Art, Mexico City; National Museum of Art, Mexico City; Palace of Fine Arts, Mexico City; Philadelphia Museum of Art; Phoenix Art Museum; Rivera Studio Museum, Mexico City; San Antonio Museum of Art, Texas; San Diego Museum of Art, California; San Francisco Museum of Modern Art;

Seattle Art Museum; Smith College Museum, Northampton, Massachusetts; St. Louis Museum; University of California, Berkeley; University of Texas, Austin; Vassar College Gallery of Art, Poughkeepsie, New York; Worcester Art Museum, Massachusetts.

Publications:

By RIVERA: Books—*La acción de los ricos yanquis y la servidumbre del obrero mexicano,* Mexico City, 1923; *Abraham Angel,* Mexico City, 1924; *Genius of America,* New York, 1931; *Portrait of America,* with Bertram D. Wolfe, New York, 1934; *Portrait of Mexico,* with Bertram D. Wolfe, New York, 1938; *My Art, My Life,* with Gladys March, New York, 1960; *Confesiones,* edited by Luis Suarez, Mexico City, 1962.

On RIVERA: Books—*Los pintores Gonzalo Arquelles Bringas y Rivera* by Jesus T. Acevedo, Mexico City, 1920; *Rivera y el pristinismo* by Eduardo Maceo y Arbeu, Mexico City, 1921; *Rivera y la filosofia del cubismo* by Martin Luis Guzman, Mexico City, 1921; *The Frescoes of Rivera* by Ernestine Evans, New York, 1929; *Rivera* by H. L. P. Weissing, Amsterdam, 1929; *The Frescoes of Rivera in Cuernavaca* by Emily Edwards, Mexico City, 1932; *The Frescoes of Rivera* by Jere Abbott, New York, 1933; *Frescoes in Chapingo by Rivera* by Carlos Merida, Mexico City, 1937; *Rivera: His Life and Times* by Bertram D. Wolfe, New York and London, 1939; *The Story of His Mural at the 1940 Golden Gate Exposition* by Dorothy Puccinelli, San Francisco, 1940; *Los dos Diegos* by Angel Guido, Rosario, Argentina, 1941; *Sus frescoes en el Instituto Nacional de Cardiologia* by Ignacio Chavez, Mexico City, 1946; *Rivera* by Elena A. Oleacha, Mexico City, 1946; *Rivera* by Bertram D. Wolfe, Washington, D.C., 1947; *Rivera* by Antonio Rodriguez, Mexico City, 1948; *Fifty Years of the Work of Rivera: Oils and Watercolors 1900–1950* by Enrique F. Gual, Mexico City, 1950; *La tecnica de Rivera en la pintura mural* by Juan O'Gorman, Mexico City, 1954; *Rivera y el arte en la revolución mejicana* by Jorge Enea Spilimbergo, Buenos Aires, 1954; *Rivera* by Hans Secker, Dresden, 1957; *Rivera: Sus frescos en el Palacio Nacional de Mexico* by Bernal Díaz del Castillo, Mexico City, 1958; *Rivera* by Samuel Ramos, Mexico City, 1958; *Rivera: Pintura mural* by Jorge Juan Crespo de la Serna, Mexico City, 1962; *Mexican History: Rivera's Frescoes in the National Palace and Elsewhere in Mexico City* by R. S. Silva, Mexico City, 1963; *The Fabulous Life of Rivera* by Bertram D. Wolfe, New York, 1963; *Rivera: The Shaping of an Artist 1889–1921* by Florence Arquin, Norman, Oklahoma, 1974; *Rivera* edited by Manuel Reyero, Mexico City, 1983; *The Murals of Rivera* by Desmond Rochfort, London, 1987; *Diego Rivera: A Retrospective* edited by Cynthia Newman Helms, New York, Norton, 1998; *Dreaming with His Eyes Open: A Life of Diego Rivera* by Patrick Marnham, New York, Knopf, 1998; *Diego Rivera* by Pete Hamill, New York, Abrams, 1999. **Articles**—"On Location with Diego Rivera" by Lucienne Bloch, in *Art in America,* 74, February 1986, pp. 103–121; "From Mexico to Montparnasse–and Back: An Ambitious Diego Rivera Retrospective Reveals the Mexican Painter's Lifelong Ambivalence toward European Modernist Art" by Edward J. Sullivan, in *Art in America,* 87(11), 1999.

* * *

Diego Rivera (1886–1957) is one of the most famous artists in the history of Latin America. One of *los tres grandes* (the three great

Diego Rivera: *Fall of the Aztec Empire,* **mural painting, Palace of Hernando Cortez, Cuernavaca, Morelos, Mexico. © Sergio Dorantes/Corbis.**

ones)–Rivera, José Clemente Orozco, and David Alfaro Siqueiros–he was the first to emerge definitively during the renaissance in Mexican mural painting that extended from 1922–when he began the art deco-like *Creación,* completed in early 1923, in the National Preparatory School–to the late 1940s. (The mural movement then enjoyed a sporadic afterlife until the 1970s.) Rivera's first gained international acclaim in the mid-1920s as a result of his magisterial epic modernist murals in the Secretaría de Educación in Mexico City (1923–28), the chapel of the National University of Argiculture at Chapingo (1926–27), the Palacio Cortés at Cuernavaca (1930), and the Palacio Nacional (1929–30, 1935) in Mexico City.

The 116 images at the Ministry of Education were executed in the little-used, labor-intensive medium of classic fresco, and they covered a staggering expanse of almost 1,600 square meters. The overarching themes of the murals, which occupy two entire court-yards, were *The Labors of the Mexican People* and *The Fiestas of the Mexican People.* The scholar Stanton L. Catlin has called them the counterpart in twentieth-century muralism to Masaccio's Brancacci Chapel in the quattrocentro. As such, the cycle self-consciously inaugurated an entirely different type of state-sponsored public art. To quote Rivera himself, "For the first time in the history of monumental painting, Mexican muralism ended the focus on gods, kings, and heads of state . . . [and] made the masses the hero of monumental art."

Moreover, the visual language in these commanding cycles was as original as the iconographic program was revolutionary. In them Rivera first used a form of epic modernism, a variation on the alternative modernism that marked off much avant-garde art in Latin America from that of western Europe. As Desmond Rochfort has contended, Rivera's language was historic because "in pictorially unifying the divergent cultural roots of his country's history . . . he created the first great example of post-colonial art." Yet Rivera never did what most art historians assume when they mistakenly call him a "nationalist," namely, present the Mexican nation as politically unified or ethnically harmonious.

In fact, Rivera's heterogeneous mural paintings always empha-sized the class divisions and ethnic differences among the Mexican people. For him national unity remained a future possibility, to be realized only after exploitation based on class divisions and racial distinctions had ended. His art was grounded in an unprecedented synthesis of non-Western and Western formal components, along with a careful attention to ethnographic detail as well as to social conflict. Thus, Rivera's hybrid and critical artworks disallowed precisely the type of "national harmony" presupposed by official nationalism in Mexico among government leaders who were his patrons, such as José Vasconcelos, minister of education in the early 1920s, or the caudillo Plutarco Calles in the late 1920s.

Nowhere is Rivera's hybrid aesthetic more evident than in his towering murals for the stairway of the Palacio Nacional, the office of Mexico's president, where he painted in a near life-size format *The History of Mexico: From the Conquest to the Future.* Compositionally, Rivera used the cubist collage framework, which allowed him to compress in close proximity unrelated events and disparate chrono-logical episodes, so that, in keeping with the conventional form of an epic, the spectator in medias res confronts a cavalcade of people over time. Similarly, Rivera was a master at forging a cohesive new style from the fragmentary parts of preexisting languages. In this case the merging of visual idioms began with the use of resolutely two-dimensional glyphs, a right-to-left way of "reading" history, and an

imbrication of parts linked to pre-Columbian forms such as screen-fold manuscripts like the *Codex Borbonicus,* from which Rivera borrowed the images of Quetzalcóatl. His style of epic modernism in the center section also drew on the tonal range, resonant palette, and diffused lighting of the Venetian school in the sixteenth century, when the conquest of Mexico had actually begun. In the final segment, on Mexico in the present, there is a quasi-cubist, gridlike partitioning of parts with a chilly, high-value matter-of-fact look that is combined with a combative form of figuration à la social realism. The whole "collage" is surmounted by a commanding portrait of Karl Marx pointing to a socially just future.

What this means is that Rivera, an epic modernist, was never simply a period social realist, however much he was engaged criti-cally with this manner of painting. Moreover, as a democratic socialist and an unorthodox Marxist with anarchist leanings, Rivera always denounced Soviet social realism as "boring art" that rou-tinely underestimated the intellectual sophistication of the popular classes. As a colorist, Rivera was surpassingly subtle and broad ranging, but he was not given to dramatic light and dark tonal contrasts, as were Orozco and Siqueiros. As a draftsman, he was one of the finest of the twentieth century. This was signaled early on by his precocious drawings done at age 12, for example, *Head of a Woman* (1898), shortly after he entered the National Academy of San Carlos.

Yet Rivera's fame has often led to numerous attacks. For example, Octavio Paz, the Mexican poet and man of letters, has contended that Rivera's work for the government translated into little more than ideological legitimacy for the established forces that constrained, rather than propelled, the revolutionary process on behalf of social transformation. At first such a reading is enticing, since it assumes that patronage for art predetermines the art produced. Yet such an assumption is hardly borne out by the facts, whether one locates the meaning of Rivera's murals in their images or in their popular reception. The murals in the presidential palace actually brought a forceful critique in 1934–35 from their patron, Calles, at a key moment when his hold on power was being contested. Moreover, period documents make clear that the response of mass organizations to Rivera's murals was often so militantly supportive that unions offset the opposition to the frescoes by prominent figures within the government. In short, the murals were not about mere ideological legitimacy for state patrons. Rather, Rivera's murals in the public sphere served as sites of ideological contention and negotiation among competing groups from various points on the political spec-trum that were vying for state power.

Because of Rivera's prodigious efforts as a muralist–he painted 15 major cycles in Mexico and 5 in the United States that, in total, cover almost 6,000 square meters of space–it is often forgotten how accomplished he was as an easel painter and as a draftsman. Yet the second volume of the catalogue raisonné produced by the Instituto Nacional de Bellas Artes lists at least 2,500 works on canvas and paper. This awe-inspiring total aside, the quality of the works varies greatly. Some of his high-society portraits for affluent patrons from the United States or Latin America are utterly vapid images that bespeak little identification on Rivera's part with his sitter. Yet other of his canvas paintings are outstanding in every respect. Such is the case with some of the 200 cubist paintings that he executed from 1913 to 1917, especially his masterful *Zapatista Landscape: The Guerrilla* (1915), in the Museo Nacional de Arte. This painting, as much as any other from the period, helps us to appreciate the observation by Antonio Castro Leal that "Diego Rivera occupies a place in painting

that corresponds to the one of Rubén Darío in poetry.'' Thus, just as Darío, who coined the word ''modernism'' around 1890, inaugurated modern poetry in Latin America, so Rivera was a founding figure for modernist painting in Latin America.

—David Craven

ROCHE (RABELL), Arnaldo
American painter

Born: Santurce, Puerto Rico, 1955. **Education:** University of Puerto Rico, School of Architecture, 1974–78; School of the Art Institute of Chicago (James Nelson Raymond fellow), 1979–84, B.F.A. 1982, M.F.A. 1984. **Career:** Lived in Chicago, 1980s; returned to San Juan, 1994. **Awards:** Medallion of Lincoln Award, presented by Mr. James Thompson, Governor of the State of Illinois, 1981; Third prize, *Bienal internacional de pinturas,* Cuenca, Ecuador, 1989; Award in the Visual Arts 10, New York, 1991; Premio Pintura, Muestra Nacional de Pintura y Escultura, Museo de Arte Contemporáneo de Puerto Rico, San Juan, 1991; Gran Premio Pintura, *I bienal internacional de arte de Cumaná,* Museo de Arte Contemporáneo de Cumaná, Venezuela, 1998.

Individual Exhibitions:

1983	James Varchmin Gallery, Chicago
	Contemporary Art Workshop, Chicago
1984	*Actos Compulsivos,* Museo de Arte de Ponce, Ponce, Puerto Rico
1986	*Eventos, Milagros y Visiones,* University of Puerto Rico Art Museum, Rio Piedras
1989	Galería Botello, Hato Rey, Puerto Rico
1990	*Espiritus,* Galería Botello, Hato Rey, Puerto Rico
	Frumkin/Adams Gallery, New York
1991	*El Ojo del Huracán,* Galería Botello, Hato Rey, Puerto Rico
	Raptos, Museo Casa Roig, Humacao, Puerto Rico
	Frumkin/Adams Gallery, New York
	Lisa Sette Gallery, Scottsdale, Arizona
	Frenetic Dreams, Organization of American States, Washington, D.C.
	Illuminaciones, Galería Alejandro Gallo, Guadalajara (traveling)
1992	Chicago International Art Exposition
	Galería Alejandro Gallo, Mexico
	Frumkin/Adams Gallery, New York
1993	*Los Primeros Diez Años,* MARCO, Monterrey, Mexico
	Pinturas y Dibujos, Galería Botelo, Hato Rey, Puerto Rico
	Frumkin/Adams Gallery, New York
1994	*Fuegos,* Museo de Arte Contemporaneo de Puerto Rico
	Cantares, Galería Botello, Hato Rey, Puerto Rico
	The Legacy, Frumkin/Adams Gallery, New York
1995	Museo Arte Moderno, Mexico
	Elite Fine Art, Coral Gables, Florida
1996	*Entre la vida y la muerte,* Galería Botello, Hato Rey, Puerto Rico

Arnaldo Roche: *Vincent Under the Bell,* **1994. Photo courtesy of George Adams Gallery, New York.**

	Festivales Internacionales, Lima
	Face to Face, George Adams Gallery, New York
	Art in Chicago 1945–1995, Museum of Contemporary Art, Chicago
	Arnaldo Roche-Rabell: The Uncommonwealth, Anderson Gallery, Virginia Commonwealth University, Richmond, Virginia (traveling)
1997	*Feria Iberoamericana de Arte,* Caracas, Venezuela
	Arnaldo Roche-Rabell: Nómada del espiritu a la materia, Fundación Museo de Bellas Artes, Caracas and Museo de Arte de Ponce, Ponce, Puerto Rico
2000	*Vuelta a la intimidad. El jardín de mi padre,* Galería Botello, San Juan
	Adentro y afuera, A. Cueto Gallery, San Juan
2001	*Back to Intimacy: My Father's Garden,* Galeria Botello, Hato Rey, Puerto Rico

Selected Group Exhibitions:

1985	*Chicago and Vicinity Show,* Art Institute of Chicago
1986	*Ocho de los Ochenta,* Arsenal de la Puntilla, San Juan, Puerto Rico
	Made in America-The Great Lakes State, Alternative Museum, New York
1987	*Hispanic Art in the United States: Thirty Contemporary Painters and Sculptors,* Museum of Fine Arts, Houston (traveling)

Art of the Fantastic Latin America 1920–1987, Museum of the Art, Indianapolis, Indiana (traveling)

Puerto Rican Painting: Between Past and Present, Museum of Modern Art of Latin America, Washington, D.C. (traveling)

1989 *Chicago Artists in the European Tradition,* Museum of Contemporary Art, Chicago

1995 *Caribbean Visions: Contemporary Paintings and Sculptures,* Center of Fine Arts, Miami

Encuentro Interamericano de Artistas Plásticos, Museo de las Artes, Guadalajara, Mexico

1998 *El papel del papel/The Role of Paper,* Guadalupe Cultural Arts Center, San Antonio, Texas

1999 *Saints, Sinners and Sacrifices: Religious Imagery in Contemporary Latin American Art,* George Adams Gallery

2000 *La Luz: Contemporary Latino Art in the United States,* National Hispanic Cultural Center of New Mexico, Albuquerque

Anthology of Puerto Rican Art, UNESCO, Fontenoy Palace, Paris

2001 *Humor and Rage–5 Contemporary Painters from the United States,* Fundacio Caixa Catalunya, Barcelona

Collections:

Metropolitan Museum of Art, New York; Hirshhorn Museum, Washington, D.C.; Art Institute of Chicago; Art Museum, Rhode Island School of Design, Providence; Indianapolis Museum of Art, Indiana; Museo de Arte Contemporaneo de Puerto Rico, San Juan; Museo de Arte de Ponce, Puerto Rico; Museo de Arte Moderno, Cuenca, Ecuador; El Museo del Barrio, New York; Museum of Fine Arts, Houston; Tucson Museum of Art, Arizona; University of Texas, Austin; Arkansas Arts Center, Little Rock; Bacardi Art Foundation, Miami; Carson, Pirie, Scott & Co., Chicago; Chase Manhattan Bank, New York City; Luis Munoz Marin Foundation, San Juan; Museum of Fine Art, Springfield; Archer Huntington Art Gallery, University of Texas at Austin; Art Museum, University of Arizona Tempe.

Publications:

On ROCHE: Books—*Arnaldo Roche Rabell: Actos compulsivos,* exhibition catalog, Museo de Arte de Ponce, Ponce, Puerto Rico, 1984; *Arnaldo Roche Rabell: Eventos, milagros y visiones,* exhibition catalog, Museo de la Universidad de Puerto Rico, San Juan, Puerto Rico, 1986; *Ocho de los ochenta,* essay by Teresa Tió, Arsenal de la Marina, San Juan, Puerto Rico, 1986; *Hispanic Art in the United States: Thirty Contemporary Painters and Sculptors,* exhibition catalog, by John Beardsley and Jane Livingston, Abbeville Press, New York, 1987; *Arnaldo Roche-Rabell: The Uncommonwealth* by Robert Carleton Hobbs, Anderson Gallery, School of the Arts, Virginia Commonwealth University, Richmond, Virginia, 1996. **Articles**—''Arnaldo Roche Rabell'' by Jeff Abell, in *New Art Examiner,* 11, February 1984, p. 15; ''The Personal View of Roche Rabell'' by Myrna Rodríguez, in *San Juan Star Magazine,* 29 July 1984, p. 7; ''The Strangers at Hand: Miguel Von Dangel, José Bedia, and Arnaldo Roche Rabell'' by Ricardo Pau-Llosa, in *Drawing,* 16, January/February 1995, pp. 102–105; ''Arnaldo Roche Rabell'' by

Antonio Espinosa, in *Art Nexus* (Colombia), 17, July/September 1995, pp. 101–102; interview by Federica Palomero, in *Art Nexus* (Colombia), 29, August/October 1998, pp. 48–53.

* * *

Since the 1970s Arnaldo Roche Rabell has produced emotionally charged works, most of monumental size, that explore issues of cultural identity and intense personal experiences. In his portrayal of cultural themes the artist reflects on being Puerto Rican. Sometimes he speaks of the complex relationship between the United States and the Caribbean Commonwealth, at other times of being mulatto and living in both countries, belonging to both and sometimes to neither. He also represents the mysteries of the psyche, using his own self as the protagonist of an intense visual artistic drama. He depicts tortuous scenes, a reflection of his personal conflicts and life's harsh experiences (his life was dramatically affected by tragic events that included the accidental death of his younger sister and his brother's struggle with mental illness and untimely death) as if they were nightmares. The close relationship with his mother, one of his favorite role models, is also one of his most represented subjects. But no matter whether in self-portraits or in depicting political, biblical, or mythological subjects, all of his works are predicated on and totally connected to the artist's inner self. All of his paintings depict the conflicting nature of Roche.

A technique Roche has used in many of his works involves a complex ritualistic process as important as the symbolic iconography he creates. His frottage technique entails draping either a figure or object with canvas or prepared paper to create the basis for his paintings and then rubbing the form beneath with his hands, spatulas, and other devices. He also applies layers of bright colors to a canvas, covers them in black, and then scrapes the surface with a pallet knife to create or uncover dramatic images. Roche describes his process as ''ritualistic human interaction'' with the intention ''to discover myself.'' The use of the frottage technique itself seems to have an effect on the artist's creative impulses. One can visualize his artistic process, his mind in motion as he is rubbing, scratching, and painting the surfaces to express the imagery of his conscious and subconscious mind. The technical process and the themes represented are cathartic for the artist. He manipulates the medium to push the limits of expression. His works overpower the viewer with an abundance of color and profusion of imagery. This symbiotic relationship between the process and the thematic and symbolic development brings to mind the life and art of the Venezuelan modernist painter Armando Reverón. The reclusive Reverón is known for painting as if in a trance, attacking the canvas with rhythmic and aggressive movements. While his ''impressionist'' style is quite different from Roche's ''expressionistic'' visions, both share an aggressive and frenzied approach to the medium in pursuit of the spiritual, the fantastic, the chaotic, and the lyrical.

Roche has been called a neoexpressionist, and in the interest of defining an artist's work the title might fit in a number of ways. His paintings are characterized by the aggressive treatment of their materials and a profound subjectivity of emotion. He comments, ''I do not call it violence, I call it intensity.'' Also, his figures often seem to be hidden or lost in the intensity of the activity of the surface. He is a studied artist, technically and academically. His mastery of the techniques of painting, drawing, and printing allows him to exploit them fully in order to express the profundity of his emotions. His

knowledge of art history provides him, on a conscious or unconscious level, with visual references from which to draw imagery and inspiration. The demons and angels in his oeuvre remind us of Goya's nightmarish visions. The corporeal figures in movement are reminiscent of the classical bodies painted by Michelangelo. The expressive and powerful colors of his canvases are as emotive as Caravaggio's, and his dense tropical foliage is suggestive of that created by the Cuban Wifredo Lam.

Roche's best-known works are self-portraits, close-up images of his face. They are works posing existential questions and searches. The figures rendered are always close to the edges, with an in-your-face effect. Roche intends to move the spectator, to draw the viewer into the painting and provoke a reaction. His continual inner dialogue is shared with all of us. The mulatto artist often paints himself with crystalline blue eyes that hypnotize the viewer. The eyes become symbols of the cultural confrontations caused by his mixed heritage in an adoptive land. They also appear to be passages to a realm of dreams and fantasies as powerful as the artist's reality. Roche's works are journeys into his own psyche, a spiritual search in which the viewer encounters layers of symbolic meaning that range from the deeply personal to the political. The persona we encounter in his work is that of a complex man living in a magical world of dreams and a Puerto Rican struggling to define his role and place in his native island and his adoptive home in the United States.

—Tariana Navas-Nieves

RODÓN, Francisco
American painter

Born: San Sebastián, Puerto Rico, 6 June 1934. **Education:** Academie Julien, Paris, 1953; La Esmeralda, Mexico City, 1955; Art Students League, New York, 1958; Taller de Artes Gráfica del Instituto de Cultura Puertorriqueña, San Juan, 1959; also studied at Academia de San Fernando, Madrid, c. 1950s. **Career:** Traveled to Central America and Mexico on scholarship, 1952–53. Instructor, 1963, and resident painter, 1968, Universidad de Puerto Rico, Río Piedras. **Awards:** First prize in painting, 1960, 1962, and second prize in painting, 1961, *Ateneo puertorriqueño;* grand prize in painting, *II salón pintura UNESCO,* 1972; Medalla Francisco Oller, Instituto de Cultura Puertorriqueña, 1983.

Individual Exhibitions:

1961 Instituto de Cultura Puertorriqueña, San Juan
1963 Museo de la Universidad de Puerto Rico, Río Piedras
1967 Museo de la Universidad de Puerto Rico, Río Piedras
1970 *Botero-Coronel-Rodón,* Museo de la Universidad de
 Puerto Rico, Río Piedras
1980 Centro de Convenciones, San Juan
1981 Museo de la Universidad de Puerto Rico, Río Piedras
1984 *Personajes de Rodón,* Museo de la Universidad de
 Puerto Rico, Río Piedras
1994 *Rodón: Las visiones secretas,* Museo José Luis Cuevas,
 Mexico (retrospective)
1998 Museo de Arte de Ponce, Puerto Rico (retrospective)

Selected Group Exhibitions:

1961 *Arte contemporáneo de Puerto Rico,* Universidad de
 Puerto Rico, Río Piedras
1972 *Pintura puertorriqueña,* Museo de la Universidad de
 Puerto Rico, Río Piedras
1974 *Grandes creadores del continente,* Galería Estudio
 Actual, Caracas
1978 *Arte iberoamericano de hoy,* Museo de Bellas Artes,
 Caracas
1979 *Exposición inaugural,* Museo de Arte e Historia, San
 Juan
1983 *VI bienal de San Juan del grabado latinoamericano,*
 Instituto de Cultura Puertorriqueña, San Juan
1986 *25 años de pintura puertorriqueña,* Museo de Arte de
 Ponce, Puerto Rico, and Museo de Bellas Artes del
 Instituto de Cultura Puertorriqueña, San Juan
1987 *Puerto Rican Painting: Between Past and Present,*
 Museum of Modern Art of Latin America, Washington, D.C. (traveling)
1989 *Pintura y escultura de los años setenta en Puerto Rico,*
 Museo de Arte Contemporáneo, Santurce, Puerto Rico
 The Latin American Spirit: Art & Artists in the U.S.,
 Bronx Museum, New York

Collections:

Art Institute of Chicago; Ateneo Puertorriqueño, San Juan; Fogg Art Museum, Cambridge, Massachusetts; Instituto de Cultura Puertorriqueña, San Juan; Interamerican University, San Germán, Puerto Rico; Metropolitan Museum of Art, New York; Metropolitan Museum of Art and Art Center, Coral Gables, Florida; El Museo del Barrio, New York; Museum of Modern Art, New York; Museo de Arte de Ponce, Puerto Rico; Universidad de Puerto Rico, San Juan; Universidad de Puerto Rico, Río Piedras.

Publications:

By RODÓN: Article—''Mi recuerdo de Borges,'' in *Quimera* (Barcelona, Spain), 32, October 1983, pp. 8–13.

On RODÓN: Books—*Personajes de Rodón (1971–1983),* exhibition catalog, Río Piedras, Puerto Rico, Universidad de Puerto Rico, 1983; *Campeche, Oller, Rodón: Tres siglos de pintura puertorriqueña,* exhibition catalog, with text by Francisco J. Barrenechea, San Juan, Instituto de Cultura Puertorriqueña, 1992; *Rodón: Las visiones secretas,* exhibition catalog, text by Francisco J. Barrenechea and Marimar Benítez, Mexico, Museo José Luis Cuevas, 1994; *Rodón: Un nuevo amanecer,* exhibition catalog, Ponce, Puerto Rico, Museo de Arte de Ponce, 1998. **Articles**—''Rodón'' by Samuel Cherson, in *El Nuevo Día* (San Juan), 11 December 1983, pp. 6–11; ''Francisco Rodón, o el ejercicio del poder'' by Efraín Barradas, in *Claridad* (San Juan), May 1984, pp. 26–27; ''Francisco Rodón: Museo de Arte de Ponce'' by Manuel Alvarez Lezama, in *Art Nexus* (Colombia), 30, November 1998/January 1999, pp. 140–141.

* * *

Francisco Rodón was born into an upper-class family in San Sebastián, Puerto Rico. Essentially self-taught, he briefly studied art

in the 1950s at the Academia de San Fernando in Madrid, the Academia La Esmeralda in Mexico City, and the Art Students League of New York. While in Spain Rodón studied the work of Velázquez, Ribera, and Goya; he was particularly taken with the fusion of psychological penetration and painterly bravura in their portraits. In New York City Rodón met the painter and teacher Hans Hofmann, who interested him in painterly surface and abstraction and whose advice he followed.

Back in his native Puerto Rico in 1959, Rodón studied graphic arts under Lorenzo Homar, director of the Taller de Artes Gráficas at the Instituto de Cultura Puertorriqueña. By 1962–63 Rodón had developed the visual vocabulary in which he would work for the rest of his life. This vocabulary consists of monumental canvases painted with both the vigor and abandon of abstract expressionism, and yet the works are figurative. Whether portraits, landscapes, or still lifes, they are endowed with great emotional intensity. His first significant group of paintings is the *Estampa vigilante* series (1963–68, based on childhood photos of his dead mother) and the triptych *Homenaje a Rubén Darío: agonía, muerte y transfiguración* (1971–72). Since the 1970s Rodón has focused on portraiture, executing a virtual gallery of Latin American personages. These oils on canvas are practically mural sized, filled with dramatic color and bold gesture, and always painted from life. From *Marta Traba* (1971–72) to *Borges o El Aleph* (1973–80) to the portraits of politicians such as Luis Muñoz Marín (1974–77) and Rómulo Betancourt (1977–79), Rodón captured in the sitters' faces not only their achievements, but also their failures and the inevitable passage of time.

Rodón's importance as an artist rests in his creation of a portraiture style that formally synthesizes the painterly vigor of abstract expressionism with acute psychological penetration.

—Alejandro Anreus

RODRÍGUEZ (SIBAJA), Juan Luis
Costa Rican painter and engraver

Born: San José, 1934. **Eduation:** Casa del Artista de San José, 1950; studied engraving, National School of Beautiful Arts, Paris (on scholarship), 1960; Free Academy of La Haya, Holland, 1961. **Career:** Coordinator, Taller de Grabado, Universidad de Costa Rica, 1972–90. **Awards:** Gold medal, *I salón anual de artes plásticas,* Museo Nacional de Costa Rica, 1973; Premio Aquileo J. Echeverría and Premio Ancora de Oro, *La Nación,* 1975; Premio Unico del Salón de los Maestros, *VI bienal L y S de pintura costarricense,* 1994.

Individual Exhibitions:

1957	USA/Costa Rica Cultural Center, San José
1964	Galería Horn, Luxemburg
	Galería Club Ibero-Americano, Bonn, Germany
1967	Hospital Belle-Isle, Metz, France
1974	Museo Nacional en San José (retrospective)
1976	Instituto Nacional de Seguros, San José
1995	*El combate,* Salas de Exposiciones Temporales de los Museos del Banco Central de San José

Selected Group Exhibitions:

1969	*IX biennale de París,* Museum of Modern Art of Paris
1979	*IV bienal del grabado latinoamericano,* Instituto de Cultura Puertorriqueño, Universidad de Costa Rica, San José
1984	*I bienal de la Habana,* Havana
1990	*Grafix aus Costa Rica,* IFA Galerie, Instituto fur Auslandsbeziehungen, Bonn, Germany
1992	*Kunst aus Costa Rica,* Sprengel Museum, Hannover, Germany (traveling)
	X bienal de gravura, Museu de Gravura, Curitiba, Brazil
1994	*Primera bienal de grabado europeo,* Espacio Cultural de Lorient, Brittany, France
1995	*Semana de la cultura centroamericana en Europe,* Museos del Banco Central, San José
1996	*VI bienal L y S de pintura costarricense,* Premio Unico Salón de Maestros, Costa Rica
	XXIII bienal de São Paulo, Brazil

Publications:

By RODRÍGUEZ: Book—*Los amores del diablo,* San José, Editorial Universidad Estatal a Distancia, 1995.

On RODRÍGUEZ: Book—*Juan Luis Rodríguez Sibaja: El combate,* exhibition catalog, text by Ileana Alvarado Venegas, San José, Museos de Banco Central de Costa Rica, 1995.

* * *

One could say that Juan Luis Rodríguez Sibaja was the artist who broke with what might be considered Costa Rican modernism, however weak that movement may have been. Although he has produced little work since the mid-1970s, his influence on the generation immediately following him is still visible, not in the formal aspects of any given artist's production but in his attitude toward art and the function of the artist. His influence also can be seen in his irreverent position toward the local self-image, a social and political construct inherited from the nineteenth century and not subject to questioning at the time but something that would start to break apart a few years later. Corrosive, sarcastic, and definitely an uncomfortable personality, Rodríguez dedicated much of his time to investigate deeply and to experiment in graphics, thanks to a scholarship from the French government during 1960 and 1961. Nonetheless, he always remained close to painting. Many of the themes developed in his pictorial works had already been studied in detail in his etchings, and the materic paintings he engaged in, using heavily structured surfaces in which nonpictorial matter such as sand, dust, and pieces of wood were applied to the canvas, were more adequate to the explosion of energy and the polarization of forces present in his wall assemblages.

After the end of his scholarship he struggled to be able to stay in Europe and started to pick up discarded materials and refuse to produce his paintings, integrating anything that could function as a pigment—sand, ashes, wood chips—and applying it directly onto rugged surfaces. This marked all of his future work, and the use of "poor," nonpictorial elements not only drove him close to the *arte povera* movement but also to the materic painters of the time. His was

not a merely formalist position; there was a real transformation of the *povera*-type materials from their humble origin toward a deep symbolic signification. Coming from a poor family and having had a deprived childhood in which he resorted even to constructing his own toys, Rodríguez worked to pay for his studies and contribute to his family. He never forgot his past, and his work never had the complacent character of much of the local Costa Rican art. His paintings, even before he traveled to France, were already heavy with an interior pressure that resulted in austere yet complex compositions. During his sojourn in France he realized several important public commissions: two mosaics, one for the hospital in Belle Isle, Metz, and another for the College Supérieur in Annemasse; a mural for the Gagarine gymnasium in Orly; and his major piece done for the lyceum in Illestre, in the French Alps, a kind of retention wall with a pyramid that followed the surrounding landscape, created a small mountain, and integrated multicolored mosaic fragments.

Rodríguez also worked on large-scale installation projects in Paris in the late 1960s and early 1970s, dealing brutally with the idea of power and authority. One of the installations, *Combat*–a virtual boxing match put up outside the Grand Palais–received recognition at the Biennale de Paris in 1969. Two large chairs made of red-tinted ice were placed at the corners of a boxing ring. Over a loudspeaker the public could hear interviews with former champions as well as recordings of the screaming public during a match at the Palais des Sports. The chairs progressively melted, leaving only red pools of ''blood'' on the white arena. A second version of the installation eliminated the chairs and placed a question mark made of red ice in the center of the ring. For the São Paulo Biennale of 1996, to subvert the theme of the biennial, the ''dematerialization of art,'' and to comment on the power of art structures and their temporality, a third version of the piece was produced under the auspices of the Contemporary Art and Design Museum of San José. In this version a pyramid of black ice blocks topped by a question mark in red ice was installed in the garden adjacent to the Niemeyer building. This was put up on the afternoon of the opening, on a bed of dry ice, allowing it to melt during the three or four following days. This ephemeral piece was accompanied by a series of poems by the artist, written crudely with graphite on handmade banana paper and held on the wall with pins in the main exhibition space.

All of Rodríguez's work is deeply immersed in the human condition and its relation to manipulation by power structures of all sorts, whether in the political, economical, or artistic domain. A constant ironic vein runs throughout, a characteristic absent from most of the former artistic development in Costa Rica and a trait that has translated into a suspicious attitude on the part of younger artists in relation to the accepted status quo and the demagogic discourses legitimated by the official culture. In fact, Rodríguez, maybe even against his own will, paved the way for many of the artists of the 1990s.

—Virginia Pérez-Ratton

RODRÍGUEZ, Mariano
Cuban painter

Born: José Mariano Manuel Rodríguez Alvarez, Havana, 24 August 1912. **Education:** Escuela de Artes Plásticas San Alejandro, Havana, c. 1928. **Career:** Artistic director and illustrator, *Ritmo* magazine,

Havana, 1936; worked for painter Rodriguez Lozano, Mexico, 1936–37; assistant professor, Escuela Libre de Pintura, Cuba, 1937; director of art, Casa de las Américas, Havana, 1962. Worked as a magazine and book illustrator. Cofounder, Asociación de Pintores y Escultores de Cuba (APEC), 1948. Traveled to New York, 1944, 1945, 1946, 1948; to Europe and the United States, 1957; to Europe, 1964; to Canada and Mexico, 1967; to Finland, Sweden, and France, 1969; to Chile, 1970, 1972; to Jamaica, 1974; to Mexico, 1975, 1976; to Costa Rica and Europe, 1977; to Nicaragua, 1982; to Portugal, 1984. **Awards:** Prize in painting, *IV salón nacional de pintura, escultura y grabado,* 1950. Orden Félix Varela de primer grado, Consejo de Estado de la República de Cuba, 1981; diploma, Museo Nacional, Palacio de Bellas Artes, Cuba, 1983; Doctor Honoris Causa in art, Instituto Superior de Arte, 1989; Medalla Haydée Santamaría, 1989. **Died:** Havana, 26 May 1990.

Individual Exhibitions:

1939	Lyceum, Havana (with René Portocarrero and Alfredo Lozano)
1943	Lyceum, Havana
	Brooklyn Museum, New York
	San Francisco Museum of Art
1944	Lyceum, Havana
1945	Feigl Gallery, New York
1946	Feigl Gallery, New York
1948	Feigl Gallery, New York
1949	*Lozano-Mariano,* Lyceum, Havana (with Lozano)
1951	*Mariano. Recent Works,* Feigl Gallery, New York
1952	Lyceum, Havana (with Lozano)
1953	*Los gallos de Mariano,* Lyceum, Havana
1955	*Mariano,* Galería Cubana, Havana
	Lyceum, Havana (retrospective)
1957	Lyceum, Havana
1958	Museo de Bellas Artes, Caracas, Venezuela
	Centro de Bellas Artes, Maracaibo, Venezuela
1962	*Exposición de Mariano,* Galería de la Habana, Havana
	Biblioteca Roberto García, Cienfuegos, Las Villas, Cuba
1963	*Mariano. Oleos y dibujos del 63,* Galería de la Habana, Havana
1964	*El artista del mes: Marinao,* Museo Nacional, Havana
1965	Galería de la Habana, Havana
1966	*The Exhibition of the Cuban Painter Mariano,* Galería Atelier, Cairo
1971	*Mariano. Frutas y realidad, oleos y dibujos,* Museo Nacional, Havana
1975	Museo Nacional, Havana (retrospective)
1976	Museo Histórico Provincial de Villa Clara, Santa Clara, Cuba
1977	*Mariano expone gallos y masas en Calzada y ocho,* Casa de la Cultura Plaza, Havana
1980	*Las masas . . . y el vedado. Mariano Rodríguez,* Museo Nacional, Havana
1981	Museo de Arte Moderno, Bosque de Chapultepec, Mexico City (retrospective)
	Homenaje a Mariano, Martínez Pedro y Portocarrero, Casa de la Cultura de Plaza, Havana
1982	Galería Habana, Havana
1982	*Reinauguración del mural y exposición de Mariano Rodríguez,* Galería L. La Habana, Havana

Mariano: Gallos y masas, Galería de Arte, Morón,
 Camagüey, Cuba
1983 *Mariano: Pintor de Cuba,* Centro de Artes del Colegio
 de Arquitectos, Núcleo de Pichincha, Quito, Ecuador
1984 *Marinao Rodríguez. Retrospectiva 1937–1983,* Semana
 de la Cultura Cubana en la URSS, Casa Central de
 los Pintores, Moscow
 Galería de Arte Servando Cabrera Moreno, Havana
1987 Galería Habana, Havana
 El artista del mes: Mariano, Museo Nacional, Havana
 *Mariano Rodríguez: Exposición homenaje en el 75
 aniversario del artista,* Museo Municipal, Havana
 Mariano, Museo Emilio Bacardí, Santiago de Cuba
1988 *Mariano uno y múltiple,* Centro Cultural de la
 Cajacanarias, Santa Cruz de Tenerife, Canary Islands
1991 *Mariano, exposición obras escogidas (1937–1990),*
 Museo Nacional, Havana
1992 *Mariano Rodríguez,* Casa de Bastidas, Santo Domingo,
 Dominican Republic
1998 *Mariano, una energía voluptuosa,* Museo Nacional/Casa
 de las Américas, Havana (retrospective)

Selected Group Exhibitions:

1938 *II exposición nacional de pintura y escultura,* Castillo
 de la Real Fuerza, Cuba
1940 *300 años de arte en Cuba,* Universidad de la Habana,
 Havana
1941 *Arte cubano contemporáneo,* Capitolio Nacional,
 Havana
1943 *International Water Color Exhibition Twelfth Biennal,*
 Brooklyn Museum, New York
 Primer salón internacional de acuarelas y gouaches,
 Institución Hispano-Cubana de Cultura, Havana
1944 *Modern Cuban Painters,* Museum of Modern Art, New
 York
1946 *Exposición de pintura cubana moderna,* Palacio de
 Bellas Artes, Mexico City
1951 *Art cubain contemporain,* Museum of Modern Art, Paris

Collections:

Museum of Modern Art, New York; San Francisco Museum; Art
Institute of Chicago; Museum of Modern Art, Paris; Art Gallery,
Stockholm; Museo de Bellas Artes, Argentina.

Publications:

By RODRÍGUEZ: Book—*Tiempo de ciclón,* with Roberto Pérez
León, Virgilio Piñero, and Fayad Jamís, Havana, Unión de Escritores
y Artistas de Cuba, 1991. **Books, illustrated—***Poesías I. Elegías* by
Lorenzo García Vega, Havana, Ediciones Origenes, 1948; *Céspedes,
el precursor* by Rafael Esténger, Havana, n.p., 1949; *La calzada de
Jesús del Monte* by Eliseo Diego, Havana, n.p., 1949; *Vida de Martí
con lecturas complementarias* by Rafael Esténger, Havana, Ediciones
Mirador, 1953.

On RODRÍGUEZ: Books—*Pintores cubanos,* Havana, Ed.
Revolución, 1962; *Pintura cubana* by Graziella Pogolotti, Havana,
Galería La Acacia, 1991; *Mariano, una energía voluptuosa,* exhibi-
tion catalog, Havana, Museo Nacional/Casa de las Américas, 1998;
Bibliografía de Mariano Rodríguez by Lázaro Rolo and José Veigas,
Havana, Biblioteca Nacional José Martí, 1999; *Todos los colores de
Mariano: Mariano Rodríguez, 1912–1990,* exhibition catalog, Mex-
ico, CONACULTA, 2000. **Article—**''Mariano Rodríguez: Casa de
las Américas'' by Miguel González, in *Art Nexus* (Colombia), 30,
November 1998/January 1999, p. 133.

* * *

The rise of modernism in Cuba was, in many ways, a reaction
against the artistic establishment. Young artists of the 1920s began to
question the validity of traditional (and European) approaches to style
and content. Like their contemporaries in Europe, they began to
explore new ways of representation. These avant-garde artists contin-
ued to travel to Europe and especially to the art capital Paris. Unlike
their predecessors, however, they did not focus on French Academy
artists but rather on the radical and new accomplishments of the
fauvists, the cubists, and the surrealists.

The avant-garde period in Cuba, from the 1920s through the
1940s, saw two generations of artists reacting to factors both at home
and abroad. From their increased awareness of artistic changes in
Europe to their attempt to redefine themselves outside the political
and economic sphere of the United States, these poets, writers,
composers, and artists broke down the walls of established traditions
in an effort to establish what it was to be ''Cuban.''

Like other Cuban artists of his generation (Mario Carreño, René
Portocarrero, Antonio Gattorno, and Carlos Enríquez), Mariano
Rodríguez was especially aware of the power of color. Mariano (as he
signed himself and as he is known) was frustrated with his experience
at the Academia de San Alejandro and traveled in 1936 to Mexico,
where he met the painter Rodríguez Lozano, who was to help the
young artist. Mariano returned to Cuba and devoted himself to the
development of his painting. His abilities were recognized early and
in 1937 he was appointed adjunct instructor of the Estudio Libre by
Eduardo Abela. From the 1940s forward Mariano devoted himself
almost exclusively to three themes: roosters, life on the small farm,
and lovers. In his *Dos Figures* (1957, in the Jay and Anita Hyman
Collection), the theme of lovers is represented. The monumental male
and female figures, set within a landscape, are as much about form as
they are about color. The figures have been broken down into patches
of color, a technique not unlike that which Cézanne used in his
canvases. These patches serve to energize the composition. Color
vibrates against color. Yet the monumentality of the figures helps to
stabilize the entire painting. The figures have mass and gravity as they
stand firmly within this landscape. *Gallo* (1956) demonstrates this
same interest in patches of color but here they are broader and flatter.
The result is an almost cubist version of a rooster, reminiscent of
Pablo Picasso or Wifredo Lam. Mariano's expressive and colorful
roosters became symbols of national pride, assertiveness, and inde-
pendence. Indeed, the rooster became almost a national symbol of
Cuba, and Mariano represented them frequently.

Mariano's work was immediately recognized for its personal
approach to the treatment of color and form. He was avidly collected
during his lifetime, and the acquisition of one of his works by New
York's Museum of Modern Art in the early 1940s established him
early in his career as an artist to watch. Always independent, Mariano
did not follow his fellow artists in their pursuit of New York–based
abstract expressionism in the 1950s or pop art tendencies in the 1960s.

Instead, he continued his exploration of those themes for which he became known and persistently explored the power of color in his work. The final result of his work was the establishment of the image of the farmer, lovers, and especially the rooster as icons of early avant-garde Cuban art.

—Sean M. Ulmer

RODRÍGUEZ, Patricia
American painter and assemblage artist

Born: Marfa, Texas, 1944. **Education:** San Francisco Art Institute, B.F.A.; Sacramento State University, California, M.A. in painting. **Career:** Involved with the mural movement in San Francisco, 1970s. Cofounder and member, *Mujeres Muralistas,* 1972–77. Instructor, University of California, 1975–78.

Individual Exhibitions:

1980 Mission Cultural Center, San Francisco
1986 La Posada Gallery, Sacramento, California
1987 Manuelitas Gallery, San Francisco
1990 Sonoma State University, California

Selected Group Exhibitions:

1974 Galeria de la Raza, San Francisco
1977 University of California, Berkeley
1984 University of Texas, Austin
1986 Museum of Contemporary Hispanic Art, New York (traveling)
1988 Mexican Museum, San Francisco
1990 University of California, Los Angeles
1993 Fine Arts Center Museum, Chicago
1994 Women's Center Gallery, University of California, Santa Barbara
1995 Northern New Mexico Community College, Española
2000 *La flor y la calavera: Altars and Offerings for the Days of the Dead,* Oakland Museum, California

Collections:

Mexican Museum, San Francisco; Hayward State University, California; Galeria de la Raza, San Francisco; La Posada Gallery, Sacramento, California; Arts Council of the Museum of Modern Art, New York; University of California, Berkeley.

Publications:

On RODRÍGUEZ: Books—*Artistas Chicanas: A Symposium on the Experience and Expression of Chicana Artists,* Santa Barbara, California, University of California, 1991; *Women Artists: Multi-Cultural Visions* by Betty LaDuke, Trenton, New Jersey, Red Sea Press, 1992; *Signs from the Heart: California Chicano Murals* by Eva Sperling Cockcroft and Holly Barnet-Sánchez, Venice, California, Social and Public Art Resource Center, and Albuquerque, University of New Mexico Press, 1993; *Latin American Women Artists of the United States: The Works of 33 Twentieth-Century Women* by Robert Henkes, Jefferson, North Carolina, McFarland, 1999.

* * *

The inspiration behind Patricia Rodríguez's artwork is her childhood recollections, specifically the memories of celebrations and festivities in the Chicano community. As a girl, Rodríguez observed her grandmother preparing for such events months in advance, creating colorful pillowcases, embroidery, pot holders, and doilies. Copies of these items would later be incorporated into Rodríguez's installations. Rodríguez was enthralled with creating things at a young age: "I can remember being creative ever since I was a child ... the earliest thing I can remember is being at a neighbor's house ... and creating a dress and trying to sew it. Actually I didn't sew it because when the lady tried to put the dress on the doll, it came apart. But it was a dress that had two parts to it which was very interesting to her. She was amazed that I could do that."

Equally amazed was Rodríguez's middle school art teacher, who fostered his student's talent, claiming that one day she would be an artist. But growing up in a Texas town where Mexicans and Anglos didn't mix was difficult. Rodríguez and other Mexican children were taunted at school. Also frustrating was Rodríguez's experience in college. On scholarship she went to the San Francisco Art Institute with the expectation of finding order and discipline, but she was disappointed to find her classes chaotic. It was not until she became a part of the Chicano mural movement that she felt at home. There, working in the muralist collective Mujeres Muralistas, Rodríguez painted murals that expressed political and spiritual themes pertinent to the Chicano community. Being a part of a group that was all women allowed Rodríguez to focus on feminist issues; at the same time, she developed her own style. This push and pull between the community and individual would be a part of Rodríguez's work in the future. She would explore cultural themes and traditions such as the harvest celebration, while at the same time delving into personal narrative. As she came into her own—leaving an Anglo husband behind, boldly stating that art was the most important thing in her life—she looked back to what she had learned from her grandmother to create work that honored her ancestors.

In her installation *Tribute to My Grandmother,* Rodríguez creates an alter for her grandmother. Surrounding her grandmother's photograph are an antique sewing machine and other nostalgic objects. Hearts and stars swirl around. A heart with the major arteries is placed beside the photograph. This montage of painting, collage, photography, and sculpture is representative of Rodríguez's work; likewise, the heart is an often-used image for Rodríguez. By placing hearts—sometimes pierced hearts recalling Christ—in her work, Rodríguez transforms her ordinary scenes into religious ones.

Rodríguez comments on herself in *Self-Portrait* (1980). In this installation Rodríguez takes a cool look at herself, somehow maintaining an objective stance. Significant objects are placed in a bureau, each one imbued with personal history. Keys, hearts, and skeletal figures all lend symbolic relevance. The beauty of the piece is in its unfinished nature. The piece is waiting for completion, for the rest of the artist's life to be lived to be finalized. In other words, the piece will never be finished.

Rodríguez sees her art as a way of giving back to the Chicano community. She sees art as a connecting point for young and old. By

creating, one is connecting to something larger than oneself—by creating, one is honoring.

—Sally Cobau

RODRÍGUEZ-DÍAZ, Angel (Luis)
American painter

Born: San Juan, Puerto Rico, 6 December 1955. **Education:** University of Puerto Rico, B.A. in fine arts 1978; Hunter College, City University of New York, M.F.A. 1982. **Awards:** Residency, Yaddo, Saratoga Springs, New York, 1992; Project Residency grant, New York State Council of the Arts and the Hillwood Museum of Arts, Long Island University, New York, 1992; Mid-Atlantic/National Endowment for the Arts regional fellowship in painting, 1994; International Artist-in-Residence Program, ArtPace Foundation, San Antonio, Texas, 1997.

Individual Exhibitions:

1975	*Paintings and Drawings,* Carnegie Library, San Juan
1980	*St. Sebastian,* Hunter Gallery, New York
1983	*The Beholder's Biography,* Cayrnan Gallery, New York
1985	*The Reflection in the Mirror,* Museum of Fine Arts, San Juan
1987	*Vision and Fantasy,* Zolla/Liebman Gallery, Chicago
1988	*Recent Works,* Mendelson Gallery, Pittsburgh
1990	*Portraits of the Self,* Ollantay Center for the Arts, New York
1992	*Identidad-Identity,* Ollery/Campeche Gallery, New York
	Portraits: The Color of People, Ollantay Center for the Arts, New York
1993	*Portraits-Retratos,* Intar Gallery, New York
1994	*Self Portraits-Autorretratos,* Taller Boricua Gallery, New York
1997	*Tienda de los milagros,* By Marcel/The Collection, San Antonio, Texas
1998	*Splendid Little War,* ArtPace Foundation for Contemporary Art, San Antonio, Texas

Selected Group Exhibitions:

1977	*National Exhibit of Puerto Rican Painting and Sculpture,* Institute of Puerto Rican Culture, San Juan
1983	*Resources: 4 Artists and 4 Crafts,* Bronx Museum of the Arts, Bronx, New York
1992	*Ten Latin American Artists from New York in Miami,* Javier Lumbreras Fine Art, Coral Gables, Florida
	The Year of the White Bear, Walker Art Center, Minneapolis, and Mexican Fine Arts Center, Chicago
1993	*Metamorphosis: Four Latin American Artists,* Center for Latin American Arts, New York
1994	*Reclaiming History through Contemporary Art,* El Museo del Barrio, New York
1995	*The State of the State: Contemporary Art in Texas,* San Antonio Museum of Art, Texas
1998	*Collective Visions,* San Antonio Museum of Art, Texas

Angel Rodríguez-Díaz: *La Guadalupana,* **1999. Photo by Al Rendón; courtesy of the artist.**

2000	*Arte Latino: Treasures from the Smithsonian American Art Museum,* El Paso Museum of Art, Texas, and National Hispanic Cultural Center, Albuquerque
	La Luz: Contemporary Latino Art in the United States, National Hispanic Cultural Center, Albuquerque

Collections:

Museo de Arte Contemporaneo de Puerto Rico, San Juan; Mexic-Arte Museum, Austin, Texas; Art Museum of South Texas, Corpus Christi; University of Texas, San Antonio; University of Texas, Austin; Guadalupe Cultural Arts Center, San Antonio, Texas; National Museum of American Art, Smithsonian Institution, Washington, D.C.; El Museo del Barrio, New York; Institute of Puerto Rican Culture, San Juan; San Antonio Museum of Art, Texas; Queensborough College Art Gallery, New York.

Publications:

By RODRÍGUEZ-DÍAZ: Article—''Splendid Little War'' in *La Voz de Esperanza,* December 1998/January 1999, p. 13.

On RODRÍGUEZ-DÍAZ: Articles—''Four Hunters,'' in *Sunday San Juan Star Magazine,* 30 October 1977, and ''The Second Gulf Salon,'' in *Sunday San Juan Star Magazine,* 26 February 1978, both by Felix Bonilla-Norat; ''Angel Rodriguez-Diaz, el retrato del otro'' by Oscar Montero, in *El Mundo-Puerto Rico Ilustrado,* 14 October 1990; ''Apuntes sobre la obra pictorica de Angel Rodriguez-Diaz''

Angel Rodríguez-Díaz: *Saints and Sinner,* **2000. Photo by Al Rendón; courtesy of the artist.**

by Gustavo Valdes, Jr., in *Noticias de Arte,* March 1992; "El autorretrato de Angel Rodriguez-Diaz" by Daniel Del Valle, in *El Antillano,* April/May 1994; "Angel Rodriguez-Diaz: Tienda de los Milagros, Carnal and Spiritual Duality" by Felipe Arévalo, in *Voices of Art* (San Antonio, Texas), 6(1), January/February 1998, pp. 24–26 (illustrated); "Artist Angel Goes up in Xmas Lights" by Susan Yerkes, in *San Antonio Express-News,* 11 December 1998; "Arte Latino: Smithsonian Show Debuts in El Paso" by Maribel Villalua, in *El Paso Times* (El Paso, Texas), 10 September 2000.

*

Angel Rodríguez-Díaz comments:

Portraiture is a representation of historical and social mores condensed into a sense of self. In my work I have pursued the social and political boundaries of portraiture by exploring issues of colonialism and representation. As a result, a tradition once used exclusively to depict the privileged is re-invented, celebrating our social and cultural diversity. These individual portraits hold the spectator in their gaze like a mirror that reflects upon the fragility of our own identity.

* * *

Since the 1980s Angel Rodríguez-Díaz has explored the social and political boundaries of portraiture. Through sophisticated brush strokes and rich, dynamic colors, his paintings celebrate the diversity

of individuals. In addition to portraiture, Rodriguez-Diaz has experimented with surreal dreamscapes that depict Latinos against dramatic, iridescent skies. He also experimented with various aspects of installation, using found objects, chalk murals, light displays, and popular cultural iconography to inject a more direct social content into his work. As a Puerto Rican and a Hispanic, he has thoughtfully engaged those marginalized and colonialized and has asked, in a variety of forms, how it feels to be seen through the distorted mirror of historical conquest. "In my paintings," he has said, "there is a psychological merging of inner and outer space. The boundary between the subject portrayed and the viewer or beholder blur—like a reflected image in a mirror. The intense relationship between the artist and his subject becomes the catalyst for the manifestation of the painter's other selves."

Rodríguez-Díaz, who was born in San Juan, Puerto Rico, in 1955, had his first solo exhibition, a collection of paintings and drawings, at the Carnegie Library there in 1975. He graduated from the Fine Arts Department of the University of Puerto Rico with a B.F.A. in 1978 and received a M.F.A. in 1982 from Hunter College, City University of New York. After attending graduate school, Rodríguez-Díaz lived in New York City for 16 years before moving to San Antonio, Texas, in 1994. His works have been widely exhibited in New York, Chicago, Washington, D.C., Puerto Rico, and Mexico, as well as at the San Antonio Museum of Art and at Blue Star Art Space, also in San Antonio.

In a renewal of the portrait tradition made memorable by masters like Goya and Rembrandt, Rodríguez-Díaz's paintings blend a Dadaesque atmosphere of ghostliness and distance with the more formal aspects of the portrait tradition. He manipulates elements such as anatomy, color, design, and lighting to create a vivid psychological dimension. In his portraits the interaction between the subject and the surroundings is constant enough that the subject portrayed and the landscape often merge into each other. This dichotomy, in turn, establishes a dialectical relationship with the viewers and their space. The effect is mirrorlike: the subjects portrayed and the viewer reflect and refract one another. Even though the works are insistently about the space within the self, they also proclaim that the space within is the space without, the external public space.

Highlighting Rodrígues-Díaz's residence and work in San Antonio was a three-month fellowship at ArtPace Foundation for Contemporary Art, the culmination of which was the 1998 installation *Splendid Little War.* In this multimedia exhibit Rodríguez-Díaz charted the historical and personal complexities of Latino-U.S. relations, offering a challenge to assumptions about distinctions between so-called high and low art and about the unspoken hierarchy between the expressions of various cultures. In the tradition of political muralists, he collaged images drawn from diverse historical and cultural sources, including maps of the Caribbean and Mexico, the Virgin of Guadalupe, the Taco Bell Chihuahua, Uncle Sam, and the Alamo. On the exterior Rodríguez-Díaz used the facade of the ArtPace building as a canvas for an enormous electric mural that was lighted to commemorate the centennial anniversary of the signing of the Treaty of Paris, the event that marked the end of the Spanish-American War. A self-portrait, constructed of 8,500 colored lightbulbs, flashed the image "Now You See Me, Now You Don't." With the range of emotions typical to him, the artist injected an experimental public artwork with accessibility and humor and maintained a serious, substantial consideration of cultural history and representation.

—Martha Sutro

ROJAS, Carlos
Colombian painter and sculptor

Born: Facatativa, Cundinamarca, 18 April 1933. **Education:** Studied architecture, Javeriana University, Bogotá, 1953–56; School of Fine Arts, National University, Bogotá; School of Fine Arts, Rome (on scholarship), 1958–60; studied applied design, Institute of Arts, Rome. **Career:** Instructor, architectural drawing, Greater School of Cundinamarca; instructor, design and drawing, National University, Bogotá; instructor, painting, School of Fine Art, University of the Andes and Jorge Tadeo Lozano University, Bogotá. **Awards:** Prize, *Primer salón intercol de pintura joven,* Bogotá, 1964; third prize, *Primer salón de la Universidad Nacional,* Bogotá, 1964; first prize in painting, *XVII salón de artistas nacionales,* 1965; prize, *XX salón de artistas nacionales,* 1969; prize, *XXIV salón de artistas colombianos,* 1973; international prize, *XII bienal internacional,* São Paulo, Brazil, 1974. Gentleman of the Order of Arts and Letters, French government, 1995. **Died:** 1997.

Individual Exhibitions:

1957	Galería El Callejón, Bogotá
	Museo de la Inquisición, Cartagena, Colombia
1958	Museo de Arte Moderno La Tertulia, Cali, Colombia
	Biblioteca Nacional, Bogotá
1960	Galería El Callejón, Bogotá
	Sociedad Colombiana de Arquitectos, Bogotá
1962	Biblioteca Nacional, Bogotá
1963	Galería El Callejón, Bogotá
1964	Galería de Arte Moderno, Bogotá
1965	Museo de Arte Moderno, Bogotá
1966	*Esculturas,* Biblioteca Luis Angel Arango, Bogotá
	Banco de la Republica, Pereira, Colombia
	Museo de Arte Moderno, Bogotá
	Galería Nacional, Cali, Colombia
1967	Biblioteca Luis Angel Arango, Bogotá
	Museo de Arte Moderno La Tertulia, Cali, Colombia
1968	Galería Belarca, Bogotá
1969	*Engineering of Vision,* Luis-Ángel Arango Library, Bogotá
1970	*EXPO 70,* Colombian Site, Osaka, Japan
	Galería San Diego, Bogotá
1973	with Santiago Cardenas, Center for Inter-American Relations, New York
	Galería San Diego, Bogotá
1974	Galería Estudio Actual, Caracas, Venezuela
	Museo de Arte Moderno, Bogotá (retrospective)
	Museo de Arte Moderno La Tertulia, Cali, Colombia
	Galería Monte Avila, Bogotá
1975	Galería San Diego, Bogotá
	XIII bienal internacional, São Paulo, Brasil
1976	Museum of Modern Art, Brasilia, Brazil
	Galería Adler Castillo, Caracas, Venezuela
	Museo de Arte Contemporáneo, Bogotá
	Galería Belarca, Bogotá
1977	*Telas de la serie América,* Museo de Arte Moderno, Bogotá
	Galería La Oficina, Medellín, Colombia
	Galería San Diego, Bogotá

1978	Galería Quintero, Barranquilla, Colombia
	Galería Juan Martin, Mexico City
1979	Galería 9, Lima, Perú
	Galería San Diego, Bogotá
1980	Galería Autopista, Medellín, Colombia
	Galería Tempora, Bogotá
1982	*Venice Biennial,* Italy
	Bienal de arte geometrico, Santiago, Chile
1983	Centro Colombo Americano, Bogotá (retrospective)
1984	*Paintings 1959–1984,* Museo de Arte Moderno, Bogotá
1989	Galería Casa Negret, Bogotá
	Museo de Arte Moderno La Tertulia, Cali, Colombia
1990	*Una constante creativa,* Museo de Arte Moderno, Bogotá (retrospective)
1992	Galería Tovar y Tovar, Bogotá
1995	Museo de Arte Moderno, Bogotá (retrospective)
	40 años de trabajo, Galería El Museo, Bogotá
1996	Museo de Arte Moderno La Tertulia, Cali, Colombia
1997	Galería El Museo, Bogotá

Selected Group Exhibitions:

1958	*Venice Biennial,* Italy
1965	*Latin-American Painting,* Guggenheim Museum, New York
	Canadian National Gallery of Art, Ottawa
1968	*I International Biennial,* Quito, Ecuador
1978	Museum of Modern Art, Río de Janeiro
1979	Museum of Modern Art, New York
1985–86	*100 Years of Colombian Art,* Museo de Arte Moderno, Bogotá (traveling)
1990	*II Biennial of Art,* Bogotá
1994	*Cubism in Colombia,* Galería El Museo, Bogotá
1996	*ARCO'96,* Galería El Museo, Madrid

Publications:

On ROJAS: Books—*Carlos Rojas, Santiago Cardenas,* exhibition catalog, New York, Center for Inter-American Relations, 1973; *Carlos Rojas: Un proceso,* exhibition catalog, text by Eduardo Serrano, Bogotá, Museo de Arte Moderno, 1974; *Carlos Rojas, telas de la serie América,* exhibition catalog, Bogotá, Museo de Arte Moderno, 1977; *Carlos Rojas: Una constante creativa,* exhibition catalog, Bogotá, Museo de Arte Moderno, 1990; *Carlos Rojas: retrospectiva, 1995,* exhibition catalog, Bogotá, Museo de Arte Moderno, 1995; *Carlos Rojas* by Carmen María Jaramillo and María Iovino Moscarella, Bogotá, Ediciones El Museo, 1995. **Articles**—''Sculpture Salon'' by Dario Ruiz Gomez, exhibition review, in *Art Nexus* (Colombia), 11, January/March 1994, pp. 235–236; ''Cubism in Colombia'' by Germán Rubiano Caballero, exhibition review, in *Art Nexus* (Colombia), 15, January/March 1995, p. 111; ''Carlos Rojas'' by Natalia Guitiérrez, exhibition review, in *Art Nexus* (Colombia), 20, April/June 1996, pp. 110–111; ''Carlos Rojas'' by María Elvira Iriarte, book review of *Carlos Rojas* by Carmen María Jaramillo and María Iovino Moscarella, in *Art Nexus* (Colombia), 21, July/September 1996, p. 31; ''Carlos Rojas: Obituary'' by Celia Sredni de Birbragher and Natalia Guitiérrez, in *Art Nexus* (Colombia), 25, July/September 1997, p. 21.

* * *

Carlos Rojas was one of Colombia's undisputed modern masters, and his influence is still felt in the younger generation of abstract artists. Born in a modest household in Facatativá, a small town near Bogotá, he spent his formative years in a seminary, which may account for the spiritual depth of his work. He studied architecture and art in Bogotá and in 1958 won a scholarship to study painting in Italy. Upon finishing his studies, he traveled extensively in Europe, and after a brief period in New York City and Washington, D.C., he went back to Colombia at the beginning of the 1960s to start teaching at the Universidad Nacional.

Rojas explored abstraction in many different ways: from the Juan Gris-influenced, synthetic-cubist paintings of the early 1960s to the hard-edged, precisely constructed *Ingeniería de la visión* series of the late 1960s and early 1970s, and from the colorful *América* series—full of symbolic references to pre-Columbian and indigenous cultures—to the muted yet luminous grandeur of his 1980 *El Dorado* series, in which one can find close ties to Mark Rothko's work, both in its formal appearance and in its spirituality. He also worked in the spirit of informalism in his *Umbrales,* monochrome, materic canvases (a mode of painting where the texture of the materials is used as a means of expression) that sometimes included found objects and architectural elements such as windows and frames.

Rojas's different lines of research regarding the possibilities for abstraction provided an alternative to the discussion on abstraction that was at the core of the art being produced in the 1960s in Colombia. His work distanced itself from (and later influenced) the more analytical abstraction of his peers and reflected on identity through its references to local concerns such as the textile tradition, architecture (his *Pueblos* series), and the symbolic nature of gold in pre-Columbian cultures.

Although Rojas is primarily recognized as a painter, he also worked in sculpture, producing large framelike structures in steel that defined architectural spaces and sometimes acted like windows to frame the landscape, such as his large-scale sculptures at the entrance of the airports both in Medellín and Bogotá.

Rojas represented Colombia in the 1958 and 1982 Venice Biennials and in the 1974 (where he received the International prize) and 1975 Sao Paulo Biennials. He was awarded prizes in the 1965, 1969, and 1973 National Salons.

—José Roca

ROJAS, Miguel (Ángel)
Colombian painter, engraver, and photographer

Born: Bogota, 1946. **Education:** Studied architecture, Universidad Javeriana, Bogota, 1964–66; studied painting, Universidad Nacional, Bogota, 1968–73. **Awards:** Prize, *Bienal latinoamericana de San Juan;* premio León Dobrzinsky, 1981; prize, *XXX salón nacional de artistas,* 1986; special mention, *V bienal americana de artes gráficas,* Museo La Tertulia, Cali, Colombia, 1986; prize, *XXXII salón nacional de artistas,* Centro de Convenciones, Cartagena, Colombia, 1989; Premio Concurso Nacional Riogrande, Antioquia.

Individual Exhibitions:

1980 *Grano,* Museo de Arte Moderno, Bogota
1982 *Subjetivo,* Galería Garcés-Velásquez, Bogota

1985 *Bio,* Inter Latin American Gallery, New York
1988 *Foto-grafia,* Museo de Arte Universidad Nacional, Bogota
1990 *Foto-grafia,* Museo de Arte Moderno, Cartagena, Colombia
 Gloff, Museo de Arte Moderno, Medellín, Colombia
 Pinturas, Galería Garcés-Velásquez, Bogota
1991 *Procesos fotograficos e imagen pictorica,* Banco de la Republica, Bogota (traveling)

Selected Group Exhibitions:

1972 Museo de Arte Moderno, Bogota
 I salón arte joven, Museo La Tertulia, Cali, Colombia
1973 *II bienal panamericana,* Museo La Tertulia, Cali, Colombia
1974 *XXV salón de artes plásticas,* Museo Nacional, Bogota
1977 *La plastica colombiana de este siglo,* Casa de las Américas, Havana
 Los novisimos colombianos, Museo de Arte Contemporáneo, Caracas, Venezuela
1980 *La nueva fotografia,* Galería La Oficina, Medellín, Colombia
1988 *I bienal de Bogota,* Museo de Arte Moderno, Bogota
1992 Biblioteca Luis-Ángel Arango, Bogota
1993 *Latin American Show,* Museum of Modern Art, New York

Collections:

Museum of Modern Art, New York; Museo de Arte Moderno, Bogota; Museo de Arte Moderno, Cartagena, Colombia; Museo de la Tertulia, Cali, Colombia; Museo Lam, Havana; Instituto de Bellas Artes, Mexico City; Museo de Arte Contemporáneo, Caracas, Venezuela; Museo de Arte de la Universidad Nacional, Bogota; Museo Nacional, Bogota..

Publications:

On ROJAS: Books—*Nombres nuevos en el arte de Colombia,* exhibition catalog, Bogota, Museo de Arte Moderno, 1972; *Miguel Ángel Rojas,* exhibition catalog, text by Raul Cristancho, Bogota, Banco de la Republica, c. 1991; *Ante América: Cambio de foco,* exhibition catalog, Bogota, Biblioteca Luis-Ángel Arango and Banco de la República, 1992. **Article**—"A Keyhole Confession" by Juliana Soto, in *Art News,* 93(6), summer 1994, p. 149.

* * *

Miguel Ángel Rojas, born in 1946, has been a key figure in the development of contemporary art in Colombia. He not only represents a clear link between the modern masters and the younger generations, but his innovative mix of different media and artistic practices, such as painting, photography, printmaking, and installation, has also helped to erode the fixed boundaries between them and has opened the way for experimentation by other artists. His work has always revolved around the notion of identity, and from an autobiographical point of view his middle-class background, acknowledged homosexuality, and indigenous descent form part of his complex work.

In the 1970s Rojas began a body of work in which he tried to redefine assumptions about sexuality in a highly conservative and traditional society. His first works were hyperrealistic drawings and photo-based prints with homoerotic subjects. In 1978 he began his *Faenza* series, photographs taken in a beautiful but run-down turn-of-the-century theater that had suffered the fate of many other cinemas in derelict areas, ending up as second-rate or porno houses. At the time there was little or no social permissiveness toward homosexuals in Colombia, and gays used such underground places, usually with action movies as a background, for encounters. Rojas's grainy, haunting images of barely discernible figures were taken with a hidden camera and with only the light that came from the screen, which gave them the aura of documentary photography. The viewer becomes a voyeur to fragments of a reality from which he or she is usually excluded.

In 1980 Rojas exhibited *Grano* at the Museo de Arte Moderno de Bogotá. He covered the floor of the entire space with paper, on which he used mineral pigments to draw realistic reproductions of the concrete tiles found in Colombian popular architecture, as in his childhood home. Two years later he showed *Subjetivo,* in which the themes of his *Faenza* series reappeared but which now involved the entire exhibition space, so that the work was experienced in more than just visual ways. On the pristine walls of the Garcés Velasquez Gallery, a former church, he drew the dirty tiles of a public bathroom, which resulted in a beautiful yet unsettling environment. Rojas reworked the theme of a partially veiled reality in his photographic works of the 1980s. He composed "ritual" scenes using indigenous or pre-Columbian figures made of plasticine that were then photographed and projected onto photographic paper. He painted the projections with a developer, partially revealing the images as he executed his pictorial gestures.

In his ongoing series *La via láctea* and *Paquita,* which have taken different configurations throughout the years, Rojas has taken hard-core photographs, copied them in very small formats, and cut them with hole punchers of different diameters. He then uses them to compose drawings, sometimes resembling cartoon characters, directly on the wall, thus placing the viewer in the uncomfortable position of being seen looking, at the same time a voyeur and an accomplice. This formal strategy has reappeared in later works, in which the photographs are replaced with small dots made with a hole puncher in coca leaves, a material that alludes to Colombia's pre-Columbian past and to the ritualistic use of coca in indigenous cultures. This places the work in the context of the current political situation of a country that is stigmatized internationally because of its role as the world's principal producer of cocaine.

Rojas has exhibited widely and has represented Colombia in the São Paulo and Sydney biennials (1981). He twice (1986 and 1989) received the prize at the Colombian National Salon.

—José Roca

ROMAÑACH, Leopoldo
Cuban painter

Born: Sierra Morena, Corralillo, 7 October 1862. **Education:** Academia de San Alejandro, Havana, 1885–87; studied in the United States, *ca.* 1887; Institute of Fine Arts, Rome, 1889–95. **Career:** Spent his youth in Barcelona. Worked as a painter in New York City, 1895–1900;

professor, then director, 1934, Escuela de San Alejandro. **Awards:** Bronze medal, *Exposición universal de París,* 1900; gold medal, *Exposición de St. Louis,* Missouri, 1904; silver medal, *Buffalo Exposition,* New York; gold medal, *Charleston Exposition,* North Carolina; grand prize, *Exposición de la Habana,* Havana, 1912; medal of honor, *Panama-Pacific Exposition,* San Francisco, 1915; grand prize, *Exposición iberoamericana de Sevilla,* Seville, 1929; medal of honor, Fine Arts Club, Havana, 1929; medal of honor, Círculo de Bellas Artes. Cruz Orden de Carlos Manuel de Céspedes. **Died:** 1951.

Selected Exhibitions:

1900 *Exposición universal de París*
1904 *Exposición de St. Louis,* Missouri
 Buffalo Exposition, New York
1905 *Charleston Exposition,* North Carolina
1912 *Exposición de la Habana,* Havana
1915 *Panama-Pacific Exposition,* San Francisco
1929 *Exposición iberoamericana de Sevilla,* Seville
 Fine Arts Club, Havana

International Artist's Club, Rome.

Publications:

On ROMAÑACH: Books—*Leopoldo Romañach,* Havana, Ministerio de Cultura, 1988; *Pintura cubana* by Graziella Pogolotti, Havana, Galerí La Acacia, 1991.

* * *

Leopoldo Romañach was among Cuba's most admired painters at the turn of the twentieth century. An accomplished academic realist, he became responsive to modernist tendencies later in his career. Although he retained the loose realist style and popular subjects of European and American art of the 1880s and 1890s, he was inspirational for the generation of early modernists in Cuba after the 1920s.

Born in 1862 the son of a Catalan father and a Cuban mother in the province of Santa Clara, Romañach was sent to Gerona, Spain, at the age of five after his mother's death. He was most likely exposed to the renewal of art and culture in Barcelona that began in the decade of the 1870s, and his interest in painting was further stimulated by a visit to New York City in 1884 before he returned to Cuba. He studied at the Academy of San Alejandro in Havana and was taught by its first Cuban director, Miguel Melero. The lion's share of his academic training, however, took place during the years from 1889 to 1895 while studying at the Institute of Fine Arts in Rome under its director, Filippo Prosperi. In 1895 his scholarship from the Santa Clara Provincial Assembly was revoked as a result of Cuba's war of independence. He spent the last five years of the nineteenth century supporting himself as an academic painter in New York City, where he joined the proindependence exile community that also included the writer and poet José Martí, considered Cuba's founding father.

In 1900 Romañach returned to his homeland, which had won its independence from Spain in the Spanish-American War of 1898. The first four decades of the twentieth century, in which Cuba made the transition from a U.S. protectorate to an independent republic, were the most productive years for Romañach, who benefited from the steady patronage of the upper classes on the island. During these

521

decades he traveled extensively and won international prizes for his paintings at expositions in Paris, Buffalo, St. Louis, Havana, and San Francisco. He also held the position of professor of painting at the Academy of San Alejandro until his dismissal in 1926. His firing took place during the first year of the dictatorship of Gerardo Machado (1925–33) and was certainly political. He won the support of the artistic community, however, and was immediately restored to his post. He accepted the position of director of the academy in 1934.

Romañach's style is notable for its firm modeling of form, brilliant light, and relatively loose handling of paint, which at times evokes the work of the Spaniard Joaquin Sorolla and the American John Singer Sargent. Although he espoused a free form of academic painting, Romañach demonstrated a solid grounding in drawing and composition. His early paintings show a penchant for melodramatic, theatrical, and idealized subjects. Typical subjects include a mother nursing her ill daughter, scenes of popular piety, and peasants returning from the fields. His later work, however, is characterized by probing portraits, particularly of children and of older people, and by picturesque landscapes and seascapes. In spite of being out of the mainstream of modern art, Romañach was supportive of young painters, particularly the generation of Cuban modernists who in the late 1920s ultimately abandoned European academism in favor of abstraction and new nationalist themes.

—H. Rafael Chácon

ROMERO, Frank

American painter

Born: Los Angeles, 1941. **Education:** Otis Art Institute, Los Angeles; California State University, Los Angeles. **Career:** Designer, Charles Eames and A&M Records; design director, Community Redevelopment Agency, Los Angeles; curator, including the exhibition *Murals of Aztlan,* Craft and Folk Art Museum, Los Angeles, 1981; muralist, including *Boy and Horse, Crossroads, Drive-Through Art Gallery, Festival of Masks, Going to the Olympics, Homage to the Downtown Movie Palaces,* and *Santa Monica Pier Circa 1930,* Los Angeles. Cofounder, with Carlos D. Almaráz, *q.v.,* Gilbert ''Magu'' Luján, *q.v.,* and Roberto de la Rocha, artist collective *Los Four,* 1973–83.

Individual Exhibition:

1998 *Frank Romero: Urban Iconography=Iconografia urbana,* California State University, Los Angeles

Selected Group Exhibitions:

1973 *Los Four,* University of California, Irvine
1974 Los Angeles County Museum of Art (with *Los Four*)
 Oakland Museum, California (with *Los Four*)

Publications:

By ROMERO: Book—*Frank Romero: Urban Iconography= Iconografia urbana,* exhibition catalog, with Susana Bautista, Los Angeles, Harriet & Charles Luckman Fine Arts Complex, California State University, 1998. **Article**—''Hispanic Ceramic

Frank Romero. Photo courtesy of the artist.

Artists: Los Angeles/Miami'' with others, in *Studio Potter,* 17, June 1989, pp. 5–31.

On ROMERO: Books—*Los Four: Almaraz, de la Rocha, Lujan, Romero,* exhibition catalog, Irvine, University of California, 1973; *Chicano and Latino Artists of Los Angeles* by Alejandro Rosas, Los Angeles, CP Graphics, 1993. **Articles**—''L.A. Chicano Art'' by Kristina van Kirk, in *Flash Art* (Italy), 141, summer 1988, pp. 116–117; ''Frank Romero's Pengolandia'' by Mary Jane Hewitt, in *International Review of African American Art,* 1992; ''A Conversation with Frank Romero'' by Collette Chattopadhyay, in *Artweek,* 23, 3 September 1992, pp. 23–25.

* * *

Frank Romero's work as a painter is intimately tied to Los Angeles, the city in which he lives. In fact, one of his best-known works, a 1984 mural that is located on the retaining wall of the 101 Freeway in downtown Los Angeles—*Going to the Olympics*—is so embedded in the city's car culture that it is best viewed in a traffic jam. A Chicano-inflected version of Los Angeles's auto-mania forms a large part of the mural's subject. Five historic cars progress across its surface, one from each of the twentieth century's first five decades. These are low riders—cars that have been retooled so they sit unusually close to the ground and are elaborately customized. In *Going to the Olympics* and elsewhere, Romero celebrates the low rider as a Mexican-American art form. Similarly, the mural deliberately evokes the energy and spirit of graffiti. He painted it in acrylic

Frank Romero: *California Plaza*, 2001. Photo courtesy of the artist.

using brooms and paint rollers, creating the effect of a spray can. The palm trees and brightly colored hearts interspersed with the low riders were also frequent subjects for Chicano graffiti artists at the time. Ironically, the lower part of the mural was later tagged in an act of gang-related graffiti and painted over by the California Department of Transportation. Romero is currently repainting the 100 foot mural.

Romero's celebratory attention to Chicano culture and East Los Angeles has been a component of his work since he first came into the public eye in 1973 as part of the collective *Los Four*—a group that included Carlos Almaráz, Gilbert Luján, and Beto de la Rocha. Their collaboration was based, in part, on a mutual discovery of the Mexican muralist tradition represented by José Clemente Orozco and Diego Rivera and on the artists' discussions of the Chicano civil rights movement that had begun in the late 1960s. *Los Four* were among the first artists in Los Angeles to create art with a specifically Chicano subject matter. Their first exhibitions at the University of California, Irvine, and at the Los Angeles County Museum of Art featured a 30-foot mural executed in spray paint. It was colorful, expressionistic, and full of references to Chicano culture and politics. The exhibitions were exceptionally popular, although *Artforum*'s Peter Plagens was critical of the artists' authenticity, which he considered tainted by their art school backgrounds.

While one may question the point of doubting the legitimacy of an artist's ethnic identity, it is true that Romero had considered himself an artist before he had given much thought to being Chicano. He studied at the Otis Art Institute, where he was drawn to the work of Edward Hopper, Ben Shahn, and Rico LeBrun. In the late 1960s he lived for a brief period to New York, where he rented space in a studio formerly occupied by Richard Serra. Romero found New York overly

cerebral and inhospitable to his art and soon returned to Los Angeles. Despite his lack of enthusiasm for the New York art world and his use of political and cultural themes, however, Romero has always maintained that art issues are more important to him than those of politics.

Romero's focus on issues specific to painting may explain why a critic in *Flash Art* described the most political works Romero executed after he stopped working with *Los Four* in 1983 as being "done in the grand manner and scale of European history paintings." *The Death of Ruben Salazar, The Closing of Whittier Boulevard,* and *The Arrest of Los Palateros* ("Ice Cream Vendors") narrate some of the conflicts between Chicanos and the police in East Los Angeles during the height of the confluence of the Chicano rights movement and the Vietnam antiwar protests in 1970. *The Death of Ruben Salazar* depicts the aftermath of a protest, when the police shot a tear gas canister into a bar and killed an *Los Angeles Times* investigative reporter who had been critical of police conduct. The policemen involved were exonerated, but the community understood the killing as a political crime. In his painting Romero used broad brushstrokes, strong color, and boldly defined shapes. Ruben Salazar's name magically appears on a cinema marquee at the moment of his death. This sensibility is typical of Romero's work. As he has said, "I do very serious paintings about pain and suffering, but they are done with a Latino sensibility, we laugh at death."

Romero is also a printmaker, photographer, sculptor, and ceramicist. His work in these mediums uses themes that also appear in his paintings—cars, hearts, horses, cityscapes, Mayan and Aztec iconography.

—Anne Byrd

ROSA (CASTELLANOS), José
American painter and printmaker

Born: Santurce, Puerto Rico, 13 June 1939. **Education:** Studied art under Rafael Tufiño, *q.v.,* 1954; studied with Domingo García, Galería Campeche, 1958; Taller de Gráfica del Instituto de Cultura Puertorriqueña (on scholarship), 1960. **Military Service:** Mandatory military service, 1963–65. **Family:** Married Rosa Lillian Galarza in 1967; two daughters and one son. **Career:** Director, Taller de Gráfica del Instituto de Instituto de Cultura Puertorriqueña, 1973–86. **Awards:** Prizes, Ateneo Puertorriqueño, 1972, 1974; prizes, *Revista sin nombre,* 1975, 1976.

Individual Exhibitions:

1967	Instituto de Cultura Puertorriqueña, San Juan (with Rafael Rivera Rosa)
1972	Colegio de Ingenieros, Arquitectos y Agrtimensores, Hato Rey
1973	La Galería, San Juan
1977	Museo de la Universidad, Río Piedras
1978	Galería Guatibirí, Río Piedras
1995	La Galería, Universidad del Sagrado Corazón, Santurce (retrospective)
	Museo de la Historia de Ponce
1997	Museo Casa Roig, Humacao
	Facultad de Derecho Eugenio María de Hostos, Mayaguez

1998 *José Rosa: Exposición homenaje: Obra gráfica,*
 1963–1996, Antiguo Arsenal de la Marina Española,
 San Juan

Selected Group Exhibitions:

1970 *Bienal de San Juan del grabado latinoamericano y del*
 caribe, San Juan
1972 *Bienal americana de artes gráficas,* Cali, Colombia
1973 *Bienal internacional de artes gráficas,* Frechen,
 Germany
1998 *XII bienal de São Paulo,* Brazil
2000 *Pressing the Point: Parallel Expression in the Graphic*
 Arts of the Chicano and Puerto Rican Movements,
 University of Texas, Austin (traveling)
 Creo en vieques, Museum of Contemporary Art of
 Puerto Rico, San Juan

Publications:

On ROSA: Book—*José Rosa: Exposición homenaje: Obra gráfica,*
1963–1996, exhibition catalog, San Juan, Programa de Artes Plástica,
Instituto de Cultura Puertorriqueña, 1998. **Article**—"José Rosa en el
Museo Roig" by Rubén A. Moreira Vidal, in *Exégesis,* 29, 1997, pp.
45–46. **Film**—*El Universo de José Rosa* by Sonia Fritz, San Juan, Isla
Films, 1999.

* * *

When in 1954 Rafael Tufiño decided to offer free classes to the
children of the San José Housing Project in Puerto Rico, the govern-
ment provided him an apartment, and the Community Education
Division (DIVEDCO) donated the materials. Thanks to an ad in the
newspaper José Rosa, then a student of Central High School, decided
to enroll in these classes. At only 15 years of age, the die was cast.
Teacher and student struck up a friendship that has lasted throughout
their lives. It was under Tufiño's tutelage that Rosa learned painting
technique and was introduced to the group of artists of the important
Generación del Cincuenta (Fifties Generation).

Four years later Rosa was mixing with the artists of the 1950s.
He was the youngest of the Campeche Gallery, a cooperative of artists
that Domingo García founded and managed until 1959, and it was
there that he completed and sold his first paintings. Although the first
exhibition in which he participated was in 1963, he has always wanted
to be considered a product of that previous generation, since all his
mentors and guides reside with them.

In 1960 Rosa obtained a scholarship to study engraving at the
Graphic Arts Workshop of the Institute of Puerto Rican Culture. With
the exception of the two years he served his obligatory military
service (1963–65), he would persist in this studio until 1986. When he
resigned, he had been its director since 1973. In the 26 years he
labored for the workshop, he distinguished himself as a graphic artist
(silk screens and woodcuts), although he persisted in painting through-
out his life.

Early in his career, Rosa defined the themes with which he
would work—portraits, self-portraits, landscapes, and religious
themes—all traditional subjects dealt with by the generation preced-
ing him. It is in the religious theme, the most out-dated of all artistic
themes, that he would shine. The series of saints he began in 1971 are

innovative and very different from those to which tradition has
accustomed us. His santos are not for devotion, at least not for
religious devotion. They are de-sanctified, popular saints, impish and
profane. The figures depart from the long and magnificent popular
tradition of the Puerto Rican wooden santos. He took the traditional
wooden images, and with an incisive irony, converted them to well-
known personalities. Most of the saints are easily recognizable. Rosa
himself is St. Valentine, a figure with cape, wings, and an enormous
phallus. Framing the image is a ribbon bearing a double entendre that
roughly translates as "I am yours to the tip of my head, and what
hangs on me is yours" All his neo-saints carry a message: *San
Negrín* reads, "this is a black saint but a decent one / black but
sainted / and good / black but with a sense of shame," a clear
reference to racial prejudice. *San-cocho,* a tribute to the tasty Puerto
Rican vegetable soup, *sancocho,* declares, "with faith—great strength /
good will / your paunch will be filled." Other saints, such as *San
Juanberger* and *San Hot-dog,* allude to and satirize the invasion of
fast food. *Santurci* is a meld of the city's suburb of Santurce and the
owner of the famous San Juan brothel, Tony Turci, a man of infinite
kindness who accepted food stamps as payment. Santa Claus, *Santa-
clo,* is a hermaphrodite—the great saint has tits, horns, and balls. Rosa
has made saints for use in landing a boyfriend, ridiculing superiors,
criticizing an event or personality in society, and making serious
political statements.

During his years at the Institute Workshop Rosa acquired two
very important things from Lorenzo Homar: he polished his tech-
nique and developed a unique style of lettering. He also made more
than 150 silk-screen posters to announce exhibitions, fairs, contests,
theater festivals, and symposia. His many years at the workshop led
him to sign his paintings backward. Another detail that distinguished
him was that for graphic works he signed the name of his firstborn
daughter, Inesita.

Rosa was a survivor from his birth. He was the only one of
triplets to survive. This strength that marked him at birth can be seen
in his many self-portraits: penetrating eyes and on occasion a mask
that fails to mask but that tells us that beneath his physiognomy there
are other secrets that we cannot decipher.

His painting was joyful and at the same time dramatic, with
grand coloring or occasionally monochromatic. In his oils, always on
masonite, he displayed a particular irony. The flavor of Borinquen
blackness, the so-called abandon of musical rhythms, and cultural
complexity were present in all his works.

With his biting portrayals, ironies, and satire and his great
genius, Rosa has bequeathed Puerto Rico a valuable document that
defines a moment in the history of a country. The Caribbean was his
legion, Puerto Rico was his nation, and he was proud to be a part of it.
He presented us his homeland with all its problems, complexities, and
exaggerations. His work is there so that Puerto Ricans can peer into a
mirror of their identity and to the world to understand its uniqueness.

—Haydee Venegas

ROSADO del VALLE, Julio
American painter

Born: Cataño, Puerto Rico, 1922. **Education:** Universidad de Puerto
Rico, 1945; New School of Social Research, New York, 1946;

Academia de San Marco, Florence, Italy (on scholarship), 1947–48. **Career:** Illustrator and poster designer, Division of Community Education, San Juan, 1949–52. Traveled to New York, 1957–58. Artist-in-residence, Universidad de Puerto Rico, 1954–79. **Awards:** Gold medal, Architectural League of New York, 1953; fellowship, John Simon Guggenheim Memorial Foundation, 1957; gold medal, *Friends of Puerto Rico,* New York, 1965.

Individual Exhibitions:

1944 Biblioteca Escuela Superior, Bayamón, Puerto Rico
1945 Universidad de Puerto Rico, Rio Piedras
1946 Universidad de Puerto Rico, Rio Piedras
1949 Ateneo Puertorriqueño, San Juan
1954 Universidad de Puerto Rico, San Juan
1956 Galería Pintadera, San Juan
1959 Instituto de Cultura Puertorriqueña, San Juan
1963 Instituto de Cultura Puertorriqueña, San Juan
 Galería Isla, San Juan
1965 Pan American Union, Washington, D.C.
1966 Universidad de Puerto Rico, Rio Piedras
1967 Universidad de Puerto Rico, Recinto de Mayagüez,
 Puerto Rico
 Universidad de Puerto Rico, Rio Piedras
1977 Instituto de Cultura Pueorriqueña, San Juan
 (retrospective)
1982 Museo de Bellas Artes, San Juan, and Museo de Arte de
 Ponce, Puerto Rico
1988 *Julio Rosado del Valle, 1980–1988,* Museo de Arte
 Contemporáneo de Puerto Rico, Santurce, Puerto Rico

Selected Group Exhibitions:

1956 *Gulf-Caribbean Art,* Museum of Fine Arts, Houston
1957 *Artistas de Puerto Rico,* Pan American Union, Washing-
 ton, D.C.
1967 Museo de Arte de Ponce, Puerto Rico
1970 *Arte latinoamericano,* Museo de Arte de Ponce, Puerto
 Rico
1972 *Pintura puertorriqueña,* Museo de la Universidad de
 Puerto Rico, Rio Piedras
1984 *Pimer congreso de artistas abstractos de Puerto Rico,*
 Instituto de Cultura Puertorriqueña, San Juan
1986 *25 años de pintura puertorriqueña,* Museo de Arte de
 Ponce, Puerto Rico (traveling)
1987 *Puerto Rican Painting: Between Past and Present,*
 Museum of Modern Art of Latin America, Washing-
 ton, D.C. (traveling)
1989 *The Latin American Spirit: Art & Artists in the U.S.,*
 Bronx Museum, New York
 Pintura y escultura de los años setenta en Puerto Rico,
 Museo de Arte Contemporáneo, Santurce, Puerto Rico

Collections:

Ateneo Puertorriqueño, San Juan; El Museo del Barrio, New York; Instituto de Cultura Puertorriqueña, San Juan; Museo de Arte de Ponce, Puerto Rico; Museum of Modern Art of Latin America, Washington, D.C.; Universidad de Puerto Rico, San Juan.

Publications:

On ROSADO del VALLE: Books—*Exposición de Julio Rosado del* Valle, exhibition catalog, Ponce, Puerto Rico, Banco de Ponce, 1982; Julio *Rosado del Valle, 1980–1988,* exhibition catalog, with essays by Nelson Rivera and Marta Traba, San Juan, Museo de Arte Contemporáneo de Puerto Rico, 1988; *Trabajo de investigación sobre el jardín escultórico en el campus del Recinto Universitario de Mayagüez de la Universidad de Puerto Rico* by Jéssica M. Toldedo, Mayagüez, Puerto Rico, n.p., 1997. **Articles**—''Rosado del Valle: No esperemos que lo de afuera digan que es bueno'' by Pedro Zervigon, in *El Reportero* (San Juan), 11 November 1986, p. 25; ''Lo nuevo de Julio Rosado del Valle'' by Ruben Alejandro Moreira, in *El Mundo* (San Juan), 2 December 1989, pp. 30–31.

* * *

Julio Rosado del Valle has maintained a leading position in Puerto Rican plastic arts since his first exhibition in 1944. A tireless artist, he realized a need to be continuously learning, working, and creating, often rising at four in the morning and working until nightfall. Sketch followed sketch until he achieved a passionate expressiveness with great economy of line, an expressiveness that monumentalized the most trivial of objects.

Rosado del Valle was born in Cataño, Puerto Rico, in 1922, and has maintained his studio in his childhood home. He studied at the University of Puerto Rico with the Spanish master Cristóbal Ruiz. Later he studied at the New School for Social Research in New York City with the Cuban master Mario Carreño and the Ecuadorian Camilo Egas. In 1947 he obtained a scholarship to study at the Fine Arts Academy of Florence and to travel to Paris. From 1949 to 1952 he worked at the Division of Community Education (DIVEDCO) and formed part of the Puerto Rican Art Center (CAP).

For almost 25 years (starting in 1954) he was painter in residence at the University of Puerto Rico. In his long career he amassed numerous prizes, garnered a Guggenheim scholarship, and exhibited in Puerto Rico and abroad. He has spent long periods with his daughters in Barcelona and during the winter has stayed in his native Cataño.

A painter since childhood, Rosado del Valle kept a small painting of a house, which resembles the work of an experienced painter, that he did at the age of 13. At 18 he completed *Autorretrato* (''Self-portrait''), which depicts a young man with a dangerous and rebellious gaze. Throughout his life he has executed a series of self-portraits that have defined and redefined him through the years in both his expressiveness and the evolution of his unmistakable and experimental rebellious style.

Early in his career (1940s) he used traditional themes, landscapes, portraits, still lifes, and regional paintings, none of them resembling the work of other artists. These contain the seeds of his rebellion. During the 1950s he continued painting portraits of his friends and family with great economy of form, and he studied in depth the structure, behavior, and movement of horses, hens, cows, flies, birds, fish, goats, and even inanimate objects such as chairs, lamps, baskets, and bottles. In the 1960s he made a series of drawings of Don Quixote that escape all distinction or reference to folklore. In this epoch he abandoned the cubist leftovers of his younger years. His drawings are expressions of movement, and the work moves toward greater abstraction.

Early in the 1970s he made the daring drawings *Serie Erótica* (''Erotic Series'') and *Orgia* (''Orgy''). He continued with two murals and their respective studies, *El caracol* (''The Shell'') and *Mural de formas marinas* (''Mural of Marine Shapes''), that he did for the offices of the president of the University of Puerto Rico. And he finished the decade with the magnificent portrait of his son David, a work of small dimensions but monumental expression.

It was the experience he gained through David that renewed Rosado del Valle's palette. From the child he learned agility, the force of color, and innocence. His later self-portraits, flowers, and landscapes are explosions of color, drama, and noise. *Multitud* is possibly the least figurative of the artist's work. This painting of large dimensions (92 inches by 87 inches) consists of square stains of blue, red, and black with touches of yellow. These stains create so much tension that, knowing they were inspired by a march of the Basque separatist group ETA that Rosado del Valle viewed from a fifth floor window in Barcelona, it all makes sense. This work unfortunately burned in a fire that broke out in a warehouse that Rosado del Valle had rented. In the 1999 fire a number of paintings burned as well as thousands of drawings.

During the 1980s and '90s he continued his investigation of how things work, inspired by wheel chair races, all types of chairs, sandals, cats, and giraffes, while he continued to study structure and offered us his impressive self-portraits, each that much freer from the superfluous. When in 1993 a computer mouse was placed in his hand, he drew his own hand, the thing he knew best, trying again and again until he mastered it.

Rosado del Valle was an artist ahead of his time, a rebel who never wanted to follow the guidelines of other movements. He marched to his own drummer. He formed part of and mixed with the artists of the 1950s, nevertheless avoiding the political and social commitments of his colleagues. His art was his commitment, his work, and his message. His artistic vision was as philosophical as it was formal: it captured the essence of things, the reason many confuse him with an abstract artist.

He guided energy with an internal force capable of deciphering and decoding each object, theme, or sentiment it represented, whether it was a goat, a shell, a cat, a flower, his own face, or a giraffe. He drew and blurred in a thousand ways. He papered the premises with his sketches and scrutinized them until he squeezed everything out of them that he wanted to express, and then he tackled the task of painting. Every painting was preceded by hundreds of drawings.

Rosado del Valle is not a figurative artist because his figures cannot be distinguished with a quick glance. He is not an abstract artist because his strokes can be deciphered as references to objects. Neither is he an expressionist because his brushstrokes, although expressive, are not loaded with angst or torment. He was an artist who defied categorizing, but he cannot hide the fact that he is a Caribbean artist. His work has the color, vibrancy, force, and energy of the lands of warmth and rhythm where he was born.

—Haydee Venegas

ROSARIO (SASTRE), Melquíades
Amercian sculptor and printmaker

Born: Morovis, Puerto Rico, 20 September 1953. **Education:** Escuela de Artes Plásticas, San Juan, 1976–80, B.B.A. in sculpture 1980; Art

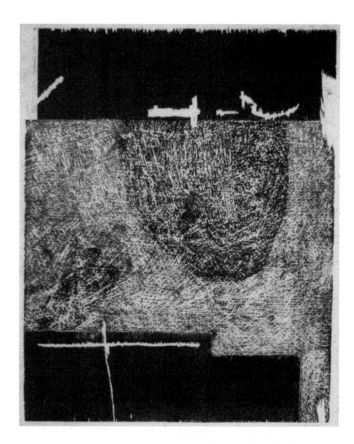

Melquíades Rosario: *Tema, Forma,* 1989. Photo courtesy of the artist.

Students League, New York, 1980–82. **Family:** Married 1) Elida Ruiz Berrios in 1969 (divorced 1976), one daughter; 2) Virginia Hernandez in 1986 (divorced 1998), three sons. Has lived with Maria S. Peréz since 1999; one son. **Career:** Cast workshop instructor, 1986–90, and professor of sculpture, 1995–2001, Escuela de Artes Plásticas, San Juan; ornamental cast instructor, Escuela Taller Ballaja, San Juan, 1990–92. Artist-in-residence, Altos de Charon, La Romana, Dominican Republic, 1994. Founder and past president, Puerto Rico Association of Sculptors; cofounder, Puerto Rico Congress of Abstract Artists. **Awards:** First prize in sculpture, Ateneo de Puerto Rico, 1980; grant, Pollock & Krasner Foundation, 1989; honor award, first national contest, 1991, and first prize, second national contest, 1993, Museum of Contemporary Art, Santurce, Puerto Rico, 1991; APAP-AIAP-UNESCO medal for artistic excellence, 1999. **Address:** San Patricio Apartments, #1603, San Patricio Avenue, Guaynabo 00968, Puerto Rico.

Individual Exhibitions:

1985 *Creations,* Institute of Puerto Rican Culture, San Juan
 Organic Revelation, University of Puerto Rico, Rio
 Piedras
1987 *Melquiades, Sculptures,* Voluntariado de las Reales
 Museum, Santo Domingo, Dominican Republic
 University of Puerto Rico, Rio Piedras
 Homage to John Cage, Dominican Convent, Institute of
 Puerto Rican Culture, San Juan
1988 *Binomio,* Fine Arts School, San Juan

Melquíades Rosario: *Allegoric to a Culture,* **1993. Photo by John Betancourt; courtesy of the artist.**

 Recent Sculptures, Melquiades Rosario Sastre, Colegio
 Universitario de Humacao, Puerto Rico
 University of Puerto Rico, Rio Piedras
1990 *Bumper Stickers Installation,* San Juan (traveling)
1991 *Waves,* Luquillo Beach, Puerto Rico
1994 Chase Manhattan Bank, Hato Rey, Puerto Rico
1997 *Melquiades Rosario. Recent Work,* Botello Gallery,
 Hato Rey, Puerto Rico
 Melquiades Rosario Sastre, Primera Bienal
 Iberoameriana de Lima, Centro Cultural, Escuela
 Nacional Superior Autonoma de Bellas Artes, Lima
 Fetiches, Botello Gallery, Hato Rey, Puerto Rico

Selected Group Exhibitions:

1984 *First Congress of Abstracts Artists of Puerto Rico,*
 Arsenal de la Marina, San Juan
1985 *Iberoamerican Sculpture Symposium,* Modern Art Gal-
 lery, Santo Domingo, Dominican Republic
1986 *Second Habana Biennial,* Wifredo Lam Cultural Center,
 Havana
1987 *Art of Today,* Budapest Gallery, Budapest

1990 *Navia, Suarez, Rosario: Three Contemporary Sculptors,*
 El Museo del Barrio, New York
 Sculpture of the Americas into the Nineties, Museum of
 Modern Art of Latin America, Organization of
 American States, Washington, D.C.
1993 *First Contest of Wood Sculpture,* Resistence Plaza, El
 Chaco, Argentina
1994 *Y Islas, Art in Transit,* New Hostos Gallery, Hostos
 Center for the Arts & Culture, Bronx, New York
1995 *Richness in Diversity: Contemporary Puerto Rican
 and Mexican Artists,* Susquehanna Art Museum,
 Pennsylvania
1998 *Espacios en transición-Transición en espacios,* Museum
 of Puerto Rican Art, Santurce

Collections:

Ateneo de Puerto Rico, San Juan; Museum of Contemporary Art, Santurce, Puerto Rico; Susquehanna Art Museum, Pennsylvania; University of Puerto Rico, Rio Piedras; Altos de Charon Gallery, La Romana, Dominican Republic; Wilfredo Lam Center, Havana.

Publications:

By ROSARIO: Article—"First Iberoamerican Symposium of Sculpture," in *Cruz Ansata* (Bayamon City, Puerto Rico), 9, 1986.

On ROSARIO: Books—*Melquiades, Sculptures,* exhibition catalog, text by Nelson Rivera Rosario, Santo Domingo, Dominican Republic, Voluntariado de las Reales Museum, 1987; *Recent Sculptures, Melquiades Rosario Sastre,* exhibition catalog, text by José Antonio Pérez Ruiz, Humacao, Puerto Rico, Colegio Universitario de Humacao, 1988; *Navia, Suarez, Rosario: Three Contemporary Sculptors,* exhibition catalog, text by Nelson Rivera Rosario, New York, El Museo del Barrio, 1990; *Melquiades Rosario Sastre,* exhibition catalog, text by Ricardo Pau-Llosa, Hato Rey, Puerto Rico, Chase Manhattan Bank, 1994; *Espacios en transición-Transición en espacios,* exhibition catalog, text by David Levi Strauss, Fernando Castro Flórez, and others, Santurce, Museum of Puerto Rican Art, 1998; *Piedra, metal y madera: La escultura en Puerto Rico,* exhibition catalog, text by Rosario Ferré, Marilú Purcell, and others, Ponce, Puerto Rico, Museo de Arte de Ponce, 2001. **Articles**—"Naturaleza y hombre en Melquiades Rosario," in *El Nuevo Dia,* 16 September 1987, and "Escultura actual en Puerto Rico," in *Plastica* (San Juan), 19(2), 1988, both by Manuel Perez Lizano; "Melquiades Rosario Sastre" by Jin Joung King, in *Art World* (Seoul), 1988; "Melquiades Rosario y el germen de su obra" by Mario Alegre Barrios, in *El Nuevo Dia,* 4 January 1991; "Exhibit Expresses Artists' Varied Styles" by Myrna Rodriguez, in *San Juan Star,* 9 December 1992; "Algorías del artista" by Nelson Rivera, in *Claridad,* April 1994; "Rosario Sastre en el Chase," in *El Nuevo Dia,* 24 April 1994; "Melquíades Rosario Sastre: Space As Body" by Ricardo Pau-Llosa, in *Sculpture* (Washington, D.C.) 16(7), September 1997, pp. 18–19; "Marco mitológico" by Larissa Vázquez Zapata, in *El Nuevo Dia,* 13 June 1999.

* * *

 Melquíades Rosario was born in Morovis, a sheltered town in the middle of the island of Puerto Rico, known for being the only town

that managed to escape from the plague epidemic at the beginning of the twentieth century. "The island except for Morovis" is the nickname that preserves the town and expresses its isolation, solitude, and primitivism. Rosario was raised among its paths and forests in close contact with its junglelike tropical vegetation and also in New York City. He grew up indomitable, high-spirited, and with an intensive knowledge of his homeland. His political formation preceded his aesthetic formation.

Although opposed by his parents, who always believed that their son would die of hunger, Rosario decided to study art at the Escuela de Artes Plásticas de Puerto Rico and later spent a year at the Art Students League in New York City. He has remained very active in art promotion, as founder and first president of the Puerto Rico Association of Sculptors and cofounder of the Puerto Rico Congress of Abstract Artists.

Rosario has loved wood and confronted it in an original way. His first sculptures were vigorous and energetic. They consisted of assemblages composed of discards of wood from a sawmill—sticks, enormous splinters, branches split apart without the intervention of his touch, merely organized, ready to be converted into dramatic sculptures. From the start of his career, Rosario introduced to Puerto Rican sculpture a sense of primitive drama that revisited forgotten roots, native elements that were not evident.

As Gaudí often said, "originality is in the origin." Rosario went to the origin of things and from there took off in a new direction; he let go of traditional forms and worn out clichés. In his decision to throw out traditional methods of sculpture, working without hammers or chisels, he imparted a monumental presence to his sculptures. In his works the wood is the protagonist. Forms interact in involved spaces with a truly blunt and innovative cultural message. *Hábitat atormentado* ("Tormented Habitat"), one of the first works in which Rosario demonstrated his fierce temperament, consists of a series of sticks placed pointing upward in a box. It has been one of his favorite sculptures; he saw it as a self-portrait, as a personal history or the history of a people. Its surface is sharpened, dangerous, charged with drama, unlovely but absolutely attractive as a work of art.

Halfway through the 1980s Rosario began to turn the wood and add other materials to his rustic sticks: copper tubes, odds and ends, hunks of wood, wire, rusty nails, even cement. Sometimes he used combinations of nontraditional materials to create an impact. The simplicity of *Símbolos contemporáneos* ("Contemporary Symbols," 1991) contrasts with the eroticism of *Altas y bajas de un artista machista* ("Ups and Downs of a Sexist Artist," 1991). His series that is composed of constructions forming small arches, most presented without titles, are among the most poetic of his works. From the classic to the Baroque, from the grotesque to the sublime, from the poetic to the erotic, Rosario has traveled the same way in all these territories and has moved from one to the other with the greatest ease.

Rosario has always been an iconoclast: when he tackled cement, he did it like any bricklayer. He saw no difference at all between the two professions, although, unlike the bricklayer's, his final product was totally different. His graphics also possess a rebellious and iconoclastic quality. Rather than using the usual gouge for his woodcuts, he used screwdrivers, picks, or hatchets. He carefully chose the block, cut it down, and abused it by throwing water over it or leaving it to the elements for several days. When he sensed that it was ready, he inked it, and his graphic was finished. He also has designed various pieces of furniture, primarily for his own home.

His work in the field of performance, installation, and conceptual art was also pioneering and dates from the second half of the

1980s. Together with Oscar Mestey, Nelson Rivera, Awilda Sterling, and the composer Francis Schwartz, he completed various collective works in which he executed the scenery or set up the surroundings so that the dancers could interact with them. He presented a number of these events at the Museum of Contemporary Art, the School of Plastic Arts, and various campuses of the University of Puerto Rico.

Rosario has always been an artist with commitment, a defender of ecology and conscious of the terrible scourge of AIDS. One of his most secret and convincing projects consisted of printing four decals that he plastered all over the city: on public telephones, benches, lampposts, etc. The first of these said simply, "This place designated for thinking," and the others used the abbreviation SIDA (AIDS) as an acronym: *No al Silencio, a la Indiferencia al Desprescio y a la Apatía* ("No to Silence, to Indifference, to Disdain, and to Apathy"). Afterward he created badges to be worn to alert people of the possibility of being infected, using the message "Si, Dá" ("Yes, it's catching"), pronounced SIDA. He called this second project the traveling gallery.

Rosario has begun to work in marble. His first works in this medium are constructions in which he mixed marble with cement, unpolished wood, metal, and stones. He mixed materials that do not seem to be compatible: noble materials with ignoble materials. It is in breaking these perceptions, taboos, and traditions that he has achieved a place of honor in Puerto Rican plastic arts. He has continued to be an implacable artist, an experimenter, bursting with irony and aggression and always looking for a different way to do things.

—Haydee Venegas

ROSENFELD, Lotty
Chilean video and performance artist

Born: Carlotta Rosenfeld, Santiago, 1943. **Education:** Escuela de Artes Aplicadas de la Universidad de Chile. **Career:** Member, performance art group *avanzada,* Chile, late 1970s and early 1980s; cofounder, performance art group *Colectivo de Acciones de Arte (CADA),* Chile, 1979. **Awards:** Scholarship, Interamerican Foundation, 1981; scholarship, Ford Foundation, New York, 1981; first prize, *Tokyo International Biennial of Video,* Japan, 1985; scholarship, Fundación Andes, Santiago, Chile, 1993; Mención Gráfica, Circle of Art Critics, Chile, 1996; Altazor prize, Santiago, Chile, 2001.

Individual Exhibition:

2001 *Who Comes with Nelson Towers?,* Museum of Contemporary Art, Forest Park, Santiago

Selected Group Exhibitions:

1985 *Tokyo International Biennial of Video,* Japan
1996 *Corpus Delecti,* Institute of Contemporary Arts, London
 VI International Festival of Video, Canary Islands, Spain
1997 ARCO 97, Madrid, Spain
1999 *CHILE: Austria,* Upper Austrian Gallery, Linz (traveling)
2001 Galería Posada del Corregidor, Santiago

Publications

On ROSENFELD: Books—*Desacato: Sobre la obra de Lotty Rosenfeld* by María Eugenia Brito, Santiago, F. Zegers, 1986; *Corpus Delecti: Performance Art of the Americas* by Coco Fusco, London and New York, Routledge, 2000.

* * *

Lotty Rosenfeld, a video and performance artist, was a member of the *avanzada* in Chile during the late 1970s and early 1980s. This movement included the artist Carlos Leppe and writers Raúl Zurita and Diamela Eltit and was supported by the French-born theorist Nelly Richard. Members of the *avanzada* did performances in the streets of Santiago as a way of protesting the authoritarian regime of General Augusto Pinochet, who came to power in 1973 and was known for his brutal suppression of any form of opposition. The *avanzada* artists escaped arrest because they cleverly designed their performances to appear superficially to contain no critique of the government whatsoever.

In 1979 Rosenfeld, Eltit, Zurita, Juan Castillo, and Fernando Balcells formed the Colectivo de Acciones de Arte (CADA). This offshoot of the *avanzada* did a series of high-visibility performances entitled *Para no morir de hambre en el arte* (''Not to Die of Hunger in Art'') that addressed the Pinochet regime's lack of commitment to social issues. They distributed packages of powdered milk among children in a slum outside of Santiago and paid for a page in the Chilean popular magazine *Hoy* to be left blank except for a message decrying the shortage of milk in Chile. In one of their most spectacular performances the members of CADA hired 10 milk trucks from the Chilean company Soprole to drive through the streets of Santiago, stopping in front of the Museo de Bellas Artes. The entrance was then covered with a white banner that was large enough to prevent people from going into the museum. The members of CADA targeted the museum as a manifestation of conservatism and government intervention in the arts. The use of milk was a reference to ''Half a liter of milk for every Chilean child,'' the campaign slogan used by Salvador Allende, the socialist president whom Pinochet had overthrown.

Rosenfeld played a crucial role in a series of performances done by Eltit in institutions such as jails and houses of prostitution. In the 1980 performance *Maipú* Eltit washed the steps and pavement outside of a brothel while a photograph of her face, taken by Rosenfeld, was projected on the wall outside. She then read parts of her novel *La lumpérica* to the prostitutes. In another performance from 1983 entitled *Trabajo de amor* (''Work of Love''), Eltit kissed a homeless man, attempting to subvert the commercialism of sex through prostitution by offering herself for free. Rosenfeld documented both CADA and Eltit's performances by videotaping and photographing them.

Rosenfeld also did several solo performances from 1979 to 1984 that she named *Una milla de cruces sobre el pavimiento* (''A Mile of Crosses on the Pavement''). In these works she went to specific locations of political importance, such as La moneda, the center of the Chilean government, and put white tape down on the broken white lines that separated traffic lanes on the street, making them into crosses. Rosenfeld did this furtively while another person videotaped her. The crosses had multiple subversive meanings, such as disrupting the flow of traffic, transforming a negative into a positive, or as crosses that might mark the graves of the Chileans who had been ''disappeared'' under Pinochet's regime. Rosenfeld made the crosses in a number of other locations, including in front of the White House

and on an Easter Island airport runway, always documenting the performances on video. She has continued to work in the field of video art, at times collaborating with the former members of CADA.

—Erin Aldana

ROSTGAARD, Alfredo (González)
Cuban poster artist

Born: Guantánamo, 10 May 1943. **Education:** Escuela de Artes Plásticas José Joaquín Tejada, Santiago, graduated 1959. **Career:** Began career as an abstract painter. Became interested in politics. Art director, *Mella* magazine, Cuba, 1963. Moved to Havana, 1965, and designed political posters. Poster designer, Cuban film board Instituto Cubano del Arte y la Industria Cinematográficos (ICAIC). Chief designer and art director of magazine *Tricontinental,* Organization in Solidarity with the People of Africa, Asia, and Latin America (OSPAAAL), 1965- mid-1970s. Began working for the Unión de Escritores y Artistas de Cuba (UNIAC) and Instituto del Libra, 1975. Since 1988 instructor of graphic design, Instituto Superior de Diseño Industrial (ISDI), Havana, and design editor, *Revolución y Cultura,* Ministry of Culture. Also created papier-mâché toys. **Awards:** Prize, International Contest of Cinema Posters, Cannes, France, 1973; gold medal, *Bienal americana de artes gráficas,* Cali, Colombia, 1976. Order of Polish Culture medal, 1980; cultural distinction award, Cuba, 1981.

Individual Exhibitions:

1992 Galería Alvaro of the Channel, Xalapa, Mexico
1997 Casa de las Américas, Havana (retrospective)
2001 *Alfredo González Rostgaard: A Retrospective: Cuban Revolutionary Posters,* Cuban Art Space, New York (retrospective)

Selected Group Exhibitions:

1976 *Bienal americana de artes gráficas,* Cali, Colombia
1983 Cuban Art Space, New York

Publications:

By ROSTGAARD: Book, illustrated--*Esta es una fuerza temible e invencible: discurso* by Fidel Castro, Havana, Ediciones Unión, 1981.

On ROSTGAARD: Book—*Alfredo González Rostgaard: A Retrospective: Cuban Revolutionary Posters,* exhibition catalog, test by Sandra Levinson and David Kunzle, New York, Cuban Art Space, 2001. **Article**—''Revolutionary Icons'' by Sam Pratt, in *ID*, 45, January/February 1998, p. 94.

* * *

With the single exception of Raúl Martínez, no other artist from the Americas since the mid-1960s has produced prints or posters of

greater international fame than Alfredo Rostgaard. His major images embody key traits of the Cuban Revolution in particular and of the insurgent New Left in the 1960s more generally. At once political engaged and yet unrelated to socialist realism, Rostgaard's posters feature a brashness derived from pop art and a sophisticated simplicity that is a hallmark of the best modernist art, such as that of the Russian constructivists. In fact, few people worldwide have not seen a reproduction of either Rostgaard's *Canción Protesta* (1967) or one of his brilliant Che Guevara posters in 1968 for the Cuban Film Institute.

By age 20, in 1963, Rostgaard was already the art director for *Mella*, the magazine of the Union of Young Communists in Cuba. Soon afterwards, he started producing a series of celebrated silk-screen posters (a technique strongly influenced by Andy Warhol and one introduced in Cuba by Raul Martínez) for various state agencies within the Cuban Revolution, particularly *ICAIC* (The Cuban Film Institute) and *OSPAAAL* (The Organization in Solidarity with the People of Asia, Africa, and Latin America). If the "golden age of the poster" in Cuba, as well as in the West, extended from the early 1960s through the mid-1970s, Rostgaard was a key reason for this highpoint.

Perhaps the "most recognized graphic image to come out of revolutionary Cuba" was *Canción Protesta* ("Protest Music"), a silk-screen poster by Rostgaard that features a bleeding purple rose on a flat yellow ground at normal value with Bauhaus-influenced sans-serif letters announcing both the occasion, a music festival, and its patron, Casa de las Américas. As with other Cuban art firmly in the Caribbean tradition, this striking image by Rostgaard features an inter-image dialogue with the Mediterranean sensibility of an artist such as Henri Matisse, especially as embodied by the vital, sensual outline that is so symptomatic of post-1959 Cuban silk-screen prints. When asked why he chose a bleeding rose for his world famous poster, Rostgaard said, "I wanted to show both the beauty and the pain of making a revolution. And that, after all, is what a protest music is about—making beautiful music about the world's pain."

Among the scores of images Rostgaard has designed and produced, there are at least two others that are equally distinguished if only slightly less well known from 1967–68. One is a silk-screen print that accompanied a documentary about the martyrdom of Che. Entitled *Hasta la victoria siempre* ("Always Onward to Victory"), it is based on a silk-screened reproduction of the celebrated photo of Che taken by Korda (Alberto Díaz Gutierrez) in 1960. In the lower half is a portrait of Che in bold primary red and white, superimposed on a list of the Latin American countries that have endured Western imperialism. The upper half of the print features Rostgaard's deft use of a technique that was made famous by Warhol in his multiple portraits of Marilyn Monroe, which repeat a reproduction of the same photo but with subtle differences in the flat two-color combination applied. Here the repetition takes on a new urgency unlike the dulling effect that emerged visually from the anticlimactic reiteration by Warhol of the Marilyn Monroe photograph, as for example in *100 Marilyns* (Tate Gallery). Instead of Warhol's self-negating pop parody with its cool presentation of a banal topic, Rostgaard gives a cool and somewhat hip representation of a "hot" topic that is at once "post-heroic" and yet still quite urgent. Unlike Soviet-style portraits, with their personalized treatment of leaders such as Joseph Stalin, this Cuban pop portrait never furthered any "cult of personality." Rather, it presents a brashly emotive, yet also abstract and rather fragmentary figure who signifies many things beyond his own "unique" biography (which is not addressed here, as it would be in an academic socialist realist painting). As such, David Kunzle was right to observe that unlike the uniformity of Soviet portraits of Stalin or those in

China of Mao, the Che is "far more various—as well as far more exciting" since "in Cuba, there are, it seems, as many ways of seeing Che as there are artists." Rostgaard has long been among the most resourceful graphic artists involved with the representation of Che.

Another outstanding silk-screen print by Rostgaard was made for the controversial film *La muerte de un burócrata* ("The Death of a Bureaucrat"), which was released in Cuba in 1967. Directed by Tomás Gutiérrez Alea, the movie triggered a national debate about the problem of bureaucracy and the lack of workplace democracy and led to noteworthy reforms. Rostgaard's poster is a masterfully surreal image of a hand displacing the head of a thoughtless person more adept at processing than thinking. This Magritte-like figure signals the problem with maximum visual economy of means, while using the Freudian tactics of condensation and displacement to produce the image.

—David Craven

RUELAS, Julio
Mexican painter and printmaker

Born: Zacatecas, 21 June 1870. **Education:** Instituto Científico e Industrial de Tacubaya, Colegio Militar de Chapultepec, and Escuela de Bellas Artes, Mexico City, *ca.* 1886; Academia de Artes de Karlsruhe, Germany, and Academia de Artes, Munich, Germany, 1892–95. **Career:** Instructor in San Carlos, Mexico, *ca.* 1895. Founding member and illustrator of magazine *Revista Moderna,* 1898; also illustrator of magazine *Revista Azul.* Moved to Paris, 1904. **Died:** Paris, 16 September 1907.

Selected Exhibitions:

1898 Escuela de Bellas Artes, Mexico City
1946 *Julio Ruelas, 1870–1907,* Salon Verde del Palacio de
 Bellas Artes, Mexico City (traveling)
1965 *Exposición homenaje: Julio Ruelas,* Instituto Nacional
 de Bellas Artes, Mexico City
1989 *Julio Ruelas: Aguafuertes y dibujos,* Museo Diego
 Rivera, Guanajuato, Mexico
2000 *Homenaje al lápiz,* Museo José Luis Cuevas, Mexico
 City

Collections:

Museo Nacional de Arte, Mexico City; Museo Francisco Goitia, Zacatecas, Mexico.

Publications:

By RUELAS: Book—*Cartones, ilustraciones de Julio Ruelas,* Mexico, Impresa de la Librería Madrileña, 1897.

On RUELAS: Books—*Julio Ruelas, 1870–1907,* exhibition catalog, text by Xavier Villaurrutia, Zacatecas, Mexico, Secretaria de Educacion Publica, 1946; *Exposición homenaje: Julio Ruelas,* exhibition catalog, Mexico City, Oficina de Ediciones del Departamento de Difusión,

Instituto Nacional de Bellas Artes, 1965; *Julio Ruelas en la vida y en el arte* by Jorge J. Crespo de la Serna, Mexico City, Fondo de Cultura Económica, 1968; *Julio Ruelas* by Teresa del Conde, Mexico City, Universidad Nacional Autónoma de México, 1976; *Julio Ruelas* by Leonor López Domínguez, Mexico City, Casa de Bolsa Cremi, *ca.* 1987; *Julio Ruelas: Aguafuertes y dibujos,* exhibition catalog, Guanajuato, Mexico, Museo Diego Rivera, 1989; *Julio Ruelas: Una obra en el límite del hastío,* Mexico City, Consejo Nacional para la Cultura y las Artes, 1997, and *Julio Ruelas . . . siempre vestido de huraña melancolía,* Mexico City, Universidad Iberoamericana, 1998, both by Marisela Rodríguez Lobato.

* * *

Mexico's leading symbolist artist, Julio Ruelas created paintings, drawings, and prints that paralleled and reflected the modernist literary movement of Latin America. Because of his fantastic subject matter he is considered by some critics to be a Mexican precursor of surrealism. Although his work has some similarities to that of Roberto Montenegro, Ruelas had no followers. Ruelas was born in Zacatecas, and his family moved to Mexico City while he was a child. He attended the Instituto Científico e Industrial Mexicano in Mexico City and attended the Colegio Militar de Chapultepec. The writer José Juan Tablada became his friend while they were students together at these two schools. Among Ruelas's first works of art were the illustrations he created for the student newspaper edited by Tablada. At the age of 16 Ruelas entered the Academy of San Carlos, later traveling to Germany to study at the School of Art of the University of Karlsruhe from 1892 to 1895. There he was exposed to German romanticism, Teutonic myths, and European symbolism, especially the works of Arnold Böcklin and Max Klinger. He was also influenced by the beginnings of the Jugenstil style and by a European fin-du-siècle mood, which was to influence his own brand of decadent, symbolist art. His oil painting *El ahorcado* (1890; "The Hanged Man") demonstrates Ruelas's affinity for European painters such as Edvard Munch. In this work Death, represented by a grimacing skeleton, ties the noose around a suicide's neck. On his scythe hangs a decapitated head that stares at the viewer.

After his return to Mexico in 1895 he joined the group of modernist writers and artists that included poets Amado Nervo, Manuel Gutiérrez Nájera, and Tablada and artists Roberto Montenegro and Germán Gedovius. He provided illustrations for the modernist publications *Revista Azul* (Blue Journal) and *Revista Moderna* (Modern Journal) using symbolist and art nouveau themes and styles. Ruelas joined his interest in European mythology with Mexican motifs. In *Fauno niño* (1896; "Boy Faun") he portrayed a child with Mexican features as a faun holding a panpipe. He often used bizarre and even sadistic imagery in his works. *La Domadora* (1897; "The Dominatrix") is a strange depiction of a woman dressed only in shoes, stockings, and a hat, wielding a small whip. She appears to be menacing a fat pig with a monkey on its back that is running away along a winding garden path. In his illustration for a 1903 masthead of *Revista Moderna* he depicted a sinuous figure of a nude woman bound to the letters of the magazine's title, a cobra poised to strike her body. In his paintings, drawings, etchings, and lithographs he depicted fantastic creatures, often combining human and animal forms. In his 1904 canvas *Entrada de don Jesús Luján a la Revista Moderna* he depicted his colleagues as a group of mythological beasts—half human, half animal—greeting one of their patrons in a pastoral landscape. His most famous work, an etching called *El crítico*

(1906–07; "The Critic"), is an imaginative symbolist work; the head of a critic stares at the viewer with a trance-like expression while a monstrous, bespectacled bird drills its sharp beak into his skull. Ruelas also painted and drew a number of sensitive portraits of his friends and family in Mexico.

In 1904 Ruelas, supported by the Mexican minister of education, Justo Sierra, and his patron, Jesús Juján, moved to Paris, where he studied etching with J. M. Cazin. He died in Paris of tuberculosis, possibly complicated by use of drugs and alcohol, and was buried in the Montparnasse Cemetery.

—Deborah Caplow

RUÍZ, Antonio "El Corcito"
Mexican painter

Born: Texoco, 1897. **Education:** Escuela de Pintura y Escultura de Bellas Artes, Mexico City, 1916; studied set and film design, Universal Films, Hollywood, California, 1926–29. **Career:** Drawing instructor, elementary schools, California, 1923–26. Returned to Mexico, 1929. Instructor of set design and art, Universidad Nacional de Mexico, Mexico City, 1938; director, Escuela de Pintura y Escultura de Bellas Artes (Esmeralda), Mexico City, 1942–54. Also taught drawing in elementary schools, Mexico, 1930s. Muralist, Pacific House, San Francisco, 1940. Founder, first Taller de Modelos Tecnícos de la Escuela Avanzada de Ingeniería y Arquitectura, Mexico City, 1932. **Died:** 1964.

Selected Exhibitions:

1928	Art Center, New York (individual)
1937	University of Minnesota, Minneapolis
1940	*Golden Gate International Exposition,* San Francisco
	Museum of Modern Art, New York
	Institute of Contemporary Art, Boston
	International Surrealist Exhibition, Mexico City
1943	Philadelphia Museum of Art
1943	*The Latin American Collection at the Museum of Modern Art,* New York
1966	*Art of Latin America since Independence,* Yale University, New Haven, Connecticut, and University of Texas, Austin

Collections:

Museum of Modern Art, New York; Philadelphia Museum of Art.

Publications:

On RUÍZ: Books—*Antonio Ruíz: El Corcito,* Mexico, Dimart, 1987; *Antonio Ruíz "El Corcito,"* exhibition catalog, by Luisa Barrios, Francisco Paniagua, and others, Mexico, Instituto Mexiquense de Cultura, 1994. **Article**—"Antonio Ruíz, El Corcito" by Maria Izquierdo, in *Hoy,* November 1942.

* * *

Antonio Ruíz's work reflects a variety of influences, among them scenography, architecture, surrealism, politics, and ironic humor. No matter what the subject matter, all his paintings depict authentic images of Mexican life, executed on an intimate scale rather than the larger-than-life proportions of famous Mexican murals. Even so, they reveal as much about Mexican culture as do the grand scale works on the walls of public buildings throughout the country. With their vibrant colors and narrative quality, Ruíz's canvases have been compared to *retablos,* small devotional paintings on wood or metal that portray scenes of miraculous intervention by saints. Like *retablos,* most of Ruíz's works measure less than 15 inches square.

One of his best paintings, *Bicycle Race at Texcoco* (1938), is characteristically small. It is marvelously expressionistic in its treatment of the cyclists who race toward the front of the picture plane. The leaves in the trees seem to rustle in the draft created by the racers as they speed past the spectators. But, more than mere scenes from Mexican life, Ruíz's paintings are always astute observations of the human condition. They delicately balance Mexican specificity with universal themes. For example, his 1937 *Summer* shows two peasants in their humble farm clothes looking at a storefront display in which three blond, fair-skinned mannequins are posed on a make-believe seashore, complete with bathing suits, beach umbrella, and palm tree. So much more than a pane of glass separates the modest couple from the mannequins and the store's clientele; they are worlds apart. Ruíz effectively spoke to the heart of race, class, and economic issues in this wordless mise-en-scène.

Although he participated in the Mexican International Surrealist Exhibition of 1940, Ruíz was never formally associated with that movement. Nonetheless, the two paintings he submitted for the show combine appropriately surreal imagery with commentary on Mexican history and sociopolitical themes. *The Dream of Malinche,* with its association of dreaming with the subconscious and of woman with nature, embodies surrealist tenets while alluding to the historically controversial Indian woman who served as interpreter and consort to Hernán Cortés during the sixteenth-century conquest of Mexico. *The Orator* takes a more humorous approach to surrealism and politics in its depiction of a miniature man perched on a wooden chair gesticulating to a crowd of *calabazas* (a Mexican reference to ignorant pumpkin heads) who are incapable of understanding his message. In these two works the artist deftly endowed allegory and comedy with a political subtext.

Ruíz's experience as a scenographer in both cinema and theater was also a strong element in his oeuvre. He had spent part of the 1920s in Hollywood, California, where he learned set design and worked for Universal Studios. The effect of this experience is seen in many of his later works, which can be described as genre paintings whose architectural and sartorial details identify them as specifically Mexican. In *The Milkman's Sweetheart* and *Serenade,* both from 1940, the figures stand like actors in front of painted stage sets. The diminutive size of the paintings (12 inches by 14 inches) gives them the appearance of maquettes, small preliminary models of stage designs, thus strengthening their association with scenography. Ruíz continued to be interested in set design throughout his career, especially in children's theater, through programs sponsored by the Mexican government.

Ruíz's commitment to Mexico and its future was apparent in his devotion to teaching after he returned to his native Mexico City from California in 1929. He simultaneously pursued successful careers in fine arts and art education. His teaching experience ranged from elementary school drawing instructor to professor at the School of

Engineering and Architecture to instructor of perspective and scenography at the National School of Fine Arts. From 1942 until 1954 Ruíz served as director of the School of Painting and Sculpture, where faculty included such luminaries as Diego Rivera and Frida Kahlo. The school, known as Esmeralda, was created by the secretary of public education to prepare young people for artistic careers. Ruíz's impact on the art of his country can be seen not only in his own work but also through the influence he exerted on subsequent generations of Mexican artists.

—Marianne Hogue

RUÍZ, Isabel
Guatemalan painter and installation artist

Born: 22 April 1945. **Education:** Universidad Popular de Guatemala, 1964–68; studied engraving at Escuela Nacional de Artes Plásticas, 1968; Centro Regional de Artes Gráficas, Universidad de Costa Rica, San José, 1978. **Career:** Artist-in-residence, Yaddo Corporation, New York, 1994. Member of artist group *Imaginaria,* 1986–91.

Individual Exhibitions:

1982	*Acuarelas y grabados,* Universidad Autónoma de Querétaro, Mexico
1991	*Sahumerios,* Galería Imaginaria, Antigua, Guatemala
1992	*Historia sitiada,* Galería de Arte Gala, Valencia, Venezuela (traveling)
1999	Universidad Rafael Landivar, Guatemala
	Autoinmersión, Galería Belia de Vico, Guatemala

Selected Group Exhibitions:

1988	Museo de Arte Moderno, Mexico City (with *Imaginaria*)
1989	Museum of Contemporary Hispanic Art, New York (with *Imaginaria*)
1994	*Land of Tempests,* Harris Museum and Art Gallery, Leicester City Gallery, Arts Council of Northern Ireland
1996	*Arqueología del silencio,* Museo del Chopo, Mexico
	Mesótica II: Centroamérica re-generación, Museo de Arte y Diseño Contemporáneo, Costa Rica (traveling)
1998	*1265 Km. Arte de Guatemala en Cuba,* Centro Wifredo Lam, Havana
1999	Mua-instala, Tegucigalpa, Honduras

Publications:

On RUÍZ: Articles—"Mujeres en las artes presenta obras de Isabel Ruíz y Patricia Cervantes," in *La Prensa,* 22 August 1997; "Imaginaria: Amidst Sausages and Hams" by Rosina Cazali, in *Art Nexus* (Colombia), 27, January/March 1998, pp. 60–63.

* * *

Certainly one could say that the work of Guatemalan artist Isabel Ruíz and her aesthetic criteria have been marked by the medium of engraving. If there is something that defines her bereaved characters and visions of despair, however, it is the sociopolitical circumstances and psychological effects that caused the civil war in her country. Throughout the years her prints and paintings with oil or watercolor have dramatically highlighted the testimonial aspect found in distinct moments of this biography, one in which she has fused the symbols of glyphs and engravings in Mayan ceramics. From these fused elements she has created a gallery of mythological beings.

Isabel Ruíz was born in Guatemala on 22 April 1954. From 1964 to 1968 she completed her studies in art at the Universidad Popular de Guatemala. But it was her specialization in engraving at the Escuela Nacional de Artes Plásticas and her studies in xylography at the Centro Regional de Artes Gráficas de la Universidad de Costa Rica in 1978 that formed her personal and inimitable style. Her organic and monstrous forms combine the influences of artists such as Mexican Francisco Toledo and Anselm Kieffer in his final period of production.

In 1986 Ruíz took part in el Grupo Imaginaria, an exhibition space and artistic meeting place situated in Antigua Guatemala, which motivated the emergence of an important group of artists, among whom could be found Luis González Palma, Pablo Swezey, and Moisés Barrios. Together with the *imaginarios* Ruíz displayed her work at the Museo de Arte Moderno of Mexico City in 1988 and the Museum of Contemporary Hispanic Art of New York in 1989. But the most valuable contribution of the collective experience was her foray into distinct mediums that she had been increasingly utilizing. In 1991 she opened her exhibition entitled *Sahumerios,* which marked her first interest in installations. This exhibition provided the motives that would be fundamental and recurring in the series she would soon exhibit in the future. Ruíz re-created spaces using pine wood chairs, wax candles, and lightbulb string with which she achieved scenographic effects with space.

This is not to say that the artist abandoned the use of watercolor and paper. Rather the paintings and paper as medium were very much a part of the installations. The objects were arranged around the paintings, which the artist generally placed on the floor. From strong religious-Catholic and ritualistic-indigenous traditions in Guatemala, Ruíz's installations evoke the dark environs of vigils and church altars in rural towns.

Subsequently watercolor was applied in rather heavy coats, and the paper was perforated with engraving tools. With spotlights placed behind the paintings, each opening projected rays of light, accentuating different shades of pigment.

In 1996, during her participation in the exhibition of cultural exchange between Mexico and Guatemala entitled *Arqueología del silencio* (Museo del Chopo, México), she introduced the use of a new material, charcoal, and since then the artist has relied on it for covering surfaces and for making carpets of varying dimensions. Ruíz recognized in the charcoal a symbolic power that intimately connects the memory of ruined lands, the various villages that were burned in order to leave no witnesses of the massacres of native inhabitants on the Guatemalan altiplano in the 1970s and '80s. The chairs symbolize the victims' absence or the silence that marked these years of political repression. Likewise, in the years of the peace agreement, Ruíz has presented these objects as symbols that invite the viewer to integrate the difficult process of reconciliation, dialogue, and regeneration of the spirit.

—Rosina Cazali

RUIZ, Noemí
American painter and silkscreen artist

Born: Mayagüez, Puerto Rico, 7 January 1931. **Education:** Inter American University, San Germán, 1949–53, B.A. in art 1953; New York University, 1955–56, M.F.A. 1956; Universidad Central, Madrid, 1962–63; studied lithography, ASUC Workshop, University of California, Berkeley, 1978. **Career:** Art program supervisor, Department of Education, Puerto Rico, 1954; professor, 1957–58, 1961–72, acting director, 1959–61, 1972–74, director, 1975–78, all fine arts department, and director, art and music departments, 1978–84, Inter American University, San Germán; professor, 1979–88, distinguished professor, beginning in 1989, and artist-in-residence, 1992, Inter American University, San Juan; instructor, School of Plastic Arts, Institute of Puerto Rican Culture, 1980. Since 1988 member of the governing board, School of Plastic Arts, Instituto de Cultura Puertorriqueña, San Juan. Organizer and director, educational seminars for public school art teachers, beginning in 1962; organizer, *International Sampler of Children's Art,* 1964; member, Education Reform Commission, Department of Education of Puerto Rico, 1976. Also worked as a consultant and advisor in fine arts for various agencies, including the Puerto Rico Education Department, as an organizer of art exhibitions, and set designer for theater productions. Traveled to Spain, France, and Belgium, 1958; to Mexico, 1959; to New York and Canada, 1962–63; to Madrid, 1965–66, 1969–70; to Europe, 1984. Cofounder, artist group *El Gremio,* 1957; cofounder and board member, Museum of Contemporary Art of Puerto Rico, 1984. **Awards:** Second prize in painting, *Third IBEC of Puerto Rico Exhibition,* 1965; Outstanding Work in Art prize, Rotary International, 1971; first prize in painting, Ateneo Puertorriqueño, 1974; Outstanding Work in Fine Arts and in Teaching of Art in Puerto Rico award, Mayor of San Juan, 1975; Mobil award, Outstanding Personality in Fine Arts in Puerto Rico, 1976; honorable mention, *Sin nombre* art competition, 1977; first prize in painting, *Art Expo,* Reynolds Tobacco Company, 1979; Outstanding Woman in the Arts in Puerto Rico, Governor of Puerto Rico, 1979; Distinguished Citizen in the Arts, Puerto Rico Medical Association, 1980; honorable mention, *12th UNESCO Painting Competition,* University of Puerto Rico, 1983.

Individual Exhibitions:

1960	Exhibition Hall, University of Puerto Rico
	Paintings and Drawings by Noemí Ruiz, San Germán
1962	Fine Arts Museum, University of Puerto Rico
1966	University of Puerto Rico, Río Piedras and Mayagüez
1968	Institute of Puerto Rican Culture, San Juan
1971	*Pielografías,* Ponce Art Museum
1972	Galería Santiago, San Juan
1975	University of Puerto Rico, Mayagüez
1976	Inter American Gallery, San Germán
1980	North End Gallery, Boston
1981	*Pinturas de Noemí Ruiz,* Art Students League, San Juan
1985	*Noemi Ruiz: Existencia de ser y tiempo,* Instituto de Cultura Puertorriqueña, San Juan, Puerto Rico
1988	*Diálogo de ser entre tiempo y espacio,* Galería Caribe, San Juan
1992	*Noemí Ruiz: Mi trópico, ritmo, espacio y tiempo,* Galería Botello, Hato Rey

1993 *Noemí Ruiz: Color y ritmo del trópico,* Galería Sala de
 Arte Contemporáneo, Quito, Ecuador

Selected Group Exhibitions:

1964 *Contemporary Art in Puerto Rico,* University of Puerto
 Rico
1966 Ponce Art Museum (with Jaime Carrero and Dan
 Brennan)
1965 *Third IBEC of Puerto Rico Exhibition*
1971 Ponce Art Museum (with Jaime Carrero and Sadot
 Marchany)
1975 *Cuatro pintoras y una escultora,* Galería María
 Rechany, San Juan
1977 *Muestra nacional de pintura y escultura puertorriqueña,*
 Instituto de Cultura Puertorriqueña, San Juan
1982 *La mujer en las artes,* Inter American University, San
 Juan
 Pintura contemporánea puertorriqueña, Inter American
 University, San Juan
1988 *Growing Beyond: Women Artists from Puerto Rico,*
 Museum of Latin American Modern Art, Washington,
 D.C.
1994 *Arte BA 94,* Buenos Aires

Collections:

Museo de Arte Contemporáneo de Puerto Rico; Ponce Museum of
Fine Arts.

Publications:

On RUIZ: Books—*Noemi Ruiz: Existencia de ser y tiempo,* exhibi-
tion catalog, San Juan, Puerto Rico, Instituto de Cultura Puertorriqueña,
1985; *Noemí Ruiz: Mi trópico, ritmo, espacio y tiempo,* exhibition
catalog, with text by Fernando Cros, San Juan, Galería Botello, 1992;
La pintura de Noemi Ruiz y la poesía visual del trópico by Jeannette
Miller, San Juan, Puerto Rico, n.p., 1996. **Article**—''Neurotic
Imperatives: Contemporary Art from Puerto Rico'' by Marimar
Benitez, in *Art Journal,* winter 1998.

* * *

The landscape and culture of Puerto Rico have undoubtedly
been a profound inspiration for Noemí Ruiz, born in 1931, one of
Latin America's leading abstract artists. Her abstract expressionism
seems to be born of the light and colors of the Caribbean. This hybrid
visual language is seen in the paintings of other abstract masters, such
as Fernando de Szyszlo and Alejandro Obregón. Like these artists,
Ruiz has contributed greatly to the abstract movement in Puerto Rico

and in Latin America, where the artistic tendencies lean toward
figuration. Her constant visibility in biennials and in solo and group
exhibitions has kept Latin American abstraction in the limelight. In
addition, Ruiz's distinction and influence as a teacher has been
particularly striking as a role model in a field where only a handful of
women artists have been successful and even fewer within abstraction.

The development of Ruiz as an abstract artist was strongly
influenced by the time she spent studying and experimenting in New
York City and in Spain. Studying for a master's degree in the fine arts
at New York University in 1955 and 1956 exposed Ruiz to the center
of the American abstract art movement. Her years in Spain during the
early 1960s also seem to have been a catalyst, as artists in that country
were just beginning their own acquaintance with abstraction. Ruiz
herself has attributed great importance to this period, stating, ''In
1965–66, back in Madrid . . . something happened that was decisive
in the technical aspects of my pictorial production . . . I experimented
[with paint rollers] and experienced a series of sensations that became
a determining factor in my painting.'' By 1966 her art had taken a
definitive turn toward abstraction.

Since then Ruiz's carefully controlled geometric paintings have
progressed toward a more open and three-dimensional composition.
Up to the mid-1980s her drawings and paintings were also centered
around a visible nucleus of forms or colors. Works such as the 1985
Island to the Wind: Time to Reap What Is Sown show this concentra-
tion of dense, collaged forms. Their color and lavish texture contrast
with the flat, wide forms surrounding them and weighing down the
center. This began to change after 1985, and critics lauded the
emergence and development of impulsive strokes and luminous
colors that broke the dominance of the nucleus in her paintings. The
Dominican professor and writer Jeannette Miller has noted that by
1988 Ruiz's ''confessed concerns with rhythm, time and space [had]
given way to the full-scale tropics. Vibration, flight, energy, color and
aura, mystery and plumage . . . these images . . . appear to have
emerged from their former nuclei . . .''

The evolution of Ruiz's technique and composition is significant
because they are inextricably linked to the successful expression of
the themes of her art. Her mature art conveys the emotional and
intellectual impression of Latin America, the underlying essence of
its tropics and its people. Like Wifredo Lam, Ruiz has achieved a
unique fusion of modernist abstract concepts with Caribbean forms
and concepts. Moreover, she works within a style that is notoriously
difficult for the public to fully appreciate, yet she is successful in
conveying subtle and complex ideas and in impressing them on the
senses, as is evident in one of her masterpieces, *My Green Island*
(1995). Beyond the impression of lush vegetation and brilliant light,
this acrylic painting encompasses ephemeral concepts such as wind,
light, vibration, heat, and stillness. Ruiz has succeeded in synthesiz-
ing European and American abstraction with Caribbean symbols and
elements and has done so with an insider's sensibility.

—Gabriela Hernández Lepe

SABOGAL (DIÉGUEZ), José

Peruvian painter

Born: Cajabamba, 1888. **Education:** Studied in Europe and North Africa, 1909–12; Academia Nacional de Bellas Artes, Buenos Aires, 1913–18. **Career:** Traveled to Mexico, 1922. Instructor, 1920–32, then director, 1932–43, Escuela Nacional de Bellas Artes, Lima. Traveled to the United States by invitation of the United States Department of State, 1942–43. Founder, magazine *Amauta,* 1926; cofounder, Instituto Libre de Arte Peruano at the Museo Nacional de la Cultura Peruana. **Died:** 15 December 1956.

Individual Exhibitions:

1916	Biblioteca Popular de Jujuy, Argentina
1917	Biblioteca Popular de Jujuy, Argentina
1919	Casa Brandes, Lima
1921	Casino Español, Lima
1923	Museo del Estado, Guadalajara, Mexico
1928	Salón Moretti y Castelli, Montevideo, Uruguay
1929	Academia Nacional de Música, Lima
1931	Universidad Nacional Mayor de San Marcos, Lima
	Delphic Studios, Florida
1933	Delphic Studios, New York
1934	Pataky Gallery, Florida
1937	Sala de la Sociedad Filarmónica, Lima
1940	Country Club, Lima
1954	Sociedad de Arquitectos del Peru, Lima

Selected Group Exhibitions:

1918	*Primer salón de la sociedad nacional de artistas,* Buenos Aires
1938	Universidad de Puert Rico, Rio Piedras
1940	*Golden Gate International Exposition,* San Francisco
1943	*The Latin American Collection of the Museum of Modern Art,* New York
1946	*Exposicion de la pintura peruana,* Concejo Provincial de Lima, Viña del Mar, Chile
1947	Pan American Union, Washington, D.C.
	Exposición internacional de Paris
1950	*Siete pintores peruanos,* Galería de Lima
1952	*Seis pintores peruanos,* Instituto Cultural Peruano Norteamericano, Lima
1966	*Art of Latin America since Independence,* Yale University, New Haven, Connecticut, and University of Texas, Austin

Collection:

Museum of Modern Art of Latin America, Washington, D.C.

Publications:

By SABOGAL: Book—*Pancho Fierro: Estampas del pintor peruano,* Buenos Aires, Editorial Nova, 1945. **Books, illustrated**—*Los hijos del sol* by Abraham Valdelomar, Ciudad de los Reyes del Peru, n.p., 1921; *Una Lima que se va* by José Gálvez, Lima, n.p., 1921; *Santa Rosa de Lima,* Lima, n.p., 1922, *Croquis de viaje,* Lima, Librería Francesa y Científica y Casa Editora E. Rosay, 1924; *José Maria Cordova,* Lima, La Voce d'Italia, 1924, *Quipus,* Lima, n.p., 1936, *La romantica vida de Marinao Melgar,* Lima, Club del Libro Peruano, 1939, *Viaje al pais de la musica,* Lima, n.p., 1943, *José Carlos Mariategui,* Lima, Ediciones Hora del Hombre, 1945, *El mar y los piratas,* Lima, n.p., 1947, *Pequeñas historias,* Lima, n.p., 1951, and *El mensaje de la musica,* Lima, n.p., 1952, all by Maria Wiesse; *Fire on the Andes* by Carleton Beals, Philadelphia, Lipincott, 1934; *Romance del viejo Peru* by Jesus Flores Aguirre, Lima, Ediciones Papel de Poesia, 1948.

On SABOGAL: Books—*José Sabogal* by Pedro Rojas Ponce, Jorge Falcón, and others, Lima, Instituto Sabogal de Arte, 1986; *Simplemente Sabogal: Centenario de su nacimiento, 1888–1988* by Jorge Falcón, Lima, Ediciones Hora del Hombre, 1988; *Sabogal: Homenaje al centenario del nacimiento de José Sabogal,* exhibition catalog, Lima, Banco Central de Reserva del Peru, 1988, and *Apuntes sobre José Sabogal: Vida y obra*, Lima, Banco Central de Reserva del Peru, Fondo Editorial, 1989, both by José Torres Bohl.

* * *

José Sabogal was a Peruvian painter closely connected with the indigenist movement in Peru during the 1920s and '30s. Various forms of indigenism occurred throughout Latin America during the early twentieth century seeking to create an art relevant to the social inequality of indigenous peoples. While associated with intellectuals such as the writer José Carlos Mariátegui, Sabogal was interested primarily in the artistic traditions and cultural identity of Peru's native peoples and often denied being an indigenist. Through his portraits of Peruvian Indians, however, he attempted to counteract the common view among the elite that Indians were inherently inferior. He did easel paintings as well as murals, woodblock prints, and lithographs, mostly of Indians in static poses dressed in brightly colored traditional clothing.

Sabogal was born in Cajabamba in 1888. As a teenager, he went to work on the Cartavio hacienda for four years, saving up money so that he could travel to Europe. In 1908 he went to Rome, where he began his artistic studies. He also traveled throughout Italy, North Africa, and Spain before going to Argentina in 1913. While attending the Academia de Bellas Artes of Buenos Aires, Sabogal met a number of Argentine artists, including Spilimbergo. He lived and worked in Argentina until 1918, when he returned to Peru. A trip to Mexico in 1922 did not influence his choice of indigenist subject matter. Although Sabogal met Diego Rivera and saw the works of Siquieros and many other Mexican artists, the highly politicized artistic style for which these artists later became famous had not yet been developed.

Sabogal's interest in indigenous peoples developed as a result of his visits to the area surrounding Lake Titicaca and Cuzco after 1918. Similar travels throughout Peru continued until 1956. He painted a number of canvases of Indians from the Peruvian highlands doing their daily work or celebrating at festivals. One of his most well known paintings from this period is *El alcalde indio de Chincheros, Vayaroc* (''The Indian Mayor of Chincheros, Vayaroc'') from 1925. It depicts an Indian in brightly colored traditional clothing holding a staff with silver decorations. He stands against a landscape painted in dramatic, fauvist colors with a town in the background. By painting an image of an indigenous person situated in a geographically specific location, with the symbols and title of leadership of that location, Sabogal makes reference, although rather subtly, to the land distribution problems that were the root of the oppression that indigenous peoples suffered.

Much of the mistreatment of the Indians in Peru had its origins in a feudal economy in which the common practice of landowners was to take possession of land being used by the Indians and then allow them to continue working on it in serflike fashion. Mariátegui pointed out this problem in his essay ''The Indian Question.'' Mariátegui was not only a writer but also a political activist who founded the Peruvian Socialist Party, which was based on the *ayllu*, or indigenous system of communal land holding. He founded the journal *Amauta* (''wise man'' in Quechua) to be a forum where he could express his ideas on the treatment of Indians. Sabogal contributed illustrations to this journal, including a woodcut that appeared on the cover of the first issue in 1926.

Sabogal and Mariátegui were good friends, but while Sabogal was sympathetic to the issues that Mariátegui addressed, his work never reached the same level of overt political activism. This was probably due as much to the inherent contradictions of indigenism as a movement as it was to Sabogal's own interests. Many of the artists who created indigenist works depicted Indians as idealized nationalist symbols instead of situating them within a specific historic context. Most of the intellectuals in the movement—Sabogal included—were of Spanish descent and did not identify culturally with the Indians. Peruvians often thought of themselves as either of Spanish or indigenous descent but not mixed. Sabogal eventually became more interested in preserving the pottery, basket weaving, and other crafts that the Indians practiced.

Sabogal was the director of the National School of Fine Arts of Peru between 1932 and 1943. During this time he had a great deal of influence on the work of artists such as Camilo Brent, Julia Codesido, and Camilo Blas as well as many others. After being rather unceremoniously discharged from this position, he spent the rest of his life preserving the popular arts and crafts of the Peruvian Indians. To this end, together with Luis E. Valcarcel, he founded the Instituto Libre de Arte Peruano at the Museo Nacional de la Cultura Peruana.

—Erin Aldana

SALAMÉ, Soledad

American painter, sculptor, mixed-media artist, and installation artist

Born: Santiago, Chile, 1954. **Education:** Santiago College, B.A. 1972; Technological Sucre, industrial and graphic design, Caracas, 1973; Design Institute, Neumann Foundation, Caracas, 1975–76; CEGRA, CONAC, Caracas, Making Paper by Hand Certificate 1978; Graphic Arts Institute for Graphic Instruction, CONAC, Caracas, M.A. 1979. **Awards:** Special recognition award, *International Biennal of Graphics,* 1982; Latina Excellence award, *Hispanic Magazine,* 1994; grant, Pollack-Krasner Foundation, 1996. **Address:** c/o Gomez Gallery, 3600 Clipper Mill Road, Suite 100, Baltimore, Maryland 21211. **Website:** http://www.gomezgallery.com.

Individual Exhibitions:

1980	City College, New York
	Wells College, Aurora, New York
1990	*Carmen,* Scenic Design and Installation, Baltimore Opera Company
	Of Time and Space, Zenith Gallery, Washington, D.C.
1994	Gomez Gallery, Baltimore
1995	*Reflexiones interiore,* Galeria Minotauro, Caracas
	Art Museum of the Americas, Organization of American States, Washington, D.C.
1996	Gomez Gallery, Baltimore
1997	*Shrines of Nature,* Gomez Gallery, Baltimore
	Zenith Gallery, Washington, D.C.
1998	Galería Arte Actual, Santiago
1999	Gomez Gallery, Baltimore
	Michael Lord Gallery, Milwaukee
2001	*Architecture and Environment,* Museo de Arte Contemporaneo, Santiago
	Labirinto de Soledad, Museo de Bellas Artes, Santiago

Selected Group Exhibitions:

1981	*Young Artists Exhibit,* Museum of Contemporary Art, Caracas
1988	*International Biennal of Graphic Arts,* Museum of Contemporary Hispanic Art, New York
1991	*Sculpture of the Americas into the Nineties,* Museum of Modern Art of Latin America, Washington, D.C.
1992	*Women of the World,* Zenith Gallery, Washington, D.C.

Soledad Salamé: *Bees, Bees Everywhere,* **1998. Photo courtesy of Gomez Gallery, Washington. D.C.**

Soledad Salamé: *Scrolls III,* **2000. Photo courtesy of Gomez Gallery, Washington, D.C.**

1994 *Across Borders, Sin Fronteras,* Museum of the Americas, Organization of American States, Washington, D.C.
1995 *Biennal barro de America II,* Museum of Contemporary Art Sofia Imber, Caracas
 Latin American Women Artists 1915–1995, Milwaukee Art Museum (traveling)
1996 *Contemporary Women Printmakers,* Gomez Gallery, Baltimore
1999 *Reflections of Time & Place: Latin American Still Life in the 20th Century,* Katonah Museum of Art, New York (traveling)
 Mastering the Millennium: Art of the Americas, World Bank in association with Organization of American States (traveling)

Collections:

Art Museum of the Americas, Organization of American States, Washington, D.C.; Baltimore Museum of Art; Inter-American Development Bank.

Publications:

On SALAMÉ: Books—*Latin American Women Artists, 1915–1995,* exhibition catalog, text by Edward J. Sullivan, Bélgica Rodríguez, and Marina Pérez de Mendiola, Milwaukee, Milwaukee Art Museum, 1995; *Soledad Salamé: De lo real a lo imaginario,* exhibition catalog, Santiago, Galería Arte Actual, 1998; *Latin American Women Artists of the United States: The Works of 33 Twentieth-Century Women* by Robert Henkes, Jefferson, North Carolina, McFarland, 1999. **Articles**—''Soledad Salame'' by Belgica Rodriguez, in *Art Nexus* (Colombia), 14, October/December 1994, pp. 106–107; ''Soledad Salame'' by K. Mitchell Snow, in *Art Nexus* (Colombia), 22, October/December 1996, pp. 157–158.

* * *

Soledad Salamé's path has traversed the entire Western Hemisphere, from her birthplace in Santiago, Chile, to Caracas, Venezuela, where she was educated at CONAC between 1977 and 1979, to North America, where she resided and worked in Baltimore, Maryland. This odyssey has enhanced her awareness of the planet, her explorations of its place in the universe, and her urgency to protect its natural resources.

In her pursuit of themes with pressing messages to protect the planet, she has combined her artistic talents in painting, sculpture, mixed-media printmaking, and installation art with an intellectual curiosity that has led to discourse with scientists, including botanists, and astrologers whose roots are deep in the South American tradition of its early civilizations and its constantly shifting constellation of the Southern Cross. Staying close to nature through extended stays in the remote La Savana region of Venezuela has inspired her work and aided her in illuminating the mystery that nature presents.

Salamé has made a partner of nature in the artistic process, beginning in the 1970s when she developed the *Sun Dial* series exploring the atmosphere and the rotation of the planet through functioning sundial sculptures. This body of work was influenced by the extraordinary pictures of men walking on the Moon in 1968. Additional contemplation on this subject led to the space investigation series entitled *Universe Structure,* which includes space shuttles, elements of the sundial series, and ringed planets.

While she was born in Chile, Salamé's family had emigrated from Arabia, and these influences seem to appear in a series of dark paintings based on architecture from the 1980s and early 1990s. In these paintings the Arabian arch recurs as an element in the buildings, which are shattered and reassembled. The series ended with an important transitional painting entitled *Two Cities,* with a city on one side of the canvas and a tree in the center. This tree signaled the artist's move toward natural life, including plants and insects, as subject matter.

Cathedral of Trees, a series of works focusing on bamboo fields, resulted from travels back and forth in the late 1980s and the 1990s to La Savana, where the rainforest meets the ocean on the Venezuela coast and visible reminders of the destruction of nature predominate. The series culminated with the use of living plants in an installation piece entitled *Garden of Sacred Light,* which was shown in the 1995 exhibition *Latin American Women Artists: 1915–1995,* organized by the Milwaukee Art Museum.

The use of the earth and other natural materials as media figured significantly in Salamé's art. The alchemy of changing powders into paints to mix her own pigments along with experimenting with earth samples connected her to the subject matter of the environment both in theme and media. Salamé explored in elegant presentations the fragile relationship of man and nature through insects frozen in amber and images of prehistoric plants and animals. Boxes that feature farm-raised insects from the Amazon region include notes from Salamé, giving these objects a connection to scientific exploration as well as adding a strong theoretical basis to her ideas and her technically masterful works. The juxtaposition of the artist's handwritten record with the insects and leaves equalizes man with nature, as both are vulnerable and mortal.

Salamé used the Sun in making a series of solar plate etchings with a technique pioneered by Dan Welden in his New York studio. This print series, entitled *Traces,* includes real insects in solar prints made with Mylar and resin. The scale of the pieces—74 inches by 50 inches—creates a presence that forces the viewer to question his place in the frozen world of amber, a material Salamé settled on when her original choice, mercury, proved too toxic. Even though the presence of mercury from gold mining waste in the Orinoco River creates a problem for the Venezuelan environment that concerned Salamé, she declined to use it because of risks to herself and others who might handle it. Quartz, a crystalline mineral created in an aqueous environment, fascinated Salamé and became part of a series of drawings on Mylar. Additional explorations of water and the condition of the oceans led to a series entitled *Waves,* consisting of solar etching and monoprints, which continue the large and small perspectives of nature's presence and its power.

From the infinite heavens to the smallest insects as subjects and with the Sun, earth, and all of nature in between as media, Salamé's elegant and thoughtful artistic production served to embrace the wholeness of nature and man's place in it as protector and destroyer. Salamé, recipient of the Pollack-Krasner Foundation grant, exhibited paintings, prints, sculptures, drawings, and installations in a major retrospective entitled *Labirinto de Soledad* (2001) at the Museo de Bellas Artes in Santiago. Her work there demonstrates that the loneliness of man and nature on this planet does present a labyrinth in which the artist's determined and thoughtful wanderings might lead to ''The Aleph'' of balance and harmony.

—Linda A. Moore

SALCEDO, Bernardo

Colombian sculptor, architect, and assemblage artist

Born: Bogotá, 1939. **Education:** Universidad Nacional de Colombia, Bogotá, 1959–65, degree (cum laude) in architecture 1965. **Career:** Instructor, Universidad Nacional, Universidad Javeriana, Universidad de los Andes y Piloto, Bogotá, 1965–84. **Awards:** First prize, *Concurso internacional de pintura Dante Alighieri,* Bogotá, 1966; special prize, government of Córdoba, Argentina, *III bienal internacional de arte,* 1966; special prize, *I bienal de Lima,* Peru, 1967; acquisition prize and honorable mention, 1968, and Premio Nacional Bolsa Viajera, 1970, *Bienal iberoamericana de artes de coltejer,* Medellín, Colombia, 1968; first mention, *I bienal de Quito,* Ecuador, 1968; first honorable mention, *Salón de las américas, VII*

festival de arte de Cali, Colombia, 1969; first national prize, *Salón nacional de artistas independientes U.J.T.,* Bogotá, 1972; honorable mention, *III bienal iberoamericana de artes gráficas,* Museo de Arte Moderno La Tertulia de Cali, Colombia, 1973; grand prize, *Primera bienal latinoamericana del Acero,* Paz del Río, Colombia, 1973; first prize, Empresa de Acueducto y Alcantarillado de Bogotá, 1988.

Individual Exhibitions:

1964	Salón Intercol de Arte Joven, Bogotá
1967	Festival de Arte de Cali, Colombia
1968	*Highway,* Museo de Arte Moderno, Bogotá
	Galería de Arte Marta Traba, Bogotá
1969	*Autopistas,* Museo de Arte Moderno, Bogotá
	Galería San Diego de Bogotá
	Centro Artístico de Barranquilla, Colombia
1970	*Planas y castigos,* Sala de Arte de la Biblioteca Nacional, Bogotá
1971	Centro de Arte y Comunicación CAYC, Buenos Aires
1972	Galería Belarca, Bogotá
1973	Galería ESEDÉ, Bogotá
1975	Galería ESEDÉ, Bogotá
	Galería Barbier, Barcelona, Spain
1976	*Notas de viaje,* Galería Pecanins, Barcelona, Spain
	Fundación Joan Miró, Barcelona, Spain
	Cajas blancas, Galería Aele, Madrid
	Cajas, objetos y operaciones básicas, Galería Aele, Madrid
	Agora Studio, Amsterdam
	Galería Asociada de Carmen Waug, Buenos Aires
	Cajas y objetos, Galería Ruiz Castillo, Madrid
1978	*Planos de proyectos de cajas,* Galería Sequier, Madrid
1979	*Cosas nuevas,* Galería Garcés Velásquez, Bogotá
1980	*Cosas nuevas,* Galería Estudio Actual, Caracas, Venezuela
1981	Galería Garcés Velásquez, Bogotá
1982	*Señales particulares,* Galería Nueve, Lima, Peru
1983	*Scier l'eau,* Galería Garcés Velásquez, Bogotá
1984	*Salcedo,* Museum of Art, Rhode Island School of Design, Providence
	Center for Inter-American Relations, New York
	Señales particulares y sierras, Galería Arte Autopista, Medellín, Colombia
1985	*Cosas nuevas, objetos y océanos,* Salón Cultural de Avianca, Barranquilla, Colombia
	Centro de Arte Actual de Pereira, Colombia
1988	*Reflexiones sobre el agua,* Galería La Oficina, Medellín, Colombia
1989	Galería Quintero, Barranquilla, Colombia
	Las flores del mal, Galería El Museo, Bogotá
1994	*XXIII bienal de São Paulo,* Brazil (retrospective)
	Salcedo esculturas, Galería El Museo, Bogotá
1995	*Instituciones, intervenciones y objetos,* Galería El Museo, Bogotá
1996	Galería Art Forum, Caracas, Venezuela
1997	*Acuarelas a la lata,* Galería El Museo, Bogotá
1999	Centro Colombo-Americano de Bucaramanga, Colombia (retrospective)
2001	*Bernardo Salcedo. El universo en caja,* Biblioteca Luis Angel Arango, Bogotá (retrospective)

Selected Group Exhibitions:

1970 *Bienal iberoamericana de artes de coltejer,* Medellín, Colombia

 Bienal, Medellín, Colombia

1973 *III bienal iberoamericana de artes gráficas,* Museo de Arte Moderno La Tertulia de Cali, Colombia

1986 *100 años de arte colombiano,* Museo de Arte de Brasil, São Paulo, Brazil

1991 *Los últimaos 50 años,* Galería El Museo, Bogotá

1993 *II feria internacional de arte—FIA 93,* Galería Garcés Velásquez, Caracas, Venezuela

1994 *Homenaje a la Barbie,* Museo de Arte Moderno La Tertulia, Cali, Colombia

 XXV salón nacional de artistas, Instituto Colombiano de Cultura, Bogotá

1997 *ARCO 97,* Madrid

2000 *La mirada del coleccionista,* Biblioteca Luis Angel Arango, Bogotá

Collections:

Galeria al Museo, Bogotá; Biblioteca Luis Angel Arango, Bogotá; Museo de Arte Moderno de Bogotá; Museo de Arte Moderno de la Universidad Nacional de Colombia, Bogotá; Museo de Arte Contemporáneo del Minuto de Dios, Bogotá; Museo de Arte Moderno La Tertulia de Cali, Colombia; Museo de Arte Moderno de Bucaramanga, Colombia; Museo de Arte Moderno de la Diputación de Barcelona, Spain; Museo de Arte Contemporáneo de Madrid; Museo de Bellas Artes de Caracas, Venezuela.

Publications:

On SALCEDO: Books—*Bernardo Salcedo 1981,* exhibition catalog, Santa Fe de Bogotá, Galeria Garces Velasquez, 1981; *Bernardo Salcedo,* exhibition catalog, Bogotá, Colcultura, 1994; *Bernardo Salcedo. El universo en caja,* exhibition catalog, Biblioteca Luis Angel Arango, Bogotá, 2001. **Article**—''Critics' Choice,'' in *Art News,* 92, summer 1993, pp. 141–143.

* * *

During the 1960s and 1970s Bernardo Salcedo renovated Colombia's artistic panorama with his daring assemblages. Influenced by Joseph Cornell, Salcedo created boxes containing found objects, particularly fragmented body parts, that shocked traditional minds. With a mixture of humor and irony, following the dadaist tradition, and with the rigor and the Bauhaus discipline of his architectural background, his work invaded and assaulted conventional spaces à la Donald Judd. From Salcedo's original boxes, painted in white and unified by the element of the absurd, to the more disturbing ones simulating domestic guillotines, he successfully adopted new aesthetic proposals in a daring and subversive way.

Salcedo's first series, *White Boxes* (1966–79), reflected both his iconoclastic mood and his love for cinema. Clearly influenced by neorealism and pop art, his tridimensional boxes, or niches, were filled with body parts and found objects, organized in a disturbing way. In some cases the public was able to open windows or doors or turn cranks, becoming participants in his aesthetic nonsense. Salcedo's creative mind was particularly brilliant playing with words. Titles

such as *Beatríz Loved Birth Control,* a box filled with eggs and children's hands; *Melodrama in One Act,* a delicate feminine hand holding a child's leg standing on a funnel; or *The Voyage,* a suitcase filled with carefully arranged body parts, were as poignant and arbitrary as the works themselves.

In Salcedo's 1968 show *Highway* at the Museo de Arte Moderno in Bogotá, the boxes acquired different dimensions. Walls and floors served as the settings for his cultural commentaries in works that were clearly influenced by American pop art. Gas stations, oil pumps, cars, and paths, all lost their original meaning to become pieces of an ironic and useless game. Works such as *La caja agraria,* a large box filled with earth, and *La caja de compensación familiar,* another box filled with rags, both referring to government institutions in charge of agricultural and family issues, also provided political commentaries on a larger scale. In these cases Salcedo played with the meaning of the word *caja* (box) and referred to their contents to indicate his conceptual intent.

In *Hectare,* a controversial piece presented for the first time at the Second Medellin Biennial (1970), he abandoned the box and piled on the floor 500 plastic bags filled with dry hay. This personal commentary about the precarious situation of Colombian farmers displaced by violence and poverty was unfortunately a premonitory vision.

Salcedo's critical view of Colombia's political and social situation continued in works such as *Frases de cajón* (''Slogans''), a series of empty guava paste boxes marked with popular sayings and commentaries such as ''Colombia is ripe'' and ''We will be the granary of the future.'' Along the same line was *First Lesson,* a public statement made on five advertising boards, one for each element of the national coat of arms. In this piece Salcedo claimed that since the condor was nearly extinct and there was no more abundance, no more liberty, and no more canal (it belongs to Panama, not to Colombia) the coat of arms did not exist and neither did the country.

Just when his political and social analysis was bordering on the anecdotical, Salcedo returned to more elaborate pieces such as *Water Boxes* (1983–85), made of glass and saws simulating ocean waves and with intervening photographs. This reminded us of the original Salcedo that strongly influenced a whole generation with his critical thinking and his way of breaking traditional schemes.

—Francine Birbragher

SALCEDO, Doris

Colombian sculptor and installation artist

Born: Bogotá, 1958. **Education:** Universidad de Bogoté Jorge Tadeo Lozano, B.F.A. 1980; New York University, M.A. in sculpture 1984. **Career:** Director, School of Plastic Arts, Instituto de Bellas Artes, Cali, Colombia, 1987–88; professor sculpture and art theory, Universidad Nacional de Colombia, Bogotá, 1988–91. **Awards:** Penny McCall Foundation grant, 1993; Solomon R. Guggenheim Foundation grant, 1995.

Individual Exhibitions:

1985 *Nuevos nombres,* Casa de la Moneda, Bogotá

1990 Galeria Garces-Velasquez, Bogotá

1992 *Doris Salcedo,* Shedhalle, Zurich
1994 *La casa viuda,* Brooke Alexander, New York
1995 White Cube, London
1996 *Atrabiliarios,* L.A. Louver Gallery, Los Angeles
 Le Creux de L'Infer, Theirs, France
 Galeria Camargo Vilaca, São Paulo
 Atrabiliarios, Edwin A. Ulrich Museum of Art, Wichita,
 Kansas
1998 *Unland/Doris Salcedo,* New Museum of Contemporary
 Art, New York, and SITE Santa Fe, New Mexico
1999 Tate Gallery, London
 San Francisco Museum of Modern Art
2000 *Tenebrae: Noviembre 7, 1985,* Alexander and Bonin,
 New York

Selected Group Exhibitions:

1995 *Sleeper: Katharina Fritsch, Robert Gober, Guillermo
 Kuitca, Doris Salcedo,* Museum of Contemporary Art,
 San Diego, California
 Carnegie International 1995, Pittsburgh
1999 *Displacements: Miroslaw Balka, Doris Salcedo, Rachel
 Whiteread,* Art Gallery of Ontario, Toronto
 Claustrophobia, Ikon Gallery, Birmingham, England
 XXIV bienal de São Paulo
 Trace, Liverpool Biennial of Contemporary Art,
 England
2000 *Still,* Alexander and Bonin, New York
 Eztetyka del sueño, Palacio de Velasquez, Museo
 Nacional Centro de Arte Reina Sofia, Madrid

Collections:

Fundacio "La Caixa," Barcelona, Spain; Biblioteca Luis Angel
Arango, Bogotá; Museum of Fine Arts, Boston; Albright-Knox Art
Gallery, Buffalo, New York; Art Institute of Chicago; Museum of
Contemporary Art, Chicago; Detroit Institute of Arts; Israel Museum,
Jerusalem; Tate Gallery, London; Los Angeles County Museum of
Art; San Diego Museum of Contemporary Art, La Jolla; Museum of
Modern Art, New York; National Gallery of Canada, Ottawa; Carne-
gie Museum, Pittsburgh; San Francisco Museum of Modern Art;
Moderna Museet, Stockholm; Art Gallery of New South Wales,
Sydney; Art Gallery of Ontario, Toronto; Hirshhorn Museum and
Sculpture Garden, Smithsonian Institution, Washington, D.C.; Worces-
ter Art Museum, Massachusetts.

Publications:

By SALCEDO: Book—*Atrabiliarios,* exhibition catalog, Wichita,
Kansas, Edwin A. Ulrich Museum of Art, 1997.

On SALCEDO: Books—*Doris Salcedo,* exhibition catalog, text by
Dan Cameron and Charles Merewether, New York, New Museum of
Contemporary Art, 1998; *Displacements: Miroslaw Balka, Doris
Salcedo, Rachel Whiteread,* exhibition catalog, text by Jessica Brad-
ley and Andreas Huyssen, Toronto, Art Gallery of Ontario, 1998;
Unland, exhibition catalog, text by Charles Merewether, San Fran-
cisco, San Francisco Museum of Modern Art, 1999; *Doris Salcedo* by

Carlos Basualdo, Andreas Huyssen, and Nancy Princethal, London,
Phaidon Press, 2000. **Articles**—"Community and Continuity: Con-
temporary Art of Colombia" by Charles Merewether, in *Art Nexus*
(Colombia), 55, June/August 1993, pp. 183–186; "Absence Makes
the Art" by Dan Cameron, in *Artforum,* 33, October 1994, pp. 88–91;
"Doris Salcedo" by Monica Amor, in *At Nexus* (Colombia), 13, July/
September 1994, pp. 166–167; "Other Directions" by Natalia
Gutierrez, in *Poliester,* 4(12), summer 1995, pp. 16–25; "Spotlight:
Doris Salcedo" by Euridice Arratia, in *Flash Art,* XXXI(202),
October 1998, p. 122; "Doris Salcedo" by Glen Helfand, in *San
Francisco Bay Guardian,* 17 March 1999.

* * *

Doris Salcedo was born in Bogotá, Colombia. She has continued
to live and work in Colombia, and her work makes eloquent reference
to the realities of life and death in her country of origin.

It used to be that Latin American artists who wished to succeed
were forced to immigrate to one of the art world centers or be
relegated to official obscurity. Salcedo is one of a generation of
renowned artists from all over Latin America who choose to stick
close to home, close to the spiritual center of their work and the
circumstances that proscribe its relevance.

Salcedo has traveled throughout Colombia interviewing those
who have survived that country's epidemic violence. She used
artifacts of individual lives in her work: furniture, or other domestic
details—buttons, shoes, lace, utensils—combined with organic mate-
rial, such as human hair, animal skin, and bits of bone. Some of her
objects are rendered mute or mutilated in their owner's absence. As an
artist, Salcedo has been a perpetual witness to violence, disappear-
ance, disorder, and the beauty of a single life hovering in the fine
details an individual leaves behind. She grafted pieces of furniture
together, creating dysfunctional objects, like the chairs whose legs
she extended until they crisscrossed the room and created a zone of
chaos in a 1998 exhibition at the New Museum of Contemporary Art
in New York City. Another work, called *Artrabiliarios,* consists of a
collection of shoes, each belonging to a woman who was "disap-
peared" and donated by the survivor's family. The shoes are encased
in alcoves in the wall, covered over with translucent animal skin sewn
over the opening with coarse black stitching. Each shoe is barely
visible through the fine skin that separates it from us. Like the families
these women left behind, we wonder in terrible silence where their
wearers have gone. In a piece from 1990, a stack of white shirts stands
tall, piled on the gallery floor. A steel pole runs through one shoulder,
fixing the shirts to the floor. The piece was inspired by the murder of
Colombian plantation workers in 1988. It is both beautiful and
painful—those who witness the piece feel the cold steel piercing the
delicate white shirts, monumental in their numbers, trapped and
destroyed by violence.

The task of commemoration, bravely and humbly undertaken in
Salcedo's work, was a formidable one in contemporary Colombia,
rent by civil war, feuding drug lords, and vigilante justice that
together claim thousands of lives each year. Many of the victims lived
in rural areas, where they were caught in the cross fire in the course of
going about their daily business. Salcedo has followed them, docu-
menting their disappearance, grieving for their deaths, and erecting,
through haunting works of sculpture, humble monuments to their
existence and their absence.

—Amy Heibel

SALERNO, Osvaldo

Paraguayan painter, engraver, and architect

Born: Asunción, 1952. **Career:** Cofounder and director, El Museo del Barro, Asunción. **Awards:** Premio Estimulo '71, 1971; Premier Premio "Hispanidad" de Pintura, 1978.

Selected Exhibitions:

1999 Palau de Pedralbes, Barcelona, Spain

La Casa de América, Madrid.

Publications:

By SALERNO: Books—*Josefina Plá: Homenage a 50 años de creación y pensamiento,* exhibition catalog, with Ticio Escobar, Asunción, Galería Artesanos, 1979; *Paraguay: Artesanía y arte popular,* with Francisco Corral and others, Asunción, Museo Paraguayo de Arte Contemporáneo, 1983; *Cabichuí: Periodico de la guerra de la triple allianza,* with Escobar, Josefina Plá, and Alfredo M. Seiferheld, Asunción, Museo del Barro, 1984; *La guerra del 70: Una visión fotográfica,* with Escobar and Seiferheld, Asunción, Museo del Barro, 1985; *Ignacio Nuñez Soler: Proyecto cultural artistas del Mercosur,* with Escobar and Ignacio Soler Nuñez, Asunción, Banco Alemán, 1999.

On SALERNO: Books—*El limite: Acerca de la obra gráfica de Osvaldo Salerno,* text by Ticio Escobar, Asunción, Lamarca, 1994; *Nueve xilograbados de la guerra del 70,* text by Josefina Plá, Asunción, Centro de Documentación e Investigaciones del Centro de Artes Visuales, Museo del Barro, 1998.

* * *

In 1982 in Asunción, Paraguay, the artist Osvaldo Salerno carried out an act that proved crucial to the development of his art. He began his career during the regime of the dictator Alfredo Stroessner, who ruled Paraguay until 1989. Like all dictators, for whom any reflective space poses a potential threat to power—20 of the most oppressive military regimes of the twentieth century have monitored and restricted all aspects of their countries' cultural production—Stroessner was vigilant in his suppression of all forms of artistic expression. Considering this history, it is doubly significant that Salerno, in addition to declaring himself in opposition to the regime, succeeded in combining his art with the predominant form of communication of the time: airmail. It is important to remember that it was the early 1980s, and fax and television cable, much less the Internet, were not widely used. Salerno faced another considerable limitation in that the nature of his work prevented him from ever repeating the same act. He did not need to accumulate objects, however, because the work defined itself along its margins, in the process of transit. To understand this, one must interrogate oneself about what the artist has done. Regarding a folded paper we must imagine that some sort of forcing action occurred, as of a manufacturing process. We can consider the manner in which it was introduced to us—how, as we encounter the parcel for the first time, the condition of the paper object changes. We can imagine a type of insistence in what the fold suggests, not as an allegory of margins but as their actual concrete form. The operation is dynamic in its symbolic placement of the artwork in the circuit of art: the work falls into a fault, beyond this circuit, questioning itself in its very relation to the culture and its systems of transport. At the same time, it builds upon the impediments of what it creates, only later reinterpreting these impediments as something that could be nothing else. In other words, it becomes the process of transit within the circuit, a circuit modernized by an international art that, paradoxically, does not officially exist.

Several years later, in Santiago, Chile, Eugenio Dittborn began sending his first airmail pieces. One could easily argue that these works, with their clear references to Salerno's own airmail pieces, constitute a form of mannerism, in the tradition of the mannerist reinterpretations of the Renaissance masters. In so doing, Dittborn aestheticizes what is fundamentally a political act on the part of Salerno. Even in 1985, when Chile was mired in the military regime of Augusto Pinochet, Dittborn was much more ambiguous than Salerno. The difference is most visible in Salerno's insertion of eclectic and juxtaposed images in his pieces, including images from old criminology journals, portraits of convicts, and boxing photographs. The most extreme expression of Dittborn's postmodernism came when he gathered photographs depicting the discovery of a communist leader's remains in a concentration camp in Pisagua. The images appeared on the cover of the newspaper *Fortin Mapocho.* When questioned about the political nature of his work, Dittborn responded, "The political is in the folds/edges." In this respect he is an architect of the notion of the moment, that convergence of time and space that the artist creates.

More recent works of Salerno are akin to those of Chilean artist Francisco Brugnoli in the early 1980s. Salerno time and time again confronts the problem of memory and history, suggesting that there is a logic of waste and consumption of manufactured products that is independent of industry, resulting in a symbolic violence. For example, in the 1997 work *The Pool* Salerno juxtaposes a box of water with a sentence from Roa Bastos: "I left the narrow cell smelling of bad weather." At the same time, he arranges a series of hourglasses on top of this box. Brugnoli had already explored this motif in his 1989 collective exhibition *Where Am I?,* in which he presents a cube of water lined with postcards of his Italian uncles—who had invited his parents to return to Italy—evoking a feeling of intense isolation. In the 1983 work *Landscape Two* Brugnoli arranges a series of 10 hourglasses on top of 10 trash bags, covered with the pieces of silver plastic with which they are typically sealed. The accompanying lists or registers put the work on an entirely different level than that of art in more industrialized countries, establishing a parallel and—in the words of Castillo Fadic—"eccentric discourse from the center without a story."

The notable Paraguayan critic Ticio Escobar has written extensively on the discursive nature of Salerno's work.

—David Maulen

SÁNCHEZ, Emilio

American painter and printmaker

Born: Camagüey, Cuba, 1921; U.S. naturalized citizen, 1968. **Education:** Yale University, 1939–40; University of Virginia, 1941–43; Art Students League, 1944. **Awards:** Eyre Medal, Pennsylvania Academy, 1969; David Kaplan Purchase award, New Jersey State

Emilio Sánchez, c. 1967. Reproduced by permission of the Estate of Emilio Sánchez.

Museum, 1970; first prize, San Juan Biennial, Puerto Rico, 1974. **Died:** 1999.

Individual Exhibitions:

1949	Joseph Luyber Gallery, New York
1951	Ferargil Gallery, New York
	Ateneo Gallery, Mexico City
1953	Ferargil Gallery, New York
	Bernheim-Jeune Gallery, Paris
	Ateneo, Mexico City
1955	Mint Museum, North Carolina
	Tucker Gallery, Miami
1956	Peridot Gallery, New York
	Lyceum, Havana
1958	Zegri Gallery, New York
	Philadelphia Print Club
1959	Lyceum, Havana
1961	Choate School, Wallingford, Connecticut
1964	Galería Fortuny, Madrid
1965	Galería Colibri, San Juan
1966	Contemporaries Gallery, New York
1967	Louisiana Gallery, Houston
	Zella Gallery, New Orleans
1968	Zegri Gallery, New York
	Galería Colibri, San Juan
	Associated American Artists, New York

1970	Bienville Gallery, New Orleans, Louisiana
1971	Center for Inter-American Relations, New York
	Coe Kerr Gallery, New York
	Associated American Artists, New York
	Museo de Bellas Artes, Caracas
1972	Biblioteca Luis-Angel Arango, Bogota
1973	Coe Kerr Gallery, New York
	Galería San Diego, Bogota
1974	Museo la Tertulia, Cali, Colombia
	Tower Gallery, Southampton
	Museo del Grabado Latinoamericano, San Juan
1975	Centro de Arte Actual Pereira, Pereira, Colombia
	Galería Lucas, Valencia & Gandia, Spain
	Tower Gallery, Southampton
	Coe Kerr Gallery, New York
	Harriet Griffin Gallery, New York
1976	Museo Ponce, Puerto Rico
	Galería Las Americas, San Juan
1977	Harriet Griffin Gallery, New York
	Miami-Dade Public Library Print Show
	Galería San Diego, Bogota
1978	*The Lithographs of Emilio Sánchez,* Williams College Museum of Art, Williamstown, Massachusetts
1979	The Gallery at 24, Miami
	S.G. Mathews Gallery, San Antonio
1980	The Gallery at 24, Miami
	S.G. Mathews Gallery, San Antonio
1981	Associated American Artists, New York
1982	Museo la Tertulia, Cali, California
	Images Gallery, Toledo, Ohio
1983	ACA Galleries, New York
	The Gallery at 24, Miami
1984	The Gallery at 24, Miami
1985	Museum of Art, Fort Lauderdale, Florida
	The Gallery at 24, Miami
	ACA Galleries, New York
1987	Carone Gallery, Fort Lauderdale, Florida
1988	Miami-Dade Public Library, Miami
1990	Park Gallery, Boca Raton, Florida
1991	Gutierrez Fine Arts, Miami
1992	Miami-Dade Community College, Kendall, Florida
1994	Elite Fine Arts, Coral Gables, Florida
1997	Elite Fine Arts, Coral Gables, Florida

Selected Group Exhibitions:

1950s	Lyceum Gallery, Havana; Contemporaries Gallery, New York
1965	Pan Am Building, New York
	Pennsylvania Academy of Art, Philadelphia
1968	Brooklyn Museum, New York
	Inter-American Graphics Biennial, Santiago, Chile
	Metropolitan Museum of Art, New York
1970	New Jersey State Museum Color Print Annual
	Biennial, Medellin, Colombia
	Biennial, San Juan
1974	Biennial, San Juan
	Art Fair, Cologne, Germany
	Museum of Modern Art, New York
1977	Museum of Contemporary Art, Madrid

Emilio Sánchez: *La Casa Amarilla,* **c, 1970. Reproduced by permission of the Estate of Emilio Sánchez.**

Emilio Sánchez: *Crosstown Traffic.* Reproduced by permission of the Estate of Emilio Sánchez.

1977	Center for Inter-American Relations, New York
1980	Center for Inter-American Relations, New York
1982	American Academy of Arts and Letters, New York
	Mary-Anne Martin Fine Art, New York
	Huntington Art Gallery, Austin, Texas
1985	Trienial, Grenchen, Switzerland
1988	Bronx Museum, New York
	John Szoke Gallery, New York
	Krasdale Gallery, New York
	Mocha, New York
	Kornbluth Gallery, Fair Lawn, New Jersey
1994	The Art and Culture Center of Hollywood, Florida
1996	Krasdale Gallery, New York
1998	Aix-en-Provence, France
1999	Museum of Art, Fort Lauderdale, Florida

Selected Collections:

Albright-Knox Art Gallery, Buffalo, New York; Brooklyn Museum, New York; Free Library of Philadelphia; Metropolitan Museum of Art, New York; Museum of Modern Art, New York; Walker Art Center, Minneapolis; Joseph Hirshhorn Museum, Washington, D.C.; Corcoran Art Gallery, Washington, D.C.; Lessing J. Rosenwald Collection, National Gallery of Art, Washington, D.C.; National Museum, Havana; Museo de Arte Moderno, Bogota; Museo la Tertulia, Cali, Colombia; Boston Museum of Fine Arts; Cooper-Hewitt Museum; Mario K. McNay Museum, San Antonio; National Gallery of Australia, Canberra; Philadelphia Museum of Art; Smithsonian Institution, Washington, D.C.

Publications:

On SÁNCHEZ: Books—*Emilio Sánchez,* exhibition catalog, New York, Center for Inter-American Relations, 1971; *Emilio Sánchez: Paintings,* exhibition catalog, Bogota, Bank of the Republic, 1972;

Emilio Sánchez, exhibition catalog, Museo de Arte La Tertulia, Cali, Colombia, 1974; *Emilio Sánchez,* exhibition catalog, Pereira, Pereira Center of Art, 1975; *The Lithographs of Emilio Sánchez,* exhibition catalog, Williamstown, Massachusetts, Williams College Museum of Art, 1978; *Realism and Latin American Painting, the 70s,* exhibition catalog, text by Lawrence Alloway, New York, Center for Inter-American Relations, 1980; *Emilio Sánchez: Recent Work,* exhibition catalog, Fort Lauderdale, Florida, Fort Lauderdale Museum of the Arts, 1985; Art of Cuba in Exile, Miami, Editora Munder, 1987; *Outside Cuba/Fuera de Cuba,* Rutgers, The State University of New Jersey and University of Miami, 1989; *Emilio Sánchez* exhibition catalog, Elite Fine Art, 1994; *Emilio Sánchez* by Carol Damian, Ann Koll, and Robert Sindelir, New York, Emilio Sánchez Foundation, 2001. **Articles**—''Cartagena in the Work of Sánchez'' by Gloria Valencia Diago, in *Time* (Bogota), August 1972; ''The Porches of Old Habana in the Painting of Emilio Sánchez,'' in *Republic* (Bogota), August 1972; ''Architect of Light and Shades'' by Giulio V. Blanc, in *Américas* (Washington, D.C.), 38(3), May-June 1986, pp. 44–49; ''Emilio, Entre Dos Grandes Espectros: La Luz y La Sombra'' by Rafael Bordao, in *La Nuez* (New York), number 2, 1988, p. 17; ''N.Y. Views Celebrate Artistry of Sánchez,'' in *Miami Herald* (Miami), 10 October 1992; ''Emilio Sánchez El Arco de Medio Punto'' by Armando Alvarez Bravo, in *El Nuevo Herald,* 2 November 1994.

* * *

The bright, tropical, high noon scenes that Emilio Sánchez described in his most familiar works were his personal vision of a world poised between dream and reality. He found material for his art in direct observation and in nostalgic re-creations that were at once a mirror of his own experiences as much as a comment on the world as he saw it. His prosaic, realistic approach to architecture, landscapes, and still lifes was marked by a radical simplification of forms and traditional painterly techniques. Sánchez was preoccupied with the

ordering of pictorial space and the resolution of light, shadow, and color on scenes that were as varied as the Manhattan skyline, Key West Conch architecture, Caribbean villages, and luminous sunsets. His imagery, apparently simple on first view, is actually as complex as the fascinating life that took him from Cuba to New York City, where he enjoyed a long and successful career. Although he always considered himself to be a truly cosmopolitan New Yorker and an American, he also described his emotional makeup as more Cuban, although he spent most of life outside his island homeland. He would never forget his heritage and was quick to distinguish his upbringing as something unique and extraordinarily cultured. It was a dream life of privilege, far from reality, similar to the world he portrayed in his paintings.

Years of travel informed his imagery, especially of the Caribbean Sánchez painted as a joyful expression of light and color concentrated on the simplified facades of wooden houses with fanciful details and shadowed portals. Few figures appear in his architectural images. Nothing disturbs the quietude of a moment frozen in time and place. Nostalgic reminiscences of Cuba are evident in the images of stained glass fanlights, called *medio punto*s, and in the tropical still lifes of the flowers and palm trees that occupied him throughout his career. As a New Yorker he found that the great metropolis also offered endless possibilities, from sunsets on the Hudson River, to the designs of doorways and awnings on old iron buildings, to traffic jams with their endless streams of headlights dissecting the city's concrete and steel canyons.

Sánchez often worked in series, repeating his subjects for years and in different media and ever refining his imaginative views. Each day began with drawing exercises, and drawing was essential to his art. Everything was a study in abstract construction and lighting effects, whether tropical or urban in concept, and his compositions captured an abstract ordering of space that was always solemn, even in the frenzy of the city. There was always a reverential mood of calm that could not really be true but was a direct result of his unique aesthetic that depended on a combination of hard-edge drawing and free painterly techniques. The contours of an ordinary house, skyscraper, tree, or volcano described more than a subject for artistic contemplation. Through the careful reduction of form and simple color combinations and contrasts, the subject was magnified as the focal point of a balanced composition that transformed the scene into something monumental and his alone.

—Carol Damian

SÁNCHEZ, Juan
American painter, photographer, and printmaker

Born: Brooklyn, New York, 1954. **Education:** Cooper Union for the Advancement of Science and Art, B.F.A. 1977; Mason Gross School of the Arts, Rutgers University, New Brunswick, New Jersey, M.F.A. 1980. **Career:** Curator, New York, 1980s and 1990s. **Awards:** Premio Anual, La Asociacion Puertorriqueña de Críticos de Arte, El Ateneo Puertorriqueño, San Juan, 1992; Youths Friends award, Art League of New York, Metropolitan Museum of Art, 1994; Lifetime Achievement in Art award, National Hispanic Academy of Media Arts and Sciences, New York, 1995.

Individual Exhibitions:

1979 *Mi mundo,* Amherst College, University of Massachusetts, and East Harlem Cultural Center, New York
Mi gente, Fourth Street Photo Gallery, New York
1980 *Lucha,* Rutgers University, New Brunswick, New Jersey
1985 *Anki: An Indigenous Word of the Taino Indian of Puerto Rico Meaning Enemy,* John Jay College, New York, and University of Massachusetts, Amherst
1987 *Guariquen: Images & Words Rican/Structed,* Exit Art, New York
1989 Exit Art, New York
Juan Sánchez: Paintings & Prints, Jersey City Museum, New Jersey
1990 *Juan Sánchez: 30 Monotype Prints,* Miami-Dade Community College, Miami
Un sueño libre: An Aesthetic of Liberation and Struggle, Taller Puertorriqueño, Philadelphia
1991 Massachusetts College of Art, Boston
University Art Museum, State University of New York, Binghamton, New York
1992 Museo del Grabado Latinoamericano, San Juan, and Casa de la Masacre, Ponce, Puerto Rico
1993 Carla Stellweg Latin Ameircan and Contemporary Art, New York
Light Factory Photographic Arts Center, Charlotte, North Carolina
Gallery 1199, New York
1994 *5 Habana bienale,* Havana
Year of the Print: The Juan Sánchez Portfolio, Fairfield University, Connecticut
Nuyorican Poets Café, New York
1995 Guadalupe Cultural Arts Center, San Antonio, Texas
Brandywine Workshop Printed Image Gallery, Philadelphia
R. Duane Reed Gallery, St. Louis
Wall Gallery, John Jay College of Criminal Justice, New York
1996 Teatro Galería Manny Maldonado, Brooklyn, New York
1997 *Juan Sánchez: Disenchanted Island,* Charter Oaks Cultural Center, Hartford, Connecticut
Dr. Pedro Albizu Campos Museum of Puerto Rican History & Culture, Chicago
1998 Jersey City Museum, New Jersey (traveling)
Bronx Museum of the Arts, New York
1999 The Regina A. Quick Center for the Arts, St. Bonaventure University, New York
2000 *Reconstructions: Paintings of the 90s,* P.S.1, New York

Selected Group Exhibitions:

1986 *Carribean Art/African Curents,* Museum of Contemporary Hispanic Art, New York
La segunda bienal de la Habana, Museo Nacional de Bellas Artes, Havana
1988 *Committed to Print,* Wright State University, Dayton, Ohio (traveling)

545

Juan Sánchez. Photo by David Dilley; courtesy of the artist.

Juan Sánchez: *Rainbow Shell: Reconciliation with Father,* 1999. Photo courtesy of the artist.

Juan Sánchez: *Cries and Whispers: Finding Your Way Back Taino,* 2001. Photo courtesy of the artist.

1988	*Unknown Secrets: Art & the Rosenberg Era,* Long Island University, New York (traveling)
1990	*The Decade Show: Frameworks of Identity in the 1980s,* New Museum of Contemporary Art, New York
1992	*Latin American Artists of the Twentieth Century,* Estación Plaza de Armas, Seville, Spain (traveling)
1995	*Premio MARCO II,* Museo de Arte Contemporáneo de Monterrey, Mexico
1996	*Think Print: Books to Billboards, 1980–1995,* Museum of Modern Art, New York
1997	*American Visions: Latino Photographers in the United States,* Smithsonian Institution, Washington, D.C.
1998	*100 en la sien: 10 artistas ante el 98,* Museo de Arte Contemporáneo de Puerto Rico, Santurce

Collections:

Metropolitan Museum of Art, New York; Museum of Modern Art, New York; Whitney Museum of American Art, New York; Mint Museum of Art, Charlotte, North Carolina; El Museo del Barrio, New York; Jersey City Museum, New Jersey; Library of Congress, Washington, D.C.; University of Colorado, Boulder; Institute of Puerto Rican Culture, San Juan; Jane Voorhees Zimmerli Art Museum, New Brunswick, New Jersey; Cooper Union for the Advancement of Science & Art, New York; Centro Wifredo Lam, Havana; Conseio Puertorriqueño de Fotografia, San Juan; Washington University, St. Louis; Miami-Dade Community College, Miami; Taller Puertorriqueño, Philadelphia; Brandywine Printmaking Workshop, Philadelphia; Bronx Museum of the Arts, New York; Rhode Island School of Design, Providence; Emory University, Atlanta; University of New Mexico, Albuquerque; University of Connecticut, Storrs; New York Public Library.

Publications:

By SÁNCHEZ: Books—*Ritual & Rhythm: Visual Forces for Survival,* exhibition catalog, New York, Kenkeleba House Gallery, 1982; *Evidence: From Twelve Photographers,* exhibition catalog, New York, Louis Abrons Arts for Living Center of the Henry Street Settlement, 1982; "The Metamorphosis/Search for the Island/Self and the Conflictive Plebiscite of the Mind," in *In Search of an Island,* exhibition catalog, Chicago, Sazama Gallery, 1990; *Remerica! America: Re-Appropriating Ourselves for Truth, Justice and Peace,* exhibition catalog, New York, Hunter College, 1992; *Puerto Rican Equation: Puerto Rican Artists Ponder 100 Years Since the 1898 Invasion,* exhibition catalog, New York, Hunter College, 1998. **Articles**—"Puerto Rican Nationalist Art: A History, A Tradition, A Necessity," with Rafael Colón Morales, in *Art Workers News,* 11(9), May 1982; "Visual Artists and Anti-Apartheid," with Jimmie Durham, in *Art & Artists,* 12(7), June 1983.

On SÁNCHEZ: Books—*Rican Structions: Disenchanted Island,* exhibition catalog, text by Marysol Nieves, Hartford, Connecticut, Charter Oak Cultural Center, 1997; *Juan Sánchez: Printed Convictions: Prints and Related Works on Paper,* exhibition catalog, text by Alejandro Anreus and Julia P. Herzberg, Jersey City, New Jersey, Jersey City Museum, 1998. **Articles**—"Rican/structions" by Coco Fusco, in *Art in America,* 78, February 1990, p. 156; "Juan Sánchez" by Julio Flores, in *New Art Examiner,* 24, July/August 1997, pp. 43–44; "Antidote to Oblivion: Popular Memory in the Work of Juan Sánchez" by Benjamin Genocchio, in *Third Text* (United Kingdom), 49, winter 1999/2000, pp. 41–50; "Juan Sánchez at P.S.1, New York" by Jonathan Goodman, in *Art in America,* 88(11), November 2000, pp. 171–172.

* * *

The colorful, beautifully layered paintings and collages of New York-born Juan Sánchez can easily mask the strong political undertones of his work. Growing up poor in New York City, he worked to support his family as soon as he could. Sánchez's political activism began with his involvement in the Young Lords, a Puerto Rican group similar to the Black Panthers. The political messages in his paintings reflect his interest in the Puerto Rican community in New York as well as issues pertaining to Puerto Rico, especially the controversial military control of the island of Vieques. A Sánchez work may contain one or more of the following symbols: the Puerto Rican flag, a crying baby, the Virgin Mary, palm trees, or the baby Jesus. Layered within these images there may appear family photographs of Sánchez's beloved daughter, news clippings featuring Puerto Rican activists, text written by Sánchez, or decorative feathers and lace. Sentimental images—his daughter in a Communion dress, for example—are juxtaposed with Sánchez's text and disturbing photographs. In his series of paintings *Cries and Whispers* Sánchez honors personal and political figures, paying tribute to both his father and Malcolm X.

Since 1979 Sánchez has used Vieques as a recurring subject in his work. The U.S. Navy's 60-year bombing of the island, its high infant mortality rate, and the prevalence of cancer on Vieques are all issues that Sánchez addresses. His first piece about Vieques was a tribute to Angel Rodríguez Cristóbal, an activist from Puerto Rico who was arrested for his opposition to the Navy's occupation. After being transported to the United States, he eventually died in a jail in Alabama. The death of Cristóbal haunted Sánchez, provoking him to return to the subject in subsequent paintings. In *Vieques en gritos* (2001; ''Vieques in Cries'') Sánchez created a digital work in which the images are turned upside down, emphasizing the destructiveness of the bombing. A Puerto Rican sailor boy is placed beside an upside-down palm tree, a mother holds a crying baby that refuses to be comforted, and the colors of a Puerto Rican flag are switched, making it a contaminated symbol. Similarly, in *El Grito II* and *El Grito III* newspaper clippings of protestors with raised fists are layered beside repeated images of Mary cradling a baby Jesus. In one a black-and-white photograph of a woman holding a screaming baby is partially obstructed by the Puerto Rican flag. The woman is holding her baby firmly, but not in a comforting way. The painting seems to ask the question, What sort of future will the woman face?

Rican-structions is an ongoing project to honor the Puerto Rican experience. This collection of paintings, which Sánchez began in the 1990s, shows the struggle of Puerto Ricans to find an identify in the United States. The paintings feature his parents, among other subjects. In *Rainbow Shell: Reconciliation with Father* (1999) Sánchez has placed a picture of his father as a young man beside a car. The text reads, ''He slaved 24 hours a day to put down a steak on our table con platanos, arroz, and beans.'' His father abandoned the family when Sánchez was a young boy, leaving his mother to rely on welfare. The text included in the portrait of his mother reads, ''My mother was very frustrated . . . she couldn't get a job, she wanted to get off welfare. I never looked at my mother as a woman; she was always my mother . . .'' The paintings are tributes, but they also explore the complex lives of his parents, including their frustrations.

There is a tension between personal history and social concern in Sánchez's work. While his pieces address issues such as Puerto Rican independence and AIDS, they also portray love, loyalty, and the comfort of the family. The formal beauty of his work, the hot tropical colors, and the intricate designs mesh with the charged newspaper clipping and political statements, creating paintings that are both aesthetically pleasing and thought provoking.

—Sally Cobau

SÁNCHEZ, Juan Manuel

Costa Rican sculptor

Born: Curridabat, 27 December 1907. **Family:** Married Berta Solano in 1952. **Career:** Illustrator for periodical *American Repertoire,* early 1930s; director,Departamento Técnico de Dibujo y Manualidades del Ministerio de Educación Pública, 1942–45; professor, Liceo de Costa Rica, 1942–45; art history professor, Facultade Bellas Artes of the University of Costa Rica, 1950. Traveled to Mexico, 1956. **Awards:** Gold medal, *Second exposición de artes plásticas del diario de Costa Rica,* 1930; silver medal in sculptor, *Third exposición de artes plásticas,* 1931; gold medal, *Fourth exposición de artes plásticas del diario de Costa Rica,* 1932; National Prize ''Aquileo J. Echevarría,'' 1965; National Prize of Magón Culture, Costa Rica, 1982. **Died:** 16 April 1990.

Selected Exhibitions:

1932	School of Osejo
1950	National Museum of Costa Rica
1964	Galería de Artes y Letras in San José
1980	Museo de Arte Costarricense and Institute of Hispanic Culture, San José
1981	Museo de Arte Costarricense and Institute of Hispanic Culture, San José
1982	Museo de Arte Costarricense and Institute of Hispanic Culture, San José
1983	Museo de Arte Costarricense, San José
1988	Gallery Enrique Echandi
1995	Museo de Arte Costarricense, San José

Publications:

On SÁNCHEZ: Books—*J. M.: Esculturas,* exhibition catalog, San José, Museo de Arte Costarricense, 1983; *Juan Manuel Sánchez: 1907–1990,* exhibition catalog, San José, Museo de Arte Costarricense, 1995.

* * *

Juan Manuel Sánchez's sculpture makes him an essential figure of the Central American avant-garde. He formed part of the workshop producing figures of saints in polychrome wood that belonged to Manuel María Zúñiga, father of the best-known figure of the Costa Rican avant-garde, Francisco Zúñiga. There Sánchez began wood carving, which was to lead him to the creation of his most important works.

Keeping up to date with the aesthetic thought of the moment, Sánchez became profoundly interested, in part because of his own native Indian background, in the development of the indigenous pictorial movement in Mexico, and he had intense debates with other local avant-garde figures on diverse aspects of native sculpture in Central America. From the start he was inclined toward the adoption

of a certain "primitivism" in carving, which was to relate him historically to expressionism. But he was also clearly influenced by modernism, which became evident in his drawings, a speciality in which he stood out for the subtlety and careful rhythm of his compositions. As an illustrator he is particularly noted for his involvement in many different publications in different genres. His taste for sinuous lines and flatness in sculpture is evident in the series of portraits of his wife in brass, done in the style of the Spanish sculptor Pablo Gargallo.

Sánchez's carvings in wood show the contrast between his artistic works and his daily work as an artisan in the production of the images of saints, which demanded polish and realism. His works highlight the appreciation of the naked wood, crudely carved, emphasizing the character of the block, with a special tendency toward verticality, and accentuating the edges as well as the subtle curves in the relief. The effect of synthesis, derived in part from the influence of pre-Columbian sculpture and in part from the observation of cubist aesthetics, confers on his works a level of abstraction that is perfectly expressed in some of his most important pieces, as in *Amantes* (1934; "Lovers").

Sánchez revealed himself to be equally talented in the carving of granite, in which the crudeness he cultivated became evident in the unfinished effect of the portraits. From formless masses, both tree trunks and pieces of granite, he made faces or bodies emerge, always with simplified features. One of his most subtle works in stone is *Saint Francis of Assisi* (1963), in which his affinity with Romanic and Gothic aesthetics can be seen, as can the influence of the Franciscan cult greatly cultivated in Central America and present in the subjects of other Costa Rican avant-garde figures such as Francisco Amighetti. Eloquent as regards the cultural climate within which the Costa Rican avant-garde arose, numerous openly religious scenes, or those that refer to religion through scenes of customs, may be found in the production of Sánchez, Amighetti, and Francisco Zúñiga.

Sánchez's tastes for the animalistic and the practice of the portrait are crucial in his work. Inspired by traces of indigenous culture, by a cosmogony in which animals played a determinant role, Sánchez inclined toward the representation of animals in sculptures in which his expressionist facet stands out. In his drawings, on the contrary, we see a lively lyricism. His small sculptures of animals, all representative of local fauna, express an intense relationship with the material.

Generally in wood, the sculptures of Sánchez always indirectly reveal a dramatic musicality, a sometimes tense containment, or a sensuality that is almost tortuous. They are defined not by a tragic feeling but rather by a vigorous passion that is transformed in his drawings into sinuous rhythms, into a dance. This last quality is revealed in his prolific work as an illustrator.

—Vivianne Loría

SANCHEZ, Robert

American painter and installation artist

Education: Memphis College of Art, Tennessee, B.F.A. 1974; University of New Mexico, Albuquerque, M.A. 1976; Cornell University, Ithaca, New York (on research fellowship), 1976–77. **Career:** Lecturer, Mesa College, San Diego, California, 1981–87; lecturer, visual arts department, University of California, San Diego, 1985–88; visiting lecturer, Cornell University, Ithaca, New York, summer 1986; lecturer, department of art, San Diego State University, California, 1987–89; instructor, Southwestern College, Chula Vista, California, 1988–89; lecturer, Mira Costa College, Oceanside, California, spring 1990. Since 1990 lecturer, Mesa College, San Diego, California. Involved with artist collective Border Art Workshop/Taller de Arte Fronterizo.

Individual Exhibtions:

1991 *La frontera nos parte hasta los huesos*, United States/ Mexican Border Art Forum, University of Baja, California (with Richard Lou)
1992 *III Istanbul Biennial*, Feshane Museum, Turkey (with Lou)
1994 *Los Anthropolocos New Digs at Mission Viejo: In Search of the Colorless Hands*, Saddleback College Art Gallery, Mission Viejo, California (with Lou)
1996 *Los Anthropolocos: In Search of the Colorless Hands and Captives of Fate; Unearthing the Future*, Centro Cultural de la Raza, San Diego, California (with Lou)
1999 *New Interiors for the Restless Border*, Porter Troupe Gallery, San Diego, California

Selected Goup Exhibitions:

1985 *Border Realities*, Centro Cultural de la Raza, San Diego, California
1987 *911—A House Gone Wrong*, Border Arts Workshop/ Tallér de Arte Fronterízo, Imperial Beach, California
1988 *Streetworks, Streetsets, Streetsites*, Sushi Performance and Visual Art, Community Concourse, San Diego, California
1989 *Crossing the Line,* San Jose Institute of Contemporary Art, San Jose, California
 Vidas perdidas/Lost Lives, Border Arts Workshop/Tallér de Arte Fronterízo, Imperial Beach, California
1991 *Traversing Borders,* Boehm Gallery, Palomar College, San Marcos, California
1992 *La reconquista: A Post-Colombian New World,* Centro Cultural de la Raza, San Diego, California
1993 *Sin fronteras: Chicano Arts from the Border States of the U.S.,* Cornerhouse Gallery/Art Centre, Manchester, England
2000 *Hecho en Califas: The Last Decade,* Plaza de la Raza, Los Angeles (traveling)

Publications:

On SANCHEZ: Books—*La reconquista: A Post-Colombian New World*, exhibition catalog, by Patricio Chávez, San Diego, California, Centro Cultural de la Raza, 1992; *American Visions: Artistic and Cultural Identity in the Western Hemisphere* by Mary Jane Jacob, Noreen Tomassi, and Ivo Mesquita, New York, ACA Books, 1994. **Articles**—"Crossing the Line" by Susan Hinton, in *Artweek*, 20, 18 March 1989, pp. 11–12; "Traversing Borders" by Victoria Reed, in *Artweek,* 22, 11 April 1991, p. 10; "Artists Writing in Public . . . ," in *Public Art Review,* 6, spring/summer 1996, pp. 15–17.

* * *

Working with performance artist and painter Richard Lou, Robert Sanchez has created dynamic, provocative installations that test and examine racial stereotypes. In a physical, unconventional style the two artists, who were involved with the Border Art Workshop/Taller de Arte Fronterizo, an art collective that looked at cultural issues relevant to the Chicano movement, have created "in-your-face," satirical pieces.

In an ongoing project called Los Anthropolocos, Sanchez and Lou transform themselves into two "C.h.D's—Doctors of Chicanoismo from the University of Aztlan" who work on the "white frying project." The project is a humorous, dark parody of anthropological research. In this case the anthropologists are trying to reconstruct the lost Colorless, or white, society. In an installation called *Los Anthropolocos: New Digs at Mission Viejo—In Search of Colorless Hands,* the artists have hung 463 pudgy white latex gloves stamped with numbers that represent individual digs. The mock digs unearthed the white society's items, as well as identified trace elements in their soil of tofu and Hostess Ding Dongs. Around the exhibition Sanchez and Lou have placed text that turned antiminority stereotypes around. In this case the extinct whites were a culture of people that "did not value work or encourage ambition or initiative." The whites also were blamed for "bland inane music such as Achy, Breaky Hand." Mocking white culture fads, Sanchez and Lou make fun of white culture's interest in New Ageism as well as the culturally appropriated piercing phenomenon. On a more serious note Sanchez and Lou create six theories of white culture, which undermine anthropological truths. For example, Theory 4 reads: "Criminal Intent Becomes a Social Identifier: A large number of Colorless created a grisly welfare scam." In a blue light projected onto a sandbox, video of *Raiders of the Lost Ark* mixes with fake archaeological footage. Sifting through sand, Sanchez discovers a white hand. Then Sanchez and Lou go crazy with joy at their discovery. On opening night of the exhibition, Sanchez and Lou played the part of the anthropologists, proudly posing for photographs in front of the digs, signing autographs, and playing up their "status" as archaeologists. They even went so far as to "sell" their excavated hands for $5.00.

Other installations created by Lou and Sanchez include *Entrance Is Not Acceptable,* which reveals an undocumented worker's plight, and *Suspended Text: A Border Matrix,* which involves a confining exercise of pushing oneself on a wheeled platform. In another piece Sanchez and Lou play with white culture, mixing cultural icons such as Barry Manilow music with the images from the television show *Dukes of Hazard.* By playing with stereotyping of whites, Sanchez and Lou create pieces that undermine cultural stereotyping of people of color. With Groucho Marx-like humor laced with anger, Sanchez and Lou make the viewer look at his or her perceptions of race. The anthropological digs remind us that the United States is a nation built on top of the cultures of colored people, and Sanchez and Lou will not let us forget it.

—Sally Cobau

SANÍN, Fanny
Colombian painter and printmaker

Born: Bogotá, 30 November 1938. **Education:** University of Los Andes, Bogotá, 1956–60, M.F.A. 1960; studied art history and printmaking, University of Illinois, Urbana-Champaign, 1962–63;

Fanny Sanín. Photo by Mayer Sasson; courtesy of the artist.

studied printmaking, Central School of Art, London, 1966–68. **Career:** Partner, Linearte, Bogotá, 1961–62; private art teacher, Mexico, 1963–66. Moved to the United States, 1971. **Awards:** VIII November Salon award, Monterrey, Mexico, 1963; Medellin award, *II Coltejer art biennial,* Medellin, 1970; Canadian Club award, *Mira: The Canadian Club Hispanic Art Tour,* New York, 1985; Colombia Award in Art, 1993. **Agents:** Ms. Andrea Marquit, 71 Pinckney Street, Boston, Massachusetts 02114, U.S.A.; Walter Gomez, Gomez Gallery, 3600 Clipper Mill Road, Suite 100, Baltimore, Maryland 21211, U.S.A.; Garces y Velasquez Gallery, Carrera 5, No. 26–92, Bogotá, Colombia. **Address:** 345 E. 86th Street, Apartment 17C, New York, New York 10028, U.S.A.

Individual Exhibitions:

1964	Modern Art Gallery, Monterrey, Mexico
1965	Technological Institute of Monterrey, Mexico
	Turok-Wasserman Gallery, Mexico City
	Lake House Gallery, National University, Mexico City
	Museum of Modern Art, Bogotá
1966	Colseguros Gallery, Bogotá
1967	Museum of Fine Arts, Caracas
1968	AIA Gallery, London

Fanny Sanín: *Acrylic No. 1,* **1999. Photo by Jim Strong; courtesy of the artist.**

1969	Pan American Union Gallery, Washington, D.C.
1970	House of Culture Gallery, Monterrey, Mexico
1972	National Institute of Culture and Fine Arts, Caracas
1977	Phoenix Gallery, New York
1978	Long Island University, Brooklyn, New York
	University of Illinois, Urbana
1979	Museum of Modern Art, Mexico City
	Quintero Gallery, Barranquilla, Colombia
	Garces Velasquez Gallery, Bogotá
1980	Phoenix Gallery, New York
1982	Garces Velasquez Gallery, Bogotá
	Phoenix Gallery, New York
1984	Rayo Museum, Roldanillo, Colombia
	Juan Martin Gallery, Mexico City
1986	Schiller-Wapner Gallery, New York
	Garces Velasquez Gallery, Bogotá
	Chamber of Commerce, Cali, Colombia
1987	*Fanny Sanín 1960–1986,* Museum of Modern Art, Bogotá (traveling retrospective)
1990	Greater Lafayette Museum of Art, Indiana
1994	Garces Velasquez Gallery, Bogotá
1995	Inter-American Art Gallery, Miami-Dade Community College, Miami
1996	Antioquia Museum, Medellin
2000	*Color and Symmetry—Retrospective Exhibition 1987–1999,* Avianca Cultural Center, Baranquilla, Colombia, and Luis Angel Arango Library, Bogotá (retrospective)

Selected Group Exhibitions:

1969	*Art of the Real: Aspects of American Painting and Sculpture 1948–1968,* Tate Gallery, London
1979	*XV international São Paulo biennial,* Convention Center, São Paulo
1983	*Colombia: Art of the Studio, Art of the Street,* School of Fine Arts, Paris
1984	*Christopher Columbia Painting Award,* Centro Cultural Conde Duque, Madrid
1985	*One Hundred Years of Colombian Art,* Museum of Modern Art, Bogotá (traveling)
1986	*II le Habana biennial,* National Museum of Fine Arts, Havana
1992	*From Torres-Garcia to Soto,* Art Museum of the Americas, Washington, D.C.
1994	*Latin American Artists in Washington Collections,* Inter-American Development Bank, Washington, D.C.
1995	*Latin American Women Artists 1915–1995,* Milwaukee Art Museum (traveling)
1997	*Colors: Contrasts & Cultures,* Discovery Museum, Bridgeport, Connecticut

Collections:

Minnesota Museum of Art, St. Paul; Everson Museum of Art, Syracuse, New York; Phoenix Art Museum,; National Museum of Women in the Arts, Washington, D.C.; New Orleans Museum of Art; Museum of Art of the Americas, Washington, D.C.; Greater Lafayette Museum of Art, West Lafayette, Indiana; Biblioteque Nationale, Paris; Museum of Modern Art, Mexico City; Museum of Modern Art, Bogotá; Museum of Modern Art, Medellin; Museum of Contemporary Art, Bogotá; Luis Angel Arango Library, Bogotá; Museum of Art of the National University, Bogotá; Antioquia Museum, Medellin; Museum of Modern Art, Barranquilla, Colombia; Museum of Modern Art Ramirez Villamizar, Pamplona, Colombia; Museum of Art, Popayan, Colombia; Museum of Art, Warsaw; Puerto Rico Institute of Culture, San Juan; Museo de Arte Abstracto Manuel Felguerez, Zacatecas, Mexico; Museum of Fine Arts, Caracas; National Institute of Culture and Fine Arts, Caracas; Municipal Museum of Graphic Arts, Maracaibo, Venezuela; National Institute of Fine Arts, Mexico City; Museum of Art, Monterrey, Mexico; Gallery of Latinamerican Art, Cravocia, Poland; Rayo Museum, Roldanillo, Colombia; Taller 5, Bogotá.

Publications:

On SANÍN: Books—*Fanny Sanín,* exhibition catalog, by Fernando Gamboa, Mexico City, Museo de Arte Moderno, 1979; *Almanaque mundial: Panorama de artes plásticas* by María Elvira Alvarez del Real, Panama, Ed. Américas, 1981; *Fanny Sanín,* exhibition catalog, by Peter Frank, New York, Phoenix Gallery, 1982; *Arte moderno en América Latina,* edited by Damián Bayón, Madrid, Taurus, 1985; *Arte Colombiano,* Bogotá, Plaza & Janés, 1985, and *Colombia en las artes,* Bogotá, Imprenta Nacional, 1997, both by Francisco Gil Tovar; *Fanny Sanín,* exhibition catalog, by Mario Amaya, New York, Schiller-Wapner Gallery, 1986; *Sanín and Gillespie,* exhibition catalog, by Sharon Theobald, West Lafayette, Indiana, Greater Lafayette

Fanny Sanín: *Acrylic No. 2,* 1999. Photo by Jim Strong; courtesy of the artist.

Museum of Art, 1990; *Fanny Sanín,* exhibition catalog, by Donald Goodall, Miami, Miami-Dade Community College, 1991; *North American Women Artists of the Twentieth Century* by Jules Heller and Nancy G. Seller, New York and London, Garland, 1995; *Latin American Artists of the Twentieth Century,* exhibition catalog, by Aracy Amaral, New York, Museum of Modern Art, 1993; *Fanny Sanín,* exhibition catalog, by Richard Humphrey, Bogotá, Galería Garcés Velásquez, 1994; *Fanny Sanín—Rosa Sanín: Abstracción,* exhibition catalog, by María Elvira Iriarte, Medellin, Libe de Zulategui, and Lucrecia Piedrahita Orrego, Museo de Antioquia, 1996; *Ensayos* by Lilia Gallo, Bogotá, Instituto de Investigaciones Esteticas, 1997; *Fanny Sanín, color y simetría,* exhibition catalog, by Germán Rubiano and José Ignacio Roca, Bogotá, Biblioteca Luis Angel Arango, 2000.
Articles—"Fanny Sanín" by Jorge J. Crespo de la Serna, in *Novedades* (Mexico City), 23 July 1965; "Fanny Sanín" by Cottie Burland, in *Arts Review* (London), September 1968; "Los planteamientos cromáticos de Fanny Sanín" by José Hernán Briceño, in *El Nacional* (Caracas), 30 October 1972; "Fanny Sanín" by Edgar Buonagurio, in *Arts Magazine* (New York), December 1977; "A geometria de Fanny Sanín" by Fernando Cerqueira Lemos, in *Folha de São Paulo* (São Paulo), 7 October 1979; "Fanny Sanín" by Valerie Natsios, in *New York Arts Journal,* February 1982; "La obra plástica de Fanny Sanín: Geometría lírica" by Ana Maria Escallon, in *El Espectador* (Bogotá), 21 June 1984; "Fanny Sanín" by Leslie Judd Ahlander, in *Art Nexus* (Bogotá), 1991; "Fanny Sanín en Bogotá, enigma sagrado" by Alister Ramírez, in *El Tiempo* (Bogotá), 10 April 1994; "Fanny Sanín" by Germán Rubiano, in *Art Nexus* (Bogotá), 13, July 1994; "Mujeres en la noticia: Fanny Sanín, sinónimo del arte pictórico" by Ana María B. de Cano, in *El Espectador* (Bogotá), 18 April 1994.
Films—*Retrospectiva de Fanny Sanín* by Mayer Sasson, Bogotá, Museo de Arte Moderno, 1987; *Fanny Sanín: Retrospective Video* by Henry Laguado, Bogotá, Producciones Moviola, 1994; *Fanny Sanín,*

Color & Symmetry by Juan Lanz and Claudia Umaña, Bogotá, arTV Producciones, 2000.

*

Fanny Sanín comments:

In my paintings, color and structure interact and have equal importance. My language is that of pure abstraction devoid of any allusion to an external reality. The experience of creation is unhurried, meditative, and gradual with a sense of calm and harmony drawn from my own imagination.

Kandinsky expressed it with great clarity in his book *Concerning the Spiritual in Art* (Wassily Kandinsky, *Concerning the Spiritual in Art,* translated by M. T. H. Sadler, New York, Dover Publications, 1977, p. 43) in discussing all the elements contained in the concept of harmony:

> The composition arising from this harmony is a mingling of color and form each with its separate existence, but each blended into a common life which is called a painting by the force of the inner need. An initial conception is explored on a series of small studies on paper. Form and color are simultaneously evoked; one does not precede the other. Color is achieved through a series of mixtures and never applied directly from the tube. I have no rules but I do have my own language expressed through concepts of a refined tonal harmony, luminosity, unity, symmetry and centrality. The character of my work is derived from a persistent search for a personal visio of color and its interaction with structure. This approach to the work results in a slow change from painting to painting matured over the years with a recognizable and profound spiritual intensity that is always present.

I was born in Colombia, and I still feel my roots deeply. However, I would say that I consider my art as universal. After living in different places in Latin America, Europe, and the United States, and traveling to other countries around the world, I would say that I am the result of a confrontation of cultures expressed through my individual personality and inner world.

* * *

Fanny Sanín belongs to a generation of Colombian artists who, in the second half of the twentieth century, worked in an abstract style despite the weight of the country's strong figurative tradition. While in the 1960s many of these artists, including Edgar Negret, Eduardo Ramírez Villamizar, and Carlos Rojas, produced works in a constructivist manner, Sanín began to develop her own abstract style mainly influenced by geometric abstraction and minimalism.

Her career began after she received her degree in fine arts from the University of Los Andes in Bogotá, in 1960. She pursued graduate studies in art history and printmaking at the University of Illinois at Urbana-Champaign and at the Chelsea School of Art and Central School of Art in London. From 1963 to 1966 she lived in Mexico, and in 1971 she moved to New York.

In 1987 the Museum of Modern Art of Bogotá presented a major retrospective of Sanín's work dating from the 1960 to 1986. John Stringer, the exhibition's curator, organized it in six phases: Genesis

(1960–63), Calligraphy (1964–68), Transition (1969–70), Stripes (1970–74), Symmetry (1974–80), and Centrality (1980–86). Even though the first two phases were characterized by expressionism, most of her career would be devoted to a serious search into the world of abstraction.

Art of the Real: Aspects of American Painting and Sculpture 1948–1968, an exhibition of minimal art organized by the Museum of Modern Art in New York and shown at the Tate Gallery in London, in 1969, was influential in the development of her "Transition" phase. Many characteristics of the works displayed in this exhibit, such as total abstraction, order, clarity, anti-illusionism, and self-reference, would later appear in her own work.

In 1970 she abandoned oil for acrylic and started working on the vertical bands that characterized her "Stripes" phase. These bands evolved into increasingly complex and unpredictable geometric patterns that characterized the "Symmetry" phase, most likely influenced by the works of abstract English painters she had encountered during her stay in London, such as Robin Denny, known for his strict bilateral and symmetric compositions, and John Hoyland, who painted interrelated shapes closely related to geometry. In 1984 she introduced her *Compositions* series, which differ from the *Acrylics* series only in the use of paper as a medium. In 1987 she painted only one work, *Acrylic No. 1,* which introduced diagonals as the basis for the composition. A year later another work, *Composition No. 1,* introduced the curve, adding a new dimension to the geometric field.

Sanín's work cannot be fully characterized as minimal or geometric. Her canvases possess a spirituality that transcends the abstract. Influenced by artists working in nongeometric forms, such as Mark Rothko, Clyfford Still, and Robert Ryman, her works transmit a great deal of emotion and project an inner luminosity.

The evolution of her work continued throughout the 1980s and 1990s, as seen in her retrospective *Color and Symmetry—Retrospective Exhibition 1987–1999,* presented at the Luis Angel Arango Library in Bogotá, in 2000.

The elements of her works are units of form and color. The former are primarily squares, rectangles, triangles, trapeziums, and other polygons, as well as bands, stripes, and lines, while the latter, the colors, vary immensely. Her rich combinations of forms are enhanced by a superb use of color. Color plays a primordial role in Fanny Sanín's work. It affects the totality of the composition and determines the presence and number of forms in the painting. Tonalities vary from light to dark, from soft to intense. In the Luis Angel Arango retrospective the color is stronger, more powerful and attractive.

For Fanny Sanín, color and structure interact and have equal importance. Her language is of pure abstraction devoid of any allusion to an external reality. The experience of creation is unhurried, meditative, and gradual, with a sense of calm and harmony drawn from her imagination. An initial conception is explored by working on a series of small studies on paper. Sanín explores multiple alternatives until a convincing composition is found. Each study is a finished work in itself.

Form and color are simultaneously evoked. Color is achieved through a series of mixtures and never applied directly from the tube. She has her own language expressed through concepts of refined tonal harmony, luminosity, unity, symmetry, and centrality. The character of her work is derived from a persistent search for a personal vision of color and its interaction with structure. This approach to the work results in a slow change from painting to painting matured over the years with a recognizable and profound spiritual intensity. It is her long-term dedication to expressive nonobjectivity that makes her one of the major creators of hard-edged abstraction in contemporary South American painting.

—Francine Birbragher

SCHENDEL, Mira

Brazilian painter and sculptor

Born: Mira Hargersheimer Schendel, Zurich, Switzerland, 1919; emigrated to Brazil, 1949. **Education:** Studied philosophy, Milan. **Career:** Moved to Porto Alegre and began painting, 1949. **Awards:** First prize, *Salon de Arte Moderno,* El Salvador, 1953; gold medal, *New Delhi Triennial,* India, 1971; Best Object of the Year, Associacao Paulista de Criticos de Arte, São Paulo, 1973; acquisition prizes, *Salan de Arte Moderna,* São Paulo, 1963, and *São Paulo Bienale,* 1967 and 1969. **Died:** São Paulo, 1987.

Individual Exhibitions:

1950	*Correio do povo* Auditorium, Pôrto Alegre, Brazil
1954	Museu de Arte Moderna, São Paulo
1960	Galeria Adorno, Rio de Janeiro
1962	Galeria Selearte, São Paulo
1963	Galeria Sao Luis, São Paulo
1964	Galeria Astreia, São Paulo
1965	Petit Galeria, Rio de Janeiro
	Signals Gallery, London
1966	Museu de Arte Moderna, Rio de Janeiro
	Signals Gallery, London
	Galerie Bucholz, Lisbon, Portugal
1967	Technische Hochschule, Stuttgart, Germany
1968	Gromholt Galleri, Oslo
1972	Galerie Ralph Camargo, São Paulo
1973	Brazilian-American Cultural Institute, Washington D.C.
1974	Schmidtbank-Galerie, Nuremberg, Germany
1975	Gabinete de Artes Graficas, São Paulo
1978	Galeria Cosme Velho, São Paulo
1980	Galeria Cosme Velho, São Paulo
1981	Galeria Luisa Strina, São Paulo
1982	Paulo Figueiredo Galeria de Arte, São Paulo
1983	Galeria Luisa Strina, São Paulo
1985	Paulo Figueiredo Galeria de Arte, São Paulo
1987	Gabinete de Arte Raquel Arnaud, São Paulo
1990	Museu de Arte Contemporanea, Universidade de São Paulo
1994	*São Paulo Bienal* (retrospective)

Selected Group Exhibitions:

1951	*Bienale,* São Paulo (also appeared in 1953, 1963, 1965, 1967, and 1981)
1968	*Biennale,* Venice

1968 *Concrete Poetry Show,* Lisson Gallery, London
1987 *Modernidade: Art bresilien du 20e siecle,* Musée d' Art
 Moderne de la Ville, Paris
1989 *Art in Latin America: The Modern Era, 1820–1980,*
 South Bank Centre, London (traveling)
 The Image of Thinking in Poetry, Solomon R.
 Guggenheim Museum, New York
1993 *Brasil: Segni d' arte: Libri e video, 1950–1993,*
 Fondazione Scientifica Querini- Stampalia, Venice
 Latin American Artists of the Twentieth Century,
 Museum of Modern Art, New York
 Ultramodern: The Art of Contemporary Brazil, National
 Museum of Women in the Arts, Washington, D.C.
1995 *Art from Brazil in New York,* Galerie Lelong, New York

Collection:

Museo de Bellas Artes, Caracas.

Publications:

By SCHENDEL: Book—*Grafische reduktionen,* Stuttgart, Germany, H. Mayer, 1967.

On SCHENDEL: Books—*Signals Newbulletin* by David Medalla, London, 1966; *Mira Schendel,* exhibition catalog, São Paulo, 1982; *Mira Schendel: Pinturas recentes,* exhibition catalog, São Paulo, 1985; *Modernidade: Art bresilien du 20e siècle,* exhibition catalog, Paris, 1987; *Projeto arte brasileira: Abstracao geometrica 2,* Rio de Janeiro, 1988; *Art in Latin America: The Modern Era, 1820–1980,* exhibition catalog, London, 1989; *Mira Schendel,* exhibition catalog, Universidade de São Paulo, 1990; *Brasil: Segni d'Arte: Libri e Video, 1950–1993,* exhibition catalog, Venice, 1993; *Latin American Artists of the Twentieth Century,* exhibition catalog, New York, 1993; *Ultramodern: The Art of Contemporary Brazil,* exhibition catalog, Washington, D.C., 1993; *No vazio do mundo: Mira Schendel* edited by Sonia Salzstein, São Paulo, Editora Marca d'Agua, 1996; *A forma volátil,* Rio de Janeiro, Editora Marca D'Agua, 1997.

* * *

Despite its similarities with a number of different artistic movements taking place during the 1960s and 1970s, the work of Mira Schendel escapes easy classification. Schendel was an autodidact who received little or no formal training, although she attended art school in Milan as a teenager. She mostly shunned the mainstream art world except for a small circle of acquaintances that included the critics Mário Schenberg and Guy Brett, the sculptor Sérgio Camargo, and the concrete poet Haroldo de Campos, among others. She discussed physics with Schenberg, engaged in theological debates with a group of Dominican monks, and studied both Western and Asian philosophy. As a result, her work cannot be understood as belonging to any single artistic movement but rather as engaging a number of discourses on various levels without belonging exclusively to any of them.

Schendel immigrated to Brazil in 1949, eventually moving to São Paulo, where she had a one-person show at the Museu de Arte

Moderna and participated in the first São Paulo Biennial. Her earliest paintings consisted of still lifes of household objects such as cups and scissors, often repeated in a series, exploring the status of these images as signs and representations. From approximately 1962 to 1965 she completed a group of nonrepresentational paintings in which she applied paint in thick layers, often adding substances such as sand to increase the texture and cutting into the surface of the canvas to create a sculptural presence. During the mid-1960s she produced almost 2,000 *Monotipia*s, strikingly spare drawings consisting of gestures, a few lines, or disjointed phrases executed on almost transparent sheets of Japanese rice paper. The *Monotipia*s captured the movement of the human hand and explored the gestural form of writing, freeing it from its role as a conveyor of meaning. At the same time, with their stark simplicity the *Monotipia*s encouraged a contemplation of empty space as related to strains of Asian philosophy such as Satori Buddhism.

Schendel discovered Japanese rice paper by accident when she received a large quantity as a gift, and she promptly began using it in a variety of rather unconventional ways, owing both to the paper's extreme delicacy as well as to her unique artistic sensibilities. Not only did she print on the rice paper, but she also worked it into ropelike forms she then knotted into organic shapes and dubbed *Droughinha*s, or, loosely translated, ''little nothings.'' She also hung sheets of paper from strings as from a clothesline, referring to these works as *Trenzinho*s, or ''little trains.'' At about the same time she produced what were known as ''graphic objects,'' consisting of large, almost transparent sheets of paper on which she printed seemingly randomly arranged typographic letters. These were sandwiched between clear plates of acrylic to permit viewing from either side. At the suggestion of fellow artist Camargo, Schendel exhibited many of these works at the Signals Gallery in London in 1965 and 1966, the first time they had received exposure outside Latin America. In 1978 she was invited to represent Brazil in the Venice Biennial.

Schendel's works incorporating elements of language had much in common with that of Brazilian concrete poetry, which focused on the form and sound of individual words, divorcing them from syntax and arranging them in formations visually related to the words' meanings. She maintained a lifelong friendship with the concrete poet de Campos, who was also interested in Asian ideologies connecting language and visual art and who wrote two poems about her work, one of which was published in an exhibition catalog. De Campos also introduced her to the German philosopher Max Bense, whom she visited several times in Germany. She was interested in Bense's theory of phenomenology, which was focused on the body instead of on existential concerns. She also studied Jungian psychoanalysis and read a great deal on a variety of topics.

Many aspects of Schendel's art suggest an affinity with conceptual art in the United States and Europe. These included its extreme fragility and ephemeral nature, its strong connections to various strains of philosophy, and her tendency to name series but not individual works, thus undermining the status of the art object as a commodity. In addition, Schendel has often been linked to the Brazilian artists Hélio Oiticica and Lygia Clark, who worked contemporaneously in Rio de Janeiro, inspired in part by European constructivism, and who explored phenomenological relationships between art and the human body. But while she was certainly aware of other artistic movements, Schendel lived and worked very much as an

individual. Toward the end of her life she returned to making still lifes and paintings, as she had in her early career. After her death in 1987 she was honored at the São Paulo Biennial in 1994.

—Erin Aldana

SEGALL, Lasar
Brazilian painter

Born: Vilna (now Vilnius), Lithuania, 21 July 1891; emigrated to Brazil, 1932. **Education:** Akademie der Bildenden Künste, Berlin, 1906–09. **Family:** Married 1) Margarete Qüack in 1918 (divorced 1924); 2) Jenny Klabin in 1925, two sons. **Career:** Student teacher, Academy of Fine Arts, Dresden, Germany, 1910. Traveled to Brazil, 1913 and 1923–28. Member, German Expressionist movement, 1910–23. Cofounder, *SPAM* (Sociedad Pró-Art Moderna), Brazil, 1932. **Award:** Libermann prize, 1910. **Died:** 2 August 1957.

Individual Exhibitions:

1910	Gallery Gurlitt, Dresden, Germany
1913	Salón Alquilado, São Paulo
1919	Gallery Emil Richter, Dresden, Germany
1920	Folkwang Museum, Hagen, Germany
	Gallery Schames, Frankfurt
1926	Neumann-Nierendorf Gallery, Berlin
	Gallery Neue Kunst Fides, Dresden, Germany
1931	Vignon Gallery, Paris
1934	House d'Arte Baragaglia, Rome
	Gallery Il Milone, Milan
1940	Neumann Willard Gallery, New York
1943	Museo Nacional de Bellas Artes, Rio de Janeiro
1948	Associated American Artists, New York
	Pan American Union, Washington, D.C.
1951	Museo de Arte de São Paulo (retrospective)

Selected Group Exhibitions:

1944	*Muestra de Modern Brazilian Pinturas,* Royal Academy of Arts, London
1945	Askanazy Gallery, Rio de Janeiro
1955	*III bienal del Museo de Arte Moderno de São Paulo*
1956	*50 años de paisaje brasileño,* Museo de Arte Moderno de São Paulo

Collections:

Jewish Museum, New York; Museum of Modern Art, New York; Museum of Modern Art of Latin America, Washington, D.C.

Publications:

By SEGALL: Book—*Souvenirs of Vilna,* Dresden, 1919.

On SEGALL: Books—*Mangue,* exhibition catalog, Rio de Janeiro, R.A., 1943; *Lasar Segall, a feição da verdade,* exhibition catalog, by

Lourival Gomes Machado, São Paulo, Centro Cultural Brasil-Israel de São Paulo, c. 1957; *Lasar Segall: Textos, depoimentos, exposições,* São Paulo, Museu Lasar Segall, 1985; *A gravura de Lasar Segall,* São Paulo, Museu Lasar Segall, 1988; *O desenho de Lasar Segall,* São Paulo, Museu Lasar Segall, 1991; *Lasar Segall cenógrafo,* Rio de Janeiro, Centro Cultural Banco do Brasil, c. 1996; *Still More Distant Journeys: The Artistic Emigrations of Lasar Segall,* exhibition catalog, by Stephanie D'Alessandro, Chicago, David and Alfred Smart Museum of Art, c. 1997; *Lasar Segall,* exhibition catalog, by Cláudia Valladão de Mattos, São Paulo, EDUSP, c. 1997; *Lasar Segall: Proyecto cultural artistas del Mercosur,* text by Vera d'Horta, Buenos Aires, Banco Velox, 1999. **Articles**—"Lasar Segall" by Mason Klein, in *Artforum International,* 36(10), summer 1998, pp. 130–131; "Still More Distant Journeys: The Artistic Emigrations of Lasar Segall" by Dorothea Dietrich, in *On Paper,* 2(5), May/June 1998, pp. 42–44; "Lasar Segall" by Reynaldo Laddaga, in *Art Nexus,* 28, May/July 1998, pp. 154–155.

* * *

Lasar Segall, who was born the son of a Torah scribe in Vilna, Lithuania, eventually became one of the most influential artists in bringing modernism to Brazil. He was involved in art from an early age, leaving Vilna in 1906 to study art at the Imperial Academy of Fine Arts in Berlin. During this time he exhibited his painting *Mother and Child* with the Berlin Secession and was heavily influenced by Max Liebermann, a leader in the movement. In 1910 Segall moved to Dresden, where he became a student instructor at the Academy of Fine Arts and eventually helped found the Dresden Secession, which included Otto Dix, Will Heckrott, and Peter August Bockstiegel, among others. His work from this time was very somber, dominated by grays and dark colors, with an emphasis on human figures who often appeared to be sad or suffering.

Traveling to Brazil in 1913, Segall exhibited his paintings in São Paulo and Campinas. This was the first time modern art had ever been seen in Brazil, and as a result his work received mixed reviews. At the same time the paintings he had selected, including *Mother and Child,* were not among his most experimental. Segall regretted not having exhibited more boldly expressionist works such as *Aldea rusa* of 1912. If he had, perhaps his exhibition would have been more widely recognized as marking the arrival of modern art in Brazil, an event that is popularly attributed to Anita Malfatti's exhibition in São Paulo in 1917. Segall returned to Germany later in 1913, where, at the beginning of World War I, he was briefly arrested for his Russian citizenship and where he married his first wife, Margarete, in 1918.

Segall returned to Brazil in 1923, this time visiting Rio de Janeiro. His work from this period, dubbed his "Brazil phase" by the art critic Mário de Andrade, is the best known of his career, combining German expressionism with Brazilian subject matter. During this period Segall was entranced by the tropical light and brilliant colors he saw in Rio, and as a result his paintings exploded in brilliant pinks, purples, greens, and yellows. At the same time he became fascinated with the people of African descent who lived in the favelas, or shantytowns, of the city. He started making realistic portraits of people ranging from the women and children of the favelas to intellectuals such as de Andrade. These works stood in stark contrast to his earlier depictions of people with solemn, masklike faces.

One of Segall's most famous paintings from this period is his *Bananal* of 1927, a scene of a banana plantation that he and his second

Lasar Segall: *Exodus,* 1947. © The Jewish Museum, New York/Art Resource, NY; gift of James Rosenberg and George Baker in memory of Felix M. Warburg.

wife, Jenny Klabin, had visited while on their honeymoon. The painting consists of the face of an elderly former slave juxtaposed against a wall of banana leaves that is highly abstracted, almost to the point of becoming geometric. The art critic Federico Morais has pointed out that the painting greatly resembles Tarsila do Amaral's *A negra* of 1923, for both works consist of archetypal Africanized figures against geometric backgrounds. Morais argues that the two artists took their work in different directions, however, with Amaral's becoming more fanciful while Segall's became more humanist. Segall's apparent sympathy for Brazilians of African descent is somewhat complicated by the fact that during this period he depicted

himself with dark skin and strongly Africanized features, doing the same in his portraits of de Andrade and the writer Geraldo Ferraz.

Segall returned to Europe for four years before settling permanently in Brazil in 1932. His work from this period on is marked by a return to the grays and earth tones that he had used in his early career, this time modulated by bright, although not exuberant, colors. Themes that he explored in his later career included a series of engravings depicting immigrants traveling by sea and scenes of prostitutes from the Mangue red-light district in São Paulo. Segall's late career is known as the Campos do Jordão phase, in which the artist depicted sunlit countrysides that gradually became almost completely abstract.

Lasar Segall: *Portrait of a Young Woman.* © Giraudon/Art Resource, NY.

Segall helped found in 1932 the Sociedade Pro-Arte Moderna (SPAM), which was short-lived but which paved the way for the later founding of the Museum of Modern Art in São Paulo. Critics are divided on whether or not Segall should be considered a Brazilian artist. Some think of the Brazilian phase of his work as a short-lived interval in a career that was more strongly dominated by European-influenced expressionism. Others believe that Segall had a lasting effect on Brazilian art and that his work should be included in the same category as that of Malfatti, Amaral, and the other artists responsible for bringing modernism to Brazil.

—Erin Aldana

SEGUÍ, Antonio

Argentine painter and printmaker

Born: Córdoba, 11 January 1934. **Education:** Studied law, 1950; influenced by the artist Ernesto Farina; traveled and studied painting in Spain and France, 1951–52; studied in Mexico, 1958–61. **Career:** Instructor, Escuela Superior de Bellas Artes, Paris; cofounder, Centro de Arte Contemporáneo, Córdoba. Moved to Paris, 1963. **Awards:**

Award, Salón de Córdoba, 1958; award, Salón Anual de San Miguel, Mexico; Acquarone prize, 1961; first prize, Benson and Hedges, 1977; Bibliofilia prize, Office of Promotion, I'Edition Francaise, Paris, 1978; second prize Sheraton, Buenos Aires, 1979; medal of honor, *VIII Biennial of Engraving,* Krakow, Poland 1980; award, *VII Biennial of San Juan,* Puerto Rico, 1986; award, Torcuato Di Tella, Buenos Aires, 1989; grand prize, Fondo Nacional de las Artes, Buenos Aires, 1990; Security prize, Buenos Aires, 1994.

Individual Exhibitions:

1957	Galería Paideia, Córdoba
	Direccion Provincial de Cultura, Córdoba
1958	Galería Genova, Mexico City
	Museo Municipal de Arte, Guatemala City
	Museo de Arte Colonial, Quito, Ecuador
	Sociedad Economica de Amigos del Pais, Bogotá
	Dirreccion General de Cultura, Buenos Aires
1959	Galería Genova, Mexico City
	Galería Mexico, Mexico City
	Bolles Gallery, San Francisco
1960	Galería Witcomb, Buenos Aires
	Galería Mexico, Mexico City
	Galería Genova, Mexico City
1961	Galería El Portico, Buenos Aires
	Instituto de Arte Contemporaneo, Lima, Peru
	Galería Witcomb, Buenos Aires
	Bolles Gallery, San Francisco
1962	Galería Witcomb, Buenos Aires
	Galería Lirolay, Buenos Aires
	Museo Provincial de Bellas Artes, Córdoba
1963	Galería Galatea, Buenos Aires
	Galería North, Buenos Aires
	Galería Antigona, Buenos Aires
1964	Galerie Jeanne Bucher, Paris
	Galerie Claude Bernard, Paris
1965	Galerie Paul Bruk, Luxembourg
	Galerie Claude Bernard, Paris
	Galerie Kaleidoscoop, Gand, Belgium
	Galería Feldman, Córdoba
	Galería Lirolay, Buenos Aires
	Galería Relevo, Rio de Janeiro
1966	Galerie Claude Bernard, Paris
	Casa de Las Américas, Havana
1967	Galerie Kolarcevog Univerziteta, Belgrade, Yugoslavia
1968	Galerie Claude Bernard, Paris
	Galerie Jeanne Bucher, Paris
	Galería 22, Caracas, Venezuela
	Galería Galatea, Buenos Aires
	Pro Grafica Arte, Chicago
	Museo Universidad Puerto Rico, Mayaguez
	Galerie T., Haarlem, Netherlands
	Universidad Central de Venezuela, Caracas
1969	Instituto de Arte Contemporaneo, Lima, Peru
	Galeria Pryzmat, Krakow, Poland
	Kunsthalle Darmstadt, Germany
	Galería Colibri, San Juan, Puerto Rico
1970	Museum Krakow, Poland
	Kleine Grafik-Galerie, Bremen, Germany
	Neue Galerie, Baden-Baden, Germany

1970 Museum van Hedendaagse Kunst, Utrecht, Netherlands
Galerie Jacqueline Storme, Lille, France
Galerie T., Haarlem, Netherlands
1971 Galerie Jalmar, Amsterdam
Musée d'art Moderne de la Ville, Paris
Museum van Hedendaagse Kunst, Utrecht, Netherlands
Groningen Museum voor Stad en Lande, Netherlands
Musée de Mons, Belgium
Noord Brabants Museum, Netherlands
Narodni Galerie, Prague, Czech Republic
Théâtre National, Centre Rogier, Brussels
1972 Lefebre Gallery, New York
Maison de la Culture, Rennes, France
Museo de Arte Moderno, Buenos Aires
1973 Galerie T., Amsterdam
Galerie Claude Bernard, Paris
Galerie Jalmar, Amsterdam
Galería Arte Contacto, Caracas, Venezuela
1974 Galerie Fred Lanzenberg, Brussels, Belgium
Galerie T., Amsterdam
1975 Galería Feldman, Córdoba
Víctor Najmías Art Gallery International, Buenos Aires
Lefebre Gallery, New York
1977 Lefebre Gallery, New York
Víctor Najmías Art Gallery International, Buenos Aires
1978 Galerie du Dragon, Paris
Galería Feldman, Córdoba
Galerie Carmen Martinez, Paris
Galería Rubbers, Buenos Aires
Museo de Bellas Artes, Caracas, Venezuela
Galería Minotauro, Caracas, Venezuela
1979 Lefebre Gallery, New York
Parques nocturnos, Musée d'art Moderne de la Ville,
Paris
Galería Rubbers, Buenos Aires
Galerie Jacqueline Storme, Lille, France
Galerie Nina Dausset, Paris
1980 Galería Rubbers, Buenos Aires
Galería de Arte Enrique Camino Brent, Lima, Peru
Nishimura Gallery, Tokyo
1981 Lefebre Gallery, New York
Elisabeth Franck Gallery, Knokke-Le-Zoute, Belgium
Le Salon d'Art, Brussels, Belgium
Galerie Nina Dausset, Paris
Leinster Fine Art, London
1982 ARCO '82, Elisabeth Franck Gallery, Madrid
Lefebre Gallery, New York
Ecole Municipale des Beaux-Arts de Boulogne-sur-Mer,
France
La Galería, Quito, Ecuador
Galería Minotauro, Caracas, Venezuela
1983 Musée de Louvain-la-Neuve, Belgium
Galerie Marquis, Vlissingen, Netherlands
FIAC, Galerie Claude Bernard, Paris
Lefebre Gallery, New York
Galería Punto, Valencia, Spain
1984 *XLI bienal de Venecia,* Italy
Centre Culturel de l'Aérospatiale, Toulouse, France
Galería Rubbers, Buenos Aires

Maison de la Culture, La Rochelle, France
Obra grafica 1948–1982, Comodoro Rivadavia, Santa
Fe, New Mexico (traveling)
1985 ARCO '85, Elisabeth Franck Gallery, Madrid
Elisabeth Franck Gallery, Knokke-Le-Zoute, Belgium
Présence Contemporaine, Cloître Saint-Louis, Aix-en-
Provence, France
Praxis Galería de Arte, Córdoba
Galería Jaime Conci, Córdoba
Galería Rubbers, Buenos Aires
1986 Galería Quintero, Barranquilla, Colombia
Galería Rubbers, Buenos Aires
Praxis Galeria de Arte, Santiago, Chile
1987 Art Chicago, Elisabeth Franck Gallery, Chicago
Galería Rubbers, Buenos Aires
Galerie Ruta Correa, Freiburg, Germany
1988 Claude Bernard Gallery, New York
1989 Centre de la Gravure et de l'Image Imprimée, La
Louvière, Belgium
Botanique, Brussels, Belgium
FIAC, Elisabeth Franck Gallery, Paris
Elisabeth Franck Gallery, Knokke-Le-Zoute, Belgium
1990 Claude Bernard Gallery, New York
Art Cologne '90, Galerie Michel Delorme, Cologne,
Germany
1991 Museo Nacional de Bellas Artes, Buenos Aires
(retrospective)
Art Miami '91, M. Gutierrez Fine Arts, Miami
SAGA '91, Galerie Michel Delorme, Paris
M. Gutierrez Fine Arts, Key Biscayne, Florida
Galería Rubbers, Buenos Aires
Centro de Arte Contemporaneo, Córdoba
Museo Nacional de Artes Visuales, Montevideo, Urugay
1992 Galerie Marwan Hoss, Paris
Teatro Auditorium, Mar del Plata, Argentina
Casa Rosada, Buenos Aires
Julio Gonzalez Space, Arceuil, France
Centre d'Art Contemporain, Mont-de-Marsan, France
Galerie Sonia Zannettacci, Geneva, Switzerland
Galería Rubbers, Buenos Aires
Galerie Ruta Correa, Freiburg, Germany
Editions du Nopal, Paris
Le Salon d'Art, Brussels, Belgium
1993 Galería San Carlo, Milan
Galería Léonora Vega, San Juan, Puerto Rico
Instituto de Cultura Puertorriqueña, San Juan, Puerto
Rico
Galerie Winance-Sabbe, Tournai, Belgium
FIAC, Galerie Marwan Hoss, Paris
1994 Galeria Fernando Santos, Porto, Portugal
Elisabeth Franck Gallery, Knokke-Le-Zoute, Belgium
1995 Art Miami '95, Claude Bernard Gallery, Miami
Galerie Sonia Zannettacci, Geneva, Switzerland
Galerie Marwan Hoss, Paris
Le Moulin du Roc/Scène Nationale, Niort, France
Galerie Janine Rubeiz, Beirut, Lebanon
Fundaçao Calouste Gulbankian, Lisbon, Portugal
Galerie du Cirque Divers, Liège, Belgium
1996 Ecureuil Space, Marseille, France

Antonio Seguí: Urban Man, Art Museum of the
 Americas, Washington, D.C.
 Galerie Municipale, Vitry-sur-Seine, France
 Centro Cultural Alberto Rougés, San Miguel de
 Tucuman, Argentina
 Galería Rubbers, Buenos Aires
 Croix-Baragnon Space, Toulouse, France
 Centre d'Art Contemporain, Istres, France
1997 Sculfort Space, Maubeuge, France
 Athanor Space, Guérande, France
 Museo Rufino Tamayo, Mexico City
 City Men, Biblioteca Luis-Angel Arango, Bogotá
 Salle Estève, Maison de la Culture, Bourges, France
 Palais Ducal, Nevers, France
 La Médiathèque, Trith Saint Léger, France
1998 *It's Up to You to Make the Story,* Maison de
 l'Amérique Latine and Marwa Hosse Gallery, Paris

Selected Group Exhibitions:

1964 *New Art of Argentina,* Walker Art Center, Minneapolis
 Pittsburgh International Carnegie Institute
 Venice Biennale
1967 *Latin American Art: 1931–1966,* Museum of Modern
 Art, New York
1970 *Latin American Print Biennial,* San Juan, Puerto Rico
1980 *Realism and Latin American Painting,* Center for Inter-
 American Relations, New York and Museo de
 Monterrey, Mexico
1984 *Venice Biennale*
1987 *Cuatero maestros latinoamericanos,* Biblioteca Luis-
 Angel Arango, Bogotá
1989 *The Latin American Spirit: Art & Artists in the U.S.,*
 Bronx Museum, New York

Collections:

Kunsthalle Darmstadt, Germany; Fondo Nacional de las Artes, Buenos Aires; Museo de Arte Contemporaneo, Buenos Aires; Museo de Arte Moderno, Buenos Aires; Museo Nacional de Bellas Artes, Buenos Aires; Museo Nacional del Grabado, Buenos Aires; Museo Municipal "Genaro Perez," Córdoba; Museo Provincial de Bellas Artes "Emilio Caraffa," Córdoba; Museo Provincial de Bellas Artes, La Plata, Argentina; Museo Provincial de Bellas Artes, Tucuman, Argentina; Centro de Arte Contemporaneo, Córdoba; Museo Castanigno, Rosario, Argentina; Ministère de la Culture Française, Brussels, Belgium; Museu de Bellas Artes, Porto Alegre, Brasil; Museu de Arte Moderna, Rio de Janeiro; Museu de Arte Contemporanea, São Paulo, Brazil; Museo Nacional de Bellas Artes, Santiago, Chile; Museo de Arte Moderno La Tertulia, Cali, Colombia; Casa de las Américas, Havana; Casa de la Cultura, Quito, Ecuador; Museo de Bellas Artes, Bilbao, Spain; Museum of Modern Art, New York; Hirschhorn Museum and Sculpture Garden, Washington, D.C; Library of Congress, Washington, D.C; Solomon R. Guggenheim Museum, New York; Archer M. Huntington Art Gallery, The University of Texas, Austin; Interamerican Development Bank, Washington, D.C.; First National Bank of Chicago; Pittsburgh National Bank; Walker Art Institute, Minneapolis; Musée de Peinture et de Sculpture, Grenoble, France; Musée Cantini,

Marseille, France; Bibliothèque Nationale, Paris; Centre Georges Pompidou, Paris; Centre National d'Art Contemporain, Paris; Musée d'Art Moderne de la Ville de Paris; Museo de Bellas Artes, Caracas, Venezuela; Museo de Arte Contemporaneo Latinoamericano, Punta del Este, Uruguay; Narodni Galerie, Prague, Czech Republic; Museo del Grabado, San Juan, Puerto Rico; Museum van Hedendaagse Kunst, Utrecht, Netherlands; Museo de Arte Moderno, Asunción, Paraguay; Museo de Arte Latinoamericano, Managua, Nicaragua; Palacio de Bellas Artes, Mexico City; Musée National d'Art Occidental, Tokyo.

Publications:

On SEGUÍ: Books—*Seguí: The Anatomy Lesson,* exhibition catalog, New York Lefebre Gallery, 1979; *Seguí: Parques nocturnos,* exhibition catalog, Paris, Musée d'art Moderne de la Ville, 1979; *Realism and Latin American Painting, the 70's,* exhibition catalog, text by by Lawrence Alloway, New York, Center for Inter-American Relations, 1980; *Antonio Seguí: XLI Bienal de Venecia,* exhibition catalog, text by Ramiro de Casasbellas, Jorge Glusberg, and Damián Bayón, Buenos Aires, Ministerio de Relaciones Exteriores y Culto and Dirección General de Asuntos Culturales, 1984; *Cuatero maestros latinoamericanos,* exhibition catalog, Bogotá, Banco de la República,1987; *Antonio Seguí: New Work,* exhibition catalog, text by Julian Clairol, New York, Claude Bernard Gallery, 1988; *Antonio Seguí : Conversation avec Eddy Devolder,* Gerpinnes, Belgium, Editions Tandem, 1989; *Antonio Seguí,* exhibition catalog, New York, Claude Bernard Gallery, 1990; *Antonio Seguí,* exhibition catalog, Buenos Aires, Museo Nacional de Bellas Artes, 1991; *1997: Colección del Museo Nacional de Bellas Artes,* collection catalog, text by Jorge Glusberg, Buenos Aires, Museo Nacional de Bellas Artes, 1997. **Articles**—''Paris-Journal: Galerie Marwan Hoss'' by Claude Bouyeure, in *L'Oeil* (Switzerland), 446, November 1992, p. 85; ''Antonio Seguí: Drawing the Lonely Crowd'' by Caleb Bach, in *Americas,* 49(1), 1997, p. 14; ''Antonio Seguí: Urban Man'' by Mitchell K. Snow, exhibition review, in *Art Nexus* (Colombia), 23, January/March 1997, pp. 143–144; ''Antonio Seguí'' by Natalia Gutiérrez, review of *City Men,* in *Art Nexus* (Colombia), 27, January/March 1998, p. 121; ''Antonio Seguí'' by Christine Frérot, review of *It's Up to You to Make the Story,* in *Art Nexus* (Colombia), 30, November/January 1998–99, pp. 134–136.

* * *

The historical moment at which Antonio Seguí appeared on the art scene was one in which figuration was having a resurgence in Europe as well as Latin America. The new figuration movement of Latin America ran parallel to the art of the CoBrA group and to the work of Willem de Kooning, Francis Bacon, and Jean Dubuffet. This renaissance of figuration depicted human forms in expressionistic ways, often fragmented and distorted. Seguí was part of the movement in Latin America, although he never fully embraced it, as he searched for a type of figuration that met his expressive needs. Like the movement in Latin America, which turned away from expressionist figures into a period of photorealism, Seguí's career took similar turns in working with the themes of the tension of the real and the unreal, irony, and sarcasm.

Born in Córdoba, Argentina, in 1934, Seguí studied in Buenos Aires, Madrid, and Paris in the 1950s. Initially he created a number of

purely informalist works, but influenced by the expressionistic works of Otto Dix and George Grosz, his paintings later evolved to a similar critical sarcasm. In the late 1950s his restlessness took him to Mexico, where he settled and traveled to pre-Columbian sites. When he returned to Buenos Aires, he was associated with, although he was never formally part of, a group referred to as Otra Figuración, which employed the use of highly expressive figures often closely related to Bacon but which was imaginative in the use of assemblage and color or the lack of it. Seguí, while he maintained contact with the group, was an independent force who kept the figure as an unfragmented whole and who dealt with themes related to his own existential concept of man. His more representational work and restrained expressiveness substituted mystery and sarcasm for gestural strokes.

Perhaps Seguí's independence from the specific style of the Latin American figuration movement stemmed from the fact that he relocated to Paris in 1963 and has remained there for most of his life. Before he left Argentina, he was experimenting with photorealism by using charcoal rubbed directly onto canvas to mimic the images seen on newsprint, creating representational images that rejected the mechanical photographic process. This process reflected a connection to Ernesto Deira of the Otra Figuración group, who also favored the use of charcoal during the early 1960s.

During the 1970s the political situation in Seguí's native Argentina changed with the resurgence of Juan Perón as president and later with Isabel, his widow, who was overturned by the military. The artist's use of photorealism on large, dark canvases reflected this noir period in Argentine history. Early paintings of the period include animals such as fierce dogs and figures in a confined space. In other paintings figures with their backs turned to the viewer stare into a distant space or landscape that is not quite visible. His paintings of this period reflect a sense of suspense or mystery that is unsettling, not unlike the Argentine political situation. But the figure with his back to the viewer is clearly a reference to Magritte, whom Seguí is said to have admired.

The 1980s, with a fresh political situation in Argentina, began a new period for Seguí with the appearance of a strange cartoon of a man in a suit and a hat, perhaps another reference to Magritte's figures or, some would say, to the artist himself. This busy figure power walks his way through urban landscapes with buildings that resemble those of Buenos Aires and Paris, cities whose architecture is similar. The figure, along with random graffiti squeezed in between the buildings, appears humorous and at the same time expressive of a society with an urban urgency about it, racing toward an unknown destination. The figures are linked in that, at times, they appear to communicate with one another in their two-dimensional worlds, with small details connecting them. If there is any doubt that the figure remains the center of these compositions, the question is answered by the proportion of the man, who often towers over the buildings of the cityscape. Occasionally the whole cityscape appears as a dream or a thought of another similar figure, who ponders it above his head.

Seguí has continued to evolve through various periods, earning him two separate appearances at the Venice Biennale, in 1964 and 1984. He may be the figure in the humorous paintings of the 1980s and 1990s whose body parts and pieces of clothing have become fragmented and moved off the canvas onto the walls and freestanding cubes, perhaps in a nod to the expressive fragmentation of the figuration movement of the 1950s.

—Linda A. Moore

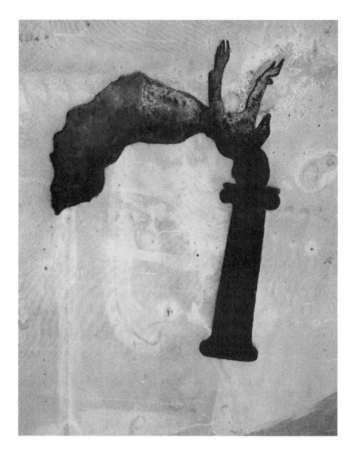

Daniel Senise: *Untitled,* **1996. Photo courtesy of Galeria Ramis Barquet.**

SENISE, Daniel
Brazilian painter and mixed-media artist

Born: Rio de Janeiro, 1955. **Education:** Universidade Federal do Rio de Janeiro, degree in civil engineering 1980; Escola de Artes Visuais do Parque Lage, Rio de Janeiro, 1981. **Career:** Professor, Escola de Artes Visuais do Parque Lage, Rio de Janeiro, 1986–94; director, Galerias do Centro Cultural Light, Rio de Janeiro, 1997.

Individual Exhibitions:

1984	Galeria do Centro Empresarial Rio, Rio de Janeiro
1985	Subdistrito Comercial de Arte, São Paulo
	Galeria do Centro Cultural Cândido Mendes, Rio de Janeiro
1986	Thomas Cohn Arte Contemporâneo, Rio de Janeiro
	Espaço Cultural Arte Contemporâneo, Brasilia, Brazil
1987	Subdistrito Comercial de Arte, São Paulo
1988	Galerie Michel Vidal, Paris
	Galeria Usina, Vitóriz, Brazil
	Espaço Capital Arte Contemporâneo, Brasilia, Brazil
1989	Thomas Cohn Arte Contemporâneo, Rio de Janeiro
	Galeria Tina Zappolo, Porto Alegre, Brazil
1990	Pulitzer Art Gallery, Amsterdam
	Pasárgada Arte Contemporâneo, Recife, Brazil
1991	Galerie Michel Vidal, Paris

Daniel Senise: *M,* **1998. Photo courtesy of Galeria Ramis Barquet.**

Galleri Engström, Estocolmo, Sweden
Museum of Contemporary Art, Chicago
1992 Thomas Cohn Arte Contemporâneo, Rio de Janeiro
Galeria Modulo, Lisbon
Galerie Michel Vidal, Paris
1993 Galeria Camargo Vilaça, São Paulo
Instituto de América-Centro Damián Bayón, Santa Fé,
Granada, Spain
Galeria de Arte UFF, Niterói, Brazil
1994 Thomas Cohn Arte Contemporâneo, Rio de Janeiro
Paço Imperial, Rio de Janeiro
Museo de Arte Contemporánea, Monterrey, Mexico
1995 Charles Cowles Gallery, New York
Galeria Camargo Vilaça, São Paulo
Museu Chácara do Céu, Rio de Janeiro
1996 Thomas Cohn Arte Contemporâneo, Rio de Janeiro
1997 Museu Alfredo Andersen, Curitiba, Brazil
Galeria Cohn Edelstein, São Paulo
1999 Galeria Ramis Barquet, New York
Diana Lowenstein Fine Arts, Buenos Aires
2000 Galeria Paulo Darzé, Salvador, Bahia, Brazil

Selected Group Exhibitions:

1978 Galeria Aberta de Ipanema, Rio de Janeiro
1987 *Modernidade: Art brésilien du XXeme siécle,* Musee
d'Art Moderne de la Ville de Paris
1989 *XX bienal internacional de São Paulo*
1992 *Latin American Artists of the Twentieth Century,*
Estación Plaza de Armas, Seville, Spain (traveling)
Entre trópicos, Museo de Arte Contemporáneo Sofía
Imber, Caracas, Venezuela
1994 *Bienal brasil século XX,* Fundação Bienal de São Paulo

1995 *Panorama da arte brasileira,* Museu de Arte Moderna,
São Paulo, and Museu de Arte Moderna, Rio de
Janeiro
1996 *Arte brasileira contemporâneo,* Museu de Arte Moderna
de São Paulo
1998 *Um olhar brasileiro,* Haus der Kulturen der Welt, Berlin
Broadening the Horizons, Pusan Metropolitan Art
Museum, Korea

Publications:

On SENISE: Books—*Daniel Senise: La mirada iluminante,* exhibi-
tion catalog, text by Ivo Mesquita and Roberto Tejada, Monterrey,
Mexico, Museo de Arte Contemporáneo de Monterrey, 1994; *Daniel
Senise,* exhibition catalog, text by Paulo Herkenhoff, New York,
Charles Cowles Gallery, 1995; *Daniel Senise-Ela que não está,*
exhibition catalog, text by Dawn Ades, Ivo Mesquita, and Gabriel
Pérez-Barreiro, São Paulo, Cosac & Naify Edições, 1998; *Daniel
Senise: January-February, 1999,* exhibition catalog, text by Gabriel
Pérez-Barreiro, New York, Galeria Ramis Barquet, 1998; *Daniel
Senise,* exhibition catalog, text by Marco Veloso, Buenos Aires,
Diana Lowenstein Ediciones, 1999. **Articles—**''The End of Solitude:
Young Artists on the Rise'' by Edward Shaw, in *Art News,* 89,
October 1990, pp. 138–143; ''Brazil Today'' by Maria Elvira Iriarte,
in *Art Nexus* (Colombia), 11, January/March 1994, pp. 231–232;
''Daniel Senise'' by Adriano Pedrosa, in *Art Nexus* (Colombia), 21,
July/September 1996, pp. 36–39; ''Daniel Senise: Ramis Barquet''
by Mary Schneider Enriquez, in *Art News,* 98(5), May 1999, p. 167.

* * *

During the early 1980s, when painting as a practice was called
into question by postmodernism, the Brazilian painter Daniel Senise
laid to rest any doubt about its viability by infusing it with conceptualist
tendencies that were usually the province of other artistic forms.
Painting's raison d'être at the time of Senise's emergence was being
debated due to its reappearance within the backdrop of conceptually
driven art such as installation, performance, and text-based work.
These art forms, though already part of the artistic fabric of the '60s
and '70s, were seen as the only vanguard manifestations of critical
practice, consequently relegating painting as an anachronistic en-
deavor. This perception of painting was compounded by the bur-
geoning identity politics of the 1980s that privileged content over
form—a type of artistic pluralism that attacked any style of art that
was thought to be exclusionary and that adhered to a perceived elitism
that masked an ideological bias. Senise's distinct style of painting,
which fused both form and content, however, proved to be an antidote
not only to the myopia of identity politics but also to the misunder-
standing of painting as an exhausted, modernist project.

Senise contributed to the reassessment of painting's status
through an astute, original, and eclectic integration of materiality,
formal execution, and iconography that imbued his works with a
multiplicity of narratives. Materials such as rust, dirt, and iron fillings
as well as ready-made objects were part of Senise's formal vocabular-
ies that linked his work to an international historical trajectory that
explored materiality as an aesthetic and as a substance permeated with
meaning. On the one hand were artists who used materials such as dirt
and discard that added visual texture to their work yet who were intent
on emptying form of meaning. Other artists emphasized the semiotic
dimension of materiality by underlining its signification rather than

its aesthetic quality. In bridging these two poles in his work, Senise was linked with artists such as Antoni Tàpies and Yves Klein, informalism in Europe of the 1950s, and contemporary artists such as Anselm Kiefer.

The early works of Senise exhibit a lyrical exuberance and formal elegance that are paradoxically conveyed through aesthetic impurity. The juxtaposition of the beautiful with the impure adds a visual presence and power that amounts to a complex formal poetics. The mixture of high and low in the form of materiality can be misconstrued as an aesthetic concern. Yet Senise is paradoxically connected to other Brazilian artists of a more conceptual bent by virtue of the notion that materials have, in and of themselves, a history that foregrounds their narrativity. When Senise's fellow Brazilians Tunga or Cildo Meireles, for example, use copper or rubber in their work, they use it much differently than do their North American and European counterparts. Although the aesthetics of copper and rubber is important to Tunga and Meireles, form to them is permeated with meaning in that these materials have a history within the Brazilian context. Not only were rubber and copper part of the Brazilian economy at one time, but rubber was also a cultural signifier to pre-Hispanic Brazilian natives. Senise also works in this register; rust not only adds artistic power to his work but the nature of rust is that it is always in a state of transformation.

Senise's collection of collage paintings collectively titled *Paintings from the North* (2001) continues with his idiosyncratic formal investigations, but his imagery refers to architecture and the interiors of canonical works of art history. This series of paintings depicts the interiors of pictures whose figures have been erased. The conceptual undercurrent of these works is evident in the dematerialization of figural representation within the context of historical hierarchies of painting. Whereas in earlier works he focused on materiality as a crucial component to the syntax of his imagery, in this instance he focuses on what has been called, in French poststructuralist philosophy, an absent presence. In alluding to what is absent in his pictures, Senise is reworking previous formal strategies with complicated and ambiguous narratives that remind us of the cerebral potential of painting. Senise's contribution, then, is his formalism. His formalism, however, is not devoid of meaning but rather a beautiful conflation of narrative and the aesthetic.

—Raúl Zamudio

SERRANO, Andrés

American photographer

Born: New York, 1950. **Education:** Brooklyn Museum of Art School, 1967–69. **Award:** Grant, National Endowment for the Arts, c. 1988. **Agent:** Paula Cooper Gallery, 534 West 21st Street, New York, New York 10011, U.S.A.

Individual Exhibitions:

1985 Leonard Perlson Gallery, New York
1986 *The Unkonwn Christ,* Museum of Contemporary Hispanic Art, New York
1987 Galerie Hufkens-Noirehomme, Brussels
1988 Stux Gallery, New York
 Greenberg/Wilson Gallery, New York

Andrés Serrano. © James L. Lance/Corbis.

1989 Stux Gallery, New York
1990 Stux Gallery, New York
 Gallery Cedar, Nagoya, Japan
 Fay Gold Gallery, Atlanta
 BlumHelman Gallery, Santa Monica, California
 Gallery Hibbel, Tokyo
 Seibu Museum of Art, Tokyo
 Akira Ikeda Gallery, Tokyo
1991 Galleri Riis, Oslo, and Galleri Susanne Ottesen, Copenhagen
 Nomads, Denver Museum of Art
 KKK Portraits, University Memorial Center Gallery, University of Colorado, Boulder
 Thomas Segal Gallery, Boston
 Seibu Museum of Art, Tokyo
 Galerie Yvon Lambert, Paris
1992 *Andrés Serrano: The Morgue,* Galerie Yvon Lambert, Paris (traveled to La Tête d'Obsidienne, la Seyne-sur-Mer, France; Palais du Tau, Reims; La Grand Hornu, Mons, Belgium; and Musée d'Art Contemporain, Montreal)
 Institute of Contemporary Art, Amsterdam
 Zone Gallery, Newcastle-upon-Tyne, England
1993 Center for Contemporary Art, Ujazdowski Castle, Warsaw (traveling)
 Andrew Serrano: Selected Works: 1986–1992, Feigen Gallery, Chicago
 The Morgue, Paula Cooper Gallery, New York

1994 Institute of Contemporary Art, University of Pennsylva-
 nia, Philadelphia (traveling)
 Moderna Galerija, Ljubljana, Slovenia
 Budapest, Paula Cooper Gallery, New York
 The Church Series, Paula Cooper Gallery, New York
 Galerie Charlotte Lund, Stockholm
 Alfonzo Artiaco, Spazio d'Arte, Naples, Italy
1996 *Primavera fotográfica,* Barcelona, Spain
 Fotografías Andrés Serrano, Sala Mendoza, Caracas,
 Venezuela, and Museo de Arte Moderno Jesús Soto,
 Bolívar, Venezuela
1997 *A History of Sex,* Paula Cooper Gallery, New York
 (traveling)
1998 Greg Kucera Gallery, Seattle
 National Gallery of Victoria, Melbourne, Australia

Selected Group Exhibitions:

1988 *Acts of Faith: Politics and the Spirit,* Cleveland State
 University
1991 *Long Live the New Flesh,* Kettle's Yard Gallery,
 Cambridge, England
1993 *American Art in the 20th Century: Painting and
 Sculpture, 1913–1993,* Martin Gropius Bau, Berlin,
 and Royal Academy of Fine Arts, London
1995 *Temporarily Possessed,* New Museum of Contemporary
 Art, New York
1996 *What I Did on My Summer Vacation,* White Columns,
 New York
1998 *Taboo: Repression & Revolt in Modern Art,* Galerie St.
 Etienne, New York
2000 *Reflections in a Glass Eye,* International Center of
 Photography, New York
 Andrea Rosen Gallery, Basel, Switzerland
 Picturing the Modern Amazon, New Museum of
 Contemporary Art, New York
 Appearance, Galleria d'Arte Moderna, Bologna, Italy

Collections:

International Center of Photography, New York; New Museum of
Contemporary Art, New York.

Publications:

By SERRANO: Book—*Body and Soul,* with Brian Wallis and
others, New York, Takarajima Books, 1995.

On SERRANO: Books—*Acts of Faith: Politics and the Spirit,*
exhibition catalog, text by Lucy R. Lippard, Cleveland, Cleveland
State University, 1988; *The Good, the Bad & the Ugly: Knowledge
and Violence in Recent American Art,* exhibition catalog, text by
Klaus Ottmann, Middletown, Connecticut, Wesleyan University,
1991; *Andrés Serrano,* exhibition catalog, text by Gertrud Sandqvist,
Oslo, Galleri Riis, and Copenhagen, Galleri Susanne Ottesen, 1991;
*Long Live the New Flesh: An Exhibition of New Art by Helen
Chadwick, Andreés Serrano, and Thomas Grünfeld,* exhibition cata-
log, second edition, text by Anna Harding, Cambridge, England,

Kettle's Yard Gallery, 1991; *Poliester: Pintura y no pintura* by Lorna
Scott Fox and Thelma Golden, Mexico City, Consejo Nacional para la
Cultura y las Artes, 1993; *Andrés Serrano,* exhibition catalog, text by
Zdenka Badovinac and Piotr Piotrowski, Ljubljana, Slovenia, Moderna
Galerija Ljubljana, 1994; *Andrés Serrano: Le Sommeil de la surface*
by Daniel Arasse, Arles, France, Actes Sud, 1994; *Andrés Serrano,
Works 1983–1993,* exhibition catalog, text by Robert Carleton Hobbs,
Wendy Steiner, and Marcia Tucker, Philadelphia, University of
Pennsylvania, 1994; *Andrés Serrano,* exhibition catalog, Barcelona,
Spain, Autoridad Portuaria de Barcelona, 1996; *Fotografías Andrés
Serrano,* exhibition catalog, Caracas, Venezuela, Sala Mendoza,
1996; *A History of Andrés Serrano, A History of Sex,* exhibition
catalog, text by Mark Wilson, Groninger, Netherlands, Groninger
Museum, 1997; *Interventions and Provocations: Conversations on
Art, Culture, and Resistance* by Glenn Harper, Albany, New York,
State University of New York Press, 1998; *Symbolic Imprints: Essays
on Photography and Visual Culture* by Lars Kiel Bertelsen, Rune
Gade, and Mette Sandbye, Oakville, Connecticut, Aarhus University
Press, 1999; *Andrés Serrano: Placing Time and Evil,* exhibition
catalog, text by Bjorn Follevaag, Trond Borgen, and Malin Barth,
Bergen, Norway, Stiftelsen, 2000; *Appearance: Mariko Mori,
Yasumasa Morimura, Luigi Ontani, Andrés Serrano, Pierre & Gilles,
Tony Oursler,* exhibition catalog, text by Achille Bonito Oliva and
Danilo Eccher, Milan, Charta, 2000. **Articles**—"Serrano's Calvary"
by Stephen Todd, in *Art & Text* (Australia), 51, May 1995, pp. 44–49;
"Andrs Serrano: Between Benetton and Caravaggio" by Jen Budney,
Emanuela De Cecco, and Helena Kontová, in *Flash Art* (Italy), 184,
October 1995, pp. 68–72; "Andrés Serrano, on the Market, the Public
and Money" by Judith Benhamou-Huet, in *Art Press* (France), 224,
May 1997, pp. 14–15; "Andreé Serrano" by Marvin Heiferman,
review of the exhibition *A History of Andrés Serrano/A History of Sex*
at Paula Cooper Gallery, in *Artforum International,* 35, summer 1997,
p. 130; "Andres Serrano: The Sea of Possibility" by Jim Harold, in
Art & Design, 12, September/October 1997, pp. 8–9.

* * *

Andrés Serrano achieved immediate, if unwelcome, fame when
New York Sen. Alphonse D'Amato, in a highly publicized act of
outrage, tore up his notorious photograph *Piss Christ* on the floor of
the U.S. Senate on May 18, 1989. Soon thereafter, Serrano found
himself at the center of a raging battle spearheaded by neoconservative
politicians over censorship and the public funding of art, which
culminated in the near dismantling of the U.S. National Endowment
for the Arts.

After attending the Art School of the Brooklyn Museum, Serrano
had his first show in New York City in 1985. As of 1983 he had begun
to explore the convergence of religion and the human body in highly
theatrical and surreal tableaux such as *Heaven and Hell* (1984).
Between 1986 and 1990 Serrano produced several series of photo-
graphs featuring bodily fluids: milk, blood, urine, and semen. The
earliest works consisted of single or juxtaposed planes of flat color
(white alongside red, as in *Milk, Blood* [1986]) in a sort of abstract
quality reminiscent of the abstractions of Kasimir Malevich and
Barnett Newman. Other pictures (*Bloodstream* [1987]) recalled the
fluid, vertical stains of Morris Louis's color-field paintings. In
ensuing photographs Serrano introduced small religious figures in-
side plexiglass water tanks filled with liquid, mainly the artist's own
urine. Known as the *Immersion* series, these photographs married

richly saturated color, lustrous surfaces, and size to provocative subject matter.

Serrano's *Immersion* photographs operate within an ambiguous space of piety and sacrilege. The artist, whose Afro-Cuban mother was a devout Roman Catholic, lived an intensely religious childhood, which may account for his fascination with Catholic symbolism and paraphernalia, some of it bordering on kitsch. It also seems to have fueled an aesthetic of transgression that derives its power from the desecration of sacred imagery and the use of base, mostly taboo substances (liquids that in the age of AIDS can be fatal) as artistic materials. Serrano has repeatedly stated his attraction to unacceptable subjects and his desire to search for beauty in areas such as sexuality and death that push the limits of public taste and consent. Of course, there is nothing in the photographs' appearance that necessarily suggests the process by which they were taken. It is only when set next to a caption–Serrano's work pivots and thrives on the tension between image and word–that the ambiguity and uncanny beauty of a semiabstract work such as *Untitled XIV (Ejaculate in Trajectory)* are inflected with a precise, highly charged meaning.

Serrano followed with three series focused on portraiture (the *Nomad* and the *Ku-Klux Klan* series of 1990 and the *Church* series of 1991) before embarking on another controversial project, the *Morgue* series of 1992. This set of photographs featured corpses in various states of decomposition. Their effectiveness stemmed from a discrepancy between the serene beauty of the image and the visceral feelings aroused by titles such as *The Morgue (Fatal Meningitis II)* and *The Morgue (AIDS-Related Death)*. Some of the pictures confront the viewer in no uncertain terms with the specter of death, even if the highly aestheticized presentation, akin to the glamorous style of fashion or advertising photography, brings about a defamiliarizing and distancing effect.

In spite of its elegance and polished surface, Serrano's photography is not devoid of depth, nor does it exist outside an artistic tradition. He has declared his ambition to elevate photography to the level of painting, and indeed his photographs evoke paintings through their monumental scale and compositional strategies, many of which pay implicit homage to the old masters. Critic Amelia Arenas has spoken of Serrano's work in relation to the Counter-Reformation art of the baroque. Like the paintings of Caravaggio or of the Spanish school (Velázquez, Ribera, Zurbarán), toward which Serrano has shown a special affinity perhaps because of his Latino background, his photography shares a love of theatricality and appeals directly to the senses and primal emotions through lighting and color. Furthermore, much of baroque art doubled as allegories of the transience of life and the inevitability of death, themes that equally pervade the *Morgue* series.

Over the years Serrano's work has further explored society's discomfort over the body. As a result, his work has become vulnerable to charges of cheap sensationalism, voyeurism, and aesthetic impropriety. This exploitative aspect has become more pronounced in Serrano's later work. *A History of Sex* (1997) and *The Interpretation of Dreams* (2001) mark a return to the use of narrative tableaux, displaying a gallery of forbidden desires and sexual practices. But the pursuit of sheer provocation tends to upstage the art, so that the pictures often times feel mannered and void of emotion or nuance. Nevertheless, at its best Serrano's photography merges formal beauty and political subtexts while engaging the viewer in an ambivalent, unsettling, and revelatory struggle between desire and revulsion.

—Gerard Dapena

SILVEIRA, Regina
Brazilian painter, printmaker, and conceptual artist

Born: Porto Alegre, 1939. **Education:** Universidade Federal do Rio Grande do Sul, Porto Alegre, B.F.A. 1959; Universidade de São Paulo, M.F.A. 1980, Ph.D. 1984. **Career:** Instructor, Art Institute, Universidade Federal Rio Grande do Sul, Porto Alegre, 1964–69, University of Puerto Rico, Mayaguez Campus, 1969–73, and Fundação Armando Alvares Penteado, São Paulo, 1973–85. Since 1974 instructor, art department, Universidade de São Paulo. Visiting artist, Cooperativa Diferença, Lisbon, 1988. Associação dos Artistas Gravadores, Amadora, Portugal, 1990, Cooperativa Arvore, Porto, Portugal, 1990, Southern University of Illinois, Carbondale, 1991, Austin Community College, Texas, 1991, University of New Mexico, Albuquerque, 1991, Pacific Northwest College of Art, Portland, Oregon, 1993, Northern Illinois University, De Kalb, 1997, and University of Texas, Austin, 1998. **Awards:** Grant, National Council for Research, 1985–87, 1987–89; award, Associação Paulista de Críticos de Arte, São Paulo, 1987; award, Sarney Law for the Brazilian Culture, São Paulo, 1988; fellowship, John S. Guggenheim Foundation, 1990; grant, Pollock-Krasner Foundation, 1993; Art Studio grant, Banff Centre, Alberta, Canada, 1993; artist-in-residence grant, Civitella Ranieri Foundation, Umbertide, Italy, 1995.

Individual Exhibitions:

1961	Museu de Arte do Rio Grande do Sul, Porto Alegre
1966	Galeria U, Montevideo, Uruguay
	Museu de Arte do Rio Grande do Sul, Porto Alegre
1967	Galeria Seiquer, Madrid
1968	Galeria U, Montevideo, Uruguay
1975	Centro de Arte y Comunicación (CAYC), Buenos Aires
1977	Gabinete de Artes Gráficas, São Paulo
1978	Pinacoteca do Instituto de Artes, Universidade Federal do Rio Grande do Sul, Porto Alegre
1982	Museu de Arte Moderna do Rio de Janeiro
1984	Museu de Arte do Rio Grande do Sul, Porto Alegre
1985	Museu de Arte Contemporânea do Paraná, Curitiba, Brazil
1987	Arte Galeria, Fortaleza, Brazil
1988	Museu de Arte do Rio Grande do Sul, Porto Alegre
1989	Museu de Arte Contemporânea da Universidade de São Paulo
	Galeria Arte & Fato, Porto Alegre
	Galeria Luisa Strina, São Paulo
1990	Micro Hall Art Center, Edewecht, Germany
	Cooperativa de Actividades Artísticas Arvore, Porto, Portugal
	Fundação Calouste Gulbenkian, Lisbon
1991	Galeria Luisa Strina, São Paulo
	Interiors, Mitchell Museum, Mount Vernon, Illinois
	On Absence: Office Furniture, Museum of Natural History, Austin, Texas
1992	*Encuentro,* Bass Museum, Miami
	In Absentia (Stretched), Queens Museum of Art, New York
1993	*Masterpieces (In Absentia),* LedisFlam Gallery, New York

1994 *Expandables,* Art Gallery, Brazilian American Cultural
 Institute, Washington, D.C.
1995 *Regina Silveira: Desenhos,* AS Studio, São Paulo
 Mapping the Shadows, LedisFlam Gallery, New York
 Museu de Arte do Rio Grande do Sul, Porto Alegre
1996 *Grafias,* Museu de Arte de São Paulo Assis
 Chateabriand, São Paulo
 Gone Wild, Inside/Out Series, Museum of Contemporary
 Art, San Diego, California
 Velox, II Gabbiano, La Spezia, Italy
1997 Galeria Casa Triângulo, São Paulo
 To Be Continued . . . , N.I.U. Art Gallery, Chicago
1998 *Regina Silveira (Velox),* Galeria Brito Cimino, São
 Paulo
 Blue Star Art Center, San Antonio, Texas
1999 *Desapariencias,* Galeria Gabriela Mistral, Santiago,
 Chile

Selected Group Exhibitions:

1977 *50 artistas latinoamericanos,* Fundacion Juan Miró,
 Barcelona, Spain
1980 *Panorama da arte atual brasileira: Desenho e gravura,*
 Museu de Arte Moderna de São Paulo
1983 *17° bienal internacional de São Paulo*
1993 *Ultramodern: The Art of Contemporary Brazil,* National
 Museum of Women in the Arts, Washington, D.C.
1996 *Arte brasileira contemporânea: Doação recentes,*
 Museu de Arte Moderna de São Paulo
1997 *Re-Aligning Vision: Alternative Currents in South
 American Drawing,* El Museo del Barrio, New York
 (traveling)
1998 *Salão nacional,* Museu de Arte Moderna do Rio de
 Janeiro
 XXIV bienal internacional de São Paulo
 El empeño latino americano, Museo de Arte
 Contemporáneo, Universidad de Chile, Santiago
1999 *O Brasil no século da arte coleção MAC-USP,* Centro
 Cultural FIESP, São Paulo

Publications:

By SILVEIRA: Books—*The Art of Drawing,* São Paulo, n.p., 1981;
Enigmas: 4 trabalhos 4, São Paulo, Poesia e Arte, 1983; *Projectio,*
exhibition catalog, Lisbon, Fundação Calouste Gulbenkian, 1988.

On SILVEIRA: Books—*Simulacros, Regina Silveira,* exhibition
catalog, São Paulo, Museu de Arte Contemporânea da Universidade
de São Paulo, 1984; *Ultramodern: The Art of Contemporary Brazil,*
exhibition catalog, with text by Aracy Amaral, Washington, D.C.,
National Museum of Women in the Arts, 1993; *Regina Silveira:
Cartografias da Sombra,* exhibition catalog, by Angélica de Moraes,
São Paulo, EDUSP, 1996; *Of Mudlarkers and Measurers: Antoni
Abad, Maria Fernando Cordoso, Gwen MacGregor, Lyndal Osborne
and Regina Silveira,* exhibition catalog, text by Sarindar Dhaliwal,
Kingston, Ontario, Canada, Agnes Etherington Art Centre, Queen's
University, 1997. **Articles**—''Regina Silveira'' by Carlos Basualdo,
in *Artforum,* November 1993, p. 109; ''In Absentia (M.D.) De Regina

Silveira'' by Lisette Lagnado, in *Artpress* (Paris), LXXXIV, Septem-
ber 1984, p. 11; ''Recapturing History'' by Susana Torruela Leval, in
Art Journal, 51(4), winter 1992, pp. 69–78; ''Regina Silveira'' by
Marlena Novak, in *Flash Art* (Italy), 195, summer 1997, p. 139;
''Regina Silveira: NIU Art Museum in Chicago'' by Ana Tiscornia,
in *Art Nexus* (Colombia), 26, October/December 1997; ''Regina
Silveira'' by Roger Welch, in *Art Nexus* (Colombia), 29, August/
October 1998, pp. 138–139.

* * *

Part of the generation of the Brazilian conceptualist artists,
Regina Silveira has been in favor of neither traditional art nor the aura
it creates for the artist and the art object. Since 1959, when she
graduated from the Federal University of Rio Grande do Sul, she has
been involved in the artistic counterculture, practicing nontraditional
techniques and motives. As an artist in a Latin American country, she
learned never to take the easy path. Although she broke barriers in her
native land and began to be respected, it took two decades for her to
gain international recognition.

Silveira lived in Puerto Rico from 1969 to 1973, then returned to
São Paulo, where she settled. There she created performances, one-
of-a-kind or small-edition artist books, and installations concerning
social and environmental matters. She also taught for many years at
the University of São Paulo but later began to travel regularly,
participating in artist-in-residence programs, setting up her installa-
tions, and serving as a postgraduate visiting professor at universities
in the United States, as well as in Canada and Europe. Her work has
been compared to that of Jan Dibbets and also shows a similarity
to Renaissance works for its interest in research, architecture,
and drawings.

Silveira's early works are silk screens, drawings, and paintings
that study the process of the image and its reproduction. She has since
explored diverse techniques and expressions: offset prints, photocop-
ies, microfilm, mail-art, video, photography, cutouts, ''architectural
distortions,'' site-specific installations, and whatever else she could
find to suit her critical vision, her sense of humor, and her obsession
with space and perfection. She has also taken into consideration
garbage and recycling, occasionally creating works by hand-cutting
unwanted or waste materials, such as computer printouts. Although
for a brief time she could not escape from the figurative expression-
ism that abounds in Latin America, geometry became the tool she
used to express her spatial researches. Silveira should not be consid-
ered a geometric artist, however; geometry merely provides a grid or
structure for her critical imagination. Indeed, the human figure did not
disappear from her work but became instead a participating element
when necessary to reinforce a feeling of altered situations, as in
Labirintos (''Labyrinths''). Continuing with the dematerialization
action in which artwork is created by altering or defying the accepted,
Silveira created each piece in situ, thus becoming, in effect, a part of
the work herself.

In an interview she gave in New York to the Mexican newspaper
La Voz de Michoacan in April 2001, Silveira said, ''I am more into
architectural projects and creating a distortion of the glance. I
articulate public and urban art together, as I set myself out of galleries
and museums.'' Silveira linked her drawings with her physical
perceptions of space architecture in such works as *Simulacros* (1982–84,
''Shams''), *To Be Continued (Latin American Puzzle)* (1997), and
installations in which she combined traditional drawings with laser

David Alfaro Siqueiros: *Self-Portrait (El Coronelazo),* **1945. © Schalkwijk/Art Resource, NY. © Estate of David Alfaro Siqueiros/Licensed by VAGA, New York, NY.**

beams to mix the real and the virtual, creating virtual spaces from the physical drawings and real spaces that are partially fictional. The distortion of space in her work expresses the damage a human being suffers by disturbances and conventions, and challenges the traditional ways of creating and seeing art.

—Graciela Kartofel

SIQUEIROS, David Alfaro

Mexican painter and muralist

Born: Chihuahua, 29 December 1896. **Education:** Colegio Franco Inglés, 1907–11; San Carlos Academy of Fine Arts, Mexico City, 1911; La Esmeralda, Mexico City, 1911–13; Mexican Academy, Mexico City, 1913–14; studied in Europe on Mexican government scholarship, 1919–22. **Military Service:** Mexican Army, 1914–22: captain; served in the Spanish Republican Army, 1937–39. **Career:** Worked at the Mexican Embassy, Madrid, 1919; founder, National Union of Technical Workers, Painters, and Sculptors, Mexico, 1922; worked with workers' unions, Guadalajara, 1925–30; imprisoned for political activities, 1930; exiled from Mexico, 1932; instructor, Chouinard Institute, Los Angeles, 1932; organized mural teams in the United States and South America, 1932–34; organized Siqueiros Experimental Workshop, New York, 1936; returned to Mexico, 1939; imprisoned, 1962–64. Beginning in 1959, executive secretary, Mexican Communist Party. **Award:** National Art prize, Mexican government, 1966. **Died:** 7 January 1974.

Individual Exhibitions:

1932	Jede Zeitlin Bookshop, Los Angeles
	Stendahl Ambassador Galleries, Los angeles
1940	Pierre Matisse Gallery, New York
1962	A.C.A. Gallery, New York
1964	New Center Art Gallery, New York
1967	Center for Inter-American Relations, New York (retrospective)
1968	Marion Koogler McNay Art Institute, San Antonio, Texas

David Alfaro Siqueiros: *Premonition,* 1950. © Archivo Iconografico, S.A./Corbis. © Estate of David Alfaro Siqueiros/Licensed by VAGA, New York, NY.

Selected Group Exhibitions:

1966 *Art of Latin America since Independence,* Yale University, New Haven, Connecticut, and University of Texas, Austin

1967 *Latin American Art: 1931–1966,* Museum of Modern Art, New York

Collections:

Museum of Modern Art, New York; Rhode Island School of Design, Providence; Museo de Arte Moderno, Mexico City; Museo Nacional de Historia, Mexico City.

Publications:

By SIQUEIROS: Books—*L'Art et la revolution,* Paris, 1973, as *Art and Revolution,* London, 1975; *Como se pinta un mural,* Mexico City, 1951, Cuernavaca, 1977, as *How to Paint a Mural,* London, 1987; *Siqueiros,* edited by Rafael Carrillo Azpeitia, Mexico City, 1974; *Textos,* edited by Raquel Tibol, Mexico City, 1974; *Me llamaban el Coronelazo: Memorias,* Mexico City, 1977.

On SIQUEIROS: Books—*70 obras recientes de David Alfaro Siqueiros,* Mexico City, Museo Nacional de Artes Plasticas, 1947; *Siqueiros: Introductor de realidados* by Raquel Tibol, Mexico City, 1961, as *Siqueiros,* New York, 1969; *Siqueiros* by Mario de Micheli,

New York, Abrams, 1968; *Siqueiros* by Antonio Rodriquez, Mexico City, 1974; *Vida y obra de Siqueiros: Juicios críticos,* edited by Ruth Solis, Mexico City, 1975; *Siqueiros e il muralismo messicano,* exhibition catalog, Florence, 1976; *Contemporary Mexican Painting in a Time of Change* by Shifra M. Goldman, Austin, Texas, 1981; *So Far from Heaven: Siqueiros' ''The March of Humanity'' and Mexican Revolutionary Politics* by Leonard Folgarit, Cambridge, Cambridge University Press, 1987; *David Alfaro Siqueiros: Portrait of a Decade, 1930–1940* by Marko Daniel, London, Whitechapel Art Gallery, 1997; *Los Murales de Siqueiros* by Raquel Tibol, Shifra M. Goldman, and others, Mexico, Instituto Nacional de Bellas Artes, 1998.

* * *

The Mexican Revolution of 1910 possibly marks the beginning of modern Mexican Art. The art revolution took place alongside the political revolution, and of primary importance is the movement of mural painting, which reflected critical historical sense. With José Orozco and Diego Rivera, David Alfaro Siqueiros is the most important exponent of mural painting. He introduced new materials, developed new techniques, and brought a critical social sense to the genre. His work reflects the most dramatic and moving account of the history of Mexico as well as the ability of humankind to rise and triumph above despair.

Siqueiros was influenced by Marxism, and his political activities often overshadowed his artistic accomplishments. The two, however, were intertwined. He believed that public murals were a powerful medium that made his work accessible to the masses. He also thought, however, that murals were ignored by art institutions catering to the elite. In 1911 Siqueiros organized his first protest at the Academia de San Carlos, a traditional art institute where he was a student. After becoming secretary of the Communist Party in 1928, he helped draft a manifesto that called for the creation of monumental public art rooted in indigenous Mexican traditions. In his view, this art should be at the service of the Mexican Revolution. The manifesto became the basis for the Mexican mural movement.

In 1932 Siqueiros was expelled from Mexico for his political activities and settled in Los Angeles for approximately six months. There he taught at the Chouinard Institute, which was considered the training ground for Disney artists. In this environment he introduced the term ''filmable art,'' or ''pictorial cinematographic art,'' which referred to art with the preconceived idea of being filmed. Siqueiros used montage in his murals along with what can be considered ''nontraditional'' technology—photography and air brushing, among other elements. He also used new and synthetic materials such as Duco, a transparent automobile paint. All of these created an illusion of movement. This is particularly revealing as it clearly shows a preoccupation with innovative techniques as strong as the preoccupation with social change.

During his time in Los Angeles, Siqueiro completed three murals, the most important of which is *Tropical America,* which was executed along the exterior of the Italian Hall at the Plaza Art Center. Made of cement rather than the traditional plaster, it focuses on an Indian peon who represents the oppression by the United States. The Indian is portrayed crucified on a double cross capped by an American eagle. Two peasants, one Mexican and the other an armed Peruvian, are sitting on the wall in the upper-right corner of a Mayan pyramid covered with vegetation. The peasants look ready to defend themselves against imperialism. The execution of this mural was done with extensive use of mechanical equipment, including the

David Alfaro Siqueiros: Detail from the mural, *For the Complete Safety of All Mexicans at Work,* **1952–54. © Schalkwijk/Art Resource, NY. © Estate of David Alfaro Siqueiros/Licensed by VAGA, New York, NY.**

airbrush, which was used by Siqueiros for the first time. Another first was his specific attack on what he believed to be U.S. imperialism.

Parts of the mural were considered inappropriate by those trying to promote the area, however, and within the year the mural was completely painted over. When the whitewash began to peel off in the late 1960s, the mural was "found." Exposure to the sun caused severe damage, and the mural was covered with plywood in 1982 to prevent total deterioration. Since then, the mural has been restored. The first large mural in the United States that was painted on an exterior wall, *Tropical America* is perhaps the beginning of public art. As murals began to appear in urban neighborhoods after the 1960s, it became a prototype.

During a trip to New York in 1936, Siqueiros established the Siqueiros Experimental Workshop. He hoped to begin a new interest and a new period of mural painting, one that would demonstrate his ideas for the use of photomontage and other techniques developed through the use of new materials, including industrial paints. Jackson Pollock was among its members, and he would later pioneer the movement known as abstract expressionism, adopting many of

Siqueiros's innovative techniques. Siqueiros supported the workshop through the sale of the easel paintings he created there. *Echo of a Scream*, an enamel on wood, is one such painting. He was inspired by a photograph that shows a crying child abandoned in the ruins of a bombed railroad station in Manchuria. The painting, in grays and browns, repeatedly depicts the face of a child distorted in a scream, with the largest image at the center of the picture. The head seems separated from the body, amplifying the child's agony and the horror of the situation. The repetition of the images reflects his friendship with and influence of Soviet film director Sergei Eisenstein. The latter introduced Siqueiros to the technique of using multiple perspectives in a work of art to emphasize ideological meaning.

Siqueiros insisted that easel painting was not a major interest for him. He believed this art form did not appeal to the average worker, but rather to the bourgeois and intellectuals. He thought his paintings were socially inferior to his murals. Ironically, it is his paintings that brought him international recognition.

Siqueiros received commissions for murals in the United States and throughout Latin America, but his best murals are in Mexico City.

The Revolution against the Dictatorship of Porfirio Díaz in the Museo Nacional de Historia portrays the corruption of the government of Porfirio Díaz and his eventual overthrow by revolutionaries. *The March of Humanity in Latin America* is the largest mural ever painted. The work, located inside and outside the Cultural Polyforum, covers 46,612 square feet and includes 12 panels of mixed curved and sculpted walls.

—Martha Gutiérrez-Steinkamp

SMITH, Ray
American painter, printmaker, and sculptor

Born: Brownsville, Texas, 1959. **Education:** Tabor Academy, Marion, Massachusetts, 1973–77; School of the Museum of Fine Arts, Boston, 1976–77; Taller de Toby Joysmith, Mexico City, 1977–78; Universidad de las Américas, Mexico City, 1977–79. **Career:** Has lived and worked in New York and Cuernavaca, Mexico.

Individual Exhibitions:

1978 *Ray Smith Yturria: Acrilicos,* Galeria del Instituto Mexicano Norteamericano de Relaciones Culturales, Mexico City
1983 *Ray Smith Yturria: Paisajes 1980–82,* Mexico City
1984 *Obras recientes,* Eduardo Hageman Gallery, Mexico City
 Ray Smith: Drawings, Tower, New York
1985 *Ray Smith Yturria: Paintings/Drawings/Sculpture,* Portico, Philadelphia
1987 Gagosian Gallery, Los Angeles
1988 Mario Diacono, Boston
 Sperone Westwater, New York
 New Paintings, Akira Ikeda Gallery, Tokyo
 Gian Enzo Sperone, Rome
1989 *Currents: Ray Smith,* Institute of Contemporary Art, Boston
 Sperone Westwater, New York
 Bruno Bischofberger, Zurich
 AC&T Corporation, Tokyo
 Fernando Alcolea, Barcelona, Spain
 Galleri Lars Bohman, Stockholm
 Akira Ikeda Gallery, Tokyo
 Galería Arte Contemporáneo, Mexico City
1990 Gian Enzo Sperone, Rome
 Galerie Folker Skulima, Berlin
 Sperone Westwater, New York
 Ray Smith: Wind Instruments, Editions Julie Sylvester, New York
 Akira Ikeda Gallery, Nagoya, Japan
1991 Galería OMR, Mexico City
 New Paintings, Galerie Thaddeus Ropac, Paris
 Sperone Westwater, New York
 Paraiso, deleites terrestres, infierno, Crazy Eights, San Francisco (installation)
 Mario Diacono Gallery, Boston

Ray Smith: *Walking the Dog,* 1999. Photo courtesy of Galeria Ramis Barquet.

1992 Sperone Westwater, New York
 Bonnefantenmuseum, Maastricht, Netherlands (traveled to Museu de Arte Contemporáneo de Monterrey)
 Galerie Barbara Farber, Amsterdam
1993 *Art at the Edge: Ray Smith,* High Museum of Art, Atlanta
 Ex-Convento de Santa Teresa La Antigua, Mexico City
 Galerie Thaddeus Ropac, Paris
1994 *Encounters 4: Ray Smith,* Dallas Museum of Art
 Galeria Ramis Barquet, Madrid
 Ruth Bloom Gallery, Santa Monica, California
 Gian Enzo Sperone, Rome
1995 *Ray Smith: Portraits of American Writers,* Sperone Westwater, New York
 Ray Smith: Recent Paintings, Arts Club of Chicago
 Galerie Lars Bohman, Stockholm
 Galerie Barbara Farber, Amsterdam
1996 *Battle of the Tailors,* Mario Diacono Gallery, Boston
 Galeria Ramis Barquet, Madrid
1997 Galerie Lars Bohman, Stockholm
 Milleventi, Turin, Italy

Ray Smith: *Kozo,* 1999. Photo courtesy of Galeria Ramis Barquet.

1998 *Ray Smith: Cadavre Exquis,* Ramis Barquet Gallery,
 New York
 Ray Smith: Recent Paintings, Ramis Barquet Gallery,
 New York
 Galerie Daniel Templon, Paris
1999 *Time and Again,* Galeria Ramis Barquet, New York
 Pop Vox, Galeria Ramis Barquet, Monterrey, Mexico
 Galería OMR, Mexico City
 100 Heads on Paper, Esso Gallery, New York
 Argonáutica, Galeria Joan Prats, Barcelona, Spain, and
 Timothy Taylor Gallery, London

Selected Group Exhibitions:

1989 *Biennial Exhibition,* Whitney Museum of American Art,
 New York
1990 *Salon de los 16,* Museo Español de Arte
 Contemporáneo, Madrid
1991 *Mito y magia en America: Los ochenta,* Museo de Arte
 Contemporáneo de Monterrey, Mexico
 *Altrove, fra immagine e identita, fra identita e
 tradizione,* Museo d'Arte Contemporanea Prato, Italy
1992 *Latin American Artists of the Twentieth Century,*
 Estación Plaza de Armas, Seville, Spain (traveling)
1993 *La Frontera/The Border: Art about the Mexico/United
 States Border Experience,* Centro Cultural de la Raza
 and Museum of Contemporary Art, San Diego,
 California (traveling)
1994 *Thirtieth Annual Exhibition of Art on Paper,*
 Weatherspoon Art Gallery, University of North
 Carolina at Greensboro
1997 *Artistes latino-américains,* Galerie Daniel Templon,
 Paris
 Drawn & Quartered, Karen McCready Fine Art, New
 York
 Poligrafa obra grafica, Joan Prats Gallery, New York

Publications:

By SMITH: Book—*Guia de Tokyo,* Tokyo, AC&T Corp., 1989.

On SMITH: Books—*Ray Smith: New Paintings,* exhibition catalog, Tokyo, Akira Ikeda Gallery, 1989; *Ray Smith, Sculpture,* exhibition catalog, edited by Midori Nishizawa, Kyoto, Japan, Kyoto Shoin, 1989; *Ray Smith,* exhibition catalog, essay by Edward J. Sullivan, New York, Sperone Westwater, 1989; *Ray Smith, pintura y escultura,* exhibition catalog, text by Carlos Monsiváis, Mexico City, La Galería, 1989; *Ray Smith,* exhibition catalog, text by Charles Merewether, Rome, Gian Enzo Sperone, 1990; *Ray Smith,* exhibition catalog, text by Francesco Pellizzi and D. James Dee, Maastricht, Bonnefantenmuseum, 1992; *Ray Smith,* exhibition catalog, essay by Susan Krane, Garza García, Mexico, Galería Ramis Barquet, 1994; *Ray Smith: Recent Paintings,* exhibition catalog, Chicago, Arts Club of Chicago, 1995; *Ray Smith: Cadavre Exquis,* exhibition catalog, New York, Galería Ramis Barquet, 1998; *Ray Smith: Recent Paintings,* exhibition catalog, New York, Galería Ramis Barquet, 1998. **Articles**—''Ray Smith'' by Jose Manuel Springer and ''Interview with Ray Smith'' by Paola Sada, in *Art Nexus* (Colombia), 15, January/March 1995, pp. 48–51; ''Ray Smith at Sperone Westwater'' by Richard Vine, in *Art in America,* 83, July 1995, p. 84; ''Ray Smith'' by Francine Koslow-Miller, in *Artforum International,* 35, March 1997, pp. 96–97; ''Artistes Latino-Américains: Latino or South American?'' by Michel Nuridsany, in *Art Press* (France), 224, May 1997, pp. 78–79; ''Ray Smith: Ramis Barquet Gallery, NYC'' by Christian Viveros-Fauné, in *Art Nexus* (Colombia), 30, November 1998/January 1999, pp. 147–148; ''Julio Galan and Ray Smith at Sotheby's and Ramis Barquet'' by Eduardo Costa, in *Art in America,* 88(9), September 2000, pp. 148–149.

* * *

A painter, printmaker, and sculptor, Ray Smith has worked with a rich vocabulary of imagery that has expressed a fluid sense of identity and an unusually comfortable embrace of wide-ranging cultural sources. Born to a Mexican mother and American father in Brownsville, Texas, near the United States-Mexico border, Smith has divided his time between both countries and has acknowledged a debt to the cultures of each in the development of his art. The large scale of many of his most important paintings and the bold simplicity of his imagery have suggested the influence of Mexican mural paintings, while his frequent depictions of animals have recalled an even older Mexican source—pre-Columbian cultures and the plethora of hybrid human/animal deities in Aztec and Mayan iconographies. In addition to the Mexican sources so frequently cited in discussions of his painting, Smith has drawn freely from and has combined aspects of European surrealism, Pablo Picasso's cubism, Andy Warhol's pop, and such popular realms as kitsch and fashion advertising. But much more than an amalgamation of myriad cultural forms, Smith's work was the result of an artist who has sought to express the complex processes of cultural borrowing and transformation that take place between cultures, such as along the border between the United States and Mexico where Smith spent his formative years.

Many of Smith's early works contained autobiographical references, often through the inclusion of stylized portraits of himself or his wife amid an array of incongruous elements. In *María de la Cruz como Choc Mool* (1988) Smith appropriated Diego Rivera's allegorical figure of a female nude representing earth seen in his Chapingo

murals of 1926–27. The artist freely transformed Rivera's reclining nude into a schematized portrait of his then-pregnant wife, while also referencing Chac Mool, the rain deity revered by many pre-Columbian peoples. By conflating an ancient historical symbol with an iconic image from Mexico's modern art history, and overlaying a deeply personal reference, Smith demonstrated his capacity to fluidly negotiate layers of time and culture as compelled by his own imaginative powers.

Guernimex (1989) was a key work by Smith. Measuring 9 feet by 21 feet, this monumentally scaled painting on wood panels clearly recalls Picasso's *Guernica,* containing such direct references as wailing, upturned heads, fragmented limbs, and a central equine form. But where Picasso's *Guernica* is an impassioned plea against civil violence, Smith's *Guernimex* is a super-charged, postmodern landscape—an anxious vision of a humanity facing an uncertain destiny.

Much of Smith's work of the 1990s centered on vivid depictions of animals and suggested the growing influence of dream and pure imagination in his oeuvre. For these compositions, dogs, birds, and occasionally simian creatures are seen in juxtaposition with people. Whether inhabiting surreal domestic settings or the outdoors, Smith's animals seem fully on par—intellectually and emotionally—with their human cohorts. Together the animals and human protagonists play out eerie psychological dramas often infused with sexual undertones.

Smith has transcended the nationalistic labels and readings accompanying much Mexican art of the 1980s and '90s. Nevertheless, in so creatively mining, and transforming elements of his own identity and cultural legacy, Smith has suggested new possibilities for an art that was simultaneously tied to a national impulse and freely universal.

—Elizabeth Ferrer

SOBALVARRO, Orlando

Nicaraguan painter and sculptor

Born: Managua, 1943. **Education:** Escuela de Bellas Artes de Managua. **Career:** Visited New York, 1968. Involved with artist group *Praxis,* Nicaragua, 1960s, and with government-related *Artist's Union,* 1980s. **Awards:** First prize, Salón ESSO de artistas jóvenes, 1965; national prize for painting, Teatro Rubén Dario, Ministerio de Cultura, Managua, 1981; national prize for painting, Casa Fernando Gordillo, Managua, 1982, 1987; first prize, *Certamen nacional de artes plásticas,* Galería Casa Fernando Gordillo, Managua, 1984; national prize for painting "Rodrigo Peñalba," Managua, 1984, 1985, 1990.

Individual Exhibitions:

1964	Galería Praxis, Managua
1965	Escuela Nacional de Bellas Artes, Managua
1966	Galería Praxis, Managua
1967	Escuela Nacional de Bellas Artes, Managua
1968	Galería Zegri, New York
1969	Glaería Zegri, New York
1974	Galeria Tagüe, Managua
1977	Galería Forma, San Salvador, El Salvador
1982	Museo de Arte Carrillo Gil, Mexico City

	Galería Casa Fernando Cordillo, Managua
1984	Centro Cultural Ruinas del Gran Hotel, Managua (retrospective)
1986	Galería Casa Fernando Gordillo, Managua
1991	*Esculturas recientes,* Museo de Arte Contemporáneo Julio Cortázar, Nicaragua
1995	Galería de Arte Contemporáneo, Managua

Selected Group Exhibitions:

1966	Pan American Union, Washington, D.C.
1970	*Arte latinoamericano,* San Antonio, Texas
1982	*Arte centroamericano,* Bonn, Germany
1996	*Mesótica II: Centroamérica regeneración,* Madrid (traveling)
	Museo de Arte y Diseño Contemporáneo, San José, Costa Rica

Publications:

On SOBALVARRO: Book—*Sobalvarro,* exhibition catalog, text by Julio Valle-Castillo and María Dolores G. Torres, Nicaragua, Galería CODICE, 1995.

* * *

Since his early involvement with the Praxis Group (1963–1972)—Nicaragua's most important vanguard movement in the visual arts prior to the "renaissance" inaugurated by the Nicaraguan revolution of 1979—Orlando Sobalvarro has been one of the most significant painters in the history of this Central American country. He was a student of the legendary Rodrigo Peñalba at the Escuela Nacional de Bellas Artes in Managua. The introduction to modernism through Peñalba's work was momentous, yet the figurative style of Sobalvarro's mentor (with its boldly expressionist link to El Greco and José Clemente Orozco) served more as a foil than as a point of departure. Among Sobalvarro's early mature works is *Mujeres moniboseñas* ("Monimbo Women") of 1978, in which he used an obliquely figurative, largely abstract manner with an encrusted surface that owed a debt, as Jorge Eduardo Arellano has written, to the *tenebrism* of Armando Morales's *arte informal* style from the early 1970s.

It was with his *Buho y luna* ("Owl and Moon") series from the late 1970s and early '80s —such as his oil on wood *Buho y luna #1*— that Sobalvarro's most distinctive manner fully emerged. Vaguely figurative and lightly textured with somber light/dark shifts, this style was transformed through Picasso-influenced motifs and subtle atmospheric effects, as well as organic shapes. Another distinguishing trait was the use of intermittently angular accents on smooth surfaces. One sees this in such noteworthy paintings as *Paisaje de verano en Subitava* ("Summer Landscape in Subtiava"). From the early 1980s through the early '90s, Sobalvarro forged one of the most nuanced styles by any painter in the history of Latin America. He used heavily glazed oil surfaces with luminous passages that varied widely, though not starkly, in value range.

Until the mid-1990s Sobalvarro tended to use warm earth tones that extended from smoldering ochres and umbers to moody olive grays. The art critic Dore Ashton was moved by the subtlety and range of Sobalvarro's style when she visited Nicaragua in the 1980s during the Sandinista years. About his highly original paintings, Ashton wrote, "For several years these artists [of Praxis] stayed within a

narrow range of black, gray, and brown, shunning the brilliant colors expected of tropical painters. Certain artists still avoid a high chromatic palette. Orlando Sobalvarro, one of the founders [of Praxis]. . . speaks of a 1968 trip to New York and the importance of Rothko and Pollock in his formation. Yet, his palette is still greatly reduced to delicate tones of ocher and grey.''

Sobalvarro was a key figure in the Sandinista-period Artist's Union, and he supervised the purchase of art by the Ministry of the Interior to aid the union throughout the 1980s. A painter's painter, even as he was a solid supporter of the 1979 revolution in Nicaragua, Sobalvarro always opposed the type of easy populism that reigned in the Soviet Bloc countries under socialist realism. He said, ''There should be no fear of abstract art. It is important that the concepts be understood by the general public.'' More advanced art, not more simplistic art, would be (in conjunction with the long-term cultural policies of the Sandinista National Liberation Front) the ''solution'' to elevating the artistic discourse in Nicaragua in relation to revolutionary social transformation. After deeply conservative forces came to power in Nicaragua during the 1990s, however, Sobalvarro found himself isolated, as did all Nicaraguan artists of any significance. His artistic practice suffered as a result, even when right-wing forces tried to ''rehabilitate'' him as a ''classic.''

—David Craven

SOTO, Jesús Rafael
Venezuelan painter and sculptor

Born: Ciudad Bolivar, 1923. **Education:** Academia de Bellas Artes, Caracas, 1942–47. **Family:** Married in 1952. **Career:** Director, Maracaibo School of Fine Arts, Venezuela, 1947–50. Since 1950 has lived and worked in Paris. Also a musician. **Awards:** Hatch prize for abstract painting, Caracas, 1957; national prize, Venezuela, 1960; Virgilio Cordo prize, Caracas, 1960; Wolf prize, *Bienal,* São Paulo, Brazil, 1963; Premio David Bright, *Biennale,* Venice, 1964; first prize, *Bienal America,* Cordova, Peru, 1964; prize of the City of Cordova, 1964; first prize, *Salon of Pan-American Painting,* Cali, Columbia, 1965; Medaglia d'Oro, Convegno Internazionale Studiosi d'Arte, Rimini, Italy, 1967. **Address:** c/o Galleria del Naviglio, Via Manzoni 45, 20121 Milan, Italy.

Individual Exhibitions:

1949	Atelier Libre de Arte, Caracas
1956	Galerie Denise René, Paris
1957	Galerie Aujourd'hui, Palais des Beaux-Arts, Brussels
	Museum of Modern Art, Caracas
1959	Galerie Iris Clert, Paris
1961	Museum of Modern Art, Caracas
	Galerie Rudolf Zwirner, Essen, Germany
	Galerie Brusberg, Hannover, Germany
1962	Galerie ad Libitum, Antwerp, Belgium
	Galerie Edouard Loeb, Paris
1963	Museum Haus Lange, Krefeld, West Germany
1964	Galerie Muller, Stuttgart, Germany
1965	Galerie Edouard Loeb, Paris

	Kootz Gallery, New York
	Signals Gallery, London
1966	Galerie Schmela, Dusseldorf, Germany
	Galleria del Naviglio, Milan
	Galleria del Deposito, Genoa, Italy
	Centre de l'Art Vivant, Trieste, Italy
	Pfalzgalerie, Kaiserlautern, Germany
1967	Galerie Denise René, Paris
1968	Galerie Françoise Mayer, Brussels
	Kunsthalle, Berne, Germany
	Stedelijk Museum, Amsterdam
	Marlborough Galleria d'Arte, Rome
1969	Palais des Beaux-Arts, Brussels
	Galleria Lorenzelli, Bergamo, Italy
	Galleria Notizie, Turin, Italy
	Galleria del Naviglio, Milan
	Galleria Flori, Florence, Italy
	Galleria Giraldi, Livomo, Italy
	Galeria Estudio Actual, Caracas
	Musée d'Art Moderne de la Ville, Paris
	Svensk-Franska Kunstgalleriet, Stockholm
1970	Galerie Denise René, Paris
	Galerie Godart Lefort, Montreal
	Galerie Suvremene, Zagreb, Croatia
	Galleria de la Nova Loggia, Bologna
	Galerie Semiha Huber, Zurich
	Kunstverein, Mannheim, Germany
	Marlborough Gallery, New York
	Galerie Buchholz, Munich, Germany
	Ulm Museum, Germany
1971	Museum of Contemporary Art, Chicago
	Galleria Rotta, Milan
	Martha Jackson Gallery, New York
	Galerie Denise Reneé-Hans Meyer, Dusseldorf, Germany
	Kunstverein, Kaiserlautern, Germany
	Museo de Bellas Artes, Caracas
1972	Galerie Pauli, Lausanne, Switzerland
	Galerie Beyeler, Basel, Italy
	Galleria Levi, Milan
	Museo de Arte Moderno, Bogota
1973	Galeria Tempora Calle, Bogota
	Galleria Corsini, Rome
	Universidad Central de Venezuela, Caracas
	Estudio Dos, Valencia, Venezuela
	Arte Contacto, Caracas
	Galleria Godel, Rome
1974	Guggenheim Museum, New York (retrospective)
	Denise René Gallery, New York
1975	Denise René Gallery, New York
1979	Museo de Arte Contemporaneo, Caracas
	Centre Georges Pompidou, Paris
1981	Galeria Tempora Calle, Bogota, Colombia
	Galeria Theo, Madrid
	Sala Celini, Madrid
1983	Museo de Arte de Caracas, Venezuela
1997	Jeu de Paume Gallery, Paris (traveling retrospective)

Jesús Rafael Soto: *Relationship of Contrary Elements,* 1965. Photo courtesy of The Art Archive/Tate Gallery, London/Eileen Tweedy. © 2002 Artists Rights Society (ARS), New York/ADAGP, Paris.

1999 Durban Segnini Gallery, Miami
2000 Fundación Corp Group Centro Cultural, Caracas

Selected Group Exhibitions:

1943 *Annual Art Exhibition,* Caracas
1955 *Le Mouvement,* Galerie Denise René, Paris
1957 *Bienal,* São Paulo, Brazil
1958 *World's Fair,* Brussels
 Bienal, São Paulo, Brazil
 Biennale, Venice
1962 *Biennale,* Venice
1967 *International Exhibition,* Carnegie Institute, Pittsburgh
1969 *Middelheim biennale,* Antwerp, Belgium
1974 *Neuve artistas venezolanos,* Museo de Arte
 Contemporaneo, Caracas

Collections:

Cali Institute of Fine Arts, Colombia; University City, Caracas; Albright-Knox Art Gallery, Buffalo, New York; Stedelijk Museum, Amsterdam; Palais des Beaux-Arts, Brussels; Centre Georges Pompidou, Paris; Kunsthaus, Zurich; Moderna Museet, Stockholm;

Louisiana Museum, Humlebaek, Denmark; National Gallery of Victoria, Melbourne.

Publications:

By SOTO: Book—*Space Art,* Miami, Center for the Fine Arts and Hispanic Heritage Festival Committee, 1986. **Article—**''Dialogue: Jesús Rafael Soto and Guy Brett'' in *Museumjournaal* (Amsterdam), February 1969.

On SOTO: Books—*Soto,* exhibition catalog, text by Jean Clay, Paris, 1969; *Soto,* exhibition catalog, by Guy Brett, New York, 1970; *Soto* by Alfredo Boulton, Caracas, 1973; *Soto,* exhibition catalog, Caracas, 1983; *Jesús Rafael Soto,* exhibition catalog, with text by Francoise Bonnefoy, Sarah Clément, and others, Galerie nationale du Jeu de Paume, Paris, 1997; *Soto: La poética de la energía,* exhibition catalog, Fundación Telefónica, Santiago de Chile, 1999. **Articles—**''J. R. Soto,'' in *Signals* (London), 1(10), 1965, and ''Soto,'' in *Connaissance des Arts* (Paris), June 1969, ''Soto's X Penetrables,'' in *Studio International* (London), September 1969; all by Jean Clay; ''Soto dans le labyrinthe'' by Philippe Comte, in *Opus International* (Paris), June 1969;''Soto's Logic'' by Patrick d'Elme, in *Cimaise* (Paris), May/August 1970; ''Soto'' by E. L. L. de Wilde, in *Museumjournal* (Amsterdam), October 1973; ''Soto: Vibrations et

vertiges'' by Itzhak Goldberg, in *Beaux Arts Magazine* (France), 152, January 1997, pp. 40–47; ''Jesús Rafael Soto: Energy As Reality'' by Roberto Guevara, in *Art Press* (Paris), 220, January 1997, pp. 36–40; ''Jesús Rafael Soto: When Soto Plays in Space'' by Gilles Plazy, in *Cimaise* (Paris), 44, January/March 1997, pp. 1–16.

* * *

Jesús Raphael Soto was an important member of the kinetic art movement in Venezuela during the 1950s and '60s. He studied at the Escuela de Artes Plásticas in Caracas during the mid-1940s and was director of the Escuela de Bellas Artes in Maracaibo until 1950. At that time he moved to Paris, where he spent the rest of his life. He was interested in cubism as well as the work of the Russian constructivists. He exhibited at the Galerie René in Paris, where many other artists working in kinetic and op art were also showing their work. The work of Piet Mondrian was an important source of inspiration for Soto, particularly his painting *Broadway Boogie Woogie.* Like Mondrian he wanted to translate musical rhythms into visual form, attempting to do so in his *Serial* and *Progression* series of paintings made up of dots or squares arranged in geometric formations. Soto was also a musician and often supported himself in Paris by playing his guitar in bars for money. His music often inspired his work, which at times sought to express visually elements of time and rhythm.

During the mid- to late 1950s Soto began to experiment with the visual effects of layering planes, sometimes placing a sheet of clear acrylic with a design on it in front of an image or hanging objects in front of the canvas. His first kinetic work was *Spiral* (1955), which contained two overlapping layers of acrylic that appeared to vibrate when the viewer looked at them from different angles. This work has similarities with Carlos Cruz-Diez's *Physichromies;* both change appearance as the viewer moves around them, thus requiring the viewer's participation to complete the works' meanings. Soto's works, however, are much more sculptural than Cruz-Diez's works, which, while having an aspect of tridimensionality, are more dependent upon the relationships between colors to create the illusion of vibration.

Soto's *Baguettes rouges et noires* (1964) is part of his early *Vibration* series of kinetic works. This series consisted of paintings of alternating black and white lines, in front of which he hung objects such as wire or bars of wood or metal that made the background appear to vibrate when moved. In this work he experimented with the visual effects that different colors create when placed against the striped background. He incorporated time and motion by requiring the viewer to move around the work in order to gain a full understanding of its meaning. He typically favored materials suggestive of industrialization and modernity, such as metal wire and tubing, nylon filament, and acrylic. During the early 1960s, however, he began making sculptures with materials such as old wooden beams and rusty, tangled wire, more suggestive of *Arte Povera* than of kinetic art. *Log* (1961) is a sculpture in this series, consisting of a wooden post with stripes painted on one section in front of which a tangle of wires is hung.

Soto also made more traditional forms of sculpture, although many of these, like the works from his *Vibration* series, were dependent upon the layering of planes. His first sculpture in this series was his *Pre-Penetrable* (1957), which consisted of coated wire in different colors arranged in striped formations and layered so that these formations combined to create optical illusions. The *Pre-Penetrables,* which were usually about the size of a person or smaller,

gave way to enormous *Penetrables.* These were large-scale installations formed by nylon filament or hollow tubes suspended from the ceiling in gridlike formations for the viewer to walk through, incorporating the sense of touch and, in the case of the tubes, sound. At times the *Penetrables* incorporated high-keyed hues, such as brilliant yellow, that would make the viewer experience color as a physical presence.

Soto often approached his work in a manner similar to that of a scientist, keeping certain elements constant and changing others to create the desired effect. Like that of Cruz-Diez, his work incorporated specific color formations that appeared to dissolve physical form, making color appear as a vibrating form of energy.

—Erin Aldana

SUÁREZ, Bibiana
American painter and installation artist

Born: Puerto Rico, 1960; moved to Chicago, 1980. **Education:** Art Institute of Chicago, B.F.A. in painting and drawing 1984, M.F.A. 1989. **Career:** Associate professor and co-chair of art department, DePaul University, Chicago. **Awards:** Individual visual artist fellowship awards, Illinois Arts Council, 1991, 1994, and 1999; visual arts fellowship, National Endowment for the Arts/Midwest region, 1992.

Individual Exhibitions:

1985	*A Grafito,* Art Student's League, San Juan, Puerto Rico
1991	*In Search of an Island,* Sazama Gallery, Chicago
1993	*Beak to Beak—Face to Face,* Sazama Gallery, Chicago
	Island Adrift: The Puerto Rican Identity in Exile, Taller Puertorriqueno, Philadelphia
1998	*Dominô/Domino,* Museo del Barrio, New York (traveled to Illinois Art Gallery, Chicago)

Selected Group Exhibitions:

1988	*Adivina! Chicago Latino Expressions,* Mexican Fine Arts Center Museum, Chicago, and Museum of Modern Art, Chapultepec, Mexico City
1988–89	*Expresiones hispanas,* Mexican Cultural Institute, San Antonio, Texas (traveling)
1991	*In the Heart of the Country,* Chicago Cultural Center
1992	*National Drawing Invitational,* Arkansas Art Center, Little Rock
1996	*Second Sight: Printmaking in Chicago, 1935–1995,* Mary Leigh Block Gallery, Northwestern University, Chicago
1998	*Puerto Rican Equation,* Hunter College, New York Bronx Museum of the Arts, New York

Publications:

On SUÁREZ: Books—*Contemporary Puerto Rican Artists,* exhibition catalog, Chicago, State of Illinois Art Gallery, 1989; *Latin*

American Women Artists of the United States: The Works of 33 Twentieth-Century Women by Robert Henkes, Jefferson, North Carolina, McFarland, 1999. **Articles—**''Bibiana Suárez: Illinois Art Gallery'' by Jenni Sorkin, in *New Art Examiner,* 26(9), June 1999, pp. 40–41; ''Bibana Suárez: Museo del Barrio'' by Graciela Kartofel, in *Art Nexus* (Colombia), 32, May/July 1999, pp. 135–136.

* * *

Bibiana Suárez moved to Chicago from Puerto Rico in 1980 after a teacher on the island told her she had no future there as an artist. Her work, which she began exhibiting in the mid-1980s, focuses largely on the problems of identity that come from this cultural displacement. In 1998 she was quoted by Victor M. Cassidy for artnet.com as saying, ''I'm a volunteer exile, for I belong neither in Puerto Rico nor in the United States, but in my work.'' She also said that she was caught in an ''ongoing dilemma—resistance to cultural assimilation. I am guided by an intense desire to retain the island of my past, but must accept the reality of my self-imposed exile, realizing that the island of my future might be irreconcilable.''

One project, executed in the early 1990s, is in fact entitled ''In Search of an Island.'' It consists of richly textured pastels, some as large as seven by eight feet. In each drawing in the series Suárez depicted the landscape and cartography of the island in ways that relate it metaphorically to the outside world—in particular, the mainland United States, which holds Puerto Rico as a commonwealth, protecting it and offering it government services but without the right of self-determination. In some of these drawings, the island seems threatened from without. In *Juracan* it rests precariously on a towering rock formation while torrential rains and hurricane winds threaten its fragile equilibrium. In *Río de agua viva* the island is an emerald green tourist paradise, complete with a palm tree—but it drifts in a radioactive red sea, which contains a gargantuan jellyfish that seems to threaten the island's peaceful existence. But in other works in the series, the island's relationship to the outer world is more challenging. In *Isla madre/isla negra* the island erupts in two enormous, breastlike mountains that nurture and destroy their homeland while spewing lava and ash across a tiny silhouette of the United States.

Other projects address the relationship between her native and adopted cultures through images treating some of Puerto Rico's traditions and pastimes. One is the violent, ritualized cockfight, or *pelea de gallo,* which Suárez has described as a symbol of both her personal struggle as an artist and Puerto Rico's search for economic freedom and national identity. One image from this 1993 series, *Cualidades necessarias en un buen gallo de la pelea* (''Qualities Necessary in a Good Fighting Cock''), is a schematic drawing of a plucked rooster with various desirable characteristics numbered and labeled. One note states that ''he should reflect his good breeding in the face of the most grievous wounds''—a noble goal, she suggested, for both the artist and the island, if a painful one.

Another favorite Puerto Rican pastime that Suárez addressed is dominoes. In *Dominô,* a series she began in 1998, she presented, according to Cassidy, her ''analysis and redrawing'' of the ''fine line between acculturation and assimilation.'' It is a wall-size installation of round drawings laminated onto 18-inch wooden disks and grouped to suggest 5-by-11-foot-wide domino pieces. The images in the drawings are taken from the history, literature, and popular iconography of the United States and Puerto Rico and demonstrate the difficulty of making a match of the two cultures. In one domino, for example,

Jacqueline Kennedy Onassis appears in mourning clothes juxtaposed with iconic images of the Virgin Mary.

—Anne Byrd

SUÁREZ, Pablo
Argentine painter and sculptor

Born: Buenos Aires, 1937. **Education:** Studied agronomy, Universidad de Buenos Aires, *ca.* 1955–59. **Career:** Involved with the artistic movement *Contexto,* 1960s. Political activist, 1960s. Member, artist group *Tucuman Arde,* late 1960s.

Individual Exhibitions:

1961	Galería Lirolay, Buenos Aires
1962	Galería Lirolay, Buenos Aires
	Galería Kalá, Buenos Aires
1965	Galería Vignes, Buenos Aires
	Galería Roland Lambert, Buenos Aires
	Galería Ames, Córdoba, Argentina
1975	Galería Balmaceda, Buenos Aires
	Galería Carmen Waugh, Buenos Aires
	Galería H, Buenos Aires
1977	Galería Balmaceda, Buenos Aires
1981	Galería El Mensaje, Buenos Aires
	Galería Jacques Martínez, Buenos Aires
	Galería Enea, Buenos Aires
	Galería Alberto Elía, Buenos Aires
	El Círculo, Buenos Aires
1984	Estudio Giesso, Buenos Aires
1985	Estudio Giesso, Buenos Aires
	Adiós a mataderos, Galería Vea, Buenos Aires
1986	Museo de Bellas Artes de Paraná, Argentina
1989	Galería Julia Lublin, Buenos Aires
1993	*De hombres y bestias,* Instituto de Cooperación Iberoamericana, Buenos Aires

Selected Group Exhibitions:

1967–68	*Experiencias,* Centro de Artes Visuales, Torcuato di Tella Institute
1977	*100 años de pintura Argentina,* Salas Nacionales de Exposición, Buenos Aires
1979	*XV bienal internacional de São Paulo,* Brazil
1981	*XVI bienal internacional de São Paulo,* Brazil
1985	*XVII bienal internacional de São Paulo,* Brazil
	Imágenes de la Argentina de hoy, Museo de Arte Moderno, Mexico City
1988	*Grupo periferia,* Museo de Artes Visuales, Montevideo, Uruguay (traveling)
1991	*Los '80 en el MAM,* Museo de Arte Moderno, Buenos Aires
1994	*Art from Argentina, 1920–1994,* Sudwestdeutsche Landesbank, Stuttgart, Germany (traveling)
	Arte argentino contemporáneo, Museo Nacional de Bellas Artes de Buenos Aires

1997 *Otra mirar,* Museo Nacional de Bellas Artes, Buenos
 Aires (traveling)

Publications:

On SUÁREZ: Books—*Argentina: XXII bienal internacional de São Paulo,* exhibition catalog, text by Nelly Perazzo, Carlos Basualdo, and Liisa Roberts, Buenos Aires, Fundación Banco Crédito Argentino, 1994; *Arte argentino contemporaneo,* exhibition catalog, text by Jorge Glusberg and others, Buenos Aires, Museo Nacional de Buenos Aires, 1994. **Articles**—"Transformism and Regionalism: A Guarango Art for Menem's Argentina" by Pierre Restany, in *Domus* (Italy), 782, May 1996, pp. 82–89; by Belgica Rodriguez, in *Art Nexus* (Colombia), 11, January/March 1994, p. 229.

* * *

Pablo Suárez held his first solo exhibition in 1961. It took place at the Lirolay Gallery, which was open to new ideas and new movements in Argentine art. From 1959 on he took part in several collective exhibitions, and from the beginning he stood out for his new ideas and for questioning regulations and the state of cultural affairs. In 1965 he worked with other artists on *La Menesunda,* a significant milestone in the history of Argentine art that has unjustly been attributed only to Marta Minujín. One might say that Suarez's work can be classified as a new kind of figuration, which was then taken over by the group Otra Figuración. The group was formed by Luis Felipe Noé, Ernesto Deira, Rómulo Macció, and Jorge Luis de la Vega, but Suárez did not participate in it. He did, however, take part in the exhibition *Experiencias* in 1967 and 1968, held at the Centro de Artes Visuales at the Torcuato di Tella Institute. Then, after a period during which he dedicated his time to politics, he returned to the art world in the mid-1970s.

Suárez's kind of figuration, which initially was very much like that of the artists mentioned above, changed progressively after his return to painting. It gained characteristics that led him to be considered one of the outstanding contemporary Argentine painters. He became particularly known for his *realismo crítico* (critical realism) and for being a role model for other artists.

Suárez is not one of those artists who are interested in, as he has put it, "an art that rises from an infinite combination of elements, but [rather] in an art that sprouts urged by a historical alternative." Although he has tried to restore the pictorial task of painting, working in a realistic mode of expression and sense, he has also created three-dimensional figures and has set up scenes in the same manner. This can be seen, for example, in such works as *La banana* and *El espejo,* both from 1985. These works show what distinguishes his painting, combining both a grotesque iconography with the presence of paint and color, which make his figures pictorial.

Suárez is an artist with conceptual roots. His vision has become more acute as he has been moved by a combative social ideology. He is mainly interested in the reality of the periphery of culture. He is the creator of, as López Anaya has called it, "an authentic iconic slang," in which he shapes for his own use social exclusions based on sex, language, idols, and politics. The coarse, kitsch, the grotesque, exhibitionism, gay paradigms, promiscuity–all are treated in irreverent, invasive, often cynical, and always malicious images. Examples include *La terraza,* an acrylic on canvas (1983), *Trepando* (1987), *Malestar en la Cumbre* (1987), and *Peint a la pluma de condor* (1987).

The art production of Suárez mirrors humanity. His work has also reflected an open desire to challenge the painting methods in Argentina, which are inclined to formal rules that risk nothing and that emphasize technical perfection and salon humor. Suárez is a sort of wizard apprentice who is always in control of his risky pictorial operations. He has actually suggested that the outcast society that inspires his paintings is the center of our social world, a suggestion we see evidence of daily when we change from one channel to another on our television sets.

—Horacio Safons

SURO, Darío
Dominican painter

Born: Darío Suro Garcia-Godoy, Nacio, 1918. **Education:** Became interested in art before an art school existed in the Dominican Republic. Studied art with his uncle Enrique García Godoy. Studied under Diego Rivera, Jesús Guerrero Galván, and Agustín Lazo, La Esmeralda Academy of Art, Mexico City, 1943–47. **Family:** Married c. 1942. **Career:** Cultural attaché, embassy of the Dominican Republic, Mexico, beginning in 1943. Exiled from the Dominican Republic, 1953; lived in New York, 1953–63. Diplomat of Dominican Republic, Spain, beginning in 1963. **Died:** 1997.

Selected Exhibitions:

1992–93 *Three Hispanic-American Masters,* Montclair Art
 Museum, New Jersey

Galería Nacional de Bellas Artes, Santo Domingo; Riverside Art Museum, Riverside, California; Rose Fried Gallery, New York; Poindexter Gallery, New York.

Collection:

Gallery of Nader Art, Santo Domingo.

Publications:

By SURO: Book—*Fleischmann,* exhibition catalog, New York, Rose Fried Gallery, 1957. **Book, Illustrated**—*Nuestro tiempo* by Carlos Edmundo de Ory, Madrid, 1951.

On SURO: Books—*Suro,* Santo Domingo, La Galería, 1985; *Los nuevos* by Rubén Suro, edited by Rodolfo Coiscou Weber, Santo Domingo, Editora Libros y Textos, 1985; *Three Hispanic-American Masters,* exhibition catalog, Montclair, New Jersey, Montclair Art Museum, 1992. **Article**—"The Painter of the Hands" (bibliography), in *Américas,* 23(6–7), June/July 1971, p. 37.

* * *

Darío Suro was one of Santo Domingo's most vital and audacious painters. He studied drawing and painting with his maternal uncle Enrique García Godoy. Suro's earliest works from this period are landscapes executed in a quasi-impressionist approach and with a preference for rainy scenes. In 1943 the recently married Suro was

appointed the cultural attaché of the embassy of the Dominican Republic in Mexico. Once in Mexico City, he registered at La Esmeralda Academy of Art, studying composition, drawing, and painting with leading Mexican artists such as Diego Rivera, Jesús Guerrero Galvan, Agustín Lazo, and Manuel Rodríguez Lozano. From Rivera, Suro learned a very formal way of composing a picture but not much about content. Yet Rivera's theories and wide-ranging knowledge of art history were influential.

The fact that Rivera and several of his contemporaries painted the indigenous people of Mexico in their daily life moved Suro to depict the blacks of Santo Domingo in the art of his country for the first time. Paintings such as *Los bañistas, El violinista,* and *Los remedios,* all from the 1940s, depict blacks or mulattoes in situations of poverty and despair. Yet the works are not social realist in the Mexican tradition, even if the figures share with the works of the Mexicans a sculptural definition of form and bright, saturated colors. In all of these paintings there is a fatalistic and poetic quality that is very much Suro's. His two self-portraits, one from 1942 and the other from 1945, reflect the influence of Rodríguez Lozano's tight, classical drawing and perhaps even a bit of Frida Kahlo's own self-portraits. These two psychologically charged works depict the painter as vulnerable, even fragile, in Hamlet-like poses that seem to question his very existence.

After refusing to paint the portrait of the Dominican dictator Rafael Leónidas Trujillo, Suro and his family went into exile in 1953. They settled in New York City, where Suro earned his living painting lamp shades. In New York he befriended American painters such as Franz Kline, Fritz Glarner, and Philip Guston and began to experiment with abstraction. The product of this experimentation was the series of paintings entitled *Composiciones numéricas,* in which Suro explored the formal quality of numbers with thick, multicolored layers of pigment.

In 1963, after the fall of the Trujillo dictatorship, Suro returned to the diplomatic service, representing the Dominican Republic in Spain. While in Spain, he began to study the coloristic structure of painters like Velázquez, Zurbaran, and Ribera, and he painted lyrical, fluid abstractions such as *Homenaje a Velázquez,* in which pinks and blues play off silvery grays and deep browns. Throughout the 1970s Suro combined thinly applied veils of color with a broken yet dark line to represent erotic subjects in which breasts, buttocks, and vaginas were transformed into turbulent landscapes of desire.

From the late 1980s until his death in 1997, Suro was involved in a violent reconstruction of the figure and the landscape in which vulgarity, even pornography, and the tricks of visual perception were fused. These last works were typical of what is called a painter's ''late style.'' Bold and imaginative works sometimes painted with a coarse freedom, they are screams against old age and impending death. Suro's contribution lies in his complete rejection of artistic formulas and the preciousness of style in favor of an existentialist ethos, in which the subject is a battlefield for open-ended experimentation.

—Alejandro Anreus

TÁBARA, Enrique
Ecuadoran painter

Born: Guayaquil, 21 February 1930. **Education:** Escuela de Bellas Artes, Guayaquil, 1946–51; studied in Barcelona, Spain (on grant), 1955–61. **Career:** Traveled to the United States, 1964. Founding member, artist group *VAN*, Ecuador, 1968. **Awards:** Premio Suizo de Pintura Abstracta, Lausanne, Switzerland, 1960; second prize, *Salón du octubre*, Guayaquil, 1964; first prize, *Salón de julio*, Guayaquil, 1967.

Individual Exhibitions:

1953	Casa de la Cultura Ecuatoriana, Guayaquil
1954	Organization of American States, Washington, D.C.
1956	Ayuntamiento de Sarriá, Barcelona, Spain
1957	Galería Layetana, Barcelona, Spain
1958	Ateneo Barcelonés, Barcelona, Spain
	Sala Gaspar, Club 49, Barcelona, Spain
1959	Sala Neblí, Madrid
1961	Galería Kasper, Lausanne, Switzerland
	Museo de Arte Contemporáneo, Barcelona, Spain
	Galería Hilt, Basil, Italy
	Galería ''La Parette,'' Milan
1962	Galería Falazik, Bochum, Germany
	Nueva Galería en Kunstherhaus, Munich, Germany
	Galería Brchbuh, Grenchen, Germany
	Galería Rottof, Karlsruhe, Germany
1963	Galería Naviglio, Milan
	Diario de Noticias, Lisbon, Portugal
	Galería René Metras, Barcelona, Spain
	Ateneo de Madrid
1964	Pan American Union, Washington, D.C.
	Galería René Metras, Barcelona, Spain
1965	Museo de Arte Moderno, Bogota, Colombia
	Centro Ecuatoriano Norteamericano, Quito, Ecuador
1966	Universidad de Puerto Rico, Rio Piedras
	Exposición de collages, Galería Siglo XX, Quito, Ecuador

Selected Group Exhibitions:

1951	*V salón nacional,* Quito, Ecuador
1955	*III bienal hispanoamericana,* Barcelona, Spain
1960	Galería Corcher, Paris
1961	*Spanische kunst,* Palacio de Bellas Artes, Brussels
1962	*Peinture internationale 1962,* Galería Kasper, Lausanne, Switzerland
1963	*Bienal de Paris*
1966	Pan American Union, Washington, D.C.
	Art of Latin America since Independence, Yale University, New Haven, Connecticut, and University of Texas, Austin
1967	Center for Inter-American Relations, New York
1989	*The Latin American Spirit: Art & Artists in the U.S.,* Bronx Museum, New York

Collections:

Museum of Modern Art, New York; Museum of Modern Art of Latin America, Washington, D.C.; Museo de Arte de Ponce, Puerto Rico; Museo de Arte Contemporáneo, Barcelona, Spain; Museo de Arte Contemporáneo de Almada, Portugal; Museo de Arte Contemporáneo, São Paulo, Brazil; Museo de la Casa de la Cultura de Quito, Ecuador; Museo de la Casa de la Cultura de Guayaquil; Museo de Arte Moderno, Bogota, Colombia.

Publications:

By TÁBARA: Book—*Palabra e imagen,* edited by Marco Antonio Rodríguez, with others, Quito, n.p., 2000.

* * *

The environment of Guayaquil, Equador, a port city of natural beauty and with its own rich pre-Columbian mythology, was instrumental in the development of Enrique Tábara's painting. Throughout his career he has maintained his independence from the *indigenismo* movement that was strong in the mountainous regions of Ecuador and other parts of Latin America, although not his respect for his people and his country. From the beginning of his career Tábara was interested in abstractionism as the basis for his work, and after he received a scholarship to study in Spain in 1955, he pursued the movement known as informalism, or informal art, which was the European counterpart to the New York abstract expressionism of the 1940s and which was in the early stages of its development. The informalist artists were involved with the same liberating processes as abstract expressionism as well as with the mythic preoccupations associated with surrealism. Richly worked surfaces and textures of almost relief-like quality were obtained from a heavy impasto and were the basis for expressive abstractions. Informalism was also influential with other artists in Latin America who were more concerned with a modernist approach to art than with social content or figuration. Tábara was interested in the geometric, or constructivist, aspects of painting, but he did not approach abstraction from a European postwar perspective. He soon became disenchanted with the existential approach to purely formal issues and returned to Ecuador in 1961 to explore other artistic directions. He remained there to become one of the country's most highly respected artists.

Tábara's paintings of the 1960s reveal a new interest in the incorporation of recognizable pre-Columbian motifs, including snakes, mirrors, plumes, flora and fauna, and pyramidical shapes. This period was especially significant to his artistic development as he pursued an independent approach to art in which abstraction and surrealism became the basis for a visual language that was also distinctly Ecuadorian in its attention to natural forms and mythological sources. His works became more magical in content as he used indigenous designs to create a symbolic repertoire that was a synthesis of the past and the present and native to the Americas. Within his geometric-informalist configurations there appeared new figurative and symbolic images endowed with primordial power and resonant with the qualities of metamorphosis associated with the ancient art forms of his heritage. These mythic overtones lend his works an air of emotionalism that has been termed "lyric abstraction." This concern for abstraction associated with informalism and combined with a poetic character is unique to Latin America.

The period between 1968 and 1984 represented a break from the overt use of pre-Columbian motifs and the beginning of Tábara's most personal and recognizable series: the *pata-pata*s. In oils, acrylics, and drawings he developed a unique visual language consisting of an elaborate interplay of shapes that included bones, feet, shoes, arms, and other body parts. In the early years of the series these forms drifted in open spaces as rhythmic patterns propelled by their own dynamics. After 1972 their environment became more complex as he built structures for their interaction and concentrated on atmospheric and lyrical colors to enhance their poetic qualities. The *pata-pata*s were undoubtedly a humorous excuse to explore the plastic elements of painting while making personal comments on everyday society and its materialistic attention to the body and its ornamentation. In the 1990s the series expanded to include clothing and birds perched in trees and "growing" from branches, a return to the metamorphosing tendencies of the Amerindian world of myth and magic that is always resident in Tábara's art and thoughts.

—Carol Damian

TACLA, Jorge
Chilean painter

Born: Santiago, 1958. **Career:** Since 1981 has lived and worked in New York. **Awards:** Scholarship, Friends of Art Corporation, 1981; scholarship, Guggenheim Memorial Foundation, 1988; prize, New York Foundation for the Arts, 1991; Echo Art prize, Brazil 1992; prize, Circle of Art Critics, Chile, 1996.

Individual Exhibitions:

1986	*New Works,* Nohra Haime Gallery, New York
1988	*Recent Paintings,* Nohra Haime Gallery, New York
1989	*Cuaresma en atacama,* Nohra Haime Gallery, New York
1991	*Hemispheric Problem: Time and Space in Negative,* Nohra Haime Gallery, New York
1991–92	*Art at the Edge,* High Museum of Art, Atlanta, Georgia
1993	*New Work,* Nohra Haime Gallery, New York

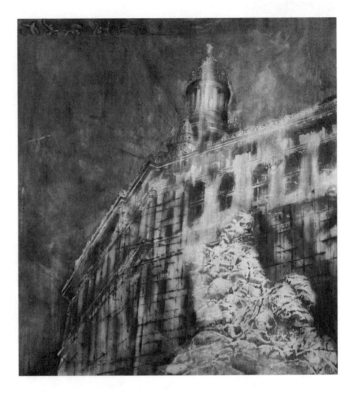

Jorge Tacla: *Empresa Peugrosa,* **1999–2000. Photo courtesy of Galeria Ramis Barquet.**

1993–94	*Irrealidad, 1982–1993,* Museo de Monterrey, Mexico
1995	*Epicentro,* Museo Nacional de Bellas Artes, Santiago, Chile and Museo Nacional de Bellas Artes, Buenos Aires
1996	*Self-Feeder: Jorge Tacla,* Galería Ramis Barquet, Garza García, Mexico
1997–98	*Drawings,* Galería Ramis Barquet, New York and Milwaukee Art Museum, Wisconsin
1998	*Organismos vivos,* Centro Cultural Fundación, Caracas, Venezuela
1999	*Informacion,* A.M.S. Marlborough Gallery, Santiago, Chile
2001	*Epicentro,* National Museum of Fine Arts, Forest Park, Santiago, Chile

Selected Group Exhibitions:

1987	*The Mind's I,* Asian Arts Institute, New York
1990	*The Decade Show,* New Museum of Contemporary Art, New York
1991	*Mito y magia en América: Los ochenta,* Museo de Arte, Monterrey, Mexico
1993	*Seven Latin American Artists,* Annina Nosei Gallery, New York
	Current Identities, Aljira, Newark, New Jersey
1994	*American Art Today: Heads Only,* Florida International University Art Museum, Miami
1996	*The Shape of Sound,* Exit Art, New York
2001	*Recent Acquisitions,* California Center for the Arts Museum, Escondido
	A. M. S. Marlborough Gallery, Santiago, Chile

Jorge Tacla: *Company Tower,* 2001. Photo courtesy of Galeria Ramis Barquet.

Collections:

California Center for the Arts Museum, Escondido; Musee d'Art Contemporain, Montreal, Quebec.

Publications:

On TACLA: Books—*Jorge Tacla: New Works,* exhibition catalog, text by Timothy Maliqalim Simone, New York, Nohra Haime Gallery, 1986; *The Mind's I,* exhibition catalog, New York, Asian Arts Institute, 1987; *Jorge Tacla: Recent Paintings,* exhibition catalog, New York, Nohra Haime Gallery, 1988; *Cuaresma en atacama, Out of Focus,* exhibition catalog, New York, Nohra Haime Gallery, 1989; *Art at the Edge,* exhibition catalog, text by Carrie Przybilla, Atlanta, Georgia, High Museum of Art, 1991; *Jorge Tacla: Hemispheric Problem: Time and Space in Negative,* exhibition catalog, New York, Nohra Haime Gallery, 1991; *Mito y magia en América: Los ochenta,* exhibition catalog, text by Miguel Cervantes and Charles Merewether, Monterrey, Mexico, Museo de Arte, 1991; *Jorge Tacla: New Work,* exhibition catalog, text by Dan Cameron, New York, Nohra Haime Gallery, 1993; *Seven Latin American Artists,* exhibition catalog, New York, Annina Nosei Gallery, 1993; *Current Identities: Recent Painting in the United States,* exhibition catalog, text by Carl E. Hazlewood, Newark, New Jersey, Aljira Inc., 1993; *Jorge Tacla: Irrealidad, 1982–1993,* exhibition catalog, text by Donald B. Kuspit, Mexico, Museo de Monterrey, 1993; *Notas y referencias: Jorge Talca,* exhibition catalog, Buenos Aires, Der Brücke Ediciones, 1993; *American Art Today: Heads Only,* exhibition catalog, text by Carol Damian, Miami, Florida International University Art Museum, 1994; *Jorge Talca,* exhibition catalog, edited by Alberto Ibarra Dorado, Garza García, Mexico, Galería Ramis Barquet, 1994; *Epicentro,* exhibition catalog, text by Donald B. Kuspit, Santiago, Chile, Museo Nacional de Bellas Artes and Buenos Aires, Museo Nacional de Bellas Artes, 1995; *Self-Feeder: Jorge Tacla,* exhibition catalog, Garza García, Mexico, Galería Ramis Barquet, 1996; *Jorge Tacla: Drawings,* exhibition catalog, text by Donald B. Kuspit, Carrie Przybilla, and Joseph Ruzicka, New York, Galería Ramis Barquet, 1997; *Jorge Tacla: Organismos vivos,* exhibition catalog, text by Donald B. Kuspit, Caracas, Venezuela, Centro Cultural Fundación, 1998; *Jorge Tacla: Informacion,* exhibition catalog, text by John Yau and Donald B. Kuspit, Santiago, Chile, A. M. S. Marlborough Gallery, 1999.

* * *

In his work the Chilean artist Jorge Tacla has remained consistently interested in building up the surface of a painting to explore the varied possibilities held by landscapes, both literal and metaphorical. Drawing from influences as diverse as the work of Francis Bacon and Chinese landscape painting, Tacla has weaved narratives that are simultaneously personal, political, and universal.

In his work from the 1980 and '90s, after arriving in New York City, Tacla began to consider personal narratives around the body as well as the body's displacement. The status of the immigrant, the trauma caused by a dramatic change in location, the shifting perceptions of ''home,'' and the pressure to assimilate are all explored in a series of works from the 1980s that feature lone male figures, metaphorical self-portraits of the artist. In an image such as *Forastero* (''Out of Towner,'' 1988), the deformed figure crouches naked in the center of the canvas, made infinitely vulnerable to the environment, which Tacla consistently rendered as an indefinable, almost menacing space. Bacon's influence is immediately apparent in the transparent layers used to suggest the fragility of the body and its vaguely grotesque appearance. Tacla reproduced this figure over and over again as a kind of standard bearer of life's complexities and difficulties. The voyages taken by the figure become potent references to the physical act of crossing borders and everything that this act implies. In his works on paper from this period, Tacla explored this figure even further, examining closely the possibilities for the grotesque as well as the conceptual. He defined his imagery in these drawings by diagramming, measuring, quantifying, and dissecting various elements and even incorporating hand-written texts.

Tacla's latest body of work examines architectural space. Taking well-known monuments such as the Metropolitan Museum of Art in New York City, Tacla rendered the normally recognizable forms as generalized, abstract shapes, underlining the most basic elements of architectural forms. The artist explored space as a series of converging lines that he drew across the surfaces of the architectural forms. These vectors reference the act of drawing and constructing space, as from an architectural plan, as well as the ways in which the human mind functions to understand the creation of such spaces. The works convey a sense of attempting to understand constructed space on an intellectual level. Sometimes planes are reduced to merely suggesting an implied structure or construction. There was a deeply contemplative quality to Tacla's analysis of interior space, as though he hoped to measure both human relationships and human proportions to these larger, heroic constructions.

The relationship between sacred and profane spaces are explored in this body of work, as Tacla examined the implications of both secular and religious buildings. The layers of imagery created by the indefinite and distant background, the construction itself, and the

careful scattering of signifying lines all work together to define each of these locations and the viewer's relationship to it, both perceived and real.

Tacla has continued to work with landscape elements, including trees and hills. Painted in black against a brightly colored background, Tacla's trees feature smaller images placed strategically around the canvas, which act as conceptual details of the larger landscape suggested by the notion of a tree. These "medallions" allow the spectator a certain intimacy with the landscape while permitting a view of the layout from a distance. Tacla's sensitive, calligraphic lines reference esoteric visions of an idealized natural space borrowed from panoramic Chinese landscape paintings. The artist took up this idealized vision but created a jarring effect by using unexpected colors, such as red, or cobalt blue for the background. The large planes intersect with the architectural motifs, ensconcing detail and revealing forms. Tacla's examination of spaces both constructed and natural, as well as his examination of the psyche of the subject, has marked his work since the 1980s.

—Rocío Aranda-Alvarado

TAMAYO, Rufino
Mexican painter, muralist, and sculptor

Born: Oaxaca, 26 August 1899. **Education:** Academy of San Carlos, Mexico City, 1917–21. **Family:** Married Olga Flores Rivas in 1934. **Career:** Head designer, department of ethnographic drawings, National Museum of Archaeology, Mexico City, 1921–23; director, Department of Fine Arts, Ministry of Education, Mexico City, 1932; delegate, Art Congress, New York, 1936; teacher, Dalton School and Brooklyn Museum Art School, New York, 1936–51. Muralist, Hillyer Art Library, Smith College, Northampton, Massachusetts, 1943, National Palace of Fine Arts, Mexico City, 1952–53, Dallas Museum of Fine Arts, 1953, Bank of the Southwest, Houston, 1955, Universidad de Puerto Rico, San Juan, c. 1958, UNESCO headquarters, Paris, 1958. Also worked as an art teacher in elementary schools, Mexico City, 1926, La Esmeralda, 1928. Elected to Institute of Academy of Arts and Letters of the United States, 1961. Visited New York, 1926; lived in the United States, 1936–51; moved to Paris, 1954; returned to Mexico, 1955. **Awards:** First prize, *Carnegie International,* Pittsburgh, 1952; first prize, *São Paulo Bienal,* 1953; first prize, *Tenth Triennale of Colour Graphics,* Grenchen Switzerland, 1958; award, Guggenheim International Foundation, 1960; fellowship, Ford Foundation, to work at Tamarind Lithography Workshop, Los Angeles, 1964; National Award for Artistic Merit, Mexico City, 1964; Calouste Gulbenkian prize, Institut Francais, Paris, 1969. Street named in his honor, Oaxaca, 1972. **Member:** Argentine Academy of Art, Accademia Disegno, Florence; Academy of Arts, Buenos Aires, 1959; American Institute and Academy of Arts and Letters, 1961. Chevalier, 1957, officier, 1970, and commandeur, 1975, Légion d'Honneur, France; comendador of the Italian Republic, 1971. **Died:** 24 June 1991.

Individual Exhibitions:

1926	Weyhe Gallery, New York
1927	Art Center, New York
1929	Palacio de Belles Arts, Mexico City
1931	Julien Levy Gallery, New York

Rufino Tamayo. © Colita/Corbis.

1937	Julien Levy Gallery, New York
	Howard Putzel Gallery, San Francisco
1938	Galeria de Arte Mexicano, Mexico City
	Catherine Kuhn Gallery, Chicago
1939	Valentine Gallery, New York
1940	Valentine Gallery, New York
1942	Valentine Gallery, New York
1945	Arts Club of Chicago
1946	Valentine Gallery, New York
1947	Cincinnati Art Museum, Ohio
	Valentine Gallery, New York
	Pierre Matisse Gallery, New York
1948	*Retrospective of 25 Years of Painting,* Palacio de Bellas Artes, Mexico City
1950	*16 Paintings, Biennale,* Venice
	Galerie des Beaux-Arts, Paris
	Palais des Beaux-Arts, Brussels
	Knoedler Gallery, New York
1951	Instituto de Arte Moderno, Buenos Aires
	Salon de la Plastica Mexicana, Mexico City
	Frank Perls Gallery, Los Angeles
	Knoedler Gallery, New York
1952	*Arte mexicain du pre-columbien a nos jours,* Musée d'Art Moderne, Paris
	Fort Worth Art Museum, Texas

Rufino Tamayo: *Musicians.* © **Christie's Images/Corbis.**

1953	Knoedler Gallery, New York
	Frank Perls Gallery, Los Angeles
	Santa Barbara Museum of Art, California
	San Francisco Museum of Art
1956	Knoedler Gallery, New York
1959	Kunstnernes Hus, Oslo
	Felix Landau Gallery, Los Angeles
	Knoedler Gallery, New York
1960	Galerie de France, Paris
1961	Gallery One, London
1962	Galeria Misrachi, Mexico City
	Knoedler Gallery, New York
1963	Mainichi Newspaper, Tokyo (retrospective)
	Association of Museum of Israel (traveling exhibition)
1965	Galerie Semiha Huber, Zurich
1968	Palacio de Bellas Artes, Mexico City (retrospective of 103 works)
	Exhibition of 124 Works from American Collections, Phoenix Art Museum, Arizona
	Biennale, Venice (retrospective of 100 works)
1971	Perls Gallery, New York

1973	Galeria Misrachi, Mexico City
	Perls Gallery, New York
1974	Museo de Arte Moderno, Mexico City
	Musée d'Art Moderne, Paris
1975	Plazzo Strozzi, Florence
1976	Museo de Arte Moderno, Mexico City
	National Museum of Modern Art, Tokyo
1977	*Bienal,* Sao Paulo (retrospective of 134 works)
	Marlborough Gallery, New York
1978	Phillips Collection, Washington, D.C.
1979	Marion Koogler McNay Art Institute, San Antonio, Texas
	Myth and Magic, Solomon R. Guggenheim Museum, New York
	Marlborough Fine Art, London
1981	Brenner Gallery, Boca Raton, Florida
	Marlborough Gallery, New York
1982	Marlborough Fine Art, London
1983	Graphische Sammlung Albertina, Vienna
1984	Marlborough Fine Art, Tokyo
1985	Marlborough Gallery, New York

1986 Marisa Del Re Gallery, New York

Selected Group Exhibitions:

1952 Pan American Union, Washington, D.C.
1954 Santa Barbara Museum of Art, California
 San Francisco Museum of Art
1956 *Gulf-Caribbean Art,* Museum of Fine Arts, Houston
1966 *Art of Latin America since Independence,* Yale Univer-
 sity, New Haven, Connecticut, and University of
 Texas, Austin
1967 *Latin American Art: 1931–1966,* Museum of Modern
 Art, New York
1968 Phoenix Art Museum

Collections:

Museo de Arte Moderno, Mexico City; Centre Georges Pompidou, Paris; Musée Royal, Brussels; Galleria Nazionale de Arte Moderna, Rome; Museum of Modern Art, Tokyo; Nasjonalgalleriet, Oslo; Museum of Modern Art, New York; Solomon R. Guggenheim Museum, New York; Albright-Knox Art Gallery, Buffalo, New York; Art Institute of Chicago; American Museum of Natural History, Washington, D.C.; Brooklyn Museum, New York; Cincinnati Art Museum; Cleveland Museum; Dallas Museum of Fine Arts; Fogg Art Museum, Cambridge, Massachusetts; IBM Corporation, Armonk, New York; University of Illinois, Urbana; Marlborough Gallery, New York; Metropolitan Museum of Art, New York; Milwaukee Art Center; Museum of Modern Art of Latin America, Washington, D.C.; Neuberger Museum, Purchase, New York; Perls Galleries, New York; Phillips Collection, Washington, D.C.; Phoenix Art Museum; Universidad de Puerto Rico, San Juan; Smith College, Northampton, Massachusetts, University of Texas, Austin; Washington University, St. Louis.

Publications:

By TAMAYO: Books—*Drawings,* Mexico City, 1950; *Rufino Tamayo: Myth and Magic,* exhibition catalog, with Octavio Paz, New York, Guggenheim Foundation, 1979.

On TAMAYO: Books—*Rufino Tamayo* by Emily Genauer, New York, Abrams, 1974; *Tamayo,* exhibition catalog, by Octavio Paz, Musée d'Art Moderne de la Ville de Paris, 1975; *Rufino Tamayo* by Octavio Paz and Jacques Lassaigne, New York, Rizzoli, 1982; *Rufino Tamayo: Recent Paintings 1980–85,* exhibition catalog, New York, Marlborough Gallery, 1985; *Rufino Tamayo: 70 años de creación,* exhibition catalog, Mexico City, Museo de Arte Contemporáneo Internacional Rufino Tamayo, 1987; *Tamayo* by José Corredor Matheos, translated by Kenneth Lyons, Barcelona, Ediciones Polígrafa, 1987; *Nature and the Artist: The Work of Art and the Observer, Rufino Tamayo: A Fiftieth-Anniversary Exhibition of Rufino Tamayo's Fresco for Smith College,* exhibition catalog, Northampton, Massachusetts, Smith College Museum of Art, 1993; *Los murales de Tamayo,* edited by Juan Carlos Pereda and others, Mexico, Americo Arte Editores, 1995; *Rufino,* edited by Isabel Arvide, Mexico, Grupo

Editorial Siete, 1997; *Tamayo,* Mexico, Grupo Financiero Bital, 1998; *Rufino Tamayo vuela con sus raices,* edited by Elisa Ramírez Castañeda, Mexico, Consejo Nacional para la Cultura y las Artes, Dirección General de Publicaciones, 1999; *Rufino Tamayo: Tres ensayos,* edited by Octavio Paz, Mexico, El Colegio Nacional, 1999; *Tamayo,* edited by Teresa del Conde, translated by Andrew Long and Luisa Panichi, Boston, Little, Brown, 2000. **Articles**—"Artist's Dialogue: Rufino Tamayo–Present Primeval" by Irene Borger, in *Architectural Digest,* 44, September 1987, p. 56; "Rufino Tamayo: Die Integration der Mythen in die Moderne" by Hans Haufe, in *Zeitschrift für Kunstgeschichte* (West Germany), 54(1), 1991, pp. 125–128; "Rufino Tamayo: 17 Years at Mixografia Workshop, 1974–1991" by Seonaidh Davenport, in *Art News,* 92, September 1993, p. 177.

* * *

Rufino Tamayo worked throughout his long career to create and preserve his reputation as an international modernist, consciously rejecting the nationalist movements that dominated Mexico during the twentieth century. Though his art demonstrates his desire to use colors derived from the Mexican landscape and traditions, and subjects drawn from Mexican life, Tamayo avoided what he saw as the parochial and political concerns of artists such as Diego Rivera and David Alfaro Siqueiros. He had been invited by those two artists, along with Jose Clemente Orozco, to join with them to form a quartet of Mexican muralists in imitation of the Four Evangelists. He turned them down, rejecting the so-called "message art" that they promoted in their belief that all art conveys a message. In spite of this, Tamayo was not averse to linking his work to political causes, though the images themselves did not have the didactic narrative content seen in the work of *los tres grandes* (the three great ones). In the last years of his life Tamayo participated in the Group of 100, an organization of artists and intellectuals allied to preserve Mexico's landscape in the face of increasing degradation from the threats of pollution and overdevelopment.

Tamayo's position as the head of the Department of Ethnographic Drawings at the Museo Nacional de Antropologia in Mexico City from 1921 to 1923 led him to study pre-Hispanic sculpture and Mexican popular arts. This knowledge appears in his paintings in the geometric renderings of form and the juxtaposition of earth tones with brilliant hues. Like many European modernists, Tamayo looked to Mexican traditional arts for formal inspiration, but he eschewed subjects of peasant life, revolution, and history that featured prominently in much Mexican art of the time. Instead, he fused European primitivism with a formal indigenism, believing that he could draw Mexico and Mexican art from a denigrated position into a broader, more universal artistic realm. His ideas for art share much with the philosophical and cosmological ideas of Jose Vasconcelos, the minister of education responsible for the many cultural programs that animated Mexico in the 1920s. Vasconcelos coined the term *La raza cosmica* to describe a Pan-American mestizo race that would distinguish itself with unique cultural achievement and finally realize its potential by drawing on the combined power of European and indigenous American traditions. Both Tamayo and Vasconcelos had come from the state of Oaxaca in southern Mexico, but Tamayo acknowledged a strong connection to his native Zapotec ancestry as a

strong element of his identity, whereas Vasconcelos had no such ties. Tamayo's dual allegiance to European modernism and native Mexican art forms can be seen in the two museums that house his collections and bear his name: the Museo Rufino Tamayo in Mexico City shows modernist art from Europe, the United States, and Mexico, featuring a large collection of Tamayo's paintings; the museum of the same name in the city of Oaxaca contains Tamayo's fine collection of pre-Columbian artifacts.

In the 1920s Tamayo painted mainly decorative still lifes focused on repetitive forms in compositional balance. He painted native fruits interspersed with musical instruments and other quotidian objects, more for the sake of the formal arrangement than to make any sort of nativist statement. Tamayo came into his own after moving to the United States, where he remained from 1936 until 1950, traveling to Mexico during the summers. In New York Tamayo saw first-hand the work of the European avant-gardists he emulated. In particular, the 1939 exhibition of Picasso's *Guernica* in the Museum of Modern Art had a clear impact on Tamayo. In a series of animal paintings in the 1940s he drew on Picasso's use of the bull as a symbol of tyranny and the horse as one of anguish. Without setting up a rigid iconographic system, Tamayo used the figures of animals as expressive metaphors for human struggle and achievement. In the 1940s and '50s Tamayo also began to depict human characters, types drawn from both urban and rural life, all with a distinctly Mexican character. The brilliant color Tamayo used makes the images less an exploration of daily life and instead renders the figures as emblems, painted icons of human activity. If a vague sinister quality appears to underlie some of his images, it remains glimmering at the edge of the subject, never fully present or explicable. The work of the late 1940s and early '50s describes Tamayo's anxieties about technology in the wake of World War II, fears shared by most of his contemporaries. Such paintings as *Children Playing with Fire* (1947) are often cited as demonstrating this skepticism about humankind's ability to control its technological power.

Tamayo's paintings had assumed gentler content and subtle monochromatic modulations of tone by the 1970s. He continued to subordinate content to formal considerations. His mature style employed all the variations on modernism with which he had experimented in previous years, settling into compositions in which the human figure appears simply as a motif as in a still life, without the metaphorical weight Tamayo had given his works in the middle part of his career.

—Laura J. Crary

TAPIA, Luis Eligio

American woodcarver

Born: Santa Fe, New Mexico, 6 July 1950. **Education:** New Mexico State University. **Family:** Married. **Career:** Furniture restorer; completed restoration work on churches throughout the Southwest. Guest lecturer, College of Santa Fe, New Mexico State University, Las Cruces, Arizona State University, Tempe, and Heard Museum, Phoenix, beginning in 1979. Founding member, artist group *La Cofradía*

de Artes y Artesanos Hispánicos. **Awards:** Distinguished Artist of the Year, Santa Fe Rotary Foundation, 1994; Governor's award, New Mexico, 1996. **Agent:** Owings-Dewey Fine Art, 76 East San Francisco Street, Santa Fe, New Mexico 87501, U.S.A.

Individual Exhibitions:

1979 *Luis Tapia and Star Tapia Exhibit,* Santuario de
 Guadalupe, Santa Fe
1980 Institute of American Indian Arts, Santa Fe
1982 Governor's Gallery, Santa Fe
1991 Owings-Dewey Fine Art, Santa Fe
1992 Albuquerque Museum, New Mexico (with Bernadette
 Vigil)
1993 Owings-Dewey Fine Art, Santa Fe
1995 Museum of International Folk Art, Santa Fe (with
 Nicholas Herrea)
1996 Owings-Dewey Fine Art, Santa Fe

Selected Group Exhibitions:

1976 *Dia de mas, dias de los muertes,* International Folk Art
 Museum, Santa Fe
1977 *Hispanic Craftsmen of the Southwest,* Taylor Museum,
 Colorado Springs, Colorado (traveling)
1988 *Santos Statues and Sculpture, Contemporary Woodcarv-
 ing from New Mexico,* Craft and Folk Art Museum,
 Los Angeles
 *Hispanic Art in the United States, Thirty Contemporary
 Painters and Sculptors,* Museum of Fine Arts,
 Houston (traveling)
1991 *Lithographs by Six New Mexican Santeros,* Museum of
 International Folk Art, Santa Fe
 Miniatures 91, Albuquerque Museum, New Mexico
1992 *Chispas! Cultural Warriors of New Mexico,* Heard
 Museum, Phoenix (traveling)
1993 *Borderless Art, Sculpture North and South of the Rio
 Grande,* Red Mesa Art Center, Gallup, New Mexico,
 and Mexico City
1994 *Crafting a Devotion, Tradition in Contemporary New
 Mexico Santos,* Gene Autry Western Heritage
 Museum, Los Angeles
 *Cuando hablan los santos—Contemporary Santos Tra-
 ditions from Northern New Mexico,* Maxwell Museum
 of Anthropology, University of New Mexico

Collections:

Smithsonian Institution, Washington, D.C.; University of New Mexico Fine Arts Museum, Albuquerque; New Mexico Museum of Fine Art, Santa Fe; Roswell Museum, New Mexico; Craft and Folk Art Museum, Los Angeles; Museum of American Folk Art, New York; Museum of Albuquerque, New Mexico; Museum of International Folk Art, Santa Fe, New Mexico; Arizona State University, Tempe; El Museo del Barrio, New York.

Publications:

On TAPIA: Books—*Luis Tapia,* exhibition catalog, text by James Moore, Santa Fe, Owings-Dewey Fine Art, 1991; *Luis Eligio Tapia:*

Luis Eligio Tapia. Photo courtesy of Owings-Dewey Fine Art.

1994 Distinguished Artist Award, Santa Fe, Santa Fe Rotary Foundation, 1994. **Articles**—''Animal Carvers of New Mexico'' by Elizabeth Wecter, in *The Clarion,* 11, winter 1986, pp. 22–31; ''Passionate Identity: The Hispanic Traditions of New Mexican Weavers and Saint Makers'' by Stephen Lewis, in *American Craft,* 51, February/March 1991, pp. 38–47; ''Luis Tapia, Technicolor Santero'' by Johanna Wohl, in *Crosswinds,* July 1993; ''Recent Carvings, Luis Tapia at Owings-Dewey'' by Ellen Berkovitch, in *The Magazine,* July 1993; ''Luis Tapia'' by Nancy Ellis, in *Southwest Art,* 27, July 1997, p. 147. **Film**—*De Colores: The Work of Luis Tapia* by Bill Field, Santa Fe, William Field Design, 1995.

* * *

Luis Eligio Tapia is recognized as one of the most significant contemporary Hispanic artists in the United States. His work has played a key role in reviving a traditional Hispanic artistic and devotional form. Tapia is a modern-day *santero,* an artist who carves and paints images of *santos* (saints). The *santero* tradition dates to the

Spanish colonial era in the Southwest. Tapia's contribution has been to recontextualize the ancient *santos* form by making his works relevant to contemporary Hispanic, and indeed American, culture.

Born in Santa Fe, New Mexico, in 1950, Tapia, like many other Latinos of his generation, had little exposure in his youth to the vast Hispanic cultural and artistic legacy. It was only in the late 1960s, after he had graduated from high school and began working in a retail business, that he began to connect with these roots. The Hispanic civil rights movement caught his attention, and prompted by his lack of knowledge about Hispanic culture, Tapia began to delve into its various art forms. During this period of exploration he discovered the *santero* tradition. Although Tapia had no formal artistic training, he was captivated by the form. With his wife's encouragement, he began creating carvings, first nudes and then *santos.* In an effort to learn the craft better, Tapia frequently visited the colonial Spanish collection at the Museum of International Folk Art in Santa Fe, and he studied original *santos.*

Tapia began exhibiting his own *santos* in 1972. Initially his work was poorly received, primarily because he had deviated from the

Luis Eligio Tapia: *Dona Sebastiana La Maestra Will Take Your Requests.*
Photo courtesy of Owings-Dewey Fine Art.

traditional *santos* style. He used highly saturated primary colors to decorate his carvings rather than the style of the more recent revivals, which featured either bare wood or artificially aged colors to make the carvings look like colonial artifacts. This break was intentional, as Tapia aimed to turn *santos* into a living part of contemporary Hispanic culture rather than to keep the traditional art form ''pure.'' The vibrant colors he used to paint his *santos* were meant to make them look new and alive, but because he had departed from the conservative style of most revival *santeros,* he was asked to stop exhibiting his work at his primary venue, the annual Spanish Market in Santa Fe.

Undeterred by the controversy his work generated, Tapia continued to strike out on his own. In the early 1980s he began to seek out new images to incorporate in his *santos.* Rather than mimic the themes and images of colonial *santos,* Tapia introduced a modern sensibility to his work. In his 1991 sculpture *The Temptations of St. Anthony,* for example, the saint is tempted not only by the pleasures of the flesh but also by alcoholism. In another 1991 piece, *Carreta de la muerta,* Tapia revisited the familiar *santos* subject of Dona Sebastiana, the Hispanic version of the Grim Reaper. Tapia showed her riding through the agonies of purgatory, not as a frightful force but as a skeletal, smiling form wielding a parasol instead of a weapon. The message is clear: death need not be violent and frightening, and even death is subject to rules. In another reworking, Tapia's 1999 statute *Pietà* depicts a modern-day Mary and Jesus, the mother holding her son at the base of a cross-shaped streetlight. The son, who is bare chested and clad in blue jeans and sneakers, has died from a single bullet wound that leaks blood down his tattooed chest.

Tapia has been active in the Hispanic arts community as more than a *santero.* In the early 1970s he and six other artists founded *La Cofradía de Artes y Artesanos Hispánicos* (Brotherhood of Hispanic Arts and Artists) to advance traditional and contemporary Hispanic

Luis Eligio Tapia: *Pieta.* **Photo courtesy of Owings-Dewey Fine Art.**

arts and crafts. At the same time that he was revolutionizing *santos* as an art form, Tapia also began to make and restore furniture, receiving several commissions for major restoration work. He reworked the surfaces of the reredos in the nineteenth-century church in Ranchos de Taos and reconstructed the altarpiece at El Calle, a church north of Espanola. Nearly 20 years after his work was originally exhibited, Tapia held his first one-man show–to much acclaim–at Owings-Dewey Fine Art in Santa Fe in 1991.

—Rebecca Stanfel

TESTA, Clorindo
Argentine painter and architect

Born: Naples, Italy, 10 December 1923; returned to Argentina, 1923. **Education:** Universidad Nacional de Buenos Aires, 1948; studied in Italy (on scholarship), 1949–51. **Career:** Worked for the Buenos Aires Regulating Plan, *ca.* 1948; traveled to Italy. Since 1951 architect. Director, Fondo Nacional de las Artes, 1992. Honorary professor, Facultad de Arquitectura, Universidad Nacional de Buenos Aires, 1996. Member, Grupo de los 13, beginning in 1972. **Awards:** First prize, *Bienal internacional de Punta del Este,* Uruguay, 1958; first prize, Instituto Torcuato Di Tella, Buenos Aires, 1965; Premio ''Arte de América'' y ''Ciudad de Córdoba,'' *Segunda bienal industrial kaiser de la Argentina,* Córdoba, Argentina, 1975; first prize

with el Grupo de los 13, Zagreb, Yugoslavia, 1977; great prize, *Biennial de São Paulo,* 1977; first prize with el Grupo de los 13, *XIV bienal internacional de São Paulo,* 1986; premio trayectoria, Asociación de Críticos de Arte, 1989; first prize "Del Sueño del Objeto," Instituto de Cooperación Iberoamericana, Buenos Aires, 1991. Honorary doctorate, Universidad Nacional de Buenos Aires, 1992.

Individual Exhibitions:

1952	Galería Van Riel, Buenos Aires
1957	Galería Van Riel, Buenos Aires
	Bonino Gallery, Buenos Aires
1978	La Galería, Buenos Aires
1980	La Galería, Buenos Aires
1986	*El ahorro,* Galería Jacques Martínez, Buenos Aires
1988	*Autorretratos,* Galería Jacques Martínez, Buenos Aires
1989	Instituto de Cooperación Iberoamericana, Buenos Aires
1990	Galería Ruth Benzacar, Buenos Aires
1991	Galería Ruth Benzacar, Buenos Aires
1994	Galería Ruth Benzacar, Buenos Aires
1994	Museo de Arte Moderno, Buenos Aires (retrospective)
1996	*Arquitectura, pintura y otras cosas,* Fundación Banco Patricios, Buenos Aires
1998	Galería Ruth Benzacar, Buenos Aires
2000	Netherlands Architecture Institute, Rotterdam

Selected Group Exhibitions:

1960	*Grupo de los cinco,* Museo Nacional de Bellas Artes, Buenos Aires
1988	Centro Cultural de la Ciudad de Buenos Aires
1990	*El espejito dorado,* Galería Ruth Benzacar, Buenos Aires
1992	*Arte Buenos Aires 92,* Centro Cultural Recoleta, Buenos Aires
1994	Museo de Arte Moderno, Buenos Aires
	Fundación Banco Patricios, Buenos Aires
1995	*La ciudad y sus pintores,* Galería De Santi, Buenos Aires
	Arte argentino contemporáneo 80/90, Fundación Banco Patricios, Buenos Aires
1996	*VI bienal internacional de arquitectura de Venecia,* Venice
	La ciudad agredida, Museo Nacional de Bellas Artes, Buenos Aires

Publications:

On TESTA: Books—*Clorindo Testa* by Julio Llinás, Buenos Aires, Ediciones Culturales Argentinas, 1962; *Clorindo Testa: Pintor y arquitecto* by Jorge Glusberg, Buenos Aires, Ediciones Summa, 1983; *CAYC Group,* exhibition catalog, Buenos Aires, Centro de Arte y Comunicación, 1993; *Clorindo Testa: Exposición retrospectiva,* exhibition catalog, text by Osvaldo Svanascini and Laura Buccellato, Buenos Aires, Museo de Arte Moderno, 1994; *Clorindo Testa,* exhibition catalog, text by Manuel Cuadra, Alfonso Corona Martínez,

and Kristin Feireiss, Rotterdam, NAI Publishers, 2000; *Latin American Architecture: Six Voices* by Malcolm Quantrill, College Station, Texas, Texas A&M University Press, 2000. **Articles**—"Homes of Porteños Architects," in *Abitare* (Italy), 342, July/August 1995, pp. 178–197; "Buenos Aires: Clorindo Testa at Ruth Benzacar" by Eduardo Costa, in *Art in America,* 86(12), December 1998, p. 104.

* * *

Clorindo Testa was born in Naples, Italy, but has been an Argentine resident since he was a few months old. He has been artistically outstanding as both a painter and an architect. Testa first chose to study engineering but eventually changed to architecture. After graduating he traveled to Italy on a scholarship, where he remained for two years, and once back, in 1952, he exhibited his artistic production. Testa's first paintings varied between figuration and abstraction. Together with figurative elements that refer to machinery and ports, platforms at train stations, and boats, he worked on a series of *yuxta,* or superimposed geometrical plans that articulate by means of filament-like lines (*Carnicería,* oil, 1953). In 1957 he abandoned figuration totally and some time later joined a group called Grupo de los Cinco with Sarah Grilo, José Antonio Fernández Muro, Miguel Ocampo, and Kazuya Sakai, with whom he exhibited in the National Fine Arts Museum in Argentina in 1960.

He began his nonfigurative art by searching the values of matter and tones with no reference to color. Blacks and whites move along a scale that exploits all luminous possibilities, together with large and simple shapes, particularly squares, circles, and irregular rectangles, where a dry brush explores the textural richness of matter. Testa's work plays around connections between transparencies and opacities, between the place of the plane in space and totally flat figures creating no sense of space. Although Testa has been called an informalist due to his style of painting, his use of matter is more organized and poetic. As Rosa María Ravera said, "He does not evidence an instinctive, almost biological brush stroke, so used by Argentine Informalists and does not wound the planes in a violent playful way."

After introducing color gradually into his pictures (*Cuadrado blanco,* oil, 1961), Testa added pieces of fabric or other materials that he glued, clipped, or nailed to the frame. Rhythmic ribbed surfaces, superimposed folds, and borders blow lamped with aerosol all emerge to show his will both to conceal and reveal the meaning of his work. Color is distributed within the coarseness of contrasts using the subtle effect of a blow lamp, which confers a certain sense of provisional seduction to the painting (*Ondulación IV,* tempera, 1965; *Plegado,* aerosol, 1969).

Apuntalamiento para un museo (1968), a scaffolding made of big iron tubes partially painted blue; his taking part in a 1971 exhibition called Arte de Sistemas; *Mediciones* (1973), honoring the German architect Neufer; *Habitar, circular, trabajar, recrearse* (1974), portraying everyday life regulated by architectural functionalism; and his becoming a member of Grupo de los Trece in 1975 (now called Grupo CAYC) showed how versatile his work was and how his sense of play tinged his entire production.

Caperucita roja con barba azul (1975), *La peste en la ciudad* (a painting that he sent to San Pablo's Biennial in 1977 as part of Grupo CAYC and with which he won the grand prize), *La peste en Ceppalini* (1978), *Tendederos* (1979), *Anotadores* (1980), and *Fiebre amarilla*

en Buenos Aires, 1871 (1992) reveal the artist's interest in the relation between his personal life and events that show the brutal side of power, sickness, social wounds, ecology, science, and the technology of death. Testa's fictitious world contained society's history as a saga of human changes and the values of his own individuality. As Ravera said, ''He who has been capable of preserving his own inner space—as opposed to an exhibitionist—longs for man's communication and not his promiscuity, which happens after self assertion of man and his history.''

—Horacio Safons

TOLEDO, Francisco (López)
Mexican painter, sculptor, and graphic artist

Born: Juchitán, Oaxaca, 17 July 1940. **Education:** Escuela de Bellas Artes de la Universidad Autónoma Benito Juárez de Oaxaca, 1954; Taller Libre de Diseño y Artesanías, Instituto Nacional de Bellas Artes, Mexico City, 1957. **Family:** Lived with Trine Ellitsgaard, ca. 1989. **Career:** Traveled to Paris, 1960–65; returned to Mexico, 1965; traveled to New York, 1976–77, 1981–82, to work in ceramics; traveled to Barcelona, Spain, and Paris, 1984–86. Cofounder, Casa de la Cultura, Juchitán; founder, publishing house Ediciones Toledo, 1983, and Instituto de Artes Gráficas de Oaxaca (IAGO), 1988; cofounder, Museo de Arte Contemporáneo de Oaxaca (MACO), 1992, and Centro Fotografico Manuel Álvarez Bravo, 1996.

Individual Exhibitions:

1959	Galería Antonio Souza, Mexico City
	Fort Worth Art Center, Texas
1962	Kunstananeshus, Oslo, Norway
1963	Galería Karl Flinker, Paris
1964	Hamilton Gallery and Saidenberg Gallery, New York
	Galería Moos, Ginebra, Switzerland
	Galería René Andrieu, Toulouse, France
	Galería Dieter Brusberg, Hannover, Germany
1965	Saidenberg Gallery, New York
	Galería Antonio Souza, Mexico City
	Galería Karl Flinker, Paris
	Galería Haaken, Oslo, Norway
	Galería Misrachi, Mexico City
1967	Glaería Tooth, London
	Galería René Andrieu, Toulouse, France
	Galería Daneil Gervis, Paris
1968	Galería Juan Martín, Mexico City
	Monasterio de Santo Domingo de Guzmán, Oaxaca
1969	Galería Juan Martín, Mexico City
1970	Galería de Artes Plásticas, Mexico City
	Jack Misrachi Gallery, New York
	Galería Arvil, Mexico City
1972	Casa del Lago, Mexico City
	Galería Juan Martín, Mexico City
	Casa de la Cultura del Istmo, Juchitán, Oaxaca

1974	Martha Jackson Gallery, New York
1975	Galería Juan Martín, Mexico City
	Martha Jackson Gallery, New York
	Ex-convento de El Carmen, Guadalajara, Mexico
1976	Escuela de Bellas Artes, Oaxaca
	Ex-convento de San José, Oaxaca
	Museo de Arte Moderno de Bogotá
1978	Museum of Modern Art of Everson, Syracuse, New York
1980	*Retrospectiva 1963–1979,* Museo de Arte Moderno, Mexico City
	Galería de Arte Mexicano, Mexico City
	Centro Cultural de México, Paris
1983	Museo Biblioteca Pape, Monclova, Mexico
	Galería de Arte Mexicano, Mexico City
	Instituto Fernando Gordillo, Managua, Nicaragua
1984	Museo del Palacio de Bellas Artes, Mexico City
	Universidad Autónoma de Guanajuato, Mexico
	Primera bienal de la Habana, Casa de las Americas, Havana
1985	Galería Nippon, Tokyo
1986	Museo Regional de Guadalajara, Mexico
	Galería López Quiroga, Mexico City
1990	Vorpal Gallery, New York
1995	Associated American Artists Gallery, New York
1996	Arvil Gallery, Mexico City
	Museo de Arte Contemporáneo de Oaxaca
1998	*Insectary,* Juan Martin Gallery, Mexico City
2000	Whitechapel Art Gallery, London (traveling retrospective)

Selected Group Exhibitions:

1962	*Primer salón de arte latinoamericano,* Museo de Arte Moderno, Paris
1975	*12 Latin American Artists Today,* University of Texas, Austin
1976	*Contemporary Printmakers of the Americas,* Organization of American States, Washington, D.C.
	Creadores latinoamericanos contemporáneos 1950–1976, Museo de Arte Moderno, Mexico City
1980	*Tamayo, Toledo, Miró,* Galería Arvil Gráfica, Mexico City
1985	*Alternancias. La generación intermedia,* Museo de Arte Moderno, Mexico City
	50 aniversario de la Galería de Arte Mexicano, Mexico City
1986	*Primera bienal iberoamericana de arte seriado,* Museo de Arte Contemporáneo, Seville, Spain
1996	*Nueve pintores oaxaqueños,* Museo de Arte Contemporáneo de Oaxaca, Mexico
1997	*Preparativos para el diluvio,* Museo de Arte Contemporáneo de Oaxaca, Mexico

Collections:

Museum of Modern Art, New York; Tate Gallery, London, Museo de Arte Moderno, Mexico City; National Museum of Modern Art, Paris.

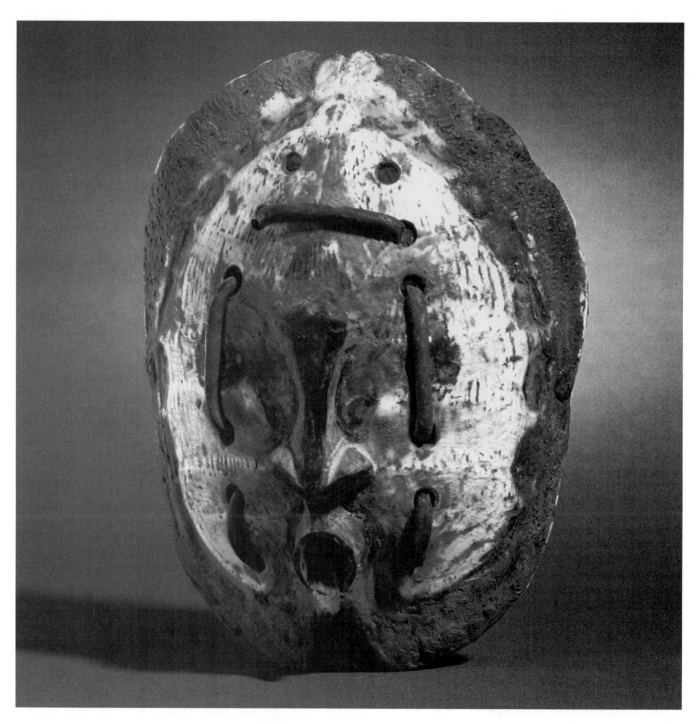

Francisco Toledo: *Mask,* 3/4 view. © Schalkwijk/Art Resource, NY.

Publications:

By TOLEDO: Books—*Lo que el viento a Juárez,* Mexico City, Ediciones Era, 1986; *Canto a la sombra de los animales,* exhibition catalog, with Alberto Blanco, Mexico, Galería López Quiroga, 1988; *Lejos de la memoria* by Elva Macías, Mexico, J. Boldó i Climent, 1989; *Zoología fantástica: Homenaje a Jorge Luis Borges,* exhibition catalog, Mexico, Galería Arvil, 1989; *Tres generaciones,* with Rodolfo Morales and Julio Galán, Mexico, Confederación de Educadores

Americanos, 1997; *Insectario, 1995–1996,* Oaxaca, Museo de Arte Contemporáneo de Oaxaca, 1998. **Books, illustrated**—*Canto a la sombra de los animales* by Alberto Blanco, n.p., Galería López Quiroga, 1988; *An Ark for the Next Millennium: Poems* by José Emilio Pacheco and others, Austin, Texas, University of Texas Press, 1993; *Los hombres que dispersó la danza* by Andrés Henestrosa and Carla Zarebska, Mexico, Grupo Serla, 1995; *Nuevo catecismo para indios remisos* by Carlos Monsiváis, Mexico City, Ediciones Era, 1996; *Tu xkúlh lhén chíw'dao=La guajolota y sus pipilos* by Mario Molina Cruz, Oaxaca, CEDES-22, 1997; *Didxaguca' sti' Lexu ne*

Gueu': Cuento zapoteco by Gloria de la Cruz and Victor de la Cruz, Mexico City, Consejo Nacional para la Cultura y las Artes, 1998; *Fantastic Zoology,* exhibition catalog, text by Jorge Luis Borges and Margarita Guerrero, Mexico City, Prisma Editorial, 1999; *El silencio de Orlando* by Homero Aridjis, Mexico City, Alfaguara, 2000.

On TOLEDO: Books—*Los signos de vida* by Marta Traba, Mexico, FCE, 1976; *Francisco Toledo,* exhibition catalog, New York, Vorpal Gallery, 1990; *Francisco Toledo,* exhibition catalog, Beverly Hills, California, Latin American Masters, 1991; *Los cuadernos insomnes de Francisco Toledo,* exhibition catalog, Mexico City, Museo Jose Guadalupe Posada, 1993; *La mordedura de la risa: Un estudio sobre la obra gráfica de Francisco Toledo* by Verónica Volkow, Mexico City, Editorial Aldus, 1995; *Francisco Toledo: Retrospective of Graphic Arts,* exhibition catalog, New York, Associated American Artists, 1995; *Francisco Toledo: Paintings & Gouaches,* exhibition catalog, New York, Associated American Artists, 1996; *Toledo, la línea metafórica: Textos poéticos sobre la figura y figuraciones de Francisco Toledo* by Miguel Flores Ramírez, Mexico, Oro de la Noche Ediciones, 1998; *Francisco Toledo: El ideograma del insecto* by Jaime Moreno Villarreal, Mexico City, Consejo Nacional para la Cultura y las Artes, 1999; *Francisco Toledo,* exhibition catalog, Madrid, Turner Libros, 2000. **Articles—**"Francisco Toledo" by Graciela Kartofel, in *Art Nexus* (Colombia), 18, October/December 1995, pp. 126–127; "Francisco Toledo" by Blanca Gutiérrez-Galindo, in *Art Nexus* (Colombia), 20, April/June 1996, pp. 115–116; "Francisco Toledo: Art of Magical Mutations" by Caleb Bach, in *Americas,* 50(6), 1998, p. 22; "Oaxaca's Paper Pioneer," in *Art on Paper,* 3(3), January/February 1999, pp. 23–24; "CALLEJERO—La pintura de Francisco Toledo" by Carlos Alfieri, in *Cuadernos hispanoamericanos,* 604, 2000, p. 135; "A Mythical, Satirical, Mexican Mix of Iguanas, Skeletons and Poetry" by Mark Gisbourne, in *Art Newspaper,* 11(103), May 2000, pp. 38–39; "Francisco Toledo: Museo Nacional Centro de Art, Reina Sofía" by Issa Maria Benitez Duenas, in *Art Nexus* (Colombia), November 2000/January 2001, pp. 147–148; "Toledo's Metamorphoses" by Christian Viveros-Faune, in *Art in America,* 89(2), February 2001, pp. 130–133. **Film—***Francisco Toledo* by Julián Pablo, Mexico, CONACULTA, 1999.

* * *

Francisco Toledo, a Zapotec Indian, was born in 1940 in Juchitán on the Isthmus of Tehuantepec, Oaxaca, to successful parents whose families worked as cobblers and butchers. The family moved within Mexico following work and resided in Veracruz and later Chiapas before returning to Oaxaca in 1951. In 1957 Toledo enrolled in the Taller Libre de Diseño y Artesanías at the Instituto Nacional de Bellas Artes in Mexico City. In 1960 he moved to Paris, where he became involved in the city's art scene. While in Paris he met a fellow Zapotec, the Mexican artist Rufino Tamayo. Like Tamayo before him, Toledo became one of the post-*ruptura* generation of Mexican artists who rejected the revolutionary art favored by many and who followed a tradition established by such Mexican artists as Diego Rivera, David Alfaro Siquieros, and José Clement Orozco.

In 1965 Toledo decided to return to Mexico to the place of his birth, where he set up a studio. He also maintained a studio in Mexico City and has continued to travel since his return to Mexico; in 1976–77 and 1981–82 he lived in New York City, and in 1984–86 he resided in Paris and Barcelona. It is to his Zapotec origins, however, that Toledo has remained faithful, drawing on the region's rich folklore and popular traditions and the pre-Columbian cultures of Monte Albán and Mitla among others. His body of work includes ceramic sculpture, drawing, photography, printmaking, textiles, and book illustration, such as *Cuento del conejo y el coyote* (1979), a traditional Zapotec tale (adapted by Gloria and Victor de la Cruz).

Although Toledo did not believe in pure tradition (the concept of an unchanged indigenous art), it is clear that he was profoundly influenced by the culture and history of Oaxaca. Indeed, the actions of his paternal great-great-uncle, the revolutionary Che Gómez, who led a separatist movement in 1911, directly link Toledo to the region's history. Much of Toledo's work is dominated by insects (the grasshopper and scorpion), animals (mules, rabbits, turtles, and crabs), the *calavera* ("fool"), and anthropomorphic beings. His work also has a powerful sexual dimension that is sometimes suggested, such as the fish that have phallic overtones in *Mujer atacada por peces* (1972), and sometimes overt, such as the twin phalluses of *Conejo avispado* (1988).

Toledo recalled pre-Columbian traditions in such works as the series *Títulos primordiales* (1988), which uses local seeds to create maps that also resonate with Mexican colonial documents. The ceramic sculpture *Autorretrato, el viejo* (1996) similarly reworks pre-Columbian vessels, but the seminaked self-portrait reveals a vulnerability and preoccupation with the self that is reflected in his numerous self-portraits on paper. In *Juárez embrujado* (1986) Toledo reworked an iconic image of Benito Juárez, another celebrated Zapotec who became Mexico's first indigenous president, placing his head onto a grasshopper. The result is a satire of Juárez and his rejection of his Zapotec heritage.

Toledo's work presents a world that ebbs and flows out of reality and into a world of mystery and imagination, which captures the essence of Oaxaca. Tradition mixes with the modern to create a powerful and dynamic art. Works such as *El perro ladra* (1974) and *Onagro* (1976) present the viewer with a window onto this world where the subject matter emerges from behind a series of sharp, leaflike forms as if looking through foliage into a secret domain. In *El petate de la serpiente* (1989) Toledo revealed what appears to be a woven grass mat made of snakes; it is into this hidden world that Toledo draws his viewer.

Although Toledo is considered one of Mexico's foremost living painters, he has become as famous for his social work in the state of Oaxaca as his art. Toledo, who referred to himself as a "cultural cacique," has been involved with the establishment of many regional cultural centers. The first project with which he became involved was the creation of the Casa de la Cultura in Juchitán with Elisa Ramírez, which has become seen as a model institution. Since then Toledo has helped establish the Instituto de Artes Gráficas de Oaxaca (IAGO) in 1988, the Museo de Arte Contemporáneo de Oaxaca (MACO) in 1992, and the Centro Fotografico Manuel Álvarez Bravo in 1996, as well as been involved with the restoration of the Santo Domingo convent that now houses the Centro Cultural Santo Domingo and a handmade paper factory at San Agustín Etla (1988). He also founded a small publishing house, Ediciones Toledo, which has published translations of foreign language works and numerous historical documents of local importance, such as the anonymous sixteenth-century *Cathecismo de la doctrina christiana, en lengua zaapoteca.*

—Adrian Locke

TONEL
Cuban painter

Born: Antonio Eligio Fernández Tonel, Havana, 1958. **Education:** University of Havana, 1977–82, degree in art history 1982. **Career:** Cartoonist, humor magazine *Dedeté,* beginning late 1970s; founder and member, Grupo Hexágono, 1982–85; artist-in-residence, Ludwig Forum for International Art, Germany, 1992, West Walls Studios & Tullie House Museum and Art Gallery, Carlisle, Cumbria, United Kingdom, 1995; art critic. **Awards:** Third prize, Concurso Humor Joven "Habana '74," Havana, 1974; prize of merit and silver medal, *Bienal de humorismo deportivo,* Ancona, Italy, 1981; prize, *Concurso 13 de marzo,* University of Havana, 1982, 1984; travel grant, Cultural Office Ministry of Foreign Affairs, Rome, 1988; Union Nacional de Escritores y Artistas de Cuba grant, Havana, 1991; Premio Colectivo al Envio de Cuba, *Premio bienal de pintura del Caribe y Centro America,* Santo Domingo, Dominican Republic, 1992; Distincion por la Cultura Nacional, Ministry of Culture, Cuba, 1994; John S. Guggenheim Memorial Foundation fellowship, New York, 1995; Rockefeller Foundation fellowship, 1997. **Address:** Avenue 11, Number 6605 (Altos), Entre 66 Y 68 Playa, Havana, Cuba. **E-mail Address:** tonel@turnercom.com.

Individual Exhibitions:

1981 *Humor,* Galeria L, Havana
1982 *Tonel expone en Santa Cruz,* Museo Historico de Santa Cruz del Norte, Havana
 Humor Chago-Tonel, Galeria de Arte Cerro, Havana
1983 *El eterno verano,* Galeria L, Havana
1984 *Dibujos,* University of Havana
1986 *Clasicos de Tonel,* Galeria L, Havana
 Provincial Museum of Santa Clara, Cuba
1989 *Yo lo que quiero es ser feliz,* National Museum of Fine Arts, Havana
1992 *Kuba in Aachen,* Ludwig Forum for International Art, Aachen, Germany
 Weisse Stadt Galerie, Cologne, Germany
1993 *Tonel,* Stadtische Kunsthalle Dusseldorf, Germany
1994 *Acuarelas y dibujos,* Galeria Havana
1995 Centro Cultural de la Municipalidad de Miraflores, Lima, Peru
 Cuatro obras: Las partes que mas me sudan, Ludwig Foundation of Cuba, Havana
1996 *Tonel,* Krings-Ernst Gallery, Cologne, Germany
2000 Morris and Helen Belkin Art Gallery, Vancouver, British Columbia, Canada

Selected Group Exhibitions:

1990 Städtische Kunsthalle Düsseldorf, Germany, and Centro de Desarrollo de las Artes Visuales, Cuba
1992 *Primera bienal de pintura del Caribe y Centro America,* Museum of Modern Art, Santo Domingo, Dominican Republic
1994 *XXII bienal internacional de São Paulo*
1995 *Metamorfosis del signo,* Centro Wifredo Lam, Havana
 Salón nacional de arte contemporáneo, National Museum of Fine Arts, Havana

1996 *Mundo sonado,* Casa de America, Madrid
 Arte cubano, siglo XX: Modernidad y sincretismo, Centro Atlantico de Arte Moderna, Las Palmas, Canary Islands, and Centro de Arte Santa Monica, Barcelona, Spain
1997 *Utopian Territories: New Art from Cuba,* Morris and Helen Belkin Art Gallery, British Columbia, Canada
 Bienal de la Habana, Havana
1998 Arizona State University Art Museum, Phoenix (traveling)

Collections:

National Museum of Fine Arts, Havana; Museo del Humor-San Antonio de los Banos, Havana; Museo de Arte Moderno La Tertulia, Cali, Colombia; Museo de Arte Costarricense, San José, Costa Rica; Van Reekum Museum, Apeldoorn, Netherlands; Ludwig Forum for International Art, Aachen, Germany; Ludwig Museum, Beijing.

Publications:

By TONEL: Books—*Kuba o.k.: Aktuelle Kunst aus Kuba,* exhibition catalog, with Jürgen Harten, Düsseldorf, Die Kunsthalle, 1990; *Contemporary Art from Cuba: Irony and Survival on the Utopian Island,* exhibition catalog, with Gerardo Mosquera and Marilyn Zeitlin, New York, Delano Greenidge Editions, 1999.

On TONEL: Books—*Utopian Territories: New Art from Cuba,* exhibition catalog, by Eugenio Valdés Figueroa, Vancouver, British Columbia, Canada, Morris and Helen Belkin Art Gallery, 1997; *Tonel: Lessons of Solitude,* exhibition catalog, by Eugenio Valdés Figueroa, Vancouver, British Columbia, Canada, Morris and Helen Belkin Art Gallery, 2001.

* * *

In the late 1970s Antonio Eligio Fernández Tonel launched his career as a newspaper and magazine cartoonist in the pages of the biweekly humor magazine *Dedeté.* His early work, simple yet ingenious pen-and-ink riddles using a free-flowing watercolor technique, was stylistically similar to that of Saul Steinberg, who was then popular among Cuban artists. Since that time, informed by the kitsch sensibility of cartoon and caricature, the language of graphic art has become an intrinsic part of visual vocabulary in Cuban art. As a by-product of colonization, Cuban artists have recognized graphic art's effectiveness as a substitute for populist taste and as a response to imposed cultures.

Tonel was an active participant in the artistic and cultural shift of the time (called the "Cuban Renaissance" by Luis Camnitzer in the 1980s), and he associated with artists around the legendary exhibition *Volumen Uno* (1981). He also formed Grupo Hexágono (1982–85), an interdisciplinary art collective that directed him to move toward more openly artistic contexts and action- or performance-oriented projects. In addition Tonel has written art criticism extensively (he graduated with a degree in art history from the University of Havana in 1982). Through his positions in the publishing and art worlds he has played a seminal role among his generation of artists, serving as both curator and collaborator.

Tonel's interest in and criticality of society and culture derived from his experiences working for print publications. His style of

nontraditional graphic humor, also seen in the works of Rafael Fornés and Santiago Armada (known as Chago), resulted from international influences in Cuba in the second half of the twentieth century: for instance, the "hand-to-hand" circulation of magazines from North America disseminated the "underground sensibility" notable in *Mad* and other magazines in the 1950s. Although Tonel, Fornés, and Chago belong to two different generations, they all placed a greater emphasis on philosophical concerns and conceptual experiments than on anecdotal or narrative quality. This deviation from the convention of caricature eventually drove them from the publishing business. Tonel developed an aesthetic and critical consciousness of the visual and linguistic strategy and learned to employ increasingly esoteric and subversive expressions.

The images that recur in Tonel's work—self-portraits, soft pornography, the body, body parts, and bodily fluids—create a synthesis of symbolism. Rife with vulgarity and banality, these images fuse Tonel's self-referential monologue and dialogue. Drawn from graffiti, as well as from North American and British pop art, his conceptual and philosophical references recall the work of Philip Guston and R. Crumb. His work often applies a predominantly masculine gaze to Cuba's phallocentric sociocultural climate, but not without suggesting women's equality and rather with a (sym)pathetic glance at their male counterparts. Isolated stumps, amputated body parts, missing eyeballs—all frequent motifs in Tonel's work—poignantly personify psychological states of frustration, alienation, and incompetence for both individuals and society as a whole.

Tonel has recorded popular ingenuity and humor as expressed in language, particularly in the use of multiple meanings of words and double entendres; these works have built upon the visual-linguistic paradox introduced by René Magritte. The line-drawn images and words at once complicate and complement one another to achieve a great space of ambiguity, not only in Tonel's two-dimensional work but also in his sculptural and installation work. His distinctive style has not been the result of merely trading the medium of caricature for the means of art or of appropriating one discipline as content for the other. Tonel has regarded the coexistent metaphysical realism and ambiguity in the graphic language of caricature as an operative medium of greater communication.

—Hitomi Iwasaki

TORAL, Mario
American-Chilean painter and printmaker

Born: Santiago, 12 February 1934; naturalized U.S. citizen. **Education:** Escuela de Bellas Artes, Montevideo, Uruguay, degree 1954; Ecole des Beaux Arts, Paris, 1958–63. **Family:** Married Andrea Hegeman; one daughter and one son. **Career:** Lived in Paris, 1958–63. Instructor of art, Universidad Católica, Santiago, 1964–71. Lived in New York, 1973–92; returned to Chile, 1992. Dean, art department, Universidad Finis Terrae, Santiago, 1994–2001. Contributed short stories to literary magazines and journals, 1980s. Artist-in-residence, Fordham University, New York, 1973, and Altos de Chavón, Dominican Republic, 1983. **Awards:** First prize, *Salón de bellas artes,* Paris, 1961; first prize, *Salón oficial de Santiago,* Chile, 1962; prize, *I bienal americana de grabado de Santiago,* Chile, 1963; first prize, *VIII bienal de São Paulo,* Brazil, for *Los signos del zodíaco,* 1965; first prize in graphic art, Museo de Arte Contemporáneo, Santiago, Chile,

1966; Premio Wolf, *IX bienal de São Paulo,* Brazil, 1967; first international prize, Union of Editors of New York, for *20 poemas de amor,* 1970; Premio Vinkovci, *III bienal internacional de Rijeka,* Yugoslavia, 1972; fellowship, John S. Guggenheim Memorial Foundation, 1975; first prize, *III bienal americana de artes gráficas,* Cali, Colombia, 1976; grand prize, *VI bienal internacional de Rijeka,* Yugoslavia, 1978; first prize, *VI bienal del grabado latinoamericano,* San Juan, Puerto Rico, 1983; Premio Creación Artística Universidad UNIACC, Santiago, 1997. **Member:** Academia de Bellas Artes de Chile, 1996. **Addresses:** 14 West 17th Street, Third Floor South, New York, New York 10011, U.S.A., or Camino Otonal 1218, Las Condes, Santiago, Chile. **E-mail Address:** mtoral@finisterrae.cl.

Individual Exhibitions:

1955	Museo de Arte Moderno, São Paulo, Brazil
1958	*Textures,* São Paulo, Brazil
1963	Galería Sudamericana, New York
1973	Fendrick Gallery, Washington, D.C.
1975	*Masters of Contemporary Art,* Sala Especial, *XII bienale de São Paulo,* Brazil (retrospective)
1977	Terry Dintenfass Gallery, New York
1981	Museum of Modern Art, Mexico City
1984	Instituto Cultural Las Condes, Santiago, Chile (retrospective)
1985	*Toral: Acuareles y dibujos, 1977–1985,* Galeria Arte Actual, Santiago (traveling)
1992	*Toral: Obras, 1987–1992,* Galería de Arte Praxis and Instituto Cultural de Las Condes, Santiago
1993	Americas Gallery, New York
1998	Tomas Andreu Gallery, Santiago
1999	*Mario Toral: El rostro multiple obras 1958–1999,* Galería Tomás Andreu and Corporación Cultural de Las Condes, Santiago
2000	*Mario Toral,* Galería Andreu, Santiago

Selected Group Exhibitions:

1959	*V bienal internacional de arte moderno,* Museo de Arte Moderno de São Paulo, Brazil
1961	*II bienal de Paris,* Museum of Modern Art, Paris
1966	*Art of Latin America since Independence,* Yale University, New Haven, Connecticut, and University of Texas, Austin
1976	*Creadores latinoamericanos 1950–1970,* Museo de Arte Moderno, Mexico City
1977	*Raices antiguas, nuevas raices,* Museum of Contemporary Art, Chicago
1980	*Maestros contemporáneos,* Forma Gallery, Miami
1983	*II exposicion latinoamericana,* Dearmas Gallery, Miami
1983	*Basic Blacks,* Smithsonian Institution, Washington, D.C.
1989	*The Latin American Spirit: Art & Artists in the U.S.,* Bronx Museum, New York

Collections:

Brooklyn Museum, New York; Metropolitan Museum of Art, New York; Museo de Arte de la Universidad de São Paulo, Brazil; Museo de Bellas Artes, Havana; Museum of Modern Art, New York; Museum of Modern Art, Rijeka, Yugoslavia; Museo de Arte Moderno

de Rio de Janeiro; Museo de Arte Moderno de São Paulo, Brazil; Museo de Arte Moderno La Tertulia, Cali, Colombia; Museum of Contemporary Latin American Art, Washington, D.C.; University of Texas, Austin; Museo del Banco Central de Guayaquil, Ecuador; Museo de Arte Moderno, Mexico City; Museum of Tel Aviv; Museo Vial Bogarín, Venezuela; Museum of Contemporary Art, Seoul.

Publications:

By TORAL: Books—*Las 4 estaciones* with Armando Uribe and Mauricio Amster, Santiago, Editorial Lord Cochrane, 1964; *Cuerpos pintados,* Santiago, n.p., 1991; *Toral imagen secreta,* Santiago, Ornitorrinco Ediciones, 1988; *Mario Toral, memoria visual de una nación,* Santiago, Banco de Santiago, 1996. Books, illustrated—*Alturas de Macchu Picchu,* Santiago, La Gargola Ediciones, 1963; *Arte de pájaros,* Santiago, Chile, Sociedad de Amigos del Arte, 1966; *Veinte poemas de amor y una canción desesperada* by Pablo Neruda, Santiago, Editorial Lord Cochrane, 1970; *El amor de Chile* by Raúl Zurita, Santiago, Ismael Espinosa Ediciones, 1992.

On TORAL: Books—*Toral, Paintings, Drawings, Watercolors,* exhibition catalog, New York, T. Dintenfass, 1977; *Exposición de obras de Mario Toral,* exhibition catalog, Santiago, Instituto Cultural de Las Condes, 1984; *Toral, tres decenios en su obra, 1954–1984,* exhibition catalog, text by Leopoldo Castedo, Santiago, Editorial Lord Cochrane, 1984; *Toral: Acuarelas y dibujos, 1977–1985,* exhibition catalog, Santiago, Cochrane, 1985; *Toral: Obras, 1987–1992,* exhibition catalog, text by Ilonka Scillag, John Berens, and others, Santiago, Instituto Cultural de las Condes, 1992; *Mario Toral: El rostro multiple obras 1958–1999,* exhibition catalog, Santiago, Galería Tomás Andreu, 1999; *Mario Toral,* exhibition catalog, text by Antonio Skármeta, Santiago, Galería Andreu, 2000. Articles—"Existence As Change" by Marta Traba, in *El Nacional* (Caracas, Venezuela), 1982; "Human Geometry" by Rodolfo Windhausen, in *Latin American Art,* 1993.

* * *

Recognized as a leading contemporary Chilean artist, Mario Toral has worked in a dizzying array of media and styles throughout his career. He has used oils, acrylics, watercolors, and ink and has done engravings, and his style has ranged from superrealism to a purified objectivity. Despite these technical, thematic, and stylistic shifts, several characteristics unify Toral's work. First, his art reflects the musical concept of the theme and variations, in which individual paintings in a collection explore a broader theme. Second, he has typically employed color and a unique treatment of space to draw the viewer into his paintings. Finally, Toral's works have typically explored the human body in different forms–naked, imprisoned, disintegrating, tortured, eroticized, or diaphanous.

The diversity of Toral's work reflects the myriad influences he absorbed. Born in Santiago, Chile, he spent his formative artistic years–and most of his adult life–away from his homeland. At 16 he moved to Buenos Aires, Argentina, and later to Montevideo, Uruguay. In Montevideo, Toral became acquainted with the work of the Uruguayan master Joaquín Torres-García, whose artistic theory of constructive universalism loomed large over the arts in South America. Although Toral did not adopt Torres-García's theoretical framework in its entirety, he appropriated those aspects he found useful.

Terse geometric shapes of the type crafted by Torres-García functioned as a backdrop for much of Toral's later work.

Toral left Montevideo for São Paulo, where he made his reputation as an innovative painter, and he held his first solo exhibition at age 21. The exhibition was a critical success, but Toral soon began to experiment with new forms in his work. In one piece he mixed layers of sand with glue and enamel and then heated the enamel with a blowtorch until it cracked. These textural experiments culminated in his 1958 show *Textures,* whose paintings subordinated form to surface quality, which was itself governed by color. Toral moved to Paris in 1959, where he soon exhibited another thematic collection entitled *Totems.* Unlike *Textures,* the pieces in *Totems* stressed form over color. Mostly painted in ocher hues, the works featured shapes that recalled mythical visions of South American origins. While in Paris, Toral also began studying engraving at the École des Beaux-Arts. Much of his subsequent work incorporated technical and stylistic elements of engraving.

In 1964 Toral returned to Santiago, where he began to incorporate more fully the human form in his art. The shift is evident in his 1965 painting *Inhabited Totem,* which depicts the geometric shapes emblematic of the *Totems* collection but with a timid figure residing between two diagonal lines. He followed this painting with the collection *Towers of Babel,* which continued to explore people inside totems. The collection won him the prize as the best Latin American artist at the IX São Paulo Biennale. Beginning in 1966, Toral also collaborated with the poet Pablo Neruda to publish three books in which he provided illustrations for Neruda's poems. In the second book, *20 Poems of Love and a Song of Despair,* Toral developed the themes of women and stone that would recur in later work.

Toral was in the United States at the time of the 1973 military coup against Chile's elected government, and he stayed in New York City for the next 19 years. During this period his Latin American artistic identity became even more deeply entrenched. He expanded on the themes that had emerged in *20 Poems of Love and a Song of Despair* with the collection of paintings *Women and Stones,* which depicted human bodies stretched and strained in prisons of stone. Toral's next series, *Stone Captives,* was even darker. In these works the stones are no longer geometric or rigid but instead drape the bodies almost like robes.

Toral's work shifted again in 1979 when he began painting his *Mask* series. Instead of portraying the human form, he painted disembodied, primeval masks, reminiscent of the stone carvings on Easter Island. In *Masks in Ambush* a row of red masks at the top of the canvas prepares to attack a row of fledgling masks that are still finding their final form. At the same time his subject changed, Toral began using a new technique. Eschewing his earlier refined style, he opted for a casually applied impasto, in which he applied thick coats of oil and acrylic paint with a spatula directly onto the canvas. Toral reintroduced human figures to his mask paintings in the early 1980s. At first he painted masks and bodies at war with one another. By 1983 the masks had become increasingly humanized and appeared to be faces.

Toral returned to Chile in 1992. Although he continued his career as a painter, he received national attention for the murals he created throughout the country. *Wings of the Desert, Without Title* and especially *Visual Memory of a Nation* are some of the better known of these murals.

—Rebecca Stanfel

TORRES, Rigoberto
American sculptor

Born: Aguadilla, Puerto Rico, 1960. **Education:** Self-taught; learned casting techniques in his uncle's religious statue business. **Career:** Began collaborating with John Ahearn, 1979. Worked on public projects with Ahearn, including Intervale Avenue Outdoor Arts Project, 1981, three outdoor sculpture murals, New York, 1983, *City College of the City of New York,* eight cast sculptures of students and teachers, 1985, and *Back to School,* an outdoor sculpture mural, New York, 1985. Returned to Puerto Rico, early 1990s, then returned to the United States.

Individual Exhibitions:

1979	*South Bronx Hall of Fame,* Fashion Moda, New York
1983	Brooke Alexander, New York (with John Ahearn)
1984	Brooke Alexander, New York (with Ahearn)
1985	*Portraits from the Bronx,* Institute of Contemporary Art, University of Pennsylvania, Philadelphia (with Ahearn)
	Bronx Museum, New York (with Ahearn)
1986	Brooke Alexander, New York (with Ahearn)
1987	Brooke Alexander, New York (with Ahearn)
1989	*Art Show of Life,* Biblioteca de la Universidad Intramericana, Aguadilla, Puerto Rico
1991	*South Bronx Hall of Fame,* Contemporary Arts Museum, Houston (with Ahearn; traveling)
	Rigoberto Torres, Sculpture 1990–1991, Brooke Alexander, New York
	La Maquina Espanola, Seville, Spain
1992	*Face to Face,* Washington Project for the Arts, Washington, D.C. (with Ahearn)
1993	*South Bronx Hall of Fame and Other Realities,* Douglas F. Cooley Memorial Gallery, Reed College, Portland, Oregon and Arizona State University Art Museum, Tempe (with Ahearn)
	Friends and Neighbors, Baltimore Museum of Art, Maryland and Lehman College Art Gallery, Bronx, New York (with Ahearn)
1995	Lehman College Art Gallery, Bronx, New York
	Brooke Alexander, New York

Selected Group Exhibitions:

1980–81	*Events,* New Museum of Contemporary Art, Fashion Moda, New York
1983	*Language, Drama, Source, and Vision,* New Museum of Contemporary Art, New York
1984	*The Human Condition,* San Francisco Museum of Modern Art
1985	*1985 Biennial Exhibition,* Whitney Museum of American Art, New York
1986	*The Gallery Show,* Exit Art, New York
1987	*Out of the Studio: Art with Community,* P.S. 1 Museum, Institute for Contemporary Art, New York
	Working Space: New Work from New York, University Art Gallery, State University of New York, Binghamton
1990	*The Decade Show,* Museum of Contemporary Hispanic Art, New Museum of Contemporary Art, and Studio Museum in Harlem, New York
1999	*Urban Mythologies: The Bronx Represented since the 1960s,* Bronx Museum, New York
2000	*Multiple Bodies,* LL Gallery, New York

Publications:

On TORRES: Books—*John Ahearn with Rigoberto Torres: Sculpture,* exhibition catalog, Philadelphia, Institute of Contemporary Art, University of Pennsylvania, 1986; *South Bronx Hall of Fame: Sculpture by John Ahearn and Rigoberto Torres,* exhibition catalog, essays by Richard Goldstein, Michael Ventura, and Marilyn A. Zeitlin, Houston, Contemporary Arts Museum, 1991; *Sculpture by John Ahearn and Rigoberto Torres: The South Bronx Hall of Fame and Other Realities,* exhibition catalog, Portland, Oregon, Douglas F. Cooley Memorial Gallery, Reed College, 1993; *The Works of Rigoberto Torres,* exhibition catalog, by Susan Hoeltzel, Bronx, New York, Lehman College Art Gallery, 1995. **Article**—"John Ahearn with Rigoberto Torres" by Carlo McCormick, in *Artforum International,* 25, February 1987, pp. 115–116.

* * *

Rigoberto Torres is best known for his painted life-size cast sculptures of family, friends, and the black and Hispanic residents of the South Bronx neighborhood where he lived until 1994. He began working at a time when a multicultural, populist approach to art thrived. Torres is often grouped with the artists Duane Hanson, John De Andrea, Antony Gormley, and George Segal, who also cast from life.

Torres's career began when he met the sculptor John Ahearn in 1979 at Fashion Moda, an alternative space in the South Bronx where Ahearn's body casts of people were on display. The busts fascinated Torres, and within the first year after their meeting Ahearn and Torres had cast each other's faces and become collaborators.

Torres came up with the idea of casting people on the South Bronx block where he lived. In 1980 he convinced Ahearn to move to his apartment building on Walton Avenue, and the two began casting works there. Although they returned to Walton Avenue in 1983, in 1981 the studio moved to Dawson Street, a destitute area of the borough. There, as a way to revitalize the inner-city neighborhood, Torres and Ahearn made exterior public murals with funding from the U.S. Department of Housing and Urban Development (HUD), the Bronx Council of the Arts, and the Department of Cultural Affairs and Community Development Program. Hanging work such as *Life on Dawson Street* (1982–83) on the outside of a building moved art out of galleries and museums and linked the work to the community. In a populist sense Torres and Ahearn annexed the community as a gallery space.

To signal to neighborhood residents that they were ready to cast, Torres and Ahearn collected busts of people cast in an earlier session and nailed them to the outside of the building. Volunteer subjects often waited in line for selection. Torres and Ahearn worked on the sidewalk or in the street, and often there was a partylike atmosphere among the crowds that assembled to watch the artists work.

Subjects lay on a folding table with straws in their noses while casting gel was poured over their faces and around their bodies.

Plaster-imbedded bandages were then wrapped around the gel, making the subjects look like mummies. The entire casting process took approximately 20 minutes. Once the dried gel impression was lifted off, a plaster cast was formed within the molded impression. Back in the studio, Torres painted realistic faces with a single flesh tone, as opposed to Ahearn's multiple tones. Polaroid pictures taken prior to the casting were used as a reference.

Torres achieves a sense of intimacy in his work, as evidenced in *Shirley* (1979), a frontal casting of a woman with a shy, direct gaze. Unlike sculptures by Hanson and Segal, Torres's figures quietly reflect the personality of the subject and respectfully present the subjects as themselves. This is evident in *Girl with the Red Halter* (1982–83), an adolescent who poses introspectively with her chin downcast and arms folded, and *Dixie* (1982–83), a man who actively shows off his strong arms in a bodybuilder pose. Art critic Peter Schjeldahl has complimented sculptures such as these, calling them "Rembrandtian."

Torres's familiarity with the people he cast was one of the things that enriched the partnership with Ahearn. Torres was able to circumvent cultural and linguistic barriers that Ahearn alone might have faced, particularly in doing social tableaux such as *Double Dutch* (1981–82), *We Are Family* (1982–82), and *Back to School* (1985). He also brought technical expertise to the work. For a time Torres worked for his uncle, Raul Arce, who owned a company that manufactured religious figurines. Arce's advice on making rubber molds and the use of fiberglass made the exterior murals possible and allowed for multiple castings. (One cast was usually given to the subject to keep.)

In 1990, on returning to his native Puerto Rico, Torres produced *Ruth Fernandez* (1991), a full body cast of a popular singer presented with outstretched arms, as if embracing the audience. More and more Torres showed people actively doing things. In *Julio, Jose, and Junito* (1991) three young boys in his family sit totem pole style, one atop the other. *The Rescue* (1993) shows a firefighter framed between pillars of a tenement as he dramatically rescues a young woman.

Torres and Ahearn worked together on a Times Square project during the fall of 1993. During the project Torres was struck with two successive asthmatic seizures that hospitalized him. Unfamiliar with his medical history, the hospital administered treatment that caused a temporary loss of sight, cortex damage, and memory loss, from which it took him several years to recover. Regaining his skill, he worked with Ahearn in 2001 on a project in China. Relocated to Florida, he has continued to involve himself in the community in much the same way he did in the Bronx.

—Susan Merrill Rosoff

TORRES, Salvador Roberto

American painter and muralist

Born: El Paso, Texas, 3 July 1936. **Education:** San Diego City College, California, certificate in commercial art 1960; California College of Arts & Crafts, Oakland, California (on art scholarship), B.A. in art education and teaching credential 1964; San Diego State University, California, M.A. in painting and drawing 1973. **Family:** Married artist Gloria Rebolledo Torres. **Career:** Assistant to the art director, XETV 6, San Diego, beginning in 1960; teacher of painting and drawing, City of Oakland Recreation Department, California, and Diablo Valley Junior College, Contra Costa, California, 1963–67;

teacher of instructional television, KGO-TV, San Francisco, 1963–67; arts and crafts specialist, California College of Arts & Crafts, Oakland, California, and Walnut Creek Civic Arts Center, California, 1963–67; assistant professor, policy studies in language and cross-cultural education, San Diego State University, 1987–91; teacher of arts, crafts, and murals, San Diego Unified School District, 1987–91; instructor of painting and drawing, Adult Education, Coronado High School, California, 1993. Since 1997 director and founder, Metro Gallery, San Diego, and since 2000 instructor of painting, drawing, and ceramics, Springfield College, San Diego. Muralist, including murals at City Towing, San Diego, and Baja Lobster, Chula Vista, California. Also organizer of art exhibitions, including first *International Chicano Art Exhibition,* San Diego, 1999, and *The Viva La Raza! Art Exhibition,* San Diego, 2000. Cofounder and director, Centro Cultural de la Raza, San Diego, beginning in 1968; cocreator, Monumental Public Mural Project, Chicano Park, San Diego, 1973; founder and director, Underground Gallery, San Diego; creator, Public Murals for Schools, Universities, and Industry, San Diego. **Award:** César Chávez Social Justice award, 1997. **Website:** http://www.tqsarts.com/Torres.

Selected Exhibitions:

1981 *Califas: Chicano Art and Culture in California,* Mary Porter Sesnon Gallery, University of California, Santa Cruz

1988 *Salvador Roberto Torres,* Hyde Gallery, Grossmont College, San Diego

1990–93 *Chicano Art: Resistance and Affirmation,* Wight Gallery, University of California, Los Angeles (traveling)

1999 *International Chicano Art Exhibition,* B St. Pier, San Diego

2000 *Viva La Raza! Art Exhibition,* Lyceum Gallery, San Diego Repertory Theater Gallery

 Made in California: 1900–2000, Los Angeles County Museum of Art

2001 *La Gráfica Chicana: Three Decades of Chicano Prints 1970–2000,* Orme Lewis Gallery, Phoenix Art Museum

Collections:

California Ethnic and Multicultural Archives, Davidson Library, University of California, Santa Barbara; Self-Help Graphics and Art, Los Angeles.

Publications:

On TORRES: Book—*Califas Seminar: Essays,* edited by Tomás Ybarra Frausto, Santa Cruz, California, Mary Porter Sesnon Gallery, 1982.

* * *

Salvador Roberto Torres is a Mexican-American artist whose primary media are painting, particularly murals. He is an important and influential figure in the Chicano art movement, owing both to his art and to his civic work as a cultural activist. Torres has described his work as Chicano art that is "based upon the creative Chicano

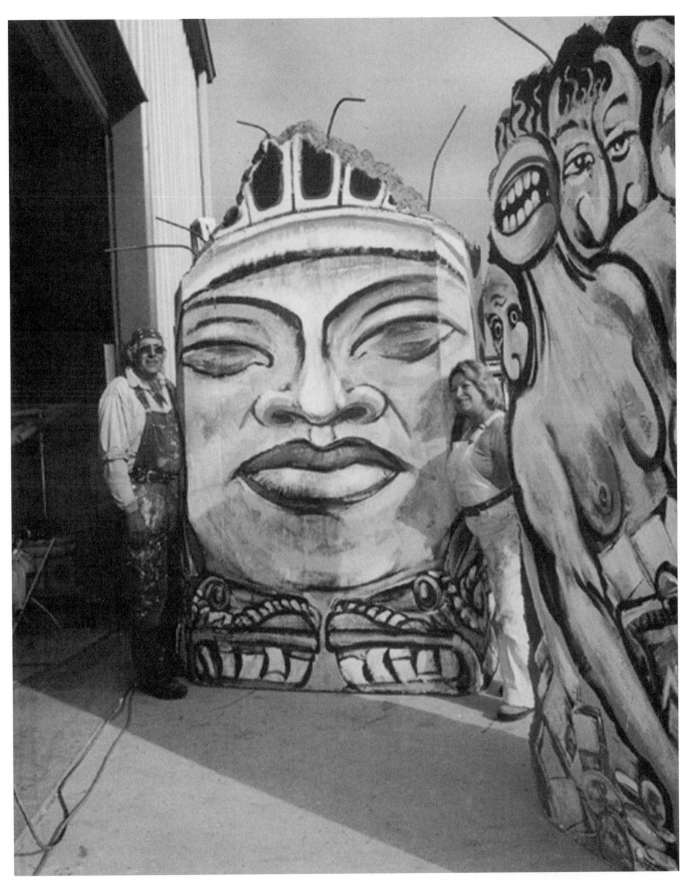

Salvador Roberto Torres with wife, Gloria Rebolledo Torres standing next to his artwork. Photo from the Salvador Torres Papers. Used with permission from the California Ethnic and Multicultural Archives, University of California, Santa Barbara.

lifestyle, whose Mexican and American interrelationships and cultural influences form its ideologies and themes.''

Torres was born in Texas but as a young child moved with his family to settle in the Logan Heights area of San Diego. He attended San Diego City College and then won a scholarship to the California College of Arts & Crafts in Oakland, where in 1964 he earned a B.A. Ed. degree in art. It was there he first met other Chicano artists who were exploring ways in which they could integrate their Mexican-American roots with their work as artists. In 1973 he earned an M.A. degree in painting and drawing from San Diego State University, where he began to bring Chicano artists together to talk about cultural and artistic issues of their community. He has become known as an arts educator, teaching students at all levels and through televised classes. But he is best known as the ''architect of the dream,'' for his crucial role in the creation of San Diego's Chicano Park, which includes the largest collection of Chicano murals in the world, and as a founder of the Centro Cultural de la Raza, also in San Diego. He became the center's first director and later helped form Las Toltecas en Aztlán, a Chicano artists group that was instrumental in converting the Ford Building in Balboa Park into a museum and cultural center. Torres also has organized exhibitions and has founded and directed galleries.

It was during the period that Torres became involved in the creation of Chicano Park that he conceived of the idea of what he has called the Monumental Public Mural Project. In April 1970 local residents occupied the land underneath the Coronado Bridge in the Logan Heights neighborhood to protest a proposal that the land be used for a highway patrol parking lot. Torres proclaimed that ''Chicano artists and sculptors would turn the great columns of the bridge approach into things of beauty, reflecting Mexican-American culture.'' He sought inspiration and guidance for the endeavor by traveling to Mexico City to videotape the dedication of David Alfaro Siqueiros's mural at the Polyforum. Hearing Siqueiros speak about the history of his murals and about the Congress of Revolutionary Painters, of which he was a part, moved Torres to want to create a similar statement for the people of Logan Heights. In 1973 he began work on the project in Chicano Park. Inviting artists from San Diego and Los Angeles and from Tijuana, Mexico, to participate, Torres turned his vision into reality as the giant pylons of Coronado Bridge, which had become known as graffiti-covered eyesores, were reclaimed for the community as immense works of mural art. He later assisted in producing an award-winning documentary film on the history of Chicano Park and the concept of the Monumental Public Mural Project.

Later projects have included the production of murals for an NBC television pilot, *The Fortunate Son,* and *The Kelco Historical Community Mural,* which Torres completed in 1993 with his artist wife, Gloria Rebolledo Torres. Located in San Diego's Barrio Logan, the mural is an evocative historical account of the contributions of the people of Logan Heights and provides a glimpse of the future of the children of the community. Torres has stated that he chooses these types of creative experiences ''to create and discover a new horizon in the history of art, a horizon inspired by the spiritual ideals and realities of La Raza and by other Chicana/Chicano and international artists who are striving to achieve social justice and freedom of self-expression on all artistic levels.'' His vision and his art have been described as ''uplifting, lyrical, inventive, and often humorous.''

As a painter Torres is best known for his compelling 1969 *Viva La Raza,* an oil on canvas that depicts the transformation of the eagle of the United Farm Workers of America into a rising phoenix. A former farm worker himself, Torres rendered the rallying cry ''Viva la Raza'' in bold, vivid strokes and slashes. These visual symbols became icons of the farm worker and the Chicano art movement. His work has been shown in a number of exhibitions, including *Salvador Roberto Torres* (1988), the nationally touring *Chicano Art: Resistance and Affirmation* (1990–93), and *Made in California: 1900–2000* (2000).

—Salvador Guereña

TORRES-GARCÍA, Joaquín
Uruguayan painter and sculptor

Born: Montevideo, 28 July 1874. **Education:** Studied at the Official School of Fine Arts and Academia Baixas, Barcelona, Spain, 1894. **Family:** Married Manolita in 1910; two daughters and two sons. **Career:** Art teacher, Escola Mont d'Or, Barcelona, then Tarrasa, *ca.* 1906–10, *ca.* 1913–17. Assistant to Antonio Gaudí on stained glass windows, Cathedral of Palma and Sagrada Familia, Barcelona, 1903–07; painter of canvases, Chapel of the Holy Sacrament and Church of San Agustín, Barcelona, 1908; muralist, Salon de San Jorge, 1913; toy designer, Artist Makers Toys, New York, *ca.* 1920s; muralist, Martirene Hospital, Colonia Saint Bois, Uruguay, 1944. Cofounder, with Michel Seuphor, *Cercle et Carré,* Paris, *ca.* 1926; founder, Association of Constructivist Art, Montevideo, 1935, the magazine *Circulo y Cuadrado,* 1935, and El Taller Torres García (School of the South), Montevideo, 1942. Also worked as an illustrator for books and magazines and as a private art instructor. Traveled to Brussels, 1909; visited Italy and Switzerland, 1912; lived in New York, 1920–22, Italy, 1922–26, and Paris, 1926–34; traveled to Spain, 1933; moved to Uruguay, 1934. **Awards:** Gran Premio Nacional de Pintura. **Died:** 8 August 1949.

Individual Exhibitions:

1933	Museo de Arte Moderno, Madrid
1949	Amigos del Arte, Montevideo
1951	Instituto de Arte Moderno, Buenos Aires
1955	Musee d'art Moderne de la Ville de Paris
1960	Rose Fried Gallery, New York
1961	Pan American Union, Washington, D.C.
	Stedelijk Museum, Amsterdam
	Organization of American States, Washington, D.C.
1962	Commission Nacional de Bellas Artes, Montevideo
1965	Rose Fried Gallery, New York
1969	Royal Marks Gallery, New York
1970	Solomon R. Guggenheim Museum, New York
	Rhode Island School of Design, Providence

Selected Group Exhibitions:

1921	Whitney Studio Club (now Whitney Museum of American Art), New York
1933	Museum of Living Art, New York
1943	New York University
	Philadelphia Museum of Art (permanent installation)
	The Latin American Collection of the Museum of Modern Art, Museum of Modern Art, New York

Joaquín Torres-García: *Composition Construction.* © Christie's Images/
Corbis. © 2002 Artists Rights Society (ARS), New York/ADAGP, Paris.

1950 Pan American Union, Washington, D.C.
1955 Pan American Union, Washington, D.C.
1959 *The United States Collects Latin American Art,* Art
 Institute of Chicago
1965 *The Emergent Decade,* Solomon R. Guggenheim
 Museum, New York, and University of Texas, Austin
1967 *Latin American Art: 1931–1966,* Museum of Modern
 Art, New York

Collections:

Albright-Knox Art Gallery, Buffalo, New York; CDS Gallery, New
York; Solomon R. Guggenheim Museum, New York; Sidney Janis
Gallery, New York; Museum of Modern Art, New York; Rhode
Island School of Design, Providence; Yale University, New
Haven, Connecticut.

Publications:

By TORRES-GARCÍA: Books--*Notes sobre art,* Gerona, 1913;
Dialegs, 1915; *Historia de me vida,* Montevideo, 1939; *La ciudad sin
nombre,* Montevideo, Asociacion de Arte Constructivo, 1941;
Universalismo Constructivo, Buenos Aires, Editorial Poseiden, 1944;
La recuperacion del objeto, Montevideo, 1952.

On TORRES-GARCÍA: Books–*J. Torres-García* by José María
Podestá, Buenos Aires, Editorial Losada, 1946; *Torres-García* by

Enric Jardí, Barcelona, Ediciones Polígrafa, 1973; *Joaquín Torres-
García* by Mario H. Gradowczyk, Buenos Aires, Ediciones de Arte
Gaglianone, *ca.* 1985; *Hommage a Torres-García: Oeuvres de 1928
a 1948,* exhibition catalog, by Marie-Aline Prat, Paris, Galerie
Marwan Hoss, 1990; *Joaquín Torres-García* by Raquel Pereda,
Montevideo, Fundación Banco de Boston, 1991; *Carta a Torres
García* by Hermenegildo Sábat, Montevideo, Ediciones de la Plaza,
1996; *A vanguarda no Uruguai: Barradas e Torres-García,* exhibi-
tion catalog, by Rafael Barradas, Sao Paulo, Centro Cultural Banco
do Brasil, 1996; *Joaquín Torres-García y la Escuela del Sur,* exhibi-
tion catalog, by Iris Peruga, Venezuela, Museo de Bellas Artes, 1997;
Joaquín Torres-García epistolari catalá: 1909–1936, edited by Pilar
García-Sedas, Barcelona, Curial Edicions Catalanes, 1997; *Joaquín
Torres-García: Sol y luna del arcano* by Adolfo M. Maslach,
Caracas, Venezuela, JTG, 1998; *Torres García: Pasión clásica* by
Joan Sureda, Tres Cantos, Madrid, Akal Ediciones, 1998; *J. Torres-
García: La trama y los signos* by Miguel A. Battegazzore, Uruguay,
Gordon, 1999. **Articles**—''Latin America's Magical Realism: The
Legacy of Torres-García'' by Ricardo Pau-Llosa, in *Art Interna-
tional,* 12, Autumn 1990; ''From the Workshop of Torres-García'' by
Karen Wilkin, in *New Criterion,* 11, April 1993; ''Torres García and
the Southern School'' by Alvaro Medina, in *Art Nexus,* 16, April/June
1995; ''Joaquín Torres-García, Rafael Barradas'' by Cristina Carlisle, in
Art News, 95, January 1996; ''Torres García in Montevideo: Avant-
garde Project and Regionalist Discourse'' by Gabriel Peluffo Linari,
and ''Seminar on Torres García: Life, Work, Legacy'' by Nelly
Perazzo, in *Art Nexus,* 22, October/December 1996; ''Joaquín Torres-
García'' by John Angeline, in *Art Nexus,* 26, October/December 1997.

* * *

Although Joaquín Torres-García was born and raised in Uru-
guay, he spent the first three decades of his adulthood in Europe after
his family moved to Spain in 1891. There Torres-García began a
serious study of art, aspiring to a career in mural painting in the
French academic style. From 1900 to 1920 he worked on various
public art projects in Belgium, France, Italy, and Spain, including
Antonio Gaudi's Holy Family cathedral. He also wrote his first
theoretical book, *Notes On Art,* during this period.

Torres-García's style changed in 1920 when, like many young
European avant-garde artists, he moved to New York City. Among
his associates in that bohemian enclave were Marcel Duchamp,
Joseph Stella, and Stuart Davis. His paintings from this era, such as
Fourteenth Street (1924) and *Bird's Eye View of New York City*
(1920), incorporate text, numerals, and architecture executed with
sketchy spontaneity. These works exhibit Torres-García's earliest
modernist tendency, which again evolved when he left New York and
settled in Paris in 1926.

In Paris Torres-García's oeuvre underwent another metamor-
phosis, as he began to create images composed primarily of simplified
geometric shapes. This shift can be traced to two sources. The first
was his continuing interest in the original wooden toys he created by
painting basic shapes that could be assembled into various combina-
tions. Although he was unable to have the blocks manufactured on a
successful commercial basis, the toys provided the conceptual frame-
work for his move toward constructivism. The second influence was
Torres-García's association with Theo van Doesburg, founder of the

magazine *De Stijl*, and Piet Mondrian, whom he met through the Belgian critic Michel Seuphor. In 1930 the four men founded the international constructivist group *Cercle et Carré* (Circle and Square), whose moniker proclaimed the ascendancy of geometric forms as the basis for genuine modern art. The group stood diametrically opposed to the surrealists, who emphasized irrational, often figurative imagery. During this time, Torres-García's two main genres were painted wood constructions based on the principles of Mondrian and gridlike paintings such as his *Composition Number 548* (1932).

Torres-García's return to Montevideo at the age of 59 marked yet another step in his artistic development, though not so much stylistically as conceptually. With his homecoming, he led a crusade to establish an avant-garde art school in Uruguay. The school's basic philosophy was to promulgate original modern Latin American art that transcended European aesthetics and principles. It was to reflect Uruguay's modernism that sprang from such diverse sources as pre-Columbian antiquity, Spanish and African influences, and urbanization. Drawing from his experience in Paris, Torres-García founded the Association of Constructivist Art and the magazine *Circulo y Cuadrado* (Circle and Square) in 1935. He promoted his theories through lectures, writing, and his workshop, the Taller Torres-García.

The 1943 cover of the atelier's publication *Taller Torres-García: Escuela del sur* (''Torres-García Workshop: School of the South'') graphically depicts the theories set forth in his *Southern School* manifesto eight years earlier. The upside down map of South America, with an ''S'' at the top, reified Torres-García's call to create a grand South American art that would reflect the modern age in its references to industry and architecture without being derivative of European models. Thus, the inverted map symbolized Torres-García's challenge to the status quo's hierarchal presumption of the north's directional and figurative superiority over the south.

Torres-García also began to use more pre-Columbian archetypes in his work. The painted wooden construction *Pachamama* (1942) incorporates mask imagery, text, and constructivism, while its title and shape refer to the widespread pre-Columbian notion of the mountain as earth mother. So too, the painting *Constructive Art with Large Sun* of the same year, while similar to his earlier grid paintings, is executed so as to appear carved from stone; the stylized objects that fill its compartments possess references to Amerindian iconography.

One work stands out as the hallmark of Torres-García's attitude toward authentically modern Latin American art. *Cosmic Monument* (1938) is a wall hewn from stone, erected in Parque Rodó in Montevideo. It has been compared to the Tiahuanaco Gateway to the Sun, a cast of which the artist had seen in Paris. The monument is said to have been inspired by pre-Columbian architectonics such as Inca stone masonry and Mayan temples. Here, though, the Mayan glyphs have been transformed into sharp, incised lines that form elemental designs—star, sun, wheel, fish, and mask. The wall eloquently merges Torres-García's philosophies into a powerful visual statement. He has assembled his blocks, now in stone, and inscribed them with stylized shapes. Crowned with three essential geometric shapes of the sphere, cube, and pyramid, *Cosmic Monument* is simultaneously a two- and three-dimensional art form. It is a constructivist tribute to an authentic Latin American art as ancient as pre-Columbian stonework and as cutting edge as the dramatic shadows cast by the Montevideo sun.

—Marianne Hogue

TORRES LLORCA, Rúben

American painter and sculptor

Born: Havana, Cuba, 3 March 1957; moved to the United States, 1993. **Education:** Escuela de Artes Plasticas de San Alejandro, Havana, 1972–76; Instituto Superior de Arte, Havana, 1976–81. **Career:** Worked as a curator. Traveled to Mexico, 1980s. **Awards:** Premio 13 de Marzo Universidad de la Habana, 1983; first prize, best national curator, Associacion Internacional de Criticos de Arte, 1990; fellowship award, Mexico City, 1991.

Individual Exhibitions:

1990	*La trampa,* Centro Cultura Ciudad de Buenos Aires
1991	Ninart Centro de Cultura, Mexico City
1992	*Historias de amor y de muerte,* Ninart Centro de Cultura, Mexico City
1993	*La mistica de las afueras,* Galeria Expositum, Mexico City
1995	Galeria Ambrossino, Coral Gables, Florida
1996	*El laberinto,* Center of Fine Arts, Miami
	Galería Ramis Barquet, Monterrey, Mexico
1997	*Fill in the Blanks,* Monique Knowlton Gallery, New York
1998	Galería Brücke, Buenos Aires
	El Museo del Barrio, New York (installation)
	Frederic Snitzer Gallery, Miami
2000	Freites-Revilla Gallery, Miami

Selected Group Exhibitions:

1986	*Second Biennial of Havana*
1990	*Kuba O.K.,* Stadtische Kunsthalle, Dusseldorf, Germany
1991	*El collage contemporaneo,* Centro Cultural Arte Contemporaneo, Mexico City
1992	*La decada prodigiosa,* Museo del Chopo, Mexico City
1993	*The Narrative in Latin American Art,* Center of Contemporary Art, Miami
1994	*Cinco artistas cubanos,* Galeria der Brucke, Buenos Aires
1995	*Expo arte Guadalajara '95,* Guadalajara, Mexico
1997	Monique Knowlton Gallery, New York

Publications:

On TORRES LLORCA: Books—*Rúben Torres Llorca,* exhibition catalog, Mexico City, Ninart, 1991; *Rúben Torres Llorca: Historias de amor y de muerte,* exhibition catalog, Mexico City, Ninart, 1992; *Cinco artistas cubanos,* exhibition catalog, Buenos Aires, Der Brücke Ediciones, 1994; *Rúben Torres Llorca,* exhibition catalog, text by José Bedia, Monterrey, Mexico, Galería Ramis Barquet, 1996; *Rúben Torres Llorca: ''Gotan,''* exhibition catalog, Buenos Aires, Der Brücke Ediciones, 1998. **Articles—**''Rúben Torres Llorca: So Quiet in Here'' by Tom Lavazzi, review of a site-specific installation, in *Art Papers,* 23(1), January/February 1999, p. 57; ''Rúben Torres Llorca: Freites-Revilla Gallery'' by Francine Birbragher, in *Art Nexus* (Colombia), 35, February/April 2000, pp. 139–141.

* * *

Rúben Torres Llorca has been associated with the development of the new Cuban art of the 1980s generation, a group of artists who were educated entirely under the revolution and who became associated with a particularly extraordinary period of artistic production on the island. They represented a pluralism of trends that originated with a series of important group projects, beginning with *Volumen I* in Havana in 1981 that included series of performances, films, and exhibitions. Their work demonstrated the young artists' interest in kitsch, Afro-Cuban rituals, nationalism, and the United States. All of the artists were intent on finding new definitions for their own particular style of art as Cuban.

Travel to Mexico in the 1980s introduced Torres Llorca to a new art market and to a new artistic environment. He was particularly impressed with Mexican religious art, and the incorporation of popular arts and crafts that is so prominent in his work was undoubtedly inspired by that trip and subsequent visits. His career breakthrough came at the Second Biennial of Havana in 1986 with a four-yard-long patchwork collage titled *Te llevo bajo mi piel* (1985; ''I Carry You under My Skin'') that brought together his interest in Cuban popular culture and advertising aesthetics. The progression from painting to sculpture and object constructions began with the inclusion of objects into his paintings and wall pieces. He was soon constructing altars and complete environments for his objects, both found and made by hand and including letters and writing from everyday phrases and magazines. With the accumulation of objects his sculptures and installations became more kitschy and conceptually more complex. Although he enjoyed traveling and the privileges of the artist in the 1980s, the Cuban political, social, and economic situation did not sustain interest or support for the arts in the 1990s, and Torres Llorca, like so many of the group, left to live in exile in Miami.

The Cuban fascination with American films, cartoons, pop art, and advertising that began with his early projects and paintings in Havana is still very much a part of Torres Llorca's work. He has come to be recognized as the artist who not only explored significant aspects of Cuban culture, including Afro-Cuban aesthetics, the Catholic religion, and social mores, but who also incorporated the effects of American and international culture on Cuban taste into his work. He has continued to work in this manner, expanding his interests to life in Miami.

A clever carpenter, woodworker, and artisan, Torres Llorca easily bridges the gap between the fine arts/high art associations of the painter and sculptor and craftsperson. Rooted in popular art forms, his installations and constructions—because they are assemblies of parts, his sculptures are best described as constructions—exist as freestanding sculptures and wall pieces. Words and objects are often strung together on the wall and range from complex assemblages to minimal commentaries. There is usually a narrative aspect to his work that brings disparate objects together in what he describes as a ''conscious act of magic.'' Each element acts like a word or letter to be read or associated with connotations of magic. The element is taken from religious and political iconography, now stripped of its ideological character to become a new icon. He creates authentic images that are capable of veneration or devotion without the supernatural aspect of formal religion attached.

—Carol Damian

TRUJILLO, Guillermo
Panamanian painter, engraver, and sculptor

Born: Horconcitos, Chiriquí, 11 February 1927. **Education:** Universidad de Panama, degree in architecture 1953; Real Academia de Bellas Artes de San Fernando, Escuela de Cerámica de la Moncloa, and Escuela Superior de Arquitectura, Madrid, 1954–58. **Career:** Professor, department of architecture, Universidad de Panama, beginning in 1959. Founder and director, Taller de Cerámica Las Guabas, Universidad de Panama, 1981–84. **Awards:** Third prize Manuel Amador Guerrero, Panama, 1953; first prize Comisariía de Ordenación Urbana de Madrid, 1956; Premio Creación Nuestra Señora de Guadalupe, Madrid, 1957, 1958; Premio de Adquisición de la Esso, El Salvador, 1965; second prize, 1968, first prize, 1970, 1973, 1974, *Xerox,* Panama. Order of Arts and Letters, Ministry of Culture of the Republic of France, 1990.

Individual Exhibitions:

1956	Clan Bookshop, Madrid
1957	Buchols Bookshop, Madrid
1958	Fernando Fe Gallery, Madrid
1959	National Museum, Panama City
1960	Gibco Gallery, Panama City
1961	Organization of American States, Washington, D.C.
1962	Panamanian Art Institute (PANARTE)
1964	Petite Galerie ''Eleven to Eleven,'' Miami
1967	Institute of Contemporary Art, Lima, Peru
	PANARTE
1968	PANARTE
1969	Organization of American States, Washington, D.C.
	PANARTE
1971	U.S.I.S. El Muro Gallery, Panama City
	El Morro Gallery, San Juan, Puerto Rico
1973	National Institute of Culture and Fine Arts, Caracas, Venezuela
	Luis Angel Arango Library, Bogotá
1974	National Palace of Fine Arts, Mexico City
	Estructural Gallery, Panama City
1975	Arvil Gallery, Mexico City
	Etcetera Gallery, Panama City
1976	PANARTE
1977	PANARTE
1978	Reolero S.A. Gallery, San José, Costa Rica
1979	Etcetera Gallery, Panama City
1980	Modern Art Gallery, Santo Domingo, Dominican Republic
1981	ArteConsult Gallery, Panama City
1982	ArteConsult Gallery, Panama City
1984	Forma Gallery, Miami
	Nader Gallery, Santo Domingo, Dominican Republic
1985	ArteConsult Gallery, Panama City
1986	Museum of Contemporary Art, Panama City
1987	Habitante Gallery, Panama City
1988	Museum of Costa Rican Art, San José
1990	Elite Fine Art, Coral Gables, Florida
1992	Elite Fine Art, Coral Gables, Florida
1993	Elite Fine Art, Coral Gables, Florida
1995	Elite Fine Art, Coral Gables, Florida

1997 Rufino Tamayo Museum, Mexico City (retrospective)
1998 Elite Fine Art, Coral Gables, Florida
 Legacy Fine Art, Panama City
2001 *Guillermo Trujillo, Ten Years of Painting, 1990–2000,*
 Museum of Latin American Art, Long Beach,
 California

Selected Group Exhibitions:

1964 Central America Pavilion, World's Fair, New York
1965 *Art of Latin America since Independence,* Yale Univer-
 sity, New Haven, Connecticut, and University of
 Texas, Austin
1967 *Biennial Art Exhibition,* São Paulo
1973 *Homage to Picasso,* Organization of American States,
 Washington, D.C.
1981 *Eight Expressions,* ATLAPA Convention Center, Pan-
 ama City
1985 *New Space,* ArteConsult Gallery, Panama City
 Museum of Contemporary Art, San Salvador, El
 Salvador
1991 *Latin American Spectrum,* Elite Fine Art, Coral Gables,
 Florida
1996 *Pintores panameños,* Casa de las Americas, Madrid
1998 *Bienal internacional de arte Cumaná,* Museum of
 Contemporary Art, Cumaná, Venezuela

Collections:

Museo de Arte Moderno, Argentina: Biblioteca Luis Angel Arango, Bogotá; Museo de la Tertulia de Cali, Colombia; Casa de las Américas, Havana; Museo de Arte Contemporáneo de San Salvador, El Salvador; Museo de Arte Contemporáneo, Panama; Museo del Hombre Panameño, Panama; Museo de Arte Moderno, Panama; Museo Nacional de Panama; Museo de Arte Moderno de Santo Domingo, Dominican Republic; Pan-American Union, Washington, D.C.; Museum of Modern Art of Latin America, Washington, D.C.; Yale University, New Haven, Connecticut.

Publications:

By TRUJILLO: Book—*Diseños autóctonos: Aves y fauna marina en la cerámica pre-hispánica panameña,* second edition, Panama, Editorial Universitaria, 1976.

On TRUJILLO: Books—*10 Artists of Panama,* exhibition catalog, Washington, D.C., Pan-American Union, 1953; *Trujillo* by Pedro Luis Prados, Caracas, Venezuela, Graficas Armitano, 1990; *Guillermo Trujillo: Retrospectiva,* exhibition catalog, text by Ramón Oviero, Panama, Museo de Arte Contemporáneo, 1993; *Guillermo Trujillo: Mito y metamorfosis,* exhibition catalog, text by Raquel Tibol, Mexico City, Fundación Olga y Rufino Tamayo, 1997.

* * *

Guillermo Trujillo can be seen as a sort of Wifredo Lam of Panama, given that he has developed a formal language appropriated from European modern masters as an instrument to reinterpret his native tropical landscape as well as the spiritualist forces and aesthetic makeup of local indigenous cultures. Because of his many followers and his talent both protean and innovative, he can also be said to be the most influential artist in twentieth-century Panama.

Trujillo was born and raised in a humble coastal village of the westernmost province of Chiriquí, surrounded by the lush vegetation that has always been one of his biggest sources of inspiration. Once he graduated as an architect in the early 1950s, he spent the rest of the decade in Madrid, where he mainly studied ceramics and landscape painting and design. Back in his own country, he taught university students for many years and founded two workshops of historic importance, one for ceramics and the other for etching, that benefited scores of young artists.

Trujillo has fruitfully explored all of the traditional arts, most especially painting, and has been a pioneer of engraving, ceramics and bronze sculpture, and tapestry in Panama. He is a consummate draftsman and restless experimenter, and his first important paintings appeared in the early 1970s, inspired by techniques, motifs, myths, and rites of the Kuna Indians, such as their funeral and festive songs, *nuchos*, or ceremonial canes, and *molas*.

Trujillo's scenes became populated by much of Panama's rural and urban contemporary society, merged with figures from pre-Columbian mythology and a tightly organic hybridization of the animal, botanical, and human realms. Compositional and chromatic variations evolved through the process of perfecting his intricate technique were related to tapestry making. His technique consists of "knitting" with paint by applying a seemingly infinite series of lines that intersect with one another and intertwine in various planes, generating a contradictory sensation of thick lightness. In addition, underlying every surface are several broadly painted areas and color patterns that are sensed rather than actually seen by the spectator, much like *molas*, whose complex method of superimposition also constitutes a strong influence in Trujillo's work. In the 1990s his long, vertical figures–at the same time human, animal, and plantlike–which seem to sprout from the soil, sometimes abandon their characteristic rigidity to levitate and jump in every direction of the canvas. His paintings have undergone two other significant changes: the switch from oil to acrylic, which has increased their luminosity, and the use of substantially enlarged formats.

Trujillo's art is an homage to the seductive mysteries of life and to the communion of humankind and the natural realm. He mocks and criticizes the powerful in Panama, but most of all he captures the gregarious spirit that animates this society and does so with an acute sense of humor, eroticism, fantasy, playfulness, sarcasm, and affection. His oeuvre is a powerful example of the thriving crossbreeding that can take place between cultures and epochs, so thriving that it resounds in the vocabulary and the spirit of countless Panamanian artists of different generations.

—Adrienne Samos

TSUCHIYA, Tilsa
Peruvian painter

Born: Maria Tilsa Tsuchiya Castillo, Supe, 24 September 1932.
Education: National School of Fine Arts, Lima, 1954–59; Ecole des Beaux Arts, Paris, 1960–64. **Family:** Married Charles M. Midelet in

1963 (separated mid-1970s); one son. **Career:** Lived in Paris, mid-1960s; set up studio in Lima. **Award:** Premio Tecnoquímica, Instituto de Arte Contemporáneo, Lima, 1970. **Died:** 22 September 1984.

Individual Exhibitions:

1959	Instituto de Arte Contemporáneo, Lima
1966	Galería Cimaise, Paris
1968	Instituto de Arte Contemporáneo, Lima
1970	Instituto de Arte Contemporáneo, Lima
1972	Gallery Carlos Rodriguez Saavedra, Lima
1975	Ars Concentra, Miraflores, Peru
1976	Galería Camino Brent, Lima
1980	Galería Enrique Camino Brent, Lima
1981	Banco Popular del Peru
1984	Sala de Arte Petroperu, Lima

Selected Group Exhibitions:

1976	Galería Astrolabio, Lima
1979	*XV Biennal of São Paulo,* Brazil
1987	*Art of the Fantastic: Latin America, 1920–1987,* Indianapolis Museum of Art (traveling)
1995	*Latin American Women Artists, 1915–1995,* Milwaukee Art Museum (traveling)

Publications:

By TSUCHIYA: Book—*Tilsa: Mitos,* Lima, Galería de Arte, 1976.

On TSUCHIYA: Books—*Tilsa–XV Bienal de São Paulo,* exhibition catalog, text by Carlos Rodriguez Savedra, Peru, Instituto Nacional de Cultura, 1979; *Tilsa,* exhibition catalog, Lima, Galeria de Arte, Enrique Camino Brent, 1980; *Tilsa Tsuchiya* by Jorge Eduardo Wuffarden, Peru, LL Editores, 1981; *Tilsa Tsuchiya* by Eduardo Moll, Lima, Editorial Navarette, 1991; *Noé delirante* by Arturo Corcuera, Lima, Walter Noceda, 1998. **Articles**—''El mundo mitico de Tilsa Tsuchiya'' by Jorge Bernuy Guerrero, in *La Prensa,* 8 July 1980; ''Tilsa: Un mito en la pintura'' by Elvira de Gálvez, in *El Comercio,* 30 September 1984.

* * *

Tilsa Tsuchiya is respected in Peru as one of the most original painters of the rich world of legend and myth that has resided in the Andes for centuries. Combining the European experience of surrealism with that of her own unique mixture of Chinese, Japanese, and Peruvian heritage, Tilsa, as she was affectionately known, created exquisite canvases of lush surfaces and meticulous details. As a student she learned about the dominant trends of modernism, including abstractionism and expressionism, as well as the realistic and sensitive depictions favored by the *indigenismo* movement that had an impact in many areas of Latin America with large indigenous populations. The *indigenismo* writers and artists celebrated the dignity of the native people, often looking to the Mexican muralists for inspiration. Even before the sojourn in Paris from 1960 to 1964 that marked her artistic advancement to a mature style, Tsuchiya was already experimenting with poetic reevaluations of the formal qualities of her compositions in still life arrangements based on the Spanish *bodegón.* Beginning with items placed in careful relationships and depicted as flat areas of muted tonalities, the *bodegón* quickly lost definition as an ordinary grouping of household jars and pitchers and assumed a shadowy quality that gave an air of mystery to the most banal of subjects. Mysterious interplays of shape and form, both real and imagined, are characteristic of her mature work. Upon her return from Paris the *bodegón* was supplanted by surreal compositions featuring armless figures and mythical landscapes inspired by the Andes.

Tsuchiya's encounter with surrealism, already in its last phase in Paris, liberated her work from its formalist and academic restrictions and brought forth the world of shadows and mystery that seemed to have been lurking in her psyche from the very beginning. She embarked upon a series of works commemorating Andean art and culture with images that appear as ancient as the stories that inspired their very existence. Although she never claimed to be reinterpreting or depicting actual myths or personages, knowledge of pre-Inca and Inca mythology and objects of the archaeological record informed her work. Andean people created their first deities of stone and rock, while natural phenomena were revered as sacred. There was also a complex Andean pantheon of nature deities, dominated by an earth mother who appears often in Tsuchiya's work as an armless figure hovering above the landscape. Numerous armless females float in her imaginary world and pay tribute to the power of the female and to the spirits who dwell in her domain.

Borrowing design elements of flat and sinuous patterns and demonic figures combined from animal, bird, and human forms from the stone carvings, textiles, and ceramics of the ancient Andean culture area, Tsuchiya created figures emerging from the mist of an imaginary setting and the vaporous and mysterious shadows that shroud Inca cities built high in the Andes. It is this combination of stylistic and symbolic devices cultivated from the variety of sources that are a part of her own heritage and feminine intellectual experience that distinguishes the work of Tsuchiya. More than a surreal rendering of indigenous subjects, her paintings draw upon the legends of the past to visualize a world of dreams beyond the imagination.

—Carol Damian

TUFIÑO, Nitza
American painter, muralist, and printmaker

Born: 1949. **Education:** Hunter College, New York; Academia de San Carlos, Mexico City, B.F.A. **Family:** Daughter of Rafael Tufiño, *q.v.* **Career:** Muralist, including murals at El Museo del Barrio, New York, 1973, and Metropolitan Transit Authority Arts for Transit Program, New York, late 1980s and early 1990s. Member of the board of trustees and employee, El Museo del Barrio, New York; member, artist workshop Taller Boricua, New York.

Selected Group Exhibitions:

1992	Hudson River Museum, New York
1998	Central Connecticut State University, New Britain
	Vista Boricua, Macy Gallery, New York
	Invested Vision, National Arts Club, New York (traveling)
2000	Taller Boricua, New York

Publications:

On TUFIÑO: Books—*In Plural America: Contemporary Journeys, Voices and Identities,* exhibition catalog, text by Stephanie French and Leigh A. Bayne, New York, Hudson River Museum, 1992; *Nitza Tufiño, Visual Artist* by Linda Goode-Bryant, in *Artist and Influence New York City,* n.p., 1994.

* * *

Nitza Tufiño has had lifelong contact with art in the studio of her father, Rafael Tufiño, in San Juan, Puerto Rico. Her formal studies took place at the Academia de San Carlos in her native Mexico City. A printmaker and muralist, she has favored linoleum block prints and ceramics in her work. After completing her studies, she joined the Taller Boricua (Puerto Rican Workshop) in East Harlem, New York, where she began to produce silk screen posters and prints that prominently featured motifs based on rock reliefs of the Taino people, the principal civilization of Puerto Rico at the time of the arrival of the Spaniards. She has used this iconography consistently, together with the Afro-Puerto Rican coconut masks of the *vejigante* revelers. (The term derives from the *vejiga,* or ''bladder,'' that masked figures use to tease and hit women and children during their outings at the feast of Saint James in the town of Loiza Aldea.)

Tufiño's mural projects in New York City, which have made her work extensively known, can be found at the Third Street School of Music, La Guardia Community College, the Metropolitan Hospital Pediatric Wing, the New York Board of Education, El Museo del Barrio, and the Bronx Museum for the Arts. Her images of tropical fruits, Taino reliefs, *vejigante* masks, and other symbols are emblems that assert the racial and cultural roots of the Puerto Rican and trans-Caribbean community in the United States. She proceeds by filling the pictorial surface with small-scale images that conform to a species of tapestry and recall the *horror vacui* strategy of naive art. Yet the effect is sophisticated and poignant. In some mural commissions she has worked with children to produce ceramic plaques for communal spaces. The New York Metropolitan Transit Authority granted her three commissions for murals in subway stations. Her best-known work is a ceramic mural, *Boriken* (1990), at the 103rd Street and Lexington Avenue station, the portal to El Barrio, or East Harlem, the main Puerto Rican enclave in New York.

Tufiño has been a constant collaborator with the Taller Boricua, a community-based art workshop in El Barrio. Founded in 1969, the workshop has become a major force in the recovery of East Harlem from the social evils that plague this community and other underserved Latino enclaves. Taller Boricua artists have taken up the combination of aesthetics and politics that defined the first stirrings of modernism in Puerto Rico in the 1950s. Like Chicano artists in the 1960s and 1970s, Tufiño and the other members of the workshop have been involved in reclaiming their heritage and asserting their identity. Her Taino and Afro-Puerto Rican motifs are intended as a means of making an art that symbolizes the enduring presence of the centuries-old artistic tradition of an uprooted people.

Tufiño has also worked for El Museo del Barrio, established in 1970, where she also has served as a member of the board of trustees. Taller Boricua and El Museo del Barrio are the benchmark institutions in the struggle to reclaim and validate the Puerto Rican/Latino/Caribbean cultural experience and expression. Tufiño has used her art as means of creating beauty and of asserting alternative voices. Her late work, a portfolio of digital images and poetry, forms part of the Taller Boricua's *Alma Boricua Portfolio,* an effort to bridge the cultural and digital divide of the East Harlem community.

—Marimar Benítez

TUFIÑO, Rafael
American painter, engraver, and poster artist

Born: Rafael Tufiño Figueroa, Brooklyn, New York, 30 October 1922. **Education:** Studied with Spanish painter Alejandro Sánchez Felipe; Academy of San Carlos, Mexico, 1947–49. **Military Service:** U.S. Army, 1943–46. **Career:** Worked for painter Juan Rosado; book illustrator, Community Education Division, Department of Education; artist, Graphic Arts Workshop of the Institute of Puerto Rican Culture; director, Division of Community Education, San Juan. Cofounder, Centro de Arte Puertorriqueño, San Juan, Puerto Rico, 1950, and Taller Boricua, New York City, 1970. **Awards:** La Peria, Centro de Arte Puertorriqueño, March 1951; painting award, Ateneo Puertorriqueño, San Juan, 1952, 1957; fellowship, John Simon Guggenheim Memorial Foundation, New York, 1954, 1966; Crystal Apple Award, City of New York, 1999.

Individual Exhibitions:

1963	*Nuevos grabados,* Galeria Colibir, San Juan
1974	Instituto de Cultura Puertorriqueña, San Juan (retrospective)
2001	*Rafael Tufiño, pintor del pueblo,* Museo de Arte de Puerto Rico, San Juan, (retrospective)

Selected Group Exhibitions:

1989	*The Latin American Spirit: Art & Artists in the U.S.,* Bronx Museum, New York
1990	Puerto Rican Center for the Arts, New York
2000	*National Masters,* Galerías Prinardi, San Juan
2001	*Treasures of Puerto Rican Painting,* Museo de Arte de Puerto Rico, San Juan

Collections:

Metropolitan Museum of Art, New York; Museo del Barrio, New York; Library of Congress, Washington, D.C.; Instituto de Cultura Puertorriqueña, San Juan; Museo de Historia, Antropología, y Arte, University of Puerto Rico; Cooperativa de Seguros Múltiples de Puerto Rico; Museo de Arte de Puerto Rico, San Juan; Museo de Arte de Ponce, Puerto Rico.

Publications:

By TUFIÑO: Book—*Nuevos grabados,* with René Marques, San Juan, Galeria Colibir, 1963. **Book, illustrated**—*Luis Palés Matos* by Luis Palés Matos, San Juan, Instituto de Cultura Puertorriqueña, 1975.

On TUFIÑO: Books—*Plenas* by Tomás Blanco, San Juan, Editorial Caribe, 1955; *Spiks* by Pedro Juan Soto, Mexico, Los Presentes, 1956;

Yerba bruja: Portada de Rafael Tufiño by Juan Antonio Corretjer, Guaynabo, Puerto Rico, n.p., 1957; *Rafael Tufiño,* exhibition catalog, text by Manuel Cárdenas Ruiz and Eugenio Fernández Méndez, San Juan, Instituto de Cultura Puertorriqueña, 1974; *Una luz para todos,* exhibition catalog, New York, Puerto Rican Center for the Arts, 1990. **Film**—*Tufiño: Una vida para el arte, un arte para la vida* by Edwin Reyes, Puerto Rico, Creativos Asociados, 1996.

* * *

Born in Brooklyn to Puerto Rican parents, Rafael Tufiño received his first lessons in art from Spanish artist Alejandro Sánchez Felipe in San Juan and pursued professional studies at the Academia de San Carlos in Mexico under José Sánchez Morado. Tufiño was one of the founders of the Centro de Arte Puertorriqueño in San Juan in 1950 and of the Taller Boricua in New York City in 1970. He contributed prints to the two portfolios edited by the Centro de Arte Puertorriqueño in 1950 and in 1951–52. His *Cortador de caña* (''Canecutter'') of 1950 is a linoleum-block print, a technique that Tufiño mastered in Mexico and that he taught his fellow artists to use.

Tufiño worked at the Community Education Division (CED) of the Department of Education, where he did illustrations for books, notably *Los casos de Ignacio y Santiago* (1953; ''The Stories of Ignacio and Santiago''), with fellow artist José Meléndez Contreras, which both artists edited as a separate portfolio of linoleum-block prints. It was the first of what became an important genre in Puerto Rican printmaking—portfolios based on literature. Tufiño collaborated with Lorenz Homer in the *Plenas portfolio* (1953–54), a set of prints with the music and stanzas of a *plena* as well as a linoleum-cut illustration on the picaresque story of this popular Afro-Puerto Rican dance form. Tufiño also did several medium- to large-scale paintings for a movie on the *plenas,* produced by the CED, which have been assembled as a mural at the Luis A. Ferro Performing Arts Center in San Juan. He executed another of his portfolios, *El café* (1953–54; ''Coffee''), when he received a Guggenheim Fellowship. In his portfolios and other prints, Tufiño emphasized the beauty of the people, a characteristic of the artist's empathy with the subjects he depicted.

Tufiño also worked at the Graphic Arts Workshop of the Institute of Puerto Rican Culture (ICPR), where he designed posters, illustrated books, and contributed drawings and prints for their cultural publication *Revista.* A friendly competition between Tufiño and Homar, the director of the Graphic Arts Workshop, pushed each artist to produce ever more excellent designs. Of particular importance are Tufiño's illustrations for the ICPR edition of Luis Palés Matos's *Tún tún de pasa y grifería,* an extraordinary book of poems that exalt Afro-Puerto Rican culture and heritage.

No less important than the prints and posters are Tufiño's paintings. Although he experimented briefly with abstract art, his work is eminently figurative and based on cityscapes, still lifes, and portraits. In contrast with the figurative *criollista* painters who depicted rural genre scenes and whose work is based on nostalgia and paternalism, the work of Tufiño evidences his identification with the plight of his people. In the rendition of this reality, the audience is confronted with the difficult conditions of Puerto Rico in the 1950s. Far from being a political artist, in the manner of Carlos Raquel Rivera, the paintings of Tufiño bear witness to the resilience and self-respect of poor people; the portrait of his mother *Goyita* (1957) is an impressive image of the strength and dignity of Puerto Rican women. In his paintings of San Juan, the artist has captured the beauty and

elegance of the colonial city without giving in to idealization or sentimentalism. Tufiño's work bears witness to his profound identification with his country and became a paradigm for succeeding generations of artists, in Puerto Rico and in New York City, where he often traveled and resided sporadically.

—Marimar Benítez

TUNGA
Brazilian painter, sculptor, and installation artist

Born: Antonio José de Barros de Carvalho e Mello Mourão, Palmares, Pernambuco, 1952. **Education:** Studied architecture, Universidade Santa Ursula, Rio de Janeiro, 1974. **Career:** Worked for *Malasartes* magazine and the periodical *A Parte do Fogo,* Rio de Janeiro, 1974. **Award:** Prize, *Triennal latinoamericana de arte sobre papel,* Buenos Aires, 1986; Hugo Boss Prize, 2000; award finalist, Solomon R. Guggenheim Foundation, 2000. **Agent:** Luhring Augustine Gallery, 531 West 24th St., New York, New York 10011.

Individual Exhibitions:

1974	Museu de Arte Moderna, Rio de Janeiro
1975	Museu de Arte Moderna, Rio de Janeiro (installation)
1976	Galeria de Arte Luisa Strina, São Paulo (installation)
1979	Centro Cultural Candido Mendes, Rio de Janeiro (installation)
	Núcleo de arte contemporânea, João Pessoa, Brazil (installation)
1980	*Camere incantate,* Palazzo Reale, Milan (installation)
	Espaço Arte Brasileira Contemporânea, Rio de Janeiro
1981	Gabinete de Arte Raquel Arnaud, São Paulo
1982	Centro Cultural Candido Mendes, Rio de Janeiro (installation)
1984	*Arte brasileira atual: 1984,* Galeria de Arte UFF, Niterói, Brazil
1985	Gabinete de Arte Raquel Arnaud, São Paulo
	Galeria Saramenda, Rio de Janeiro
1986	Museu de Arte UFMT, Cuiabá, Brazil
	Galeria Saramenha, Rio de Janeiro
1989	Whitechapel Gallery, London
	Galeria Paulo Klabin, Rio de Janeiro
	Lezarts and Through, Kanaal Art Foundation, Kortrijk, Belgium (with Cildo Meireles)
	Option 37: Tunga, Museum of Contemporary Art of Chicago
1990	The Third Eye Center, Glasgow, Scotland
	Pulitzer Art Gallery, Amsterdam
	Interceptions, The Power Plant, Toronto
1991	*Preliminares do palindromo incesto,* GB Arte, Rio de Janeiro, and Galeria Millan, São Paulo
	Award Mario Pedrosa
1992	*Sero te amavi,* Galeria Saramenha, Rio de Janeiro, and Galeria André Millan, São Paulo
	Antigas minúcias, Galeria Lê & Marília Razuk, São Paulo
1994	Galeria de Arte Luisa Strina, São Paulo

Tunga: *True Rogue,* **1998. Photo courtesy of Luhring Augustine and the artist.**

1994	Galeria André Millan, São Paulo	1985	*Escultura 85,* Museo Ambiental de Caracas, Venezuela
	Galeria Paulo Fernandes, Rio de Janeiro		*Transvanguarda e cultura,* Museu de Arte Moderna do
1995	*Installations and Sculptures,* The Contemporary Art		Rio de Janeiro
	Institute, New York		*Contemporary Art of Brazil,* Hara Museum of Contem-
1997	Morumbi Fashion, São Paulo (performance)		porary Art, Tokyo
	Museum of Contemporary Art, Miami	1990	*Transcontinental—Nine Latin American Artists,* Ikon
	Center for Curatorial Studies Museum, Bard College,		Gallery, Birmingham and Cornerhouse, Manchester,
	Annondale-on-Hudson, New York (retrospective)		England
1998	Luhring Augustine Gallery, New York	1992	*Latin American Artists of the Twentieth Century,*
1999	Christopher Grimes Gallery, Los Angeles		Estación Plaza de Armas, Seville, Spain (traveling)
	Galeria Luisa Strina, São Paulo, Brazil	1993	*100 años de arte moderna,* Coleção Sergio Sahione
	Galeria Millan, São Paulo, Brazil		Fade, Museu de Belas Artes, Rio de Janeiro
2001	Galerie Nationale du Jeu de Paume, Paris	1994	*Call It Sleep,* Witte de Withi Center for Contemporary
			Art, Rotterdam, Netherlands
		1995	*Bienal del barro,* Museo de Arte de Caracas, Venezuela
		1998	*Etre Nature,* Fondation Cartier pour l'art contemporain,

Selected Group Exhibitions:

			Paris
1975	*Panorama da arte atual,* Museu de Arte Contemporânea		Luhring Augustine Gallery, New York *Amnesia,* Track
	de São Paulo		16 and Christopher Grimes Gallery, Santa Monica
1981	*16 International Biennial São Paulo* (installation)		

2000 *Untitled (Sculpture),* Luhring Augustine Gallery, New
 York
 Biennale d'art Contemporaine de Lyon
 Brasil 500 Anos, Parque Ibirapuera, São Paolo

Publications:

By TUNGA: Books—*O mar a pele,* with Ronaldo Brito and Arthur
Omar, n.p., Pano de Pó, 1977; *Tunga: Barroco de lírios,* exhibition
catalog, São Paulo, Cosac & Naify Edições, 1997.

On TUNGA: Books—*Tunga,* exhibition catalog, Chicago, Museum
of Contemporary Art, 1989; *Tunga,* exhibition catalog, Glasgow,
Scotland, Third Eye Centre, 1990; *Désordres: Nan Goldin, Mike
Kelley, KiKi Smith, Jana Sterbak, Tunga,* exhibition catalog, Paris,
Galerie Nationale du Jeu de Paume, 1992; *Body to Earth: Three
Artists from Brazil,* exhibition catalog, Los Angeles, Fisher Gallery,
University of Southern California, 1993; *Tunga, 1977–1997,* exhibi-
tion catalog, text by Emilia Maury and Moraima Márquez Zerpa,
Caracas, Venezuela, Museo Alejandro Otero, 1998; *Etre Nature,*
exhibition catalog, Paris, Fondation Cartier pour l'art contemporain,
1998; *Tunga,* exhibition catalogue, Paris, Galerie Nationale du Jeu de
Paume, 2001. **Articles**–''Documenta 10: priorite au debat d'idees''
by Catherine Francblin and Jean Yves Jouannais, in *ART PRESS,* June
1997, pp. 34–42; ''Not the UN'' by Kim Levin, in *The Village Voice,*
July 22, 1997, p. 77; ''Tunga: 1977–1997'' by Ken Johnson, in *New
York Times,* November 14, 1997; article by Reinaldo Laddaga, in *Art
Nexus,* January-March, 1998, pp. 48–53; ''Tunga's Lost World'' by
Roni Feinstein, in *Art in America,* 86(6), June 1998, p. 84; ''Tunga:
Exhibit'' by Eduardo Aquino, in *Parachute* (Canada), 90, April/June
1998, pp. 52–54; ''Tunga'' by Elisa Turner, in *Art News,* 97(7),
summer 1998, p. 162; review by Kristin M. Jones, in *Artforum,*
summer 1998, pp. 137–38; ''Teoria Dell'Eccesso'' by Federico
Chiara, in *Italian Vogue,* September, 1998, pp. 594–99, 616; ''Amne-
sia'' by Michael Darling, in *Art Issues,* September/October, 1998, p.
37; ''Amnesia'' by Christopher Miles, in *Flash Art,* October 1998, p.
81; ''Tunga'' by Ken Johnson, in *New York Times,* October 16, 1998;
''Art Choices'' by Kim Levin, in *The Village Voice,* October 21–27,
1998; article by Jan Avgikos, in *Artforum,* December 1998, pp.
128–29; ''Tunga: Twisted Cigars, Straight Smoke'' by Nelson Aguilar,
in *Art Press* (France), 249, September 1999, pp. 20–25; article in
Frieze, Issue 48, September-October, 1999, p. 112; ''Untitled (sculp-
ture)'' by Rex Weil, in *Art News,* 99(5), May 2000, pp. 229–30;
''Amnesia'' by Holland Cotter, in *New York Times,* February 11,
2000, p. E37; ''Guggenheim Finalists'' by Carol Vogel, in *New York
Times,* June 30, 2000; article in *Art Journal,* Morin, France, fall,
number 3, 2000, pp. 4–17; ''Tunga: Instauration of Worlds'' bu Suely
Roknik, translated by Surpik Angelini, in *ArtLies,* fall 2000; ''Tunga:
Christopher Grimes'' by Peter Frank, in *Art News,* 100(4), April
2001, p. 150; ''Tunga: Centro Cultura Banco do Brasil'' by Rex Weil,
in *Art Nexus,* 41(3), 2001.

* * *

Antonio José de Barros de Carvalho e Mello Mourão, known as
Tunga, belongs to the younger generation of artists who have fol-
lowed in the steps of the Brazilian neoconcrete movement headed by
people like Lygia Clark and Hélio Oiticica. Tunga's work, like that of
his predecessors, operates within the notion of the art object as having
a presence. The artwork is seen not as an object per se but in terms of
the physical relationship it establishes with the spectator so as to
create an awareness of that person's body and of the space that
surrounds it. His work is closely related to the psychoanalytical
notion of the object as an element of transition and interaction
between the body and the outside world, leading him to convey the
contingency of the art object and to subvert its autonomy and
integrity. These concerns have led Tunga to work mostly with
sculpture, even though his efforts extend well beyond its domain, and
he has moved into performance, painting, installation, film, video,
photography, writing, and drawing to form a hybrid body of work that
stresses the idea of the art object as a process in constant evolution.

Apart from the inevitable adherence to the ideas and work of his
neoconcrete predecessors, particularly Clark and Sérgio de Camargo,
Tunga's early work was influenced by such artists as Joseph Beuys
and Robert Morris. His first works in leather, felt, and rubber bear
witness to this affinity, which, however, is not only grounded in his
use of materials but also in a vision of sculpture that goes be-
yond its physical volumes and monumentality to engage the
spectator's participation.

From the early 1980s onward, Tunga's art acquired a distinct
personality, and since then it has developed into a unique body of
work that defies traditional taxonomies. The diversity of materials
and mediums that is present in his work could be said to define it; his
work exists through this seemingly haphazard combination and
recombination of materials, objects, and even people. Wood, leather,
clay, sand, steel, copper, gold, silver, lead, silk, water, magnets,
mercury; objects of all kinds–lamps, wigs, hats, ribbons, white shirts,
sponges, lanterns, thermometers, suitcases; and people–the body is a
key element in his work–make up the artist's peculiar inventory.
Nonetheless, there are persistent strategies rather than structures in
his work. But the material also seems to be a conducting one in
Tunga's work and is indicative of the fluidity of a body of art in which
the object is only a transition toward the next one. This appears
recurrently in his snakelike sculptures, for example, *A vanguarda
viperina* (1985; ''A Viperine Avant-Garde''), and in others that
allude to human and animal hair, such as *Tranças* (1983; ''Tresses''),
Pente (1984; ''Scalp''), and *Xipófagas capilares* (1985; ''Capillary
Siamese''). Another of these strategies is his use of the mirror image
and the symmetry it affords. Related to this is the idea of the double
and also that of the ''shape of the void'' in relation to the body, of
which his *Eixos exóginos* (1986- *ca* 1996; ''Exogenous Axes''), a
series of wooden columns that seem to pivot around the axis defined
by the void left by a bodily presence, is a good example.

Finally, there is one strategy in particular that betrays the legacy
of neoconcretism in Tunga's work. This is the use of the topological
figure, be it the torus or the Möbius strip so dear to Clark. Topology,
not only as it refers to forms but also in the mathematical sense that
involves space and time, is present throughout Tunga's art. One of his
most eloquent works in this regard is $\bar{A}o$ (1981), an installation using a
film of the Dois Irmãos Tunnel in which a loop of the film turns the
tunnel into a never ending one, a topological figure. In this sense
Tunga's work is a sort of circular continuum, like a loop in which
objects from previous works or the works themselves reappear in
others and in which narratives are intertwined to blur the boundary
between fact and fiction. Even the figure of the artist as author
disappears as the artist himself becomes the protagonist of his
own fictions.

—Julieta Gonzalez

U-V

UGALDE, Gastón
Bolivian painter, sculptor, and installation artist

Born: 1946. **Career:** Lived in Washington, D.C.

Selected Group Exhibitions:

1997	*6th bienal de la Habana,* Havana
1998	*1st Biennial of Mercosul,* Porto Alegre, Brazil

Publications:

By UGALDE: Book—*La Paz: CDXLII aniversario,* La Paz, Municipalidad, 1990.

On UGALDE: Book—*El fin de los margenes,* exhibition catalog, by Fernando Casás and Juan Cristóbal McLean, Santiago de Chile, Museo de Arte Contemporáneo,1996. **Article**—''Painting from under the Volcano'' by Susana Torruella Leval, in *Art News,* 84, March 1985, p. 141.

* * *

Gastón Ugalde's work is most notable for its political foundations. His installations, sculptures, and paintings critique social and political conditions in both his native Bolivia and the United States but at the same time display a distinctive aesthetic sensibility. Ugalde's style is impulsive and gestural, and he often creates his art from nontraditional media, ranging from shredded newspapers to videos to huge pieces of cloth.

Ugalde's commitment to using art as a form of political protest has its roots in the broader social tradition of Bolivian art. His forebears were members of the Bolivian Generation 52, a group of young artists who came of age after Bolivia's revolution of 1952. Painters such as Miguel Alandia Pantoja and Gil Imana conceived of themselves as vanguard artists engaged in the forging of a national identity through their production of visual arts for the people. But Ugalde grew up in a markedly different sociopolitical climate. A military coup ousted Bolivia's revolutionary government in 1964, and Ugalde and others of his generation grew up in the coup's aftermath. Ugalde came to view art as a means of direct protest against a repressive regime rather than as a more abstract form of social commentary.

Inequalities or injustices constitute the bulk of Ugalde's subject matter. In his 1997 installation, for example, which was included in the *Sixth Havana Biennial,* Ugalde explored the plight of Andean women victimized by both the Bolivian government and the modern drug trade. The multimedia installation, titled *March for Life,* commemorated a protest by *coqueras,* Andean women who cultivate cocoa on their mountain garden plots. While cocoa leaves have been a sacred and vital part of Andean culture for hundreds of years, the cocaine trade—and the Bolivian government's sometimes brutal efforts to stamp it out (often at the behest of the United States)—has wreaked havoc on these women's traditional way of life. Outraged by the disintegration of their culture, the *coqueras* held a march to demand a return to their ancestral farming. Ugalde's *March for Life* documents this protest through three media. The centerpiece of the installation was a 20-by-6-foot length of cloth on which the protesters had left their footprints. Ugalde superimposed an outline drawing of Christ crucified on the footprints. On a second wall of the installation, Ugalde played a color video of the march. The third wall displayed a text laying out the background to the march and a narrative description of the protest.

Ugalde has not limited his focus solely to injustice in Bolivia. He has lived in Washington, D.C., and has used the political and social events of that city—and the United States as a whole—as the basis for several works. In *Monument to Northeast I* and *Monument to Northeast II,* Ugalde drew attention to Washington's racial and economic divides. In both works he applied bold lines of paint across maps of the city. The slashes of paint demarcate the districts of the city. Ugalde depicted an angry white face peering down from the Northwest district and a Christlike black figure in the Southeast. In *The White House with a Hungry Man,* Ugalde portrayed a hunched figure weighed down beneath the White House. The man and the building are surrounded by slashed lines and smeared paint. Ugalde's choice of materials further reinforces the underlying message that his work is less about the aesthetics of art than the politics. His pieces have often incorporated unconventional mixed-media elements—sometimes simply whatever he happened to have on hand when the mood struck.

—Rebecca Stanfel

VAISMAN, Meyer
Venezuelan painter, sculptor, installation artist, and performance artist

Born: Caracas, 23 May 1960. **Education:** Parsons School of Design, New York, graduated 1983. **Career:** Codirector, International with Monument gallery, New York City, 1980s; worked as a critic and curator. Has lived in New York, Caracas, and Barcelona.

Individual Exhibitions:

1986	Jay Gorney Modern Art, New York
1988	La Jolla Museum of Contemporary Art, California
1989	Jablonka Galerie, Köln, Germany
1990	Sonnabend Gallery, New York
	Waddington Galleries, London

Jay Gorney Modern Art, New York
1992 Jason Rubell Gallery, Palm Beach, Florida
1993 *Meyer Vaisman,* Centro Cultural Consolidado, Caracas
1994 *Turkey,* Galerie Daniel Templon, Paris
 Editions Julie Sylvester, New York (with Thomas
 Struth)
1996 *Green on the Outside/Red on the Inside (My Parents'
 Closet)* (installation), 303 Gallery, New York
1999 Galeria Camargo Vilaça, São Paulo
2000 Gavin Brown Enterprises, New York

Selected Group Exhibitions:

1984 *Alice Albert, Peter Nagy & Meyer Vaisman,* Interna-
 tional with Monument Gallery, New York
1987 *Currents: Simulations, New American Conceptualism,*
 Milwaukee Art Museum
1990 *Figuring the Body,* Museum of Fine Art, Boston
1992 *Quotations: The Second History of Art,* Aldrich
 Museum of Contemporary Art, Ridgefield,
 Connecticut
1993 *Contemporary Self Portraits: Here's Looking at Me,*
 Centre D'Echanges de Parrache, Lyon, France
1995 *Ars 95,* Museum of Contemporary Art, Helsinki
1996 *Migration,* Steirscher Herbst 96, Graz, Austria
1997 *No Place (Like Home),* Walker Art Center, Minneapolis
1998 *24th Biennal International,* São Paulo
 Claustrophobia, Ikon Gallery, Birmingham, England

Publications:

By VAISMAN: Book—*Premio Eugenio Mendoza: Sexta edición,*
with Ricardo Alcaide, Caracas, Sala Mendoza, 1992. **Article**—
"Cumulus from America: I Want to Be in America," in *Parkett*
(Germany), 39, 1994, pp. 155–157.

On VAISMAN: Books—*Meyer Vaisman,* exhibition catalog, text by
Trevor J. Fairbrother, La Jolla, California, La Jolla Museum of
Contemporary Art, 1988; *Meyer Vaisman,* exhibition catalog, text by
Isabelle Graw, Köln, Germany, Jablonka Galerie, 1989; *Meyer
Vaisman,* exhibition catalog, London, Waddington Galleries, 1990;
Meyer Vaisman: Obras recientes, exhibition catalog, text by Dan
Cameron and Robert Guevara, Caracas, Centro Cultural Consolidado,
1993. **Articles**—"Who Is Meyer Vaisman?" by Dan Cameron, in
Arts Magazine, 61, February 1987, pp. 14–17; interview with Meyer
Vaisman by Jack Bankowsky, in *Flash Art* (Italy), 147, summer 1989,
pp. 122–123; "Poultryculturalism: Meyer Vaisman Dresses the Bird"
by Jim Lewis, in *Artforum International,* 31, November 1992, pp.
90–91; "Meyer Vaisman" by Christophe Marchand-Kiss, in *Beaux
Arts Magazine* (France), 122, April 1994, pp. 114–115; "Venezia/
Venezuela: A Project for Artforum by Meyer Vaisman," in *Artforum
International,* 33, summer 1995, pp. 82–85, and "Aperto Vene-
zuela," in *Flash Art* (Italy), 198, January/February 1998, pp. 59–61,
both by by Jesús Fuenmayor; "Meyer Vaisman" by Josefina Ayerza,
in *Flash Art* (Italy), 182, May/June 1995, p. 101; "Meyer Vaisman at
303" by Carolina Ponce de León, in *Art in America,* 84, October
1996, pp. 116–117; "Meyer Vaisman: Galeria Camargo Vilaça" by
Bill Hinchberger, in *Art News* (Colombia), 98(11), December 1999,
p. 192; "Meyer Vaisman at Gavin Brown's Enterprise, New York"

by Edward Leffingwell, in *Art in America,* 88(11), November 2000,
p. 162; "Meyer Vaisman: Gavin Brown Enterprises" by Nicolas
Guagnini, in *Art Nexus* (Colombia), 38, November 2000/January
2001, pp. 150–151.

* * *

Meyer Vaisman has produced an extraordinarily diverse body of
work; he began his career as a painter but has since created perform-
ance and installation works, as well as sculpture and wall hangings.
Born in Venezuela, of Ukrainian and Romanian parents, Vaisman has
been living and working in New York City and Barcelona. He has
been a critic and curator, artist and intellectual. In the 1980s Vaisman
served as codirector of the International with Monument gallery in
New York City, where he helped promote artists including Jeff
Koons, Laurie Simmons, and Richard Prince. During that time he
helped launch the neo-geo movement with Koons, Peter Halley, and
Ashley Bickerton. In the 1990s Vaisman became an active part of the
Venezuelan art world, exhibiting his work there and producing pieces
that comment on Venezuelan social realities.

Much of Vaisman's heavily satirical work concentrates on issues
of identity. His piece *Barbara Fischer/Psychoanalysis and Psycho-
therapy* depicts the nude form of the artist's former therapist, seated in
the pose of the Pietà and draped in pink tulle. She wears a jester's hat
and holds in her lap a harlequin's costume, made from the clothing of
the artist's mother and father. The piece is arresting, amusing, and
somewhat repulsive. In another piece from the 1990s, Vaisman
decorated a series of taxidermied turkeys in costumes that suggest
different national or cultural identities—a clever riff on American
iconography, identity, and plurality.

But Vaisman also made work that was a more direct and less
ironic commentary on social and political realities. During the 1990s
he created a series called *The Ranchos,* crude cinder block and cement
shelters. The shelters are a reference to the ranchos or shanties that
cover the hillsides of Venezuela's cities. Vaisman installed various
artifacts from his own childhood home inside these structures. In fact,
one, called *Red on the Outside Green on the Inside,* contains a realistic
re-creation of the bedroom Vaisman occupied in Caracas while he
was growing up. The middle-class comfort of the interior contrasts
sharply with the harsh, humble exterior in a comment on the dramatic
class differences that divide Venezuelan society.

The heterogeneity of Vaisman's work and his intellectual clever-
ness make it impossible to categorize him. At various times we can
see in his work the influences of *arte povera,* conceptualism, installa-
tion and performance art, and the neo-geo movement. Vaisman has
created a body of work that speaks in many different voices from
myriad cultural locations. His has been difficult to place and nearly
impossible to predict.

—Amy Heibel

VALADEZ, John
American painter

Born: 1951. **Education:** East Los Angeles College, c. 1970s; Cali-
fornia State University, Long Beach, B.F.A. 1976. **Career:** Muralist,
including murals for the Federal General Services Administration, El

Paso, Texas, 1991, and the federal courthouse, Santa Ana, California, 1996–98.

Selected Exhibitions:

1985 University Art Gallery, California State University,
 Dominguez Hills
1987–88 *A Sense of Place,* de Saisset Museum, Santa Clara
 University, California, and Fisher Gallery, University
 of Southern California, Los Angeles
1989 B-1 Gallery, Los Angeles
1993 *Art of the Other Mexico: Sources and Meanings,*
 Mexican Fine Arts Center Museum, Chicago
2001 *John Valadez: La Frontera/The Border,* Carnegie Art
 Museum, Oxnard, California
 Mexicanidad, Mexican Fine Arts Center Museum,
 Chicago
 *Arte Latino: Treasures from the Smithsonian American
 Art Museum,* Orlando Museum of Art, Florida

Collections:

Smithsonian American Art Museum, Washington, D.C.; de Saisset Museum, Santa Clara University, California; Carnegie Art Museum, Oxnard, California.

Publications:

On VALADEZ: Books—*Symbolic Realities,* exhibition catalog, Dominguez Hills, California, California State University, 1985; *Sense of Place: D. J. Hall, F. Scott Hess, John Valadez,* exhibition catalog, Los Angeles, Fisher Gallery, University of Southern California, 1987; *Chicano and Latino Artists of Los Angeles* by Alejandro Rosas, Glendale, California, CP Graphics, 1993. **Articles—**''Art with a Chicano Accent. Historical and Contemporary Chicano Art in Los Angeles'' by Steven Durland, Linda Frye Burnham, and Lewis MacAdams, in *High Performance,* 9(3), 1986, pp. 40–45, 48–57; ''A Sense of Displacement. Fisher Gallery, University of Southern California, Los Angeles'' by Nancy Kay Turner, in *Artweek,* 18, 21 November 1987, p. 3; ''Citings from a Brave New World'' by Victor Alejandro Sorell, review of the exhibition *Art of the Other Mexico,* in *New Art Examiner,* 21, May 1994, pp. 28–32.

* * *

Los Angeles artist John Valadez is known for his brightly colored, meticulously executed paintings and murals that explore the dark side of Los Angeles street life. He studied at East Los Angeles Junior College and earned a BFA from California State University, Long Beach. While in school, he was a member of the Mexican American Center for Creative Arts, a theater group that gave performances of plays written by Chicanos in prisons and community centers. He also began to study art at this time and developed a preference for the human figure as well as, in the artist's words, a ''sympathy for people who were having a hard time.'' Valadez collaborated with the artists Barbara Carrasco and Carlos Almaraz on a 1978 production of the musical *Zoot Suit* that involved painting a mural on the walls of the Mark Taper Forum in Los Angeles. During this time he also assisted groups of teenagers in painting a number of public murals that were later destroyed.

Valadez has developed an artistic style unique among Chicano artists, for it consists of extremely detailed, photo-realistic portraits of street people often involved in situations that are hyperrealistic to the point of bordering on fantasy. The 1985 pastel triptych *Beto's Vacation* depicts a series of mysterious scenes of people swimming and boating on the ocean, with a central panel of sharks and other fish leaping out of the water and almost into the boat. There is an undercurrent of threat, although the source of this threat is disturbingly unclear. Like many other Chicano artists of his generation, Valadez was inspired by the work of the Mexican muralists. During the 1960s many Chicano muralists favored scenes of heroes from the Mexican Revolution and mythological characters. In contrast Valadez has taken as his subject matter the people surrounding him every day on the streets of Los Angeles, adding an element of darkness and surrealism reminiscent of the work of Salvador Dalí.

The detail with which Valadez has depicted his subjects' clothing and hairstyles became itself an expression of Chicano pride. The 1983 pastel drawing *La Butterfly* is a half-length portrait of a young Latina woman dressed in the latest street fashion, with exaggerated eye makeup and a low-cut tank top that reveals her butterfly tattoo. Despite the masklike appearance of the woman's heavy eyeshadow, Valadez depicts her in a way that emphasizes her unique beauty and confidence. The Chicano art journal *Chismearte,* published during the late 1970s and early '80s, featured similar illustrations by Valadez of proud and fashionable women of color on the cover of one of its issues devoted to Chicana artists. Valadez often has said that in his attention to detail and ability to depict different types of people from various walks of life, he is constructing a sort of ''Chicano image bank'' to counteract the invisibility of Chicanos in popular culture.

Many consider Valadez's *The Broadway Mural* (1981) to be his crowning achievement. Six feet tall and 80 feet long, it once adorned the walls of the Victor Clothing Company on Broadway in downtown Los Angeles, later becoming part of the collection of Peter and Eileen Norton. The mural simply depicts people walking down Broadway, a street that serves as a commercial center for the Latino community in Los Angeles and is one of the grittiest and busiest streets in the city. Valadez captures with an unflinching eye the jaded countenances of the people on the street as well as the dirt and grime of the buildings and sidewalks. With its celebration of strength in the face of everyday adversity, the mural is considered one of the most important works of the Chicano mural movement. Valadez has continued to produce pastels and paintings and has contributed works to the collections of the Carnegie Art Museum and the Smithsonian American Art Museum, among others.

—Erin Aldana

VALCÁRCEL, Roberto
Bolivian painter and conceptual artist

Born: La Paz, 19 August 1951. **Education:** Studied architecture at University of Darmastadt, Germany. **Career:** Instructor, Universidad Católica and Universidad UPSA. **Awards:** Prize, *Salón ''P. D. Murillo,''* La Paz, 1978, 1979, 1980; prize, *Bienal internacional de dibujo,* Maldonado, Uruguay, 1979; prize, Concurso ''Recuperación del dibujo'' INBO/EMUSA, La Paz, 1987; prize, Concurso Mural Colegio de Arquitectos de La Paz, 1991; prize, *IX bienal de artes*

plásticas, Santa Cruz, Bolivia, 1993; prize, Concurso Arcángeles Contemporáneos, La Paz, 1995. **Address:** Casilla de Correo 5382, Santa Cruz, Bolivia. **E-mail Address:** valc@cotas.com.bo.

Individual Exhibitions:

1984 Museo Nacional de Arte, La Paz
1996 Museo Nacional de Arte, La Paz
 Museo de la Universidad G. R. Moreno, Santa Cruz,
 Bolivia

Fundación BHN, La Paz; Galería EMUSA, La Paz; Galería Arte Unico, La Paz; Sala Guzmán de Rojas, La Paz;

Selected Group Exhibitions:

1979 *Bienal de São Paulo*
1984 *Bienal de la Habana,* Havana
 Museo de Bellas Artes, Santiago, Chile
 Museo Nacional de Arte, La Paz
1992 *Bolivia—Pintura actual,* Exposición de Seville, Spain
1995 *Actualidad en la pintura boliviana,* Casa de América,
 Madrid
1996 *Bolivian Contemporary Art,* Mall Galleries, London
 El fin de los márgenes, Museo de Arte Contemporáneo,
 Santiago, Chile
 Bolivian Art, Americas Society, New York
 Museo Nacional de Arte, La Paz
1997 *Festivales internacionales de Lima,* Peru

Publications:

By VALCÁRCEL: Book—*María Luisa Pacheco, pintora de los Andes,* exhibition catalog, with Valeria Paz, La Paz, La Palelera, 1993.

On VALCÁRCEL: Book—*El fin de los margenes,* exhibition catalog, text by Juan Cristóbal McLean, Santiago, Chile, Museo de Arte Contemporáneo, 1996.

* * *

Bolivian-born artist Robert Valcárcel creates explosive, colorful pieces critical of the Bolivian government. As part of the generation following the subtly critical ''generation of 52,'' he openly addresses the oppression of the government, using performances, events, and used materials to comment on the middle class. Using a hyperrealistic technique, he creates bold representations such as his painting *Artichoke Field* (1981).

Trained as an architect, Valcárcel, who now lives in the Santa Cruz mountains, uses different media to get his ideas across. In 1977 he created the Valcárcel group, an imaginary collection of seven artists in one person (himself). He used this ''organization'' to address issues relating to the role of art and the aesthetic value of certain kinds of art. His works have appeared in the Museo Nacional de Arte (La Paz, 1984 and 1996), as well as in Madrid, Peru, London, New York, Brazil, and Cuba. At once confrontational and forthright, the works of Valcárcel dissect our world. Whether looking at an overblown artichoke field or at a piece designed to construct a ''void''

(showcased at the International Salon of Standards), Valcárcel provokes and stimulates with his wide-ranging touch.

—Sally Cobau

VALDEZ, Patssi
American painter, photographer, performance artist, and installation artist

Born: Los Angeles. **Education:** East Los Angeles College, A.A.; Otis/Parsons School of Art and Design, Los Angeles, B.F.A. *ca.* 1981. **Career:** Cofounder and member, performance art group *ASCO,* Los Angeles, 1971–80; worked as a visual artist in Los Angeles. Artist-in-residence, Self-Help Graphics, Los Angeles, 1989. Visual and cultural consultant for motion-picture and theatre productions. **Awards:** Brody Arts fellowship in visual arts, 1988; Medal of Recognition, City of Nantes, France, 1989; fellowship in painting, National Endowment for the Arts, 1989; grant, Art Matters, 1990; U.S./Mexico artist-in-residence, National Endowment for the Arts, 1994; grant, Durfee Foundation, 1999.

Individual Exhibitions:

1987 Gallery Posada, Sacramento, California
1992 *Distant Memories,* Daniel Saxon Gallery, Los Angeles
1993 *Viva la muerte bella,* Mexican Museum, San Francisco
 Rooms de la vida, Julie Rico Gallery, Santa Monica,
 California
 The Painted World of Patssi Valdez, Boat House
 Gallery, Plaza de la Raza, Los Angeles
 Recent Works, Mars Artspace, Phoenix
1995 *Patssi Valdez: A Room of One's Own,* San Jose
 Museum of Art, California
1996 *Cinco de Mayo Exhibition,* Mexican Cultural Institute
 Gallery, Los Angeles
1999 *A Precarious Comfort,* Laguna Museum of Art,
 Laguna Beach, California, and Mexican Museum, San
 Francisco
 Patssi Valdez: The Living Room, Patricia Correia
 Gallery, Santa Monica, California
2000 *New Work,* Patricia Correia Gallery, Bergamot Station,
 Santa Monica, California

Selected Group Exhibitions:

1990 *Chicano Art: Resistance and Affirmation, 1965–1985,*
 Wight Art Gallery, University of California, Los
 Angeles (traveling)
1991 *Domestic Allegories,* Galeria de la Raza, San Francisco
1993 *Art of the Other Mexico: Sources and Meaning,* El
 Museo del Barrio, New York (traveling)
1994 *Dia de los muertos,* Galeria La Mano Magica, Oaxaca,
 Mexico
 Calaveras pa todos, Mexican Fine Arts Museum,
 Oxnard, California

Patssi Valdez. Photo by Vern Evans. Reproduced by permission.

1995 *Across the Street: Self Help Graphics and Chicano Art in Los Angeles,* Laguna Museum of Art, Laguna Beach, California (traveling)

 Altars, Armory Center for the Arts, Pasadena, California

1996 *Ceremony of Spirit: Nature and Memory in Contemporary Latino Art,* Studio Museum, Harlem, New York (traveling)

 The Mythic Present of Chagoya, Valdez and Gronk, Fisher Gallery, University of Southern California, Los Angeles

1997 *Collaboration and Transformation, Lithographs from Hamilton Press,* Montgomery Gallery, Pomona College, Claremont, California

Collections:

Smithsonian Institution, Washington, D.C.; Laguna Art Museum, California; Tucson Museum of Art, Arizona; Mexican Fine Arts Center Museum, Chicago; Mexican Museum, San Francisco; Plaza de la Raza, Center for the Arts, Los Angeles.

Publications:

On VALDEZ: Books—*Ceremony of Spirit: Nature and Memory in Contemporary Latino Art* by Amalia Mesa-Bains, San Francisco, Mexican Museum, 1993; *Patssi Valdez: A Precarious Comfort,* exhibition catalog, text by Tere Romo, San Francisco, Mexican Museum, 1999. **Articles**—"Patssi Valdez" by Margarita Nieto, in *Latin American Art* (Scottsdale, Arizona), 2(3), summer 1990, p. 9; "Artist Patssi Valdez Final Answers on a Painted Canvas" by Nancy Kapitanoff, in *Los Angeles Times,* 21 March 1992; "Dream Spaces: The Hallucinatory Rooms of Patssi Valdez" by Ann Elliot Sherman, in *Metro Art* (San Jose, California), 2(25), 17–23 August 1995;

"Patssi Valdez at the San Jose Museum of Art" by Anthony Torres, in *Artweek,* 26, October 1995, pp. 20–21; "A Painter's Great Escape," in *Los Angeles Times,* March 1999, and "Patssi Valdez at the Mexican Museum," in *Artweek,* March 1999, both by Lorenza Munoz; "Patssi Valdez at the Mexican Museum" by Juan Rodriguez, in *Artweek,* 30(3), March 1999, pp. 17–18.

* * *

A leading figure in the Chicano art movement, Patssi Valdez has worked in diverse artistic formats, including performance and installation art, painting, and photography. Her teenage years in East Los Angeles, California, in the late 1960s were a time when young Chicanos were pressing for greater civil rights and protesting inferior schools in their neighborhoods. Valdez attended Garfield High School, then a center for these political stirrings and where a nascent Chicano aesthetic sensibility was being forged. A few years after graduating from high school, Valdez, along with artists Harry Gamboa, Gronk, and Willie Herrón, founded the group that they later named ASCO (Spanish for "nausea" or "disgust"), which was dedicated to creative experimentation and to critiquing social and political issues in their work. The group deployed varied artistic strategies, including absurdist performance pieces such as the seminal *Walking Mural* of 1972. Presented on Christmas Eve, it featured Valdez costumed as a liberally interpreted Virgin Mary dressed in black, Gronk festooned as a Christmas tree, and Herrón as a Christ figure. The three paraded as a "mural" down East L.A.'s main commercial artery, Whittier Boulevard, thus satirizing the profusion of murals being painted in their neighborhood. In *Instant Mural* (1974) Gronk simply taped Valdez and colleague Humberto Sandoval to a wall. These ephemeral, essentially urban performance pieces marked ASCO's members as provocateurs who critiqued the norms of the mainstream society that excluded them, even while parodying newly codified models of a Chicano aesthetic.

Valdez left ASCO in 1980 to continue her fine-arts training. Long before then, however, she had created individual works, particularly with the photographic medium. *Downtown Los Angeles* (1983), a hand-colored photo-collage, is a major work from that decade. In it Valdez suggests the significance of the city of Los Angeles to her artistic outlook, showing scenes of friends, relatives, and passersby juxtaposed against the city's skyscrapers and a bridge that spans the Los Angeles River—a physical and symbolic dividing line between East Los Angeles and downtown as well as other parts of the city to the west. In contrast, installations such as *Living Room* and *Little Girl's Room,* both 1999, reflect upon the character and spirit of one's most intimate physical spheres.

Beginning in the late 1980s, Valdez began to also paint. The domestic interiors and still lifes depicted in these works represent a conscious shift from her earlier explorations of the external world and of social issues to considerations of her inner life and personal concerns. These compositions are typically distorted bird's-eye views of rooms and objects depicted with dense, bright colors and strongly outlined forms. Many of the paintings reveal the influence of her Catholic upbringing and feature images of the Virgin Mary as part of home altars surrounded by a miscellany of everyday objects, reminiscent of the 1940s paintings by María Izquierdo. Many compositions of the early 1990s, more secular in subject matter, conjure domestic disharmony: knives and pointed umbrellas hover threateningly; overturning goblets hold bloodred, flamelike forms; and furnishings seem

to swirl anxiously. In the 1990s and early 2000s Valdez lightened her palette, and the domestic scenes express greater tranquility, a move, she has noted, that was prompted by her own growing sense of personal balance and serenity.

Of special importance in Valdez's paintings is her commemorations of womanhood, either through portrayals of Christian virgins, queens, domestic goddesses, or her own self; the latter in probing, close-up painted views of her dramatic visage. Female identity, in fact, has been a leitmotiv for Valdez. She has explored it in myriad ways, beginning with the glamorous if melodramatic persona she assumed for ASCO's performance pieces of the 1970s, to explorations of domesticity in paintings and installations, to canvases portraying woman as spiritual icon. Throughout these works femininity is multivalent, even conflictive in meaning, symbolic of strength and resilience, beauty and desire, and repression and sustenance.

Valdez has also served as a visual and cultural consultant for motion-picture and theatre productions, including the Gregory Nava film *Mi familia* (1995).

—Elizabeth Ferrer

VANEGAS, Leonel
Nicaraguan painter

Born: Managua, 1942. **Education:** Escuela Nacional de Bellas Artes, Managua. **Family:** Married Carolina Selva, two daughters; also had four other children. **Career:** Member of *Praxis,* a group of Nicaraguan painter and sculptors, 1963–72; involved with *Union de Artistas Plásticas (UNAP),* 1980s. **Awards:** *Certamen nacional de artes plásticas,* 1982, 1983, 1984, 1986; Simposio Internacional de Pintura, Casa de la Creación Dzintazi, Moscow, 1983; Orden Independencia Cultural Rubén Darío, Teatro Nacional Rubén Darío, Managua, 1988. **Died:** 7 February 1989.

Individual Exhibitions:

1964	Galería Praxis, Managua
1965	Escuela de Artes y Letras, San Jose, Costa Rica
1966	Escuela Nacional de Bellas Artes, Managua
	Galería Praxis, Managua
1969	Galería Zegri, New York
	Galería XX, Washington, D.C.
1986	Art Gallery of the Asociacion Sandinista de Trabajadores Culturales, Managua (retrospective)
1996	Galería Praxis, Managua (retrospective)
1999	Galería Praxis, Managua

Selected Group Exhibitions:

1963	Galería Praxis, Managua
1964	*Exposición X certamen de cultura,* Dirección de Bellas Artes, San Salvador
	Central American Pavilion, Worldwide Fair of New York
	Socios para el progreso, Kougreshalle, Berlin

1968	Dirección de Bellas Artes de Guatemala
	Pan American Union Pavilion, San Antonio, Texas
	II bienal de Lima
1969	*Exposición de pintura contemporánea centroamericana,* Instituto Italo- Latinoamericano, Rome
1974	*I salón internacional Xerox-74,* Panama
1986	*Certamen nacional,* Managua

Publications:

On VANEGAS: Books—*Leonel Vanegas,* exhibition catalog, text by Pedro León Carvajal, Managua, Galería Praxis, 1996; *El evangelio visible: Rodrigo Peñalba,* exhibition catalog, Managua, Imprimatur Artes Gráficas, 1998. **Articles**—"Al pintor no se debe limitar," in *Novedades,* 1970; "La praxis de Leonel Vanegas" by Napoleón Fuentes, in *Revista Nicarauac,* 7(3), June 1982.

* * *

Leonel Vanegas, who was born in 1942, was one of the most significant painters in modern Nicaraguan history. He is known for a sophisticated style of semiabstract color-field painting that, on the one hand, advanced the "geographical" aesthetic of the Praxis Group and, on the other, promoted the technical lessons of *arte informal* from Spain and elsewhere. After studying with the legendary teacher Rodrigo Peñalba at the Escuela Nacional de Bellas Artes in Managua, Vanegas became a member of Praxis, Nicaragua's leading avant-garde group in the period 1963–72. The group was characterized by a double commitment to vanguard art and to radical politics, both of which were at odds with the Somoza dictatorship during these years. Experimental art and visionary politics thus strongly reenforced each other in the work of Vanegas and others in the period leading up to the Nicaraguan revolution of 1979.

After the victory of the Sandinistas, Vanegas became a stalwart figure in the Unión de Artistas Plásticas (UNAP), which provided artistic leadership throughout the decade of the 1980s. In 1986 he was definitively recognized by his peers as one of the major painters of Nicaragua. The recognition came in two key exhibitions in Managua at the Art Gallery of the ASTC (Asociación Sandinista de Trabajadores Culturales). One involved a retrospective of his paintings, and the other was the National Salon, or Certamen Nacional, at which Vanegas won a first prize in painting from the artists' union.

The Vanegas work awarded one of the top prizes in the 1986 salon is symptomatic of his painting at its most distinguished. It is an oil on canvas that both features allusions to the landscape and then denies any clearly readable sense of a comprehensive landscape. Craggy, suggestive, and brooding in almost equal measures, it is a painting that seems to achieve an organic unity of igneous-like formations with a neosymbolist atmosphere.

In a perceptive review of the 1986 salon, the critic Donaldo Altamirano mentioned the salient traits of the leading paintings in the show, especially the one by Vanegas. He pointed out the deeply resonant spectrum of colors, the shifting sense of humid terrain, and a type of surface animation evocative of something like continental drift, what he called the "metabolismo vivo del paisaje nicaragüense" (the living metabolism of the Nicaraguan landscape). The end result, according to Altamirano, was a "caza de raros enlaces" (search for rare connections). Here and elsewhere the integrity of Vanegas's

Adriana Varejão: Installation view at Lehmann Maupin Gallery, 1999. Photo courtesy of Lehmann Maupin Gallery, New York.

approach to painting was as evident as was his seriouness of artistic purpose. When he died unexpectedly in 1989, UNAP understandably renamed its top prize in painting at the Certamen Nacional the Premio Leonel Vanegas.

—David Craven

VAREJÃO, Adriana
Brazilian painter and installation artist

Born: Rio de Janeiro, 1964. **Address:** c/o Lehman Maupin Gallery, 39 Greene Street, New York, New York 10013, U.S.A.

Individual Exhibitions:

1988	Thomas Cohn Arte Contemporánea, Rio de Janeiro
1991	Thomas Cohn Arte Contemporánea, Rio de Janeiro
1992	Galerie Barbara Farber, Amsterdam
	Galeria Luisa Strina, São Paulo
1993	Thomas Cohn Arte Contemporánea, Rio de Janeiro
1995	Annina Nosei Gallery, New York
1996	Galerie Camargo Vilaça, São Paulo
	Galerie Barbara Farber, Amsterdam
1997	Galerie Ghislaine Hussenot, Paris
1998	Galeria Soledad Lorenzo, Madrid
	Pavilhão Branco, Museu da Cidade, Instituto de Arte Contemporánea, Lisbon
2000	Lehman Maupin Gallery, New York
	BildMuseet, Sweden, and Boras Konstmuseum, Boras, Sweden

	Camargo Vilaça, Rio de Janeiro
2001	Victoria Miro Gallery, London
	Galeria Pedro Oliveira, Porto, Portugal

Selected Group Exhibitions:

1987	*IX salão nacional de artes plásticas,* Fundaçao Nacional de Arte, Rio de Janeiro
1994	*Mapping,* Museum of Modern Art, New York
1995	*Viajeros del sur—Una mirada sobre Mexico,* Museo Carrillo Gil, Mexico City
	TransCulture, XLVI biennale di Venezia, Palazzo Giustinian Lolin, Venice
1997	*Asi esta la cosa: Arte objecto e instalaciones de America Latina,* Centro Cultural Arte Contemporaneo, Mexico City
1998	*O contemporáneo na produçao artistica de Brasil e Portugal,* Centro Cultural São Paulo
	Desde el cuerpo: Alegorias de lo feminino, Museu de Bellas Artes, Caracas
1999	*Cinco continentes y una ciudad,* Museo de la Ciudad, Mexico City
2000	*Ultra Baroque,* Museum of Contemporary Art, San Diego (traveling)

Publications:

On VAREJÃO: Books—*Varejão, A China within Brazil,* exhibition catalog, Amsterdam, Galeria Barbara Farber, 1992; *Terra incógnita,* exhibition catalog, São Paulo, Galeria Luisa Strina, 1992; *Adriana Varejão: Páginas de arte a teatro da história,* exhibition catalog, by Paulo Herkenhoff, Rio de Janeiro, Thomas Cohn Arte Contemporánea,

Adriana Varejão: *Margem (Edge)*, 2000. Photo courtesy of Lehmann Maupin Gallery, New York.

1993; *Pintura/Sutura, Painting/Suturing,* exhibition catalog, São Paulo, Galeria Camargo Vilaça, 1996; *New Art* by M. Murphy Rosana and E. Sinaico, New York, Abrams, 1997; *En carne viva,* exhibition catalog, by Rosa Olivares, Madrid, Galería Soledad Lorenzo, 1998.
Articles—''Adriana Varejão surge no circuito'' by Reynaldo Roels, in *Jornal do Brasil* (Rio de Janeiro), 20 October 1988; ''Adriana Varejão—pintura como fim'' by Lisette Lagnado, in *Galeria* (São Paulo), 11, 1988, pp. 74–77; ''Adriana Varejão, da China brasileira á unificação com o mundo'' by Paulo Herkenhoff, in *Galeria* (São Paulo), 31, 1992, pp. 24–31; ''Adriana Varejão, Serpents, Catheters, and Chinese Porcelain'' by Elizabeth Heilman Brooke, in *Art News* (New York), 6, summer 1993, p. 88; ''Adriana Varejão e os demônios dilacerados'' by Manya Millen, in *O Globo* (Rio de Janeiro), 30 September 1994; ''Adriana Varejão abre mostra na cidade'' by Angélica de Moraes, in *O Estado de São Paulo,* 4 September 1996; ''Adriana Varejão laat zich inspireren door geschiedenis'' by Paola Van de Velde, in *La Telegraaf* (Amsterdam), 19 March 1996; ''A pintura teatral de Adriana Varejão'' by Sabina Deweik, in *Jornal da Tarde* (São Paulo), 7 May 1996; ''Os padrões de pele da pintura/ Adriana Varejão, uma artista brasileira em Lisboa'' by João Pinharanda, in *Público,* 24 April 1998; ''Adriana Varejão'' by José Marin

Medina, in *ABC Cultural* (Madrid), 16 January 1998; ''La poética de Adriana Varejão'' by Fernando Huici, in *El País* (Madrid), 24 January 1998; ''A pintura digere a história'' by Kathia Canton, in *Bravo,* 13, October 1998; ''Uma alma barroca em viagem pelo mundo'' by Luicia Christina de Barros, in *A&D* (São Paulo), 217, February 1998, pp. 20–23; ''Adriana Varejão, the Presence of Painting'' by Stella Teixeria de Barros, in *Art Nexus* (New York), 34, November-January 2000, pp. 48–53.

* * *

Both formally and conceptually, the work of Adriana Varejão pivots on cross-cultural references and around the legacy of cultural exchange experienced in Brazil. Although she draws her subject matter from art history, sociology, and anthropology, the underlying themes of her oeuvre speak to the residual traumas of colonial expansion in the Americas.

Varejão's work can best be described as constructed painting. Using assemblage, juxtaposition, and superimposition, she radically subverts the traditional notions of painting and defies the two-dimensional constraints of modernist formalism. The dramatic and

corporeal quality of Varejão's work bears out her idea that painting is a body in which history, culture, and memory commingle to form a tangible reality.

Much of Varejão's work explores the relationship between sixteenth- and seventeenth-century French, Dutch, and Portuguese art and the sociopolitical symptoms of a colonial legacy. *Mapa de Lopo Homem* (1992; "Map of Lopo Homem") portrays an early sixteenth-century Portuguese map that depicts China and Brazil as a united terrain. The piece refers to Brazil's ties to the former Portuguese colony of Macau in southern China, from which the Portuguese appropriated techniques for making porcelain, tiles, and tattoos. Varejão's oval map is ripped down the middle–like an ethnographic wound–and partially stitched back together, as though an autopsy had been performed on it. The bloody interior revealed by the tear alludes to the violence of colonial Brazil. *América* (1996) depicts the continents as erupting flesh against the hard surface of tiled wall. The interference in the pigmented surface produces spatial ambiguity in the relation between surface and support. The disruption of patterns and the formal slippage replicate the psychosocial metaphors.

"I am interested in verifying in my work dialectical processes of power and persuasion," Varejão has said. "I subvert those processes and try to gain control over them in order to become an agent of history rather than remaining an anonymous, passive spectator. I not only appropriate historic images–I also attempt to bring back to life processes which created them and use them to construct new versions."

In 1928 the Brazilian poet Oswalde de Andrade employed the term *antropofagia* (customarily translated as "cannibalism," a recurring theme of Brazilian aesthetic and cultural theory) to suggest Latin America's ingestion, or co-option, of outside influences. Varejão's hybridization of visual and iconic references–from decorative tile and porcelain patterns, to tattoos, to historical paintings–alludes to the notion of *antropofagia*. Her extensive research into the tangled history of racial and cultural blending and into international exchanges provides her with the diverse visual heritage that refers to the many outside influences Brazilian culture has absorbed and transformed.

Paulo Herkenhoff has described the powerful references in Varejão's work as the "historical forging of bodies during the making of the Americas." In *Carpet-Style Tilework in Live Flesh* (1999) Varejão exposes massive viscera beneath the surface of elaborate blue and white Portuguese tiles, which once again suggests the violence, mutilation, and displacement that underlie the ordered exterior of a culture. In its paradoxical conflation of the beautiful and the abject, her work questions the disconcerting relationship between order and chaos, culture and nature, the colonizer and the colonized.

Formally, Varejão's work melds ostensibly disparate elements, integrating them into a state of pictorial carnality, as if to consummate the very essence of *antropofagia*. In her work the manipulation of illusionism and literalism, memory, emotion, physical pain, and knowledge blend and replicate the way the history dwells in the reality of the human psyche.

—Hitomi Iwasaki

VARGAS, Kathy
American photographer

Born: San Antonio, Texas, 1950. **Education:** University of Texas, San Antonio, M.F.A. 1984. **Career:** Rock-and-roll photographer,

Kathy Vargas: *Self-portrait.* Photo courtesy of the artist.

1973–77; director of visual arts program, Guadalupe Cultural Arts Center, 1985–2000; chair of art music and assistant professor of art, University of the Incarnate Word, c. 2000. Also worked as an instructor of photography, University of Texas, San Antonio, and Healy-Murphy Learning Center; arts writer, *San Antonio Light;* freelance photographer and curator. **Awards:** Grant, National Endowment for the Arts; individual artist's grant, Department of Arts and Cultural Affairs, City of San Antonio, Texas, 1991; fellowship, Light Work, Syracuse, New York, 1994; grant, Mid-America Arts Alliance, 1995; residency, San Antonio, Texas, 1997, and London Studio, San Antonio, Texas, 1997, Pace-Roberts Foundation for Contemporary Art; Artist of the Year, San Antonio Art League Museum, 1998.

Individual Exhibitions:

1984	Galeria Sala Uno, Rome
	Galeria San Juan, Mexico City
	Amerika Haus, Stuttgart, Germany
1985	University of California, Santa Barbara
1988	Univeristat Erlangen-Nurenburg, Erlangen, Germany (retrospective)
1990	Francis Wolfson Art Gallery, Miami-Dade Community College, Miami
1991	Louisiana State University, Shreveport, and University of Texas, El Paso
1993	*Images of Loss and Hope,* Houston Center for Photography, and Galveston Fine Arts Center, Texas

Kathy Vargas: *Broken Column: Mother,* **1997. Photo courtesy of the artist.**

Kathy Vargas: *Miracle Lives, Juanita,* 1997. Photo courtesy of the artist.

1993 Galeria Posada, Sacramento, California
1996 *Miracle Lives,* Galeria Alejandro Gallo, Guadalajara,
 Mexico
 Fotofest 96, Houston
1997 *State of Grace: Angels for the Living/Prayers for the
 Dead,* ArtPace, San Antonio, Texas
2000 *Kathy Vargas: Photographs, 1971–2000,* Marion
 Koogler McNay Art Museum, San Antonio, Texas
 (traveling)

Selected Group Exhibitions:

1987 *Third Coast Review: A Look at Art in Texas,* Aspen Art
 Museum, Colorado (traveling)
1988 *The Presence of the Sublime,* San Antonio Museum of
 Art, Texas, and Tyler Art Museum, Texas
1990 *Mixing It Up,* University of Colorado, Boulder
 Chicano Art: Resistance and Affirmation (CARA),
 Wright Gallery, University of California, Los Angeles
 (traveling)
1992 *From Media to Metaphor: Art about AIDS,* Emerson
 Gallery, Hamilton College, Clinton, New York
 (traveling)
 *The Chicago Codices: Encountering the Art of the
 Americas,* Mexican Museum, San Francisco
 (traveling)
1994 *Contemporary Women Photographers,* Museum of Fine
 Arts, Houston

1995 *From the West,* Mexican Museum, San Francisco
 (traveling)
1996 *Hospice: A Photographic Inquiry,* Corcoran Gallery of
 Art, Washington, D.C. (traveling)
 The Human Condition, San Antonio Museum of Art,
 Texas

Collections:

Smithsonian Institution, Washington, D.C.; Mexican Museum, San Francisco; Museum of Fine Arts, Houston; Art Museum of South Texas, Corpus Christi; San Antonio Museum of Art, Texas; Lightwork, Syracuse, New York; University of Texas, Austin; Casa de las Americas, Havana; Universidad Nacional Autonoma de Mexico, Mexico City; University of California, Santa Barbara; Consejo Mexicano de Fotografia, Mexico City.

Publications:

By VARGAS: Books—*Intimate Lives: Work by Ten Contemporary Latina Artists,* exhibition catalog, with Connie Arismendi, Austin, Texas, Women & Their Work, 1993; *Kathy Vargas 97.1,* exhibition catalog, San Antonio, Texas, ArtPace, 1997.

On VARGAS: Books—*Target, South Texas: Depth of Field,* exhibition catalog, Corpus Christi, Texas, Art Museum of South Texas, 1992; *Aztlán hoy: La posnación chicana,* exhibition catalog, text by Berta M. Sichel, Madrid, Comunidad de Madrid, 1999; *Kathy Vargas: Photographs, 1971–2000* by Lucy R. Lippard and MaLin Wilson-Powell, San Antonio, Texas, Marion Koogler McNay Art Museum, 2000. **Articles**—''Kathy Vargas'' by Shifra Goldman, in *Nueva Luz,* 4(2), 1993, pp. 2–11, 32–33; ''Immortalizing Death–The Photography of Kathy Vargas'' by Diana Emery Hulick, in *Latin American Art,* 6(1), fall 1994, pp. 62–65; ''Kathy Vargas'' by Jeffrey Hoone, in *Contact Sheet,* 85, June 1995, pp. 20–23; ''Photographers Explore a Gentler Way to Die'' by Jay Malin, in *Photo District News,* March 1996, pp. 70–74.

* * *

Although she claimed to have taken her first photograph at the age of 21, Kathy Vargas's relationship with photography began as a child in her hometown of San Antonio, Texas. It was there, under the tutelage of her uncle, that she began to study and hand color his commercial photographs, the latter a technique that she has continued to use. Vargas began her career as a photographer in the documentary tradition, working from 1973 to 1977 as a professional rock-and-roll photographer. Several years earlier, in 1971, while working with special effects at a film production house, Vargas had an epiphany: that photography was the perfect medium for manipulation. Following this artistic revelation, she abandoned commercial work in favor of a style that was far more personal and emotionally evocative. Her work turned inward, and she began to focus on biographical and autobiographical subjects; an example is an early series of black-and-white works in which she documented the household and yard shrines found in the neighborhood where she grew up.

By photographing objects that embody memory, Vargas explained, ''sometimes it is possible to photograph the missing being.'' This is manifest in works that are dedicatory in nature, that function as meditations on death and love, or those that document our mortal coil

by exploring the mystical cycle of life, death, and resurrection. Vargas's photographs allude to paradoxical, dualistic concepts in that they simultaneously reference loss and recovery, absence and presence, birth and decay, disjunction and harmony.

Vargas also obtained inspiration from Latin American magic realism. From this genre of literature she drew the inspiration for layering text and imagery, much like Colombian author Gabriel García Marquez, who connected fantasy and reality through the written word. A symbiotic relationship is formed between text and image in Vargas's photographs, one in which the verbal is in dialogue with the nonverbal. Her hand-tinted photographic montages and still lifes are subtly colored and nearly monochromatic and often employ the process of double-exposure, one that lends an ephemeral, ghost-like quality that elucidates the temporality of time and space. Rather then relying solely upon photographs to convey aspects relating to memory and ritual, Vargas has expanded the medium of photography to include installations, contemporary shrines, and mixed-media art, works in which feathers, wings, hearts, and hands are frequently used leitmotivs.

Pre-Columbian thought and myth also pervades Vargas's work, specifically the notion of duality and the multiple meaning of symbols. In 1987 Vargas studied sarcophagi located at the Mayan archaeological site of Palenque in Chiapas, Mexico, where she admired the manner in which this ancient culture inserted puns and hidden, multiple meanings into its art. In response, she began to conceal deeper, more profound messages beneath deceptively simple images in her photographs, working with a form of image making that appears to exist somewhere in the subconscious. Catholicism ironically also has been an influence on her work. According to Vargas, she was drawn to minimalism because of ''its inherent theme of absence and contemplative concern with time and space,'' attributes that she felt were shared by Catholicism.

Vargas credited artists César Martínez and Mel Casas, whom she met during the mid-1970s while they were members of Con Safo, a San Antonio artist collective, as giving her her ''first break'': she learned from them how to approach art and art making in terms of community. She served as the director of the visual arts program of San Antonio's Guadalupe Cultural Arts Center from 1985 to 2000.

—Kaytie Johnson

VARO, Remedios
Mexican painter

Born: Anglés, Catalonia, Spain, 1908; immigrated to Mexico, 1942. **Education:** Academia de San Fernando, Madrid, 1924; studied in Paris and Barcelona. **Family:** Married 1) Gerardo Lizarraga, 1931 (divorced ca. 1936); 2) Benjamin Péret in 1937 (marriage ended, 1946); 3) Walter Gruen in 1949. **Career:** Moved to Paris, ca. 1937, then to Mexico, 1942. Worked as a commercial illustrator and as a furniture painter, 1940s. Founder, avant-garde artist group *Logocophobics,* early 1930s. **Died:** 1963.

Individual Exhibitions:

1955 Galería Diana, Mexico City
1962 *Oleos recientes de Remedios Varo,* Galería Juan Martín, Mexico City

1964 Museo Nacional de Arte Moderno, Palacio de Bellas Artes, Mexico City
1971 Museo de Arte Moderno, Mexico City
1983 *Remedios Varo 1913/1963,* Museo de Arte Moderno, Mexico city
1985 *Consejos y recetas de Remedios Varo,* Museo Biblioteca Pape, Monclova, Mexico
1986 *Science in Surrealism—The Art of Remedios Varo,* New York Academy of Sciences
1987 Museo Carrillo Gil, Mexico City
1988 Fundación Banco Exterior, Madrid
1989 Museo de Monterrey, Mexico
1991 *Remedios Varo—Arte y literatura,* Museo Provincial de Teruel, Mexico
1992 Casa de Cultura Tomás de Lorenzana, Gerona, Spain Torreón Fortea, Zaragoza, Spain
2000 *The Magic of Remedios Varo,* National Museum of Women in the Arts, Washington, D.Ca. (traveling retrospective)

Selected Group Exhibitions:

1936 *Fantastic Art, Dada, Surrealism,* Museum of Modern Art, New York
1938 *Exposición internationale du surréalisme,* Galerie Beaux-Arts, Paris
1959 *Primer salón nacional de pintura,* Museo Nacional de Arte Moderno, Palacio de Bellas Artes, Mexico City
1961 *Pintura mexicana contemporánea de la Galería Antonio Souza,* Instituto de Arte Contemporáneo, Lima, Peru
1967 *Frida Kahlo acompañada de siete pintoras,* Museo de Arte Moderno, Mexico City
1973 *El arte del surrealismo,* Museo de Arte Moderno, Mexico City
1978 *Dada & Surrealism Reviewed,* Hayward Gallery, London
1986 *Women Artists of the Surrealist Movement,* City University of New York and State University of New York, Stony Brook
1987 *19a bienal de São Paulo,* Brazil
1991 *La mujer en México,* Centro Cultural/Arte Contemporáneo, Mexico City

Publications:

On VARO: Books—*Remedios Varo,* compiled by Octavio Paz, Mexico City, Ediciones Era, ca. 1966; *Remedios Varo* by Edouard Jaguer, Paris, Filipacchi, 1980; *Science in Surrealism–The Art of Remedios Varo,* exhibition catalog, by Peter Engel, New York, New York Academy of Sciences, 1986; *Unexpected Journeys: The Art and Life of Remedios Varo* by Janet Kaplan, New York, Abbeville Press, 1988; *Remedios Varo: En el centro del microcosmos* by Beatrice Varo, Mexico City, Fondo de Cultural Economica, ca. 1990; *Remedios Varo, 1908–1963,* exhibition catalog, edited by Walter Gruen, Mexico City, Museo de Arte Moderno, ca. 1994; *The Magic of Remedios Varo,* exhibition catalog, Chicago, Mexican Fine Arts Center Museum, 2000. **Articles**—''The Antipodes of Surrealism: Salvador Dali and Remedios Varo'' by Gloria Duran, in *Symposium: A Quarterly Journal in Modern Literatures,* 42(4), winter 1989; pp. 297–311; ''The Art of Remedios Varo: Issues of Gender Ambiguity and

Remedios Varo: *Armonia.* © Christie's Images/Corbis. © 2002 Artists Rights Society (ARS), New York/VEGAP, Madrid.

Religious Meaning'' by Deborah J. Haynes, in *Woman's Art Journal,* 16, spring/summer 1995, pp. 26–32; ''Remedios Varo'' by Marta Rodriguez, in *Art Nexus,* 26, October/December 1997, pp. 135–136; ''Remedios Varo: Tejedoras del universo'' by María Laura Rosa, in *Goya,* 271–272, July/October 1999, pp. 271–278; ''Remedios Varo: National Museum of Women in the Arts'' by Stephen May, in *Art News,* 99(7), summer 2000, p. 213.

* * *

Remedios Varo produced the vast majority of her signature-style corpus during the last 10 years of her life. These works deftly combine aspects of surrealism, alchemy, psychology, humor, and autobiography. They possess depth and subtlety in both technique and subject matter, with the smallest detail painstakingly crafted. Her works abound with multivalent themes disguised as what seem to be obvious subjects. Influenced by Spanish and Flemish masters, she depicted the narrative past and future simultaneously. The visual imagery adopted

by Varo has often been compared to that of the northern Renaissance artist Hieronymus Bosch. The luminous surfaces of her paintings teem with all manner of fantastic mechanical inventions and peculiar modes of transportation, a possible outgrowth of her childhood practice of copying her father's mechanical diagrams.

After attending the Academia de San Fernando in Madrid, Varo married fellow artist Gerardo Lizarraga in 1931. Together they traveled to Paris and then settled in Barcelona, where she first became interested in surrealism. When the Spanish Civil War broke out in 1936, Varo left Lizarraga and fled to Paris with the French surrealist poet Benjamin Péret. There she became a member of the inner circle of the movement. As muse to Péret and an artist in her own right, she participated in surrealist exhibits in Paris, Mexico, and New York. Their relationship endured the Nazi invasion of Paris, an event that led to their escape to Mexico in 1941 along with other exiled European artists.

It was not until her separation from Péret in 1946, however, that Varo embarked upon the serious production of a body of work. It was

Remedios Varo: *Find the Mutant Plants.* © Christie's Images/Corbis.
© 2002 Artists Rights Society (ARS), New York/VEGAP, Madrid.

at this time that Leonora Carrington and Walter Gruen came to figure prominently in her life and work. Carrington, whose paintings share many of the elements of Varo's art, was a kindred spirit and confidant, and Walter Gruen, whom she later married, provided Varo with the freedom to pursue her art in earnest for the first time. Her reputation was unequivocally secured by two solo exhibits, one in 1955 at the Galería Diana and the second at the Galería Juan Martin seven years later.

Varo's deft exploitation of surrealist techniques such as frottage, fumage, grattage, and decalcomania creates visual effects that intensify the otherworldly quality of her narrative images. In her later paintings she effectively adapted some of the basic philosophies of surrealism. She used them as a springboard to produce works that are inhabited by beings and objects that possess a dreamlike quality by virtue of juxtaposition, flotation, or strange means of locomotion. Thus, they convey an innate sense of the merging of the conscious and unconscious, a basic tenet of surrealism.

The personages featured in Varo's narratives are often hybrids who combine human, animal, plant, animate, inanimate, male, or female characteristics. For example, in *The Encounter* of 1962 the protagonist wears a ruffled cloak that resembles veiny leaves. She carries a head hidden in its folds and opens a door behind which stands a leggy owl-faced being, while a small bird peers out from the bottom of her garment. Varo's experience as a costume designer is evident in her theatrical tableaus inhabited by characters wearing impossible masquerades. Often there is a sense of impending metamorphosis in their appearance, and birds, a Jungian symbol of transformation, recur frequently in her oeuvre.

Varo's stagelike interiors are often presented as architectural cross sections of buildings that afford the viewer an intimate glance into the artist's complex psyche. The protagonist in *Celestial Pablum* (1958) sits in a stifling polygonal structure in the clouds, grinding up stardust and feeding it to a caged crescent moon. In this painting, as in many others, Varo gives domestic drudgery a magical twist through the use of fantastic mechanisms.

Varo achieves an unsettled feeling not only through her manipulation of architectural elements but also through a sense of surveillance. The labyrinthine walls in *Hairy Locomotion* (1960) set an ominous tone for this depiction of a girl being pulled into a small, high window where a man lurks. Architectonics elicit an impression of stricture, as does the man's beard, which twines around the young woman, forcing her arms stiffly down to her sides. Whatever the meaning, there is an unequivocal sense of enclosure and isolation prevalent in this and many of her works. The tall, narrow buildings that occupy her canvases, with their arched windows and doorways bathed in shadow, have often been compared to those in the art of Giorgio de Chirico.

The miniature fantasy worlds that fill Varo's canvases have been compared to macrocosms. With an even hand she dispenses references to scientific discovery, music, weaving, and occultism in finely articulated narratives. She plumbs the depths of her psyche, experience, and wit to transform the raw material of surrealist concepts and techniques to create authentic works unique in the history of modern Mexican art.

—Marianne Hogue

VATER, Regina
Brazilian painter, conceptual artist, and video installation artist

Born: Río de Janeiro, Brazil, 1943. **Education:** Universidade Federal, Río de Janeiro, B.A. in architecture; Downtown Video Community Center, New York; studied photography, University of Texas, Austin. **Career:** Assistant director, art agencies DPZ and MPM, São Paulo, Brazil; worked as graphic artist. Moved to the United States, 1973. Since 1985 has lived and worked in Austin, Texas. Artist-in-residence, Museum of Contemporary Art, São Paulo, Brazil. **Awards:** Prize, Hall of Modern Art, New York, 1972; fellowship, Guggenheim Foundation, 1980.

Individual Exhibitions:

1975 Museum of Modern Art, Río de Janeiro
1978 Galería Arte Global, São Paulo, Brazil
1988 Museum of Contemporary Art, University of São Paulo, Brazil
1990 *Videos by Regina Vater,* Upstate Films, Rinebeck, New York
1992 *Artist's Window,* Donnell Library Center, New York
 Solar Grandjean du Montigny, Río de Janeiro
 Galería Paulo Figueiredo, São Paulo, Brazil
 Comigo ninguem pode, Teatro Oficina, São Paulo, Brazil
1993 Southeast Museum of Photography, Daytona Beach, Florida

Carrington & Gallagher Gallery, San Antonio, Texas
1994 *Brazil by Brazilians,* Center for the Arts, San Francisco
1995 *Voices and Visions,* Mexic-Arte Museum, Austin, Texas
SESC Paulista Gallery, São Paulo, Brazil
1997 *Curandarte,* Women and Their Work Gallery, Austin, Texas

Selected Group Exhibitions:

1967 *Paris Biennial*
1976 *Venice Biennial*
1982 *Latin American Women Artists,* Bronx Museum, New York
1984 *Latin Americans Aqui/Here,* Fisher Gallery, University of Southern California, Los Angeles
1992 *America, the Bride of the Sun,* Koninklijk National Royal Museum, Antwerp, Belgium
1993 *Ceremony of Spirit: Nature and Memory in Contemporary Latino Art,* Mexican Museum, San Francisco (traveling)
Ultramodern: Art of Contemporary Brazil, National Museum of Women in the Arts, Washington, D.C.
1994 *Rejoining the Spiritual: The Land in Contemporary Latin American Art,* Maryland Institute, College of Art, Baltimore
1999 *Home Altars: Sacred Space in the Domestic Realm,* John Michael Kohler Arts Center, Sheboygan, Wisconsin
2000 *An Independent Vision of Contemporary Culture 1982—2000,* Exit Art, New York

Collection:

Ruth and Marvin Sackner Collection, Miami Beach, Florida.

Publications:

By VATER: Books—*O que é arte?: São Paulo responde,* São Paulo, Brazil, Massao Ohno, 1978; *Tungo-tungo* (children's book), São Paulo, Brazil, Editora Atica, 1980; *Comigo ninguém pode,* São Paulo, Brazil, SESC, 1995; *The Continent of Ashé, an Essay on "Voices of Color – Art and Society in the Americas,"* New Jersey, Humanity Press International, 1997. **Articles**—"Espiritus Sanus in Terra Sana," in *New Observations* (New York), 1991; "The Poetic and Mythologic Crossroads of Ecological Art," in *Art Journal,* 51, summer 1992, p. 25.

On VATER: Books—*Regina Vater,* exhibition catalog, text by Frederico Morais and Jorge Glusberg, Argentina, n.p., 1977; *Regina Vater: VEART,* exhibition catalog, São Paulo, Brazil, Galeria Arte Global, 1978; *Mixed Blessings: New Art in a Multicultural America* by Lucy Lippard, New York, Pantheon Books, 1990; *Intimate Lives: Work by Ten Contemporary Latina Artists,* exhibition catalog, by Connie Arismendi and Kathy Vargas, Austin, Texas, Women & Their Work, 1993; *Ceremony of Spirit: Nature and Memory in Contemporary Latino Art,* exhibition catalog, by Amalia Mesa-Bains, San Francisco, Mexican Museum, 1993; *Rejoining the Spiritual: The Land in Contemporary Latin American Art,* exhibition catalog, text by Barbara Price, Baltimore, Maryland Institute, College of Art, 1994; *Regina Vater: Retrotempo,* exhibition catalog, by Esther Emilio Carlos, Rio de Janeiro, IBEU, 1995. **Articles**—"Arte Contemporânea"

by Walter Zanini, in *Histori Geral da Arte no Brasil* (São Paulo), 2, 1983; "Latin Americans Aqui/Here" by Shifra M. Goldman, in *Artweek,* 15, 1 December 1984, pp. 3–4; "Regina Vater, Marie-Judite Dos Santos, Catalina Parra: Three South American Women Artists" by Robert C. Morgan, in *High Performance,* 9(3), 1986, pp. 58–62; "Liliana Porter and Regina Vater: Upstairs/downstairs and through the Looking Glass" by Janis Bergman-Carton, in *Women's Art Journal,* 10, fall 1989/winter 1990, pp. 13–18; "On Nationality: 13 Artists" by Lilly Wei, Maurice Berger, Brigitte Werneburg, and others, in *Art in America,* 79, September 1991, pp. 124–131; "Linking Two Artists to Voices and Visions" by Madeline Irvine, in *Austin Statesmen,* 17, February 1997; "Curandart: Seeing through the Jaguar's Eye" by Cari Marshall, in *Austin Chronicle,* 6, June 1997.

* * *

Brazilian Regina Vater has worked in photography, installation, and conceptual art. With a strong interest in environmental issues, she has expressed her concerns in a variety of ways, frequently incorporating sources from African and Native American cultures to show how other societies have lived in harmony with nature. She studied in Rio de Janeiro with the painters Iberê Camargo and Frank Schaeffer. During the mid-1960s she produced a series of dramatic paintings on the plight of women in modern society. At the same time she went through what she described as a *tropicalista,* or pop, phase, marked by references to bright colors and tropical plants.

Around 1971 Vater began working in a more conceptual mode, making a series of sculptures out of knotted ropes entitled *Nós,* a play on the word that in Portuguese means both "we" and "knots." She also staged a happening in São Paulo in which she stopped traffic with a series of ropes in one of the busiest parts of the city, which also happened to be located in the financial district. In the affluent Ipanema neighborhood of Rio she staged another event in which she encouraged passersby to make their own sculptures out of knots. These works were rich with multilayered references to societal conformity and repression. Audience participation possessed a phenomenological quality that was an important aspect of works by Brazilian artists such as Lygia Clark and Hélio Oiticica, whom Vater has cited as sources of inspiration.

In 1973 Vater moved to New York. She had already earned a sizeable reputation for herself in Brazil, having exhibited her work in the São Paulo and Venice biennials. In New York her work underwent a drastic transformation, incorporating aspects of both installation and video. That same year she produced the mail art work *Luxo-Lixo,* also the title of a concrete poem by Augusto de Campos meaning "luxury-garbage" in Portuguese. She photographed garbage produced in the affluent neighborhoods of New York and turned one image into a postcard, creating a biting commentary on wealth creating a vast amount of waste.

Vater's installation and video projects have typically incorporated elements of indigenous Brazilian cultures. She has also included elements of *candomblé,* a religion brought to Brazil by Yoruba slaves that involves the worship of personified forces of nature. Indigenous and Afro-Brazilian cultures assign a great deal of importance to the natural world, and their inclusion in Vater's work is part of a strategy she has used to criticize modern consumer culture. As early as 1970 she had done performances, such as *Magi(o)cean,* in which she and some friends performed an homage to the *candomblé* deities Oxumare and Ogum Beira Mar using garbage collected from Joatinga Beach in Rio de Janeiro. In 1988 she created the work *Snake Nest* for an

installation in Austin, Texas. This work consisted of 88 images of snakes from different cultures arranged in a figure eight that extended across the walls and the floor, illustrating how the snake was a positive figure in many societies, while in Texas it was feared and destroyed.

Later Vater made works that were powerful commentaries on the role of the natural world in modern society. In *Electronic Nature* (1988) she made color photographs taken of animals shown on television nature programs, which were the only way some people ever experienced the natural world. For the *Transcontinental* exhibition she collaborated with Roberto Evangelista on *Nika Uiícana,* an installation in homage to Chico Mendes, the leader of the rubber tappers' union and a rainforest preservation activist who was murdered in Brazil. The work featured feathers gathered from tropical birds hanging from the ceiling and gourds to collect water on the floor. In addition to her artistic work, Vater has taught, given lectures, and curated exhibitions of Latin American art.

—Erin Aldana

VELASCO, José María
Mexican painter

Born: Temascalcingo, 6 July 1840. **Education:** Academia de San Carlos, Mexico City, 1855–58; studied botany, zoology, and physics, Academia de Medicina, Mexico City, 1865. **Family:** Married in 1859; 13 children. **Career:** Professor of landscape perspective, Academia de San Carlos, Mexico City, 1868-c. 1912. Traveled to the United States, 1876, and to Europe, 1889–90. **Awards:** Prize, Philadelphia Centennial Exhibition, 1876; Chevalier d'Honneur award, Universal Exhibition, World's Fair, Paris; first place, Chicago World's Fair, 1893. Decorated by the Emperor of Austria, 1902. **Died:** 25 August 1912.

Selected Exhibitions:

1858	Academia de San Carlos, Mexico City
1859	Academia de San Carlos, Mexico City
1860	Academia de San Carlos, Mexico City
1861	Academia de San Carlos, Mexico City
1864	Academia de San Carlos, Mexico City
1865	Academia de San Carlos, Mexico City
1869	Academia de San Carlos, Mexico City
1871	Academia de San Carlos, Mexico City
1873	Academia de San Carlos, Mexico City
1875	Academia de San Carlos, Mexico City
1876	Philadelphia Centennial Exhibition
1877	Academia de San Carlos, Mexico City
1878	International Exposition, Paris
1879	Academia de San Carlos, Mexico City
1881	Academia de San Carlos, Mexico City
1884	International Exposition, New Orleans
1889	World's Fair, Paris
1891	Academia de San Carlos, Mexico City
1893	World's Fair, Chicago
1897	International Exposition, Nashville, Tennessee
1942	Palacio de Bellas Artes, Mexico City (individual retrospective)
1944	Philadelphia Museum of Art (individual)
	Brooklyn Museum, New York (individual)

Collections:

Museo Nacional de Arte, Mexico City; Museo José María Velasco, Toluca, Mexico; Universidad Nacional Autónoma de México, Instituto de Geología and Instituto de Biología; Museo Nacional de Antropología e Historia, Mexico; Instituto Nacional de Bellas Artes, Mexico; Biblioteca Nacional de Antropología e Historia, Mexico; National Museum of Prague.

Publications:

On VELASCO: Books—*José Maria Velasco 1840–1912,* exhibition catalog, privately printed, 1944; *José Maria Velasco* by Xavier Moyssén Echeverría, Mexico City, Fondo Editorial de la Plástica Mexicana, 1991; *Velasco en blanco y negro,* Toluca, Instituto Mexiquense de Cultura, 1992; *José Maria Velasco: Un paisaje de la ciencia en México* by Elías Trabulse, Toluca, Instituto Mexiquense de Cultura, 1992; *Homenaje nacional, José Maria Velasco* by María Elena Altamirano Piolle, Mexico City, Amigos del Museo Nacional de Arte, 1993; *José María Velasco* by Claudia Ovando and Carmen Cardemil, Mexico City, Instituto Nacional de Estudios Histórica de la Revolución Mexicana, 1998.

* * *

José María Velasco is perhaps the single best-known Mexican artist of the nineteenth century. His vast corpus, comprised of oil paintings, watercolors, drawings, and lithographs, as well as photographs, attests to a prolific and indeed successful career. He entered the Academy of San Carlos at the moment in which the 1843 reforms of the Santa Anna regime had been all but fully enacted. A key reform required that new faculty for the academy be chosen from among European artists. This resulted in the hiring of the Italian landscape artist Eugenio Landesio, who began teaching Velasco and his fellow students in what, in 1858, became the official academic designation of landscape painting. Although landscapes had been produced previously by nineteenth-century academic artists, this new and formal academic track enhanced the status of the genre.

From 1858 on, Velasco and other students of Landesio responded to the pressures of an emergently modern nation by painting images of haciendas for their owners (*Hacienda de Monte Blanco,* with Eugenio Landesio, 1879), national historical themes staged in landscapes (*La caza,* 1865) site-specific images of the city and countryside (*Patio del ex-convento de San Agustín,* 1860, and *Ahuehuetes de Chapultepec,* 1876), the railroad (*Chapultepec visto desde la estación del ferrocarril,* 1878), and, perhaps the best-known, his images of the Valley of Mexico (*Valle de Mexico tomado cerca el panteón de dolores,* 1884). Images of the latter are emblematic of the visual tropes of national identity constructed by artists and writers in the nineteenth century. The image of the Valley of Mexico implicitly inscribed the intertwined ideological pillars of nineteenth-century Mexican national discourse, namely, of modernity and of antiquity (often read then as ''Aztec''). Velasco's paintings could establish the ''exotic'' but accurately rendered flora of Mexico from which the railroads of progress and ruins of ancient high culture could

also emerge (*Cañada de Metlac,* 1897, and *Piramide del sol en Teotihuacán,* 1878).

Velasco also contended with the pressures on a highly devout Roman Catholic working in a nation-state riven since the early nineteenth century by competing political parties, both striving militarily and politically to institute their positions with regard to church and state. The liberal La Reforma and constitution of the 1850s guaranteed the separation of church and state. Yet Velasco, a conservative, clearly inserted his religiosity into his paintings, perhaps best exemplified by some of his images of the Valley of Mexico. In several of these his written descriptions clearly identified the location of the Villa de Guadalupe, which by the nineteenth century had become both a colonial cultural relic and also an emblem of Catholicism (as well as, eventually, his own home). He might locate the villa at the visual center of the painting, and hence the valley, implicitly emphasizing its importance (*Villa del Valle de México tomada desde el cerro de Santa Isabel,* 1877). Ironically, such an image also exemplified Velasco's interest in science and the empirical, both crucial tenets of late nineteenth-century positivist discourse and practice. In the academy catalogs available for viewers at exhibitions, Velasco often narrated his paintings, providing detailed information about the location, weather, time of day, cloud formations, and so on. He carefully and concretely mapped his scene for the viewer, insisting on the "reality" of it. Academic landscape artists in particular were highly trained in the mathematics necessary to produce carefully crafted perspectival views of their subject (the academic rules for the landscape curriculum were drafted in detail by Landesio). Velasco remained committed to an empirical and "documentary" foundation for his works. He continued to use photographs as a basis for his paintings and produced natural studies and copies of pre-Hispanic codices as well as ruins. In 1905, for example, he painted a series of images of land and aqueous environments for the Instituto Geológico de México.

As a basis for imagery, however, this heretofore modern foundation was being roundly challenged in many ways at the end of the nineteenth century. Although Velasco lived into the first decade of the twentieth century and traveled to Europe, the modernist attractions of the formal and the "personal" (rather than the content) that were compelling younger artists around the turn of the century, and especially through their travels to Europe, did not so compel him. By 1912, the year of his death, the director of the academy, Antonio Rivas Mercado, argued that Velasco's teaching methods were anachronistic in order to remove him from his 42-year-long teaching post at the Academy of San Carlos. Ironically, the academic and "anachronistic" foundation of his work was not itself entirely abandoned by his students, who included, for example, Diego Rivera, whose interest in science and the natural world owed a debt to his training with Velasco.

—Stacie G. Widdifield

VÉLEZ, Humberto

Panamanian installation, performance, and video artist

Born: Panama City, 1965. **Education:** Studied law and political science, University of Panama, 1983–89; studied filmmaking, International School of Cinema and Television, Cuba, 1990–92. **Career:**

Documentary filmmaker, educational television channel, Panama; consultant, opening exhibition at Panama Canal Museum; directed social and cultural videos, Diputacio de Barcelona, Spain, 1993–95. Since 1997 has lived and worked in England. Artist-in-residence, Austrian Chancellery, Vienna, 1998, and Triangle Arts Trust-Gasworks Gallery, London, 2001. Art correspondent, art magazine *Talingo,* a division of *La Prensa,* Panama; workshop and seminar instructor, University of Panama and Santa Maria La Antigua University, Panama. **Award:** Grant, New Latin American Cinema Foundation, 1990. **Address:** 1 Totnes Road, Chorlton Cum Hardy, Manchester M21 8XF, England. **E-mail Address:** mulatito@hotmail.com.

Individual Exhibitions:

1996 *El amor,* Museo de Arte y Diseño Contemporáneo, San
 José, Costa Rica
 Lluvia tropical, Aleph Gallery, Panama (video
 installation)
1998 *Traumland/La tierra sonada/Dreamland,* Café Savoy,
 Vienna (video installation)
2000 *Instalaciones,* Museum of Contemporary Art of Panama

Humberto Vélez: *Chaque.* **Photo courtesy of the artist.**

Humberto Vélez: *Poquito.* **Photo courtesy of the artist.**

Selected Group Exhibitions:

1996 *Third International Alternative Video Show,* Barcelona,
 Spain
2000 *Puerto Rico 00,* San Juan
 National Gallery, First Central American Symposium of
 Artistic Practices, Costa Rica
2001 *New Contemporary Panamanian Artists,* Centro Cultural
 Andres Bello, Colombia
 Ventanas, Centro de Arte.Com, Madrid
 Periferic Biennal, Iassi's Turkish Baths, Romania
2002 *III bienal iberoamericana,* Lima, Peru

Collections:

Museum of Contemporary Art of Panama; Museum of the
Panama Canal.

 *

Humberto Vélez comments:

 As an artist in the past, the aim of my work was to reflect on the
concept of non-Western European cultural identities from the point of
view of their own representations as well as from the Western
European perspective. During the development of this theme, I
became interested in the relation between emotions and territories. I
have therefore explored mediums like video, video installation,
installation, photography, and CD-ROM. I have also used disciplines
with different methods like philosophy, psychology, sociology, an-
thropology, linguistics, and archeology.

 * * *

 Like no other Panamanian, Humberto Vélez has produced a
body of work that can aptly be termed conceptual. Rather than
fabricate objects, he transforms them through language and ideas,
much like Joseph Kosuth and Félix González-Torres, two of his
strongest influences. Aware of the ways in which people invest things
and places with meaning and identity, he maintains that a valid artistic
product is one that "projects itself over and beyond any individual
attribute" by suggesting to each spectator an array of connotations
and perspectives that dislodge its specificity.

 In videos, installations, sculptures, digital artwork, and
readymades, Vélez makes use of highly diverse materials and tech-
niques appropriated from both the popular and the high-tech, the
traditional and the contemporary realms. Examples are the works he
created for his 2000 solo exhibition in the Museum of Contemporary
Art of Panama. *Barcelona* was a vinyl curtain showing an idyllic
seashore photographed in Havana, posing the question of who dreams
about whom and where. *The Big Wheel* was a quilt sewn by Kuna
women in the traditional *mola* technique but with a digital pattern
provided by the artist, along with the words of a British pop song.
Love (Illuminated) consisted of neon signs reproducing a small note
found in an attic of an old building. *Merry Britannia* reproduced the
famous ex-royal yacht as a piñata "floating" in a sea of candies.
Poquito a poquito nace un amor bonito consisted of golden, translu-
cent, and amorphous sculptures made with clusters of the little plastic
bags of cooking oil that are consumed by the urban poor in Panama.

 The long sojourns of Vélez in Havana, Barcelona, Vienna, and
Manchester have prompted him to go beyond his early interest in re-
creating, ritualizing, and parodying contemporary social habits and
mores in order to explore the way in which people relate emotionally
and verbally to their corporal, psychic, and geographical territories.
Along these lines, in *Dreamland,* a performance and video installa-
tion presented at Vienna's legendary Café Savoy in 1998 and
reconceived a year later as a CD-ROM, 17 persons (including the
artist) of different nationalities drew, wrote, and recounted in their
mother tongues the primordial scene of their childhood dreams. The
CD-ROM's central page simulates an electrical circuit whereby the
spectator can access the spaces inhabited by each "dreamer," filled
with sounds, images, and words that define aspects of his or her
psyche. Dreams and spaces were also central to *Chaque rêve est un
pays* (Periferic Biennal, 2001), the site-specific installation exhibited
in the antique Turkish baths of Iasi, Romania. A video projecting the
futile wandering of a security guard in the semiabandoned Manches-
ter Baths functioned as a distorted mirror that reflected correspon-
dences and disparities in space and time.

 Seeking to work only with fundamentals in the past few years,
Vélez has created pieces that have undergone a reductive conversion.
The artist's project for exhibition in the III Bienal Iberoamericana de
Lima in 2002 investigates the links between two utopian ideas that
have profoundly shaped Western man's consciousness and actions:
the belief in progress and in romantic love.

 Vélez has been influential with a group of young sculptors,
filmmakers, and photographers who share certain traits. These people
reject the traditional idea of the artist as someone who finds inspira-
tion only in the solitude of his studio. They often choose to work
together, an unusual practice in Panama, and take the local urban and
popular culture as the basis for their art, but they also keep well
informed of innovations on the international scene. Like Vélez, they
reveal an aesthetics closely linked to digital technology as well as to
graphic and industrial design.

 —Adrienne Samos

VENEGAS, Germán
Mexican painter and sculptor

Born: Magdalena Tlatlauquitepec, Puebla, 1959. **Education:** Stud-
ied woodworking, 1974; La Esmeralda, National School of Painting,
Sculpture, and Engraving, Mexico City, 1977–82. **Career:** Worked
in a tapestry studio, 1974; as an engraver, 1970s. Cofounder, Gallery
ZONE: Space of Artists. **Awards:** Honorable mention, *I biennial
Rufino Tamayo,* Oaxaca, Mexico, 1982; honorable mention, drawing
section, Salón Nacional de las Artes Plásticas, Mexico City, 1983;
acquisition painting prize, III Encuentro Nacional de Arte Jóven,
Palacio de Bellas Artes, Mexico City, 1983.

Individual Exhibitions:

1984 Gallery of the Secretary of Hacienda, Contemporary Art
 Gallery, Mexico City
1988 Galería OMR, Mexico City
1990 Parallel Project, New York
1991 Wenger Gallery, Los Angeles
1991–92 Galería OMR, Mexico City

1992 *Polvo de imágenes,* Galería Fernando Gamboa and
 Museo de Arte Moderno, Mexico City
1993 Museo de Arte Contemporáneo, Monterrey, Mexico

Selected Group Exhibitions:

1983 *Los artistas celebran a orozco,* Palacio de Bellas Artes,
 Mexico City
1984 *Pintura narrativa,* Museo Rufino Tamayo, Mexico City
1985 *Joven pintura mexicana,* Pierre Cardin Space, Paris
1986 *Four Contemporary Mexican Painters,* Phoenix Art
 Museum
1988 *Rooted Visions: Mexican Art Today,* Museum of
 Contemporary Hispanic Art, New York
1990 *Out of the Profane,* Adelaide Festival of Arts, Australia
1991 *III bienal de Cuenca,* Ecuador
1992 *Sobre papel,* Galería Metropolitana, Mexico City
 ARCO Fair, Madrid
1995 *Configura 2,* Ekfurt, Germany

Collections:

Marieluise Hessel Collection, Bard College, New York; Museo de
Arte Moderno, Mexico City; Museo de Arte Contemporáneo, Mon-
terrey, Nuevo Leon, Mexico; Metropolitan Museum, New York;
Centro Cultural de Arte Contemporáneo, Mexico City.

Publications:

On VENEGAS: Books—*Germán Venegas,* exhibition catalog, text
by Javier Anzures, Galería Arte Contemporáneo, Mexico City, 1984;
Four Contemporary Mexican Painters, exhibition catalog, Phoenix,
Art Museum, 1985; *17 artistas de hoy en Mexico,* exhibition catalog,
text by Luis Roberto Vera, Museo Rufino Tamayo, Mexico City,
1985; *Mexico, Out of the Profane,* exhibition catalog, text by Charles
Merewether, Adelaide, South Australia, Adelaide Festival of Arts
Inc., 1990; *Germán Venegas: Dibujos 1983–1990,* exhibition catalog,
Mexico City, Galería Omr with Carlos Ashida, 1991; *Out of the
Volcano: Portraits of Contemporary Mexican Artists* by Margaret
Sayers Peden, Washington, D.C., Smithsonian Institution Press,
1991; *Germán Venegas: Polvo de imágenes,* exhibition catalog,
Mexico City, La Sociedad Mexicana de Arte Moderno, 1992; *Sobre
papel,* exhibition catalog, text by Renato González Mello, Mexico
City, Galería Metropolitana with Artes Gráficas Panorama, 1992.
Articles—''Museo de Arte Moderno, Mexico City; Exhibit'' by
Raphael Rubinstein, in *Art in America,* 81, February 1993, p. 119;
''Critics' Choice: Mexico, Germán Venegas'' by Mary Schneider
Enriquez, in *ARTnews,* 92(6), summer 1993, p. 138.

* * *

Like many artists in modern Mexico, Germán Venegas has
drawn on multiple traditions, from the *artesanias* of Mexican villages
to Classical Greece, for his mixed-media compositions. His back-
ground has differentiated him from a large number of these artists,
though; his earliest training was with a wood-carver, a maker of
masks in his home village of La Magdalena Tlatlauquitepec, Puebla.
Only later did he study academically, at La Esmeralda in Mexico
City. This combination of education appears in Venegas's use of oil
paint, wood relief, and paper but does not account entirely for the

amalgam of motifs within his works. Rather, one can look at these
syncretic themes as part of a tradition themselves.

In works from the 1980s, such as *El paraiso perdido* (''Paradise
Lost''), Venegas used bright, garish colors to add a commercial effect
to his modern renderings of biblical themes. In *El paraiso perdido* a
classicized Zeus-like god holds a maquette of a mountain village, his
foot resting on a painted skull, his left hand raised as if in judgment on
the scene below. Beneath, in high gloss relief, a blue boxer faces out,
his fists poised to parry a blow. A mostly naked woman looks back at
the viewer over her shoulder. She only wears black stockings and
silver slides, suggesting that she is a prostitute. Behind her a demonic
figure, part dog, part spider, part serpent, snarls, and another serpent
chokes out Venegas's signature as the woman stomps on his throat.
This mix of modern pop culture, classicism, and Mexican folk art
lacks the irony of works by other contemporary artists such as Rocio
Maldonado. Though a highly skilled execution, the sensibility is that
of a village artisan, one who casts religious themes in vernacular
terms. The effect is similar to paintings by Hieronymus Bosch and
other artists of the Middle Ages; the beasts below recall the grotesque
figures by the Dutch painter and in the margins of Gothic manuscripts.

In the late 1980s and early 1990s Venegas created a series of
large mixed-media and carved wood pieces from an *ahuehuete* tree
given to him by the people of his native village. The tree had died, and
the people asked him to carve new saints for the church; he could use
the remaining wood himself. The resulting pieces evoke tormented
souls, struggle, and despair. He approached the wood as a process of
revealing what already lay within it, but the expressionistic scenes
recall images of the expulsion of Adam and Eve and other Old
Testament themes of judgment, consistent with much of his earlier work.

In later works, such as some untitled lithographs from 1996,
Venegas has turned to pre-Hispanic antecedents. These works on
paper use glyphic forms drawn from Olmec, Mayan, and Egyptian art,
along with his own inventions in the form of ancient friezes. The
synthesis of motifs from Mexican and African sources is more
primitivist than pop, a tendency already seen in the carvings from the
ahuehuete tree. Venegas has continued to mine a variety of art
historical veins in his work, which has been gaining an academic
sophistication in the process.

—Laura J. Crary

VICUÑA, Cecilia
American sculptor, performance, and installation artist

Born: Santiago, Chile, 1948; moved to the United States, 1980.
Education: University of Chile, Santiago; Slade School of Fine Arts,
London, M.F.A. 1971; University College, London, 1972–73. **Fam-
ily:** Married César Paternosto, *q.v.,* in 1981. **Career:** Exiled from
Chile, 1973; lived in London, 1973–75. Festival coordinator, Arts
Festival for Democracy in Chile, Royal College of Art, London, 1974.
Lived in Bogota, Colombia, 1975–80. Designed stage sets for theatre,
Bogota, Colombia, late 1970s. Editor, *Palabra sur* series of Latin
American literature, Graywolf Press, 1986–89. Also a poet. Cofounder,
Artists for Democracy, London, c. 1974. **Awards:** LINE II award,
New York, 1983; Human Rights Exile award, Fund for Free Expres-
sion, New York, 1985; Arts International award, Lila Wallace-
Reader's Digest Fund, 1992; Fund for Poetry award, New York,

1995–96; award, Lee Krasner-Jackson Pollock Foundation, New York, 1995–96.

Individual Exhibitions:

1971	National Museum of Fine Arts, Santiago
1990	*Precario,* Exit Art, New York
1996–97	*Precario,* Inverleith House, Royal Botanic Garden, Edinburgh, Scotland
1998	University Art Gallery, University of Massachusetts, Dartmouth, Massachusetts
1998–99	*Cloud-Net,* Hallwalls Contemporary Arts Center, Buffalo, New York (traveled to DiverseWorks Artspace, Houston, and Art in General, New York)

Selected Group Exhibitions:

1997	*Biennial Exhibition,* Whitney Museum of American Art, New York
1998	*Dangerous Cloth,* American Primitive Gallery, New York
2000	*An Independent Vision of Contemporary Culture 1982—2000,* Exit Art, New York

Publications:

By VICUÑA: Books, poetry—*Saborami,* translated by Felipe Ehrenberg, England, Beau Geste Press, 1973; *Siete poemas,* Bogota, Centro Colombo Americano, 1979; *Precario/Precarious,* translated by Anne Twitty, New York, Tanam Press, 1983; *Luxumei, o, el traspie de la doctrina: Poemas 1966–1972,* Mexico, Editorial Oasis, 1983; *Palabrar mas,* Capital Federal, Argentina, El Imaginero, 1984; *Samara,* Ediciones Roldanillo, Colombia, Embalaye del Museo Rayo, 1987; *La Wik'uña,* Santiago, Francisco Zegers, 1990; *Unravelling Words & the Weaving of Water,* edited by Eliot Weinberger and translated by Weinberger and Suzanne Jill Levine, St. Paul, Minnesota, Graywolf Press, 1992; *Palabra e hilo=Word & Thread,* translated by Rosa Alcalá, Edinburgh, Morning Star Publications, 1996; *The Precarious: The Art and Poetry of Cecilia Vicuña,* edited by M. Catherine de Zegher, Hanover, New Hampshire, and London, University Press of New England, 1997; *Bloodskirt,* translated by Rosa Alcalá, New York, Belladonna Books and Boog Literature, 2000. **Books, edited**—*The Selected Poems of Rosario Castellanos,* with Magda Bogin, n.p., 1988; *A Plan for Escape* by Adolfo Bioy Casares, translated by Suzanne Jill Levine, n.p., 1988; *Altazor* by Vicente Huidobro, translated by Eliot Weinberger, n.p., 1988; *The Cardboard House* by Martin Adan, translated by Katherine Silver, n.p., 1990; *Ül: Four Mapuche poets,* New York and Pittsburgh, Americas Society and Latin American Literary Review Press, 1997. **Article**—''Impossible Weavings,'' in *Parkett* (West Germany), 52, 1998, pp. 191–198.

On VICUÑA: Books—*Voicing Today's Visions: Writings by Contemporary Women Artists,* edited by Mara Rose Witzling, New York, St. Martin's Press, 1994; *Cecilia Vicuña: Cloud-Net,* exhibition catalog, text by Surpik Angelini, Laura J. Hoptman, and David Levi Strauss, New York, Art in General, 1999. **Articles**— ''Cecilia Vicuña'' by Ann Wilson Lloyd, in *Sculpture* (Washington, D.C.), 17(6), July/August 1998, pp. 72–73; ''Cecilia Vicuña: Immaterial Material & Resonant Thread'' by Lois Martin, in *Art Nexus* (Colombia), August/October 1998, pp. 68–72; ''The Politics of Spirituality'' by Jenni Sorkin, in *New Art Examiner,* 26(6), March 1999, pp. 18–22; ''Cecilia Vicuña: Art in General'' by Mary Schneider Enriquez, in *Art News,* 98(8), September 1999, p. 150; ''Cecilia Vicuña and Lenor Malen: Art in General,'' in *Sculpture* (Washington, D.C.), 18(8), October 1999, pp. 75–76.

* * *

Also widely known as a poet and social activist, Chilean-born Cecilia Vicuña is an artist whose works reveal and embody the tremendous power of art. For Vicuña, whose mediums are words and images, art awakens a mysterious dimension of reality. The central element of her visual art is the ''precario,'' a precarious, seemingly unimportant object that, in the artistic universe, directly symbolizes not only the precarious nature of human existence but also the profound fragility of a world in crisis. The etymology of the term ''precarious''—it stems from the Latin word *prex,* which means ''prayer''—is crucial to understanding Vicuña's world view and artistic vision. She interprets human destiny in the wider context of a web that includes forces transcending the human condition, forces to which it is appropriate to address words of prayer.

Aside from the found objects, or *basuritas* (bits of garbage), that Vicuña uses in her art, two major elements are included in her installations and performance art: words and weaving. Weaving is both a poetic and a visual symbol for Vicuña, because it connects her two mediums of artistic expression, language and visual art. The word ''language'' means ''thread'' in Quechua, the ancient language of the Andean people, and ''complex conversation'' means ''embroidery.'' For Vicuña these words have great metaphorical significance. Weaving also has another important meaning. In the Andes finely woven cloth was often interred as offerings to the dead. Such a practice led Vicuña to say, ''to weave is to give light.'' Interestingly, the type of wool used in Andean cloth, which is known for the flowing patterns symbolizing the transience of life, is obtained from the vicuña, a llamalike creature that lives in the Andes, and Vicuña takes the symbolism of her name very seriously. In creating webs encompassing precarious objects, Vicuña draws the viewer's attention to the fact that human beings can never escape—though they often try under the aegis of destructive and thoughtless cultures—the web of the universe, which manifests itself as the ''being and non-being of weaving.''

Born in 1948 Vicuña started working with precarios in the 1960s. In 1966 on a beach near Santiago, she created her first publicized performance work, which included ancient divination rituals and constructions with found objects. In her next installation, *Otono* (1971; ''Autumn''), Vicuña filled an entire room of the National Museum of Fine Arts in Santiago with fallen leaves. Her career in Chile ended abruptly in 1973, when the country's democratically elected government was overthrown and replaced with a military dictatorship. She was able to continue her career abroad, however, establishing herself in New York in 1980. There she has flourished as an artist, poet, and human rights activist.

Vicuña's 1999 installation *Cloud-Net,* which was seen in several U.S. cities, truly epitomizes and crystallizes her complex, and sometimes puzzling, artistic vision. Reminiscent of loosely, almost randomly, arrayed strands of handwoven textiles, this work, in addition to recapitulating the artist's previous variations on the theme of cosmic webs, introduces the symbolism of clouds. Her webs are also

clouds, or cloud-webs. While her original webs recall the powerful and fundamental symbolism of thread, the 1999 installation incorporates the rich symbolism of clouds, the traditional visual context of prophecy, religious visions, and spiritual revelations. With this work, it seems, Vicuña ingeniously addressed the baffling, yet inspiring, complexity of humankind's connection with a mysterious and ultimately inexhaustible and never totally decipherable universe.

While much of Vicuña's work can stand alone, without reference to her poetry, she is a performance artist, and it should be noted that, for some installations, she wears her art and recites her poetry. Vicuña has published many books of her poetry and has performed ''Ritual Readings'' throughout Europe and the Americas. Below is a sample of her written work, as translated by Rosa Alcalá, which in many ways complements and confirms her visual art.

> PALABRA WORD
> E &
> HILO THREAD
>
> Word & Thread
> Word is a thread and the thread is language
>
> Non-linear body
>
> A line associated to other lines.
>
> A word once written risks becoming linear,
> but word and thread exist on another dimen-
> sional plane.
>
> Acts of union and separation.
> The word is silence and sound.
> The thread, fullness and emptiness.

—Christine Miner Minderovic

VINATEA REINOSO, Jorge
Peruvian painter and caricaturist

Born: Arequipa, 22 April 1900. **Education:** Escuela Nacional de Bellas Artes, Lima, 1919–24. **Career:** Art critic, *El Comercio* newspaper; caricaturist, *Mundial* and *Variedades* magazines; instructor, Escuela Nacional de Bellas Artes, Lima, beginning in 1925. **Died:** 15 July 1931.

Selected Exhibitions:

1957 *Exposición retrospectiva de Vinatea Reinoso,* El
 Instituto de Arte Contemporáneo, Lima
1997 *Vinatea Reinoso: 1900–1931,* Sala de Exposiciones de
 Telefónica del Perú, Lima (traveled to Arequipa,
 Peru)

First exhibited in Arequipa, 1917; exhibited many times at Escuela Nacional de Bellas Artes, Lima.

Collections: Museo Banco Central de Reserva del Peru, Lima; Museo de Arte de Lima.

Publications:

On VINATEA REINOSO: Books–*Exposición retrospectiva de Vinatea Reynoso,* exhibition catalog, El Instituto de Arte Contemporáneo, Lima, 1957; *Vintea Reinoso y otros hitos para un gran arte nacional* by Xavier Bacacorzo, Lima, 1966; *Jorge Vinatea Reinoso* by Luis Enrique Tord, Banco del Sur del Perú, Lima, 1992; *Vinatea Reinoso: 1900–1931,* exhibition catalog, text by Luis Eduardo Wuffarden, Telefónica del Perú, Lima, 1997. **Articles–**''Jorge Vinatea Reinoso,'' in *Copé* (Lima), 5(II), 1971, pp. 12–17, and ''Pintura y provincias,'' in *Debate* (Lima), 6, 1980, both by Carlos Rodríguez Saavedra; ''Vinatea Reinoso,'' in *Kantú* (Lima), 5, February 1989, pp. 6–10, and ''Los catálogos de las exposiciones del pintor Jorge Vinatea Reinoso,'' in *Letras* (Lima), 92–93, 1993, pp. 92–107, both by Dora Felices Alcántara; ''Vintea sospechoso'' by Natalia Majluf, in *Arte Actual,* (Lima), September 1995, pp. 42–45.

* * *

Jorge Vinatea Reinoso was a leader of the indigenist school that flourished in Peru in the 1920s and '30s. An outgrowth of the wave of patriotic nationalism that swept Peru after the populist Augusto B. Leguía y Salcedo succeeded the old oligarchic regime in 1919, indigenism sought to forge connections to an idealized version of Peru's precolonial past. With their complex perspectives and structures, subdued colors, and fragmentary brushstrokes that also reflected the influence of French impressionists, Vinatea's paintings depict local subjects and landscapes. An accomplished illustrator, Vinatea also produced caricatures and sketches for popular and artistic magazines.

Born in the southern Peruvian town of Arequipa in 1900, Vinatea demonstrated his artistic talent at a young age. He used watercolors to produce his first landscape painting at age 12 and had his cartoons exhibited in Arequipa at age 17. The following year he moved to Lima and, after a brief stint as a journalist and cartoonist, enrolled in the newly formed Escuela Nacional de Bellas Artes (ENBA). ENBA played a major role in Peruvian artistic life during the period known as the *Oncenio,* the economic and cultural flowering that occurred in Peru under Leguía, and had a profound influence on Vinatea's work. At ENBA Vinatea first became acquainted with the work of another leader of the indigenist movement, José Sabogal. Moreover, under the tutelage of Daniel Hernández, Vinatea refined his painting technique, graduating with the first gold medal awarded by ENBA. While still a student, Vinatea also became the resident caricaturist and artistic director of *Mundial,* a popular magazine founded by Saline Andrés Aramburú.

After his graduation in 1924, Vinatea continued to pursue both of his artistic inclinations. He remained at *Mundial* and continued to amuse and lampoon all segments of Lima's thickly layered and rapidly changing society. Reflecting the influence of Pancho Fierro, Vinatea's cartoons tended toward the gently satiric rather than the caustic. In 1925 Vinatea also took a position as an instructor at ENBA and began a series of journeys back to southern Peru, where he found the buildings and landscapes that he repeatedly made his subjects. In these works Vinatea created idealized representations of indigenous

Andean peoples and society in a fashion that perfectly captured the spirit of his times.

—Rebecca Stanfel

VITERI, Oswaldo
Ecuadoran painter and sculptor

Born: Ambato, 8 October 1931. **Education:** Studied architecture at Universidad Central del Ecuador, Quito, 1951–66; studied under painters Jan Schreuder, Holland, 1954, and Lloyd Wulf, 1955–56; Instituto Superior de Arte, Havana, 1981–83. **Career:** Professor, department of architecture, Universidad Central del Ecuador, 1960–89. Founder, Ecuadorian Institute of Folklore, 1961. Traveled to Spain, 1969. **Awards:** First prize "Mariano Aguilera," Quito, Ecuador, 1960, 1964; honorable mention, Sixth Biennial of São Paulo, 1961; first prize, *Salón bolivariano,* Guayaquil, Ecuador, 1961; fourth prize, *II bienal americana de arte,* Córdoba, Argentina, 1964; fourth prize, *I bienal de Quito,* 1968; first prize, *Salón nacional banco central,* Quito, Ecuador, 1977; national prize "Eugenio Espejo" for the arts, Quito, Ecuador, 1997.

Individual Exhibitions:

1959	Ministerio de Obras Públicas, Quito, Ecuador
1960	J.L. Salcedo Bastardo, Ecuador
1978	Banco Central de Ambato, Ecuador
1988	Museo Rufino Tamayo, Mexico City
1994	Alianza Francesa, Quito, Ecuador

Also exhibited in Columbia and Madrid, 1961.

Selected Group Exhibitions:

1964	*II bienal americana de arte,* Córdoba, Argentina
1966	*Art of Latin America Since Independence,* Yale University, New Haven, Connecticut, and University of Texas, Austin
1968	*I bienal de Quito,* Ecuador
1986	Museo Nacional de Buenos Aires
1989	*Arte en Iberoamérica,* Palacio Velazquez, Madrid Moderna Museet, Stockholm
	Arte latinoamericano, Hayward Gallery, London
1997	Instituto de Artes Visuales El Hueco, Quito, Ecuador

Collections:

Museo del Banco Central, Quito, Ecuador; Museo del Banco Central Guayaquil, Ecuador; Museo de Arte Moderno Latinoamericano, Quito, Ecuador; Biblioteca Luis Angel Arango, Bogotá; Fort Lauderdale Museum of the Arts, Florida; Museo Municipal, Quito, Ecuador; Museo Guayasamín, Quito, Ecuador; Los Angeles Arts and Crafts Museum.

Publications:

By VITERI: Books—*Viteri: Pintores ecuatorianos,* Quito, Nueva Editorial de la Casa de la Cultura Ecuatoriana, 1985; *Viteri,* Mexico, Museo Rufino Tamayo, 1988. **Book, illustrated**—*Estancias del lobo; poesía* by Nogreví Mattallá Golú, Quito, Editiones Rimay, 1966.

On VITERI: Books—*Art of Latin America Since Independence,* exhibition catalog, New Haven, Connecticut, Yale University, 1966; *Arte en iberoamerica, 1820–1980* by Dawn Ades, Madrid, Ministerio de Cultura, 1989. **Articles**—"Oswaldo Viteri" by Walter Engel, in *El Espectador* (Bogotá), November 1962; "La historia olvidada de un pueblo," in *El Siglo* (Bogotá), May 1979.

* * *

Oswaldo Viteri was born in the small Andean town of Ambato in central Ecuador. He was trained as an anthropologist and architect. His work is very anthropological in content; one of his missions as an artist was to seek a revival of Ecuadorean symbols of *Mestizaje,* or mixed heritage, populations. This desire is apparent in his well known assemblages incorporating found objects of material culture. His early work was more of a symbolic expressionist nature using techniques of texture, limited spacing, and contrasting planes and colors.

Viteri began to paint professionally in 1955, though he had painted since he was a young boy. At this time his paintings were figurative but apparently evolved into a symbolist, or expressionist, mode. He painted live models, still lifes, and portraits. In 1955 he studied with the Dutch painter Jan Schreuder, whom Viteri met in Ecuador. He also worked at the studio of Lloyd Wulf, a North American painter, in 1955–56.

It was not until 1960 that Viteri gained his national status as a painter. In that year Viteri won the Grand Prize at the *Mariano Aguilera* salon in Quito with his painting *Man, House, and Moon,* an example of the artist's symbolic expressionistic work. It featured very stark and simple aspects, contrasting thick and smooth paint texturing, and each of the elements well separated into its own space. Also in 1960 Viteri was hired as a professor in the school of architecture at the Central University of Ecuador in Quito, where he taught until 1989.

The following year Viteri began working with Paulo de Carvalho Neto, a Brazilian folklorist, in researching Ecuadorean folklore. Viteri began dedicating more time to his anthropological interests, and he founded the Ecuadorean Institute of Folklore. According to Viteri this experience of direct contact with the physical environment of Ecuador and folk cultures had a long-lasting impact and clarified and enriched his vision of Latin American society. Throughout this time the artist was very much inspired by his ancestral past and his sense of cultural heritage in the present. His paintings began to feature cultural symbols, signs, and iconographic motifs. From the beginning of his culturally influenced work Viteri began receiving national and international acclaim and was awarded a number of important prizes, including honorable mention at the Sixth Biennial of São Paulo in 1961 and first prize in the Salon Bolivariano in Guayaquil, Ecuador. He also exhibited in Colombia and Madrid that year.

In 1963 Viteri began his abstract period. He felt constrained by his symbolic works and came to perceive them as too rigid and structured for his evolving tastes. He began the abstract working only with a ballpoint pen and later with huge spots of color on canvas. Viteri began to seek a synthesis in which he focused more on pre-Columbian themes and continually asked the viewer questions such as "Who are we and from where do we come?" He formed a deep-seated belief that all art should have meaning and content. For this reason he never joined the prominent Grupo VAN, a group of artists of Viteri's generation who were attempting to defend abstraction and

artistic freedom. Viteri dismissed the offer because he did not like groups unless they included a new art form such as cubism or neoplasticism. In 1964 Viteri again won the grand prize at the Salon Mariano Aguilera and was awarded with fouth prize at the Second Biennial of American Art in Cordoba, Argentina.

After a period of gestural abstraction and collage in which there were no motifs of cultural identity, the artist began to work with assemblages. Before the assemblage work began, however, he traveled to Spain to work with a group of Spanish painters in Madrid. Here Antonio Saura, Luis Feito, and Juan Millares influenced him. Once Viteri's interest in the abstract was spent, he returned to Ecuador to undertake a more conceptual search into his questions of cultural identity, and from this the assemblages emerge.

The assemblages incorporated objects drawn from ancestral and folk cultures, objects whose inner life—prior to the work of art—was irreversibly transformed within a new aesthetic, plastic context. These objects—sackcloth, ragdolls, and other found items—acquire new context that is conceptual and time-space related, and they left their own symbolic context from a previous phase of influence as the functional items of Ecuador's indigenous population. An international audience applauded his assemblages, and Viteri won the First Quito Biennial in 1968.

In 1969 Viteri went to Spain to continue working with the assemblages in a new context. Here he struck a friendship with the Jewish/Polish painter Pinchus Maryan. Viteri worked with him and felt his influence in a new neofigurative style while he continued to delve into the assemblage work.

Viteri's work took on a new character after he worked with Maryan, one that includes many emotionally charged ink drawings. During this time of development Viteri's assemblages earned him widespread international recognition for their concept of global *mestization,* the merging of cultures.

Since 1969 Viteri has worked on a number of murals and sculpture projects. He also spends his time traveling and sometimes acting as juror of important national and international arts events and competitions. He has participated in more than 50 individual exhibitions and more than 120 collective shows around the globe.

His assemblages continue to prove very popular. In *America Thirsting Crowd* Viteri glues ragdolls to the surface of an oil painting. The distribution of these dolls across the surface preserves the two-dimensionality of the work and at the same time provides an original solution for the artist's search for his cultural identity. In this sense Viteri continued the ideals and mission of indigenism after the previous generation had faded.

—Daniel Lahodo

VOLPI, Alfredo
Brazilian painter

Born: Lucca, Italy, 1896. **Career:** Moved to Brazil, *ca.* 1898. Worked as an artist, decorator, carpenter, plumber, and wood carver. Joined Grupo Santa Helena, mid-1930s. Traveled to Italy, 1950. **Awards:** Bronze medal, SPBA, 1935; prize of acquisition, *Bienal de Veneza,* Venice, 1952; prêmio de melhor pintor nacional, *II bienal de São Paulo,* 1953; prêmio Governo do Estado, 1955. **Died:** 1988.

Selected Exhibitions:

1938	*Salão de maio,* São Paulo
	I exposição da família artística Paulista, São Paulo
1940	*VII salão paulista de belas artes*
1941	*I salão de arte da feira nacional de indústrias,* São Paulo
	XL VII salão nacional de belas artes, Rio de Janeiro
	I exposição do osirarte
1944	São Paulo
1952	*Bienal de Veneza,* Venice
1953	*II bienal de São Paulo*
1954	National Gallery of Modern Art, Rome
1955	International Display of Pittsburgh
1956	*Exposição nacional de arte concreta,* Museu de Arte Moderna de São Paulo
1957	Museu de Arte Moderna do Rio de Janeiro (retrospective)
1959	Solomon R. Guggenheim Museum, New York
	Bienal of Tokyo
1960	Gallery Bonino
1961	Clube dos Artistas e Amigos da Arte, São Paulo
1963	*Exposição da representação brasileira a XXXI bienal de Veneza,* Venice
	Galeria da Casa do Brasil em Roma, Rome
	Galeria Novas Tendências, São Paulo
	Galeria Studium Generale, Stuttgart
1966	*Premissas 3,* Fundação Armando Alvares Penteado, São Paulo
	Museu de Arte Moderna do Rio de Janeiro

Publications:

On VOLPI: Books—*Retrospectiva Alfredo Volpi,* exhibition catalog, São Paulo, Museu de Arte Moderna, *ca.* 1975; *Volpi,* introduction by Theon Spanudis, Düsseldorf, H. Kruger Verlag, and Rio di Janeiro, Livraria Kosmos Editoria, *ca.* 1975; *Era uma vez, três,* text by Ana Maria Machado, Rio de Janeiro, Berlendis & Vertecchia Editores, 1980; *Volpi, as pequenas grandes obras: Três décadas de pintura,*São Paulo, Raízes Artes Gráficas, 1980; *Volpi, a construção da catedral,* introduction by Olívio Tavares de Araújo, São Paulo, Logos Engenharia, 1981; *Volpi 90 años,* exhibition catalog, São Paulo, Museu de Arte Moderna, *ca.* 1986; *Dois estudos sobre Volpi* by Olívio Tavares de Araújo, Rio de Janeiro, FUNARTE, 1986; *A. Volpi,* São Paulo, Art Editora, 1984; *Volpi, Ianelli, Aldir: 3 coloristas* by Alberto Beuttenmuller, São Paulo, Grupo IOB, 1989; *Volpi: 90 años,* text by Jacob Klintowitz, São Paulo, SESC, 1989.

* * *

Emigrating from Italy to Brazil before his second birthday, Alfredo Volpi grew up in the working-class world of São Paulo. Without academic training, he arrived at painting through his work as a wood-carver, carpenter, and housepainter. In the 1910s and 1920s, while still practicing the craft of the decorative muralist, Volpi began to develop as an easel painter. Although he was self-taught, his early works show the influence of the Macchiaioli (an Italian impressionist movement) and of the Posillipo school, as well as an interest in the expressionism of the fauves.

In the mid-1930s Volpi joined the Grupo Santa Helena, an informal band of artists who gathered in São Paulo to exchange ideas and draw from life. Between 1937 and 1940 he also exhibited with the Família Artística Paulista. While never strictly mimetic, Volpi's painting during this period was essentially realistic. Like many of those in the Grupo Santa Helena, he had a sympathy for the common person and chose subjects from everyday life, which he treated with a slightly primitivizing style.

During the 1940s and early 1950s Volpi underwent a slow evolution that would lead him to his own trademark style, a form of geometric abstraction. This same period saw his rise to national and eventually international recognition. He had his first solo exhibition in São Paulo in 1944 and received other honors in subsequent years, including the prize for best Brazilian painter at the second São Paulo Bienal (1953). The stylistic development of these years can be tracked through Volpi's examination of the facades of popular houses, a favorite motif. Departing from a relatively realistic treatment of townscape, he began to eliminate figures and anecdote, then gradually disposed of all organic and incidental details so that only the house facades remained. Working with these as planes, Volpi eventually suppressed all vestiges of perspective. Freed from pictorial illusionism, he was able to concentrate on problems of line, form, and color, the elements he considered to be the essential problems of painting. During this same period Volpi also transformed his palette, gradually intensifying and purifying his colors.

Although Volpi arrived at his mature style in an entirely intuitive manner, the paintings that resulted were related to the international constructivist and concretist movements. Volpi, who resolutely avoided theorizing and overintellectualizing his art, nevertheless did not object to his adoption by the Brazilian neoconcretists, participating in their *Concrete Art* exhibitions in São Paulo (1956) and Rio de Janeiro (1957). But some critics do not consider Volpi a true concretist, for, except for a brief period in the mid-1950s when he produced pure

abstractions, he rooted his paintings in motifs drawn from his own vernacular world. These motifs could be the windows and doors of modest houses, wind-filled sails, or the poles and strings of pennants that decorated village streets on religious feast days. Yet Volpi's sympathy for the tenets of concretism may be detected in his insistence that his celebrated pennants, for instance, were merely modules that comprised the structure of a two-dimensional painted surface. As such, their function is strictly formal and not narrative or symbolic.

Volpi's activity as a painter of religious subjects, a relatively small but nevertheless important part of his production, continued even during the most abstract phase of his concretism. In works like the frescoes at the Chapel of Our Lady of Fátima of the Social Pioneeresses, the artist combined his tendency toward geometric abstraction with references to traditional folkloristic iconography and a lyrical figurative style that rivals the late works of Matisse. In both his religious and his nonreligious works, there is a sense of joy and spirituality that springs from his combination of meticulous handicraft and vibrating chromatic contrasts.

In his last decades Volpi distanced himself more and more from the concretist movement. Having stood at the precipice of a nonobjective, pure art, the painter stepped back toward a sort of "figuration without figures," in which his favorite motifs of banners and house facades continued to play a central role. While still constructivist, the work of this final phase, which includes the so-called ogival paintings of the 1970s and early 1980s, is geometrically looser and more full of movement than the work of the 1950s and 1960s. In a career that spanned from late romantic beginnings to neoconcretism and beyond, Volpi managed to answer intuitively the central question of Brazilian modernism: how to be distinctly Brazilian and at the same time be a protagonist of contemporary trends on an international level.

—James G. Harper

W-Z

WILSON-GREZ, Liliana
American painter

Born: Valparaíso, Chile, 1953; moved to the United States. **Education:** Instituto de Bellas Artes, Vina del Mar, Chile, 1976–77; Austin Community College, Texas, 1980–83; Southwest Texas State University, San Marcos, 1991–95. **Career:** Artist-in-residence, Villa Montalvo, Saratoga, California, 1995. **Awards:** First prize, *Ninth Annual Juried Women's Art Exhibit,* Guadalupe Cultural Arts Center, 1993; Best of Show, *Works on Paper 2000,* Albert L. Schultz Jewish Community Center, Palo Alto, California, 2000.

Individual Exhibitions:

1995 *Miradas y Gestos One,* Guadalupe Cultural Arts Center,
 San Antonio, Texas
1997 *Vuelcos/Shifts,* Las Manitas, Austin, Texas
 Galería de la Raza/Studio 24, San Francisco

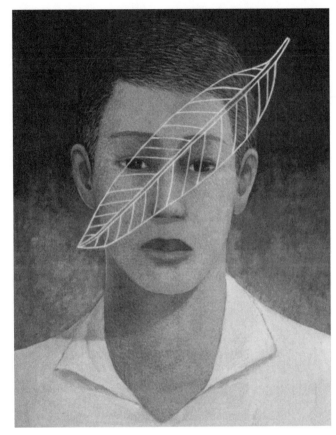

Liliana Wilson-Grez: *Hombre y hoja.* **Photo courtesy of the artist.**

 Madera, Jump-Start Gallery, San Antonio
1998 Inter-American Book Fair and Literary Festival, Guada-
 lupe Cultural Arts Center, San Antonio
2000 *Gestos One,* Mission Cultural Center for Latino Arts
2001 *Miradas,* Suffolk University, Art Gallery, Boston
 Barreras, San Francisco State University, Art Gallery,
 San Francisco

Selected Group Exhibitions:

1990 *Raza Sí Latino/a–Chicano/a,* University of Texas,
 Austin
1992 *La Reina Cósmica,* Dougherty Art Center Gallery,
 Austin
 Lo mejor de lo nuestro, Dougherty Art Center Gallery,
 Austin
1994 *Compañeras,* travelling exhibit, Dougherty Art Center
 Gallery, Austin

Liliana Wilson-Grez. Photo courtesy of the artist.

Liliana Wilson-Grez: *El ojo perdido.* **Photo courtesy of the artist.**

1994	*Transformations,* Women and Their Work Gallery, Austin
1996	*Magic, Legends and Myths,* Western Illinois University, Macomb, Illinois
1997	*Graphic Ink,* Austin Museum of Art, Texas
1998	*Silk Screen Series '97-'98,* Dougherty Art Center Gallery, Austin, Texas
1999	*Two Women,* Encantada Gallery, San Francisco
	Barro, piedra y madera, La Peña Gallery, Austin, Texas
2000	*Faces of Woman,* New Mexico Highlands University, Las Vegas
	10 Views/22 Dimensions, Hollis Street Project, Emeryville, California

Publications:

By WILSON-GREZ: Books, illustrated—*En el barrio* by Alma Flor Ada, New York, Scholastic, 1994; *Mexican Adventure* by Rick Brightfield, New York, Macmillan, 1997; *Reflexiones 1999: New Directions in Mexican American Studies,* edited by Richard R. Flores, Austin, Texas, Center for Mexican American Studies, 1999.

On WILSON-GREZ: Books—*Intimate Lives: Work by Ten Contemporary Latina Artists* by Kathy Vargas and Connie Arismendi, Austin, Texas, Women & Their Work, 1993; *Latin American Women Artists of the United States: The Works of 33 Twentieth-Century Women* by Robert Henkes, Jefferson, North Carolina, McFarland, 1999; *Reflexiones 1999: New Directions in Mexican American Studies* by Richard R. Flores, Austin, University of Texas, 2000.

*

Liliana Wilson–Grez comments:

As a Latin American woman who has lived through a dictatorship in Chile, I use art to give meaning to a life history that is at once hard to confront and important to remember. My experiences as an immigrant infuse the context of the subjects in my pieces who often face human dilemmas including domination by societal forces. Through my drawings and painting, I explore the transformative power of complex emotions implicit in the human struggle for integrity.

My images come from the subconscious. Many of the figures I create appear in ''other-worlds'' environments where their outward composure is in direct contrast to their inner turmoil. Realities collide on multiple levels while beauty emanates from the subjects. Often my compositions represent moments in the lives on individuals that serve as metaphors for those lives.

* * *

Liliana Wilson-Grez studied law in Chile before moving to the United States and enrolling at Southwest Texas State University as an art student. She has continued to create poetic images, paintings that speak of a strange yet familiar world of long journeys through a highly personal and imaginative interior. Her images are disorienting but peaceful. In a vein similar to that explored by painters such as Ismael Frigerio, her spare, haunting images are infused with symbolism. They speak eloquently of loss, mystery, and redemption. Of her painting *Vuelcos* (1999)—an image of a boy wading in water, his eyes closed, his head on fire—Wilson-Grez said, ''There's no fear or pain because it's a symbol of getting rid of the old and moving on.''

Many of the artist's paintings suggest liberation and a break with the past, but they are not celebratory, and they often leave the viewer wondering what comes next. The figures in her work occupy a spare, lonely landscape—dimly lit and without depth. Often they face us head-on with blank or impenetrable expressions on their faces. Sometimes they appear as images in a dream: one woman clasps a giant fish; another appears to fly, her mouth open, arms outspread. The artist has said of her work: ''I'm interested in the idea of change, transformation and dreams. I find that animals can often help me as symbols of the common dilemmas of the human condition.''

In her paintings Wilson-Grez constructs a new reality. Perhaps drawing in part on the artist's experience of starting over in a new country, the paintings are imbued with narrative content that suggests both personal and cultural history. Many feature figures who find themselves in strange circumstances, strange surroundings. Tugging at the imagination like a memory or a dream, they provoke subconscious associations. Wilson-Grez has a particular way of setting a single subject—a figure or a tree, for example—dead center, either against a flat, colored surface or against a stark horizon line that separates a dusky sky from a sparse earth. The light is often moody and dark, fading to black near the edges of the canvas. The eyes of the figures communicate very little—they are involved in pure experience, unable or unwilling to tell us how to interpret that experience. Like the artist they draw us into a world of sensations and sensuality experience uncompromised by logical understanding.

—Amy Heibel

XUL SOLAR, Alejandro
Argentine painter

Born: Oscar Alejandro Agustín Schultz Solari, San Fernando, 14 December 1887 (changed name to Xul Solar, 1916). **Education:** Self-taught artist. **Career:** Traveled to Europe, 1911–24; returned to Argentina, 1924. Member, *Martinfierristas,* group of poets, writers, and artists, 1924. Interested in the creation of new languages. **Died:** 9 April 1963.

Individual Exhibitions:

1920	Gallery of Art, Milan (with Arturo Martini)
1929	Nuevo Salón, Buenos Aires
1949	Galería Samos, Buenos Aires
1953	Galería Van Riel, Sala V, Buenos Aires
1977	Musée d'Art Moderne de la Ville de Paris (retrospective)
1978	*Xul Solar: Obras 1919–1962,* Museo Nacional de Bellas Artes, Buenos Aires

Selected Group Exhibitions:

1924	Musée Galleria, Paris
1932	*50 años de La Plata,* Museo Provincial de Bellas Artes, La Plata, Argentina
1933	*Amigos del arte,* Buenos Aires
1949	Salón Florida, Buenos Aires
	Galería Cavallotti, Buenos Aires
1951	Galería Guión, Buenos Aires
	Salón de Artes Plásticas, La Plata, Argentina
1952	*Pintura y escultura argentina de este siglo,* Museo Nacional de Bellas Artes, Buenos Aires
1960	*150 años de arte argentino,* Museo Nacional de Bellas Artes, Buenos Aires
1962	National Museum of Modern Art, Paris

Publications:

On XUL SOLAR: Books—*Xul Solar,* exhibition catalog, text by Jorge Luis Borges and Aldo Pellegrini, Paris, Musée d'Art Moderne de la Ville de Paris, 1977; *Xul Solar–Obras 1919–1962,* exhibition catalog, Paris, Connaissance de Artes, 1978; *Alejandro Xul Solar, 1887–1963* by Mario H. Gradowczyk, Buenos Aires, Ediciones Anzilotti, ca. 1988; *Xul Solar: Collection of the Art Works in the Museum,* exhibition catalog, text by Jorge Luis Borges, Buenos Aires, Xul Solar Museum, ca. 1990; *Alejandro Xul Solar* by Mario H. Gradowczyk, Buenos Aires, Ediciones ALBA, ca. 1994; *Xul Solar: The Architectures,* edited by Christopher Green, London, Courtauld Institute Galleries, ca. 1994; *Xul Solar,* Buenos Aires, Museo Nacional de Bellas Artes, 1998. **Articles—**"Xul Solar" by Aldo Galli, in *La Prensa* (Buenos Aires), 3 June 1978; "Fiac 1978 un intento de revitalizar el mercado de paris" by Martha Nanni, in *Horizontes,* 3, February/March 1979; "El mundo esotérico de Xul Solar" by Romualdo Brughetti, in *Clarín* (Buenos Aires), 2 June 1979; "Xul Solar, un anticipo surrealista" by Héctor A. Galea, in *Clarín* (Buenos Aires), 9 September 1984; "Invicto de juego inexistente Xul Solar" by Jorge B. Rivera, in *Tiempo Argentino* (Buenos Aires), 17 May 1985; "Xul Solar, el umbral de otros cosmos" by Mario H. Gradowczyk, in *Artinf Arte Informa* (Buenos Aires), 65, 1987, p. 16.

* * *

Alejandro Xul Solar is unique in the Argentine artistic world, not only for his work but for his unconventional personal life as well. At the age of 25 he embarked on a journey to Hong Kong; he never arrived at that destination, however, because he stopped in London and proceeded to live in Europe for the next 12 years. During his stay in Europe he concentrated on the study of religion and read such authors as Madame Blavatsky, Rudolf Steiner, Emanuel Swedenborg, William Blake, and others submerged in mysticism and hermetic philosophy.

A self-taught artist, Xul Solar was very young when he mastered the use of watercolors, which he continued to use in most of his works. In 1912 he also began painting in oils on small-sized sheets of cardboard. Examples of these works show Kandinsky's influence and include *Nido de fénices* (22 by 26.5 centimeters) and *Paisaje con monumento* (22 by 27 centimeters). Xul Solar's most famous painting from this period is *Entierro* (1914; three identical versions exist), a watercolor on paper that has been compared to *La isla de los muertos* ("Dead Men's Island") by Arnold Böcklin and to Jan Toorop's *Fatality.* Both Böcklin and Toorop are masters of the symbolist style who create an atmosphere very much like Xul Solar's. Indeed, Toorop's figuration resembles that of Xul Solar but is essentially different because of the sense of force, emphatic two-dimensional effects, rarefied lighting, and expressionist touches in Xul Solar's work.

In 1917, during his stay in Milan, Xul Solar created elaborate, fantastical architectural paintings inspired by the extravagant castles built by Louis II of Bavaria, the Duomo's grandiosity, and the "filigree" of Gaudi's Sagrada Familia in Barcelona. These architectural works, which include *Estilos 3,* he named *Bau* or *Styles* and were his attempts at an activity capable of generating spiritual paradigms.

Xul Solar's later work is linked more to expressionism. From 1919 to 1923 he painted mostly watercolors on small oblong diptychs, depicting mountains, the paths that run between them, and individuals—all strangely two-dimensional and geometrized. In these paintings he also began including writings in "Neocriollo," or Creole, an eclectic language created by Xul Solar himself, using words in Spanish, Portuguese, English, and German. *Subo, os alcanzaré, mais ke alas tengo* and *Probémonos alas también nos,* both watercolors on paper set up on 21-by-7.5-centimeter cards, are typical examples. During this period he also painted masks and faces among abstract figures (*Filia Solar, Los cuatro, Espero*).

After returning to Buenos Aires, Xul Solar formed part of an avant-garde group set up around the magazine *Martín Fierro* and in touch with the most eminent representatives of the Argentine intellectual circle (Victoria Ocampo, Oliverio Girondo, Macedonio Fernández, and especially Jorge Luis Borges, among others). He tried to make his language Neocriollo more widely known and by including it in his paintings strengthened his images in a morphological and colorist sense. He also worked hard at creating Panalengua, "a universal language, on a numerical and logical basis," which he considered "the best solution to the problem, after studying six or seven previous suggestions, well known and imperfect."

Cosmogony visions caused him to make changes in his architectural paintings, including introducing greater color refinement (scales and transparency), incorporating perspectives with diverse vanishing points, and using cracked folds and diagonal lines to make the planes

more dynamic (*Místicos,* pencil and watercolor on paper [1924], *Teatro,* ink and watercolor on paper [1924], *Sandanza,* watercolor on paper [1925], *Proa,* tempera on paper [*ca* 1926]).

From 1934 to 1942 Xul Solar continued to investigate language and astrology. Flying men and floating cities appeared in his paintings during this period (*Paisaje, Vuel Villa, Gente Kin Vuelras, Dos mestizos de avión y gente*), as did juxtaposed spaces and foreshortening (*Ciudá Lagui*). This was followed by a period of black-and-white paintings (*Fiordo, Valle Hondo*) and then by a return to his original sources and images and signs of a mystic nature.

Painting was a totality for Xul Solar, and in his preoccupation with making his artwork more effective at transmitting mysticism and intrigue (like the cave painters), he made descriptive and invented forms coexist. His work abounds with cabalistic numbers and gesture signs; unreal transparencies and opaque sensibilities; cracked spaces; naive, unrealistic, fantastic perspectives; and points that seem to escape or evade the total effect, that seem to radiate light or vibrations, or that seem to converge or close. From this inventive profusion arises a will for formal coherence that is attained in a poetic and narrative background. Xul Solar's paintings express the most profound and vital human forces in an ascending path toward higher knowledge.

—Horacio Safons

ZACHRISSON, Julio (Augusto)
Panamanian painter and printmaker

Born: Panama City, 5 February 1930. **Education:** Escuela Nacional de Pintura, Panama City; Instituto Nacional de Bellas Artes, Mexico City, 1953–59. **Career:** Traveled to Europe, 1959; moved to Madrid, 1961. Instructor, Academia Pietro Vanucci, Italy, 1960, and Academia de San Fernando, Madrid, 1961–63. **Awards:** Prize, Instituto de Cultura Hispánica, Madrid, 1962, 1963; second prize in drawing, *Arte actual de América y España;* Premio Dirección General de Bellas Artes, *XIII salón del grabado,* Madrid, 1964; second medal in drawing, Fundación Rodríguez Acosta, Granada, Spain, 1965; Premio "Castro Gil," *XIV salón de grabado,* Madrid, 1967; first prize in drawing, *Concursos nacionales,* Madrid, 1969; first prize in drawing, *Concurso soberanía,* Instituto Nacional de Cultura, Panama, 1975; Goya-Aragón prize, Spain, 1996.

Individual Exhibitions:

1960	Universidad de Panama
1961	Instituto de Cultura Hispánica, Panama
1963	Galería Forum, Madrid
	Instituto Panameño de Arte, Panama
	Escuela de Bellas Artes, Guatemala
1964	Pan-American Union, Washington, D.C.
1965	Galería Sudamericana, New York
	Instituto Panameño de Arte, Panama
1966	Zegry Gallery, New York
1967	Galería Seiquer, Madrid
	Sobot Gallery, Toronto
	Galería Wit, Canarias, Spain
1968	Zebry Gallery, New York
1969	Galería Colibrí, Puerto rico
	Zebry Gallery, New York

1971	Caja de Ahorros de Antequerra, Malaga, Spain
	Galería Seiquer, Madrid
1972	Instituto Panameño de Arte, Panama
	Galería Egam, Madrid
1974	Salan Luzan, Zaragoza, Spain
1975	Galería Italia, Alicante, Spain
	Galería Trazos Dos, Santander, Spain
1977	Galería Aele, Madrid
1978	Instituto Nacional de Cultura, Panama
1979	Instituto Panameño de Arte, Panama
	Galería Torques, Santiago de Compostela, Spain
1980	Galería Costa 3, Zaragoza, Spain
1981	Colectivo Palma, Malaga, Spain
	Museo Municipal de Bellas Artes, Santander, Spain
	Museo de Arte Contemporáneo, Panama City
1993	*Zachrisson: Obra pictórica, 1984–1993,* Museo de Arte Contemporáneo, Panama City
1996	Sala de la Corona de Aragón, Zaragoza, Spain
1998	Godwin-Ternback Museum, Queens College, New York (retrospective)
1999	Habitante Gallery, Panama City

Selected Group Exhibitions:

1959	*I salón nacional de pintura,* Museo de Arte Moderno, Mexico City
1964	*Contemporary Painters and Sculptors as Printmakers,* Museum of Modern Art, New York
1967	*Exposición latinoamericana de dibujo y grabado,* Caracas, Venezuela
1970	*I bienal de grabado latinoamericano,* San Juan, Puerto Rico
	Exposición panamericana de artes gráficas, Cali, Colombia
1971	*XI bienal de São Paulo,* Brazil
1972	*II bienal de grabado latinoamericano,* San Juan, Puerto Rico
1977	*Certamen de grabado,* Museo de Costa Rica, San José
1979	*Trienal latinoamericana de grabado,* Galería Italia, Alicante, Spain
1980	*El collage,* Galería Aele, Madrid

Collections:

Biblioteca Nacional, Madrid; Museo de Arte Contemporáneo, Madrid; Instituto Panameño de Arte, Panama; Bibliotheque National, Paris; Museo de Ponce, Puerto Rico; Museum of Brooklyn, New York; Metropolitan Museum of Art, New York; Smithsonian Institution, Washington, D.C.; Cincinnati Art Museum; Museum of Contemporary Art of Latin America, Washington, D.C.; Museo Fundación Rayo, Roldanillo, Colombia.

Publications:

On ZACHRISSON: Books—*Zachrisson: Obra pictórica, 1984–1993,* exhibition catalog, text by Erik Wolfschoon, Panama City, Museo de Arte Contemporáneo, 1993; *Zachrisson,* exhibition catalog, text by Isabel Biscarri, Zaragoza, Spain, Gobierno de Aragón, Departamento de Educación y Cultura, 1996. **Articles**—"El doble fondo: Julio Zachrisson," in *Cuadernos hispanoamericanos,* 576, 1998, p. 163;

"Julio Zachrisson: Habitante Gallery" by Monica E. Kupfer, in *Art Nexus* (Colombia), 33, August/October 1999, pp. 144–145.

* * *

Julio Zachrisson's artistic career blossomed in Spain, his home since the 1960s, as evidenced by being awarded the prestigious Goya-Aragón prize. Although he studied in Mexico, Italy, and Spain and held multiple exhibitions in Europe and the Americas over the past 40 years, Zachrisson consistently developed a figurative oeuvre that reflected his Panamanian identity and dark sense of humor.

A prolific artist, Zachrisson first became known for his exceptional work as a printmaker. The huge volume of etchings, drypoints, and lithographs he created as of the 1960s reflect an extraordinary technical ability and a rich imagination. His surrealistic prints—with titles such as *Candido the Sorcerer, Susana and the Birds,* and *Homage to Quevedo*—usually focus on themes related to literature, ancient and popular mythology, Panamanian legends, and urban folklore. The careful draftsmanship, masterful use of chiaroscuro, and restless strokes, as well as the detailed—often lurid—world depicted in his prints peopled with grotesque figures, link Zachrisson to the Spanish artistic tradition, to Latin American artists such as José Luis Cuevas, and to the social reality and political problems of his native Panama.

Zachrisson has also created an oeuvre in paintings on canvas, which include notable compositions such as *The Wake for Panchamanchá* (1977) and the series of works shown in the early 1990s at Panama's Museo de Arte Contemporáneo. At first glance there seems to be an enormous difference between his etchings and his paintings because his works on canvas emphasize design and color over volume and are characterized by flat and intense tonalities, hard edges, and practically invisible brushwork that leave little sign of the artist's intervention on the canvas. Zachrisson's characteristic sense of humor and his strong connection to Panamanian themes, however, are ever present. His paintings are visually reminiscent of the *molas* sewn by the Kuna Indians of San Blas, in which bright colors are appliquéd over each other, creating edges that echo forms in contrasting hues. Moreover, the deformed figures and the titles of his works still show the artist's typical subjects and love of irony. Zachrisson's characters in the paintings of that period include women such as the primordial *Eve,* whom he depicts with a long, sinuous—and insinuating—snake; the hysterical female figure in *Despavorida (Terrified);* and a sorceress surrounded by spermlike worms in *Kuna Witch.* The men, on the other hand, appear in less interesting—and less critical—poses, often smoking, eating, or playing music. Certain elements drawn from the natural world also form part of the repertory in Zachrisson's paintings at the time. *Cazanga* depicts a colorful parrot found in the wild in Panama, one that locals like to hunt and eat, and the leaf of the Bijao plant, usually employed to wrap corn tamales, serves in Zachrisson's canvas to wrap a woman.

In the late 1990s Zachrisson produced mixed-media compositions on paper of small, almost intimate proportions, dominated by the presence of one central figure delicately rendered in muted colors. As if honoring—or mocking—the cubist tradition, Zachrisson played with geometry, employing prisms in space, varied perspectives, and even a futuristic sense of contained movement, unusual elements in the work of an artist who has mainly explored human sensuality and organic forms in a personal interpretation of surrealism. Moreover, Zachrisson's images of the 1990s were no longer characterized by the descriptive titles nor the story-filled content of his earlier work, as the artist turned more toward the creation of emblematic forms, such as those in his *Figures* of 1999. Nevertheless, Zachrisson did not stop creating images that seem to taunt the observer with a combination of playfulness, sexuality, and double meaning.

—Monica E. Kupfer

ZAMORA CASAS, David
American painter, sculptor, and performance artist

Born: San Antonio, Texas, 1960. **Career:** Creator of a grotto, Henry B. Gonzales Convention Center, 1996; muralist, Social and Public Art Resource Center, Venice, California, 2001. Since 1988 curator and lecturer, Texas. Artist-in-residence, ArtPace, London, 1995. **Awards:** Rockefeller Foundation grant, 1992; Andy Warhol Foundation grant, 1992; New Forms Regional Initiatives grant, National Endowment for the Arts, 1992; Individual Artists grant, City of San Antonio Department of Arts and Cultural Affairs, 1993. **E-mail Address:** zamoracasas@hotmail.com.

Individual Exhibitions:

1990	*David Zamora Casas, a.k.a. Nuclear Meltdown,* Bonham Exchange, San Antonio
	No Lips Are Redder Than Mine, Planta de Arte Nuclear, San Antonio
1993	*Contemporary Art Month at the Church,* Anti-Oppression Church of Hard Core Folk Art, San Antonio
1994	*El nuevo mestizo,* Esperanza Peace & Justice Center, San Antonio
	Installation Trilogy, Guadalupe Cultural Arts Center, San Antonio
1995	*New Works: 95.3,* ArtPace, San Antonio
1997	*Dia de los angelitos muertos,* Galeria Ortiz, Blue Star Art Complex, San Antonio
1999	*The Devil's Advocate,* Carver Community Cultural Center, San Antonio
	Flowers for Stephanie, IV ArtSpace, San Antonio
	Cuentos de la llorona . . . and Other Oral Kiss Stories, Sala Diaz, San Antonio
2000	*Altar para los muertos,* Guadalupe Cultural Arts Center, San Antonio
	Rites of Passage: Quinceaneras, Debs and Other Queens, Blue Star Art Space, San Antonio
	Mrs. Bluebonnet America & Mr. Fiesta Homeboy USA, IV Art Space, San Antonio
2001	*Going to Be Gay in LA,* Esperanza Peace and Justice Center, San Antonio

Selected Group Exhibitions:

1993	*Ceremony of Spirit: Nature and Memory in Contemporary Latino Art,* Mexican Museum, San Francisco
1995	*New Works for a New Space,* ArtPace, San Antonio
	The Heart of Art, Parshman Stremmel Galleries, San Antonio
1996	*New American Art-A Sampler,* Guadalupe Cultural Arts Center, San Antonio

1996 *Proposition 187 . . . ,* Dougherty Art Center Gallery,
 Austin, Texas
1997 *La causa R.O.S.A.,* San Antonio Central Library
 Gallery, Texas
1998 *Collective Visions,* San Antonio Museum of Art, Texas
 Community Altar, Benavedes Park Pavilion, San
 Antonio
1999 *6th Annual CineSol Latino Film Festival,* Corpus
 Christi, Texas
 *Latino Redux: A New Collection of Stories, Lies and
 Embellishments,* University of North Texas School of
 Visual Arts, Denton

Collections:

San Antonio Museum of Art; Esperanza Peace and Justice Center,
San Antonio; Guadalupe Cultural Arts Center, San Antonio.

Publications:

On ZAMORA CASAS: Books—*Ceremony of Spirit: Nature and
Memory in Contemporary Latino Art* by Amalia Mesa-Bains, San
Francisco, Mexican Museum, 1993; *New Works 95.3: Antony Gormley,
David Avalos, David Zamora Casas,* exhibition catalog, San Antonio,
ArtPace, 1996; *Out West,* exhibition catalog, Santa Fe, New Mexico,
Plan B. Evolving Arts, 1999. **Articles**—''Artist Explores History of
Culture'' by Elda Silva, in *San Antonio Express-News,* 1994; ''Touching
on the Breadth of Hispanic Art Today'' by Holland Cotter, in *New
York Times,* 1996; ''Latino MacArthur Fellows Gather to Celebrate
and Hear a Call to Arms'' by David Wheeler, in *Chronicle of Higher
Education,* 1997; ''Homeboy on the Range'' by Retha Oliver, in *San
Antonio Current,* 4 February 1999.

* * *

David Zamora Casas described himself as a self-taught Mexi-
can-American media artist. His works, which include paintings,
installations, tableaux, altars, and multimedia performances, reflect
his Latino heritage and address contemporary and potentially volatile
issues such as homophobia, sexism, and AIDS. Casas, who worked
out of his Alamo-like, stucco studio in San Antonio, Texas, called the
Anti-Oppression Church of Hardcore Folk Art, was a man who
flamboyantly waxed the tips of his mustache in a Dalí-esque fashion
and often showed up in drag at his art openings. His art, described as
''sexy and political at the same time'' by critic Barbara Renaud
Gonzalez, is a fusion of his personal experiences, folklore, and
various religious and/or devotional symbols. Admitting that he lived
life as a daily performance piece, Casas said, ''I love the fact that I am
inspired by my family, history, lovers, and music to create work
which allows me to vent, admire, and question universalities in two
languages and in various cultures, including queer culture.''

Casas first began to paint as a means of expressing the intimate
feelings he had for a man he loved. But, as Casas explained, ''My
passion for painting soon surpassed my passion for him,'' and from
then on he relied on art to further explore his identity. Casas felt
blessed to be able to translate his life experiences onto a canvas or as a
performance piece. His paintings contain a myriad of images, some of
which are ambiguous or symbolize metamorphosis, such as a moon
with two faces, a mermaid, or a Medusa-like image. His works
explore both political and spiritual themes. For example, *Horns*

(1999), an oil painting that contains two horned figures, has the
caption, ''Nuclear Meltdown Please Stand Up,'' while *Child* (oil,
1999) and *Virgin in the Clouds* (oil, 1999) obviously express spiritual
concerns. In a tribute to artists who have died of AIDS, Casas
constructed an altar that was a contemporary version of a Mexican
tradition. The altar featured a voodoo doll, some skulls, the head from
a mannequin, and a figure of Jesus surrounded by candles and marigolds.

Investigating one's life or identity through gender is an impor-
tant process for a developing artist and often becomes a prominent
theme in his or her work. Expressing sexuality through art, abstractly
or figuratively, has been done throughout history, but by the end of the
twentieth-century, the subject of gender and sexuality became
politicized. Casas's efforts to express his gay Latino identity must be
seen, therefore, in the context of art as an aesthetic and political
statement. In the mid-1990s Casas participated in the *Beyond Desire:
New Gay and Lesbian Performance and Film* series, where he
performed two works that included sculpture, music, and poetry. The
pieces, *The Last Temptation of the Little Mermaid* and *One Hundred
Love Letters . . . The Reformation, through Education and Communi-
cation, of a Chicano Sexist,* were described as ''Born Again Mexi-
can'' by a Houston newspaper. In an exhibition entitled *Gender Myth
and Exploration* Casas presented three performance pieces and a film.
Critic David Freeman said, ''The beauty of his costumes, makeup,
and facial expressions, as well as an accomplished command of
performance set Casas apart from other performance artists.''

—Christine Miner Minderovic

ZENIL, Nahum B(ernabé)
Mexican painter, sculptor, and mixed-media artist

Born: Chicontepec, Veracruz, 1 January 1947. **Education:** Escuela
Nacional de Maestros, 1959–64; Escuela Nacional de Pintura y
Escultura ''La Esmeralda,'' Mexico City, 1968. **Career:** Grade
school instructor, Mexico, 1970s and early 1980s. Since 1984 painter.

Individual Exhibitions:

1974 Galería José Maria Velasco, Mexico City
 Palacio del Gobierno, Chilpancingo, Mexico
1976 Galería José Maria Velasco, Mexico City
 Casa de la Cultura, Puebla, Mexico
1977 Galeria Pintura Joven, Mexico City
1979 Galería José Maria Velasco, Mexico City
1980 Sala de Arte CREA, Tepeyac, Mexico City
1982 Museo Carillo Gil, Mexico City
1983 Galeria SHCP, Mexico City
1985 Galeria de Arte Mexicano, Mexico City
 Galeria Arte Actual Mexicano, Monterrey, Mexico
1987 *Yo tambien soy mexicano,* Museo de Arte Moderno,
 Mexico City
1988 Mary-Anne Martin/Fine Art, New York
1989 Galeria de Arte Mexicano, Mexico City
1990 Parallel Project, Los Angeles (traveling)
 Mary-Anne Martin/Fine Art, New York
1991 *Nahum B. Zenil . . . Presents,* Museo de Arte
 Contemporáneo de Monterrey, Mexico

Nahum B. Zenil: *Self-Portraits with Angels,* **1992. Photo courtesy of George Adams Gallery, New York; from a private collection, New York.**

1991 Mary-Anne Martin/Fine Art, New York
1992 *Se busca,* Galeria de Arte Mexiano, Mexico City
1994 *Del circo y sus alrededores,* Galeria de Arte Mexicano,
 Mexico City
1996 *Nahum B. Zenil: Witness to the Self,* Mexican Museum,
 San Francisco (traveling)
 Platiquemos con Naham B. Zenil, Centro Cultural Arte
 Contemporáneo, Mexico
1997 *El eterno retorno,* Galeria del Estado de Xalapa, Mexico
 (traveling)
 List Center for Visual Arts, M.I.T., Cambridge,
 Massachusetts
1999 *El Gran Circo del Mundo,* Museo de Arte Moderno,
 Mexico City

Selected Group Exhibitions:

1971 Palacio de Bellas Artes, Mexico City
1983 *Arte contemporaneo latinoamericano,* Museos y Casas
 de la Cultura del Norte de la Republica Mexicana y
 Academia de San Carlos, Mexico City (traveling)
1984 *Bienal de São Paulo*
 Primera bienal de la Habana, Havana
1985 Espace Cardin, Paris
1986 Centro Cultural de Arte Contemporaneo, Mexico City
1987 Museo de Arte Moderno, Mexico City
1988 Museum of Contemporary Hispanic Art, New York
 Galeria del Centro Cultural de la Secretaria de Hacienda
 y Credito Publico, Mexico City
1989 The Fisher Gallery, University of Southern California,
 Los Angeles
1991 *Mito y Magia en América: los ochenta,* Museo de Arte
 Contemporáneo de Monterrey, Mexico
1996 *Love and Pain,* Mary-Anne Martin/Fine Art, New York
1999 *Saints, Sinners and Sacrifices: Religious Imagery in
 Contemporary Latin American Art,* George Adams
 Gallery, New York

Collection:

Metropolitan Museum of Art, New York.

Publications:

By ZENIL: Books—*Del circo y sus alrededores,* exhibition catalog,
Mexico City, Galería de Arte Mexicano, 1994; *El gran circo del
mundo,* exhibition catalog, Mexico City, Sociedad Mexicana de Arte
Moderno, 1999.

On ZENIL: Books—*Mexico, Out of the Profane: Six Contemporary
Mexican Artists,* exhibition catalog, text by Charles Merewether,
Adelaide, Australia, Adelaide Festival of Arts, 1990; *Nahum B. Zenil:
Witness to the Self,* exhibition catalog, text by Edward J. Sullivan and
Clayton Kirking, San Francisco, Mexican Museum, 1996; *In Search
of Nahum B. Zenil* (thesis) by Daniel J. Bender, Chicago, School of
the Art Institute of Chicago, 1997. **Articles—**"Nahum Zenil's Auto-
Iconography" by Edward J. Sullivan, in *Arts Magazine,* 63, Novem-
ber 1988, pp. 86–91; "Nahum B. Zenil: Witness to the Self/Testigo
del Ser" by Anna Indych, exhibition review, in *Drawing,* 19(3),

winter/spring 1998, pp. 92–93; "The Colonial Self: Homosexuality
and Mestizaje in the Art of Nahum B. Zenil" by Eduardo de Jesús
Douglas, in *Art Journal,* 57(3), fall 1998, pp. 14–21; "Nahum B.
Zenil: A Stab at Fortune" by Santiago Espinosa de los Monteros,
exhibition review, in *Art Nexus* (Colombia), 33, August/October
1999, pp. 64–68.

* * *

Nahum B. Zenil was born in Chicontepec, Veracruz, Mexico, in
1947. He studied at the National Teacher's School and worked as a
teacher before attending the Escuela Nacional de Pintura y Escultura
"La Esmeralda" in Mexico City. Zenil began producing artwork in
the 1970s and throughout the 1980s concentrated fully on his art,
exhibiting nationally and abroad. In his drawings, collages, paintings,
sculptures, and mixed-media installations, Zenil has represented the
layered and hybrid cultural identity of Mexico.

Zenil rose to prominence in the 1980s during a flourishing period
of Mexican visual arts that saw a resurgence of artists examining
various aspects of the Mexican national character. In his work Zenil
investigated a variety of themes regarding Mexican culture, including
the powerful influence of Catholicism, the legacy of colonialism, the
presence of an indigenous population, and the effect of such earlier
artists as Diego Rivera and David Alfaro Siqueiros on contemporary
artists. In the 1990s Zenil shifted from figurative to self-portrait work.
Since then, nearly all his works on paper and canvases have focused
on his own image, though occasionally including the image of his
lover, Gerardo Vilchis. In these highly personal and intimate depic-
tions Zenil employed his own body as a vehicle with which to analyze
the current sociopolitical atmosphere. These autobiographical—often
highly sexualized—portrayals consider complex themes of homo-
sexuality and gay rights, mestizaje, and identity that reflect his
personal experiences. As a gay rights advocate, Zenil has been an
active member of Circulo Cultural Gay, which since the 1980s has
staged annual parades, conferences, and symposia on gay rights in
Latin America.

Zenil's style and compositions borrow from the craft and artisan
traditions of Mexico, especially the forms of retables and ex-votos. In
the tradition of the renowned Mexican painter Frida Kahlo, whom he
admired, much of Zenil's work also appropriates images from Catholi-
cism (especially the Bleeding Heart and Virgin of Guadalupe, Mex-
ico's patron saint), colonial painting, and indigenous subject matter.
Zenil has become one of Mexico's foremost artists for consistently
reflecting themes of identity and marginalization that had often been
ignored and disregarded. He received his first solo exhibition in 1985
at the Galería de Arte Mexicano, and in 1991 the Museo de Arte
Contemporaneo in Monterrey, Mexico, held a retrospective of his work.

—Miki Garcia

ZERPA, Carlos
Venezuelan painter and performance artist

Born: Valencia, 1950. **Education:** Instituto Politécnico de Diseño,
Serigrafía y Fotografía, Milan; Art Students League, New York; also
studied in Bogotá, Colombia. **Award:** Most promising young artist
award, International Association of Art Critics, Caracas, 1987.

Individual Exhibitions:

1990 Galeria Sen, Madrid
1993 Ambrosino Gallery, Coral Gables, Florida
 Galería Ramis Barquet, Garza García, Mexico
1995 *Zillaz,* Museo de Bellas Artes, Caracas
1996 Euroamericana Gallery, Caracas
1999 Sala Mendoza, Caracas
 Grupo Li Centro de Arte, Caracas

Selected Group Exhibitions:

1982 Museo de Arte Moderno, Mexico City
 Alternative Museum, New York
1985 *XVI bienal de São Paulo,* Brazil
1988 *Miguel von Dangel, Ernesto León, Carlos Zerpa: Three
 Venezuelans in Two Dimensions,* Americas Society
 Art Gallery, New York
1990 Galería Sen, Madrid
1993 Museo de Arte Moderno de Monterrey, Mexico
1994 Museo de Bellas Artes, Caracas, Venezuela
 Latin American Artists of the Twentieth Century,
 Museum of Modern Art, New York
1997 Museo de Arte Moderno Juan Astorga Anta, Mérida,
 Venezuela
 Museo José Lorenzo Alvarado, Tovar, Venezuela

Publications:

On ZERPA: Books—*Miguel von Dangel, Ernesto León, Carlos Zerpa: Three Venezuelans in Two Dimensions,* exhibition catalog, New York, Americas Society Art Gallery, 1988; *Carlos Zerpa: Pinturas,* exhibition catalog, Madrid, Galeria Sen, 1990; *Carlos Zerpa: Iconoclasta, iróico y humorista,* exhibition catalog, Garza García, Mexico, Galería Ramis Barquet, 1993; *Kick Boxer,* exhibition catalog, Caracas, Sala Mendoza, 1999; *Budo,* exhibition catalog, Caracas, Grupo Li Centro de Arte, 1999. **Articles**—"Recent Latin American Art" by Luis Camnitzer, in *Art Journal,* 51, winter 1992, pp. 6–15; "Carlos Zerpa, in *Sculpture* (Washington, D.C.), 14, January/February 1995, p. 53; "Visions and Visionaries" by Patti Lane, in *Art News,* 94, December 1995, pp. 132–135; "Carlos Zerpa" by Juan Carlos Palenzuela, in *Art Nexus* (Colombia), 22, October/December 1996, p. 158; "Carlos Zerpa: Sala Mendoza" by Eugenio Espinoza, in *Art Nexus* (Colombia), November 1999/January 2000, pp. 148–149.

* * *

Carlos Zerpa's work is an ongoing study of individual and social identity. By appropriating and transforming objects, images, and themes drawn from popular traditions and mass culture, he creates a unique stylistic world. His performances, paintings, and installations are known for their baroque quality, their poignant criticism, and their reference to Roman Catholicism, popular religions, patriotic symbols, and fetishism. His characters, drawn from myths, traditions, and legends excerpted from popular culture and art history, are depicted with irony and humor. Zerpa uses the absurd to dig into the human soul in a search that borders on the grotesque, violence, and death.

It was precisely the violent and irreverent attitude of his performances that caught the attention of Venezuelan and Latin American

critics in the early 1980s. In *God's Messenger,* a performance presented at the *First Colloquium of Non-Objective Art* in Medellin in 1981, Zerpa played the role of a healer, selling glass bottles filled with coagulated blood. After he carefully unwrapped small religious statues, encased in cellophane paper with the colors of the Venezuelan flag, he displayed them, creating an altar. He prayed to the saints and, after making several references to the flag, then exploded in an outburst of violence, destroying the statues and replacing them with a television monitor.

This controversial performance presents the major themes of Zerpa's work: the magical-religious world, rooted in Catholicism and in native and African religions, and its strong relationship with fetishism and consumption; the notion of fatherland as a political tool; and the myth of Simón Bolívar, the Latin American hero, and other patriotic symbols such as the flag and the Venezuelan currency, the bolivar. All of these critical elements are present not only in his work as a graphic designer, postal artist, and performance artist in the 1960s and 1970s but also in his paintings and installations dating from the 1980s and 1990s.

In Zerpa's appropriations popular and traditional objects acquire a whole new meaning. A deck of Spanish cards, for example, used for enjoyment and divination in Venezuela and Latin America, lose their nobility and ceremonious character when elegant figures of gold, cups, clubs, and swords are converted into colorful paraphernalia overloaded with signs, icons, and occult meanings. The noble figures of the cards are replaced by popular heroes such as Bolívar or wrestlers and by images inspired by art history, such as Frida Kahlo, a fetish icon par excellence, or Modigliani's elongated women.

Zerpa's style is unique and free of any formal influence. In his paintings characters and objects are outlined and colored in strong and shiny tones that overflow the contours. His fingerlike brush strokes create expressive images of paste that look like clay models amassed on the surface of the canvases. Zerpa loves tridimensionality and frequently adds objects to the canvas to emphasize this effect, simulating a holograph or a 3-D movie.

Both in painting and installation, Zerpa plays with a multiplicity of elements and with levels of readings and meanings. The possibilities for combinations are unlimited, and Zerpa exploits them with great inventiveness and intellect. Nevertheless, all of the games converge into one objective: to comprehend the contemporary sense of identity. While he effectively directs our attention to the existence of his culture, art for Zerpa is an expression of cultural identity, and his work is a critique of his own identity. It is a critique that, beyond an excellent purely aesthetic production, sees in art and its close connection to daily life the most effective medium to comprehend the significance of the cultural identity of the individual and of society itself.

—Francine Birbragher

ZÚÑIGA, Francisco
Costa Rican painter and sculptor

Born: San José, 27 December 1912. **Education:** School of Fine Arts, San José, 1927–38. **Career:** Assistant in his father's religious sculpture studio, San José, 1928–33. Traveled to Mexico, 1936. Professor of sculpture and art, La Esmeralda, Mexico City, 1938–70. **Awards:**

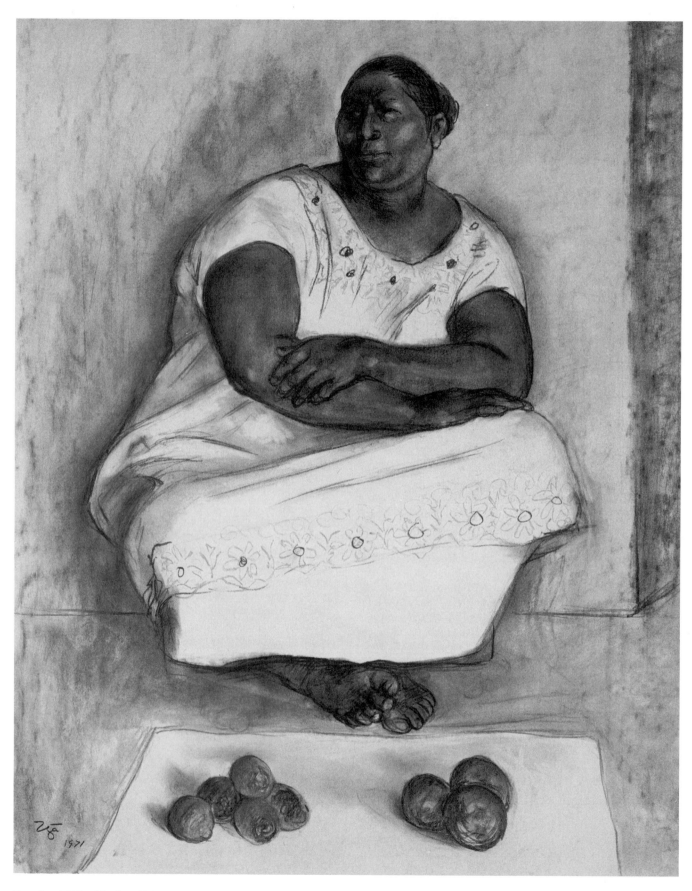

Fráncisco Zúñiga: *Vendor with Lemons,* **1971.** © Christie's Images/Corbis.

First prize, Ann Salon Sculpture, Mexico, 1957; first prize in sculpture, International Biennial, 1960; Mexican Award for the Arts, Mexican government, 1992. **Died:** 1998.

Individual Exhibitions:

1954	National Museum of Costa Rica, San José
1966	Modern Art Gallery, Scottsdale, Arizona
1969	Museum of Modern Art, Mexico City
1971	Fine Arts Gallery, San Diego, California
1972	Phoenix Art Museum
	Saisset Art Gallery, University of Santa Clara, California
	Fresno State College, California
1974	Phoenix Art Museum
	National Museum of Art, Tokyo
	Galería Tasende, Acapulco, Mexico
1976	Brewster Gallery, New York
	International Art Fair, Basel, Switzerland
1977	Everson Museum of Art, University of Syracuse, New York
1977	De Cordova and Dana Museum and Park, Lincoln, Massachusetts
	Oakland Museum, California
	Sindin Gallery, New York
	Galería Tasende, Acapulco, Mexico
1978	La Jolla Museum of Contemporary Art, California
	Santa Barbara Museum of Art, California
	Gallery 99, Bay Harbor, Florida
	Salt Lake City Art Center, Utah
	Tucson Museum of Art, Arizona
1979	Salt Lake City Art Center, Utah
1982	Honolulu Academy of Fine Arts
1985	Contemporary Sculpture Center, Tokyo
	Museum of Modern Art of Costa Rica, San José
1995	Museum of Modern Art, Mexico City (retrospective)

Selected Group Exhibitions:

1951	International Art Fair, Basel, Switzerland
1969	*Second Inter-American Biennial of Art,* Mexico City
1971	*Eleventh Biennial,* Antwerp, Belgium
1974	*Contemporary Mexican Art,* National Museum of Art, Tokyo and Kyoto, Japan
1984	*3rd Biennial Sculpture,* Hakone Open Air Museum, Japan

Collections:

Metropolitan Museum of Art, New York; Los Angeles County Museum; Mexican Museum, San Francisco; Phoenix Art Museum; Hirschorn Museum Sculplture Garden, Washington, D.C.; Museum of Modern Art, New York; National Museum of Modern Art, Kyoto; Hakone Open Air Museum, Japan.

Publications:

By ZÚÑIGA: Books—*Zúñiga,* exhibition catalog, introduction by Ali Chumacero, Galería de Arte Misrachi, Mexico, 1969; *Francisco Zúñiga,* Ediciones Galerí de Arte Misrachi, Mexico, 1980; *Zúñiga-Costa Rica: Colección Daniel Yankelewitz,* exhibition catalog, Museo de Arte Costarricense, San José, 1985; *Francisco Zúñiga,* El Equilibrista and Turner Libros, Mexico and Madrid, 1994; *Francisco Zúñiga: Homenaje nacional, mayo-junio, 1994,* exhibition catalog, Consejo Nacional para la Cultura ya las Artes, Mexico, 1994.

On ZÚÑIGA: Books—*Francisco Zúñiga: An Exhibition of Drawing and Sculpture,* exhibition catalog, text by Ronald D. Hickman and José Maria Tasende, San Diego, California, Arts and Crafts Press Printers, 1971; *Excerpts from a Conversation with Francisco Zúñiga,* exhibition catalog, Rubicon Gallery, Los Altos, California, 1978; *Francisco Zúñiga: Sculptor* by Sheldon Reich, University of Arizona Press, Tucson, 1980; *Francisco Zúñiga: Sculptures, Drawings, Lithographs,* New York, Brewster Editions, 1982; *Zúñiga: The Complete Graphics,* edited by Jerry Brewster and Burt Chernow, New York, Alpine Fine Arts Collection, 1984; *Zúñiga, Costa Rica: Colección Daniel Yankelewitz* by Luis Ferrero, Editorial Costa Rica, San José, 1985; *Zúñiga: La abstracción sensible,* exhibition catalog, by Marcel Paquet, El Taller del Equilibrista, Mexico, 1989. **Articles**—"Francisco Zúñiga" by Judith Hancock de Sandoval, in *Arts Magazine,* April 1977; "Francisco Zúñiga" by Burt Chernow, in *Arts Magazine,* January 1978; "Immovably Centered . . ." by Donald Holden, in *Arts Magazine,* June 1983, pp. 85–87.

* * *

Although he was born in San José, Costa Rica, Francisco Zúñiga has always been considered a Mexican artist. He spent most of his life in Mexico, and his connections were to the Mexican masters of the twentieth century—Diego Rivera, José Clemente Orozco, David Alfaro Siqueiros, and José Luis Cuevas. Although he worked as a painter throughout his career, his primary energies went into sculpture. His greatest works are synonymous with an aesthetic that captures the essence of a contemporary multicultural Latin America. Multicultural for Zúñiga also meant multitemporal, as he sought to resurrect and celebrate the mixed residues of pre-Columbian social iconography. He not only celebrated the representations of former existence, embodied in the gestures of his archetypal women, but also the timelessness and power of daily life, dignified and important, in defiance of the women's forgotten reality.

Born in 1912, Zúñiga started helping in his father's artisan workshop when he was 13, where he was exposed to the wood carvings of religious figures his father, a sculptor himself, sold to local churches. When he was 16, Zúñiga began painting in oils, which came to serve as a complement to sculpting. When he was 18, he produced his first sculpture in stone, an important step toward independence from his father's wood shop. By the time Zúñiga moved to Mexico City in 1936, he had produced *Maternity,* a depiction of a mother tenderly caressing her newborn that was carved out of a massive, rough stone. By balancing the relationship between material and depiction, Zúñiga's work was an announcement of a new approach to sculpture.

In the late 1930s Zúñiga traveled extensively throughout Mexico to learn about its people, and he became especially intrigued with the indigenous features in their faces. This visual study became the basis for the social iconography in the numerous public monuments he ultimately created throughout the country. After 20 years of creating monumental public sculptures, Zúñiga found his personal mode of expression in the 1960s: the single, individualistic form or the eternal

female earth force personified in Indian women. He said, ''It is obvious that I pay attention to all the artistic manifestations of the moment, that I analyze and learn from all that I consider important contributions to art. But what I consider most important is that process of investigation of cultural forms which are our own and which go into making up our identity in universal culture.'' Zúñiga essentially argued that abstraction was empty of any real conviction and, more critically, was international rather than Mexican. Never an advocate of naturalism, which he believed was empty and worthless, Zúñiga promoted a realism that held meaning for the viewer as it carried the valence of the art of the prehistoric past.

In 1972 Zúñiga created his first lithograph, and his prints came to be charged with the same sensitivity and sensuality as his sculpted figures. His work has been exhibited frequently in prominent galleries throughout the world and may be found in the permanent collections of dozens of museums, including the Metropolitan Museum of Art in New York City, the Los Angeles County Museum, the Mexican Museum in San Francisco, and the Phoenix Art Museum.

—Martha Sutro

A SELECTED BIBLIOGRAPHY ON HISPANIC ARTISTS_____

GENERAL REFERENCE

Ades, Dawn. *Art in Latin America: The Modern Era, 1820–1980.* New Haven: Yale University Press, 1989.

Alloway, Lawrence. *Realism and Latin American Painting: The 70s.* New York: Center for Inter-American Relations; Monterrey, Mexico: MUSEO, 1980.

———. *Topics in American Art since 1945.* New York: W.W. Norton, 1975.

Anzaldúa, Gloria. *Making Face, Making Soul/Hacienda Caras: Creative and Critical Perspectives by Feminists of Color.* San Francisco: Aunt Lute Foundation Books, 1990.

Baddeley, Oriana, guest editor. *New Art from Latin America: Expanding the Continent.* London: Academy Group Ltd., 1994.

Baddeley, Oriana, and Valerie Fraser. *Drawing the Line: Art and Cultural Identity in Contemporary Latin America.* London and New York: Verso in association with the Latin American Bureau, 1992.

Barnett, Alan W. *Community Murals: The People's Art.* Philadelphia: Art Alliance Press; New York: Cornwall Books, 1984.

Barnitz, Jacqueline. *Twentieth-Century Art of Latin America.* Austin: University of Texas Press, 2001.

Bayón, Damián. *Adventures in Contemporary Spanish-American Art: Painting, Kinetic and Action Arts, 1940–1972.* Translated by Galen Douglas Greaser. Paris: Damian Bayon, 1973.

Bayón, Damián, and Murillo Marx. *History of South American Colonial Art and Architecture: Spanish South America and Brazil.* New York: Rizzoli, 1992.

Beardsley, John. *Earthworks and Beyond: Contemporary Art in the Landscape.* New York: Abbeville Press, 1984.

Biller, Geraldine P., et al. *Latin American Women Artists: 1915–1995.* Milwaukee, Wisconsin: Milwaukee Art Museum, 1995.

Billeter, Erika. *A Song to Reality: Latin American Photography, 1860–1993.* Translated by Richard Lewis Rees. Barcelona and New York: Lunwerg, 1998.

Braun, Barbara. *Pre-Columbian Art and the Post-Columbian World: Ancient American Sources of Modern Art.* New York: Harry N. Abrams, 1993.

Brentano, Robyn, and Mark Savitt. *112 Workshop, 112 Greene Street: History, Artists, and Artworks.* New York: New York University Press, 1981.

Brett, Guy. *Transcontinental: An Investigation of Reality: Nine Latin American Artists.* London and New York: Verso, 1990.

Bucher, Bernadette J. *America: Bride of the Sun: 500 Years Latin America and The Low Countries.* Brussels and Gent, Belgium: Flemish Community, Administration of External Relations, Imschoot Books, 1992.

Camnitzer, Luis, Jane Farver, Rachel Weiss, and László Beke. *Global Conceptualism: Points of Origin, 1950s-1980s.* New York: Queens Museum of Art, 1999.

Castedo, Leopoldo. *A History of Latin American Art and Architecture from Pre-Columbian Times to the Present.* Translated by Phyllis Freeman. New York: Frederick A. Praeger, 1969.

Catlin, Stanton Loomis, and Terence Grieder. *Art of Latin America since Independence.* New Haven: Yale University Press, 1966.

Chaplik, Dorothy. *Latin American Art: An Introduction to Works of the 20th Century.* Jefferson, North Carolina: McFarland & Company, Inc., 1989.

Chase, Gilbert. *Contemporary Art in Latin America: Painting, Graphic Art, Sculpture, Architecture.* New York: The Free Press, 1970.

Cockcroft, Eva, John Weber, and James D. Cockcroft. *Toward a People's Art: The Contemporary Mural Movement.* New York: E.P. Dutton, 1976.

Damaz, Paul F. *Art in Latin American Architecture.* New York: Reinhold Publishing Corp., 1963.

Day, Holliday T., and Hollister Sturges. *Art of the Fantastic: Latin America, 1920–1987.* Indianapolis, Indiana: Indianapolis Museum of Art, 1987.

Duncan, Barbara, and Damián Bayón. *Recent Latin American Drawings, 1969–1976: Lines of Vision.* Catalog entries by Ana M. Casciero. Washington, D.C.: International Exhibitions Foundation, 1977.

Espinoza, Antonio. *Four Decades after the Muralists/Cuatro Décadas Después del Muralismo.* Los Angeles: Kimberly Gallery, 1992.

Fane, Diana, editor. *Converging Cultures: Art and Identity in Spanish America.* New York: Harry N. Abrams, 1996.

Ferrer, Elizabeth, Suzanne L. Stratton, and Edward J. Sullivan. *Modern and Contemporary Art of the Dominican Republic.* New York: Americas Society and The Spanish Institute, 1996.

Fierst, Frederick U., and Giulio V. Blanc. *Nuevas Vistas: New Insights into Contemporary Latin American Art.* Holyoke, Massachusetts: Wistariahurst Museum, 1985.

Findlay, James A., editor. *Modern Latin American Art: A Bibliography.* Westport, Connecticut: Greenwood Press, 1983.

Fletcher, Valerie J. *Crosscurrents of Modernism: Four Latin American Pioneers: Diego Rivera, Joaquín Torres-García, Wifredo Lam, Matta.* Washington, D.C.: Hirshhorn Museum and Sculpture Garden in association with the Smithsonian Institution Press, 1992.

Fox, Howard N., Miranda McClintic, and Phyllis D. Rosenzweig. *Content: A Contemporary Focus, 1974–1984.* Washington, D.C.: Hirschhorn Museum and Sculpture Garden in association with the Smithsonian Institution Press, 1984.

Franco, Jean. *The Modern Culture of Latin America: Society and the Artist.* London: Pall Mall Press, 1967.

Fusco, Coco. *English Is Broken Here: Notes on Cultural Fusion in the Americas.* New York: The New Press, 1995.

Glusberg, Jorge. *Cool Museums and Hot Museums: Towards a Museological Criticism.* With original drawings by Luis Benedit. Buenos Aires: Center for Art and Communication, 1980.

Goldman, Shifra M. *Dimensions of the Americas: Art and Social Change in Latin America and the United States.* Chicago: University of Chicago Press, 1994.

Hitchcock, Henry Russell. *Latin American Architecture since 1945.* New York: The Museum of Modern Art, 1955.

Hultén, Pontus. *Futurism & Futurisms.* London: Thames and Hudson, 1987.

Kirking, Clayton C., and Edward J. Sullivan. *Latin American Still Life: Reflections of Time and Place.* Katonah, New York: Katonah Museum of Art, 1999.

Kirstein, Lincoln. *The Latin-American Collection of the Museum of Modern Art.* New York: The Museum of Modern Art, 1943.

Kupfer, Monica E. *A Bibliography of Contemporary Art in Latin America: Books, Articles and Exhibition Catalogs in the Tulane University Library, 1950–1980.* New Orleans: Center for Latin American Studies and Howard-Tilton Memorial Library, Tulane University, 1983.

Lam, Wifredo, Giulio V. Blanc, Julia P. Herzberg, Lowery Stokes Sims, and Maria R. Balderrama. *Wifredo Lam and His Contemporaries, 1938–1952.* New York: The Studio Museum in Harlem, 1992.

Lindsay, Arturo, editor. *Santería Aesthetics in Contemporary Latin American Art*. Washington, D.C.: Smithsonian Institution Press, 1996.

Lippard, Lucy R. *From the Center: Feminist Essays on Women's Art*. New York: E.P. Dutton, 1976.

———. *Mixed Blessings: New Art in a Multicultural America*. New York: Pantheon Books, 1990.

Lucie-Smith, Edward. *Latin American Art of the 20th Century*. New York: Thames and Hudson, 1993.

McWillie, Judith, and Inverna Lockpez, curators. *The Migrations of Meaning: A Source Book*. New York: INTAR Gallery, 1992.

Mesa-Bains, Amalia, curator. *Ceremony of Memory: New Expressions in Spirituality among Contemporary Hispanic Artists*. Santa Fe, New Mexico: Center for Contemporary Arts of Santa Fe, 1988.

———. *Ceremony of Spirit: Nature and Memory in Contemporary Latino Art*. San Francisco: Mexican Museum, 1993.

Messer, Thomas M., and Cornell Capa. *The Emergent Decade: Latin American Painters and Painting in the 1960s*. Ithaca, New York: Cornell University Press, 1966.

Mosquera, Gerardo, editor. *Beyond the Fantastic: Contemporary Art Criticism from Latin America*. London: Institute of International Visual Arts, 1995.

Mosquera, Gerardo, Carolina Ponce de León, and Rachel Weiss. *Regarding America/Ante América*. Translated by Andrew Reid and Cola Franzen. Bogotá, Colombia: Biblioteca Luis-Ángel Arango, 1992.

Oettinger, Marion. *The Folk Art of Latin America: Visiones del Pueblo*. New York: Dutton Studio Books in association with the Museum of American Folk Art, 1992.

Ortiz, Benjamin. *The Awakening/El Despertar*. Bridgeport, Connecticut: The Discovery Museum, 1990.

Panyella, August, editor. *Folk Art of the Americas*. Photographs by Francesc Català Roca. New York: Harry N. Abrams, 1981.

Paternosto, César. *The Stone and the Thread: Andean Roots of Abstract Art*. Translated by Esther Allen. Austin: University of Texas Press, 1996.

Perazzo, Nelly. *Constructivist Art from Latin America*. New York: Sotheby's, 1997.

Poupeye, Veerle. *Caribbean Art*. New York: Thames and Hudson, 1998.

Puerto, Cecilia. *Latin American Women Artists, Kahlo and Look Who Else: A Selective, Annotated Bibliography*. Westport, Connecticut: Greenwood Press, 1996.

Ramírez, Mari Carmen, editor. *El Taller Torres-Garcia: The School of the South and Its Legacy*. Austin: The Archer M. Huntington Gallery, College of Fine Arts, The University of Texas Press, 1992.

Rasmussen, Waldo. *Artistas Latinoamericanos del Siglo XX/Latin American Artists of the Twentieth Century*. With essay by Edward J. Sullivan. New York: The Museum of Modern Art; Sevilla: Comisaría de la Ciudad de Sevilla para 1992; Madrid: Tabapress, 1992.

Rasmussen, Waldo, editor, with Fatima Bercht and Elizabeth Ferrer. *Latin American Artists of the Twentieth Century*. New York: The Museum of Modern Art, 1993.

Richard, Nelly. *Art from Latin America: La Cita Transcultural*. Sydney, Australia: Museum of Contemporary Art, 1993.

Robinson, Barbara J., editor. *Artistic Representation of Latin American Diversity: Sources and Collections*. Albuquerque: SALALM Secretariat, General Library, University of New Mexico, 1993.

Rodman, Selden. *Artists in Tune with Their World*. New Haven: Yale University Art Gallery, 1985.

Rodríguez, Bélgica. *Images of Silence: Photography from Latin America and the Caribbean in the 80s*. Washington, D.C.: Museum of Modern Art of Latin America, Organization of American States, 1989.

Rodríguez, Bélgica, and José Bustillos, editors. *Latin American Art: A Resource Directory*. Washington, D.C.: Museo de arte de las Américas, OEA, 1993.

Rodríguez, Bélgica, exhibition director, with Humberto Rodríguez-Camilloni, Félix Angel, and Malena Kuss, curators. *Tradition and Innovation: Painting, Architecture and Music in Brazil, Mexico and Venezuela between 1950 and 1980*. Washington, D.C.: Organization of American States, 1991.

Roth, Moira, editor, with Mary Jane Jacob. *The Amazing Decade: Women and Performance Art in America, 1970–1980*. Los Angeles: Astro Artz, 1983.

Rowe, William, and Vivian Schelling. *Memory and Modernity: Popular Culture in Latin America*. London and New York: Verso, 1991.

Scott, John F. *Latin American Art: Ancient to Modern*. Gainesville: University Press of Florida, 1999.

Seitz, William Chapin. *The Responsive Eye*. New York: The Museum of Modern Art, 1965.

Siqueiros, David Alfaro. *Art and Revolution*. Edited and translated by Sylvia Calles. London: Lawrence and Wishart, 1975.

Stellweg, Carla, curator. *Uncommon Ground: 23 Latin American Artists*. New Paltz, New York: State University College of New York, 1992.

Stofflet, Mary, curator. *Latin American Drawings Today*. With essays by Shifra M. Goldman, Gloria Zea, and Bélgica Rodríguez. San Diego: The San Diego Museum of Art, 1991; distributed by the University of Washington Press, Seattle.

Sullivan, Edward J., editor. *Latin American Art in the Twentieth Century*. London: Phaidon, 1996.

Torruella Leval, Susana. *Voices from Our Communities: Perspectives on a Decade of Collecting at EL Museo del Barrio, June 12th—September 16th, 2001*. New York: El Museo del Bario, 2001.

Torruella Leval, Susana, curator, with Víctor Zamudio-Taylor and Jhovanny Camacho. *Artists Talk Back: Visual Conversations with El Museo/Los artistas responden: conversando en imagenes con El Museo*. New York: El Museo del Barrio, 1994.

Traba, Marta. *Art of Latin America, 1900–1980*. Washington, D.C.: Inter-American Development Bank, 1994; distributed by Johns Hopkins University Press, Baltimore.

Weismann, Elizabeth Wilder. *Americas: The Decorative Arts in Latin America in the Era of the Revolution*. Washington, D.C.: Renwick Gallery of the National Collection of Fine Arts and Smithsonian Institution Press, 1976.

Weiss, Rachel, and Alan West, editors. *Being América: Essays on Art, Literature and Identity from Latin America*. Fredonia, New York: White Pine Press, 1991.

Wheeler, Monroe. *Looking South: Latin American Art in New York Collections*. New York: Center for Inter-American Relations, 1972.

Yúdice, George, Jean Franco and Juan Flores, editors. *On Edge: The Crisis of Contemporary Latin American Culture*. Minneapolis: University of Minnesota Press, 1992.

CENTRAL AMERICA

Flores, Juan Carlos. *Magic and Realism: Central American Contemporary Art*. Tegucigalpa: Galeria Trio's, 1992.

Kunzle, David. *The Murals of Revolutionary Nicaragua, 1979–1992*. Berkeley: University of California Press, 1995.

Kupfer, Monica E., and Edward J. Sullivan. *Crosscurrents: Contemporary Paintings from Panama, 1968–1998*. New York: Americas Society, 1998.

Prados S., Pedro Luis. *Contemporary Panamanian Art, Panamanian Painting Today—Panorama of a Quest*. Madrid: Americas House, 1996.

CUBA

Alvarez, Tito, and Max Kozloff. *Cuba, A View from Inside: 40 Years of Cuban Life in the Words and Works of 20 Photographers*. New York: Center for Cuban Studies, 1985.

Bedia, José, et al. *Contemporary Art from Havana*. London: Riverside Studios, 1989.

Bedia, José, Flavio Garciandía, and Ricardo Rodríguez Brey. *New Art from Cuba*. Old Westbury, New York: Visual Arts Program, SUNY College at Old Westbury, 1985.

Block, Holly, editor. *Art Cuba: The New Generation*. Translated by Cola Franzen and Marguerite Feitlowitz. New York: Harry N. Abrams, 2001.

Boswell, Thomas D., and James R. Curtis. *The Cuban American Experience: Culture, Images, and Perspectives*. Totowa, New Jersey: Rowman & Allanheld, 1984.

Camnitzer, Luis. *New Art of Cuba*. Austin: University of Texas Press, 1994.

Gómez Sicre, José. *Art of Cuba in Exile*. Translated by Ralph E. Dimmick. Miami: Editora Munder, 1987.

Loomis, John A. *Revolution of Forms: Cuba's Forgotten Art Schools*. New York: Princeton Architectural Press, 1999.

Martínez, Juan A. *Cuban Art and National Identity: The Vanguardia Painters 1927–1950*. Gainesville: University Press of Florida, 1994.

———. *Origins of Modern Cuban Painting*. Miami: Frances Wolfson Art Gallery, Miami-Dade Community College, 1982.

Matt, Gerald. *Cuba: Maps of Desire*. Vienna: Kunsthalle Wien, 1999.

Merewether, Charles. *Made in Havana: Contemporary Art from Cuba*. Sydney: Art Gallery of New South Wales, 1988.

Mosquera, Gerardo, and Rachel Weiss, editors. *The Nearest Edge of the World: Art and Cuba Now*. Boston: Polarities, Inc., 1990.

Santis, Jorge H., curator. *Breaking Barriers: Selections from the Museum of Art's Permanent Contemporary Cuban Collection*. Catalog essay by Carol Damian. Fort Lauderdale, Florida: Museum of Art, 1997.

———. *Cuban Artists of the Twentieth Century: October 22, 1993-January 2, 1994*. Essays by Giulio V. Blanc. Fort Lauderdale, Florida: The Museum of Art, 1993.

Seppälä, Marketta, editor. *No Man Is an Island: Young Cuban Art*. Pori, Finland: Pori Art Museum, 1990.

Valdés Figueroa, Eugenio. *Utopian Territories: New Art from Cuba*. Vancouver, British Columbia: Morris and Helen Belkin Art Gallery; La Habana, Cuba: Fundación Ludwig de Cuba, 1997.

Zeitlin, Marilyn A., editor. *Contemporary Art from Cuba: Irony and Survival on the Utopian Island*. New York: Arizona State University Art Museum, Delano Greenidge Editions, 1999.

MEXICO

Arceo-Frutos, René H., Juana Guzmán, and Amalia Mesa-Bains, curators. *Art of the Other México: Sources and Meanings*. Catalog design by Yolanda Durán; translated by Alejandro Velasco. Chicago: Mexican Fine Arts Center Museum, 1993.

Barnitz, Jacqueline. *Young Mexicans: Corzas, Gironella, López-Loza, Rojo [and] Toledo*. New York: Art Gallery, Center for Inter-American Relations, 1970.

Billeter, Erika, editor, with Alicia Azuela. *Images of Mexico: The Contribution of Mexico to Twentieth Century Art*. Dallas: Dallas Museum of Art, 1988.

Cetto, Max L. *Modern Architecture in Mexico*. Translated by D.Q. Stephenson. New York: Frederick A. Praeger, 1961.

Charlot, Jean. *Mexican Art and the Academy of San Carlos, 1785–1915*. Austin: University of Texas Press, 1962.

———. *The Mexican Mural Renaissance, 1920–1925*. New Haven: Yale University Press, 1963.

Debroise, Olivier. *Mexican Suite: A History of Photography in Mexico*. Translated and revised in collaboration with the author by Stella de Sá Rego. Austin: University of Texas Press, 2001.

Emerich, Luis Carlos. *New Mexican Arts*. Mexico City: Editorial Diana, 1997.

Escobedo, Helen, editor. *Mexican Monuments: Strange Encounters*. New York: Abbeville Press, 1989.

Fernández, Justino. *A Guide to Mexican Art, from Its Beginnings to the Present*. Translated by Joshua C. Taylor. Chicago: University of Chicago Press, 1969.

———. *The History of Art in Mexico*. With photographs by Constantino Reyes-Valerio. Mexico City: Distribuidora Británica, 1990.

———. *Mexican Art*. Twickenham, England: Hamlyn, 1965.

Folgarait, Leonard. *Mural Painting and Social Revolution in Mexico, 1920–1940: Art of the New Order*. New York and Cambridge, England: Cambridge University Press, 1998.

Franco, Jean. *Plotting Women: Gender and Representation in Mexico*. London: Verso, 1989.

Giffords, Gloria Fraser. *Mexican Folk Retablos*. Revised edition. Albuquerque: University of New Mexico Press, 1992.

Goldman, Shifra M. *Contemporary Mexican Painting in a Time of Change*. Foreword by Raquel Tibol. Albuquerque: University of New Mexico Press, 1995.

———. *Mexican Muralism: Its Social-Educative Roles in Latin America and the United States*. Austin: Institute of Latin American Studies, University of Texas, 1980.

Helm, MacKinley. *Modern Mexican Painters*. New York: Harper & Brothers, 1941.

Hurlburt, Laurance P. *The Mexican Muralists of the United States*. Albuquerque: University of New Mexico Press, 1989.

Kelker, Nancy L., editor. *Mexico: The New Generations*. San Antonio, Texas: San Antonio Museum of Art, 1985.

Merewether, Charles, guest curator. *Mexico, Out of the Profane: Six Contemporary Mexican Artists: Works by Monica Castillo, Rocio Maldonado, Ruben Ortiz, Georgina Quintana, German Venegas and Nahum Zenil*. Adelaide, Australia: Adelaide Festival of Arts Inc., 1990.

Mérida, Carlos. *Modern Mexican Artists: Critical Notes*. Mexico: Frances Toor Studios, 1937.

Mesa-Bains, Amalia, and Tomás Ybarra-Frausto. *Lo del Corazón: Heartbeat of a Culture: The Mexican Museum, 16 April-15 June 1986*. San Francisco: The Museum, 1986.

Paz, Octavio. *Essays on Mexican Art*. New York: Harcourt Brace, 1993.

Rascón, Armando, curator. *Xicano Progeny: Investigative Agents, Executive Council, and Other Representatives from the Sovereign State of Aztlán*. San Francisco: Mexican Museum, 1995.

Reed, Alma M. *The Mexican Muralists*. New York: Crown Publishers, 1960.

Rivera, Diego, and Bertram David Wolfe. *Portrait of Mexico*. New York: Covici, Friede, 1937.

Rodríguez, Antonio. *A History of Mexican Mural Painting*. New York: Putnam, 1969.

Stewart, Virginia. *45 Contemporary Mexican Artists: A Twentieth-Century Renaissance*. Stanford, California: Stanford University Press, 1951.

Sullivan, Edward J. *Aspects of Contemporary Mexican Painting*. New York: Americas Society, 1990.

Weismann, Elizabeth Wilder. *Art and Time in Mexico: From the Conquest to the Revolution*. Photographs by Judith Hancock Sandoval. New York and London: Harper and Row, 1985.

SOUTH AMERICA

Acha, Juan. *Peru*. Translated by William McLeod Rivera. Washington, D.C.: Pan American Union, 1961.

Amaral, Aracy A. *Arts in the Week of '22*. Revised edition. Translated by Elsa Oliveira Marques. São Paulo: BM&F, 1992.

Amaral, Aracy A., editor. *Constructive Art in Brazil: Adolpho Leirner Collection*. Texts by Adolpho Leirner. São Paulo, Brazil: Dórea Books and Art, 1998.

Amaral, Aracy A., and Rubens Fernandes, Jr., coordinators. *São Paulo Imagens de 1998*. São Paulo, Brazil: Editora Marca D'Agua, 1998.

Amaral, Aracy A., and Paulo Herkenhoff. *Ultramodern: The Art of Contemporary Brazil*. Washington, D.C.: National Museum of Women in the Arts, 1993.

Andrade, Mário de. *Brazilian Sculpture: An Identity in Profile*. São Paulo, Brazil: Associação dos Amigos da Pinateca, 1997.

Bardi, Pietro Maria. *Profile of the New Brazilian Art*. Translated from the Italian by John Drummond. Rio de Janeiro: Kosmos, 1970.

Barnitz, Jacqueline, guest curator. *Abstract Currents in Ecuadorian Art: Araceli, Maldonado, Molinari, Rendón, Tabara, Villacis*. New York: Center for Inter-American Relations, 1977.

Bedel, Jacques, with Sally Baker, editor. *Art of the Americas: The Argentine Project*. Texts by Joseph Azar. Hudson, New York: Baker & Co., 1992.

Bercht, Fatima, curator. *Contemporary Art from Chile*. New York: Americas Society, 1991.

Castro, Robert Montero. *Caracas Museum of Contemporary Art*. Translated by Aisbel Salamanqués and Gladys Sanz. Caracas: Lagoven Booklets, 1988.

Evenson, Norma. *Two Brazilian Capitals: Architecture and Urbanism in Rio de Janeiro and Brasília*. New Haven: Yale University Press, 1973.

Glusberg, Jorge. *Art in Argentina*. Milan, Italy: Giancarlo Politi, 1986.

——. *Venezuela: Young Generation*. Buenos Aires: International Association of Art Critics, 1977.

Glusberg, Jorge, Ernesto Deira, Rómulo Macció, Luis Felipe Noé, and Jorge de la Vega. *Argentine New Figuration*. Buenos Aires: Argentine Association of Art Critics, 1986.

Glusberg, Jorge, and Philip Verre, curators. *Ideas and Images from Argentina*. New York: The Bronx Museum of Arts, 1989.

Guss, David M. *To Weave and Sing: Art, Symbol, and Narrative in the South American Rain Forest*. Berkeley: University of California Press, 1989.

Haber, Alicia, with Mark D. Szuchman, editor. *Vernacular Culture in Uruguayan Art: An Analysis of the Documentary Function of the Works of Pedro Figari, Carlos González, and Luis Solari*. Miami: Latin American and Caribbean Center, Florida International University, 1982.

Hoffenberg, H.L. *Nineteenth-Century South America in Photographs*. New York: Dover Publications, 1982.

Lemos, Carlos Alberto Cerqueira, José Roberto Texeira Leite, and Pedro Manuel Gismonti. *The Art of Brazil*. Translated by Jennifer Clay; with an introduction by Pietro Maria Bardi and an essay by Oscar Niemeyer. New York: Harper and Row, 1983.

Perazzo, Nelly. *El Arte Concreto en la Argentina en la Década del 40*. Buenos Aires: Ediciones de Arte Gaglianone, 1983.

Ramírez, Mari Carmen. *Visual Parody in Contemporary Argentinean Art*. With additional texts by Marcelo Eduardo Pacheco and Andrea Giunta. Austin: Jack S. Blanton Museum of Art, the University of Texas at Austin; Buenos Aires: Fondo Nacional de las Artes, Argentina, 1999.

Ramírez, Mari Carmen, and Edith A. Gibson, curators. *Re-aligning Vision: Alternative Currents in South American Drawing*. Translated by Albert G. Bork. Austin: Archer M. Huntington Art Gallery, University of Texas at Austin, 1997.

Safons, Horacio, Fermín Fèvre, and Jorge Glusberg. *Art Criticism in Argentina*. Buenos Aires: Argentine Association of Art Critics, 1979.

Sullivan, Edward J., editor. *Brazil: Body and Soul*. New York and London: Harry N. Abrams, 2001.

Traba, Marta. *Colombia*. Translated by Clarabel C. Waite. Washington, D.C.: Pan American Union, 1959.

Whitten, Dorothea S., and Norman E. Whitten, Jr. *From Myth to Creation: Art from Amazonian Ecuador*. Urbana: University of Illinois Press, 1988.

UNITED STATES AND PUERTO RICO

Barnitz, Jacqueline, et al. *Latin American Artists in the U.S. before 1950*. Flushing, New York: Godwin-Ternbach Museum at Queens College, 1981.

——. *Latin American Artists in the U.S. 1950–1970*. Flushing, New York: Queens College Office of Publications, Printing, and Office Services, 1983.

——. *Latin American Artists in New York since 1970*. Austin: Archer M. Huntington Art Gallery, College of Fine Arts, The University of Texas at Austin, 1987.

Beardsley, John, and Jane Livingston. *Hispanic Art in the United States: Thirty Contemporary Painters and Sculptors*. With an essay by Octavio Paz. Houston: Museum of Fine Arts; New York: Abbeville Press, 1987.

Boyd, Elizabeth. *Popular Arts of Spanish New Mexico*. Santa Fe: Museum of New Mexico Press, 1974.

Briggs, Charles L. *The Wood Carvers of Córdova, New Mexico: Social Dimensions of an Artistic ''Revival.''* Knoxville: The University of Tennessee Press, 1980.

Cancel, Luis R., et al. *The Latin American Spirit: Art and Artists in the United States, 1920–1970*. New York: Bronx Museum of the Arts in association with Harry N. Abrams, 1988.

Chavez, Patricio, and Madeleine Grynsztejn, curators. *La Frontera/ The Border: Art about the Mexico/United States Border Experience*. Exhibition and catalog coordinator, Kathryn Kanjo. San Diego: Museum of Contemporary Art, 1993.

Clark, Yoko, and Chizu Hama. *California Murals*. Photographs by Marshall Gordon. Berkeley, California: Lancaster-Miller Publishers, 1979.

Cockcroft, Eva Sperling, and Holly Barnet-Sánchez. *Signs from the Heart: California Chicano Murals*. Venice, California: Social and Public Art Resource Center, 1990.

Espinosa, Eugenio, project director. *Into the Mainstream: Ten Latin American Artists Working in New York*. Curated by Giulio V. Blanc. Jersey City, New Jersey: Jersey City Museum, 1986.

Gaspar de Alba, Alicia. *Chicano Art Inside/Outside the Master's House: Cultural Politics and the CARA Exhibition*. Austin: University of Texas Press, 1998.

Goldman, Shifra M., guest curator. *Chicana Voices and Visions: A National Exhibit of Women Artists: 27 Artists from Arizona, California, Colorado, Michigan, New Mexico, and Texas*. Coordinated by Mary-Linn Hughes. Venice, California: Social and Public Arts Resource Center, 1983.

Goldman, Shifra M., and Tomás Ybarra-Frausto. *Arte Chicano: A Comprehensive Annotated Bibliography of Chicano Art, 1965–1981*. Berkeley: Chicano Studies Library Publications Unit, University of California, 1985.

Griswold del Castillo, Richard, Teresa McKenna, and Yvonne Yarbro-Bejarano, editors. *Chicano Art: Resistance and Affirmation, 1965–1985*. Los Angeles: Wight Art Gallery, University of California, 1991.

Guglielmo, Rudy, project director and curator, with Tomás Ybarra-Frausto and Lennee Eller, curators. *Chicano Aesthetics: Rasquachismo*. With essays by Tomás Ybarra-Frausto, Shifra M. Goldman, and John L. Aguilar. Phoenix, Arizona: MARS, 1989.

Hall, Dawn, editor. *Drawing the Borderline: Artist-Explorers of the U.S.-Mexico Boundary Survey*. With a preface by Robert V. Hine. Albuquerque, New Mexico: Albuquerque Museum, 1996.

Kubiak, Richard, and Elizabeth Partch, editors. *Body/Culture, Chicano Figuration*. With essays by Amalia Mesa-Bains and Victor Alejandro Sorell. Rohnert Park, California: University Art Gallery, Sonoma State University, 1990.

Levick, Melba, photographer. *The Big Picture: Murals of Los Angeles*. With commentaries by Stanley Young. London: Thames and Hudson, 1988.

Lomelí, Francisco, editor. *Handbook of Hispanic Cultures in the United States: Literature and Art*. Houston: Arte Público Press and Madrid Instituto de Cooperacion Iberoamericana, 1993.

Martínez, Santos. *El Chicanismo, el Arte Chicano en Texas/ Chicanismo, Chicano Art in Texas*. Houston, Texas: Contemporary Arts Museum, 1977.

Noriega, Chon A., curator. *From the West: Chicano Narrative Photography*. San Francisco: Mexican Museum, 1995; distributed by University of Washington Press, Seattle.

Perisho, Sally L., curator. *Sin Fronteras, Crossing Borders: Mexican American Artists in the Southwest*. Colorado Springs: Gallery of Contemporary Art, University of Colorado, Colorado Springs, 1989.

Polkinhorn, Harry, editor. *Visual Arts on the U.S./Mexican Border*. Calexico, California: Binational Press; Mexicali, Baja California: Editorial Binacional, 1991.

Quirarte, Jacinto. *The Art and Architecture of the Texas Missions*. Austin: University of Texas Press, 2002.

———. *The Art of Mexican-America*. Houston: Humble Oil & Refining Co., 1970.

———. *Art of the Americas: Published and Unpublished Papers*. Revised edition. San Antonio: Research Center for the Visual Arts, The University of Texas at San Antonio, 1989.

———. *Chicano Art History: A Book of Selected Readings*. San Antonio: Research Center for the Arts and Humanities, University of Texas at San Antonio, 1984.

———. *Hispanic-American Art/El Arte Hispanoamericano*. Washington, D.C.: National Museum of American Art, 1970.

———. *A History and Appreciation of Chicano Art*. San Antonio: Research Center for the Arts and Humanities, University of Texas at San Antonio, 1984.

———. *Mexican American Artists*. Austin: University of Texas Press, 1973.

———. *The Murals of El Barrio*. Houston: Exxon USA, 1974.

Quirarte, Jacinto, editor. *The Hispanic American Aesthetic: Origins, Manifestations, and Significance*. San Antonio: Research Center for the Arts and Humanities, University of Texas at San Antonio, 1983.

Ramírez, Mari Carmen, editor. *Puerto Rican Painting: Between Past and Present*. Princeton, New Jersey: Squibb Corp., 1987.

Rivera, Diego, and Bertram David Wolfe. *Portrait of America*. New York: Covici, Friede, 1934.

Romotsky, Jerry, and Sally R. Romotsky. *Los Angeles Barrio Calligraphy*. Los Angeles: Dawson's Book Shop, 1976.

Roth, Moira, editor. *Connecting Conversations: Interviews with 28 Bay Area Women Artists*. Oakland, California: Eucalyptus Press, Mills College, 1988.

Steele, Thomas J. *Santos and Saints: The Religious Folk Art of Hispanic New Mexico*. Santa Fe, New Mexico: Ancient City Press, 1982.

Stellweg, Carla. *Spanish Remnants: Borders Real and Imagined*. Arlington, Texas: Arlington Museum of Art, 1992.

Sturges, Hollister. *New Art from Puerto Rico/Nuevo arte de Puerto Rico*. Springfield, Massachusetts: Museum of Fine Arts, 1990.

Torruella Leval, Susana, curator. *Women Artists from Puerto Rico: November 3–30, 1983, Cayman Gallery*. New York: Cayman Gallery, 1983.

Weigle, Marta, editor, with Claudia and Samuel Larcombe. *Hispanic Arts and Ethnohistory in the Southwest: New Papers Inspired by the Work of E. Boyd*. Santa Fe, New Mexico: Ancient City Press, 1983.

Wroth, William. *Christian Images in Hispanic New Mexico: The Taylor Museum Collection of Santos*. Colorado Springs, Colorado: The Museum, 1982.

NATIONALITY INDEX

American

Laura Aguilar
Olga Albizu
Juana Alicia
Carlos D. Almaráz
Celia Alvarez Muñoz
Jesse Amado
Felipe B. Archuleta
David Avalos
Judith F. Baca
Myrna Báez
Patrociño Barela
Santa Barraza
Angel Botello
Rolando Briseño
María Magdalena Campos-Pons
Barbara Carrasco
Charlie Carrillo
Mel Casas
Rolando Castellón
Enrique Castro-Cid
Enrique Chagoya
Wilfredo Chiesa
Carlos Collazo
Rafael Colón Morales
Luis Cruz Azaceta
Jaime Davidovich
Irene Delano
Jack Delano
Juan Downey
Agustín Fernández
Teresita Fernández
Rafael Ferrer
Ramón Frade
Antonio Frasconi
Daniel Galvez
Diane Gamboa
Harry Gamboa, Jr.
Rupert García
Guillermo Gómez-Peña
Felix Gonzalez-Torres
Robert Graham
Gronk
Ester Hernández
Luis Hernández Cruz
Willie Herrón III
Lorenzo Homar
Salomón Huerta
Carlos Irizarry
Alfredo Jaar
Luis Jiménez
Roberto Juárez
Julio Larraz
Carmen Lomas Garza
Alma López
Yolanda M. Lopez
Richard A. Lou
Gilbert ''Magu'' Luján
Pedro Lujan
James Luna

Iñigo Manglano-Ovalle
Ralph Maradiaga
Marisol
César Martínez
Daniel J. Martinez
María Martínez-Cañas
Ana Mendieta
Amalia Mesa-Bains
José Montoya
Malaquías Montoya
José Morales
Manuel Neri
Francisco Oller
María de Mater O'Neill
Rafael Ortiz
Pepón Osorio
Alfonso Ossorio
César Paternosto
Amado M. Peña, Jr.
Miguel Pou
Nick Quijano
Alfred J. Quiróz
Raquel Rabinovich
Mel Ramos
Armando Rascón
Miguel Angel Rios
Carlos Raquel Rivera
Dhara Rivera
Arnaldo Roche
Francisco Rodón
Patricia Rodríguez
Angel Rodríguez-Díaz
Frank Romero
José Rosa
Julio Rosado del Valle
Melquíades Rosario
Noemí Ruiz
Soledad Salamé
Emilio Sánchez
Juan Sánchez
Robert Sanchez
Andrés Serrano
Ray Smith
Bibiana Suárez
Luis Eligio Tapia
Mario Toral
Rigoberto Torres
Salvador Roberto Torres
Rúben Torres Llorca
Nitza Tufiño
Rafael Tufiño
John Valadez
Patssi Valdez
Kathy Vargas
Cecilia Vicuña
Liliana Wilson-Grez
David Zamora Casas

Argentine

Jacques Bedel

Tania Bruguera
Agustín Cárdenas
Mario Carreño
Guillermo Collazo
Antonia Eiriz
Juan Francisco Elso
Carlos Enríquez
Arístides Fernández
Ever Fonseca
Carlos Garaicoa
María Elena González
Kcho
Wifredo Lam
Guido Llinás
Los Carpinteros
Víctor Manuel
Raúl Martínez
Alejandro Mazón
Manuel Mendive
Amelia Peláez
Umberto Peña
Marta María Pérez Bravo
Marcelo Pogolotti
Fidelio Ponce
Ricardo Porro
René Portocarrero
Ernesto Pujol
Mariano Rodríguez
Leopoldo Romañach
Alfredo Rostgaard
Tonel

Dominican
Tony Capellán
Jaime Colson
Marcos Lora Read
Jorge Pineda
Belkis Ramírez
Darío Suro

Ecuadoran
Camilo Egas
Oswaldo Guayasamín
Eduardo Kingman
Estuardo Maldonado
Enrique Tábara
Diógenes Paredes
Oswaldo Viteri

French
Roberto Matta

Guatemalan
Rodolfo Abularach
Margarita Azurdia
Moisés Barrios
Luis González Palma
Carlos Mérida
Isabel Ruíz

Honduran
Regina Aguilar
Xenia Mejía

Mexican
Lola Álvarez Bravo
Manuel Álvarez Bravo
Francis Alÿs
Raúl Anguiano
Dr. Atl
Luis Barragán
Adolfo Best Maugard
Miguel Calderón
Lilia Carrillo
Leonora Carrington
Jean Charlot
José Chávez Morado
Elena Climent
Miguel Covarrubias
Germán Cueto
José Luis Cuevas
Marius de Zayas
Manuel Felguérez
Gabriel Fernández Ledesma
Julio Galán
Arturo García Bustos
Gunther Gerzso
Mathias Goeritz
Francisco Goitía
Jorge González Camarena
Sylvia Gruner
Jesús Guerrero Galván
Saturnino Herrán
Graciela Iturbide
María Izquierdo
Frida Kahlo
Agustín Lazo
Ricardo Legorreta
Pedro Linares
Leopoldo Méndez
Pedro Meyer
Tina Modotti
Pablo Monasterio
Roberto Montenegro
Juan O'Gorman
Pablo O'Higgins
Gabriel Orozco
José Clemente Orozco
Mario Orozco Rivera
Luis Paredes
José Guadalupe Posada
Fermín Revueltas
Adolfo Riestra
Diego Rivera
Julio Ruelas
Antonio Ruíz
David Alfaro Siqueiros
Rufino Tamayo
Francisco Toledo
Remedios Varo

José María Velasco
Germán Venegas
Nahum B. Zenil

Nicaraguan
Patricia Belli
Armando Morales
Orlando Sobalvarro
Leonel Vanegas

Panamanian
Brooke Alfaro
Isabel De Obaldía
Sandra Eleta
Guillermo Trujillo
Humberto Vélez
Julio Zachrisson

Paraguayan
Olga Blinder
Osvaldo Salerno

Peruvian
Enrique Camino Brent
Fernando de Szyszlo
José Sabogal
Tilsa Tsuchiya
Jorge Vinatea Reinoso

Salvadoran
Benjamín Cañas
Noé Canjura
Luis Paredes

Uruguayan
Julio Alpuy
Carmelo Arden Quin
Rafael Barradas
Juan Manuel Blanes
Luis Camnitzer
Carlos Capelán
José Cúneo
Pedro Figari
Gonzalo Fonseca
Nelsón Ramos
Joaquín Torres-García

Venezuelan
Jacobo Borges
Carlos Cruz-Diez
Gego
José Antonio Hernández-Diez
Alejandro Otero
Armando Reverón
Jesús Rafael Soto
Meyer Vaisman
Carlos Zerpa

MEDIUM INDEX

Architectural and Freehand Drafting
Carlos Garaicoa

Architecture
Luis Barragán
Luis F. Bénedit
Benjamín Cañas
Mathias Goeritz
Ricardo Legorreta
Juan O'Gorman
Ricardo Porro
Bernardo Salcedo
Osvaldo Salerno
Clorindo Testa

Assemblage
Marisel Jiménez
Richard A. Lou
Patricia Rodríguez
Bernardo Salcedo

Caricature
Jorge Vinatea Reinoso

Ceramics
Amelia Peláez

Collage
Moisés Barrios
Catalina Parra

Conceptual
Francisco Brugnoli
Daniel J. Martinez
Regina Silveira
Roberto Valcárcel
Regina Vater

Digital
Alma López
Pedro Meyer

Engraving
Francisco Amighetti
Moisés Barrios
José Luis Cuevas
Eugenio Dittborn
Cándido López
Estuardo Maldonado
José Guadalupe Posada
Juan Luis Rodríguez
Miguel Rojas
Osvaldo Salerno
Guillermo Trujillo
Rafael Tufiño

Graphic
Rodolfo Abularach
Myrna Báez
Ester Hernández

Carlos Irizarry
Marisol
Raúl Martínez
José Montoya
Óscar Muñoz
Carlos Raquel Rivera
Francisco Toledo

Illustration
Juana Alicia
Santiago Armada
Rafael Barradas
Emiliano di Cavalcanti
Antonio Martorell

Installation
Celia Alvarez Muñoz
David Avalos
José Bedia
Patricia Belli
Francisco Brugnoli
Luis Camnitzer
María Fernanda Cardoso
Josely Carvalho
Gonzalo Díaz
Eugenio Dittborn
Juan Downey
Juan Francisco Elso
Teresita Fernández
Guillermo Gómez-Peña
María Elena González
Felix Gonzalez-Torres
Robert Graham
Sylvia Gruner
Ester Hernández
Alfredo Jaar
Marisel Jiménez
Kcho
Jac Leirner
Yolanda M. Lopez
Marcos Lora Read
James Luna
Iñigo Manglano-Ovalle
Antonio Martorell
Amalia Mesa-Bains
Priscilla Monge
José Morales
Hélio Oiticica
Gabriel Orozco
Pepón Osorio
Lygia Pape
Jorge Pineda
Ernesto Pujol
Nick Quijano
Belkis Ramírez
Armando Rascón
Rosângela Rennó
Miguel Angel Rios
Dhara Rivera
Isabel Ruíz

Soledad Salamé
Doris Salcedo
Robert Sanchez
Bibiana Suárez
Tunga
Gastón Ugalde
Meyer Vaisman
Patssi Valdez
Adriana Varejão
Regina Vater
Humberto Vélez
Cecilia Vicuña
David Zamora Casas
Naham B. Zenil
Carlos Zerpa
Francisco Zúñiga

Interdisciplinary
Daniel J. Martinez

Lithographs
José Clemente Orozco
Alicia Peñalba
José Guadalupe Posada

Mixed Media
Francisco Brugnoli
María Magdalena Campos-Pons
Tony Capellán
Enrique Chagoya
Eduardo Costa
Agustín Fernández
Harry Gamboa, Jr.
Leonilson
Los Carpinteros
Cildo Meireles
Priscilla Monge
María Luisa Pacheco
Lygia Pape
Luis Paredes
Soledad Salamé
Daniel Senise
Nahum B. Zenil

Multimedia
José Antonio Hernández-Diez
Yolanda M. Lopez
James Luna

Murals
Juana Alicia
Carlos D. Almaráz
Francisco Amighetti
David Avalos
Judith F. Baca
Santa Barraza
Barbara Carrasco
José Chávez Morado
Daniel Galvez
Arturo García Bustos

Willie Herrón III
Carlos Mérida
Juan O'Gorman
Pablo O'Higgins
Mario Orozco Rivera
Diego Rivera
David Alfaro Siqueiros
Rufino Tamayo
Salvador Roberto Torres
Nitza Tufiño

Painting
Eduardo Abela
Rodolfo Abularach
Olga Albizu
Brooke Alfaro
Juana Alicia
Carlos D. Almaráz
Julio Alpuy
Celia Alvarez Muñoz
Francis Alÿs
Jesse Amado
Francisco Amighetti
Raúl Anguiano
Nemesio Antúñez
Débora Arango
Carmelo Arden Quin
Santiago Armada
Dr. Atl
Margarita Azurdia
Judith F. Baca
Myrna Báez
José Balmes
Rafael Barradas
Santa Barraza
Moisés Barrios
José Bedia
Patricia Belli
Luis F. Bénedit
Cundo Bermúdez
Antonio Berni
Adolfo Best Maugard
Juan Manuel Blanes
Olga Blinder
Marcelo Bonevardi
Arturo Borda
Jacobo Borges
Norah Borges
Angel Botello
Fernando Botero
Claudio Bravo
Tania Bruguera
Miguel Calderón
Enrique Camino Brent
Luis Camnitzer
Benjamín Cañas
Noé Canjura
Carlos Capelán
Tony Capellán
Agustín Cárdenas

Antonio Caro
Barbara Carrasco
Mario Carreño
Charlie Carrillo
Lilia Carrillo
Leonora Carrington
Mel Casas
Enrique Castro-Cid
Emiliano di Cavalcanti
Enrique Chagoya
Jean Charlot
José Chávez Morado
Wilfredo Chiesa
Elena Climent
Carlos Collazo
Guillermo Collazo
Rafael Colón Morales
Jaime Colson
Eduardo Costa
Miguel Covarrubias
Mário Cravo Neto
Luis Cruz Azaceta
Carlos Cruz-Diez
José Luis Cuevas
José Cúneo
Jaime Davidovich
Juan Dávila
Ernesto Deira
Irene Delano
Jorge Luis de la Vega
Isabel De Obaldía
Fernando de Szyszlo
Marius de Zayas
Antonio Dias
Cícero Dias
Gonzalo Díaz
Eugenio Dittborn
Arturo Duclós
Camilo Egas
Antonia Eiriz
Sandra Eleta
Carlos Enríquez
Fernando Fáder
Manuel Felguérez
Agustín Fernández
Arístides Fernández
Lola Fernández
Gabriel Fernández Ledesma
Rafael Ferrer
Pedro Figari
Ever Fonseca
Gonzalo Fonseca
Lucio Fontana
Ramón Frade
Ismael Frigerio
Julio Galán
Daniel Galvez
Diane Gamboa
Harry Gamboa, Jr.
Rupert García

Arturo García Bustos
Gego
Gunther Gerzso
Mathias Goeritz
Francisco Goitía
Juan Gómez Quiróz
Beatríz González
Juan Francisco González
Jorge González Camarena
Felix Gonzalez-Torres
Enrique Grau
Victor Grippo
Gronk
Sylvia Gruner
Oswaldo Guayasamín
Jesús Guerrero Galván
Cecilio Guzmán de Rojas
Ester Hernández
Luis Hernández Cruz
Lorenzo Homar
Salomón Huerta
Carlos Irizarry
María Izquierdo
Luis Jiménez
Max Jiménez
Roberto Juárez
Frida Kahlo
Kcho
Eduardo Kingman
Gyula Kosice
Guillermo Kuitca
Wifredo Lam
Julio Larraz
Agustín Lazo
Leonilson
Julio Le Parc
Benjamin Lira
Guido Llinás
Carmen Lomas Garza
Alma López
Cándido López
Yolanda M. Lopez
Los Carpinteros
Richard A. Lou
Gilbert "Magu" Luján
James Luna
Rómulo Macció
Eduardo MacEntyre
Estuardo Maldonado
Tomás Maldonado
Anita Malfatti
Victor Manuel
Ralph Maradiaga
Marisol
César Martínez
Raúl Martínez
Antonio Martorell
Roberto Matta
Alejandro Mazón
Cildo Meireles

Xenia Mejía
Leopoldo Méndez
Ana Mendieta
Manuel Mendive
Carlos Mérida
Marta Minujín
Priscilla Monge
Roberto Montenegro
José Montoya
Malaquías Montoya
Armando Morales
José Morales
Óscar Muñoz
Manuel Neri
Luis Noé
Alejandro Obregón
Juan O'Gorman
Pablo O'Higgins
Hélio Oiticica
Francisco Oller
María de Mater O'Neill
Gabriel Orozco
José Clemente Orozco
Mario Orozco Rivera
Rafael Ortiz
Alfonso Ossorio
Alejandro Otero
María Luisa Pacheco
Diógenes Paredes
César Paternosto
Amelia Peláez
Amado M. Peña, Jr.
Umberto Peña
Emilio Pettoruti
Marcelo Pogolotti
Fidelio Ponce
Liliana Porter
Cándido Portinari
René Portocarrero
Miguel Pou
Nick Quijano
Alfred J. Quiróz
Raquel Rabinovich
Belkis Ramírez
Mel Ramos
Nelsón Ramos
Armando Rascón
Armando Reverón
Fermín Revueltas
Adolfo Riestra
Miguel Angel Rios
Carlos Raquel Rivera
Diego Rivera
Arnaldo Roche
Francisco Rodón
Juan Luis Rodríguez
Mariano Rodríguez
Patricia Rodríguez
Angel Rodríguez-Díaz
Carlos Rojas

Miguel Rojas
Leopoldo Romañach
Frank Romero
José Rosa
Julio Rosado del Valle
Julio Ruelas
Antonio Ruíz
Isabel Ruíz
Noemí Ruiz
José Sabogal
Soledad Salamé
Osvaldo Salerno
Emilio Sánchez
Juan Sánchez
Robert Sanchez
Fanny Sanín
Mira Schendel
Lasar Segall
Antonio Seguí
Daniel Senise
Regina Silveira
David Alfaro Siqueiros
Ray Smith
Orlando Sobalvarro
Jesús Rafael Soto
Bibiana Suárez
Pablo Suárez
Darío Suro
Enrique Tábara
Jorge Tacla
Rufino Tamayo
Clorindo Testa
Francisco Toledo
Tonel
Mario Toral
Salvador Roberto Torres
Joaquín Torres-García
Rúben Torres Llorca
Guillermo Trujillo
Tilsa Tsuchiya
Nitza Tufiño
Rafael Tufiño
Tunga
Gastón Ugalde
Meyer Vaisman
John Valadez
Roberto Valcárcel
Patssi Valdez
Leonel Vanegas
Adriana Varejão
Remedios Varo
Regina Vater
José María Velasco
Germán Venegas
Jorge Vinatea Reinoso
Oswaldo Viteri
Alfredo Volpi
Liliana Wilson-Grez
Alejandro Xul Solar
Julio Zachrisson

David Zamora Casas
Nahum B. Zenil
Carlos Zerpa
Francisco Zúñiga

Papier-Mâché
Pedro Linares

Performance
David Avalos
Tania Bruguera
Juan Dávila
Harry Gamboa, Jr.
Guillermo Gómez-Peña
Gronk
James Luna
Ana Mendieta
Manuel Mendive
Priscilla Monge
Hélio Oiticica
Rafael Ortiz
Lotty Rosenfeld
Meyer Vaisman
Patssi Valdez
Humberto Vélez
Cecilia Vicuña
David Zamora Casas

Photography
Laura Aguilar
Lola Álvarez Bravo
Manuel Álvarez Bravo
Celia Alvarez Muñoz
Francis Alÿs
Moisés Barrios
Miguel Calderón
María Magdalena Campos-Pons
Mário Cravo Neto
Jack Delano
Marius de Zayas
Gonzalo Díaz
Sandra Eleta
Diane Gamboa
Harry Gamboa, Jr.
Carlos Garaicoa
Luis González Palma
Felix Gonzalez-Torres
Graciela Iturbide
Alfredo Jaar
Leandro Katz
Benjamin Lira
Cándido López
Ralph Maradiaga
César Martínez
Daniel J. Martinez
Raúl Martínez
María Martínez-Cañas
Ana Mendieta
Pedro Meyer
Tina Modotti

Pablo Monasterio
Vik Muniz
Gabriel Orozco
Luis Paredes
Marta María Pérez Bravo
Liliana Porter
Ernesto Pujol
Rosângela Rennó
Miguel Rojas
Juan Sánchez
Andrés Serrano
Patssi Valdez
Kathy Vargas

Poster
Alfredo Rostgaard
Rafael Tufiño

Printmaking
Juana Alicia
Celia Avarez Muñoz
Cundo Bermúdez
Luis Camnitzer
Tony Capellán
Leonora Carrington
Enrique Chagoya
José Chávez Morado
Gabriel Fernández Ledesma
Antonio Frasconi
Rupert García
Arturo García Bustos
Gego
Juan Gómez Quiróz
Ester Hernández
Lorenzo Homar
Julio Larraz
Carmen Lomas Garza
Ralph Maradiaga
Antonio Martorell
Xenia Mejía
Leopoldo Méndez
Malaquías Montoya
Amado M. Peña, Jr.
Umberto Peña
Jorge Pineda
Belkis Ramírez
Miguel Angel Rios
Carlos Raquel Rivera
José Rosa
Melquíades Rosario
Julio Ruelas
Emilio Sánchez
Juan Sánchez
Fanny Sanín
Antonio Seguí
Regina Silveira
Ray Smith
Mario Toral
Nitza Tufiño
Julio Zachrisson

Sculpture

Rodolfo Abularach
Regina Aguilar
Brooke Alfaro
Julio Alpuy
Francis Alÿs
Jesse Amado
Felipe B. Archuleta
David Avalos
Margarita Azurdia
Judith F. Baca
Patrociño Barela
Jacques Bedel
Marcelo Bonevardi
Angel Botello
Fernando Botero
Rolando Briseño
Waltércio Caldas
Miguel Calderón
Sérgio de Camargo
Luis Camnitzer
Benjamín Cañas
Agustín Cárdenas
María Fernanda Cardoso
Leonora Carrington
Rolando Castellón
Amílcar de Castro
Lygia Clark
Carlos Collazo
Mário Cravo Neto
Germán Cueto
Isabel De Obaldía
Fernando de Szyszlo
Tarsila do Amaral
Juan Francisco Elso
Manuel Felguérez
Agustín Fernández
Teresita Fernández
Ever Fonseca
Gonzalo Fonseca
Lucio Fontana
Julio Galán
Mathias Goeritz
María Elena González
Jorge González Camarena
Felix González-Torres
Robert Graham
Enrique Grau
Sylvia Gruner
José Antonio Hernández-Diez
Luis Jiménez
Marisel Jiménez
Max Jiménez
Kcho
Gyula Kosice
Jac Leirner
Pedro Linares
Benjamin Lira
Carmen Lomas Garza
Marcos Lora Read

Los Carpinteros
Pedro Lujan
Estuardo Maldonado
Marisol
Maria Martins
Roberto Matta
Ana Mendieta
Manuel Mendive
Marta Minujín
Priscilla Monge
José Morales
Óscar Muñoz
Edgar Negret
Manuel Neri
Ernesto Neto
Marina Núñez
Hélio Oiticica
Gabriel Orozco
Mario Orozco Rivera
Rafael Ortiz
Pepón Osorio
Nadín Ospina
Alejandro Otero
Lygia Pape
Alicia Peñalba
René Portocarrero
Raquel Rabinovich
José Resende
Adolfo Riestra
Dhara Rivera
Carlos Rojas
Melquíades Rosario
Soledad Salamé
Bernardo Salcedo
Doris Salcedo
Juan Manuel Sánchez
Mira Schendel
Ray Smith
Orlando Sobalvarro
Jesús Rafael Soto
Pablo Suárez
Rufino Tamayo
Francisco Toledo
Rigoberto Torres
Joaquín Torres-García
Rúben Torres Llorca
Guillermo Trujillo
Tunga
Gastón Ugalde
Meyer Vaisman
Germán Venegas
Cecilia Vicuña
Oswaldo Viteri
David Zamora Casas
Nahum B. Zenil
Francisco Zúñiga

Serigraph

José Montoya

Silkscreen
Noemí Ruiz

Video
Brooke Alfaro
Miguel Calderón
Josely Carvalho
Jaime Davidovich
Eugenio Dittborn
Harry Gamboa, Jr.

Sylvia Gruner
James Luna
Lotty Rosenfeld
Humberto Vélez

Woodcarving
Patrociño Barela
Lilia Carrillo
Nick Quijano
Luis Eligio Tapia

INDEX TO ILLUSTRATIONS

The following index lists the titles of works illustrated in the text, followed by the name of the artist in whose entry the illustration can be found. Artist portraits are not indexed here, nor are untitled works that appear in the text.

NOTES ON
ADVISERS and CONTRIBUTORS

ABERTH, Susan. Visiting assistant professor, Bard College, New York. **Essay:** Leonora Carrington.

ALDANA, Erin. Member, Department of Art and Art History, University of Texas at Austin, and formerly at Museum of Contemporary Art, Los Angeles, J. Paul Getty Museum, Los Angeles, and Blanton Museum of Art, University of Texas at Austin. **Essays:** Carlos Cruz-Diez; Manuel Felguérez; Harry Gamboa, Jr.; Rupert García; Gronk; Willie Herrón III; Cándido López; Eduardo MacEntyre; Tomás Maldonado; Marta Minujín; Alejandro Otero; María Luisa Pacheco; Emilio Pettoruti; Raquel Rabinovich; Lotty Rosenfeld; José Sabogal; Mira Schendel; Lasar Segall; Jesús Rafael Soto; John Valadez; Regina Vater.

ALVARADO RODRÍGUEZ, Eluid. Director of exhibitions, Museum of Latin American Art, Long Beach, California. **Essay:** Luis Hernández Cruz.

ANREUS, Alejandro. Associate professor of art history, William Paterson University, Wayne, New Jersey. Author of *Orozco in Gringoland: The Years in New York,* University of New Mexico Press, 2001. Editor of and contributor to *Ben Shahn and the Passion of Sacco and Vanzetti,* Rutgers University Press and Jersey City Museum, 2001. Contributor to *ArtNexus* and *Encuentro de la Cultura Cubana.* **Essays:** Nemesio Antúñez; Jacobo Borges; Arístides Fernández; Armando Morales; Alejandro Obregón; Juan O'Gorman; José Clemente Orozco; Marcelo Pogolotti; Francisco Rodón; Darío Suro.

ARANDA-ALVARADO, Rocío. Assistant curator, Jersey City Museum, New Jersey, and adjunct lecturer, Rutgers University and Lehman College, City University of New York. Contributor to *Nka: Journal of Contemporary African Art.* **Essays:** Francisco Brugnoli; María Magdalena Campos-Pons; Juan Dávila; María Elena González; Roberto Matta; Catalina Parra; Ernesto Pujol; Jorge Tacla.

BARKER, Carrie. Freelance writer and journalist, London. **Essay:** Robert Graham.

BARNITZ, Jacqueline. Professor of Latin American art history, Department of Art and Art History, University of Texas, Austin, and formerly professor, State University of New York, Stony Brook, and University of Pittsburgh. Author of *Twentieth Century Art of Latin America,* Austin, Texas, University of Texas Press, 2001. Contributing author to *Latin American Artists of the Twentieth Century,* New York, Museum of Modern Art, 1993. Contributor to *Arts Magazine.* Co-curator of the exhibition *Latin American Artists in New York since 1970,* A. Huntington Art Gallery, University of Texas, Austin.

BAZAROV, Konstantin. Freelance writer and researcher, London; also, professional geologist-zoologist. Author of *Landscape Painting,* 1981. **Essay:** Julio Le Parc.

BEDOYA, Roberto. Executive director, National Association of Artists' Organizations (NAAO), Washington, D.C., and formerly project associate and visiting scholar, Getty Research Institute for the History of the Arts and Humanities. Contributor to *Hungry Mind Review, Five Fingers Review,* and *Los Angeles Times.*

BELL, Jane. Contributing editor, *New York Arts Journal,* since 1974; editorial associate, *Artnews,* since 1978; associate director,

International Network for the Arts, since 1979; and senior editor, *The Art Economist,* since 1981. Associate editor, *Art Express,* 1980–81. **Essay:** Alfonso Ossorio.

BENÍTEZ, Marimar. Art historian and critic and, since 1993, chancellor, Escuela de Artes Plásticas de Puerto Rico. Formerly curator of collections, Instituto de Cultura Peuertorriqueña; director of cultural affairs, San Juan city government; and visiting curator and registrar, Ponce Art Museum, where she edited and contributed essays to exhibition catalogs. Author of *Aserrín-Aserrán, obras recientes de Carlos Raquel Rivera,* San Juan, Escuela de Artes Plásticas, 1999, and *Pepón Osorio: Door to Door/De puerta en puerta,* San Juan, Escuela de Artes Plásticas, 2001. Contributor to *Puerto Rico, Arte e identidad,* San Juan, Editorial de la Universidad de Puerto Rico, 1998, *The Latin American Spirit, Art and Artists in the United States, 1920–1970,* New York, Bronx Museum for the Arts, 1988, and the periodicals *Art Journal, American, Plástica,* and *Rivista de la liga de Arte de San Juan.* **Essays:** Carlos Collazo; Lorenzo Homar; Carlos Irizarry; Antonio Martorell; Carlos Raquel Rivera; Dhara Rivera; Nitza Tufiño; Rafael Tufiño.

BERCHT, Fatima. Chief curator, El Museo del Barrio, New York. Author of *Brazilian ex votos: Devotional Sculptures from North-Eastern Brazil,* New York, A. Kren Gallery, 1985. Contributing author to *House of Miracles; Votive Sculpture from Northeastern Brazil,* New York, Americas Society, 1989, *Beyond the Surface: Recent Works by Creus Rabinovich Sutil,* New York, Americas Society, 1990, *Contemporary Art from Chile,* New York, Americas Society, 1990, *Latin American Artists of the Twentieth Century,* New York, Museum of Modern Art, 1993, and *Taíno: Pre-Columbian Art and Culture from the Caribbean,* New York, El Museo del Barrio, 1997, among others. **Essay:** Preface.

BIRBRAGHER, Francine. Contributing editor, *ArtNexus,* Miami, Florida, and independent scholar. **Essays:** Débora Arango; María Fernando Cardoso; Bernardo Salcedo; Fanny Sanín; Carlos Zerpa.

BYRD, Anne. Editor and writer, Antenna Audio, and formerly at Costume Institute, Metropolitan Museum. Author of *Ingres Portraits, Chardin, Vermeer and the Delft School* and *Orazio and Artemesia Gentileschi,* both from Metropolitan Museum, *Sol LeWitt,* Whitney Museum of American Art, *Light! The Industrial Age 1750–1900,* Carnegie Museum of Art, and *Rembrandt's Women,* Toyal Academy, London. **Essays:** Felipe B. Archuleta; Judith F. Baca; Mel Casas; Malaquías Montoya; Ernesto Neto; Frank Romero; Bibiana Suárez.

CAPLOW, Deborah. Visiting lecturer, University of Washington. Author of *Revolutionary Art and the Mexican Print: In Service of the People,* Seattle, University of Washington. **Essays:** Lola Álvarez Bravo; José Chávez Morado; Germán Cueto; Arturo García Bustos; Francisco Goitía; Graciela Iturbide; Leopoldo Méndez; Pablo O'Higgins; Fermín Revueltas.

CARO, Mario A. Professor of visual studies, Evergreen State College, Olympia, Washington. **Essay:** Laura Aguilar.

CAZALI, Rosina. Independent curator and critic in Guatemala. Curator of various exhibitions for the Centro Wifredo Lam, the Bienal de Sao Paulo, the first and second Bienal de Lima, and the Museo de Arte y Diseño Contemporáneo de Costa Rica. Contributor to *ArtNexus*

in Columbia, *Artefacto de Nicaragua,* and centrodearte.com. **Essays:** Rodolfo Abularach; Margarita Azurdia; Moisés Barrios; Carlos Mérida; Isabel Ruíz.

CHÁCON, H. Rafael. Associate professor of art history and criticism, University of Montana, Missoula, Montana. Author of "In the Mind's Eye . . . ," *Folk Art,* "Mr. Imagination and Derek Webster, Self Taught Artists," *disClosure: A Journal of Social Theory,* and "Rudy Autio Drawings," *American Ceramics.* Curator of the exhibitions *Rediscovering Helen McClauslen: Montana Modernist, An Argument for Drawing,* and *Harnessing the Divine,* all at Art Museum of Missoula. **Essays:** Eduardo Abela; Cundo Bermúdez; Mario Carreño; Guillermo Collazo; Carlos Enríquez; Wifredo Lam; Víctor Manuel; Raúl Martínez; Amelia Peláez; Fidelio Ponce; René Portocarrero; Leopoldo Romañach.

COBAU, Sally. Freelance writer. **Essays:** Juana Alicia; Santa Barraza; Norah Borges; Barbara Carrasco; Antonio Dias; Cícero Dias; Fernando Fáder; Juan Francisco González; Leandro Katz; Alma López; César Martínez; José Morales; Marina Núñez; Gabriel Orozco; Patricia Rodríguez; Juan Sánchez; Robert Sanchez; Roberto Valcárcel.

CRARY, Laura J. Visiting assistant professor, Allegheny College, Meadville, Pennsylvania. Author of articles and catalog essays for Whatcom County Museum of Art and History, Bellingham, Washington, and Milagros Gallery, San Antonio, Texas. Contributor to *Studies in Iconography* and *Encyclopedia of Twentieth Century North American Women Artists.* **Essays:** Dr. Atl; Jean Charlot; Saturnino Herrán; Frida Kahlo; Roberto Montenegro; Rufino Tamayo; Germán Venegas.

CRAVEN, David. Professor of art history, University of New Mexico. Author of *Diego Rivera: As Epic Modernist,* GK Hall, 1997, and *The Future That Was: Art and Revolutionary Movements in Latin America, 1910–1990,* Yale University Press, 2002. Contributor of almost a hundred articles and reviews to leading journals in the United States, Canada, Latin America, and Europe. **Essays:** Juan Francisco Elso; Gabriel Fernández Ledesma; Jorge González Camarena; Jesús Guerrero Galván; Tina Modotti; Umberto Peña; Diego Rivera; Alfredo Rostgaard; Orlando Sobalvarro; Leonel Vanegas.

DAMIAN, Carol. Chairperson, Visual Arts Department, Florida International University. Miami correspondent for *ArtNexus* and *Art al Dia.* Author of *The Virgin of the Andes: Art and Ritual in Colonial Cuzco,* Grainsfield Press, 1995, and *Alberto Pancorbo: Laberintos del Alma,* Ediciones Cultural Colombiana, 1994. **Essays:** Luis Cruz Azaceta; Fernando de Szyszlo; Antonia Eiriz; Agustín Fernández; Julio Larraz; María Martínez-Cañas; Emilio Sánchez; Enrique Tábara; Rúben Torres Llorca; Tilsa Tsuchiya.

DAPENA, Gerard. Member, Department of Art History, Graduate Center, City University of New York, and instructor of film and art history courses, Parsons School of Design and City College, City University of New York. **Essays:** Juan Manuel Blanes; Emiliano di Cavalcanti; José Luis Cuevas; Andrés Serrano.

FERRER, Elizabeth. Executive director, Austin Museum of Art, Austin, Texas, and formerly curator and gallery director, Americas Society, New York. Author of *A Shadow Born of Earth: New Photography in Mexico,* New York, 1993, *The True Poetry: The Art of Maria Izquierdo,* New York, 1997, and "Mariana Yampolsky: Una Mirada apasionada," in *Mariana Yampolsky, Imagen Memoria,* Mexico City, 1999. **Essays:** Manuel Álvarez Bravo; Fernando Botero; Tony Capellán; Gunther Gerzso; Salomón Huerta; María Izquierdo; Ray Smith; Patssi Valdez.

GARCIA, Miki. Lila Wallace Curatorial Intern, Museum of Contemporary Art, San Diego, California. Contributor to *Ultrabaroque: Aspects of Post-Latin American Art,* 2000, *Encyclopedia of Sculpture,* 2001, and *Lateral Thinking: Art in the 90's* (forthcoming publication). **Essays:** Celia Alvarez Muñoz; David Avalos; Felix Gonzalez-Torres; Luis Jiménez; Carmen Lomas Garza; Daniel J. Martinez; Armando Rascón; Nahum B. Zenil.

GARCIA, Nora. Freelance writer and contributor. **Essay:** José Guadalupe Posada.

GLUSBERG, Jorge. Director, Centro de Arte y Communicacion, Buenos Aires. Author of *Towards a Topological Architecture,* with Clorindo Testa, 1977; *The Rhetoric of Latin American Art,* 1978; *Socio-Semiotic of Architecture,* 1978; *Myths and Magic of Fire, Gold and Art,* 1978; *From Incan Habitat to the Lima of the Future,* 1979; *The Theory and Criticism of Architecture,* 1979. **Essay:** Luis F. Bénedit.

GONZALEZ, Jennifer. Assistant professor of art history and visual culture, University of California, Santa Cruz. Contributor to *Frieze, World Art Diacritics, Inscriptions,* and various anthologies, including *The Cyborg Handbook, Prosthetic Territories, Race in Cyberspace,* and *With Other Eyes: Looking at Race and Gender in Visual Culture.* **Essays:** Juan Downey; Pepón Osorio; Tunga.

GONZÁLEZ, Julieta. Curator of contemporary art, Department of Painting and Sculpture, Museo de Bellas Artes, Caracas. Contributor to *Revista Extracámara, Revista Imagen, Revista Atlántica,* and *Papel Literario (El Nacional).* **Essays:** Carlos Garaicoa; Gego; Guillermo Gómez-Peña.

GREET, Michele. Member, Institute of Fine Arts, New York University, and adjunct professor, Pratt Institute, Baruch College, and Fashion Institute of Technology. Formerly lecturer, College Art Association (CAA), Barnard College, Bowdoin College, University of Western Ontario, and SUNY Potsdam. Formerly at Museum of Metropolitan Art, El Museo del Barrio, and Americas Society. **Essays:** Camilo Egas; Oswaldo Guayasamín; Eduardo Kingman.

GRISSOM-KIELY, Kay. Associate editor, *St. James Guide to Hispanic Artists,* and formerly member, Department of Art History, School of the Art Institute of Chicago. **Essay:** Marta María Pérez Bravo.

GÜEREÑA, Salvador. Director, California Ethnic and Multicultural Archives, Donald C. Davidson Library, University of California, Santa Barbara. **Essay:** Salvador Roberto Torres.

GUTIÉRREZ-STEINKAMP, Martha. Museum and multicultural specialist/Smithsonian fellow. Author of *Docents: Training or Education,* 1990, *The Forts of Old San Juan,* 1995, *El Balserito/The Little Rafter,* 1996, *Brief History of Cuba for Teachers and Docents,* 1998, and *African Traditions in the Americas,* 1999. Coauthor of *Hispanic Contributions: One Voice-Many Cultures,* 1999, and *Women: Honoring the Past/Challenging the Future,* 2001. Contributor to *Latinos in*

Museums: A Heritage Reclaimed, 1995. **Essays:** Jack Delano; David Alfaro Siqueiros.

HABER, Alicia. Art historian. Contributor to *Grove Dictionary of Art* and *Kunstler Lexicon.* Co-curator of the Cuenca Biennale exhibition, Ecuador. **Essays:** Carmelo Arden Quin; Rafael Barradas; Luis Camnitzer; José Cúneo.

HARPER, James G. Assistant professor, Department of Art History, University of Oregon. Author of *Verso: The Flip Side of Master Drawings,* Cambridge, Massachusetts, Harvard University Art Museum, 2001. **Essay:** Alfredo Volpi.

HEBERT, Mary. Author of *Horatio Rides the Wind,* Templar, 1995. Contributing editor, *Not Black and White: Inside Words from the Bronx Writers Corps,* Plain View Press, 1996, and contributing author, *I've Always Meant to Tell You: Letters to Our Mothers,* Pocket Books, 1997, and *From Daughters and Sons to Fathers: What I've Never Said,* Story Line Press, 2001. **Essay:** Juan Gómez Quiróz.

HEIBEL, Amy. Creative director, Antenna Studio. Author of audio guides for art exhibitions at various institutions, including Whitney Museum of American Art, Los Angeles County Museum of Art, and Art Institute of Chicago. **Essays:** Olga Albizu; Charlie Carrillo; Josely Carvalho; Enrique Castro-Cid; Jaime Colson; Teresita Fernández; Ismael Frigerio; Marcos Lora Read; Los Carpinteros; Gilbert "Magu" Luján; Pedro Lujan; Vik Muniz; Mario Orozco Rivera; Doris Salcedo; Meyer Vaisman; Liliana Wilson-Grez.

HELGUERA, Pablo. Senior education program manager, Solomon R. Guggenheim Museum, New York. Contributor to *ArtNexus* in Columbia and *Tema Celeste* in Milan. **Essays:** Luis Barragán; Cildo Meireles.

HERNÁNDEZ-LEPE, Gabriela. Associate director of exhibitions, Museum of Latin American Art, Long Beach, California. **Essay:** Noemí Ruiz.

HOGUE, Marianne. Member, Department of Art History, Virginia Commonwealth University, Richmond, Virginia. Contributor to *CAA* Review and *SECAC Review.* **Essays:** Olga de Amaral; Anita Malfatti; Cándido Portinari; Antonio Ruíz; Joaquín Torres-García; Remedios Varo.

HUACUJA-PEARSON, Judith. Assistant professor of contemporary Latin American art history, University of Dayton, Ohio. Author of ''Tierra de Vida, the Art of Robert Campbell,'' in an exhibition catalog, Houston, Diverse Works Artspace, 1995. Contributing author to *Chicana Literary and Artistic Expressions: Culture and Society in Dialogue,* Santa Barbara, California, Center for Chicano Studies, 2000. **Essays:** Yolanda M. Lopez; Amalia Mesa-Bains.

INTERLENGHI, Luiza. Member, Department of Curatorial Studies, Bard College, and curator of exhibitions, including at Art in General, New York. Formerly lecturer, Candido Mendes University, School of Visual Arts, Parque Lage, and Centro Cultural Banco do Brasil, Rio de Janeiro. Author of reviews on Brazilian artists. **Essay:** José Resende.

IWASAKI, Hitomi. Associate curator, Queens Museum of Art, New York. **Essays:** Miguel Calderón; Eduardo Costa; Sylvia Gruner; Tonel; Adriana Varejão.

JOHNSON, Kaytie. Independent art historian and curator. Author of *Contemporary Chicana and Chicano Art: Artists, Works, Culture, and Education,* Tempe, Arizona, Bilingual Review Press, 2001. Contributor to *The Bridge Review,* El Paso, Texas. **Essays:** Enrique Chagoya; Ester Hernández; Alfredo Jaar; Richard A. Lou; James Luna; Kathy Vargas.

KALIS, Andrea. Curator of Ancient Americas and African Art. **Essays:** Miguel Covarrubias; Rafael Ferrer.

KARTOFEL, Garciela. Independent art critic and curator. Contributor to *Arte Argentina,* Buenos Aires, Center for Technical Research Editions, 1975, *Cesareo Bernaldo de Quiros,* Buenos Aires, CEAL, 1979, *Naomi Siegmann,* Mexico City, KATUN, 1985, *Jose Luis Cuevas, su concepto del espacio,* Mexico City, UNAM, 1986, *Mathias Goeritz, einem deutsche Kunstler in Mexiko,* Marburg, Germany, Jonas Verlag Publisher, 1987, *Mathias Goeritz-Un artista plural. Conceptos y Dibujos,* Mexico City, CNCA, 1987, and *Visual Arts Editions—The Formal and the Alternative,* Mexico, UNAM, 1991. Contributor to numerous periodicals, including *ArtNexus, Revista del Colegio de Bachilleres, Mexico en el Arte, Plural, Vogue, Reforma, Excelsior, Uno Mas Uno, Avance, Textile Arts, Southward Art, Correo de Arte,* and *G.A.M.* **Essays:** Julio Alpuy; Adolfo Best Maugard; Marcelo Bonevardi; Gonzalo Fonseca; Mathias Goeritz; Marisol; César Paternosto; Regina Silveira.

KUPFER, Monica E. Director, Panama Art Biennial, and adjunct curator, Museo de Arte Contemporáneo, Panama. **Essays:** Sandra Eleta; Julio Zachrisson.

LAHODA, Daniel. Director, Equator Gallery, Boston. **Essays:** Arturo Borda; Enrique Grau; Cecilio Guzmán de Rojas; Estuardo Maldonado; Diógenes Paredes; Oswaldo Viteri.

LEON, Glenda. Editor, *Cúpulas* magazine, and artist. Formerly member, Facultad de Artes y Letras, University of Havana. Author of *La condición performática,* Havana, Editorial Letras Cubanas, 2001. Contributor to *Enema, Noticias de Arte Cubano, La Gaceta de Cuba,* and *Encuentro de la Cultura Cubana.* **Essays:** Tania Bruguera; Ana Mendieta.

LIMA, Marcelo Guimarães. Assistant professor, Visual Arts Department, Sangamon State University, Springfield, Illinois. Contributor to *New Art Examiner, Psychohistory Review,* and *Revista do Museu de Arte Contemporanea.* **Essay:** Maria Martin.

LIQUOIS, Dominique. Freelance art writer and researcher, Paris. Formerly worked with the Galerie Chantal Crousel, Paris, the Galeria Yvan Martin, Mexico City, and the Centre Beaubourg, Paris. **Essay:** Gyula Kosice.

LOCKE, Adrian. Freelance curator. Contributor to *Encyclopedia of Latin American and Caribbean Art,* London, MacMillan, 1999, and *Censorship: An International Encyclopedia,* London, Fitzroy Dearborn, 2001. **Essays:** José Bedia; Pedro Figari; Tarsila do Amaral;

679

Victor Grippo; Guillermo Kuitca; Lygia Pape; Armando Reverón; Francisco Toledo.

LORÍA, Vivianne. Art historian, independent curator, and art critic. Contributor to *Lápiz Revista Internacional de Arte,* Madrid. **Essays:** Francisco Amighetti; Sérgio de Camargo; Mário Cravo Neto; Eugenio Dittborn; Max Jiménez; Iñigo Manglano-Ovalle; Liliana Porter; Rosângela Rennó; Juan Manuel Sánchez.

MARÉCHAL-WORKMAN, Andree. Curator, Berkeley Art Center, and instructor, University of California, Berkeley. Curator, Center for Visual Arts, Oakland, California, 1977–80; Creative Growth Gallery, Oakland, California, 1984–86. Author of the catalogs *The Siegriests: A Family of Artists and Their Work,* 1980; *Robert DeNiro: Recent Paintings and Drawings,* 1981; *Chris Ranes: A Survey of Recent Paintings,* 1983. **Essay:** Mel Ramos.

MARTÍNEZ, Pablo. Artistic director, Guadalupe Cultural Arts Center, San Antonio, Texas.

MASUOKA, Susan N. Art historian. Author of *En Calavera: The Papier-Maché Art of the Linares Family.* **Essays:** Ricardo Legorreta; Pedro Linares.

MAULEN, David. Curator, Third Bienal of Joung Art, National Museum of Fine Arts, Santiago, Chile. **Essays:** José Balmes; Osvaldo Salerno.

McDOWELL, Lola. Member, Department of Art and History, and lecturer, Center of Studies of Women in Society and Museum of Art, University of Oregon, Eugene. Formerly professor, University La Republica, 1994–97. Author of *Licenciada in Art Theory,* University of Chile, and exhibition catalogs, including *Sergio Vallejos Aquarelles,* University La Republica Press, 1994, and *M. Fabegra- V. Bosquejos,* University of Chile Press, 1995. **Essay:** Ricardo Porro.

MINDEROVIC, Christine Miner. Freelance writer. Contributor to *Contemporary Artists,* 1995, *St. James Guide to Black Artists,* 1997, *International Dictionary of Modern Dance,* 1998, *Truthtellers of the Times: Interviews with Contemporary Women Poets,* 1998, *World of Biology,* 1999, *Contemporary Poets,* 2000, and *Contemporary Black Photography,* 2001. **Essays:** Olga Blinder; Angel Botello; Lilia Carrillo; Jaime Davidovich; Antonio Frasconi; Daniel Galvez; Manuel Neri; Cecilia Vicuña; David Zamora Casas.

MOORE, Linda A. Owner, Linda Moore Gallery. Author of *Itarria,* San Diego, California, Rush Press, 1991, *Virginia Patrone: Lo Maravilloso,* Montevideo, Uruguay, Imprenta AS, 1992, and *Drowned Ophelia: DeLoss McGraw,* San Diego, California, Sidekick Press, 1992. **Essays:** Raúl Anguiano; Carlos Capelán; Nelson Ramos; Soledad Salamé; Antonio Seguí.

MOSQUERA, Gerardo. Adjunct curator, New Museum of Contemporary Art, New York, and formerly head, Department of Research, Center Wifredo Lam, Havana. Cofounder and co-curator for first three Havana Biennales. Editor of *Sobre Wifredo Lam,* Havana, Letras Cubanas, 1985, *Plastica del Caribe,* Havana, Letras Cubanas, 1987, *Del Pop al Post,* Havana, Editorial Arte y Literatura, 1989, and *Beyond the Fantastic: Contemporary Art Criticism from Latin America,* London, INIVA, and Cambridge, MIT Press, 1995. Author of

Exploraciones en la plastica cubana, Havana, Letras Cubanas, *Con la primera cantante,* Havana, Letras Cubanas, 1984, *El diseño se definió en octubre,* Havana, Arte y Literatura, 1989, and *Contracandela,* Caracas, Monte Avila Editores, 1995, among others. Contributor to *Aperture, Art & Text, Art Criticism, Art Journal, ArtNexus, Lapiz, Poliester, Third Text,* and others. Co-curator of the exhibitions *Cildo Meireles,* New Museum of Contemporary Art, *Absent Territories* and *It's Not What You See. Perverting Minimalism,* both Madrid, *Arte America,* traveling exhibition, *Los Hijos de Guillermo Tell,* Caracas and Bogotá, and *The Nearest Edge of the World,* traveling exhibition.

NAVAS-NIEVES, Tariana. Curator of collections, Museo de las Américas, Denver, Colorado, and curator of the exhibitions *Diego Rivera: The Brilliance before the Brush, Ancestral Roots, African Rituals in the New World, Images of Devotion in Spanish Colonial America,* and *Reviving the Spirit of Casa Grandes: The Pottery of Mata Oriz.* **Essays:** Patrociño Barela; Arnaldo Roche.

NIEVES, Marysol. Senior curator, Bronx Museum of the Arts, New York. Contributor to *Rimer Cardillo: Araucaria,* New York, Bronx Museum of the Arts, 1998. Curator of the exhibitions *El Ritmo Latino del Mundo,* Flushing Town Hall, New York, and *Game Show: Installations and Sculptures by Willie Cole,* Bronx Museum of the Arts, 2001, among others. Co-curator of numerous exhibitions, including *Artist in the Marketplace* annual exhibitions and *Bronx Spaces,* 1996, all Bronx Museum of the Arts.

PELLEGRINI, Elena. Contributor to *Modern and Contemporary Art of the Dominican Republic.* **Essays:** Jorge Pineda; Belkis Ramírez.

PÈREZ-RATTON, Virginia. Independent curator and artist. Director founder, TEOR/éTica, a project for the research and diffusion of regional art, San José, Costa Rica. Formerly general director, Contemporary Art and Design Museum, Costa Rica, and founder, Atelier La Tebaida printmaking workshop. Author of numerous articles and essays, including ''Mesótica II: Central America/Re-generation,'' in MADC exhibition catalog, San José, 1996, ''Central America and the Caribbean: A Story in Black and White,'' in São Paulo Biennale exhibition catalog, 1998, ''Central America: Beyond Bananas and Volcanoes,'' in Taiwan Museum of Fine Arts exhibition catalog, Taipei, 1999, and ''Cultural Perspectives in a Global World: A View from Central America,'' in *Journal for Humanities* (Amsterdam), 2000. **Essays:** Regina Aguilar; Patricia Belli; Rolando Castellón; Luis González Palma; Marisel Jiménez; Xenia Mejía; Priscilla Monge; Luis Paredes; Juan Luis Rodríguez.

PONCE de LEÓN, Carolina. Executive director, Galería de la Raza, San Francisco. Author of *The Butterfly Effect: Critical Writings on Art and Culture in Latin America,* Bogotá, Villegas Editores, 2001. Contributing author to *Beyond the Fantastic: Contemporary Art Criticism from Latin America,* London, INIVA, and Cambridge, MIT Press, 1995. Contributor to *ArtNexus, Poliester, Parkett, Art in America,* and *Bomb Magazine.*

ROBINSON, William H. Associate curator of modern paintings, Cleveland Museum of Art, and adjunct associate professor of art history, Case Western Reserve University, Cleveland. Contributor to *American Art Review, Apollo, New Art Examiner, Sculpture, Dialogue, Bulletin of the Cleveland Museum of Art,* and *Inland Architecture.* Author of ''Otto Dix,'' in *Modern Arts Criticism,* vol. 2, New

York, Gale Research, 1992, "La Época del Impressionismo," in *Maestros del Impressionismo,* Mexico City, Instituto Nacional de Belles Artes de México, 1998, *Diego Rivera: Art and Revolution,* with Luis-Martín Lozano and Augustín Arteaga, Mexico City, Instituto Nacional de Belles Artes, 1999, "Puvis de Chavannes's *Summer* and the Symbolist Avant-Garde," in *Art History,* New York, Prentice-Hall, 1999, "De Chirico's Forgeries: The Treachery of the Surrealists," in *International Foundation for Art Research,* Journal 4, 2001, and "La Vie: Theater of Life and Philosophical Speculation," in *Picasso: The Artist's Studio,* London, Yale University Press, 2001. **Essay:** Roberto Juárez.

ROCA, José. Curator and critic. Director of temporary exhibitions, Luis Angel Arango Library, Bogotá. Contributor to *Lapiz* and *El Espectador.* Editor of *columna de arena,* an online column on art and contemporary culture. **Essays:** Santiago Cárdenas; Antonio Caro; Beatríz González; Óscar Muñoz; Nadín Ospina; Carlos Rojas; Miguel Rojas.

ROSOFF, Susan Merrill. Curator of education, Orlando Museum of Art, Florida. Contributor to *An American Palette: Works from the John and Dolores Beck Collection,* St. Petersburg, Florida Museum of Fine Arts, 2000. **Essay:** Rigoberto Torres.

SAFONS, Horacio. Regional secretary, AICA Latin America and South Caribbean. Author of *Poemas Amigos,* Buenos Aires, Editorial Arte y Palabra, 1962, *Racconto,* Buenos Aires, Editorial Humanista de Bellas Artes, 1963, *Encuentro con Tarás Shvchenko en su Testamento, Carpeta de Arte Xilografias de Daniel Zelaya,* Buenos Aires, Montanari Editores, 1964, *Xilografias y Poemas,* Buenos Aires, Carpeta de Arte, Ediciones Arte Duro, 1964, and *Arte Argentino Contemporáneo,* Madrid, Editorial Ameris, 1979. **Essays:** Antonio Berni; Ernesto Deira; Jorge Luis de la Vega; Rómulo Macció; Luis Noé; Pablo Suárez; Clorindo Testa; Alejandro Xul Solar.

SAMOS, Adrienne. Editor in chief, *Talingo,* and president, Arpa, a nonprofit foundation for the arts. Contributor to *Temas Centrales,* San José, TEOR/éTica, 2001, *Políticas de la Diferencia,* Valenciana, Generalitat Valenciana, 2001, and *ArtNexus.* Curator of the exhibition *Urban Intrusions in New Panamanian Art,* Bogotá, 2001. **Essays:** Brooke Alfaro; Guillermo Trujillo; Humberto Vélez.

SCHEFCIK, Jerry A. Director, Donna Beam Fine Art Gallery, University of Las Vegas, and formerly curator, Nevada Institute for Contemporary Art, Las Vegas, and Amarillo Art Center, Texas. Contributing writer to *Nevada Historical Society Quarterly* and to numerous galleries, including Old Main Art Gallery, Northern Arizona University, Barrick Museum, Las Vegas, and Salt Lake Art Center, Salt Lake City. **Essay:** Alfred J. Quiróz.

SCOTT, John F. Professor, School of Art and Art History, University of Florida. Author of *Latin American Art: Ancient to Modern,* Gainesville, University Press of Florida, 1999. Contributor to *Hispanic American Historical Review, Handbook of Latin American Studies,* and *Latin America: Perspectives on a Region.* **Essay:** Lola Fernández.

STANFEL, Rebecca. Freelance writer. **Essays:** Carlos D. Almaráz; Jesse Amado; Rolando Briseño; Enrique Camino Brent; Benjamín Cañas; Wilfredo Chiesa; Elena Climent; Isabel De Obaldía; Gonzalo Díaz; Arturo Duclós; Benjamin Lira; Alejandro Mazón; Amado M. Peña, Jr.; Alicia Peñalba; Adolfo Riestra; Luis Eligio Tapia; Toral; Gastón Ugalde; Jorge Vinatea Reinoso.

SULLIVAN, Edward J. Chairman, Department of Fine Arts, and professor of art history, New York University. Curator of exhibitions in the United States, Spain, and Latin America, including at the Guggenheim Museum, New York, and Museo de Arte Contemporáneo, Monterrey, Mexico. Editor of *Latin American Art in the 20th Century,* London, Phaidon, 1996. Author of *Baroque Painting in Madrid: Contributions of Claudio Coello with a Catalogue Raisonné of His Works,* Columbia, University of Missouri Press, 1986, *Women in Mexico,* Mexico City, Fundación Cultural Televisa: Centro Cultural/Arte Contemporáneo, 1990, *Aspects of Contemporary Mexican Paiting,* New York, Americas Society, 1990, and *Fernando Botero: Drawings and Watercolors,* New York, Rizzoli, 1993, among others. Contributor to numerous exhibition catalogs and art publications.

SUTRO, Martha. Freelance writer. **Essays:** Santiago Armada; Jacques Bedel; Noé Canjura; Amílcar de Castro; Rafael Colón Morales; Irene Delano; Marius de Zayas; Diane Gamboa; José Antonio Hernández-Diez; Kcho; Agustín Lazo; Jac Leirner; Leonilson; Ralph Maradiaga; Pedro Meyer; Pablo Monasterio; José Montoya; Rafael Ortiz; Angel Rodríguez-Díaz; Francisco Zúñiga.

ULMER, Sean M. University curator of modern and contemporary art, University of Michigan Museum of Art. Author of *Cuba! The Jay and Anita Hyman Collection of Twentieth-Century Cuban Paintings,* 2000, and *Uncommon Threads: Contemporary Artists and Clothing,* 2001, both from Ithaca, New York, Herbert F. Johnson Museum of Art, Cornell University. **Essays:** Claudio Bravo; Agustín Cárdenas; Ever Fonseca; Guido Llinás; Manuel Mendive; Mariano Rodríguez.

VENEGAS, Haydee. Professor of art history, Escuela de Artes Plásticas de Puerto Rico, and formerly deputy director, Museo de Arte de Ponce, Puerto Rico. Author of essays in exhibition catalogs, including *Francisco Oller: A Realist-Impressionist,* Puerto Rico, Museo de Arte de Ponce, 1983, *Caribe Insular, Exclusión, Frangmentación y Paraíso,* Badajoz, España, MEIAC, 1998, and *Pepon Osorio: Door to Door,* Puerto Rico, Escuela de Arte de Plásticas, 2001. Contributor to *Caribbean Art Criticism: Fashioning a Language Forming a Dialogue,* Barbados, AICA-Press, 1998, *Art and Center of Conflict,* Belfast, AICA-Press, 2001, *ARCO Noticias, Orificio, Archipiélago,* and *Revista América.* **Essays:** Myrna Báez; Ramón Frade; Francisco Oller; María de Mater O'Neill; Miguel Pou; Nick Quijano; José Rosa; Julio Rosado del Valle; Melquíades Rosario.

WHITTET, G. S. Art critic and consultant, London. Assistant editor, 1946–50, managing editor, 1950–58, and editor, 1958–64, *The Studio,* London, and editor, *Studio International,* 1964–66. London art correspondent, *Le Monde,* Paris, 1969–72; London editor, *Pictures on Exhibit,* New York, 1972–80. Author of *Bouquet,* 1949; *London* (in the series "Art Centres of the World"), 1967; *Scotland Explored,* 1969; *Lovers in Art,* 1972. **Essay:** Edgar Negret.

WIDDIFIELD, Stacie G. Associate professor of art history, University of Arizona. Author of *The Embodiment of the National in Late Nineteenth-Centruy Mexican Painting,* Tucson, University of Arizona Press, 1996. **Essay:** José María Velasco.

ZAMUDIO, Raúl. Art historian, critic, and independent curator. Contributor to *TRANS, NYARTS, Estilo, Zingmagazine, Tema Celeste, PART, Journal of the West,* and *The Encyclopedia of Sculpture.* Curator of the exhibitions *Parallax Hotel, Loompanics, Hopscotch,* and *Lost in Space,* all 2001. **Essays:** Francis Alÿs; Waltércio Caldas; Lygia Clark; Lucio Fontana; Julio Galán; Hélio Oiticica; Miguel Angel Rios; Daniel Senise.